WITHDRAWN

art

OVER 2,500 WORKS FROM CAVE TO CONTEMPORARY

FOREWORD BY ROSS KING

LONDON, NEW YORK, MUNICH,
MELBOURNE, DELHI

DORLING KINDERSLEY

Senior Art Editors
Vivienne Brar
Mandy Earey

Designer
Clare Joyce

Production Controller
Sarah Hewitt

Creative Technical Support
Adam Brackenbury

Picture Research
Jenny Faithfull
Sarah Smithies

Managing Art Editors
Louise Dick
Christine Keilty

Art Director
Bryn Walls

Senior Editor
Janet Mohun

Editors
Anna Fischel
Michael Fullalove
Neil Lockley
Ed Wilson

Production Editor
Jonathan Ward

Managing Editor
Julie Oughton

US Editor
Chuck Wills

Publishing Manager
Liz Wheeler

Publisher
Jonathan Metcalf

COBALT ID

The Stables, Wood Farm, Deopham Road,
Attleborough, Norfolk NR17 1AJ

Art Editors
Annika Skoog
Lloyd Tilbury
Paul Reid

Editors
Kati Dye
Susan Malyan
Marek Walisiewicz

BRIDGEMAN ART LIBRARY

Imaging
Dave Nicol
Julian Page
Esmond Bridgeman

Project Manager
Jenny Page

Project Coordinator
Katrien Demoor

Sales Manager
Didier Lenart

First American Edition, 2008

Published in the United States by
DK Publishing
375 Hudson Street
New York, New York 10014

08 09 10 11 10 9 8 7 6 5 4 3 2 1

[AD356—October 2008]

Published in Great Britain by Dorling Kindersley Limited.

A catalog record for this book is available from the Library of Congress.

ISBN 978-0-7566-3972-3

DK books are available at special discounts when purchased in bulk for sales
promotions, premiums, fund-raising, or educational use. For details, contact:
DK Publishing Special Markets, 375 Hudson Street, New York, New York 10014
or SpecialSales@dk.com.

Printed and bound in Singapore by Star Standard Industries

Discover more at
www.dk.com

Foreword
Ross King

Ross King is the author of books on French painting (*The Judgment of Paris*) and Italian art and architecture (*Brunelleschi's Dome* and *Michelangelo and the Pope's Ceiling*). He has also published two novels and a biography of Niccolò Machiavelli. Born and raised in Canada, he now lives in England, near Oxford.

Chief Consultant
Ian Chilvers

Writer and editor, whose books include *The Oxford Dictionary of Art*, *The Baroque and Neoclassical Age*, *A Dictionary of Twentieth-Century Art*, and *The Artist Revealed: Artists and Their Self-Portraits*. Specialist consultant for the 17th- and 18th-century chapters of this book.

Consultants

Prehistory to 1400CE
Dr. Paul Taylor
Deputy Curator, Photographic Collection, The Warburg Institute, University of London. Recent publications include *Iconography without Texts*

Renaissance and Mannerism
Dr. Maddalena Spagnolo
Research Fellow at Villa I Tatti, The Harvard University Center for Italian Renaissance Studies, Florence

19th-century art
Caroline Bugler
Editor of *Art Quarterly* and *Review*, The Art Fund, London. Publications include *Art in Focus: Vienna*

20th-century art
John Glaves-Smith
Writer and former Senior Lecturer in Art History at Staffordshire University, England. Publications include *Contemporary Art* and *A Dictionary of Modern Art*

American art
Dr. Julia Rosenbaum
Professor of Art History, Bard College, Annandale-on-Hudson, New York. Publications include *Visions of Belonging: New England Art and the Making of American Identity*

Latin-American art
Dr. Susan L. Aberth
Assistant Professor of Art History at Bard College, Annandale-on-Hudson, New York, and author of *Leonora Carrington: Surrealism, Alchemy and Art*

Australian art
Dr. Jennifer Mitchell
Honorary Research Associate, Monash University, Melbourne

Indian and Southeast Asian art
Dr. Heather Elgood
Course Director of the Postgraduate Diploma in Asian Art, School of Oriental and African Studies, University of London

Japanese art
Dr. Meri Arichi
Tutor, lecturer, and external academic assistant, School of Oriental and African Studies, University of London

Chinese art
Dr. Alison Bailey
Director, Centre for Chinese Research, Institute of Asian Research, University of British Columbia, Vancouver

African art
Barbara Murray
Writer, editor, curator, and activist for contemporary art in Africa

Contributors

Simon Adams
Anna Fischel
Ann Kay
Dean Kenning
Dave King
Larry Mcginity
Matthew Rake
Nigel Ritchie
Peter Sharrock
Marcus Weeks
Jude Welton
Iain Zaczek

The barefoot, sad-eyed figure wears a yellow robe and perches on a tiny throne. In one hand he holds a book, in the other a staff. He is painted with colors made from insect wings and crushed pearls, and someone once said he looked more like the handiwork of an angel than of human beings.

This image of St. John is found in the library of Trinity College, Dublin, on folio 291v of *The Book of Kells*. It's not always easy to see this astonishing manuscript: the crowds can be enormous and the wait long, and the calfskin pages are under glass and protected by guards. But for a few precious seconds, as you bend over the glass, the centuries fall away and you are arrested by the transcendent skill of a handful of anonymous monks who lived 1,200 years ago. You can understand how that long-ago scholar, Giraldus Cambrensis, got his theory about the angel: the illustrations simply look too delicate, too perfect, for human hands.

Like so many of the other works of art discussed in this wonderful new volume, *The Book of Kells* reveals humanity at its finest. Great art, more than anything else, is the benchmark of human achievement. What links so many of the works featured here is a genius in design, an extraordinary craftsmanship, and an almost supernatural devotion to the task of creation. As the German poet Goethe wrote after visiting Rome in the 1780s, it is impossible for us to comprehend what wonders a human being can accomplish without seeing Michelangelo's frescoes in the Sistine Chapel.

In the pages that follow, we see many more of these marvelous human accomplishments. Art is shown in its many guises: as an object of religious veneration; as a repository of cultural value; as a vehicle of personal expression. A number of the works also showcase another vital

Foreword
by Ross King

feature. As Georges Braque wrote: "Art is meant to disturb." Some of the most valuable works probe, challenge, and shock, forcing us from our routines and preconceptions, making us look anew at ourselves and the world around us. Goya's *Third of May, 1808* and Picasso's *Guernica* are indictments of the savagery of war as forceful and relevant today as when they were first unveiled. The paintings of the Impressionists—beautiful as they might seem to us today—caused outrage in 19th-century Paris because of their deviation from traditional forms. Much 20th-century art has been the sworn enemy of convention, from its unorthodox materials and methods to its questioning of our social, moral, and aesthetic values. Such works may not always be popular or easy to look at, but it's no exaggeration to say that we experience the world differently because of them.

To have so many of these artists, artworks, and artistic movements brought together in a single volume, so beautifully illustrated and eloquently described, is both an admirable feat and a true joy. Leonard Bernstein once wrote: "Any great work of art is great because it creates a special world of its own. It revives and readapts time and space, and the measure of its success is the extent to which it makes you an inhabitant of that world—the extent to which it invites you in and lets you breathe its strange, special air." There are many worlds created here, and to turn the pages is to breathe their strange, special air.

Contents

1945
onward 500

When you look at a work of art you may quickly decide whether you like it or not. But have you ever wondered why some pictures appeal to you more than others? There is no definitive answer to this question, but if you can start to understand how and why the artist created the piece, you will appreciate and enjoy it more.

Looking

Art is rarely created in a moment of inspiration. To understand the artist's aims and intentions there are a myriad of factors to consider—the size is the painting or sculpture, its subject matter or story, and how the different elements of the piece relate to each other. What is the artist's viewpoint and how has she or he used color, perspective, light, and shade—and why? What materials and surfaces have been used, and how do these contribute to the qualities at the finished work?

Looking at Art explains how to "read" a work of art more thoroughly, and understand what the artist was trying to achieve. The section also introduces the language of art, so that you gain the vocabulary to analyze what you see. As you begin to develop an informed sense of why you like some works of art more than others, the experience of looking at art will become more meaningful and enjoyable.

at **art**

Subject and composition

When you look at a work of art, the first question to ask is, what is it about? Once you have established the content, you can consider how the artist has arranged the elements of the piece—the composition. Whether the image is of people, landscape, still life, or abstract, it has to work as an integrated whole, in which the other pictorial qualities such as color, light, and shade also play their part.

Portraits

Knowing that faces always attract attention, the artist has to think how best to present a sitter. Composing a portrait is more than a question of how true a likeness to attempt. Size, scale, shape, and viewpoint are important for all subjects and, for a portrait, the pose and props depend on what the artist and the sitter want to convey. If the sitter has commissioned the portrait, their opinion counts, but a paid model has no say in the composition.

Format

The typical shape for a portrait is the so-called "portrait format," a rectangle that is taller than it is wide. A head-and-shoulders portrait fits neatly into this format, without leaving empty space at the sides or chopping off the top of the sitter's head. Oval shapes are less common but also suit human proportions. Artists do not have to use the portrait format, as they may want to include a broader setting or some space.

◀ ▶ **Classic shape** Here the portrait format has been used to enclose the sitter within a plain background that provides breathing space. *Portrait of a Boy, Rosalba Carriera, 1726*

Size

How big or small a portrait is depends on its purpose as well as practicalities. In general, the larger the image, the more expensive the materials are and the longer it takes the artist. Huge portraits create an impact by their sheer size alone, and suggest that the subject is a god, of noble birth, prominent in society, or wealthy. Small portraits tend to be personal and intimate.

◀ **Miniature** Measuring a mere 5⅜ x 2⅛in, this portrait of an Elizabethan nobleman may have been intended as a love token. *Young Man among Roses, Nicholas Hilliard, c1587*

▶ **Giant-sized** Averaging 36ft high, about six times life size, the massive volcanic stone statues on Easter Island, Polynesia, may be memorials to dead chiefs. *c1000–1600*

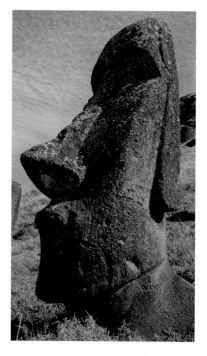

Length

With a portrait, the artist has to decide how much of the sitter to include. A head, shoulders, and upper chest (**1**), often called a bust in sculpture, is the most common format. A half length (**2**) is common for seated portraits. A three-quarter length portrait (**3**) requires some skill to make it look as if it is meant to stop at the subject's knees. Full-length "swagger" portraits proclaim a person's grandeur and superiority.

◀ ▲ **Full-length glamour** Sargent both scandalized and delighted high society in London and Paris with his flattering, elongated swagger portraits. This one is life size. *Portrait of the Countess of Clary Aldringen, John Singer Sargent, 1896*

View

Full-face portraits were originally reserved for God in Christian societies. The ancient Egyptians, however, depicted several viewpoints at once, such as a full-face eye within a profile, something not attempted in Western art until Picasso. The three-quarter view (**1**) is more common, providing a good idea of what the sitter looks like, as is the profile or side view (**2**), which was much used in early portraiture.

◀ ▶ **Looking at you** Full-face portraits can appear confrontational but in this picture the sitter's expression is warm and engaging rather than aggressive. *Madame Antonia de Vaucay, Jean-August-Domique Ingres, 1807*

Scale

Whether the sitter fills the canvas, looming large at you, or is just one of several elements competing for attention within the frame, scale is an important consideration. Psychological portraits tend to go close in on the human form and features. But moving further out and including a setting and props gives the artist an opportunity to suggest more about the sitter's character, interests, and situation in life.

◀ ▼ **Bigger picture** Here the artist could have focused on the sitter's face, but chose to include her plain tea-table and cat too. *Quaker Girl, Grace Cossington Smith, 1915*

Cropping

Sometimes what is left out of a painting says more about the subject than what is left in, intimating life beyond the confines of the canvas. Cropping—deliberately truncating a figure—can make you look afresh at the everyday and can suggest that what we see is not always what it seems. It may also imply that the subject was moving too fast to be captured within the frame or was not posing at all, as in a candid snapshot.

◀ ▲ **Less is more** Bonnard, just visible top left, painted his wife in the bath many times. Cropping both figures makes the image disturbingly voyeuristic. *Nude in the Bath, Pierre Bonnard, 1925*

The multiple portrait

Depicting more than one person presents practical challenges for the artist, who may not be able to persuade all the sitters to pose at the same time. Even if they pose separately, they must look like part of an integrated composition or the completed portrait will look artificial and stilted. The space between the sitters plays a key part in the composition, as does the background, which both encompasses and links the sitters.

Relationships

In multiple portraits the sitters are often engaged in a communal activity, such as feasting, which helps to relate them to each other. If the portrait is of just two or three people, the artist can suggest their relationship by their poses as well as through the composition.

◀ ▲ **Looking out** The banner leads your eye into the painting, and the circular arrangement takes you to each face in turn. The men are all looking in different directions, helping you to understand where they are in the composition. *A Banquet of the Officers of the St. George Militia Company, Frans Hals, 1616*

▲ ▶ **Eye contact** The trust between this pair is emphasized by their gaze of mutual affection. *An Old Man and a Boy, Domenico Ghirlandaio, 1480s*

◀ ▼ **Intimate group** In this study the positions of the hands and arms keep you looking from parents to baby. *Family Portrait, Anthony van Dyck, 1618–21*

Space and form

To suggest isolation, an artist may contrast the solid, positive forms of people with the empty spaces between them, which is often referred to as negative space. These gaps between figures or objects strengthen the composition and can make the characters seem more three dimensional and therefore more convincing.

▶ **Staggered depth** The spaces between the solemn children, emphasized by the dark background, make them poignantly separate. *The Daughters of Edward Darley Boit, John Singer Sargent, 1882*

◀ ▲ **Family split** The sharp division between space and form signals a rift between the sitters. The contrast between the duchess's full-frontal pose and the daughters half out of the picture accentuates the split. *The Duchess de Montejasi and her Daughters Elena and Camilla, Edgar Degas, 1876*

Nudes

The art historian Kenneth Clark pointed out that while being naked was embarrassing, nudity was art. In Christian iconography, nakedness is linked with Adam and Eve's fall from grace. From the Renaissance, however, studying the male nude became essential for anatomical accuracy and classical myth made it more respectable to paint female nudes, who were idealized and made more beautiful and less individual than in real life.

Traditional

"Before dressing a nude we first draw him nude, then we enfold him in draperies," wrote the Renaissance art theorist Leon Battista Alberti. The male nude, exemplified by Michelangelo's works, was active. Artists and patrons were nearly always men, and spying on nude women bathing or asleep became an artistic genre. When awake, nude women tended to recline before an imagined male onlooker in front of the picture.

▶ **Active man** The tradition of nude sculptures of men in upright active poses goes back to classical antiquity. *Bronze Soldier, 5th century BCE*

▼ ▶ **Picture format** A wide format is best suited to portraits of a reclining nude as it allows for the length of her body. Titian set the standard for the genre. *Danae Receiving the Shower of Gold, Titian, 1554*

Modern

While traditional female nudes were meant to be erotic, today's artists aim for psychological realism or to shock. They tend to accentuate the naked truth rather than idealizing the image of women for male delectation.

▼ ▶ **On a diagonal** The model sprawls diagonally across the canvas, cropped at the head and knees to fit the nearly square format. *Naked Woman on a Sofa, Lucian Freud, 1985*

Stories and action

Most art has a purpose. Looking at it is more than an aesthetic pleasure—a work of art has a message. In societies where few people are literate, art often tells a religious story. In Western art, *istoria* paintings that retell stories from history or the Bible were considered the most important form of story painting, followed by classical myths. Genre scenes of everyday life were thought by the art academies to be inferior to both.

◀ **Diptych and triptych** Some altarpieces or smaller portable religious pictures are in the form of a diptych (1) with two hinged panels like a book. A triptych (2) has a central panel and two wings. A polyptych is a more elaborate form of altarpiece with many panels, like the one below.

History

History paintings ennobled the past to create morally uplifting tales that were relevant to contemporary viewers. They are usually on a grand scale (1). David's painting measures a huge 127¼ x 167in. It has classical architecture and motifs (2), dramatic gestures of bravery (3), and ennobled features (4) that emphasize the serious nature of the work.

▲ ▲ **Formal and classical** David specialized in history paintings that likened the ancient Roman Republic to the newly formed French Republic. *Lictors Bearing to Brutus the Bodies of his Sons, Jacques-Louis David, 1789*

Religion

Art and religion have long been linked. Paintings were often commissioned for churches, but may no longer be in their original setting. Church altarpieces were often made in panels and sometimes shaped like a cathedral (1). Key figures of Christianity are the Madonna and Christ child (2). Saints (3) died for their faith, and usually have an object, or attribute, related to their martyrdom, which identifies them. Altarpieces often have a predella at the bottom (4), depicting a series of religious scenes.

◀ ◀ **Christian altarpiece** Typical of the early Renaissance, Mary and Jesus are in the center of this altarpiece, with two saints on either side. *Madonna and Child Enthroned with Angels and Saints, Fra Angelico, 1437*

▶ **African fetish** Traditional African sculpture was made for religious ritual. This piece was used to mediate between the living and the dead. *Kongo container of spirits from the land of the dead, late 19th century*

Genre

In contrast to huge history and religious paintings, genre paintings (scenes of everyday life) are small (1), partly because their subject matter is relatively unimportant and partly because they were made to hang in modest houses rather than churches or palaces. The characters are peasants and the bourgeoisie (2), enjoying pastimes (3) such as drinking, flirting, or gambling. Genre art often has a moral message.

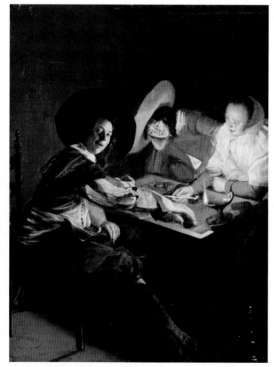

▶ ▲ **Candlelit scene** Genre paintings often showed domestic interiors and included objects with symbolic meanings. The Netherlands was the 17th-century home of the art form. *A Game of Tric-Trac, Judith Leyster, c1630*

Myth

Paintings based on classical myths are often large (1) as they were made for palaces. The main source was Ovid's *Metamorphoses*. The book is about changing form and usually involves a god turning into something else for the purpose of seduction. Nude females (2) abound, as do gods disguised as animals (3), and small Cupids (love figures) (4).

◀ ◀ **Amorous conquest** In this Italian Mannerist painting Zeus, the leader of the Ancient Greek gods, has cunningly disguised himself as a swan in order to seduce a nymph. *Leda and the Swan, Jacopo Pontormo, c1512–13*

Composing a narrative

When a painting tells a story, the artist uses composition to give the work a natural flow that helps the spectator to follow the action. The composition can therefore help you understand what is going on. In a well-made composition the spectator's eye is led to each of the main components of the story in turn by various visual means, such as shapes, linking devices, contrasts in scale, and the use of color.

Balance

All the different components of a picture have to balance each other so that the image works as an integrated whole. There are different ways to go about it, depending on the artist's aim. Some artists want to convey harmony and serenity, whereas others opt for contrast and dynamism or want to create a feeling of jagged discord.

◀ ▲ **Changes in scale** The dramatic contrast between the size of the figures in the foreground, who are so close you can almost hear their conversation, with the scale of the bustling activity on the river leads your eye from the women to the scene behind them. The posts in the foreground also direct your gaze toward the river. *Winter Scene, Yamamoto Shoun, c1900*

◀ ▲ **Harmony** Christ is firmly established as the central figure of this painting because the composition is based upon the most stable of shapes: a triangle with a wide base narrowing to a point at the top of the picture. This creates a feeling of serenity. *The Resurrection, Piero della Francesca, c1463*

◀ ▲ **Diagonals** A walk along one of Oslo's main streets has become a nightmare vision in this painting, as the pedestrians fan out and appear to come right out of the painting toward you. The curves of their cadaverous faces contrast with the strong diagonals of the composition. The solitary figure heading in the opposite direction increases the sense of nightmare and alienation. *Evening on Karl Johan, Edvard Munch, 1892*

Rhythm

A painting or sculpture should have rhythm like a piece of music. Shapes can be repeated or set in oppositon to each other. Visual links and a sense of rhythm are particularly important in a picture where there is a lot going on, or it can look like a jumble of unrelated elements that rapidly lose your attention. The spaces between the shapes are just as important as the shapes themselves and play a vital role in the composition, providing places for moving elements to go. As with all aspects of composition, a unified color scheme and finish, the interplay of light and shade, and the use of perspective all help to weave the action together.

◀ ▲ **Visual flow** In this scene Boucher used a billowing swirl of cloth to create a figure-of-eight design that links the sky and figures and keeps you looking from one to the other. The cloth also echoes the shape of the clouds at the top right of the picture. Fluttering Cupids lead your eye toward Venus, as does the wave of figures undulating from left to right. *The Triumph of Venus, François Boucher, 1740*

Following the plot

Most stories in art taken from history, religion, or myth were known to their contemporary audience but may be unfamiliar now. To help viewers, artists provided visual clues, such as dramatic gestures, or objects, such as attributes, weapons, or crowns, to identify the key characters. The style of dress provides another clue: classical drapery indicates a history or mythological theme, but nudity is rarely a feature of historical tales.

◀ ▲ **Scene of virtue** This painting depicts a popular 17th-century theme, in which Scipio, a Roman general returns a captive woman to her fiancé. Poussin divided the figures into groups. Scipio can be identified by his throne and crown **(1)**, and his magnanimous gesture toward the woman in blue is answered by her fiancé's grateful acceptance **(2)**. The soldiers on the right **(3)** remind you that this is war. *The Continence of Scipio, Nicolas Poussin, 1640*

Landscape

In Oriental, notably Chinese, art, landscape painting has a long history dating back 1,000 years and more. Western landscape painting has its roots in the Renaissance, when religious pictures were first given realistic, rather than gold, backgrounds. Over time the figures became smaller, while the landscape expanded and became a theme in its own right. At about the same time, the idea of what a picture could communicate expanded to include atmosphere and poetry. Landscape lent itself to such treatment.

Format

While a tall rectangle is best suited to portraits, a wide rectangle, known as the "landscape" format, is generally better suited to landscapes. Like using a wide-angled lens in photography, it provides scope for breadth of vision, without too much sky. Artists do not, of course, have to use this format and may choose a portrait format for a landscape—to fit in tall trees perhaps, to emphasize the height of towering mountains, or for a cloud study. To make a really wide painting, an artist can use a panoramic format—a stretched rectangle that is much wider than it is tall.

▼ **Panoramic format** Here the artist has chosen a format that is two-and-a-half times wider than it is tall. The huge size creates a powerful impact. The format suits the depiction of the Roman god of the sea driving the wave forward as a line of white horses. *Neptune's Horses, Walter Crane, 1892, 33⅛ x 85in*

▲ ▶ **Landscape format** In this painting a wide format has been used to good effect, with the horizon a pleasing two-thirds of the way up the canvas. The same scene painted in an upright format might have resulted in the sky and land competing unsatisfactorily for attention. *Classical Landscape, Gaspard Dughet, c1650*

Framing

The standard formula for the ideal classical landscape was established by the French artist Claude. The landcape is usually framed by tall trees in the foreground, which act like curtains on a stage, adding depth to the scene beyond. Claude's landscapes are not real places, but are based loosely upon the landscape around Rome. His framing device has inspired generations of landscape artists.

▲ ▲ **Framing the view** The frame of trees draws your eye into the picture. The weight on the right is offset by the figures pointing to the archway in the middle distance. *Landscape with Hagar and the Angel, Claude, 1646*

Depth

Creating a sense of depth is paramount in traditional landscape painting: the artist tries to make the spectator look from the foreground into the middle ground and then the background. Paths or rivers are an effective route into a picture, as are figures, animals, or other points of interest dotted strategically through the picture like stepping stones to lead your eye toward the focal point.

▼ ▶ **Focal point** The river and rainbow in Constable's painting both lead your eye to the focal point—the cathedral. The river is particularly important because of the way in which Constable has highlighted the water and the light on the field behind, allowing the eye to roam backward and forward across the picture. *Salisbury Cathedral from the Meadows, John Constable, 1831*

Opening out

Artists do not always want to contain a scene within a framing device. Open-sided paintings suggest space beyond the confines of the canvas, widening the pictorial scope. The artist leaves something to your imagination hinting that there is more than literally meets the eye.

▲ **Total picture** Chinese painters aimed to offer a vast and limitless landscape with varying viewpoints—the opposite of the single, fixed viewpoint of the Western spectator. *Mountain View, Ming Dynasty, 1368–1644*

▲ ▲ **Expanding the horizon** The vast expanse of sky above is matched by a seemingly limitless horizontal landscape. The artist has retained interest by alternating areas of light—the sunlit fields, castle, and water—with dark woods, mirrored with subtlety in the sky. *Landscape with Ruined Castle and Church, Jacob van Ruisdael, c1665–70*

Still life

The advantage of a still life over landscapes or portraits is that the artist has complete control over content, composition, and lighting. While painters can edit details of a landscape, there is no need to with a still life. They can select objects and arrange them exactly as they wish, tinkering with the composition for as long as they like, without trying the patience of a portrait sitter.

Composing

Still lifes are generally indoor compositions, but even in the smallest interior the artist wants to convey the interaction of space and form. Still life is a chance for an artist to show his or her skill at creating a balanced, pleasing composition, which shows off colors, forms, contrasts in texture, and their relationships to each other. Try turning a still life upside down—the composition should be just as satisfying as it is the right way up.

◀▶ **Directing the eye** The knife handle projecting from the edge of the table appears to come out of the painting toward you. The artist has placed it there to act like an arrow into the painting. *Copper Cauldron with a Pitcher and a Slice of Salmon, Jean-Siméon Chardin, c1750*

▲▶ **Height and depth** In this Dutch still life the artist has built up height from right to left and given her painting depth by setting objects behind one another. *Still Life of Flowers and Dried Fruit, Clara Peeters, 1611*

▲ **Linking shapes** By repeating similar objects, the artist encourages you to see them as a design in which the spaces between the solid shapes are just as important as the shapes themselves. *Grey Container, Tony Cragg, c1980*

▲▶ **Line-up** The dark background adds an air of mystery to this painting and adds a surreal dimension to everyday objects that are lined up almost as if they were sacred. *Still Life, Francisco de Zuburán, c1650*

Abstracts

Artists do not always want to copy nature: they may use it as a starting point and transform it beyond recognition. Piet Mondrian drew his abstract forms from landscape, but believed if you reduced a picture to its bare essentials you would gain a spiritual experience unhampered by associations with the natural world. Expressionist artists, such as Wassily Kandinsky or Mark Rothko, stylized and exaggerated forms to state their own feelings or provoke a response.

◀ **Geometric abstraction** Sharp-edged rectangular blocks of color are removed from immediate connotations with the natural world. *Train Landscapes, Ellsworth Kelly, 1952–53*

Semi-abstract

In semi-abstract works, there are hints of recognizable subject matter. Some Impressionist paintings are semi-abstract because the subject has been used as a vehicle for showing light effects. Most 20th-century abstract painters went through a semi-abstract phase, but only Monet stayed true to the ideals of Impressionism.

Wholly abstract

The Dutch painter Theo van Doesburg said in 1930 that art had "no significance other than itself" and "nothing is more real than a line, a color, a surface." Art that does not represent the physical world in any recognizable way is called non-representational, or abstract.

▼ **Minimalism** Eva Hesse believed that basic geometric forms, such as a cube, arouse specific emotions in the viewer. *Accession II, Eva Hesse, c1960*

◀ **Fleeting glimpses** In this semi-abstract composition of shimmering colors Monet has tried to capture the ever-changing light made by reflections on water. You can, however, just make out the waterlilies. *Waterlilies and Reflections of a Willow Tree, Claude Monet, 1916–19*

◀▲ **Aboriginal expression** Elements of asymmetry within the overall symmetry make this personal vision an aesthetically pleasing composition. *Men's Dreaming, Clifford Possum Tjapaltjarri, 1990*

Perspective and viewpoint

For artists who want to convey an impression of space and depth, perspective is the key. Some aspects of it can be worked out mathematically, but many artists reach a similar result through intuition. Viewpoint—the position from which both the artist and spectator look at the picture—has a bearing on perspective.

The illusion of reality

Since the Renaissance most Western painters have wanted to make it look as if the picture they are painting on a flat surface is three dimensional—has depth as well as breadth, like the real world. There are many ways to create this illusion, such as making the same object look smaller the further away it is, which the viewer interprets as a visual code for depth. Artists make the most of such visual devices and use them to represent the real world around us. Many, however, from the Ancient Egyptians to modern painters, have had no interest at all in creating the illusion of three-dimensional work.

Picture plane

When painters talk about the picture plane, they are describing the flat surface of the picture as if it were a pane of glass. Artists can accentuate the flatness with a decorative design or they can create the illusion of depth, visually piercing the pane of glass, like a window offering a view of a scene beyond.

◄▲ **Picture zones** This scene has been composed in three zones to give it depth: the foreground (**1**), where most of the action takes place, the middle ground (**2**) where the boats are, and the background (**3**) beyond the aqueduct. *The Finding of Moses, Nicolas Poussin, 1638*

Overlapping

One simple way for artists to give a picture depth is to overlap the figures or other elements of the composition. The viewer reads this as a representation of what happens in the real world—one thing behind another automatically translates as distance. Also, the further away an object is, the smaller it looks.

◄▲ **Layers** Overlapping the horses and jockeys has created a sense of space receding into the distance. *The Race Course, Edgar Degas, c1876–87*

Aerial perspective

Sometimes called atmospheric perspective, aerial perspective mimics the natural effect of light that makes things in the distance appear paler and more blue than those in the foreground. Things also seem closer if they are in sharp focus, but further away if they are hazy. Renaissance artists often accentuated the effects of light on distance by painting the foreground green, the middle ground brown, and the background blue. Later artists tend to blur the distinction between one zone and another.

▲▶ **Hazy hills** Aerial perspective is most effective when painting landscapes. These mountain ranges become blue in the middle distance and paler in the background. *Landscape in the Riesengebirge, Caspar David Friedrich, 1810–11*

▲ **Chinese landscape** The detail in the foreground is crisp and dark, whereas the craggy outline in the background is faint. The middle ground bridges the distance between the two. *Willows and Distant Mountains, Ma Yuan, Song Dynasty (960–1279)*

Linear perspective

◄▲ **Getting narrower** The sides of the road seem to meet at a vanishing point (**1**). The small figure on horseback draws your eye into the painting, taking you down the road. *The Poplar Avenue, David Cox, c1820*

If you look down a straight road, the sides appear to converge in the distance. Eventually they seem to join up, at a point known as the vanishing point. You know that the road sides do not actually meet, but you interpret it as a sign of distance. Artists exploit this mathematical law of linear perspective, also called single viewpoint perspective, or one-point perspective, to convey space.

FORESHORTENING

Foreshortening—making an object look shorter than it really is to create the illusion of recession—is an extreme example of linear perspective. The term is often applied to the human body when shown in poses that compress its length. It makes the part nearest you look larger than those further away.

▼ **Master of foreshortening** In this Renaissance picture Christ's body looks very short and his feet appear larger than his head. Perspective had just been discovered, and the foreshortening would have been even more startling to contemporary viewers than it is now. *The Dead Christ, Andrea Mantegna, late 15th century*

Viewpoint

You automaticallly stand further away from a large picture than a small one, to take it all in. It's also natural to peer closely at a detailed image, then move back to look at loose brushwork, for example. If you are in an art gallery, the picture you are looking at was probably intended for a different setting, such as a church, a palace, or a house, so you are at the mercy of the curator's decision on how high to hang it. In fact, the artist had already decided on which viewpoint to use before he started work on the painting. From the Renaissance until the 20th century, when many rules about how to convey depth and reality were broken, most artists took a single viewpoint. They stood in one place and simply painted what they saw from that spot.

Portraits

Whether the painter is looking up or down at their sitter affects the psychological impact of the portrait, just as a conversation between a standing person and a seated one puts the two on an unequal footing. If the artist—and, therefore, the viewer—looks up at the sitter, the sitter appears powerful and dominant. If you look down on the sitter, the roles are reversed: you are in the position of strength and the subject of the portrait looks vulnerable as a result.

Looking up Despite his youth, the young Italian nobleman in this painting looks haughty and imperious because the artist was looking up at him and therefore gave him the psychological advantage. *Portrait of a Halberdier, Jacopo Pontormo, c1528–30*

Looking down By looking down at himself and bringing his face right into the foreground, the Expressionist painter Kirchner emphasizes his frailty. The exaggerated perspective, which makes the bedstead look large in relation to the window, heightens the effect. *Self-portrait as an Invalid, Ernst Ludwig Kirchner, 1917–20*

SPATIAL DISTORTION

Distorting the perspective, or including two or more different perspectives, is unsettling as your brain cannot follow the visual conventions normally used to make things look real. Some painters, such as Paul Klee, play around with perspective with childlike glee, while others, such as de Chirico, change the rules to disturb you and make you feel you are dreaming. Cézanne changes his viewpoint to mimic how you look at objects in real life, moving around and looking at them from here and there.

Odd perspective In this painting de Chirico has created a visual cul-de-sac with a wooden path that ends abruptly. The effect is surreal. As if on a diving board, you are dared to jump into the street beyond, where the buildings look like dolls' houses compared with the mannequins in the foreground. *Disquieting Muses, Giorgio de Chirico, 1925*

Landscapes

The horizon line in a landscape equates to the painter's eye level. The artist can maximize the amount of land visible by taking a mountain top viewpoint and looking down over lower ground. The highest viewpoint is a bird's eye view, in which the artist looks straight down at the landscape below. A worm's eye view, from which the artist looks up, as if lying on the ground, is at the other extreme. Some artists shift viewpoint within a painting.

High horizon Although you are looking down at this landscape, there is also a sense of a shifting viewpoint, as you can see it from several angles, particularly in the foreground. *Rocks at l'Estaque, Paul Cézanne, 1879–82*

Low horizon The Dutch made a virtue of their flat country, creating a national tradition of landscape painting. Here the artist has taken a low viewpoint that emphasizes the expanse of sky. He has contained the landscape with a frame at the left but suggests it is endless at the right. *Dutch Landscape with Skaters, Salomon van Ruysdael, 17th century*

Light and shade

Like perspective, lighting is a tool that artists can use to make a painting look realistic. Showing the play of light makes objects look three dimensional even on a flat canvas. They are paler where the light falls and darker in shadow. Seeing color in terms of black and white is called "tone."

Direction of light

When looking at an artist's use of light, the first point to consider is its source. The easiest way to determine this is to look at the direction of the shadows and see where the highlights fall. This helps you work out how high or low the light source is as well as where it is coming from. Whatever the direction, artists interested in realistic depiction tend to light their pictures from the side or another angle, to create tonal contrasts. Screwing up your eyes makes it easier to see where the main areas of light and dark in a painting are. Sometimes a painting is lit from more than one angle. The sun is the main source of natural light. In an indoor scene daylight might come through a window, or the artist may use artificial light, which remains constant and can be controlled.

Front lighting

When the light shines straight from the front, it spotlights the action in the foreground of the painting. It bleaches people and objects, and casts shadows behind them. You cannot see the shadows. It is more common with front-lit paintings to angle the light from one side or the other, creating visible shadows to help define shape and form.

▲ ► **Falling light** Here the light source is shining down from the top center left of the canvas toward the kneeling Lady Jane. It throws her pitiful figure into sharp, pale relief against the darker backdrop and picks out the face of her lady-in-waiting. *The Execution of Lady Jane Grey, Paul Delaroche, 1833*

Back lighting

Particularly effective in landscapes, back lighting makes the horizon glow and draws the eye toward it. Backlit figures or objects look dark and indistinct but have an aura of light around them. As with front lighting, it is rare to have the light source pointing straight at the viewer because everything would be in shadow.

◄ ▲ **Sunny glow** Here the sun is low over the horizon, casting long shadows toward the viewer. *A Seaport, Claude, 1639*

Side lighting

Light shining from either side works well for portraits and still lifes because it creates an even division of light and shade. The artist can show the full tonal range of the subject matter, which helps to define shapes and make things look convincingly solid. Indoors, the light may come from a window, sometimes shown in the painting, or be artificial, in the form of a candle, a lantern, or a light bulb.

◄ ▲ **Realistic lighting** Here Vermeer used side lighting, to help him model light and shade on the girl's face. The light comes down at a slight angle to highlight her vibrant hat. *Girl with a Red Hat, Jan Vermeer, c1665*

Three-quarter lighting

◄ ▲ **Tonal range** The shadows in this still life point diagonally down to the right, throwing the objects into relief. *Still life with Dead Birds, Fruit and Vegetables, Juan Sanchez Cotan, 1602*

A light source near one of the top corners of the canvas is also popular for indoor subject matter. It creates a full range of tones and seems to push the objects forward, making them appear more solid and realistic.

Lit from within

Sometimes a painting has no external light source, as the light comes from within the picture and radiates outward. An inner light source creates an intimate feel that suits certain types of painting, such as genre (scenes of everyday life). It is particularly apt for religious scenes, in which the light emanates from holy beings and symbolizes godly powers.

◄ ▲ **Inner light** In this scene, light helps you to see the birth as the shepherd does. The light from the Christ child leads the eye out in all directions and is reflected in Mary's face. *Nativity Scene, Antonio Correggio, 1522–30*

Quality of light

As both its source and quality affect how light reveals form, the artist not only has to decide what direction the light will come from, but also what kind of light it will be. Light contributes to the mood of a painting. It can be soft and gentle or harsh and razor sharp. It may cast a garish glare or be as uplifting as a summer's day. It can create a claustrophobic atmosphere or an elating feeling of freedom. Like all aspects of looking at a work of art, light does not work in isolation but blends with color, style, and technique to create an overall harmony. Not all artists want to paint naturalistically. For those who want to depict inner truths or a spiritual world, reality, in terms of tonal contrasts, is less significant and the lighting can be uniform and flat.

Diffused lighting

◄▲ **Soft tones** Fog envelops Friedrich's landscape like a blanket. The snow and the pinkish sky create two faint sources of light. Apart from the dark tree standing out against the snow, there are only subtle tonal variations from light to dark in the foreground, middle ground, and background. *Winter Landscape, Caspar David Friedrich, c1811*

Dim lighting subdues a painting. It creates neither highlights nor noticeable shadows and narrows the range of tones. The artist may choose naturally diffused light, such as mist, or filter artificial sources of light.

Colored lighting

◄▲ **Brightness** The midday sun fills this scene with golden light and creates a warm feeling. *Apple Picking at Eragny-sur-Epte, Camille Pissarro, 1888*

Light can dominate a painting. Coloring the light draws attention to it and affects the painting as a whole, just as a tinted filter suffuses a photograph. Colored lighting creates a mood, whether sunny or sad. If the light is colored, the shadows are too. The tonal contrast is narrower with colored lighting because even yellow is darker than white. Its corresponding shadows are therefore lighter in tone than black.

Flat lighting

Apart from some Chinese painting, light and shade is a European obsession, particularly from the Renaissance until the Modern era. Artists who are not concerned with imitating the physical world do not need to use light and shade to make people think that their paintings or drawings are three dimensional.

▲ **Spirit worlds** The path taken by the soul on its journey to the other world is in a stylistic language that excludes light effects. *Aboriginal bark painting, undated*

◄ **Color relationships** The visual language of this painting does not rely on tonal contrast or trying to make things look three dimensional. *Blue Red, Ellsworth Kelly, 1964*

Strong lighting

Bright light creates sharp tonal contrasts with brilliant highlights and dark shadows, and throws detail into focus. Strong lighting works best when it comes from an angled source to emphasize the play of opposite ends of the tonal range. The Italian word *chiaroscuro* (meaning light-dark) is sometimes used to describe how artists distribute light and shade to depict form.

◄▲ **Gritty realism** The strong light in this painting creates dramatic tonal contrasts and focuses the eye on the most important point in the story— St. Thomas's contact with Christ's wounds. *The Incredulity of St. Thomas, Antonio Caravaggio, 1602–03*

Spot lighting

◄▲ **Shaft of light** Artistic device and symbolism are fused in this painting. The moonlight symbolizes the Roman moon goddess Diana and draws attention to the beautiful face and form of Endymion, sent to sleep forever in return for perpetual youth. *The Sleep of Endymion, Anne-Louis Girodet, 1791*

Another dramatic way to light a painting is to focus a beam of light on one area. As on a stage, it focuses your attention on the spot-lit section, thrown into dramatic relief by the surrounding deep shadow.

HIGHLIGHTS

Artists use highlights to show pinpricks of light. They can make a surface look shiny or show movement on water. Because highlights are the lightest tones in a picture, they catch your eye, like a lit window on a dark night. In oil painting, artists traditionally work from dark to light and add highlights last. Thick paint can heighten the impact. Highlights do not have to be white to be effective: Velásquez, for example, also used lemon-yellow and pale orange.

◄ **Glints** Touches of white make the glaze of a humble earthenware pot sparkle. *An Old Woman Cooking Eggs, Diego Velásquez, 1618*

Media and techniques

Pigment—powdered color—is suspended in a liquid medium to create paint. The medium can be oil, egg, or just water, and when it dries, it binds the paint to the support (working surface). Drawing materials are different as they are already dry. Granules of pigment stick to fibers in the paper. Sculpture has its own set of media: mainly stone, metal, or wood plus a host of modern materials. Each medium has its own techniques. Some media dictate the artist's technique; others are more versatile.

MEDIA AND TECHNIQUES

24

LOOKING AT ART

Early media

When it came to paintings, medieval and early Renaissance artists only had one option: egg tempera on panel (wood). The type of wood depended on what grew locally and this is used by art historians as a clue to the country of origin. Italian panel paintings of the 14th to 16th centuries are generally on poplar, Flemish artists worked on oak, and Germans on pine, fir, linden, or oak. Alternatively, early artists could paint murals, in the form of frescoes, which were popular in Italian churches and chapels. Medieval and Renaissance artists worked to commission, usually to produce work on a religious theme.

Egg tempera

Vibrant and crisp, egg tempera is stable, durable, and the colors remain strong. The medium, however, is egg, usually just the yolk, mixed with water to make a creamy paste. Egg dries in minutes, so the a;rtist cannot blend colors on the surface of the picture or use impasto (thick paint). He has to build up thin layers of paint, using small hatching strokes—lines side by side—to create form. This demanding medium was superseded by oil paints but has been revived several times in recent centuries.

▶ **Egg tempera on poplar** Early Italian painters prided themselves on mastering the technical difficulties of egg tempera. Many worked in the Byzantine style of the time, using much gilding. *The Transfiguration of Christ, Duccio, 1311*

▲ **Cross section of panel support** Planks of wood were glued together and planed until smooth (**1**). They were then covered with several layers of white gesso in Italy, or chalk in northern Europe, mixed with animal-skin glue (**2**) before being painted (**3**) and gilded (**4**).

▲ **1. Underdrawing** Working from preliminary sketches, the artist makes a detailed underdrawing on the top, thinnest layer of gesso or chalk. The drawing shows through where the paint has thinned.

▲ **2. The paint layers** The drapery of the kneeling figure is painted with green earth and lead white. Magnified x 380, some black drawing particles are visible between the paint and the gesso.

▲ **3. Cross section of gilding** The lines showing the folds of Christ's ultramarine robes are gilded, following the Byzantine tradition. This magnification of x130 shows the gilding on top of the paint.

▲ **4. Fragment of gilding** Magnified x185, you can see the thin gold leaf has worn away from Christ's robes, revealing the yellow-brown of the mordant size that Duccio used to glue on the gold.

Fresco

The artist traces a cartoon (detailed drawn plan) on to the wall and paints water-based pigment straight on to wet plaster, hence the word fresco, meaning "fresh" in Italian. The wall has to be painted in sections. When the plaster dries, the fresco is part of it and will last as long as the plaster. Artists can paint on to dry walls, which is easier, but the paint is liable to flake off because it has not bonded with the surface of the plaster. Fresco is only practical in dry climates like that of Italy, as damp damages plaster.

▲ ▶ **Restoring frescoes** Earthquakes are the biggest threat to frescoes in Italy. Restorers try to replace any missing fragments, not to hide the original work or "improve" it with additional paint. This fresco in S. Francesco Church, Assisi, was completely restored after an earthquake in 1997. *Four Fathers of the Church, Giotto, 1290–95*

◀ ▲ **Visible joins** Giotto, who painted all four walls of the Scrovegni Chapel in Padua, had to estimate how much work he could do each day, as just that area of wall was plastered first thing in the morning. A face might take a whole day, while flat areas of color were quicker. Colors had to be matched from one section to another: where the colors do not match, the joins show. These are called *giornate*, from the Italian word for "day." *Baptism of Christ, Giotto, 1303–05*

Oil painting

In oil paints the medium is a vegetable oil that dries naturally when exposed to air—olive oil is no good. Linseed oil is the best and most commonly used, although walnut oil was sometimes used in 16th-century Italy, and poppy seed oil in Dutch and French paintings of the 17th and 19th centuries.

The introduction of oil paint made artists' lives easier and the new medium had replaced egg tempera by the mid-16th century. Oil paint is easy to work and the artist can create a variety of finishes. Venetians started working on canvas and this lighter form of support also gained widespread popularity.

Preparing an oil painting

As for egg tempera, the support—be it wood panel or canvas—has to be prepared for an oil painting. Layers of gesso or chalk mixed with animal size create a smooth, absorbent ground, which can be sealed to prevent subsequent layers of paint sinking in. Oil paintings are usually varnished, to intensify the color, show up details, and add gloss. The varnish darkens with age, lasting less well than the paint beneath.

◄▼ **Layers of a panel painting** The ground layer of chalk and animal glue (**1**) was sealed with an isolation layer (**2**). The artist probably added the black particles (**3**) to darken the layer of green paint (**4**). Once dry, the painting was varnished (**5**). *Last Judgement, Jan van Scorel, c1550*

Glazing

Oil paints can be transparent as well as opaque. The artist applies thin layers of paint, letting each layer dry before adding the next, to build up complex, luminous layers of translucent color. This classic use of oil paint, known as glazing, was perfected by the Flemish painter Jan van Eyck. He often glazed over an opaque underlayer of tempera.

▲▶ **Depth of color** Like laying sheets of cellophane on top of one another, each layer of glaze changes the color of those above and below it. This effect can be seen in the turban. *A Man in a Turban, Jan van Eyck, 1433*

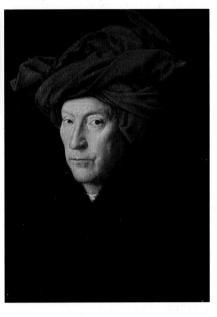

Seamless blending

"All [oil painting] asks of the artist is care and love, for oil in itself possesses the property of making color smoother, softer, more delicate, and more easily harmonized and shaded", wrote the Italian art historian, Giorgio Vasari, in 1550, thrilled by the medium. One of the joys of oil paint is that the artist can work at leisure all over the painting – unlike egg tempera or fresco, both of which demand a piecemeal approach. Oils can be blended on the surface of the painting, to create smooth transitions from one color to the next without leaving any visible brushmarks.

▲▶ **Subtle tonal shifts** In this Dutch still life, the artist has made full use of the versatility of oils, mimicking the fall of light to model form and show surface textures. Such realism was simply not possible with earlier media. *Vanitas, Pieter van Steenwyck, 17th century*

▲ **Cross section of a canvas support** Steenwyck's painting is on canvas, made of linen and stretched taut (**1**). It was then coated with a glue-sizing ground (**2**), before being painted (**3**), often in several layers, and varnished (**4**).

OIL ON COPPER

Flat copper is rigid, as long as it is small, and provides a smooth, non-absorbent surface. It is suited to detailed painting and jewel-like color with good contrast of light and shade. Some artists, such as Elsheimer, made a career out of painting on copper.

◄ **Grandeur on a small scale** The detail in this painting on copper is exquisite, despite the small scale of 11¾ x 9¾in. *Ceres and Stellio, Adam Elsheimer, c1600*

Painting with a knife

Oil paint is usually diluted with turpentine or similar solvent (not water, which will not mix with the oil), to make it more runny and easier to work. The thinner also makes the paint dry more quickly. However, oils can also be used really thickly, without being diluted, in a technique called impasto. While Old Masters tended to reserve impasto for pale, opaque highlights, modern painters sometimes revel in thick paint for its own sake.

▶ **Troweling it on** Frank Auerbach is renowned for his flamboyant use of impasto, in which the marks of the palette knife are strikingly apparent. *Head of Gerda Boehm, Frank Auerbach, 1965*

▲ **Application** Cranked shaft and straight palette knives are available for impasto knife-painting.

▼ **Impasto cross-section** Instead of smooth, thin layers, the canvas (**1**) is loaded with thick, craggy paint (**2** and **3**).

Media on paper

Paper is absorbent but, unlike canvas, is not strong enough to take layers of priming and oil paint. It is, however, ideal for drawings in a variety of media as it is light and portable. Paper is made up of a web of fibers that file off particles of lead, charcoal, or whatever the artist is drawing with. Even paper that looks completely smooth has enough fiber to catch all drawing media. Heavier papers are suitable for watercolor, a water-based paint that is usually applied in thin washes. Textured papers tend to be used for their interesting surface rather than any specific function.

Watercolor

Built up in washes of delicate color, watercolor is transparent and lets the white of the paper shine through. It is good for sketching as all the artist needs is cakes of paint, water, and brushes. Watercolor can also be used for more detailed work by letting one layer of paint dry before applying another.

▶ **Wet-on-wet** Washes of paint have been applied to wet paper for the canal. The artist has sponged out areas of paint to create highlights. *Palazzo Dario, Venice, Hercules Brabazon Brabazon, c1870*

◀ **Fine detail** Watercolor is traditionally used for botanical, bird, and animal illustrations. It combines the detail of a drawing with the color of a painting. *Golden Pheasant, Ch'ien-lung period (1736–95)*

Pastel

▲ **Highlights** Degas let the tinted paper show, to make highlights on the dancers' shoulders and arms. Its pallor stands out against the predominant deep blue.

▲ **Vivid sketch** Degas described himself as a colorist with line, using pastel as a bridge between drawing and painting. *Blue Dancers, Edgar Degas, c1899*

Pastels—sticks of color bound with gum or resin—have existed in their modern form for over 200 years. They come ready-mixed in a range of tints and shades and are applied directly, usually to mid-toned paper. Hatching (parallel lines), as on the back of the central dancer above, is one way of creating tone in this versatile medium. Colors can also be blended or layered.

▲ **Strength of color** Blending blues on the paper creates a matte, dense area of blue on the dancer's bodice.

Conté crayon

Named after Nicolas-Jacques Conté, an 18th-century French scientist, conté crayons can be used on their side to build up tone or held like a pencil for linework. The pigment in conté crayons is bound with a waxy or oily substance, so they are harder and less crumbly than pastel or chalk. The particles stick to the paper and do not need fixing (spraying with liquid resin to hold them in place).

▶ **Velvety tones** Seurat is renowned for his tonal drawings in conté crayon. He created tone solely with differing pressure. *Study for "La Grande Jatte", Georges Seurat, 1884*

◀ **Conté crayon colors** From the left, sepia, sanguine, and bistre are the core earth colors. White and black are common, too, and nowadays a wider range of colors is available.

Pencil

Rods of graphite—a carbon mineral—encased in wood date from the 16th century. Confusingly, until about 1800, the word "pencil" was used to mean a small brush. Nicolas-Jacques Conté created pencils of differing hardness, which were used to great effect by French artists such as Ingres and Géricault.

▲ **Crosshatching** The tone on the horse's flank was created with crosshatching (a lattice of parallel lines). *Rearing Stallion Held by a Nude Man, Théodore Géricault, c1820*

Ink

First used in China and Egypt around 2500 BCE, when blocks of lampblack ink were mixed with water, ink is suitable for writing or drawing — Chinese artists combine the two. It can also be used for detailed work.

▼ **Pen** Drawn freely with a sparing use of line, this drawing is all the more expressive. *Yvette Guilbert, Henri de Toulouse-Lautrec, 1894*

▲ **Brush** In this Chinese painting poetry and image are integrated calligraphically with ink. *A Chicken, Cockscomb, and Chrysanthemum, Li Shan, 18th century*

Charcoal

Dating back to ancient Rome, charcoal is easy to rub off on the drawing surface. It is therefore a favored choice for underdrawing, because it is easy to correct mistakes and its impermanence does not matter if it is going to be covered up. As a finished work, it must be sprayed with fixative (liquid resin) for the drawing to last.

◀ **Light and dark** The tonal and linear potential of charcoal are exploited to record the grooves and hollows of the man's face. *Head of a Man, Lucian Freud, 1990*

▶ **Willow charcoal** Charcoal sticks make a smudgy gray mark. Charcoal also comes in compressed form, which creates an intense, velvety black, or pencils, which are easiest to handle.

Chalk

This medium, used in prehistoric cave paintings, came into its own in the High Renaissance in the hands of Leonardo and Michelangelo and, later, Rococo artist Watteau. White chalk came from limestone, red from red earths, and black from stones such as shale. Nowadays, chalk pigments are often made synthetically, bound, and then pressed into sticks rather like pastels or conté crayons.

▲ **Human form** Red chalk is used to describe how the muscles ripple as the body moves. *Study for the Creation of Adam, Michelangelo, c1508*

Printmaking

The advantage of prints is that the artist can reproduce the same image over and over again. The picture is printed from a metal plate, wooden block, or other surface on to a sheet of paper. There are two main types of print: in relief prints such as woodcuts or linocuts, the parts to print black are left in relief and the remainder cut away. Intaglio prints, such as engravings and etchings, are passed through rollers like a mangle and ink is forced into incised furrows. The more recent technique of lithography is a surface method in which the print is taken from a flat slab. The antipathy of grease and water separates the areas that receive or reject the printing ink. Screenprinting is a stencil method, in which color is brushed through on to the paper beneath.

Woodcut

▲ **Graphic image** Belgian graphic artist and painter Frans Masereel gouges out the areas to be white in the printed sheet. Woodcuts create strong images with tonal contrast. *The Kiss, Frans Masereel, 1924*

For a woodcut, the drawing is transferred to a woodblock. The blank areas are gouged away, leaving the drawing in relief. The drawing prints black and the other areas stay white. The printmaker cannot vary the depth of color as the relief surfaces are of equal height. The raised strips of wood have to be thick enough to withstand the pressure of printing, so the result is bold and graphic.

Lithograph

The design is drawn with greasy chalk on to limestone or a synthetic equivalent (often zinc or aluminum today), which absorbs both grease and water. When the drawing is completed, the stone is wetted. Water only penetrates the part of the stone that is free from grease. Greasy ink is rolled on to the stone. It is repelled by the wet surface but sticks to the greasy chalk and can then be transferred to paper. Multicolored prints can be made by inking different parts of the stone with different colors.

▲ **Posters** Multicolored lithography was used to make eye-catching advertising posters in the 19th century. The technique allows the artist to combine line and color. *The Simpson Chain, Henri de Toulouse-Lautrec, 1896*

▼ **Personalizing a print** A large part of the American artist Jasper Johns's output is prints. Here he is shown working on a wax model for an embossed lead version of *Numerals* in 1968.

Etching

▲ **Free-flowing lines** Rembrandt was as great a graphic artist as painter. His etchings show the free-flowing lines typical of the medium. Tone is created by hatching (close parallel lines). *Self-portrait with Wife, Rembrandt, 1636*

A metal plate is covered with an acid-resistant layer of wax or resin and the lines of the image are scratched into it with a needle. When the plate is placed in an acid bath, the metal exposed by the drawn lines is eroded by the acid. The plate can then be inked and printed.

Engraving

The engraver incises the image on to a metal plate. The deeper the furrow, the stronger the line. The plate is inked, then wiped clean so that ink is only left in the incised lines. The plate and a dampened sheet of paper are then passed through the rollers of the printing press. The pressure forces the paper into the inky grooves of the plate and the image is transferred to the paper.

▶ **Sharp versus grainy** The engraver uses a tool called a burin. Its shaped metal point cuts a V-shaped groove (**1**), producing a sharp, clean line. Etching lines tend to be slightly fuzzier, with a granular texture (**2**) where the acid seeps out.

◀ **Hard lines** Dürer's work shows how fine and clear engraved lines are. This demanding technique requires great control and precision on the part of the engraver. *Nemesis (The Great Fortune), Albrecht Dürer, c1501–02*

Screenprint

A refinement of the stencil printing used by textile printers, screenprinting was adopted by artists in the United States in the 1930s. A finely meshed silk screen is stretched over a wooden frame, then a cut stencil design is attached to it, and paper placed underneath. Color is forced through the unmasked area of the screen, leaving the cut stencil image on the paper.

▲ **Printing process** The stencil is put in place, ready for the color to be pressed through on to the paper beneath.

◀ **Bold design** Screenprinting is an ideal medium for producing graphic blocks of strong color, as in this design. *Start 2000, Bridget Riley, 2000*

Modern media

The explosion of new media in the 20th century prompted a reappraisal of the whole purpose of art. Artists no longer had to reproduce reality faithfully as photographers could do it better, and films took on many of the traditional narrative roles of painting, such as stories of battles and religious or historical subjects. The invention of new materials also gave artists scope for different methods of working. Acrylics revolutionized painting in the 1950s and 60s, and plastics and polymers led to innovations in three-dimensional work.

Collage

In the early 20th century, the Cubists Pablo Picasso and Georges Braque made collage, traditionally used in scrapbooks, into an art form. A collage (from the French verb *coller*, meaning to stick or glue) is a composite image made by sticking newspaper cuttings, photographs, and other printed images on to a flat surface, often combined with paint. By definition, collage uses mixed media—more than one medium—in a single work. Mixed media can also mean using more than one type of paint, or both painting and drawing media.

◀▲ **Modern statement** Scraps of newspaper, factory chimneys, and stick-like figures are juxtaposed on brown paper to suggest the bleakness of life in an industrialized world. *Industrial Landscape, Julian Trevelyan, c1950*

Acrylics

After centuries of oils dominating painting, acrylics were developed in the 1940s. Made from pigment, acrylic polymer emulsion, and chemicals that control texture, stability, and durability, acrylics can be thinned with water and used like watercolor, or applied thickly like oils, with the advantage that they dry within hours. Acrylics can be applied to all types of surface, on their own or with other media, and act as a glue and sealant in collages. They come in a huge array of colors and finishes.

▲ **Acrylic palette** Colors come in a variety of consistencies, from fluid to paste-like, and adding water makes them more liquid. They are also available with different intensities of pigment and various finishes: matte, shiny, or metallic (as above), as well as opaque, semi-opaque, or transparent.

▲ **Thick paint** By adding an impasto medium, Hoyland makes acrylic so thick that it stands out in relief from the surface of the painting. *Farewell Paradise, John Hoyland, 1995*

▶ **Shiny surface** In this minimalist painting, fine, vertical lines of graphic on a smooth layer of acrylic bear no trace of the artist's hand. *Untitled No 12, Agnes Martin, 1990*

Assemblage

Assemblage is a three dimensional form of collage. The French artist Jean Dubuffet coined the term in 1953 to describe a collage, made from objects such as household items, which transforms everyday things into a work of art. The word is used more loosely to apply to photomontage—sticking parts of different photos together to make an image—and ready-mades such as Marcel Duchamp's *Fountain* (see p.467), tableaux, and installations.

▼ **Found objects** A miscellany of items including a paintbrush, hat, spoon, and stick, has been used here to create a mixed media assemblage. *Saddle, Provisions, Tools for the Primary Surveyor, Tim Storrier, 1982*

Installation

Installations are site-specific three-dimensional works. They are not made traditionally, but are assembled from everyday objects so that the artist can dismantle the work and recreate it elsewhere. It is important that the artist's hand is not as visible in the work as it would be in a painting or sculpture.

▲ **Stained glass wall** This installation consists of colored glass framed with steel rods. Although the materials are relatively conventional, the vast size is typical of this recent genre of art. *The Glass Wall, Brian Clarke, 1998*

Sculpture

Sculptors carve hard materials such as stone, wood, or ivory, but model soft materials such as clay, building up the object rather than chiselling it away. Sculptures made from metal are either cast or welded together. Sculptures on buildings are in relief—meaning that they project from the background to a greater (high) or lesser (low) extent. In the past, relief was often used on tombs, sarcophagi, or bronze doors, to depict stories in three dimensions.

Stone

Marble (rock that formed when limestone recrystallized) and stone are very hard, and sculpting them is physically strenuous. This may be one reason why early statues were stylized—they were easier to carve than realistic work. The tools used by sculptors today are the same as in Michelangelo's time: flat- and toothed-claw chisels, drills to create tracks and holes, hammers, and files to reach into areas such as armpits.

▼ **Sculptor at work** Eric Gill chisels away at his sculpture of Prospero and Ariel, one of four external groups he was commissioned to make in the 1930s for Broadcasting House, the headquarters of the BBC in London.

▲ **Work in progress** This unfinished work shows how Michelangelo "released" a figure from a marble block. It is one of a series of four for the tomb of Pope Julius II. *The Awakening Slave*, Michelangelo, 1519–20

Bronze

Most sculptures made of bronze, an alloy of copper and tin, are created using the lost-wax technique (see box far right), which works on a similar principle to making ice cubes. The bronze is cast from a mold. Since the 18th century, this has often been made in sections (called a piece mold) so it can be removed and reassembled to make a copy of the sculpture. Up until then, the mold had to be broken in order to remove it, so only one sculpture could be made.

▲ **Sculptor's studio** Henry Moore worked in stone, wood, and bronze as well as making drawings and etchings. Cast bronze became his favored medium towards the end of his life.

◄ **Bronze sculpture** With the lost-wax method, the model can be scaled up or down to change the proportions of the finished sculpture and the castings can be made in several versions. All metal develops a patina (surface coloration). This is often greenish on bronze. *Warrior with a Shield*, Henry Moore, 1952

Wood

Like stone, wood is carved, but it is not as hard, making it easier to work. Some woods, such as linden (lime), are particularly soft and can be carved in great detail, hence the tradition of limewood carving around 1500 in Germany, where it was used for altarpieces. Woods such as oak and walnut are harder to carve, but are less likely to rot in damp conditions.

▼ **Wooden figure** Few of these wooden Polynesian ancestral figures or deities survive today because 19th-century Christian missionaries destroyed them. *Nude figure from Raratonga, Cook Islands, undated*

▲ **Painted wood** Nowadays, sculptors emphasize the natural color and grain of wood, but in earlier centuries it was common to paint all carved wood. *Swedish ship's figurehead, 18th century*

LOST-WAX TECHNIQUE

To make a bronze, the sculptor starts with a model of the desired form. By the lost-wax technique, the model is coated in wax and encased in plaster (**1**). The wax is replaced by molten bronze. Once the bronze has solidified (**2**), the plaster mold is broken off. The final bronze can be smoothed and polished (**3**). *Working Model for Draped Reclining Mother and Baby, Henry Moore, 1982*

1

2

3

Color

Color is often one of the most exciting components of a painting, but what exactly is it? Understanding the basic principles of color theory helps you to analyze how artists exploit and manipulate it in their work. They use color together with composition, perspective, and light and shade to strengthen the impact of the subject matter.

Mixing and comparing colors

The properties of light make colors visible. Light travels in waves of different lengths, and our eyes (and brains) perceive different wavelengths as different colors. The range of wavelengths you can see is called the visible spectrum: the shortest visible wavelengths appear as violet, and the longest as red. Artists use paint made from powdered pigments that absorb some wavelengths and reflect others. Like all colors in the physical world, the colors in a painting are actually the colors of reflected light.

The color wheel

Artists' understanding and use of color was revolutionized in the 19th century, partly thanks to a French chemist Michel Eugène Chevreul. When he was working as the Director of Dyeing at the Gobelins tapestry workshops near Paris, Chevreul realized that colors appeared brighter or duller depending upon the color they were placed next to in a design. To demonstrate how colors modify each other, Chevreul created a color wheel. It shows the three primary colors—red, yellow, and blue—and various mixtures of secondary colors, which are made by mixing two primaries. Chevreul's theories underpinned the Impressionist painters' use of color in the late 19th century. In earlier centuries, artists had used color intuitively.

▶ **Technical tool** The color wheel links the colors of the rainbow in a circle. The colors are red, orange, yellow, green, blue, and violet (purple).

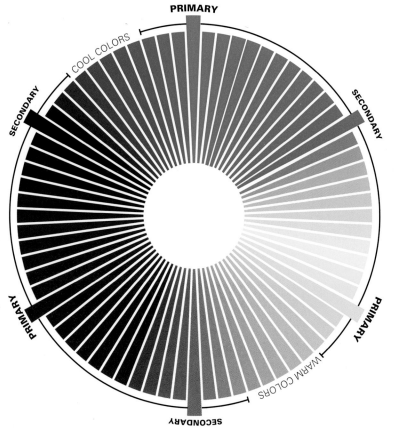

Primary and secondary

Red, yellow, and blue pigments cannot be mixed from other colors, which is why they are described as primary. All other colors can be mixed from primaries, starting with the secondaries, made from any pair out of red, yellow, and blue.

▲ **Making secondaries from primaries** Mixing red and yellow makes orange; yellow and blue make green; and blue and red make purple.

More color mixtures

When a primary and secondary color are mixed together, they make a tertiary color (also called an intermediary), such as yellow-green or red-purple.

▲ **Tertiaries** Red and orange combine into red-orange, and blue and green create blue-green.

Warm and cool

Colors are sometimes described by their "temperature". Warm colors are those in the red–orange–yellow range. Cool colors are on the opposite side of the color wheel —those in the blue–green–violet range. While warm colors appear to advance toward the viewer, cool colors recede.

▲ **The two extremes** Red is hot and fiery and leaps out at the viewer; blue is more understated and drifts into the background.

Complementary

Each primary color is opposite a secondary on the color wheel. These pairs of colors are as different as can be in terms of tone or temperature and visually vibrate against each other. They make each other look brighter when they sit side by side.

▲ **Color contrast** The complementary pairs are yellow and purple, blue and orange, and red and green. Yellow and purple are tonal opposites, while the other two pairs contrast in temperature alone.

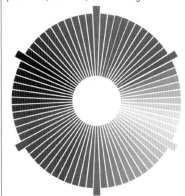
Intensity

Pure pigment looks vivid and can be described as "saturated." Its saturation can be weakened with water or another thinner, or by mixing in another color. Pure color is bright; when mixed it looks duller. Dull in this sense does not mean dreary—it is just the opposite of bright. Intensity also varies to the viewer according to how bright or dull the surrounding colors are.

▲ **Bright and dull** Red, like any color, can be made duller by diluting the saturation of the pigment (above left) or adding another color (above right). Pure red looks strong and is likely to make any colors next to it appear duller by contrast.

Translucence

Some paints, for instance, watercolor, are translucent—you can see through them. Others are opaque, covering up colors beneath. Oil paints and acrylics may be translucent or opaque, depending on the particular paint and how it is used.

▲ **Opacity** If one color completely covers an underlying layer (above left), it is opaque. Translucent paint allows underlying layers to shine through and modify colors above (above right).

How artists use color

In nature and in art, color has a profound effect on the viewer. Artists can choose and use color naturalistically—to recreate the colors they have seen in a landscape, for example. By convention, grass is green and water is blue but on a closer look they may be made up of many different colors.

However, artists do not have to imitate the colors they see in the physical world. In both figurative and abstract painting, color can be used for its decorative beauty, to create a mood, or to express or arouse an emotion. It can be also be used symbolically.

Creating impact

Colors that are close together on the color wheel (see opposite) harmonize with each other when an artist places them side by side in a painting. For the opposite effect, to make colors demand attention, an artist can use complementaries. Impressionists and modern artists deliberately exploit the visual impact of opposite colors, but painters instinctively juxtaposed complementaries for centuries before the theory was known.

▲ ▼ **Complementary pairings** The orange-reds of the boats and their reflections contrast with the bright green weeds. Likewise, the yellow highlights of the masts contrast with the complementary violet shadows.

▲ **Playing with primaries** This painting celebrates the bold, childlike freshness of primary colors. Pure black and white are neutral and, like primaries, cannot be made by mixing other colors together. *Gouache, Alexander Calder, 1974*

▲ **Light on water** Monet was fascinated by the ever-changing shimmer of light on water and used Chevreul's theory (see opposite) to recreate what he saw. He questioned the convention of blue sky or green leaves, preferring to paint the colors he saw, including vividly colored shadows. *Argenteuil, Claude Monet, c1872–75*

Distance

One of the ways an artist creates the illusion of space on a flat canvas is to use aerial (also called atmospheric) perspective. Distant objects appear progressively paler and bluer, because the shorter blue wavelengths travel through the atmosphere more easily than the longer wavelengths. Artists can apply this principle by using blues and grays to give depth in landscapes. It also works to imply distance in more confined spaces.

▲ ▼ **Warm and cool** In this landscape Turner exploits the push and pull of warm and cool colors. Warm golds in the foreground advance, and hazy blues recede toward the horizon. *Lake Constance, JMW Turner, 1842*

▲ ▶ **Hot colors** Cézanne made the fruit stand out in this painting by using warm colors that instantly catch the eye. Visually, he pushed the cloth, bowl, and background away by making them bluish, to accentuate their distance from the warm fruits in the foreground. *Fruits, Paul Cézanne, 1879–80*

Expressing emotion

Expressions such as "feeling blue" and "seeing red" have come about because color has an emotional effect independent of its subject matter. Wassily Kandinsky, one of the most significant figures in the development of abstract art, thought artists should use form and color not to copy objects but to express emotion and to arouse feelings in the viewer. It is not just bright primaries and secondaries that create a mood. Intermediary or tertiary colors, such as brown, mixed from primary and secondary colors, also affect the viewer, but have a more subtle effect.

◀ **Tranquil blue** This composition is divided so that the left side relates to worldly existence and the right to the spiritual. The right side is dominated by "heavenly," "restful" blue. *Improvisation 19, Wassily Kandinsky, 1911*

▶ **Reflective mood** The muted, monochromatic palette—limited to tones of brown, with contrasts of black and white—contributes to the stillness and serenity of this domestic scene. *A Woman Sewing in an Interior, Vilhelm Hammershøi, c1900*

Pigments

The finely ground substance that provides color when mixed with liquid to form paint is called pigment. It does not dissolve, or it would be dye. A pigment can be used in different media, such as oils or watercolor, with some provisos: fresco pigments, for example, need to be alkaline-resistant to cope with lime plaster. Traditional Renaissance pigments came from minerals such as rocks and earth—which were made into artificial compounds, such as lead-tin yellow—or came from organic sources. Indigo, for example, was made from a plant and cochineal from insects. Vegetable-based pigments tend to fade with time, whereas other pigments may darken. The transparent green glaze from copper resinate gradually turns brown over the centuries.

Primaries

The most prized blue is ultramarine, made from the mineral lapis lazuli. It had to be extracted from a single source of mines in what is now northeast Afghanistan. Ultramarine was so expensive that patrons specified, sometimes in a separate contract, where in a painting they wanted it to be used—usually on the Madonna's cloak. Cheaper blues, such as smalt, were used for the sky. The only intense red was vermilion, which was either made naturally from cinnabar, a mineral, or prepared synthetically. Lead-tin was an early yellow; yellow ocher was also popular.

◄▲ **Yellow ocher** This pigment has been used for Judas's robe, applied full strength for the shadows in the folds of cloth, and mixed with white to create the highlights. *Betrayal of Christ, Scrovegni Chapel frescoes, Giotto, c1305*

▲▶ **Ultramarine and vermilion** Here, the most beautiful blue, ultramarine, has been used for Ariadne's robe and vermilion for her sash. Both preserve well in oil paint, although this picture has been restored. *Bacchus and Ariadne, Titian, 1520–23*

Earth colors

Warm, natural siennas, umbers, and ochers, which make dull reds and mellow yellows, were the staple pigments of the Renaissance and Baroque palettes. Earth colors were stable in oil paint and cheap. They could either be used raw or roasted like coffee to create a richer color. Some artists, including Rembrandt, primed the panel or canvas with an earth color mixture that glowed through the subsequent layers of paint. Any cool colors used contrasted with the overall warmth of the painting.

◄▲ **Burnt sienna, Spanish brown, and burnt umber** The thick white and gray strokes of the shift and the slightly blue-tinged flesh tones stand out against the underlying earth colors that suffuse this painting with warmth. *Woman Bathing in a Stream, Rembrandt, 1654*

Black and white

▲ **Tonal contrast** Lead white was used for the ruff in this painting. It makes a striking contrast to the background and draws attention to the sitter's face. *Portrait of a Man, Frans Hals, c1643–45*

Carbon-based blacks included charcoal and the warmer bone black, the precursor of ivory black. Lead white dominated easel painting and, in oils, acted as a drying agent. The faster an oil painting dried, the better it was preserved.

PREPARING PIGMENTS

Renaissance painting was a team effort. Apprentices spent about four years learning their trade, starting with mixing colors. They could collect their own earth pigments and buy in the rarer ones. They had to grind the pigments until they were fine enough to be evenly suspended in the medium and make the strongest color possible. Once they had mastered prepararing materials, apprentices moved on to drawing and painting.

▶ **Azurite** This purplish blue pigment acquires a green tinge when it is ground up, making it too green for sky. It was widely used in the Renaissance, as an undercoat or as a cheaper alternative to the fabulously expensive ultramarine.

◄ **The medieval artist's studio** This illuminated manuscript shows a female artist painting an icon of the Madonna and Child in egg tempera. Her brushes are laid out behind her, and an apprentice is grinding pigment with a stone. The pigment was mixed with egg just before use, as egg tempera dries quickly. *French School, 1402*

Technological advances

At the end of the 18th century, a wider range of stable pigments was discovered and by the mid-19th century a huge number of strong new colors had emerged. Packaging methods also improved, making paints portable and far more easy to use. These advances transformed the ways in which artists worked and also opened up painting to the amateur artist.

19th century

Before the 19th century, artists had a limited range of pigments at their disposal. Towards 1800, chromium was discovered and chrome yellow, viridian (chrome green), and cadmium yellow, orange, and red became available to buy. Naples yellow replaced lead-tin yellow. In the 19th century, a whole raft of artificial dyes produced mauve and more stable blues and greens, such as emerald green (later found to be toxic) and cobalt blue. These pigments were strong in color, cheap, and synthetic, and they worked in every medium from oils to watercolor. Even ultramarine was now made synthetically, and called French ultramarine.

▶ **Portable materials** Manet painted his Impressionist friend Monet at work outdoors, something neither could have done without portable easels, canvases, or tubes of ready-prepared paints. *Monet in his Floating Studio, Édouard Manet, 1874*

◀ ▶ **Complementaries** Renoir has used blue against the orange boat, to make it look vibrant. A cross-section of the water (right) reveals pure cobalt blue painted over light green. *Boating on the Seine, Pierre-Auguste Renoir, c1879*

▶ **New colors** The cross-section of the rushes shows that Renoir made full use of the new range of 19th-century colors. The new green, viridian, is laid over chrome yellow.

20th century

The invention of new painting and three-dimensional media in the 20th century was matched by a vast range of pigments, textural possibilities, and finishes. Computer-generated art has widened the artist's possibilities still further and technological advances gather pace in the 21st century.

◀ **Wide range** Just as with household paints, artists can now buy a vast range of colors ready mixed, in every medium.

▶ **Flat, bold colors** Modern media, such as acrylics and screenprinting, can mimic the effects of newsprint or posters with areas of flat, matte color that mask the artist's hand. Matte need not mean muted; in this screenprint garish color is combined with an impersonal touch that disturbingly dehumanizes the glamorous face of Marilyn Monroe. *Green Marilyn, Andy Warhol, 1962*

▶ **Graphic quality** Acrylic on tarpaulin has been used to create an image with bold color, thick outlines, and a strong impact. *Untitled, Keith Haring, 1981*

▲ **Monet's palette** Monet is best known for the brilliance of his colors, which he used unmixed. Ironically, in early works he mixed new pigments to make dull colors when he could have used pure earth pigments.

▲ **Pig's bladder bag** Prepared paint first appeared in the 17th century but the bags it came in tended to burst. They had to be punctured for use, which made any leftover paint dry out and go hard.

▲ **Collapsible tubes** In 1841, light, airtight metal tubes of paint were invented. This meant that oil-painters could work outside and sketch, as if they were using watercolors or drawing.

GOLD AND PRECIOUS METALS

Gilding was the standard backdrop for religious pictures, symbolizing the heavenly realm, before realistic settings and landscapes became popular during the Renaissance. Gold was also used for haloes. Gold leaf was laid or stuck on to the dampened area, often spread with red clay to give a warm underglow. The gilded area was then tooled—given patterns with a punching tool—so that it shimmered and sparkled in the candlelight. Occasionally artists used powdered gold paint, called shell gold because it was kept in a mussel shell. Silver leaf was sometimes substituted for gold.

◀ **Medieval gold** Early Florentine tempera artists made lavish use of gilding, giving their paintings a magical, luminous quality. *Miracle of the Dragons from the Altarpiece of St. Matthew, Andrea and Jacopo di Cione, c1367–70*

▼ **Metallic acrylics** Artists today still use metals for decorative effect. Metallic pigments, acrylic, aluminum, brass, and collage were used to create this homage to the stars. *Lunetta con Constellazioni, Lucio del Pezzo, c1965*

33

Brushstrokes and texture

A sculpture is tactile as well as three dimensional—touching it is as much a part of experiencing it as looking at it. Paintings have texture, too: smooth and flat, or ridged and lumpy depending on how thickly the paint has been applied. The paint finish may be matte or glossy; varnish makes it shiny.

The artist's hand

Fashions change as to whether artists want you to see their brushstrokes in their work. During some periods they have favored a high degree of finish, in which the artist's technique conceals all traces of the working process. The finish, combined with skillful use of perspective and tone, helps to create a realistic illusion of the physical world. At other times, artists have taken great pride in revealing the craftsmanship in their work.

Invisible traces

Some media are more forgiving than others. Because egg tempera dried so fast, artists had to paint with tiny brushstrokes, just visible to the naked eye. Oil paint enabled them to conceal their brushwork in a fluid blend on the canvas or panel. Invisible brushwork reached the peak of its popularity in 19th-century traditional works, and was partly responsible for provoking later artists to daub—and in the 20th century even pour—paint on. A counter-reaction to this has led to some artists creating ultra-smooth surfaces, helped by the new acrylics.

▶ **Sculptural realism** Tura was working when oil painting first became popular and he used both oils and egg tempera in this work. Blended brushstrokes with crisp highlights convey stiff folds of cloth, as if the figure were a sculpture. *St. Jerome, Cosimo Tura, c1470*

▲ ▼ **Smooth flesh** Cabanel was a leading light of French Academic painting. His slick, highly finished handling of oil paints made flesh in his paintings look completely smooth—the acceptable face of female nudity posing as high art on the pretext of retelling a classical myth. *Birth of Venus, Alexandre Cabanel, 1863*

Visible brushstrokes

Oil paints give artists the choice of whether to hide or show their brushstrokes. Some Old Masters, including Velásquez and Rembrandt, made visible brushmarks. The invention of tube paints in the late 19th century made it easier for artists to use thick, undiluted paint. If you look at a painting from the side, you can see how thick the paint is.

◀ ▼ **Thick impasto** Kossoff's work is characterized by craggy impasto—thickly applied opaque paint— and heavy black outlines. *Portrait of Father No. 3, Leon Kossoff, 1972*

▲ ▶ **Slabs of paint** Van Gogh is known for working at feverish speed, but his brushstrokes are actually laid down carefully and precisely. They sit side by side in series of lines and differently colored dots, with the canvas visible in between. *The Garden at Arles, Vincent van Gogh, 1888*

▲ ▶ **Conveying movement** Renoir blurred one shape into another, using his long brushes (right) to create feathery strokes of varying size and direction. The rapid brushstrokes convey the impression of scudding clouds and windblown grass. *The Gust of Wind, Pierre-Auguste Renoir, c1872*

Surface appearance

How a painter applies paint or a sculptor finishes the surface of a sculpture gives the work the characteristic imprint of the artist. Both paintings and sculptures can look smoothly polished, or textured and pitted. An artist may adopt a spontaneous, fluid style that leaves you free to supply the missing information or provide every detail for you—either approach can look realistic.

Identifying the artist

Each artist's brushstrokes are unique, just as handwriting is. When experts want to determine whether a painting is genuinely by the artist to whom it is attributed, or which parts of a work were by an Old Master, such as Rubens, and which parts were delegated to his workshop, they analyze the brushstrokes. Even when two artists work in the same period and on the same subject matter, as in these paintings of Venice, their personal style is recognizably different.

▲▼ **Fluid brushwork** Guardi also painted scenes of Venice but in a much looser style than Canaletto. His canal waves do not conform to a set pattern, but vary with the changing weather conditions. *Rio dei Mendicanti, Venice, Francesco Guardi, c1750*

▲▶ **Linear precision** Long before postcards, Canaletto painted scenes of Venice for people on the Grand Tour. He painted waves with a characteristic curved white line. *Bridge of Sighs, Venice, Canaletto, c1740*

Chinese brushstrokes

In the early 6th century, Chinese scholar Xie He set out six principles of painting, the second of which refers to brushwork. Brushstrokes, according to him, are the "bones" of the painting and give it its structure. Through each brushmark, the painter should express the spirit that flows through everything in the universe. The vitality of the brushwork conveys the energy of life and breath. The way the Chinese use brushes is often described as calligraphic because it is like handwriting—and Chinese works of art frequently combine image and writing.

▲ **Confident brushwork** Sparing use of line is fleshed out with tonal washes. The inscription balances the composition. *Figure painting, Li Keran, c1950*

◀ **Brush and ink** Chinese brushes tend to be larger than European ones and have a fine tip. Ink traditionally comes as an inkstick, ground on an inkstone with a little water.

Sculpture

Both wooden and marble sculptures were often painted until the Renaissance, though the pigment seldom survived the centuries. Later sculptors preferred to let the nature of the material, such as the grain of the wood or the smooth coldness of marble, show. Metal sculptures can be left to patinate (develop a surface film). As natural patination can take centuries, sculptors since the Renaissance have added acid to speed up the process of creating a mellow surface appearance.

◀▲ **Smooth surface** The Italian sculptor Canova worked mainly in marble. The smooth white finish is typical of neoclassical sculptures, modeled on classical examples in the mistaken belief that they were not painted. *Cupid and Psyche, Antonio Canova, 1783–93*

▲ **Rough and lumpy** The Swiss-born sculptor Alberto Giacometti works on a clay model for one of the many elongated figures he made in the mid-20th century. The roughly kneaded surface accentuates the edginess and fragility of the spindly figure.

▼ **Bronze with patina** Bronzes usually develop a patina of green oxidation. The weathered-looking surface incrustation forms an integal feature of this outdoor sculpture. *Sea Form (Atlantic), Barbara Hepworth, 1964*

When four boys were playing in the woods at Lascaux in France in 1940, they little expected to come across cave paintings of bulls dating back to about 15,000 BCE. Some cave paintings, found in Australia, Africa, and Europe, date back even earlier. While scholars can find out how and roughly when the earliest art was made, they will probably never be sure why. The same goes for much paleolithic, neolithic, and Bronze Age art.

Prehistory

3000 BCE	2000	1000	750	500

ANCIENT EGYPT c3000–300

EUROPEAN BRONZE AGE c2500–800

GREEK ARCHAIC c700–c480

MINOAN c3000–1100

GREEK CLASSICAL 480–323

MYCENAEAN c1500–1100

CHAVIN c850–200

The Ancient Near East saw the rise of the first cities and city-states in Mesopotamia (modern-day Iraq). Temple complexes combined worship and business, and in these places archaeologists have discovered cuneiform tablets showing the earliest system of writing as well as figure sculptures whose size attests to their importance.

Fascination with Ancient Egypt has rarely dimmed since Napoleon's army went up the Nile in 1798. The discovery of more than 100 mummies in 2000 fueled yet more interest in the era. Similarly, Ancient Greece and Rome, from the

Minoan civilization on Crete, home of the legendary Minotaur, through the Athenian democracy in the 5th century BCE, and on to the wall paintings discovered in Pompeii and Herculaneum, have been a continual cultural influence. Islam, Buddhism, and Hinduism inspired art in the East, while the Maya developed the pre-eminent civilization in pre-Columbian America and, in Western art, Christian iconography gathered strength.

to **1400** CE

0	500	1000	1200	1400

BYZANTINE 330–1453

CAROLINGIAN c750–c900

OTTONIAN c900–c1050

ROMANESQUE c1000–c1200

HELLENISTIC c323BCE–27BCE

GOTHIC 1140–1500

INTERNATIONAL GOTHIC c1375–1425

NAZCA 400BCE–600CE

VIKING c800–1050

MAYA 300CE–900

MOCHE 0CE–c600

KHMER EMPIRE 802–1431

TEOTIHUACAN c50CE–600S

◀ **Horses and Deer** *Sometimes known as "the Sistine Chapel of Palaeolithic Art," Altamira in Spain is famed for its lifelike depictions of animals. Dating from c1300 BCE, the cave paintings capture the creatures sense of movement and the texture of manes and fur.*

deliberately left uninhabited; in many cases, too, images were drawn on top of earlier paintings, which would detract from any decorative effect they might have. The most common theory is that the act of drawing the animals formed part of some magic ritual that was designed to bring the cavemen better hunting.

The oldest examples of prehistoric art date from the Upper Palaeolithic. The first artists adorned their caves with a wide range of engravings and paintings. The latter were produced with a limited range of earthy colors—blues and greens were rarely available. The pigments were obtained mainly from mineral extracts, mixed with animal fat or blood.

in a more cursory manner. Abstract signs are plentiful, but are much harder to interpret.

There is considerable debate over the purpose of the animal paintings. Some may have been decorative, but there are good reasons for believing that they fulfilled some ritual purpose. Often, they were produced in parts of a cave that were barely accessible, where they could never have been seen properly; sometimes, they were located in areas where no human debris has been found, suggesting that these were sacred spots,

Subjects

The most popular subjects were animals. Human figures were less common and were generally portrayed

Prehistoric cave paintings are as beautiful as they are mysterious. No one can be sure of their purpose, but they provide a tantalizing record of the earliest days of human existence, along with an insight into the first stirrings of art itself.

CURRENTevents

Lower Palaeolithic Era Appearance of the earliest forms of primitive humans.

Middle Palaeolithic Era Neanderthal era.

c38,000 BCE Upper Palaeolithic era Modern humans appear. The earliest examples of cave painting are created.

c15,000–c10,000 BCE Magdalenian era, named after the La Madeleine site, in the Dordogne region of France. Produces the finest examples of cave painting in Europe.

c12,000–3000 BCE Mesolithic era, or "Middle Stone Age".

Prehistoric art

European Cave and Rock art

30,000 BCE–10,000 BCE

Some of the finest European cave art was produced in southwestern France and northern Spain during the final phase of the Ice Age, from 15,000–10,000 BCE. The paintings at Altamira in Spain, which were discovered in 1879, are so well preserved that for many years archaeologists doubted their authenticity. Most of the images depict bison, although there are also a number of horses and red deer.

The paintings at Lascaux in France were discovered accidentally, by four boys playing in the woods. The cave, which contains more than 600 paintings, boasts some of the most spectacular prehistoric artworks ever found, most notably in the celebrated "Hall of Bulls." This is dominated by pictures of four black bulls, each measuring up to 16ft long. The cave complex at Chauvet in France also includes a remarkable array of animal paintings and is much older, dating back to around 30,000 BCE.

◀ **Bison** *Most cave paintings show live animals, but this bison appears to have been depicted after its death, with its legs trussed up. The striking image was created with just three colors—ocher, red, and black. c13,000 BCE, rock painting, Altamira, near Santillana del Mar, Spain*

▶ **Lions** *The animal paintings at Chauvet include bears, lions, panthers, rhinos, and owls. These lions are an extinct variety, with males that have no manes. c30,000 BCE, rock painting, Chauvet-Pont-d'Arc, Ardèche Département, France*

▲ **"The Shaft of the Dead Man"** *Discovered in 1940, the cave paintings at Lascaux are often cited as the finest examples of prehistoric rock art in the world. This enigmatic scene shows a man with a bird-like head along with a bison that seems to be disemboweled. c17,000 BCE, rock painting, Lascaux, Dordogne, France*

CLOSERlook

HUNTER OR SHAMAN?
Archaeologists have made numerous suggestions about the identity of this figure with his bird-headed stick. Some suggest he is a hunter with a decoy; others, a shaman with a totem.

Australian Cave and Rock art

c40,000 BCE – ?

Australian art has a very long pedigree. Rock engravings at Wharton Hill and Panaramitee North in South Australia are thought to be more than 40,000 years old, while traces of pigment at Cape York in Queensland appear to date back to c25,000 BCE. Many Australian Aboriginal paintings are more difficult to date, however, as they have often been retouched on several occasions. Australian Aboriginals believed that the original designs had been formed by creation spirits during the Dreamtime—the ancestral past—when their shadows passed over the landscape. The most important concentrations of rock painting can be found at Arnhem Land and Kimberley, near the northern coast, and Victoria in the south-east. The images usually consist of slender, anthropomorphic figures or "X-ray" paintings of animals.

▼ **Wandjina Paintings** *The Wandjina are ancestral figures— the spirits of clouds, who govern the weather. These paintings were discovered in 1837.* Main figure 39⅜ x 30¾in, Kimberley District, Western Australia

▲ **The Lightning Brothers** *These images come from a rock shelter in the ancestral territory of the Wardaman people. The Lightning Brothers were two Creation heroes—Jabaringi and Yagjagbula— who brought lightning and the monsoon rains.* Rock painting, Ingalari Waterhole, Willeroo Station, Victoria River, Australia

CLOSERlook

FACELESS There were no fixed images for Creation heroes, as these were tribal deities, varying from region to region. In most cases, the Brothers were shown as simple, human-like forms with few facial details. They often had rays emanating from their heads.

African Cave and Rock art

c4000 BCE–c1500 BCE

The finest surviving examples of prehistoric African art are located in remote, mountainous regions. In many cases, the sites were occupied for centuries, and contain thousands of paintings and engravings. At Tassili N'Ajjer in Algeria, paintings are so numerous that different periods can be detected. The earliest feature hunters pursuing animals that are now extinct. Following this, there are scenes of herdsmen tending cattle and, finally, images of more recent animals, such as horses and camels.

The most intriguing paintings, perhaps, were produced by San bushmen in the Drakensberg area. Some prehistorians believe these depict shamans and therianthropes (composite human and animal forms), involved in trance ceremonies with elands (large antelopes). The elands were thought to possess spiritual power, which shamans tried to harness through ritual dances and trances.

▲ **Hunters with Bowman** *Thousands of paintings and engravings were produced at Tassili N'Ajjer, a rocky plateau in the Sahara, in a period when the climate was more favorable than today. Early scenes of hunters were followed by paintings of herdsmen.* c4000 BCE, rock painting, Tassili N'Ajjer, near Djanet, Algeria

▶ **Shamanistic Image with Eland** *This prehistoric masterpiece, from the mountainous Drakensberg region, has been interpreted as a trance picture. The animal is accompanied by humans with hooves.* Rock painting, Game Pass, Kamberg Nature Reserve, South Africa

▲ **"The White Lady"** *When it was first discovered, this painting was interpreted as a white woman. Some now believe, however, that the figure is a male shaman wearing white body paint.* c1st century BCE, rock painting, height 15¾in, Tsibab Ravine, Brandberg Mountain, Namibia

Portable figurines

c30,000 BCE – c10,000 BCE

Alongside their rock art, early humans also produced a variety of portable objects. Weapons were often decorated with images of prey, presumably as a form of hunting magic. There was also an intriguing group of very ancient European sculptures known collectively as "Venus" figurines. Dating from the Palaeolithic era (c35,000–8000 BCE), most of the statuettes represent naked, well-rounded women. Their purpose is unknown, although their obvious voluptuousness has led some archaeologists to regard them as fertility figures.

More than a hundred of the figures have been found, at sites ranging from France to Russia. They generally have tiny legs and arms—indeed, the arms on the Willendorf figure, folded across her breasts, are barely discernible. Most of the statuettes could not have stood independently, and it is possible that they were designed to be held in the hand.

▼ **The Kostionki Venus**
The earliest surviving non-functional objects come from the Paleolithic period. This female figure is from the Voronezh region in south-western Russia. c23,000 BCE, stone, 3⅜in high, Hermitage, St. Petersburg, Russia

▼ **Bison Carving** *This delightful carving was made from a reindeer antler and used as a spear-thrower. It was found at La Madeleine, in France. c12,000 BCE, ivory, 3⅞in long, private collection*

▶ **The Venus of Willendorf**
The most famous of all the Venus figurines, this carving takes its name from the Austrian village where it was discovered, during construction work on a railroad. It was made from a small stone and tinted with red ocher. c24,000 BCE, limestone, 4¼in high, Naturhistorisches Museum, Vienna, Austria

CLOSERlook

FACELESS APPEARANCE
One feature common to virtually all of the Venus figures is their lack of facial detail. In the case of the Willendorf statuette, the entire head is covered in hair. This may have served to emphasize the universality of the figure.

Neolithic Pottery

c9000 BCE – c2400 BCE

The earliest known ceramic vessels are from c1100 BCE in Eastern Siberia and Japan. Ceramic objects, including a Venus figure and numerous animal figurines, have been found at Dolni Vestonice in the Czec Republic. These date from c2400 BCE. However, the craft became much more common in the Neolithic period, as nomadic hunter-gatherers were gradually superseded by farming communities, who kept livestock and grew crops. Their settled lifestyle enabled them to acquire more belongings, without the worry of transporting them.

Initially, most pottery was either modeled or built up in coils. In many communities, women made the pots for their own households. However, the invention of the potter's wheel stimulated the growth of a specialist "industry." The wheel was introduced in Western Asia in c3400 BCE, and reached Europe in the following millennium.

CLOSERlook

CRYING MOUTH This gummy cry could have had more meaning than appears at first sight: a crying toothless baby-god often appears in Olmec art.

▲ **Olmec Baby** *This ceramic baby was made by the Olmec culture of Mexico. The purpose of this and similar crying babies is unknown, but some archaeologists have suggested that the Olmec performed infant sacrifice, and the ceramic babies may have been connected to this practice. c800 BCE, earthenware with bichrome slip, 12¼ x 9½ x 7¼in, Museum of Fine Arts, Houston, Texas, US*

▲ **Pot with sculpted Shaman Head** *This was produced by the Majiayao culture, which was based in the Chinese province of Gansu. 3rd millennium BCE, painted earthenware, 15¾in high, Museum of Fine Arts, Boston, US*

▶ **Pot with Whorl Design** *This comes from the Middle Jōmon period in Japan. Characteristically, the vessel is decorated with an elaborate, curvilinear design.* c7500–300 BCE, low-fired ceramic clay, 15 x 13in, Museum of Fine Arts, Houston, US

◀ **Crouching Male Figure** *Popularly known as* The Thinker, *this famous piece is a product of the Hamangia culture.* c3500–3000 BCE, pottery, 44½in high, National Museum of Art, Bucharest, Romania

▼ **Skarpsalling Bowl** *The decoration on some Neolithic pots mimics other materials. Parts of this vessel resemble the stitching that might have been found on leatherwork.* c3000 BCE, terracotta, 6¾in high, National Museum, Copenhagen, Denmark

▶ **Nok Bird-man Figure**
Nok figures take their name from a village near the Niger River, where the first finds from this culture were made. These consist almost exclusively of ceramic sculptures, depicting an imaginative range of human and animal forms. Their original purpose can only be guessed at. It has been suggested, for example, that they may represent ancestor figures or deities, or that they were used in funerary rites. c500 BCE–200 CE, terracotta, 18½ x 7⅞ x 8¾in, private collection

CLOSERlook

COMPOSITE FORMS Nok artists blended human and animal forms. This creature appears to have human hands, but its fingers are clenched tightly together, like a bird's claws gripping a perch.

▲ **Stylized Head** *This is a typical example of the distinctive figures produced by the Vinča culture, which flourished at a large farming settlement on the banks of the Danube, a few miles from modern-day Belgrade.* c4500–4000 BCE, terracotta, 7⅛ x 5in, Musej Kosova, Pristina, Serbia

Origins and Influences

In antiquity, Mesopotamia referred to the land "between the rivers"—namely, the Tigris and the Euphrates. This is roughly equivalent to modern-day Iraq. As the Sumerians and later the Akkadians and Babylonians occupied the area, they progressed from being hunter-gatherers to herding and agriculture. Production of surplus food led to the growth of "states" adminstered by cities, which had huge temples, called ziggurats, at their centers. The biblical Tower of Babel may have been based on the ziggurat of Babylon.

People went to temples to worship their gods and offer them sacrifices. Because some of the gods were

▲ **The Ishtar Gate (replica)** *One of eight gateways of the ancient city of Babylon constructed in c580 BCE by Nebuchadnezzar II. Built of bricks decorated with glazed reliefs of bulls and dragons, the gateway is 76ft high. It formed part of a sacred, processional avenue into the heart of the city.*

associated with planets (for example, Shamash with the Sun, Sin with the Moon, and Ishtar with Venus) planetary movements were thought to be very

important by Mesopotamians. As a result, astronomy was born and with it mathematics, which would one day lead to modern science.

CURRENTevents

c1792 BCE Hammurabi comes to power, establishing Babylon as the center of his considerable empire.

c717 BCE The Assyrian city of Khorsabad (Dur Sharrukin) was founded by Sargon II. He erected a magnificent palace there, famed for its guardian figures, but his son relocated the capital to Nineveh.

c518 BCE Darius I founds Persepolis, making it the centerpiece of the Achaemenid empire. It remained an important seat of power, until Alexander the Great destroyed it in 331 BCE—an action he later regretted.

Civilization was founded in Mesopotamia. The inhabitants of this region invented the wheel, agriculture, vehicles, cities, writing, law, medicine, philosophy, mathematics, and astronomy. Mesopotamian art was mostly connected to the gods who were thought to watch over these early city states.

Ancient Near East

TIMEline

The Sumerians emerged in southern Mesopotamia around 3400 BCE, with the magnificent finds at Ur dating from c2800 BCE onward. By c2350 BCE, the Akkadians were in power, though they in turn were supplanted by the Babylonians (c1790 BCE). The Assyrians began their rise in the 9th century BCE, eventually competing with a revitalized Babylonian empire. The ancient Persians had their greatest success under the Achaemenid dynasty (559–333 BCE).

2600–2400 BCE

SUMERIAN The Queens Lyre

c1750 BCE

BABYLONIAN The Worshiper of Lhasa

858–823 BCE

ASSYRIAN King Shalmaneser III

604–562 BCE

BABYLONIAN Mushushu

516–465 BCE

PERSIAN Giant Griffin

Chronology

Although Mesopotamia and its neighbors were occupied by a dizzying succession of races and cultures in ancient times, their art forms were often very closely linked. The Akkadians, for example, adopted many aspects of Sumerian civilization as their own. By the same token, the Stele of Naram-Sin—a monument to Akkadian military prowess—was eventually carried off by the Elamites, who used it as a symbol of their own victories.

Style and Subjects

Sculpture was the most durable medium employed during this period. On a miniature scale, the most ubiquitous item was the cylinder seal. The Akkadians produced some of the finest examples, but the device was commonplace throughout western Asia from around 3000 to 500 BCE. Usually an image was produced by rolling the cylinder across a clay tablet, but they were also used

◄ **Statue of Gudea** *Gudea was a prince of Lagash (now Al Hiba). He was known for his piety and commissioned several statues of himself, listing the temples that he had founded.* c2150 BCE, diorite, height 24½in, Louvre, Paris, France

◄ **Akkadian Cylinder Seal** *In this mythological scene, Ea—the Sumerian god of water and wisdom—passes judgment on Anzu, a monstrous bird-man.* c2200 BCE, serpentinite, height 1½in, British Museum, London, UK

to seal doors and vessels of all kinds, or worn as amulets to ward off evil. Seals were also employed in various rituals, such as those connected with childbirth and sickness. They were marks of ownership or a person's authority, but were only rarely donated as offerings in temples.

Sculpture in the round was also popular, as is confirmed by the many statues of worshipers and royal figures. The latter were not portraits, but symbols of power. Some of the most celebrated examples depict the Sumerian ruler, Gudea of Lagash, He took the trouble to import stocks of diorite—an extremely hard stone—to ensure that his memorials would survive.

The ready availability of good, workable stone enabled the Assyrians and the Persians to create impressive, monumental

sculpture—most notably in their huge, sculpted reliefs and their massive guardian figures. The Babylonians, however, specialized instead in polychrome (multicolored) reliefs on glazed bricks. These were so admired by the Persians that they employed Babylonian craftsmen to adorn their palaces. The Achaemenid rulers were equally fond of opulent metalwork—their taste for luxury was proverbial in Greek circles—so they also employed the finest goldsmiths and silversmiths of the day.

Sumerian

c3400 – 2000 BCE

Sumer is situated in Lower Mesopotamia (part of modern-day Iraq). The Sumerians are credited with the invention of writing (cuneiform), urbanization, and the wheel, while their cultural influence spread throughout western Asia. In the arts, their craftsmen produced outstanding pottery, metalwork, and sculpture.

Sumer was divided into city states, the most important of which was Ur. Spectacular finds have been made in the Royal Cemetery there, particularly in the grave of a high-ranking woman called Pu-abi, buried with servants, jewelry, golden vessels, and musical instruments.

CLOSERlook

WAR CHARIOT When they were unearthed, the shell figures were loose, and their original order could only be guessed at. Experts have assembled them into two panels, representing War and Peace.

▼ **The Standard of Ur** *Many researchers now believe that this was not a military standard but the sound-box of a musical instrument.* c2600–2400 BCE, shell, lapis lazuli, and red limestone, 10¼in high, British Museum, London, UK

▶ **Royal Game of Ur** *Found in the Royal Cemetery at Ur, this game was similar to modern-day backgammon.* c2250 BCE, wood with inlays of shell, red limestone, and lapis lazuli, ¾ x 4¼ x 11¾in, British Museum, London, UK

◀ **Queen's Lyre** *This instrument, from the grave of "Queen" Pu-abi in the Royal Cemetery at Ur, was intended to provide music in the afterlife. In the grave, a sacrificed slave was placed next to the lyre, with her hands over its strings.* c2600–2400 BCE, wood, shell, lapis lazuli, and gold, height 44⅛in, British Museum, London, UK

Akkadian

c2500 – 1790 BCE

The Sumerians were eventually conquered by Sargon, who united Mesopotamia under his rule and established his capital at Akkad. The Akkadians adopted many aspects of Sumerian culture, but made new advances in sculpture. The *Stele of Naram-Sin*, for example, records a military victory in an entirely novel fashion. Instead of a narrative sequence on horizontal strips, the sculptor has produced a single, unified composition. There is a sense of upward movement, as Naram-Sin ascends to claim equal status with the gods, and it also includes landscape elements.

▼ **Head of Sargon** *This regal portrait is thought to be Sargon I (c2334–2279 BCE), the founder of the Akkadian Empire.* c2350–2200 BCE, copper, height 14⅝in, Iraq Museum, Baghdad, Iraq

▶ **Victory Stele of Naram-Sin** *Naram-Sin is shown at the top of the slab, wearing the horned helmet of a god.* c2230 BCE, pink limestone, height 82¾in, Louvre, Paris, France

Hittite

c2000 – 1000 BCE

The Hittites were living in Anatolia (modern-day Turkey) by c2000 BCE, reaching the peak of their power during their Imperial period, when they controlled most of Asia Minor and northern Syria. Their surviving art consists mainly of metalwork and stone reliefs. The latter formed an integral part of their architecture. On gateways, they produced monumental, high-relief sculptures of lions, warriors, and mythical creatures. The adjoining walls, meanwhile, were decorated with friezes of low-relief carvings, usually depicting hunting scenes and religious ceremonies.

▼ **Sphinx Gate** *The practice of erecting monumental guardian figures at the entrances to a city was common in many parts of the Near East. The image of the male sphinx originated in Egypt, but in Anatolia it was portrayed as a winged female.* c1450–1200 BCE, stone, Alaca Höyük, Turkey

Assyrian

c1500 BCE – 612 BCE

The Assyrian heartlands were in northern Mesopotamia (modern-day Iraq). The Assyrians took their name from the land they came from around Ashur, their religious capital, but soon built the far greater cities of Nineveh, Nimrud, and Khorsabad. At the height of their power (from 883 to 612 BCE), the Assyrians commanded an empire that stretched from Persia to the Mediterranean.

Assyrian art is most notable for its relief carving and sculpture. The most important theme was the lion hunt—an event that had both royal and religious significance. Depictions of the hunt frequently adorned royal palaces. On a much smaller scale, the Assyrians also produced very fine ivory carvings on plaques, which were mostly used as veneers on their furniture.

▶ **Winged Guardian Figure** *This is one of a pair of monumental statues from the palace of Sargon II at Khorsabad. It is a* Lamassu—*a winged bull with a human head.* 8th century BCE, gypseous alabaster, height 165½in, Louvre, Paris, France

CLOSERlook

DIVINE PROTECTOR
The Assyrians erected statues of guardian figures to ward off evil spirits. These creatures wore horned helmets to signify their divinity. Several local deities, such as Assur, Ishtar, and Shamash, were portrayed wearing a cap with one or more pairs of horns. The remainder of each creature's body emphasized its strength (a bull or a lion), its speed (the wings), and its intelligence (the human head).

INContext
CUNEIFORM WRITING Cuneiform ("wedge-shaped") writing, the world's first script, was invented in Mesopotamia around 3000 BCE. It was written by pressing a reed pen into wet clay. A number of different Near Eastern languages—Sumerian, Akkadian, Elamite, Hittite, and Hurrian—were written in this way.

Cuneiform brick *This inscription lists the name and titles of Shalmaneser III, King of Assyria, before referring to the construction of a temple in Nimrud.* 9th century BCE, clay, British Museum, London, UK

▲ **King Shalmaneser III** *This shows the king in an important ritual role, as the protector of the Tree of Life.* 9th century BCE, ivory, Iraq Museum, Baghdad, Iraq

▶ **Ashurnasirpal II at a Lion Hunt (detail)** *Lion hunting was more than a sport of Assyrian kings; it had religious connotations.* 7th century BCE, whole panel length 88in, limestone, British Museum, London, UK

Babylonian

c1800 – c1595 BCE; NEO-BABYLONIAN c1150 BCE – 539 BCE

Babylon first came to prominence during the reign of King Hammurabi (1792–50 BCE), who introduced a celebrated law code and is commemorated in a number of sculptures and stelae (upright stones inscribed with names or figures). The Babylonians were overrun by the Hittites for a time, but recovered their fortunes and reached the peak of their power under King Nebuchadnezzar II (605–562 BCE). He created a powerful empire, restoring Babylon itself to its former glory.

The Babylonians' most distinctive artworks were animal reliefs, which they produced on glazed, polychrome bricks. The creatures were modeled on a panel of damp clay, which was then cut up into bricks and fired. The examples adorning the Ishtar Gate, the spectacular entrance to Babylon, are particularly impressive.

▼ **Mushushu** *A lion-bird-snake monster adorning the Ishtar Gate, Mushushu is the attribute and mount of Marduk, the nation's protective deity.* 605–562 BCE, glazed terracotta bricks, 45¾x65¾in, Detroit Institute of Arts, Detroit, US

◄ **The Worshiper of Larsa**
An inscription on the base identifies this as a commission by a man from Larsa. It invokes the protection of the god Amarru for King Hammurabi of Babylon. c1750 BCE, bronze and gold, Louvre, Paris, France

Persian

c3000 BCE – 642 CE

The inhabitants of the area now known as Iran were producing distinguished artworks from the Bronze Age. At Susa, the Elamites developed an elegant style of pottery, while in the west, the Luristan culture was noted for its highly decorative horse-trappings. The Persians themselves emerged in the 7th century BCE, and eventually controlled an empire that extended from Libya to India.

Assyrians, Babylonians, and Greeks probably made sculptures for the Persians, producing their finest masterpieces at Persepolis. Even in its present, ruined state, its monumental sculptures and relief-carvings are spectacular. On a smaller scale, they also created exquisite metalwork, such as the lavish, golden objects found in the Oxus Treasure. The Persian Empire, the largest of the ancient world, was conquered by Alexander the Great, in the 4th century BCE.

> ❝ It was the **wealthiest city** under the sun... filled with **precious objects** of every kind ❞
>
> DIODORUS SICULUS, 1ST CENTURY BCE, GREEK HISTORIAN, FROM HIS DESCRIPTION OF THE BURNING OF PERSEPOLIS BY ALEXANDER THE GREAT

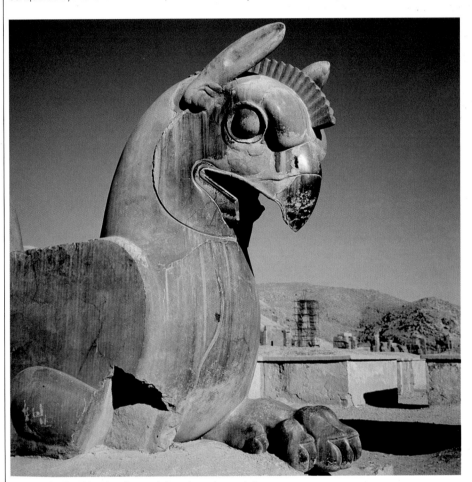

▲ **Giant Griffin** *This colossal statue is from the ancient capital Persepolis. The griffin, which combined a lion's body with an eagle's head, was a common, ornamental feature in eastern art.* c518–465 BCE, limestone, Persepolis, Iran

► **Winged Creature Ornament**
This exquisite item of jewelry depicts a winged stag with the head of a horned lion. c5th–4th century BCE, gold, height 2⅜in, British Museum, London, UK

▲ **Dish Depicting King Ardashir II**
Ardashir II belonged to the later Sassanian dynasty, which produced outstanding examples of embossed silver vessels. c380 CE, silver, diameter 11in, National Museum of Iran, Tehran, Iran

Origins and influences

Egyptian civilization grew up around the fertile Nile Valley. The annual flooding of the river provided rich farming land, in stark contrast with the deserts that surrounded it. In addition, the area was blessed with extensive mineral resources, while Egypt's cities were well placed to control the Nile region's trading routes. The resulting wealth attracted a diverse mix of conquerors, who helped to create the nation's complex culture.

From the outset, Egyptian art reflected its geographical and political setting. The country was formed from the union of Lower Egypt (the Nile Delta) and Upper Egypt (the thin strip of land along the length of the Nile Valley). These kingdoms were symbolized, respectively, by a red and a white crown, by the cobra and the vulture, and by the papyrus plant and the lotus flower. These pairs of symbols were ubiquitous. They can be found on the pharaoh's head-dress, his throne, and in temples.

Egyptian art was opulent, monumental, and often very colorful. Using natural form and geometric designs, it was almost entirely symbolic and had very precise meaning. Egyptian art flourished little changed for almost 3,000 years, and had a profound influence on neighboring Greek cultures.

▲ **Funerary Mask of Tutankhamun** *This gold inlaid funerary mask, now in the Egyptian National Museum Cairo, was placed over the head and shoulders of Tutankhamun's mummy. The latter was encased in three coffins, the innermost of which was made of solid gold.*

CURRENTevents

2518–493 BCE Rule of Chephren. Chephren was buried in one of the largest of the pyramids at Giza and may be the model for the Sphinx.

1336–1327 BCE Reign of Tutankhamun, the boy king. His rule was marked by a return to orthodoxy. He died very young, but his tomb is the only one from the New Kingdom period to have survived intact.

1279–1213 BCE Renowned as a great warrior, Rameses II defeated the Hittites at the Battle of Qadesh (c1274 BCE).

Ancient Egypt

TIMEline

Egyptian history is traditionally divided into three main periods: the Old Kingdom (c2647–2124 BCE) witnessed the building of the Sphinx and the pyramids at Giza; the Middle Kingdom (c2040–1648 BCE) extended from the 11th to the 17th Dynasty; while the New Kingdom (c1540–1069 BCE) produced the tomb and treasures of Tutankhamun and the monuments of Rameses II, which include Abu Simbel.

2600–2500 BCE

4TH DYNASTY The Great Sphinx

1400–1350 BCE

18TH DYNASTY Fowling the Marshes

c1340

18TH DYNASTY Bust of Queen Nefertiti

1279–1213 BCE

19TH DYNASTY Rameses II Smiting his Enemies

664–332 BCE

26TH–30TH DYNASTIES The Canopic Jars of Horemsaf

▲ **Mummy Case of Nespanetjerenpere** *The deceased was a priest from Thebes. His coffin is adorned with various scenes of protection and rebirth. 22nd Dynasty (945–730 BCE), cartonnage, Brooklyn Museum of Art, New York, US*

Chronology

The splendors of Egyptian art developed slowly, over the course of many centuries. The Predynastic phase, which dates back to around 5000 BCE, produced a range of pottery and small-scale sculpture. By the time that the 1st Dynasty of kings (c2972–2793 BCE) assumed control, many of the basic forms of the culture were taking shape. Some of these altered remarkably little over the years, surviving until after 332 BCE, when Alexander the Great displaced the 31st and final Dynasty.

Style and subjects

The Egyptians had no word for art. They valued fine craftsmanship, but did not necessarily link it with aesthetics or individual expression. Their artworks were purely functional, designed to facilitate their worship of the gods and help smooth their passage to the afterlife. There was a firm belief that, when objects or events were correctly reproduced, accompanied by the necessary rituals, they could provide a genuine point of contact between the realms of the living and the world beyond.

This "correct" form of depiction amounted to a distinctive type of stylization, for example, the larger the size of a figure the higher his or her status. Artists were also expected to portray the essence of their subject, without distracting, temporary features. Figures in paintings and reliefs were depicted in a form of profile, while statues were carved in a rigid set of postures and had blank, otherworldly expressions. There was no perspective. Instead, complex events were shown in sequence, rather like a cartoon strip. The figures were placed on horizontal base-lines, known today as "registers" and, if any explanations were needed, these were provided by hieroglyphs (literally "sacred carvings"). The symbols used in this pictorial language were incorporated into the overall composition. They can appear very decorative, and normally had religious overtones, especially when they were used to form incantations on objects relating to the dead.

▲ **Amulet in the form of a Vulture** *This exquisite object was placed as a charm around the neck of Tutankhamun's mummy. 18th Dynasty (c1540–1295 BCE), gold encrusted with lapis lazuli and cornelian, 2⅜ x 4¼in, Egyptian National Museum, Cairo, Egypt*

Egyptian Funeral Art

A considerable proportion of the artworks produced in ancient Egypt were created for the benefit of the dead. Throughout their long history, the Egyptians believed firmly in the existence of an afterlife and their need to prepare for it. First and foremost, this meant preserving their physical remains. Their corpses were elaborately embalmed and certain internal organs were stored in four canopic jars, each presided over by one of the four sons of Horus.

The dead were furnished with everything that they might need in the afterlife, from jewellery to furniture, and the tombs of the wealthy were lavishly decorated, to provide a pleasing environment for the occupants. The dead were expected to work in the afterlife, but servants called *shabtis* eased this burden. The path to the afterlife was smoothed by a host of rituals and incantations. Many of these were contained in a series of texts entitled *Spells for Coming Forth by Day*, popularly known as *The Book of the Dead*.

◀ **The Canopic Jars of Horsemsaf**
These jars held the internal organs—liver, lungs, stomach, and intestines—which were removed during the mummification process. Late Period (664–332 BCE), alabaster, height 14⅝in, Louvre, Paris, France

CLOSERlook

DIVINE PROTECTOR
This stopper represents Hapi, the ape-headed guardian of the North. His jar held the lungs.

▼ **Fowling in the Marshes** *From the tomb of Nebamun at Thebes. This painting shows an Egyptian artist's typical blend of realism and stylization—the goose on the boat is closely observed, while the cat performs an impossible balancing act on two reeds.* 18th Dynasty (c1350 BCE), wall painting, 38⅝ x 32¾ x 8¾in, British Museum, London, UK

" The **heart of Osiris** has in truth been weighed and his soul has **stood as a witness** for him "
INCANTATION FROM THE BOOK OF THE DEAD

◀ **Shabti Figures** *Shabti (Answerer) figurines were symbolic servants, placed in the tomb with the dead. In the afterlife, they would carry out any menial tasks for their masters.* New Kingdom (c1567–1085 BCE), wood and faience, various sizes, Louvre, Paris, France

▲ **The Weighing of the Heart Against the Feather of Truth** *This is the judgment scene from* The Book of the Dead *belonging to a man called Any. He stands on the left with his wife, watching as his heart is weighed against the feather, which is the symbol of Maat (divine order). Any's ba (the human-headed bird representing his spirit) also observes the process.* 19th Dynasty (c1275 BCE), painted papyrus, 17¾ x 12¼in, British Museum, London, UK

CLOSERlook

FUNERARY DEITY The jackal-headed god Anubis was a key figure in the judging of the dead. He guarded the mummy and weighed the deceased's heart—regarded as the seat of character and intellect. If it was found wanting, it would be consumed by the "devourer," the creature on the right.

Egyptian Sculpture

2ND DYNASTY FROM c2793 BCE TO 2647 BCE

The Egyptians excelled at low-relief carving, producing high-quality work from the Predynastic Era (5500–3100 BCE) onward. Fine examples can be found on palettes, stelae, and in tombs. From the outset, they adopted certain artistic conventions. The human figure was shown in partial profile: the head and the limbs were viewed from the side, while the chest and a single eye faced the front. A similar approach was employed in paintings. Figures were portrayed on different scales, with kings and gods towering over their inferiors. Background details were normally kept to a minimum. Instead, the context of the scene would be explained in the accompanying hieroglyphs.

Sculpture in the round only came into its own in the 2nd Dynasty, but here, too, the figures were highly stylized. The models gazed ahead and were seen in strict profile, when viewed from the side. High-status figures were idealized. Male figures might be portrayed in a walking pose, but otherwise there was very little suggestion of movement. The overall shape of the sculptures shows the block from which each was carved.

INcontext

MAGIC SYMBOLS The Egyptians believed that divine symbols could ward off evil, and the wedjat eye was one of the most potent examples. Representing the eye of Horus, which was torn out and then restored, it was linked with regeneration and was often placed in mummy wrappings.

Ornament with Wedjat Eye (c1370–52) This lavish item was found on Tutankhamun's mummy.

◀ **Statue of Chephren** The king is seated on a lion throne with Horus, the falcon-headed god, perched on the back of Chephren's chair (not visible from this view). The bird spreads its wings protectively around Chephren's head, emphasizing that the king is his representative on earth. The statue was discovered in 1860, at Chephren's valley temple at Giza. 4th Dynasty (c2500 BCE), diorite, height 66in, Egyptian Museum, Cairo, Egypt

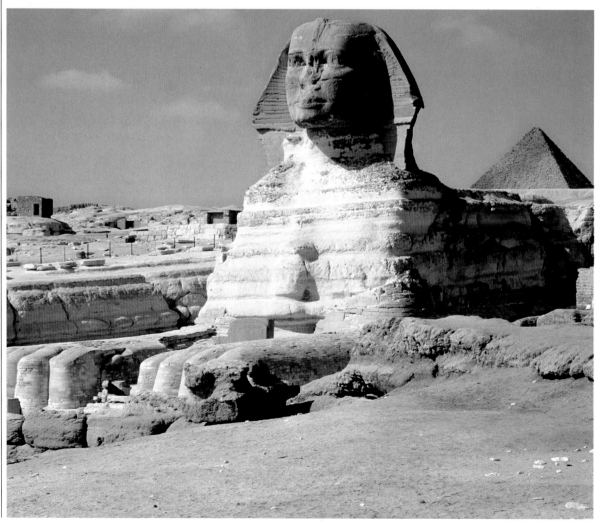

◀ **The Great Sphinx** This enormous statue—the largest in Egypt—was built as a guardian figure. It combines the body of a lion with the head of a man wearing the royal head-cloth. 4th Dynasty (c2500 BCE), limestone, height 25ft, length 96ft, Giza, Egypt

❝ Details of the room emerged slowly from the haze: **strange animals**, statues, and gold—**everywhere the glint of gold** ❞

HOWARD CARTER, ARCHAEOLOGIST, DESCRIBING HIS FIRST GLIMPSE INSIDE TUTANKHAMUN'S TOMB

CLOSERlook

THE "BLIND" EYE Although the portrait was highly finished in other respects, one of Nefertiti's eyes was left blank. One theory is that the bust was actually a template, so there was no need to duplicate this detail.

▼ **Ramesses II Smiting his Enemies** *This was a favorite theme in Egyptian art, demonstrating the power and authority of the Pharaoh. Here, Ramesses grips a Nubian, a Libyan, and a Syrian by their hair. As the most important figure in the composition, he is shown on a larger scale than the prisoners.* 19th Dynasty (c1297–1185 BCE), painted limestone, Egyptian National Museum, Cairo, Egypt

◀ **Bust of Queen Nefertiti** *This famous portrait was excavated from a studio belonging to Thutmose, the court sculptor of Akhenaten (Nefertiti's husband). It dates from the Amarna Period, when Egyptian art displayed a degree of naturalism, allowing Nefertiti's beauty to shine through.* 18th Dynasty (c1340 BCE), painted limestone, height 19¾in, Aegyptisches Museum, Berlin, Germany

▶ **Statue of Horus** *Discovered at Edfu, one of the best-preserved Egyptian temples, this is a fine example of monumental sculpture. Horus, the sky-god, was sometimes portrayed as a human with a falcon's head. Here, he is shown as a living falcon, wearing the double crown of Upper and Lower Egypt.* Ptolemaic period (332–30 BCE), stone, Temple of Horus, Edfu, Egypt

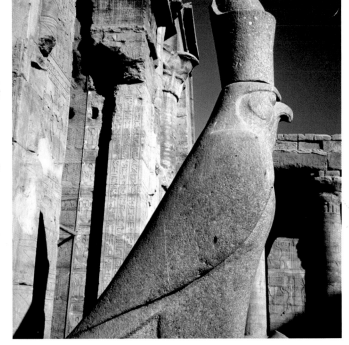

India

One of the world's earliest civilizations grew up along the Indus Valley. By around 2500 BCE, a number of cities had emerged, with grid-plan streets, a sophisticated drainage system, and bathing facilities. The two main centers were at Harappa and Mohenjo-Daro. This culture produced some pottery and carving, but is best remembered for its distinctive seals.

The Indus Valley civilization went into decline after 1800 BCE and there was a considerable gap before the arts revived under Emperor Ashoka (c269–232 BCE). He encouraged the development of a new kind of sculpture through his many Buddhist monuments. This was aided by the devastating impact of Alexander the Great's triumphs in Persia. These had culminated in the destruction of Persepolis (331 BCE), which prompted many of their artists to seek new patrons in India.

▲ Head of a Soldier (Terracotta Army) *Despite the vast number of figures that were required for the tomb of Qin Shi Huang, craftsmen took pains to ensure that every figure appeared different. Made around 210 BCE, this soldier has a topknot indicating his rank of general.*

China

The Shang Dynasty bronzes mark a defining moment in Chinese culture. The Bronze Age may have come relatively late to this area, but it produced items of rare distinction, unparalleled elsewhere. Craftsmen mastered the art of piece-mold casting quickly and employed an unusual alloy, adding lead to the normal mix of copper and tin. The vessels were then adorned with fantastic, animal-like imagery, which undoubtedly related to ancient funerary rites.

The creation of the Terracotta Army for the tomb of Shi Huang Di is equally remarkable, but for different reasons. This was an early example of mass-production. Standard molds were created for the main body parts: there were eight different types of torso, two types of leg, eight faces, and so on. These were assembled in different combinations and then finished by hand, to give the figures an individual look. This care and attention to detail is particularly impressive, given that the figures were never meant to be seen by any living person.

Some of the most spectacular examples of ancient art were produced in the Far East and the Indian subcontinent. Chinese craftsmen produced a magnificent range of metalwork and sculpture for the tombs of the mighty, while Indian artists created their first Buddhist masterpieces.

Civilizations of the East

India

c2500 BCE – 185 BCE

For many historians, the extraordinary seals produced in the Indus Valley are India's first artworks of genuine quality. More than 4,000 of these have been unearthed. Most depict animals, though there are a few, enigmatic human figures. The script has not yet been deciphered, but there is speculation that the words are personal names, as the seals were used as tokens of ownership, in the region's commercial dealings with Mesopotamia.

The Mauryan era heralded the arrival of Buddhist art. In early images, the Buddha was not portrayed physically, but was represented indirectly by symbols such as a wheel and a lion, both of which are featured on the Ashoka Pillar. Yakshis were originally linked with nature worship, but they were adapted for use in Buddhist art.

▶ **Yakshi Figure**
Discovered at the ancient site of Tamralipta (now Tamluk), this figure is thought to be a yakshi—a nature spirit—although the weapons in her headdress may suggest a more powerful role.
1st century BCE, terracotta, Ashmolean, Oxford, UK

▲ **Seal from Mohenjo-Daro** *Indus seals were among the earliest objects to combine words with images. This curious creature has been dubbed a "unicorn" bull, because only one horn is visible. c2300 BCE, steatite, width 1½in, National Museum of Pakistan, Karachi, Pakistan*

▲ **Ashoka Pillar (detail)** *The emperor Ashoka erected a series of pillars with Buddhist symbols to mark his conversion to the faith. The Buddha preached his first sermon in a deer park at Sarnath. 3rd century BCE, sandstone, height 84in, Sarnath, Uttar Pradesh, India*

China

c1500 BCE – 207 BCE

Many of China's earliest masterpieces were produced for the benefit of the dead. During the era of the Shang Dynasty (c1500–1050 BCE) and the Zhou Dynasty (c1050–221 BCE), the graves of rulers frequently contained items made of bronze or jade. These materials were costly and, as such, were recognized symbols of high status, though they also served a variety of ritual functions.

The Chinese had been fascinated with jade since Neolithic times, believing it had magical qualities. Celestial discs were often interred with the dead, though these pale into insignificance beside Liu's burial suits. These were made up of 2,000 jade tablets, sewn together with gold thread.

Bronze was used for a sizeable repertoire of ritual vessels. Most of these were containers for the food and drink used in funerary banquets and sacrifices. Initially, these took place in temples, though the objects were subsequently buried with their owners. The material used for the Terracotta Army had no such intrinsic value, but the scale of the production costs more than compensated for this.

▲ **Dou Vessel** *This was produced during the Warring States era, the final phase of the Zhou Dynasty. The Dou is a food container. Its lid can also serve as a bowl.* 5th–4th century BCE, bronze and gold, height 7½in, China

▼ **Ritual Vessel with Cover** *A product of the Western Zhou Dynasty, this ceremonial bucket is decorated with a taotie (monster) mask, featuring the face of a horned monster.* c11th–10th century BCE, bronze, height 9¾in, Museum of Fine Arts, Boston, US

◀ **Burial Suit of Princess Dou Wan** *Jade was a rare and expensive stone in China and was believed to have the power to preserve human bodies. With this in mind, Prince Liu Sheng ordered lavish burial suits for himself and his wife.* 2nd century BCE, jade, length 74in, Hebei Provincial Museum, Hebei Province, China

◀ **Yu Vessel** *Thought to have been made in Hunan province, this is the most famous of the ritual vessels produced in the Shang Dynasty period. A yu is a ceremonial bucket with a swinging handle, designed to hold alcohol.* 11th century BCE, bronze, height 13¾in, Musée Cernuschi, Paris

CLOSERlook

FELINE MONSTER Nicknamed "the Tigress," the precise meaning of the human figure that clings perilously below the monster's fangs is uncertain, although it may be linked with the blood sacrifices that played an important part in the ancient rituals.

▲ **The Terracotta Army** *More than 7,000 clay warriors were produced, together with hundreds of horses and chariots, as a posthumous escort for China's first emperor. They were placed in a network of corridors and pits, guarding the main tomb complex.* c210 BCE, terracotta, average height of figure 71–75in, Tomb of Emperor Qin Shi Huang, Lintong, near Xi'an, China

Origins and influences— the Aegean

Greek culture dates back to the Bronze Age (c3000 BCE). In the Aegean, there were important developments in the Cyclades and on Crete although, ultimately, both cultures were absorbed by the Mycenaeans. However, their association was not straightforward. At first, the Minoan (Cretan) influence was far stronger and some historians used to regard Mycenaean art as a provincial form of it.

The Minoans were not Greek-speakers. Their origins are uncertain, although some believe that they came from Anatolia (Asian Turkey). Certainly, their art forms display a number of eastern traits, most notably from Egypt, Syria, and Anatolia. Minoan

▲ **View of the Acropolis** *The citadel of Athens was built on top of the Acropolis, overlooking the city. Its principal structure is the Parthenon, a temple which was begun in 447 BCE, to replace the buildings that were destroyed during the Persian occupation.*

craftsmen rapidly outshone these sources, though, producing a rich culture, centered on their palaces and their bull-cult.

The Mycenaeans absorbed Minoan ideas, only taking the lead when the Cretan civilization collapsed in c1400 BCE. The Mycenaeans, who were

dominated by a warrior aristocracy, rapidly grew rich and powerful, as the wealth of their graves attests. One theory suggests that they fought as mercenaries for the Egyptians, who paid them in gold. Their decline dates from around 1100 BCE.

CURRENTevents

c1250 BCE Regarded as a legend by some, there is evidence that the famous Trojan War took place around this time.

776 BCE First recorded Olympic Games.

490 BCE The Persians invade Greece and occupy Athens. They are expelled after defeats at Salamis (480) and Plataea (479).

356 BCE Birth of Alexander the Great. Educated by Aristotle, he went on to create a vast empire. He also founded the city of Alexandria in 331 BCE.

Greek art is widely regarded as the chief cornerstone of Western civilization. Inspired by the achievements of the Egyptians and the Minoan culture on Crete, Greek sculptors strove for—and succeeded in creating—a perfect balance of beauty, harmony, and proportion.

Ancient Greece

TIMEline

The first major achievements on the Greek mainland stemmed from the Mycenaean culture, which flourished from around 1600 to 1100 BCE. The Archaic period produced some early masterpieces, most notably the Lady of Auxerre (c640 BCE), but it was during the Classical era that Greek art blossomed fully. The Parthenon sculptures (447–432 BCE) provide the highlight of Athenian culture, which Alexander the Great (356–323 BCE) spread far and wide.

c1500 BCE

AEGEAN Funerary Mask

640–630 BCE

ARCHAIC The Lady of Auxerre

540–530 BCE

ARCHAIC Achilles Slaying Penthesilia

447–432 BCE

CLASSICAL Lapith Fighting a Centaur

c42–20 BCE

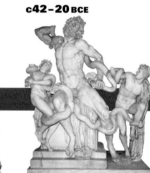

HELLENISTIC Lacoön and his Sons

▲ **Horse of Selene** *One of the most famous sculptures from the Parthenon frieze. It displays the exhaustion and strain that the horse has suffered while pulling the chariot of Selene— the moon goddess—across the night sky. 447-432 BCE, stone, length 32⅜in, British Museum, London, England*

Origins and influences— Greece

During the Iron Age, Greek culture needed to renew itself. Following the decline of the Mycenaeans, which may have been prompted by Dorian invaders from the north, parts of the mainland became increasingly depopulated. The era of the Mycenaeans was remembered as a heroic age, celebrated in Greek legends, but little of its material culture survived.

The revival began to take place during the Geometric period (c900–c750 BCE), which takes its name from the simple, linear designs of the pottery of the time. Toward the end of this phase, Eastern influences began to creep in, as trading links with the East improved. This continued throughout the Archaic period (c750–480 BCE), when Greek artists became more confident and gained a taste for experimentation.

The scale of Archaic artworks was usually modest, but exposure to the opulent and monumental sculpture of Egypt changed attitudes. In the 7th century BCE, Greek mercenaries were employed in Egypt and

were allowed to settle at a single site— Naucratis. Through this, their only legitimate entry point into the land of the pharaohs, Greek artists gained inspiration and a new sense of ambition.

Classical Art

For much of the Archaic period, Greek art was still essentially regional. The idea of a national Greek identity only began to take root in the 6th century BCE. This grew more pronounced in the following century, when the country faced a common threat. The Persian invasion (490 BCE) stirred the Greeks into action and, once the invaders had been expelled, they founded the Delian League (478 BCE), to maintain this sense of unity.

The achievements of the Classical era epitomized these bonds. The building of the Parthenon was a physical symbol of national pride, while the spirit of the new style was the defining point of Greek civilization. The twin goals of naturalism and idealism were unparalleled in the ancient world and they provided inspiration for generations of artists in the West.

▲ **The "Ludovisi Throne" or "Throne of Venus,"** **from the Villa Ludovisi** *This is an example of the Western Greek style, produced by an expatriate artist working in Italy. The carving is particularly notable for the subtle treatment of the drapery. c470–460 BCE, marble, Palazzo Altemps, Rome, Italy*

Aegean

Before the heyday of Ancient Greek art, a group of different cultures flourished in the area around the Aegean Sea. The earliest of these developed in the Cyclades Islands, where settlers from Asia Minor arrived in around 3000 BCE. Their most distinctive artifacts are tiny, marble figurines, with spare, minimalistic forms that have been greatly admired by modern sculptors.

Minoan culture emerged on Crete at a similar period. The name was coined by the archaeologist, Sir Arthur Evans, because of the island's mythical association with King Minos and his Minotaur. Minoan art was centered around its palaces, which were adorned with spectacular wall-paintings. The Cretans also produced fine pottery and jewelry.

Mycenaean culture developed on the Greek mainland. Its outstanding artworks were discovered in the "royal" graves at the city of Mycenae itself. These yielded up a stunning array of gold masks, jewelry, weapons, and vessels.

◀ **Minoan Pottery Jar** *Cretan artists were particularly fond of decorating their pots with extravagant octopus designs that wound around the entire vessel. This type of jar was probably used for storing or transporting olive oil.* c1450–1400 BCE, painted earthenware, Ashmolean, Oxford, UK

▶ **Funerary Mask** *This piece is popularly known as the "Mask of Agamemnon" (the Greek leader in the Trojan War). It is not a death mask—the object was created separately and then placed over the dead man's face.* 16th century BCE, gold, height 10¼in, National Archaeological Museum, Athens, Greece

◀ **The Bull-Leaping Fresco** *This famous mural comes from the Palace at Knossos. It depicts the Minoan custom of bull-leaping, which was probably a ritual ceremony rather than a sport. Although heavily restored, enough of the original painting has survived to give an idea of the local artists' gift for long, graceful, taut curves.* c1500 BCE, fresco, National Archaeological Museum, Athens, Greece

▶ **Female Figurine** *This is the most common form of Cycladic sculpture. Most of the figurines depict women with their arms folded across their body, although images of musicians have also been found. The carvings were generally placed in graves, but their precise function is uncertain.* c2600–2500 BCE, marble, height 8¼in, Benaki Museum, Athens, Greece

CLOSERlook

ACROBAT These acrobatic displays were part of the bull cult, which flourished in Ancient Crete. Historians have questioned whether such daring somersaults were physically possible, and some have suggested that the bulls were carefully tethered.

INcontext

KNOSSOS The grandest of the Minoan palaces, Knossos was not only a royal residence, but also contained shrines, granaries, workshops, and an open court, where public ceremonies were staged. Large parts of the palace have been reconstructed.

Knossos, viewed from the east *According to legend, this is the site of the palace where King Minos lived.*

Greek Archaic

c750 TO 480 BCE

The Archaic Period covers the early development of Greek art, from around 750 BCE until 480 BCE, when the Persians sacked Athens. In sculpture, Greek artists eagerly assimilated ideas from Egypt and the East, gradually producing their own, highly individual style. Progress was most evident in depictions of the *kouros* (nude male), and the *kore* (draped female). Most of these statues were used as grave markers, although some represented gods. In the earliest phase, the figures had stereotyped features and a rigid stance, with their arms barely leaving their sides. Over the course of this period, the poses became more relaxed, and the treatment of anatomy grew more convincing.

The Archaic Period was also the golden age of vase painting. Initially, the Corinthians dominated this field but, by the early 6th century BCE, the lead had been taken by Athens. Its artists became masters of the "black-figure" technique, highlighted in the work of Exekias, and later of the more sophisticated "red-figure" technique, which superseded it.

▲ **Antefix of a Gorgon's Head** *Plaques of this kind were very common in early Greek architecture. They were used as ornaments to mask the end of a row of roof tiles. The designs often featured monsters, as it was thought that these would ward off evil spirits. Gorgons, with their projecting fangs, tongues, and glaring eyes, were a popular choice.* c6th century BCE, terracotta, length 9¾in, private collection

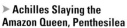

▶ **Achilles Slaying the Amazon Queen, Penthesilea** *This moment of high drama was painted by Exekias, the most famous exponent of the black-figure style of decoration. As he delivers the fatal blow, Achilles falls in love with his enemy.* 6th century BCE, pottery, height 16½in, British Museum, London, UK

▲ **Anavysos Kouros** *Named after the village where it was found, this* kouros *was a warrior's grave-marker.* c530 BCE, marble, height 76½in, National Archaeological Museum, Athens, Greece

◀ **Achilles Tending the Wounded Patrocles** *This red-figure scene was produced for the interior of a kylix (cup) by the Sosias Painter. He belonged to a group of vase-painters now known as the Pioneers.* c500 BCE, pottery, diameter 7⅞in, Staatliche Museen, Berlin, Germany

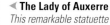

◀ **The Lady of Auxerre** *This remarkable statuette owes its name to its first known owner, a theater manager in Auxerre, who used it as a prop in an operetta. It is the finest surviving example of the "Daedalic" style of sculpture, named after the mythical figure Daedalus, who was said to have created the first Greek statues. It was made in Crete and was originally painted.* c640 BCE, limestone, height 25⅝in, Louvre, Paris, France

CLOSERlook

THE ARCHAIC SMILE
Many statues from the Archaic Period had a smile on their face. This probably had a symbolic meaning, as the smile was often featured in contexts that were far from humorous. Most historians believe that a smile was meant to signify health and vitality.

Greek Classical

Greek culture reached new heights during the Classical Period, from 480 to 323 BCE, when victory over the Persians ushered in an era of prosperity and self-confidence. In Athens, democracy took root, literature flourished, and the study of history and philosophy became established. National and civic pride increased, particularly in Athens, which became dominant in Greece up to c413 BCE. The Parthenon, with its magnificent sculptures of Greek triumphs, was designed to embody this new mood.

In the visual arts, sculptors gained a fine understanding of the structure of the body and how it moved, and achieved a new blend of realism and the ideal. This was particularly evident in the work of Polyclitus, who liked to contrast the taut, straining muscles of one limb with the relaxed pose of another. Classical sculptors were not satisfied, however, with mere anatomical accuracy: their concept of beauty entailed both ideal proportions and a serene nobility of expression. In pursuit of this goal, they produced statues of mortals that are barely distinguishable from those of their gods.

◄ **Statue of Zeus or Poseidon** *This figure probably once held a weapon—a thunderbolt (Zeus) or a trident (Poseidon). c460 BCE, bronze, height 82¼in, National Archaeological Museum, Athens, Greece*

CLOSERlook

DECORATIVE DETAILS
The figure would originally have looked even more realistic, with eyes and eyebrows inlaid with a different material, probably glass or stone.

► **Cavalcade** *Taken from the frieze that was on the Parthenon, these horsemen form part of a procession. Even though the carving is in very shallow relief, the overlapping horses provide a sense of depth and movement.* 447–432 BCE, marble, height 41¾in, British Museum, London, UK

◄ **The Spear Carrier** *This is a Roman copy of a lost bronze statue by Polyclitus of Argos, one of the greatest sculptors of antiquity. The impassive gaze is typically classical, as are the harmonious proportions of the figure and the perfect balance of the pose.* c440 BCE (Greek original), marble, height 83½in, Museo Archeologico Nazionale, Naples, Italy

► **Discobolus (The Discus Thrower)** *This Roman copy is thought to be a marble version of a lost bronze by Myron. A native of Attica, he was famed for his realism and for his skill at depicting figures in active poses. Unlike modern athletes, the Greeks did not spin around before hurling the discus.* c450 BCE (Greek original), marble, height 61in, Vatican Museums and Galleries, Vatican City

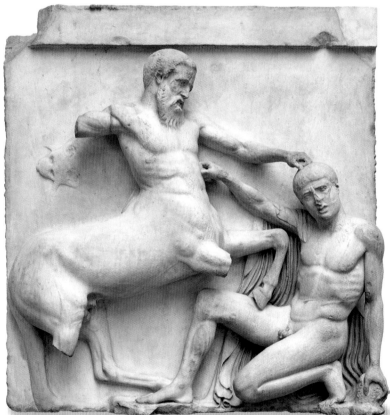

▲ **A Lapith Fighting a Centaur** *The Parthenon had 92 high-relief carvings of mythical battles. The most memorable examples show the human Lapiths confronting the Centaurs at a wedding feast, after the latter had been maddened by wine.* 447–432 BCE, marble, height 67¾in, British Museum, London, UK

Nudes

The nude was central to the art of the ancient Greeks and in their statues of naked heroes and goddesses they created standards of beauty that have been a challenge and an inspiration to later ages. Many artists, however, have used the nude not only to create images of beauty, but also to explore ideas and emotions. Drawing directly from a naked model has formed a part of art education for centuries, although in certain times and places the nude has been subject to censorship.

◀ **Cycladic kouros** Greek, artist unknown. *Greek study and development of Egyptian statuary led to a more realistic figuring of the body.* c550 BC, marble, 84in, National Archaeological Museum, Athens, Greece

▼ **Relief of Eve from Autun Cathedral** Gislebertus *Thought to be the first European nude since antiquity, Gislebertus's relief sculpture shows a shapely Eve picking an apple.* c1130, stone, Cathedral of St. Lazare, Autun, France

▼ **The Grande Odalisque** Jean-Auguste-Dominique Ingres *Ingres' accomplishment as a painter is exemplified by his cool, classical nudes, which were a reaction to the emotionally-charged Romanticism of the period.* 1814, oil on canvas, 35 x 64in, Louvre, Paris, France

▼ **Susanna and the Elders** Guercino *This biblical subject was a popular one with artists because of the chance it gave to portray a beautiful naked young woman.* 1617, oil on canvas, Galleria Nazionale, Parma, Italy

▲ **Panathenaic Amphora Depicting a Boxing Contest** Greek, artist unknown *Greek vase-painters contributed significantly to advances in the depiction of musculature.* c336 BCE, pottery, British Museum, London, UK

▲ **David** Michelangelo *This monumental emobodiment of human beauty stood at the entrance of Florence's Palazzo Vecchio for over 300 years.* 1501–04, marble, 171in, Galleria dell'Accademia, Florence, Italy

▲ **Adam and Eve** Titian *The Venetian artist's delicately sensitive flesh tones, which he was still developing in the latter stages of his career, humanize this famous scene.* c1550, oil on canvas, 95 x 73in, Prado, Madrid, Spain

▲▲ **Reclining Nude (Miss O'Murphy)** François Boucher *This provocative nude depicts Marie-Louise O'Murphy, a mistress of King Louis XV.* 1749, oil on canvas, 23 x 29in, Wallraf Richartz Museum, Cologne, Germany

▲ **The Naked Maja** Francisco de Goya *Goya's depiction of the unabashedly naked maja—who makes no attempt to conceal her breasts or pubic hair—was too forceful a portrayal of female sexuality for the Spanish Inquisition, who branded it obscene.* c1800, oil on canvas, 38 x 75in, Prado, Madrid, Spain

▼ The Source or Bather at the Source
Gustave Courbet *Courbet's radically naturalistic approach to painting, throwing off academic convention, is expressed in his realistic depictions of the female form.* 1868, oil on canvas, 50 x 38in, Musee d'Orsay, Paris, France

▼ The Dance Henri Matisse *The use of vibrant colors makes Matisse's boldly executed dancers come alive with a rampant energy.* 1910, oil on canvas, 102 x 154in, The State Hermitage Museum, St. Petersburg, Russia

◄ Self Portrait Egon Schiele *The angular contortions of this self-portrait are typical of Schiele's Expressionist approach to painting the nude.* 1911, watercolor and pencil on paper, 18 x 12in, private collection

▼ Small Naked Portrait Lucian Freud *Harshly-lit skin tones are characteristic of his uncompromising approach to nude portraiture.* 1973–74, oil on canvas, 8 x 10in, Ashmolean Museum, Oxford, UK

▲ Nude, or Nude Seated on a Sofa Pierre-Auguste Renoir *The subtle use of color and shade lends Renoir's subject a delicate sensuality.* 1876, oil on canvas, 36 x 28in, Pushkin Museum, Moscow, Russia

▲ Reclining Figure No.2 Henry Moore *The fluid movement and undulations of Moore's female forms owe a debt to the influence of African sculpture.* 1953, bronze, 16 x 35in, private collection

▲ Woman Putting on her Stocking Henri de Toulouse-Lautrec *Typical of the artist's style, the figures are somewhat linear and the painting has an unfinished appearance.* c1894, oil on card, 22 x 18in, Musée d'Orsay, Paris, France

▲ Reclining Nude from the Back
Amedeo Modigliani *In his nudes Modigliani often crops the arms and legs, helping to create a sense*

Hellenistic

The Hellenistic era covers the period from the death of Alexander the Great in 323 BCE to the accession of the first Roman emperor in 27 BCE. Alexander's conquests had spread Greek culture throughout Egypt and Western Asia, and the city of Alexandria in Egypt, rather than Athens, became the center of the Hellenistic world.

Among Hellenistic sculptors there was a growing taste for figures that conveyed fiery emotions or violent movement. This could be achieved by a contorted pose or by elaborate, swirling drapery. Another change was that art was no longer dominated by state patronage. Private collectors increased dramatically, creating a demand for different styles and subjects. There was a new interest in humorous or low-life themes, such as aged drunks, comic actors, and lust-filled satyrs. Portrait sculpture also gained in popularity. Occasionally, the results were unflattering, offering a foretaste of the Romans' realistic approach. In this field, the leading figure was Lysippus, the favorite sculptor of Alexander, who apparently refused to be portrayed by any other artist.

◀ **Venus de Milo** *The serene expression of this goddess is classical in style, but her twisting, spiral pose is typically Hellenistic. The statue was made from two blocks of marble, pegged together, and was once adorned with metal jewelry.* c100 BCE, marble, height 80¼in, Louvre, Paris, France

▼ **Laocoön** *According to Greek legend, Laocoön and his sons were slain by serpents, after trying to warn their fellow Trojans against the Greeks' wooden horse. This statue was discovered in 1506, in a vineyard in Rome.* 1st century BCE, marble, height 82¾in, Vatican Museums and Galleries, Vatican City, Italy

▲ **The Farnese Hercules** *Hercules rests on his club after completing his labors. The original statue, now lost, was probably by Lysippus.* 4th century BCE (copy), marble, Museo Archeologico Nazionale, Naples, Italy

◀ **Victory of Samothrace**
This famous statue shows Nike, the winged goddess of Victory, alighting on the prow of a ship. It was made to commemorate a naval triumph, perhaps in Rhodes in 190 BCE, and was prominently displayed on a cliff-top sanctuary. c190 BCE, marble, height 129in, Louvre, Paris, France

CLOSERlook

VIOLENT EMOTION
Hellenistic sculpture is noted for its emotional intensity. Laocoön's agonized expression was greatly admired when the statue was found, and proved a key influence on Michelangelo and later Baroque artists.

DRAMATIC MOVEMENT
In contrast to classical art, with its calm sense of grandeur, Hellenistic sculptors tried to give an impression of dynamic movement, shown here in Laocoön's despairing attempts to struggle free.

INContext
ALEXANDER THE GREAT
In his short life, Alexander the Great (356–323 BCE) transformed Greece by conquering the vast Persian Empire, which extended as far as India. His victory at Issus in 333 BCE was commemorated in the Alexander Mosaic.

The Alexander Mosaic *(c100 BCE)*
This detail shows Alexander himself, riding into battle against the Persian King, Darius III.

The Etruscans

Distinctive Italian cultures can be traced back to the Bronze Age. In the 9th century BCE, the Villanovans flourished briefly in the area around present-day Tuscany, producing some fine metalwork. In the following century, they were superseded by the Etruscans, an Italian people, whose origins are still hotly disputed. They rapidly built up an extensive trading network, which brought them considerable wealth.

Etruscan artists built on the achievements of the Villanovans, but owed a greater debt to foreign styles. They were heavily influenced by Greek craftsmen, many of whom came to work in Etruria, central Italy. Their artworks also displayed a strong Near Eastern flavor, which probably stemmed from their trading links with the Phoenicians (natives of present-day Lebanon and Syria).

Rome

While the Etruscans had artistic flair they lacked political organization. Increasingly, they were caught between the expansion of the Celts in the north and the Romans in the south and by the 3rd century BCE, they had fallen under the latter's control. Founded by Romulus, son of the God of War, in 753 BCE, the city rose to greatness during the period of the Republic (510–27 BCE). The Romans borrowed from both the Etruscans and the Greeks, copying slavishly from the latter, employing traveling craftsmen to carry out the task. The rank of artists was not as high as in Greece, and the creators of many of the Romans' greatest monuments are unknown. They did pioneer a taste for realism, shown in their portrait sculptures and still-life paintings.

Italian art played a key role in the history of Western culture. One of the twin pillars of Classicism, Roman art helped provide the basis of European civilization, while the Romans in turn owed much to their Etruscan forebears.

◀ **She-Wolf** *The wolf figure is Etruscan, but the sculptures of Romulus and Remus were added by Antonio Pollaiuolo in c1484–96.* 6th century BCE, bronze, height 29½in, Museo Capitolino, Rome, Italy

Etruscans and Ancient Rome

Etruscan art

ITALY, c8TH – c2ND CENTURY BCE

Before the emergence of the Romans, Italy was dominated by the Etruscans, a people who appear in the historical record around the 8th century BCE. Their trading links brought them into contact with many cultures, but their art was chiefly influenced by the Greeks. The Etruscans were concerned with the the preservation of the body and the afterlife, and they developed an elaborate cult of the dead. They created huge necropolises and staged funeral games—a precursor of the gladiator combats in ancient Rome. They decorated their tombs with lively murals, illustrating the sporting contests. The finest examples can be found in central Italy at Tarquinia and Cerveteri, both of which have been classed as world heritage sites. The Etruscans were also noted for their tomb sculpture and high-quality metalwork. The latter includes some remarkable bronze mirrors, decorated with mythological scenes, highlighting the benefits of physical beauty.

▲ **Sarcophagus of a married couple** *From the Banditaccia necropolis in Cerveteri. The couple recline, as if at a banquet. The wife anoints her husband's hand with perfume, a traditional funeral ritual.* c520–510 BCE, terracotta, 43¾ x 76½in, Louvre, Paris, France

◀ **Phersu Dancing, from the Tomb of the Augurs** *The paintings in this tomb depict some of the sporting activities that the Etruscans staged at their funerals. Many involve a masked figure "Phersu," which, via Latin, may be the source of the word "person."* c530–520 BCE, wall painting, Tomb of the Augurs, Tarquinia, Italy

CLOSERlook

BIRD DECORATION The tomb gained its nickname from the "augur," a classical priest whose duty was to predict the future and interpret the will of the gods by observing the flight and cries of birds.

Roman Painting

Only a small number of Roman paintings have survived. From written sources, we know that the Romans produced panel paintings on a variety of wooden surfaces, but these have vanished almost without trace. However, the preservation of houses at Pompeii and Herculaneum, following the eruption of Vesuvius in 79 CE, provides a clearer picture of Roman wall paintings. These were executed using a traditional fresco technique, with watercolors applied on wet plaster.

Historians have detected four different styles of decoration in the remains at Pompeii, but there is less agreement about their source. Some murals may have been modeled very closely on Greek and Hellenistic examples, but no Hellenistic painting survives to judge from. Roman artists had a feeling for nature and a taste for realism. There was an interest in closely-observed landscapes, which created the illusion of distance, as if the viewer was looking out of a window. Paintings of gardens were particularly popular. Artists did not feel constrained to include human figures in these, but portray flowers, birds, and shrubs. This same detail can be observed in Roman still lifes.

> " **Antiquity** has not ceased to be the **great school** of modern painters, the source from which they draw the **beauties of their art** "
>
> JACQUES-LOUIS DAVID (1748–1825)

▼ **Woman selling Cupids** *Discovered in the Villa Arianna at Stabiae, a luxury seaside retreat just south of Pompeii, this curious, light-hearted theme later captured the imagination of Neoclassical artists. Angelica Kauffmann was one of many to produce a version of it.* c1st century BCE–79 CE, fresco, 11 x 13¾in, Museo Archeologico Nazionale, Naples, Italy

▶ **Cupids Making Gold** *This example of the "Fourth Style" of Roman painting comes from a house owned by two merchants called Vettius. It can be dated precisely, as their home was rebuilt after the earthquake of 62 CE. Roman artists portrayed cupids in a wide variety of whimsical subjects. There are even scenes of them playing games such as hide-and-seek and blindman's buff.* 62 CE, fresco, Museo Archeologico Nazionale, Naples, Italy

▶ **Portrait of a Married Couple** *This couple have been tentatively identified as a baker, Terentius Neo, and his wife. He holds a scroll, which may be their marriage contract, while she has a wax tablet and stylus pen.* 1st century CE, fresco, 22¾ x 20½in, Museo Archeologico Nazionale, Naples, Italy

◀ **The Head of Silenus with a Mask** *This is part of a fresco cycle, illustrating the initiation rites for a Bacchic cult (see p.59).* c60–50 BCE, fresco, Villa of the Mysteries, Pompeii, Italy

◀ **Still Life with Peaches**
In their still-life paintings, Roman artists achieved a freshness and an eye for detail that no one attempted to equal for many centuries. This outstanding example was discovered in a house in Herculaneum. c50 CE, fresco, 13¾ x 13½in, Museo Archeologico Nazionale, Naples, Italy

CLOSERlook

ILLUSIONISTIC EFFECTS
Roman painters loved showing off their technical skills. In a genuine *tour de force*, this one has highlighted the transparency of the glass, even showing the reflection of a leaf behind it.

Roman Sculpture

c510 BCE – 476 CE

Roman sculpture served a number of purposes, ranging from pure decoration to political propaganda. Statues were designed to boost an emperor's prestige, while columns and triumphal arches, covered in high-relief carvings, commemorated his achievements in vivid detail. The Emperor Augustus commissioned a huge number of portrait sculptures—more than 200 still survive—and they highlighted different aspects of his role. Sculptures of ordinary citizens were far less grand and could often be unflatteringly realistic. Sometimes, they were even based on death masks.

▶ **Augustus of Prima Porta** *This statue was discovered at the Villa of Livia at Prima Porta. The breastplate is decorated with military achievements, including the recapture of legionary standards.* c20 BCE, marble, height 80in, Vatican Museums and Galleries, Italy

Sarcophagi

2ND CENTURY CE – 476 CE

The development of the sarcophagus (a stone or terracotta coffin) resulted from changes in funerary customs. Originally, the Romans cremated their dead but, from around the 2nd century CE, burials became more common. The sarcophagus was set against a wall, so not every side was decorated. The Etruscans had developed a *kline* (couch) format with reclining effigies, which the Romans borrowed, though they soon developed a large repertoire of their own. Typical examples of decoration included heroic battles, usually reserved for high-ranking soldiers, classical legends, or hunting scenes. Depictions of the seasons, with their overtones of rebirth and renewal, were also popular.

▲ **The Ludovisi Sarcophagus** *Formerly in the Ludovisi collection, this magnificent high-relief carving shows Roman soldiers battling against Germans. The commander on horseback has been identified as Hostilian, the son of Emperor Decius.* c250 CE, marble, 59 x 106 x 51in, Museo delle Terme, Rome, Italy

▲ **Garden Painting** *This remarkable wall painting was produced for a subterranean chamber in the Villa of Livia, at Prima Porta. The occupants of the house would have withdrawn here in summer, to escape from the heat and the dust of the outside world.* c20 BCE, fresco, height 79in, Museo Nazionale Romano, Rome, Italy

Origins and influences

As the Roman Empire expanded, some of the peoples who blocked its progress were nomadic. In practical terms, this meant that their artworks were very different. There was no great architecture, no monumental sculpture, no wall painting. Most artworks, such as jewelry and belt buckles were portable, although some grave-markers and shrines have survived.

On a more positive note, the mobility of these peoples ensured that cultural traits were received and transmitted over great distances. Some of the tribes in the Asian Steppes travelled as far afield as China and the Balkans, while Celtic influences eventually reached most parts of Europe. This created a genuine melting-pot of different styles. Altai craftsmen, for example, shared links with the Ordos culture, which flourished in the Yellow River region of northern China, the Scythians drew influences from Greek colonists, the

Sarmatians looked to Persia, while the Celtic style included patterns from the Near East.

Subjects

The dominant theme for many of these nomadic peoples was animal life. Almost without exception, they portrayed wild animals or birds, rather than their domesticated flocks and herds. In most cases, the forms were highly stylized. Often, the creature's body was elongated and molded into a ring or an "S" shape, so that the image would fit onto a circular object. Violent animal combats were popular, as were savage heads, confronting each other at the ends of a necklace or an armband. Historians can only speculate on the meaning. Some believe that the imagery was a survival of prehistoric hunting magic, while others interpret the animals as totemic ancestor figures for individual tribes.

◄ **Relief Depicting a Man Fighting a Roman Soldier** *The Romans liked to commemorate their victories with sculpted reliefs on triumphal arches and columns. Here, a soldier confronts a man thought to be a Dacian. 2nd century CE, stone, 33 x 34½in, Louvre, Paris, France*

The Romans exerted such a huge impact on Western civilization that, for centuries, the culture of less powerful peoples was dismissed as barbaric. Increasingly though, it has become clear that the artworks of these peoples were often highly sophisticated and very beautiful.

Outside the empires

Scyths

EURASIAN STEPPES; c6TH CENTURY BCE

The Scythians were a semi-nomadic people of Iranian origin, who migrated to the Eurasian Steppes in around the 8th century BCE. In its narrowest sense, the term relates to the tribes who lived to the west of the River Volga and north of the Black Sea. However, the word "Scythia" was also frequently applied to a much wider area, extending from the Ukraine to Siberia.

The Scythians produced magnificent, golden artifacts, including shield ornaments, buckles, clasps, combs, mirrors, and torcs. Their metallurgical techniques derived, in part, from their contact with Greek colonies around the Black Sea. In time, the Scythians' vigorous, highly original animal style of decoration influenced Celtic craftsmen. Peter I (1672–1725) amassed more than 200 Scythian artefacts.

▼ **Belt Buckle** *Animal fights were a popular theme in Scythian art. This ornate piece, which was cast in two sections, comes from the huge collection amassed by Peter the Great. 7th century BCE, gold, 3⅞ x 6⅝in, Hermitage, St. Petersburg, Russia*

Altaic

PAZYRYK; c6TH–4TH CENTURY BCE

The Altai nomads take their name from a Siberian mountain range, overlooking the eastern Steppes of Russia. Their trading contacts, which ranged from China to Mesopotamia, are reflected in the eclectic style of their artworks. The most intriguing finds come from the Pazyryk burial mounds, where the cold climate preserved items that would normally have perished long ago. These include high-status objects such as saddle covers, carpets, and even an elaborate set of tattoos on the skin of a tribal chief.

▲ **Felt Wall-hanging Depicting a Mounted Warrior** *This was discovered in the Pazyryk burial mounds, a unique, high-altitude site in central Asia, where the contents of the tombs were permanently frozen. 5th–4th century BCE, textile, 177 x 256in, Hermitage, St. Petersburg, Russia*

Sarmatians

SCYTHIA; c600 BCE–400 CE

▲ **Diadem** *This head piece was discovered in a kurgan (burial mound) at Khoklach. The intricate decoration shows sacred animals flanking a tree. The diadem may have been related to a fertility ritual. 1st century CE, gold, turquoise, coral, amethyst, garnet, pearl, and glass, 5⅞ x 24in, Hermitage, St. Petersburg, Russia*

The Sarmatians were a group of tribes who hailed from Iran but eventually flourished in western Scythia, in parts of the Ukraine, and the eastern Balkans. Their artifacts display a blend of classical and Scythian influences. The richest finds come from the burial mound at Khoklach, near Novocherkassk, where many exquisite items of jewelry were discovered. Made of gold and precious stones, these were decorated with stylized animal forms, which were thought to have talismanic powers.

Celts

The Celts were a loose association of tribes, who were first recorded by classical authors in the 6th century BCE. At this stage, their heartlands were in the Upper Danube region of Central Europe, though their migrations were considerable. The Galatians, for example, settled in Asia Minor, while the Gauls moved west. The Celts were known for their martial prowess. At different times, they sacked Rome (386 BCE) and occupied Delphi (279 BCE).

A distinctive Celtic style emerged over a lengthy period, blending influences from the classical world, designs from the Scythians and the Persians, and geometric motifs from Hallstatt (an Iron Age culture). Many finds come from watery sites, where high-status objects were deposited as ritual offerings to the gods. The most famous example is La Tène, by Lake Neuchâtel in Switzerland, which has given its name to a phase of the Iron Age.

▼ **Wine Flagon from Basse-Yutz** *This is one of a pair of flagons, discovered in 1927. The two were made in eastern France, but were based on the shape of Etruscan vessels.* 4th century BCE, bronze with coral and enamel inlay, height 15¼in, British Museum, London, England

CLOSERlook

ANIMAL ORNAMENT The idea of using animal forms on wine vessels had its origins in the classical world, but the Celts added their own, grotesque brand of humor. Here, a canine creature that forms the handle looms over a stylized cat on the lid of the jug. This, in turn, casts a predatory eye over a duck, swimming happily up the spout.

▲ **Gundestrup Cauldron** *This unique piece was left as a prayer offering in a Danish peat bog. The workmanship is typical of Thracian silversmiths, but the imagery is thoroughly Celtic.* 1st century BCE, silver (once gilded), diameter 27¼in, National Museum, Copenhagen, Denmark

◄ **Figure of a god** *This Gaulish sculpture from Bouray, France, has strong Roman influences, but the torc and the animal hooves confirm that it is a Celtic deity.* 1st century BCE–1st century CE, bronze, height 16½in, Musée des Antiquités Nationales, Saint-Germain-en-Laye, France

▲ **The Agris Helmet** *This outstanding example would originally have been surmounted by a crest, now broken off at its base.* 4th century BCE, iron, bronze, gold, coral inlay, height 8⅜in, Musée Archéologique et Historique, Angoulême, France

CLOSERlook

INTRICATE DECORATION The cheekpiece of the helmet is decorated with a horned serpent. The serpent could be a symbol of the underworld, leading to speculation that the place where the object was deposited—a grotto near Angoulême—may once have been regarded as an entrance to the Celtic underworld.

From being an obscure sect in Palestine in the 1st century CE, Christianity rose to become the state religion of the Roman empire in 313 CE. As the congregations swelled, so too did the demand for art works that would provide a focus for Christian prayer and teaching.

Early Christian art

The term "Early Christian" describes the period between c300 and 750, when the influence and organization of the faith were growing rapidly in the West. To begin with, it was a clandestine religion. Persecution by the Roman authorities, which reached a peak during the reign of Diocletian (284–305), ensured that meetings were held in secret and artworks were either portable or—as in the case of the Catacombs—hidden away from public view.

The situation improved in 313, when Emperor Constantine granted Christians full religious freedom. Even so, it took time for Christian artists to develop their own religious language. Images of the Crucifixion, for example, were abhorrent, because this degrading form of execution was reserved for slaves and criminals. Instead, artists borrowed ideas from

▲ **San Vitale, Ravenna, 526–48** *The building of this unusual octagonal church began during the rule of the Ostrogoths, but was completed after Justinian had ousted them.*

classical depictions of Roman gods. Their favorite theme was the Good Shepherd, which was frequently depicted in paintings, mosaics, and carvings, but fell out of favor after the Middle Ages.

Byzantine art

In 330, Emperor Constantine moved his capital to Byzantium, renaming it Constantinople. Here, Christian artists were exposed to very different influences. The city was Greek, but affected by cultures of the Near East. Byzantine artists created their first religious masterpieces in mosaic; some of the finest examples created at Ravenna. After the fall of Rome, Ravena played a key role, as Justinian made it his capital in the West.

The veneration of holy images led to problems in the 8th century, when it was deemed idolatrous. During the Iconoclastic crisis (c725–843), thousands of religious works were destroyed. In later Byzantine art, wall-paintings and icons played a growing role. The latter, in particular, transmitted Byzantine influences far beyond the empire's borders, with the greatest icons being produced in Russia, where Andrei Rublev (c1360–1430) and Theophanes the Greek (c1330/40–c1410) were the leading figures.

Early Christian and Byzantine

Early **Christian**

ROMAN EMPIRE, c300–750 CE

In the West, Christian art appeared before the religion was officially established in 313. Some of the earliest examples can be found in the Catacombs—the subterranean burial galleries just outside Rome—which were used for covert prayer meetings during the days of persecution. The images there are very basic, often little more than a symbol: a fish, a dove, an anchor, the Cross.

More ambitious artworks were generally inspired by classical models. Christ was frequently depicted as a beardless youth, a form that derived from statues of Apollo, Mercury, or Orpheus.

Once Christianity had been sanctioned officially by the emperor, this allowed artists to place greater emphasis on the grandeur of the Lord. Working within the Byzantine tradition, the mosaics produced by artists at Ravenna were on a far grander scale than previous work.

▲ **The Raising of Lazarus, Scenes from the Life of Christ**
Early Christian artists often used imperial imagery to underline the majesty of Jesus. Here, a young and beardless Christ is shown wearing purple robes—a color associated with kings and emperors. 6th century, mosaic, Sant'Apollinare Nuovo, Ravenna, Italy

▲ **The Three Hebrews in the fiery furnace** *The Biblical tale of Shadrach, Meshach, and Abed-nego (Daniel III) had particular resonance, at a time when Christians were still threatened with persecution.* Late 3rd century, fresco, Catacombs of Priscilla, Rome, Italy

▲ **The Good Shepherd** *A very popular Early Christian theme. The youthful figure of Christ is based on classical statues of Mercury, the protector of flocks. The sheep returned to the fold symbolizes the repentant sinner.* c300, marble, Pio-Christian Museum, Vatican City, Italy

Byzantine

EASTERN MEDITERRANEAN, 330 CE–1453

Byzantine art flourished from 330 CE, when Constantinople was founded, until 1453, when the city fell to the Turks. Within this huge time-span, the boundaries of the empire fluctuated considerably, though this did not prevent Byzantine trends from affecting artistic developments as far afield as Italy, Egypt, and Russia.

In 395, following the death of Theodosius the Great, the empire was divided and the artistic traditions of its two halves rapidly began to diverge. In the West, constant warfare led to an era of diminished artistic production, while in Byzantium a new order of art work emerged. Religious icons and imperial images were venerated, and their appearance was strictly controlled. Their forms were symbolic and stylized, and any artistic individuality was frowned upon.

In other fields, Byzantine craftsmen serviced a thriving market for luxury objects. The quality of their silks, jewelry, cloisonné enamels, and carved ivories was outstanding. The latter often took the form of diptychs, adorned with religious or imperial subjects.

◀ **The Barberini Ivory** *The central panel depicts the Emperor Triumphant. Above, Christ offers a blessing, flanked by winged Victories; below, earthly powers pay homage. The emperor is probably Justinian.* Early 6th century, ivory, 13½ x 10½in, Louvre, Paris, France

▶ **Emperor Justinian and Attendants**
Justinian commissioned this mosaic, shortly after his troops had captured Ravenna from the Ostrogoths. He never visited the city, but this portrait emphasized his official presence in his western capital. c547, mosaic, San Vitale, Ravenna, Italy

CLOSERlook

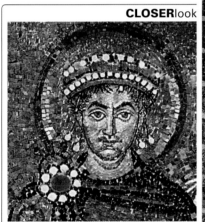

DIVINE STATUS Justinian is shown with a halo, underlining the theocratic nature of the emperor's role. He is God's representative on earth, playing a central role in the celebration of Mass. In his left hand, he carries a golden paten that will hold the communion bread.

▲ **The Old Testament Trinity** *Painted by Andrei Rublev, this depicts the three angels who visited Abraham. Byzantine artists used this theme to illustrate the Holy Trinity.* c1411, tempera on panel, 56 x 45in, Tretyakov Gallery, Moscow, Russia

▲ **The Anastasis (Descent into Limbo)** *Created for the Chora Monastery (now a museum), this shows Christ rescuing the souls of the virtuous.* 1316–21, fresco, height of Christ 64¼in, Kariye Camii, Istanbul, Turkey

INcontext
THE TETRARCHY In 293 CE, Diocletian devolved responsibility to four rulers ("Tetrarchs")—an emperor ("Augustus"), along with a subordinate ("Caesar"), for the empire's eastern and western halves. The system failed, but the titles survived.

The Four Tetrarchs *The sculpture underlines the sense of unity that the Tetrarchs were meant to provide.* c300, porphyry, St. Mark's, Venice, Italy

Origins and influences

The term "Carolingian" derives from Charlemagne (742–814), who became King of the Franks in 768 and was crowned the first Holy Roman Emperor in 800. The name Charlemagne is derived from the Latin word for Charles, *Carolus*, and means "Charles the Great." His use of this title showed his ambition to revive the lost glories of Rome, and assume the leadership of Christendom.

These ambitious aims could not be achieved by military prowess alone. Charlemagne introduced sweeping political and economic reforms, as well as a far-ranging revival of learning. The effects of his policies were felt long after his death and the Carolingian epoch lasted until around 900.

Subjects

With regards to the visual arts, Charlemagne made a deliberate effort to build on the achievements of

Following the collapse of the Roman Empire in 476, Europe endured centuries of turmoil, as different people battled for supremacy. Order was not restored until the rise of Charlemagne. His coronation as emperor in 800 signaled the start of a new era.

▲ **Reliquary of Charlemagne** *Charlemagne was buried in Aachen cathedral. In 1349, the tomb was opened and his skull was transferred to this shrine.* 1350, gold inlaid with gems, Treasury, Aachen Cathedral, Germany

classical and early Christian art, while also keeping abreast of the latest developments in the Eastern empire. Some notable frescoes survive at Auxerre and Müstair, along with a fine mosaic at Germingny-des-Prés, but the best evidence comes from illuminated manuscripts. The most original examples of these were the illuminated manuscripts produced at the monastic workshops in Reims.

Arguably though, the most crucial innovation in manuscript production relates to its script. By Charlemagne's time, the existing Merovingian form had become virtually unreadable. In its place, he promoted a new version— the Carolingian minuscule. Developed at the palace school in Aachen, this lettering was so clear that it became the basis of many modern typescripts.

The Carolingians produced no monumental sculpture, but the quality of their small-scale work was extremely high. Ivory-carvers and goldsmiths, in particular, created some exquisite pieces. The ivory-carvers specialized in intricate book-covers, while the finest metalwork was made to adorn the high altar.

Carolingian

Manuscripts

EUROPE, 8TH–10TH CENTURIES

Carolingian manuscripts provide one of the chief legacies of the age. As with other aspects of the revival, the key sources were classical and Byzantine. This did not produce a recognizable Carolingian style, however, as different centers developed variations. The opulent Godescalc Evangelistary, for example, was stiff, with its text written in letters of gold and silver on purple vellum. By contrast, the illustrations in the Ebbo Gospels had an intense, almost frenzied appearance, while the images in the Utrecht Psalter—arguably the greatest of all Carolingian manuscripts—were dynamic and expressive.

CLOSERlook

DIVINE INSPIRATION While he is writing his gospel, Mark looks upward to the winged lion—his traditional symbol—for divine inspiration. The lion is an apocalyptic beast, described in the Book of Revelation.

▼ **St Mark** *The sketchy style of this manuscript commissioned by Ebbo, Archbishop of Reims, was typical of the manuscripts produced by the School of Reims.* Ebbo Gospels, c816–35, vellum (animal skin parchment), 7⅛ x 5½in, Bibliothèque Municipale, Épernay, France

Ivory

FRANCE, 8TH–10TH CENTURIES

Ivory carving was the most popular form of sculpture during the Carolingian era. The material had been used for luxury items since ancient times, and local craftsmen drew inspiration from both classical and Byzantine models. The vast majority of the carvings were rectangular plaques, which were used as centerpieces on book-covers. Because of the close links with manuscript production, the principal workshops for both art forms were frequently located in the same vicinity, in places such as Tours and Metz. In addition, the scenes portrayed on the ivories were often loosely based on manuscript illustrations.

▶ **St. Gregory** *One of the Fathers of the Church (c540–604), copies of St. Gregory's writings were frequently produced. This ivory may have formed part of a book cover for one such manuscript.* c850–875, ivory, Kunsthistorisches Museum, Vienna, Austria

The Ottonian era takes its name from Otto I (Otto the Great), who became King of the Germans in 936 and was crowned Holy Roman Emperor in 962. His reign was followed by those of Otto II (973–83) and Otto III (996–1002), but the scope of the term extends beyond this, covering most of the 11th century.

Origins and influences

The Ottonian style was a cocktail of many different influences. There was a conscious attempt to recapture the achievements of the Carolingian era and, as a logical extension of this, a desire to echo the grandeur of classical and late antique models. At the same time, the sheer volume of ecclesiastical patronage led to a reawakening of interest in Early Christian art. Finally, there were strong cultural links with the Byzantine empire. These reached a peak during

▲ **Otto II** *From the* Epistles of St. Gregory, *produced in Trier, this shows Otto receiving homage from the four provinces of his empire.* c983, vellum, 10½ x 7⅞in, Musée Condé, Chantilly, France

the time of Otto II, who married Theophanu, a Byzantine princess.

Although imperial support was important, the outstanding patrons of the age were powerful clerics: men such as Archbishop Gero of Cologne,

who commissioned the finest monumental sculpture of the period; Archbishop Egbert of Trier, who ordered several major manuscripts, among them *The Epistles of St. Gregory*; and Bernward of Hildesheim, who is said to have done metalwork himself. Canonized in 1192, he later became the patron saint of goldsmiths.

Subjects

In many areas, Ottonian craftsmen followed a similar path to their Carolingian predecessors. Ivory relief carvings remained popular, the vast majority depicting religious subjects, many of them produced in the flourishing workshops at Echternach and Reichenau. However, the growing interest in large-scale sculpture, epitomized by the Gero Crucifix and the bronze doors at Hildesheim, marked a significant departure from Carolingian tradition. Together with Ottonian manuscripts, they provide hints of the Romanesque style that was to follow.

After Charlemagne's death, the Holy Roman Empire rapidly disintegrated. Its glories were only revived in the following century, when Otto the Great came to power. During his reign, and those of his German successors, imperial art regained much of its luster.

Ottonian

Bronze-casting

GERMANY, 11TH CENTURY

Ottonian craftsmen achieved marked advances in the field of sculpture, most notably through their revival of bronze-casting with the "lost-wax" method (casting with a wax mold). The two most celebrated examples were commissioned by Bernward of Hildesheim (c960–1022) for the local church of St Michael. These consisted of a bronze column—which served as a gigantic candlestick and was loosely based on Trajan's Column in Rome—and a magnificent pair of doors—decorated with relief carvings of scenes from the Scriptures, adapted from illustrations in illuminated manuscripts.

▲ **Door from Hildesheim Cathedral (detail)** *The door was commissioned by Archbishop Bernward, the former tutor of Otto III. The Adoration of the Magi is depicted here, above the door-knocker.* 1015, bronze, width of panel 23¼in, Hildesheim, Germany

Jewelry

GERMANY, 11TH CENTURY

▲ **Eagle Brooch** *This magnificent item was produced for Gisela of Swabia (995–1043), the wife of Emperor Conrad II. The eagle became a potent symbol for the Holy Roman Emperors.* 11th century, gold, enamel, and precious stones, Mittelrheinisches Landesmuseum, Mainz, Germany

Like the Carolingians before them, Ottonian craftsmen worked with precious materials. Some items were produced for imperial use. There is the celebrated Crown of the Holy Roman Empire, bearing an inscription to Conrad II, as well as jewelry belonging to his wife. The most lavish pieces, however, were generally destined for the Church. Typical examples include Bible covers, ornate crosses, and receptacles for relics, all made out of gold and studded with gems, pearls, enamel, or cameos.

Manuscripts

GERMANY, 10TH–11TH CENTURIES

Although few wall paintings have survived from the Ottonian era, some manuscripts have survived. These were created and preserved at the major monastic centers, such as Trier, Echternach, Reichenau, and Cologne. The miniatures themselves betray a number of different influences, most notably Byzantine, late antique, and Carolingian. From these diverse sources, Ottonian artists developed their own, distinctive style.

They focused primarily on human figures, restricting background details to a minimum. These figures were often stylized, with slender, elongated bodies, and highly expressive, making expansive gestures with their large hands.

◀ **The Ascension, Liber Evangelicorum** *Ottonian illuminators shifted their emphasis from the Old to the New Testament. Gospel books and pericopes (extracts from the Gospels) became the most popular form of manuscript. Here, Christ ascends in a golden mandorla, an almond-shaped halo.* 10th century, painting on vellum, 14 x 10in, Biblioteca Medicea-Laurenziana, Florence, Italy

Origins and influences

"Viking" is a collective name for the seafaring people of Scandinavia, who had a devastating impact on northern Europe during the Medieval period. Although the Vikings are most famous as pirates and marauders, their artistic style came about through commercial contacts.

Scandinavian seamen regularly traveled to Russia and Constantinople, building up a rich trade in precious metals, fur, and tusks. In the process, they became influenced by Carolingian, Byzantine, and Celtic culture.

In its most basic form, Viking decoration consisted of interlacing plants and animals. Over the centuries, there were subtle developments.

In chronological order, the main phases are known as Oseberg, Borre, Jelling, Mammen, Ringerike, and Urnes. Most of these take their names from finds at important burial sites.

▼ **The Oseberg Ship** *Excavated in 1904, now in the Viking Ship Museum in Oslo, the well-preserved remains of this 71⅔ x 16¼ft wooden ship were originally used for the burial of a high-ranking female, perhaps Queen Asa.*

Subjects

Throughout the period, the most common motifs were stylized animals. One of these animals was a ribbon-shaped beast, which cannot be linked to any existing creature with real certainty. However, lions and snakes were frequently featured, along with some birds—chiefly hawks, ravens, and eagles. More rarely, there were depictions of horses and toward the end of the period, dragons. Human figures were even scarcer, although some examples can be found.

In most cases, the animals' purpose seems to be purely ornamental. However, attempts have been made to look for deeper symbolic meanings, either by linking the designs with episodes from the Viking sagas or the Bible. The most convincing example is the image of a fight between a lion and a snake, which can be seen on several Christian memorials. This has been interpreted as a symbolic struggle between good and evil.

The Viking Age blossomed in Scandinavia in the Middle Ages, from around 800 to 1050. Northern craftsmen developed a form of animal decoration, which influenced neighboring cultures and became an important element of the Romanesque style.

Viking art

Metalwork

SCANDINAVIA, c800–c1050

▲ **Helmet, from the Vendel treasure** *In the 1880s, archaeologists found a rich array of weaponry in a group of ship burials at Vendel, in the Swedish province of Uppland.* c600 CE, iron and bronze, Historiska Museet, Stockholm, Sweden.

The earliest Scandinavian metal objects known to us were made around 1500 BCE, but there seems to have been no sustained practice of metalworking until c 550 CE. From this later period an impressive array of shields, helmets, and swords has been unearthed from graves, notably at Vendel and Valsgärde. Both in their decoration and overall design, these have strong affinities with weaponry found at the Anglo-Saxon burial site, Sutton Hoo (see opposite).

Carving

SCANDINAVIA, c800–c1050

During the Early Middle Ages, the Vikings built up extensive trading contacts with Russia and the East. Influenced by these contacts, their craftsmen developed a distinctive style of design using interlacing animals, with biting snakes and monsters. Over the years, a number of different variants evolved, all of which featured similar, densely entwined patterns. The style itself was extremely versatile. Although usually associated with woodcarving, it has been found on objects made of stone, bone, and metal. The designs were also used on military equipment, such as weaponry and longships, inside churches, and on rune-stones ("memory stones" placed by graves of warriors).

▼ **Figurehead of the Oseberg Longship** *The decorations on this prow show a monstrous head formed from patterns of interlace.* 9th century, wood, Viking Ship Museum, Oslo

▶ **The Cammin Casket (copy)** *The original casket was housed in Cammin Cathedral, Pomerania, but was destroyed during World War II.* c1000 CE, wood, elk-horn, bronze, 24¾ x 10¼in, Nationalmuseet, Denmark

▶ **North Portal** *This carving, with its mix of entwined ribbon-snakes and dragons, has given its name to a versatile form of decoration known as urnes. The panel was transferred from an earlier painting.* c1050–1100, wood, Urnes Stave Church, near Lustrafjord, Norway

CLOSERlook

MAMMEN STYLE
The combination of stylized animals with intricate interlacing is typical of Mammen decoration.

Anglo-Saxons

Many of the newcomers originated from Germany or Scandinavia. The Angles hailed from the southern part of the Danish peninsula and settled along the east coast, from Northumbria to Essex. The Saxons were Germanic and have left their mark in local place-names, such as Essex (East Saxons), Wessex, and Sussex. The first of the incomers were brought across by the Romans, to serve as mercenaries against the Picts and Scots, but full-scale migration began in the 4th century.

The magnificent finds at Sutton Hoo have tended to overshadow other Anglo-Saxon achievements. In the north, sculptors produced some outstanding stonework. The most noteworthy examples are the high crosses of Ruthwell and Bewcastle, which combine Germanic decoration with imposing figures.

The British Isles did not escape the turmoil that followed the collapse of the Roman Empire. Shiploads of settlers from across the North Sea sailed there, bringing a range of cultural influences. These merged with local styles, to create new artistic trends.

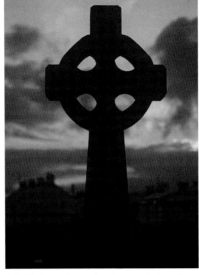

▲ **Celtic Cross** *Some believe that the wheel motif on Celtic crosses, such as this 10th century Irish example, refers to the sun, others that it represents a halo.*

The Anglo-Saxons also developed an impressive tradition in manuscript illumination. This owes its fame to the success of the Winchester School, which flourished in the 10th century. Their illustrations are notable for their large, ornate borders.

Celts

The Celts had migrated to Britain a few centuries before the arrival of the Romans, but the arrival of Germanic tribes pushed them further west, until their strongholds were in Scotland, Ireland, Wales, and Cornwall. Their art survived these disruptions, bridging the transition from paganism to Christianity. This is most obvious from their metalwork. The designs on their weaponry and horse-trappings were still being used, centuries later, on chalices, croziers, and shrines.

In their stonework and manuscripts, the Christian Celts broke new ground. In Ireland, they developed a style of monumental high cross, lavishly decorated with biblical scenes. And manuscripts like the *Book of Kells* (see pp.70–71) won much admiration.

Anglo-Saxon and Celtic art

Anglo-Saxon

BRITAIN, LATE 4TH CENTURY CE–1066

When the Roman hold on Britain began to crumble, the country was invaded by successive waves of Germanic migrants. These included, among others, Angles, Saxons, Jutes, and Frisians, who have become known collectively as Anglo-Saxons. The majority of their artworks were produced in Christian workshops, although the ship burial at Sutton Hoo contains some outstanding exceptions. The site can probably be linked with Redwald (died c627), an East Anglian king who is said to have erected both Christian and pagan altars. Discovered in 1939, Sutton Hoo contained a veritable treasury of gold buckles, silver bowls, decorated weaponry, and lavish symbols of royal authority.

Insular Celtic

BRITAIN, c500 BCE–c1000 CE

In the British Isles the Celtic style proved highly durable, surviving long into the Christian era. This was possible, as their designs had long been composed of abstract patterns and stylized animals. Depictions of the gods appear to have been rare—although as the Chrsitians were very systematic about destroying idols, there may have been more than we can surmise from the surviving record. As a result, Christian artists were able to borrow some elements from old, pagan arti-facts, adapting them for use in their Gospel Books, their stone crosses, and their metalwork. In the Crucifixion plaque below, for example, the garments of Christ and the angels, as well as the Cross itself, are adorned with Celtic spirals and interlacing.

▲ **The Alfred Jewel** *Made for Alfred the Great, this is thought to be an aestel—a pointer for following the text of a manuscript. The figure may represent the sense of sight.* 9th century, gold, rock crystal, and enamel, length 2½in, Ashmolean Museum, Oxford, UK.

▲ **Helmet from the Sutton Hoo Ship Burial** *The helmet is decorated with interlacing and heroic scenes, while the face-mask is adorned with a dragon.* c625–30 CE, iron and gilt bronze, height 12½in, British Museum, London, UK

▲ **St. John's Crucifixion Plaque** *Discovered near Athlone, this was probably once attached to the cover of an early Gospel Book.* Late 7th century, gilt bronze, height 8¼in, National Museum of Ireland, Dublin, Ireland

CLOSERlook

PLAYFUL DESIGN The curvilinear patterns are similar to continental, Celtic designs, while the central boss is raised, to accommodate the hand-grip underneath. Figurative forms of stylized birds are concealed amid the swirling lines.

▲ **The Battersea Shield** *This beautiful but flimsy shield-covering was designed for ceremonial purposes. It was placed in the Thames as an offering.* 350–50 BCE, bronze with enamel inlay, length 30½in, British Museum, London, UK

Folio 34 from *The Book of Kells*
Artist unknown, c800, vellum illuminated manuscript, 13 x 9¾in,
Old Library, Trinity College, Dublin, Ireland

The Book of Kells

The Book of Kells is one of the crowning achievements of Celtic art, a masterpiece of sumptuous decoration. It is a Gospel Book—a manuscript that consists principally of the four Gospels. This format was originally devised for missionaries, as the shorter text was easier to transport than a complete Bible. The Kells manuscript, however, was meant for display. It is lavishly illustrated with stunning calligraphy, depictions of the Four Evangelists, and biblical scenes. These decorations had a practical purpose—they helped the priest to find his way around a text that, as yet, had no chapters or verses—but they were also designed to dazzle potential converts.

Composition

This magnificent example of Celtic calligraphy is generally known as the Monogram Page. It represents just three Latin words: *Christi autem generatio* ("Now the birth of Jesus Christ...", Matthew 1: 18). Indeed, most of the page is taken up with two characters. These form the *Chi-Rho*, the first two letters of Christ's name in Greek, which were traditionally represented by "XP". Beneath this, in much smaller letters, the scribe continues with "h" (the standard contraction for *autem*) and *generatio*. Christ's monogram was a potent symbol in early Christian art.

▲ **VIRGIN AND CHILD** The manuscript boasts a unique blend of styles. The Virgin, with her *maphorion* (Greek robe), appears to be based on a Byzantine icon, while the beard-tuggers to her right are typically Celtic.

▲ **EVANGELIST SYMBOLS** The symbols of the Four Evangelists — the authors of the Gospels — recur throughout the manuscript. Drawn from passages in Ezekiel and Revelations, they are a winged man (Matthew), a lion (Mark), an ox (Luke), and an eagle (John).

Technique

Manuscripts of this kind were produced in a monastic workshop known as a *scriptorium*. The number of monks assigned to this task is unknown, although experts claim to have detected the hands of three different artists and three or four scribes. Animal hides were prepared, smoothed out, and then stretched to form the vellum, the fabric from which the book is made. Tiny holes were pricked into the surface, to mark out the writing area, while the artists would have tried out their compositions on wax tablets, before using the costly parchment.

▲ **PIGMENTS** The pigments came from a variety of natural sources. Some were available locally (red lead, chalk, and woad), while others had to be imported. These included folium (pink) and kermes (red), which was obtained from a Mediterranean insect.

▲ **MATERIALS** The manuscript was produced on vellum, a material made out of calfskin. In general, the hide of a single animal was enough for a double sheet of vellum, so around 200 calves would have been required for the *Book of Kells*.

INcontext

CELTIC STYLE Celtic design was remarkable for its adaptability. The swirling, curved lines that are so typical of the style were developed by the pagan Celts, from around the 5th century BCE. Centuries later, Christian artists borrowed these motifs and used them in their own work.

Tara Brooch Complex interlacing was a feature of Celtic jewelry, metalwork, and manuscripts. 8th century, silver, gold, amber, and glass, National Museum of Ireland, Dublin

Story

Despite its lavish appearance, the manuscript was never completed and its origins are uncertain. The likeliest scenario is that it was begun on the Scottish island of Iona, which headed a wealthy confederation of monasteries devoted to the teachings of St. Columba. In the early 9th century, however, Iona was repeatedly raided by Vikings and the surviving monks were eventually forced to flee to Ireland, where they established a new home at Kells. Their abrupt departure may explain why work on the manuscript was abandoned.

▼ **CATS AND MICE** A pair of mice are nibbling a communion wafer, while two cats stand on their tails. This is probably just a piece of whimsy, illustrating the difficulty controlling rodents. There is a similar scene on Muiredach's Cross at Monasterboice, also in Ireland.

▼ **HUMAN HEAD** Celtic artists often used human heads as decorative flourishes on a wide variety of objects. They can be found, for example, on the hilt of a sword, the ends of a torc (metal collar), or on the clasp of a brooch.

▲ **OTTERS AND FISH** Monastic painters loved to add tiny, humorous details to their work. Some experts have looked for symbolic meanings in these, but they are often unconvincing. The fish, for example, is an ancient Christian symbol.

◄ **ANGELS** Three angels adorn the edge of a letter. The two on the left have L-shaped bodies, with tiny feet protruding from their tunics, underneath the wings. They are shown here, as the page is close to the passages on the Annunciation and the Nativity.

The history of Islamic art in medieval times reflects the power of the ruling dynasties. An early period, from the life of Muhammad to around 1000, was first under the centralized control of the Ummayad dynasty in Damascus, and later the Abbasid dynasty in Baghdad and Samarra; this was followed by a period up to about 1500 in which various dynasties vied for dominance, and invasions from Asia resulted in various regional centers, each with recognizably different artistic cultures.

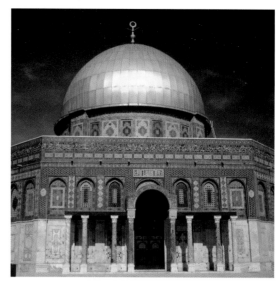

◄ **The Dome of the Rock, Temple Mount, Jerusalem, completed 691 CE** *Architecture, especially that of the mosque, has been central to Islamic culture and displays the regional and stylistic variations of Islamic art. Buildings of early Islam became increasingly ornate, with decorative tiles, carved and painted arabesques, and precious metals.*

The Islamic faith, as revealed to the Prophet Muhammad in the 7th century, spread rapidly from Arabia across the Middle East and into Asia and Africa, influencing the arts of many cultures. Decorative arts and crafts in particular flourished from the beginnings of Islam.

Subjects and styles

At first, Islamic art and architecture was influenced by Byzantine, Roman, and early Christian styles, but a distinctly Islamic style soon emerged. Because of a convention (not a Quar'anic proscription) forbidding the depiction of people, there was no tradition of easel painting, and artistic expression is seen mainly in architecture and the decorative arts, calligraphy and the arts of the book.

Domed mosques were decorated sumptuously with ceramic and glass mosaics, and carved or painted arabesques—elaborate repeated embellishments using floral, vegetal, or birdlike motifs. These abstract, often geometric, designs were also seen in crafts such as ceramics and textiles, especially carpets.

Another profound influence was the written word, specifically the Qur'an's, in various ornate scripts. Calligraphy was important not only in copies of the Qur'an, but also as sacred inscriptions in mosques and craftwork decoration.

Early Islamic art

Calligraphy

7TH–13TH CENTURY

The central role of the Qur'an in Islamic culture has made calligraphy the most revered of its art forms, a visual expression of the spiritual. The art of the book has been central to Islamic art since the first transcriptions of the Qur'an, and arabic calligraphy has been a major influence in all the decorative arts. The angular Kufic script was first to gain popularity, but more elaborate and cursive scripts emerged in the early Islamic period, and regional variations developed throughout the following centuries. The finest examples of Islamic calligraphy are naturally to be found in editions of the Qur'an, often ornately illuminated, but extracts from the holy book were also used decoratively in mosques or on ceramics— often in highly stylized, almost abstract, scripts where it is difficult to decipher the meaning of the words.

▲ **Seljuq style Qur'an** *The cursive script of this Qur'an is typical of the Turko-Persian Seljuq dynasty (11th–14th century). In addition to the elegant calligraphy, the text is illuminated with sunburst marks, and marginal decorations depicting small trees.* 13th century, vellum, Museum of the Holy Ma'sumeh Shrine, Qom, Iran

▲ **Fragment from a Qur'an with Kufic script** *The angular, unadorned Kufic script evolved through the early Islamic period into a number of more elaborate styles, but in areas such as the Maghreb (northern Africa) it was widely used, often without any illumination, until about 1000 CE.* 10th century, North African school, vellum

CLOSERlook

ILLUMINATIONS The illuminations in the margin, like those within the text, are not merely decorative but are designed as an aid to the correct reading of the holy book. As well as marking the sections of the text, they also indicate the points for prostration.

Mosaic

7TH–13TH CENTURY

One of the distinguishing features of Islamic architecture is the intricate and extensive decoration of both interior and exterior surfaces. Alongside carved and painted decorations, tilework and mosaic played a major role from the first Islamic buildings such as the Dome of the Rock in Jerusalem (completed 692), using techniques of Byzantine mosaic but in non-representational geometric and arabesque patterns, and the Great Mosque of Damascus (715), which unusually also has a mosaic depicting buildings and an imaginary city. Through the 8th century, the use of mosaic decoration spread as far afield as Spain, where it can be seen in the Great Mosque of Córdoba and later in the Alhambra; specific styles such as *zillij*, using purpose-made tiles, were developed in the Arabic countries and North Africa; and in Eurasia in the 13th century Seljuq mosques and palaces were decorated with richly colored glazed tiles.

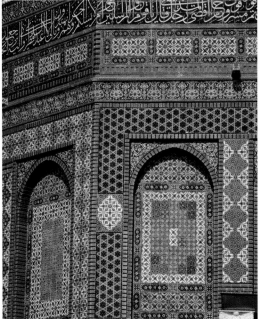

▲ **The Dome of the Rock, Temple Mount** *This earliest extant example of Islamic building is essentially Byzantine in structure, but its mosaic decoration in repeating geometric patterns is distinctly Islamic. The rich blues and greens are typical of the mosaics of early Islamic architecture.* Completed 692 CE, Jerusalem, Israel

◄ **Mosaic above a doorway of the Prayer Hall** *Originally a Christian church, the Mezquita was rebuilt as a mosque by a succession of Islamic rulers from c785. Among the alterations was the addition of mosaics in the Prayer Hall of the extension built by al-Hakam II.* 961–66 CE, Great Mosque of Córdoba, Spain

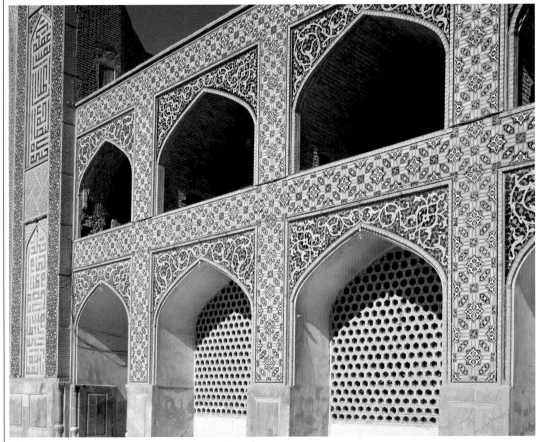

▲ **Courtyard arcade (*riwaq*) and vaulted entrance (*iwan*)** *Islamic decoration was integrated into Persian architecture under the Abbasid dynasty, producing mosques with large courtyards enclosed by elegant arcades with an iwan, a vaulted porch, decorated with colorful arabesque tilework.* c1121–22 CE, Masjid-i-Jomeh mosque, Isfahan, Iran

Glass and ceramics

7TH–13TH CENTURY

As with the decorative arts, crafts such as ceramics assumed great importance in Islamic culture. Baghdad craftsmen developed a tin-glaze technique to imitate Chinese porcelain, while the process of using metallic overglazes to produce lusterware spread from Egypt throughout the Islamic world. Persia adopted the techniques in the 10th century. It became a major center for ceramic production and introduced faience (alkaline-glazed ware). Innovations in glasswork included Fatmid Egypt's cut glass and luster-painted glass, and Syria's enameled glass lamps.

▲ **Ewer with birds** *The finest early Islamic glasswork came from Egypt, and especially prized were the carved rock crystal pieces produced toward the end of the Fatimid dynasty.* Fatimid Period, late 10th century, rock crystal, Treasury of Saint-Denis

▲ **Jug with molded decoration** *A feature of many 12th-century Persian pots was calligraphic decoration: the words "glory" and "prosperity" can be seen in the glaze of this jug.* Iran, 12th century, stone-paste with turquoise glaze, height 8⅝in

▲ **Bowl from Kashan, Iran** *An overglaze containing metal oxides gave Seljuq pottery a goldlike finish, and sometimes incorporated painted illustrations in the style of Persian miniatures.* 1211–12 CE, stone-paste with luster overglaze, diameter 7⅞in, Ashmolean, Oxford, UK

INcontext

ISLAMIC CULTURE in the medieval period encouraged scientific learning, continuing a long tradition of scholarship in mathematics and astronomy in particular. Craftsmen were also often innovative in their use of new materials.

Transcriptions
Islamic scholars also studied other civilizations' achievements, translating the works of philosophers and scientists, as in this edition of Greek physician Dioscorides' De Materia Medica, transcribed in the 13th century.

The internet of the medieval world was formed by a network of trade routes that linked China to India and Rome, and later the Arab states. The complex overland network was called the Silk Route because it transported the precious fabric the world desired and whose production method the Chinese kept secret.

The more southerly maritime trade route carried Roman technology, Chinese ceramics, and spices. However, its most precious cargo was not material but ideological. Indian ideas of religion, statesmanship, art, languages (Sanskrit and Pali), and writing scripts.

Influences

India was a treasure-house of religion, philosophy, art, and technology for the smaller nearby states that came into formation in the first millenium. The great stupas of India erected to hold relics of the Buddha, the temples

▲ Ananda and Paranirvana Buddha *At Gal Vihara in Sri Lanka a 12th-century recumbent Buddha over 48¾ ft long, carved from a granite rock face, is seen at the moment of transition to Nirvana. His disciple, Ananda, stands forlornly with arms crossed.*

dedicated to the Hindu universal gods—Shiva, Vishnu, and Brahma—as well as the precisely-ordered layout of Indian cities, were all the product of the long intellectual tradition of the Vedas, the Brahmins, and Buddhist monks. The great Indian religions—Buddhism, Hinduism, and Jainism—waxed and waned throughout the Middle Ages, as did the political

dynasties that sought supernatural support from them, but the subcontinent's creative impulse toward art, philosophy, and metaphysics made India the cultural fulcrum of Asia. China had an enormous technological and commercial impact, but India was the crucible of fundamental notions of man, the gods, the city, the state, and of the art that could capture and embellish these notions. Art that was to act as a principal stimulus to the fledgling states forming between India and China.

South Asia includes the areas now covered by modern India, Pakistan, Bangladesh, Sri Lanka, Nepal, and other small Himalayan states. In the first millennium CE, many ideas on religion, philosophy, and the arts came from these areas and were expressed in the sacred texts, icons, and temples of Buddhism and Hinduism.

South Asia

Buddhist art

1ST CENTURY BCE – 8TH CENTURY CE

One of the most important Buddhist discoveries was the excavation of a 1st century BCE to 3rd century CE mound at Amaravati in eastern India. Artifacts discovered included slabs of carved limestone from a collapsed Buddhist stupa.

During the golden age of the Gupta Empire in India around 450 CE the image of the Buddha with lowered eyes, placid features, long ears, short "snail shell" curls of hair, and cranial bump was invented in the city of Mathura. This image was refined at the city of Sarnath on the Ganges, where it was adopted by the many Buddhist communities that sprang up across Asia between the 4th and the 11th centuries, and it became a universal icon of peace, power, and reflection.

Before the start of the first millennium, Buddhism also crossed from India to Sri Lanka. Among the innovations of the Sri Lankan Buddhists were ceremonies centred on colossal images of the Buddha and the bodhisattvas (one who helps others achieve Englightenment) Avalokiteshvara, Tara, Maitreya, and Manjushri. In the 5th century, the renowned monk and scholar Buddhaghosa assembled the Pali language texts of the Buddhist canon and secured the island's place as the headquarters of southern Theravada ("way of the elders") Buddhism, a status it still holds today.

▶ Standing Buddha *The long ear lobes of this Gupta Empire Buddha betray the Buddha's earlier status as a prince who wore heavy gold earrings. This Buddha has a circular halo of concentric floral bands and diaphanous robes. 5th century CE, stone, Government Museum, Mathura, India*

▲ Amaravati *This slab from the Great Stupa at Amaravati shows a group worshiping at the spot where the Buddha received enlightenment. On the other side is an elaborately carved stupa. 1st century BCE to 3rd century CE, stone, 48¾ x 40in, British Museum, London, UK*

▶ Tara *This 8th-century gilded bronze from Sri Lanka is of Tara, the consort of Avalokiteshvara, the bodhisattva of compassion. Tara's right hand is shown in the position of varada mudra, the gesture of giving. It is cast in one piece and is one of the finest Asian figural bronzes. 8th century, gilded bronze, British Museum, London, UK*

Hindu art

INDIA, 5TH–13TH CENTURY

The Gupta Empire of northern India produced sacred art of unsurpassed beauty. The Dashavatara temple at Deogarh in Orissa on the east coast has red sandstone walls paneled with deeply cut narrative scenes of the god Vishnu. Northern Indian temple building reached its height in the temples at Khajuraho, capital of the Candella kings from the 10th to the 12th century.

The Sun Temple at Konark on the shore of the Bay of Bengal is the largest of Orissa's shrines. The 230-ft-high temple is constructed in the form of the chariot of the sun god Surya, with seven life-size horses pulling the vast temple on 24 huge wheels.

In the south of India, the Chola dynasty of the Tamils became the most powerful empire in this part of the world from the 9th to the 13th century. As well as building great temple complexes, they were masters of bronze. Their greatest icon is Shiva Nataraja (Lord of the dance)—who dances the creation and destruction of the Universe.

▲ **Surya Temple, Konark** *The temple's 24 giant 46-ft diameter wheels have 16 spokes and are carved with spiraling floral motifs in a spectacular design that makes the whole mass of stone look capable of rolling forward.* 13th century, stone, Konark, Orissa, India

▲ **Dashavatara Temple, Deogarh** *Here, Vishnu sleeps in potent, majestic ease on the pneumatic coils of the giant, multi-headed serpent Ananta (representing the pre-Hindu serpent cults). Vishnu dreams into existence a new* kalpa *(eon) for the Universe, as four-headed Brahma rises above him on a lotus flower to implement his creation.* c500 CE, stone, Deogarh, India

CLOSERlook

GANGA The goddess Ganga (personification of the Ganges River) floats in Shiva's flowing ascetic's locks. Ganga holds her palms together to venerate Shiva as the source of all, including the cool waters of the mighty river named after her which flow down from Shiva's Himalayan home.

▶ **Shiva Nataraja** *This Chola period bronze shows Shiva holding the small* damara *(drum) of creation in his upper right hand and a burst of the fire of destruction in his upper left hand; his lower right hand signals "have no fear," and the lower left hand points to his uplifted left leg, signifying release or salvation.* 12th century, bronze, 38¼ x 32¾ in, National Museum of India, New Delhi, India

▶ **Kandariya Mahadeo Temple, Khajuraho** *The gods appear at times with aristocratic arrogance, posturing in jewel-bedecked minimal courtly dress. Here Agni, the ancient Vedic god of fire and destruction, poses with foppish waxed mustache and soft, swelling girth.* 12th century, stone, Khajuraho, Madhya Pradesh, India

Artists and craftsmen were highly prized in the courts of medieval Southeast Asia. However, artists did not leave their names on their works until colonialists arrived centuries later and introduced this European convention. As a result, we will never know the names of the artists and architects who conceived and constructed Borobudur, Angkor Wat, and the Ananda Temple—some of the most beautiful sacred monuments that have ever been built.

State art

The sculptors and architects in the royal workshops who built Borobudur in Java and Angkor Wat in Cambodia were of great value to the state. This was because they alone could create the stone temples that were believed to mirror the heavenly homes of the gods. It was believed that the gods

▲ **The Ananda Temple at sunrise** *Built by king Kyanzittha around 1090, the Ananda Temple—seen here at sunrise—is one of the finest surviving temples of the Pagan Empire.*

came down and occupied these temples during religious festivals, so conferring power and prosperity on the earthly kingdom.

From the slopes of the volcanoes of Java and from the Kulen Mountain north of Angkor, tons of stone was

carved by hand from surface quarries and transported by river on rafts before being hauled into position to make the walls of these monuments. Finally, masons perched on bamboo scaffolding with simple iron chisels carved the the surface of the rock with narrative scenes from the Hindu and Buddhist epics, beautiful goddesses, and scrolling foliage swirls.

From 800 to 1400, recently formed states in Southeast Asia such as Cambodia and Srivijaya (Indonesia) constructed the largest elaborately carved stone temples in the world for the veneration of Buddhist and Hindu deities.

Southeast Asia

Borobodur

JAVA, INDONESIA, 750–850 CE

The arrival of the new Shailendra dynasty (Lords of the mountain) in 760 CE—possibly from eastern India—gave the naturally artistic people of Java in Indonesia an opportunity to express their art on a monumental scale, and they created the most impressive and beautiful Buddhist monument ever built. The largest Buddhist shrine in the world, Borobudur is at once a stupa holding holy relics, a mystical mandala (or cosmic diagram), and a mountain of narratives in stone that show the way to Buddhist enlightenment.

The monument, constructed from a million blocks of volcanic rock and set like a mantle on a natural hill, rises in singular splendor from a fertile plain of rice paddies. The lower galleries are superbly carved with intimate tales of Buddhist heroes. Monks and elite visitors would ascend the summit for ceremonies, where 72 icons of the supreme tantric Buddha, Vairocana, sit inside latticed stone stupas looking out over the plain to the nearby volcanoes.

◀ **Temple of Borobudur** *Seventy-two supreme Buddhas, their hands turning the Buddhist "wheel of the law," sit on top of the monument inside elegant latticed stupas that look out to the surrounding volcanoes. Below them 500 other Buddhas, concentrated but gentle, face the quarters of the Universe they control. 778–850, stone, Borobudur, Java, Indonesia*

▲ **Borobudur carvings** *Tales about royal courts and Buddhist heroes—all rendered in a close-up, social style that is uniquely Javanese—stretch along the four square galleries that mount like a pyramid toward the cosmic Buddhas at the summit. 778–850, stone, Borobudur, Java, Indonesia*

Angkor

CAMBODIA, 800–1400 CE

In 800 CE the ancient Cambodians started to build brick temples to the Hindu god Shiva in the lakeside region of Angkor. By 1200 CE, they had built the largest, lavishly sculpted, stone monuments in the world with highway, canal, and hospital networks that stretched from Burma to the Malay peninsula and Vietnam. The largest temple is the vast and palatial Angkor Wat dedicated to the Hindu god Vishnu. The temple's five majestic towers rising within a 1000 square kilometre walled enclosure and 627-ft-wide moat represent the home of the gods on Mount Meru.

The second largest temple, the Bayon, marks the historical switch of the ancient Cambodians to Buddhism in spectacular fashion with its 59 towers bearing giant faces of a supreme protective Buddha rising high into the air at the centre of a new citadel in the capital called Angkor Thom.

▼ **Angkor Wat** *Behind a 627-ft-wide wide moat and elaborately carved galleries rise the five central towers of the high central "Bakan" section where the king and court Brahmins performed the rituals necessary to appease the gods. The temple is the largest stone monument on Earth.* 12th century, stone, height 215 ft, Angkor, Cambodia

CLOSERlook

GODDESSES
The walls of Angkor Wat are carved with thousands of goddesses in flimsy courtly dress and with exotic hairstyles. In Hindu belief, their radiated female essence resonated with the male essence of the king and Brahmins and elevated them to a state where they could communicate with the gods.

▲ **Buddha face, Bayon Temple** *Two hundred giant faces of Buddhas look out with staring eyes and gentle Cambodian smiles from the Bayon Temple and from the gates of the new citadel, Angkor Thom.* 1181–1219, stone, Angkor, Cambodia

Pagan

BURMA, 1000–1300 BCE

By the 11th century, Pagan began to develop rapidly as a Buddhist kingdom under king Anawratha (reigned 1044–77). His successor, king Kyanzittha, who reigned from 1084 to 1113, purged the northern Mahayanist Buddhist sects from Pagan and promoted southern Theravada Buddhism, which it still follows today. Burmese temples are distinguished by their murals and frescoes. The vast Ananda Temple is covered with internal murals that were explicitly designed to plant Theravada Buddhist thoughts in the minds of subjects. Ananda was in constant use and endowments by later kings resulted in further murals being painted.

▼ **Fresco, Ananda Temple** *In this court scene the dancers have been painted for visibility with bright turquoise and ochre.* Fresco, Ananda Temple, Bagan, Burma

▲ **Standing Buddha** *At the heart of the Ananda temple stand four huge gilt wooden Buddhas measuring 29ft high and representing Gotama Shakyamuni and the three earlier Buddhas — Kakusandha, Kassapa, and Konagamanda.* Wood, 29¼ft, Bagan, Burma

Sukhothai

THAILAND, 1250–1350 CE

As the great Cambodian empire began to decline after the death of its greatest King Jayavarman VII in about 1220, the western provinces of the empire began asserting their independence. For some centuries gifted and technologically advanced Thai people had been gradually descending the valleys from Yunnan, southwest China. On the Yom River, in central northern Thailand, arose Sukhothai, the first great city of the Thais. The rulers of Sukhothai inherited the Khmer tradition of grandiose temple construction and quickly demonstrated their already enhanced technological skills in bronze casting and ceramics under king Ramkhamheng who ruled from 1279–98. Vast temple parks with gigantic standing and seated Buddhas were constructed from brick and stucco, and the distinct Buddhist culture of the Thai people was founded.

▼ **The Buddha at the Moment of Victory** *Bronze images of the Buddha achieved unsurpassed classical status at the first Thai kingdom of Sukhothai. The smooth limbs, lowered eyes, and flame rising from the Buddha's head produce a powerful effect of serenity.* Bronze, height 36¼in, Walters Art Museum, Baltimore, US

The ruthless conquests of Emperor Wendi brought China under the single rule of the Sui Dynasty, paving the way for an unprecedented period of cultural achievement. Trade with India and the Middle East brought contact with craftsmen and artists that reinvigorated Chinese art. Buddhism, which had spread from India, became in effect the national religion when it was adopted by the imperial family.

Imperial patronage

The empire continued to grow under the Tang Dynasty. The increased prosperity enabled the building of large cities, such as the capital Chang'an (modern Xian), which quickly became important cultural centers. Tang emperors were enthusiastic patrons of the arts attracting the finest artists and craftsmen to their palaces from as far afield as Persia. The reign of Xuanzong in the 8th century was the height of

▲ **Silver bottle, Tang Dynasty** *Western influences, such as Persian techniques and design, were noticeable during the Tang period (618–907).* Silver, height 7⅛in, Museum of Fine Arts, Boston, Massachusetts, US

the Tang period: calligraphy and traditional figure painting flourished in his court, but landscape painting also emerged as an important genre. Unfortunately, Xuanzong was not so successful politically, and his reign ended in civil war and a fragmentation of the empire.

Reunification

Stability returned to China in 960 when the empire was reunified under the Song Dynasty in Bianliang (modern Kaifeng), and a rise in maritime trade produced the wealth to allow the arts to flourish again. Emperor Huizong (reigned 1101–25) encouraged landscape painters, and there were also a growing number of literati (scholar-amateur) painters working outside the courts.

Eventually conquered in the north by the Jin, the Song continued to rule south of the Huai River until 1279, when Kublai Khan united China once again, but under the divisive rule of the Mongol Yuan Dynasty.

After centuries of division, China became a unified empire in 581, and the arts flourished under the patronage of successive emperors. The period of the Tang Dynasty (618–907) in particular is regarded as a golden age of Chinese art and literature.

East Asia

Tang Dynasty

618–907

Under the Tang Dynasty, musicians, poets, and artists enjoyed imperial patronage and as a result Chinese culture prospered. The adoption of Buddhism led to the building of temples, pagodas, and tombs, decorated with wall and silk paintings, and containing ceramic figures and pots; and emperors attracted the finest artists and craftsmen to their courts.

Taizong (reigned 626–49) employed the two brothers Yan Lide and Yan Liben, who revitalized the art of figure painting, but the height of Tang art was reached under Xuanzong (reigned 712–56). His court at Chang'an included the great poet and artist Wang Wei, and attracted the most prominent painters of the day such as the traditional figure painters Wu Daozi and Han Gan; and also a group of artists including Li Sixun, Li Zhaodao, and Wang Mo, who were responsible for establishing the landscape as an important genre in Chinese art.

▲ **A Groom with Horses** Han Gan *Sponsored by Wang Wei, Han Gan became the foremost painter of the Tang court. He painted many portraits and figure paintings, but was best known for his sensitive portrayals of horses.* 8th century, watercolor on paper, Musée Cernuschi, Paris, France

▶ **The Court Instructress Writing the Admonitions** Gu Kaizhi *The 4th-century artist Gu Kaizhi was revered as the greatest of all painters by scholars in the Tang period, and inspired many figure painters of the time. Most famous of his paintings was the series of illustrations for Zhang Hua's parody* The Admonitions of the Instructress to the Court Ladies, *of which this is an 8th-century copy.* British Museum, London, UK

▶ **Emperor Wudi of Northern Zhou Dynasty (The Thirteen Emperors)** Yan Liben *As a government official and portrait artist in Emperor Taizong's court, Yan Liben painted a number of important historical figures. The best known, a handscroll depicting 13 emperors from the Han to Sui dynasties, follows the tradition of figure painting established by Gu Kaizhi.* c600–673, ink and color on silk, 70¼ x 209in, Museum of Fine Arts, Boston, Massachusetts, US

Song Dynasty

960–1279

After Xuanzong's abdication in 756, China was not reunited until the Song Dynasty. At first governed from the north, it was less expansionist than previous dynasties, devoting more energy to culture. International trade prompted advances in the crafts, especially ceramics, and the imperial courts attracted artists such as Dong Yuan, Guo Xi, and Ju Ran, whose elegant landscapes became very different from the painting of contemporary Daoist literati. The Jin invasion drove the Song south to Lin'an (modern Hangzhou), where Gaozong founded the Southern Song Dynasty (1127–1279). Landscape painting developed in this era, led by Ma Yuan and Xia Gui, into a more atmospheric, gentler style than that of the Northern Song.

▲ **Wintry Groves and Layered Banks** Dong Yuan *As seen here, Don Yuan's elegant style was marked by carefully balanced composition using sophisticated perspective and a wide range of brushstrokes.* c950, hanging scroll, ink and color on silk, 71½ x 46in, Kurokawa Institute of Ancient Cultures, Hyogo, Japan

◄ **Bare Willows and Distant Mountains** Ma Yuan *The landscapes of Ma Yuan marked the highpoint of Southern Song painting. His unusual compositions based on diagonals earned him the nickname "One-Corner Ma."* Ink and light color on silk, 9⅜ x 9½in, Museum of Fine Arts, Boston, US

▲ **Early Spring** Guo Xi *Many elements of his almost abstract compositions are shown in this work. Subtly different textures and brushstrokes emphasize the symbolic significance of the mountains and trees and give a three-dimensional feel.* 1072, hanging scroll, ink and light colors on silk, 62¼ x 42½in, National Palace Museum, Taipei, Taiwan

Yuan Dynasty

1279–1368

Although the Mongol invasion under Kublai Khan reunited north and south China, the Yuan Dynasty was nevertheless a foreign occupation. The empire stretched as far as eastern Europe, bringing many new influences to the arts and revitalizing trade in crafts, but the Yuan were not great patrons of fine arts. Mongol discrimination against the Chinese meant only a few native artists worked under imperial patronage. A class of literati, including the four great late-Yuan masters Huang Gongwang, Wu Zhen, Ni Zan, and Wang Meng, rejected the Mongol rule, and what they saw as its vulgar influence, and instead developed a more allegorical style of landscape painting in the Chinese tradition. Rebellions after Kublai Khan's death led to the overthrow of the Yuan, and the succeeding Ming Dynasty was more appreciative of native Chinese art.

◄ **Landscape** Ni Zan *This artist refused to work under the Mongol rulers. He painted landscapes almost exclusively, often in an austere monochrome, tending to abstraction in which balance of composition was of prime importance.* Pen and ink on paper, Osaka City Museum, Japan

▲ **Horse and Groom in Winter** Zhao Mengfu *After the Mongol invasion, Zhao was one of the few court artists. Horses, important to the Mongol way of life, often feature in his paintings, whose archaic style was influenced by Chinese art history.* Ink on paper, National Palace Museum, Taipei, Taiwan

◄ **Dwelling in the Fuchun Mountains** Huang Gongwang *After serving as a court official and being wrongfully imprisoned for misconduct, Huang Gongwang became a Daoist priest. He retreated to the Fuchun mountains where, rejecting the Yuan emperors' style, he painted some of his finest landscapes in ink on paper with brushstrokes akin to calligraphy.* 1347–1350, handscroll, ink on paper, height 13in, National Palace Museum, Taibei, Taiwan

Starting around 2,800 years ago, the peoples of Central and South America developed civilizations that were among the most artistically advanced cultures in the world at that time. Their buildings and artistic works still inspire us today.

The two main areas for the development of civilizations in the Americas were the valleys and plains of southern Mexico and Guatemala in the center, and the central Andes of Peru in the south. All the civilizations were culturally advanced, producing a wide range of buildings, stonework, pottery, textiles, and goldwork.

Central America

The civilizations of Central America developed out of the Olmec culture that flourished around the coastline of the Gulf of Mexico from 1700–400 BCE. It was the Olmecs who first built ceremonial platforms and temple pyramids, carved large stone sculptures, and developed an early form of glyphic, or picture, writing, and a ritual calendar. Such works were part of a religion that placated the gods through offerings and eased the sufferings of daily life through worship.

▲ **Avenue of the Dead** *The main avenue of the city of Teotihuacán in Mexico runs north–south through the city. On the left is the imposing Pyramid of the Sun, measuring 187 feet in height.*

Both the city-state of Teotihuacán in central Mexico and the Maya of the Yucatán peninsula developed from Olmec culture. The Maya went on to create the only complete writing system in pre-Colombian America.

South America

It is difficult to date the early civilizations of the central Andes region, but the first, the Chavín, with its temple complex of Chavín de Huántar, which was located in Peru, was well established by about 850 BCE. The Moche and then Nazca peoples succeeded them, both leaving a rich artistic legacy of temples, pottery, and textiles.

Central and South America

Chavin

PERU; c1300–c200 BCE

There has always been debate about the Chavín culture of the eastern Andes in Peru, but most historians believe that the civilization began in the coastal regions around 1300 BCE and then spread to the highlands, reaching its culmination in the temple complex of Chavín de Huántar after 850 BCE.

The stone-block temple faces out over a large sunken plaza while a staircase leads down to a sunken circular court lined with stone blocks carved with jaguars and other creatures. The outside walls of the temple feature carved heads of gods, the only works of three-dimensional sculpture in the temple. Canals once ran through the temple, providing water for ritual purposes.

▶ **Raimondi Stone** *Chavín deities adopt the features of tropical forest creatures, in this case the jaguar, carved on a standing stone. 460–300BCE, stone, height 78¾in, Museo Nacional de Antropologia y Arqueologia, Lima, Peru*

Moche

MOCHE PERU; c0–c600 CE

The Moche people of northern coastal Peru built up a substantial civilization based on the city of Moche, near modern-day Trujillo in Peru. The enormous Huaca del Sol, or Pyramid of the Sun, dominated the valley. Built of adobe (mud) bricks, it now measures 130 feet high and 1,155 feet long, although it was much bigger when it was built. Opposite it is the smaller Pyramid of the Moon. The two pyramids being the focus of Moche religion.

The Moche were skilled potters, textile workers, and goldsmiths. They decorated their ceramics with high-relief modeling, low-relief stamping, and scenes painted on to flat surfaces. Most vessels were handcrafted, although some were made in molds, showing a wide variety of shapes and decorative styles.

These craftsmen also produced hundreds of portrait heads like the one pictured. They are unique in that every face is completely different.

▲ **Vessel** *Moche ceramic vessels often had a stirrup spout through which to pour out the liquid, and depicted either Moche men, as in this case, or the heads of deities. Ceramic, Museo del Banco Central ded Reserva, Lima, Peru*

Maya

YUCATÁN; 300–900 CE

The Maya rose to prominence around 530 CE. In pre-Columbian America they were the only people to construct a fully literate and numerate culture. They were based in the Yucután and Petén peninsula of southern Mexico and Guatemala but their impact was felt throughout the wider region.

The Maya lived in a series of city-states, of which Tikal, at more than six square miles, was one of the greatest. They constructed tall, limestone temple-pyramids faced with limestone stucco and decorated with sculptures and carvings. Later buildings were horizontal and colonnaded. The Maya were also skilled wall painters, using bright colors, elaborate detailing, and an individual creativity by the artist when drawing figures that kept within the conventions of officially commissioned art.

▲ **Temple of the Jaguar** *One of five temples in the ceremonial heart of Tikal, the Jaguar Temple stands in the middle of the complex and has nine terraces. Causeways and ramps link these temples to other outlying temples.* 700s–800s CE, stone, height 528ft, Tikal, Guatemala

◄ **Wall painting** *The murals at Bonampak cover all four walls of a small building built by a Maya king. They depict a warring expedition that captured and killed their prisoners while the king performed ritual honors to the gods.* c776 CE, stucco, Bonampak, Chiapas, Mexico

▲ **Carved lintel from Temple 23, Yaxchilán** *The ruler, Shield Jaguar, watches while his wife, Lady Xoc, passes a rope of thorns through her tongue. Blood letting was practiced by all Mayan rulers.* 726 CE, stone, British Museum, London, UK

Nazca

NAZCA; 400 BCE–600 CE

The Nazca people of the coastal deserts of southern Peru established a centralized state based around towns and ceremonial centers. Their art, often linked to religion, included delicate polychromatic pottery decorated with decorative motifs. At first these were mainly naturalistic representations but included mythic figures and zoomorphic subjects. Later pots became less experimental in design and were decorated with warlike themes.

The most extraordinary artworks were cut out of the neighboring desert by removing the dark surface gravel to reveal the lighter-colored earth underneath, the gravel and stones piled along the edges. The lines can only be appreciated properly from the air.

▲ **Hummingbird** *The famous lines in the desert depicting animals, birds, and flowers, as well as straight lines and various geometric and abstract forms, cover more than 190 square miles.* 200 BCE–600 CE, earth drawings, Nazca, Peru

◄ **Mantle** *Nazca weavers decorated their textiles with repeating geometric or naturalistic figures, often set within a differently colored border. They used a variety of skills, including embroidery, brocading, needlework, and lacework.* 0–600 CE, cotton and camelid fiber, 118 x 63¾in, Brooklyn Museum of Art, US

Teotihuacán

MEXICO; c50 CE–600s CE

For almost 600 years, the city of Teotihuacán ruled over Mexico and the wider Mesoamerican region. At its height, the city contained perhaps 125,000 people, making it among the largest in the world at that time. The city was dominated by the 230-ft, four-tiered Pyramid of the Sun built over a natural cave that ended in a chamber near the center of the pyramid.

The exterior of the pyramid and other buildings were covered with white plaster painted with red or polychrome mythical scenes. Artisans also worked obsidian (a volcanic glass-like rock) to make tools and cutlery as well as to use it in masks and other artifacts.

◄ **Anthropomorphic mask** *The mask makers of Teotihuacán used a variety of natural materials to create their life-size images. The masks may have been attached to mummies and might have been portraits rather than simply human representations.* Stone, turquoise, obsidian, coral, shell, 11¾ x 9⅜in, Museo Nacional de Antropologia, Mexico City, Mexico

Two styles of architecture and art dominated western Europe after 1000. The first was Romanesque, succeeded gradually during the 1100s by the new Gothic style, which lasted in some places until well into the 16th century.

The terms "Romanesque" and "Gothic" were originally applied only to architecture, and although they are still used mainly in this field, they have been extended to cover other arts of their respective periods. The two styles spread all over Europe, taking on many different national and local variations as they did so.

Romanesque

As the name suggests, Romanesque architecture revived certain features of ancient Roman art, especially its sheer ambition: Romanesque buildings are often immense, expressing a new confidence following a period when Western Christendom had been threatened with destruction. Large-scale sculpture similarly was revived, and painting and the "minor arts" also flourished.

▲ **Chartres Cathedral** *Begun in 1194, Chartres is one of the greatest of the French Gothic Cathedrals, famous for its sculpture and stained glass as well as for its architecture shown here.*

Gothic

Whereas Romanesque architecture is massive and often overpoweringly austere, Gothic architecture at its most characteristic is soaringly graceful, based on a new skeletal

system of construction that enabled large windows to take the place of solid areas of wall. In painting and sculpture, too, art of the Gothic period is typically refined, with figures often having elongated proportions and a sense of flowing elegance. Like Romanesque art, Gothic art was used predominantly in the service of the Christian Church, although it also had secular expressions, particularly when it developed into the courtly style known as International Gothic.

CURRENTevents

910 The Benedictine abbey of Cluny in Burgundy, France, is established, initiating a period of monastic reform throughout Europe.

962 Otto I is crowned Roman emperor by the pope in Rome, setting up the Holy Roman Empire as the main temporal power in western Europe.

1066 William of Normandy invades and conquers England.

1346–51 Black Death (plague) devastates Europe, killing perhaps one third of the total population.

Romanesque and Gothic art

Gislebertus

ACTIVE FIRST HALF OF 12TH CENTURY

Most Romanesque art is of anonymous workmanship, but the names of a few artists have survived, notably the great sculptor Gislebertus, who worked in the Burgundy region of France around 1125. Nothing is recorded about his life or personality, but his name is known because he signed his masterpiece, *The Last Judgment* at Autun Cathedral. Other sculpture at the cathedral is obviously by the same hand, and on the strength of these works he is regarded as one of the giants of medieval art. His style is imaginative and emotionally intense, with an expressive use of distortion that is typical of Romanesque art.

The Last Judgment fills the tympanum (decorative semicircular area) over the west doorway (the main entrance) of Autun Cathedral. In addition Gislebertus carved about sixty capitals (the topmost part of columns) inside the cathedral and decoration for the north doorway. This doorway has been destroyed, but fragments of the sculpture survive, including a famous reclining nude figure of Eve. Gislebertus must have had assistants when working on such large commissions, but all the carving at Autun is so distinctive and of such high quality that they were presumably involved only in fairly menial capacities.

▲ **Eve** *The lintel of the now destroyed north doorway of the cathedral showed the Temptation and Fall. This figure of Eve is unique in medieval art, for it shows her in large scale as a reclining nude.* c1125–35, stone, Musée Rolin, Autun, France

▼ **The Last Judgment** *The awe-inspiring image of Christ, depicted much larger in scale than all the other figures, dominates the tympanum on the west portal. He is shown separating the blessed (on the left-hand side) from the damned (on the right).* c1125–35, stone, Cathedral of St. Lazare, Autun, France

CLOSERlook

INSCRIPTION The sculptor prominently signed his name beneath the figure of Christ: *Gislebertus hoc fecit*—"Gilbert made this".

HIGH RELIEF Below the main scene are figures of the blessed being resurrected (left) and the damned being chased to hell. They are carved in high relief, at times almost detached from the background.

Nicholas of **Verdun**

ACTIVE LATE 12TH–EARLY 13TH CENTURY

During the Romanesque and Gothic periods there was no hierarchy dividing the "major" arts of painting and sculpture from what are now sometimes described as the "minor" arts, such as metalwork. Indeed, work in precious materials had great prestige, especially when it was used in the creation of prominent art for the Church. One of the most notable artists who produced such work—incorporating classical and natural elements — was the goldsmith and enameller Nicholas of Verdun. Nothing is known of his life, apart from the fact that—as his name indicates—he came from Verdun in France. There are two signed works by him, both still in the churches for which he made them: the Klosterneuburg Altar (finished 1181 and originally made to decorate a pulpit) in Klosterneuburg Abbey, near Vienna; and the Shrine of the Virgin Mary (1205), which is in Tournai Cathedral, Belgium.

▶ **Shrine of the Virgin Mary**
Tournai Cathedral is dedicated to the Virgin Mary and this shrine was made to contain relics relating to her (although these no longer exist). It is decorated with various scenes relating to Mary and Jesus.
1205, gold and other materials, 30¾ x 34½ in, Cathédrale de Nôtre-Dame, Tournai, Belgium

▼ **The Klosterneuberg Altar** *The altar is the greatest piece of enamel work of the Middle Ages. Enamel is a glassy substance that is fused to a metallic background by means of intense heat. It can create brilliant color effects.* 1181, gold and enamel, Klosterneuburg Monastery, Austria

CLOSERlook

BIBLICAL SCENES The altarpiece shows the complex relationship between various scenes from the Old and the New Testament

VIGOROUS DESIGN Animals, such as this donkey, as well as human figures are described by Nicolas of Verdun with engaging vitality

COLOR Different colored enamels are used with great effect to tell the biblical stories, this one showing the Nativity

Mosan School

MEUSE VALLEY, c1125 TO c1200

"Mosan" refers to the River Meuse, which flows through parts of France, Belgium, and the Netherlands. During the 12th century art flourished in the Meuse valley, especially in the area around Liège, and it is to this that the phrase "Mosan School" is applied. Mosan artists were particularly renowned for their lavish metalwork and enamelwork, but other skills, including ivory carving and manuscript illumination, also developed in the area, which was very prosperous at this time.

Several leading Mosan artists are known by name, notably Nicholas of Verdun. Although Mosan art comes within the broader category of Romanesque art, it has certain distinct features, particularly in the treatment of the human figure. Instead of the free use of distortion and exaggeration found in much Romanesque art, work of the Mosan School has an almost classical dignity in its figure style.

▶ **Cross** *Attributed to Godefroid de Huy. Godefroid was famous in his time as a goldsmith, but attributions to him are highly speculative.* c1130–50, gold, enamel, and other materials British Museum, London, UK

Gothic stained glass

c1150 TO 1500

Stained glass was first used on an extensive scale during the Romanesque period, but it really came of age in the Gothic era, when it was one of the glories of medieval art. As the Gothic style matured and glassmaking technology improved, church windows grew to huge size, encouraging stained-glass designers to develop their art. It flourished particularly in France, but also in other countries of northern and western Europe, not least England (it was of comparatively marginal importance in Italy, where the Gothic style was never fully assimilated and wall painting remained the primary form of church decoration). The cathedrals of Chartres and Canterbury are among the buildings that are especially renowned for their glass. Early Gothic stained glass has a magnificent grandeur and boldness, with strong, pure colors, but from the 15th century it tended to imitate the effects of painting, gaining in subtlety but often losing in vigor.

▲ **Scene from the Life of St. Thomas à Becket** *The murder of Archbishop Thomas à Becket in 1170 in his own cathedral turned Canterbury into a pilgrimage site. The windows in the Trinity Chapel behind the high altar depict scenes from his life.* c1220, stained glass, Trinity Chapel, Canterbury Cathedral, UK

▲ **Noah's Ark** *This is part of a large window depicting the Old Testament story of Noah and the flood.* c1200–20, stained glass, Chartres Cathedral, France

Italian art of the late 13th and 14th centuries differs fundamentally from that produced elsewhere in Europe at the time. While art in other countries was predominantly of anonymous authorship, in Italy there were numerous painters and sculptors who are known by name and who left a body of documented or firmly attributed works.

Italy at this time was not a unified country, but was made up of a number of small states. It was much more urbanized than other parts of Europe and the major cities competed in many ways, including artistic patronage. They wanted their churches and civic buildings to be bigger and better than those of their rivals, and they wanted to have them decorated by the best available artists.

Origins and influences

Various currents flowed through Italian art in the early 14th century, including influences from the Gothic style, which was dominant in most of Europe, and from Byzantine culture. Constantinople (Byzantium) was captured by Crusaders in 1204, and this increased the contact between Italian and Byzantine art. In the later 14th century, however, the austere otherworldliness of Byzantine art began to be softened by a new naturalism and humanity, looking forward to the Renaissance.

Subjects

Religion was a major inspiration to artists at this time: altarpieces and church frescos were the dominant

▲ **St. John Baptizing** *This guilded bronze panel from a set of doors by Andrea Pisano, was designed around 1330–36 for the Florence Baptistery, a commission expressing great civic pride.*

forms in painting, and sculptural types included pulpits and statues of saints. However, secular subjects were beginning to emerge, notably in the decoration of civic buildings such as town halls.

Style and techniques

During this period, Italian painters established ways of working that endured for centuries. The two standard techniques of painting were tempera (in which the colors are mixed with egg) and fresco. Tempera was used on wooden panels, and fresco is a method of wall painting in which paint is applied to fresh wet plaster. Many artists were masters of both techniques.

In sculpture, the materials for the most prestigious works were marble and bronze. Sometimes the bronze was gilded (covered with a thin layer of gold), an expensive and time-consuming process.

Early Italian art

Nicola and Giovanni **Pisano**

NICOLA: b APULIA, c1220; d PISA, c1278–84;
GIOVANNI: b PISA, c1245–50; d SIENA, c1314–19

Nicola and Giovanni Pisano, father and son, were the first great personalities in the history of Italian sculpture. They are often seen as counterparts of their near contemporary Giotto (see p.86) in painting, even though their work was not quite so momentous as his. They occasionally worked together but mainly had separate commissions. These included a series of four magnificent pulpits, two by Nicola and two by Giovanni, in the Baptistery at Pisa (1259), Siena Cathedral (1265–68), S. Andrea, Pistoia (1300–01), and Pisa Cathedral (1302–10). The first of these is Nicola's masterpiece, showing a strength and dignity that reflects the influence of ancient Roman sculpture.

Giovanni's style was more emotional and energetic than his father's and sometimes had a Gothic elegance. In addition to his pulpits, his work included the rich sculptural decoration of the façade of Siena Cathedral, of which he was also the architect.

CLOSERlook

MASSACRE OF THE INNOCENTS
King Herod presides over his order to kill all the male infants in Bethlehem. Below him is a scene of horrific violence.

◀ **Adoration of the Magi** *One of the six reliefs around Nicola's pulpit shows the three kings worshiping Jesus. The Virgin Mary has the dignity and grandeur of a Roman noblewoman as she holds up the baby to the kings, while their horses look on. 1259, marble, pulpit height 181in, Baptistery, Pisa, Italy*

◀ **Pulpit** *Giovanni's pulpit is similar in basic format to his father's in the nearby Baptistery. But the style of the carving is a total contrast: crowded and dynamic where Nicola's is weighty and serene. 1302–10, marble, height 181in, Pisa Cathedral, Italy*

▶ **Virgin and Child** *Giovanni carved this sculpture for the Scrovegni Chapel, where Giotto painted his famous fresco cycle (see p.86). Mother and baby hold each other's gaze with a tenderness quite different from that in a typical medieval portrayal, in which symbolic gesture was more important than human feeling. c1305, marble, Scrovegni Chapel, Padua, Italy*

Cimabue

ACTIVE TUSCANY, 1272–1302

"Cimabue" is a nickname meaning "Ox-head", perhaps indicating that the artist had an aggressive personality; his real name was Cenni di Peppi. Very little is known of his life and works, but he was probably the leading Italian painter in the generation before Giotto, and he may well have been Giotto's teacher, as early sources suggest. In one of these sources, Giorgio Vasari's *Lives of the Artists* (1550), he is described as the first Italian painter to break with Byzantine tradition. The works that are usually attributed to him include a magnificent panel of the *Madonna Enthroned* (c1280–90), painted for the church of Santa Trinità, Florence.

▼ **Madonna Enthroned**
Cimabue gives the Madonna a tender humanity, and the prophets below are individualized to a degree not previously seen in Byzantine art. c1280–90, tempera on panel, 153½ x 86½in, Uffizi, Florence, Italy

CLOSERlook

ANGELS The angels' gold haloes set off the Madonna's blue robe. The gold would have glinted in the light of the church for which this altarpiece was made. The solemn expressions follow Byzantine tradition, but there is an elegance and a delicacy of touch that is personal.

Ambrogio and Pietro **Lorenzetti**

AMBROGIO: ACTIVE SIENA, 1320–45; PIETRO: ACTIVE SIENA, 1319–48

These two brothers were among the leading Sienese painters of their time. They sometimes collaborated but mainly worked independently; both may have died in an epidemic of the plague in 1348. Most of their work is on religious subjects, but there is one great exception—Ambrogio's fresco cycle on Good and Bad Government (1338–39) in Siena's Palazzo Pubblico (town hall). This is one of the most original works of its time in all European art, showing remarkable panoramic views of town and country, with many beautifully observed details of contemporary life. The frescoes occupy three walls of the large room where the counsellors who governed Siena held their meetings.

▲ **Good Government in the City**
This is part of one of the side walls of the council's meeting room. It moves seamlessly into a scene depicting Good Government in the Country *beyond the city wall on the right of the picture.* 1338–39, fresco, overall length 14m, Sala della Pace, Palazzo Pubblico, Siena, Italy

CLOSERlook

PEOPLE AT WORK To show how well-ordered the city is, bustling citizens are busily at work everywhere, even on the rooftops. These human figures also give a sense of scale to the magnificent architectural panorama of Siena.

Duccio di Buoninsegna

b UNKNOWN; d SIENA, 1318/19

Duccio was the greatest and most influential of all Sienese painters, his flowing draftsmanship and wonderfully subtle and expressive coloring inspired followers for generations. There is only one surviving work that is fully documented as his, but this is one of the supreme masterpieces of Italian art—a huge double-sided altarpiece (finished 1311) painted for Siena Cathedral. The central scene on the front is known as the Maestà ("Majesty") and there are numerous smaller front and back panels, mainly showing scenes from Christ's life. Most of the altarpiece survives in Siena Cathedral's museum, but a few panels are lost or have been dispersed to collections outside Italy.

◄ **Reverse side of the Maestà** *The back of the main panel shows 26 scenes from the life of Christ: the 11 here are on the left-hand side of the altarpiece. They include the entry of Christ into Jerusalem on the bottom left, and, next to it, Jesus washing the feet of the disciples and the Last Supper.* Completed 1311, tempera on panel, Museo dell'Opera del Duomo, Siena, Italy

▲ **The Madonna Enthroned** *In the central panel of the Maestà altarpiece, Duccio alters the Byzantine tradition, with expressive glances rather than stylized faces, and fluid instead of stiff drapery. Around the base of the throne is an inscription: "Holy Mother of God, be the cause of peace to Siena, and of life to Duccio because he has painted you thus."* Completed 1311, tempera on panel, 84 x 156in, Museo dell'Opera del Duomo, Siena, Italy

CLOSERlook

COMPOSITION The symmetrical structure focuses the eye on the centrally placed Madonna and Child. They are the largest figures, because they are the most important. Saints and angels are ranked on either side.

Giotto

b **COLLE DI VESPIGNANO?, NEAR FLORENCE, c1270**; d **FLORENCE, 1337**

The Florentine painter and architect Giotto di Bondone trained under Cimabue but, going further than his master, he replaced the Byzantine art tradition with a degree of naturalism. Giotto rediscovered how to make a flat surface look three-dimensional, using artistic devices that had been forgotten since the classical Greek world. However, achieving the illusion of space, through perspective and light and shade, was not an end in itself for Giotto. Realism was merely the tool he used for his greatest innovation—telling a story with all its human pathos and drama.

Giotto's realism was appreciated in his own lifetime, and he was famous and sought-after throughout Italy. Despite the plague ravaging 14th-century Florence and much of Europe, Italian art never looked the same after Giotto, and his influence was carried all over Europe by Simone Martini and others.

▲ **Scrovegni Chapel** *This chapel was commissioned by a local banker, Enrico Scrovegni, and stands next to his palace in Padua. Giotto's frescoes fill the interior.* 1305–06, Padua, Italy

◄ **The Nativity** *Giotto uses vivid color to make the story of the birth of Christ come alive. The robe of Joseph, who is seated in the foreground, is intense yellow in its shadows and lightened with white for highlights.* c1305, fresco, Scrovegni Chapel, Padua, Italy

▲ **Adoration of the Magi** *All the action in this scene takes place in the foreground, which makes the viewer feel like a participant, worshiping the Christ child along with the kings. The rounded figures look as solid as sculpture.* c1305, fresco, Scrovegni Chapel, Padua, Italy

► **Crucifix** *Emotion and suffering were part of the Byzantine symbolism that Giotto inherited. Christ has a look of dignified resignation, and his greenish death pallor contrasts with the blood coming from the wound in his chest. Crucifixes like this one were hung high up in churches so that all the congregation could see them.* c1312, tempera on panel, height 224½in, Santa Maria Novella, Florence, Italy

▲ **The Lamentation of Christ** *Giotto uses the composition to bring out the poignancy of this scene, in which Christ's mother and followers mourn over his dead body. The ridge swoops down from right to left, and John the Baptist's arms swept back contribute to the downward thrust toward the prostrate figure of Christ. The single tree is a medieval symbol of death and may also represent the Tree of Knowledge in the Garden of Eden.* c1305, fresco, Scrovegni Chapel, Padua, Italy

b SIENA?, 1284?; d AVIGNON, 1344

Simone Martini probably trained under Duccio, and, like his master, he is one of the greatest Sienese painters. His most famous work is *The Annunciation* (1333), which he was commissioned to make for Siena Cathedral to partner Duccio's *Maestà* (1311). *The Annunciation* is normally jointly assigned to Simone and his brother-in-law, Lippo Memmi.

Simone shared Duccio's interest in colorful pattern, but his style was more Gothic than Byzantine. The delicate grace and decorative detail of *The Annunciation* appealed to the French, and he spent the last 10 years of his life working in Avignon. Here, his work paved the way for the International Gothic style, adopted by French and other European manuscript illuminators and painters.

▼ **The Annunciation** *Flanked by two local patron saints of Siena, the angel Gabriel tells a hesitant Mary that she is to be visited by the Holy Ghost—the dove in the center—and will become the mother of God's son, Jesus Christ.* 1333, tempera on panel, 118 x 106¼in, Uffizi, Florence, Italy

CLOSERlook

ANGEL GABRIEL The words "Hail Mary, full of grace, the Lord is with you" in Latin stream in gold from Gabriel's mouth, and further words from the Hail Mary, a key prayer of Catholicism, are written in the hem of his robes. Gabriel holds an olive branch, a symbol of peace.

◄ **St. Martin Shares his Cloak with a Beggar** *This scene of generosity is part of a fresco cycle on the life of the saint. Simone gives the action a contemporary castle entrance setting.* 1326, fresco, Lower Church of S. Francesco, Assisi, Italy

CLOSERlook

THE ANGELS While the earth-bound figures are frozen in anguish, the angels move freely in the sky. However, their faces mirror the grief below. Each angel has an expression as individual as its pose, and all of them lead the eye to Mary and Jesus.

MOTHER AND SON The emotional weight of the tableau is off-center, in the grief-stricken features of the Virgin Mary as she sees her son for the last time. The haggard strain on her face contrasts with the deathly calm on his, especially as she is awkwardly hunched over for this close caress.

Origins and influences

The term "International Gothic" describes a medley of trends that affected the art of various countries in the period from about 1380 to 1430. Elegance of pose and gesture typical of the Gothic style of northern Europe were combined with a new interest in naturalistic detail. Such fashions were spread by the increased mobility of artists and by the rivalry between courts in making extravagant displays of wealth.

Subjects

Religion continued to be the mainstay of art in this period, but secular subjects increased in importance, for example in the manuscript illuminations of the Limbourg brothers. Although the books they created were nominally religious, they contain a wealth of beautifully observed detail of the everyday world.

Style and techniques

International Gothic art is often conspicuously luxurious—created for rich and sophisticated patrons who appreciated beautiful craftsmanship. *The Wilton Diptych* and *Adoration of the*

Jewel-bright colors, slender, elongated figures in elaborate costumes, and nature observed and recorded in minute detail all characterize the charmed world of International Gothic. Artists of the time blended elements from Italy and northern Europe into a sophisticated idiom.

▲ **Portrait medal of Gianfrancesco Gonzaga** *by Pisanello. The solidity and clarity exemplify Renaissance values, but the delicate observation of plants is typical of International Gothic.*

Magi, for example, make abundant use of gold leaf and are painted with exquisite sensitivity. There is also often a strong element of fantasy, as in the architectural background of Pisanello's *St. George Rescuing the Princess of Trebizond*.

International Gothic art

Pisanello

b PISA?, c1394; d ROME?, 1455?

Tantalizingly little remains of the frescoes and panel paintings of Antonio Pisano, nicknamed Pisanello ("the little Pisan"). He and Gentile da Fabriano were Italy's leading International Gothic artists, and they collaborated on frescoes in the Doges' Palace in Venice. Unfortunately, these have not survived. Pisanello worked in various other cities in Italy, including the northern courts of Ferrara, ruled by the Este family, and Mantua, ruled by the Gonzagas.

In addition to being an outstanding painter, Pisanello is notable as the inventor and perhaps the finest of all exponents of the portrait medal. He was also a superb draftsman, and many of his drawings of animals survive. The accuracy of his studies shows that close scrutiny of nature could sit side by side with the courtly, gem-like style of painting.

◀ **Portrait of a Lady** *There are many romantic theories about this painting. The sitter could be Ginevra d'Este, identified by the juniper (ginepro in Italian) on her shoulder —in folklore, it was said to protect against early death. She died in 1439, aged 22, rumor had it after being poisoned by her husband, Sigismondo Malatesta, Lord of Rimini. c1436–38, oil on panel, 16⅞ x 11¾in, Louvre, Paris*

▶ **Guinea Fowl** *Pisanello's drawings include many lively studies of birds and other animals.* Pen and ink and watercolor on paper, Louvre, Paris, France

▲ **St. George Rescuing the Princess of Trebizond** *This is one of only two surviving frescoes documented as Pisanello's work. The golden-haired St. George has dismounted after slaying the dragon that held the princess captive. She is seen in profile, wearing all her royal splendor. Originally his armor and her train would have sparkled with gold and silver, but it has been damaged by water seepage. c1433–38, fresco, Sant'Anastasia, Verona, Italy*

Gentile da Fabriano

b **FABRIANO, c1385?**; d **ROME, 1427**

Along with Pisanello, Gentile is the most renowned Italian painter to exemplify International Gothic. Little of his work has survived, however, and his reputation largely rests on one piece—the *Adoration of the Magi* (1423), a large altarpiece made for the Strozzi chapel in the church of S. Trinità in Florence. Within its elaborate, pinnacled frame, a cavalcade follows the three kings to worship the newly born Jesus in the left foreground. A golden light unifies the painting, complementing the gilt frame, tooled haloes, and embroidered patterns on the kings' robes. Gentile's blend of naturalistic light and decorative detail influenced later painters, such as Jacopo Bellini and Fra Angelico.

▶ **Adoration of the Magi** *The kings in the foreground represent old age (kneeling), middle age (bowing), and youth (standing). Behind the standing king is Palla Strozzi, the Florentine banker who commissioned the work.* 1423, tempera on panel, 119¼x111in, Uffizi, Florence, Italy

CLOSERlook

THE NATIVITY The predella—the three panels below the central image—shows further episodes from Christ's infancy. Gentile uses light rather than line to show form. The light also has a symbolic element—it comes from the baby Jesus himself.

THE FLIGHT INTO EGYPT In the central predella panel, Mary carries Jesus on a donkey through a Tuscan-style landscape. Fra Angelico repeated this composition 30 years later.

Paul, Herman, and Jean de **Limbourg**

ACTIVE 1402–16

The Limbourg brothers were Netherlandish manuscript illuminators, and their work is the epitome of the International Gothic style. The colors are bright, with lavish use of blue and gold. The detail is naturalistic and minute, probably painted with the aid of a magnifying glass; figures are gracefully elongated; the nobility wear fantastic finery, while peasants work the fields.

The brothers' main patron was Jean, Duc de Berry, a great manuscript collector for whom they produced two illuminated Books of Hours: selections of prayers and readings. They contain illustrations of various types, but the most remarkable are the full-page depictions of the months in the second book, the *Tres Riches Heures*.

All three brothers died in the same year—1416—probably of the plague, leaving the *Très Riches Heures* unfinished. It was completed by the French illuminator Jean Colombe about 70 years later.

▶ **December, Hunting Wild Boar** *In this page from* the Très Riches Heures, *a swathe of trees separates the foreground hunt from the background towers. Signs of the zodiac appear at the top of each page devoted to a month.* 1411–16, gouache on parchment, 9⅛x5⅜in, Musée Condé, Chantilly, France

Master of the **Wilton Diptych**

DATES UNKNOWN

The Wilton Diptych gets its name from Wilton House in Wiltshire, England, where it was in the collection of the Earls of Pembroke for more than two centuries before being bought by the National Gallery in 1929. It is one of the most famous and beautiful paintings of its time, but nothing is known of its origins, and the identity (and even the nationality) of the artist is unknown. Almost certainly, however, it was painted for King Richard II of England (reigned 1377–99) for his personal use. Small hinged altarpieces like this could be closed like a book, carried on travels, and opened up when the owner wanted to pray. The unidentified artist who created this radiant masterpiece was most likely English or French, but other nationalities have been suggested.

▲ **The Wilton Diptych** *Backed by John the Baptist (carrying the lamb) and two canonized former kings of England, Richard II kneels in front of Mary, Jesus, and a host of angels.* c1395, tempera on panel, each wing 20⅞x14⅝in, National Gallery, London, UK

The Renaissance, a revival of the cultural ideals of ancient Greece and Rome, flowered during the 15th and 16th centuries in Europe. Based on a new scientific spirit of observation, painting and sculpture became more naturalistic and artists used perspective to portray a three-dimensional world, rather than the spiritual space depicted by medieval artists.

15th and 16th

1400	1425	1450	1475

ITALIAN RENAISSANCE c1400–c1525

FLEMISH RENAISSANCE c1400–c1540

GERMAN RENAISSANCE c1440–c1540

MING DYNASTY (CHINA) 1368–1644

MUROMACHI PERIOD (JAPAN) 1333–1573

INCAS 1220s–1533

AZTECS 1325–1521

The Renaissance started in Italy, where wealthy bankers and merchants commissioned paintings, sculptures, and frescoes for churches and palaces. Figures in paintings became more realistic and sculptures of the nude were based on anatomical study. The development of oil paint freed artists from the limitations of egg tempera and enabled them to experiment with layers of colour. In Flanders and Germany, artists produced masterful altarpieces and realistic portraits. Landscape became a new genre, with nature depicted in minute detail.

In the 1520s the classical harmony of the High Renaissance began to break down as Mannerism emerged. This was a sophisticated style in which poses, colours, and perspective were exaggerated.

Art also blossomed in the Far East during this period. Under the Ming Dynasty in China, artists painted vast landscapes, flower and bird compositions, and narrative paintings, using ink wash and calligraphy. In Japan, evocative ink paintings and screens featuring scenes on gold backgrounds showed the influence of Zen philosophy.

centuries

| 1525 | 1550 | 1575 | 1600 | 91 |

HIGH RENAISSANCE c1500–1520s

VENETIAN RENAISSANCE c1450–1580

MANNERISM c1520–c1610

AZUCHI–MOMOYAMA PERIOD (JAPAN) 1573–1615

For the first time since classical antiquity, painting gave a convincing illusion of three dimensions, with solid-looking figures set in a unified space. The figures have noble proportions and features and show believable emotions. While Florentines approached art intellectually, Venetians revelled in the luscious color of oil paint.

Origins and Influences

Renaissance means "rebirth" and the idea stems from the 14th-century Italian poet Petrarch. He divided history into ages: the golden age of classical antiquity; the dark age after the Roman Empire collapsed; and his own modern age, when the values of antiquity were "reborn."

Although classical texts had in fact been important throughout the Middle Ages, Petrarch believed that he and his contemporaries had revived Greek and Roman ideals and thought after a period of cultural stagnation.

▲ **Cathedral dome** Filippo Brunelleschi *The huge dome of Florence cathedral was a remarkable feat of engineering and the most prominent symbol of the city's leadership in cultural affairs. 1417–36, Florence, Italy*

Alongside an intellectual rebirth, the economy in the Italian city-states flourished. By 1400 merchants and bankers were the most powerful citizens. Unlike aristocrats who inherited their wealth and position, the new middle classes had achieved their status themselves. Instead of bowing to inevitable death and focusing on the afterlife, they took pride in their contribution to society in this life. Part of this involved a good education in classical law, rhetoric, and philosophy. This cultural shift was labeled humanism in the 19th century.

Subjects

Christianity remained as strong as ever and religious subjects were the most common themes in art. Some were highly critical of corruption in the Catholic Church, ultimately leading to the Protestant Reformation in the 16th

Italian Renaissance

TIMEline

Donatello's *St. George* looks like a purposeful young man, and his friend Masaccio's *Holy Trinity* has a powerful new sense of space. Piero's *Dream* added light for drama, while Botticelli's *Venus* reflected the culture of the Medici court. *David, Mona Lisa,* and the *School of Athens* of the High Renaissance giants Michelangelo, Leonardo, and Raphael show the realization of the naturalistic aims of their predecessors. Titian's *Venus* is a Venetian match for them.

c1413–17

DONATELLO St. George

c1425–28

MASACCIO Holy Trinity

c1430–32

FRA ANGELICO The Annunciation

c1457–65

PIERO DELLA FRANCESCA The Dream of Constantine

1485

BOTTICELLI The Birth of Venus

Schools

Throughout the 15th century Florence was Italy's most innovative and productive art center, but in the 16th century Rome and Venice rivaled it in importance. Several other leading cities—including Mantua, Milan, and Padua—had impressive artistic traditions, and numerous smaller places were significant, notably Urbino, which had a brief but brilliant cultural flowering.

Florence

Florence is often described as the cradle of the Renaissance. In the early 15th century it was home to a remarkable group of artists who brought about a revolution in style and set the agenda for much of what followed. Masaccio in painting, Donatello in sculpture, and Brunelleschi in architecture were the most influential of these figures. Brunelleschi revived the decorative vocabulary and lucid harmony of ancient

▲ **The Holy Family with a Lamb** Raphael *His early works included intimate and tender religious images like this. In Rome, his style became grander. 1507, oil on panel, 11⅜ x 8¼in, Prado, Madrid, Spain*

Roman architecture, decisively breaking with the Gothic style (see p.82), while his friends Donatello and Masaccio brought a new naturalism to their respective arts. They and their successors flourished in a stimulating environment, for Florence was extremely prosperous and the bankers and merchants who created its wealth were often generous (and competitive) patrons of art, helping to create a constant flow of major commissions. The city was a republic, but from 1434 it was, in effect, ruled by the Medici family. Its members included several of the leading patrons of the age. Sandro Botticelli, Michelangelo, Benvenuto Cellini, and Agnolo Bronzino are among the host of illustrious artists who worked for them.

Rome

For much of the early Renaissance Rome was of secondary importance. Because of anarchic political conditions there, the papacy transferred its court to Avignon in France from 1309 to 1377 and it was not until the reign of Pope Martin V (1417–31) that Rome began to stabilize and emerge from this bleak period. His successors included some notable patrons, who started rebuilding Rome and attracted major artists to the city (Giulio Romano is the only

◀ **Adam and Eve Banished from Paradise**
Masaccio *Adam and Eve look like real people, distraught at being thrown out of the Garden of Eden. Previously, the fall from grace had been presented more symbolically. c1425–28, fresco, Brancacci Chapel, Santa Maria del Carmine, Florence, Italy*

century. From the mid-15th century, portraits reflected the new sense of self-worth. Patrons also collected art with mythological themes to enjoy at home.

Style and techniques

Painting and sculpture became realistic, representing the living, visible world rather than, as in medieval art, symbolically portraying the heavenly realm. Discovery of the laws of perspective put art on a rational footing that showed mathematically calculated depth and proportion. Technically, the use of oil paint freed artists from the constraints of quick-drying egg tempera.

▲ **Detail** *The angel's sorrowful face with eyes cast down and tears running down his cheeks makes a poignant expression of bereavement.*

◀ **The Dead Christ Supported by an Angel** Antonello da Messina *This Sicilian artist's use of oil paint to give a strong sense of atmosphere made an impact in Venice.* c1475–78, oil on panel, 29⅛ x 20⅛in, Prado, Madrid, Spain



CURRENTevents

1492 Florentine ruler Lorenzo de' Medici dies. Preacher Girolamo Savonarola takes advantage of the power vacuum, possibly influencing Michelangelo among others. "Pagan" works of art are burned in street bonfires.

1498 Savonarola is executed. After a brief spell as a republic, the Medici, absent since 1494, return to power in Florence in 1512.

1527 In the Sack of Rome, Holy Roman Emperor Charles V's troops and Protestant mercenaries loot the city's art treasures and murder many inhabitants.



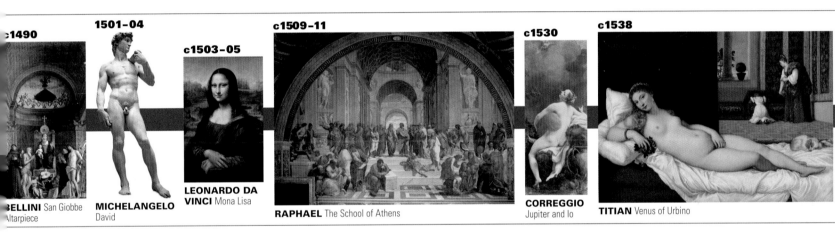

c1490

BELLINI San Giobbe Altarpiece

1501–04

MICHELANGELO David

c1503–05

LEONARDO DA VINCI Mona Lisa

c1509–11

RAPHAEL The School of Athens

c1530

CORREGGIO Jupiter and Io

c1538

TITIAN Venus of Urbino

outstanding artist of the period who was born there). The greatest of these papal patrons was Julius II (1503–13), who began the rebuilding of St. Peter's Basilica, with Donato Bramante as his architect, and employed Michelangelo and Raphael on frescoes in the Vatican. These three artists, together with Leonardo da Vinci, were largely responsible for creating the grand, noble High Renaissance style. The golden age it represented ended when Rome was sacked by troops of the Emperor Charles V in 1527. By the end of the 16th century the city had recovered and was the most important art center in the country.

Venice

Venice was enormously wealthy because of maritime trade, but it lagged behind as an art center until the late 15th century, when it was transformed, largely through the work of Giovanni Bellini. He matched the skill of his Italian contemporaries, and also gave Venetian art a particular character, showing a concern with color and light that contrasted with the Florentine emphasis on line. Bellini ran a busy workshop and passed on his methods and ideals to his pupils and other

painters of the next generation, including Giorgione and Titian. Other artists, notably Jacopo Tintoretto and Paolo Veronese, continued this age of Venetian painting almost to the end of the 16th century.

▲ **Pietà** Giovanni Bellini *Bellini put Venice on the artistic map with the strength of his color and atmosphere, contrasting with the Florentine emphasis on line.* c1505, oil on panel, 25⅝ x 34¼in, Galleria dell' Accademia, Venice, Italy

▶ **Danae** Titian *Loose brushwork and mellow color make Titian's retelling of classical myths soft and sensuous. Here Zeus seduces Danae in the guise of a shower of gold.* c1554, oil on canvas, 53⅛ x 59¾in, Kunsthistorisches Museum, Vienna, Austria

Lorenzo **Ghiberti**

Self-portrait

b FLORENCE, c1380; d FLORENCE, 1455

Lorenzo Ghiberti's breakthrough came in 1401, when as a young and little-known goldsmith he defeated Brunelleschi (opposite) and five others in a competition set by the Cloth Importers' Guild of Florence. The prize was a commission to decorate the North doors of the city's Baptistery, situated in front of the cathedral. The reliefs for the pair of bronze doors took him 23 years to complete. The result—closer to International Gothic than Renaissance in its elegant lines, rhythmic drapery, and detailed landscape—was so successful that the guild commissioned a further pair of doors for the East entrance. Dubbed the "Gates of Paradise" by Michelangelo, they were ahead of their time for their clever spacing of figures within varying depths of relief. Ghiberti moved on from his Gothic roots in his designs for the second pair of doors. His later reliefs put him in the vanguard of the Renaissance use of perspective. While the doors took up most of Ghiberti's career, he claimed that "few works of importance were made in our city that were not designed or devised by my hand." Indeed, some of the best artists of the day trained in his workshop.

LIFEline

1401 In his early 20s, wins commission to decorate the North doors of the Baptistery in Florence
1413–17 Makes first of three large bronze statues of saints for the Orsanmiche
1424 The completed North doors are hung
1425 Embarks on second pair of doors for the Baptistery's East entrance
1440 Writes *Commentarii*, one of the first art history books and the first surviving autobiography of an artist
1452 Finishes East doors

INcontext

CITY GUILDS By 1400, there were seven main guilds in Florence, each representing a key trade or profession. They wielded great power, and only guild members could hold government office. Luckily for the arts, rivalry meant that the guilds vied to commission the best sculptors to decorate their buildings. All the guilds competed to decorate the niches of Or San Michele, a combined guild hall, granary, and church near Florence cathedral. Ghiberti was commissioned to make larger-than-life bronze statues of St. John the Baptist, St. Matthew, and St. Stephen.

Portal for the Tailors' and Drapers' Guild,
Museo di San Marco, Florence, Italy

▶ **North doors** *Surrounded by a frieze of foliage, the 28 relief panels illustrate a cycle of New Testament subjects. Ghiberti's panels were modeled on Andrea Pisano's earlier doors for the Baptistery. Each panel is in the Gothic shape of a quatrefoil, consisting of four lobes and points—a tricky space to fill. The decoration surrounding the panels incorporates the heads of prophets and sibyls and Ghiberti's self-portrait. 1424, part-gilded bronze, Baptistery, Florence, Italy*

CLOSERlook

THE TRANSFIGURATION, NINTH PANEL The disciples are shown falling to the ground as Christ reveals His divine nature, flanked by the prophets Moses and Elijah. Ghiberti uses the quatrefoil's lower lobes as a dividing point between the standing and prone figures.

▲ **The Sacrifice of Isaac** *Ghiberti's winning entry for the design of the North doors was cast in one piece, except for the naked figure of Isaac. This use of metal was economical and unified the sculpture. Ghiberti uses the diagonal of the rocky landscape to separate and balance the subordinate attendants and their donkey and the key characters. The turning figures of Abraham and his son Isaac gracefully echo each other's movements. 1401, bronze, Bargello, Florence, Italy*

▲ **Cain and Abel** *In this panel from the East doors, Ghiberti uses subtle gradations of relief to suggest receding depth and represent different aspects of the story. Cain cudgels Abel to death with convincing brutality; Ghiberti has moved on from symbolic Gothic gestures. Completed 1452, gilded bronze, 20½ x 17¾in, Baptistery, Florence, Italy*

Filippo **Brunelleschi**

b FLORENCE, 1377; d FLORENCE, 1446

After Brunelleschi lost out to Ghiberti in the competition to design the doors to the Florence Baptistery in 1401, he devoted himself mainly to architecture. A former goldsmith, he is credited with discovering the mathematical laws of perspective. His mathematical skills and knowledge of Roman construction enabled him to design the vast dome of the Florence Cathedral, which spans 148.5ft (45m) without supports. His revival of Roman architectural forms shaped the Renaissance, and his perspective laws were soon applied to painting.

▲ **The Sacrifice of Isaac** *In Brunelleschi's version—more dramatic but less graceful than Ghiberti's—an angel holds Abraham's arm away from Isaac. The elements were cast separately and pinned to a plate.* 1401, bronze, Bargello, Florence, Italy

Jacopo **della Quercia**

b SIENA, c1374; d SIENA, 1438

Jacopo hovers between the medieval and the classical: heavy Gothic folds of drapery grow increasingly fluid, and the figures have a sense of volume and muscle that stems from Roman sources. The leading sculptor of the Sienese school (more conservative than trend-setting Florence), Jacopo worked in many Italian cities, often moving on before completing a commission.

Jacopo was influenced by Donatello, and both contributed bronze reliefs for the marble font in the Siena Baptistery. Jacopo lagged behind schedule, and his *Annunciation to Zacharias* owed a debt to Donatello's already completed *Feast of Herod* in its portrayal of space and depth. His last work was a commission for a series of relief scenes from Genesis and Christ's nativity for the doors of S. Petronio, Bologna. In the ultimate accolade, Michelangelo reinterpreted some of them on the Sistine Chapel ceiling.

LIFEline

1401 Enters competition for the Florence Baptistery doors
1405 Receives commission for first known work
1408 Commissioned to carve the Fonte Gaia in Siena
1417–30 Works on reliefs for Siena Baptistery font
1425 Begins the portal of S. Petronio in Bologna

▶ **Fonte Gaia** *Jacopo's sculptures for the fountain in Siena's city square show a Renaissance solidity. The outer figures have a Gothic swaying axis and sweeping drapery.* 1414–19, marble, Siena, Italy

▼ **Creation of Eve** *In most of the S. Petronio door panels, Jacopo used only three figures, interpreting them with individual character.* Begun 1425, marble, S. Petronio, Bologna, Italy

Luca della Robbia

b FLORENCE, c1399; d FLORENCE, 1482

Luca della Robbia was the leading proponent of the "sweet style" of sculpture, an alternative to Donatello's expressive style. His marble reliefs of children singing and dancing for the Singing Gallery in Florence Baptistery were outstandingly original in their joy of life and exuberance. He was among the first to bring out the sentimental bond between the Virgin and Christ Child.

Luca's greatest technical innovation was his use of glazed terracotta for sculptures. Adding color made statuary much more visible in the dim lighting of a church. The bright and permanent colors also made the terracottas suitable for use on the outside of buildings, such as in coats of arms and niches. Luca's workshop flourished on these commissions. His nephew, Andrea, and other members of his family carried on the tradition well into the 16th century.

LIFEline

1414 Probably apprenticed as a teenager to Nanni di Banco
1431–38 First documented work, the Singing Gallery over the North doors of the Baptistery in Florence
1463–66 His workshop makes roundels of babies on the façade of Florence's Foundling Hospital

▲ **Virgin and Child** *Roundels of gently expressive, half-length Madonna groups in glazed white terracotta on a blue ground were the bread and butter of Luca's workshop.* 15th century, terracotta, Bargello, Florence, Italy

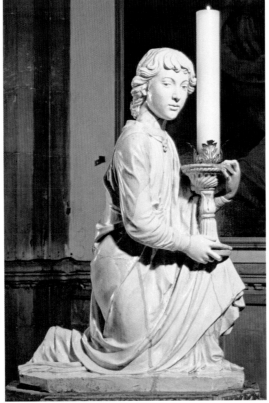

▲ **Angel Holding a Candle** *This is one of a pair of angels modeled in white terracotta for the cathedral in Florence. It was the first use of the medium for free-standing sculpture.* 15th century, glazed terracotta, Florence Cathedral, Italy

CLOSERlook

INDIVIDUALLY MODELED
The two angels are unique, but both have similarly sweet faces and serene expressions. Later figures were mass-produced from molds, with an inevitable reduction in quality.

Masaccio

Portrait by Giorgio Vasari

b SAN GIOVANNI VALDARNO, 1401; d ROME, 1428/29

In his short life, Masaccio took up where Giotto left off. Together with Brunelleschi and Donatello, he was the greatest innovator of Italian art in the 15th century. While his contemporaries were painting in the International Gothic style, he applied his friend Brunelleschi's mathematical laws of perspective to create the illusion of space on a flat surface. Masaccio used a single light source so that the play of light and shadow added solidity. And instead of decorative detail and generalized elegance, he gave his figures strong bodies, individual looks, and expressive faces. Masaccio is best known for a polyptych (multi-panelled altarpiece) for a church in Pisa (its panels are now scattered around art galleries in Europe and the US), a fresco cycle in Florence's Brancacci Chapel, and the *Holy Trinity* in Maria Novella, Florence. The Brancacci Chapel was a training ground for later Florentine artists such as Michelangelo, who went there to copy and study Masaccio's figures.

LIFEline

1401 Born near Florence

1422 Becomes a member of the Painters' Guild in Florence

c1425–28 Collaborates with Masolino on a fresco cycle of the life of St. Peter, including scenes of Adam and Eve, in Brancacci Chapel, Santa Maria del Carmine, Florence

1428 Moves to Rome before completing the frescoes

c1428/29 Dies suddenly, perhaps from plague but some suspect he may have been poisoned

▼ Holy Trinity with the Virgin, St. John, and Donors

Using the laws of linear perspective, Masaccio makes the architectural niche look like a hole in the wall. The donors, who paid for the painting, kneel outside the niche. c1425–28, fresco, 22ft 3in x 10ft 5in, S. Maria Novella, Florence, Italy

► Brancacci Chapel

The banking Brancacci family paid for the three walls of this chapel in the Florentine church of Santa Maria del Carmine to be painted with scenes from the Gospels. The Tribute Money (below) runs almost the entire length of the upper register of the left wall. It tells of a tax demanded of St. Peter— a story that resonated with Florentines, who paid an unpopular tax for the defense of their city.

CLOSERlook

TRIANGLES The triangular arrangement stabilizes the figures and represents the Trinity: God the Father (top), the Holy Ghost (the dove), and God the Son (Christ).

▲ **The Tribute Money** *The figures get proportionately larger from the left to the right of this fresco, mirroring the perspective of the building shown in the picture, and also that of the adjoining fresco.* c1425–28, fresco, Brancacci Chapel, S. Maria del Carmine, Florence, Italy

CLOSERlook

THE MAIN CHARACTER St. Peter appears three times in the story: in the right-hand group giving money to the tax collector; in the main group, gesturing, and hooking a coin out of a fish's mouth on the left.

LIGHT AND REALISM To match the perspective, light falls from a single source (top right), creating shadows and highlights that make the individualized figures look more realistic.

Donatello

b FLORENCE, c1386; d FLORENCE, 1466

Donatello (short for Donato di Niccolo) was to sculpture what his friend Masaccio was to painting. Abandoning his Gothic training in Ghiberti's workshop, Donatello grafted a psychological insight on to classical models. His figures are anatomically accurate with individual characters—the embodiment of humanism. Donatello mastered the art of linear perspective from his friend Brunelleschi, combining it with emotional reaction to forge a startling realism. He was prolific and versatile, and his work had enormous impact on his contemporaries. His influence was spread by his travels—he worked not just in Florence, but also in several other major art centers.

St. George and the Dragon (see panel at foot of statue, right) shows Donatello's technical virtuosity in the imperceptibly subtle way in which it depicts space. High relief gives way to a barely scratched background that suggests hazy trees in the distance. Donatello was the inventor of this kind of drawing in stone.

LIFEline

1404–07 In his early 20s, is an assistant in Ghiberti's workshop

1430–33 Works and studies classical sculpture in Rome

1443–1453 Based in Padua, where his works include an equestrian monument to military leader Gattamelata, cast in 1447. Donatello's reliefs influenced painters as well as sculptors

1454 Returns to Florence, where he spends most of the rest of his life

▼ **Dead Christ Tended by Angels** *The impassive expression on Christ's face contrasts with the anguish of the two angels.* c1435–43, marble, 31¾ x 44⅜in, Victoria and Albert Museum, London (on loan to National Gallery, London), UK

▲ **St. George** *The square stance and slight frown of concentration imply the saint's strength of purpose. In the shallow panel below the statue, St. George slays the dragon.* c1413–17, marble, Bargello, Florence, Italy

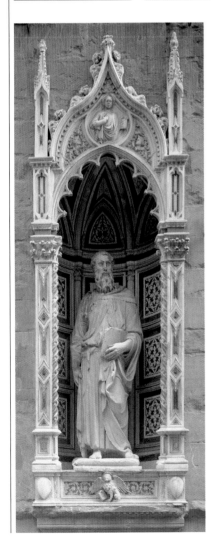

◀ **St. Mark** *In this classical pose, the weight-bearing leg is covered by vertical cloth folds, like the flutes of a column, while fabric wrinkles emphasize the bent knee of the other leg. The elongated torso compensates for the viewer looking up at the high niche.* 1411, marble, Orsanmichele, Florence, Italy

▲ **The Feast of Herod** *In the center of the scene, where the main action might be expected to take place, Donatello leaves a vacuum—a rift between the presentation of St. John's head on a platter on one side and the horrified recoiling of the guests on the other. Applying the new system of linear perspective, the sculptor uses a low wall to separate the earlier scenes in the story from the key episode in time and place.* c1417–30, gilded bronze, S. Giovanni, Siena, Italy

Masolino

b PANICALE, UMBRIA? c1383?; d UNKNOWN, c1435/40?

Tommaso di Cristofano, known as Masolino, collaborated with Masaccio on the Brancacci Chapel frescoes (opposite) in Florence. Although about 20 years his senior, he joined the Painters' Guild in Florence a year later than Masaccio, in 1423, and the younger artist influenced the older. Little is known of his life, except that he worked in various places in Italy and in Hungary. More is known of his style, which is softer and more decorative than Masaccio's, and graceful rather than bold—qualities that grew more pronounced after Masaccio's untimely death.

▼ **Banquet of Herod** *This fresco straddles old and new styles: the figures are more decorative than realistic, yet the diminishing size of the colonnade puts Masolino at the forefront of spatial representation.* c1435, fresco, Baptistery, Castiglione Olona, Italy

CLOSERlook

FRAMING DEVICE
The tree of temptation creates a canopy over the heads of Adam and Eve in an otherwise bare setting. The snake curls over Eve's head like a branch from the tree.

▲ **Temptation of Adam and Eve** *Masolino bathes the two figures in a diffused light and makes them look slim and elegant, emphasizing the beauty God gave to humanity and the pair's happiness before the Fall.* c1425–28, fresco, Brancacci Chapel, S. Maria del Carmine, Florence

Paolo **Uccello**

b **FLORENCE, c1397**; d **FLORENCE, 1475**

Self-portrait

Paolo Uccello was obsessed by perspective. According to the biographer-artist Giorgio Vasari (see p.178), he spent all night working out vanishing points. When his wife urged him to come to bed, he dawdled, unable to tear himself away from his drawings. He solved the problem of making objects look three-dimensional on a flat surface using linear perspective, without the help of light and shadow. Born Paolo di Dono, this eccentric man was dubbed Paolo Uccello ("Paolo of the bird") because of his love of birds and animals. But even they were neglected in his pursuit of a mathematical system that submitted the material world to human logic.

Unlike his fellow Florentines, Uccello used perspective for its own sake. He was not interested in furthering realism, or bringing a religious story to life, or even in symbolic value. His art was ornamental, and has a rich narrative vein that gives a fairy-tale tone to his work.

LIFEline

c1412 Apprenticed as a teenager to Ghiberti

1425–27 Makes mosaics at Basilica di S. Marco, Venice

1436 First surviving dated work, a fresco depicting an equestrian statue in Florence Cathedral

1444–45 Works in Padua

1465–68 Works in Urbino

c1470 Paints *St. George and the Dragon*, one of the first Italian works on canvas

1475 Dies in Florence, where he spent most of his life

▲ **Birth of the Virgin** *The space is convincingly deep, receding into a bedroom niche. The painting is close in style to Uccello, but some authorities think it is by a follower rather than the master himself.* c1440–50, fresco, Duomo, Prato, Italy

◄ **Battle of San Romano** *One of Uccello's biggest commissions was a series of three paintings depicting a recent battle between Florence and Siena. Lorenzo de' Medici was so anxious to obtain the pictures that he resorted to force when the owners would not sell them, and the dispute ended up in court.* c1440–50, tempera on panel, 72 x 127in, Uffizi, Florence, Italy

◄ **Battle of San Romano** *Battle pennants unfurl against a hedge of rose and orange trees and, beyond, a farm peopled with tiny figures. The splendid hat of the general, on a white horse in the center, contrives to be both round and octagonal.* c1440–50, tempera on panel, 72 x 126in, National Gallery, London, UK

▲ **The Hunt in the Forest** *Uccello combines a world of chivalric make-believe with a study of perspective.* 1460s, oil on panel, 28¾ x 70in, Ashmolean, Oxford, UK

"Oh, what a **sweet thing** this **perspective** is!**"**

PAOLO UCCELLO, ACCORDING TO VASARI

CLOSERlook

VANISHING PREY The lines of the trees, diminishing in size into the distance, and the fallen tree trunks direct the eye to a central vanishing point (the spot where receding lines seem to converge). Uccello makes this the place where the stag—the focus of the hunt—disappears from view.

Fra **Angelico**

Portrait by
Carlo Dolci

b VICCHIO, c1395; d ROME, 1455

Fra Angelico was beatified by the Vatican, the first step to sainthood, in 1982. His painting was influenced by Masaccio's handling of space, but still connected to the Gothic tradition of lively narrative. He made numerous versions of the Annunciation to the Virgin Mary, but he is best known for the frescoes he painted in the convent of S. Marco, Florence. In painting the frescoes, his aim was to encourage, express, and channel the devotion of the monastic community.

Fra Angelico's simplicity of line and vivid color carry spiritual conviction and serenity. He is able to represent space as realistically and harmoniously as Masaccio, but he keeps his setting bare so as not to distract from the religious purity of the work. His use of light and pure color was a starting point for painters such as Piero della Francesca.

LIFEline

1417 First recorded as a painter while in his early 20s
By 1423 Becomes a Dominican friar, taking the name Fra Giovanni
c1438–45 Paints series of frescoes in S. Marco, Florence
1447–50 Paints frescoes in the Vatican chapel of Pope Nicholas V
1455 Dies, and is buried in S. Maria sopra Minerva, Rome

▼ **The Annunciation** *The elegantly elongated figures are in the courtly International Gothic style, although the architecture is classical and the perspective gives realistic depth. Fra Angelico shows the moment when the Virgin Mary submits to the news that she is to give birth to the son of God.* c1430–32, tempera and gold, central panel, whole altarpiece 76 x 76in, Prado, Madrid, Spain

CLOSERlook

DIVIDERS The columns separate Mary, the Archangel Gabriel, and Adam and Eve, mirroring the triptych (three-part altarpiece) format of which it forms the central panel. The shaft of holy light links all three sections.

◀ **The Sermon on the Mount**
A single light source illuminates the semi-circle of disciples listening to Jesus. Not one plant relieves the rocky landscape: all attention is on the religious message. c1442, fresco, Cell 32, Museo di S. Marco, Florence, Italy

Benozzo **Gozzoli**

b FLORENCE, c1421; d PISTOIA, 1497

Gozzoli was apprenticed as a goldsmith, and helped Ghiberti to make bronze panels for the Florence Baptistery. He then became the pupil of Beato Angelico and worked as his assistant, but Gozzoli's talent was for the ornamental. He is famed for one particular work: the *Procession of the Magi*, commissioned by the Medici family for the private chapel in their city palace in Florence. Revelling in the International Gothic style of a French *Book of Hours* (see p.89), he covered the walls with the decorative pageantry of the kings' royal journey through an enchanted landscape. After finishing this fresco, he worked on altarpieces and created a fresco cycle of Old Testament scenes in the Campo Santo in Pisa, which was damaged by bombing in World War II.

▼ **The Procession of the Magi** *Gozzoli applies the new knowledge of light and shade and recession to suggest space. However, his real interest lies in portraying fine costume and jewel-like detail.* c1459–61, fresco, chapel of Palazzo Medici-Riccardi, Florence, Italy

CLOSERlook

SELF-PORTRAIT
Gozzoli painted himself in the procession, in a red cap with the words *Opus Benotii* (work of Benozzo). Also featured are the Medici family whose dynasty the fresco celebrated.

INcontext
ILLUMINATED MANUSCRIPTS Before the invention of printing in the 15th century, the Bible was transcribed by monks and illuminated (richly decorated). Monks such as Fra Angelico, who may have started as a manuscript illuminator, were the last generation to work in the International Gothic style.

The Crucifixion *attributed to Fra Angelico (early 1430s). This decorated initial "N" is a detail from an illuminated Missal.*

Piero della Francesca

b BORGO SAN SEPOLCRO, UMBRIA, c1415; d SANSEPOLCRO, 1492

Like Uccello, Piero della Francesca was a theorist of perspective, and late in life devoted a treatise to the subject. His mastery of perspective was so comprehensive that Leonardo da Vinci abandoned plans to write a book about it when he heard of Piero's work. Piero combined perspective with a clarity of color, form, and outline. His treatment of light builds on the perspective, using shadows to give solidity and a sense of depth. The result is one of stillness and religious solemnity.

Piero absorbed many influences. He spent much of his life in his home town, but he was fully aware of the latest artistic developments in Florence. His most important patron was the enlightened Federico da Montefeltro, who ruled Urbino. At his court, Piero met artists from Spain and Flanders. He learnt about oil painting with glazes, and enriching the surface space with colorful textures and details.

After his death, Piero was remembered more as a mathematician than a painter, especially as many of his works are off the beaten track in Tuscan and Umbrian churches. However, his artistic reputation began to revive in the 19th century.

LIFEline

1439 Works as assistant to Domenico Veneziano in Florence, the first record of him outside his home town

1445 Receives his first documented commission, the *Madonna della Misericordia* in Sansepolcro

c1450–65 Works on the *Legend of the True Cross* in Arezzo, his largest fresco commission

1478 Last mention as a painter, before he devotes himself to mathematics

▼ **Battista Sforza and Federico da Montefeltro** *The Duke and his wife are shown in profile, which hides the fact that Federico had lost his right eye fighting in a tournament.* c1465–75, oil on panel, each 18½ x 13in, Uffizi, Florence, Italy

◄ **The Dream of Constantine** *This scene is part of a cycle of frescoes in the church. A foreshortened angel appears out of the sky to Constantine, bearing the cross of victory. The flash of light illuminates the scene like a stage set and makes the figures look solid.* c1457–65, fresco, 129 x 75in, S. Francesco, Arezzo, Italy

INcontext

URBINO This Umbrian city briefly flourished under Federico da Montefeltro, a Renaissance man who combined the qualities of a warrior with benevolent rule and a cultivated mind. He appreciated the quality of Piero's work. The beauty of the exterior of the palace of Urbino—the Palazzo Ducale—was matched inside by the best library in Italy.

The Palazzo Ducale, begun about 1450, is now one of Italy's most famous monuments.

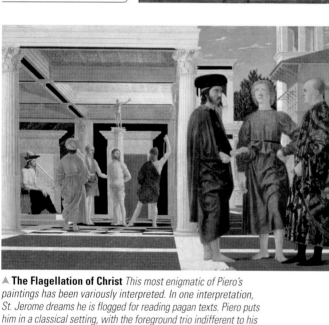

▲ **The Flagellation of Christ** *This most enigmatic of Piero's paintings has been variously interpreted. In one interpretation, St. Jerome dreams he is flogged for reading pagan texts. Piero puts him in a classical setting, with the foreground trio indifferent to his plight. The low viewpoint, at about knee level, makes the figures look monumental.* c1450–60, tempera on panel, 22¾ x 32¼in, Galleria Nazionale delle Marche, Urbino, Italy

▶ **The Baptism of Christ** *This silent ritual takes place in the Umbrian countryside. Piero's birthplace is visible in the background, between Christ and the angels. This level of landscape detail shows a Flemish influence.* 1450s, tempera on panel, 66 x 46in, National Gallery, London, UK

CLOSERlook

GEOMETRIC STRUCTURE The central vertical goes up through Christ's clasped hands to the dove representing the Holy Spirit. The horizon line falls halfway down the painting. Rhythmic lines, mostly vertical, are broken by the curve of John the Baptist's arm and leg, and the figure preparing for baptism.

❝ Piero makes us understand how **important** it is to **copy things** as they are in **nature** and to refer constantly to what is **being copied** ❞

VASARI, ARTIST-BIOGRAPHER

Domenico Veneziano

b VENICE?, EARLY 15TH CENTURY; d FLORENCE, c1461

The artist-biographer Vasari (see p.178) claimed that Domenico brought oil painting from Venice to Florence. This is no longer thought to be true, but he did inject color, clarity of lighting, and texture into the linear Florentine style. These qualities are visible in the work of Piero della Francesca, who was Veneziano's assistant on a fresco cycle in Florence. Only fragments of these frescoes survive, and little else is known about Domenico's career. His main surviving work is the *St. Lucy* altarpiece, painted for the church of S. Lucia de' Mangnoli in Florence; the central panel is in the Uffizi, Florence, Italy.

▲ **St. John in the Desert** *The classical style of this nude contrasts with his halo and the rocks, which look Flemish or Byzantine.* c1445, tempera on panel, panel from the St. Lucy altarpiece, 11 x 12¾in, National Gallery of Art, Washington DC, US

Luca **Signorelli**

b CORTONA, c1440–50; d CORTONA, 1523

▲ **Preaching of the Antichrist (detail)** *With gesture and expression, Signorelli conveys the Devil's insidious whispers and Christ's unease.* 1499–1504, fresco, Chapel of the Madonna di S. Brizio, Orvieto Cathedral, Italy

Said to be a pupil of Piero della Francesca, Signorelli added movement and emotion to his master's solid forms and clear light and color. He finished the wall frescoes for the Sistine Chapel, left incomplete by other artists, and went on to even greater things in Orvieto Cathedral. In his depiction of the end of the world, figures writhe in agony and faces show torment and terror. His expressive, muscular nudes inspired Michelangelo in his fresco painting of male nudes in the Sistine Chapel.

▲ **The Montefeltro Altarpiece** *This type of altarpiece, in which the Madonna and Child are flanked by saints and, here, angels, is called a* sacra conversazione *(holy conversation). Bright color offsets the solemnity of their expressions. Above the Madonna is an ostrich egg, a symbol of the Virgin birth that was sometimes hung over altars dedicated to her.* c1472–74, oil on panel, 98 x 70in, Pinacoteca di Brera, Milan, Italy

CLOSERlook

PERFECT SYMMETRY
The overall symmetry of the painting is relieved by the kneeling donor (the Duke of Urbino, who commissioned the work), and by the fall of light. Shadow crosses over the center of the shell-like structure above the Madonna's head. In Italian Renaissance painting, the Madonna is often centrally placed.

Antonello da Messina

Antonello
da Messina

b **MESSINA, c1430;** d **MESSINA, 1479**

Antonello was one of the great pioneers of oil painting in Italy. Although born in Sicily, he probably trained in Naples. There he would have been able to study the work of contemporary Flemish artists (Naples and Flanders had strong links at this time). Combining Flemish oil-painting techniques and realism with the clear and dignified Italian approach to form and space, he developed a style that greatly influenced Venetian artists in particular, including Giovanni Bellini (see p.126).

Little is known of Antonello's life. He may have made several visits to the Italian mainland, but only one is securely documented, in 1475–76, when he painted a large altarpiece for the church of S. Cassiano in Venice. Only fragments of this work now remain, but it greatly impressed his Venetian contemporaries.

LIFEline

c1430 Born in Messina, Sicily
c1450 Probably trains in Naples with Niccolò Colantonio, the leading painter of the day there
1456 Documented working independently in Messina
1475–76 Visits Venice where he paints the *S. Cassiano Alterpiece*
1479 Dies in Messina

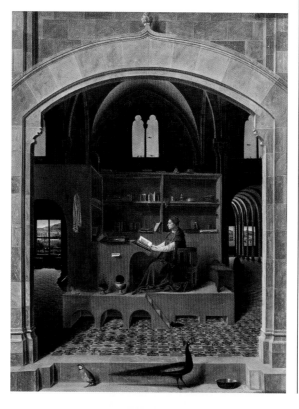

► **St. Jerome in his Study**
The austerity of the architectural setting is counterbalanced by the central image of St. Jerome with his books and papers, and by the birds and glimpses of landscape through the windows to either side. c1475, oil on panel, 18¼ x 14¼in, National Gallery, London, UK

Portrait of a Man *Antonello's three-quarter view bust portraits were popular in Venice. This one may be a self-portrait.* c1475, oil on panel, 14¼ x 9¾in, National Gallery, London, UK

◄ **Calvary (also known as the Antwerp Crucifixion)** *The Virgin Mary and St. John mourn the dead pitiable Christ. He is flanked by the two thieves crucified with him.* 1475, oil on panel, 20¾ x 16¾in, Koninklijk Museum voor Schone Kunsten, Antwerp, Belgium

Filippo **Lippi**

b **FLORENCE, 1406;** d **SPOLETO, 1469**

Filippo di Tommaso di Lippo—better known as Fra Filippo Lippi—was an innovative Florentine painter, famous mainly for his frescoes and depictions of the Madonna and Child. He was brought up in a Carmelite friary, and became a friar himself, but he eventually left the order after a scandalous affair with a nun. Lippi's first major work, the *Barbadori Altarpiece*, led to important commissions and the support of the powerful Medici. From 1452 to 1466, Lippi painted frescoes in Prato Cathedral, probably his finest works. Immediately afterward, he began work on frescoes in the cathedral at Spoleto, where he died in 1469.

▲ **The Barbadori Altarpiece** *This is one of the earliest examples of a* sacra conversazione, *in which Madonna, Child, and saints are grouped in a single panel.* 1437, oil on panel, 82 x 96in, Louvre, Paris, France

Antonio del **Pollaiuolo**

b **FLORENCE, c1432;** d **ROME, 1498**

Antonio and his younger brother Piero (c1441–c1496) ran a successful workshop together in Florence and later in Rome. They worked in various media, including painting and sculpture, and it is often difficult to distinguish their individual contributions. However, Antonio is regarded as the more creative and innovative, his mastery in depicting the human figure putting him in the forefront of Florentine artists of his time. He is said to have dissected corpses to study anatomy. The brothers were known as Pollaiuolo because they were the sons of a chicken seller (*pollo* is Italian for chicken).

◄ **The Martyrdom of Saint Sebastian**
This altarpiece was painted for the church of SS. Annunziata, Florence, which owned a relic of St. Sebastian. The figures are probably by Antonio and the landscape by Piero. 1475, oil on panel, 115 x 80in, National Gallery, London, UK

Piero di Cosimo

b **FLORENCE, 1462**; d **FLORENCE, 1522**

Famous as much for his bizarre lifestyle (described in Vasari's *Lives of the Artists*) as his paintings, Piero di Cosimo developed an idiosyncratic and eclectic style of painting. The son of Lorenzo di Piero Ubaldini, a goldsmith in Florence, Piero adopted the name of Piero di Cosimo when he was apprenticed to the painter Cosimo Rosselli, whom he assisted in painting frescoes in the Sistine Chapel.

Little is really known of Piero's life, but he had a reputation as an eccentric loner who, unusually for an artist of that time, often painted without commission. None of his works are dated. Initially influenced by Botticelli and Ghirlandaio, Piero adopted elements from many of his contemporaries to his own fantastical style. This can be seen particularly in his paintings on mythological subjects, which are among the most distinctive works of the time—full of whimsical and tender detail. In later life, perhaps influenced by the preaching of the Dominican friar Girolamo Savonarola, he returned to religious subjects.

▼ **A Satyr Mourning over a Nymph** *Piero was fascinated with animals and portrayed them with great sensitivity—here, the dog looks as sorrowful as the satyr. In the background are other creatures, including a pelican in the water.* c1495, oil on panel, 25¾ x 72in, National Gallery, London, UK

▲ **The Immaculate Conception and Six Saints** *Piero's religious paintings, which date mainly from the later part of his life, are generally in a more conventional style than his mythological subjects.* c1505, oil on panel, 81 x 68in, Uffizi, Florence, Italy

▲ **Portrait of Simonetta Vespucci** *The inscription identifying this Florentine beauty (who died in 1476) was added later. From the snakes coiled around the neck, it may represent Cleopatra.* Oil on panel, 22¼ x 16½in, Musée Condé, Chantilly, France

Andrea del **Castagno**

b **CASTAGNO, c1418**; d **FLORENCE, 1457**

Andrea del Castagno's realistic portrayal of human figures made him one of the most influential of the Florentine artists of his time. He was born Andrea di Bartolo di Bargilla, but was known by the name of his birthplace. By 1440 he had moved to nearby Florence, where the influence of Masaccio, Brunelleschi, and Donatello was strong. In about 1442 he moved to Venice, painting frescoes in S. Zaccaria and St. Mark's Basilica, but returned to Florence a few years later. The frescoes in the refectory of Sant'Apollonia, probably his best-known works, occupied the next few years, followed by a series of frescoes for the Annunziata. He died of the plague in 1457.

▼ **The Last Supper** *Above the Apostles at the Last Supper are depictions of the Resurrection, Crucifixion, and Entombment. The figures are arranged against a classically balanced, geometric architectural structure.* 1447, fresco, Convent of Sant'Apollonia, Florence, Italy

CLOSERlook

ST. JAMES THE GREATER Detailed portraits of the Apostles emphasize their individual characters. They are depicted with three-dimensional realism, using perspective to give shape to their haloes. Their naturalistic hand gestures and expressions are echoed from one side of the painting to the other.

Andrea **del Verrocchio**

b FLORENCE, c1435; d VENICE, 1488

Considered the finest sculptor of the Italian Renaissance between Donatello and Michelangelo, Andrea di Cioni adopted the nickname Verrocchio (true eye) from the goldsmith he was originally apprenticed with. Little is known of his early life, and few of his paintings have survived, although his studio was well known at the time and attracted such distinguished students as Perugino and Leonardo da Vinci. After Donatello's death in 1466, Verrocchio came under the patronage of the Medici. He died in Venice while working on his masterpiece, a huge equestrian statue of Bartolommeo Colleoni. It was unveiled in 1496, eight years after his death.

LIFEline

c1470 Paints *Baptism of Christ*, assisted by Leonardo

c1475 Bronze statue of David (now in Palazzo Vecchio, Florence)

1476–83 Works on statue of Christ and St. Thomas, Or S. Michele, Florence

1481 Begins Colleoni equestrian monument, Venice

▶ **Lorenzo de' Medici** *Though some scholars doubt Verrocchio's own hand, the sculptor captures his patron's confident nobility.* 1480, terracotta, Palazzo Medici-Riccardi, Florence, Italy

CLOSERlook

EXPRESSIVE FEATURES
Colleoni's face, depicted in realistic detail, shows the grim determination of the *condottiere*, breaking the tradition of calm, dignified monumental statues, and paving the way for the more expressive sculptures of later sculptors such as Michelangelo.

▲ **Equestrian monument to Bartolomeo Colleoni** *Verrocchio's finest work, this bronze statue of a Venetian general was completed by assistants after the sculptor's death. It has a powerful sense of movement, with the rider standing in his stirrups and the horse turning, one hoof raised.* 1483–90, gilded bronze, height 156in, Campo S. Giovanni e Paolo, Venice, Italy

Pietro **Perugino**

Self-portrait

b CITTÀ DELLA PIEVE, c1450; d PERUGIA, 1523

A formative influence on the young Raphael, Pietro Perugino was hailed as "the best painter in Italy" in 1500. Today he is famous for his many altarpieces and frescoes. Born Pietro Vannucci, he is said to have studied in Florence with Verrocchio (at about the same time as Leonardo), but he spent much of his later life in Perugia, from which he earned his nickname. His first major commission was for frescoes in the Sistine Chapel, Rome, where he worked alongside Botticelli and Ghirlandaio. He later set up workshops in Perugia and Florence.

His numerous portraits, frescoes, and altarpieces show a mastery of figure painting within classically balanced compositions. But from 1512, his style became conventional and repetitive.

LIFEline

c1450 Born in Umbria

c1470 Probably studies with Verrocchio in Florence

By 1475 Working in Perugia

c1480 Moves to Rome to work in the Sistine Chapel

1481–82 Paints *Christ Delivering the Keys to St. Peter* in the Sistine Chapel

c1486 Returns to Florence, but keeps a studio in Perugia

1490s Travels throughout central Italy

c1505 Moves permanently to Perugia

1523 Dies of the plague

◀ **Madonna and Child** *Painted at the height of Perugino's career, this altarpiece shows his sweet, idealized style. His sentimental, devotional approach was popular in 15th-century Florence, but Perugino's work looked old-fashioned in the High Renaissance of Leonardo, Michelangelo, and Raphael.* c1500, tempera on panel, 31¾ x 25¾in, The Detroit Institute of Arts, Detroit, US

▲ **Crucifixion** *The three frescoes known as the* Pazzi Crucifixion *were commissioned in 1493. The central panel depicts Christ and Mary Magdalene, with St Bernard and the Virgin to the left, and St. John the Evangelist and St. Benedict to the right. The harmonious balance is characteristic of Perugino's approach to structure.* 1493–96, fresco, 15ft 7in x 26ft 6in, Santa Maria Maddalena dei Pazzi, Florence, Italy

CLOSERlook

CRUCIFIXION The symmetrically arranged figures beneath the outer arches emphasize the pyramidal form, with Christ at its apex. Painted in the idealized style of Perugino's altarpieces and portraits, they suggest piety and devoutness, rather than passion.

Domenico **Ghirlandaio**

Self-portrait

b FLORENCE, c1449; d FLORENCE, 1494

Born Domenico di Curradi di Bigordi, Ghirlandaio was nicknamed after the golden garland necklaces made by his father. He was a religious painter first and foremost, and was also one of the most popular and proficient portrait painters in 15th-century Florence. He often incorporated portrayals of Florentine people and life into his religious works.

In the early 1480s was commissioned to paint frescoes in the Palazzo Vecchio, Florence, and in the Sistine Chapel. On his return to Florence in 1485, the Medici's banker Francesco Sassetti commissioned Ghirlandaio to paint a cycle of frescoes in S. Trinità, and immediately after this Sassetti's successor, Giovanni Tornabuoni, employed him to replace the frescoes in his family chapel. Both commissions were of biblical scenes, but included portraits of the noble families. Ghirlandaio's busy workshop also produced a number of altarpieces and society portraits, painted with often startling realism. The young Michelangelo was apprenticed there.

LIFEline

1449 Born a goldsmith's son
1475 Receives first commissions for frescoes in the Collegiata in S. Gemignano
1481–85 Works on frescoes in Florence's Palazzo Vecchio
1485 Works on six frescoes for S. Trinità, Florence
1486–90 Paints a fresco cycle in S. Maria Novella for the Tornabuoni family
c1485 Paints tender double portrait of *An Old Man with a Boy*
1494 Dies of the plague in Florence

◀ **Giovanna Tornabuoni, née Albizzi** *This is one of the few surviving portraits by Ghirlandaio. The posthumous portrayal of Giovanna Tornabuoni depicts her as an ideal of beauty in formal profile, with her delicate features and sumptuous dress realistically highlighted against the dark background.* 1488, oil on panel, 30¼ x 19¼in, Thyssen-Bornemisza Collection, Madrid, Spain

CLOSERlook

LUDOVICA TORNABUONI AND HER RETINUE Ludovica Tornabuoni, the daughter of Ghirlandaio's patron, leads her four companions to pay their respects to the mother of the Virgin. She is depicted in profile and dressed in fine brocade, as in a society portrait.

▲ **The Birth of the Virgin** *Perhaps Ghirlandaio's finest fresco, The Birth of the Virgin is set in an architectural framework and painted in realistic detail. The setting owes more to contemporary Florence than to the Bible.* 1486–90, fresco, S. Maria Novella, Florence, Italy

INcontext

ARTISTS' WORKSHOPS
Renaissance artists ran busy workshops to supply their patrons. Apprentices began by doing menial tasks, such as preparing panels or grinding and mixing pigments, later drawing and copying paintings under the master's supervision.

Moving up *Skills learned as an artist's assistant enabled some talented apprentices to start their own workshops.*

Andrea **Mantegna**

Portrait from Vasari's *Lives*

b **ISOLA DI CARTURO, c1431; d MANTUA, 1506**

Mantegna was the leading artist of his time in northern Italy. He was an engraver as well as a painter, and his prints helped to give his work wide influence (Dürer was among his admirers). His style reflects his ardent study of ancient art and is also remarkable for his virtuoso skill with perspective and foreshortening.

Aged about 11, Mantegna became the apprentice and adopted son of Paduan painter Francesco Squarcione, but he left in 1448 after an acrimonious dispute over Squarcione's exploitation of his pupils. Mantegna had no difficulty finding work in Padua, which brought him into contact with the painter Jacopo Bellini, father of the artists Gentile and Giovanni, and Nicolosia—their sister and his future wife. He left Padua in 1460 for Mantua. Apart from a short period working in Rome, he remained in Mantua for the rest of his life as court painter to the ruling Gonzaga family.

LIFEline

c1431 Born a carpenter's son in Isola di Carturo, Italy

c1442 Moves to Padua

1448 Decorates the Ovetari Chapel of the Eremitani Church

1453 Marries Nicolosia Bellini

1459 Appointed court painter to Ludovico Gonzaga at Mantua and moves there the following year

1465–74 Works on the Camera degli Sposi in the Palazzo Ducale, Mantua

1488–90 Paints frescoes (destroyed) in the Vatican for Pope Innocent VIII

1506 Dies in Mantua

▶ **Altarpiece of St. Zeno of Verona** *The young Mantegna's superb use of perspective creates a feeling of depth. The finely observed and executed details, particularly the* trompe l'oeil *garlands and architectural features, add to the three-dimensional effect. 1456–60, oil on panel, 189 x 177in, Church of S. Zeno Maggiore, Verona, Italy*

SHARP DEFINITION
Mantegna's Madonna and Child in the center of the polyptych are depicted with the crisp outline for which he was renowned. The Madonna's throne is decorated with classical motifs, like the architectural setting.

▲ **Agony in the Garden** *An innovative approach to composition, based on diagonals rather than the traditional symmetry, helps give this painting its expressive power. Judas leads the soldiers along a winding road via some rabbits toward the sleeping Apostles. Steps go up to the praying figure of Jesus. The scene is set against a brooding landscape and wintry sky. c1460, tempera on panel, 24¾ x 31½in, National Gallery, London, UK*

▲ **The Camera degli Sposi (or Camera Picta)** *Two walls of the Camera degli Sposi (bridal chamber) in Mantua's Palazzo Ducale are decorated with frescoes of life at the palace, while the ceiling gives the illusion of a central opening to the sky. A representation of the Court on the north wall looks across to three scenes of the estate on the west wall (Servants with Horse and Dogs, Inscription with Putti, The Meeting). 1465–74, fresco, Palazzo Ducale, Mantua, Italy*

THE COURT OF MANTUA This fresco depicting members of the court is found above the fireplace on the north wall of the Camera degli Sposi. A group portrait of Ludovica Gonzaga and his family, it forms part of the visual narrative of the room as a whole.

Sandro **Botticelli**

Portrait from Vasari's *Lives*

b **FLORENCE, c1445**; d **FLORENCE, 1510**

Although Sandro Botticelli was highly successful at the peak of his career, he spent the last decade of his life in obscurity, considered outmoded compared to the new generation of artists such as Leonardo. Botticelli's work was eventually rediscovered by the Pre-Raphaelites (pp.332–333) almost 500 years later, and he is now one of the best-loved painters of 15th-century Italy.

 Botticelli developed his graceful and ornamental linear style, harking back to elements of the Gothic period and ignoring anatomical realism, during his apprenticeship with Filippo Lippi. In his large-scale paintings, including the famous *Primavera* and *Birth of Venus*, he treated mythological subjects with as much seriousness as religious themes. Although Botticelli is most famous for his secular subjects, his late years were almost entirely devoted to religious themes, influenced by the Dominican friar and preacher Savonarola. Other than the two years in Rome spent on the frescoes of the Sistine Chapel, Botticelli remained in Florence all his life.

LIFEline

c1445 Born Alessandro di Mariano di Vanni Filipepi, in Florence

c1459 Apprenticed to Fra Filippo Lippi

before 1470 Establishes his own workshop in Florence

c1478 Paints *Primavera*

1481–82 Works in the Sistine Chapel, Rome

c1485 Paints *Birth of Venus*

1480s Works for the Medici and other Florentine nobles

1500 Paints the *Mystic Nativity*, the only surviving work signed by Botticelli

1510 Dies in Florence

◀ **Portrait of Giuliano de' Medici** *This posthumous portrait of Giuliano de' Medici is one of several probably commissioned by the family after his assassination in 1478. Botticelli also included likenesses of the Medici, frequent clients of his workshop, in some of his religious paintings.* c1480, tempera on panel, 23¼ x 16¼in, Galleria dell' Accademia Carrara, Bergamo, Italy

CLOSERlook

ZEPHYR AND AURA Symbolic of spiritual passion, the figures of Zephyr, god of the winds, and Aura, the breeze, embrace each other as they blow Venus toward the shore of Cythera.

HORA FIGURE OFFERING HER CLOAK The goddess of Spring, one of the Horae, is here depicted in profile against the flowered cloak she offers to Venus as she is blown ashore.

▲ **The Birth of Venus**
Perhaps Botticelli's best-known painting, it shows Venus's arrival on the shores of Cythera, driven by Zephyr and Aura. The statuesque goddess of Love stands demurely on a scallop shell, her hair blown by the wind, as she is welcomed by the dancing Hora of Spring. The painting was probably designed to hang with Primavera *(see pp.108–111)* c1485, tempera on canvas, 71 x 110in, Uffizi, Florence, Italy

▲ **The Adoration of the Magi** *The grouped figures lean toward the central Virgin and Child, making a satisfying composition.* c1478–82, tempera and oil on panel, 27¾ x 40¾in, National Gallery of Art, Washington DC, US

◀ **Madonna and Child with St. John the Baptist** *This depiction of the Madonna handing the infant Jesus to a young St. John is painted in the more serious, devotional style Botticelli adopted during the 1490s. Nevertheless, it retains much of his earlier elegance of line.* c1490–95, tempera on canvas, 53 x 36¼in, Palazzo Pitti, Florence, Italy

Primavera
Sandro Botticelli
c1482, tempera on panel,
79 x 123⅝in, Uffizi,
Florence, Italy ▶

CLOSERlook
Primavera Sandro Botticelli

This is one of the most famous, admired, and discussed works in European art. Scholars have devoted a huge amount of effort to trying to trace its origins and interpret its meaning, but much about it remains enigmatic. Almost certainly it was commissioned by or on behalf of Botticelli's most constant patron, Lorenzo di Pierfrancesco de' Medici (1463–1503), although the idea that it was painted for his wedding in 1482 remains speculative (many authorities date it a few years earlier than this).

Composition

The raised central figure of Venus stresses her symbolic importance in fusing classical and Renaissance ideas about love and beauty. It also marks a division between two separate "stories" taking place on either side of her, relating to spiritual love (the Three Graces) and physical love (Zephyr's ravishing of Chloris).

▲ **SYMMETRY** The orange trees bend in over Venus's head to frame her in a halo-like arch. The verticals and diagonals of the background trees mirror the figures' postures, creating a strong pictorial harmony.

▲ **LEADING THE EYE** The elevated position of the figures at the sides of the picture help to lead the eye in toward the central figure of Venus, while the contrasting directions of hands and feet create a sense of movement.

▲ **CHARACTERS** The nine figures derive from classical mythology and are all associated with ancient festivals of springtime. From left to right they represent Mercury, the Three Graces, Cupid (above), Venus, Flora, Chloris, and Zephyr.

Story

Writings by various classical and contemporary authors (including Poliziano, the Medici court poet) have been suggested as sources for certain aspects of *Primavera*, but it does not seem to follow the narrative of any one specific literary work. "Primavera" is Italian for "spring" and the various figures depicted symbolize the season and its association with love. On the left is Mercury, messenger of the gods, and beside him are the three Graces, handmaidens of Venus, the goddess of love, who stands in the center, with Cupid above; at right, Zephyr (the west wind) pursues the nymph Chloris, who at his touch is transformed into Flora, the goddess of flowers.

▲ **VENUS** In the center of the picture Venus presides over the eternal springtime flourishing in her garden. Although this goddess is now often seen as primarily an erotic symbol, in the Renaissance she represented many virtues. Lorenzo di Pierfrancesco de' Medici was still a teenager when the picture was painted and Venus was perhaps intended to point his way to an honorable life.

❝ Spring **goes on her way** and ... before them treads **Venus's winged harbinger** ❞

LUCRETIUS, ROMAN POET, 1ST CENTURY BC

▲ **MERCURY** Mercury, messenger of the gods, depicted here as the garden's guardian, is shown raising his caduceus, a staff entwined with winged serpents (the symbol of doctors), to hold back the clouds so that nothing can spoil the garden's eternal springtime. This is surely a playful reference to the Medici family, whose name in Italian means "doctors."

◀ **ZEPHYR AND CHLORIS** Zephyr (the west wind) is shown pursuing the nymph Chloris. Botticelli captures the moment of her transformation into Flora, the flower-goddess, beginning to breathe "the roses of spring" out of her mouth. In the adjacent figure she is shown fully transformed into Flora.

Technique

Primavera is painted in tempera on wooden panel, which was Botticelli's usual technique, although he sometimes used canvas instead as the support (as in *The Birth of Venus*) and he often modified the standard tempera method by adding oil to the paint, perhaps to make it more fluid and transparent. He was a superb craftsman, who used only the finest available materials, and he applied layer upon layer of paint to create extraordinarily subtle effects of tone and luminosity.

▶ **IDEAL BEAUTY** Botticelli favored a distinctive type of female beauty whether he was painting religious or mythological works—his Virgin Mary and his Venus are from the same mold. Golden hair, ivory skin, and solemn, exquisite grace are characteristic of his women.

▼ **RAISED DECORATION** Botticelli was fascinated by decoration and stylized pattern. Flora's white, floral dress may be based on one that was worn at a masquerade, and described by Poliziano as "painted with roses and flowers and greenery." The slightly raised gold detail on the sleeve was produced by a form of powdered gold mixed with glue.

▲ **CARPET OF FLOWERS** The picture has little sense of depth and this "floral carpet" recalls the flat patterning of the Flemish tapestries that were popular in Florence at the time. The flowers are left uncrushed by the weightless figures above.

▲ **EXPRESSIVE HANDS** Botticelli was a superb draftsman and expressive hand gestures were a favorite device of his for adding poetic grace to images. Here the hands of two of the Graces entwine in an elegant arch above their heads.

Leonardo da Vinci

Artist unknown

b VINCI, 1452; d CLOUX, NEAR AMBOISE, 1519

Leonardo is now famous for the range and variety of his talents, embracing science as well as art. However, most of his scientific work remained hidden in his notebooks for centuries, and his contemporaries knew him primarily as a painter. His output of paintings was small (and he left several works unfinished), partly because his mind was constantly roaming to new interests, but in spite of this he was immensely influential. He is regarded as the main creator of the majestic High Renaissance style, which moved away from the emphasis on line and decorative detail characteristic of so much 15th-century Italian painting. Although no one painted detail more exquisitely than Leonardo, he combined this with grandeur of form and unity of atmosphere, in part achieved through his wonderfully subtle handling of light and shade.

At times Leonardo led an unsettled existence, but his career was divided mainly between Florence and Milan. He spent his final years in France as an honored guest of Francois I. By the time of his death he had already acquired a legendary aura.

LIFEline

1452 Born at Vinci, near Florence
c1472 Completes apprenticeship with Verrocchio
c1482 Moves to Milan, where he works mainly for Duke Ludovico Sforza
c1495–98 Paints *Last Supper*
1499 Leaves Milan after city is captured by French
1500–08 Works mainly in Florence
c1503–05 Paints *Mona Lisa*
1508–13 Based in Milan
1513 Moves to Rome
1516–17 Moves to France at the invitation of Francois I
1519 Dies aged 67

▼ **Head of a Young Woman with Tousled Hair (La Scapigliata)** *The subject of this beautifully executed study is unclear. It has some similarities with Leonardo's portrayals of Leda, but could also be a study for the head of the Madonna.* c1508, gouache on panel, 10¾ x 8¼in, Galleria Nazionale, Parma, Italy

▶ **The Annunciation** *Nothing is known of the circumstances in which this work was created, but it is regarded as Leonardo's earliest surviving independent painting, probably dating from soon after he completed his apprenticeship with Verrocchio. The angel's wings (which look as if they are based on those of a bird) and the closely observed botanical detail indicate his scientific curiosity.* c1472–75, tempera on wood, 38¾ x 85¼in, Uffizi, Florence

▲ **Technical Drawing From a Notebook** *Leonardo was described as the most relentlessly curious man in history. His notebooks are filled with technical drawings of engineering projects and inventions, and detailed illustrations of anatomy. He wrote from right to left, so his notes can only be read in a mirror.* Sepia ink on linen paper, Galleria dell'Accademia, Venice, Italy

❝ I have **offended God** and mankind because **my work** did not **reach the quality** it should have ❞

LEONARDO DA VINCI

CLOSERlook

LINKING GESTURES
Unusually, Leonardo has placed the infant Christ at the Virgin's feet, with her hand above him. The angel has a protective arm around Christ as he raises his hand in blessing to St. John, who is reaching out from beneath the Virgin's other hand. In this way, all the figures are linked by gestures.

◀ **Madonna of the Rocks** *The Virgin, Jesus, the infant St. John, and an angel are arranged in a pyramid—a stable composition. The unusual grotto setting indulges Leonardo's fascination with rocks and water, which stemmed from his birthplace of Vinci, a town built above a river gorge.* c1483–85, oil on panel transferred to canvas, 78 x 48in, Louvre, Paris, France

CLOSERlook

MONA LISA'S EYE The eyes fix the viewer with an amused gaze, complementing the slight curve of her mouth. The transition of tone at the corners is gentle and lifelike.

THE "ENIGMATIC" SMILE
Leonardo's use of *sfumato* (subtle blending of tones) makes the edges of Mona Lisa's lips "melt" into fleshtones, giving her her mysterious smile. *Sfumato* was not only a technique, but also a poetic device, fixing neither the boundaries of forms nor human expression.

▲ **The Lady with the Ermine (Cecilia Gallerani)**
The mistress of Ludovico Sforza is innovatively depicted in three-quarter view. She turns as if someone, perhaps Sforza himself, has just entered the room. The ermine was a symbol of purity. c1490, oil on wood, 21¾ x 15¾in, Czartoryski Museum, Kraków, Poland

▲ **Mona Lisa (La Gioconda)** *This painting is now so famous that it is difficult to imagine how fresh and innovative it must have looked to Leonardo's contemporaries. The relaxed naturalism of the pose, with the hands casually overlapping, and the intriguing subtlety of the expression would have made most earlier portraits look stiff. The mysterious landscape, too, differs greatly from the plain background characteristic of 15th-century portraits.* c1503–05, oil on panel, 30¼ x 20¾in, Louvre, Paris, France

The Last Supper *Leonardo da Vinci*
c1495–98, experimental technique on plaster, 181⅛ x 346½ in,
refectory of the Monastery of S. Maria delle Grazie, Milan, Italy ▶

The Last Supper Leonardo da Vinci

Leonardo's patron in Milan, Duke Ludovico Sforza, commissioned him to decorate the refectory of the Dominican monastery of S. Maria delle Grazie, which housed the Duke's family chapel. His coat of arms appears above the painting. The mural took Leonardo about three years, to the Duke's irritation. Often he just stood on the scaffolding and looked at it for hours at a time without painting a stroke. On completion, the painting became instantly famous and was copied by numerous artists, including Peter Paul Rubens (see p.224). Sadly, by the 17th century, it was in such a dilapidated state that the monks cut a doorway through the center of the wall. The refectory was reduced to rubble by bombs in World War II but the sandbagged wall survived—just.

Composition

No other artist has surpassed Leonardo's ability to compose figures into dramatically and visually satisfying arrangements, and this painting is the supreme example of this skill. The disciples all react differently, yet they form nobly harmonious groups on either side of the central figure of Christ; art historian Kenneth Clark describes them as "two dynamic masses united and kept in repose by a single point of balance." Instead of giving Christ a halo, he is framed by a "window" and a glimpse of countryside, which brings out the pathos of his human plight rather than emphasizing his divinity. It also increases the illusion of reality.

▶ **LINEAR PERSPECTIVE** Leonardo continues the perspective of the refectory with converging walls and a coffered ceiling of recessed decorative panels. The illusion of real space is so powerful that monks must have felt they were with Christ at "top table."

▲ **CENTRAL TRIANGLE** Christ forms a stable triangle with his outstretched hands. All the disciples' gestures lead the eye back to Jesus. Christ's robe contains the warm and cold colors echoed in the garments of the disciples.

▲ **SYMMETRY AND ORDER** The apostles are grouped in threes rather than the traditional linear pattern. The groups link them compositionally and psychologically. In contrast to the serene Christ, they all make shocked and sudden movements.

INcontext
BREAKING CONVENTION
The Last Supper was a popular theme for a monastic refectory, where monks or nuns dined in silence before images of the apostles and Christ at table. While Leonardo depicted Judas sitting alongside the other disciples, most other artists seated him apart.

The Last Supper *Andrea del Castagno* In early Renaissance depictions such as this fresco in S. Apollonia, the disciples sit calmly in a row with Judas opposite. (c1445–50)

Techniques

Leonardo was dissatisfied with the restrictions of fresco technique, in which the artist has to work quickly one area at a time, on a day's worth of wet plaster. He wanted to work slowly and subtly, as with an oil painting, so he used a tempera-like paint—the exact formula is unknown—on dry plaster. The paint started to decay even in his own lifetime. Fifty years on, it was hardly visible. It has been restored several times, most recently in 1980–99.

▲ **MODELING** Use of light and shade makes Christ's outstretched fingers look realistic, which brings out the poignancy of the gesture. The flesh tones, made from earth-based pigments, have survived better than the stronger colors used on the robes.

▲ **STUDY FOR AN APOSTLE**
Leonardo made numerous studies to come up with particular features appropriate for each apostle. His aim was to "show the intention of man's soul" through gestures and expressions.

▲ **INDIVIDUALIZED FACE** Based on drawings such as the study (left), Leonardo takes pains to recreate the gray hair and sunken eye sockets of an elderly man for apostle Jude. In true fresco technique, the head of a key figure usually took a day and just that area of wall was plastered in the morning. Leonardo was unwilling to submit to such a restriction, with disastrous consequences.

Story

The Last Supper is recorded in the New Testament as the final meal Christ took with his 12 disciples in Jerusalem before he was arrested. Leonardo takes the moment of anticipation when Jesus has just announced that one of them will betray him, and the apostles respond in horror. Within the traditions of the disciples' appearance—John young, long-haired, clean-shaven, and slightly effeminate; Peter with short curly gray hair and a blue cloak, for instance—Leonardo adds psychological depth.

▲ **THE APOSTLES** Left to right, the 12 apostles are: Bartholomew, James, son of Alphaeus (James the Less), and Andrew; Judas Iscariot, Peter, and John; Thomas, James, son of Zebedee (James the Greater), and Philip; and Matthew, Jude, and Simon the Zealot.

▶ **JESUS** The classical beauty and calmness of his face express order in the midst of recoil and disbelief. His downcast eyes and slightly open mouth suggest acceptance of his fate.

" *And whilst they were eating, he said: Amen, I say to you that* **one of you is about to betray me**. *And they being* **very much troubled** *began every one to say:* **Is it I, Lord**? "

MATTHEW 26:21–22, THE BIBLE

▲ **PHILIP AND MATTHEW** On the right, Matthew seeks reassurance from his fellow-apostles, while Philip looks anguished. Despite being in separate groups, Matthew's gesture links the two, forming another triangle of negative space and pointing at Jesus. Originally, the apostles' robes were reflected in the metal tableware—unfortunately, this subtlety is lost forever.

◀ ▲ **PETER, JUDAS, AND JOHN** Peter, sitting in the middle, jerks forward with a knife (with which he will shortly cut off a Roman's ear) and says something to John. He moves Judas forward into shadow— the only face not in the light. Judas knocks over the salt, which is a bad omen. He is the only apostle to show little expression. John, true to form, looks dreamy. He will go on to write the Book of Revelations.

Michelangelo Buonarroti

Michelangelo Buonarroti

b CAPRESE, NEAR AREZZO, 1475; d ROME, 1564

Michelangelo's titanic career lasted virtually three-quarters of a century and for most of that time he was unchallenged as the greatest artist in Europe, his contemporaries looking on him with awe. He regarded himself primarily as a sculptor, but he was equally outstanding as a painter, draftsman, and architect. His career was divided mainly between Florence, where he was much employed by the Medici family, and Rome, where he produced most of his greatest works in the service of the papacy, particularly the decoration of the Sistine Chapel and the rebuilding of St. Peter's.

In both painting and sculpture Michelangelo showed an unequaled mastery in portraying the nude human figure and also an intense spirituality that reflected his own devout way of life. He concentrated almost entirely on deeply serious subjects, treated with superhuman beauty and grandeur, and he was unconcerned with the anecdotal or the ornamental. In spite of his huge success and fame, he lived modestly, completely devoted to religion and art and working tirelessly (a contemporary biographer said that to save time he sometimes went to bed with his boots on). His work was immensely influential not only on his contemporaries but also on generations of later artists.

LIFEline

1475 Born in Caprese to a family of minor Florentine nobility

1488 Trains in fresco painting with Ghirlandaio

1489 Joins the household of Lorenzo de' Medici

1501–04 Creates statue of *David* for the city of Florence

1505 Receives commission to create sculptures for the tomb of Pope Julius II

1508–12 Paints frescoes on the Sistine Chapel ceiling

1534 Settles in Rome

1536–41 Paints *Last Judgement* fresco on altar wall of the Sistine Chapel

1546 Appointed architect to St Peter's Rome

1564 Dies aged 88

▼ **Moses** *This imposing figure is part of the tomb of Pope Julius II. The tomb was commissioned in 1505 and was conceived on an immense scale, but when finally erected in 1545 it was in much reduced form. c1513–15, marble, height 92in, S. Pietro in Vincoli, Rome, Italy*

▲ **Pietà** *Michelangelo made his name with this work. When critics said the Virgin looked too young to have a fully grown son, he said that sin was what aged people. 1498–99, marble, height 68in, St. Peter's, Vatican City*

▶ **Holy Family (Doni Tondo)** *This is Michelangelo's only known completed panel painting. It was commissioned by Agnolo Doni, a wealthy Florentine weaver, hence its name "Doni Tondo" (tondo is Italian for '"round" and the word is applied to circular paintings such as this). Although Michelangelo claimed not to be a painter, the sheer polish of his technique is masterly. The frame is original and was perhaps designed by the artist. c1503–04, oil on panel, diameter 47¼in, Uffizi, Florence, Italy*

▶ **David** *This gigantic figure of the biblical character David came to symbolize the new Republic of Florence in its strength and potential for powerful action. 1501–04, marble, height 17ft, Galleria dell'Accademia, Florence*

CLOSERlook

ANATOMICALLY ACCURATE
Michelangelo dissected corpses to help him understand how the muscular system worked and portray the human body realistically.

READY FOR ACTION One realistically sinewed hand holds the sling from which David will hurl the rock that kills the giant, Goliath. He looks poised to unfurl his arm and take aim.

◀ **The Creation of Adam** *As God fires Adam with the divine spark of life, the gap between their fingers heightens the anticipation. The outlines are clean and uncluttered to make them easy to "read" from the floor, 65ft 6in below.* 1511, fresco, Sistine Chapel ceiling, Vatican City

◀ **The Sistine Chapel** *To paint the ceiling frescoes, Michelangelo worked uncomfortably on scaffolding for four years, without helpers. When he finished the nearly 300 figures, he was hailed as il divino Michelangelo (the divine Michelangelo). However, his* Last Judgment *on the end wall was harshly criticized for its "obscene" nude figures and censored by the Council of Trent (see p.199) in 1563.* Ceiling painted 1508–12, end wall 1536–41, fresco, ceiling 45 x 128ft, Rome, Italy

▲ **The Fall of Man** *Michelangelo combines two incidents from the story of Adam and Eve in one image. At left they are tempted by the serpent to eat the fruit of the tree of knowledge, and at right they are expelled from the Garden of Eden for disobeying God.* 1509–10, fresco, Sistine Chapel ceiling, Rome, Italy

❝ Brush **splatterings** make a **pavement of my face**... I'm not a painter ❞

MICHELANGELO, ON PAINTING THE SISTINE CHAPEL CEILING

Raphael

Self-portrait

b **URBINO, 1483**; d **ROME, 1520**

Whereas Leonardo and Michelangelo are regarded as the great innovators of the High Renaissance, Raphael—the third member of the triumvirate that dominated the period—was the great synthesizer, building on the ideas of others and blending them into a supremely graceful unity. The balanced character of his art reflected his personality, for unlike Leonardo and Michelangelo—both of whom tended to be solitary and obsessive—Raphael was renowned for his charm and social poise. Nevertheless, he was extremely hardworking, producing a large and varied output in his short life.

From an early age Raphael enjoyed a career of continual success: he was working independently when he was only 17 and was summoned to Rome by Pope Julius II when he was 25. For the rest of his life he was employed mainly on major projects for the papacy. Most of his work was on religious subjects, but he was also an outstanding portraitist and a leading architect. His work became a model and inspiration to other artists for centuries.

LIFEline

1483 Born in Urbino, son of the painter Giovanni Santi
1500 Working as an independent master
c1502 Works with Perugino, the strongest influence on his early work
1504–08 Works intermittently in Florence, where he is influenced by Leonardo and Michelangelo
1508 Moves to Rome to work for Julius II
c1512–14 Paints the *Sistine Madonna*
1514 Appointed architect to St. Peter's, Rome
1520 Dies in Rome

◀ **Portrait of Agnolo Doni**
Raphael's study of Leonardo shows clearly in this portrait. The composition, and even the positioning of the hands, echoes the Mona Lisa, *but here the landscape gives way to clear sky.* c1505–06, oil on wood, 24¾ x 17¾in, Palazzo Pitti, Florence, Italy

▲ **The School of Athens**
This is the most famous painting in the first room Raphael decorated for Julius II in the Vatican. The room was probably used as a library, and Raphael appropriately created this imaginary assembly of some of the greatest minds of antiquity. c1509–11, fresco, Stanza della Segnatura, Vatican, Rome, Italy

CLOSERlook

PLATO Several of the figures are based on contemporaries of Raphael. The dignified white-haired figure at the centre of the painting, representing the Greek philosopher Plato conversing with his student Aristotle, is a likeness of Leonardo da Vinci.

HERACLITUS The brooding figure in the foreground, representing the philosopher Heraclitus, is based on Michelangelo. While working on *The School of Athens*, Raphael saw the first half of the Sistine Ceiling unveiled in 1511 and he added this figure as a tribute to its creator.

SELF-PORTRAIT On the right, the astronomer Zoroaster and geographer Ptolemy are leading a discussion. They each hold a globe, showing the heavens and the earth respectively. Listening to them is Raphael himself, his gaze directed out of the painting and toward the viewer.

> " Leonardo da Vinci **promises** us **heaven**, Raphael gives it to us "
>
> PABLO PICASSO

◀ **The Triumph of Galatea (study)** *Classical models were important to Raphael. He drew many studies for his major works, both of individual figures and of the painting as a whole. Numerous versions, with slight variations, were made before he was satisfied with the composition.* Red chalk on paper, Ashmolean, Oxford, UK

▼ **The Triumph of Galatea** *Raphael's lively depiction of the sea-nymph Galatea's apotheosis anticipates the expressive figure painting of the Mannerist style.* c1511, fresco, 116 x 87in, Villa Farnesina, Rome, Italy

CLOSERlook

CIRCULAR EMPHASIS The upraised arms of the figures in the lower half of the painting create a compositional harmony complementing the arc of the cherubs above and framing the central figure of Galatea. The focal center is further emphasized by the cherubs' arrows.

▲ **The Transfiguration** *This was Raphael's final large work, still unfinished at his death. The agitated movement and emotion marks a move away from the serenity of the High Renaissance, presaging the Mannerist style.* 1518–20, oil on wood, 159 x 109in, Vatican City

◀ **The Sistine Madonna** *This is one of Raphael's most celebrated works. Flanked by St. Sixtus and St. Barbara, the Virgin carries the infant Christ, apparently from the area behind the curtains to the real world beyond.* c1512–14, oil on canvas, 106 x 79in, Gemäldegalerie, Dresden, Germany

CLOSERlook

CHERUB Contrasting with the seriousness of the figures above, the impishly childlike *putti* leaning on a balustrade provide a link between the viewer and the space in the painting.

INcontext

CLASSICAL PHILOSOPHY The humanism that characterizes the Renaissance invoked a fascination for all things classical. Artists rediscovered the art and architecture of Ancient Rome, which heavily influenced their style. Raphael in particular was attracted to the work of classical artists.

Portrait of Aristotle *by Joos van Gent (c1475).*

Andrea **del Sarto**

Self-portrait

b FLORENCE, 1486; d FLORENCE, 1530

One of the great artists of the High Renaissance, Andrea spent most of his working life in Florence. The major influences on his work were Fra Bartolomeo, Raphael, and Leonardo da Vinci.

In his best work, the figures have a classical monumentality, set in atmospheric surroundings enlivened by his use of color. His preparatory drawings are admired for their immediacy and direct observation of life. Artist-biographer Vasari (see p.178) described him as a "painter without mistakes." His work became extremely important in the late 16th century to Tuscan artists dissatisfied with Mannerism.

LIFEline

1486 Born son of a tailor
1493 Apprenticed to Piero di Cosimo
1507–1526 Works on first large commission, 12 frescoes
1508 Sets up a workshop with the artist Franciabigio
c1511 Probably visits Rome
1513–14 Paints *Birth of the Virgin* for SS Annunziata
1518–19 Works in France
1530 Dies of plague

◀ **Lady with a Book of Verse by Petrarch** *Dating from late in Andrea's life, this watchful portrait has the immediacy and painterly brushwork of his late style.* c1528, oil on panel, 34¼ x 27¼in, Uffizi, Florence, Italy

▼ **Annunciation** *In this unusual composition, the action takes place at either side, with classical ruins occupying center stage.* 1512, oil on panel, 72 x 71in, Palazzo Pitti, Florence, Italy

▼ **Madonna of the Harpies** *Restoration in 1984 revealed the glorious colors that sing out from this otherwise austere composition. The winged harpies can be seen on the plinth.* 1517, oil on panel, 81 x 70in, Uffizi, Florence, Italy

CLOSERlook

CONTRASTS OF COLOR The intense rose of the Madonna's gown is set off by the golden yellow of the drapery over her shoulder: this bold juxtaposition compels the eye into the center of the picture.

IN THE SHADOWS Soft highlights and nebulous shadows allow the eye to travel in and out of the space. Here, a tiny cherub peeps from the shadows behind the Virgin.

Fra **Bartolommeo**

Fra Bartolommeo

b **FLORENCE, 1472**; d **FLORENCE, 1517**

Fra Bartolommeo was a key figure in the evolution of High Renaissance painting in Florence. He started his training in the workshop of Cosimo Rosselli. There he met Piero di Cosimo, who taught him and Mariotto Albertinelli, with whom he later set up a studio.

Bartolommeo combined an understanding of Leonardo's use of light and shade to model form with a feeling for the luminous light and brilliance of color that characterized Venetian art. He achieved his control of *chiaroscuro* (light and shade) by laying in a composition in monochrome first, then building up the color as glazes—a technique he borrowed from Leonardo da Vinci. In his *sacre conversazioni,* the participants react to situations and interact with each other, rather than simply standing in devout contemplation.

Bartolommeo was a follower of reforming friar and preacher Savonarola, and became a Dominican friar in 1501. He had plenty of opportunities for absorbing influences from beyond Florence: it is likely that he met Raphael who visited the city in around 1504; he went to Venice in 1508; and he visited Rome in 1513.

LIFEline

1485 Apprenticed to Rosselli in his early teens

1501 Joins the Dominican Order and adopts the name Fra Bartolommeo

1509–13 Works with Albertinelli, sharing a workshop in the convent of San Marco

1517 Dies in Florence

▼ **The Mystic Marriage of St. Catherine of Siena with Saints** *Commissioned for his convent, S. Marco in Florence, this painting was admired for the grandeur of the architectural background and the convincing way the figures occupy the space.* 1511, oil on panel, 101 x 90in, Louvre, Paris, France

CLOSERlook

ST. CATHERINE Shown kneeling with her back to the viewer, St. Catherine of Siena wears the white habit of the Dominican order. She is receiving a ring from the infant Christ. On the far right is her namesake, St. Catherine of Alexandria.

▶ **Study of a Man and a Woman for the Madonna della Misericordia**
Bartolommeo was a pioneer of drawing with black chalk, a material that allowed him to model form with light and dark tones. c1515, chalk on paper, Uffizi, Florence, Italy

Dosso **Dossi**

Self-portrait

b **MIRANDOLA?, c1485**; d **FERRARA, 1542**

Little is known of the early life of Giovanni Francesco Luteri, known as Dosso Dossi. However, by 1513 he was recorded at Ferrara, home of the magnificent court of the Este family. For most of his career he worked for the Dukes of Ferrara, producing religious images, mythological subjects, portraits, and landscapes, often in collaboration with his brother, Battista. Dosso's work is sometimes eccentric, with complex themes and obscure allegorical references. His paintings reflect the poetry of Giorgione and the rich color of Titian. He signed his work with a pictorial pun—the letter "D" next to a bone (*osso* in Italian).

▲ **Apollo and Daphne** *The god Apollo is shown making music, while in the background Daphne, the subject of his unwanted attentions, is transformed into a laurel tree.* c1525, oil on canvas, 191 x 116cm Galleria Borghese, Rome, Italy

INcontext

THE CLASSICAL IDEAL Artists of the High Renaissance sought to create beautiful and harmonious effects. Everything should look effortless and right, with no jarring colors or harsh transitions of tone. In architecture, Bramante's Tempietto epitomizes this classical ideal in the harmony of its proportions and the simple forms and austerity of the Doric order.

The Tempietto *of S. Pietro in Montorio, Rome, designed by Donato Bramante, c1502–12*

Correggio

b CORREGGIO, 1489?; d CORREGGIO, 1534

Artist unknown

Inventive and technically accomplished, Correggio worked in and around Parma but was aware of the innovations in Florence, Rome, and Venice. His early work has a hard, linear quality, which echoes Mantegna, but soon this was overtaken by a skillful use of *sfumato* effects—the gradations of tone and color for which Leonardo was so famous. From Mantegna Correggio also took an interest in illusionism, and it became a distinctive mark of his style. Correggio's work falls into three major categories: frescoes, altarpieces, and mythological paintings. He was admired for his ability to create dazzling illusions in fresco, using extreme foreshortening and other painterly devices to dissolve the architectural structures on which he painted. In the *Assumption of the Virgin* in Parma Cathedral, the Virgin does indeed appear to be soaring through the dome into the heavens beyond. Correggio also produced ravishing nudes.

LIFEline

1489? Born in Correggio, from which he takes his name
1514–15 Earliest existing work: *Virgin of St. Francis* for S. Francesco, Correggio
c1519 Moves to Parma. Works on frescoes for the Benedictine convent of S. Paolo
1522 Wins commission for frescoes in Parma Cathedral
1522–25 Works on a cycle of illusionistic frescoes for S. Giovanni Evangelista in Parma
1534 Dies in Correggio

ITALIAN RENAISSANCE

124

15TH AND 16TH CENTURIES

▶ **Madonna and Child with Angels** *Correggio painted many small devotional works such as this. Cherubs and music-making angels inject a sense of playfulness into this intimate study of Madonna and Child.* c1510–15, oil on panel, 7¾ x 6¼in, Uffizi, Florence, Italy

▶ **Nativity Scene** *Correggio was an acknowledged master of painted light. At the center of this picture, the Virgin is bathed in the supernatural light emanating from her baby son, while the young woman at the foot of the cradle shields her eyes from the dazzling rays.* 1522–30, oil on panel, 101 x 74in, Gemäldegalerie Alte Meister, Dresden, Germany

CLOSERlook

MASTERY OF OIL PAINT
Correggio had a specially subtle and delicate way to "touch the colors," producing soft and luminous flesh tones. The blush on the Virgin's cheek is created using transparent glazes, which modify the paint layers.

▼ **Jupiter and Io** *The god Jupiter disguised himself as a gray mist in order to seduce the shy nymph Io. His face and hand can just be seen. As in the frescoes of the domes in Parma, Correggio shows his mastery at depicting clouds, a difficult thing to paint, being transparent and soft.* c1530, oil on canvas, 65 x 29¼in, Kunsthistorisches Museum, Vienna, Austria

CLOSERlook

GESTURE OF SURRENDER Io throws her head back in complete surrender as she abandons herself to Jupiter's embraces. Correggio has captured her swooning expression and the pearly, sensuous quality of her skin. Jupiter's features emerging from the mist are suggested with the lightest of touches, his bodiless quality contrasting with Io's flesh-and-blood substance.

Lorenzo **Lotto**

b **VENICE, c1480;** d **LORETO, 1556**

Born in Venice, Lotto was a contemporary of, and an eccentric alternative to, Giorgione, Palma Vecchio, and the young Titian. He had a quirky and idiosyncratic style—he combined a dynamic line with brilliant color and carefully rendered detail to create images that are charged with emotion and express the new devout tendencies of the mid-16th century.

Lotto lived and worked in various locations throughout central and northern Italy, including Bergamo, Rome, Recanati, and Venice, and made a good living producing altarpieces, devotional pictures, and portraits. His account book for the years 1538 to 1554 survives and provides information about his patrons, the materials he used, and his working methods. Lotto never married, and he spent his final years as a lay brother in the monastery of Santa Casa in Loreto.

▶ **Christ Carrying the Cross**
The pathos and violence of Christ's Passion is captured in this intense, close-up image.
1526, oil on canvas, 26 x 23¾in, Louvre, Paris, France

▼ **The Annunciation** *In this dramatic image, both Mary and the cat are startled by the unexpected arrival of the Archangel Gabriel carrying a lily, a symbol of virginity.* c1534–35, oil on canvas, 65 x 44¾in, Museo Civico, Recanati, Italy

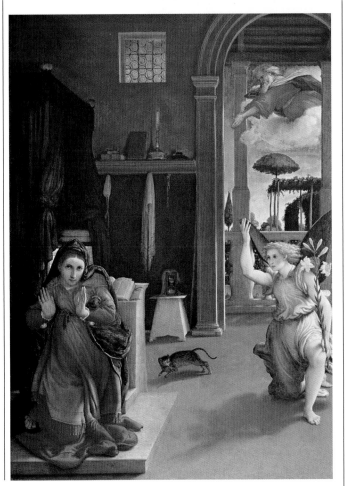

Sebastiano del Piombo

b **VENICE?, c1485;** d **ROME, 1547**

Sebastiano worked successively in Venice and Rome. His early paintings display the harmonious qualities of the Venetian painters Giovanni Bellini and Giorgione. After his move to Rome in 1511, he began to work in a bolder, more vigorous style under the influence of Michelangelo, who introduced him to patrons, procured commissions for him, and supplied drawings.

Sebastiano produced many important religious works and achieved fame as a painter of portraits. Despite his reliance on Michelangelo for important drawings, he was an accomplished draftsman in his own right, often working in black chalk on a tinted paper, heightened with white. At the height of his career, he combined the classicism of Rome with the rich palette of Venice. In his later work, muted colors provide a foil for bright accents. In 1531, Sebastiano became the keeper of papal seals; they were made of lead—piombo in Italian—and this is how he got his nickname.

▲ **The Raising of Lazarus**
This immense altarpiece was commissioned by Cardinal Giulio de' Medici for the cathedral at Narbonne. Michelangelo probably negotiated the commission for Sebastiano, and provided drawings for the main figures, some of which survive.
c1517–19, oil on canvas (transferred from wood), 150 x 114in, National Gallery, London, UK

LIFEline
1511 Settles in Rome
1512 Produces several important portraits, including *Cardinal Ferry Carondelet and his Secretary*
c1513 Painted *Pietà,* for S. Francesco in Viterbo, central Italy
1531 Becomes Keeper of the Papal Seals—the *Piombo*—from which he gets his name
1532 Paints important portrait of *Giulia Gonzaga*
1547 Dies in Rome

CLOSERlook

DIRECTING THE EYE The kneeling figure, whose profile is outlined against the dark ground, gazes up at Christ, while Christ's extended arm points the viewer to Lazarus, emerging from his tomb.

BORROWED FROM THE MASTER For Lazarus and the attendant figures, Sebastiano used a drawing, in red chalk with some black chalk, provided by Michelangelo.

◀ **Portrait of Andrea Doria**
The subject of this brooding and watchful portrait was a native of Genoa. The maritime motifs on the marble frieze refer to his position as Admiral of the Fleet.
1526, oil on canvas, 60 x 42in, Galleria Doria Pamphilj, Rome, Italy

Giovanni **Bellini**

Portrait by Vittore Belliniano

b **VENICE, c1430–35;** d **VENICE, 1516**

The leading Venetian artist of the High Renaissance, Giovanni Bellini was largely responsible for giving the city its distinctive poetic painting style. In doing so, he helped Venice rival the cities of Rome and Florence as a major art center.

Venice is a city of beautiful, fluid light—and this is reflected in Bellini's paintings, which are suffused with warm colors and a delicate atmosphere. Unlike Florentine artists, who focused on draftsmanship, Bellini relied on paint rather than line. He applied his paint gradually, in overlapping layers, to attain softly blended colors. Bellini's pupils Giorgione and Titian continued this tradition.

LIFEline

c1430–35 Born, son of the painter Jacopo Bellini and brother (probably younger) of Gentile Bellini

1453 Becomes Mantegna's brother-in-law when his sister Niccolosa marries Mantegna

1479 Takes over from his brother Gentile, painting historical scenes in the Great Council hall in Venice

c1490 Altarpiece of San Giobbe

c1501–04 Paints The Doge Leonardo Loredan

1516 Dies in his 80s

◀ **Madonna of the Trees**
This exquisite picture epitomizes Bellini's tender approach to painting. The Madonna and Child, composed in a triangle, are softly lit by light from the left. c1487, oil on panel, 28 x 22¾in, Gallerie dell'Accademia, Venice, Italy

▼ **Altarpiece of San Giobbe**
Bellini uses his mastery of perspective to set the figures in the curved apse of a church. The golden mosaic above shimmers and reflects a warm light on the figures. c1480–1490, tempera and oil on panel, 185 x 102in, Gallerie dell'Accademia, Venice, Italy

► **Pietà** In a Pietà ("pity"), Mary cradles Jesus's dead body in her lap. Bellini includes St. John and, unusually, shows Jesus upright. This Pietà was painted in tempera before Bellini mastered oil painting. The precise linear description of the dramatic poses shows the influence of Bellini's brother-in-law, Mantegna. c1468, tempera on panel, 33¾ x 42¼in, Pinacoteca di Brera, Milan, Italy

CLOSERlook

FACIAL EXPRESSION The Doge seems hypnotically calm. Instead of staring at the viewer, he gazes into the middle distance, perhaps a little wistfully.

PLAY OF LIGHT Subtle tonal contrasts reveal the folds of the exquisitely patterned fabric and help convey the play of light.

► **The Doge Leonardo Loredan** This painting of the Venetian Republic's head of state has the sculptural solidity of a Roman portrait bust. c1501–04, oil on poplar, 24¼ x 17¾in, National Gallery, London, UK

CLOSERlook

ST. FRANCIS Wearing his traditional monk's habit, St. Francis holds out his hands to show his stigmata (marks like Christ's nail wounds). One hand almost seems to be beckoning the viewer into the picture.

Vittore **Carpaccio**

b **VENICE?, c1460**; d **VENICE?, c1525–26**

Vittore Carpaccio is best known for his grand depictions of religious subjects. He generally set these stories in Venice, the city in which he spent all his working life, and would often include contemporary Venetian notables in the scenes.

Carpaccio worked mainly for the Venetian *Scuole* (religious and trade associations), whose tastes for richly colored panoramas celebrating the city's success perfectly matched his artistic talents. Decorative and pageant-like, his paintings contain wonderful anecdotal detail such as dogs and pet monkeys and lounging cavaliers, along with bustling activity everywhere.

LIFEline

1490 Begins painting the St. Ursula cycle for the Scuola di S. Orsola

1502–07 Paints cycle of St. George and St. Jerome for the Scuola di S. Giorgio degli Schiavone

1507 Employed to decorate the Doge's Palace

1511–20 Works on cycle of St. Stephen paintings for the *Scuola di Santo Stefano*

c1525–26 Dies, probably in Venice

▼ **The King of Brittany Receives the English Ambassadors** *This painting, from the St. Ursula series, shows the English ambassadors bringing a letter with a marriage proposal. In the room on the right, a pensive King of Brittany discusses the matter with Ursula.* c1495, oil on canvas, 101 x 232in, Gallerie dell'Accademia, Venice, Italy

▼ **The Dream of St. Ursula** *An angel steals into Ursula's chamber to forewarn of her martyrdom.* c1495, oil on canvas, 107 x 105in, Gallerie dell'Accademia, Venice, Italy

CLOSERlook

DOORWAY The objects and furnishings are depicted with meticulous care, providing a faithful reproduction of an upper-class Venetian bedroom. The doorway is open, suggesting the journey that Ursula will take. She and her fellow pilgrims were killed by Huns who were besieging Cologne.

Gentile **Bellini**

b **VENICE, c1430–35**; d **VENICE, 1507**

Giovanni Bellini's brother, Gentile, started his career in his father's workshop. In his middle age, he became a very successful artist, winning prestigious commissions from both the Doge and the *Scuole* (religious and trade associations).

Gentile Bellini was known as an excellent portrait painter, but today only about six portraits are definitely attributable to him. His reputation now rests on his *teleri*—narrative paintings on canvas. These are immensely detailed and are of great interest as records of Venice at the moment of its greatest splendor.

LIFEline

1460 Paints in the workshop of his father, Jacopo Bellini

1465 Produces his first documented painting

1469 Knighted by German Emperor Frederick II

1474 Starts working on paintings for the Council Hall at the Doge's Palace

1479–81 Serves at the court of Sultan Mehmet II in Constantinople

1507 Dies 9 years before his brother Giovanni

▲ **Portrait of the Doge John Mocenigo** *This profile view allows Bellini to make a strong statement about the dignity of the Doge but precludes acute insight into his character.* c1478–85, tempera on panel, 24¼ x 17¾in, Museo Correr, Venice, Italy

▲ **Miracle of the Cross at the Bridge of San Lorenzo** *This is the first in a series of eight paintings, depicting the history of a relic of the True Cross—the wooden cross on which Jesus was crucified. It provides a wonderfully detailed record of Venice's palaces.* 1500, tempera and oil on canvas, 127 x 169in, Gallerie dell'Accademia, Venice, Italy

CLOSERlook

SAVING THE CROSS The guardian of the Scuola di San Giovanni, for which the painting was made, saves the relic from the canal.

Palma **Vecchio**

b **NEAR BERGAMO, c1480**; d **VENICE, 1528**

Palma Vecchio is first documented in Venice in 1510, and he spent the rest of his working life in the city. He specialized in altarpieces, particularly *sacre conversazioni,* in which the Madonna and infant Jesus are shown amid saints. He is also renowned for his half-length pictures of beautiful women, often thought to be courtesans. In line with the Venetian artistic tradition, Palma Vecchio painted wonderfully balanced compositions in bold color.

▲ **Portrait of a Young Woman** *Often called* La Bella, *this painting has a mood of sensuous opulence.* c1525, oil on canvas, 37¼ x 31½in, Thyssen-Bornemisza Museum, Madrid, Spain

Myth and legend

For thousands of years, artists' imaginations have been fired by the evocative and inspiring subjects of myths and legends. Indeed, artistic representations of classical myths are responsible for much of our knowledge of the ancient world. Many of these stories have been depicted by more than one artist, and their depictions have varied greatly, such as Cézanne and Dalí's different treatments of the Leda myth.

▼ **The Hero Gilgamesh Holding a Lion that He Has Captured** Assyrian School *In subduing a lion, the Babylonian king Gilgamesh demonstrates his superhuman powers.* c725 BCE, gypsum, Louvre, Paris, France

▼ **Mithras Sacrificing the Bull** Roman *Mithras's slaughter of the bull was a central image in Mithraic religious practice, associated with Spring. As the bull dies, a dog and serpent drink its blood while a scorpion attacks its testicles.* 2nd century, marble relief, Museo Archeologico, Venice

▼ **The Judgement of Paris** Lucas Cranach the Elder *The goddesses Hera, Athena, and Aphrodite try to bribe Paris, who was asked by Zeus to choose the most beautiful. Features such as the hat on the middle nude make the story Cranach's own.* c1528, tempera and oil on panel, 40¼ x 28in, Metropolitan Museum of Art, New York, US

◄ **Feathered Coyote** Aztec *Adopted as a symbol by Aztec warrior orders, the feathered coyote's unusually long fur signifies movement.* 16th century, stone, 15 x 6¾ x 5⅛in, Museo Nacional de Antropologia, Mexico City, Mexico

▼ **Landscape with St. George and the Dragon** Domenichino *The action of St. George's symbolical triumph over evil takes place in front of a classically beautiful landscape.* c1610, oil on panel, National Gallery, London, UK

▲ **The Second Incarnation of Vishnu as Kurma "The Tortoise": The Churning of the Ocean** Indian School *All the things lost in the deluge were recovered and the Hindu goddess Lakshmi was born from the churning ocean.* c16th century, paint on paper, Chandigarh Museum, Chandigarh, Punjab, India

▲ **Landscape with the Fall of Icarus** Pieter Bruegel the Elder *Having flown too close to the sun and melted the wax that held his wings, Icarus fell into the sea. This dramatic event goes unnoticed amid everyday affairs.* c1555, oil on canvas, 29 x 44in, Musées Royaux des Beaux-Arts de Belgique, Brussels, Belgium

▶ **A Seal in the Form of a Qilin** Chinese School, Ming Dynasty *This Chinese mythological creature symbolizes longevity and good government.* 15th–17th century, carved ivory, 2⅜ x 2¾in, private collection

▼ Medea Frederick Sandys *Jason only succeeded in stealing the Golden Fleece because Medea helped him in return for his promise to marry her. Many of Sandys's works depict moments from well-known mythological stories.* 1868, oil on panel, 24 x 18in, Birmingham Museums and Art Gallery, UK

▼ Prometheus Gustave Moreau *Mythical subjects preoccupied Moreau. He depicts Zeus's punishment of Prometheus for the theft of fire from the gods with typically sparkling color.* 1868, oil on canvas, 34¼ x 20½in, Musee Gustave Moreau, Paris, France

PROMETHEVS

▼ Leda and the Swan Paul Cézanne *Cezanne is just one in a long line of artists to have depicted Zeus's rape, or seduction, of the mortal Leda in the form of a swan. His treatment captures the bizzarre ambiguities of this relationship.* c1880–82, oil on canvas, 23½ x 29½in, The Barnes Foundation, Merion, Pennsylvania, US

▲ Leda Atomica Salvador Dalí *This is Dalí's reinterpretation of the myth Leda and the Swan in the light of nuclear physics: various elements of the painting gravitate around the "nucleus" of Leda like the electrons of an atom.* 1949, oil on canvas, 24 x 17¾in, Teatro-Museo Dalí, Figueras

▲ Kriemhild Sees the Dead Siegfried in a Dream Henry Fuseli *A German legend in which Kriemhild foresees the murder of her husband Dreams were a frequent source of inspiration for Fuseli.* 1805, wash with white heightening, 50½ x 57½in, Museum of Fine Arts, Houston, Texas, US

► Sir Galahad—the Quest of the Holy Grail Arthur Hughes *Three knights set out from Camelot in search of the Holy Grail; Sir Galahad was considered to be the purest of them. Hughes bathes his journey in an ethereal light.* 1870, oil on canvas, 44½ x 66in, Walker Art Gallery, National Museums Liverpool, UK

▲ Ulysses Deriding Polyphemus J.M.W. Turner *Ulysses blinds Polyphemus, the man-eating giant cyclops. Turner contrasts the size of the hero—who taunts the giant from his ship – with the might of his foe.* 1829, oil on canvas, 52½ x 80in, National Gallery, London, UK

Giorgione

Self-portrait

b CASTELFRANCO, c1477; d VENICE, 1510

Although Giorgione is one of the most important Venetian Renaissance painters, little is known about his life, and very few surviving paintings can definitely be attributed to him.

Giorgione's work proved hugely influential. His *Sleeping Venus* (finished by Titian) established the tradition of the reclining nude, and his sensual portraits were much imitated by other artists. He was also one of the first painters to specialize in "cabinet pictures"—paintings made for private collectors. But perhaps Giorgione's biggest contribution was the moody, evocative depiction of the landscape and lyrical relationship between figures and nature.

LIFEline

c1477 Born inCastelfranco

c1490 Probably studies under Giovanni Bellini

c1505 Paints *The Tempest*

c1505–10 Paints *Sleeping Venus*

1507–08 Paints a canvas (now lost) for the audience chamber of the Doges' Palace

1508 Paints frescoes with Titian for German warehouse in Venice. Fragments survive

1510 Dies of the plague while in Venice

▲ **The Tempest** *Although many have tried to interpret this work, the identity of the figures is uncertain. They may be Adam and Eve after being cast out of Eden. The real subject seems to be the landscape, brought alive by the dense, hazy atmosphere and stormy light. Giorgione also added a thunderbolt, considered extremely difficult for a painter. c1505, oil on canvas, 32¼ x 28¾in, Galleria dell'Accademia, Venice, Italy*

▶ **Laura** *This intriguing portrait was named in the 1600s after the laurel as a symbol of chastity and fidelity. But many critics believe the subject was a courtesan, because of her exposed breast and fur collar. c1506, oil on canvas, 16¼ x 13¼in, Kunsthistorisches Museum, Vienna, Italy*

Titian

Self-portrait

b PIEVE DI CADORE, c1485–90; d VENICE, 1576

Titian was the greatest painter of the Venetian school. In a long and prolific career, he won the most prestigious commissions from the Hapsburg court.

Titian revolutionized every genre of painting that he worked in. His dramatic altarpieces have complex, innovative compositions—famously, the Madonna and Child are placed off-center in the *Pesaro Altarpiece* (1519–26). His mythological paintings are exuberant and colorful, and celebrate erotic passion. And his portraits present subjects actively, in a variety of poses and formats—one of the best shows Charles V mounted on his horse at the Battle of Mühlberg.

LIFEline

c1485–90 Born Tiziano Vecellio

c1500–02 Arrives in Venice and begins apprenticeship

1511 Paints first firmly dated pictures attributable to him—frescoes of three episodes of the life of St. Anthony in the Scuola del Danto

1533 Made Knight of the Golden Spur by Charles V

1538 Paints one of his most celebrated works, *Venus of Urbino* (see pp.123–5)

1545 Visits Rome and meets Michelangelo

1548 Travels to Augsburg to work for Charles V

1576 Dies of a fever while plague rages in Venice: his exact cause of death is unknown

◀ **Concert Champêtre** *Titian, or Giorgione, or both may have painted this work. The description of the landscape, with its hazy atmosphere, seems to be Giorgione's, while the distinctive poses of the figures seem to be Titian's. c1510, oil on canvas, 41¼ x 54in, Louvre, Paris, France*

▲ **Sacred and Profane Love** *The twin figures in this painting are now both thought to be Venus. The clothed figure represents earthly love—she holds a chalice of jewels, symbolizing fleeting happiness in this world. The nude figure represents celestial love—she holds a lamp, symbolizing eternal happiness in heaven. c1514, oil on canvas, 46½ x 110in, Galleria Borghese, Rome, Italy*

CLOSERlook

COAT-OF-ARMS Titian made this painting for the marriage of Nicolo Aurelio, whose coat-of-arms appears on the sarcophagus.

LANDSCAPE The landscape shows the influence of Giorgione, but the rich colors and the vitality of the figures are typical of Titian.

❝ The *Assumption of the Virgin* has the **grandeur** and the **awesomeness** of Michelangelo, the **pleasing beauty** of Raphael, and the **colors of nature** itself ❞

LODOVICO DOLCE, VENETIAN CRITIC, 1557

◀ **The Assumption of the Virgin**
The animated figures, bold, luminous color, and dramatic tonal contrasts give this massive painting a turbulent intensity. The Virgin's twisting body adds to the dynamism. 1516–18, oil on panel, 272 x 142in, Santa Maria Gloriosa dei Frari, Venice, Italy

CLOSERlook

DYNAMIC COMPOSITION The earthbound apostles are contained within a rectangle at the bottom of the painting, while the Virgin and God make a loose circle at the top. Two apostles in red, one of whom is reaching up, form a triangle, which pulls the viewer's eye up to the Virgin.

▲ **Venus and Adonis** *This scene is based on a story in Ovid's Metamorphoses. Venus is trying to stop Adonis going on a hunt that will end in a wild boar killing him. Cupid sleeps in the background, a symbol of Adonis's refusal of Venus's embrace. The pose of Venus is modeled on ancient prototypes, like Io in Correggio's Jupiter and Io (see p.124). But where Correggio's version is lyrical and sweet, Titian's is vivid and dynamic. 1553, oil on canvas, 66 x 81in, Prado, Madrid, Spain*

Venus of Urbino *Titian*
c1538, oil on canvas, 46⅞ x 65in,
Uffizi, Florence, Italy ▶

Venus of Urbino Titian

Venus of Urbino is one of the most celebrated—and debated—of Titian's paintings. It was commissioned by Guidobaldo II della Rovere—who became the Duke of Urbino in 1539—and was probably intended for the bridal chambers of his palace. A young woman looks frankly at the beholder. She is naked expect for earrings, a bracelet, and a ring. Her body creates voluptuously flowing rhythms against the precisely rendered order of the Venetian interior. However, many critics see the image not primarily as an allegory of lust but of marital love. The myrtle tree and the roses allude not only to the goddess Venus but also to constant love. The dog symbolizes faithfulness.

Composition

Titian has created a beautifully balanced composition dominated by two diagonals. One diagonal—from top left to bottom right—is formed by Venus; the other—from top right down to bottom left—leads through the two heads of the maids and the left hand of Venus. Together they create a dynamic cross-like composition. The figures in the background play an important role—counterbalancing Venus and helping create a sense of tension. Similarly the dog on the right counterbalances the strong point of interest formed by Venus's face and posy on the left.

▲ **COMPOSITIONAL GRAPHICS** The edge of the room divider and Venus's left hand lie on the central vertical; Venus's left nipple and the bottom of the *cassoni* (bridal chests) are on the central horizontal.

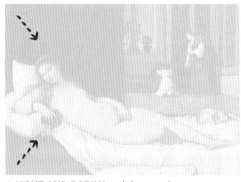

▲ **LIGHT AND DARK** Venus's face stands out from the dark curtain in the background. The darkness of the curtain in the top left corner is balanced by the light tones of the sheet in the bottom right corner.

Technique

Titian earned a reputation for extending the expressive effects of oil painting—especially in his late paintings, when he employed extremely loose brushwork. Here, however, the pictorial handling is one of precision and refinement. Titian uses thick paint to create forms. The broad areas of color are offset by crisp details. It is a technique that suits the tightly structured composition and the exact geometric perspective used to construct the picture space. Moreover, Titian has deployed a technique that befits the bold, forthright confidence of the subject.

▲ **FLESH TONES** Venus's pale, smooth flesh tones immediately catch the viewer's eye. The soft transitions from pearly white highlights to rose-colored shadow tones add to the sensuous allure of the body.

▲ **THE POSY** Roses are associated with Venus, the goddess of love and this posy of roses, with its strong tonal contrast, deep red color, and detailed rendition, also provides a strong point of interest. The color red is repeated in the mattress and in the maid's dress.

▶ **HAIR** Venus's chestnut tresses, defined in individual strands as they shimmer in the light, fall seductively over her shoulders. Together with the roses, which languidly drop from her hand, they add an erotic charge to the painting.

Story

The identity of the nude figure has been debated for centuries. In contemporary correspondence, she is described as the "nude woman" or "woman reclining." The figure seems to have been referred to as Venus, the Roman goddess of love and beauty, only after the painting was moved from Urbino to Florence in the 17th century. Roses and the myrtle tree are traditional attributes of Venus—but the inclusion of Venus's son Cupid would have made the identification unequivocal. Instead, the setting—with maidservants in the background busying themselves with the subject's clothes—suggests the temporary nakedness of a mortal rather than the ideal nudity of a goddess.

▲ **THE FACE** Venus stares straight at the viewer, with a nonchalant, almost provocative, expression. Apparently unconcerned with her nudity, she seems to challenge, rather than be challenged by, her unseen beholder.

▲ **THE TWO MAIDS** The maids take clothes out of a bridal chest (*cassone*). Such chests were often painted with erotic scenes similar to this painting. Critics who see this painting as an allegory of marital love have suggested the maids are involved in their mistress's nuptial preparations.

▲ **WINDOW** The window is the same as one in a drawing of the Duke's palace in Urbino. It suggests this painting was destined to be displayed in his palace. The myrtle tree on the sill symbolizes eternal commitment.

▲ **THE SPANIEL** The dog, a traditional symbol of fidelity, implies that the painting is a story of conjugal love. However, dogs were also used by artists as symbols of lust.

Jacopo Robusti **Tintoretto**

Self-portrait

b **VENICE, 1518**; d **VENICE, 1594**

After Titian, Tintoretto was the most respected and prolific Venetian painter of the Renaissance, but very little is known of his life. Born Jacopo Robusti, Tintoretto was nicknamed for his father's occupation from the Italian word *tintore*, meaning "dyer." Tintoretto may have trained with Venetian artist Bonifazio Veronese (no relation to Paolo Veronese), and legend has it that he also studied with Titian, but was dismissed because of the master's jealousy of his talent.

Tintoretto set up a workshop of his own some time before 1539. But it was not until 1548 that he produced a major work in his distinctive style, the *Miracle of St. Mark Freeing a Slave*. His draftsmanship, seen vividly in his drawings, was perfected by making wax models of the figures for his paintings and producing studies of them, from all angles and with different light sources. One of Tintoretto's hallmarks was dramatic foreshortening. Bold brushwork matched the striking poses. Tintoretto's work in the churches and *Scuole* of Venice established his reputation as an alternative to Titian and he had enormous influence, on El Greco in particular. His children—Domenico, Marco, and Marietta—helped in his workshop once it was well established.

▼ **The Miracle of St. Mark Freeing a Slave** *The use of foreshortening, contrast of light and shade, and closely observed figure painting give this picture a sense of drama and movement.* 1548, oil on canvas, 163 x 213in, Galleria dell' Accademia, Venice, Italy

▼ **Study of a Male Nude from Behind** *Tintoretto's drawings show even more energy and brilliance than Michelangelo's.* c1577, charcoal on paper, 13¾ x 9¾in, Hermitage, St Petersburg, Russia

LIFEline

1518 Born in Venice, son of a cloth dyer

before 1539 Sets up his own workshop

1552–62 Works in the church of Madonna dell'Orto

1562–66 Paints a series of four works for the Scuola Grande di San Marco

1564 Produces several series of scenes from the Bible for church and Scuola di S. Rocco

after 1588 Paints *Paradise* for the Doge's Palace

1594 Dies aged 76

➤ **The Last Supper** *Many of Tintoretto's later works were painted in collaboration with his assistants, but this one is undoubtedly his own work— his glorious swansong. It is a distinct break with the traditional portrayal of this subject. The dramatic depiction of Christ serving the Eucharist beneath the supernatural angels contrasts with the very earthly figures of the Apostles.* 1594, oil on canvas, 144 x 224in, S. Giorgio Maggiore, Venice, Italy

▲ **The Crucifixion of Christ** *Tintoretto's massive Crucifixion scene is teeming with movement, and depicts the raising of the cross rather than the conventional contemplative portrayal of the crucified Christ.* 1565, oil on canvas, 17ft 6in x 40ft 2in, Scuola Grande di San Rocco, Venice, Italy

CLOSERlook

DIAGONAL FRAMEWORK The visionary quality of this *Last Supper* is heightened by the unconventional viewpoint—from above and to one side. The table forms a diagonal framework for the painting.

SHINING HALOES The main light source in this painting is the blazing halo around the head of Christ, echoed in the auras around the Apostles' heads. Christ's halo lights the whole scene, and highlights the figures of the angels above.

Jacopo **Bassano**

b **BASSANO, c1515**; d **BASSANO, 1592**

Although he spent most of his life in Bassano, a village about 40 miles northwest of Venice, where his father Francesco the Elder worked as a painter, Jacopo Bassano is considered part of the Venetian school. He studied with Bonifazio Veronese in Venice in the 1530s, but otherwise remained in his home town all his life.

Like his father, Bassano often placed biblical scenes in a rural setting, peopled with peasants and animals, anticipating the 17th-century taste for genre scenes of everyday life. His knowledge of the work of Raphael, Parmigianino, and other Mannerists lifted his work far above that of a village artist. Bassano experimented with a more expressive approach to anatomy in his figure painting, and he developed a dramatic use of light and color which continued throughout his career. His four sons—Francesco the Younger, Giovanni Battista, Leandro, and Gerolam—were also painters. They assisted their father in his later years, and took over his workshop after his death.

▶ **Adoration of the Magi**
The unnatural postures of the figures in this rural setting of the Adoration are typical of Bassano's mature style, as is the intensity of color created by the light falling on them. 1563–64, oil on canvas, 36¼ x 46½in, Kunsthistorisches Museum, Vienna, Austria

▲ **The Adoration of the Kings** *This is as much a portrayal of country people and animals as of the Adoration. The pageant of acutely observed figures leads to the Madonna.* c1540, oil on canvas, 72 x 92in, National Gallery of Scotland, Edinburgh, UK

INcontext

HOLY INQUISITION In 1571, Veronese painted a *Last Supper*, set in contemporary Venice. He was called before the tribunal of the Holy Inquisition because he had included figures and ornaments that were not in the biblical account. Four days later, he changed the title to *Feast in the House of Levi*, in which Jesus ate with tax collectors and sinners.

Detail from Auto da Fe in the Plaza Mayor, Madrid *by Francisco Ricci (1680).*

Paolo **Veronese**

Self-portrait

b **VERONA, 1528**; d **VENICE, 1588**

Known by the nickname Veronese, after his native city of Verona, Paolo Caliari became one of the most important members of the Venetian school. He absorbed some of the elements of Mannerism, particularly the use of unusual perspectives and foreshortening, but his work is generally characterized by its dazzling use of color and light, expressing the magnificence of the time.

Veronese trained in Verona. After a short period in Mantua, he moved to Venice in 1553. He almost immediately started work on ceiling paintings in the Doge's Palace, and was then commissioned to provide canvases for the church of S. Sebastiano—a task that was to occupy him for about 10 years. Veronese's work was much in demand, especially the banquet paintings for which he was renowned, and his career culminated in a second series of works for the Doge's Palace.

LIFEline

1528 Born in Verona
1553 Moves to Venice
1555–65 Paints a series of works for the church of S. Sebastiano
1562–63 Paints the *Marriage Feast at Cana* in the refectory of S. Giorgio Maggiore
1575–82 Commissioned to decorate the interior of the fire-damaged Doge's Palace
1585 Paints the *Apotheosis of Venice* for a ceiling in the Doge's Palace
1588 Dies in Venice

CLOSERlook

HORSE AND GROOM
Veronese's eye for detail and love of ornamentation, seen here in the boot and the horse's hoof, add to the realism of his narrative cycles.

▼ **The Triumph of Mordecai**
This is part of the massive cycle of paintings in S. Sebastiano. The work's striking "worm's-eye" viewpoint is explained by its position on the ceiling of the nave. The Mannerist portrayal of figures and horses adds to the drama. 1556, fresco, 197 x 146in, S. Sebastiano, Venice, Italy

▲ **The Marriage Feast at Cana** *The banquet at which Christ turned water into wine is depicted here in a Venetian setting, with classical architecture, guests in contemporary clothes, and Renaissance musicians all realistically portrayed. Veronese's approach to religious themes was generally celebratory, even light-hearted, rather than devotional.* 1562–63, oil on canvas, 21ft 6in x 32ft 5in, Louvre, Paris, France

In the 14th and 15th centuries, artists in northern Europe—as in Italy—began to depict the world in a more realistic way. While Italian artists attained this greater naturalism through the study of anatomy, perspective, and classical art, northern artists achieved it by developing and mastering oil paint and paying precise attention to detail.

Origins and influences

The Northern Renaissance lasted from the end of the 14th century to the end of the 16th century. Many scholars look to the flourishing of the arts under the French king Charles V (reigned 1364–80) and the Holy Roman Emperor Charles IV (reigned 1355–78) as the start of the Northern Renaissance.

The princely courts of northern Europe sponsored the Renaissance much as the cities in Italy did. Royal patrons were able to attract the best artists with large salaries and enticing opportunities. Two Dukes of Burgundy, Philip II (the Bold) (reigned 1363–1404) and Philip III (the Good) (reigned

▲ **West End of King's College Chapel, Cambridge** Frederick Mackenzie. *King's College Chapel, started in 1446, is one of the finest examples in England of the last phase of the Gothic style, known as the Perpendicular.* Aquatint from "The History of Cambridge", published by R. Ackermann in 1815, private collection

1419–67), hired Claus Sluter and Jan van Eyck respectively. The English king Henry VIII, meanwhile, employed Hans Holbein.

Artistic inspiration also came from Italy. There were extensive trading contacts between northern Europe and Italy—Giovanni Arnolfini, the subject of van Eyck's portrait (below), was an Italian merchant working in Bruges. Albrecht Dürer worked for German merchants when in Venice. And French king Francis I (reigned 1515–47) brought many Italian artists, including Leonardo da Vinci, to France.

Subjects

Most of the best artworks of the 15th century were altarpieces. There were also highly detailed prints, both woodcuts and copperplate engravings.

Northern Renaissance

TIMEline

Van Eyck and Rogier van der Weyden pioneered the use of oils, creating intricate detail in *The Arnolfini Marriage* and *Descent from the Cross*. In the early 1500s Hieronymus Bosch and Mathis Grünewald made powerful sermons in pictures. Dürer idealizes Adam and Eve in the manner of Italian artists. After the Reformation, saints and the Virgin were rarely painted. Instead Hans Holbein turned to portraits such as *The Ambassadors*, while Cranach and Bruegel painted myths.

1434

VAN EYCK The Arnolfini Marriage

c1435

VAN DER WEYDEN Descent from the Cross

c1440

ROBERT CAMPIN Virgin and Child before a Firescreen

c1500

BOSCH The Carrying of the Cross

1504

DURER The Fall of Man (Adam and Eve)

▲ **Portrait of a man, aged 93** Albrecht Dürer *The detail and acute psychological observation is characteristic of the best of northern portraiture.* 1521, pen and ink heightened with white drawing, 16⅛ x 11⅛in, Graphische Sammlung Albertina, Vienna, Austria

Schools

In the 15th century, the Northern Renaissance centerd on Flanders and Germany. Flanders lies in what are now Belgium and northern France. Germany was a vague entity—it was made of small states, all nominally part of the Holy Roman Empire. This Empire covered the whole of central Europe and was ruled by Austrian Habsburgs. Germanic artists lived in areas now in eastern France, Switzerland, Austria, and northern Italy.

15th-century Flemish

Two of the most influential 15th-century Flemish artists were Jan van Eyck, who worked mainly in Bruges, and sculptor Claus Sluter, a native of Haarlem, who worked in Brussels, then Dijon. Van Eyck and Sluter recreated the real world with clarity, moving away from the stylistic conventions of medieval art. In the Ghent Altarpiece, for instance, van Eyck paints an extraordinarily lifelike Adam and Eve. They are not the flat figures of medieval art, nor are they idealized as in Italian Renaissance painting. Similarly, Sluter's sculpted figures

▲ **Madonna and Child with Canon Joris van der Paele** Jan van Eyck *Van Eyck uses his portrait skills to show the Canon being introduced to the Virgin and Child by St. George.* 1436, oil on panel, 48 x 61¾in, Groeningemuseum, Bruges, Belgium

Martin Schongauer and Dürer were the masters of printmaking. Portraits, too, were in demand from royal and clerical patrons and the new bourgeoisie. While sitters in early Italian Renaissance portraits were generally painted in profile, van Eyck began to use three-quarter views—adding vitality and allowing for more exploration of facial expression.

In the 16th century, Northern Renaissance artists also instigated painting genres. Albrecht Altdorfer was the first artist to paint landscapes in oils without any figures or story. Holbein's portrait *The Ambassadors* (below) anticipates the still-life genre, while Breugel's paintings of peasants at work and play were among the first scenes of everyday life.

▲ **The Flood** Hans Baldung Grien *The German's work is full of drama and doom—similar to that of his contemporary Matthis Grünewald.* 1516, oil on canvas, Neue Residenz, Bamberg, Germany

◄ **Detail from The Flood** *Baldung Grien envisages the Old Testament flood as a desperate riot of splashing, struggling, and drowning humans and animals.*

CURRENTevents

c1440–1450 Johannes Gutenberg of Mainz develops the printing press. It is key to spreading the ideas of the Renaissance and later the Protestant Reformation.

1517 In Wittenberg, Martin Luther begins the Reformation, leading to a decrease in religious art.

1566–67 A wave of Protestant iconoclasm, the *Beeldenstorm*, hits the Low Countries. Much religious art is destroyed.

c1512–15

GRÜNEWALD The Isenheim Altarpiece

c1520

MASSYS Ecce Homo

c1528

CRANACH The Judgement of Paris

1533

HOLBEIN The Ambassadors

c1555

BRUEGEL THE ELDER Landscape with the Fall of Icarus

are remarkably naturalistic. They appear to be flesh-and-blood people who exude vigor and emotion. They are also highly detailed as can be seen in the wrinkles, tendons, veins, and sagging flesh.

Northern art was transformed by the use of oil paint, a medium first mastered by Jan van Eyck. Panel painting had previously been in egg tempera—this required laboriously building up the picture in small brushstrokes. Oils meant greater freedom. By using transparent layers, known as glazes, dazzling jewel-like colors could be attained. *Chiaroscuro* (light and shade) could bring faces alive. Above all, details could be depicted precisely.

German

Two of the greatest German artists of the time—Albrecht Durer and Mathis Grünewald—are vividly contrasting figures. Grünewald looked back to the medieval idea of delivering sermons in pictures, but in an original way, with vivid color and powerful emotion. Dürer was thoroughly contemporary. He was the first German artist to travel extensively in Italy. He mastered the color, light, composition, and perspective of Italian painters, especially the Venetians. And yet he retained the psychological insight,

meticulous design, and masterful observation of detail characteristic of northern painters.

16th-century Flemish and Dutch

The Reformation profoundly affected the Northern Renaissance in the 16th century. Many Protestants objected to paintings and sculptures of saints as popish idolatry and commissions for altarpieces dried up. Book illustration and portrait painting became major sources of income. Pieter Bruegel the Elder, the most renowned Flemish artist of the era, painted peasant scenes and found patrons among the bankers of Antwerp and the court at Brussels.

The Low Countries became increasingly unstable at the end of the century and conditions were not conducive to commissioning arts. In 1566 many paintings and statues were destroyed in Protestant iconoclastic riots. In 1576, Spanish soldiers rampaged through Antwerp, leaving 7,000 dead. Three years later, the seven northern provinces of the Low Countries signed the Union of Utrecht and started the formation of Holland.

▲ **Haymaking, possibly the months of June and July** Pieter Bruegel the Elder *This is one of a series of six paintings Bruegel painted entitled* The Months. *Before 1566, oil on panel, 46⅛ x 63⅜in, Lobkowicz Collections, Nelahozeves Castle, Czech Republic*

Claus **Sluter**

b **HAARLEM, c1350**; d **DIJON, 1405/06**

Sluter was the greatest sculptor of the 15th century in northern Europe. He was active in Brussels and Haarlem, but spent most of his life working in Dijon for the Duke of Burgundy. His most famous work is the Well of Moses, of which only the base survives undamaged.

Living in an era when the "soft" or "sweet" Gothic style was prevalent, Sluter developed a robust naturalism. His figures are all individualized humans, who exhibit a range of emotions and are characterized with distinctive details. Furthermore, they are weighty and expressive, projecting from their architectural settings with great emphasis on their three-dimensionality. His work influenced not just sculptors but also painters such as Robert Campin.

LIFEline

1379 Documentation shows he is living in Brussels and came from Haarlem

1385 Moves to Dijon to enter the service of Philip the Bold, Duke of Burgundy

1389 Succeeds Jean de Marville as the Duke's chief sculptor

1404 Joins Augustinian monastery in Dijon

Melchior **Broederlam**

b **YPRES, c1350**; d **YPRES, c1411**

Broederlam was a Netherlandish painter, who, from the 1380s, worked as a court painter to Philip the Bold, Duke of Burgundy. Documents testify that he was a busy and versatile artist, but his only surviving works are two wings from an altarpiece for the chapel in the Carthusian monastery at Champmol, Dijon.

Showing *The Annunciation* and *Visitation* and *The Presentation* and *The Flight into Egypt*, they are among the finest examples of International Gothic art, a style characterized by brilliant color and a rich sense of pattern. The panels are full of naturalistic details—the figure of St. Joseph in *The Flight into Egypt* is depicted as an authentic peasant—and they look to the future of realism in later Netherlandish art.

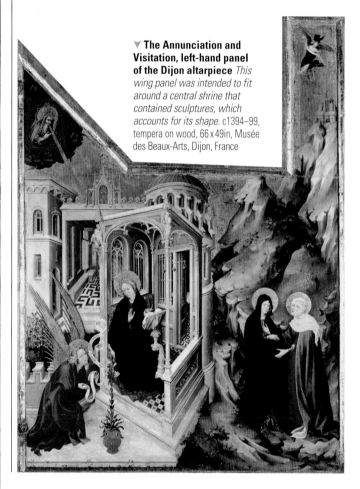

▼ **The Annunciation and Visitation, left-hand panel of the Dijon altarpiece** *This wing panel was intended to fit around a central shrine that contained sculptures, which accounts for its shape.* c1394–99, tempera on wood, 66 x 49in, Musée des Beaux-Arts, Dijon, France

INcontext

CHARTREUSE DE CHAMPMOL
Philip the Bold began building this Carthusian monastery in 1383 and made its chapel a family mausoleum. To adorn the chapel, Philip recruited a team of artists, including Sluter and Broederlam. The monastery was largely destroyed in the French Revolution.

Chapel portal *The portal of the chapel, which contains Sluter's sculptures of Philip and his wife (both kneeling) being presented to the Virgin (center), still survives at the site—along with the Well of Moses (left).*

CLOSERlook

PROPHET JEREMIAH
Jeremiah typifies Sluter's skills as a sculptor. The prophet is a believable old man with wrinkles across his forehead and around his deep-set eyes. His thumb makes an impression on the manuscript. To make him as lifelike as possible, originally Sluter gave him a pair of copper glasses.

▲ **The Well of Moses** *This sculpture was originally situated in a cloister in the Chartreuse de Champmol, forming the base of a 24.75ft (7.5m)-high fountain with the crucified Christ at the top. Six prophets—David (shown here with a crown), Moses, Jeremiah, Zachariah, Daniel, and Isaiah—stand before small niches, while six grieving angels hover above.* 1395–1403, stone, height 72in, Chartreuse de Champmol, Dijon, France

Robert **Campin**

b VALENCIENNES?, c1375; d TOURNAI, 1444

Robert Campin was the leading painter in Tournai, in Belgium, from about 1410 until his death. Jacques Daret and probably Rogier van der Weyden (see p.144) were among his pupils. No works can certainly be attributed to Campin, but there are strong reasons to think that he is responsible for the body of work previously grouped under an invented name—the Master of Flémalle.

Campin developed a distinctive realist style that had a huge influence on Netherlandish art. He humanized subject matter, showing religious scenes taking place in convincingly represented, middle-class Tournai homes. The famous *Merode Altarpiece* triptych, for instance, shows the Virgin reading in a dining room, unaware of the Archangel, while Joseph makes mousetraps in his workshop. *The Virgin and Child before a Firescreen*, now thought to be the work of a follower rather than Campin himself, also presents the Virgin in a domestic interior.

LIFEline

1410 Buys citizenship in Tournai, suggesting he may have been born elsewhere

1423 Secures deanship of Tournai's painters' guild

1425 Becomes captain of his quarter of the city

1429 Sentenced to make a pilgrimage to Provence, following a revolt against the government of Tournai

1432 Banished from Tournai for a year for a scandal in his private life. The sentence is commuted to a fine on the intervention of the Countess of Holland

▼ **The Annunciation** *Like his Northern European contemporaries, Campin had no scientific understanding of perspective, but he creates a convincing illusion of depth intuitively. He is also rigorous in his depiction of architectural details.* Workshop of Robert Campin, c1430–40, oil on panel, 29¾ x 27¾in, Prado, Madrid, Spain

▶ **The Virgin and Child before a Firescreen** *This is attributed to a follower of Robert Campin. Like the master, he presents a true-to-life contemporary interior. A humble firescreen serves as the Virgin's halo.* Oil with egg tempera on panel, 24¾ x 19¼in, National Gallery, London, UK

CLOSERlook

FRAMING ARCH The architecture doubles as an artistic device, framing the Virgin. God the Father in the top left-hand corner sends diagonal golden rays toward her.

CLOSERlook

SYMBOLIC DECOR The gold background of all three of the panels is decorated with a motif of vine branches and grapes, which are symbols of Christ.

▲ **Entombment Triptych** *This triple panel shows the unidentified donor in the left panel with the empty cross, then the Entombment, and finally the Resurrection. The painting has a medieval-style gold background, but the figures have a sculptural solidity that anticipates High-Renaissance art.* c1410–20, tempera and gold leaf on panel, 25¾ x 21¼in (center), 25¾ x 10¾in (wings), Courtauld Institute Gallery, London, UK

Jan van Eyck

Portrait by Theodor Galle

b MAASEYCK?, c1390; d BRUGES, 1441

Jan van Eyck was one of the greatest and most important painters of the Northern Renaissance. He did not invent oil painting, as 16th-century artist-biographer Vasari (see p.178) suggested, but he did perfect the technique of glazing—building up layers of transparent paint. This allowed him to create wonderfully deep colors and to work up minute details. Nobody before— and very few since—had mimicked reality so exquisitely.

Van Eyck's painstaking craftsmanship was matched by rigorous observation. He was extraordinarily sensitive to the fall of light. He loved describing folds in cloth, delineating the precise point at which the form turns away from the light. He painted sculpture with such precise contrasts of light and dark that it is hard to believe they exist only in two dimensions. His portraits were brought to life by this close scrutiny. For his bust-length portraits, he would register stubble, light reflected in the eyes, and every crease in the skin. While his Italian contemporaries generally used a profile view for portraits, van Eyck pioneered the three-quarter view, which allowed facial expressions to be fully investigated.

LIFEline

c1390 Born perhaps in Maaseyck, near Maastricht

1422 Works in The Hague at the court of John of Bavaria, Count of Holland

1425 Travels to Lille, then Bruges, as a painter and equerry for Philip the Good, Duke of Burgundy

1426 Death of his brother Hubert, who had started work on the *Ghent Altarpiece*

1428–29 Travels to Portugal on a diplomatic mission for Philip the Good

1432 Completes the *Ghent Altarpiece*

1432 Paints the *Arnolfini Portrait*

1441 Dies in Bruges

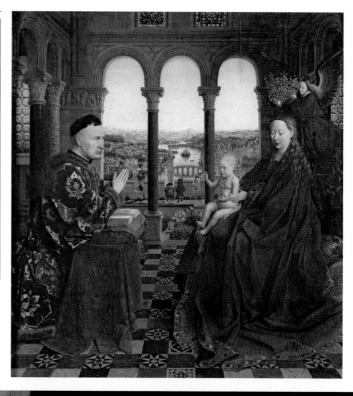

▼ **Ghent Altarpiece, interior view** *This masterpiece consists of 20 paintings, 12 of which appear when it is opened, as here. On the upper level, God the Father is flanked by the Virgin and John the Baptist, angels, and Adam and Eve. Below, saints travel to adore the Lamb of God.* Finished 1432, oil on panel, 137¾ x 181½in, St Bavo's Cathedral, Ghent, Belgium

▶ **The Virgin of Chancellor Rolin** *Here, the donor, Nicolas Rolin, Chancellor to Philip the Good, is shown stern and care-worn opposite the flawless Virgin. Beyond is a garden, with roses and lilies symbolizing the Virgin's virtue.* c1435, oil on panel, 26 x 24⅜in, Louvre, Paris, France

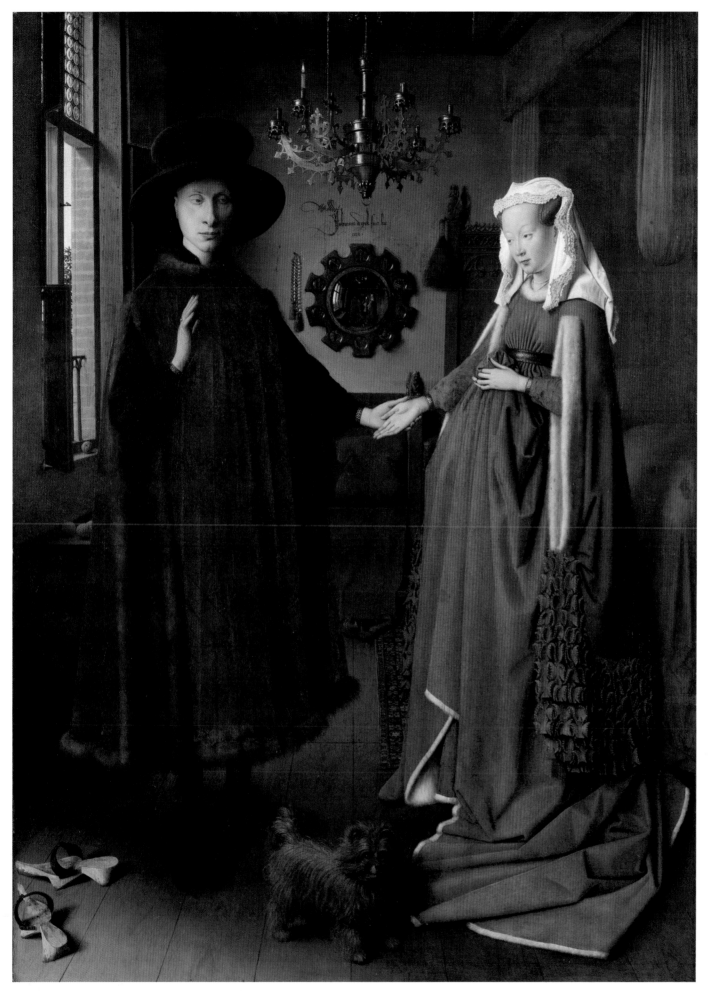

The Arnolfini Portrait *Jan van Eyck*
1434, oil on oak panel, 32¼ x 23⅝, National Gallery, London, UK ▶

The Arnolfini Portrait Jan van Eyck

This celebrated double portrait has long been the focus of scholarly debate about whom and what it depicts. It used to be known as "The Arnolfini Marriage", following the classic interpretation by art historian Erwin Panofsky. Until recently, the couple were identified as Giovanni di Arrigo Arnolfini and Giovanna Cenami, a wealthy Italian couple living in Bruges. However, in 1997 documentation was published showing that they did not marry until 1447. Experts now think that the painting depicts Giovanni's cousin and his wife. What no one disputes is that this masterpiece displays van Eyck's skill at using oil paint to create an image of unprecedented illusionism.

Composition

Van Eyck's composition creates the illusion of two figures in a believable space, even though the linear perspective is approximate rather than absolutely accurate, and the figures are too large in proportion to the room. It is a beautifully balanced composition in which apparently significant elements, such as the chandelier, van Eyck's signature, the ornate convex mirror, the wife's red shoes, the couple's joined hands, and the little dog, are arranged along an imaginary central vertical and flanked by the figures themselves. The windowed wall to the left of the painting is counterbalanced by the brilliant red bed hangings on the right.

▲ **LIGHT SOURCES**
Consistent lighting is part of the painting's realism. The fall of light and shadow (see Arnolfini's clogs) indicates several sources: the window to the left, an unseen window to the front, and/or the open door reflected in the mirror.

▲ **SLOPING FLOORBOARDS**
Van Eyck relied on intuition rather than rules of perspective to create a sense of recession and space. The converging lines of the floor boards, beamed ceiling, window frames, and bed pelmet define the box-like interior.

> " The meaning of this painting is that wealth—**the wealth to hire van Eyck—can purchase immortality**, even if no one will be quite sure what your name was "
>
> JONATHAN JONES, 2000
> JOURNALIST

Story

The painting's story remains a fascinating enigma. Is it a marriage? A betrothal? Or a memorial to Arnolfini's young wife Constanza who died the year before the picture is dated? Are the objects "disguised symbols," or are they simply ravishingly realistic depictions of household contents? Is the dog a symbol of fidelity, of lust, or simply a reference to the dogs seen on funerary monuments?

On the back wall hangs a convex mirror in which two figures are reflected: Arnolfini raises his hand, perhaps to greet them. The painting probably originally had shutters: and so when they were opened, it would have seemed as if the viewer was entering the room and being greeted too.

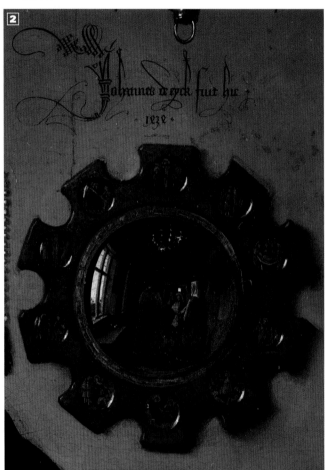

▲ **MIRROR AND INSCRIPTION** Two figures are reflected in the mirror, above which is is a Latin inscription that means "Jan van Eyck was here/1434." It has been suggested that the inscription was a marriage certificate, with van Eyck a witness to the ceremony. However, it may simply be an ornate signature.

▲ **EXPENSIVE ORANGES** Imported citrus fruit was included to signify affluence, "fruitfulness," and/or to display van Eyck's skill at modeling its spherical form.

▼ **ST. MARGARET** On the bench, the carved figure emerging from a dragon, is probably St. Margaret, the patron saint of pregnant women. Constanza may have died in childbirth.

▲ **ARNOLFINI'S GAZE** Arnolfini raises his hand—in affirmation of an oath, or in greeting?—yet his solemn, heavy-lidded gaze is pensive and sidelong. He does not look at the viewer, the figures in the mirror, or his wife.

▲ **HOLDING HANDS** The couple's hands were seen as joined in matrimony, but in the Christian ceremony it is both right hands which are joined. In the underdrawing Arnolfini grips his wife's hand firmly—here it is slipping through his fingers just as Constanza did.

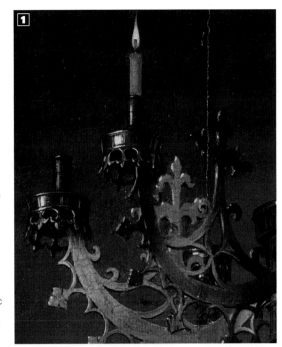

Technique

Much of the powerful impact of the painting comes from its exceptional sense of realism. Surfaces are depicted with a precision that was only made possible by the skilful use of oil paint. Although the long-standing belief that van Eyck "invented" oil painting has been discredited, it is evident that he refined and perfected the technique. Oil paint dries slowly, and allowed van Eyck to apply layers of transparent glazes to build up forms, create realistic textures, and even give the illusion of light. Van Eyck worked his oil paints with great care and skill, using rags and fingertips to obliterate any signs of brushmarks and create his jewel-like finish.

◀ **POLISHED CHANDELIER** Van Eyck not only recreates in meticulous detail the way the complex form of the chandelier takes up space: he captures the different ways light is reflected on its polished surfaces, and even shows the tool marks.

▼ **HIGHLIGHTS** The prayer beads are depicted with an astonishingly economical technique. Bold strokes and blobs of paint create highlights, shadows, and the thread running through them.

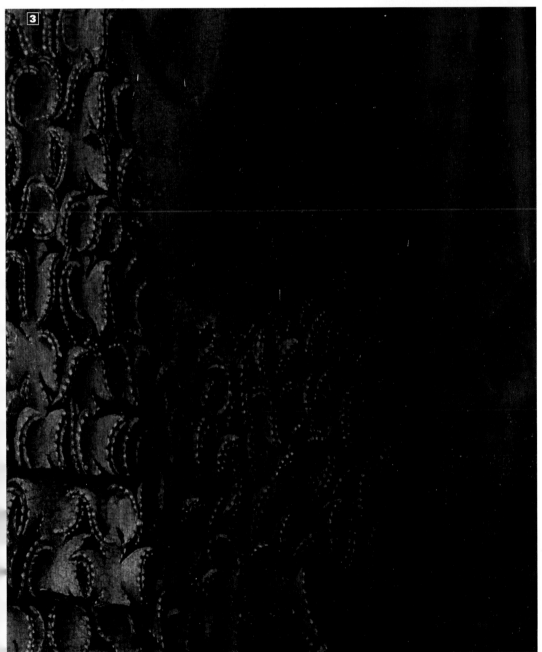

◀ **CROPPING AND PERSPECTIVE** Arnolfini's wooden pattens (shoes that are worn outdoors) reveal van Eyck's extraordinary level of observation. He distinguishes different textures with minute detail. The smooth upper surface contrasts with the mud spattered heels, where the artist uses strokes of gray and pink to indicate chisel marks. The strongly cast shadows make the pattens appear to project into "real" space.

▲ **GREEN AND RED** The brilliance of the dress's green is heightened by placing it next to its complementary color, red. The colors may have symbolic significance: green signifying fertility, red signifying passion. Tiny dots of paint suggest the intricate decorative cut-work on the dress.

▲ **DELICATE BRUSHSTROKES** The little dog, looking directly at the viewer (unlike the humans), was added later. The vertical line of the floorboards is visible beneath its meticulously painted wiry coat and there is no underdrawing.

Rogier van der Weyden

Portrait by
Esme de
Boulonois

b TOURNAI, c1399; d BRUSSELS, 1464

The work of Rogier van der Weyden combines the expressive realism of his probable master, Robert Campin, with a deep spirituality and empathy. Rogier's most characteristic work is the *Descent from the Cross*, in which the grief of the Virgin Mary and Christ's attendants is palpable. All of his surviving works are religious subjects or portraits. The latter combine a Flemish attention to detail with flattery and piety.

As with many early artists, very little is known about Rogier's life. He spent most of his career in Brussels, where he was the leading painter of the day, but nothing is recorded of his personality. There are no signed works, and paintings are attributed to him mainly on stylistic grounds. Although Rogier was famous in his lifetime, with a busy workshop exporting copies of his paintings to France, Germany, Spain, and Italy, after he died his name gradually faded from view. It was only in the 20th century that his reputation regained its 15th-century status.

LIFEline

1427 Apprenticed to Robert Campin
1432 Becomes master in Tournai's painters' guild
1436 Is appointed official painter to city of Brussels
c1445–50 *Last Judgement* altarpiece for hospital in Beaune
1450 Goes on pilgrimage to Rome
1464 Dies in Brussels

▶ **Descent from the Cross** *For this scene, showing the lowering of Christ's body from the cross, Rogier painted a gold backdrop, so there is no depth. The effect is to thrust the highly realistic, grief-stricken players into the viewer's space, as if they are at the very front of a stage.* c1435, oil on panel, 87 x 103in, Prado, Madrid, Spain

▶ **St. Luke Drawing the Virgin** *The window in this picture looks onto a Flemish city scene, in which a river winds with converging linear perspective into the distance. The silverpoint drawing that St. Luke is making was the usual first stage of a painting at this time.* c1435–40, oil and tempera on panel, 54 x 43¾in, Museum of Fine Arts, Boston, US

> ❝ Roger felt and expressed **emotions and sensations**—mostly of a bitter or **bittersweet** nature—that no painter had ever recaptured ❞

ERWIN PANOFSKY, ART HISTORIAN

CLOSERlook

ECHOING SHAPES The pose of the swooning Mary repeats that of the dead Christ. Groups of three figures balance either side, while John the Baptist's red robe counters Joseph of Arimathea's gold brocade.

INDIVIDUAL FEATURES
The faces, particularly of the men, are recognizable portraits. John the Baptist's youthful face is furrowed in concern as he supports the Virgin Mary. His ruddy glow contrasts with her deathly pale face.

Hugo van der Goes

b **GHENT, c1440;** d **RODE KLOOSTER, NEAR BRUSSELS, 1482**

The reputation of Hugo van der Goes rests on the one piece of work that he certainly painted—the *Portinari Altarpiece*. However, on the strength of stylistic similarity, a handful of other paintings are also attributed to him.

The *Portinari Altarpiece* shows Hugo's ability to arrange groups of figures within a realistic setting and to portray intense emotion. He applies his Flemish love of naturalistic detail and surface texture to the symbolic objects in the foreground of the picture, as well as to the rich fabrics. Set against such realism, Hugo uses the medieval device of including the figures of the donors, who commissioned the altarpiece, in the foreground, but showing them much smaller than the important religious figures behind them. When Portinari, a Medici agent in Bruges, took this altarpiece back home to Florence, it influenced local artists such as Ghirlandaio.

LIFEline

c1440 Born in Ghent

1467 Becomes master in the Painters' Guild of Ghent

1468–72 Works in Bruges and Ghent

c1474–78 Paints the *Portinari Altarpiece*

1475 Becomes Dean of the Painters' Guild. Enters the monastery of Rode Klooster, near Brussels

1482 Dies, having suffered a mental breakdown the previous year

◄ **The Fall of Man and the Redemption** *Hugo revels in the details of foliage and in the serpent in the Garden of Eden. Atmospheric perspective—the blue background—gives the landscape depth. In both panels, the figures are arranged in a diagonal slope from left to right, echoing the descent of man and Christ.* After c1480, oil on panel, 12¾ x 8¾in and 13¼ x 9¼in, Kunsthistorisches Museum, Vienna, Austria

▲ **Altarpiece of the Seven Sacraments (central panel)** *The red garments and white headdresses focus attention on the figures at the foot of the cross. They are set against the neutral tones of the architecture, which soars heavenward.* c1445–50, oil on panel, Koninklijk Museum, Antwerp, Belgium

◄ **Portrait of Young Woman in a Pinned Hat** *Typically of Rogier's portraits, the young woman is seen half-length and in three-quarter view. Her pose shows devoutly clasped hands and a fashionable high waistline.* c1435, oil on panel, 18½ x 12¾in, Gemäldegalerie, Berlin, Germany

▲ **The Portinari Altarpiece** *This central panel shows the adoration of the Christ child. Instead of lying on Mary's lap or in a manger, he is isolated on the bare ground, radiating light.* c1474–78, tempera and oil on panel, 100 x 120in, Uffizi, Florence, Italy

CLOSERlook

PSYCHOLOGICAL SYMPATHY The humble status of the shepherds is raised by the rapt expressions on their faces. This tightly knit group contrasts with the solitary subject of their worship.

INcontext

THE GOLDEN LEGEND This 13th-century collection of saints' lives was a sourcebook for Renaissance artists. It included, for instance, the story of St. Luke drawing the Virgin Mary's portrait, a tale that made him the patron saint of many painters' guilds. About 900 manuscripts of *The Golden Legend* survive, and after the invention of printing it became the most popular book in 15th-century Europe.

Manuscript page from The Golden Legend *by Jacobus de Voragine (14th century).*

Petrus **Christus**

b **BAERLE-DUC?, c1410; d BRUGES, 1475/76**

Petrus Christus is credited with being the first northern European artist to use geometrically accurate perspective, in his *Madonna with Two Saints* of 1457. He was the leading artist in Bruges in the generation after Jan van Eyck. Christus may indeed have been one of van Eyck's pupils and have completed some of his unfinished works. He certainly helped to spread van Eyck's naturalism—like him, Christus observed and recorded details of the world around him with meticulous accuracy. In his religious scenes, Christus borrowed from both van Eyck and Rogier van der Weyden. He shows greater individuality in indoor scenes, especially his portraits. Gone are the black, blank backgrounds of earlier artists. Instead, he provides a room setting that complements the realism with which he depicts the sitter's particular features.

◀ **Edward Grimston** *Christus's portraits were his most successful works. Here, the sitter's face is lit from the side, so the artist can model the features with a full range of tones.* 1446, oil on panel, 13 x 9¼in, Earl of Verulam Collection, on loan to National Gallery, London, UK

▼ **The Lamentation over the Dead Christ**
This composition is based on Rogier van der Weyden's Lamentation, *but the result is less dramatic.* Oil on panel, 39¾ x 176in, Musées Royaux, Brussels, Belgium

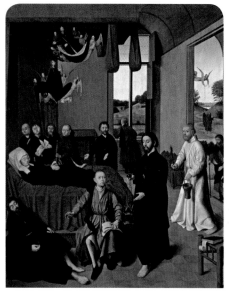

▶ **The Death of the Virgin** *The use of perspective was intended by Flemish artists to increase the sense of space in all directions, not to unify the scene, as for Italian painters. The spatial setting is detailed, and the figures at the door and window lead the eye into the world outside. A limited palette of red, black, and earth tones unifies the various elements.* c1460–65, oil on panel, 67 x 54in, Timken Museum of Art, San Diego, US

Hans **Memling**

Self-portrait

b **SELIGENSTADT, c1435–40?; d BRUGES, 1494**

Born in Germany, Memling (or Memlinc) became the leading painter in Bruges after the death of Christus. Tradition has it that he trained under Rogier van der Weyden. Memling had a large workshop, and many of his small altarpieces were exported to Italy. The style of his background landscapes, with a blue and hazy far distance, influenced Italian artists, such as Perugino.

Memling had the skill of creating an intimate Madonna and Child scene in a setting that approximated to an Italian palace in a Flemish landscape—a hybrid style that appealed both at home and abroad. His success brought him wealth—he was one of Bruges's richest citizens.

▶ **Benedetto Portinari**
The sitter for this portrait was a Florentine agent of the Medici bank. Memling puts this pious memorial in a realistic setting. 1487, oil on panel, 17¾ x 13¼in, Uffizi, Florence, Italy

▲ **Triptych of St. John the Baptist and St. John the Evangelist** *Flanked by the two Johns—shown in other scenes from their lives in the outer panels—the Virgin and Child are also accompanied by female saints. St. Catherine has the wheel she was tortured on, and St Barbara the tower she was locked in.* c1474–79, oil on panel, Memling Museum, Bruges, Belgium

INcontext

BRUGES In this period, Bruges was drifting into financial decline. Once an international trading center where European merchants bought Flemish cloth, it was superseded by Antwerp, with its bigger harbor, during the 16th century.

Town plan of Bruges *as it was in the 16th century.*

Geertgen tot Sint Jans

b **LEIDEN?, c1460;** d **HAARLEM?, c1490**

Very little is known of Geertgen, whose full name means "Little Gerard of the Brotherhood of St. John," after the religious order in Haarlem of which he was a lay brother. Paintings are attributed to him by their stylistic similarity to two works—the *Lamentation of Christ* and the *Burning of the Bones of St. John the Baptist*—which are known to be by him. Geertgen added a new element of humility to the devotional works of the northern Netherlands. He relied on radiant light, slender, childlike figures, and naturalism to convey his holy vision.

▼ **The Nativity** *Light emanates from the Christ Child, revealing the tender look on his mother's face. A campfire on the hillside lights up the angel.* Late 15th century, oil on panel, 13¼ x 9¾in, National Gallery, London, UK

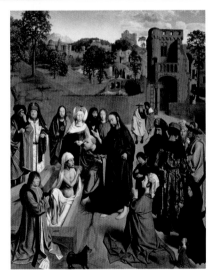

▲ **The Resurrection of Lazarus** *The high viewpoint shows Lazarus stepping out of his coffin after Jesus miraculously raises him from the dead. The detailed landscape is typically Flemish.* Late 15th century, oil on panel, 50 x 38¼in, Louvre, Paris

Dieric **Bouts**

b **HAARLEM?, c1420;** d **LOUVAIN, 1475**

Dieric, or Dirk, Bouts is remembered chiefly for his long, thin figures and also for the beauty of his landscape settings, in which the foreground slides seamlessly and continuously into the far distance. He used paths and walls to lead the eye from one figure to the next, and to coax the viewer into enjoying the full illusion of depth. His backgrounds gradually become lighter and bluer, imitating the natural effects of atmospheric perspective.

Bouts's early life is obscure, but he probably moved from Haarlem to Louvain in the early 1460s. He received a major commission in 1464 for the altarpiece for the chapel of the Confraternity of the Holy Sacrament at St. Peter's in Louvain. Bouts set the narrative events in his paintings in his own day. The figures often looked like people he knew, dressed in contemporary costume, and mingled with imaginary characters. The realistic space, landscape, and faces contrast with the stiffly elongated figures, unemotional in the face of the gory events.

▲ **The Justice of the Emperor Otto** *Town halls were often decorated with justice scenes. Here Bouts uses his adopted city of Louvain as the backdrop for the grisly tale. The emperor's wife attempted to seduce a nobleman and later accused him of rape. Her husband had the man beheaded before the truth came out, and she was later burned at the stake.* 1470–75, oil on panel, 128 x 72in, Musées Royaux, Brussels, Belgium

▼ **The Last Supper** *In this central panel from the Louvain altarpiece, Bouts uses linear perspective in the converging lines of the room to create a sense of depth. The meal takes place in a light-filled room with Gothic arches, complete with contemporary details, such as the double portrait hanging on the wall.* 1464–68, oil on panel, 71 x 59in, St Peter's, Louvain, Belgium

CLOSERlook

CATCHING ATTENTION
The condemned man, wrongly convicted of rape, is shown twice. In the foreground, his decapitated body spews blood while behind him, again in white, he earlier pleads his innocence to his wife. The V-shaped group of figures converges on the arrow-like tower in the top left-hand corner.

Nuno **Gonçalves**

ACTIVE **PORTUGAL, 1450–71**

While there are no certain works by Gonçalves, the six-paneled St. Vincent polyptych is attributed to him on good evidence. Made in Lisbon, it is the most impressive painting produced in Portugal during the 15th century. Shortly before Gonçalves painted it, Jan van Eyck was sent by the Duke of Burgundy to paint a Portuguese princess whom he had in mind as a potential wife. Gonçalves's work shows the influence of van Eyck and other Flemish artists such as Bouts in his concentration on surface texture and color and his interest in individualized faces. The panels show an array of people, from fishermen to monks to royalty, venerating St. Vincent, the patron saint of Lisbon.

◄ **St. Vincent of Saragossa** *The portrait of St. Vincent, the patron saint of Lisbon, is idealized, while all the other faces are of real people. The saint's gorgeously embroidered deacon's garment outshines that of the prince, kneeling in supplication, and the haughty archbishop in gold.* c1466–70, oil on panel, 81 x 50in, National Museum, Lisbon, Portugal

Enguerrand **Quarton**

ACTIVE **PROVENCE, 1444; d 1466?**

This French artist is documented as working in Aix, Arles, and Avignon, but his only two certain works are *The Madonna of Mercy* and *Coronation of the Virgin.* Their quality has caused scholars to tentatively attribute to him the Louvre's *Avignon Pietà*, widely considered to be the greatest French painting of the time.

The Coronation of the Virgin is an ambitious work, encapsulating a great deal of Christian doctrine. The top two-thirds of the painting is devoted to a serene vision of heaven, while the bottom half is crammed full with earthly figures panicking at the Last Judgement. Christ, depicted on the cross, links the two realms.

▼ **Madonna of Mercy** *The Madonna appears as a monumental protector. The figures resemble sculptures of the region at the time.* 1452, oil on panel, 26 x 74in, Musée Condé, Chantilly, France

▼ **Coronation of the Virgin** *Areas of white lead lead the eye up in loops to the dove (the Holy Ghost) and the arms of God the Father and Son crowning Mary Queen of Heaven.* 1453–54, oil on panel, 72 x 87in, Musée de l'Hospice, Villeneuve-lès-Avignon, France

Bartolomé **Bermejo**

b **CORDOBA?, c1440?; d BARCELONA?, c1498**

Mixing the intense religious feeling of the Spanish with the naturalistic detail of the Flemish, Bermejo was the leading painter of the 15th century in Spain. The dynastic marriage joining the Spanish kingdoms of Castile and Aragon increased the trade links with Flanders and made travel for artists and diplomats both possible and necessary. Bermejo worked in various cities of northern Spain and may have been apprenticed in Bruges.

Such attention to detail, beloved of Gothic and Flemish artists, was made easier by the introduction of oil paint, and Bermejo was one of the first to use it in Spain. His real name was Bartolomé de Cárdenas, and his nickname Bermejo ("red") is more likely to refer to his appearance than his color palette.

LIFEline

1486 Working in Barcelona, having left Aragon

1490 Completes the *Pietà* in Barcelona Cathedral

c1498 Dies, after spending most of his career in Barcelona

▶ **The Resurrection** *In the sister panel to* The Descent, *Christ's appearance dazzles one soldier, while the other has yet to see him. The three Maries in the background are small (even allowing for perspective), following the Gothic tradition of making the key characters the largest.* c1480, oil on panel, 35 x 26¾in, Museo de Arte de Catalunya, Barcelona, Spain

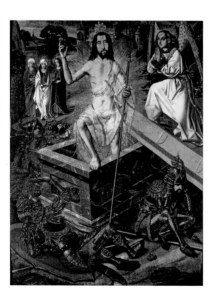

▶ **The Descent of Christ into Limbo** *From the ground in front of the figures, littered with skulls and snakes, to the background trees and hills, Bermejo displays a Flemish-influenced love of naturalistic detail. The realism of the figures is almost exaggerated.* c1480, oil on panel, 35 x 26¾in, Museo de Arte de Catalunya, Barcelona, Spain

CLOSERlook

TONAL CONTRAST
Glowing from the fires of hell on one side and Christ's halo at the other, a swathe of light adds pathos to the plight of the supplicating sinners.

Jean **Fouquet**

b TOURS, c1420; d TOURS, c1481

The leading French painter of the 15th century, Fouquet had a uniquely cool, severe style. Influenced by both Italian and Flemish art, he created his own brand of realism with sculptural figures, chiseled features, simplified forms, and broad expanses of color.

Self-portrait

Fouquet excelled equally as a manuscript illuminator and a painter on wood panel. He wroked a good deal for the court, which at this time was based in his home town of Tours. His patrons included Etienne Chevalier, the royal treasurer under Charles VII. For him, Fouquet produced both a Book of Hours and his most famous painting, *The Melun Diptych*. Its two panels are now in different galleries, one in Germany and the other in Belgium.

The likeness of the kneeling Chevalier is accurate, as is known from other portraits of him. His namesake saint, Stephen (Etienne in old French), puts a protective arm around him, but otherwise appears oblivious to the rock with which he will be martyred or the blood already trickling down the back of his head. In contrast to the realism of the left-hand panel, Mary is an idealized if improbable Madonna, held adrift from time and space by cherubs.

LIFEline

1444 Paints portrait of Charles VII
c1446–48 Probably visits Rome
c1450–60 Creates a Book of Hours for Etienne Chevalier
c1452 Paints *The Melun Diptych*
1474 Designs for the Louis XI's tomb
1475 Made royal painter

▼ **Etienne Chevalier and St. Stephen** *Fouquet makes no attempt to flatter the face of Chevalier, the powerful donor who commissioned the altarpiece, giving him a long nose and grimly compressed mouth. Chevalier kneels in a classical Italian interior with accurate perspective. Fouquet sets the realism of the earthly realm apart from the ethereal world of the Virgin and child in the right wing of this diptych (right), with St. Stephen bridging the two. c1452, left wing of the Melun Diptych, oil on panel, 36¾ x 33½in, Gemäldegalerie, Berlin, Germany*

▼ **Virgin and Child** *The Virgin's face is said to be modeled on that of Agnes Sorel, Charles VII's mistress. One pneumatic breast is bared, although she is not nursing the Christ Child, who points at Chevalier in the left wing of this diptych (below). She has an hourglass figure and fashionably shaved hair, giving her a high, bulbous forehead. c1452, right wing of the Melun Diptych, oil on panel, 37 x 33½in, Koninkliijk Museum, Antwerp*

CLOSERlook

COLOR CONTRASTS While the flesh and cloak of *The Virgin and Child* look as cool and chiseled as marble, the framework of cherubs is composed of vivid reds and blues. Each face is seen from a different angle and, although the coloring differs quite starkly, the forms are stylized and simplified in an appeal to rational order rather than emotion.

INcontext

JOAN OF ARC Fouquet owed his patronage indirectly to Joan of Arc and her part in restoring the French monarchy. Charles VI of France died in 1422, and England tried to claim the throne. As a teenager, Joan heard voices that inspired her to lead the crusade that restored Charles VII to his throne. He made no attempt to save her from her fate—she was burned at the stake as a witch and heretic in 1431. But the English were successfully routed. Under Charles's son, Louis XI, royal patronage of the arts flourished. Joan of Arc was eventually made a saint in 1920.

Signature of Joan of Arc
Joan of Arc's crusade ended centuries of struggle for power and territory between England and France. Thanks to her, Charles VII was crowned at Reims in 1429.

Landscape

In China, landscape painting has for centuries been one of the most prominent forms of art. In Europe, however, its history has been more uneven. It was often used in the decoration of ancient Roman buildings, but then lost popularity until the Middle Ages. During the 16th century it began to develop into an independent speciality for artists and eventually attained widespread importance in the 17th century. The Impressionists, in the 19th century, helped to turn landscape into one of the most popular branches of all art.

◀ **Landscape with Bathers** Antonio Carracci *This landscape was once attributed to Agostino Carracci, but is now thought to be by his illegitimate son Antonio.* c1615, oil on canvas, 12⅝ x 13⅜in, Palazzo Pitti, Florence, Italy

▼ **Herdsmen with cows** Aelbert Cuyp *Cuyp's depictions of his native Holland—often bathed in warm sunlight—were influenced by the work of the French painter Claude.* 1620–91, oil on canvas, 39 x 56¾in, Dulwich Picture Gallery, London, UK

▼ **Pygmies Hunting, from the 'Casa del Dottore' (House of the Doctor) from Pompeii** Roman *In Roman art, pygmies are often used to evoke exoticism.* c50–79 CE, fresco, 50 x 29in, Museo Archeologico Nazionale, Naples, Italy

▲ **Willows and distant mountains** Ma Yuan, *Monochrome images with calligraphic brushwork are characteristic of landscape paintings of this period. Mountains, as symbols of stability, were favorite subjects.* Song Dynasty (960–1279), ink and watercolor on silk, private collection.

▲ **March: peasants at work on a feudal estate** Limbourg Brothers *This detailed pastoral scene comes from the* Très Riches Heures du due de Berry, *one of the most beautiful of all illuminated manuscripts.* c1414–1418, vellum, Musée Condé, Chantilly, France

▲ **Wooded Landscape with a Cottage, Sheep, and a Reclining Shepherd** Thomas Gainsborough *Gainsborough's pastoral landscapes combine his idiosyncratic vision with the influence of Rubens.* c1748–50, oil on canvas, 16⅞ x 21¼in, Yale Center for British Art, Paul Mellon Collection, US

▶ **A Cottage in a Cornfield** John Constable *Constable's quintessentially English landscapes were often inspired by Dedham Vale, the area in which he grew up.* 1817, oil on canvas, 12⅝ x 10¼in, National

▼ Wheatfield with Cypresses Vincent van Gogh
The urgent brushwork and bold colors of van Gogh's landscapes combine his love of Japanese art with his understanding of Impressionism. 1889, oil on canvas, 28¼ x 36in, National Gallery, London, UK

◄ Drifting Smoke Fred Williams *The remoteness of the Australian outback is vividly expressed in this painting.* 1981, oil on canvas, 60 x 72in, National Gallery of Victoria, Melbourne, Australia.

▼ Western Hills Graham Sutherland *The English artist often uses abstract forms to lend his landscapes a surreal, dreamlike quality.* 1938–41, oil on canvas, 22 x 36in, Scottish National Gallery of Modern Art, Edinburgh, UK

▲▲ Haystack, Hazy Sunshine Claude Monet
His series of Haystack paintings helped Monet to develop his masterful treatment of light. 1891, oil on canvas, 24 x 40in, private collection

▲ Cayambe Frederic Edwin Church *Church's panoramic landscapes are bold celebrations of the majesty of nature.* 1858, oil on canvas, 30 x 48in, Collection of the New-York Historical Society, US

▲ Mont Saint Victoire Paul Cézanne *Mont Saint Victoire was a frequent subject of Cezanne's. His radical approach to form influenced Cubism.* c1900, oil on canvas, 30¾ x 39in, Hermitage, St. Petersburg, Russia

◄ An Angler Tarsila do Amaral *The bold colors and shapes of Amaral's landscapes were a cornerstone of Brazilian modernism.* 1920s, oil on canvas, 26 x 29½in, Hermitage, St. Petersburg, Russia

▲ Wessex Flint Line Richard Long *The English land artist's sculptures are an expression of his personal relationship walking in landscapes.* 1987, flint, 445 x 63in, Southampton City Art Gallery, UK

Gerard **David**

Self-portrait

b OUDEWATER?, c1460; d BRUGES, 1523

David was one of the last painters to work in the early Flemish style of Jan van Eyck and Rogier van der Weyden. He used translucent layers of oil paint to build up richly colored glazes, and depicted a meticulously ordered world. Consolidating rather than innovative, David was at his best when painting quiet, pious reigious scenes.

A contemporary of the Antwerp master Massys, David became the leading painter in Bruges after the death of Memling in 1494. His technical skill and familiar style and subject matter made him popular in his day, and his works were much copied for export to Spain. David broke from his normal themes in a pair of pictures of the *Judgement of Cambyses* (1498) for Bruges town hall, but returned to religious subject matter thereafter.

LIFEline

c1460 Born, probably in Oudewater, near Gouda
1484 Settles in Bruges
1498 Paints *Judgement of Cambyses*, his main secular works
1507 Paints *Baptism of Christ* triptych
c1515 May have opened a workshop in Antwerp
1523 Dies in Bruges

▶ **Madonna and Child Crowned by Two Angels**
David excels in detail, from Mary's tender look to the glittering crown. c1520, oil on panel, 13¼ x 10¾in, Prado, Madrid, Spain

▲ **Triptych of the Sedano Family** *Both the foreground group of donors, with their patron saints flanking the Madonna and Child, and the landscape background are unified across the three panels.* c1495–98, oil on panel, 38¼ x 57in, Louvre, Paris, France

INcontext

SECULAR THEMES Lucas van Leyden founded a tradition of genre painting (scenes of everyday life), which was to become a Dutch speciality in the 17th century. Massys also painted secular themes, while Marinus van Reymerswaele later specialized in painting caricatures of bankers, misers, and tax collectors.

The Engagement *by Lucas van Leyden (early 16th century).*

Jan **Gossaert (Mabuse)**

b MAUBEUGE?, c1478; d ANTWERP?, 1532

"Better in execution than invention" was Dürer's verdict on Jan Gossaert, which chimes more with today's opinion of him than the artist-biographer Vasari's (see p.178) praise. He wrote that Gossaert was the first "to bring the true method of representing nude figures and mythologies from Italy to the Netherlands."

Gossaert, whose alternative name, "Mabuse," derives from his probable birth place, attempted to pull off an artistic marriage between the styles of northern and southern Europe. This was more successful in some of his paintings than in others. After a trip to Rome, he kept his loyalty to the traditions of Jan van Eyck and followers, but changed the settings in his paintings. He liked to show off his skill at drawing in perspective, knowledge of Italianate architecture, and mastery of light and shade. Gossaert was also influenced by Dürer, and the large, muscular bodies of his "Romanizing" style owe as much to the German artist as to the Italians.

LIFEline

1503 Becomes Master of the Antwerp Painters' Guild
1508–09 Goes to Rome with Philip of Burgundy, the ambassador to the Vatican
1520 Paints *St. Luke Painting the Virgin Mary*

◀ **Adoration of the Magi** *In this early work, the Virgin has long wavy hair, a demure face, and angular drapery, following the 15th-century Netherlandish tradition. In the same vein, Gossaert relishes the surface detail.* Oil on panel, Museo Lazaro Galdiano, Madrid, Spain

▼ **Danaë** *Here, the god Jupiter seduces Danaë by disguising himself as a shower of gold. Gossaert integrates the figure within her classical interior much more successfully than in Neptune and Amphitrite.* 1527, oil on panel, 44½ x 37¼in, Alte Pinakothek, Munich, Germany

▲ **Neptune and Amphitrite** *These life-size figures look too large for their setting, a misinterpreted ancient Roman temple. The leaves in their hair and shell shielding Neptune's genitals strike an unintentionally comic note.* 1516, oil on canvas, 74 x 49in, Nationalgalerie, Berlin, Germany

CLOSERlook

LIKE THE MADONNA
Apart from the semi-nudity, Danaë looks like one of Gossaert's Madonnas, down to the traditional blue robe.

CONTRASTS The sharply focused marbled columns and classical motifs vie with the figure for attention.

Quentin **Massys**

Portrait by Theodor Galle

b **LOUVAIN, c1466**; d **ANTWERP, 1530**

Massys, also referred to as Matsys or Metsys, was the leading painter in Antwerp from about 1510 to the end of his career. His style is deeply rooted in the Netherlandish tradition, but it also shows a strong influence from Italian Renaissance art, and he may well have visited Italy at some point in his career. Like Gossaert, he included Italian motifs, especially in architectural decoration. In some of his work, the landscape backgrounds were painted by his friend Joachim Patinir.

As well as religious pictures, Massys painted portraits and genre scenes that satirized everyday life. His satires were the pictorial equivalent of *The Praise of Folly* (published in 1511), written by the great Dutch humanist Erasmus, whom he painted twice. The resulting pair of portraits influenced Hans Holbein.

LIFEline

1491 Aged 25, becomes Master of the Antwerp Painters' Guild

c1500–09 Paints *Madonna Standing with the Child and Angels*

1507–09 Paints his first dated work, an altarpiece of *St Anne*

1517 Paints two portraits of Erasmus for Sir Thomas More

▶ **Ecce Homo** *The ugly faces on the left and right evoke a jeering mob. By contrast, Christ submits to his pain and humiliation with dignified endurance. Oil on canvas, Palazzo Ducale, Venice, Italy*

◀ **Madonna Standing with the Child and Angels** *The Virgin Mary's sweet face and her blue robes falling into sculptural folds are typically Netherlandish. But the cherubs and classical architecture show that Massys was also familiar with Italian art. c1500–09, oil on panel, 19¼ x 13¼in, Courtauld Institute of Art, London, UK*

CLOSERlook

EXQUISITE HIGHLIGHTS
The Madonna's wavy hair is part of the Netherlandish tradition. Massys uses a fine brush to highlight the individual curls.

Lucas Van Leyden

Self-portrait

b **LEIDEN, c1494**; d **LEIDEN, 1533**

Lucas was a highly skilled printmaker from an early age. In an engraving entitled *Mohammed and the Murdered Monk* (1508)—made in his teens—he had already mastered figure groups in space, foreshortening, and landscape. However, what really interested Lucas were caricatures and genre scenes. He was among the first artists to make everyday life the subject, not the background, of a work of art. His prints were widely circulated at home and abroad, including Italy.

Lucas was highly rated by his contemporaries. The artist-biographer Vasari thought that some of his work was better than Dürer's—though Vasari's Netherlandish counterpart, van Mander, thought Lucas was lazy and pleasure-seeking. He was the precursor of another brilliant printmaker born in Leiden—Rembrandt.

LIFEline

c1494 Born in Leiden

1514 Becomes member of the Painters' Guild in Leiden

c1517 Paints *The Card-Players*

1521 Travels to Antwerp, where he meets Dürer

1526–27 Paints *The Last Judgement*

1527 Travels to Middleborg and meets Gossaert

1533 Dies in Leiden

▲ **The Last Judgement** *This Renaissance design, filled with nude figures, is unified by bright light, giving the impression of vast space. The light is matched by brilliant colors. 1526–27, oil on panel, Lakenhal Museum, Leiden, Netherlands*

◀ **The Card-Players** *This pioneering work set the trend for morally questionable subject matter to take center stage in a painting. The close viewpoint, revealing a player's cards, makes the viewer feel like a participant in the game. c1517, oil on canvas, 14¼ x 18¼in, Wilton House, Wiltshire, UK*

▲ **The Milkmaid** *Lucas's deft touch shows in details, such as the modeling of light and shade on the cow's flank and the texture of the tree trunks. 1510, engraving, British Museum, London, UK*

Joachim **Patinir**

Portrait by
Dürer

b **DINANT OR BOUVIGNES, c1480;** d **ANTWERP, 1524**

Patinir, also called Patenier or Patinier, was the first artist to specialize in painting landscape and to make it more important than the people in it. In addition to independent works he sometimes painted the landscape backgrounds for other artists, such as his friend Massys.

Typically, Patinir takes a panoramic viewpoint, as if scanning the landscape like a bird—or God. Craggy mountains and lush valleys dominate the nominally religious subject matter, while tiny human figures give a sense of scale. The landscape resembles Patinir's home locality, the Meuse River gorge, its steep cliffs a far cry from the flat scenery typical of the Netherlands.

As David and Bosch had already done, and Bruegel was to do, Patinir divided his landscapes into a warm brown-red foreground, a green middle ground, and a cool blue background. He also alternated light and dark areas. Together, this use of color temperature, tone, and viewpoint conveys an impression of space.

LIFEline

c1480 Born in Meuse valley

1515 Becomes a member of the Antwerp Painters' Guild in his mid-30s

c1515 Paints the *Baptism of Christ*

c1520 Paints *Landscape with St. Jerome*

1521 Meets Dürer, who attends his second wedding and describes him as a "good landscape painter"

1524 Dies; the painter Quentin Massys becomes guardian of his children

▲ **Baptism of Christ** *John the Baptist appears here in the foreground and again, preaching, in the middle ground.* c1515, oil on panel, 23¾ x 29¾in, Kunsthistorisches Museum, Vienna, Austria

▲ **Landscape with St. Jerome** *In the foreground, the hermit Jerome removes a thorn from a lion's paw. The lion becomes his pet. But the strange rock formations, the lush forests, and the avenues of space leading to a blue horizon all dwarf the human activity.* c1520, oil on panel, 29¼ x 35¾in, Prado, Madrid, Spain

CLOSERlook

ZONES OF DISTANCE Patinir divides the landscape into colored zones. St. Jerome sits in a triangle of brown. The green middle ground and blue distance shift from bright to dull, and dark to pale.

Hieronymus **Bosch**

Portrait by
Theodor Galle

b **'s-HERTOGENBOSCH, c1450;** d **'s-HERTOGENBOSCH, 1516**

Although some of his paintings are fairly traditional, Hieronymus Bosch also created pictures that rank among the most powerful and imaginative fantasy scenes in the history of art. They depict a weird world full of grotesque and horrifying creatures, giving vivid form to the fear of Hell that haunted the medieval mind. Little is known of Bosch's life and because his work is so compellingly strange it has prompted ideas that he was involved with witchcraft or heresy. However, all the contemporary evidence suggests that he was a devout Christian as well as a respected and successful citizen of the prosperous provincial town where he evidently spent all his life. His work was popular and influential (for example on Bruegel) during the 16th century, but then long forgotten. Since his rediscovery in the early 20th century he has continued to fascinate and perplex viewers.

LIFEline

c1450 Born to a family of artists in 's-Hertogenbosch, from which his name derives and where he worked all his life

1474 First documentary reference to Bosch

c1480 Paints *The Cure of Folly* —one of his favorite themes

1504 Burgundian ruler Philip the Fair commissions a large altarpiece of *The Last Judgment* (this no longer exists)

1516 Dies in 's-Hertogenbosch'; by this time his reputation has spread to Italy and Spain

1517 First record of his most famous work: *The Garden of Earthly Delights*

◄ **Nativity** *This is one of several similar treatments of the subject by Bosch and his followers. His work was greatly admired in his lifetime and was much imitated.* Oil on panel, Erasmus House, Anderlecht, Belgium

▲ **The Carrying of the Cross** *Here, the extreme close-up heightens the grotesque faces, which cram the frame around the resigned Christ. There is no depth—the viewer cannot look beyond the foreground horrors.* Oil on panel, c1485–90, 29¼ x 31¾in, Museum voor Schone Kunsten, Ghent, Belgium

▲ **Tabletop of the Seven Deadly Sins**
Bosch's concern with human wickedness appealed to the gloomy Philip II of Spain, which is why many of his paintings are in Spain. King Philip kept this table in his bedroom in the Escorial palace, near Madrid. Bosch's transparent, bright colors glow against the black background. c1480–90, oil on panel, 47¼ x 59in, Prado, Madrid, Spain

CLOSERlook

ANGER Bosch presents wrath as a drunken man brandishing a sword in a lover's tiff. More often the aggressor was portrayed as a warrior, bandit, or woman.

GLUTTONY In the Middle Ages and Renaissance, the sin of gluttony was represented by a fat man or woman, gorging on food and drink. The glutton might be accompanied by a voracious wolf, pig, bear, or hedgehog, although this man has only human attendants.

HELL A nun beats a sinner's naked body in Bosch's vision of Hell (in the bottom left circle of the tablecloth). Others are thrown into sulfurous flames or submerged in a freezing river.

> ❝... others try to paint man as he appears **on the outside**, while [Bosch] alone had the **audacity** to paint him as he is **on the inside** ❞
>
> JOSÉ DE SIGÜENZA, LIBRARIAN TO PHILIP II

Garden of Earthly Delights *Hieronymus Bosch*

c1500, oil on panel, 86⅝ x 153½in total size, Prado, Madrid ➤

Garden of Earthly Delights Hieronymus Bosch

This vast painting was evidently made for the private home of an aristocrat in Brussels, where it is first recorded in 1517, the year after Bosch's death. Although the format of a triptych (three painted or carved hinged panels) was traditionally used for altarpieces, the ribald subject matter would have been inappropriate in a church. Among the many interpretations of its meaning, one is that God's instruction to married couples to "increase and multiply" has become misdirected into a license for debauchery. Far from creating a lovers' paradise, this orgy of lustful sin leads to Hell.

Composition

Once the monochrome exterior panels of the triptych are opened, they reveal a colorful world unified by the landscape that continues across the three panels. The fantasy landscape is peopled by humans, animals, and make-believe creatures set amid lakes and strange, fleshy protuberances. A high horizon line suggests a godlike viewpoint, looking down on earth. The use of atmospheric perspective—the landscape turns blue in the background—combines with the high viewpoint to give a sense of depth.

▶ **THE CLOSED TRIPTYCH,** When the panels are shut, the two halves join to form a globe painted in shades of gray. In the top left-hand corner is the figure of God with a Bible in his lap. The image possibly represents the third day of creation before light came to an as yet people-free world—hence the lack of any color.

▲ **THE OPEN TRIPTYCH** The left-hand panel shows the Garden of Eden, the central panel the Garden of Earthly Delights (sometimes called the World Before the Flood), and the right-hand panel depicts Hell. Exactly in the center is an egg teetering on a horseman's head, speaking of the creation of life and its fragility.

◀ **THREE DISTINCT LAYERS** The general mayhem in the foreground of the central panel is bounded by a thicket. The middle layer is ordered. Naked women flaunt themselves in a central pool, while a cavalcade of ogling men ride round them in circles. In the distance, the waters part in four directions. This may refer to a biblical passage in which the waters of lust split and travel to four places through a land of paradise.

▼ **STRAWBERRY MOTIF** Exotic fruit, most of all strawberries, appear as food, shelter, and even a boat. The huge and luscious fruit are sexually symbolic. According to a writer of 1600 the triptych was called *The Strawberry Plant.*

▶ **TREE OF KNOWLEDGE** With a serpent coiled around its trunk ready to tempt Eve, the tree's forbidden fruit is ripe for the plucking. Its position, butted up to the panel join, leads the eye on to the central action.

Story

People believed fervently in the afterlife in medieval times, and Bosch's images of hellish torment would have seemed only too plausible. Bosch's extraordinary vision includes creatures out of his own imagination, medieval monsters, exotic animals like giraffes newly discovered by explorers such as Columbus, and creatures such as unicorns, on the very left of the Garden of Eden, thought to be "real" at the time.

▲ **GLUTTONY PUNISHED** A throned hybrid creature with a cauldron hat eats human beings and excretes them into a pit below. Below the throne, one man vomits into the pit while another defecates coins, and a woman is ensnared by a human tree.

◄ FOUNTAIN STRUCTURE Crab, shell, plant, human edifice—this imaginary form houses an owl peering out from the globe at its base. The owl stands for wisdom and folly, and watches God creating Adam and Eve.

▲ SELF-PORTRAIT This white face, probably Bosch's own, stares out from a construction that is part man, part egg, part tree, which mirrors the pink fountain in the left panel. The bagpipe on Bosch's hat is likely to be another sexual symbol.

▼ PIG DRESSED AS NUN One of the few characters with any clothes on at all, the pig seems to be attempting to seduce the man so he will sign away his fortune to the church. Looking at the armor-clad crouching creature beside the man, it is easy to see why the Surrealists (see p.470) took Bosch to their hearts.

◄ TRANSPARENT BALL The motif of hiding inside and emerging from fantasy structures that look both natural and artificial is repeated across the panels. Whether such imagery speaks of innocent paradise or uncontrolled debauchery is a matter of opinion. The globe may be a glass distilling chamber and refer to alchemy—making gold out of base metals—just as Christ's power raised human nature from base to spiritual.

Technique

Bosch was as technically skilled as he was imaginative. Vivid color is his hallmark, applied with fine brushes that allow minute detail. He made an underdrawing of the whole scheme, which shows through the overlying paintwork in some places. His drawing is sometimes careful, sometimes casual, just as he varied between thick brushwork and more fluid, thin application.

▲ DETAIL The accuracy of these recognizable species of birds—albeit giant sized—makes the imaginary creatures believable. Dotted highlights make the eyes beady, bright, and bird-like. All the life forms are presented with the same painstaking precision.

▲ PAINT TEXTURE The right inner panel is thinly painted and rapidly executed, in contrast to the precise detail and thicker paint of the left inner panel. Fiery light illuminates the blackness.

◄ COLOR When the panels are opened, the overwhelming impression is of green, made all the brighter by the accents of contrasting red and the pink structures. Beside the darker tonality of the panel depicting Hell and the pale human flesh, the colors appear to glow.

Pieter **Bruegel the Elder**

Pieter Bruegel
the Elder

b BREDA?, c1525; d BRUSSELS, 1569

Pieter Bruegel pioneered the painting of rural life. With wit and color, he showed peasants hunting, herding, harvesting, and enjoying themselves at feasts and festivities. Bruegel was nicknamed "The Peasant," but this is misleading, for he was a sophisticated artist and a townsman rather than a countryman. Little is known of his early years, but he spent most of his working life in Antwerp and Brussels, and he had rich, educated clients and friends, who included the geographer Abraham Ortelius.

Like many northern European painters of this era, Bruegel traveled to Italy, but Italian art seems to have had little impact on him. His lively, crowded scenes, full of frank, humorous observation, are the antithesis of the beauty and refinement of Italian Renaissance painting. Instead, he was more influenced by the Alpine scenery he crossed on his way to Italy. As a result, mountains and rocky crags appear in the landscapes he painted of the Low Countries.

LIFEline

1551 Becomes a master in the Antwerp Painters' Guild

c1552–54 Visits Italy, traveling as far south as Sicily

1555 Returns to Antwerp, where he designs engravings for print publisher Jerome Cock

1563 Marries, moves to Brussels, and begins to work primarily as a painter

1565 Commissioned to paint *The Months*, six paintings showing the seasons

1569 Dies in Brussels, leaving two infant sons, Pieter the Younger and Jan, who both go on to be painters

▼ **The Parable of the Blind** *In one of his last paintings, Bruegel uses dark humor to illustrate Christ's warning: "And if the blind lead the blind, both shall fall into a ditch."* 1568, tempera on canvas, 33¾ x 61in, Museo e Gallerie Nazionali di Capodimonte, Naples, Italy

▶ **Children's Games** *In this scene, hordes of children run amok in a town. The moral of the picture—if there is one—is unclear. Is Bruegel celebrating the innocent and imaginative— if at times cruel—behavior of these children? Or is he using the children as a metaphor for the irresponsibility and folly he sees in the adult world?* 1560, oil on wood, 46½ x 63¼in, Kunsthistorisches Museum, Vienna, Austria

CLOSERlook

DIAGONAL COMPOSITION By using a vista down the street, and setting up a strong diagonal from the bottom left to the top right, Bruegel helps pull us into the picture. The restless activity of the town is balanced by the tranquility of the Flemish countryside in the top left corner.

GIRL PLAYING WITH A TOP In the foreground, a girl bends over to play with a spinning top. Next to her, another girl bangs a drum and bursts her lungs playing a pipe.

ACROBATIC BOY In a topsy-turvy world, in which children have taken over, Bruegel shows two boys literally upside down. Setting their comical body positions against a plain wall helps attract the eye to their japes.

Landscape with the Fall of Icarus *Icarus, who flew too close to the sun, appears almost incidental in this scene. While our eye is pulled to the left—from plowman to horse to distant coastline—Icarus falls into the sea in the bottom right corner.* c1558, oil on canvas, 29¼ x 44¼in, Musées Royaux, Brussels, Belgium

◄ **The Adoration of the Kings** *This painting is remarkable for its naturalism. The figures are not idealized—Jesus struggles in the Virgin's lap, the Virgin has her face partially hidden, and the kings appear almost as caricatures. The king to the bottom left has an elongated figure, characteristic of the Mannerist style, which makes him look awkward and discomfited.* 1564, oil on oak panel, 44¼ x 33¼in, National Gallery, London

▲ **Hunters in the Snow (January)** *This is one of a series of six paintings, entitled* The Months. *The viewer's eye travels from the hunters, dogs, and trees to the people skating on the ice, and ultimately to the mountainous background. This is an example of Bruegel including Alpine scenery in a scene supposedly set in the Low Countries.* 1565, oil on panel, 46¼ x 64in, Kunsthistorisches Museum, Vienna, Austria

Jan van **Scorel**

b **SCHOORL, NEAR ALKMAAR, 1495**; d **UTRECHT, 1562**

Portrait by
Anthonis Mor

Jan van Scorel was one of the first artists to bring the ideas of the Italian Renaissance to the area we now call Holland. His best paintings show that he grasped the Renaissance sense of monumentality, achieved through the use of linear perspective. Furthermore, his figures have a sculptural solidity reminiscent of Andrea Mantegna, while his palette could be as colorful as the best of Venetian painting.

Pope Adrian VI acknowledged Scorel's devotion to Italy—and its classical heritage—by appointing him curator of the papal collection of antiquities, a highly privileged position previously held by Raphael. Scorel was an amateur archaeologist, engineer, ecclesiastic, and cultivated man of letters as well as a painter of religious works and portraits. From 1524, he lived in the Low Countries, mainly in Utrecht. His pupils included Marten van Heemskerck and Anthonis Mor.

LIFEline

c1512 His training probably includes brief period with Gossaert in Utrecht

1518–24 Visits Italy and during this period makes pilgrimage to holy Land

1524 Settles in Utrecht, where he spends most of the rest of his life

1550 Visits Ghent to restore van Eyck altarpiece

► **Head of a Girl** *This unknown girl has a remarkably gentle expression of thoughtfulness, resignation, and sadness.* Undated, Kunsthistorisches Museum, Vienna, Austria

▲ **Adam and Eve in Paradise** *This painting shows van Scorel's mastery of atmospheric perspective. In the distance, the landscape turns from green to blue and details become less distinct, helping create a great sense of recession.* 16th century, tempera on panel, Johnny van Haeften Gallery, London, UK

Marten van **Heemskerck**

b **HEEMSKERCK, 1498**; d **HAARLEM, 1574**

Self-portrait

Named after his birthplace in Holland, Heemskerck studied with Cornelis Willemsz and Jan Lucasz in Haarlem, and briefly but more significantly under Jan van Scorel in Utrecht.

In the early 1530s, Heemskerck lived in Rome, where he spent a lot of time sketching architecture, sculpture, and the paintings of Raphael and Michelangelo. This experience had a profound effect on his art. He adopted the muscle-bound figures and animated compositions of Michelangelo and helped to popularize mythological subject matter in the Low Countries. He proclaimed his identification with Rome by painting a self-portrait in 1553 in front of the Colosseum—the timeless symbol of the Eternal City. From 1548 onward, he also produced many designs for engravings.

LIFEline

1498 Born in Heemskerck, the son of a farmer

c1527–29 Studies with Jan van Scorel

1532–36 Travels to Italy

1537 Returns to Haarlem

1554 Is made deacon of the Guild of Saint Luke

1572 Moves to Amsterdam when the Spanish lay siege to Haarlem

1573 Returns to Haarlem, where he dies the following year

CLOSERlook

DIAGONALS The dramatic diagonals created by Christ's arms are echoed by the figures in the foreground and the clouds in the background.

► **The Crucifixion** *Christ occupies an unusually small part of this picture, but, set against the dark cloud, He immediately attracts the eye. The drama is enhanced by the deep space, from the figures close to the picture plane through to the background landscape.* c1530, oil on panel, 15¼ x 14¼in, Detroit Institute of Arts, Detroit, US

▲ **Pieter Jan Foppeszoon and His Family** *This lively group portrait is strikingly original. Its array of food looks forward 17th-century still-life paintings. The laughter of the two children, rarely seen in portraiture of this era, foreshadows Frans Hals.* 1530, oil on panel, 46¾ x 55in, Gemäldegalerie Alte Meister, Kassel, Germany

▲ **Momus Criticizes the Work of the Gods** *This painting of Momus, a Greek god who was banished from Mount Olympus, shows that Heemskerck was well-acquainted with anatomy. Momus stands in front of a legend that starts: "My name is Momus, born of Night, without a father, the comrade of Envy. I enjoy criticizing each individual thing."* 1561, oil on panel, Bode Museum, Berlin, Germany

Anthonis **Mor**

Self-portrait

b UTRECHT, c1516–20; d ANTWERP, 1576?

A pupil of Jan van Scorel, Mor became one of the most celebrated portraitists of the 16th century. His strong, severe portraits won him commissions at the courts of England, Germany, Spain, Portugal, and Italy.

Mor's portraits often convey a penetrating insight into character, revealing not just the dignity and solemnity that befitted his royal and aristocratic sitters, but also thoughtfulness and even a faraway wistfulness. Unlike Hans Holbein—the leading court portraitist of the previous generation—he used *chiaroscuro* (light and shade) to define facial features. And he usually painted his sitters with their head slightly turned.

Mor's most important patrons were Cardinal Granvelle, a key figure at the Hapsburg court, and later Philip II, King of Spain. The painter is often better known by the Spanish version of his name, Antonio Moro.

LIFEline

c1516–20 Born in Utrecht

1547 Becomes a member of Guild of St. Luke at Antwerp

1549–50 Travels to Rome with his patron, Cardinal Granvelle

1554 Travels to England, where he paints the portrait of Queen Mary I

1573 A document shows he is settled in Antwerp, where he probably dies in 1576

▶ **Portrait of a Noblewoman with a Puppy** *A three-quarter-length view, with the head slightly turned, is typical of Mor's portraits.* 1555, oil on oak panel, 42¼ x 30¾in, Gemäldegalerie Alte Meister, Kassel, Germany

◀ **Queen Mary I** *Mary was the elder daughter of Henry VIII. In 1554, aged 38, she became the wife of Philip II of Spain. This portrait was painted in connection with her marriage.* 1554, oil on panel, 42¾ x 33¼in, Prado, Madrid, Spain

CLOSERlook

PINK ROSE The rose adds a delicate touch to an otherwise austere painting. With its use of *chiaroscuro* (light and shade) and wary expression, this differs from other Tudor portraits, perhaps to emphasize Mary as a Hapsburg consort not an English queen.

Frans **Floris**

b ANTWERP, c1519; d ANTWERP, 1570

Frans Floris played a huge role in disseminating Italian ideas in the Low Countries. In the 1540s he studied in Rome, where he filled sketchbooks with drawings of classical sculpture and the frescoes of Michelangelo.

On his return north, Floris ran a successful workshop in Antwerp with his brother Cornelis, a sculptor and architect who designed Antwerp Town Hall. Floris painted large religious and mythological pictures in the Mannerist style—crowded with athletic figures in the midst of action.

During the Reformation, Antwerp remained Catholic apart from two waves of iconoclasm, in 1566 and 1581. Floris has been seen as a Catholic propagandist—his *Fall of the Rebel Angels*, for example, can be interpreted as virtuous Catholics fighting off heretical Reformers.

LIFEline

c1537 In his late teens, studies in Liège with painter Lambert Lombard

1540s Studies in Rome

1554 Paints *Fall of the Rebel Angels*

1570 Dies in Antwerp

▶ **Portrait of an Elderly Woman, or The Falconer's Wife** *Floris was a gifted portraitist, forthrightly characterizing his sitters. His frank, assertive style and bold brushwork anticipates the portraiture of Frans Hals.* 1558, oil on panel, 42½ x 32¾in, Musée des Beaux-Arts, Caen, France

▲ **Fall of the Rebel Angels** *This painting, showing St. Michael fighting the devils, was the middle panel of a triptych for the altar in the Church of Our Lady, Antwerp. Floris was clearly inspired by the writhing, muscular bodies in Michelangelo's* Last Judgement, *which was unveiled while he was in Rome.* 1554, oil on panel, 121 x 87in, Koninklijk Museum voor Schone Kunsten, Antwerp, Belgium

INcontext

ANTWERP For much of the 16th century Antwerp was the leading port in northern Europe. Through it, England traded with continental Europe, and exotic goods, such as pepper and silver, were imported from newly discovered parts of the world. Artists were attracted to Antwerp by its new art-buying middle class.

Antwerp Town Hall *Built between 1561 and 1565 to the design of Cornelis Floris, this is one of the great Renaissance buildings of the north.*

Stefan **Lochner**

b **MEERSBURG, c1410;** d **COLOGNE, 1451**

Noted for his characteristic "soft" style, Lochner created poetic, gentle paintings, often of the Madonna accompanied by angels. In the mid-1800s, these images were a major inspiration for the group of English painters known as the Pre-Raphaelite Brotherhood.

Lochner's work belongs to the late Gothic style and looks back to medieval devotional art, especially in his extensive use of gold and ultramarine. Yet his paintings also show his familiarity with contemporary art, especially that of Robert Campin and Jan van Eyck. He included a wealth of naturalistic detail, and, in contrast to the flatness of medieval art, his figures are sculptural and occupy three-dimensional spaces.

LIFEline

c1410 Born in Meersburg, in southwest Germany
c1430s Moves to Cologne
c1440–45 Paints *Adoration of the Magi* altarpiece for Cologne Cathedral
1447 Joins Cologne town council
1451 Dies in Cologne, in his early 40s

▶ **The Adoration of Christ**
This nativity scene with its attendant angels and farm animals epitomizes Lochner's painting. The subject, composition, and style all speak of harmony and tenderness. c1445, oil on panel, 15 x 9¼in, Alte Pinakothek, Munich, Germany

▲ **Adoration of the Magi** *The use of gold in the background and for Christ's halo was a medieval convention, symbolizing holiness. However, in Renaissance style, Lochner places the figures in correctly measured space and records minute detail, especially in the robes of the kings.* c1440–45, oil on panel, central panel of an altarpiece, Cologne Cathedral, Germany

Konrad **Witz**

b **ROTTWEIL, c1400;** d **BASEL, c1446**

Very little is known of Konrad Witz's life, except that he spent most of his career in Basel, probably attracted by the opportunities for commissions at Pope Martin V's great Church Council (1431–37). Witz developed a specific naturalistic style—his religious paintings provide a direct sense of nature, not the rarefied, fabled atmospheres of his predecessors. His figures are expressive and solidly modeled, and the light falls naturally, casting shadows and shimmering on water.

Witz's most celebrated picture, *The Miraculous Draught of Fishes*, is remarkable in many ways. The location is specific—not the Holy Land, but Lake Geneva. It is one of the first examples of a topographical view—one that shows an identifiable landscape—and Witz has ensured it is recognizable, defining the fields, houses, and trees, and the Savoy Alps in the background. Moreover, real people inhabit this real landscape. The disciples look ungainly, struggling with the tackle and oars, and the wading St. Peter looks unstable, with his legs distorted below the water and arms held helplessly above it.

LIFEline

1440 Born in Rottweil in southwestern Germany
1434 Becomes a master painter in the Basel Guild
1435 Marries Urselin von Wangen
1444 Paints *The Miraculous Draught of Fishes*
c1446 Dies in Basel, leaving a wife and five children

▼ **The Miraculous Draught of Fishes** *Witz merges three stories—the miraculous catch of fish, Christ walking on water, and the resurrected Christ calling seven disciples.* 1444, oil on panel, 52 x 59in, Musée d'Art et d'Histoire, Geneva, Switzerland

▲ **Cardinal François de Mies Presented to the Virgin and Child** *Witz delights in showing the sheen, color, and detail of de Mies's robe as he is introduced to the Virgin and Child by St. Peter.* 1444, oil on panel, 52 x 61in, Musée d'Art et d'Histoire, Geneva

CLOSERlook

WATER The treatment of the water is remarkably naturalistic. The reflections of the architecture and light shimmer on its surface. In the foreground, by contrast, the water is translucent, revealing murky depths, with green slime and stones on the lake bed.

Martin **Schongauer**

b **COLMAR?, c1450**; d **BREISACH, 1491**

The son of a goldsmith from Augsburg, Martin Schongauer was the greatest engraver of his generation. He brought a painterly quality to engravings, using a broken, fluid line that enabled him to capture the solid form and tactile quality of his subjects. The refined sensitivity of his work gave rise to such nicknames as *Hübsch* (charming) Martin and *Schön* (beautiful) Martin.

Although his work was late Gothic in style, Schongauer was widely admired by High Renaissance artists, especially Dürer. Giorgio Vasari (see p.178) noted in his *Lives of the Artists* that Michelangelo copied Schongauer's *Temptation of St. Anthony*. Very few paintings are definitely attributable to Schongauer; but 115 engravings are known to be his, all signed with his distinctive monogram.

LIFEline

c1450 Born, probably in the town of Colmar in Alsace
1465 Enrols at the University of Leipzig
1473 Paints *Madonna of the Rose Bower* altarpiece
1488 Is mentioned as a house-owner in Colmar
1489 Becomes citizen of Breisach
1492 Dürer travels to visit Schongauer, without knowing he has died the previous year

CLOSERlook

CONTRASTING FORMS
The solidity of the Virgin contrasts with the delicate background, which is like a tapestry of rose bushes filled with birds.

▶ **Madonna of the Rose Bower** *The detailed, twisting rose bushes echo the intertwined bodies of the Madonna and Christ — and reveal the hand of an expert engraver.* 1473 (his only dated work), oil on panel, 79 x 45¼in, Church of St Martin, Colmar, France

▼ **The Temptation of St. Anthony** *Schongauer shows St. Anthony—a Christian monk who fled to the Egyptian desert to escape persecution—assailed in mid-air by fantastic demonic creatures.* c1475, engraving, Uffizi, Florence

Michael **Pacher**

b **BRUNECK?, c1435**; d **SALZBURG, 1498**

Both a wood carver and a painter, Michael Pacher was one of the leading Austrian artists of the 15th century. While his sculpture is late Gothic in style, his painting is influenced by Italian Renaissance art, especially Andrea Mantegna. However, his rich narrative vein led him to a complex, inventive, and almost visionary painting style.

One of the first German-speaking artists to master perspective fully, Pacher exploited this skill in his painting by using low viewpoints and depicting foreshortened figures close to the picture plane.

His great work, the extraordinarily elaborate St. Wolfgang altarpiece, remains intact in the Salzburg church it was made for. Illustrating Pacher's skill as both a sculptor and a painter, it comprises 16 painted compartments, a central carved relief of the Coronation of the Virgin, and an ornate crowning piece showing the Crucifixion. The exterior wings show scenes from St. Wolfgang's life.

▶ **The Raising of Lazarus, from the St. Wolfgang Altarpiece** *With its dramatically receding perspective, low viewpoint, and figures close to the picture plane, this painting shows an awareness of Italian art. But Pacher uses perspective to create an eccentric, multi-faceted space in which the light seems to vibrate against the fantastic architecture.* 1479-81, oil on panel, Church of St. Wolfgang, Salzburg, Austria

▲ **The St. Wolfgang Altarpiece** *This shows the Coronation of the Virgin, flanked by paintings of the Nativity (top left), the Circumcision (bottom left), the Presentation of Christ in the Temple (top right) and the Death of the Virgin Mary (bottom right).* 1471–81, pine and limewood sculpture with oil on panel painting, center 153 x 124in, Church of St. Wolfgang, Salzburg, Austria

INcontext

ARTISTIC CROSSROADS The Tyrol in the Alps, where Pacher spent most of his working life, was an important crossroads between northern Europe and Italy. Pacher was a product of both cultures. His figures, for instance, are anatomically correct in line with Italian art, yet their features and intense expressions often owe more to northern art. Pacher's precise perspectives show Italian influence, but he paints vernacular and Gothic architecture, rather than the classical buildings favored by Italian artists.

The View Toward the Fenderthal, Tyrol *by James Vivien de Fleury (1870).*

Albrecht **Dürer**

Self-portrait

b **NUREMBERG, 1471**; d **NUREMBERG, 1528**

The greatest German artist of the Renaissance, Dürer was a brilliant draftsman, and his paintings rivaled those of his Italian contemporaries. His minutely detailed, subtly toned prints elevated the printmaking medium to a new level of accomplishment. Like his contemporary Leonardo da Vinci, Dürer found wonder in everyday subject matter. He was the first to paint realistic watercolors—one of the most famous showing a simple sod of turf, beautifully and accurately observed. Also like Leonardo, he had skills beyond art—in the 1520s, he published books on measurements, fortifications, and proportion in the human body.

LIFEline

1484 Aged 13, creates an exquisite self-portrait in silverpoint
1486 Apprenticed to painter Michael Wolgemut
1494 Visits Italy
1498 Publishes *Apocalypse*—the first book printed entirely by an artist
1505 Visits Italy again, staying mainly in Venice
1507 Returns to Germany
1520 Travels to the Netherlands
1528 Dies in Nuremberg

CLOSERlook

THE EYE Dürer faithfully records his imperfections—here, he shows his right eye as larger and lower than his left one. There is also psychological insight—he is clear-eyed, but with a look of foreboding.

▶ **Virgin and Child with a Pear** *This is one of many Virgin and Child paintings by Dürer. The Virgin is portrayed with delicacy, while the Child is depicted more robustly. 1512, oil on panel, 19¼ x 14¾in, Kunsthistorisches Museum, Vienna, Austria*

▲ **Self-Portrait** *Dürer believed that his artistic mission reflected that of Jesus, and here he seems to have deliberately painted himself as a Christ-like figure. Jesus was often shown in full-frontal, symmetrical compositions like this one. The darkened tone of the background creates a mood of sanctity. His fingers hold a piece of the fur he is wearing, possibly alluding to his profession as a painter in its resemblance to a brush. 1500, oil on panel, 26¼ x 19¼in, Alte Pinakothek, Munich, Germany*

◀ **St. Jerome in his Study** *Dürer shows St. Jerome (with his legendary companion, the lion) in contemplative solitude—a subject that would have appealed to the educated Renaissance elite. 1514, engraving, 9¼ x 7½in, Bibliothèque Nationale, Paris, France*

CLOSERlook

THE FALL OF LIGHT Dürer achieved a unique subtlety of shading and richness of texture. His dedication to registering the fall of light here seems to echo the dedication of St. Jerome in his studies.

▲ **Adam and Eve** *Eve receives the apple from the serpent, while Adam stretches his hand out to take it. Dürer based the figure of Adam on the Apollo Belvedere, a famous classical sculpture. 1504, engraving, 9¾ x 7½in, British Museum, London, UK*

▲ **Festival of the Rose Garlands**
Dürer created this altarpiece for the German church of S. Bartolomeo in Venice. His aim was to show he could compete with Venetian painters and "silence those who said I was good as engraver, but did not know how to handle colors in a painting." 1506, oil on panel, 64 x 76in, Národní Galerie, Prague, Czech Republic

❝ What **beauty** is, I know not, though it **adheres** to **many things** ❞

DÜRER'S EPITAPH

CLOSERlook

EMPEROR MAXIMILIAN I
Many important people appear in the painting, including Pope Alexander VI, kneeling to the left of the Madonna. This is Emperor Maximilian I—one of Dürer's most important patrons—on whose head the Madonna is placing a crown of roses.

THE ARTIST HIMSELF
Dürer painted himself among the exalted company in this picture. He wears a luxurious fur cloak and grabs attention by turning his head to the viewer. He is holding a document with his name, the date of the painting, the time it took him to complete it—five months—and, significantly, his nationality.

INcontext

PIONEER OF SELF-PORTRAIT
Dürer was the first artist to make a series of self-portraits—both drawn and painted—at different ages. They reveal a successful and self-assured man. Dürer's travels in Italy showed him that the artist need not be a humble, provincial craftsman but could be celebrated and revered. In Venice, he wrote to a friend in Germany, "Here I am a gentleman, there I am a parasite."

Self-Portrait with Gloves *by Albrecht Dürer (1498).*

Mathis **Grünewald**

b **WÜRZBURG, c1475/80**; d **HALLE, 1528**

Although he lived during the Renaissance, Grünewald in many ways looked back to medieval art. While Italian painters sought to reveal beauty, he had a simpler and older aim—to deliver sermons. He did this using expressive distortion and brilliant color, to astonishing effect.

Grünewald's undoubted masterpiece is the *Isenheim Altarpiece*. It was painted for the hospital church of the abbey at Isenheim in Alsace, now in France. Christ is first shown in darkness on the cross—dirty, lacerated, and disfigured—and then resurrected, with spotless skin against golden light. Looking at this altarpiece, the patients at the hospital would be able to see their own suffering as part of a divine plan.

LIFEline

1475/80 Born in Würzburg
1504–05 Works in Aschaffenburg, near Frankfurt
1510 Employed by the archbishop of Mainz
c1512–15 Works on the *Isenheim Altarpiece*
1525 Moves to Frankfurt, after the archbishop's palace is besieged during the Peasant's War
1527 Flees to Halle, where he dies of plague a year later

▲ **The Annunciation** *When the altarpiece is opened, it reveals the second face. This shows the Annunciation, the choir of angels, the Nativity with the divine spirit hovering overhead, and Christ's Resurrection against a stunning halo of light. Unusually, in the Nativity scene, there is an everyday chamber pot and washtub.*

▲ **Isenheim Altarpiece**
Grünewald's altarpiece has three faces. The various wings were opened and closed in accordance with dates on the liturgical calendar. This first face shows the Crucifixion, flanked by portraits of St. Anthony and St. Sebastian. The bottom panel—known as the predella—*shows the entombment of Christ. c1512–15, oil on panel, Musée d'Unterlinden, Colmar, France*

CLOSERlook

IN HORROR The Virgin and John the Evangelist recoil in horror. John's face echoes that of Christ—his mouth agape, head cast down and tilted to the left.

HANGING HEAD Christ's hanging head, with its fearsome crown of thorns, and his disfigured body are full of horror. Wounds dripping with bright red blood cover the whole body.

IMPALED Christ's hand is shown graphically impaled on the rough-hewn log. While the body slumps, Christ's fingers twist upward in agony, or perhaps rigor mortis. The upraised fingers are echoed by those of Mary Magdalene—she holds her hands and fingers up in prayer.

Albrecht **Altdorfer**

b REGENSBURG?, c1480; d REGENSBURG, 1538

Altdorfer was the leading member of the Danube School, which also included Lucas Cranach and Wolfgang Huber. Although working independently, all these artists used landscape prominently, to add drama and realism to the stories they told. Altdorfer's unique contribution was to make pictures that had no story, and were nothing but landscape. In doing so, he instigated a new genre of painting.

One of Altdorfer's early works shows the tiny figure of St. George, overwhelmed by a great forest. His celebrated altarpiece (now dismembered) for the Austrian abbey of St. Florian featured magnificent skyscapes, and he used dramatic skies again to heighten the emotional impact of *The Battle of Issus*.

As well as painting, Altdorfer produced prints and worked as an architect. Although none of his buildings survive, his skill at handling tricky perspective is evident in several paintings.

LIFEline

c1480 Born, probably in Regensburg

1505 Granted the citizenship of Regensburg

1509 Begins work on the altarpiece for the Austrian abbey of St. Florian, which he completes 7 years later.

1512–13 Works for Emperor Maximilian I

1526 Appointed city architect of Regensburg

1538 Dies in Regensburg

▶ **The Battle of Issus** *This painting shows Alexander the Great's victory over the Persian army of King Darius III in 333 BCE. Altdorfer's depiction manages to be both historical and visionary at the same time. He gives a remarkable bird's-eye view over the teeming, ant-like armies and a mountainous northern landscape below a swirling sky with a triumphant sun.* 1529, oil on panel, 62 x 47¼in, Alte Pinakothek, Munich, Germany

▲ **The Large Spruce** *Altdorfer produced some of the first prints of pure landscape subjects in European art, as well as some of the first landscape paintings. His etchings are free and vigorous in style.* c1520, etching, 9¼ x 7⅛in, Fitzwilliam Museum, Cambridge, UK

◀ **Christ taking Leave of His Mother** *Christ, accompanied by St. Peter and St. John the Evangelist, leaves for Jerusalem to face his coming death. The Virgin—attended by holy women—is prostrate with grief. Altdorfer has elongated the figures and enlarged their hands and feet, allowing him to add drama to the gestures and stances.* c1520, oil on panel, 55 x 42¾in, National Gallery, London, UK

Hans **Baldung**

b SCHWÄBISCH GMÜND, 1484/85; d STRASBOURG, 1545

Baldung, who spent most of his life working in Strasbourg, was one of the most expressive painters of the northern Renaissance. He painted many religious works, but is now known for his gruesome allegorical paintings and erotic nudes. He was fascinated with death, witchcraft, and suffering and painted these subjects with dramatic color and distorted figures.

◀ **Woman and Death** *Baldung painted women with Death many times. This reflected popular notions, based on the story of Eve, that women were powerfully seductive and associated with evil.* c1517, tempera on panel, 11¾ x 7¼in, Kunstmuseum, Basel, Switzerland

Lucas **Cranach**

b **KRONACH, 1472;** d **WEIMAR, 1553**

Cranach was one of the most successful and innovative artists of the Northern Renaissance. He was fascinated by the old forests and romantic vistas of Germany, and used them as settings for his biblical and classical stories. He was also fond of erotic, coquettish nudes—which had little precedent in either Italian or northern European art.

Cranach became truly successful in Wittenberg, where he worked as court painter to Frederick III (the Wise). He was great friends with Martin Luther, and became known as the official artist of the Lutheran Reformation. He also ran a flourishing studio, and his paintings, especially those showing female beauty, were eagerly sought by collectors.

LIFEline

1472 Born in Kronach

1501 Establishes his reputation in Vienna, working in the humanist circle around the newly founded university

1504 Moves to Wittenberg to become court painter for Frederick III (the Wise) of Saxony

1519 Is elected to Wittenberg Town Council

1522 Creates woodcuts for Martin Luther's first German translation of the New Testament

c1528 Paints *The Judgement of Paris*

1550 Follows John Frederick (the Unfortunate) into exile in Augsburg

1553 Dies in Weimar, in his 80s

▶ **Henry, Duke of Saxony** *Cranach uses a full-length format, which was unusual in the early 1500s. This format allows him to create an image of power, with the assertive pose and fine dress shown in their entirety.* 1514, oil on wood, 72 x 32¾in, Gemäldegalerie Alte Meister, Dresden, Germany

▼ **Portrait of Dr. Johannes Cuspinian**
Dr. Cuspinian was a lecturer at the University of Vienna, so appropriately he is shown with a book. His upturned face gives him the air of an erudite Renaissance humanist. This portrait was intended to be seen next to that of his wife, Anna (right), as a diptych, and the landscape runs across the two paintings. 1502–03, oil on panel, Dr. Oskar Reinhart Collection, Winterthur, Switzerland

▲ **The Judgement of Paris**
Cranach transports this story from classical mythology to a Germanic forest. Paris is dressed as a Teutonic knight in a suit of armor, while Mercury, in the guise of a Norse god, stands nearby holding a glass orb in place of the golden apple. c1528, oil on wood, 40¼ x 28in, MoMA, New York, US

◀ **Portrait of Anna Cuspinian**
When side by side, Anna and her husband Johannes are framed by two trees, one to the right of Anna, the other to the left of Johannes. 1502–03, oil on panel, Dr. Oskar Reinhart Collection, Winterthur, Switzerland

CLOSERlook

EROTICALLY ADORNED
Cranach often adorned his nudes with necklaces and large hats, as he does here with Venus, the Roman goddess of love.

Hans **Holbein**

Self-portrait

b AUGSBURG, c1497; d LONDON, 1543

Holbein was a man of versatile artistic talents. At the beginning of his career, he worked in Switzerland as a book designer and printmaker, and also painted mural decorations for government buildings. When he became the court artist to Henry VIII of England, he made designs for all manner of decorative arts—from buttons, jewelry, and goblets to costumes for pageants, furniture, and architectural details.

However, it is as a portraitist that Holbein is most renowned. He created magnificent large portraits, such as *The Ambassadors*, that radiated wealth and power. His wall painting at Whitehall Palace, showing Henry VIII with his parents and third wife, Jane Seymour, is said to have "annihilated" and "abashed" visitors. But some of Holbein's best works in England were exquisitely detailed miniatures – portraits that would sit in the palm of the hand. These paintings could be presented to visiting dignitaries or sent abroad with ambassadors. They were also in demand as keepsakes—tokens of love and desire in an age of courtly love.

LIFEline

c1497 Born in Augsburg

1515–19 Works in Basle

1521 Paints *Body of the Dead Christ in the Tomb*

1524 Visits Paris

1526 Visits Sir Thomas More in England and paints portrait of the More family, now lost

1528 Returns to Basle to complete his mural decoration in the council chamber of the town hall

1532 Moves to London permanently, leaving his wife and two children in Basle

1533 Paints his most famous portrait—*The Ambassadors*

c1536 Becomes court painter for Henry VIII

1543 Dies in London

▶ **Portrait of Erasmus** *Erasmus was an admired humanist scholar. In this portrait, Holbein looks forward to* The Ambassadors *by surrounding the sitter with objects that reflect his interests. 1523, oil and egg tempera on panel, 29¼ x 20½in, private collection*

▼ **The Body of the Dead Christ in the Tomb** *Rarely has Christ been shown as here— dead in His tomb, when He was neither man nor deity. Holbein's image is harrowing: the eyes and the mouth are open, the hand looks like a claw, and rigor mortis seems to have set in. 1521, oil on panel, 12¼ x 79in, Kunstmuseum, Basle, Switzerland*

CLOSERlook

CENTER OF THE WORLD The globe under Dinteville's left arm bears the name of his château at Polisy, near Troyes, as if it was at the center of the world. The painting was first hung in this château.

DISTORTED SKULL This is an example of anamorphosis, where an object is only seen in the correct perspective if viewed from an angle—in this case from the right. Skulls were often used in 16th- and 17th-century painting to symbolize mortality.

▲ **Portrait of Anne of Cleves** *Henry VIII was looking for a new wife and sent Holbein to paint a prospective bride—Anne of Cleves. Henry clearly liked what he saw, and married Anne in 1540, but he had the marriage annulled later that year. 1539, oil on canvas, 25¾ x 18¾in, Louvre, Paris, France*

◀ **The Ambassadors** *This powerful and detailed painting shows Jean de Dinteville, French Ambassador at the court of Henry VIII, and his friend Georges de Selve, Bishop of Lavaur. Around them, the musical, astronomical, and scientific instruments testify to their learning, success, and wealth. 1533, oil on panel, 81 x 83in, National Gallery, London, UK*

Tilman **Riemenschneider**

b **HEILIGENSTADT, c1460;** d **WÜRZBURG, 1531**

A contemporary of Dürer, Riemenschneider was southern Germany's leading sculptor of this period, and one of the last to work in the late Gothic style. Although he also sculpted in alabaster, sandstone, and marble, he is best known for his limewood altarpieces. Riemenschneider was among the first sculptors to leave his woodwork unpainted, just using pigmented varnish and touches of color on lips and eyes. His early figures relied on the complex play of light and shade, but his mature work became more simplified and flattened.

Riemenschneider was probably apprenticed in Strasbourg and Ulm, both centres for sculpture. He spent most of his working life in Würzburg, where he had a large workshop. However, his career came to an abrupt halt when he sided with the peasants who revolted against the city's prince-bishop.

LIFEline

1485 Aged about 25, becomes a citizen of Würzburg and a member of the Painters' Guild of St. Luke

1490–92 Carves *Münnerstadt* altarpiece for the church of Mary Madgalen

1501–05 Carves the *Holy Blood* altarpiece for the Jakobskirche in Rothenburg

1504 Elected to Würzburg city council

1520–21 Elected mayor

1525 Is arrested and probably tortured after the Peasants' Revolt. Part of his estate is confiscated

1531 Dies, and is buried in the cathedral cemetery

> ▶ **Assumption of the Virgin** *This early work uses the play of light and shade on deep carving to make the figures expressive.* 1505–10, limewood, central panel of the altar, Herrgottskirche, Creglingen, Germany

▼ **Tomb of Henri II and his Wife Kunigunde** *The sides of the tomb are carved with reliefs depicting the couple's lives. In this one, Kunigunde is subjected to trial by fire on suspicion of adultery.* 1499–1513, stone, Bamberg Cathedral, Bavaria, Germany

Bernt **Notke**

b **LASSAN, POMERANIA?, c1440;** d **LÜBECK, c1509**

The painter and sculptor Bernt Notke was the leading woodcarver around the Baltic, and the north German counterpart to Stoss. He had a strong personality, matched by the huge scale he worked on. His *Dance of Death* frieze (1463–66) was 100 feet long, while his *Triumphant Cross* group (1470–77) was 56 feet high.

Notke made his reputation with the *Triumphant Cross* in Lübeck Cathedral, which consisted of 78 figures, all the large ones carved from single tree trunks. Its size was unprecedented, as was Notke's use of strips of leather for veins and plaited cords as fabric trims. These materials both increased the realism and speeded up work. Notke is perhaps best known for his sculptural group of *St. George and the Dragon* (1483–89). Again he used real materials: hair, elk antlers on the dragon, and coin imprints to decorate the armor and horse's bridle.

LIFEline

1467 Is first recorded in Lübeck, as a painter

1470–77 Sculpts *Triumphal Cross* for Lübeck Cathedral

1483–89 Sculpts *St. George and the Dragon* in Stockholm

1499 Creates his last great work, the *Mass of St. Gregory*, for Marienkirche, Lübeck

1505 Made Master of Works in Lübeck

▲ **Dance of Death** *Called the Totentanz in German, a Dance of Death is an allegory on the certainty of death for everyone. Under each figure are the words with which Death invites them to dance, and their reluctant response.* 1463–66, tempera on linen (detail), 63 x 295in, St Nicholas's Church, Art Museum of Estonia, Tallinn, Estonia

CLOSERlook

THE POPE Emaciated skeletal figures, representing death, take the hand of a row of figures from pope to peasant. The pope and emperor were at the top of the medieval hierarchy.

THE EMPRESS Her finely embroidered robe and elaborate headdress will soon be stripped away by the ultimate equalizer, Death. Dances of Death were popular at this time, as a reminder of how fleeting material goods are in the face of the fragility of life.

Veit **Stoss**

b **HORB AM NECKAR?, c1450;** d **NUREMBERG, 1533**

▲ **The Assumption of the Virgin Mary** *The faces are full of character, while swoops of fabric, defined in paint, add to the theatricality.* 1477–89, wood, altarpiece of St. Mary's Church, Kracow, Poland

Best known for his bold woodcarving, usually painted, German-born Stoss also worked in stone, and was a painter and engraver. His masterpiece was the huge altarpiece for St. Mary's Church in Kracow, Poland.

Stoss later returned to Nuremberg where, in 1503, he forged a document to recover an investment. When his forgery was discovered, Stoss was tried, convicted, his cheeks branded, and confined to the city. He escaped being blinded or killed only through the intervention of the prince-bishop of Würzburg. Stoss carried on working, his career somewhat blighted, and six of his sons went on to work as artists.

The painter and biographer Giorgio Vasari (1511–74) was the first to use the word *maniera* ("stylishness") to praise the work of his contemporaries in the 16th century. However, as "Mannerism" it became a disparaging label for later critics who dismissed work in this vein as an affected transition between the Renaissance and the Baroque. In the 20th century the term began to be used neutrally, but with differing opinions as to exactly what style and period it defines.

Origins and influences

The roots of Mannerism were in Italy. It is sometimes specifically traced to Rome and the followers of Raphael after his death in 1520. Some scholars see Mannerism as a reaction against the classical harmony of Raphael and

▲ **The Conversion of St. Paul** Parmigianino *The dramatic tension and movement of Parmigianino's work are characteristic of Mannerism.* c1527–30, oil on canvas, 69⅞ x 50⅝in, Kunsthistorisches Museum, Vienna.

his High Renaissance contemporaries such as Leonardo and Michelangelo, others as an evolution from elements in their work. Most definitions of the Mannerist style are in terms of either the distortion or refinement of late Renaissance ideals.

Style and technique

Mannerist style can be seen as either refined and emotional, or affected and decadent, but there are stylistic elements that can be agreed upon. It was a courtly style, but beneath the elegance and technical brilliance there is often an element of emotional disturbance. Tension and drama were achieved by the use of elongated figures in exaggerated poses, bold colors and lighting, and a dramatic distortion of scale and perspective.

After the High Renaissance in Italy there followed a period in which painting, sculpture, and architecture broke with many of the classical conventions. The term Mannerism was later adopted to describe both the period and its stylistic characteristics.

Mannerism

TIMEline

Mannerism began to develop around the time of Raphael's death in 1520. It flourished in Florence, Rome, and other cities, including Parma. Expatriate Italians, and artists trained in Italy, helped spread Mannerism to other countries in Europe throughout the 16th century, establishing it as the "house style" of several courts. The period came to a close with the emergence of the Carracci brothers and Caravaggio in about 1600.

1525–28

PONTORMO The Deposition of Christ

1534–40

PARMIGIANINO Madonna with the Long Neck

c1540–50

BRONZINO An Allegory with Venus and Cupid

1541–43

PRIMATICCIO The Holy Family with Elizabeth and St. John the Baptist

c1580–82

SPRANGER Hercules, Deianeira, and the Centaur Nessus

1586–88

EL GRECO The Burial of Count Orgaz

Schools

Mannerism began and flourished in Italy, but the style was influential elsewhere in Europe. In essence it is a sophisticated, sometimes rather inbred style, so it is not surprising that its most refined manifestations were produced for courtly settings. Italian artists were employed at several foreign courts (particularly at Fontainebleau in France) and Mannerist influence was also spread widely by engravings.

Italy

Florence was the principal setting for Italian Mannerist art. Jacopo Pontormo exemplifies the style at its most emotionally intense and Agnolo Bronzino at its most lasciviously chic. Slightly later, Giorgio Vasari shows how the style could easily degenerate into elegant but rather empty posturing. Mannerist sculpture also flourished in Florence, particularly in the work of Benvenuto Cellini (see p.177) and Giambologna (see p.179). Apart from Florence, Rome was the main home of the style, with Michelangelo (in his later work) its most potent exemplar. Some of the most remarkable Mannerist art, however, was

▲ **Vulcan's Forge** Giorgio Vasari *Elongated figures in contorted poses were a characteristic of much Mannerist painting and sculpture. Vasari not only adopted the style, but also chronicled the lives of Mannerist painters.* 1565, oil on panel, 15 x 11in, Uffizi, Florence, Italy

produced outside the traditional major art centers, notably in Parma, where Parmigianino represents the style at its extreme of elongated elegance.

▲ **Water** Giuseppe Arcimboldo *In his witty portraits and caricatures Arcimboldo took Mannerist playfulness to extremes. His paintings were so popular he painted several versions to satisfy the demand.* 1566, oil on canvas, 26¼ x 19⅞in, Kunsthistorisches Museum, Vienna

Outside Italy

The courts at Fontainebleau in France and Prague in Bohemia were perhaps the most impressive settings for Mannerist art outside Italy. In the 1530s and 1540s King Francis I brought outstanding Italian artists (notably Fiorentino Rosso, Francesco Primaticcio, and Benvenuto Cellini) to work at his favorite residence of Fontainebleau, near Paris, which he transformed from a hunting lodge into a palace. These artists created a distinctively elegant style—featuring long-limbed, small-headed figures—that formed an influential current in French art until the end of the 16th century. In Prague, the art-loving Emperor Rudolf II (reigned 1576–1612) made his court one of Europe's most dazzling cultural centers, employing an international roster of painters and sculptors, among them Arcimboldo and Bartholomeus Spranger. The most powerful and personal interpretation of Mannerism outside Italy, however, is perhaps that of El Greco (see pp.182–83), a Cretan who spent most of his career in Spain. Although his work is intensely individual, his elongated figures have a stylistic kinship with those of other artists of the time.

Parmigianino

Self-portrait

b **PARMA, 1503;** d **CASALMAGGIORE, 1540**

Girolamo Francesco Mazzola is better known as Parmigianino—"the little one from Parma." He was a Mannerist painter and printmaker, famous for the exquisite draftsmanship of his portraits and religious frescoes. Orphaned as a small child, Parmigianino was brought up by his uncles and showed a precocious talent for art—he painted frescoes alongside Correggio in S. Giovanni Evangelista, Parma, while still a teenager.

In 1524, he travelled to Rome, where his *Self-Portrait in a Convex Mirror* impressed Pope Clement VII and led to important commissions. The Sack of Rome in 1527 forced Parmigianino to move to Bologna; then in 1530 he returned to Parma to work on frescoes in S. Maria della Steccata—a project that landed him in jail when he failed to complete the work. His highly original figure painting is seen at its best in his many portraits, and in the sensuous *Madonna with the Long Neck*.

LIFEline

1503 Born into a family of artists in Parma

1522 Meets Correggio and works with him in S. Giovanni Evangelista, Parma

1524 Paints *Self-Portrait in a Convex Mirror*, which he takes with him to Rome

1530 Returns to Parma

1534–40 Works on his masterpiece, the *Madonna with the Long Neck*

1539 Imprisoned for breach of contract over paintings for S. Maria della Steccata

1540 Dies tragically young

 Madonna and Child with St. John the Baptist and St. Jerome *This representation of the sleeping Jerome's vision has John the Baptist in a stylized, Mannerist pose, directing attention through his turning torso, curved arm, and hand to the Virgin and Child above.* 1526–27, oil on panel, 135 x 59in, National Gallery, London, UK

CLOSERlook

HEAD OF THE MADONNA
The Virgin's modest expression and realistic hair, framed by the light blazing from her halo, are painted here in meticulous detail, in the style Parmigianino adopted for his many portraits. Her slightly elongated features presage the famous *Madonna with the Long Neck*.

▶ **Madonna with the Long Neck** *Parmigianino spent six years working on this painting. The length and slenderness of all the limbs is exaggerated, but it is the Madonna's neck, likened to the ivory-colored column behind her, that gives the picture its expressive power.* 1534–40, oil on canvas, 85 x 52in, Uffizi, Florence, Italy

Giulio **Romano**

Self-portrait

b **ROME, c1499;** d **ROME, 1546**

Born Giulio Pippi in Rome, Giulio trained as an assistant to Raphael. After Raphael's death, Giulio completed his frescoes in the Vatican and went on to succeed him as head of the Roman School. In addition to his undoubted skill as a painter, Romano was also an accomplished engineer and architect. He was invited to Mantua to oversee a number of projects for Federigo Gonzaga, including the renovation of the city's cathedral, and the planning and construction of a ducal palace, the church of S. Benedetto, and the Palazzo del Tè. He also submitted a design for the facade of S. Petronio in Bologna but it was not used.

▲ **The Fall of the Giants (detail)** *This is one of the impressive frescoes in the Sala dei Giganti in the Palazzo del Tè, depicting the Gods of Olympus and the Fall of the Giants.* 1530–32, fresco, Sala dei Giganti, Palazzo del Tè, Mantua, Italy

Benvenuto **Cellini**

b **FLORENCE, 1500**; d **FLORENCE, 1571**

A goldsmith, sculptor, musician, and soldier, Benvenuto Cellini is as famous for his exaggerated and risqué autobiography as for his exquisite craftsmanship and Mannerist sculptures. His training was initially in Florence, but various escapades took him to Siena, Bologna, Pisa, and Rome, picking up his craft along the way. In Rome, he worked mainly as metalworker, but also played the flute in the Pope's court and fought

Portrait by Rafaello Morghen

bravely in the Sack of Rome. He traveled widely in Italy, and spent some years working at Fontainebleau in France, before returning to his native Florence. The last two decades of his life were spent under the patronage of Cosimo I de' Medici, for whom he created several fine sculptures.

LIFEline

c1515 As a teenager, runs away to Siena, then to Bologna and Pisa

1519 Moves to Rome

c1527 Returns to Florence, where he kills his brother's murderer, then flees to Naples

1534 Kills a rival goldsmith, but is pardoned by the Pope

1540–45 Works at Fontainebleau, France

1545 Returns to Florence to work for Cosimo I de' Medici

▲ **Portrait Bust of Cosimo I de' Medici**
Cosimo I de' Medici encouraged Cellini to extend his fine metalworking skills to the art of large-scale sculpture. This portrait bust of his patron was one of his first sculptures in the round, and combines a Mannerist approach to form with a goldsmith's delicate attention to detail. 1545, bronze, height 43¼in, Bargello, Florence, Italy

▲ **Perseus with the Head of Medusa** *This statue of Perseus was an attempt to outdo Michelangelo's* David *and Donatello's* Judith and Holofernes, *and is considered Cellini's masterpiece. The intricacy of the helmet, the head of Medusa, and the reliefs on the base show his mastery of metalwork, and the statue took several years to complete. When unveiled, it was highly acclaimed, and poets wrote sonnets in praise of it.* 1545–53, bronze, height 126in, Loggia dei Lanzi, Florence, Italy

▲ **Saltcellar of Francis I** *Cellini transformed a table accessory into a valuable sculpture, so desirable that it was stolen in 2003 from the Kunsthistorisches Museum in Vienna. (It was recovered in 2006 and returned to the museum.) Neptune, Roman god of the sea, the source of salt, leans in counterpoint to Earth, nurturer of the pepper plant. The salt fits into a boat-shaped bowl.* 1539–43, gold with enamel, 10¼ x 12⅜in, Kunsthistorisches Museum, Vienna, Austria

Pontormo (Jacapo Carucci)

b **PONTORMO, 1494**; d **FLORENCE, 1557**

Known simply as Pontormo, Jacopo Carucci was a key figure in the transition from Renaissance to Mannerism. His passionate and restless style shows an early break with Renaissance classicism, and explores disturbing spatial effects and distortions of scale. These interests led Pontormo to study northern prints, especially those of Dürer, in order to overtake the classicism of earlier

Self-portrait

models such as Andrea del Sarto. He spent all his life in Florence and was famous for his religious works. The altarpiece of S. Michele Visdomini marks the beginning of his mature style, and he followed it with a Passion cycle and—the greatest of his achievements—the altarpiece in S. Felicità.

▲ **The Deposition of Christ**
Pontormo creates a mood of grief and confusion by an almost neurotic use of agitated movement, in abstract colors, within a complex and unstable composition. c1526–28, oil on panel, 123 x 76in, Felicità, Florence, Italy

◄ **The Holy Family with Saints** *Although the subjects are symmetrically arranged with the Virgin at the apex of a triangular composition, the restless figures and the compressed perspectives give no feeling of the equilibrium associated with classicism.* 1518, oil on canvas, 84 x 73in, S. Michele Visdomini, Florence, Italy

Bronzino

b FLORENCE, 1503; d FLORENCE, 1572

Agnolo di Cosimo, nicknamed Bronzino, was court painter to the Medici family. He produced mainly portraits and allegorical paintings, in a somewhat analytical Mannerist style. Bronzino trained with Pontormo, and learnt much of his technique from him. Unlike his master, however, he was not at home with religious subjects, as his unemotional style was better suited to profane subjects and formal portraiture. Apart from a couple of years spent in Rome, Bronzino spent his whole life in Florence, but he was well known across Europe and highly respected, becoming an active founder member of the Accademia del Disegno, Florence. Although best known at the time for his portraits, Bronzino is today remembered also for his allegorical paintings, especially that of Venus and Cupid. Among his pupils was his own adopted son, Alessandro Allori.

LIFEline

1503 Born in Florence
c1515 Becomes pupil of Pontormo
1546 Begins working for Cosimo dé Medici, Duke of Florence
1563 Co-founds the Accademia del Disegno
1572 Dies in Florence

▶ **Eleonora of Toledo and Her Son, Giovanni de Medici** *Eleonora, the wife of Cosimo I de' Medici, is portrayed here with their son in a dignified and aristocratic pose.* c1544–45, oil on panel, 45¼ x 37¾in, Uffizi, Florence, Italy

▼ **Allegory with Venus and Cupid** *As Venus and Cupid embrace, they are surrounded by the figures of Folly, Deceit, and Jealousy, while above them Time prevents Oblivion drawing a veil over the scene. The complex meaning of this allegory is still to be fully understood.* c1540–50, oil on panel, 57 x 45¾in, National Gallery, London, UK

CLOSERlook

EYE MOVEMENT The viewer's gaze is drawn around the figures, from the masks at Venus's feet, through her upstretched arm, to the sweep of Time's arm across the top of the painting.

HANDS OF FOLLY Encouraging the lovers is the cherubic Foolish Pleasure, who has a handful of rose petals he is about to throw over the couple.

Giorgio **Vasari**

Self-portrait

b AREZZO, 1511; d FLORENCE, 1574

Better known for his biographical book, *Lives of the Artists*, than for his paintings and architecture, Giorgio Vasari was born in Arezzo, but worked mainly in Florence and Rome. His Mannerist style was much influenced by his friend and hero Michelangelo.

Although he was a prolific and well-regarded painter in his time, producing numerous large fresco schemes in the Vatican and the Palazzo Vecchio in Florence, Vasari's painting is now considered somewhat derivative. However, his architectural designs, notably those for the Palazzo degli Uffizi in Florence and his home in Arezzo, are of much higher quality. But it is his writing on art that was most influential—not only his biographies of Italian painters, sculptors, and architects, but also his analytical study of art history. His works have been, and still are, *the* source books for art historians of the Renaissance period.

LIFEline

1511 Born in Arezzo, Tuscany
1527 Goes to Florence to train with Andrea del Sarto and his pupils, Rosso and Pontormo
1529 Visits Rome
1550 Publishes the first edition of his *Lives of the Most Eminent Italian Architects, Painters, and Sculptors*
1560 Begins work on design of the Palazzo degli Uffizi
1563 Co-founds the Accademia del Disegno
1568 Second expanded revision of his *Lives*
1574 Dies in Florence

▲ **Lorenzo de Medici, "The Magnificent"** *Lorenzo's dynamic posture, curving diagonally across the picture, is typical of the later Mannerist style, and is accentuated by Vasari's dramatic use of color.* Oil on panel, 35¼ x 28¼in, Uffizi, Florence, Italy

◀ **Cosimo I and His Artists** *One of Vasari's most ambitious projects was a series of frescoes in the Palazzo Vecchio, showing scenes from the history of Florence. They included this portrayal of the artists he knew well.* 1560s, fresco, Palazzo Vecchio, Florence, Italy

▲ **Allegory of the Immaculate Conception** *Crowded with allegorical symbols gleaned from his discussions with cultivated men of letters, this classical composition in subdued colors derives its power from the movement of the figures in the lower half.* 1541, oil on panel, 22¾ x 15¼in, Uffizi, Florence, Italy

Giambologna

Portrait bust by Pietro Tacca

b DOUAI, 1529; d FLORENCE, 1608

Flemish-born Jean Boulogne—also known as Giovanni da Bologna, or simply Giambologna after his move to Italy—was second only to Michelangelo as the finest sculptor of the Mannerist period. He trained first with a Flemish sculptor, but when he traveled to Rome to study classical sculpture, he discovered the work of Michelangelo. Giambologna established his reputation with a series of marble statues, and soon enjoyed the patronage of the Medici family, becoming their official sculptor. His work is characterized by a strong sense of movement, executed with classical elegance and refinement, despite the often complex Mannerist forms. His small bronze statuettes were eagerly sought by connoisseurs of his time, and large-scale statues—especially his two innovative equestrian monuments—were not only popular, but influenced sculptors across Europe in the following two centuries.

LIFEline

1529 Born in Douai, Flanders (now in France)
c1550 Studies in Rome for two years
1553 Settles in Florence, and is commissioned by Pope Pius IV to create *Fountain of Neptune* in Bologna
1550s Becomes official sculptor to the court of the Medici
1583 Completes the *Rape of the Sabines*
1608 Dies in Florence

▶ **Edward the Confessor** *Giambologna produced a number of monumental statues for ducal palaces and churches. In spite of its memorial purpose, this representation of Edward the Confessor, in a niche of the Salviati Chapel, has elements of the Mannerist poses for which he was famous. 1579–89, marble, church of S. Marco, Florence, Italy*

▲ **Fountain of Neptune** *Giambologna originally intended this fountain for Florence. When commissioned for a fountain in Bologna's main square, he used the designs to create his first major sculpture. 1563–66, bronze and marble, height 132in, Piazza Maggiore, Bologna, Italy*

▶ **The Rape of a Sabine** *Carved from a single block of marble, the intertwining spiral of bodies in this masterpiece has no principal viewpoint. His knowledge of classical sculpture is evident. c1582, marble, height 161in, Piazza della Signoria, Loggia dei Lanzi, Florence, Italy*

Federico Barocci

Self-portrait

b URBINO, c1535?; d URBINO, 1612

Preferring to work in his native Urbino after two unhappy stays in Rome, Federico Barocci had a long and productive life, despite his constant complaints of ill health. In central Italy he was the finest painter and engraver of his time. His work was an influence on Carracci and Rubens, among others, and formed a bridge between the High Renaissance and the coming Baroque period.

Barocci trained with his father Ambrogio, a sculptor, and later with the Venetian Battista Franco in Urbino, developing a taste for the warm colors of Venetian painting. His prolific output was mainly of religious subjects, conventionally but sensitively handled in a Mannerist style. In later life he experimented with spatial effects and a more contemplative mood, presaging the devotional style that emerged in the new century.

LIFEline

c1548 Travels to Rome to study with Taddeo Zuccaro
c1560 Second visit to Rome, working with Federico Zuccaro
1561 Commissioned to paint frescoes in the Vatican
1563 Moves to Perugia
1565 Returns to Urbino
c1566 Joins a lay order of Capuchin monks
1612 Dies in Urbino

◀ **Study for the Head of Christ** *Barocci was a fine draftsman, and one of the first to use colored chalks in his numerous sketches and studies. Chalk, private collection*

▲ **St. Francis Receiving the Stigmata** *Barocci's later works moved away from the Venetian-inspired colors of his earlier paintings. Oil on canvas, Palazzo Ducale, Urbino, Italy*

Federico Zuccaro

b SANT'ANGELO IN VADO, NEAR URBINO, c1542; d ANCONA, 1609

Zuccaro was in his 20s when his brother, Taddeo, died in 1566 and he took over the work of his studio. Federico completed Taddeo's decoration of the Villa Farnese at Caprarola and the Sala Regia in the Vatican. He traveled widely across Europe, working in England and Spain, returning to Rome to become founding President of the Accademia di San Luca in 1593. Together with Bronzino and Vasari, Zuccaro was the model of a court artist mingling with the most illustrious patrons of his time.

▲ **Francis I and Alessandro Farnese Entering Paris in 1540** *Zuccaro's Mannerist frescoes cover the walls of the state rooms in the Villa Farnese, and in the Sala dei Fasti Farnese (Hall of the Splendours of the Farnese) they feature the exploits of the Farnese family. 1557–66, fresco, Villa Farnese, Caprarola, Italy*

CLOSERlook

KEY FIGURES Central to this painting are the portraits of Alessandro Farnese and the King of France, as they ride into Paris in triumph.

Rosso Fiorentino

b **FLORENCE, 1494;** d **PARIS OR FONTAINEBLEAU, 1540**

Giovanni Battista di Jacopo was known as *Rosso Fiorentino* (the Red Florentine) because of his red hair. He was one of the leading figures in early Florentine Mannerism. Rosso's altarpieces were sometimes rejected by patrons because they lacked decorum: the saints were depicted in such a way that they appeared as "devils." After the Sack of Rome (see p.119), Rosso traveled around Italy until he was invited to Fontainebleau by François I of France. Arriving in France in 1530, he established the "First School of Fontainebleau" with Francesco Primaticcio, and remained there until his death in 1540.

LIFEline

1494 Born in Florence
c1510 Trains under Andrea del Sarto at the same time as Pontormo
1521 Paints his masterpiece *The Deposition*, in Volterra, Tuscany
1523 Moves to Rome
1527 Sack of Rome forces him to flee the city
1530 Moves to France
1540 Dies in France

▶ **Moses and the Daughters of Jethro** *Moses defends Jethro's daughters from the Midianites. The subject gave Rosso the opportunity to explore contrapposto (twisting poses), which he had seen in Michelangelo's work. The tortuous figures express the violence of the scene and give a powerful sense of movement.* 1523–24, oil on canvas, 63 x 46in, Uffizi, Florence, Italy

CLOSERlook

PYRAMID COMPOSITION
The complex composition of this painting, outlined by the limbs of the brawling figures, is basically pyramidal, with a diagonal separating the terrified women from the fight.

▲ **The Marriage of the Virgin** *This elegant altarpiece is still in the church for which it was painted—the parish church of the Medici family.* 1523, oil on wood, 128 x 98in, San Lorenzo, Florence, Italy

▲ **View of the Galerie François I** *François I commissioned Rosso to design the main gallery of his palace at Fontainebleau. Rosso's paintings are framed by stuccos by Francesco Primaticcio (see opposite), and show how he refined his Florentine Mannerist style to suit the elegance of the palace.* c1534–39, Château de Fontainebleau, Seine-et-Marne, France

Jean **Goujon**

b **NORMANDY?, c1510;** d **BOLOGNA, c1565**

Very little is known of the early life of Jean Goujon, who ranks as one of the finest and most distinctive sculptors of 16th-century France. His earliest-known work was in Rouen, France, in 1540, but it is possible that he had traveled to Italy before then.

As a Huguenot Protestant, Goujon was at a disadvantage in Catholic France. However, he gained highly prestigious commissions in Paris, particularly working with the architect Pierre Lescot on the sculptural decoration of the Louvre in 1546. In 1562, Goujon fled from the anti-Protestant atmosphere of Paris, and is believed to have died in Bologna a few years later.

LIFEline

c1510 Born, probably somewhere in Normandy
1540–42 Works at the church of St. Maclou and the Cathedral in Rouen
c1544 Moves to Paris
1547 Appointed "sculptor to the king," Henri II
1547–49 Produces his masterpiece—the *Fountain of the Innocents*
1549–62 Collaborates with Lescot on the decoration of the Louvre
1562 Flees to Italy
c1565 Dies in exile in Bologna, Italy

▼ **Reliefs from the Fountain of the Innocents** *The relief panels from the Fontaine des Innocents depict nymphs who personify the rivers of France they are considered to be Goujon's masterpiece.* 1547–49, marble, Louvre, Paris, France

▲ **The Fountain of the Innocents** *Goujon originally built this fountain as a pavilion adjoining the corner of the Rue aux Fers and Rue St. Denis in Paris. It was reconstructed as a free-standing block in the 18th century. Most of the relief panels are now housed in the Louvre.* 1547–49, Paris, France

INcontext

THE "SCHOOL OF FONTAINEBLEAU"
François I's enthusiasm for Italian art, starting with his patronage of Leonardo at the Château d'Amboise, prompted him to invite several prominent Italian artists to work in France. At Fontainebleau, Rosso, Primaticcio, and others established a distinctive style, that influenced Goujon and many other French artists.

Château de Fontainebleau *Formerly a hunting lodge, Fontainebleau was rebuilt as a richly decorated palace from 1528.*

Francesco **Primaticcio**

Self-portrait

b **BOLOGNA, 1504**; d **PARIS, 1570**

A leading figure in the "School of Fontainebleau," Francesco Primaticcio adapted Italian Mannerism to French sensibilities, and with his colleague Rosso Fiorentino created an elegant style that influenced French art throughout the 16th century. In 1532, Primaticcio's master, Giulio Romano, was invited by François I to work in France, but he sent his pupil instead. He worked mainly on the stuccos framing Rosso's paintings in the Château at Fontainebleau, and took over as director there after Rosso's death. Much of the work has been destroyed or radically altered in later remodeling of the palace, but many of Primaticcio's drawings fortunately survive.

" The **first works in stucco** that were done in France, and the **first labors in fresco** of any account, **had their origin**, it is said, **from Primaticcio** "

GIORGIO VASARI (1511–74)
ARTIST-BIOGRAPHER

LIFEline

1504 Born in Bologna, Italy
1525–26 Trains with Giulio Romano in Mantua
1532 Moves to France to work at Fontainebleau
1540 Takes over from Rosso as head at Fontainebleau
1545 Travels to Rome to make casts of sculptures in the papal collection
1547 Francois I dies, Primaticcio works for his successor Henri II on various commissions, turning his hand to architecture in his later years
1570 Dies in Paris

▶ **Masquerade at Persepolis**
This is a preparatory drawing for the decoration of the Room of the Duchesse d'Etampes at Fontainebleau, later much altered. 1541–45, pen and ink on paper, Louvre, Paris, France

▲ **The Holy Family with St. Elizabeth and St. John the Baptist** *Easel paintings by Primaticcio are fairly rare. This one has formerly been attributed to various other Italian artists.* 1541–43, oil on slate, 16¾ x 12¼in, The Hermitage, St. Petersburg, Russia

▲ **Female figures and cherubs surrounding a painting of Alexander the Great** *Primaticcio developed a Mannerist style, in which sophistication and elegance were more important than emotion. His stucco decorations at Fontainebleau often feature graceful, slender female figures.* c1540–45, stucco, Room of the Duchesse d'Etampes, Château de Fontainebleau, Seine-et-Marne, France

François **Clouet**

b **TOURS, c1510**; d **PARIS, 1572**

As official painter to the French royal house of Valois, François Clouet was the foremost portraitist of the French Renaissance, but little is known of his life. His father, Jean Clouet, was François I's court painter before him; the two artists bore the same nickname, Janet, which is one reason why attribution of paintings to them has often been problematic.

François took over his father's post in about 1540. He supervised a workshop through the reigns of François I, Henri II, François II and Charles IX, producing various artworks in addition to the portraits for which he became famous. Although his portraits were in the Flemish naturalist style of the time, Clouet was also much influenced by Italian portraiture, in particular the work of Agnolo Bronzino and Leonardo da Vinci.

▲ **Pierre Quthe** *This is one of only two paintings signed by François Clouet. The sitter is Clouet's neighboor, Pierre Outhe, a Parisian apothecary and owner of a well-known garden of medicinal plants.* 1562, oil on panel, 35¾ x 27½in, Louvre, Paris, France

CLOSERlook

BALANCE Exquisitely painted to show the sheen of the fabric, the curtain forms an effective frame for the sitter, echoing the line from his right hand to his head, and balancing the essentially pyramidal composition with the shadow to the left of the sitter.

Alonso **Berruguete**

b **PAREDES DE NAVA**, c1488; d **TOLEDO**, 1561

One of the foremost sculptors of Renaissance Spain, Alonso Berruguete originally trained as a painter with his father, Pedro. Having worked for a time in Italy, Pedro encouraged his son to complete his artistic education there. In about 1504 Alonso travled to Florence, where he studied the work of Michelangelo, and discovered the early Mannerist style of Jacopo Pontormo and Fiorentino Rosso. Returning to Spain in around 1517, he was appointed court painter to Charles V in Valladolid, but increasingly turned to sculpture. In 1539 he was invited to provide sculptures for the cathedral in Toledo, where he worked until his death in 1561.

▲ **Salome with John the Baptist's Head** *Painted while in Italy, this picture is very much in the style of Florentine Mannerism: the expressive, contorted pose and glimpse of Tuscan landscape are reminiscent of Pontormo and Rosso.* c1512–16, oil on wood, 34½ x 180¼in, Uffizi, Florence, Italy

INcontext

TOLEDO For centuries Toledo was the capital of Spain, and although Philip II made Madrid the capital in 1561, Toledo continued to be a major cultural center and the country's spiritual heart. Toledo's archbishop was Spain's most powerful churchman and the city had more than a hundred religious establishments, providing plentiful work for El Greco and other artists.

Cityscape of Toledo *Situated on a bend of the River Tagus, Toledo is crowded with buildings in a mix of styles, from Roman to Moorish and Hispano-Flemish, reflecting its cosmopolitan history.*

El Greco

Self-portrait

b **CANDIA, 1541**; d **TOLEDO, 1614**

El Greco spent some of his formative years in Italy, but he settled in Spain when he was in his mid-30s and is now regarded as the first great personality in the history of Spanish painting. His real name was Domenikos Theotokopoulos but he became known as El Greco (the Greek). He began his career as a traditional icon painter, before moving to Venice, where he absorbed influences from the great artists of the day, particularly the emotionalism of JacopoTintoretto. In 1570 he moved to Rome and in 1576 to Spain. After briefly staying in Madrid, he moved to Toledo, where he spent the rest of his life. In Italy he had achieved only modest success, but in Todelo he quickly became the leading artist of the day. His deeply spiritual side was well suited to the religious zeal of his adopted country, although after his death he was long forgotten and not fully appreciated again until the advent of Expressionism in the 20th century (see pp.408 and 502).

LIFEline

1541 Born in Candia, now known as Heraklion, on Crete
c1567/8 Moves to Venice
1570 Settles in Rome
1576 First recorded in Spain, in Madrid; by the following year he has settled in Toledo
1577 Paints altarpiece for the church of Santo Domingo el Antiguo in Toledo, the first in a stream of major commissions
1578–82 Works for the court of Philip II
1586–88 Paints *The Burial of the Count of Orgaz*, his masterpiece
1614 Dies in Toledo

❝ Cézanne and El Greco are **spiritual brothers**, despite the **centuries** that separate them ❞

FRANZ MARC (1880–1916), EXPRESSIONIST PAINTER, IN *THE BLUE RIDER ALMANAC*, 1912

▶ **The Trinity** *El Greco's first commission in Spain was the altarpiece of Santo Domingo el Antiguo in Toledo. This is one of nine paintings for the church, and was designed to go above his depiction of the Assumption. The Mannerist style established El Greco's reputation in the somewhat conservative city.* 1577, oil on canvas, 118 x 70½in, Prado, Madrid, Spain

CLOSERlook

CLOUDS OVER TOLEDO The storm clouds help to make this a personal interpretation of the city, rather than a straightforward depiction, enhancing the mood of foreboding and expressing the passionate nature of the artist.

DRAMATIC LANDSCAPE The swoops and curves of the hills and river valley are accentuated by buildings on the slopes and ridges. Together, the composition, eerie lighting, and dramatic sky give a spiritual, otherworldly feel.

▲ **View of Toledo** *This cityscape of Toledo is more than a simple representation—in fact El Greco has moved various features from their real positions—it tries to capture the essence of the city.* c1600–10, oil on canvas, 47½ x 43in, Metropolitan Museum of Art, New York, US

▼ **Portrait of Jorge Manuel Theotokopoulos**
Although primarily a religious painter, El Greco was also a superb portraitist. This is his son, depicted in aristocratic pose, but with the tools of his trade. Jorge Manuel was one of the few artists to adopt his father's idiosyncratic style. El Greco and Jorge Manuel's mother never married, perhaps because he had left a wife in Crete or Italy. c1603, oil on canvas, 29 x 20½in, Museo de Bellas Artes, Seville, Spain

▲ **The Burial of the Count of Orgaz** *This painting is generally regarded as the finest expression of El Greco's very personal style. It depicts a 14th-century nobleman being laid to rest by St. Stephen and St. Augustine and received in heaven by the Virgin and St. John the Baptist. The mourners are represented by a line of portraits of contemporary local dignitaries, including the artist. The absence of background, and the contrast of the mundane and the spiritual, combine to give a visionary and otherworldly atmosphere. The count had been a benefactor of Santo Tomé, which was El Greco's parish church. 1586–88, oil on canvas, 189 x 142in, Santo Tomé, Toledo, Spain*

CLOSERlook

JORGE MANUEL The pageboy at the graveside is believed to be the artist's son, Jorge Manuel. He became a painter, working as his father's chief assistant from about 1603.

HEAVEN AND EARTH
The two halves of the painting, distinctly separated by a line above the mourners' heads, represent the realms of the terrestrial and the spiritual. The movement of the lower section is directed downward, towards the mortal body of the Count; in the upper section, it is ascending heavenward with his soul.

▲ **The Virgin of the Immaculate Conception** *This is one of the final masterpieces of El Greco's career. Above Toledo, mysteriously lit by both sun and moon, the figures spiral upward, with no regard for perspective or anatomical accuracy, towards a blaze of supernatural light. 1608–13, oil on canvas, 137 x 69in, Museo de Santa Cruz, Toledo, Spain*

Giuseppe **Arcimboldo**

b MILAN, c1527; d MILAN, 1593

A favorite court painter to the Hapsburg emperors, Giuseppe Arcimboldo enjoyed a resurgence of popularity when his eccentric "vegetable" portraits were rediscovered by the Surrealists in the 20th century. His early artistic career was conventional. Born the son of a painter in Milan, he learned his trade with his father. He assisted his father at Milan Cathedral, where he provided designs for stained-glass windows, and later worked in the cathedrals at Monza and Como.

Arcimboldo's work came to the attention of the Holy Roman Emperor, Ferdinand I, who invited him to his court in Vienna. It was there that he painted the first of his bizarre portraits, *Spring*— a clever arrangement of fruit, flowers, and vegetables forming the likeness of a human head. The fantastic wit of these portraits, which may have been satirical or allegorical, was immensely popular with the Emperor and his successors, and Arcimboldo continued to receive Rudolf II's patronage, even when he returned to Milan for the final years of his life.

LIFEline

c1527 Born in Milan

1549 Works with his father in Milan Cathedral

1556 Carries out various works for cathedrals at Monza and Como

1562 Called to the court of Ferdinand I in Vienna

1563 Paints the first of his *Seasons* series

1564 Made portrait painter to Maximilian II in Prague after the death of Ferdinand I

1576 Maximilian II dies and is succeeded by Rudolf II

c1590 Paints *Vertumnus*, a portrait of Rudolf II in fruit and vegetables

1593 Dies in Milan

▼ **Spring** *Arcimboldo painted a number of versions of his cycle of portraits representing the four seasons. His choice of fruit, flowers, vegetables, and other objects was partly dictated by the subject, but probably also had some symbolic or satirical significance for contemporary viewers.* 1573, oil on canvas, 30 x 25½in, Louvre, Paris

▲ **Summer**

▲ **Autumn**

▲ **Winter**

Hans **von Aachen**

b COLOGNE, 1552; d PRAGUE, 1615

A leading painter in the late Mannerist style, Hans von Aachen traveled widely throughout Europe. With Bartolomeus Spranger, he established the court of Rudolf II in Prague as a centre of artistic excellence.

Born in Cologne (not Aachen, which was his father's birthplace), he trained there before making his way to Venice in the 1570s, and then spending some time in Rome and Florence. In 1587 he returned to Germany, working as a portrait painter in Augsburg and Munich, where he was first commissioned by Rudolf II. In 1596 he settled permanently in Prague where he was employed both as court painter and as an agent and diplomat for the Emperor.

◄ **Bacchus, Ceres, and Cupid** *The art of Rudolf II's court combined the influences of Italian Mannerism and Flemish Realism. It featured refined, elongated figures, particularly sensuous female nudes, in allegorical or mythical scenes alluding to the qualities of the Emperor.* c1600, oil on canvas, 64 x 44½in, Kunsthistorisches Museum, Vienna, Austria

Bartholomeus **Spranger**

b ANTWERP, 1546; d PRAGUE, 1611

◄ **Hercules, Deianeira, and the Centaur Nessus** *Spranger's sophisticated Mannerist paintings appealed to Rudolf II because they contained both flattering references to his reign and erotically depicted figures.* c1580–82, oil on canvas, 44 x 32¼in, Kunsthistorisches Museum, Vienna, Austria

After training in his native Netherlands, Bartholomeus Spranger traveled to France in about 1565. He worked in Paris, where he discovered the work of Primaticcio, then travelled to Milan and Parma, before settling in Rome in the service of the Farnese family who ruled Parma and Piacenza. In 1575, Spranger was appointed court painter to Maximilian II in Vienna. With his successor, Rudolf II, Spranger later moved to Prague, where he introduced the Italian Mannerist style and helped to establish the court as a cultural centre.

Adriaen **de Vries**

b THE HAGUE, c1545; d PRAGUE, 1626

Like Spranger and von Aachen, the sculptor Adriaen de Vries left his homeland for Italy, before becoming one of the foremost artists of Rudolf II's court in Prague. Little is known of his life before he arrived in Florence in 1581 to study with Giambologna, under whom he developed his elegant Mannerist style. In the 1590s he worked in Augsburg, producing three fountains and receiving his first commission for the Emperor— *Mercury and Psyche* (1593). De Vries became Rudolf's court sculptor in 1601, and remained in Prague for the rest of his life.

◄ **Mercury and Psyche** *Taking the lightness and elegance of his teacher Giambologna's work one step further, this sculpture seems to defy gravity in its upward-spiralling movement. The slender, long-limbed figures and delicate drapery, typical of Mannerist sculpture, are designed to be viewed equally well from any angle.* 1593, bronze, height 84½in, Louvre, Paris, France

The cosmopolitan, but nevertheless alien, Yuan dynasty had virtually forced Chinese art underground, so the early Ming period was a time of rebuilding. The Yongle emperor (the third emperor of the Ming dynasty), moved the Ming capital from Nanjing to Beijing, where the Forbidden City was built, and courts there and in the major cities became important patrons of the arts.

Ceramics

Ceramic techniques became more sophisticated in the Ming period. As well as the appearance of the first cloisonné work, innovations in porcelain overglazing, blue-and-white ware, porcelain, and lacquer reached a height of refinement, with elegant decoration in specifically Chinese styles.

Painting

Through the 15th century, court patronage of the arts increased, leading to the formation of various

▲ **Pilgrim's "Blue and White" Gourd** *The return to Chinese artistic traditions under the Ming Dynasty is epitomized by the elegant decorations of ceramics of the period. c1403–24, ceramic, Musée Guimet, Paris, France*

schools of painting. As well as the official court painters, there was an academic group founded by Dai Jin in Zhejiang, painting in the manner of the Southern Song period, known as the Zhe School, and also a number of

artist–scholars. Led by the Four Great Masters Shen Zhou, Wen Zhengming, Tang Yin, and Qiu Ying, these literati painters were all accomplished in the "Three Perfections" (poetry, calligraphy, and painting) in the style of the Yuan masters, and became known as the Wu School, after the town of Wumen (modern Suzhou), where the majority were based.

Various individualist artists also emerged, especially toward the end of the Ming era, including the painter and art theorist Dong Qichang. He interpreted the divergent styles of Ming painting as being two separate traditions—a Northern and a Southern School—and believed that the Southern style, which was derived from the great Yuan masters, should be the model for literati painters. His theories were to prove important in the establishment of an Orthodox School of painting in the subsequent Qing dynasty (see p.281).

After almost a century of Mongol rule, China regained a sense of national pride with the foundation of the Ming Dynasty. The Ming emperors encouraged indigenous culture, and their patronage aided the revival of Chinese traditions in painting and ceramics.

China: Ming Dynasty

Dai Jin

b **QIANTANG, 1388**; d **HANGZHOU, 1462**

Dai Jin was the foremost painter of the academic Zhe school in Zhejiang. He worked for a short time at emperor Xuande's court in Beijing, but his conservative style was viewed with suspicion by the other artists there. Accused of anti-imperial tendencies, he fled back to Hangzhou, but returned to Beijing after the emperor's death. Most of his existing paintings date from about 1440, when he was a court painter in Beijing, adopting the compositional style of the Southern Song painters, but reinvigorating it with dynamic brushwork. At the end of his career, he returned to Hangzhou where he died in 1462.

▶ **Yuan An Sleeps Through the Snow** *Much of Dai Jin's mature work followed the tradition of Southern Song silk scroll painting, often adopting the diagonal compositional style of Ma Yuan, and demonstrating a mastery of dynamic brush techniques. His landscapes also show the influence of Yuan painters and the boldness of their perspective. c15th century, ink and slight color on silk, 79½ x 42in, Indianapolis Museum of Art, US*

❝ Late in life he begged to **return to Hangzhou**, where his **fame had increased** ❞

DU QIONG (1396–1474)

Shen Zhou

b **XIANGCHENG, 1427**; d **XIANGCHENG, 1509**

The literati (scholar-amateur) painters of the ancient Wu area around Suzhou in southern China, known as the Wu school, worked independently from the imperial courts in a style very different from the painters of the Zhe school. The most accomplished of the Wu artists, Shen Zhou, was influenced by the four Yuan masters Ni Zan, Huang Gongwang, Wu Zhen, and Wang Meng, continuing the literati tradition of innovative and individualist landscape painting. Shen was from a wealthy and educated family, and his status allowed him the freedom to paint without the restrictions of patronage, exploring the aesthetic links between poetry, calligraphy, and painting and studying China's artistic history.

▲ **Invitation to Reclusion at Chaisang** *In contrast to the sometimes strict academicism of the Zhe school, Shen's landscapes are in a gentler and more elegant style. For Shen, inspiration, expression, and sensitivity to the subject matter were of greater importance than composition or technique for their own sake. c16th century, ink and color on paper, 9¾ x 431in, Indiapolis Museum of Art, US*

▲ **Ode to the Pomegranate and Melon Vine** *This painting shows the integration of poetry, calligraphy, and painting that was central to the aesthetic of the Wu literati artists. c1506–1509, pen and ink and watercolor on paper, 58¾ x 29¾in, The Detroit Institute of Arts, US*

Wen Zhengming

b SUZHOU, JIANGSU PROVINCE, 1470; d SUZHOU, 1559

Considered one of the four Masters of the Ming period, Wen Zhengming was the most influential of the second generation of Wu school artists. He studied under Shen Zhou (p.185), and like his teacher was inspired by the literati of the Yuan period, but spent much of his early career trying to obtain civil servant qualifications. He finally got a teaching post at the Hanlin Academy in Beijing in 1523, but returned to Suzhou disillusioned with official life, four years later. His mature paintings show some of this disaffection, and his highly individual style often conveys a feeling of solitude. Wen was best known for his garden scenes (he also helped to design gardens), illustrations of poems, scenes celebrating events in scholarly life, but also painted landscapes, often simplifying the composition to focus on a single rock or tree.

▼ **Old Pine Tree** *Trees feature frequently in Wen's work especially pines, junipers, and cypresses, for their symbolic meaning of human struggle. A respected calligrapher, the range of brushstrokes in Wen's paintings derive from calligraphic techniques, emphasizing the decorative patterns and textures of the tree.* 1530s, handscroll, ink on paper, 10⅝ x 54¾in, Cleveland Museum of Art, US

▲ **The Peach Blossom Spring** *Wen's landscapes showed the influence of Yuan masters, especially Huang Gongwang. He adopted a severe, almost desolate style. This painting is an illustration of a poem, Tao Yuan Bi Jing, by the 8th-century poet, Wang Wei.* 1524, ink and color on paper, 11¼ x 148½in, private collection

CLOSERlook

ROCKS AND TREES A recurrent theme in Wen's landscapes and illustrations is the portrayal of tree-topped mountains, built up from separate rock formations. Each element of the mountain, the rocks and the trees, is independently positioned, but dictated by the overall composition. This gives a sense of movement within a carefully balanced structure.

Tang Yin

b SUZHOU, JIANGSU PROVINCE 1470; d SUZHOU 1524.

The son of a restaurateur, Tang Yin was not of the same social status as most of the contemporary literati artists, however he was acknowledged as one of the four Masters of the Ming dynasty, despite some scandal. He was an excellent student, achieving top grades in the provincial civil service examinations, but he was then accused of bribery in the final exams in Beijing, jailed, and sent home in disgrace. He went on to study painting with Zhou Chen in Suzhou and embarked on a career as an artist, financing himself by selling his work. The absence of an independent income and his notoriously debauched lifestyle was frowned upon by other literati artists, but his undoubted skill as a landscape and figure painter eventually secured his reputation.

▲ **The Immortal Ge Changgeng Sitting on his Three-legged Toad** *Tang was famous for his sensitive figure painting, particularly of beautiful women, in the style of the Tang period: a solitary figure on a blank background. This keenly observed portrait of the calligrapher and Buddhist scholar, Ge Changgeng, portrays him as the embodiment of the Chinese God, Liu Hai, and the mythical toad symbolizes the unattainable.* 1506–10, ink and color on paper, 43 x 15⅞in, private collection

▲ **Scenes of Hermits' Long Days in the Quiet Mountains** *Influenced by his study of Northern Song landscape painting, Tang often chose secluded, peaceful scenes as his subjects—favorite haunts of the reclusive literati. Typical of this style are the large mountains in the background of this picture, and the expressive sinewy shapes of the pine trees in the center.* c16th century, ink and color on silk, 43 x 24½in, private collection

❝ To dab at paper and smear at silk is only **a trifling skill for amusement**. And the career of a sour scholar or decrepit clerk—**how can that be worth doing**? ❞

TANG YIN AS A YOUNG MAN, ON HEARING A PROPHECY THAT HE WOULD BE A SUCCESSFUL A PAINTER OR WRITER

Qiu Ying

b TAICANG, JIANGSU PROVINCE, 1494; d c1552

The youngest of the four Ming Masters, Qiu Ying came from a peasant family, and although he studied with Zhou Chen in Suzhou, he remained only a peripheral member of the Wu school. His lack of independent income meant that, unlike most Wu literati, he was reliant on patrons for his living and became proficient in a wide range of styles and genres. Three of these patrons in particular, all art collectors, enabled him to pursue his career: Chen Guan in Suzhou, Zhou Fenglai in nearby Kunshan, and Xiang Yuanbian in Jiaxing in Zhejiang Province.

Qiu was somewhat apart from the Wu school stylistically. He chose to work in richer colors, muted earth tones, and especially his characteristic blues and greens, rather than the ink washes favored by most of the Wu literati, probably to satisfy the tastes of his patrons. He was renowned as a draftsman, especially in his faithful portrayals of human figures, but it is for his sensuous landscapes that he is best known today.

◀ **Two Scholars Playing the Qin and Erhu Under a Pine Tree** *The dramatic contrast of the finely detailed musicians against a gentle background is a feature of several of Qiu's most striking paintings. The fineness of this figure painting is complemented by his sensitive, naturalistic depiction of the pine tree.* c16th century, ink and color on silk, 39¾ x 17in, private collection

▼ **The Garden of Wang Chuan's Residence** *As well as painting original works, Qiu made many detailed copies of old masterpieces and was proficient in styles of previous periods. In this landscape, after the painting style and poetry of Wang Wei (701–761), he incorporates the sensuous, translucent color of his own work into the style of the old master.* c16th century, ink and color on silk, 11¾ x 183in, private collection

Dong Qichang

b SHANGHAI, 1555; d HUATING?, 1636

The painter, calligrapher, and art theorist Dong Qichang was an individualist, not associated with any school of painting. He painted mainly landscapes in an eclectic style, borrowing from the Yuan masters, but it was as a theoretician that he was most influential. Noting the different styles of the Zhe and Wu schools, Dong argued that there were Northern and Southern traditions, and that the literati should paint exclusively in the Southern style.

▲ **Rivers and Mountains on a Clear Autumn Day** *Dong's landscapes often distorted perspective for compositional effect. In his late paintings, such as this mountainscape, this was sometimes taken to extremes, contrasting with the monumental style of his earlier work.* c1624–1627, handscroll, ink on paper, 15 x 54in, Cleveland Museum of Art, US

Chen Hongshou

b ZHUJI, ZHEJIANG PROVINCE, 1598; d SHAOXING?, ZHEJIANG PROVINCE, 1652

Born to a family of wealthy civil servants, Chen Hongshou's initial ambition was for a career as an official, but after several failed attempts to gain a position in Beijing, he devoted his time to painting, calligraphy, and poetry. He employed a self-conscious archaic style, adopting the mannerisms of the Tang and Song periods, and became known for his whimsical figure painting and colorful depictions of birds and flowers; unlike many of his contemporaries, he seldom painted landscapes. Although Chen lived the life of a typical scholar-recluse on the family estate, it is quite likely that many of his paintings were commissions that were not strictly approved by the code of the literati artists.

◀ **Immortals Celebrating a Birthday** *Typical subjects for Chen's figure paintings were depictions of literati and elegant ladies, or as in this painting, groups of immortals. The archaic style emphasizes the mystical nature of the scene.* 1649, ink and color on silk, 66½ x 26¾in, Indianapolis Museum of Art, US

▶ **One Hundred Butterflies, Flowers and Insects** *This handscroll, in the style of the old master Yi Yuanji, shows Chen's eye for detail and use of exuberant color. He was well-kown for his realistic painting of birds, flowers, and insects.* c17th century, handscroll, ink and color on silk, 12½ x 209in, private collection

CLOSERlook

BALANCED COMPOSITION
Chen's naturalistic depiction of butterflies fluttering around blossom is handled with great delicacy and elegance. The balance and apparent simplicity of the composition counteracts the bold colors and carefully observed details, to give a feeling of spontaneity.

Origins and influences

Zen Buddhism was introduced to Japan in the 13th century by two priests, Eisai and Dogen, who traveled to China to study Zen teachings. On their return to Japan, they established the Rinzai and Soto sects of Zen Buddhism. The austere simplicity and stress on self-discipline appealed to the *samurai* (warrior) class, and many Zen temples were built in the 14th and 15th centuries under the patronage of the Ashikagas.

Subject matter

Art of this period reflects a strong influence of Zen philosophy, which promoted a balance between physical work and the practice of meditation. Artistic activities such as ink painting, calligraphy, poetry, and garden design were important aspects of training for monks. Themes of Zen art address the individual's search for the true

Shoguns (military rulers) from the Ashikaga family ruled Japan from the 14th to the late 16th century. The Ashikagas were great patrons of art, and the origin of many traditional Japanese art forms such as Noh (masked drama) theater, ink painting, garden design, flower arrangement, and the tea ceremony date from this period.

▲ **Rock Garden of Ryoan-ji Temple, Kyoto** *Dry landscape gardens in Zen temples symbolize the vast universe with a few rocks amid gravel.*

meaning of human life and the greatness of the natural world.

After the political and economic failures of the Ashikaga government in 1573, three successive military rulers, Oda Nobunaga, Toyotomi Hideyoshi, and Tokugawa Ieyasu, fought for the control of the country. They had magnificent castles built to show off their power, authority, and wealth. In sharp contrast to the quiet atmosphere of Zen temples, the interior of castles were richly decorated with colorful paintings on gold background.

Japanese art

Sesshu Toyo

b OKAYAMA, 1420; d YAMAGUCHI, 1506

Sesshu became a monk at a young age and was trained in the tradition of Chinese ink painting. In the 1460s, he left his temple and went to China where he saw contemporary Ming art as well as studying Song and Yuan masters. Sesshu established his own distinctive style of ink painting by breaking away from the Chinese ideals of the "mind landscape." On his return from China, he settled in the province of Yamaguchi and continued to paint real places from his observation. His late works in the style of *haboku* (broken ink) became highly abbreviated, free, and almost abstract—as if the ink had splashed randomly on to the paper.

LIFEline

1420 Born in Okayama, but little is recorded about his family

1430s Enters Hofuku-ji temple as a monk, then moves to Shokoku-ji, Kyoto

1464 Leaves the temple, and moves to the province of Yamaguchi

1467–69 Travels widely in China

1470s Settles back in Japan first in Kyushu, then in Yamaguchi

1495 Paints his masterpiece *Landscape in the* haboku *Technique*, now in the Tokyo National Museum

1506 Dies, having achieved recognition as the greatest ink painter of his age

▲ **Ama no Hashidate, Landscape of Mountain and Sandbar** *Ama no Hashidate in the north of Kyoto is one of the three famous scenic spots in Japan, celebrated in classical poetry. c1501, ink on paper, 35¼ x 70in, Kyoto National Museum, Japan*

CLOSERlook

HISTORIC SITES Sesshu painted famous landmarks such as temples and shrines, which still exist today. The accurate depiction of the scene suggests Sesshu actually visited the location.

▶ **Winter Landscape** *Having mastered the Chinese idiom, Sesshu successfully created depth of space with zigzagging diagonal lines, expressive brushstrokes, and varying tones of ink. c1470s, ink on paper, 18¼ x 11¼in, Tokyo National Museum, Japan*

Kano **Eitoku**

b **KYOTO, 1543**; d **KYOTO, 1590**

Kano Eitoku came from the family of professional painters who had enjoyed the patronage of Shoguns since the time of his great grandfather, Kano Masanobu. Eitoku distinguished himself as a talented artist from a young age. He established a dynamic and vibrant style of painting in a large format that suited the needs of feudal lords in the late 16th century. Eitoku was chosen to be in charge of the extensive decorative scheme for the magnificent castle built by Oda Nobunaga in Azuchi between 1576 and 1581. The castle was unfortunately destroyed by fire after Nobunaga's death in 1582. The opulent interior of the castle can be imagined from the records and some of Eitoku's surviving screen paintings.

◀ **Hawks in the Pine** *Subject matter of the Kano school painters was mainly secular landscape, birds, and flowers with auspicious symbolism. The generous use of expensive mineral pigment and gold indicates the prestige of the owner. Late 16th century, six-panel folding screen, Tokyo National Museum, Japan*

LIFEline

1543 Born the son of Kano painter Shoei

1566 Collaborates with his father to paint the sets of sliding doors in the temple Daitoku-ji in Kyoto

1583 Begins work on the decoration of Osaka Castle for Toyotomi Hideyoshi

1587 Commissioned to paint screens for Jurakudai Palace in Kyoto

1590 Dies, reputedly from overwork

CLOSERlook

GOLD LEAF Large areas of walls and screens were covered in thin squares of gold leaf. The gold provided a luminous background that reflected light in the dark castle interior.

◀ **Cypress** *The large tree is brought to the foreground with branches extending sideways over eight panels to create a powerful composition that characterizes Eitoku's style. 1580s, eight-panel screen, color and gold leaf on paper, 67 x 182in, Tokyo National Museum, Japan*

Sen no **Rikyu**

b **SAKAI, 1522**; d **SAKAI, 1591**

A merchant from Sakai, Sen no Rikyu is credited with perfecting Chado (literally, the Way of Tea—the Japanese ritual of drinking tea). His principles for an ideal tea ceremony were harmony, respect, purity, and tranquillity. Rikyu thought tea utensils should have *wabi* (simplicity, frugality) and *sabi* (patina of age, tranquillity) under the influence of Zen philosophy. He endorsed the beauty of natural materials in simple rustic tea huts and handmade pottery.

▲ **Raku Earthenware Black-glazed Tea Bowl** *Rikyu commissioned a humble tilemaker, Chojiro, to create this handcarved tea bowl. The irregular shape of the vessel has a tactile quality, and the rich black glaze enhances the color of the green tea.*

Hasagawa **Tohaku**

b **NANAO IN NOTO, 1539**; d **KYOTO, 1610**

Hasegawa Tohaku began his career as a painter of Buddhist images in his native province of Noto. He moved to the capital Kyoto in the 1580s and studied the dynamic and colorful style of painting in the Kano studio. His most famous work in the decorative style is the *Maple Tree* in the Chishaku-in temple, Kyoto. Tohaku also studied monochrome ink paintings by Chinese masters in the Zen temple Daitoku-ji, and was deeply influenced by Zen teaching. Tohaku's ink paintings, with his imaginative use of empty space, inspire a contemplative mood as Zen temples do. He was a versatile artist who created his individual style by combining the best qualities from different traditions.

▼ **Forest of Pines** *The image is extremely simple, yet it captures the atmospheric morning mist in the forest. The depth of space is subtly handled by the dark and pale tone of ink, and conveys a wonderfully evocative mood. Late 16th century, a pair of six-panel screens, ink on paper, 61 x 137in, Tokyo National Museum, Japan*

The Inca and Aztec empires were both relatively short-lived: the Inca empire lasted from the 1220s to 1533, the Aztec empire from 1325 to 1521. However, their achievements and artistic creations were immense.

The Incas

The Inca empire of the Peruvian Andes was founded in the 1220s as a small chiefdom in the Cuzco area of central Peru. After 1438, the empire began a period of rapid expansion so that by 1493 the Incas eventually controlled most of western South America, from modern day Ecuador in the north to central Chile in the south. The Inca emperors maintained control of this vast area through a lengthy network of stone-built roads through the mountains that allowed for rapid communications and the movement of troops. The Incas were skilled masons, although functional rather than original architects, and used local gold and silver to create ceremonial artifacts. The Spanish conquistador Francisco Pizarro invaded and conquered the empire in 1532–33.

The Aztecs

The Aztecs moved south from the northern Mexican deserts into the Valley of Mexico around 1325, founding their capital, Tenochtitlan, on Lake Texcoco. That city soon became one of the biggest and most splendid cities in the world, the population of more than 200,000 people living on an island in the middle of a large lake connected to the mainland by causeways. During the 1400s, Aztec armies built up an empire that ruled more than ten million people and dominated southern Mexico and Guatemala from the Pacific to the Caribbean coasts. The Aztecs built great temples on which to sacrifice victims to their gods, and carved often monumental sculptures of their deities. The Spanish, led by Hernan Cortés, conquered the empire in 1519–21, bringing the Aztec civilization to an end.

▲ **Machu Picchu** *Built during the reign of Pachacuti Inca Yupanqui (1438–71) as country retreat for the nobility, this Inca town was never discovered by the invading Spanish and remained hidden until 1911.*

In the 14th and 15th centuries the two powerful empires that dominated Central and South America were the Incas and the Aztecs. Both civilizations produced outstanding artworks. The Inca and the Aztec empires both fell in the early 1500s to Spanish conquest.

Central and South America

The Incas

PERUVIAN ANDES; 1220s–1533

Inca art is more functional and less elaborate than earlier Andean civilizations, although evidence is patchy as much was destroyed, lost, or melted down after the Spanish conquest. The Inca's main skill was in stonemasonry, using perfectly cut, massive stones fitted without the use of mortar to create walls and buildings. Some of these stones, as well as living rocks, were carved with religious symbols drawn from nature. Inca artists developed considerable skill and sophistication in gold and other metalwork, developing a copper-arsenic bronze into which they inlaid gold and silver. Their textiles were finely woven using vicuna, alpaca, or llama wool. Repeating geometrical patterns feature regularly in this work, perhaps having a heraldic significance.

▼ **Llama figurine** *This Inca llama is made of several pieces of sheet silver. The blanket in cinnibar, and the diamond design may have been originally inlaid with turquoise; the blanket trim is gold.* After 1438, silver, American Museum of Natural History, New York USA

SYMMETRY Each patterned square of this geometrically patterned poncho has a symmetrical design, often consisting of single, dark colored thread set against a lighter background.

CLOSERlook

▶ **Inca poncho** *Ponchos were worn by all classes of Incas, the poor wearing alpaca wool, the rich a silkier vicuna wool. The elaborate decoration on this poncho suggests it was not for everyday use.* c1500, wool, American Museum of Natural History, New York, USA

The **Aztecs**

VALLEY OF MEXICO; 1325–1521

Aztec art was almost all produced as a material expression of Aztec cosmology—their vision of the creation of the Universe. The Aztecs drew their beliefs from previous Mexican civilizations and believed that their world had been created by the Sun god, Huitzilopochtli, whose continuing appearance in the morning sky required a constant supply of hearts and blood from captured enemies. The Sun and other gods dominated everyday life, their images and the myths associated with them represented in human form or as flora or fauna. The Aztecs never carved actual portraits, as those sculptures with a human appearance—whether of gods, priests, or common people—represent the inhabitants of the sacred Universe. Repeated symbols—often based on nature—reinforced the message of the gods' spiritual powers.

The main Aztec art form was stone sculpture, often monumental in form, although their craftsmen were also skilled in using wood, fired clay, precious stones, feathers, and other materials. However, it is mainly the sculptures that have survived, as more vulnerable works of art, as well as any decorative items in palaces and houses, were almost all destroyed during the Spanish conquest.

◀ **Feather mosaic shield** *The animal on this shield is an ahuizotl, a mythical "water-thorn beast" that dwelled on riverbanks and was said by the Aztecs to seize people who came too close to the water. It gave its name to the Aztec emperor, Ahuizotl, who reigned from 1486 to 1502. c1500, feathers, sheet-gold, agave paper, leather, reed, 27½x27½in, Museum für Völkerkunde, Vienna, Austria*

▲ **Coyolxauhqui** *The name of the moon goddess, Coyolxauhqui means "the one with bells on her face." As usual, she is shown decapitated and with closed eyelids, as she was beheaded by her brother, Huitzilopochtli the sun warrior. c1500, diorite, 31½x31½x26in, Museo Nacional de Antropología, Mexico City, Mexico*

◀ **Coatlicue** *The goddess of the Earth and patron of life and death, Coatlicue is shown here decapitated and with serpents entwining her body. They represent the blood gushing from her neck. She is wearing a necklace of human hands and hearts. c1500, stone, height 101¼in, Museo Nacional de Antropología, Mexico City, Mexico*

▲ **Chacmool** *The carved figure of Chacmool strikes a characteristic pose. He wears a feather headdress, necklaces, bangles, and bracelets with bells attached. A Chacmool figure wears a mask, which identifies him as Tlaloc, the rain god. c1500, stone, 29x42½x17¾in, Museo Nacional de Antropología, Mexico City, Mexico*

▲ **Grasshopper** *When the Aztecs first arrived in the Valley of Mexico, they attempted to found their capital at Chapultepec, the "hill of the grasshopper." Pictograms always show the hill with a grasshopper on its summit. This grasshopper from Chapultepec is made from cornelian quartz. c1500, cornelian, 7¾x6¼x18½in, Museo Nacional de Antropología, Mexico City, Mexico*

The dominant artistic style of the 17th century was Baroque, a bold, theatrical style characterized by movement, intense emotion, and dramatic contrasts in lighting. Originating in Rome to celebrate the renewed power of the Catholic Church, it spread to Spain, Portugal, Germany, and France, where it also came to represent the grandeur and power of monarchs, notably Louis XIV of France.

17th and 18th

1600	1625	1650	1675

BAROQUE c1600–c1720

QING DYNASTY (CHINA) 1644–1911

EDO PERIOD (JAPAN) 1615–1858

MUGHAL EMPIRE 1526–1857

The Low Countries adopted a more restrained version of the Baroque style, leading to a golden age of Dutch painting dominated by portraits, landscapes, and scenes of everyday life. Early in the 18th century the Baroque style was superseded by the more lighthearted and ornamental Rococo style associated initially with the court of Louis XV of France. Light, shimmering colors and swirling forms were used with wit and elegance in paintings, sculptures, and dazzling frescoes for palaces and churches. A renewed interest in the art of ancient Greece and Rome and the influence of the Enlightenment, a philosophical movement promoting the power of human reason, led to a rejection of Rococo around the middle of the 18th century in favor of a revived classical style: Neoclassicism. Perfectly composed, muted paintings featured noble, heroic scenes from classical literature and history, often with high moral values, and highly accomplished marble sculptures were inspired by the "lost art" of the ancients.

centuries

1725 1750 1775 1800 193

ROCOCO c1700–c1780s

NEOCLASSICISM c1770s–1810s

"Baroque" is the name given to the vigorous style that dominated art and architecture in the 17th century. This style originated in Rome, from where it spread throughout Europe. It flourished mainly in Catholic countries and has strong ties with the Counter-Reformation movement in religion.

By the late 16th century, the Mannerist style had become rather lifeless and contrived, with artists placing more emphasis on polish and virtuosity than on genuine feeling. In some ways the Baroque style looked back to the grandeur, dignity, and directness of the High Renaissance, but it also took elements from Mannerism—notably intense emotion and a sense of movement—blending these influences into a fresh and dynamic style.

Origins and influences

This new style was linked with contemporary religious events. From the mid-16th century the Catholic

▲ **The Four Rivers Fountain,** Gianlorenzo Bernini *This powerful and energetic work in the Piazza Navona was created in 1648 and is the most famous of several fountains Bernini created in Rome.*

Church made forceful efforts to assert its authority in the face of the spread of the Protestant Reformation. This fight-back is known as the Counter-Reformation. The Church realized the propaganda value of art and it set

official guidelines for artists, encouraging them to create realistic works to which ordinary men and women could relate. However, there is much more to Baroque art than this religious element, and there were other stylistic currents in the 17th century. In France particularly there was a strong strain of classicism, and in Dutch art, for example, there was often an earthy naturalism. These three currents—Baroque, classicism, and naturalism—often overlap or blend.

Subjects

Although religion remained central to art in most countries, other subjects became increasingly important during the 17th century. Portraits were in

Baroque

TIMEline

Italian Baroque art is sometimes divided into three main phases: early Baroque, c1600–25; high Baroque, c1625–75 (coinciding roughly with the career of Bernini); and late Baroque, c1675 onward, the style blending imperceptibly with Rococo in the early 18th century. Bernini visited Paris in 1665 and the subsequent rejection of his designs for the Louvre indicated that the balance of artistic power was beginning to shift from Italy to France.

1601

CARAVAGGIO Supper at Emmaus

1603–06

MONTAÑÉS The Merciful Christ

1611–14

RUBENS The Descent from the Cross

1622–25

BERNINI Apollo and Daphne

1624

HALS The Laughing Cavalier

▲ **The Betrayal of Christ** Guercino *The dramatic lighting and vigorous sense of movement are typical of Baroque art.* c1621, oil on canvas, 44¾ x 55⅛ in, Fitzwilliam Museum, Cambridge, UK

Schools

Italy, France, Spain, and Flanders (which at this time was ruled by Spain) were the main Catholic countries where art flourished in the 17th century. Among Protestant countries, the Dutch Republic had by far the most vigorous tradition, particularly in painting, but England also played a significant role in artistic affairs, partly because of the patronage of Charles I, one of the greatest of all royal connoisseurs.

Italian

At the beginning of the 17th century Italy led Europe in the visual arts, just as it had done during the Renaissance. Rome was the main artistic center, and it was there—in the years around 1600—that Caravaggio and Annibale Carracci laid the foundations of the Baroque style in painting. They abandoned the conventions of Mannerism, introducing a new gravity but also a new vitality.

Sculpture was similarly reinvigorated by Gianlorenzo Bernini, who was the dominant figure in Italian Baroque art, running a large workshop in Rome that was involved in

many of the major commissions of the time. Outside Rome, both Bologna and Naples rose to prominence as leading centers of painting, and although Florence had declined in importance, Pietro da Cortona produced some of his finest work there.

Foreigners in Rome

Painters and sculptors flocked to Rome from all over Europe—not only to study its unrivaled storehouse of ancient and Renaissance art, but also to seek work. It was a prosperous and growing city, with a steady demand for artists to decorate the many new churches and palaces that were being erected. Some foreign artists settled permanently in Rome, but others returned to their homelands, thereby helping to spread knowledge of the Baroque style.

French

During the 17th century France became the most powerful state in Europe and began to rival Italy for artistic leadership. While in Italy the most characteristic Baroque art was religious, in France it was used in the service of the state—specifically to glorify King Louis XIV. His palace at Versailles is one of the great monuments of the style. The two most illustrious French painters of

demand virtually everywhere; landscape, which had begun to emerge as an independent theme in the 16th century, became a speciality for many artists; mythological and allegorical subjects were popular with sophisticated patrons; and genre (scenes of everyday life) flourished, particularly in the Dutch Republic.

Style and techniques

Baroque art in its purest form was produced only in Catholic countries, often as part of the decoration of churches. Rich materials, spectacular altarpieces, and grandiose paintings on walls and ceilings were in keeping with the ritual of Catholic worship. Protestant churches and ceremonies were usually much plainer, and Baroque art generally seemed overemotional to Protestant eyes.

However, elements of the Baroque style often occur in Protestant countries and in secular as well as religious subjects. The swagger of Hals's *Laughing Cavalier*, for example, is thoroughly in the Baroque spirit.

▲ **The Israelites Gathering Manna,** Nicolas Poussin 1639, oil on canvas, 57⅞ x 78¾in, Louvre, Paris, France

▼ **Detail of The Israelites Gathering Manna** *Poussin's style was strongly influenced by the classical dignity of ancient and Renaissance art, but the eloquent gestures he uses here are typically Baroque.*

and CURRENT events box

CURRENTevents

1618–48 The Thirty Years' War, at the end of which Spain's power has greatly declined and France's has increased.

1626 St. Peter's, Rome, consecrated; its decoration goes on throughout the century.

1652–78 A series of wars with England and later France devastates the Dutch economy, including its art market.

1642

REMBRANDT The Night Watch

1648

POUSSIN The Ashes of Phocion Collected by his Widow

1650

VELÁZQUEZ Portrait of Pope Innocent X

c1665–66

MURILLO The Immaculate Conception

1666–68

VERMEER The Artist's Studio

BAROQUE

195

17TH AND 18TH CENTURIES

the century—Claude and Nicolas Poussin—worked mainly in Rome, but they were highly influential in France, helping to create an ideal of classical dignity and restraint that had a profound and enduring impact on the country's art.

▶ **Portrait of the Blessed John Houghton** Francisco de Zurbarán *This painting has an austere naturalism and a classical grandeur, but its emotional directness can be considered Baroque. It shows an English Carthusian monk who was martyred in the reign of Henry VIII.* 1637–39, oil on panel, 48 x 25¼in, Museo de Cádiz, Cádiz, Spain

Spanish

Although it declined greatly in political power, Spain had a glorious flowering of art in the 17th century and the Baroque style was well suited to the religious fervour of the country. Religion dominated its art, although the greatest Spanish artist of the time—Diego Velázquez—was primarily a portraitist. His work sometimes has a rhetorical quality characteristic of Baroque art, but it is always tempered by naturalism. He spent most of his career in Madrid, which was becoming the most important art center in the country, although other cities, notably Seville, were also of major importance at this time.

Dutch and Flemish

Art in Flanders (roughly equivalent to modern-day Belgium) and the Dutch Republic (Holland) shared a common heritage, as the two countries had been united in the 16th century. However, while the Dutch broke away from Spanish rule to create an independent, largely Protestant state, Flanders remained loyal to Spain and to the Catholic Church. Consequently, although there are many similarities between the countries' art, religious subjects remained of major importance in Flanders

▲ **Young Woman with a Water Jug** Jan Vermeer *This is an example of the everyday life subjects beloved of Dutch artists, but its strength of composition and wonderful handling of color and light lift it far above the commonplace.* c1662, oil on canvas, 17½ x 15⅜in, Metropolitan Museum of Art, New York, US

but were relatively uncommon in Holland. Peter Paul Rubens dominated Flemish art and ranks as one of the archetypal figures of the Baroque style, his work being full of warmth and energy. Rembrandt was a figure of comparable stature in Holland, although his influence was less pervasive, as 17th-century Dutch art was unprecedented for its volume and variety of painters.

English

England had only modest native-born talent in painting and sculpture during the 17th century and imported most of its best artists. The art-loving Charles I attracted both Rubens and Anthony van Dyck to work for him—the latter was chief court painter—as well as numerous lesser lights. His son, Charles II, was much less of a connoisseur, but nevertheless he was a highly cultivated man who employed artists of the caliber of Grinling Gibbons and Peter Lely. Gibbons had English parents, but he was born and brought up in Holland. The outstanding native-born English artist of the period was portraitist William Dobson.

Annibale **Carracci**

Self-portrait

b **BOLOGNA, 1560**; d **ROME, 1609**

Annibale Carracci was the greatest member of a family of artists from Bologna who gave a new impetus to Italian painting in the years around 1600. By the later 16th century, much Italian art had become rather "inbred" and artificial, but the Carracci created vigorous and dignified works that heralded the Baroque style.

To some extent they revived the grandeur of the High Renaissance, but they added a new warmth and sense of movement. Although they admired the great masters of the past, they also based their work on observation of the world around them.

Annibale's varied output included altarpieces, portraits, genre scenes, landscapes, and caricature drawings (a type he invented). His greatest work, the fresco decoration of the *Galleria* of Rome's Palazzo Farnese, was considered a worthy successor to Michelangelo's Sistine Ceiling.

LIFEline

1560 Born the son of a tailor

Early 1580s Tours northern Italy. Opens art academy in Bologna with Ludovico and Agostino Carracci

1583 Completes his first major religious painting, *The Crucifixion with Saints*

1595 Moves to Rome, his base for the rest of his life, to decorate the Palazzo Farnese

1597–1601 Paints his masterpiece: ceiling frescoes for the *Galleria* of the Palazzo Farnese

c1604 Paints *Flight into Egypt*

1606–09 Unproductive final years, blighted by illness and melancholia

▶ **Christ Appearing to St. Peter on the Appian Way**
The subject of this picture is an early Christian legend in which St. Peter encounters a vision of Christ outside Rome. 1601–02, oil on panel, 30½ x 22in, National Gallery, London, UK

▼ **Galleria Farnese Ceiling (detail)** *The ceiling depicts various mythological scenes linked by the theme of love. The main figure here is the giant Polyphemus, who hopelessly loved the nymph Galatea.* 1597–1601, fresco, Palazzo Farnese, Rome, Italy

CLOSERlook

DRAMATIC GESTURES Although the picture is fairly small, it has tremendous strength and dignity, partly because of the force and economy of the gestures. Christ points to Rome, which Peter had been fleeing in fear of his life. Strengthened by the vision, Peter turns back to face martyrdom.

▲ **Flight into Egypt** *This scene of people, buildings, and nature in serene harmony is regarded as the first great example of the "ideal landscape."* c1604, oil on canvas, 48 x 90½in, Galleria Doria Pamphili, Rome, Italy

Agostino **Carracci**

b **BOLOGNA, 1557; d PARMA, 1602**

The older brother of Annibale, Agostino is famed chiefly as an engraver. His many prints after the work of leading painters circulated across Europe, and engravings of his anatomical drawings were still used as teaching aids in the late 1700s.

Portrait by Annibale Carracci

Agostino was less accomplished and distinctive as a painter than Annibale and Ludovico. He was Annibale's chief assistant at the Palazzo Farnese from 1597 to 1599, but the brothers then quarreled and Agostino moved to Parma. There he began a grand fresco scheme of his own at Ranuccio Farnese's palace, left unfinished at his death.

LIFEline

1557 Born the son of a tailor
1576 First dated engravings
Early 1580s Opens art academy in Bologna with brother Annibale and cousin Ludovico
1597–99 Helps Annibale paint the frescoes at the Galleria Farnese, Rome
1599–1602 Decorates the Palazzo Farnese, Parma
1602 Dies and is buried in Parma

▶ **Portrait of Giovanni Gabrielli**
These impressively engraved facial details and exuberant hair belong to a comic actor, also known as Il Sivello. c1599, engraving, 6¼ x 4¾in, Art Gallery of New South Wales, Sydney, Australia

▶ **The Annunciation** *Early in their careers the Carracci often worked together, and it is sometimes difficult to distinguish their hands. This picture is now thought to be by Agostino, but in the past it has been attributed to Annibale and Ludovico.* c1585, oil on canvas, 19 x 13¾in, Louvre, Paris, France

INcontext
THE CARRACCI ACADEMY
The Carracci family academy, also known as the *Accademia degli Incamminati* (Academy of the Progressives), stressed drawing from life and the close study of nature. Many important Baroque artists trained there.

Head of a Youth by Annibale Carracci. *All three Carracci drew constantly. A contemporary wrote that even when eating they had "bread in one hand and a pencil or charcoal in the other."*

Ludovico **Carracci**

b **BOLOGNA, 1555; d BOLOGNA, 1619**

Ludovico Carracci

Ludovico, the cousin of Agostino and Annibale, was a dedicated teacher. He took most of the responsibility for running the academy (art school) that the family founded in Bologna in the early 1580s. Many distinguished artists trained there, including Domenichino and Reni, and they carried on the Carracci tradition of clear, strong draftsmanship. Although Bologna was important for commerce and education, it had previously been relatively undistinguished in art, but the Carracci and their academy turned the city into a major center of painting. Ludovico's own paintings are almost all on religious subjects, often treated in a highly emotional way.

LIFEline

1555 Born a butcher's son in Bologna, where he lives most of his life, in spite of lucrative offers to work elsewhere
Early 1580s Helps to found the Carracci academy
Mid to late 1590s Runs the academy alone from this point
c1595 Paints *The Transfiguration*
1619 Dies, still sole head of the family academy

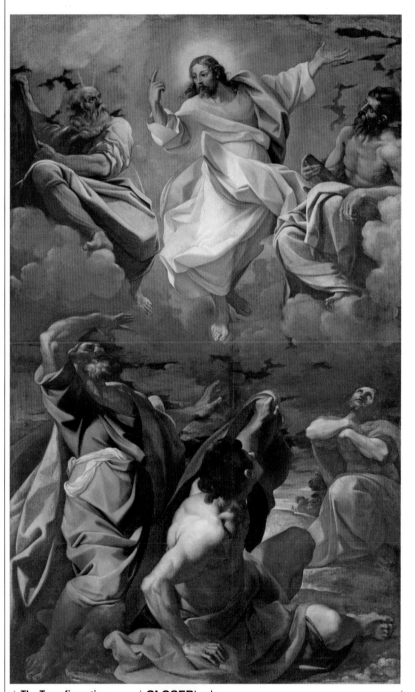

▲ **The Transfiguration**
This explosive altarpiece was for the church of S. Pietro Martire in Bologna. It depicts Christ—flanked by Moses and Elijah—revealing his divine nature to three of his disciples. c1595, oil on canvas, 172½ x 105½in, Pinacoteca Nazionale, Bologna, Italy

CLOSERlook

DRAMATIC CONTRAST The contrast of light playing across this upturned head is typical of Ludovico's work in the 1590s. It helps to create an emotionally charged mood of spiritual ecstasy, true to the ideals of the Counter-Reformation.

Michelangelo Merisi da **Caravaggio**

Portrait by Ottavio Leoni

b CARAVAGGIO OR MILAN, 1571; d PORT'ERCOLE, 1610

Although his life was short and troubled, Caravaggio made an overwhelming impact on Italian (and indeed European) art. He broke with the stale Mannerist tradition, introducing a new solidity and weightiness to painting. Early in his career he painted hedonistic subjects, but in his maturity he concentrated on somber religious works. He imagined the familiar stories afresh, depicting characters who look like real people from the streets of Rome rather than idealized visions. Some contemporaries thought it was disrespectful to bring religion down to earth like this, but many painters imitated his realistic details and dramatic contrasts of light and shade, even though few could rival his grandeur or depth of feeling.

Caravaggio became notorious for his violent temperament as well as famous for his genius. In 1606 he fled Rome after killing a man in a quarrel. He spent the remaining four years of his life as a fugitive from justice, but he continued to receive major commissions (and to influence local artists) wherever he went, working in Naples, Malta, and Sicily.

LIFEline

1571 Born the son of an architect-mason

1584 Apprenticed in Milan to Simone Peterzano, an undistinguished local painter

c1592 Settles in Rome

1599 Starts a series of major religious commissions

1606–10 Leads a wandering life in Naples, Malta, and Sicily after killing a man in Rome

1608 Paints his masterpiece *Beheading of St. John the Baptist*

1610 Dies while returning to Rome to seek a pardon

▼ **Sick Bacchus** *This is almost certainly a self-portrait of the young Caravaggio, painted soon after he arrived in Rome.* c1593–94, oil on canvas, 26 x 20½in, Galleria Borghese, Rome, Italy

◀ **Crucifixion of St. Peter** *Caravaggio painted this powerful altarpiece for a church in Rome, and it can still be seen there. When St. Peter was about to be martyred, he asked to be crucified upside down, as he did not feel worthy to die in the same way as Christ.* 1601, oil on canvas, 90½ x 69in, S. Maria del Popolo, Rome, Italy

▶ **Beheading of St. John the Baptist** *Many people consider this huge work to be Caravaggio's masterpiece. It was painted for the Knights of the Order of St. John (the Knights Hospitaller), who at this time effectively ruled the island of Malta. John the Baptist was their patron saint.* 1608, oil on canvas, 142 x 205in, Co-Cathedral of St John, Valletta, Malta

CLOSERlook

OFF-CENTER ARRANGEMENT The bold composition—with the main group on the left and an expanse of wall on the right—was highly unusual, but it helps create a compelling sense of reality. The two men gawping through the bars are perhaps prisoners. Caravaggio himself was briefly imprisoned several times for various offenses and must often have witnessed bloodshed during his violent life.

" He thinks that **all paintings are mere nothings**, child's play or trifles, whatever their subject matter or authorship, unless they have **been painted from life**, and that nothing can be good and **nothing better** than to **follow nature** "

CAREL VAN MANDER (1548–1606), DUTCH ARTIST AND WRITER

FOREGROUND DEVICE
Caravaggio often used foreground objects to draw viewers in. He was a superb painter of still-life details such as this.

▼ **Supper at Emmaus** *In this painting, the resurrected Christ reveals himself to his disciples. The realism of the faces and clothing invites instant involvement.* 1601, oil and egg tempera on canvas, 55½ x 77in, National Gallery, London, UK

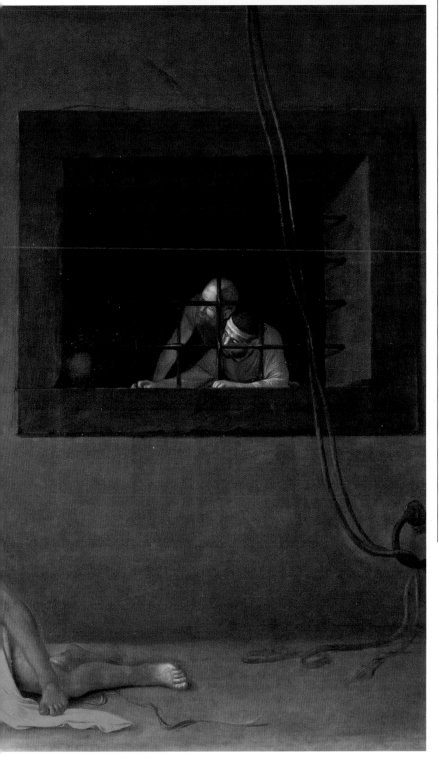

Artemisia **Gentileschi**

b **ROME, 1593**; d **NAPLES, 1652/53**

Like her painter father Orazio Gentileschi (1563–1639), Artemisia was an outstanding follower of Caravaggio. Her work did much to spread his style, and she became one of the first female painters to be widely acclaimed. Unusually for a woman of her day, Artemisia lived a life of great independence, and she tackled ambitious historical and religious themes in preference to the still lifes typically chosen by 17th-century female artists. Her favorite subject (which she treated several times) was Judith Beheading Holofernes. Her liking for this bloodthirsty theme has been interpreted as "pictorial revenge" for her own youthful sufferings: she was allegedly raped by the painter Agostino Tassi and was tortured at his trial to test the truth of her evidence.

LIFEline

1593 Born in Rome
1611 Allegedly raped by Tassi
1612 Rape trial; Artemisia marries
1612–20 Lives in Florence; becomes first woman to join city's *Accademia del Disegno*
c1613–14 *Judith Beheading Holofernes* (Uffizi version)
c1630 Moves to Naples
1638–41 In England, working for King Charles I
1641 onwards Probably works mainly in Naples
1652/53 Dies in Naples

▲ **Judith Beheading Holofernes** *This is Artemisia's most famous painting of the subject. The drama, violent realism, Caravaggesque lighting, and solid figures are all characteristics of her work.* c1613–14, oil on canvas, 78½ x 64in, Uffizi, Florence, Italy

INcontext

ART SERVING RELIGION During the 16th and early 17th centuries, the Catholic Church underwent a period of reform and renewal, now called the Counter-Reformation. Artists such as Caravaggio were acutely aware that religious art must move the masses to devotion.

The Council of Trent *A series of high-level church councils (1545–63) issued decrees to strengthen the Catholic Church's authority.*

Gianlorenzo **Bernini**

Self-portrait

b NAPLES, 1598; d ROME, 1680

If any one artist embodies Baroque art, it is Bernini, who ranks as the greatest sculptor of the 17th century and one of its greatest architects (he was also a brilliant painter, but mainly as a private pleasure). His work, which is passionate and rhetorical, often expresses his deep religious feelings, but he also excelled at secular subjects, including portraits. He achieved great success while still very young, and for most of his long career he was the dominant artist in Rome. His buildings, fountains, and outdoor sculptures have had a huge impact on the city's appearance. He worked for every pope who reigned during his career, and some of his greatest masterpieces are in St. Peter's. His other patrons included Louis XIV of France, for whom he worked in Paris in 1665.

LIFEline

1598 Born son of Florentine sculptor Pietro Bernini
1618–25 Produces a series of life-size marble sculptures for Cardinal Scipione Borghese, his first major patron
1623 Appointed architect to St. Peter's, for which his work includes the Baldacchino
1645–52 Creates *Ecstasy of St. Theresa*
1665 Visits Paris
1680 Dies, aged 81

▶ **Baldacchino** *This massive canopy rises over the high altar of St. Peter's. Its twisted bronze columns rest on marble bases.* 1623–34, gilded bronze and marble, height 95ft, St. Peter's, Vatican City

▼ **Ecstasy of St. Theresa** *Bernini shows the mystic Theresa in a spiritual faint in front of an angel, who has speared her heart with divine fire. Natural light falls across the group from a hidden window.* 1645–52, marble, life-size, Cornaro Chapel, S. Maria della Vittoria, Rome, Italy

CLOSERlook

GILT PERFECTION The canopy's spiraling columns were modeled on ancient examples, thought to have come from King Solomon's Temple in Jerusalem. Gilded surface decoration stands out strikingly against the dark bronze of the columns. The decoration takes the form of beautifully wrought vine leaves, often interpreted as a reference to the wine used in the Catholic Eucharist

▲ **The Cornaro Chapel** *Bernini was at his greatest when combining his skills as a designer, sculptor, and architect, as he did here. Notoriously self-critical, he regarded this masterpiece as his "least bad" work.* 1645–52, marble, bronze, and other materials, S. Maria della Vittoria, Rome, Italy

❝ Bernini **strove** with everything in him **to make resplendent** all the conceptual **beauty inherent** in whatever he was working on ❞

FILIPPO BALDINUCCI (1624–96), FLORENTINE ART HISTORIAN

Alessandro **Algardi**

b **BOLOGNA, 1598**; d **ROME, 1654**

Apart from the great Bernini, Algardi was the leading Italian sculptor of his time. His style was more sober than Bernini's, and during the pontificate (1644–55) of Innocent X, whose taste was conservative, he was the leading sculptor at the papal court. He had several large commissions, including one for a huge marble relief for St. Peter's, *Pope Leo the Great Driving Attila from Rome* (1646–53). However, Algardi is now most admired for his portrait busts, which show great dignity and skill in characterization.

▼ **Beheading of St. Paul** *This group is part of an elaborate altar composition.* Completed 1644, marble, over-life-size, S. Paolo Maggiore, Bologna, Italy

CLOSERlook

MIRACLE IN MARBLE Bernini's extraordinary skill in cutting marble enabled him to create effects that would have been beyond any other sculptor. Here he not only convincingly shows a woman turning into a tree but also captures the astonished expression on her beautiful face.

◄ **Apollo and Daphne** *This is one of a group of early masterworks commissioned by Cardinal Scipione Borghese. Bernini shows the moment from Ovid's poem Metamorphoses when Daphne is transformed into a tree.* 1622–24, marble, 8ft high, Galleria Borghese, Rome, Italy

► **Cardinal Paolo Emilio Zacchia** *The figure has an imposing dignity, but the hands leafing through the book add a note of intimacy.* 1650s, marble, 64in, Bargello, Florence, Italy

◄ **Four Rivers Fountain** This is Bernini's best-known and most impressive fountain, full of movement and peopled with over-life-size figures representing the Danube, Ganges, Nile, and Plate rivers. 1648–51, marble and other stones, Piazza Navona, Rome, Italy

▲ **Piazza S. Pietro** With this vast colonnaded piazza in front of St. Peter's, Bernini succeeded in creating a grand space that could be used for many purposes, including holding the huge crowds that gathered for papal blessings. 1656–67, Piazza S. Pietro, Vatican City

Domenichino

b BOLOGNA, 1581; d NAPLES, 1641

Domenichino (Domenico Zampieri) trained in the Carracci Academy in Bologna, then in 1602 moved to Rome—one of a number of Bolognese artists who followed in the footsteps of Annibale Carracci and capitalized on his success. He began his career in Rome assisting Annibale with his frescoes at the Palazzo Farnese, but he soon made a reputation of his own. By 1615, he was established as the leading painter in the city.

Domenichino worked mainly on church commissions (frescoes and altarpieces), but he also painted outstanding portraits and landscapes. His style was noble and restrained—looking back to Raphael and forward to Poussin—although it became somewhat freer as his career advanced. He spent his final years working in Naples, notably in the cathedral.

LIFEline

1581 Born in Bologna, the son of a shoemaker

c1595 Joins the Carracci Academy (see p.197)

1602 Moves to Rome. Works at the Palazzo Farnese with Annibale Carracci

1614 Paints *Last Communion of St. Jerome*

1617–21 Works in Bologna and Fano

1621–31 Returns to Rome. Paints frescoes for S. Andrea della Valle

1631 Moves to Naples to work on a commission in the cathedral

1641 Dies in Naples, allegedly poisoned by hostile local artists

▲ **St. Luke** *Domenichino skillfully fitted figures of the Evangelists into the awkward shapes beneath the dome.* 1624–25, fresco, S. Andrea della Valle, Rome, Italy

◄ **Last Communion of St. Jerome** *This is Domenichino's best-known altarpiece, renowned for the pathos with which it depicts the dying St. Jerome. It was inspired by a painting of the same subject by Agostino Carracci, but far outshone its model in fame.* 1614, oil on canvas, 165 x 101in, Pinacoteca Vaticana, Vatican City

CLOSERlook

SURFACE TEXTURES Detailed surface treatment of the fabric of the priest's garment, with shimmering highlights glancing beautifully off the perfectly observed folds, introduces a sumptuous note. This is echoed in the various different surfaces throughout the picture, as well as in the rich palette of colors that Domenichino has used.

Guercino (Giovanni Franscesco Barbieri)

Self-portrait

b CENTO, NEAR BOLOGNA, 1591; d BOLOGNA, 1666

Giovanni Francesco Barbieri is commonly known by his nickname *Guercino*, which means "squinter." He was one of the most individual Italian painters of the 17th century, creating a bold and lively style that is highly distinctive. Guercino spent most of his career in his native north Italy, but he also had a brief period (1621–23) in Rome. There he worked for Pope Gregory XV and for Gregory's nephew, Cardinal Ludovico Ludovisi, for whom he painted his most famous work, the exuberant ceiling fresco *Aurora* (1621).

When Guido Reni died in 1642, Guercino moved from Cento to Bologna and took his place as the city's leading painter. By this time, his style had moved away from the energy of his youth, becoming calm and dignified, and some of his late works have a Reni-like serenity and refinement.

LIFEline

1591 Born in Cento

1607–10 Apprenticed to local painter, Benedetto Gennari

1621 Paints *Aurora* fresco

1642 Moves to Bologna and succeeds Guido Reni as the city's leading painter

1666 Dies in Bologna

► **Erminia Finds the Wounded Tancred** *This painting is typical of the artist's early, boldly lit style.* 1618–19, oil on canvas, 57½ x 74in, Galleria Doria Pamphili, Rome, Italy

◄ **Aurora** *This captivating work depicts dawn's chariot speeding across the skies.* 1621, fresco, ceiling of the Casino, Villa Ludovisi, Rome, Italy

CLOSERlook

CEILING PAINTINGS Here, Guercino has skillfully foreshortened his figures so that they look as if they are being viewed from below (this is especially clear in the horses). However, not all painters adopted this approach. Guido Reni painted his *Aurora* (opposite) as if it were to be seen at normal eye level.

Giovanni **Lanfranco**

b **TERENZO, NEAR PARMA, 1582;** d **ROME, 1647**

Lanfranco spent part of his early career in northern Italy and most of his later years in Naples, but his key works were produced in Rome. There he was a rival of Domenichino, and during the 1620s he overtook him as the leading fresco painter in the city. During this period both painters worked in the church of S. Andrea della Valle, Lanfranco decorating the dome with a glorious scene of the *Assumption of the Virgin* (1625–27). This was the first dome painting in a full-blooded Baroque style—teeming with movement and emotion—and it was influential throughout Europe. In addition to his frescoes, Lanfranco produced many smaller paintings (mainly on religious subjects). He was also a prolific draftsman.

LIFEline
1582 Born near Parma
Late 1590s Apprenticed to Agostino Carracci in Parma
1612–34 In Rome. Paints *Assumption of the Virgin*
1634–46 Works in Naples
1646–47 Back in Rome
1647 Dies, shortly after producing frescoes for S. Carlo ai Catinari

▶ **Ecstasy of St. Margaret of Cortona** *The saint swoons in front of a vision of Christ in this powerful altarpiece.* 1622, oil on canvas, 90½ x 73in, Palazzo Pitti, Florence, Italy

▲ **Assumption of the Virgin** *Lanfranco's great dome painting was much admired by his contemporaries. The biographer Giovanni Pietro Bellori compared the thronging figures to the blending of voices in a choir "when all the sounds are in harmony."* 1625–27, fresco, S. Andrea della Valle, Rome, Italy

Guido **Reni**

Guido Reni

b **BOLOGNA, 1575;** d **BOLOGNA, 1642**

Reni was the most famous Italian painter of his time, renowned throughout Europe for the grandeur and gracefulness of his work. In spite of his enormous success, however, he was often in debt because he was addicted to gambling.

Reni spent most of his career in Bologna, but from 1601 to 1614 he was based in Rome, where his work included the ceiling fresco *Aurora* (1614), painted for Cardinal Scipione Borghese. This is much more serene and classical in style than the slightly later—and equally famous—treatment of the subject by Guercino (see p.202). Reni painted several other mythological pictures, but the bulk of his work was on religious subjects. He is said to have taught more than 200 pupils, and they, and other imitators, produced a huge number of copies and adaptations of his pictures.

LIFEline
1575 Born a musician's son
c1584–97 Studies with Denys Calvaert, then at the Carracci Academy
1601–14 Based in Rome; paints *Aurora* fresco (1614)
1614–42 Settles in Bologna
1642 Dies, and is buried with great ceremony in Bologna

▼ **St. Matthew and the Angel** *The dignified features are typical of Reni's work.* c1635–40, oil on canvas, 33½ x 27in, Pinacoteca Vaticana, Vatican City

▲ **Aurora** *Although this is a masterpiece of fresco painting, Reni rarely used the medium again, preferring to work in oil.* 1614, fresco, Casino dell'Aurora, Palazzo Rospigliosi–Pallavicini, Rome, Italy

CLOSERlook

DIAGONALS The use of strong diagonals is a feature of Baroque art. Here, the two diagonals are curved, giving a feeling of movement.

ATTENTION TO DETAIL The viewer can feel the saint grip his pen as he writes down the Gospel dictated to him by an angel.

Pietro da **Cortona**

Pietro da Cortona

b **CORTONA, 1596**; d **ROME, 1669**

Painter, architect, and designer, Cortona ranks second only to Bernini as the most versatile genius of Italian Baroque art. Like Bernini, he spent most of his career in Rome, but he also carried out major works in Florence. As a painter he specialized in grandiose fresco decoration in palatial interiors: his most famous works in this vein were produced for the Barberini family in Rome (its members included Pope Urban VIII) and for the ruling Medici family in Florence. He often combined his frescoes with elaborate stucco ornamentation, creating a highly sumptuous effect. Such treatment was much imitated, for example at Louis XIV's palace at Versailles.

In addition to his large-scale decorative schemes, Cortona produced many smaller paintings (mainly on religious and mythological subjects), and designed tapestries and festival decorations. He was also one of the greatest architects of his time, even though he claimed that architecture was merely a recreation for him.

LIFEline

1596 Born the son of a stonemason and builder

c1612 Arrives in Rome

1624–26 Receives his first major commission, to paint frescoes in the church of S. Bibiana for Pope Urban VIII

1633–9 Paints *Allegory of Divine Providence and Barberini Power*

1640–47 Works mainly in Florence, decorating the Palazzo Pitti

1647 Returns to Rome

1669 Dies and is buried in his church of SS. Luca e Martina, Rome

◄ **SS. Luca e Martina**
This is Cortona's architectural masterpiece, the first church to be designed and built in a unified Baroque style throughout. 1635–50, the Forum, Rome, Italy

▼ **Allegory of Divine Providence and Barberini's Power** *Cortona's most famous work as a painter glorifies Pope Urban VIII and his aristocratic Barberini family.* 1633–39, fresco, approx 82 x 49ft, Gran Salone, Palazzo Barberini, Rome, Italy

▲ **Sala di Apollo (detail)** *The combination of painted image and elaborate stuccowork in ceilings such as this was highly influential.* 1640s, fresco, Palazzo Pitti, Florence, Italy

▲ **Romulus and Remus Given Shelter by Faustulus**
Expressive gestures, rich colors, and majestic figures are characteristic elements of Cortona's painting. c1643, oil on canvas, 8¼ x 8½ft, Louvre, Paris, France

CLOSERlook

THE ART OF ILLUSION The figure representing Divine Providence is backlit with a blinding glow and points toward the Barberini family emblem of three bees. Like the other figures, Providence is expertly foreshortened to give the feeling of a dizzying view from below. Spectators are pulled up toward this focal point, and the ceiling seems to open to the sky.

Salvator **Rosa**

Self-portrait

b **ARENELLA, 1615;** d **ROME, 1673**

A poet and actor as well as a painter and printmaker, Salvator Rosa was a colorful character who did a great deal to create the popular romantic image of the artist as a rebel and outsider. He trained in Naples and spent most of the 1640s in Florence, but otherwise he worked mainly in Rome.

Although he regarded his historical and religious pictures as his most important works, Rosa is now best known for his landscapes, in which he created a new type of image of nature—wild and raw—that contrasted with the serene "ideal" landscapes of Claude and Poussin. In a similar vein, he also painted macabre subjects, including scenes of witchcraft.

▶ **Democritus in Meditation** *Rosa was an accomplished etcher who made prints such as this reproducing his paintings.* c1662, etching, 18 x 10½in, Leeds City Art Gallery, Leeds, UK

▲ **Rocky Landscape with a Huntsman and Warriors** *Showing humans dwarfed by a threatening and untamed nature, this picture exemplifies the wild, romantic strain in Rosa's work.* 1660s, oil on canvas, 56 x 75½in, Louvre, Paris, France

CLOSERlook

ROCKS AND CRAGS Well known for using large rocks and crags as prominent features in his landscapes, Rosa was expert at rendering their rough surfaces with vigorous brushwork. This was part of his way of stressing nature's wild, elemental forces.

NOTES OF DRAMA The eye goes quickly to the tiny figures, despite the expanse of turbulent landscape around them. Although painted sketchily, they are picked out deftly with patches of bright color against highlights in the dramatic sky above.

Carlo **Dolci**

b **FLORENCE, 1616;** d **FLORENCE, 1687**

Dolci was one of the leading artists of his time in Florence. Deeply devout, he specialized in religious works, which included some large altarpieces. He is best known for small, intimate works for private devotion. These were highly popular in his lifetime and for many years afterwards, but then fell out of favor, being dismissed as cloyingly sentimental. The past half-century has seen renewed interest in his work, especially his beautifully polished craftsmanship. Dolci also painted portraits, but these are strong and sober—very different from his religious works.

▲ **Virgin and Child with the Infant St. John the Baptist** *The sweet sentiment and smooth finish are typical of Dolci's style.* c1635, oil on panel, diameter 38¼in, Museum of Fine Arts, Houston, Texas, US

Bernardo **Strozzi**

b **GENOA, 1581;** d **VENICE, 1644**

Strozzi's two nicknames—*Il Cappuccino* (the Capuchin) and *Il Prete Genovese* (the Genoese priest)—reflect his years as a Capuchin monk in a Genoese monastery (1598–1610). He had trained as a painter before entering the monastery, and may have painted devotional works while inside its walls. Strozzi left the monastery in 1610 to support his widowed mother and his sister. After his mother died, the monastery pressurized him to return, but he moved to Venice in 1630/31, becoming one of the leading painters in the city. As befits a monk, he painted mainly religious works, but he also produced portraits, allegories, and genre scenes. His style shows many influences (including that of Rubens, who worked in Genoa), but it has a distinctive richness and warmth.

▲ **Alexander the Great Restoring the Throne Usurped from Abdolonimus** *This obscure story from Greek history inspired several operas, including Mozart's* Il re pastore *(1775).* c1615–17, oil on canvas, 48½ x 69in, Tokyo Fuji Art Museum, Tokyo, Japan

Giovanni Battista **Gaulli**

Self-portrait

b **GENOA, 1639; d ROME, 1709**

Gaulli, who is also known as Baciccio (a dialect form of his Christian names), spent most of his career in Rome, where he was a protégé of Bernini. His most famous work is the *Adoration of the Name of Jesus*, a glorious ceiling fresco in the Gesù (the mother church of the Jesuits) in Rome. In its energy, virtuosity, and spiritual conviction, this is one of the archetypal Baroque works. Gaulli also produced many smaller religious paintings and was a fine portraitist. His sitters included seven popes.

LIFEline
1639 Born in Genoa
c1657 Settles in Rome
1674–77 *Adoration of the Name of Jesus*
c1675 Paints portrait of Bernini
1709 Dies in Rome

▼ **The Three Marys at the Empty Sepulcher** *Here, rich Genoese colors shine through.* c1684–85, oil on canvas, 34 x 45in, Fitzwilliam Museum, Cambridge, UK

Luca **Giordano**

Self-portrait

b **NAPLES, 1634; d NAPLES, 1705**

Although he began his career working in the somber tradition of Caravaggio, Luca Giordano developed a light, airy style that heralds the Rococo. He was the most prolific decorative painter of his time, so renowned for his speed and energy that he was nicknamed *Luca fa presto* (Luke work quickly). His life began and ended in Naples, but he also did a good deal of work in Florence and Venice, and he spent a decade in Spain, mainly in the employ of King Charles II. Initially he worked at the Escorial, the huge monastery–palace near Madrid, and then on other royal and church commissions. When he returned to Naples he was approaching 70, but he continued working with vigor and passion.

LIFEline
1634 Born in Naples, the son of painter Antonio Giordano
1653 First dated works
1658 Marries
1665 Begins period of extensive travels, spending much of it working in Florence and Venice
1692 Goes to Spain to work for King Charles II
1702 Returns to Naples
1705 Dies in Naples a wealthy, famous, and respected man

▶ **Celestial Glory and the Triumph of the Habsburgs** *This fresco adorns the ceiling over the Escorial's Imperial Staircase. Giordano created such works with extraordinary fluency.* 1692–94, fresco, El Escorial, Spain

Andrea **Pozzo**

Artist unknown

b **TRENTO, 1642; d VIENNA, 1709**

Andrea Pozzo is a perfect example of religious faith wedded to art. A painter and architect, he became a lay brother in the Roman Catholic Jesuit order in his twenties. After this, he completed numerous projects for Jesuit churches, especially in and around Rome. His masterpiece is the *Glory of St. Ignatius Loyola and the Missionary Work of the Jesuits* in the church of S. Ignazio, Rome—one of the most breathtaking ceiling paintings ever created. It shows the formidable skill with perspective that lay at the heart of Pozzo's work.

In 1703 Pozzo moved to Vienna, where he spent the rest of his life, mainly engaged on Jesuit projects. He wrote a major treatise on perspective, which was published in Latin and Italian in two volumes in 1693 and 1700 and was soon translated into other languages.

LIFEline
1642 Born in Trento, where he receives his initial training
1665 Becomes a Jesuit lay brother
1681 Settles in Rome
1688–94 Paints ceiling of S. Ignazio, Rome
1693 and 1700 Writes the two-volume treatise, *Perspective in Painting and Architecture*
1703 Moves to Vienna
1709 Dies in Vienna; is buried in the Jesuit Church

CLOSERlook

IMAGINARY ARCHITECTURE Pozzo was one of the greatest masters of quadratura, a type of decoration in which painted architecture seems like an extension of the real architecture of a building. An indicator on the floor of the church of S. Ignazio shows the place to stand to get the most convincing effect.

◀ **Guardian Angel** *Even in this relatively small work, Pozzo manages to convey a vigorous sense of movement typical of Baroque art.* c1685–94, oil on canvas, 68 x 48in, Musée des Beaux-Arts, Caen, France

▶ **Glory of St. Ignatius Loyola and the Missionary Work of the Jesuits** *Here, the perspective scheme sweeps the viewer's eye up to the single vanishing point at the central figure of Christ.* 1688–94, fresco, vault of nave, S. Ignazio, Rome, Italy

Adam **Elsheimer**

b **FRANKFURT AM MAIN, 1578; d ROME, 1610**

Although he died aged 32 and left only a small number of works, Elsheimer was a highly influential painter, inspiring artists of the caliber of Rubens (who was a friend) and Rembrandt to imitate his poetic lighting effects. As well as being brief, his life seems to have been unhappy, blighted by melancholia and debt. It was only after his death that his work began to be widely admired.

Elsheimer spent most of his short career in Rome. Almost all his paintings are small, painted on copper with a miniaturist-like delicacy. However, they never seem fussy and have a grandeur of conception out of all proportion to their size. Most of them depict figures in a landscape setting, and he is particularly renowned for his sensitive treatment of nocturnal scenes.

> " Surely, after **such a loss** our entire profession ought to **clothe itself in mourning**… We will not easily succeed in replacing him; in my opinion **he had no equal** in small figures, in landscapes, and in many other subjects "
>
> PETER PAUL RUBENS, 1610, ON ELSHEIMER'S DEATH

LIFEline

1578 Born the son of a tailor
1598 Travels to Venice
1600 Settles in Rome
1606 Marries; becomes a member of the Accademia di S. Luca
1610 Dies in poverty and is buried in the church of S. Lorenzo in Lucina, in Rome

▶ **The Mocking of Ceres**
The goddess Ceres, searching for her daughter Proserpina, thirstily gulps down a barley drink offered by an old woman. c1607, oil on copper, 11¾ x 9¾in, Prado, Madrid, Spain

CLOSERlook

LIGHT EFFECTS As the old lady stands outside her cottage at night, the flickering candle picks out parts of her lined face in a way that makes her seem rather sinister. Elsheimer seems to have experimented with lighting and compositional effects by using little wax figures that he arranged on a kind of miniature stage set.

François **Duquesnoy**

b **BRUSSELS, 1597; d LIVORNO, 1643**

The Flemish-born Duquesnoy came from a distinguished family of sculptors. After training in his father's studio in Brussels, he moved to Rome. There he rivaled Algardi as the leading sculptor of the day, after the great Bernini. Duquesnoy's style is more classical and restrained than Bernini's, although it often displays warmth and charm, especially in his smaller pieces. He was renowned for his skill in representing children. In 1643 Duquesnoy was summoned to France to work for King Louis XIII, but he died on the way.

LIFEline

1597 Born son of sculptor Jérôme Duquesnoy, with whom he trains
1618 Moves to Rome, where he initially works mainly on restoring antique sculpture
1627–28 Assists Bernini with Baldacchino in St. Peter's
1629–40 Carves statue of *St Andrew* for St. Peter's
1643 Falls ill and dies at Livorno, Tuscany

▶ **Putto with a Dolphin**
Duquesnoy is especially well known for this kind of piece, featuring putti (cherubs) depicted in a charming way. c1625–30, ivory, Galleria e Museo Estense, Modena, Italy

▲ **St Andrew** *This was the most important public commission of Duquesnoy's career. It shows St. Andrew with the X-shaped cross on which he was crucified.* 1629–40, marble, 14ft 9in high, St Peter's, Vatican City

Gerrit van **Honthorst**

b **UTRECHT, 1592; d UTRECHT, 1656**

The Dutch painter Honthorst was one of the best of the many foreign artists who were influenced by Caravaggio's work in the early 17th century. He spent roughly a decade in Rome, from about 1610, and earned the nickname *Gherardo delle Notti* (Gerard of the Night Scenes) because of his skill with nocturnal light effects, especially in scenes illuminated by candlelight.

After his return to the Netherlands, he played a major role in establishing his home town of Utrecht as a stronghold of Caravaggio's style. It lingered there into the 1650s, long after it had gone out of fashion in Rome. However, Honthorst himself abandoned the style in his later years, when he worked mainly as a portraitist.

▲ **The Freeing of St. Peter from Prison** *Honthorst clearly shows his debt to Caravaggio in the dramatic gestures and bold lighting.* c1616–20, oil on canvas, 51 x 70½in, Bodemuseum, Berlin, Germany

Still Life

Still life, the painting of ordinary objects without human presence, was long regarded in the Western world as a lowly form of art on the grounds that it required only technical skill—not imagination. It was frequently associated with themes of transience, decay, and the vanity of earthly things. Since the late 19th century, however, its neutrality has made it a powerful vehicle for artists engaged with issues of pure form.

▼ **Still Life with Peaches** Roman *Fruit and other still life objects were not painted in isolation at first but formed part of much larger paintings.* c50 BCE, mural from Herculaneum, 13¾ x 13½in, Museo Archeologico Nazionale, Naples, Italy.

▶ **Still Life of Kitchen Utensils** Jean-Siméon Chardin *Chardin's domestic still lifes are typical of his understated realism.* 18th century, oil on canvas, 12½ x 15½in, © Ashmolean Museum, Oxford, UK.

▼ **Still Life with Lemons, Oranges, and a Rose** Francisco de Zurbarán *Fruit is a popular still life subject and here Zurbarán has produced a masterly study.* 1633, oil on canvas, 24½ x 43in, Norton Simon Collection, Pasadena, CA, US

▲ **Six Kakis** Chinese School *This early oriental still life, depicting six persimmon fruits, avoids realism in favor of abstraction, conveying a feeling of the subject, rather than representing it exactly.* 13th century, ink on paper, 13¾ x 11½in, private collection.

▲ **Still Life of Flowers and Dried Fruit** Clara Peeters *This example of "breakfast" art comprises flowers, a dish of nuts and dried fruits, and another of pretzels.* 1611, oil on panel, 20½ x 28¾in, Prado, Madrid, Spain.

▶ **Vanitas Still Life** Sébastien Stoskopff *Symbolic of the transience of life, vanitas paintings often include a skull as a sign of death.* 1641, oil on canvas 49 x 65in, Musée des Beaux-Arts, Strasbourg, France

▲ **Old Models** William Michael Harnettt *The composition of this painting evokes a feeling of refinement through leisure acitvities—here music and reading.* 1892, oil on canvas, 54 x 28in, Museum of Fine Arts, Boston, Massachusetts, US

▼ **Still Life with Dishes** Amedee Ozenfant
This kind of flat, almost diagrammatic still life is characteristic of the intellectual approach of Ozenfant, who was a renowned teacher and writer on art. 1920, oil on canvas, Hermitage, St. Petersburg, Russia

apparent but has been softened by Braque's subtle use of color. 1929, oil on canvas, 57 x 45in, Phillips Collection, Washington DC, US

▼ **New Stones —Newton's Tones** Tony Cragg *Made from fragments of discarded plastic, this sculpture is arranged according to Isaac Newton's spectrum of color. Cragg uses found materials to comment on urban waste.* 1978, found plastic objects, 144 x 96in, Arts Council Collection, Hayward Gallery, London, UK

▲ **Wine Glasses** Patrick Caulfield *The plain but brightly colored background of the painting provides a stark contrast to the simple outline of the wine glasses.* 1969, screenprint, 14¼ x 12¼in, private collection.

▲ **Still life with Basket** Paul Cezanne *A basket overflowing with fruit has been carefully arranged on a table with a white cloth and three different pots.* 1888-90, oil on canvas, 26 x 32in, Musée d'Orsay, Paris, France

◄ **Two Cut Sunflowers** Vincent van Gogh *One of a series of van Gogh paintings depicting sunflowers, the wilted heads and use of brown pigment, infuse it with a wistful melancholy.* 1887, oil on canvas, 20 x 23½in, Kunstmuseum, Bern, Switzerland

▲ **Le Reveil du Lion** Daniel Issac Spoerri *Known as a "snare picture," everyday items including a slipper, a bowl, and a lamp have been attached to a board and then hung on the wall, with the intention of "snaring" a moment in time.* 1961, mixed media, 35½ x 30 x 19in, Galerie Schwarz, Milan, Italy.

Simon **Vouet**

b PARIS, 1590; d PARIS, 1649

Self-portrait

In the early 17th century, French art was at a low ebb, as the country recovered from a lengthy civil war. One man was largely responsible for reviving French painting from this period of stagnation—Simon Vouet. He did this not only through his own works, but by training many artists of the next generation, when his country made such giant cultural strides that it began to challenge Italy for leadership in the visual arts.

Vouet formed his style during a lengthy stay in Italy from 1613 to 1627. He combined elements from various sources into a suave and vigorous manner. His work sometimes lacks individual personality and rarely shows emotional depth, but it is always dignified, superbly drawn, and beautifully polished in technique. He was versatile and highly professional, carrying out a great variety of work, although most of his major decorative schemes have, unfortunately, been destroyed.

LIFEline

1590 Born the son of Parisian painter Laurent Vouet

1611-12 Visits Constantinople

1613–27 Lives in Italy, mainly in Rome

1624 Elected president of The Academy of St. Luke, Rome, a great honor for a non-Italian

1627 Recalled to Paris by King Louis XIII to become his principal painter

1640-42 His pre-eminence is threatened when Poussin visits Paris

1641 Paints *The Presentation in the Temple*

1649 Dies in Paris while still the dominant artist in France

▲ **Justice** *This formed part of a decorated ceiling on the theme of the four cardinal virtues. c1637–38, oil on canvas, 55 x 62½in, Musée National du Château et des Trianons, Versailles, France*

◄ **The Presentation in the Temple** *This altarpiece was commissioned by Cardinal Richelieu for the Jesuit Church, Paris (now St. Paul and St . Louis). 1641, oil on canvas, 154¾ x 98⅜in, Louvre, Paris, France*

CLOSERlook

SERENE FACES The faces in this biblical scene have a gentle, poetic serenity and, like the rest of the picture, bask in a warm, glowing light that unifies the whole work.

Georges de **La Tour**

b VIC-SUR-SEILLE, 1593; d LUNÉVILLE, 1653

Georges de La Tour enjoyed a successful although fairly low-key career in his native Lorraine (now part of France, but at this time an independent duchy). After his death, however, his work was virtually forgotten for about for 250 years, and the process of rediscovery did not begin until the early 20th century. Since then, his reputation has grown enormously, and he is now generally considered the greatest of all Caravaggesque painters.

Like many other artists, he imitated Caravaggio's dramatic use of light and shade, but he looked beyond the obvious trademarks of the master's work to capture something of its grandeur and solemnity, to which he added his own sense of mystery and contemplation. Little is known of his life and it is uncertain whether he visited Italy and saw Caravaggio's work at first hand or learned about it from intermediaries.

▶ **The Newborn Child**
This is the type of painting for which La Tour is best known: a serene nocturnal scene with flickering candlelight and simple, monumental shapes. Few of La Tour's paintings are dated and it has proved difficult to establish a chronology, but this is usually considered a late work. c1645–50, oil on canvas, 30 x 36in, Musée des Beaux-Arts de Rennes, Rennes, France

LIFEline

1593 Born the son of a baker

1616 First documentary reference to La Tour as an adult; in his earlier unrecorded years he possibly visited Italy

1617 Marries Diane Le Nerf, from Lunéville

1620 Moves to Lunéville, where he lives for the rest of his life.

1639 Visits Paris and is made a painter to the French king

1653 Dies in Lunéville, and his work slips quickly into obscurity

▲ **The Payment of Taxes** *It is uncertain if this is a pure genre scene or is meant to represent an incident from The Bible. c1620, oil on canvas, 39 x 60in, Lviv State Art Gallery, Lviv, Ukraine*

CLOSERlook

MYSTIC LIGHT This wonderfully tender and very intimate scene is illuminated by a single candle held in the hand of the woman on the left, but because she shields the candle from the viewer, the light seems to emanate from the baby's head. In this way, what is evidently a scene of human maternity takes on a very spiritual aura, with the baby evoking images of the Christ Child.

Antoine, Louis, and Mathieu **Le Nain**

b **LAON, c1600, c1600, c1607; d PARIS, 1648, 1648, 1677**

The three Le Nain brothers represent one of the great unresolved problems in the history of art, for in spite of much research on their lives and work, there is still uncertainty about what each brother painted individually and how much they operated as a team. Several paintings are signed with their surname, but none of them with a first name, and all their dated pictures belong to the period 1641-48, when all three were still alive.

We know from early accounts that the brothers collaborated at times, but there is sufficient variety in subject and treatment among their pictures to suggest that all three had separate artistic personalities. The most distinctive of these pictures—and the main reason for the Le Nains' fame—are the peasant scenes, which are strong, sober, and dignified, in spite of their lowly subjects. These paintings have often been attributed to Louis Le Nain, but without any solid evidence.

LIFEline

c1600–07 Born into a good family in Laon

c1628–29 The three brothers move to Paris, and set up a joint workshop

1633 Mathieu is made artist to the city of Paris

1648 All three brothers become founder members of the Académie Royale de Peinture et de Sculpture

1648 Antoine and Louis die within days of one another, presumably of a contagious disease

1677 Mathieu dies

▼ **The Adoration of the Shepherds** *This biblical scene combines a suitable sense of awe and serenity with vividly observed naturalistic details.* c1640, oil on canvas, 43 x 55in, National Gallery, London, UK

CLOSERlook

HANDLING LIGHT
A distinct, well-observed light falls on one side of this family's faces, suggesting a window to their left. The expert handling of light and fairly limited palette help to create a harmonious and quietly powerful piece.

▲ **Peasant Family in an Interior** *Although it is a scene of everyday life, this picture has the dignity worthy of a grand history painting. In the 19th century, Gustave Courbet and other Realist painters found works such as this inspiring.* c1640, oil on canvas, 44 x 63in, Louvre, Paris, France

Philippe de **Champaigne**

Portrait by Jean-Baptiste de Champaigne

b **BRUSSELS, 1602; d PARIS, 1674**

Philippe de Champaigne was a distinguished religious painter, but he is famous primarily as the greatest French portraitist of the 17th century. His sitters included some of his leading contemporaries, including most memorably Cardinal Richelieu, of whom he created the definitive images. His work is severely dignified in composition, strong and pure in coloring, and piercingly direct and honest in characterization. In the 1640s he became involved with the Jansenists—an extremely austere Catholic sect—and his work subsequently became even more sober and ascetic in tone, completely unconcerned with normal worldly values.

LIFEline

1602 Born in Brussels

1620 Enters workshop of landscape painter Jacques Fouquier

1621 Moves to Paris

1625 Begins working for the royal family, particularly Marie de Médicis

1629 Becomes a French citizen

c1635–42 Paints several of portraits of Cardinal Richelieu

1645 Becomes involved with the Jansenists, for whom he paints several works

1674 Dies in Paris

◄ **Omer Talon** *Talon, a distinguished lawyer and parliamentarian, is here depicted in magnificent judicial robes. His candid expression exemplifies Champaigne's penetrating characterization.* 1649, oil on canvas, 89 x 64in, National Gallery of Art, Washington, DC, US

▲ **Mother Catherine-Agnès Arnault and Sister Catherine de Sainte Suzanne de Champaigne** *Champaigne's daughter (right) was a nun at Port-Royal, a Jansenist convent in Paris. This work gives thanks for her miraculous recovery from paralysis.* 1662, oil on canvas, 65 x 90in, Louvre, Paris, France

Nicolas **Poussin**

b **LES ANDELYS, NORMANDY, 1594**; d **ROME, 1665**

Self-portrait

Although he spent almost all his mature career in Rome, Poussin is regarded as the most important French painter of the 17th century, exerting a powerful influence not only on his contemporaries, but also on future generations of artists in France. His beginnings, however, were inauspicious, for his achievements were modest when he settled in Rome aged nearly 30, and initially he struggled there before finding his true direction. He was inspired by the art and the classical world to create paintings of great grandeur and lucidity. His work is so deeply pondered that he later became known as the painter-philosopher. This rational approach appealed profoundly in France, and the Académie Royale de Peinture et de Sculpture (founded in Paris in 1648) held up Poussin as the embodiment of its ideals.

Poussin worked mainly on modest-sized paintings for private patrons who shared his intellectual tastes. He lived quietly and unpretentiously, but by the time of his death he was internationally famous and revered.

▼ **The Adoration of the Golden Calf** *While Moses was receiving the Ten Commandments, the Israelites made a golden calf and worshiped it as a false god.* c1633, oil on canvas, 60 x 83½in, National Gallery, London, UK

CLOSERlook

USING COLOR Poussin uses white to pick out a major figure in the worshiping revelers. This is Aaron, Moses's brother, who was responsible for creating the false idol. Poussin was a master at using color to animate a composition.

LIFEline

1594 Born in Normandy

1612 Inspired to take up painting when an itinerant artist, Quentin Varin, works in his home town. Soon afterwards, he moves to Paris

1624 Settles in Rome

1626–28 First conspicuous success with *Death of Germanicus* painted for Cardinal Francesco Barberini

1640–42 Reluctantly works in Paris for Louis XIII

1648 Paints *Landscape with the Ashes of Phocion*

1665 Dies in Rome

▶ **Landscape with the Ashes of Phocion** *This is one of a pair of paintings illustrating the story of Athenian general and statesman Phocion, who was executed on unjust charges of treachery. Here his widow gathers his ashes. The somber landscape provides a perfect setting. Poussin became increasingly interested in landscape in the 1640s.* 1648, oil on canvas, 46 x 70½in, Walker Art Gallery, Liverpool, UK

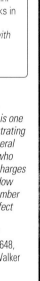

▶ **The Exposition of Moses** *Poussin depicts the biblical tale of baby Moses being set adrift on the Nile to escape the order of the Pharaoh of Egypt that all the newborn sons of Israelites should be killed.* 1654, oil on canvas, 59 x 80¾in, Ashmolean, Oxford, UK

CLOSERlook

SETTING THE SCENE The trees at either side act like curtains, an artistic device called *coulisses* ("theater wings" in French). They frame the action, separating the foreground figure from the middle ground activity and background city of Megara, where Phocion's body was cremated because it was refused burial in Athens.

FOREGROUND FOCUS The figure of Phocion's widow is small but it draws our attention through her light-colored clothing. Her maid looks around apprehensively, fearing they will be discovered preserving the remains of the disgraced politician.

INcontext

THE LOUVRE This is now one of the world's greatest museums, but in Poussin's time it was a royal palace. Begun in the 1540s by Francis I, it was expanded and adorned by many subsequent French monarchs. Louis XIII commissioned Poussin to decorate the immensely long Grande Galerie, but nothing survives of his work there.

The Louvre seen from the Pont Neuf, *engraving after a work by 19th-century artist Jean Jacottet.*

Claude Gellée

Claude Gellée

b **CHAMAGNE, LORRAINE, c1605; d ROME, 1682**

In his own lifetime and for generations afterward, Claude Gellée (also known as Claude Lorraine) was almost universally regarded as the greatest of all landscape painters. He was considered the supreme exponent of the ideal landscape—a type of picture that created a noble vision of nature without any of the imperfections of the real world. Like Poussin (who became his friend), Claude spent most of his career in Rome, but his work was much sought after in France and elsewhere in Europe (his patrons included Philip IV of Spain).

In dignity and grandeur, Claude's paintings have much in common with Poussin's landscapes, but Claude was much less austere than Poussin and was more concerned with light and atmosphere. During the 18th and 19th centuries his work was particularly esteemed in England, Constable and Turner being among his professed admirers.

LIFEline

c1605 Born in Lorraine, northeastern France

c1617–20 Moves to Rome

1625 Returns to Lorraine and works on church frescoes (destroyed) in Nancy

1627 Settles permanently in Rome

1634 His work is being imitated, indicating he already has a high reputation

1637–39 Paints four pictures for Pope Urban VIII

1653 Fathers an illegitimate daughter, who helps care for him in his old age

1663 Seriously ill with an unknown ailment

1682 Paints *Landscape with Ascanius Shooting the Stag of Sylvia*. Dies in Rome

▼ **Christ and the Adulteress**
The frieze-like composition reflects Poussin's study of ancient Roman reliefs. He painted the picture for André Le Nôtre, famous designer of the gardens at Versailles. 1653, oil on canvas, 47½×77in, Louvre, Paris, France

◄ **Seaport with the Embarkation of St. Ursula**
This work depicts St. Ursula (in yellow) and her companions leaving Rome following a pilgrimage to the city. Grand seaports of this kind were one of Claude's specialities. 1641, oil on canvas, 44½×58½in, National Gallery, London, UK

▲ **Winter, or The Flood**
Poussin's last completed works were a series of four paintings on the seasons. In addition to depicting a season, each picture represented a different time of day and an appropriate biblical subject, and each one is dominated by a particular color—here a steely gray. c1660–64, oil on canvas, 46½×63in, Louvre, Paris, France

▲ **Landscape with Ascanius Shooting the Stag of Sylvia** *Claude's last painting takes its subject from Virgil's* Aeneid. *It shows the ethereal, dreamlike quality the artist developed in his final years.* 1682, oil on canvas, 47¼×59in, Ashmolean, Oxford, UK

CLOSERlook

COMPOSITION The struggling figures fill a foreground triangle, and Poussin leads the eye to the middle-ground figure at the waterfall and the streak of lightning in the background. The structure is similar to that in *Landscape with the Ashes of Phocion*, but more loosely executed.

Charles **Le Brun**

Self-portrait

b **PARIS, 1619;** d **PARIS, 1690**

For most of the second half of the 17th century, Charles Le Brun was the dominant artist in France. He was a favorite of Louis XIV, who employed him to give visual expression to his ideas of personal and national glory. Le Brun did this not only through his own paintings, but also in the many projects in which he had a supervisory role, particularly the decoration of royal palaces.

Born into an artistic family, Le Brun was highly precocious: he was Vouet's star pupil and was already making a name for himself by the time he was 20. When Poussin visited Paris in 1640-42 he was greatly impressed by the young man, who accompanied him back to Rome. Le Brun stayed there until 1646, and when he returned to Paris he was quickly launched on a hugely successful and productive career. His most famous work is the decoration of the Galerie des Glaces (Hall of Mirrors) at the palace of Versailles—his lavish style was perfectly attuned to the scale and pomp of the building and to the task of glorifying his flamboyant king.

LIFEline

1619 Born in Paris, the son of a sculptor
c1634 Begins training with Simon Vouet
1642 Travels to Rome with Nicolas Poussin
1646 Returns to Paris
1662 Appointed first painter to the king
1663 Made director of Académie Royale and the Gobelins tapestry factory
1679–84 Decorates *Galerie des Glaces* (Hall of Mirrors), Versailles
1690 Dies in Paris
1698 Treatise on emotions in art published posthumously

▶ **Spain Recognizing the Pre-eminence of France in 1662** *Le Brun filled the ceiling of Versailles' spectacular Hall of Mirrors with grand images glorifying Louis XIV's reign. Spain had long been the most powerful nation in Europe, but under Louis France took this position.* 1678–84, oil on canvas, Galerie des Glaces (Hall of Mirrors), Versailles, France

▲ **Molière** *Le Brun was an accomplished portrait painter. His notable sitters included this famous French playwright.* 1660, oil on canvas, 26 x 22½ in, Pushkin Museum of Fine Arts, Moscow, Russia

CLOSERlook

POTENT SYMBOLISM The drooping lion, cowering at the feet of an allegorical figure of France, symbolizes Spain's acknowledgement of France's pre-eminence. Art played a vital propaganda role for Louis XIV.

François **Girardon**

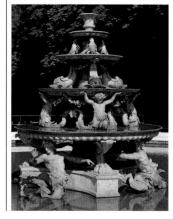
François Girardon

b **TROYES, 1628;** d **PARIS, 1715**

Among the army of artists and craftsmen who worked with Le Brun at Versailles, one of the finest was the sculptor François Girardon. His work is sometimes light in spirit, appropriate to the garden settings in which it was often placed, but it also has a classical dignity. He produced impressive work in very different vein, too, most notably his marble tomb of Cardinal Richelieu (1675–94) in the church of the Sorbonne, Paris.

▼ **Apollo Tended by the Nymphs** *Originally placed in a grotto, but now in the Palace gardens, this is often cited as Girardon's masterpiece.* 1666–75, marble, life-size, Bosquet des Bains d'Apollon, gardens of Versailles, France

◀ **Pyramid Fountain** *Girardon produced various fountains at Versailles, of which this is the most impressive. It was based on designs drawn by Charles Le Brun.* 1668–70, low parterre, gardens of Versailles, France

INcontext
VERSAILLES In the 1620s, Louis XIII built a hunting lodge at Versailles, near Paris. He later enlarged this into a chateau, and from the 1660s his son Louis XIV began expanding it into a palace of stupendous size and magnificence. In 1682 it became his official residence and seat of government.

The Groves of Versailles, *by Jean Cotelle the Younger. 1688, oil on canvas, 78¾ x 55 in, Château du Grand Trianon, Versailles, France*

Pierre **Puget**

Pierre Puget

b **MARSEILLE, 1620**; d **MARSEILLE, 1694**

Puget is now acknowledged as the most powerful and original French sculptor of his time. However, in worldly terms he had a less successful career. This was a reflection of his independent and obstinate temperament. The artistic dictatorship of Le Brun demanded efficient teamwork, but Puget was too distinctive in style and abrasive in personality to fit in easily. Consequently he carried out relatively little work for the court and instead spent most of career in his native south of France (where he worked as an architect and painter as well as a sculptor) and also in Italy. His vigorous, highly emotional Baroque style was strongly influenced by Italian art.

Puget did have one conspicuous triumph at Versailles, however, with *Milo of Crotona*. In ancient Greece, Milo was a famous athlete of prodigious strength. He tried to split open the trunk of a tree, but his hand became trapped and he was devoured by wild beasts.

LIFEline

1620 Born the son of a master-mason

1634 Apprenticed to a wood carver

1638–43 First of several visits to Italy

1643 Begins work decorating ships at Toulon's naval yards

1660s Works mainly in Genoa

1668–94 Works mainly in Toulon and Marseille

1671–82 *Milo of Crotona Attacked by a Lion*

1694 Dies, after a succession of late projects are rejected by the French court

▲ **Stone Portal for the Hôtel de Ville (Town Hall), Toulon** *For this typically expressive work, Puget carved two Atlas figures straining to support the balcony.* 1656–57, stone, Musée Naval, Toulon (the Hôtel de Ville was destroyed in 1944)

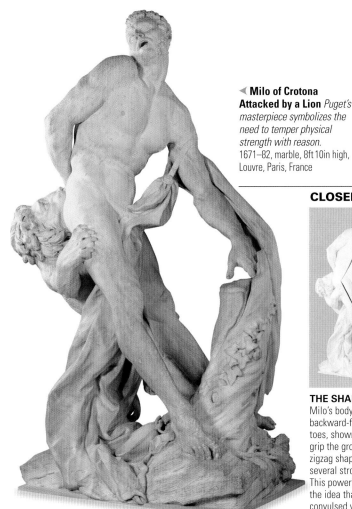

◄ **Milo of Crotona Attacked by a Lion** *Puget's masterpiece symbolizes the need to temper physical strength with reason.* 1671–82, marble, 8ft 10in high, Louvre, Paris, France

CLOSERlook

THE SHAPE OF AGONY Milo's body—from his backward-flung head to his toes, shown tensed as they grip the ground—has a zigzag shape, featuring several strong diagonals. This powerfully underlines the idea that Milo is convulsed with pain.

Hyacinthe **Rigaud**

Self-portrait

b **PERPIGNAN, 1659**; d **PARIS, 1743**

Rigaud was the outstanding French court portrait painter of his time, working for both Louis XIV and Louis XV. He excelled at creating magnificent formal portraits of important people, emphasizing their status with stately poses and sumptuous detail. His masterpiece in this vein is his famous full-length portrait of *Louis XIV*, painted in 1701. This is the definitive image of Louis and one of the most imposing of all portrayals of royal majesty.

Rigaud's Baroque style, with its vivid coloring and attention to surface texture, reflected a mix of influences from Flemish and Italian art, notably van Dyck and Titian. He also had a much more informal side to his art, expressed in intimate portraits of friends and relatives.

LIFEline

1659 Born the grandson of a painter

1681 Settles in Paris

1688 Makes his name with a portrait of Louis XIV's brother

1700 Admitted to Académie Royale as a history painter

1701 Paints portrait of *Louis XIV*, which brings him a European reputation

1733 Made director of the Académie Royale

1743 Dies, brought low by the death of his wife the previous year

▲ **Double Portrait of Madame Rigaud** *These studies of Marie Serre, the artist's mother, show Rigaud's more personal side. There is a Rembrandt-like quality in the wrinkled face and very human expressions.* 1695, oil on canvas, 32¾ x 40½in, Louvre, Paris, France

CLOSERlook

EYE FOR DETAIL The coronation robes in which the king is dressed are painted with an extraordinary flair that owes much to van Dyck. Rigaud's brushwork picks up every detail, such as the embroidery of the royal *fleur-de-lis* motif.

◄ **Louis XIV** *Louis commissioned this portrait as a gift for King Philip V of Spain (his grandson). However, he was so impressed with it that he decided to keep it for himself.* 1701, oil on canvas, 109 x 76½in, Louvre, Paris, France

Juan Martínez **Montañés**

Portrait by
Velázquez

b ALCALÁ LA REAL, JAEN, 1568; d SEVILLE, 1649

Spanish sculpture of the 17th century fundamentally differs from that produced elsewhere in Europe. In most other countries the favored materials were stone (particularly marble) and bronze, but Spanish sculptors preferred wood, usually painted in lifelike colors. Almost all Spanish sculpture of this period was on religious subjects, and the realistic colors helped to make it believable and emotionally involving for the devout spectator.

There were many eminent sculptors in this great age of Spanish art, but the most famous was Juan Martínez Montañés, whose skill as a carver was so superlative that he was nicknamed "*el dios de la madera*" (the god of wood). He spent most of his career in Seville, but his work had wide influence in Spain and South America.

LIFEline

1568 Born in Alcalá la Real

c1579 Begins his training in Granada

1587 Moves to Seville

1597 Carves *St Christopher*, his first major work

1603–6 Carves *The Merciful Christ*

1635–36 Visits Madrid to make portrait head of Philip IV, his only secular work

1649 Dies in Seville

> **The Merciful Christ**
Montañés's contract specified that Christ was to be shown looking at anyone who might be praying at his feet, suggesting: "It is for him that He suffers." 1603–06, painted wood, life-size, Sacristy of the Chalices, Seville Cathedral, Spain

CLOSERlook

MOVING REALISM The expertly carved anatomical detail is made even more convincing by the flesh tones in which it is painted. Montañés was a perfectionist, and he chose only the finest masters to paint his works.

△ **St. Christopher** *Montañés' realism shows in the figure's muscular legs and the detailed treatment of folded fabric.* 1597, painted wood, El Salvador, Seville, Spain

INcontext

MADRID In 1561 Philip II made Madrid his capital, and the city soon became a magnet for artists, rivaling and then outstripping such established art centers as Seville and Toledo. Its population increased rapidly, from about 20,000 when it became the capital to about 150,000 only 60 years later.

Plaza Mayor, Madrid, Spain *The Plaza Mayor, originally built in 1617–19, is a huge square at the heart of the Spanish capital.*

Juan **Sánchez Cotán**

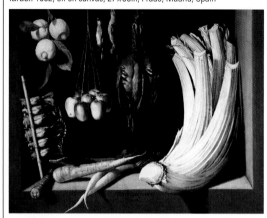

Portrait by
Carderera y
Solano

b ORGAZ, 1560; d GRANADA, 1627

Religion was the mainstream of 17th-century Spanish painting, but still life was a fascinating tributary. Juan Sánchez Cotán was one of the earliest and greatest European specialists in this area, producing paintings of extraordinary power and originality. Usually they show a few fruits or vegetables arranged with mathematical precision against a plain dark background. Despite the humble objects, these works have a haunting spiritual quality, conveying awe at the mystery of God's creation. In 1603, Sánchez Cotán became a lay brother at a monastery in Granada, abandoning still life for much less memorable religious paintings.

▽ **Still Life with Game Fowl, Fruit, and Cardoon**
The dark, recessed spaces in which Sánchez Cotán arranges his still lifes are based on a typical Spanish larder. 1602, oil on canvas, 27 x 35in, Prado, Madrid, Spain

△ **Quince, Cabbage, Melon, and Cucumber** *This is considered by many to be Sánchez Cotán's masterpiece. The hyper-realism seems to raise these ordinary objects to a spiritual plane.* c1600, oil on canvas, 27 x 33½in, San Diego Museum of Art, California, US

CLOSERlook

STAGE SET The items are arranged in a precise curve, suggesting a perfect natural order. The receding shelf is like a stage, with the fruit and vegetables as actors.

Francisco de **Zurbarán**

b **FUENTE DE CANTOS, BADAJOZ, 1598**; d **MADRID, 1664**

Although he occasionally turned to other subjects, Zurbarán was essentially one of the great religious painters of the 17th century. His style in his most typical works was massively austere and intensely spiritual—perfectly in tune with the religious fervor of his country. He spent most of his career in Seville, which at the t ime he moved there was immensely prosperous (it was the main port for Spain's lucrative trade with its American colonies).

However, Zurbarán also worked elsewhere, including Madrid, where he painted a series of ten pictures on the Labors of Hercules (his major secular commission) for Philip IV's Buen Retiro Palace. In 1658 he moved permanently to Madrid, but by this time his career was in decline, partly because of a general economic slump in Spain and partly because Murillo—who worked in a very different style—had overtaken him as the leading painter in Seville.

LIFEline

1598 Born the son of a merchant trader
1614 Studies in Seville; spends most of the next decade in Llerana, near his home village
1629 Settles in Seville
1634–35 Visits Madrid, where he works for Philip IV's Buen Retiro Palace
1658 Moves to Madrid
1664 Dies, with his career in decline

CLOSERlook

FACIAL EXPRESSION
The strong lighting brings out the forceful combination of mystical intensity and somber naturalism that is typical of Zurbarán.

SIMPLE LINES This composition is strikingly bold. Its colors are muted, and its stark design features a single centrally placed figure in a frontal pose. As usual, Zurbarán uses a plain background against which the figure stands out with enormous physical presence.

▲ **St. Francis Standing** Zurbarán made something of a specialty of figures such as this, showing a saint or monk in prayer or meditation. 1650–60, oil on canvas, 82 x 43in, Musée des Beaux-Arts, Lyons, France

Jusepe de **Ribera**

Jusepe de Ribera

b **JÁTIVA, VALENCIA, 1591**; d **NAPLES, 1652**

Known as *Lo Spagnoletto* (the Little Spaniard) after the country of his birth, Ribera settled in Italy at an early age and spent almost all his career in Naples, where he became the leading painter of his generation. At this time the city was ruled by Spain and much of Ribera's work was exported back to his homeland.

He was a versatile artist, capable of expressing great tenderness as well as powerful drama, and he painted various types of secular subjects as well as the religious works that were his mainstay. His early work was somber and strongly influenced by Caravaggio, but his style later became much lighter and more richly colored, although always retaining an essential seriousness.

LIFEline

1591 Born the son of a shoemaker
1611 First documented in Italy (in Parma)
1616 Settles in Naples
1639 Paints *Martyrdom of St. Philip*, presented by the Viceroy of Naples to Philip IV of Spain
1652 Dies after years of recurrent illness

▶ **Adoration of the Shepherds** *This shows many of Ribera's trademarks: rich coloring, tenderness of feeling, and realism in the shepherds' clothes.* 1650, oil on canvas, 94 x 71in, Louvre, Paris, France

▲ **Democritus** *Ribera invented this type of picture, in which he depicted an ancient Greek philosopher as a beggar or vagabond.* 1635–37, oil on canvas, 61 x 47in, Collection of the Earl of Pembroke, Wilton House, Salisbury, Wiltshire, UK

Diego **Velázquez**

Self-portrait

b SEVILLE, 1599; d MADRID, 1660

Velázquez was the greatest figure of Spain's golden age of the arts, which reached its peak during the reign (1621–65) of his major patron, King Philip IV. At the age of only 24, Velázquez was appointed a royal painter, and he spent most of his life working for Philip in Madrid. The majority of his paintings are portraits of the royal family and other members of the court, but he produced masterpieces in other fields too. All his work is notable for its dignity, its penetrating sense of actuality, and its beauty of technique, his brushwork developing from almost clotted richness in his early pictures to sparkling freedom in his final paintings.

Velázquez made two visits to Italy, and his work was acclaimed there. However, after his death most of his paintings remained hidden from the public in royal palaces and it was not until the Prado, Spain's national museum, opened in 1819 that his work became widely known. Many artists were subsequently influenced by it, notably Manet, who admired Velázquez above all other painters.

LIFEline

1599 Born in Seville to a family of minor gentry

1617 Following a 6-year apprenticeship with Francisco Pacheco, he qualifies as a master painter

1618 Marries Pacheco's daughter

1623 Settles in Madrid as court painter to King Philip IV

1629–31 Visits Italy

1634–35 Paints *The Surrender of Breda*

1649–51 Returns to Italy on an art-buying trip for the king

c1656 Paints *Las Meninas*

1660 Dies in Madrid after a sudden illness

> " Velázquez… **makes the journey worthwhile**… He is **the supreme artist**; he didn't surprise me, **he enchanted me** "
>
> CLAUDE MANET, 1865

▶ **An Old Woman Cooking Eggs**
Velázquez' early works included some superb scenes of everyday life. He treated these subjects with incisive realism and a respectful humanity. 1618, oil on canvas, 40 x 47in, National Gallery of Scotland, Edinburgh, UK

▼ **Pope Innocent X** *During his second visit to Italy, Velázquez painted this famous portrait. It captures the pope's wily character so vividly that the sitter himself called it "too truthful."* 1650, oil on canvas, 55½ x 47in, Galleria Doria Pamphili, Rome, Italy

CLOSERlook

FACES OF THE VICTORS Velázquez brilliantly conveys the human drama of the scene, suggesting the pride but also the fatigue of the victors following a 10-month siege. The bristling array of pikes behind them has given the picture its popular name in Spanish—"*Las Lanzas*" (The Lances).

◀ **The Surrender of Breda**
This is one of a series of pictures celebrating military triumphs of Philip IV's reign, painted for his Buen Retiro Palace in Madrid. It shows the defeated Dutch commander handing the key of the captured city of Breda to the victorious Spanish general. 1634–35, oil on canvas, 10ft 1in x 12ft, Prado, Madrid, Spain

Las Meninas *Diego Velázquez*
c1656, oil on canvas, 10ft 6in x 9ft 3in, Prado, Madrid, Spain ▶

Las Meninas Diego Velázquez

A stunning group portrait, *Las Meninas* shows the Infanta Margarita, daughter of the Spanish king and queen, with her maids of honour (*meninas*). Velázquez, who was court painter to the Spanish monarchy, has skilfully reversed the traditional relationship between painter and sitter by giving himself a prominent position in the painting while showing a reflection of the king and queen in the mirror in the background. This is not simply a painting of the royal couple—it is a picture of what the royal couple sees as they are painted. Velázquez's masterpiece is painted on a large canvas and employs a delicate harmony of colors, exquisitely arranged light and darks, and, above all, amazingly fluent brushwork.

INcontext

INTERPRETATIONS *Las Meninas* is a hugely influential artwork that has been reinterpreted by several artists including Goya and Salvador Dalí. The painting obsessed Pablo Picasso— between August and December in 1957, he shut himself in his house near Cannes and painted about 40 versions of it. This Picasso version almost looks as if it has been painted by the girl Infanta or one of her maids. The figures are blocked in with a child-like simplicity. The hunting dog looks like a friendly cartoon character and takes the starring role in the foreground.

Las Meninas, 19 September 1957 Pablo Picasso. Oil on canvas, 63¾x51in, Museu Picasso, Barcelona, Spain

Composition

The composition has been carefully worked out, with different figures—and different figure groupings—perfectly balancing each other. Various focal points and tonal contrasts direct the viewer's eye back and forth across the canvas. It's almost as if the viewer becomes engaged in the activity of the room.

▲ **FIGURE GROUPINGS** The two dwarfs and dog are balanced by the three girls. In the middle ground, Velázquez stands to the left and the bodyguard and nun to the right. The royal couple's reflection is balanced by a chamberlain in the doorway.

▲ **COLOR** Red accents are dotted throughout the painting. They lead the eye in a zigzag from the dwarf (bottom right) to the dresses, the jug, Velázquez's palette, and ultimately to the red drapery reflected in the mirror.

▲ **LIGHTING** Velázquez uses the light from the windows to make the Infanta the focal point of the picture. She stands turned toward the light source and her illuminated face and dress immediately catch the eye among the large areas of shadow.

Story

Thanks to a description written by painter Antonio Palomino, published in 1724, we know almost everyone in the picture. The Infanta Margarita, daughter of Philip IV and his second wife Mariana of Austria, is at the center. She is attended by two maids of honor. On the right are two court dwarfs, a nun (a chaperone to the Infanta), and a bodyguard. On the left is Velázquez. In the background in the doorway is the palace chamberlain.

▲ **INFANTA'S FACE** The Infanta, with her pale face and luminous hair, is the focal point of the painting. She was only four or five years old when the picture was made, but her dispassionate, knowing stare (and corseted dress) gives her a regal bearing.

▲ **GROUP OF TWO DWARFS** Two court dwarfs appear in the foreground on the right. One dwarf's face is horizontally aligned with the Infanta's face—this juxtaposition enhances the beauty of the princess. The other is in shadow and playfully rests a foot on the king's sleepy hunting dog.

➤ **VELÁZQUEZ** On his chest Velázquez bears the red cross of the order of Santiago. He did not gain this high honor until 1659, a few months before his death. According to legend, the king painted the cross, but Velázquez presumably added it himself.

▲ **THE ROYAL COUPLE** Philip and Mariana appear in the mirror in the background and we assume they must be standing where the viewer is. However, the mirror does not reflect what is directly in front of it. Furthermore, the size of the reflection and the perfect cropping of the royal couple in the frame are not consistent with the viewer's position.

Technique

Velázquez painted *Las Meninas* with audaciously fluid brushwork. If viewed close up, the painting dissolves into an incomprehensible network of brushstrokes. It is only when the viewer stands back that the sparkling brushwork resolves itself into distinctive forms. This technique helps make the figures seem alive, as if they are on the move. Velázquez has frozen the scene in an almost camera-like way, and yet he also suggests that the group will immediately rearrange themselves.

➤ **HIGHLIGHTS AND SHADOW** The Infanta's sleeve is composed of loose strokes of white, brown, and black. Flicked strokes of purer white have been added on top to show the light catching on the shimmering fabric of the dress. These are applied with very dry paint so the underlying colors show through.

▲ **DIFFERING BRUSHSTROKES** The painting contains endless varieties of brushwork. Here, Velázquez uses exciting zigzagging brushstrokes to render his white sleeve, but applies small, smudgy dabs of paint to put in the pigments on the palette.

▲ **MODELING FORM** Velázquez describes the rounded form of the jug by subtly varying the tone and color of his red mix. Small, dashing brushstrokes of white capture the light reflecting on the shiny glaze of the jug.

◄ **SHIMMERING FABRIC** The Infanta's dress contains a tangle of brushstrokes, varying both in size and intensity. Dabs of pure white are used to register the buttons, and linear strokes describe some of the folds. Thick daubs of impasto, using nearly dry pigment, further enliven the fabric.

> ❝ [Las Meninas] **represents the theology** of painting ❞
> LUCA GIORDANO, 1692, COURT PAINTER

Bartolomé Esteban **Murillo**

Self-portrait

b SEVILLE, 1617; d SEVILLE, 1682

Murillo spent virtually all his life in Seville, where he enjoyed a highly successful career. His output consisted mainly of religious works, but he also had a distinctive sideline in pictures of beggar children, and he was an excellent, although infrequent, portraitist. Early in his career he was influenced by the somber style of Zurbarán, but he developed a much lighter, airier, and more colorful manner, particular in his many pictures of the Immaculate Conception, a subject he made his own. Murillo's work was so popular that it was influential in Seville for generations. This eventually damaged his posthumous reputation, as countless saccharine imitations obscured the high quality of his own work.

LIFEline

1617 Born in Seville, the son of a barber-surgeon

1645 Marries; receives first major commission, for S. Francisco convent

1655 Described by Seville Cathedral's archdeacon as "the best painter in Seville."

1660 Is one of the founders of Seville's art academy (the first in Spain) and becomes co-president

1682 Dies after falling from scaffolding while painting a huge altarpiece

▼ **The Vision of Fray Lauterio** *Murillo's early style is more solid and less soft-focus than his later manner.* c1640, oil on canvas, 86 x 68in, Fitzwilliam Museum, Cambridge, UK

► **Two Boys Eating Melons and Grapes** *Paintings of beggar children such as this were highly popular with collectors in the 18th century, helping to give Murillo an international reputation unequaled among Spanish artists of his time.* c1650, oil on canvas, 57½ x 41in, Alte Pinakothek, Munich, Germany

BAROQUE

222

17TH AND 18TH CENTURIES

CLOSERlook

SOFT FOCUS These *putti* (cherubs) are so softly modeled that they almost seem to be dissolving into the surrounding space. The Spanish use the term *"estilo vaporoso"* to describe this characteristic.

► **Immaculate Conception**
The Immaculate Conception is a Catholic doctrine that the Virgin Mary was conceived in her mother's womb free of the "original sin" with which all human beings are burdened. Various details, such as the crescent moon, a symbol of chastity, allude to her purity. The subject was very popular in Spanish art. c1678, oil on canvas, 108 x 75in, Prado, Madrid, Spain

Alonso **Cano**

...

b GRANADA, 1601; d GRANADA, 1667

Cano was the most versatile Spanish artist of his time, distinguished as a painter, sculptor, draftsman, and architect—hence his nickname, the Spanish Michelangelo. He also had one of the most eventful lives of any Spanish artist, for his stormy temperament often led him into trouble: he fought a duel, spent time in prison for debt, and—most notoriously—was tortured when he was accused of murdering his wife (he was eventually declared innocent).

In keeping with this turbulent life, Cano moved around a good deal, but he worked mainly in Seville, Madrid, and finally Granada. His art, in contrast to his character, is typically calm and sometimes even sweet. Almost all his work is on religious subjects.

Portrait by Théodule Ribot

LIFEline

1601 Born in Granada

1614 Moves to Seville, where he studies painting under Francisco Pacheco and probably under Juan Martínez Montañés

1644 Tortured in Madrid under suspicion of murdering his second wife

1667 Dies and is buried in the crypt of Granada Cathedral

► **Façade of Granada Cathedral** *Cano died a few months after his design for the cathedral façade was accepted. It is his most important work as an architect.* 1667, Granada, Spain

▲ **Architectural study** *Cano was the son of an altarpiece designer, and was brought up understanding the architectural elements involved in the elaborate altarpieces typical of Spanish art.* Pen and ink and wash on paper, 10¾ x 7¾in, Kunsthalle, Hamburg, Germany

▲ **St. John the Evangelist** *This altarpiece was painted for a convent in Seville. St. John is shown with a snake in a chalice—an allusion to a legend that he drank from a poisoned cup to prove the power of his faith and then restored to life two men who had died from the poison.* 1635–37, oil on canvas, 21¼ x 14in, Louvre, Paris, France

Claudio **Coello**

Self-portrait

b MADRID, 1642; d MADRID, 1693

By the later 17th century, Spain was in steep political decline, and its golden age of the arts was coming to an end. Claudio Coello was the last of the major Spanish painters working in Madrid before art at court began to be dominated by foreigners: he died a year after the Italian Luca Giordano arrived to work for King Charles II. Coello was mainly a religious painter, but he was also a fine portraitist. His work is notable for its rich color and vigorous brushwork, showing the influence of the Venetian paintings in the royal collection.

LIFEline

1642 Born, the son of a bronze worker

1660s Studies in Madrid with Francisco Rizi

1684 Appointed one of Charles II's royal painters

1685–90 Paints *Charles II and His Court Adoring the Host*

1691 Appointed chief painter at Toledo Cathedral

CLOSERlook

REAL OR IDEAL Charles II was a notoriously ugly man, with a strangely shaped nose and chin. Here, Coello has diplomatically given him an idealized face. The other portraits—there are around 50 in the painting—are generally more realistic. Coello made painstaking studies for most of them.

▲ **Charles II and His Court Adoring the Host ("La Sagrada Forma")** *Coello's masterpiece is a huge altarpiece commemorating a ceremony in 1684 involving* La Sagrada Forma *(Sacred Form). This is the name of a miraculous consecrated host (the wafer representing Christ's body) that is said to have shed blood when desecrated by a Protestant soldier in 1572. 1685–90, oil on canvas, 16ft 5in x 9ft 10in, Monasterio de El Escorial, Spain*

Juan de **Valdés Leal**

Juan de Valdés Leal

b SEVILLE, 1622; d SEVILLE, 1690

After the death of Murillo in 1682, Valdés Leal was Seville's leading painter until his own death eight years later. He too was mainly a religious painter, but he worked in a very different vein from that of Murillo, his style being highly emotional, often with a rather weird flavor and a taste for the macabre.

However, the two artists produced works of effective contrast in neighboring commissions for the Hospital de la Caridad: Valdés Leal's paintings gave a glimpse of Hell, before Murillo's offered a vision of redemption.

▼ **In Ictu Oculi (In the Blink of an Eye)** *This allegorical work shows the skeleton of Death snuffing out a candle and trampling on the attributes of worldly success.* 1670–72, oil on canvas, 86½ x 85in, church of the Hospital de la Caridad, Seville, Spain

Antônio Francisco **Lisboa**

b VILA RICA [MODERN OURO PRÊTO] c1738; d VILA RICA, 1814

During the 17th and 18th centuries, a great deal of art was exported from Spain and Portugal to their American colonies. There were also some accomplished native-born artists working in the colonies, most notably the Brazilian sculptor and architect Antônio Francisco Lisboa.

The illegitimate son of a Portuguese architect and a black slave girl, Lisboa worked mainly in Ouro Prêto, a wealthy gold-mining center. He was nicknamed *O Aleijadinho* (Little Cripple) because he suffered from a deforming disease (perhaps leprosy) that eventually affected him so badly that he lost several fingers and toes and had to have his tools strapped to his hands. Although he continued working until the end of his life, he died in poverty.

◀ **S. Francisco de Assis** *This church was Lisboa's first major commission. As well as designing the building, he also carried out much sculptural decoration, including the splendid ornamentation of the entrance, seen here.* 1766–94, in Ouro Prêto, Minas Gerais, Brazil

Peter Paul **Rubens**

b SIEGEN, WESTPHALIA, 1577; d ANTWERP, 1640

Self-portrait

"Prince of painters and painter of princes", as he was described in his lifetime, Rubens was the greatest and most influential Baroque artist in northern Europe. The huge demand for his work could be satisfied only with the help of a workshop of pupils and assistants. Cultured, cosmopolitan, and a gifted linguist, Rubens was employed by some of the greatest patrons in Europe. He was both a famous international figure and a devoted family man, and his touching portraits of family members are as celebrated as his spectacular religious, mythological, and historical paintings.

Rubens was born in Germany (where his father was a refugee from religious strife), but he returned to the family home in Antwerp when he was 10 and spent most of his life there. However, his powerful style was shaped largely in Italy, where he was based from 1600 to 1608. Although his artistic output was vast and varied, Rubens also worked as a diplomat, and he was justly proud of helping to negotiate peace between England and Spain. The kings of both countries knighted him.

LIFEline

1577 Born in Germany
1587 Moves to Antwerp
1600–1608 Based in Italy
1609 Appointed court painter to Archduke Albert and Infanta Isabella, Spanish governors of the Netherlands; marries Isabella Brant
1626 First wife dies
1628–30 Visits Spain and England on diplomatic missions
1630 Marries second wife Hélène Fourment
1640 Dies in Antwerp

CLOSERlook
PHYSICAL DRAMA

Baroque painting gained its effect by emotionally overwhelming the spectator. Rubens uses dramatic physical gestures to express the characters' feelings, and heighten the painting's emotional impact. Grabbing Christ's bloodied arm, Nicodemus clenches the white shroud in his teeth, adding dynamic tension in both compositional and psychological terms.

▼ **The Descent from the Cross** *Rubens accentuates the human drama of this biblical scene. Against a dark background, and surrounded by mourners, Christ's limp body sweeps down in a diagonal white gash.* 1611–14, oil on panel, 13ft 9in x 10ft 2in, Cathedral of Our Lady, Antwerp

▲ **An Autumn Landscape with a View of Het Steen in the Early Morning** *This magnificent panoramic landscape shows the artist's country estate at Steen, south of Antwerp, which he bought in 1635 and where he enjoyed private times away from official duties. The picture was painted for pleasure and remained in Rubens's possession until he died.* c1636, oil on panel, 51½ x 90in, National Gallery, London, UK

▶ **Marie de Médicis Arriving at Marseilles** *The ex-Queen of France commissioned Rubens to glorify her in a vast cycle of 24 paintings. The artist used poetic license and mythological figures to lend her life heroic grandeur.* 1622–25, oil on canvas, 12ft 11in x 9ft 8in, Louvre, Paris, France

▲ **Le Chapeau de Paille** *This charming, informal portrait may depict the sister of the woman who later became Rubens's second wife. Her rosy, translucent skin tones reflect the red of the silk sleeves. Reynolds said that Rubens's figures "look as though they fed on roses."* c1622–25, oil on panel, 31 x 21¼in, National Gallery, London, UK

◀ **The Rape of the Daughters of Leucippus**
The Greek myth of the abduction of Helaera and Phoebe, daughters of King Leucippus, by the demi-god twins Castor and Pollux has been seen as an allegory for the soul's transport into heaven. The winged cupids holding the horses' reins may signify that lust is reined in by love. c1618, oil on canvas, 88 x 83in, Alte Pinakothek, Munich, Germany

CLOSERlook

TWISTED POSES The women's twisted poses originate in the famous antique sculpture the *Laocoön* (see p.58). Outflung arms create dynamic sweeping movement in the composition.

OPPOSITES Rubens sets up contrasts of color and texture: ruddy, muscular, male hands against soft, pale, female flesh.

Anthony **van Dyck**

Self-portrait

b ANTWERP, 1599; d LONDON, 1641

Apart from Rubens, in whose Antwerp workshop he served at the beginning of his brilliant career, van Dyck was the greatest Flemish painter of the 17th century. His aristocratic portraits won him a European reputation and were particularly influential in England, where he spent much of his career.

Precociously talented, van Dyck was apprenticed at the age of just 10. He was strongly influenced by Rubens, although his style was less muscular, tending more toward exquisite sensitivity. Van Dyck also greatly admired Titian, and avidly studied his work when he lived in Italy from 1621 to 1627. In these early years, he was in demand for his paintings of religious and mythological subjects, as well as for portraits. But for the last decade of his life, as court painter to King Charles I of England, his work consisted almost entirely of portraiture.

LIFEline

1599 Born in Antwerp

1618 Enrolled as master in Antwerp painters' guild; working with Rubens

1621–27 Lives in Italy, working mainly in Genoa

1627 Returns to Antwerp

1632 Settles in England; knighted by Charles I

1640 Marries Mary Ruthven, lady-in-waiting to the Queen

1641 Dies in London, aged 42

▶ **Charles I on Horseback**
This is the most majestic of all of van Dyck's portraits of the king.
c1636, oil on canvas, 12ft 4in x 9ft 7in, National Gallery, London, UK

▲ **The Rest on the Flight into Egypt (Virgin with Partridges)**
This popular religious subject is given an unusual treatment, with dancing putti (cherubs) entertaining the Holy Family, and the traditional choir of angels replaced by flying partridges. Sunflowers and a parrot are further quirky additions. The painting may have been created for Charles I's wife, Queen Henrietta Maria, and the mixture of Catholic and classical imagery may originate in the masques (royal entertainment with dance, poetry, and costumes and lavish stage sets) held at Charles's court. Early 1630s, oil on canvas, 85 x 112in, Hermitage, St. Petersburg, Russia

 ❝ Anthony van Dyck, who **while he lived** gave **immortality** to many ❞

TRANSLATION OF THE LATIN INSCRIPTION (ORDERED BY CHARLES I) ON VAN DYCK'S MONUMENT

CLOSERlook

DAZZLING ELEGANCE
Van Dyck's aristocratic sitters are often shown with slender, elegantly drooping hands. Here, Lord Bernard is holding one of his kid gloves, and its fingers extend the graceful, rhythmic line of his left hand. The glove's pale kid leather is set against shimmering blue satin and white lace, with each different texture brought alive by van Dyck's breathtaking brushwork.

▲ **Lord John and Lord Bernard Stuart**
This magnificent double portrait is characterized by a languid, aristocratic elegance. The teenage brothers are differentiated by their poses, their positioning (the older brother slightly above the younger), and by the contrasting warm gold-and-brown and cool blue-and-silver of their dazzling Cavalier costumes. Both died a few years later in the English Civil War. c1638, oil on canvas, 94 x 57½in, National Gallery, London, UK

Jacob **Jordaens**

Self-portrait

b **ANTWERP, 1593**; d **ANTWERP, 1678**

After the death of Rubens, Jordaens became the leading painter in Flanders. His often boisterous Baroque style shows a huge debt to Rubens, whom he often assisted, even when he was running a large and successful workshop of his own in Antwerp. However, his figure types tend to be coarser than those of Rubens. A versatile and prolific artist, Jordaens produced mythological, genre, and religious works as well as portraits, etchings, and tapestries.

Like Rubens, Jordaens spent most of his life in Antwerp, but he received commissions from across Europe. Although he never visited Italy, the strong contrasts of light and shade in his works show the influence of Caravaggio. Late in life Jordaens converted from Catholicism to Calvinism; he continued to work for Catholic clients, although his painting became more subdued.

LIFEline

1593 Born in Antwerp
1607 Begins training with Adam van Noort
1616 Marries van Noort's daughter; enters the Antwerp painters' guild
1621 Becomes head of the guild
1636–37 Assists Rubens with paintings for Philip IV of Spain's hunting lodge
c1655 Converts to Calvinism
1678 Dies in Antwerp

▶ **The Holy Family and St. John the Baptist** *This dramatically lit work may have been inspired by Caravaggio's* Madonna of the Rosary *(1607).* c1620–25, oil on panel, 48½ x 37in, National Gallery, London, UK

▶ **Satyr with Peasants** *This scene from Aesop's Fables was one of Jordaens's favorite subjects, and he painted it a number of times. The strong lighting, ruddy coloring, and earthy figures are typical of his work.* 1620, oil on canvas, 67 x 76½in, Gemäldegalerie Alte Meister, Kassel, Germany

Frans **Snyders**

b **ANTWERP, 1579**; d **ANTWERP, 1657**

The finest animal artist of his day, the Flemish painter Frans Snyders was often called upon by fellow artists, including Rubens, to paint the animals, fruit, and flowers in their paintings. Rubens sometimes returned the favor by painting figures in Snyders's pictures. The two men were close friends, and Snyders was an executor of Rubens's will. Snyders collaborated in a similar way with other artists, including van Dyck, Jordaens, and his brother-in-law Cornelis de Vos.

▼ **The Poulterer's Shop** *Snyders painted still lifes as well as animal scenes. The figures here were added by one of Rubens's workshop.* c1612–15, oil on canvas, 74 x 60in, National Museum Cardiff, UK

Adriaen **Brouwer**

b **OUDENAARDE, 1605/6**; d **ANTWERP, 1638**

Providing an important link between Flemish and Dutch art, the Flemish painter Adriaen Brouwer popularized a new form of humorous, low-life genre painting in both countries. Brouwer spent some years in Holland, where he probably trained with Frans Hals, and influenced artists such as Adriaen van Ostade. Though his subjects were coarse, his technique was delicate and much admired by contemporaries, such as Rubens and Rembrandt, both of whom collected his works.

▲ **Peasants Quarreling** *Brouwer's popular low-life genre scenes often featured grotesquely caricatured peasants brawling in run-down taverns, but they are painted with a delicate touch.* Private collection

Jan **Brueghel**

b **BRUSSELS, 1568**; d **ANTWERP, 1625**

▲ **Large Bouquet of Flowers in a Wooden Tub** *Brueghel's flower paintings were highly prized by his contemporaries.* c1606–07, oil on panel, 38½ x 29in, Kunsthistorisches Museum, Vienna, Austria

Jan Brueghel was the second son of the great Pieter "Peasant" Bruegel. He had a meticulous, almost miniaturist style, and was nicknamed "Velvet" Brueghel, perhaps because of his skill at painting delicate textures. He specialized in painting lush, detailed woodland scenes and still lifes, especially flower paintings. He often collaborated with other artists, including his friend Rubens.

David **Teniers**

b **ANTWERP, 1610**; d **BRUSSELS, 1690**

The son-in-law of Jan Brueghel, and the most celebrated member of a family of Flemish painters, Teniers the Younger was a hugely popular and prolific artist. He is best known for his genre scenes, some which show the influence of Brouwer, although they are more refined. Employed in Brussels as Court Painter and Keeper of Pictures by Archduke Leopold Wilhelm, Teniers also made paintings of the galleries housing the Archduke's famous art collection.

▲ **The Dentist** *Teniers treats this scene of a peasant visiting the dentist with restraint and sympathy. The glistening bottles and pots have been painted with great delicacy.* 1652, oil on panel, 13 x 18½in, Manchester Art Gallery, UK

Frans **Hals**

Self-portrait

b ANTWERP, 1582/83; d HAARLEM, 1666

One of the greatest and most original of all portrait painters, Hals brought his sitters to life with dashing, virtuoso brushwork and an uncanny ability to capture fleeting expressions. Almost all of his 300 or so works are portraits. The first great Dutch artist of the 17th century, he brought a new vitality and realism to Dutch painting and revolutionized the staid, formal portraiture of the day. Hals was born in Antwerp, but spent most of his life in Haarlem. Despite being in demand there for individual and group portraits, he was plagued by money troubles. Indeed, most of the few facts known about his life relate to domestic and financial crises.

LIFEline

1582/83 Born in Antwerp, the son of a cloth-worker
c1585 Family moves back to his father's native Haarlem
1610 Enters the Haarlem Guild of St. Luke
1615 First wife dies
1616 Receives his first major commission, *Banquet of the Officers of the St. George Civic Guard Company*
1617 Marries his second wife. They have eight children, five of whom become painters
1624 Paints *The Laughing Cavalier*
1654 Sells his belongings to settle his debt with a baker
1664 Is destitute, and living off charity. Paints *Regentesses of the Old Men's Alms House*
1666 Dies in poverty

▼ **Gypsy Girl** *This shows the bold, sketchy freedom of Hals's technique. The subject is probably a prostitute rather than a gypsy.* c1628–30, oil on panel, 22¾ x 12¾in, Louvre, Paris, France

▼ **The Laughing Cavalier** *This is one of the most famous portraits in the world. Lit from the left, and set against a plain wall on to which his shadow falls, this unidentified character seems to leap out at the viewer. An air of immediacy is created by his swaggering pose and expression: hand on hip, he turns his glance (slightly downward) towards us. Despite the painting's title, he is not laughing.* 1624, oil on canvas, 32¾ x 26¼in, Wallace Collection, London, UK

▲ **Banquet of the Officers of the St. George Civic Guard Company** *In his first major commission, and the first of his celebrated civic guard paintings, Hals reveals his skill at bringing freshness and vitality to a group portrait.* 1616, oil on canvas, 69 x 128in, Frans Hals Museum, Haarlem, Netherlands

❝ His paintings are imbued with **such force** and **vitality** that he seems to **defy nature** herself with his brush ❞

THEODORUS SCHREVELIUS, A HAARLEM SCHOOLMASTER WHO SAT FOR A PORTRAIT BY HALS

▲ **Regentesses of the Old Men's Alms House**
Painted when Hals was in his eighties, this subdued group portrait is a poignant, moving image of old age. The painting behind the regentesses may show the Good Samaritan, illustrating their charitable role. 1664, oil on canvas, 67 x 98in, Frans Hals Museum, Haarlem, Netherlands

CLOSERlook

THE SITTER'S AGE Although we do not know the sitter's name, we do know his age. The inscription on the back wall tells us (in Latin) that he was 26 when the portrait was painted, in 1624.

EMBROIDERY DETAILS While much of the sitter's costume is painted in broad, free strokes, Hals picks out the embroidery on his chest and sleeve with nimble precision. The embroidered motifs, which include winged arrows and bees, are emblems of love.

Rembrandt Harmensz van Rijn

Self-portrait

b **LEIDEN, 1606**; d **AMSTERDAM, 1669**

The greatest of all Dutch painters, Rembrandt enjoyed domestic happiness and professional success early in his career, but his later life was marred by personal and financial misfortune. The bulk of his work was in portraiture, but he excelled in other areas of painting and drawing, including mythological and religious subjects.

After settling in Amsterdam in 1631/32, Rembrandt became the city's leading portraitist, enlivening group portraits with a dramatic sense of narrative. Early works feature vivid lighting effects and expressive gestures. Later works, less fashionable then but more admired now, are more introspective— characterized by less overt drama, a broader, less polished technique, and a deeply compassionate psychological insight.

LIFEline

1606 Born in Leiden, the son of a prosperous miller
c1624 Trains with Pieter Lastman in Amsterdam;
1631/32 Settles in Amsterdam
1632 Paints *The Anatomy Lesson of Dr. Tulp*
1634 Marries Saskia van Uylenburch. They have four children, three die as babies
1642 Paints *The Night Watch;* Saskia dies
1654 Hendrickje Stoffels enters Rembrandt household as a servant; she becomes one of his favorite models and has two children with him
1656 Is declared insolvent
1663 Hendrickje dies
1668 His son Titus dies
1669 Dies in Amsterdam

▼ **Jacob III de Gheyn** *This striking early portrait shows the polished technique that helped bring the young Rembrandt success.* 1632, oil on panel, 11¾ x 9¾in, Dulwich Picture Gallery, London, UK

▼ **The Storm on the Sea of Galilee** *The diagonal composition and the shaft of light help create intense drama in this biblical scene.* 1633, oil on canvas, 64 x 51in, Isabella Stewart Gardner Museum, Boston, US

▼ **Young Woman Sleeping** *Rembrandt created this masterful drawing, reminiscent of oriental calligraphy, with a few broad brushstrokes.* c1654, ink on paper, 9¼ x 7¾in, British Museum, London, UK

▲ **The Three Crosses** *Rembrandt was one of the greatest of all printmakers. Most of his prints are etchings, but this expressive, richly textured masterpiece is a drypoint, made by scratching into a copper plate with a needle-like tool.* 1653, drypoint, 15¼ x 17¾in, British Museum, London, UK

▶ **The Night Watch** *This huge painting earned its misleading title because of its darkened varnish, but was originally called* The Militia Company of Captain Frans Banning Cocq and Lieutenant Willem van Ruytenburch. *Instead of showing the militiamen posed in the usual neat rows or seated around a table, Rembrandt depicts a lively, dramatic scene, as if the men are about to march out toward the viewer.* 1642, oil on canvas, 143 x 172in, Rijksmuseum, Amsterdam, Netherlands

CLOSERlook

COMPANY MASCOT Illuminated by a shaft of light, this little girl stands out amid the surrounding darkness, with her butter-yellow dress echoing the Lieutenant's gorgeous costume. She is probably the mascot of the company, and carries its emblems—chicken claws, a pistol, and the company goblet.

Self-Portrait *Rembrandt van Rijn*
c1665, oil on canvas, 44⅞ x 37in, Kenwood House, London, UK

Self-Portrait Rembrandt van Rijn

During his lifetime, Rembrandt left around 70 self-portraits—half of them paintings and half of them etchings and drawings. It was a remarkable, unprecedented 40-year exercise in self-examination. This self-portrait was made in c1665 when Rembrandt was in his mid- to late fifties. By this time, he had declined from his earlier days of prosperity. He had lost three of his children in infancy, his wife Saskia had died aged 30 in 1642, and he had been declared bankrupt in 1656. We can sense Rembrandt's tribulations in this masterpiece. And yet, in his expression, there is also serenity—perhaps even confidence. He looks at us as if we are the ones to be pitied—the ones who don't understand his genius.

Technique
The painting has a wonderful variety of marks. Bold strokes of paint define the turban. Deft brushwork helps describe the curly locks of hair. Rembrandt applies dabs of pigment across the skin tones in feints and starts—resulting in an exciting array of textured marks. By contrast, he sketches in his clothed body with fluent, thin passages of paint. Here, the picture dissolves into a half-painted blur of brown—only understated highlights on the brushes and mahlstick hold our attention.

◀ **MUSTACHE** To create the illusion of the thin, wispy mustache, Rembrandt has scratched into the wet paint with the brush handle. A pale highlight beneath the mustache helps to define the top edge of the upper lip.

▲ **BROAD STROKES**
Broad, thick strokes of white paint are used to build up the form of the turban, a type of headgear that Rembrandt wore in several of his self-portraits.

▲ **LEFT HAND** Rembrandt defines his left hand with fast, sketchy brushwork imitating the way we perceive objects in murky shadow. Rembrandt was quite relaxed about leaving parts "unfinished" in a self-portrait—although for a commissioned portrait, the patron would want more precise, detailed work.

Composition
Rembrandt is holding the tools of his trade—brushes, a mahlstick (to support the hand without smudging the paint), and a palette. In the background there are two circles. Many critics have speculated on their meaning—are they a representation of hemispheres found on maps of the world or purely an abstract design?

▲ **TONAL CONTRAST**
The light source comes from the top left, illuminating the turban and side of the face, but leaving the bottom half of the picture in mysterious, melancholy shadow.

▲ **STABLE STRUCTURE**
Rembrandt's head, shoulders, palette, and mahlstick form a triangle. This provides a stable composition and emphasizes the confidence exuded by Rembrandt.

▲ **BACKGROUND CIRCLES** Rembrandt has painted two circles on his canvas. The right-hand one counterbalances Rembrandt's head and body, which are on the left side of the canvas.

▲ **EYES AND NOSE** In an act of brutal honesty, Rembrandt applies two dabs of paints to the end of his nose—one white and one crimson. Just as Rembrandt's expression is open and candid, so too is his style of painting. He seems resigned to old age.

INcontext
COMPARE WITH OTHER SELF-PORTRAITS
In the early self-portraits Rembrandt generally shows himself as confident, successful, and playful. This is particularly evident in the colorful, lively painting of him as the prodigal son with his latest conquest (the model was his wife, Saskia). Many of Rembrandt's early self-portraits—such as the c1628 and c1639 examples here—were "tronies," head-and-shoulder studies in which the model plays a role or expresses a particular emotion. The later self-portraits tend to be melancholy and reflective. They are frank, often unflattering, but nevertheless dignified—exemplified by the 1669 self-portrait, believed to be his last.

Self-Portrait as a Young Man *c1628, oil on panel, 9⅛ x 7½in, Rijksmuseum, Amsterdam*

The Prodigal Son in the Tavern *c1635, oil on canvas, Gemäldegalerie, Dresden*

Self-Portrait with Gorget and Beret *c1639, oil on panel, Uffizi, Florence*

Self-Portrait at the Window *1648, 6¼ x 5⅛in, etching, Rijksmuseum, Amsterdam*

Self-Portrait *1669, oil on canvas, 25¼ x 22¾in, Mauritshuis, The Hague*

Gerrit **Dou**

Self-portrait

b **LEIDEN, 1613**; d **LEIDEN, 1675**

Rembrandt's first pupil, Dou was much influenced by his master's use of dramatic contrasts of light and dark. However, he went on to develop his own style, painting small-scale, meticulously detailed pictures using a highly polished, smooth technique. As well as genre subjects and portraits, he painted historical scenes and still lifes.

Dou was a slow and obsessively fastidious worker: he is said to have waited until the dust settled in his studio before starting work. Hugely successful in his day and a popular teacher, Dou founded the tradition of *fijnschilders* (fine painters) in Leiden, which continued until the 19th century.

LIFEline

1613 Born in Leiden, the son of a glass engraver
1628 Joins Rembrandt's workshop, aged 15
1648 Becomes a founding member of Guild of St. Luke (painters' guild) in Leiden
1665 Exhibition of 27 of Dou's paintings in Leiden
1675 Dies in Leiden

> **Anna and Tobit**
Rembrandtesque light and shade combine with Dou's own interest in detail and surface textures in this touching scene. c1645, oil on panel, 24 x 18in, Louvre, Paris, France

◀ **Maid Servant at a Window**
Dou often set his figures under a stone arch. The objects that appear to project over the window ledge and into the viewer's space emphasize the illusionism of his exquisitely precise technique. Museum Boymans Van Beuningen, Rotterdam, Netherlands

CLOSERlook

POLISHED SURFACE The reflective surface of the water pitcher is painted in painstaking detail. Dou's highly finished technique creates an enamel-like surface in which brushstrokes are imperceptible. He further displays his skill in the water flowing over the carved window ledge.

Jan **Lievens**

b **LEIDEN, 1607**; d **AMSTERDAM, 1674**

The son of an embroiderer, Lievens was extraordinarily precocious. Only 10 years old when he went to study in Amsterdam with Pieter Lastman, he was working as an independent painter in Leiden by the age of about 13. In the late 1620s, Lievens worked with Rembrandt, and contemporaries sometimes had difficulty differentiating their work.

Lievens enjoyed more worldly success than Rembrandt, but his later work, despite being highly accomplished, did not mature into equivalent greatness. He spent some time in England, where he was influenced by Anthony van Dyck, then lived in Antwerp, The Hague, and Amsterdam. The lasting impression of van Dyck can be seen in Lievens' fashionable portraits and history painting.

> **Raising of Lazarus**
In 1629 Lievens was described as exceeding Rembrandt "in a certain imaginative grandeur and boldness." This melodramatic image of the dead Lazarus emerging from his tomb—hands first— was painted around this time. 1631, oil on canvas, 42 x 45in, Brighton Museum and Art Gallery, UK

▲ **Fire and Childhood**
Painted when Lievens was in his teens, this picture, lit only by the glowing embers, shows his precocious mastery of lighting. c1623–25, oil on panel, 32½ x 23in, Gemäldegalerie Alte Meister, Kassel, Germany

Carel **Fabritius**

b **MIDDEN-BEEMSTER, 1622**; d **DELFT, 1654**

Renowned as Rembrandt's most gifted pupil, Fabritius is also celebrated, along with Vermeer and de Hooch, as one of the masters of the Delft school. Sadly, his life and promising career were cut short when he was killed by the gunpowder explosion that devastated Delft in 1654. Only about a dozen of his works survive, but they show the range and sensitivity of his art.

▲ **The Goldfinch** *A painting remarkable for its bold simplicity, subtle coloring, and striking illusionism.* 1654, oil on panel, 13¼ x 9in, Mauritshuis, The Hague, Netherlands

Hendrick **Avercamp**

b AMSTERDAM, 1585; d KAMPEN, 1634

The most famous Dutch painter of winter scenes, Avercamp trained in Amsterdam with Pieter Isacks, but spent most of his life in the provincial backwater of Kampen. He was unable to speak and was known as "the Mute of Kampen" because of this disability. Although pictures of skating existed before the 17th century, Avercamp established them as a specific *genre*. He painted these lively scenes, densely populated by a cross-section of Dutch society, not on commission, but for sale on the open art market.

▲ **Winter Scene with Skaters Near a Castle** *This early landscape is full of carefully observed incidents. c1608–09, oil on panel, diameter 16in, National Gallery, London, UK*

Jan **Both**

b UTRECHT, c1618; d UTRECHT, 1652

The son of a Utrecht glass painter, Both was a pioneer of Dutch Italianate landscape painting. He probably studied in his native Utrecht with Abraham Bloemaert, before spending several years (c1637–41) painting in Italy with his brother Andries. He was influenced by the great landscape artist Claude, whom he met in Rome.

Both returned north to Utrecht after his brother's accidental death by drowning in Venice. He made his name with his idyllic Italianate landscapes, suffused with the sunlight of the warm south and peopled with peasants or travelers. Such scenes were hugely popular with the Dutch art-buying public.

▲ **Italian Landscape with Monte Socrate** *Beneath a warm southern sky, a winding road leads to a distant mountain in this gentle landscape. c1637–41, oil on canvas, 58 x 81in, Fitzwilliam Museum, Cambridge, UK*

Jan **van Goyen**

b LEIDEN, 1596; d THE HAGUE, 1656

▲ **View from Rhenen** *Van Goyen's muted landscapes often feature a vast expanse of sky. Here it occupies three-quarters of the picture space. Oil on panel, 25 x 33½in, Kunsthalle, Hamburg, Germany*

An influential pioneer of realistic Dutch landscape painting, van Goyen was a consummate master of the "tonal" style, in which the primary concern was to capture atmospheric effects. He often based his paintings on open-air drawings made during extensive sketching journeys. Van Goyen was hugely prolific, and about a thousand of his drawings survive, ranging from chalk sketches to elaborate watercolors.

Van Goyen learned to paint in Leiden, but he became a pupil of the landscape painter Esaias van de Velde in Haarlem, and later established a studio in The Hague.

Nicolaes **Berchem**

b HAARLEM, c1620; d AMSTERDAM, 1683

Although he adopted a different name, Berchem was the son of the still-life painter Pieter Claesz, who was his first teacher. He studied with Jan van Goyen and went on to become very successful and prolific—he ranks with Jan Both as the outstanding Dutch specialist in Italianate landscapes.

Berchem worked in Haarlem and Amsterdam, and probably visited Italy during the 1650s. He had many pupils and followers, and his pastoral landscapes were highly prized by collectors.

▼ **Peasants with Four Oxen and a Goat at a Ford by a Ruined Aqueduct** *Against a luminous sky, Italian peasants lead cattle home beneath ancient Roman ruins. c1655–60, oil on panel, 18½ x 15¼in, National Gallery, London, UK*

Aert **van der Neer**

b AMSTERDAM, 1603/04; d AMSTERDAM, 1677

A much-imitated Dutch landscape painter, van der Neer specialized in two types of paintings—winter scenes with skaters, and nocturnal landscapes, which were illuminated either by moonlight or by a burning building. His earliest dated work is from 1630, but his most accomplished landscapes date from the 1640s and 50s.

Although none of van der Neer's contemporaries could equal his skill at nocturnal scenes, he struggled to make a living through his art. In 1658 he opened a wine shop, but he was declared bankrupt four years later. Two of van der Neer's sons were also painters.

▼ **Canal Scene by Moonlight** *Nocturnal scenes suited a tonal approach to landscape. Van der Neer silhouettes a Dutch skyline and fishermen working by a canal against a luminous, moonlit sky. c1645–50, oil on canvas, 23¼ x 28¾in, Wallace Collection, London, UK*

Jan van de **Cappelle**

b AMSTERDAM, 1626; d AMSTERDAM, 1679

The wealthy heir to his father's Amsterdam dye works, Cappelle painted in his spare time but was one of the greatest Dutch marine painters. Self-taught, he learned partly by copying seascapes. He enjoyed excursions on his pleasure yacht, and his drawings indicate that he sketched from nature. Most of his paintings show handsome ships on calm rivers and estuaries beneath cloudy skies. His great skill was in capturing atmospheric conditions. He also painted beach scenes and winter landscapes. An avid collector, Cappelle owned some 200 paintings and 7,000 drawings by leading Flemish and Dutch artists, including about 500 by Rembrandt.

▲ **A Dutch Yacht Firing a Salute as a Barge Pulls Away, and Many Small Vessels at Anchor** *Although Dutch ships are the ostensible subject, the impact of this seascape comes from its delicate tonal harmonies and enveloping, hazy atmosphere. 1650, oil on panel, 34 x 45in, National Gallery, London, UK*

Jacob van **Ruisdael**

b **HAARLEM, 1628/29**; d **AMSTERDAM?, 1682**

Ruisdael is regarded as the greatest of all Dutch landscape artists. He may have been taught by his father, who was a frame-maker and art dealer, or by his uncle, Salomon van Ruysdael, who was a prolific painter of quiet tonal landscapes similar to those of van Goyen. But Ruisdael soon developed his own moody, emotionally charged style of landscape, using rich coloring, dramatic lighting, and vigorous brushwork. His landscape imagery is inventive and wide ranging—from rocky waterfalls to woodland scenes and sky-filled panoramic views.

Few facts are known about Ruisdael's life. He left his native Haarlem in about 1656 and settled in Amsterdam, where he lived for the rest of his life. Ruisdael's only known pupil was Meindert Hobbema, but his influence on future painters—from Gainsborough to Constable and the Barbizon painters—was immense.

LIFEline

1628/29 Born in Haarlem

1646 Paints his earliest dated works

c1650 Travels to the Dutch/German border with fellow painter Nicolaes Berchem

c1655–60 Paints two versions of *The Jewish Cemetery*

c1656 Moves to Amsterdam

1657 Is baptized into the Reformed Church

1660 Writes testimonial for Meindert Hobbema, his only documented pupil

1667 Presumably suffers serious illness, as he twice makes a will, describing himself as a bachelor

1682 Dies, probably in Amsterdam; is buried in the cathedral at Haarlem

◄ **Peaceful Landscape** *The tree has been called the hero of Ruisdael's art. It could be noble and strong, as in this drawing, or blasted and dying.* Pen and ink with watercolor on paper, Musée Condé, Chantilly, France

▼ **The Jewish Cemetery** *This scene creates a darkly emotional impact unique in landscapes of the time.* c1655–60, oil on canvas, 33 x 37½in, Gemäldegalerie Alte Meister, Dresden, Germany

CLOSERlook

SHADOWY TOMBSTONES The landscape is a "vanitas"—an allegory reminding us of the transience of human life. It is based both on observation (of the cemetery at Ouderkerk near Amsterdam) and on imagination.

BROODING CLOUDS Cloudless skies are unknown in Ruisdael's landscapes, and he used clouds to evoke mood. Here, brooding storm clouds create the graveyard's dramatic lighting and intense, melancholy atmosphere.

Meindert **Hobbema**

b **AMSTERDAM, 1638**; d **AMSTERDAM, 1709**

The Dutch landscape painter Hobbema is now mainly famous for just one painting, *The Avenue, Middelharnis*—perhaps the most memorable of all Dutch landscapes. It was painted relatively late in his career, and toward the end of the great age of Dutch landscape. The powerful simplicity of the composition, with its celebrated central perspective scheme, is unforgettable.

Based in Amsterdam, Hobbema was a friend and the only documented pupil of Jacob van Ruisdael. His early paintings show similarities to Ruisdael's, but his work is generally sunnier, less dramatic, and narrower in range. He concentrated on a few favorite types of composition, typically featuring woody landscapes and watermills around a pool, sometimes with a winding road. Such paintings influenced Gainsborough's early landscapes.

It used to be thought that Hobbema gave up painting after marrying and taking a well-paid job as a wine-gauger for the Amsterdam customs. But it now seems that he continued painting in his spare time—his masterpiece, *The Avenue*, is dated 1689.

LIFEline

1638 Born in Amsterdam

c late 1650s Studies with Jacob van Ruisdael

1668 Marries Eeltije Vinck; begins working for the Amsterdam customs and excise, supervising the weighing and measuring of imported wine, and thereafter paints mainly as a leisure activity

1689 Paints *The Avenue, Middelharnis*

1704 Death of his wife

1709 Dies in Amsterdam

▲ **A Ruin on the Bank of a River** *This serene landscape, with leafy trees, a tiny figure, and a ruin reflected in the still water of a pond, is typical of most of Hobbema's work. The unidentified ruin recurs in several other paintings.* 1667, oil on panel, 23½ x 33in, Wallace Collection, London, UK

▲ **The Avenue, Middelharnis** *Hobbema draws the eye deep into the landscape, along the straight, tree-lined road at right angles to the picture surface. The perspective scheme makes the viewer feel he is entering the avenue and will meet the walking figure.* 1689, oil on canvas, 41 x 55½in, National Gallery, London, UK

CLOSERlook

MEETING POINT The rapidly converging lines created by the straight road, the trees, and the dykes meet at a distant vanishing point on the horizon, close to the head of the man walking toward us.

Aelbert **Cuyp**

b **DORDRECHT, 1620**; d **DORDRECHT, 1691**

Celebrated for his luminous landscapes, Aelbert Cuyp was a versatile artist who also painted portraits, sea-pieces, and still lifes. The son and probably the pupil of Jacob Gerritz Cuyp, he was first employed to paint in the landscape backgrounds to his father's portraits.

Cuyp's early works are influenced by Jan van Goyen's tonal landscapes, but in the mid 1640s he adopted an Italianizing manner, evocative of Claude, and probably inspired by Jan Both. Cuyp never actually visited Italy, but he did make numerous sketching trips along the Rhine and other rivers.

Cuyp developed his Italianate landscapes in an individual way, peopling them with recognizably Dutch shepherds and farmers. His reputation rests on his beautifully composed, tranquil landscapes, often featuring monumental cattle set against glowing skies.

LIFEline

1620 Born in Dordrecht, into a family of artists
1639 Earliest dated painting
c1651–52 Travels up the Rhine
1658 Marries a rich widow and thereafter evidently paints comparatively little
1691 Dies in Dordrecht

► **Ubbergen Castle** *The ruined castle at Ubbergen, partly destroyed during the Spanish occupation, was a Dutch national symbol.* c1655, oil on panel, 12½ x 21½in, National Gallery, London, UK

▲ **Sunset after Rain** *With its placid cows and evening sky, this poetic scene has a calm grandeur.* c1648–52, oil on panel, 33 x 27½in, Fitzwilliam Museum, Cambridge

Adriaen van **Ostade**

b **HAARLEM, 1610**; d **HAARLEM, 1685**

Best known for his peasant *genre* paintings and etchings, Ostade also occasionally painted small portraits and biblical subjects. He lived all his life in Haarlem and, according to the Dutch painter and writer Arnold Houbraken, he trained with Frans Hals. One of his fellow pupils was Adriaen Brouwer, whose works had a great influence on him. Ostade's use of light and shade also reflects a knowledge of Rembrandt.

Ostade had joined the Haarlem painters' guild by 1634 and was elected dean in 1662. He is thought to have taught his brother Isaak and Jan Steen. A successful, prolific artist, Ostade died a wealthy man.

▲ **The School Master** *Ostade's early works often depict drunken peasants, but later ones, such as this, have more respectable subjects.* c1662, oil on panel, 15¾ x 12¼in, Louvre, Paris

Gabriel **Metsu**

b **LEIDEN, 1629**; d **AMSTERDAM, 1667**

An accomplished painter of genre pictures as well as other subjects, Gabriel Metsu was the son of the painter Jacques Metsu. Some sources suggest Metsu was a pupil of Gerrit Dou, but this seems unlikely because his early style is much broader than Dou's *fijnschilder* (fine painter) manner. Later, Metsu's technique became more meticulous. He mainly painted genteel middle-class scenes, some of which have been compared to the work of Gerard Terborch and Jan Vermeer. In 1648, Metsu became a founder member of the painters' guild in Leiden. He spent the last decade of his life in Amsterdam.

▲ **The Sleeping Sportsman** *This painting has various sexual allusions that would have been apparent to Metsu's audience.* 1650s, oil on canvas, 15¾ x 13¾in, Wallace Collection, London, UK

Willem **van der Velde the Younger**

b **LEIDEN, 1633**; d **LONDON, 1707**

The son of Willem van der Velde the Elder (1611–93), who was the official Dutch war artist, Willem the Younger was taught by his father and by Simon de Vlieger. Though born in Leiden, he grew up in Amsterdam, and moved to England with his father in the winter of 1672/73. The following year, both men were appointed naval war artists by Charles II, provided with a studio in Greenwich, and commissioned to make tapestry designs as well as paintings.

Renowned for his mastery of composition and atmosphere, Willem the Younger painted battle scenes, portraits of individual ships, and seascapes. He was in high demand from both the English and Dutch markets, but was particularly influential in England, where the entire tradition of marine painting originates from him.

▲ **Storm at Sea** *The sun bursts through clouds, as ships face destruction on mountainous waves.* Oil on panel, Worcester Art Museum, Massachusetts, US

◄ **A Hoeker alongside a Kaag at Anchor** *This beautifully balanced composition shows one of Willem the Younger's preferred subjects—magnificent Dutch ships in calm weather. It is the evocation of space and atmosphere that is so impressive.* Harold Samuel Collection, Mansion House, London, UK

Jan **Steen**

b **LEIDEN, 1625/26**; d **LEIDEN, 1679**

Self-portrait

Along with Rembrandt, Hals, and Vermeer, Jan Steen is one of his nation's most popular painters. His name has even become part of Dutch proverbial language: a "Jan Steen household" refers to a rowdy, chaotic home such as the one depicted in *In Luxury, Look Out* (right). Although he is best known for such comic scenes of contemporary life, Steen was actually an inventive, versatile, and prolific artist. He painted a wide range of subjects, including portraits and historical and mythological works. In all, about 800 paintings are attributed to him.

Steen is thought to have studied with various masters, including Adriaen van Ostade and Jan van Goyen (whose daughter he married). As well as painting, Steen ran a brewery, then a tavern, but he still ended his life heavily in debt.

LIFEline

1625/26 Born in Leiden, the son of a brewer
1648 Joins Leiden painters' guild
1649 Marries daughter of Jan Van Goyen
1660–70 Lives in Haarlem
1670 Returns to Leiden
1679 Dies, and is buried in family grave in the Pieterskerk

▶ **Skittle Players Outside an Inn** *Bathed in shimmering light, this small-scale scene creates a gentle view of Dutch society at leisure.* c1660–63, oil on panel, 13 x 10⅝in, National Gallery, London, UK

CLOSERlook

MEANINGLESS BANTER The quacking duck on the man's shoulder suggests he is talking nonsense—paying no attention to the chaos around him.

SNIFFING PIG A pig sniffs a rose in a reference to vice in a Dutch proverb: throwing roses before swine represents wastefulness.

◀ **In Luxury, Look Out** *This comic masterpiece has a serious moral message, which is written on the slate in the bottom right corner:* In Luxury, Look Out. *Steen's chaotic cast of well-off characters enact various forms of folly and debauchery. Meanwhile, a basket hanging over their heads contains objects such as a crutch, indicating the poverty and disease that await them.* 1663, oil on canvas, 39½ x 55in, Kunsthistorisches Museum, Vienna, Austria

Gerard **Terborch** the Younger

b **ZWOLLE, 1617**; d **DEVENTER, 1681**

Self-portrait

Terborch showed his talent early, as can be seen in drawings he made at the age of eight. They were dated by his father, a minor artist who was his first teacher. Born in the provincial Dutch city of Zwolle, Terborch was unusually widely traveled— visiting England, Italy, Germany, Spain, and Flanders. In 1654 he settled in Deventer, where he was an extremely successful painter of genre (everyday life) scenes featuring elegant members of Dutch society. He had a gift for suggesting individual character, and was astonishingly skillful at rendering surface textures, such as those of shiny silks and satins.

◀ **The Lute Player** *This picture comes alive because of its strong characterization and the meticulous technique with which Terborch captures the brilliant sheen of the lute player's dress.* 1667–68, oil on panel, Gemäldegalerie Alte Meister, Kassel, Germany

Pieter **de Hooch**

b **ROTTERDAM, 1629**; d **AMSTERDAM, 1684**

One of the most accomplished of the Dutch genre painters, Pieter de Hooch is best known for his tranquil, homely interiors and sunny courtyard scenes, characterized by convincing perspective, masterful lighting, and peaceful atmosphere. Along with Vermeer, he is one of the masters of the Delft school. His reputation rests on the quiet masterpieces he painted during his short time (c1652–60) living there.

Although he is most associated with Delft, de Hooch moved around the Netherlands. He was born in Rotterdam and trained in Haarlem with the landscape painter Nicolaes Berchem. He left Delft in about 1660 and moved to Amsterdam, where he lived and worked until his death in 1684, painting more elaborate but less touching works. He died in an insane asylum.

◀ **A Boy Bringing Pomegranates** *In this tender domestic scene, line and light combine to create a realistic and atmospheric sense of space. The converging perspective lines of the receding floor tiles, and an alternating pattern of light and shade, measure the movement into depth. Warm, golden light models forms and adds to the tranquil mood.* c1662, oil on canvas, 29 x 23½in, Wallace Collection, London, UK

▲ **The Courtyard of a House in Delft** *De Hooch uses perspective to create compartments of space in this subdued courtyard scene: the eye is led into depth across the paving stones, through the archway, and into the hallway, where a woman stands looking away from us at the window of the house across the street.* 1658, oil on canvas, 29 x 23½in, National Gallery, London, UK

Jan **Vermeer**

b DELFT, 1632; d DELFT, 1675

After centuries of obscurity, Vermeer is now celebrated as one of the greatest of all Dutch artists. He is renowned for his serene, beautifully composed and lit, and uncannily realistic paintings. His subject matter is usually a woman at home in a Dutch interior, writing, reading, playing a musical instrument—or simply posing—or a servant engaged in domestic activity such as pouring milk. He was "discovered" in 1866 by the French writer Théophile Thoré, who called him "the Sphinx of Delft," because so little was known about him. There are few documented facts about Vermeer's life, and only about 35 paintings are known to be by him.

Vermeer was the son of an innkeeper and art dealer in Delft, and seems to have lived all his life in the city. Nothing is known of his youth or training until he became a member of the painters' guild in 1653— the same year that he married Catharina Bolnes, a Catholic. The couple had 15 children. In his later years, Vermeer suffered dire financial hardship, and he died in debt in Delft at the age of only 43.

LIFEline

1653 At the age of 21, becomes member of Delft painters' guild

1656 Earliest known dated picture, *The Procuress*

1662 (and 1670) Elected *hooftman* (headman) of the painters' guild

c1665–6 Paints much-loved *Girl with a Pearl Earring*

1672 Vermeer's art business collapses after French invasion of the Netherlands triggers a national economic crisis

1675 Dies in debt

▼ **Girl with a Pearl Earring** *Against a dark background, a girl turns to look, almost questioningly, towards the viewer. This exquisite painting gains its effect through strikingly simple composition, pearly lighting, and the muted harmony of yellow and blue.* c1665–66, oil on canvas, 17¼ x 15¼in, Mauritshuis, The Hague, Netherlands

◀ **View of Delft** *One of only two exterior views by Vermeer, this picture of his home town is a celebrated masterpiece of lighting, atmosphere, and almost photographic realism. As townsfolk chat on the quayside in the foreground, the busy skyline and clouds are reflected in the glistening water.* c1660–61, oil on canvas, 38 x 46in, Mauritshuis, The Hague, Netherlands

CLOSERlook

SPECKLES OF PAINT From a distance, Vermeer's paintings may appear smoothly painted, but in close-up the individual brushmarks and blobs of paint with which he recreates the play of light reflected off different surfaces are visible. His paint surface has been likened to "crushed pearls melted together." Molten highlights evoke the texture of the grainy bread crust and woven wicker.

▶ **The Milkmaid** *There was a long tradition of picturing milkmaids in Dutch art, but Vermeer's image is unique in its serenity and monumental simplicity. Sunlight from a window falls upon the milkmaid, modeling her rounded figure with strong contrasts of light and shade.* c1657–58, oil on canvas, 17¾ x 16¼in, Rijksmuseum, Amsterdam, Netherlands

The Art of Painting (The Artist's Studio) *Jan Vermeer*
c1666–68, 47¼ x 39⅜in, oil on canvas, Kunsthistorisches Museum, Vienna, Austria

CLOSERlook
The Art of Painting Jan Vermeer

Vermeer painted this picture (also known as *The Artist's Studio*) in his 30s, and, despite dire financial problems, he never sold this masterpiece —perhaps keeping it as a showpiece for prospective clients. It is larger than most of his paintings and uses symbolism and allegory to comment on the status of art and artists in the 17th century.

Technique

No known drawings or preliminary studies by Vermeer exist, so this painting is important because it suggests his working methods. Having covered his canvas in light gray to create a base color, he added compositional elements with white, probably chalk, lines. Features such as exaggerated perspective (the chair), soft-focus (Clio's face), and the molten highlights (curtain and chandelier) suggest the use of a *camera obscura* (see right).

Composition
The curtain and the diagonal lines created by the floor tiles help draw the viewer into the composition. Vermeer used laws of linear perspective: he marked the vanishing point with a pin, and the orthogonals—receding parallel lines— with chalked lengths of string tied to the pin.

▲ **DARK TO LIGHT** The curtain and chair create a dark foreground, which leads into the scene beyond—lit, as usual with Vermeer, from the left.

▲ **VANISHING POINT** Orthogonals drawn through the pale floor tiles and along the table edge meet at the vanishing point in front of the girl.

▲ **BEADS OF LIGHT** Vermeer had a remarkable ability to create an almost tangible illusion of different surface textures. Pinpoints of light pick out the woven stitches on the curtain.

▲ **PAINTING IN PROGRESS** This detail gives a fascinating glimpse of Vermeer's working method: using a mahlstick (the black stick on which his hand rests), the artist paints Clio's laurel crown, having first drawn in the outlines in chalk.

Story and Characters

Vermeer presents his painting as if the viewer has pulled aside the curtain to see the artist at work, painting a model dressed as Clio, the Muse of history in Greek mythology. The painter himself is viewed from the back, wearing an elegant costume from an earlier period. Illusion and symbolism combine in the beautifully observed details— from mask to map and ornate chandelier.

▶ **PAINTED MASK**
Although it may seem to be a casually discarded studio prop, the mask on the table can be viewed as a symbol of imitation, one of the functions of painting. Depicting a convincing imitation of reality —"a mirror of Nature"— was a central aim of many 17th-century Dutch artists.

> ❝ Vermeer's most **remarkable** trait... is the **quality** of his **light** ❞
>
> THÉOPHILE THORÉ, FRENCH WRITER ON ART, c1866

▶ **THE MUSE OF HISTORY** This figure can be identified as Clio, the Muse of history, because of the objects she wears and carries. Her crown of laurel leaves symbolizes glory and honor, which will survive for posterity. She holds a trumpet, indicating fame (which can be achieved by the artist), and a book (symbolizing history).

▲ **SPANISH DECLINE** Apart from being a virtuoso display of painting, the chandelier may refer to the waning of Spanish power. It shows the Hapsburg symbol—the double-headed eagle—but, significantly, there are no candles.

▲ **A COUNTRY DIVIDED**
The age-worn map of the Netherlands behind Clio relates to history. The Dutch northern provinces gained independence from Spain with the Treaty of Münster in 1648. Vermeer has depicted this split by painting a crease (above, center) along the frontier of the Protestant Dutch Republic on the right and the Catholic Spanish Hapsburg southern provinces on the left (north is to the right of the map).

Willem Claesz **Heda**

b HAARLEM, c1594; d HAARLEM, 1680

Willem Claesz Heda was one of the masters of 17th-century Dutch still-life painting, and he made a particular speciality of the *ontbijt* ("breakfast piece"). Along with Pieter Claesz, he was the leading exponent of this type of work, and the two men founded the tradition of still-life painting in his native Haarlem. Characterized by subdued, close tonal harmonies, their paintings can be seen as the still-life equivalents of the tonal landscapes of Jan van Goyen.

In common with other Dutch still-life painters of the time, Heda was concerned both with rendering different textures—distinguishing between the dull sheen of pewter and the gloss of silver, for example—and with creating images that were symbolic of the transience of human life and achievements. Heda's son, Gerrit, imitated his father's style, and their works are often hard to tell apart.

▼ **Still Life with Food and Drink** *Heda's objects appear almost to float against a plain, softly illuminated background. This still life is a "vanitas"— symbolizing the brevity of life. All food decays, and Heda's speciality, the mincemeat pie, is already partially eaten.* Oil on panel, 20¾ x 28¾in, private collection

CLOSERlook

LEMON PEEL Lemons alluded to a deceptive appearance—beautiful to look at, but sour to taste. The works by Heda, de Heem, and Kalf shown here all feature a half-peeled lemon—a symbol and a display of the painter's skill.

Jan Davidsz **de Heem**

b UTRECHT, 1606; d ANTWERP, 1683/84

One of the most accomplished of the Dutch still-life painters, Heem is renowned for his flower pieces and for tables laid with luxury foodstuffs. The son of the Utrecht painter David de Heem, he was trained by Balthasar van der Ast. In 1635, he settled in Antwerp.

Heem's work links the Flemish and Dutch schools. After his arrival in Antwerp, he was influenced by the Baroque exuberance of Rubens and Snyders and developed his speciality, *banketje*—lavish "banquet pieces", featuring luxury items such as oysters, lobsters, and exotic fruits. Heem had many followers, including his sons Cornelius and Jan Jansz.

▼ **Still Life** *The velvet curtain, ornate silver, oyster, and exquisitely painted fruit make this a more ostentatious image than Heda's muted "breakfast piece."* Oil on panel, Prado, Madrid, Spain

Willem **Kalf**

b ROTTERDAM, 1619; d AMSTERDAM, 1693

Perhaps the greatest of all Dutch still-life painters, Willem Kalf is the most famous exponent of a type of still life known as *pronkstilleven* ("still lifes of ostentation"). His ravishing images of precious objects show a mastery of lighting, color, and composition that bears comparison with Jan Vermeer.

The son of a Rotterdam cloth merchant, Kalf lived in Paris during the 1640s, painting peasant interiors and humble kitchen still lifes. After he settled in Amsterdam in 1653, he worked as an art dealer, and specialized in painting *pronkstilleven*, using fewer, grander objects, exquisitely lit against a dark background. In 1797, Goethe wrote that Kalf's paintings showed, "in what sense art is superior to nature and what the spirit of man imparts to objects when it views them through creative eyes."

◀ **Still Life with a Late Ming Ginger Jar** *Works such as this one, featuring precious objects from abroad—a Ming vase, Venetian glass, an Indian carpet—would have appealed to the pride Kalf's Dutch contemporaries took in their country's trading power.* 1669, oil on canvas, 30¼ x 26in, Indianapolis Museum of Art, Indiana, US

Rachel **Ruysch**

b THE HAGUE, 1664; d AMSTERDAM, 1750

One of the leading Dutch flower painters of the first half of the 18th century, Ruysch was the daughter of Anthony Ruysch, a celebrated botanist and anatomist. Her knowledge of botany shows in her paintings. She had a long career: at 15, she was apprenticed to the Dutch flower painter Willem van Aelst, and she continued painting until she was in her eighties. However, only about 100 paintings by Ruysch are known. The reason for this may be that, after marrying the portrait painter Juriaen Pool, she had 10 children. Ruysch worked mainly in Amsterdam, but also in The Hague, and in Düsseldorf, where she was court painter to the elector palatine (ruler of the Rhine region) from 1708 to 1716.

Portrait by Godfried Schalken

CLOSERlook

SHINY SHELLS Ruysch's flower paintings teem with life and movement, partly because of the inclusion of insects, mollusks, and reptiles. Here, the hard, shiny snail shells create an effective contrast with the delicate colors and textures of the blooms.

▲ **Still Life of Flowers on Woodland Ground** *Ruysch often mixed exotic and hedgerow flowers in her complex compositions.* c1690, oil on canvas, 37 x 29in, Gemäldegalerie Alte Meister, Kassel, Germany

Grinling **Gibbons**

b **ROTTERDAM, 1648**; d **LONDON, 1721**

The celebrated and influential woodcarver Grinling Gibbons was the son of English parents who had business interests in the Netherlands. He may have trained in Amsterdam with the Quellin family of sculptors before settling in England, aged about 19. Working mainly in limewood, he became renowned for his virtuoso naturalistic carving—particularly swags of fruit, flowers, and foliage, which could festoon walls, ceilings, fireplaces, and furniture. The architect Sir Christopher Wren employed Gibbons to work on St. Paul's Cathedral and Hampton Court Palace, and in 1693 he was appointed royal master carver by King William III.

Portrait by Godfrey Kneller

◀ **Detail of wood carving** *Gibbons's astonishingly fine woodcarving can be seen in numerous English country houses. This detail from a panel shows a complex cluster of musical instruments.* Limewood, Petworth House, Sussex, UK

CLOSERlook

"AIRY LIGHTNESS" Horace Walpole admired Gibbons's ability to give wood a "loose and airy lightness." Here, Gibbons combines delicate leaves and feathers with solid man-made objects.

William **Dobson**

b **LONDON, 1611**; d **LONDON, 1646**

The first great native-born English painter after the miniaturist Nicholas Hilliard, Dobson is renowned for his powerfully observed Royalist portraits, produced during the English Civil War. Most of his 60 or so known pictures date from 1642 to 1646, when he worked for Charles I's wartime court in Oxford. The extent of Dobson's royal patronage is unclear, but after van Dyck's death in 1641 he was the best painter in the country. Dobson is said to have lived a "loose and irregular" life, which may explain his poverty and early death, just a few months after the Royalists surrendered to the Parliamentarians.

Self-portrait

◀ **Portrait of Sir Charles Lucas** *This striking portrait of a Cavalier combines a heroic pose with down-to-earth characterization. The rich coloring and vigorous technique show the influence of Titian and other Venetian painters.* Oil on canvas, 17¾ x 14¼in, private collection.

Peter **Lely**

b **SOEST, 1618**; d **LONDON, 1680**

Originally named Pieter van der Faes, Lely was born into a Dutch family living in Germany. He trained in Haarlem, but in the 1640s moved to England, where he was to spend most of his working life. After the deaths of Anthony van Dyck and William Dobson, Lely became the country's leading portraitist. He was made principal painter to the king in 1661, was naturalized in 1662, and knighted just months before he died.

Self-portrait

Lely painted a range of sitters, among them Charles I and Oliver Cromwell, but it is as the image-maker of the Restoration court of Charles II that he is best remembered. He lived in grand style and amassed a magnificent collection of art.

▲ **Diana Kirke, later Countess of Oxford** *Daringly draped in silk, this aristocratic beauty has the large, languorous "Lely" eyes, which gave many of his sitters a similar look.* c1665–70, oil on canvas, 12½ x 41in, Yale Center for British Art, New Haven, Connecticut, US

◀ **Studies of hands** *Lely made numerous preparatory drawings, like this one. He had a large number of assistants who would also have used these studies as reference.* Chalk on paper, 15 x 10½in, Ashmolean, Oxford, UK

Godfrey **Kneller**

b **LÜBECK, 1646**; d **LONDON, 1723**

Born in Germany, Kneller studied in Amsterdam with Rembrandt's pupil, Ferdinand Bol. In the 1670s, he settled in England, where he dominated portrait painting from Lely's death through to the early 18th century. Kneller was appointed principal painter to William III in 1689, and later knighted and created a baronet. Notoriously arrogant, he was also hugely prolific, sometimes taking as many as 14 sitters in a day.

Self-portrait

▲ **Samuel Pepys** *Kneller has been accused of running his studio as a production line, but he was capable of great quality. This portrait of the diarist Pepys shows Kneller at his best.* 1689, oil on canvas, 30 x 25¼in, National Maritime Museum, London, UK

Emerging in about 1700, the Rococo style dominated European art for most of the 18th century. Superseding the Baroque movement, it emphazed elegance, frivolity, and decorative charm. The greatest Rococo painters were Watteau, Boucher, and Tiepolo.

The word "Rococo" is thought to derive from *rocaille*, a French word describing an ornamental form of rock-work that uses shells and pebbles to adorn fountains and grottoes. This seems to have been combined with *barocco*, a source-word for Baroque.

Origins and influences

The term Rococo is said to have been coined by one of David's pupils, shortly after the French Revolution. It was meant as a humorous insult, mocking the supposed triviality of the florid, aristocratic style. It remained a pejorative term throughout the first half of the 19th century, but is now free from any negative connotations.

▲ **Interior of a Benedictine Abbey Church** German School *Built by Johann Michael Fischer (1692–1766), the simplicity of the church's architecture is transformed by the brilliant frescoes and the sumptuous stucco-work.* 1748–68, Ottobeuren, Bavaria, Germany

The Rococo style had a major impact on architecture, interior design, and the decorative arts, as well as painting. It developed initially in France, but eventually spread to most other parts of Europe. In the main, it was transmitted either by engravings or by expatriate French artists.

Subject matter

Rococo painters retained many of the themes that had been in vogue during the Baroque era, but treated them in a lighter, more playful manner. Symbolic and mythological subjects were still in demand, but they lost much of their serious content. In many cases, they simply provided a pretext for tastefully erotic depictions of the female nude.

Amorous themes were especially popular. Watteau pioneered the *fête galante*, a new type of subject in which elegant young couples, dressed in rich attire, wandered blissfully

Rococo

TIMEline

Watteau pioneered the Rococo style, completing his masterpiece *Embarkation for Cythera* in 1717. Canaletto's career painting scenes of Venice began to prosper a decade later. In Britain, Hogarth produced social satires such as *Marriage à la Mode* and Gainsborough painted elegant portraits. Austrian painter Maulbertsch completed his *Apotheosis* three years before his French contemporary Fragonard produced *The Swing*.

1717

WATTEAU Embarkation for Cythera

1730

CANALETTO Return of the Bucintoro on Ascension Day

1743

HOGARTH Marriage à la Mode: the Toilette

c1748–49

GAINSBOROUGH Mr. and Mrs. Andrews

▲ **Ruined gallery of the Villa Adriana** Giovanni Batttista Piranesi *The artist used a low viewpont and tiny figures to make his Roman ruins seem large and imposing, while the profusion of creepers adds an air of mystery.* 1756, engraving, Bibliothèque Nationale, Paris, France

Schools

The Rococo movement was nurtured in France, where it was closely associated with the reign of Louis XV (1715–74). It subsequently gained popularity in other countries, but often in very different forms.

French

French Rococo painting was dominated by Jean-Antoine Watteau, François Boucher, and Jean-Honoré Fragonard (see p.246). Watteau developed the style, but his successors did the more typical work. In their hands, Rococo became the art of the boudoir—a blend of elegance, wit, and eroticism.

The lightness of the themes is evident from the ease with which they could be transferred from one medium to another. For example, Boucher used the same infants and nymphs for his paintings, his porcelain figures, and his tapestry designs.

Directness and informality were also the keynotes of Rococo sculpture, typified by the approach of Jean-Antoine Houdon, its leading practitioner. On a smaller scale, the style also made a significant impact on the burgeoning porcelain industry.

German and Central European

In the early 18th century, when Germany began to recover from the Thirty Years War (1618–48), there was a building boom. Princes erected new palaces while, in the Catholic south, there was a spate of church building, where Rococo decoration achieved its fullest flowering. The interiors were adorned with frescoes, and some of the most elaborate stucco-work (architectural decoration) ever produced. Occasionally, artists covered both these fields. Johann Zimmermann, for example provided both the paintings and the stucco-work for his brother's buildings.

Meanwhile, Franz Anton Maulbertsch painted altarpieces and frescoes with exuberant flair in his native Austria as well as in the Czech Republic, Hungary, and Slovakia. He was a Rococo artist to the last, ignoring the onset of Neoclassical austerity.

Italian and Venetian

In Italy, the emergence of the Rococo style coincided with the heyday of the Grand Tour, and many of its leading exponents

around a dreamy, parkland setting. Pastoral scenes provided a similar form of escapism. The aristocratic figures were replaced by shepherds and shepherdesses, idling away the time with their flirtatious games.

Style and techniques
The Rococo style was marked by a light-hearted, decorative approach. In narrative subjects, the story was often amplified by playful *putti* (cherubs) or by statues that seemed to come alive, eager to participate. Even in more somber themes, painters indulged in ornamental flourishes or effortless, virtuoso effects. In the applied arts, the emphasis on decoration was even more pronounced. Scrollwork and shell motifs were everywhere, and there was a taste for curvilinear and asymmetrical designs.

▲ **Portrait of Madame de Pompadour** François Boucher, 1759, oil on canvas, 35¾ x 26¾in, Wallace Collection, London, UK

◀ **Portrait of Madame de Pompadour (detail)** *Boucher's skill lay in his rendering of delicate frills and flounces rather than in the portrait itself.*

CURRENTevents
1702–13 The War of the Spanish Succession divided Europe for more than a decade, but also made military pictures more topical. Watteau tried his hand at this theme in 1709, when he was living in Valenciennes.

1740s Herculaneum and Pompeii became regular attractions on the Grand Tour, which proved so important for the careers Canaletto and Piranesi.

1751

BOUCHER Reclining Nude (Miss O'Murphy)

1757

FALCONET The Bather

1758–60

TIEPOLO Young woman with a Parrot

1764

MAULBERTSCH Apotheosis of St. James the Greater

1767

FRAGONARD The Swing

1767

BATONI Thomas William Coke

▲ **Ceiling fresco** Giambattista Tiepolo *This scene greeted visitors as they walked up the palatial staircase of the Residenz. Court dignitaries, musicians, and artists mingle with allegorical figures: the reclining officer is thought to be Balthasar Neumann, the architect of the building.* 1750–53, fresco, Residenz, Würzburg, Germany

geared their work toward this market. In Rome, Giovanni Paolo Panini, Giovanni Battista Piranesi, and French-born Hubert Robert all found distinctive ways to portray the grandeur of the ancient ruins, while Pompeo Batoni's graceful portraits of visiting nobility were in constant demand.

In Venice, Canaletto achieved similar success with his sparkling pictures of the city's best-loved sights and spectacles. Tourists, however, were not the only patrons. Giambattista Tiepolo, the greatest Venetian painter of the age, worked for a much broader clientele. His dazzling frescoes and canvases were commissioned to adorn some of the finest villas and churches in the region.

Tiepolo's fame spread far beyond Italy. Arguably his greatest masterpiece was produced in Würzburg, Germany, for the Residenz (palace) of the local Prince-Bishop.

Tiepolo's task was to produce a range of frescoes, showing the Four Continents—Asia, Africa, America, and Europe—and paying tribute to his patron. This could have resulted in a sterile allegory of symbolic figures. Tiepolo, however, transformed the setting into a virtuoso display of illusionism

with ancient gods in a make-believe sky, and human figures on the cornices, gazing down at the bishop's guests.

British
Rococo had less impact in Britain, but it still affected the major artists of the day. The crucial influence came from Hubert Gravelot, a French painter and engraver. He settled in London, where he introduced Rococo ideas to his friends Francis Hayman and William Hogarth. He also taught at the St. Martin's Lane Academy, where Thomas Gainsborough was a student.

The effects of the new style were most apparent in portraiture, where the conversation piece—an elegant and informal variation of the theme—gained great popularity.

▶ **Music**, Étienne-Maurice Falconet *This sensuous allegorical figure was commissioned by Madame de Pompadour for her home, the Château de Bellevue.* 1757, marble, height 79⅞in, Louvre, Paris, France

Jean-Antoine **Watteau**

Portrait by
Rosalba
Giovanna
Carriera

b **VALENCIENNES, 1684;** d **NOGENT-SUR-MARNE, NEAR PARIS, 1721**

The greatest French painter of his time, Watteau played a major part in shaping the Rococo style. His art was formed in Paris, where he was strongly influenced by Claude Gillot, a painter of theatrical scenes. Gillot took Watteau to see the improvised, knockabout shows of the Italian Comedy, which inspired his most distinctive creation: the *fêtes galantes* (courtship parties). These idyllic scenes show elegant costumed figures amusing themselves in romantic parklands. They stroll around, they flirt, they serenade each other.

Depictions of *fêtes galantes* were common in the Rococo era, but no others had the fragile beauty of Watteau's versions. They display a melancholic air, an apparent awareness that these pleasures cannot last for long. In part this may be due to the artist's habit of assembling his compositions from individual studies, so that his figures often appear solitary, isolated from their neighbors. It may also be linked to his illness. Watteau suffered for years from tuberculosis, and there is always a temptation to interpret his work as the expression of a man who knew that he was living on borrowed time. Certainly, there is a strong element of pathos in pictures such as *Gilles*.

Toward the end of his life, there are hints that Watteau was beginning to change direction—for example, the signboard painted for the picture dealer Gersaint was more realistic than his characteristic works. Even so, after his death, Watteau's *fêtes galantes* were rapidly dismissed as being artificial and old-fashioned.

▼ **Gilles** *A "Gilles" was a traditional type of clown, who was an innocent fool. In sketches, a donkey would be led across the stage to emphasise his stupidity. c1718–19, oil on canvas, 73 x 58½in, Louvre, Paris, France*

▼ **L'Enseigne de Gersaint**
Watteau's final masterpiece displayed a new interest in naturalism. 1721, oil on canvas, 64 x 120½in, Charlottenburg Castle, Berlin, Germany

> 66 His pictures reflect some of the **impatience and inconstancy** of his nature... he had a need to **switch from subject to subject**; he often began a composition **already half-bored** with its perfection 99

EDME GERSAINT (1694–1750),
PICTURE DEALER AND FRIEND

CLOSERlook

WISTFUL GLANCE The amorous "pilgrims" have paired off and are preparing to leave the island of love. A woman gazes back wistfully at a couple, who are still wrapped up in each other. She is aware that this degree of passion is all too fleeting. Her melancholy expression is echoed by the autumnal coloring and the approaching twilight.

▶ **Pilgrimage to the Island of Cythera** *Inspired by a contemporary play, this is the greatest of Watteau's* fêtes galantes. *Cythera is where Venus, goddess of love, is said to have come ashore after being born in the sea. 1717, oil on canvas, 51 x 76½in, Louvre, Paris, France*

Jean-Siméon **Chardin**

Self-portrait

b **PARIS, 1699**; d **PARIS, 1779**

Chardin's sober domestic scenes and still lifes make a striking contrast to the wilder excesses of the Rococo style, which was flourishing at the time. Despite some training from two history painters, Chardin was largely self-taught. His early preference was for still-life pictures in the Dutch tradition, as the Académie Royale confirmed in 1728, when it granted him membership as "a painter skilled in animals and fruit."

Chardin gained even greater plaudits when he turned his attention to genre scenes (scenes of everyday life) in the early 1730s. These often featured still-life elements—such as the charcoal heater in the right-hand corner of *Saying Grace*—but were more remarkable for the quiet interplay between mothers and their children. Late in his career, Chardin also tried his hand at pastel portraits, with some success.

LIFEline

1728 In his late 20s, gains membership of the Académie Royale

1731 Marries Marguerite Saintard

1735 Marguerite dies

1755 Elected Treasurer of the Académie, a post that he holds for almost 20 years

1771 First exhibits pastel portraits

1779 Dies in Paris

▶ **Saying Grace** *Chardin presented this painting to King Louis XV, after their meeting in 1740.* 1740, oil on canvas, 19¾ x 15⅜in, Louvre, Paris, France

▼ **The Skate (or The Ray)**
This is the painting that established the artist's reputation. Chardin presented it to the Académie as his reception piece. c1725, oil on canvas, 44¾ x 57½in, Louvre, Paris, France

CLOSERlook

HISSING CAT Still-life artists of this period often liked to add a living element to their scenes. Here, a startled cat protects its find of oysters. The skate itself almost looks as if it has a face. Marcel Proust described it as "a strange monster," with its red flesh, blue nerves, and white muscles.

245

FRENCH ROCOCO

17TH AND 18TH CENTURIES

François **Boucher**

Portrait by Gustav Lundberg

b **PARIS, 1703**; d **PARIS, 1770**

One of the chief highlights of the Rococo style is the art of François Boucher. In his paintings, he conveyed blatant sensuality with a wit and a playfulness that was much admired in royal circles. He was also extremely versatile, creating designs that worked equally well in paintings, in tapestries, or on china. The two main figures in his *Autumn Pastoral*, for example, were remodeled as a biscuit group by the Vincennes porcelain factory, while the entire scene was reproduced on a Sèvres vase.

Boucher possessed an unrivaled talent for depicting the rosy tints of human flesh. This is seen to best effect in his female nudes, masquerading as nymphs or goddesses, and also in the plump cherubs who accompany them.

LIFEline

1703 Born in Paris

1723 Wins the *Prix de Rome*

1728–31 Travels in Italy

1733 Marries Marie-Jeanne Buseau

1735 Receives his first royal commission

1751 Paints *Mademoiselle O'Murphy*, his famous nude

1755 Appointed director of the Gobelins tapestry factory

1765 Becomes director of the Académie Royale

1770 Dies in his studio

INcontext

MADAME DE POMPADOUR Born Jeanne-Antoinette Poisson, Madame de Pompadour was the principal mistress of Louis XV. Beautiful, intelligent, and charming, she remained the king's *maîtresse en titre* (official mistress) long after they had ceased to be lovers. She met François Boucher in the late 1740s, and he rapidly became her favorite artist. Boucher painted several portraits of Madame de Pompadour, and she involved him in a wide range of other projects, including the decoration of regal residences, the production of designs for Sèvres porcelain, and the creation of costumes and sets for her private theatricals.

Madame de Pompadour *by François Boucher (c1758). Boucher's portraits show his chief patron as a mature, intelligent woman. The book and writing implements underline her wide-ranging literary and artistic interests.*

CLOSERlook

RUMPLED SHEETS Rococo artists loved to create a decorative sense of disorder in their boudoir scenes. The luxurious fabrics and unmade bed had erotic overtones.

◀ **Mademoiselle O'Murphy**
Louise O'Murphy was a mistress of Louis XV and was mentioned in Casanova's memoirs. 1751, oil on canvas, 23½ x 29in, Wallraf-Richartz-Museum, Cologne, Germany

Jean-Honoré **Fragonard**

b **GRASSE, 1732**; d **PARIS, 1806**

Fragonard's art represents the final, magnificent flourish of Rococo in France. After a brief apprenticeship with Chardin, he trained under Boucher, inheriting his lightness of touch and feeling for color. In 1752, he won the prestigious *Prix de Rome*, which enabled him to study in Italy, where he became friends with Hubert Robert.

Following his return to France, Fragonard made his mark at the Salon with a dramatic history painting, *Coroesus Sacrificing himself to Save Callirhoe*. A successful academic career beckoned, but he only exhibited once more at the Salon, preferring decorative, sensual themes more suitable for the boudoir than for public display. These pictures proved enormously popular, winning Fragonard commissions from the king's mistress. By the 1770s, though, tastes were changing, as the Neoclassical style took root.

Portrait by M. Gerard

LIFEline

1732 Born in Grasse, the son of a glove-maker

1747 Moves to Paris, studying briefly with Chardin

1748 Enters the studio of Boucher, his principal master

1756–61 Studies in Italy

1765 Member of the Académie Royale

1769 Marries his pupil Marie-Anne Gérard

1793 Takes a museum job, as his style goes out of fashion

1806 Dies, a forgotten man

► **The Swing** *This private fantasy was commissioned by a courtier (bottom left), who wanted a picture of his young mistress with a bishop. Fragonard replaced the bishop with a cuckolded husband and turned the scene into a witty piece of flirtation.* 1767, oil on canvas, 32 x 25¼in, Wallace Collection, London, UK

CLOSERlook

LIVING STATUES Raising a finger to his lips, Cupid seems to share the secret of the lovers' affair. He looks at the flying slipper, which echoes the playful actions of the lovers but is also a symbol of lost innocence.

THE SUN shines from the top left, enveloping the woman in a shaft of light. The darker foliage surrounds her like a frame, setting off the central action.

▼ **Figure in Fancy Dress** *Fragonard liked to demonstrate his virtuosity by painting at incredible speed. He claimed to have finished this portrait of a friend, the Abbé de Saint-Non, in one hour.* 1769, oil on canvas, 31½ x 25½in, Louvre, Paris, France

▼ **The Bolt** *Amazingly, this delightfully risqué picture was commissioned to hang alongside a religious scene. The idea was to highlight the contrast between sacred and profane love.* c1778, oil on canvas, 28¾ x 36½in, Louvre, Paris, France

Jean-Baptiste **Greuze**

Self-portrait

b TOURNUS, 1725; d PARIS, 1805

Trained in Lyon and Paris, Greuze achieved early success with his sermonizing scenes of domestic life. These caught the mood of the times and the influential critic, Denis Diderot (1713–84) described them as "morality in paint." Greuze hoped that they would bring him the status of a history painter—the highest accolade for an artist—but the Académie Royale failed to grant him this honour. Crestfallen, Greuze stopped exhibiting at the Salon and turned increasingly to the market for sentimental pictures of young women. By the time of the French Revolution, public taste had changed and his work was deemed mawkish and melodramatic. In spite of a commission to paint Napoleon's portrait, his later years were marked by poverty and neglect.

LIFEline

1725 Born in Tournus
1755 Enjoys first major success at the Salon
1759 Marries Anne-Gabrielle Babuti
1769 Stops exhibiting at the Salon after criticism of his work
1778 Paints *The Punished Son*
1793 Divorces his wife
1805 Dies in poverty in Paris

▶ **The Punished Son**
From a pair of paintings illustrating The Father's Curse. *A disobedient youth (right) seeks forgiveness, but returns home too late after his father has died.* 1778, oil on canvas, 51¼ x 64¼in, Louvre, Paris, France

CLOSERlook

SHY LOOK Greuze's gave all his female portraits coyly upturned eyes. He called them "figures of sentiment" with "romance in their eyes."

▼ **Morning Prayer** *Greuze created an uneasy blend of innocence, piety, and veiled eroticism in his sentimental pictures of young girls. Even so, they proved immensely popular.* Oil on canvas, Musée Cognacq-Jay, Paris, France

247

FRENCH ROCOCO

17TH AND 18TH CENTURIES

Joseph **Vernet**

b AVIGNON, 1714; d PARIS, 1789

▲ **Port of Marseille (detail)** *This is one of a series of 15 views of French seaports, commissioned by Louis XV.* 1754, oil on canvas, 65 x 103½in, Musée de la Marine, Paris, France

Vernet formed his style during a long stay in Italy (1734–1753), where he made his name as a marine painter. He produced two very different types of seascape: bustling harbor scenes, bathed in soft light, and action-packed images of storms and shipwrecks. Both were equally popular, bringing him a number of royal commissions. Vernet became the head of a proud artistic dynasty. His son (Carle, 1758–1836) and his grandson (Horace, 1789–1863) both became distinguished painters.

Hubert **Robert**

b PARIS, 1733; d PARIS, 1808

Robert learned his craft in Italy, where he developed a taste for painting lush, overgrown gardens, landscapes, and city views. His most distinctive creation was the "anticipated ruin"—a modern building imagined in a future state of decay. In later life, he proved an able administrator, becoming keeper of the king's pictures. Robert enjoyed a long and successful career, though he was imprisoned during the French Revolution (he is said to have escaped the guillotine when another man of the same name was mistakenly executed in his place).

▼ **Architectural Capriccio with Obelisk** *Robert became so fond of this type of subject that it earned him the nickname "Robert des Ruines."* 1768, oil on canvas, 47¾ x 54¾in, Bowes Museum, Barnard Castle, County Durham, UK

Jean-Baptiste **Perronneau**

b PARIS, c1715; d AMSTERDAM, 1783

Perronneau is one of the leading portraitists of his day, at home working in oils or pastels. His approach was less vivacious than that of his chief rival—Maurice-Quentin de La Tour (1704–88)—but his sober, reflective style and his attention to detail won him many admirers. He was well traveled, visiting England, Netherlands, Italy, Poland, and Russia. He was a prolific artist, and his work is well represented in many galleries in France and elsewhere.

▲ **Portrait of Jean-Baptiste Oudry**
Perronneau shows Oudry—a painter who specialized in still lifes and hunting scenes—richly attired, and bearing the tools of his trade. c1753, oil on canvas, 51½ x 41¼in, Louvre, Paris, France

Jean-Antoine **Houdon**

b VERSAILLES, 1741; d PARIS, 1828

Best remembered for his vivid portraits, Houdon was also a versatile sculptor. He trained under Michel-Ange Slodtz and Jean-Baptiste Pigalle, before completing his studies in Rome. Initially, he made his mark with a series of sensual, mythological figures in the Rococo manner, but he was increasingly in demand as a portraitist. Here, Houdon's approach was direct and unadorned, ignoring the trend for depicting statesmen in classical garb. Houdon portrayed some of the greatest figures of his day, Americans as well as Frenchmen, but he fell out of favor during the French Revolution. In spite of a commission from Napoleon, he produced little of note after 1800.

Portrait by
Louis-Léopold
Boilly

LIFEline

1741 Born in Versailles
1764–68 Studies in Italy
1767 Gains recognition with his *Écorché* figure
1778 Makes studies of Voltaire
1785 Travels to America, to make portrait of Washington
1806 Produces a bust of Napoleon
1828 Dies in Paris

▶ **Winter** *This is one of a pair of statues showing Winter and Summer. In true Rococo fashion, Houdon chose to portray the seasons as young nymphs.* 1783, marble, height 57in, Musée Fabre, Montpellier, France

◀ **Voltaire** *Houdon produced several portraits of the philosopher Voltaire—this is the most famous of them. Begun shortly before the old man's death in 1778, it shows him looking out at the world with a quizzical glance that has been interpreted as "the smile of reason."* 1778–81, marble, height 65in, Comédie Française, Paris, France

CLOSERlook

SHIVERING GIRL Traditionally, the figure of Winter was represented by an old man or woman, warming themselves by a fire. Houdon's decision to opt for a more erotic image was very much in keeping with contemporary taste.

▲ **George Washington**
This is a bronze replica of Houdon's original marble statue in Richmond, Virginia. Houdon travelled to the US to study George Washington in person. 1788, bronze, height 6ft 2½in, Trafalgar Square, London, UK

▶ **L'Écorché (Flayed Body)**
This anatomical figure was one of Houdon's early masterpieces. Casts of it were used in many art academies. 1767, bronze, École des Beaux-Arts, Paris, France

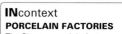

INcontext
PORCELAIN FACTORIES
The Sèvres porcelain factory was established in 1738 and was France's answer to the dominance of Meissen in Germany. It was promoted by Louis XV's mistress, Madame de Pompadour, who enlisted the help of two of her favorite artists—Falconet, who became director of sculpture, and Boucher, who provided many designs.

The Education of Love *by Étienne-Maurice Falconet, after François Boucher (1763), Sèvres porcelain.*

Étienne-Maurice **Falconet**

b **PARIS, 1716;** d **PARIS, 1791**

Falconet came from humble origins and was initially apprenticed to a carpenter, before Lemoyne took him on as a pupil. He made his mark in the 1750s when his delightful figures of nymphs and cupids proved a hit at the Salon. They also impressed two of the royal mistresses, Madame du Barry and Madame de Pompadour (see p.245), and it was through the latter's influence that Falconet gained his directorship at the Sèvres porcelain works.

Portrait by Marie-Anne Collot

He found even greater success in Russia, with his daring portrayal of Peter the Great. Newly weds still visit this, to be "blessed" by the horseman's outstretched arm. Falconet's cantankerous manner won him few friends, but his writings on art were admired, and he was ahead of his time in condemning "the blind adulation of everything that is ancient."

LIFEline

1716 Born into a poor family, in Paris

1757 His *Bather* is warmly received at the Salon

1757–66 Director of sculpture at the Sèvres factory

1766 Catherine the Great invites him to Russia

1778 Returns to Paris

1782 His statue of Peter the Great is finally unveiled

1783 Suffers a stroke

1791 Dies in Paris

▶ **The Bather** *Exhibited to great acclaim at the Salon of 1757, this was Falconet's most popular work, and it was reproduced in a variety of different sizes and materials.* 1757, marble, 32 x 10¼in, Louvre, Paris, France

▲ **Peter the Great** *This majestic equestrian portrait was Falconet's most important commission during his 12-year stay in Russia, though it was only unveiled after his return to France.* 1782, bronze, triple life-size, St Petersburg, Russia

CLOSERlook

MODESTY As she steps forward gingerly to test the water, the bather's modest pose is typically Rococo. Her appearance is graceful and erotic, but without a hint of vulgarity—a combination that proved extremely popular with the aristocratic patrons of the period.

> 66 I love **simple ideas**, they often say more than **complicated or far-fetched ones** 99
>
> ÉTIENNE-MAURICE FALCONET

Jean-Baptiste **Pigalle**

b **PARIS, 1714;** d **PARIS, 1785**

Pigalle was the most versatile sculptor of his time, equally capable of producing light-hearted Rococo masterpieces and grandiose tomb sculpture. Even so, his early career was a struggle. After training with Jean-Baptiste Lemoyne, Pigalle failed to win the *Prix de Rome* and endured considerable hardship in financing his studies in Italy.

But all these efforts proved worthwhile when his figure of *Mercury* eventually brought him success. The sculpture of the young deity—seated on a cloud, twisting round to tie up his winged sandals—was a triumph. Early versions in plaster and terracotta won Pigalle his membership of the Académie Royale, and Louis XV was so impressed that he commissioned a marble version, which he presented to Frederick II of Prussia. Having made his reputation, Pigalle received a string of important commissions. These ranged from the imposing tomb of Maurice of Saxony, with its majestic allegorical figures, to his dazzlingly original portrait of the philosopher and playwright Voltaire.

LIFEline

1714 Born in Paris, the son of a carpenter

1736–39 Studies in Rome

1744 Statue of *Mercury* wins him membership of the Académie Royale

1750–58 Under patronage of Madame de Pompadour

1753 Designs the tomb of Maurice of Saxony

1776 Completes his striking nude portrait of Voltaire

1785 Dies in Paris

▶ **Voltaire** *Pigalle worked on the head and body separately, using a professional model for the latter. Voltaire was unsure at first, but applauded the result.* 1776, marble, height 59in, Louvre, Paris, France

▲ **Mercury Attaching his Winged Sandals** *Pigalle's figure was partly inspired by a famous classical statue, the* Belvedere Torso. 1744, marble, height 22¾in, Louvre, Paris, France

Guillaume **Coustou**

b **LYONS, 1677;** d **PARIS, 1746**

A leading French sculptor, Coustou developed his style in Rome, where he became a great admirer of Bernini's work. His supreme achievement was the *Marly Horses*, in which the violent movement of the animals was balanced by the confident athleticism of their grooms. Unusually, the statues were not linked with any specific myth or allegory. Their classical pedigree is clear, however, as they were partly inspired by the sculptures of the *Dioscuri* in Rome.

▲ **Marly Horse** *One of a pair of statues, also known as* The Horse Tamers, *commissioned by Louis XV for his château at Marly.* 1739–45, marble, Place de la Concorde, Paris, France

Johann Baptist **Zimmermann**

b **WESSOBRUNN, c1679/80; d MUNICH, 1758**

This German painter and stuccoer came from an area that had a strong tradition in stucco decoration and was trained by Johann Schmutzer, a specialist in the field. Zimmermann's younger brother, Dominikus (1685–1766), became a celebrated architect and the pair occasionally collaborated on projects. Their outstanding ventures were at the pilgrimage churches of Steinhausen and Die Wies, where the architecture, frescoes, and stucco decoration blended perfectly into a single, harmonious design. Zimmermann also worked for secular patrons and eventually became court painter in Munich. As in his religious commissions, his work displayed an exquisite delicacy and lightness of touch.

LIFEline

1679/80 Born in Wessobrunn
1685 Birth of his brother Dominikus, who will later become his chief collaborator
1701 Receives his first significant commission, from a church at Gosseltshausen
1706 Count of Maxlrain becomes his first major patron
c1706 Marries Elisabeth Ostermayr, a chambermaid
1727–33 Collaborates with Dominikus at Steinhausen
1734–39 Produces his finest stucco decorations for the Amalienburg hunting lodge
1746–54 Works with his brother on the church at Die Wies, their masterpiece
1758 Dies in Munich

▶ **The Last Judgement** *The pilgrimage church at Die Wies, a collaboration between the Zimmermann brothers, is arguably the most spectacular of all Rococo churches. UNESCO granted it World Heritage status in 1983.* 1746–54, ceiling fresco, Wieskirche, Die Wies, Germany

Johann Michael **Rottmayr**

b **LAUFEN, NEAR SALZBURG, 1654; d VIENNA, 1730**

The Austrian artist Rottmayr may have received his initial training from his mother, who was also a painter. However, his main studies took place in Venice, in the workshop of Johann Carl Loth, where he worked as his assistant for several years. Later, he formed a fruitful partnership with the architect Johann Fischer von Erlach, providing the decorations for many of his buildings. Rottmayr specialized in frescoes characterized by large, powerful figures and a robust sense of movement.

LIFEline

1654 Born at Laufen
1675–87 Works in Venice with Johann Carl Loth
1688 Moves to Salzburg, working for the prince-bishop
1695 Collaborates with Fischer Von Erlach at Frain Castle in Moravia
c1696 Settles in Vienna
1716–22 Carries out decorations at Melk Abbey
1725–29 Paints the fresco in the Karlskirche, Vienna
1730 Dies in Vienna

▼ **Hercules slaying the Hydra** *Hercules dispatches the many-headed snake with his club, while nearby Minerva rides in her chariot.* 1716–22, ceiling fresco, Melk Abbey, Melk, Austria

Paul **Troger**

b **ZELL UNTER WELSBERG, 1698; d VIENNA, 1762**

Troger was a leading Austrian painter in the period of transition from the Baroque to the Rococo style. He studied in Italy for almost a decade, learning much from the work of Piazzetta, Pittoni, and Ricci. On his return to Austria, Troger gained a series of important fresco commissions, notably at Altenburg Abbey and Göttweig Monastery. These frescoes are characterized by intense coloring and a dramatic sense of movement. Later in his career, Troger taught at the Vienna Academy, where he was influential on the next generation.

LIFEline

1698 Born in the South Tyrol
early 1720s Travels in Italy
1733–34 Paints frescoes in Altenburg Abbey
1739 Produces decorations for Göttweig Monastery
1750s Becomes professor and later director of the Vienna Academy
1762 Dies in Vienna

▲ **The Apotheosis of the Emperor Charles VI**
Troger's detailed study for a ceiling fresco, carried out at Göttweig Monastery in Austria. c1739, oil on canvas, 28¾x 35¾in, private collection

Ignaz **Günther**

b **ALTMANNSTEIN, 1725;** d **MUNICH, 1775**

The outstanding woodcarver of his age, Günther began his training in his father's workshop and completed it at the Vienna Academy. In his carvings of saints and biblical scenes, he displayed a mix of Rococo elegance and religious fervor, which won him many commissions throughout Germany. Günther's greatest achievement was probably the church of Rott-am-Inn, where he provided many of the furnishings. His most famous individual piece, however, was the elongated figure of the guardian angel leading Tobias by the hand, produced for the Bürgersaalkirche in Munich.

LIFEline

1725 Born in Bavaria
1754 Settles in Munich
1757 Marries Maria Hollmayr
1759–62 Works on his masterpiece, the decoration of the church in Rott-am-Inn
1763 Carves *Tobias and the Angel*
1764 Produces sculptures for collegiate church of Weyarn
1775 Dies in Munich

CLOSERlook

CALM NOBILITY In this impressive sculpture, Günther's obvious talent for portraying religious intensity is almost overshadowed by his taste for depicting intricate, wind-blown drapery.

◄ **Saint Peter** *This elaborate carving was produced for the high altar of a monastic church.* 1756, limewood, Church of St Peter and St Paul, Freising, Germany

Johann Joachim **Kändler**

b **FISCHBACH, 1706;** d **MEISSEN, 1775**

Kändler was working as a sculptor in the service of Frederick Augustus, Elector of Saxony, when he was transferred to the new porcelain works at Meissen. For centuries, the Chinese had guarded the secret of porcelain manufacture, but in 1709 the Germans finally learned the process. The Meissen factory was founded in the following year and, under Kändler's guidance, it became the leading porcelain center in Europe. He transferred popular themes from Rococo painting into three-dimensional form, designing Watteau-inspired figurines, charming animal models, and pastoral scenes.

LIFEline

1706 Born in Fischbach
1730 Becomes court sculptor to the Elector of Saxony
1731 Begins work at the porcelain factory at Meissen
1733 Becomes chief modeler at the factory, a post he holds until his death
1737–41 Works on the 2,200-piece Swan Service
1775 Dies in Meissen

◄ **Meissen Figure of a Poultry Seller** *Kändler designed a range of tradesmen figures for the factory, including a saddler, a woodcutter, and a goat seller.* c1750, porcelain, Clandon Park, Surrey, UK

Franz Anton **Maulbertsch**

b **LANGENARGEN, c1724;** d **VIENNA, 1796**

The leading Austrian painter of his age, Maulbertsch is renowned for both his altarpieces and his monumental frescoes. After receiving some training from his father, who was also a painter, he studied at the Vienna Academy. Early influences came from Andrea Pozzo and Paul Troger, but Maulbertsch rapidly developed his own virtuoso style. His first major fresco commission came from the Piarists' church in Vienna, but Maulbertsch's talents were soon in demand at religious establishments throughout central Europe. The decorative schemes at Sümeg in Hungary, at the archbishop's palace at Kremsier, in Moravia, and at the Hofburg in Innsbruck are fine examples of his style.

Maulbertsch was a dazzling colorist with a lively approach to composition. This is particularly apparent in his oil sketches, now prized almost as much as his large-scale works, and is seen to outstanding effect in his dashing portrayal of St. James, appearing triumphantly at the Battle of Clavijo.

LIFEline

1724 Born son of a painter
1741 Enrolls at the Vienna Academy
1757–58 Decorates Sümeg church in Hungary
1770 Becomes professor at the Vienna Academy
1775 Works on frescoes at the Hofburg in Innsbruck
1796 Dies in Vienna

► **Presentation in the Temple** *This is a dazzling example of Maulbertsch's illusionistic skills. The central episode, where St. Simeon holds out the infant Christ to the Virgin, is viewed at eye level, while the swirling host of angels is seen from below.* Oil on canvas, Stiftsmuseum, Klosterneuburg, Austria

► **Apotheosis of St. James the Greater** *Here St. James tramples the Saracens underfoot.* Oil on canvas, Österreichische Galerie Belvedere, Vienna, Austria

Giacomo **Serpotta**

b PALERMO, 1656; d PALERMO, 1732

Working in his native Sicily, Serpotta took Rococo sculpture to its most decorative extremes. His favorite medium was stucco, which he employed in a series of high-relief sculptures in various churches around the island. Serpotta concentrated mainly on religious subjects, but this did not deter him from producing figures of extraordinary delicacy and charm. His compositions were equally ornate. In its traditional format, the presentation of the infant Christ in the Temple could be a very modest theme, with just four or five figures, but Serpotta transformed it into a bustling crowd scene. *Putti* (cherubs) swarm around the biblical figures, sitting on the hems of their robes, materializing between pillars, or simply gazing in wonder at the miraculous child.

▲ **Presentation in the Temple** *This illustrates Simeon holding the infant Christ, who is being presented in the temple, according to Jewish ritual (Luke 2:22–39).* 1695, stucco, Church of Santo Spirito, Agrigento, Italy

Giovanni Paolo **Panini**

b PIACENZA, 1691; d ROME, 1765

Panini trained initially as a stage designer, but he found fame with his colorful views of Roman ruins. These proved extremely popular with French and English tourists, even though the artist took many liberties with the topographical accuracy of his scenes. Most of his pictures conjured up ancient Rome, although he also portrayed modern festivities and processions. Panini maintained a large workshop to keep pace with the demand for his paintings. He also found time to teach at the French Academy in Rome, and to paint a number of decorative frescoes in local palaces and villas.

LIFEline

1691 Born in Piacenza
1711 Settles in Rome
1719 Elected to the Accademia di San Luca
1724 Marries Catherine Gosset, the sister-in-law of the painter Vleughels
1732 Becomes a member of the French Academy in Rome
1738 Birth of his son Francesco, who later becomes an artist
1765 Dies in Rome, aged 74

◄ **Roman Ruins with Blind Belisarius** *Panini often spiced up his views of Rome by including figures from the Classical world.* Oil on canvas, 56 x 52in, Temple Newsam House, Leeds, UK

Giovanni Battista **Piranesi**

Portrait by Francesco Polanzani

b MOGLIANO, NEAR VENICE, 1720; d ROME, 1778

The son of a stonemason and master builder, Piranesi trained as an architect in the workshop of his uncle, Matteo Lucchesi, in Venice. He also studied with Carlo Zucchi, learning the techniques of printmaking and perspective. Armed with these skills, Piranesi moved to Rome in 1740, where he was employed by the Venetian ambassador. Shortly after his arrival, he also worked for the Valeriani brothers, who were known for their stage designs and paintings of ruins. This very varied training would stand Piranesi in good stead in his later career.

In Rome, his principal source of income came from his prints of the city's splendors, aimed at connoisseurs on the Grand Tour. With his architect's eye, he portrayed the antiquities with precision and a captivating sense of grandeur. Piranesi also tackled the popular theme of the *capriccio* (fantasy), in his *Imaginary Prisons* series. These extraordinary etchings, part stage set and part grotesque fantasy, have proved to be one of his most lasting achievements.

LIFEline

1720 Born near Venice, the son of a master builder
1740 Settles in Rome, where he spends most of his career
1745 First edition of his *Vedute* (views) of Rome is published
1761 Publication of his *Imaginary Prisons*
1764–66 Rebuilds the church of S. Maria del Priorato, Rome, his only work as an architect
1770 First visit to Pompeii
1778 Dies in Rome

❝ I drew **chasms**, and subterranean hollows, the domain of **fear and torture**, with chains, racks, wheels and **dreadful engines** in the style of Piranesi ❞

WILLIAM BECKFORD, 1786 AUTHOR, EXPLAINING HOW *IMAGINARY PRISONS* INFLUENCED HIS GOTHIC NOVEL, *VATHEK*

◄ **The Well** *This is one of the nightmarish visions from Piranesi's famous* Imaginary Prisons. 1761, etching, 15¾ x 21¾in, Calcographia dello Stato, Rome, Italy

▲ **The Colosseum** *From Piranesi's* Antiquities of Rome. 1756, etching, 5⅛ x 10⅝in, Central Saint Martins College of Art and Design, London, UK

Pompeo **Batoni**

Self-portrait

b LUCCA, 1708; d ROME, 1787

After receiving some training in his father's goldsmith's workshop in Lucca, Batoni moved to Rome and studied under Sebastiano Conca. Initially, he made his name with highly finished drawings of ancient statuary, then as a painter of religious and mythological subjects, though he was never more than competent in this field, and his style was a pale imitation of Raphael's. Batoni's real strength lay in painting portraits, and from around 1750 this became his speciality.

Over the years, Batoni painted popes, princes, and rulers, but the majority of his clients were British aristocrats undertaking the Grand Tour. These portraits were supremely elegant, if a little formulaic. Usually, the sitters were shown posing alongside a famous Roman landmark or sculpture. The same backgrounds appeared again and again, but this scarcely mattered. Batoni was successful enough at this work to support a family of 12 children and to own a large house with exhibition rooms and a studio. In later life, he became the curator of the papal art collections.

LIFEline

1708 Born in Lucca, the son of a goldsmith

1727 Settles in Rome

1741 Becomes a member of the Accademia di San Luca

c1750 onwards Specializes in portraiture

1761 His chief rival, Mengs, departs for Spain

1774 Produces one of his finest portraits, *Thomas William Coke*

1787 Dies in Rome, one of the most famous artists in Europe

▶ **Achilles at the Court of Lycomedes** *Here, Achilles is disguised as a woman, but his identity is revealed when he chooses a sword as a gift, rather than jewelry.* 1746, oil on canvas, 62½ x 50in, Uffizi, Florence, Italy

CLOSERlook

HIGHLAND DRESS The wearing of traditional Scottish highland dress was a political statement at this time. Tartan was outlawed in the wake of the Jacobite uprising of 1745–46, so this portrait could not legally have been painted in Gordon's homeland.

▲ **William Gordon of Fyvie** *The highlander poses against a backdrop of the Colosseum. The fragments in the bottom right-hand corner reappear in the Coke portrait (above).* 1766, oil on canvas, Fyvie Castle, Aberdeenshire

▼ **Thomas William Coke** *The inscription suggests that this picture was ordered by the Countess of Albany, who was said to be in love with Coke. Her features appear on the reclining statue, which seems to gaze adoringly at the young nobleman.* 1774, oil on canvas, 95 x 66in, Holkham Hall, Norfolk, UK

INcontext

THE GRAND TOUR In the 18th century, many young European aristocrats undertook a "Grand Tour" of the continent as part of their education. Rome was the highlight of the tour, and many brought back works of art as a souvenir of their stay. This aided the spread of Neoclassical ideas.

Interior of St. Peter's, Rome *by Giovanni Paolo Panini.*

Giambattista **Tiepolo**

b VENICE, 1696; d MADRID, 1770

Tiepolo was the finest Italian artist of the Rococo era and the last great master of his country's fresco tradition. He was apprenticed to Gregorio Lazzarini, a minor history painter, but learned far more from the examples of Piazzetta and Veronese. Tiepolo's first major commission came from the Dolfin family, who hired him to paint the frescoes in the Archbishop's Palace in Udine. This work helped him to secure a string of other fresco commissions, although he never restricted himself to this field, as his powerful canvases for the church of S. Alvise in Venice confirm.

Tiepolo's great skill lay in his ability to depict huge, illusionistic scenes with immense verve and imagination. This is best seen in his masterpiece, the decorations of the Residenz (palace) in Würzburg.

Portrait by Giuseppe Ghislandi

LIFEline

1696 Born in Venice, the son of a shipping merchant
1719 Marries Cecilia Guardi
1728 Completes his first major fresco cycle at Udine
c1740 Paints his finest religious pictures for the church of S. Alvise, Venice
1750 Begins work on his masterpiece, at the Residenz in Würzburg
1762 Moves to Madrid, to work in the royal palace
1770 Dies in Madrid

CLOSERlook

IMPERIAL SPLENDOUR
In Tiepolo's hands, an obscure historical event—the marriage of the 12th-century German ruler Frederick Barbarossa to Beatrice of Burgundy—is given mythic status. Beatrice is transported to her groom in Apollo's mighty horse-drawn chariot, with the emblems of love—cupids and doves—swarming around her.

► **The Road to Calvary** *In this moving biblical scene, Christ has collapsed under the weight of the cross. On the left, the two thieves look on with brute compassion while, opposite them, St. Veronica holds her veil, on which Christ's features were miraculously imprinted when she wiped the sweat from his face.* c1740, oil on canvas, 14ft 9in x17ft, S. Alvise, Venice, Italy

▼ **Apollo Conducting Beatrice of Burgundy to Frederick Barbarossa (detail)** *This grandiose allegorical vision is part of Tiepolo's most important cycle of decorations, produced for the Kaisersaal (Imperial Hall) of the palace of Würzburg's powerful prince-bishop.* 1751, ceiling fresco, approx 29ft 6in x 59ft, Residenz, Würzburg, Germany

▲ **Neptune Offering Gifts to Venice** *This magnificent allegory, commissioned by the Venetian Republic, emphasized the city's commercial and maritime power.* c1745–50, oil on canvas, 53¼ x 108in, Palazzo Ducale, Venice, Italy

◄ **Young Woman with a Parrot** *In this fine example of Tiepolo's portraiture, the woman was probably meant to be an allegorical figure representing summer. The model may have been one of his daughters.* c1758–60, oil on canvas, 27½ x 20½in, Ashmolean, Oxford, UK

❝ Tiepolo has been made expressly for us…he is **full of spirit**…of an **infinite fire**, an **astonishing coloring**, and an **amazing speed**. He **paints a picture** in less time than it takes another to **grind his colors** ❞

COUNT TESSIN TO THE KING OF SWEDEN, WHO TRIED TO SECURE TIEPOLO'S SERVICES

Canaletto (Giovanni Antonio Canal)

Portrait by
Giambattista
Piazetta

b VENICE, 1697; d VENICE, 1768

Canaletto is renowned, above all, for his superlative views of the city of Venice. He was trained by his father, a theatrical scene painter, and spent the initial years of his career assisting him on sets for Scarlatti and Vivaldi operas. By the early 1720s, Canaletto had turned his attention to topographical views. Venice itself could be compared to a gigantic stage set, and he spared no effort in capturing its drama and spectacle.

From the outset, his chief clients were English aristocrats, visiting the city as part of their Grand Tour. Canaletto geared his pictures specifically toward these buyers, providing them with exquisite souvenirs of their stay. He painted the obvious tourist sights, such as St. Mark's Square and the Grand Canal, as well as the most colorful festivals—the carnival, the regatta, the Ascension Day celebrations. Accuracy and detail were strong selling points, so Canaletto made them the basis of his style. He is thought to have used a *camera obscura* (see p.239) as a drawing aid, but he also made countless sketches of the city, to ensure his work remained fresh.

In the 1740s, the War of the Austrian Succession had a drastic effect on tourism in Venice, so Canaletto decided to pursue his career in England. His approach remained remarkably similar, particularly in his scenes of the Thames River. Increasingly though, his style was criticized for being too mechanical and there were even rumors that he was an impostor. Canaletto himself never regained his former popularity, but his pictures were still widely imitated.

LIFEline

1697 Born in Venice, the son of a theatrical scene painter

1719 Travels to Rome to design opera sets

c1727 Paints *The Stonemason's Yard*

1735 Engravings of his work appear in the *Prospectus Magni Canalis Venetiarum*

1740–48 The War of the Austrian Succession affects his business

1744 Canaletto's agent, Joseph Smith, becomes British Consul in Venice

1746 Decides to work in England

1755 Returns to Venice

1762 Joseph Smith sells his art collection to George III

1763 Canaletto is elected to the Venetian Academy

1768 Dies in Venice; is buried in the church of S. Lio

▼ **Bacino di San Marco** *Canaletto exaggerated when necessary. Here, he used two different viewpoints in order to make this panorama as spectacular as possible.* c1735, oil on canvas, 49¼ x 80¾in, Museum of Fine Arts, Boston, US

▲ **The Stonemason's Yard** *In this unusual picture, Canaletto presents a charming scene of everyday life in Venice: a mother runs to her fallen child, while another woman draws water from a well.* c1727, oil on canvas, 48¾ x 64¼in, National Gallery, London, UK

" The **Famous Painter of Views**, Canaletto of **Venice**, has procured a great reputation and his great **merit and excellence** in that way... is **much esteemed** "

GEORGE VERTUE, 1746,
ENGRAVER AND ANTIQUARY

▼ **Return of the Bucintoro on Ascension Day** *Here, the Doge in his* Bucintoro *(state barge) casts a ring into the sea, symbolizing the city's "marriage" with the sea.* c1730, oil on canvas, 71¾ x 102in, Aldo Crespi Collection, Milan, Italy

Francesco **Guardi**

b **VENICE, 1712;** d **VENICE, 1793**

The principal member of a family of painters, Guardi is best remembered for his views of Venice. These were often based on Canaletto's pictures, although Guardi's approach was very different. His style was sketchy and spontaneous, but his best works have a shimmering, atmospheric quality. This did not prove popular with tourists, who preferred the sharper detail and greater accuracy of Canaletto. As a result, Guardi gained little recognition and died in poverty, although he was later fêted by the Impressionists. Guardi also specialized in the *capriccio* (caprice). His versions usually took the form of an imaginary landscape, featuring invented ruins picturesquely covered in creepers. Guardi's sister married the artist Tiepolo, while his son, Giacomo, also became a painter.

Portrait by
Pietro Longhi

▼ **Venice: Piazza San Marco (detail)** *In his views, Guardi placed far more emphasis on the figures than Canaletto did.* c1760, oil on canvas, 28¼ x 46¾in, National Gallery, London, UK

▲ **Caprice with Ruins** *Guardi created a series of paintings of imaginary ruins, inspired by excavations on the islands in the Venetian lagoon.* c1775–80, oil on canvas, Victoria and Albert Museum, London, UK

◄ **Westminster Bridge with the Lord Mayor's Procession** *In London, Canaletto reproduced the formula that had been so successful in his native city. Here, the most topical feature is Westminster Bridge, which was under construction at the time of the painting and was only opened in 1750.* 1746, oil on canvas, 37¾ x 54¼in, Yale Center for British Art, New Haven, Connecticut, US

Bernardo **Bellotto**

b **VENICE, 1721;** d **WARSAW, 1780**

Bellotto was Canaletto's nephew, and joined him as a pupil and later as a member of his workshop. Not surprisingly, his early work was strongly influenced by the master, and some of his Venetian scenes have been mistaken for Canalettos. This confusion may well have been intentional, as he often used his uncle's name. Bellotto only worked in Venice for a limited time, however, spending most of his career in Dresden, Vienna, and Warsaw. Here, he worked mainly for royal patrons, rather than tourists, and his mature style is marked by a fine attention to detail. Indeed, his scenes of Warsaw are so accurate that they were used during the reconstruction of the city following World War II.

CLOSERlook

PROCESSION The larger barges belong to the various city guilds. Canaletto enhanced the spectacle by adding a flotilla of smaller boats.

WESTMINSTER The twin towers are those of Westminster Abbey. To the left is Westminster Hall, where the new Lord Mayor will be sworn in.

▲ **Entrance to the Grand Canal, Venice** *This is almost identical to one of Canaletto's views.* c1745, oil on canvas, 23¼ x 37½in, Fitzwilliam Museum, Cambridge, UK

William **Hogarth**

Self-portrait

b **LONDON, 1697**; d **LONDON, 1764**

Pugnacious, patriotic, satirical, and humane, Hogarth was the outstanding British artist of his day. He devoted his life to raising the status of British artists. An innovative engraver, he was also a gifted portrait painter. But it is as the inventor of a new art form—a series of paintings on "modern moral subjects"—that he is best remembered.

Hogarth began his career as a silver-plate engraver. In 1720, he set up in business in London while studying painting in his spare time. He graduated from engraving shop cards to painting conversation pieces, theater pieces, and his "modern moral" series. Engraving these as prints for sale brought financial success, and Hogarth's campaign against unauthorized copying effectively invented artist's copyright.

> " Other pictures **we see**, Hogarth's **we read** "

WILLIAM HAZLITT, 1845, WRITER AND CRITIC

LIFEline

1697 Born in London
1729 Marries Jane Thornhill, daughter of painter James Thornhill
1732 Sells first "modern moral" prints: *A Harlot's Progress*
c1743–45 Paints the *Marriage à la Mode* series
1753 Publishes his art treatise, *The Analysis of Beauty*
1764 Dies in London

▶ **The Graham Children**
Despite the smiles, symbols of death (the hourglass and scythe) reflect that the baby died while the portrait was being painted. 1742, oil on canvas, 63½ x 71in, National Gallery, London, UK

◀ **Gin Lane** *Gin drinking among the poor was at its height when Hogarth created this hellish vision of the backstreets of London, as part of a campaign to support the Gin Act of 1751. The gin-soaked, snuff-taking mother is oblivious as her baby falls to its death.* 1751, etching and engraving on paper, 14⅛ x 12¼in, private collection

CLOSERlook

SIGN OF THE CUCKOLD
Numerous details in this painting reveal that the countess is having an affair. As the boy servant unpacks a basket, we see a tray depicting Leda being seduced by the swan (Jupiter in disguise), and a figure of Actaeon, whose horns can allude to a cuckold—a man whose wife commits adultery.

▶ **Marriage à la Mode: The Toilette** *This is the fourth scene of a narrative series satirizing marriages arranged for money. Here, the young countess is in her boudoir with her lover and pretentious hangers-on.* c1743–45, oil on canvas, 28 x 35¾in, National Gallery, London, UK

Richard **Wilson**

b **PENEGOES, 1713;** d **LLANBERIS, 1782**

Portrait by Anton Raphael Mengs

The son of a well-to-do Welsh clergyman, Richard Wilson began his artistic career as a portrait painter but went on to transform British landscape painting into an art form of poetic vision that could express ideas and emotions.

Following his apprenticeship to a London portrait painter, Wilson was working independently by 1735, but it was not until the 1750s during a trip to Italy that he decided to devote himself to landscape. He may have been influenced by encouragement from the Italian landscape painter Francesco Zuccarelli, but Wilson's primary inspirations seem to have been the countryside around Rome and the landscapes of the 17th-century painters Claude and Gaspard Dughet. Returning to London, Wilson was the first artist to apply this idealizing, classical tradition to English and Welsh views.

A founder member of the Royal Academy, Wilson was highly successful at his peak, but he had a difficult, abrasive personality, developing a drinking problem in later years, which led to his decline and death.

LIFEline

1713 Born in North Wales
1729 Apprenticed to Thomas Wright, portrait painter
1735 Working independently in London
1750–56 Visits Italy, working chiefly in and around Rome
c1765 Paints *Snowdon from Llyn Nantlle*
1768 Becomes a founder member of Royal Academy
1776 As an act of charity, Royal Academy appoints him librarian; by this time he is an alcoholic and impoverished
1781 Returns to Wales
1782 Dies in Wales

▼ **Snowdon from Llyn Nantlle** *This serene, classically balanced composition shows how Wilson imbued his native British landscape with an unprecedented poetic grandeur. He often painted repeats of popular (money-making) compositions: there are two versions of this celebrated work.* c1765, oil on canvas, 41 x 50in, Castle Museum, Nottingham, UK

CLOSERlook

THE CLASSICAL REPOUSSOIR This composition follows the classical convention of *repoussoir* (from the French word *repousser*, to push back). The dark shapes of the trees and reflection frame a lighter center and enhance the sense of depth.

▲ **Wilton House from the South East** *Wilson painted many impressive views of country houses, including five of Wilton House. The coloring and composition are reminiscent of the works of Claude and Dughet.* c1758–60, oil on canvas, Collection of the Earl of Pembroke, Wilton House, Salisbury, Wiltshire, UK

CLOSERlook

SKETCHING PARTY Following the tradition of classical landscape artists of the 17th century, Wilson often included small figures in his foregrounds. Here, a seated artist paints the view, watched thoughtfully by two standing companions. The silhouetted figures, lit by an aura of glowing evening light, form a picturesque group against the cloud reflections on the still lake.

Allan **Ramsay**

b **EDINBURGH, 1713;** d **DOVER, 1784**

Artist unknown

Allan Ramsay was the leading portraitist in London from about 1740 until the mid 1750s, when Joshua Reynolds began to rise to prominence. Ramsay also played a leading role in the literary and intellectual life of the time.

The son of a Scottish poet, Ramsay studied in Edinburgh, London, and Italy, before settling in London. It may have been Reynolds's rising reputation that led him to visit Italy again in 1755–57. In 1767, he became principal painter to George III, but it is for his intimate portraits, rather than those in the Grand Manner, that Ramsay is most admired. He gave up painting in 1773 after an arm injury.

▼ **Portrait of Margaret Lindsay** *This tender painting of his second wife has an elegantly French air.* c1758–60, oil on canvas, 26 x 24½in, National Galleries of Scotland, Edinburgh, UK

▲ **David Hume** *Ramsay painted this wonderfully direct portrait as a gift for Hume, an eminent Scottish philosopher and historian. They were close friends.* 1766, oil on canvas, 30 x 25in, National Galleries of Scotland, Edinburgh, UK

Animals

Some of the earliest images known are of animals, daubed on the walls of caves some 40,000 years ago. Since then, animals have been portrayed in religious rituals, as sacrifices, mythical creatures, or incarnations of gods and goddesses, symbolically in Christian art, or simply as pets. Animals began to take center stage in the 18th and 19th centuries as proud owners commissioned "portraits" of their well-bred livestock and pets. Some painters made a living specializing in hunting and racing scenes. Today, animal art is as popular as ever, even down to installations that put a contemporary spin on taxidermy.

▼ **Vision of St. Augustine (detail)** Vittore Carpaccio *The Venetian artist depicts the dog's devotion with fond realism.* 1502–08, oil on canvas, Scuola di San Giorgio degli Schiavoni, Venice, Italy

▼ **Rhinoceros** Albrecht Dürer *The master of the German Renaissance was inspired to make this woodcut after receiving a letter from a friend describing an Indian rhinoceros. Dürer had never seen an animal anything like it and took his friend's phrase "armor-plated" literally.* 1515, woodcut, 8¼ x 11¾in, private collection

▼ **St. Jerome in his Study** Attributed to Jan van Eyck *The artist reveled in detail and texture such as the lion's mane.* Early 15th century, oils, 7¾ x 5¼in, The Detroit Institute of Arts, Detroit, US

▼ **Rock Painting of Bison** Prehistoric *Although these two bison are rubbing haunches, they may have been painted hundreds of years apart. It is still unclear why prehistoric people covered cave walls with animal paintings like these.* c14,000 BCE, Lascaux, Périgord, France

▲ **Gilt-bronze Sea Dragon** Chinese, artist unknown *Chinese dragons are depicted as snake-like creatures with four claws and are a symbol of auspicious power controlling the element of water.* Six Dynasties period (295–589 CE), private collection

▲ **St. George and the Dragon** Paolo Uccello *This Florentine artist started in the courtly International Gothic style, elegantly elongating the princess and embellishing the dragon with butterfly-like spots on its wings—and a lead. Uccello later became obsessed with perspective and realism.* c1470, oil on canvas, 23¼ x 29¾in, National Gallery, London, UK

▲ **Turkey** Mughal Empire *Under the art-loving Emperor Akbar, a vigorous, naturalistic style developed.* Mid-17th century, watercolor, 8¼ x 5½in, Fitzwilliam Museum, Cambridge, UK

▲ **Kublai Khan Hunting (detail)** Attributed to Liu Kuan-tao *The founder of the Mongol dynasty in China and his followers spot their prey, intriguingly not revealed to the viewer.* c1270–1300, Yuan Dynasty, ink and color on silk, National Palace Museum, Taipei, Taiwan

▼ **Whistlejacket** George Stubbs *The English artist specialized in painting horses. This thoroughbred, the product of recent knowledge on breeding horses, merits a portrait huge enough for a human subject.* 1762, oil on canvas, 115 x 97in, National Gallery, London, UK

▼ **The Parade** or **Race Horses in front of the Stands** Edgar Degas *The races gave Degas the chance to experiment with unusual cropping and composition, as if he were taking a candid snapshot.* c1866–68, oil on paper, 18¼ x 24in, Musée d'Orsay, Paris, France

◀ **Tiger** Franz Marc *The German Expressionist considered animals to be on a higher plane. He used simplified shapes and symbolic color to express their "animalness."* 1912, oil on canvas, 43¾ x 44¼in, Stadtische Galerie im Lenbachhaus, Munich, Germany

▼ **The Physical Impossibility of Death in the Mind of Someone Living** Damien Hirst *The controversial artist's most famous work— a shark floating in a tank—reflects his fascination with death.* 1991, glass, steel, silicone, shark, and formaldehyde, 84 x 252 x 84in, Saatchi Gallery, London, UK

▲ **Tiger Attacking a Wild Horse** Eugène Delacroix *French Romantic Delacroix painted horses with wild Byronic vitality. Sweeping brush marks capture the horse's fear and agony in the face of certain death.* c1826–29, pen and ink and watercolor, 17¼ x 9¾in, Louvre, Paris, France

▲ **Monarch of the Glen** Sir Edwin Landseer *Queen Victoria's favouite painter appealed to the Victorians for his sentimental humanizing of animal subjects —the very reason that caused his reputation to decline in the 20th century.* 1851, oil on canvas, 65 x 67in, United Distillers and Vintners, Fife, UK

▲ **Tiger in a Tropical Storm (Surprised!)** Henri Rousseau *The artist's childlike style and vivid color palette peaked in his "jungle" scenes of exotic animals.* 1891, oil on canvas, 51 x 64in, National Gallery, London, UK

▲ **Joe's Black Dog** Marjorie Weiss *The contemporary American artist shows a giant dog dwarfing the landscape. The low viewpoint makes it seem even larger.* 2000, acrylic on canvas, 29¾ x 29¾in, private collection

Joshua **Reynolds**

Self-portrait

b **PLYMPTON, DEVON, 1723**; d **LONDON, 1792**

The most distinguished portraitist of his day, a learned art theorist, and the first president of the Royal Academy, Reynolds did more than anyone else in history to elevate the status of British art and artists.

The son of a headmaster and clergyman, he was apprenticed at the age of 17 to Thomas Hudson in London. After some years painting in Devon and London, in 1750–52 Reynolds visited Italy, where he made a profound study of classical and Renaissance art. Returning to London, he set out to raise the status of portraiture from lowly "face painting" to the level of history painting, by making reference to the great art of the past. He was phenomenally successful and productive, but so versatile and inventive that he rarely repeated himself. His *Discourses on Art*— lectures delivered between 1769 and 1790 at the Royal Academy— are the classic exposition of the academic ideal of the Grand Manner.

◀ **Mrs Siddons as the Tragic Muse** *The greatest tragic actress of her day is shown in the guise of Melpomene, the muse of Tragedy. Her pose echoes one of the prophets from the Sistine Chapel, painted by Michelangelo.* 1789, oil on canvas, 94½ x 58in, Dulwich Picture Gallery, London, UK

❝ Damn him, **how various** he is! ❞

THOMAS GAINSBOROUGH

▼ **Henry, Eighth Lord Arundell of Wardour**
In this grand portrait, Reynolds consciously makes references to past art. Lord Arundell's pose derives from classical art, while the column echoes van Dyck's portraits. c1764–67, oil on canvas, 94 x 58in, Dayton Art Institute, Ohio, US

LIFEline

1723 Born in Devon

1750–52 Visits Italy

1768 Royal Academy founded; Reynolds is its first president

1769 Delivers his first *Discourse on Art*

1789 Stops painting due to his failing eyesight

1792 Dies in London, and is buried in St. Paul's Cathedral

▶ **Georgiana, Countess of Spencer, and her Daughter**
This lovely preliminary sketch for an intimate portrait is based on a Madonna and Child format. 1759, oil on canvas, 56 x 66in, private collection

CLOSERlook

THREE GRACES With heads bent towards each other, faces shown in different views, and arms creating a linking line, the grouping evokes classical statues of the Three Graces.

▲ **The Ladies Waldegrave** *Reynolds's skill at composing portraits which reflected the sitters' characters and interests is shown in this triple portrait. Lady Charlotte and Lady Elizabeth wind silk, while Lady Anna is making lace on a tambour.* 1780, oil on canvas, 56¼ x 66⅛in, National Galleries of Scotland, Edinburgh, UK

Thomas **Gainsborough**

Self-portrait

b SUDBURY, SUFFOLK, 1727; d LONDON, 1788

Like Reynolds, Gainsborough was a giant of 18th-century British art. But where Reynolds was scholarly and diligent, Gainsborough was intuitive and impulsive. His influences included Dutch, Flemish, and French Rococo art, but he was a painter of great originality, renowned for portraits, landscapes, and sentimental "fancy pictures."

Precociously talented, Gainsborough was sent to train in London aged about 13. He worked with the French engraver Hubert Gravelot (a pupil of Boucher) and possibly Francis Hayman. His provincial portrait business in Suffolk was not lucrative, but a move to Bath in 1759 proved a turning point in his style and fortunes. Seeing the works of van Dyck inspired a new, elegant style that appealed to the fashionable and wealthy clientele of Bath, and later London. Although portrait painting was Gainsborough's livelihood, landscape remained his real love.

LIFEline

1727 Born in Sudbury

c1740 Begins his training in London

1748–59 Works in Suffolk

1759–74 Enjoys success in Bath

1768 Founder member of Royal Academy

1774 Settles in London

1784 Quarrels with the Royal Academy; exhibits privately for the rest of his life

1788 Dies after a long illness

> ❝ His cranium is so **crammed with genius** of every kind that it is in danger of **bursting** upon you, like a **steam engine** overcharged ❞
>
> DAVID GARRICK, 1824, ACTOR AND PLAYWRIGHT

▷ **The Harvest Wagon** From his boyhood, Gainsborough painted landscapes for pleasure. This is one of his finest, unified by the feathery touch of his mature style. The group on the wagon are inspired by Rubens's Descent from the Cross. c1767, oil on canvas, 47¼ x 56¾in, The Barber Institute of Fine Arts, Birmingham, UK

▽ **The Honourable Mrs. Graham** This ravishing full-length portrait shows Gainsborough's later style, which was supremely elegant and glamorous. c1775–77, oil on canvas, 93½ x 60½in, National Galleries of Scotland, Edinburgh, UK

▲ **The Painter's Daughters with a Cat** Gainsborough painted his daughters several times. Here, Mary is apparently giving Margaret a hug while surreptitiously tweaking the cat's tail. The brushwork is looser than in his early paintings, but because of its intimate nature, it remained an unfinished work that did not require the usual pristine finish. c1760–61, oil on canvas, 30 x 24¾in, National Gallery, London, UK

CLOSERlook

EMPTY LAP Gainsborough has left an area of unpainted canvas in Mrs Andrews's lap, surrounded by the delicate blue of her hooped skirt. An outline suggests he intended to fill this gap with a bird, perhaps shot by her husband, who is proudly holding a gun.

▲ **Mr. and Mrs. Andrews** With its doll-like figures, posed by artist's mannequins, and tight brushwork, this delightfully fresh masterpiece is typical of Gainsborough's early work. Although this is a portrait, the entire right half is a lovingly observed landscape. c1748–49, oil on canvas, 27½ x 47in, National Gallery, London, UK

James **Barry**

b **CORK, 1741;** d **LONDON, 1806**

A history painter on an ambitiously grand scale, Barry is best remembered for his grandiose cycle of paintings entitled *The Progress of Human Culture*. With no less an aim than to paint the history of the world, he created this enormous—and overambitious—cycle largely at his own expense. Barry was a protégé of the statesman-philosopher Edmund Burke, who financed an inspiring trip to Italy. Barry became professor of painting at the Royal Academy but was expelled for slanderous attacks on colleagues, including Reynolds. He died in poverty.

▼ **Crowning the Victors at Olympia (detail)**
This scene is taken from one of six paintings making up The Progress of Human Culture *cycle. 1777–83, oil on canvas, Royal Society of Arts, London, UK*

CLOSERlook

ANCIENT VICTOR
The ancient Greek poet Diagoras the Atheist is shown as one of the victors at Barry's imaginary Olympic Games.

Louis-François **Roubiliac**

b **LYONS, 1702;** d **LONDON, 1762**

Born in France, Roubiliac spent almost all of his career in England, where he was the greatest sculptor of his day. He may have trained in Dresden and Paris before settling in London. A full-length statue of the composer Handel established Roubiliac's reputation, but he also made his name for portrait busts, which are remarkable for their vivid sense of life, and for tomb sculptures.

Portrait by François Vispre

On a trip to Italy in 1752, Roubiliac was deeply impressed by the work of the great Baroque sculptor Bernini, whose influence can be seen in much of his subsequent work.

LIFEline

1702 Born in Lyons, France
1730 Moves to London
1738 Makes his name with a marble statue of Handel for Vauxhall Gardens, London
1745–49 Creates monument of John, Duke of Argyll, in Westminster Abbey, London
1751–57 Makes celebrated series of busts of members of Trinity College, Cambridge.
1752 Travels to Italy with the painter Thomas Hudson
1758–61 Creates the tomb of Lady Elizabeth Nightingale in Westminster Abbey, London
1762 Dies in London, in debt despite his highly successful career

▲ **George Frederick Handel** *This brilliantly observed bust of the composer has a life-like energy. Terracotta, Foundling Museum, London, UK*

▲ **Sir Isaac Newton** *Newton died almost 30 years before this sculpture was made: it is a fine example of Roubiliac's imaginative and technical ability. 1755, marble, Trinity College, Cambridge, UK*

Michael **Rysbrack**

b **ANTWERP, 1694;** d **LONDON, 1770**

Flemish-born Rysbrack was the leading sculptor in England in the 1720s and 30s, until he was outshone by Roubiliac. He was a versatile artist, his works including tombs, portraits, and architectural elements. Best known are his reclining monument to Sir Isaac Newton in Westminster Abbey and his equestrian statue of William III in Bristol.

▲ **Alexander Pope** *Rysbrack popularized two types of portrait bust in England: all'antica (referring to classical Rome) and en négligé (in contemporary costume), as in this portrait of the poet Pope. Marble, private collection*

Joseph **Wright of Derby**

b **DERBY, 1734;** d **DERBY, 1797**

One of the most original artists of the 18th century, Wright spent most of his life in his native town. After training in London with Thomas Hudson, he worked as a portraitist in Derby. In the 1760s, he began to paint extraordinarily innovative scenes with dramatic *chiaroscuro* (light and shade). He became justly famous for these "candle-lights," which often featured scientific or industrial subjects. After a trip to Italy (1773–75), Wright turned to more literary themes, but pictures of Vesuvius erupting and moonlit landscapes reveal his continued interest in the effects of light.

Self-portrait

INcontext
THE INDUSTRIAL REVOLUTION In Wright's lifetime, England changed from a rural society into a major industrial nation. Factories, mills, and cities transformed the landscape and the way of life. Derby was one of the centers of the Industrial Revolution.

Loading Coal on Cargo Ships *engraving by Thomas Bewick.*

CLOSERlook

SCIENTIST AND SHOWMAN A candle throws features and expressions into relief. With his glazed eyes, wrinkled brow, and wild hair, the lecturer looks as much magician as scientist. At the time, scientists would visit wealthy families to demonstrate the wonders of modern science.

◄ **An Experiment on a Bird in the Air Pump**
Wright's candlelit masterpiece shows the life-or-death moment when the scientist is poised, ready to let air into the pump to revive the bird. 1768, oil on canvas, 72 x 96in, National Gallery, London, UK

Henry **Raeburn**

Engraving by T. W. Knight

b **STOCKBRIDGE, 1756**; d **EDINBURGH, 1823**

Based mainly in his native Edinburgh, Raeburn was the leading Scottish portraitist of his day. His vivid portraits include many of the scientists, philosophers, and scholars of the Scottish Enlightenment. Renowned for his ability to capture the personality of his sitters, Raeburn was also admired for his free, painterly technique.

Raeburn was probably self-taught as a painter. After a two-year visit to Italy, he returned to Edinburgh where he developed his "square touch," achieved by using free brushwork without underdrawing. He contemplated moving to London in 1810, but decided against it on account of the competition from Lawrence. He remained in Edinburgh, where he was in constant demand.

LIFEline

1756 Born in Stockbridge, now a suburb of Edinburgh

1784–86 Travels to Italy via London; possibly meets Reynolds

c1798 Builds an elaborate studio, including a framing workshop and picture gallery

1822 Knighted by George IV and appointed His Majesty's Limner (painter) for Scotland

▶ **The Paterson Children** *This charming portrait has a real sense of freedom and spontaneity.* Polesden Lacey, Surrey, UK

> " He is the **last and greatest** visual representative of the **Scottish Enlightenment** "
>
> WILLIAM VAUGHAN

▶ **Sir Walter Scott** *Raeburn's painterly technique is evident in this celebrated portrait of the great Scottish poet and historical novelist. By all accounts, the two men did not hit it off.* 1822, oil on canvas, 30 x 25in, Scottish National Portrait Gallery, Edinburgh, UK

Sir Thomas **Lawrence**

Self-portrait

b **BRISTOL, 1769**; d **LONDON, 1830**

An infant prodigy, Lawrence was the most gifted and successful English portrait painter of his generation. He was almost entirely self-taught, but at the age of 18 he confidently announced that "excepting for Sir Joshua [Reynolds] for the painting of a head, I would risk my reputation with any painter in London."

With the death of Reynolds in 1792, Lawrence became the official painter to George III. He was knighted in 1815, and in 1818 the Prince Regent sent him on a tour of Europe to paint the sovereigns and statesmen involved in Napoleon's overthrow. On his return, he was made president of the Royal Academy.

Lawrence's glittering style and fluid brushwork earned him admirers throughout Europe, including the Romantics, particularly Delacroix. But his reputation declined after his death and has never fully recovered.

LIFEline

1769 Born in Bristol

1794 Member of the Royal Academy

1818–20 Goes on painting tour of Europe

1820 Becomes president of the Royal Academy

1824 Exhibits at the Paris Salon; helps found National Gallery in London

1830 Dies suddenly, leaving huge debts

▶ **Queen Charlotte** *With its dazzling brushwork, this touching portrait helped to make Lawrence's reputation. However, the royal family did not like it, perhaps because they found the bareheaded, care-worn likeness too frank.* 1789-90, oil on canvas, 94 x 58in, National Gallery, London, UK

▲ **Portrait of Princess Darya Lieven** *This glamorous drawing shows the Russian ambassador's wife, who was based in London from 1812. She was a diplomat and society hostess, and introduced the waltz to England.* c1812, pencil and chalk on canvas, 30½ x 25in, Hermitage, St Petersburg, Russia

The prefix "neo" comes from the Greek word for "new," so "Neoclassicism" means "new classicism." The style was inspired by the art of classical Greece and Rome—specifically its qualities of "noble simplicity and calm grandeur." These are the words of Johann Joachim Winckelmann (1717-68), a German scholar whose writings played an important role in spreading the ideals of Neoclassicism.

Neoclassicism was the dominant style of the late 18th and early 19th centuries. In its purest form, Neoclassical art is severe and high-minded—often linked with the fervent political ideals of the time—but it also has more intimate and decorative aspects.

Origins and influences

Neoclassicism originated in Rome, a city with unrivaled remains of ancient buildings and sculpture. Knowledge of ancient art increased greatly in the 18th century, partly because of archaeological discoveries in Rome and in Herculaneum and Pompeii, two buried cities near Naples. Thousands of artifacts were excavated, many of which were published as engravings, which were influential in spreading Neoclassical taste.

Subjects

Neoclassical artists were often inspired by Greek and Roman history, literature, and myth, but they also treated many other subjects. These included staples, such as portraits and landscapes, but also more innovative themes from the political and social events of the time. The 18th century is often loosely described as the Age of Enlightenment, in reference to the prevailing philosophical outlook, which questioned traditional beliefs and stressed the primacy of rational thought. The Neoclassical style, with its emphasis on order and clarity, was very much in tune with this spirit, and some artists—above all Jacques-Louis David—used their work as a vehicle for their moral convictions.

Neoclassicism

TIMEline

The first stirrings of Neoclassicism started to appear as early as the 1720s, but it was not until after the middle of the 18th century that the style began to represent a serious challenge to the dominance of Rococo. By the 1770s Neoclassicism was in the ascendancy and it continued to flourish well into the 19th century—in architecture and design as well as painting and sculpture.

1760-1

MENGS Parnassus

1762

STUBBS A Lion Attacking a Horse

1764

JUEL Still Life with Flowers

1784
DAVID The Oath of the Horatii

▲ **Juno and Jupiter** Gavin Hamilton *The Scottish painter Gavin Hamilton spent most of his career in Rome. He was an influential figure in the spread of Neoclassicism, mentoring British visitors to Italy and carrying out serious archaeologoical work.* Collection of the Earl of Leicester, Holkham Hall, Norfolk, UK.

Schools

Although Rome lay at the heart of Neoclassicism and continued to attract ambitious artists because of its past achievements, Italian painting of this period was comparatively undistinguished. The most momentous developments took place elsewhere, particularly in France.

French

French (and to an extent European) Neoclassical painting was dominated by Jacques-Louis David. He not only created several of the archetypal masterpieces of the style, but also exerted a powerful influence through his role as the outstanding teacher of the day. His pupils included some of the leading artists of the next generation, notably Anne-Louis Girodet, Antoine-Jean Gros, and Jean-Auguste-Dominique Ingres. In the work of Girodet and Gros, Neoclassical severity is tempered with the glamour and dash of the burgeoning Romantic movement, but Ingres is regarded as the main upholder of classical values in 19th-century painting. A more intimate side to Neoclassicism is seen in the work of Elisabeth Vigée-Lebrun. Unlike David, who supported the French Revolution, she was a royalist and left France in 1789, working successfully in several countries before returning permanently to her homeland in 1805.

Northern European

Among the other countries in which Neoclassicism flourished were several in northern Europe, including Germany and Denmark. In Denmark there was a remarkable flowering of painting in the late 18th and early 19th centuries that was part of a golden age in the country's art, expressed also in Thorvaldsen's sculpture and in some superb buildings. Danish painting of this time generally shuns the elevated tone of contemporary French art, concentrating on everyday life rather than heroic deeds. However, the clarity of form seen in the work of an artist such as Jens Juel is Neoclassical in spirit.

▲ **Portrait of a Young Woman** Elisabeth Vigée-Lebrun *The clarity of form and cool precision of the brushwork are Neoclassical in spirit, but the sheer prettiness of the work recalls the Rococo style.* c1797, oil on canvas, 32¼ x 28in, Museum of Fine Arts, Boston, US

Style and techniques

David's paintings represent Neoclassicism at its most powerful and severe, and a similar lofty tone (although a lesser level of inspiration) is seen in the sculpture of Bertel Thorvaldsen. However, many other artists of the time were much less austere. Neoclassicism is often characterized as a stern reaction against the frivolity of the preceding Rococo idiom (see p.242). Although this interpretation holds good for some artists, the two styles did, in fact, overlap considerably. Elisabeth Vigée-Lebrun, for example, combined Neoclassical purity of line with Rococo delicacy of sentiment and lightness of touch. Similarly, although they are often presented as polar opposites,

▲ **The Sleep of Endymion** Anne-Louis Girodet, 1791, oil on canvas, 78 x 102¾in, Louvre, Paris, France

there are sometimes strong links between the Neoclassical style and the Romantic style (see p.296) that followed it.

◄ **Detail from The Sleep of Endymion** *The sleek drawing and smooth handling are Neoclassical, but the melodramatic treatment is Romantic in spirit.*



CURRENTevents

1775 The War of Independence breaks out between Britain and its American colonies.

1789 Economic and social unrest erupts in the French Revolution, during which a republic is established and the king and queen are executed.

1799 Napoleon becomes dictator of France.

1815 Final defeat of Napoleon at the Battle of Waterloo.

1787

VIGÉE-LEBRUN Marie-Antoinette and Her Children

1787–93

CANOVA Psyche Revived by the Kiss of Love

1795

SCHADOW Princesses Louisa and Friderica of Prussia.

1800

DAVID Madame Récamier

1808

GROS Napoleon on the Battlefield of Eylau

1808

INGRES The Valpinçon Bather

British

British art tends to avoid extremes, and Neoclassicism rarely appeared in a pure and doctrinaire form in the country's painting. Its influence is seen, however, in various ways, for example in the dignity and lucidity of George Stubbs's work. Stubbs had scientific inclinations and he experimented with painting on earthenware panels made for him by the famous pottery manufacturer Josiah Wedgwood, who was renowned for his elegant Neoclassical wares. Among the designers employed by Wedgwood was the sculptor John Flaxman, who was the most original and committed British exponent of Neoclassicism.

Neoclassical sculpture

While Neoclassical painting was geographically diverse, Neoclassical sculpture was very much concentrated in Rome. Almost all the leading European sculptors of the time worked in the city at one time or the other, and the two most famous—Antonio Canova and Bertel Thorvaldsen—spent virtually their whole careers there. Canova became an international celebrity and was invited to settle in Paris (by Napoleon), Russia (by Catherine the Great), and Vienna

(by the Emperor Francis II), but he maintained that his creativity was inseparable from Rome.

Both Canova and Thorvaldsen ran large workshops, which carried out prestigious commissions all over Europe. Although they occasionally worked in other media, their favored material was marble—with its strong associations with ancient statuary. Much of the actual carving was done by assistants, although Canova cared a great deal about personal handling of his materials and applied what he called "the last touch" himself. Thorvaldsen's sculpture is generally

more austere, without Canova's sensuous qualities (even when he did the final carving himself, he preferred a more matt surface).

The other leading Neoclassical sculptors included John Flaxman, the German Johann Gottfried Schadow, and the Swede Johan Tobias Sergel, all of whom spent periods in Rome. The tradition was maintained well into the 19th century, Thorvaldsen's studio continuing to operate even after he retired and returned to his native Copenhagen in 1838.

▲ **Sleeping Nymph** Antonio Canova *One of Canova's final works, this was inspired by a famous ancient sculpture of a sleeping hermaphrodite.* c1820–22, marble, length 76⅜in, Victoria and Albert Museum, London

Jacques-Louis **David**

b PARIS, 1748; d BRUSSELS, 1825

The leading artist of the Neoclassical movement in France, David studied under Joseph-Marie Vien. However, his real education took place in Rome, where he was overwhelmed by the splendor of the ancient remains, and by the artworks of the great Italian masters. Following his return to Paris in 1780, David set about creating his own vision of the antique, combining themes from classical history with an air of stern morality and heroic sacrifice. This seemed to echo the growing mood of republican fervor in the country and quickly made him a national celebrity.

Portrait by François Navez

When the revolution came, David proved as passionate about politics as he was about art. He joined the National Convention, staged republican pageants, and attacked the Academy. His actions almost led him to the guillotine, but he escaped with just a brief spell of imprisonment. Then, with the rise of Napoleon, the pattern repeated itself. David placed his art wholeheartedly at the service of the emperor. After Napoleon's defeat, David went into exile in Belgium, where he continued to work until his death nine years later.

▶ **The Intervention of the Sabine Women** *This was David's comeback painting, after his near-fatal involvement in politics—hence its conciliatory theme. The Sabine women stop the fighting by taking their children onto the battlefield.* 1794–99, oil on canvas, 12ft 8in x 17ft 2in, Louvre, Paris, France

LIFEline

1748 Born in Paris, the son of an ironmonger
1766 Trains under Vien
1774 Wins the *Prix de Rome*
1775–80 Studies in Rome
1782 Marries Charlotte Pécoul
1784–85 Paints his most influential picture, *The Oath of the Horatii*
1789 Outbreak of the French Revolution
1792 Joins the National Convention
1794 Imprisoned for his revolutionary activities
1804 Becomes Napoleon's official painter
1816 Moves to Brussels, following defeat of Napoleon
1825 Dies in exile in Brussels

CLOSERlook

BALANCE AND ORDER David's composition has a rigorous sense of order. The three arches echo the grouping of figures into three divisions. Similarly, the diagonal line of the lance and the brothers' strides is balanced by that of the father and the swords.

UNITED IN GRIEF The heroic actions of the Horatii brothers are balanced by the passive resignation of their sisters. One of them is betrothed to a member of the opposing family and so, whatever the outcome of the fight, loved ones are bound to perish.

The Oath of the Horatii *Three Roman brothers take a vow to their father as they prepare to fight to the death against three enemy champions. The lamenting women on the right include a sister who is betrothed to one of the enemy. This paean to duty and self-sacrifice for the good of the state captured the mood of the times. As such, it has been seen as a call to arms for the French Revolution. 1784–85, oil on canvas, 10ft 10in x 13ft 11in, Louvre, Paris, France*

The Death of Marat *The revolutionary leader Jean-Paul Marat had to spend hours in the bath because of a skin complaint. In July 1793, he was stabbed to death in his bathtub by the royalist Charlotte Corday. David immediately painted this tribute, showing Marat in a pose reminiscent of the dead Christ. 1793, oil on canvas, 65 x 50½in, Musées Royaux, Brussels, Belgium*

CLOSERlook

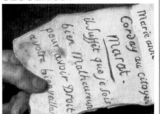

A REVEALING STILL LIFE Marat used his bathroom as an office. In his left hand, he holds Corday's letter of introduction, while beside it is a note offering money to a soldier's widow. The old crate, used as a table, was a deliberate contrast to the luxurious furniture owned by the rich. Here David is illustrating his friend's charitable nature and his austere principles.

Napoleon Crossing the Alps *This is a striking piece of propaganda. Napoleon wanted to be shown "calm on a fiery steed" and David obliged, creating an image of dashing authority. In reality, Napoleon made the journey on a mule. 1801, oil on canvas, 8ft 6in x 7ft 3in, Château de Malmaison, Rueil-Malmaison, France*

INcontext

THE FRENCH REVOLUTION The most turbulent period in French history began in 1789, when rebel politicians formed a new government—the National Assembly—and rioters stormed the Bastille prison. The insurgents swept away the powers of the monarchy and the Church, but divisions appeared within their ranks. Extremist groups took control, unleashing the "Terror" (1793–94), when thousands went to the guillotine. By 1795, the violence began to subside, leaving a power vacuum that would eventually be filled by Napoleon.

Arrest of the Governor of the Bastille by Jean-François Janinet.

Madame Récamier *Julie Récamier was a famous society beauty. Her "Grecian" ringlets, Empire-style dress, and bare feet give her a convincing classical appearance. 1800, oil on canvas, 68½ x 96in, Louvre, Paris, France*

Antoine-Jean **Gros**

Self-portrait

b **PARIS, 1771**; d **MEUDON, 1835**

The art of Gros marks the transition between Neoclassicism and Romanticism. He was one of David's star pupils, but his emotive use of color and his taste for scenes of suffering heralded the Romantic style to come. Delacroix and Géricault were both enthusiastic admirers of his work.

Gros's best pictures were produced for Napoleon. He met him in Milan in 1796 and immediately joined his entourage. This gave him first-hand experience of the general's campaigns, which in turn enabled him to endow his war scenes with an unusual degree of realism. Although his work projects a glamorized vision of war, the prominent pile of corpses in *Eylau* shocked the Parisian public when the picture was shown at the Salon.

LIFEline

1771 Born into an artistic family in Paris

1785 Becomes pupil of Jaques-Louis David

1793–1800 Works in Italy, where he meets Napoleon

1808 Paints *Napoleon on the Battlefield of Eylau*

1816 Becomes Professor at École des Beaux-Arts; takes over the studio of David, who has gone into exile

1835 Drowns himself in the Seine near Paris

" Pictures by Gros... have this **power of projecting** me into that **spiritual state** which I consider to be **the strongest emotion** that the **art of painting** can inspire "

EUGÈNE DELACROIX

▶ **Napoleon on the Battlefield of Eylau**
Gros emphasizes the emperor's compassionate side. He is shown with his arm raised, as if he is blessing the wounded and the defeated, who cluster around him. 1808, oil on canvas, 17ft x 25ft 6in, Louvre, Paris, France

▲ **Napoleon Visiting the Plague-Stricken at Jaffa** *This is a scene from Napoleon's Syrian campaign of 1799. The picture was commissioned to counter accusations that Napoleon had wanted to execute the sick.* 1804, oil on canvas, 17ft x 23ft 6in, Louvre, Paris, France

CLOSERlook

HEROIC LEADERSHIP Gros underlines Napoleon's bravery by showing him touching a plague-sore. This contrasts with the behavior of the officer behind him, who covers his mouth to protect himself from infection. Napoleon's gesture is reminiscent of some Christian images showing Jesus healing the sick by touching them.

Élisabeth **Vigée-Lebrun**

Self-portrait

b **PARIS, 1755**; d **PARIS, 1842**

Élisabeth was the daughter of Louis Vigée, a minor artist who also trained her, and the wife of the picture dealer, Jean-Baptiste Lebrun. She established herself as a leading portraitist, known in particular for her many depictions of Marie-Antoinette, France's doomed queen. Their rapport is immediately evident from these paintings. Because of her royal connections, Vigée-Lebrun was forced to flee during the French Revolution, later working in Italy, Russia, and England.

▼ **Marie-Antoinette** *The empty cradle is a reference to Princess Sophie-Beatrix, who had just died.* 1787, oil on canvas, 108¼ x 84⅝in, Château de Versailles, France

Anne-Louis **Girodet**

Self-portrait

b **MONTARGIS, 1767**; d **PARIS, 1824**

Like his contemporary Gros, Girodet forms a bridge between the Neoclassical and Romantic movements. He was one of David's most gifted pupils and won the *Prix de Rome* in 1789. Stylistically, he owed much to his master, but his approach was very different. *Endymion*, painted at the height of the French Revolution, was a far cry from David's stern republican dramas—the idea of using a symbolic source of light to represent the goddess would have been anathema to his old teacher.

▲ **The Sleep of Endymion** *The lunar goddess Selene is in love with Endymion and visits him here as a shaft of moonlight.* 1791, oil on canvas, 78 x 103in, Louvre, Paris, France

Jean-Auguste-Dominique **Ingres**

Self-portrait

b **MONTAUBAN, 1780**; d **PARIS, 1867**

Ingres found fame as the champion of the classical tradition in France. After training briefly with David, he spent his early career in Italy, where he earned a good deal of his living with exquisite pencil portraits.

Returning to Paris in the 1820s, Ingres became embroiled in aesthetic controversy. With his emphasis on draftsmanship and classical values, he was revered as the leading exponent of academic art, in contrast to the wilder approach of the Romantics (see pp.296–97) headed by Delacroix. In fact, the distinctions between the two were somewhat artificial. Ingres's preference for highly finished pictures—he said that paint should be as smooth "as the skin of an onion"—was certainly a classical trait, but some of his exotic subjects bordered on the Romantic.

LIFEline

1780 Born in southern France
1797 Moves to Paris
1801 Wins the *Prix de Rome*
1806–24 Lives in Italy
1835–41 Director of the French Academy in Rome
1863 Completes *The Turkish Bath*, his final masterpiece
1867 Dies in Paris

▶ **Madame Moitessier** *In true classical fashion, Ingres based the pose on an ancient Roman painting of a goddess at Herculaneum.* 1856, oil on canvas, 47¼ x 36¼in, National Gallery, London, UK

▲ **The Apotheosis of Homer** *Inspired by Raphael's* School of Athens, *this is effectively a classical manifesto, showing Homer being crowned by Victory.* 1827, oil on canvas, 152 x 201⅝in, Louvre, Paris, France

▶ **The Turkish Bath** *Ingres's most erotic painting was completed when he was well into his eighties.* 1863, oil on canvas, diameter 78in, Louvre, Paris, France

CLOSERlook

IDEALIZED NUDE Line takes precedence over color, and this figure, lost in thought, resembles a living statue. The softly curving outlines of the figure contrast with the vertical folds of cloth. Critics often complained that Ingres's nudes seemed boneless, noting here that the bather appears to have no ankles.

▲ **The Valpinçon Bather** *Throughout his career, Ingres sought to create the perfect, classical nude. He returned to this pose again and again, sometimes placing the figure in a harem, but he never surpassed his youthful work. The picture is named after an early owner. Painted while he was in Rome, this is one of Ingres's most classical works. The subject has exotic potential—the sunken pool hints at a bath-house, for example— but the mood is cool and remote.* 1808, oil on canvas, 57½ x 38½in, Louvre, Paris, France

Antonio **Canova**

Self-portrait

b **POSSAGNO, 1757;** d **VENICE, 1822**

The greatest and most successful sculptor of the Neoclassical era, Canova worked initially in Venice, but he made his breakthrough in Rome. His *Theseus and the Minotaur* (1781–83) brought him to the public's attention, helping him to win prestigious commissions to design two papal tombs. After this, Canova's reputation was made. He was employed by many of the crowned heads of Europe, as well as the Church, although his most spectacular pieces were probably the nude statues of Napoleon and his sister.

Canova was both versatile and original. He took an unusual interest in the display of his sculptures. His *Cupid and Psyche*, for example, was designed to be rotated and viewed in subdued, colored lighting. Similarly, he preferred to show his work to clients by candlelight.

LIFEline

1757 Born near Treviso, the son of a stonemason
c1770 Moves to Venice
1780 Settles in Rome
1783 Begins work on papal tombs of Clement XIII and Clement XIV
1787–93 *Cupid and Psyche*
1805–07 Statue of Pauline Borghese
1815 Visits London to see the Elgin Marbles
1822 Dies, and is buried in Possagno

◄ **Cupid and Psyche** *In one of Canova's most tender sculptures, Cupid revives his swooning lover with a kiss.* 1787–93, marble, height 61in, Louvre, Paris, France

► **Hercules and Lichas** *Mortally wounded, Hercules takes revenge on the youth who has unwittingly poisoned him.* 1795–1802, marble, height 11ft 6in, Galleria Nazionale d'Arte Moderna, Rome, Italy

▲ **Pauline Borghese as Venus** *This daring sculpture of Napoleon's sister was never put on public display. It was only viewed by candlelight, by friends of the family.* 1805–07, marble, length 79in, Galleria Borghese, Rome, Italy

CLOSERlook

ACT OF FURY Some critics found Canova's work too cold and restrained, but he was equally capable of fiery brilliance. Here, Hercules strains every sinew, while the despair of his victim, clutching vainly at the hero's lion skin, is vividly portrayed.

John **Flaxman**

b **YORK, 1755;** d **LONDON, 1826**

Both as a draftsman and as a sculptor, Flaxman was England's most important Neoclassical artist. As a young man, he worked for Josiah Wedgwood and gained an interest in classical pottery.

Portrait by Henry Howard

Flaxman's understanding of classical art is evident from his tomb sculptures, many of which resemble antique reliefs. It was his book illustrations, however, that were most influential. His simple, pared-down drawings brought the works of Homer and Aeschylus to life.

INcontext

WEDGWOOD POTTERY Flaxman's association (1775–87) with the potter Josiah Wedgwood produced some of his most beautiful Neoclassical designs. Flaxman emulated the style of classical reliefs, while Wedgwood was inspired by Greek vases and antique cameos. In this example, Flaxman illustrates a moral fable invented by a friend of Socrates: Hercules must choose between the rocky road to Virtue and the easy path leading to Vice.

The Choice of Hercules, by John Flaxman, Wedgwood Jasperware.

▼ **Monument to Lord Mansfield** Flaxman's finest monumental sculpture is of the eminent judge Lord Mansfield, flanked by the figures of Wisdom and Justice. 1795–1801, marble, Westminster Abbey, London, UK

Johan Tobias **Sergel**

b **STOCKHOLM, 1740;** d **STOCKHOLM, 1814**

Sergel spent most of his career in his native Stockholm, though he formed his Neoclassical style during an 11-year stay in Rome. There, he joined Henry Fuseli's circle of friends, immersing himself in the more sensual aspects of antique culture. This was reflected in his sculptures, which often combined raw vitality with thinly veiled eroticism. His terracotta models were particularly spirited, while his pen-and-ink drawings displayed a lively sense of humor.

As Sergel's reputation grew, he was summoned back to Sweden by King Gustavus III, who made him his court sculptor. His later career was largely devoted to portraiture, the most notable example being a statue of Gustavus himself, loosely based on a famous classical work—the *Apollo Belvedere*.

◄ **Mars and Venus** Neoclassical art was not always high-minded and serious. There were often strong erotic undercurrents in Sergel's sculptures. Here, it is unclear whether Mars is rescuing or ravishing the goddess. c1775, marble, height 36½in, Nationalmuseum, Stockholm, Sweden

SCULPTURE

273

17TH AND 18TH CENTURIES

Bertel **Thorvaldsen**

b **COPENHAGEN, 1768/70;** d **COPENHAGEN, 1844**

After training at the Copenhagen Academy, the Danish sculptor Thorvaldsen won a scholarship to Italy, where his style reached full maturity. His portrayal of Jason, which owed much to an ancient sculpture by Polyclitus, established his credentials as a lover of the antique and helped to launch his career. Soon, he had so many commissions that he needed 40 assistants to cope with the demand.

Portrait by Christoffer Wilhelm Eckersberg

Despite pleas to return to his homeland, Thorvaldsen remained based in Rome for almost 40 years, aware that this boosted his claims to international status as an artist. He became Canova's chief rival. Thorvaldsen's work lacked the Italian's versatility and warmth, but it had a greater classical severity.

LIFEline

1768/70 Born in Copenhagen
1797 Settles in Rome
1802–03 His statue *Jason* seals his reputation
1824–31 Works on the tomb of Pius VII in St. Peter's
1838 Returns to Denmark a national hero
1844 Dies in Copenhagen

▼ **Ganymede and Jupiter** Jupiter disguised himself as an eagle, in order to carry the youth away to become his servant. 1817, marble, height 37in, Thorvaldsens Museum, Copenhagen, Denmark

CLOSERlook

PHRYGIAN CAP Ganymede's Phrygian cap identifies him as a Trojan, but it had revolutionary overtones in Thorvaldsen's day. Traditionally given to freed slaves, the cap was adopted during the French Revolution as a symbol of liberty. This is ironic, given that Ganymede is about to be enslaved.

CUP-BEARER There is further irony in the fact that Ganymede is giving water to the divine eagle. This prefigures his future role, as cup-bearer to the gods.

Johann Gottfried **Schadow**

b **BERLIN, 1764;** d **BERLIN, 1850**

A crucial two-year stay in Rome, where he became friends with Canova, honed the Neoclassical style of this German sculptor and printmaker. Although Schadow's work could be very imposing—his most famous sculpture was the magnificent chariot and horses

Self-portrait

on the Brandenburg Gate in Berlin (now replaced by a replica)—he could also produce portraits that displayed genuine charm and intimacy.

◄ **The Princesses Louisa and Friderica of Prussia** A delightful double portrait produced to commemorate the weddings of the two sisters. 1795–97, marble, height 67½in, Alte Nationalgalerie, Berlin, Germany

Anton Raphael **Mengs**

Self-portrait

b AUSSIG, BOHEMIA, 1728; d ROME, 1779

Although his reputation is no longer as exalted as it was in his own day, Mengs remains one of the key figures of the Neoclassical movement. Trained by his father, he showed talent at an early age, and he rapidly established himself as a successful portraitist.

Mengs's career changed course in the 1750s, when he settled in Rome and became friends with Johann Joachim Winckelmann, an influential archaeologist and art historian. Winckelman had just published a ground-breaking treatise, proclaiming the superiority of Greek art, and this had a profound effect on Mengs. In 1761, he produced his *Parnassus* for a ceiling in the Villa Albani, where Winckelmann held the post of librarian. Combining the influence of antique statuary and Raphael's painting style, this swiftly assumed the status of a manifesto for the new movement, all the more so because the Villa Albani was frequently visited by artists and connoisseurs.

LIFEline

1728 Born in Bohemia, the son of a court painter
1740 First visit to Rome
1752 Settles in Rome
c1755 Becomes friend of Winckelmann
1761 Completes his most famous painting, *Parnassus*
1761–69 Court painter in Spain
1774–77 Second spell as court painter in Spain
1779 Dies in Rome

▼ **Parnassus** *Mengs's most important painting shows Apollo surrounded by the Muses.* 1760–61, ceiling fresco, 118⅛ x 236¼in, Villa Albani (now Villa Torlonia), Rome, Italy

CLOSERlook

SUMPTUOUS ROBES
Mengs's portraits are now considered to be his finest achievements. He has captured Clement's mild, well-intentioned character, as well as the rich apparel of his new office.

▼ **Pope Clement XIII** *This painting was produced to celebrate Carlo Rezzonico's recent election as pope. He took the name Clement XIII.* 1758, oil on canvas, Ca' Rezzonico, Museo del Settecento, Venice, Italy

Christen **Købke**

b COPENHAGEN, 1810; d COPENHAGEN, 1848

Christen Købke enjoyed only modest success during his short life, but he is now recognized as one of the outstanding figures of a golden age of Danish art in the late 18th and early 19th centuries. Rather than the severe, heroic face of Neoclassicism (as seen in his countryman Bertel Thorvaldsen's sculpture), his work exemplifies a more intimate side of the movement—rooted in the everyday world but still marked by dignity and clarity.

▲ **Adolphine Købke** *This typically precise portrait is of the artist's younger sister.* 1832, oil on canvas, 16½ x 13¾in, Louvre, Paris, France

Angelica **Kauffmann**

b CHUR, 1741; d ROME, 1807

▲ **Vendor of Love** *This frivolous subject was loosely based on an ancient wall-painting.* c1763, oil on canvas, Musée Bargoin, Clermont Ferrand, France

A Swiss-born painter who spent much of her career in England and Italy, Kauffmann had her earliest training from her father, who was also a painter. However, her mature style was more influenced by Mengs, whose work she saw in Rome. In 1776, she settled in London, becoming a close friend of Joshua Reynolds. Like him, Kauffmann was a founder member of the Royal Academy. She spent the final part of her career in Italy, after marrying the Italian painter Antonio Zucchi.

Kauffmann chose fashionable Neoclassical themes, but executed them in a light Rococo manner. Her *Vendor of Love*, for example, is a prettified version of a newly discovered mural at Herculaneum.

Jens **Juel**

b BALSLEV, FUNEN, 1745; d COPENHAGEN, 1802

The son of a clergyman, Juel studied in Hamburg. He travelled widely, working in Dresden, Rome, and Paris, before finally settling in Copenhagen. There he forged an impressive reputation with his astute portraits and decorous still lifes, and was appointed court painter in 1780. Juel was also regarded as a fine teacher. In 1784, he became a professor at the Copenhagen Academy, where his pupils included Caspar David Friedrich and Otto Runge.

▲ **Still Life with Flowers** *Juel's flower pieces are both orderly and elegant.* 1764, oil on canvas, 20⅞ x 15⅜in, Kunsthalle, Hamburg, Germany

John **Flaxman**

Portrait by Henry Howard

b **YORK, 1755**; d **LONDON, 1826**

Both as a draftsman and as a sculptor, Flaxman was England's most important Neoclassical artist. As a young man, he worked for Josiah Wedgwood and gained an interest in classical pottery. Flaxman's understanding of classical art is evident from his tomb sculptures, many of which resemble antique reliefs. It was his book illustrations, however, that were most influential. His simple, pared-down drawings brought the works of Homer and Aeschylus to life.

INcontext

WEDGWOOD POTTERY Flaxman's association (1775–87) with the potter Josiah Wedgwood produced some of his most beautiful Neoclassical designs. Flaxman emulated the style of classical reliefs, while Wedgwood was inspired by Greek vases and antique cameos. In this example, Flaxman illustrates a moral fable invented by a friend of Socrates: Hercules must choose between the rocky road to Virtue and the easy path leading to Vice.

The Choice of Hercules, *by John Flaxman, Wedgwood Jasperware.*

▼ **Monument to Lord Mansfield** *Flaxman's finest monumental sculpture is of the eminent judge Lord Mansfield, flanked by the figures of Wisdom and Justice.* 1795–1801, marble, Westminster Abbey, London, UK

Johan Tobias **Sergel**

b **STOCKHOLM, 1740**; d **STOCKHOLM, 1814**

Sergel spent most of his career in his native Stockholm, though he formed his Neoclassical style during an 11-year stay in Rome. There, he joined Henry Fuseli's circle of friends, immersing himself in the more sensual aspects of antique culture. This was reflected in his sculptures, which often combined raw vitality with thinly veiled eroticism. His terracotta models were particularly spirited, while his pen-and-ink drawings displayed a lively sense of humor.

As Sergel's reputation grew, he was summoned back to Sweden by King Gustavus III, who made him his court sculptor. His later career was largely devoted to portraiture, the most notable example being a statue of Gustavus himself, loosely based on a famous classical work—the *Apollo Belvedere*.

◄ **Mars and Venus** *Neoclassical art was not always high-minded and serious. There were often strong erotic undercurrents in Sergel's sculptures. Here, it is unclear whether Mars is rescuing or ravishing the goddess.* c1775, marble, height 36½in, Nationalmuseum, Stockholm, Sweden

Bertel **Thorvaldsen**

Portrait by Christoffer Wilhelm Eckersberg

b **COPENHAGEN, 1768/70**; d **COPENHAGEN, 1844**

After training at the Copenhagen Academy, the Danish sculptor Thorvaldsen won a scholarship to Italy, where his style reached full maturity. His portrayal of Jason, which owed much to an ancient sculpture by Polyclitus, established his credentials as a lover of the antique and helped to launch his career. Soon, he had so many commissions that he needed 40 assistants to cope with the demand.

Despite pleas to return to his homeland, Thorvaldsen remained based in Rome for almost 40 years, aware that this boosted his claims to international status as an artist. He became Canova's chief rival. Thorvaldsen's work lacked the Italian's versatility and warmth, but it had a greater classical severity.

LIFEline

1768/70 Born in Copenhagen
1797 Settles in Rome
1802–03 His statue *Jason* seals his reputation
1824–31 Works on the tomb of Pius VII in St. Peter's
1838 Returns to Denmark a national hero
1844 Dies in Copenhagen

▼ **Ganymede and Jupiter** *Jupiter disguised himself as an eagle, in order to carry the youth away to become his servant.* 1817, marble, height 37in, Thorvaldsens Museum, Copenhagen, Denmark

CLOSERlook

PHRYGIAN CAP Ganymede's Phrygian cap identifies him as a Trojan, but it had revolutionary overtones in Thorvaldsen's day. Traditionally given to freed slaves, the cap was adopted during the French Revolution as a symbol of liberty. This is ironic, given that Ganymede is about to be enslaved.

CUP-BEARER There is further irony in the fact that Ganymede is giving water to the divine eagle. This prefigures his future role, as cup-bearer to the gods.

Johann Gottfried **Schadow**

Self-portrait

b **BERLIN, 1764**; d **BERLIN, 1850**

A crucial two-year stay in Rome, where he became friends with Canova, honed the Neoclassical style of this German sculptor and printmaker. Although Schadow's work could be very imposing—his most famous sculpture was the magnificent chariot and horses on the Brandenburg Gate in Berlin (now replaced by a replica)—he could also produce portraits that displayed genuine charm and intimacy.

◄ **The Princesses Louisa and Friderica of Prussia** *A delightful double portrait produced to commemorate the weddings of the two sisters.* 1795–97, marble, height 67½in, Alte Nationalgalerie, Berlin, Germany

Anton Raphael **Mengs**

Self-portrait

b AUSSIG, BOHEMIA, 1728; d ROME, 1779

Although his reputation is no longer as exalted as it was in his own day, Mengs remains one of the key figures of the Neoclassical movement. Trained by his father, he showed talent at an early age, and he rapidly established himself as a successful portraitist.

Mengs's career changed course in the 1750s, when he settled in Rome and became friends with Johann Joachim Winckelmann, an influential archaeologist and art historian. Winckelman had just published a ground-breaking treatise, proclaiming the superiority of Greek art, and this had a profound effect on Mengs. In 1761, he produced his *Parnassus* for a ceiling in the Villa Albani, where Winckelmann held the post of librarian. Combining the influence of antique statuary and Raphael's painting style, this swiftly assumed the status of a manifesto for the new movement, all the more so because the Villa Albani was frequently visited by artists and connoisseurs.

LIFEline

1728 Born in Bohemia, the son of a court painter
1740 First visit to Rome
1752 Settles in Rome
c1755 Becomes friend of Winckelmann
1761 Completes his most famous painting, *Parnassus*
1761–69 Court painter in Spain
1774–77 Second spell as court painter in Spain
1779 Dies in Rome

▼ **Parnassus** *Mengs's most important painting shows Apollo surrounded by the Muses.* 1760–61, ceiling fresco, 118⅛ x 236¼in, Villa Albani (now Villa Torlonia), Rome, Italy

CLOSERlook

SUMPTUOUS ROBES
Mengs's portraits are now considered to be his finest achievements. He has captured Clement's mild, well-intentioned character, as well as the rich apparel of his new office.

▼ **Pope Clement XIII** *This painting was produced to celebrate Carlo Rezzonico's recent election as pope. He took the name Clement XIII.* 1758, oil on canvas, Ca' Rezzonico, Museo del Settecento, Venice, Italy

Christen **Købke**

b COPENHAGEN, 1810; d COPENHAGEN, 1848

Christen Købke enjoyed only modest success during his short life, but he is now recognized as one of the outstanding figures of a golden age of Danish art in the late 18th and early 19th centuries. Rather than the severe, heroic face of Neoclassicism (as seen in his countryman Bertel Thorvaldsen's sculpture), his work exemplifies a more intimate side of the movement—rooted in the everyday world but still marked by dignity and clarity.

▲ **Adolphine Købke** *This typically precise portrait is of the artist's younger sister.* 1832, oil on canvas, 16½ x 13¾in, Louvre, Paris, France

Angelica **Kauffmann**

b CHUR, 1741; d ROME, 1807

▲ **Vendor of Love** *This frivolous subject was loosely based on an ancient wall-painting.* c1763, oil on canvas, Musée Bargoin, Clermont Ferrand, France

A Swiss-born painter who spent much of her career in England and Italy, Kauffmann had her earliest training from her father, who was also a painter. However, her mature style was more influenced by Mengs, whose work she saw in Rome. In 1776, she settled in London, becoming a close friend of Joshua Reynolds. Like him, Kauffmann was a founder member of the Royal Academy. She spent the final part of her career in Italy, after marrying the Italian painter Antonio Zucchi.

Kauffmann chose fashionable Neoclassical themes, but executed them in a light Rococo manner. Her *Vendor of Love*, for example, is a prettified version of a newly discovered mural at Herculaneum.

Jens **Juel**

b BALSLEV, FUNEN, 1745; d COPENHAGEN, 1802

The son of a clergyman, Juel studied in Hamburg. He travelled widely, working in Dresden, Rome, and Paris, before finally settling in Copenhagen. There he forged an impressive reputation with his astute portraits and decorous still lifes, and was appointed court painter in 1780. Juel was also regarded as a fine teacher. In 1784, he became a professor at the Copenhagen Academy, where his pupils included Caspar David Friedrich and Otto Runge.

▲ **Still Life with Flowers** *Juel's flower pieces are both orderly and elegant.* 1764, oil on canvas, 20⅞ x 15⅝in, Kunsthalle, Hamburg, Germany

George **Stubbs**

b LIVERPOOL, 1724; d LONDON, 1806

The most famous of all horse painters, Stubbs belongs in some respects to the burgeoning Romantic movement, but his magnificent purity of line links him in spirit with Neoclassicism. He worked initially as a portraitist, though his chief interest lay in anatomy. The key period in his career began in 1756, when he withdrew to a remote farmhouse in Lincolnshire and spent 16 months dissecting horses. The results of these studies were eventually published in his ground-breaking book, *The Anatomy of the Horse*.

Portrait by Ozias Humphry

After a move to London, Stubbs began to make his mark in horse-racing circles. His thorough understanding of the animal enabled him to win a series of lucrative commissions for horse "portraits" and racing scenes. He also expanded his repertoire to include other aspects of these horse-owners' lifestyles, such as fox hunts and picturesque scenes of the farmwork on their country estates.

LIFEline

1724 Born in Liverpool, son of a leatherworker
1745 Moves to York to study anatomy
1754 Visits Rome
1756–57 Dissects horses to study anatomy
1758 Moves to London
c1762 Paints *Horse Attacked by a Lion*
1766 *The Anatomy of the Horse* is published
1781 Becomes member of the Royal Academy
1806 Dies in London

▼ **Horse Attacked by a Lion** *Stubbs produced numerous paintings on this subject, of which this is the largest. He is said to have witnessed such a scene in Morocco (on his return journey from Italy), but he was perhaps inspired by an antique sculpture on the subject.* c1762, oil on canvas, 96⅛in x 131⅛in, Yale Center for British Art, New Haven, Connecticut US

▼ **Lord Torrington's Hunt** *In preparation for a hunt, two of Torrington's servants set out from home.* c1765–68, oil on canvas, 24 x 41¼in, private collection

Gavin **Hamilton**

b MURDIESTON HOUSE, LANARKSHIRE, 1723; d ROME, 1798

This Scottish painter spent most of his career in Rome, gaining the rare distinction for a British artist of being far better known in continental Europe than in his homeland. Hamilton's greatest paintings were produced in the 1760s, and were mainly drawn from subjects in Homer's *Iliad*. These were widely reproduced as engravings, which influenced a younger generation of artists, among them Jacques-Louis David. Hamilton himself was gradually diverted away from painting into other, more lucrative activities. He became an archaeologist, conducting lengthy excavations at Hadrian's Villa, and a successful picture-dealer, selling Old Masters to British collectors.

LIFEline

1723 Born the son of a Scottish laird
1748–50 First visit to Italy
1756 Settles permanently in Rome, where he encourages numerous British artists who visit the city
1763 Commissioned to paint *The Death of Lucretia*
1769 Begins excavations at Hadrian's Villa
1798 Dies in Rome

◀ **The Death of Lucretia**
Lucretia takes her own life after being raped, while Junius Brutus (founder of the Roman Republic) vows to avenge her. 1763–67, oil on canvas, 83⅞ x 103⅞in, Yale Center for British Art, New Haven, Connecticut, US

CLOSERlook

DRAMATIC GESTURES To modern eyes, Hamilton's picture may seem overcrowded and melodramatic. The figures' interlocking gestures resemble an elaborate mime, rather than a scene from real life. However, this painting inspired other "oath" pictures, notably David's *Oath of the Horatii* (see pp.268–69).

INcontext

THE SPORT OF KINGS Stubbs's career coincided with a golden age for horse racing. The use of imported Arab stallions improved the bloodstock, producing genuine thoroughbreds. The Jockey Club was founded in 1752, and three of the "classics" were introduced—the St. Leger (1778), the Oaks (1779), and, most famous of all, the Derby (1780).

A Young Jockey *George Stubbs.*

The very name of this medium suggests its qualities. Fluid and translucent, watercolor paint is ideal for pale washes and ambiguous shifts of color. An understated medium, it is halfway between drawing and painting, making it ideal for outdoors, hence its use in English landscape.

Origins and influences

Watercolor has a long history in England. During the Tudor period, miniaturists, such as Nicholas Hilliard, used gouache—opaque watercolor— for its jewel-like brilliance, while in the 1630s, portraitist Van Dyck spent his spare time sketching the landscape in watercolors. The diarist Samuel Pepys dabbled in watercolor in the 1640s, but it wasn't until 1784, when Reeves (still renowned today for artists' materials) created watercolor cakes, that the medium became easily portable for outdoor use.

Subjects

Landscapes were the main subject matter for English watercolorists, who were divided into two groups. In the 18th century, military draftsmen, such as Paul Sandby, recorded scenes in a map-like way. Their topographical

▲ **Chirk Aqueduct** *John Sell Cotman used a low viewpoint and left out detail to give the aqueduct a generalized grandeur.*

approach was used before the advent of photography to produce accurate representations of natural and artificial features. The other group featured artists such as Alexander Cozens and John Sell Cotman, who highlighted imaginative and poetic qualities as opposed to topographical function.

Tension between the two camps was high. The topographers criticized Cozens's textbooks on the picturesque and his "blot" landscape method (see below), while the picturesque painters thought the work of the topographers was far too conservative.

Techniques

The partnership between the water, paint, and paper makes this medium unlike any other. With oils, the paint stays put; watercolor swims across the paper. Unlike other artists, watercolorists obey unwritten rules: for example, some do not use black or white paint. So for white, they let the paper show or use a technique called "stopping out": blotting color while the paint is still wet. Turner, on the other hand, scraped out whites with his fingernail when the paint had dried.

Landscape painters raised the status of watercolor. They founded the Old Watercolor Society in 1804 and made paintings of such quality they rivaled oil paintings.

English watercolorists

Alexander **Cozens**

b **RUSSIA, 1717**; d **LONDON, 1786**

Alexander Cozens is regarded as one of the leading watercolorists of the 18th century and one of the first important British painters to focus exclusively on landscapes. His work helped to propel landscape art to the fore, by presenting it from a subjective, imaginary viewpoint. This poetic approach ultimately culminated in the Romantic style of the 19th century.

Born in Russia, where his father was working as a shipbuilder, but educated in Britain, Cozens later studied landscape under Claude-Joseph Vernet in Rome. On his return to Britain, he worked as a drawing master and teacher while developing his theories on landscape painting. Cozens devised a technique called blot drawing, which he developed from one of Leonardo da Vinci's ideas. He used randomly placed "blots" on the drawing paper to fire his imagination, developing them into imaginary landscapes. He expounded on this in his 1786 treatise, *A New Method of Assisting the Invention in Drawing Original Compositions of Landscape.*

▲ **Classical Landscape** *Cozens' work was executed almost exclusively in monochrome wash. He used contrasting areas of light and dark to suggest nature's power and inscrutability.* Mid-18th century, sepia on paper, 6¾ x 8¼in, Ferens Art Gallery, Hull, UK

▲ **Fantastic Landscape** *Cozens identified 16 landscape themes and 27 viewing situations, such as times of day or types of weather, that could be used to produce poetic depictions of landscape.* c1780–85, wash with pencil on paper, 15¾ x 20¾in, Yale Center for British Art, New Haven, US

John Robert **Cozens**

b **LONDON, 1752**; d **LONDON, 1797**

◀ **Bessanone, South Tyrol** *Here, Cozens brilliantly captures the haunting grandeur and mystery of alpine scenery in a way that inspires the imagination of the viewer. The low-toned combinations of gray, blue, and green watercolor add to the atmosphere.* c1782–83, watercolor on paper, University of Liverpool Art Gallery, UK

John Robert Cozens was described by John Constable as "the greatest genius that ever touched landscape." He studied under his father, Alexander Cozens, but developed a more naturalistic, yet highly evocative and atmospheric style. His watercolors proved hugely influential with British landscape artists for several generations to come.

Cozens held his first exhibition of drawings in 1776 at the Society of Artists. He made two extensive painting trips to continental Europe in 1776–79 and 1782–83, discovering in the Alps and the Italian countryside the inspirational subject matter that was to profoundly influence his art. His brooding paintings of weather, clouds, and mountains presage the work of artists such as Thomas Girtin and J.M.W. Turner. Cozens' art often had a melancholic air, probably because he suffered from severe depression; this led to insanity and death at 45. Nevertheless, the poetic vision of his later paintings, such as *View of Windsor from the South West* (1792), surpassed that of any of his contemporaries in English landscape art.

Thomas **Girtin**

Portrait by
John Opie

b **LONDON, 1775**; d **LONDON, 1802**

Considered the equal of Constable and Turner in his own field, Thomas Girtin was known for his innovative watercolor landscapes, and he played a central role in establishing the medium as a major art form.

Girtin's early works were in the 18th-century topographical style, but he later developed a bolder technique, which evoked a sense of space and mood and made a lasting impression on English landscape painting. Girtin made several sketching tours of Britain and by 1799 had attracted eminent patrons, including the art collector Sir George Beaumont. He was also a friend of J.M.W. Turner; as boys they had both been employed to color engravings for a print-seller.

LIFEline

1775 Born in London
1794 Begins to exhibit at the Royal Academy
1800 Marries Mary Ann Borrett—16-year-old daughter of a London goldsmith
1801–02 Visits Paris to make a series of etchings, which are published posthumously
1802 His huge London panorama, *Eidometropolis*, is exhibited. Dies, aged just 27, from tuberculosis

▼ **Lyme Regis, Dorset** *Girtin painted this view during a sketching tour of the West Country. Here he displays the bolder style he had developed, with its use of broad washes of strong color.* c1797, watercolor over pencil on textured paper, 8¾ x 16¾in, Yale Center for British Art, New Haven, US

> " If Tom Girtin had **lived**, I should have **starved** "
>
> J.M.W. TURNER, (1775–1851)

▶ **The White House at Chelsea** *Girtin painted two versions of this scene, which show his mastery of watercolor and his increasing power as an artist. This view of the Thames at sunset brilliantly creates a mood of peace and reflection.* 1800, watercolor on paper, 12¼ x 20in, private collection

CLOSERlook

WHITE LIGHT Here, Girtin has magically captured the effect of the setting sun lighting up the white house by leaving the paper virtually unpainted. He has added yellow as a contrast.

John Sell **Cotman**

Portrait by
John Varley

b **NORWICH, 1782**; d **LONDON, 1842**

A landscape painter and etcher, John Sell Cotman was virtually self-taught, yet by the age of 18 he was already exhibiting at the Royal Academy.

He left his home-town of Norwich in 1798 to study in London. Between 1800 and 1806, he made several sketching trips to Yorkshire and Wales, and some of his works from this period are ranked among the best English landscape paintings of their time. In 1806, Cotman returned to Norwich, where he exhibited with the Norwich Society of Artists and also taught. He later worked as an architectural draftsman in Great Yarmouth, eventually returning to London in 1834.

▲ **Greta Bridge, Durham** *This is probably Cotman's most famous work, and is typical of the watercolors he produced while visiting the area. It is made up almost entirely of controlled, flat washes of cool color.* c1805, watercolor, British Museum, London, UK

David **Cox**

b **BIRMINGHAM, 1783**; d **BIRMINGHAM, 1859**

Son of a Birmingham blacksmith, the landscape painter David Cox became one of the leading British watercolorists of his era. Indeed, in 1852 a report in the *Spectator* magazine declared that "In his work there are power and insight enough to swamp all the others put together."

Cox started his career as an apprentice to a painter of miniatures, and also worked as a theatrical scene painter. In 1804 he moved to London, where he began exhibiting at the Royal Academy, combining his art career with teaching. Between 1826 and 1832, Cox made several sketching trips to mainland Europe. From 1844, he also made regular visits to North Wales, where he produced some of his most celebrated watercolor landscapes.

▲ **View in North Wales** *Painted during his final trip to North Wales, when his eyesight was beginning to fail, this watercolor is typical of Cox's lively style. It shows a drover driving cattle across a bridge amid the rugged Welsh scenery.* 1858, watercolor on paper, 20½ x 29½in, private collection

CLOSERlook

VIGOROUS STYLE The rough texture of the rocks is accentuated by Cox's vigorous brushwork. He often painted on a kind of coarse wrapping paper that was well suited to his technique.

As the population of the British colonies grew and colonists amassed greater wealth, the demand for consumer and luxury goods surged. The desire for decorative objects, fine furniture, prints, paintings, and the like not only spurred a brisk overseas trade, particularly with Great Britain, but it also increasingly supported the work of local artists and artisans.

Origins and influences

By the late 1700s, a strong market for portrait painting had developed throughout the colonies as affluent colonists from Boston to Philadelphia to Charleston sought to visually preserve their family histories and assert their social and political standing. Europe, and particularly London and its vibrant art world, provided important artistic models, and artists and their patrons often relied on imported prints and books for the latest trends and fashions.

Many colonial artists themselves were European-born and -trained. Artists such as Benjamin West, however, crossed the Atlantic in the other direction to establish their careers, never to return, while others such as Charles Willson Peale and Gilbert Stuart travelled abroad only to train and hone their skills. West's

▲ **Monticello** *Thomas Jefferson, one of the most prominent political figures in colonial America, designed his house near Charlottesville, Virginia, according to classical architectural principles of order, rationality, and symmetry.*

London studio, for example, attracted a generation of American painters eager to study art and painting.

Subjects

European art centers remained important destinations for aspiring artists long after the War of Independence. At home, portrait painting flourished and political heroes such as George Washington offered ready material.

The birth of the nation also stimulated a greater interest in public sculpture and in history painting. The decoration of the United States Capitol building in Washington, which houses Congress, the national legislature, was renewed and expanded after the damage it sustained in the 1812 war with Britain, perhaps most vividly commemorating in paint and marble the stories of the country's founding and its charismatic leaders.

CURRENTevents

1776 The Second Continental Congress of thirteen American colonies approves the Declaration of Independence during the Revolutionary War with Great Britain.

1786 Charles Willson Peale establishes a public museum in Philadelphia highlighting both art and nature, and displays portraits of Revolutionary War heroes.

1789 Following the ratification of the United States Constitution and its creation of a new government, George Washington is elected the first president of the United States of America.

Colonial America

Benjamin **West**

Portrait by Christian Josi

b **SPRINGFIELD, PENNSYLVANIA 1738;** d **LONDON, 1820**

Described as the "Father of American painting," Benjamin West was the most celebrated historical painter of his day, and the first American painter to win an international reputation.

West enjoyed early success as a portrait painter in his home country. He then studied in Europe, absorbing influences from Renaissance, Baroque, and contemporary artists before settling in London, where he remained for the rest of his life. His colonial charm intrigued patrons, and he quickly gained both popular acclaim and the friendship of Joshua Reynolds, the most influential of the 18th-century English painters. Royal patronage followed, enabling West to give up portraits and concentrate on the historical, religious, and mythological subjects that became his forte. Although West never returned to the United States, he was a popular mentor to visiting American artists, and his work profoundly influenced the development of American art in the early 19th century.

LIFEline

1738 Born in Springfield, which is now Swarthmore
1760–63 Studies in Italy
1763 Settles in London
1765 Marries Elizabeth Shewell of Philadelphia
1770 Paints *The Death of General Wolfe*, which creates a fashion for depicting contemporary events with figures in modern dress
1772 Appointed history painter to George III
1792 Becomes President of the Royal Academy
1820 Dies in London; buried in St. Paul's Cathedral

▲ **William Penn's Treaty with the Indians** *Depicting the foundation of Pennsylvania in 1681, this painting became part of American mass culture, appearing on everything from curtains to cards. 1771–72, oil on canvas, 75⅝ x 107⅞in, Pennsylvania Academy of the Fine Arts, Philadelphia, US*

◀ **Death on the Pale Horse** *This apocalyptic vision marked a departure from Neoclassicism and heralded the emotional style of the Romantics. 1796, oil on canvas, 23¼ x 51in, Detroit Institute of Arts, US*

CLOSERlook

MOTHER AND BABY A child sits beside a Native American woman while she feeds her baby—a suggestion of peace and plenty. To lend realism, West incorporated Native American objects, such as the baby's cradleboard.

John Singleton **Copley**

b **BOSTON, 1738;** d **LONDON, 1815**

Regarded as colonial America's greatest painter, John Singleton Copley was virtually self-taught. His remarkable skills brought him early success as a portraitist, and by the 1760s he was earning a small fortune and mixing with affluent society. His colonial portraits are sometimes a little stiff or awkward, but they have great strength of design and vigor of characterization. Often he painted sitters with objects relevant to their daily lives, helping create a sense of intimacy.

Copley moved to Europe in 1774, encouraged to do so by his countryman Benjamin West. Unlike West, however, he failed to find lasting professional success in England. His style became more ornate, losing the vigor and originality that had infused his earlier works. Copley turned from portraiture to history painting, and although he enjoyed some accolades, his popularity began to decline in the 1780s. He died in debt.

LIFEline

1738 Born in Boston

c1760 Is established as the colonies' leading portrait painter

1765 Paints the acclaimed *Boy with a Squirrel*, the first American-painted work to be exhibited abroad

1775 Settles in England after visiting Italy

1778 Exhibits *Watson and the Shark* at The Royal Academy to great acclaim; he paints two other versions

1785 Career begins to decline

1815 Dies of a stroke in London

➤ **Watson and the Shark** *This portrayal of a real event focuses on an ordinary person— a 14-year-old attacked by a shark off Havana. This is a slightly later version of the picture Copley exhibited in 1778.* 1782, oil on canvas, 35¾ x 30¼in, Detroit Institute of Arts, US

CLOSERlook

HEIGHTENED DRAMA Attention is focused on the tension and drama of the rescue by the clever composition of figures, which are placed within a "triangle" of oars, pole, and outstretched arms.

▲ **Mrs. James Warren** *Mercy Warren, a brilliant satirist, was torn between convention and ambition. Her direct gaze hints at this, but Copley typically focuses on her fashionable elegance and femininity; the nasturtium vine symbolizes her womanly role as nurturer.* c1763, oil on canvas, 50 x 39¼in, Museum of Fine Arts, Boston, US

❝ You can scarcely help **discoursing** with them, **asking questions** and **receiving answers** ❞

JOHN ADAMS, SECOND US PRESIDENT, 1817

▲ **Mr. and Mrs. Ralph Izard** *Copley painted this portrait of the wealthy American and his wife while touring Italy. Lavish furnishings and classical references suggest their refinement and culture.* 1775, oil on canvas, 69 x 88in, Museum of Fine Arts, Boston, US

INcontext

TURBULENT TIMES The revolutionary era began in 1763, when Britain imposed a series of unpopular taxes on its American colonies. Gradually, the old social hierarchy was cast aside, as democratic ideals took hold. Boycotts of British goods, such as lace, are reflected in Copley's portraits of plainly dressed merchants. Since his clients included both patriots and loyalists, Copley remained pointedly neutral.

Portrait of George Washington *by James Peale the Elder. Washington was a distinguished general, winning the American Revolutionary War in 1783 and becoming the first president of the United States of America in 1789.*

Charles Wilson **Peale**

b **QUEEN ANNE'S COUNTY, 1741**; d **PHILADELPHIA, 1827**

Portrait by Rembrandt Peale

Charles Wilson Peale was a brilliant American portraitist who displayed a particular talent for capturing the character of his sitters. He is best known for his paintings of leading figures of the Revolutionary period, particularly those of George Washington. During the course of his long life, Peale painted more than a thousand portraits. Their sharp outlines, somber colors, and restrained emotions give them an affinity with the Neoclassical style.

An enlightened, multi-faceted man, Peale was also a soldier, inventor, agricultural reformer, author, political activist, naturalist, and founder of the country's first major museum. He was married and widowed three times, and had 17 children, several of whom became noted artists in their own right. Peale assisted in establishing the Pennsylvania Academy of the Fine Arts in Philadelphia, and continued to paint throughout his life. However, his later years were dominated by his growing interest in natural history.

LIFEline

1741 Born in Maryland
1766 Studies in London with Benjamin West
1769 Returns to the US
1776 Settles in Philadelphia
1782 Opens a portrait gallery of Revolutionary heroes, the first art gallery in the US
1786 Founds the Peale Museum in Philadelphia; later it moves to Baltimore
1794 Retires as an artist to concentrate on his museum
1827 Dies, aged 86

◀ The Exhumation of the **Mastodon** *The most celebrated exhibit in Peale's Museum was the first complete skeleton of an American mastodon. This painting depicts its excavation in 1801.* 1806, oil on canvas, 50 x 63in, Peale Museum, Baltimore, US

▶ **George Washington at Princeton** *Regarded as the definitive image of Washington at the height of his military career, this optimistic portrait was widely acclaimed.* 1779, oil on canvas, 92 x 58in, Pennsylvania Academy of the Fine Arts, Philadelphia, US

◀ **Self-Portrait with Angelica Peale and Portrait of Rachel** *This complex self-portrait includes Peale's wife, Rachel, and his daughter, who is depicted as an allegorical muse of painting.* c1782–85, oil on canvas, 36¼ x 27¼in, Museum of Fine Arts, Houston, US

Gilbert **Stuart**

b **SAUNDERSTOWN, RHODE ISLAND, 1755**; d **BOSTON, 1828**

Portrait by Charles and Rembrandt Peale

One of the outstanding portrait painters of his time, Gilbert Stuart painted virtually all the leading figures of the American Federal era. He is credited with creating a distinctively American style of portraiture, and his work is known for its fluent brushwork, brilliant characterization, vitality, and down-to earth naturalness.

Stuart trained and worked in London under Benjamin West, and also spent time in Scotland and Ireland. In 1793 he returned to the States, where he made a name for himself. He is best known for his portraits of George Washington, and his work strongly influenced the work of younger artists.

◀ **Portrait of a Young Woman, c1802–04** *Benjamin West praised Stuart for "nailing a face to the canvas." Stuart succeeds in creating a spontaneous-looking pose, as if the sitter has just looked up from writing a letter, and captures the dewy fleshtones of a fashionable young woman.* c1802–04, oil on canvas, 97 x 58in, Indianapolis Museum of Art, US

John **Trumbull**

b **LEBANON, CONNECTICUT, 1756**; d **NEW YORK, 1843**

Engraving by S.L. Waldo

Artist, author, soldier, and diplomat, John Trumbull is famous for painting the key events and people of the American Revolution. After graduating from Harvard, he worked as a teacher and Revolutionary soldier.

He made several visits to London, studying there for a time with Benjamin West. In 1817, he was commissioned to paint four large murals for the Rotunda in the Capitol, in Washington, showing "the most important events of the American Revolution." They include a version of his most famous work, *The Declaration of Independence*.

▼ **The Declaration of Independence** *Trumbull's iconic painting is one of the most reproduced images in American art, and has even appeared on the back of a two-dollar bill. Most of the people featured were painted from life.* 1786–1820, oil on canvas, 20¾ x 31¼in, Yale University Art Gallery, US

When Manchu forces seized power from the Ming in 1644, they founded what was to be the last, and perhaps greatest, Chinese dynasty. To avoid the unpopularity that dogged the Mongols of the short-lived Yuan Dynasty, Qing emperors did not impose an alien culture, but gained general acceptance by becoming almost completely sinicised (brought under Chinese influence). In this way, they ruled over a prosperous empire until the mid-19th century, when food shortages, natural disasters and a corrupt civil service precipitated their decline.

▲ **Man's Robe** *The rise of an affluent merchant class alongside the Qing imperial courts stimulated demand for fine crafts such as textiles, ceramics, jade and metal work as well as the fine arts. This full length, exquisitely decorated robe is made from satin silk and dates from the first quarter of the 18th century.*

wealthy merchants in southern China. Crafts too were thriving, but became geared to mass-production rather than artistic excellence as the empire grew, especially in ceramics.

Styles and techniques

The Qing emperors were however conservative in their artistic tastes, and the Huayuan chu, the official painting academy, advocated traditional styles following the classically inspired Ming masters. As a result, especially in the early Qing period, an Orthodox school of mainly landscape painters predominated, but other groups of individualist artists emerged outside the capital, including some who had connections with the Ming emperors and harbored some anti-Qing tendencies.

Under the Qing Dynasty, China became the largest and richest empire in the world, and peace and prosperity allowed the arts to flourish. Although ethnically Manchu, Qing emperors embraced and actively promoted Chinese culture, establishing artistic institutions and encouraging patronage.

Origins and influences

Economic success from the expanding Qing empire resulted in increased patronage of the arts: not only in the courts of the Kangxi (1662–1722), Yongzheng (1723–35), and Qianlong (1736–96) emperors in Beijing and the official painting academy they sponsored, but also among the growing number of

China: Qing Dynasty

TIMEline

Between the founding of the Qing Dynasty in 1644 and the end of the century, the Orthodox School was established, led by Wang Shimin and Wang Jian, and later their protégés Wang Yuanqi, Yun Shouping, and Wu Li. Individualists, such as the Buddhist monk-painters and the Eight Masters of Nanjing, were also working at much the same time and in the 18th century the Eccentrics of Yangzhou emerged as an important school.

C17TH

WANG JIAN Landscape with mountains, rivers and huts among trees

1689

WANG HUI The Kangxi Emperor on His Southern Inspection Tour

C17TH

YUN SHOUPING Lotus flower

C17TH

GONG XIAN Snow covered landscape

C18TH

LI SHAN Chicken, Cockscomb, and Chrysanthemum

Development

Artistic life continued virtually uninterrupted in the changeover from Ming to Qing dynasties, largely because the Manchu rulers astutely founded institutions based on the theories of the Ming artist Dong Qichang. Although there was some anti-Qing feeling among the remaining Ming aristocracy, the continuity afforded by the Orthodox School ensured a stable, if conservative and derivative, artistic establishment which was tolerant of dissenting artists.

Schools and styles

Dong Qichang's theoretical Southern Tradition of painting was the model for the Orthodox School, and the so-called Six Masters of the Early Qing (the four Wangs, Yun Shouping and Wu Li) continued the tradition of landscape painting in the style of the literati rebels of the Yuan period, or in Yun's case resurrected an earlier genre of flower painting. This rather archaic,

◄ **Wang Shimin, Landscape After Huang Gongwang** *Landscape painters of the Orthodox School worked within the genre rather than introducing innovations.* Ink and colors on paper, 44⅞ x 62⅝in, The Minneapolis Institute of Arts, US

academic style was popular in the imperial courts and satisfied the patriotism of many conservative Chinese artists, but some rebelled against its restrictions. The four monks Bada Shanren, Shitao, Hongren and Kuncan, working in monasteries isolated from the prevailing orthodoxy, developed very personal and innovative styles influenced both by their Buddhist philosophy and antipathy towards the Manchu occupation; and in Nanjing a group of literati artists led by Gong Xian catered to the tastes of their more cosmopolitan new patrons. Most striking of all, however, were the eight "Eccentrics of Yangzhou," a group including Li Shan and Gao Xian that flourished in the 18th century, whose various expressive styles in mainly bird-and-flower or bamboo painting verged on abstraction and were totally at odds with the teachings of the Orthodox School.

▶ **Zhu Da, Landscape** *Outside Beijing and the imperial courts, individualist painters such as the Buddhist monk Bada Shanren rejected the imitative dogma of the Orthodox School, and developed new, sometimes subversive styles.* Pen and ink on paper, Musée Guimet, Paris, France

Wang Shimin

b TAICANG, JIANGSU PROVINCE, 1592; d 1680

The eldest of the four Wangs, Wang Shimin was a pupil of Dong Qichang, following his guidance for scholar-painters to adopt the style of the Yuan period masters. He was especially influenced by the work of Huang Gongwang. Illness forced him to abandon his career as an official in 1636, but he had already established a reputation as an artist, and continued to paint during his long retirement. Although his landscapes are often derivative of Yuan models, in his later work he developed a more personal interpretation of the style, producing some undoubted original masterpieces. His pupils included Wang Hui, Wu Li, and his grandson Wang Yuanqi.

▼ **Landscape in the style of Huang Gongwang (detail)**
Although adopting the style of his influence, Huang Gongwang, Wang Shimin avoided slavishly copying. He simplified the composition to the main elements and emphasised areas of light and dark. c17th century, ink on silk, 11 x 93¼in, Musée Guimet, Paris

Wang Jian

b TAICANG, JIANGSU PROVINCE, 1598; d 1677

A friend and near contemporary of Wang Shimin, but unrelated, Wang Jian was an enthusiastic supporter of Dong Qichang's theories, following the principles of the Four Masters of the Yuan and denouncing anything other than the Orthodox school as degenerate. He painted mainly landscapes, which despite being deliberately in the Yuan or even earlier traditions, have a unique style characterized by delicate brushwork and use of color. He gained an official post as a young man, but he retired early to concentrate on his painting and writing.

▶ **Landscape with mountains, rivers, and huts among trees** *Wang Jian painted a number of hanging scroll landscapes in archaistic styles, with similar themes and an almost formulaic composition. However his understanding of the underlying formal elements and elegant brushwork saves them from being merely imitative.* c17th century, hanging scroll, ink on paper, 3⅞ x 3⅛in

Wang Hui

b CHANGSHU COUNTY, JIANGSU PROVINCE, 1632; d CHANGSHU COUNTY, 1717

Described as the most talented of the early Qing Orthodox painters, Wang Hui studied under Wang Jian and Wang Shimin, but where they emulated classical traditions along the lines of Dong Qichang's theoretical Southern School, he sought to combine and transform the styles of all the Song and Yuan masters. Nevertheless, he remained their protégé even when he had established his own career, and after their deaths his work became less versatile without their encouragement. Like most of the Orthodox artists, he was primarily a landscape painter, but collaborated with his contemporary Yun Shouping on several albums of alternate landscape and flower pictures.

Wang Yuanqi

b TAICANG, JIANGSU PROVINCE, 1642; d 1715

The youngest of the four Wangs of the Orthodox school, Wan Yuanqi was also possibly the most conforming in following the literati tradition as laid down by Dong Qichang. He was the grandson of Wang Shimin, who recognized his exceptional talent at an early age and became his mentor, encouraging his studies of the classical landscape artists. As well as being a talented painter, Wang Yuanqi had a successful career as an official under the Kangxi emperor, and was also a leading member of the Hanlin Academy, where he was known as an influential art theorist. He saw his paintings, almost exclusively landscapes, as part of a long but evolving tradition. His personal interpretation of the principles of the old literati masters was a continuation of the line stretching back to Wang Wei in the 8th century.

▼ **Wooded Islands** *Not content to merely imitate the classical masters, Wang Yuanqi combined elements from various periods to create a truly original style. In* Wooded Islands, *for example, he incorporates the blue and green colors associated with Tang landscapes with the elegant, calligraphic brushwork of later periods.* c17th century, ink on paper, The Barnes Foundation, Merion, Pennsylvania, US

◀ **Autumn Mountains**, *While broadly following Dong Qichang's code of working within the tradition of the Southern literati, Wang Hui's aim was a "Great Synthesis," incorporating the calligraphic brush techniques of the Yuan masters into the narrative formal composition of Song landscape style.* c18th century, pen and ink on paper, Musée Guimet, Paris, France

❝ ... if one considers the **wonders of brushwork**, then landscape cannot **equal painting** ❞
DONG QICHANG (1555–1636)

◀ **The Kangxi Emperor on His Southern Inspection Tour (detail)** *After reinforcing his control over the former Ming territories, the Kangxi emperor recruited Orthodox southern literati and made an inspection tour of the area. Wang Hui was called to oversee the production of monumental commemorative handscrolls.* 1689, handscroll, ink and color on silk, 26¾ x 61½in, Musée Guimet, Paris, France

▲ **Landscape After Wang Meng (detail)**
One of four hanging scrolls in the style of the Yuan master, this landscape is executed in the appropriate monochrome style, but is more homage than imitation. Part of Yuanqi's theory of painting was to capture the "dynamic force" of a scene rather than reproduce it. 1702, ink and light color on paper, 40½ x 18⅞in, Kyoto National Museum, Japan

Wu Li

b CHANGSHU, JIANGSU PROVINCE, 1632; d 1718

A close friend of Wang Hui and fellow student of Wang Shimin and Wang Jiang, Wu Li also studied literature and poetry and was the archetypical cultured literatus envisaged by Dong Qichang for the Qing Orthodox School. However, unlike other literati, he converted to Christianity in 1681, after studying Confucianism, Daoism, and Buddhism, and later became a Jesuit priest. His various religious and philosophical leanings seem not to have influenced his painting—he worked in the traditional Chinese style of the Orthodox artists, taking the Song and Yuan masters as his model. Huang Gongwang was his main influence as a young man, but in his mature work he adopted and combined techniques from all of the four Yuan masters, and despite his Catholicism in later life, had little time for Western art.

▲ **The Lute Song (detail)** *Painted in Macao, the Portuguese colony where Wu was baptized as a Catholic, The Lute Song expresses his nostalgia for Chinese culture and shows no European influence. Its subject is a poem from the Tang period by Bo Juyi which tells of an exile being reminded of home by the sound of a lute.* 1681, handscroll, ink and colors on paper, 9¾ x 39½in, Herbert F Johnson Museum of Art, Cornell University, US

Zhu Da

b 1626, NANCHANG, JIANGXI PROVINCE; d 1705

A descendant of the Ming prince Zhu Quan, Zhu Da fled from his native Nanchang when the Manchu invaded in 1644, and sought refuge in a Buddhist temple. As well as becoming a respected monk and eventually an abbot, he was known as a poet and painter, and after the death of his Buddhist master left the temple to become an itinerant monk and artist. An emotionally unstable man and bitterly opposed to the Manchu dynasty, he suffered a breakdown in 1680, burning his monk's robes and devoting himself to painting. He painted mainly flower and bird pictures in an increasingly abstract calligraphic style, and often with sarcastic and seditious references to the Qing dynasty.

◀ **Birds on a Lake Rock** *By 1690, Zhu Da had moved away from the very realistic, detailed style of his early work and stripped his composition down to a minimum of skillful brushstrokes. Here the subject is suggested by simplified lines and shapes, with abstract rather than representational significance.* 1690, ink on satin, 51½ x 18½in, Indianapolis Museum of Art, US

▶ **Lotus, Homage to Xu Wei** *Zhu Da's radical attitude to art had some precedence in the work of Xu Wei, a similarly unstable Ming dynasty painter. This homage was as much political as aesthetic and demonstrates a range of brush techniques.* c1689–90, ink on paper, 73¼ x 35½in, Museum of Fine Arts, Boston, US

Yun Shouping

b WUJIN, JIANGSU PROVINCE, 1633; d 1690

Brought up in a family of prominent artists, Yun Shouping became one of the masters of the Qing Orthodox school, best known for his painting of flowers. After moving to Jianning as a child, he was separated from his family and adopted by an invading Manchurian general, but reunited with his father by chance after the general's assassination. He then studied painting, calligraphy, and poetry, but on seeing the landscapes of his friend Wang Hui felt he could not match their excellence and realised that his talent lay elsewhere. Consequently, he decided to concentrate on flower painting, specifically in the "boneless" style (without ink outlines) that originated with the 10th-century master Xu Chongsi, and established a school of painting in Changzhou.

▼ **Lotus flower, from an Album of Flowers** *Yun revitalised the art of Chinese flower painting by resurrecting the ancient "boneless" technique, without inked outlines. With subtle variations of tone and watercolor washes, rather than carefully detailed ink brushwork, he introduced a freshness and expressiveness enhanced by a striking use of color.* c17th century, watercolor on silk backed paper, Osaka Museum of Fine Arts, Japan

283

17TH AND 18TH CENTURIES

Shitao

b GUILIN, GUANGXI PROVINCE, 1642; d YANGZHOU, JIANGSU PROVINCE, 1707

A member of the imperial Zhu family of the Ming Dynasty, Shitao was taken by a family servant to a monastery to escape the Manchu invasion, and adopted the life of an itinerant Buddhist monk. He became an accomplished calligrapher and painter and developed a very personal style integrating an influence of Classical and Buddist masters, and later Daoist teachings. In the last years of his life, he wrote a treatise, *Huayu lu (Remarks on painting)*, which systematically explained his theories of art, and showed his contempt for the Orthodox school's slavish imitation of previous eras.

▲ **Returning Home** *Opposed to the imitative ethos of the Orthodox school, Shitao was innovative in his painting. His landscapes show a very personal style of calligraphic brushwork and a subjective approach to composition. From an album of 12 paintings,* c1695, ink and color on paper, each painting: 6¾ x 4¼in The Metropolitan Museum of Art, New York, US

▲ **Mountain Landscape, after Huang Gongwang** *In the 1670s Shitao lived in a temple in the mountains of Anhui Province that had provided inspiration for generations of painters. Here, he has adopted the linear style of the Ming painters, but also found inspiration in the work of Huang Gongwang of the Yuan period, a Daoist who also rebelled against an alien occupation.* 1671, pen and ink on paper, 34 x 16⅛in, Musée Guimet, Paris, France

Hongren

b SHE XIAN?, ANHUI PROVINCE, 1610; d SHE XIAN, 1664

The leading master of the Anhui school, Hongren, became a Buddhist monk in 1646 during a brief exile from his native province following the Qing invasion. When he returned to She Xian, he adopted the life of a monk-artist living in monasteries in Anhui and made several visits to the Mt. Huang region. He was an influential artist and scholar, painting landscapes in the manner of the Yuan masters Ni Zan and Huang Gongwang, but in the 1650s developed a distinctively angular style which can be seen in all his later work.

▶ **Monumental Landscape** *Hongren was much influenced by the sparse style of the Yuan master Ni Zan, making it popular among the Anhui school painters. Combining Ni Zan's use of empty space with his own light brushwork and jagged, linear style, he achieved an impressive sense of depth and perspective.* 1662, ink on paper, 116 x 40¼in, Indianapolis Museum of Art, US

Kuncan

b CHANGDE, HUNAN PROVINCE, 1612; d NANJING, JIANGSU PROVINCE, 1673

Along with Shitao, Zhu Da, and Hongren, Kuncan is considered one of the four Great Monk Painters of the early Qing period. He originally studied to become a civil servant, but became increasingly interested in Buddhism and painting, eventually giving up his career to move to Nanjing in search of enlightenment. After the Manchu occupation, he took up a traveling lifestyle lasting some ten years before settling to life as a monk-artist, first in a temple in Nanjing, then, in 1659, at the nearby Youqi Temple on Mt Zutang. This marked the beginning of his most productive period as a painter, in which he developed his lively landscape style inspired by Huang Gongwang and Wang Meng.

▼ **Winter** *One of four scenes depicting the seasons, Winter was painted at the request of the scholar Qingxi and rather than depicting a particular location, is an expression of Kuncan's personal recollection. The colophon (calligraphy) explains, "I have merely noted a little of the atmosphere and flavor."* 1666, handscroll, ink and color on paper, British Museum, London, UK

Gong Xian

b KUNSHAN, 1619–20; d NANJING, 1689

▲ **Snow covered landscape** *The apparent solidity of elements is achieved by tonal contrasts uncommon in Chinese art of the period, and possibly influenced by contact with Western art.* c17th century, ink and watercolor on paper, Oriental Museum, Durham University, UK

One of a family of Ming aristocrats, Gong Xian spent much of his life in exile following the Qing invasion, and refused to serve under the Manchu regime. He made his living as a painter and poet in the tradition of the literati artist–scholars, becoming the influential leading light of the Nanjing school. Gong's landscapes were markedly different from those of his contemporaries, rejecting linear, calligraphic brush techniques in favor of a more three-dimensional approach using tonal shading and emphasising the contrast of space and solid forms.

Zheng Xie

b XINGHUA, JIANGSU PROVINCE, 1693; d 1765

Despite being an orphan from a poor background, Zheng Xie had a successful career in the civil service, becoming Official Calligrapher and Painter to the Qianlong emperor until a corruption scandal in 1753 forced his retirement. He then devoted himself to poetry and painting, and as a prominent member of the Chinese painting group, Eight Eccentrics of Yangzhou, he lived comfortably on commissions and the income from his estate. Best known for his paintings of bamboo, rocks, orchids, and chrysanthemums, his style was highly personal, but inspired by the freedom of artists such as Xu Wei and Shitao.

◀ **Bamboo and Rocks** *Zheng was a skillful and innovative calligrapher, and incorporated elements of calligraphy into his painting, especially the depictions of bamboo. Here, composition and representation are less important than the expressive range of the individual brushstrokes, and the colophon (calligraphy) forms an integral part of the picture.* c1760, ink on paper, 67¾ x 39in, Minneapolis Institute of Arts, US

Li Shan

b XINGHUA, JIANGSU PROVINCE, 1686; d YANGZHOU, 1760

Although he received a classical education, including instruction in landscape painting in the Orthodox style, Li Shan had an erratic career in the civil service in Beijing, regularly interrupting it to concentrate on his painting, both in his home town Xinghua, and Yangzhou. He studied with the finger-painter Gao Qipei and was inspired by the freedom of the Buddhist masters Shitao and Zhu Da, soon turning his back on Orthodox landscapes and becoming one of the Eight Eccentrics of Yangzhou. In the 1740s he retired from public service completely, earning his living from sales of his mainly bird and flower paintings.

▶ **A Chicken, Cockscomb, and Chrysanthemum** *Li Shan's exuberant painting style, characterised by lively and spontaneous brushwork, is made even more unique by his sensitive use of color washes. Like other members of the Yangzhou school, he rejected Orthodox principles of imitative landscape painting in favor of a more intimate and expressive style.* c18th century, handscroll, ink and color on paper, 61 x 20⅛in, private collection

Fifteen generations of Shoguns from the Tokugawa family ruled Japan for 250 years after Tokugawa Leyasu defeated his enemies in the decisive battle of Sekigahara in 1600. He moved the seat of government from Kyoto to Edo (the present day Tokyo).

Origins and influences

The Tokugawa Shogunate controlled the country with strict rules and social orders. The class system according to Confucian principles was structured from four categories. At the top of society were the samurai warriors. The second category was the farmers who produced food. Then came artisans who made useful objects. At the bottom of the social ladder were merchants who earned their living by simply exchanging goods with money.

▲ **Pair of Hexagonal Kakiemon Vases and Covers**
17th-century Japanese porcelain was avidly collected by European royalty and aristocrats for its high quality. The bright enamel decoration on a milky white body directly inspired the development of European porcelain at Meissen.

Subject matter

Although condemned to the lowest class, merchants enjoyed the wealth generated from their business. They became the main participants of the so-called "Floating World," the urban community of lively Kabuki (dance and drama) theater and the pleasure quarters. The name "Floating World"

was originally a Buddhist term, denoting the transient nature of human life, but in the Edo period it began to mean seeking a fleeting pleasure in this exciting and sensuous world. The visual culture associated with the group flourished, and a large number of men from the samurai class were drawn to it too.

Christianity was seen as a threat to Japanese autonomy and was banned in 1617. All Europeans were expelled from Japan, and the Tokugawa government enforced the official policy of isolation. In the 17th and 18th centuries, contact with the outside world was limited to Dutch Protestant and Chinese merchants. No Japanese were allowed to travel abroad, but this policy did not prevent the export of Japanese porcelain and lacquer wares to Europe, or the import of western books and scientific materials, as well as Chinese goods, into Japan.

The peace brought about by stable rule during the Edo period (1615–1868) encouraged trade and industry, which in turn createdeconomic prosperity. Against this backdrop, secular art and culture flourished.

Japanese art

Kano **Tan'yu**

b **KYOTO, 1602**; d **KYOTO, 1674**

Artists from the Kano School served as official painters to the Shogunate throughout the Edo period. Kano Tan'yu, the grandson of Kano Eitoku (see p.189), was one of the most successful painters of the day. He was named an official painter at the age of 15. He undertook many important commissions to decorate Shogun castles and residences, painting the subject matter that reflected the ideals and authority of the rulers. Tan'yu continued the family tradition of large dynamic paintings on gold leaf, and excelled at painting animals and themes from Chinese classical tales. He was also a collector and connoisseur of classical Japanese and Chinese paintings, and left a large number of sketches of the works he had been asked to authenticate.

▲ **Scholar Viewing a Lake**
The ideal landscape inspired by the Chinese style ink painting continued to be popular during the Edo period.
c17th century, ink and color on paper, 34¼ x 49¼in, Indianapolis Museum of Art, US

CLOSERlook

COPYING THE MASTER Artists of the Kano School studied trees and rocks from a model painted by the master, rather than from nature, ensuring the tradition of the Kano style continued.

Tawarayo **Sotatsu**

active **1600–40**

Tawaraya Sotatsu started his career as a painter of fans and owned a shop in Kyoto. From the 1610s, he collaborated with Hon'ami Koetsu, who established a commune of artisans in Takagamine in the northern hills of Kyoto. The innovative and decorative style of their works catered for the taste of sophisticated urban consumers. In his later years, Sotatsu revived the colorful traditional Japanese painting (yamato-e) style. He produced large scale paintings on gold screens with themes taken from classical literature such as the *Tale of Genji*. Sotatsu's painting is characterized by his strong sense of design with highly stylized motifs.

▼ **Scroll of Classical Poems (detail)** *Calligraphy by Koetsu is decorated by Sotatsu with flying cranes. The combination of black ink and simplified motifs in gold and silver makes a distinctive design.* c1615, ink, silver, and gold on paper, Kyoto National Museum, Japan

▶ **Setting out for Kawachi, from the Tale of Ise** *Sotatsu illustrated scenes from the classical* Tale of Ise, *which relates the journey of a courtier who was banished from the capital.* Early 17th century, 9⅝ x 8¼in, album leaf, ink, and color on paper, Indianapolis Museum of Art, US

Ogata **Korin**

b KYOTO, 1658; d KYOTO, 1716

Together with his ceramicist brother Kenzan, Ogata Korin created the decorative and elegant style of art that reflected the taste of the wealthy merchant class in Kyoto in the early years of the 18th century. Their father had a textile shop called Kariganeya, which supplied luxurious *kimono* to the members of the imperial family. Korin's flair for design was probably nurtured in such an environment, surrounded by rich and beautiful materials from a young age.

Korin was inspired by the works of Sotatsu (see p.285), and adopted themes from classical Japanese literature just as Sotatsu did. He also studied Sotatsu's painting techniques by copying his work, and adapting it to develop his own distinctive style. Korin was primarily a painter, but also designed lacquer wares and textiles as well as collaborating with his brother to decorate ceramics. His masterpieces display his love of simplified forms and bold composition. He was also notorious for his extravagance, and is said to have once wrapped food in gold leaf for a picnic, discarding the wrappings afterward. Korin's works inspired a group of artists in Edo in the early 19th century, and the style is today known as "Rimpa" (School of Rin).

LIFEline

1658 Born to a family of wealthy textile merchants in Kyoto

1690s Inherits the business after his father's death, but squanders the family fortune with his flamboyant life style

1704 Moves to Edo to seek the patronage of *samurai*

1710 Returns to Kyoto

1716 Dies in modest circumstances

▼ **Lacquer Box** *As with the* Irises *screens, the theme for the lacquer box comes from an episode from the* Tale of Ise. *The design incorporates the* Yatsuhashi *(Eight-plank bridge), applied with large pieces of lead on top of the gold and black lacquer. Height 5½in*

CLOSERlook

MOTHER-OF-PEARL
The irises are inlaid with mother-of-pearl. The contrast between the iridescent flowers and the dark lead bridge creates a bold design typical of the Rimpa style.

◄ **Irises** *The theme is thought to come from the Heian period* Tale of Ise, *in which the hero travels to a place famous for its beautiful irises. c1700, pair of six-panel screens, color and gold on paper, each 60 x 134in, Nezu Institute of Art, Tokyo, Japan*

Hishikawa **Moronobu**

b AWA, 1618; d EDO, 1694

Hishikawa Moronobu started his working life in the province of Awa drawing designs on textile for his family business of embroiderers. He moved to Edo in the 1660s and illustrated over 150 books, becoming one of the most popular illustrators of the Edo publishing world. He is credited with the invention of single-sheet prints without text, depicting the pleasure quarters and the everyday lives of common people in Edo.

His prints are mostly inexpensive black and white, but he colored some by hand, probably for particular patrons. He was also the first artist to sign his prints, raising the status of print designer to that of artist. Moronobu is considered to be the father of *ukiyo-e* (woodblock) prints and his works greatly contributed to the popularity of the genre.

INcontext
UKIYO-E **(WOODBLOCK PRINTS)**
The technique had been used in Japan for producing Buddhist texts since the 8th century, but the enormous popularity of secular illustrated books encouraged the development of single-sheet prints in the 17th century.

Teamwork *Ukiyo-e prints were produced by the collaborative efforts of the artist (designer), woodblock carver, printer, and publisher.* Block Cutting and Printing Surimono *by Katsushika Hokusai, 1825, Fitzwilliam Museum, Cambridge, UK*

◄ **Music under the Cherry Tree at Ueno** *Moronobu's single-sheet prints of genre scenes were cheap so even townspeople of modest means could own and enjoy works of art. Moronobu established the Hishikawa school and his followers continued to produce popular prints in his style. c1680, woodblock print, Fitzwilliam Museum, Cambridge, UK*

Okumura **Masanobu**

b EDO, 1686; d EDO, 1764

Masanobu was a talented, energetic print designer who experimented with new formats and techniques throughout his long career. He was also a successful publisher who vigorously promoted his own works. He claimed to be the inventor of *hashira-e* ("pillar prints" in a tall, thin format, suitable for displaying on pillars) but is best known for his *uki-e* (floating pictures), which used Western perspective.

All woodblock prints were monochrome at first, but Masanobu produced a variety of hand-colored prints on subjects as diverse as beautiful women, actors, birds and flowers, and interior scenes. From around the 1740s, he succeeded in producing so-called *benizuri-e* (rose-printed pictures), which included pink and green colors.

▲ **Interior of a Kabuki Theater** *Masanobu's uki-e prints used Western linear perspective to give depth of space. They were enormously popular with the Edo public, who were always eager to see a novel image. c1745, woodblock print, 17¼ x 25in, British Museum, London, UK*

Suzuki **Harunobu**

b **EDO, 1725**; d **EDO, 1770**

In 1765, the invention of full-color *nishiki-e* prints (brocade pictures) was a major innovation in the art of woodblock printing. Suzuki Harunobu is credited with producing the first *nishiki-e* when he was commissioned to design a multicolored picture calendar for the members of a poetry club to distribute as a New Year gift. It was so successful that Harunobu immediately embarked on commercial production of *nishiki-e*. He designed hundreds of colorful genre scenes in the next five years until his death in 1770. Harunobu's favorite subject matter was beautiful young girls with delicate features, slender figures, and dainty little hands. He was also fond of the *mitate* form, in which scenes from famous Noh plays or ancient tales were shown in contemporary settings.

▶ **Osen of the Kagiya Serving Tea to a Customer**
Osen was a famous beauty who worked in the tea shop by Kasamori Shrine in downtown Edo. Harunobu's women are all idealized and look like pretty dolls. c1767, polychrome woodblock print, 10¾ x 7¾in, British Museum, London, UK

Toshusai **Sharaku**

DATES UNKNOWN

Sharaku is one of the most enigmatic *ukiyo-e* artists. Virtually nothing is recorded about his life. The success of his striking bust portraits of Kabuki actors thrust him into the limelight in the spring of 1794, but he disappeared completely from the scene after 10 months. In that short period, he produced about 150 designs, almost all of Kabuki actors. Some of these portraits were not very flattering, but brilliantly captured the essence of their character.

▲ **Actor Segawa Tomisaburo** *All actors in the popular Kabuki theater were male. This print depicts a female impersonator, bedecked in a gaudy costume with elaborate hair ornaments.* 1794, polychrome woodblock print, 14¾ x 9½in, British Library, London, UK

▲ **Actor Otani Oniki** *The actor is caught in mid-movement. The gray background is sprinkled with mica dust, which glistens in the light.* 1794, polychrome woodblock print, 14¾ x 9½in, British Library, London, UK

Kitigawa **Utamaro**

b **MUSASHI PROVINCE, 1753**; d **EDO, 1806**

One of the greatest *ukiyo-e* designers in the late 18th century, Kitagawa Utamaro was the foremost artist in the genre of *bijin-ga* (pictures of beautiful women). Under the guidance of his mentor Tsutaya Juzaburo, the most successful publisher of the day, Utamaro first came to prominence with his fine illustrations of nature.

From about 1792, Tsutaya published many series of women's portraits designed by Utamaro. *Okubi-e* (large-head prints) showed only the upper half of a woman's figure. Utamaro depicted women from all social backgrounds including prostitutes and respectable wives. He captured both physical and psychological characteristics.

After Tsutaya died in 1797, Utamaro's life turned downhill. He was arrested for publishing a banned political image. The punishment was three days in jail and 50 days in handcuffs, which directly contributed to his ill health and death in 1806.

LIFEline

1753 Born in Musashi

1780s Discovered by publisher Tsutaya Juzaburo

1789 Designs illustrations for *Book of Shells* and other poetry books

1792/3 Publishes *Ten Studies in Female Physiognomy, Great Love Themes of Classical Poetry*, and other series

1804 Imprisoned for publishing a print of Hideyoshi, the historical figure of a former ruler

1806 Dies in despair

▲ **Lovers from the series Poems of the Pillow** *The technique of polychrome printing reached its peak in the 1780s and 90s. Utamaro conveys the fine texture of the transparent material in this erotic image.* c1789, polychrome woodblock print, 10 x 14¾in, Victoria and Albert Museum, London, UK

CLOSERlook

EROTIC OVERTONES
The back of a woman's neck was considered a sexy sight. Eroticism is expressed in this image without being explicit. Utamaro's attention to detail can be seen in the minute lines of the hairline.

◀ **Three Beauties of the Present Day** *The print is inscribed with the title and the names of three women famed for their beauty in the top right corner on a pale mica background. The publisher's seal and Utamaro's signature are on the left. The women's faces look similar at first but, on closer inspection, each can be identified from the shape of their nose and the motifs on their kimono.* c1793, polychrome woodblock print, 13¾ x 9¾in, Museum of Fine Art, Boston, US

In the 17th and 18th centuries, Islamic art reached a peak of excellence in three great empires: the Ottomans, Safavids, and Mughals. Some of the finest Islamic architecture dates from this period, and ceramics and the art of the book also flourished.

After an age during which the Islamic world was ruled by many disparate dynasties and invaders, such as the Mongols, there followed a period of stability under the three empires that emerged in this region in the early 16th century.

The first of these, the Ottoman Empire, stretched from Turkey to Tunisia, while the Safavid Empire ruled in Iran, and the Mughals in India. The arts thrived in the prosperity of these empires, developing a distinctive regional style.

Origins and influences

In Turkey and Persia, there was already a long Islamic artistic tradition, in architecture and the decorative arts in particular, and under the Ottomans and Safavids they continued to flourish. However, other arts also became important.

The arts of the book were adopted for secular themes, for example, and illustration of manuscripts prompted the beginnings of a mainstream Islamic tradition of representational art. Crafts such as ceramics, textiles, paper, and jewelry were also important means of artistic expression across the Islamic world. The artistic developments of each empire influenced those of its neighbors, but as well as this "cross-fertilization" the influence of Chinese porcelain and decoration can be seen in Turkish and Persian ceramics, and Mughal illustration shows elements of both European and Hindu art.

◄ **Madrasa-yi Madar-i Shah, Isfahan, Iran, early 17th century** *Art and achitecture of unsurpassed magnificence can be seen in the mosques and palaces of cities such as Isfahan and Istanbul, and the Mughal Taj Mahal (see p.291).*

Islamic art

Ottoman

TURKEY TO TUNISIA, c1300–1932

The longest surviving of the Islamic empires, the Ottoman era saw Turkey emerge as a major center of Islamic art. Its architecture, based on Byzantine models, came to international prominence in the work of Sinan (1489–1588), whose 50-year career included the Selmiye Mosque in Edirne and the Suleiman Mosque in Istanbul, and his apprentices went on to build Istanbul's famous Blue Mosque and the Taj Mahal in Mughal India.

Turkey became famous too for fine ceramics and crafts such as jewelry, carpets, and paper marbling. Influenced by Persian manuscript illumination, artists also created illustrated books, such as the two "books of festivals."

▲ **Jug with red decoration** *The Turkish town of Iznik became a center of ceramic production in the Ottoman Empire, famous for the distinctive "Iznik red" used in painted decorations.* Turkish School, 16th century, earthenware, Hanley Museum & Art Gallery, Staffordshire, UK

◄ **Tile with two parrots** *Complementing the magnificent Ottoman architecture, Turkish ceramicists produced decorated tiles as well as pottery. These were often finely decorated with geometric designs featuring floral, vegetal, and animal motifs.* Turkish (Iznik), 17th century, ceramic tile, Fitzwilliam Museum, University of Cambridge, UK

▲ **The Forces of Suleyman the Magnificent Besieging a Christian Fortress** *Manuscript illumination under the Ottoman Empire, influenced by Safavid art, evolved into an art of book illustration, generally on historical themes depicting the exploits of Emperors such as Suleyman I and the expansion of the Empire.* From the Hunername by Lokman, 1588, gouache on paper, Topkapi Palace Museum, Istanbul, Turkey

Safavid

IRAN, c1501–1786

The Safavid Empire differed from the Ottomans and Mughals in several respects: importantly, its Shahs were Shi'a rather than Sunni; and as well as a strong artistic tradition dating back to pre-Islamic times, it had absorbed many Chinese and Mongol elements after the conquests by Timur in the 14th century. Between 1501 and 1786 (when the Safavids lost power to the Qajar dynasty) Persia enjoyed a Golden Age of artistic achievement. In cities such as Isfahan, architecture flourished under Shah Abbas the Great, and the ceramic industry thrived, inspired by Chinese porcelain. However, the finest art was to be found in illuminated manuscripts of secular narrative poetry, particularly Ferdowsi's epic *Shahnameh*. As with Persian miniatures, these book illustrations incorporated elements of Central Asian art, marking the start of a new style of representational painting within Islamic art.

▼ **The Persian Prince Humay Meeting the Chinese Princess Humayun in a Garden**
The Timurid dynasty in the 15th century produced fine manuscript illustrators, who worked for aristocratic patrons. Iranian, Timurid School, c1450, gouache on paper, Musée des Arts Décoratifs, Paris, France

▲ **Ceiling of the Palace of Hasht Behesht (Eight Paradises)** *When Isfahan became capital of the Safavid dynasty, Shah Abbas I initiated a massive program of building. The domed palaces and mosques built in the following two centuries featured huge spaces and were lavishly decorated with mosaic.* Safavid dynasty, 16th–17th century, Isfahan, Iran

▲ **Princess Sitting in a Garden** *The Islamic restrictions on representational art did not apply to secular buildings, which in addition to traditional mosaic and arabesque decoration, were adorned with paintings similar in style to Persian book illustration.* Safavid Dynasty, 17th century, fresco, palace of Chehel Sotun ("40 Columns"), Isfahan, Iran

▲ **Zal Being Rescued by the Mythical Simurgh** *from a copy of Shahnameh. Individual illustrations were considered as works of art in their own right, and were later collected in albums known as muhaqqa.* Safavid Dynasty, late 16th century, gouache and watercolor on paper, Chester Beatty Library, Dublin

CLOSERlook

ORIENTAL INFLUENCES
The delicately detailed depiction of the flowers and trees shows an eastern influence, in contrast with the distinctively Islamic portrayal of geometric architectural features and decorative calligraphy.

Mughal India

INDIA, 1526 – 1707

Babur founded of the great Mughal dynasty in Delhi in 1526. He was a poet and warrior king descended from Tamerlane, the Turco–Mongol conqueror of West and Central Asia. In India, Mughals continued the tradition of building mosques, palaces, and majestic tombs that had been started 300 years earlier. The Mughals brought perfection to this art, the culmination of a long Islamic tradition that became more and more rooted in the rich and older indigenous culture. Each Mughal ruler constructed a grandiose new capital and graced the empire with the breathtaking beauty of royal tombs like the Taj Mahal at Agra.

Mughal architecture was born from a mixture of Persian, Turkish, and Indian traditions, but in painting the Persian influence was more direct. The second Mughal, Humayan, was forced into Persian exile, but when he returned to India in 1555 he brought two Persian masters, Mir Sayyid Ali and Abd al-Samad, to establish a Mughal atelier. Humayan died suddenly, but his 14-year-old son Akbar not only extended and consolidated the empire, he set about creating the dynastic archives. The *Akbar-nama* (*Book of Akbar*), written in Persian by Abu'l Fazi recorded his military triumphs and heroic exploits. Akbar's first surviving child became emperor Jahangir. The 5th Mughal, Shah Jahan, traveled all over the empire with his third wife, Mumtaz Mahal, rather than be separated from her. On her death he created the perfectly proportioned Taj Mahal—an elegy in white marble to his beloved wife. His conciliatory attitude to the Rajputs and his fascination with their culture led to the Mughal innovations in art and architecture being rapidly reflected throughout the empire.

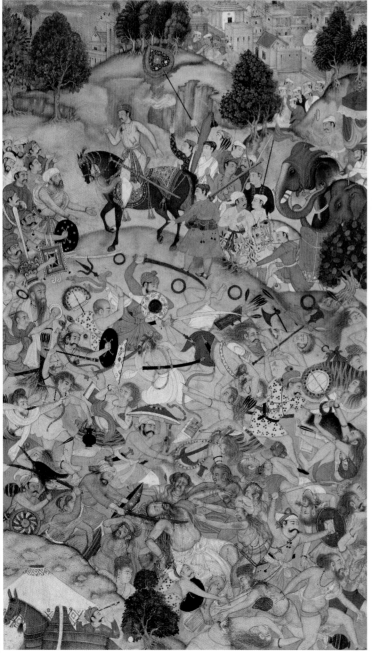

▲ **Akbar Tames the Savage Elephant, Hawa'i, Outside the Red Fort at Agra** *In a dramatic narrative painting from the* Akbar-nama *by Basawan and Chatai, Akbar keeps his hold on the charging elephant, Hawa'i, with an elephant hook as the demented animal crashes over a pontoon bridge of boats on leaving Agra, sending attendants diving into the Jumna River. This is the left-hand page of a double illustration. c1590, gouache on paper, 13½ x 8½in, British Museum, London, UK*

◄ **Akbar Assisting in the Quarrel of the Ascetics** Here, Akbar intervenes in an ascetics' quarrel in the Akbar-nama. *The organized chaos of the scene again shows the mastery of space in a condensed narrative painting by Basawan. c1590, gouache on paper, Victoria & Albert Museum, London, UK*

CLOSERlook

THE STRENGTH OF AKBAR The painting shows the moment when the matting rips and pontoon boats shoot out of the water as elephants dash across the river. Akbar, renowned for his strength and battlefield coolness, thrusts his feet under the neck strap and hangs on to the hook sunk in the elephant's hide.

▼ **Dying Inayat Khan** *The former paymaster of the imperial cavalry, Inayat Khan, was sketched in 1618 on Jahangir's orders after he was carried to the palace dying from addiction to opium and wine. In his memoirs, Jahangir recorded his astonishment at the deterioration in the once proud officer and close adviser. The sketch and subsequent painting are a unique realist record and a cruel portrait. An inscription on the edge of the painting in Jahangir's successor Shah Jahan's hand attributes the work to Balchand, a renowned Indian miniaturist (1596–1640) who had a long career in the Mughal atelier. 1618–19, ink and light wash on paper, 3¾ x 5¼in, Museum of Fine Arts, Boston, US*

▶ **Emperor Jahangir Holding a Portrait of Emperor Akbar**
Portrait painting was an important part of the Mughals' dynastic archive. This genre had been previously unknown in Persia and India. The early portraits are detailed, focused on courtly robes and jewelry and are often somewhat wooden. Here, Jahangir shows his affection for the new genre by having himself portrayed holding a portrait of his father, Akbar. 17th century, gouache on paper, Musée Guimet, Paris, France

▶ **Squirrels on a Plane Tree** *The red squirrels (not native to India) that race about a plane tree, depicted in autumn colors, attest to European influence in this celebrated piece by the renowned portrait painter by Abu'l Hasan. c1610, gouache on paper, 14¼ x 9in, British Library, London, UK*

▲ **Aurangzeb Hunting Lions** *The Mughal, Aurungzeb locked up his sick and aging father Shah Jahan in his Agra palace and seized the throne in 1658. Aurungzeb was a ruthless general and no patron of the arts. As a consequence, the masters of the imperial workshops soon dispersed to the surrounding Rajput courts. However, the dynastic portrait tradition lingered on as in this scene of Aurungzeb hunting lion. c1670–80, vellum, Chester Beatty Library, Dublin, Ireland*

INcontext

TAJ MAHAL The masterpiece of Mughal art, is the Taj Mahal at Agra. The tomb of Shah Jahan and his wife Mumtaz Mahal rises in perfect symmetry in a 1,000 square foot formal garden with sunken flower beds and raised marble tanks. Its shimmering white marble facades, inlaid with jasper, are crowned with a high bayed arch and a raised dome amid four elegant, towering minarets.

The Taj Mahal *The royal tomb completed around 1650 by Shah Jahan stands at the end of a canal that runs through a walled garden. Under the 200-ft dome, the royal tombs are set behind carved marble screens inlaid with precious stones.*

Islamic art and architecture had been steadily spreading across northern and central India for centuries before the Mughal Persian-Indian dynasty rose to power in Delhi. The Mughals began to reshape the landscape by building elegant palaces, new cities, and imperial tombs. These new developments drained much of the artistic resource from traditional Hindu art forms. However, in the south of India, beyond the reach of Delhi, the tradition of sculptured Hindu temple art continued to thrive in the 17th and 18th centuries.

Sacred art

Among the devotional cults that flourished many focused on Krishna, the powerful, playful, and amorous avatar (human incarnation) of Vishnu. While some were devoted to Hanuman, the monkey general who

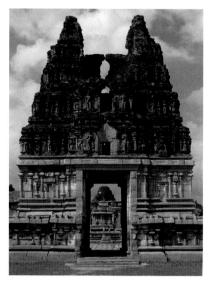

◀ **Vittala Temple** *Vijayanagara, often known by its older name Hampi, developed into the greatest capital in the south of India. Its scores of well-preserved temples and palaces make it one of the most important art and architectural sites in modern India.* 16th century, stone, Hampi, Karnataka, India.

helped Rama, another Vishnu avatar, recover his wife Sita from the demons on Sri Lanka. At festivals the major deities were installed in carriages and drawn through the streets. An innovation was carving portraits of donor kings in the carriage hall to

greet the deities as they exited and returned to the temple.

Further north, under the sway of the Mughals, Hindu sacred art still prospered in a tradition of miniature painting that hailed back to the illustrated covers of sacred palm-leaf manuscripts. This tradition blossomed among the small independent states below the Himalayas into lyrical, bucolic paintings of fresh, vital color and simple design known as Pahari and Rajput painting.

The traditions of Hindu art were revived in south India in magnificent temples like those at Vijayanagara in Karnataka and later at Madurai. In the north, the old purely Hindu miniature painting tradition burst into a final flowering in 17th-century Pahari and Rajput art.

Hindu art

Indian temple art

KERALA, c1790; TAMIL NADU, c1750

In the far south, the final wave of southern Hindu temple building was often centered on the revived cult of Vishnu and his avatars (human incarnations). After the Muslim kingdoms of the Deccan plateau crushed Vijayanagara in the west, their viceroys further south in Madurai proclaimed the independent Nayaka dynasty. In the 17th century they constructed large complexes with multiple sanctuaries behind multi-tiered ornate gateways. The gaudy colors of the gateways (or gopuras) and the somewhat muscled form of the deities indicate a more popular art than the graceful forms of deities achieved in the smaller Hindu temples of earlier centuries.

The monkey general Hanuman would usually be housed in a shrine outside Vishnu's main sanctuary, but in the southern state of Kerala he often stands alone as a monumental statue to ward off evil spirits. In Trivandrum he is honored with his own temple.

◀ **Meenakshi Temple** *One of the giant, elaborately sculpted gopuras (gateways) teeming with deities at Meenakshi, the great temple at Madurai, which was the principal shrine of the Nayaka emperors in the 18th century* 18th century, Madurai, Tamil Nadu, India

CLOSERlook

SHIVA AND PARVATI Shiva and his consort Parvati are depicted here in painted stone on the exterior wall of the southern gopura of the Meenakshi Temple. They are riding Shiva's white bull, Nandi "the happy one," who is a symbol of fertility.

▲ **Sri Hanuman Temple** *Hanuman, the monkey general, is given prominence on the roof of his own temple in the center of Trivandrum.* 1808, Trivandrum, Kerala, India.

Pahari painting

INDIA, c1700–1900

Pahari means "of the mountains" in Hindi, and the miniature paintings from the small states below the western Himalayas are full of fresh air, mountain fields, and woods painted in bright simple colors. In the Punjab hill states of Himachal Pradesh, Jammu, and Kashmir the favorite themes include Krishna's amorous exploits with the adoring gopis (cowherd girls), and Rama's dramatic rescue of his wife Sita, with a monkey army under Hanuman, from the demon-controlled island of Sri Lanka. Such marvelous narratives were underpinned by a passionate devotion to the universal Hindu gods, especially Krishna, in a growing religious pilgrimage movement. The origin of the Pahari genre remains mysterious. It suddenly appeared as a mature style in the mid-17th century and seems to owe something to the color and space already present in the art of the Rajasthani plains. When Delhi was sacked in 1739, Pahari art was boosted by the arrival of artists from the Mughal court, and the hill art blossomed into India's last pure Hindu art before the intrusion of European aesthetics that occurred in the 19th century.

▼ **Krishna Steals the Clothes of Gopis** *In this illustration from the* Bhagavata Purnana *Krishna steals the clothes of the gopis as they bathe at sunrise. The gopis are painted in flowing lines with charming naturalism as they emerge shyly and gracefully from the river.* 1780, medium, 10¾ x 14in, National Museum of India, New Delhi, India

◀ **Krishna Fluting for Gopis and Cows** *Krishna is depicted standing on a giant lotus flower that shows his divine nature. He plays his flute between two trees and brings the cows and gopis—each holding a lotus blossom in their hand—to a swoon.* 1700, watercolor and silver on paper, 6¼ x 9½in, Museum of Fine Arts, Boston, US

▶ **Having Coaxed My Lotus-Faced Girl to Come Toward the Bed, I Eagerly Prepare to Undo Her Bodice** *The more somber and formal tradition of the Basohli school of Pahari painting is seen in the darker colors here, but the content is romantic. This watercolor illustrates Krishna's seduction of his favorite gopi.* 1660–70, watercolor, Victoria & Albert Museum, London, UK

Rajput painting

INDIA, 1800–1900

The Rajputs were the rajas (princes or kings) who ruled small states in the plains of Rajasthan and other areas of northern central India that became dependencies of the central Islamic Mughal court in the 18th and 19th centuries. They generally maintained cordial relations with the Mughals and enjoyed autonomous Hindu courts based on military prowess, hunting, lineage, passion for music, and romantic art. Also important was a devotion to the Hindu gods, especially Krishna the enticing and powerful human form of Vishnu enacting his romance with Radha, a cowherd who rejected her husband in favor of Krishna. In their erotic entanglement, Radha represents the human soul uniting with Krishna as the Godhead. Epics and scriptures were no longer the preserve of the brahmins and entered mainstream daily life through popular *bhakti* devotional cults. Rajput art also benefited from the dispersal of the artists of Mughal Delhi in the 18th century, but whereas Mughal art was always realistic and politicized, Rajput (and Pahari) art was suffused with poetic metaphor and religious symbolism.

◀ **The Fight Between Arjuna and Karna** *The desert of Rajasthan shows through in the hot pink terrain of this battle between Arjuna and Karna from the Indian epic the* Mahabharata. *Dead soldiers and horses are heaped in the foreground in this painting from Bundi or Kota.* c1740, watercolor and gold on paper, 11 x 14½in, Museum of Fine Arts, Boston, US

▲ **Prince Hunting Antelope and Boar** *After imperial service, art, fashion, and religion, the pastime of the Rajputs was hunting. Here, a prince in a chariot hunts abundant antelope and boar in an idealized and luminous landscape of rolling green hills.* c1810, watercolor, 8¼ x 11in, Museum of Fine Art, Boston, US

CLOSERlook

COUNTRY LIFE The high walls of the city behind the hunting scene remind the viewer that the idyllic Rajput country life—imitating the grand style of the fabulous Mughal court in Delhi—was buttressed by a standing army for local feuds and strong defences.

Early in the 19th century Romanticism reached its peak.
Unlike the Neoclassicists, who promoted order and reason,
the Romantics believed in the power of the imagination,
emotion, and individualism. Much of their work focused on the
past but was typically set in the Middle Ages rather than classical
antiquity. They also created a distinctive form of landscape
painting in which the forces of nature were seen as an extension
of feelings and were often given a mystical, visionary role.

19th

1800

1825

ROMANTICISM c1790–1850

NAZARENES c1809–1830

NEOCLASSICISM c1750–1830s

EDO PERIOD (JAPAN) 1615–1868

Around the middle of the 19th century, Realism emerged in France as a reaction against French academic art. Instead of tackling noble themes, Realist artists painted the harsh conditions of rural life. In England, the Pre-Raphaelites tried to return to the simplicity of early Italian painting.

Inspired by the work of the Realists and Japanese woodblock prints, the Impressionists strove to capture the fleeting impressions of light in everyday scenes, using quick brushstrokes and flecks of pure color. The Neo- and Postimpressionists developed this technique, hoping to express feelings and ideas by distorting shapes and experimenting with color, line, and perspective.

Rejecting naturalism, the Nabis simplified forms and used flat areas of color to capture the "essence" of objects. Toward the end of the century the Symbolists created evocative, dreamlike works derived from literature or legends. Art Nouveau took Symbolist imagery, such as sinuous lines based on plant forms and pale, seductive women, and used it primarily for decorative effect.

century

REALISM c1850–1900

PRE-RAPHAELITES c1848–c1910

FRENCH ACADEMIC ART c1840–1900

MEIJI ERA (JAPAN) 1868–1912

IMPRESSIONISM c1870–1900

NEOIMPRESSIONISM c1885–1900

POSTIMPRESSIONISM c1880–c1905

NABIS c1890–1900

SYMBOLISM c1885–1910

ART NOUVEAU c1890–1914

Romanticism was a multi-layered movement that took many forms and affected most branches of the arts. It began in the late 18th century, and flowered most fully in the early years of the following century.

Origins and influences

One strain of Romanticism took its name from the old romances—the colorful tales of chivalry and honor that circulated in the Middle Ages. The term "romantic" was used very loosely to conjure up this nostalgic view of the past and it gained added force with the revival of the Gothic style in architecture.

In the late 18th century, a group of German authors began to use the term in a different sense, as the antithesis of classicism. While the core values of classicism were reason and order, the Romantics laid greater emphasis on the power of the imagination, the emotions, and individualism. These qualities could be evoked in very different ways. Some painters, for example, liked to show the individual dwarfed by the forces of nature. At the same time, individualism can also be linked with the spirit of rebellion that epitomizes the Romantic era. This manifested itself in popular uprisings against the state and in the spread of new nationalist movements.

Style and techniques

In France, the contest between Romanticism and classicism was, to some degree, a confrontation of different styles. The Romantics, led

▶ **Songs of Innocence** William Blake *The title page from Blake's celebrated book of poems, printed in 1789, bears the hallmarks of the Romantic style*

Romanticism

TIMEline

The seeds of Romanticism were sown in the 1780s, when the French Revolution epitomized the spirit of rebellion. By 1800, Goya had made a series of prints entitled *Los Caprichos*, while in 1810 the Nazarenes moved to Rome. The movement reached its peak around 1820, when Géricault and Constable produced their finest works. Cole settled in the Hudson River Valley in 1836, while Turner's most daring pictures date from the early 1840s.

1781

FUSELI The Nightmare

1794

BLAKE The Ancient of Days

c1800

GOYA The Naked Maja

1813

OVERBECK The Adoration of the Kings

1814–15

CONSTABLE Boat Building

Schools

Perhaps more than any other movement, Romanticism developed along very different lines from country to country.

French

In France, more than anywhere else, Romanticism was seen as the direct antithesis of classicism. During the 1820s, in particular, reviewers of the exhibitions at the Salon placed Delacroix and Ingres in opposing camps. Traditionalists despised the former, not only for his style, but also for his choice of subjects. They attacked his depictions of the nationalist uprising in Greece, for example, deeming the topic more suitable for journalists than painters, and they were equally appalled by his alleged tendency of lingering on the goriest details in his pictures.

In reality, the boundary between the two styles was rather blurred. Delacroix was a great admirer of tradition, while Ingres chose some themes—most notably, his harem paintings—that were decidedly Romantic in spirit.

▲ **The Wounded Cuirassier** Théodore Géricault *Having achieved his breakthrough with The Charging Cuirassier, this picture, exhibited by Géricault two years later, was less popular, as it signalled Napoleon's impending defeat. 1814, oil on canvas, 140⅞ x 115¾in, Louvre, Paris, France*

Spanish

Spanish Romanticism is dominated by Goya, whose work is powerful and highly individual. This is exemplified In his pioneering depictions of warfare which concentrate on the suffering of individuals, rather than on any glory that might be achieved. Goya also often focused on the darker side of the human psyche, tackling themes that dealt with madness, superstition, the supernatural, and the macabre. This was most evident in his graphic work—particularly in the set of prints entitled *Los Caprichos*. For subsequent generations, though, it is the *Black Paintings*, produced in old age, that typify Goya's Romantic leanings. These nightmarish visions decorated the walls of his own house and were not revealed to the public until 1878.

German

Although they enjoyed only limited success in their time, Caspar David Friedrich and Philipp Otto Runge now stand out as the two leading German Romantic painters, with Friedrich in particular regarded as one of the giants of the time. He shared some of the attributes of his compatriots. His paintings are steeped in religious belief and he also betrayed a similar taste for medievalism, as can be seen in his pictures of cowled monks and ruined abbeys.

▲ **Morning** Philipp Otto Runge *The only completed section of Runge's* Times of Day *series. According to his poetic definition "Morning is the limitless illumination of the universe." 1808, oil on canvas, 42⅞ x 35in, Kunsthalle, Hamburg, Germany*

by Eugène Delacroix, were powerful colorists and often produced work that seemed sketchy and unfinished to their opponents. In contrast, the classical camp, headed by Jean-Auguste-Dominique Ingres, regarded sound draftsmanship and a highly detailed, enamel-like finish as the most important aspects of art.

This division of opinion was evident elsewhere. One of J.M.W. Turner's storm scenes, for instance, was famously likened to "a mass of soapsuds and whitewash." These attitudes, however, were by no means universal. In Germany, for example, the Nazarenes developed a style that may have focused on the past, but was far closer to the academic norm.

▲ **The Witches' Sabbath** Francisco de Goya *His witch paintings were often inspired by popular plays.* 1797–98, oil on canvas, 16⅞ x 12¼in, Museo Lazaro Galdiano, Madrid, Spain

Subjects

The Romantic approach lent itself to a very broad range of subjects. Its anti-rationalist overtones led artists to explore themes that were linked with horror, madness, violence, and the supernatural. There was also a taste for the exotic, as well as visionary, mystical ideas

Romantic artists often produced historical or legendary scenes, but generally set these in the Middle Ages, rather than in the ancient times. They also developed a distinctive form of landscape painting. Classical artists reshaped nature to suit their ordered compositions, but the Romantics portrayed it as wild and ungovernable.

CURRENTevents

1805 Following the Battle of Trafalgar, King George IV commissions Turner to paint a picture celebrating the victory.

1808–14 The Spanish Peninsular War leads Francisco de Goya to produce 65 etchings depicting the horrors of war. He also continues painting portraits, including that of Joseph Bonaparte during the French occupation.

1821–32 The Greek War of Independence. Delacroix's painting on this subject wins the gold medal at the Paris Salon in 1824.

c1818

FRIEDRICH
The Wanderer above the Sea of Fog

1819

GÉRICAULT The Raft of the Medusa

1821

CONSTABLE The Hay Wain

1830

DELACROIX Liberty Leading the People

1838

TURNER The "Fighting Temeraire" Tugged to her Last Berth to be Broken up

c1854

DURAND Shandaken Ridge, Kingston, New York

However, his attitude to nature was far more original and there is an indissoluble link between the physical and the spiritual worlds. His human figures seem small and insignificant compared with the vast panoramas that stretch out before their eyes, but they can find redemption if they can recognize the symbols of Christian salvation that lie all around them.

Nazarenes

The Romantic movement in Germany was led by the Nazarenes. Contemporary critics believed that the Nazarenes were

▲ **Hadleigh Castle** John Constable *This melancholy masterpiece was painted when Constable's wife was dying.* 1829, oil on canvas, 48 x 65in, Yale Center for British Art, Paul Mellon Collection, US

responsible for the rebirth of German art, although they conceded that much of their work was focused on the past. This was most obvious from their attempts to revive the art of fresco painting and to mimic the lifestyle of the painter-monks from the early Renaissance. In some ways, these aims found a parallel in William Morris's efforts to reproduce the most positive aspects of the medieval guild system. The Nazarenes were also closely linked with the upsurge of nationalist sentiments in Germany. This led some of their members to portray patriotic themes from German history and legend.

British Romantics

In Britain, too, landscapes provided some of the most potent examples of Romantic art. In their very different ways, Turner and John Martin portrayed the terrible beauty of nature, when the full force of its powers was unleashed. The Romantic aspects of John Constable's work are more subtle. In his canvases, nature becomes an extension of his feelings, echoing William Wordsworth's definition of poetry as "emotion recollected in tranquillity."

▲ **The Magic Apple Tree** Samuel Palmer *The enormous crop of apples and the flock of plump, healthy sheep are signs of God's bounty.* c1830, brown ink and watercolor, 6¾ x 11in, Fitzwilliam Museum, Cambridge, UK

Visionaries

No artist produced a more extreme form of Romanticism than William Blake. His hatred of rationalism is evident from his pictures of authoritarian figures wielding compasses, while his individualism is highlighted in his strange, personal mythologies. Blake revered the imagination but he was also deeply religious. Samuel Palmer, too, was very pious, though in a more restrained manner. Even in a visionary picture, such as *The Magic Apple Tree* (see left), the composition is centerd around a church spire.

American Romantics

In America, the spirit of Romanticism shone brightest in the landscapes of the Hudson River School. Headed by Thomas Cole and Asher B. Durand, this influential group of artists celebrated the unspoiled beauties of their native land.

Pierre-Paul **Prud'hon**

b **CLUNY, 1758**; d **PARIS, 1823**

A fine portraitist, Prud'hon became one of Napoleon's favorite artists. After training in Dijon, he won the *Prix de Rome* and completed his studies in Italy. There, he was influenced by the work of Leonardo and Correggio. Prud'hon gained a string of commissions from Napoleon, although his most celebrated painting was *Justice and Divine Vengeance Pursuing Crime* (1808), a lurid allegory produced for the Palais de Justice. Prud'hon's style could be delicate and charming, but some of his pictures display a slightly neurotic taste for emotionalism, which may reflect the unhappiness of his own life. His wife gradually went insane, while his mistress committed suicide in his studio.

LIFEline

1758 Born in Cluny
1784 Wins the *Prix de Rome* and goes to study in Italy
1788 Returns to Paris
1803 Obtains a separation from his wife
1805 Paints *Portrait of the Empress Josephine*
1808 Produces his most famous picture, *Justice and Divine Vengeance Pursuing Crime*
1808 Is awarded the Cross of the Legion of Honor
1821 His mistress, Constance Mayer, commits suicide
1823 Dies in Paris in his 70s

CLOSER look

RED AND GREEN Prud'hon's use of complementary tones on the empress's dress ensures that his main subject resonates with vibrant color. Around her, the setting is dark and oppressive.

◄ **Portrait of the Empress Josephine** *Napoleon's wife is pictured in the grounds of her home, the Château of Malmaison. The painting was commissioned shortly after Josephine had been crowned empress, though this triumph was marred by personal misfortune. Napoleon was already thinking of divorcing her, because she was infertile.* 1805, oil on canvas, 96 x 70in, Louvre, Paris, France

François **Gérard**

Portrait by Jean Alaux

b **ROME, 1770**; d **PARIS, 1837**

The son of a diplomat, Gérard trained under David and enjoyed a successful career as a portraitist. He also produced a number of attractive mythological scenes. Neoclassical subjects remained in vogue after the Revolution, but they were no longer conveyed with the same moral and political force. Gérard's *Cupid and Psyche* (1798) is typical of this new mood. The figures still have a sculptural appearance, but the overall approach is decorative, superficial, and mildly erotic.

▲ **Portrait of Madame Récamier** *Récamier much preferred this informal portrait to David's severely classical one (see p.269).* 1805, oil on canvas, 88⅝ x 58¼in, Musée Carnavalet, Paris, France

◄ **Cupid and Psyche** *Here Psyche, the symbol of the human soul, is surprised by Cupid, who is invisible to her.* 1798, oil on canvas, 73 x 52in, Louvre, Paris, France

Théodore **Géricault**

Self-portrait

b **ROUEN, 1791**; d **PARIS, 1824**

Théodore Géricault came from a wealthy family, which enabled him to pursue a truly independent course in his art. Trained by Vernet and Guérin, he completed his studies in Italy. On his return to France, he laboured for 18 months on *The Raft of the Medusa* (1819), the monumental painting that secured his reputation.

Géricault's art typifies the spirit of Romanticism. He was drawn to themes of violence, horror, and madness. He painted wounded soldiers and wild, untamed horses. Even a traditional subject, such as *The Epsom Derby* (1821), was set against a threatening sky. Géricault's temperament and lifestyle were equally Romantic. He conducted a doomed love affair with the young wife of his uncle, which threw his family into turmoil; he had a brief, but hazardous military career, fighting for the Royalists against Napoleon; and he was a reckless rider, loving nothing more than a battle of wills with a lively horse. Riding accidents helped to bring about his early death, which in turn added to the Romantic aura surrounding his name.

LIFEline

1791 Born in Rouen, the son of a lawyer
1808 Studies in the studio of Carle Vernet
1812 The *Charging Cuirassier* wins gold medal at the Salon
1819 His masterpiece, *The Raft of the Medusa*, causes a sensation at the Salon
1820–21 Lives in England
1822 Begins series of portraits of mental patients
1824 Dies in Paris, aged 32, following a fall from a horse

❝ I have seen the death mask of poor Géricault... and **his sublime *Raft***. What hands and heads! I cannot express the **admiration** it inspires... I feel a longing to make a sketch of it. What a precious reminder of this **extraordinary man** ❞
EUGÈNE DELACROIX, 1824

▲ **The Madwoman Afflicted with Envy** *Toward the end of his life, Géricault produced a pioneering and compelling series of portraits of mental patients. Each one highlighted a specific medical condition with clinical accuracy.* 1822–23, oil on canvas, 28¼ x 22¾in, Musée des Beaux-Arts, Lyon, France

▲ **The Raft of the Medusa**
This huge painting depicts the shipwreck of the Medusa *in 1816, which became the focus of a major political scandal. Géricault's decision to tackle a subject of this kind proved highly controversial, as many critics believed the topic was better suited to journalism than to high art.* 1818–19, oil on canvas, 193 x 282in, Louvre, Paris, France

CLOSERlook

HORRIFIC REALISM Géricault went to extraordinary lengths to capture the full horror of the situation. He observed the dead and the dying in a local hospital, made studies in its dissecting room, and sketched the remains of guillotined criminals. Some critics felt that he went too far, and was wallowing in morbid details, such as this prostrate corpse.

▲ **The Epsom Derby** *Géricault's horses perform a "flying gallop," with all four legs off the ground. Advances in photography later proved that this was impossible.* 1821, oil on canvas, 36¼ x 48in, Louvre, Paris, France

Eugène **Delacroix**

Self-portrait

b **CHARENTON-SAINT-MAURICE, 1798**; d **PARIS, 1863**

A leading figure of the French Romantic movement, Delacroix studied under Guérin, but was greatly influenced by Géricault. He posed for one of the figures in Géricault's *Raft of the Medusa* (1818–19) and was astounded by the passion and energy of the finished work. Its impact can be seen in the remarkable series of paintings that Delacroix produced during the 1820s.

On the strength of these, critics hailed him as the leader of a new school, contrasting his youthful, Romantic approach with the stale classicism of Ingres. Delacroix was wary of these labels, regarding himself as a traditionalist, and it is significant that he won a number of prestigious state commissions to decorate public buildings.

A visit to north Africa in 1832 broadened the range of his work, providing him with new kinds of Orientalist subjects. In these, Delacroix was unbridled in his use of color, which was later to exert a powerful influence on the Impressionists.

LIFEline

1798 Born near Paris

1815 Studies with Guérin

1824 *The Massacre of Chios* causes a stir at the Salon

1830 Paints *Liberty Leading the People*

1832 Visits Morocco, Algeria, and Spain

1833 Commissioned to decorate the Salon du Roi, in the Palais Bourbon

1855 Work is shown at the World Fair. Made Commander of the Legion of Honor

1861 Completes the murals at Saint-Sulpice

1863 Dies at his Paris home

CLOSERlook

ROMANTIC SUFFERING
Delacroix tried to symbolize the suffering of the islanders by placing a row of despairing figures in the foreground. Critics disliked the modernity of the subject, the staginess of the composition, and the unremitting emphasis on misery.

▶ **The Massacre of Chios**
In April 1822, Turkish soldiers slaughtered civilians on the island of Chios, believing that they were assisting Greek rebels. Delacroix verified the details of this event by talking to eyewitnesses. 1824, oil on canvas, 164 x 139in, Louvre, Paris, France

INcontext

GREEK WAR OF INDEPENDENCE In 1821, the Greeks launched a bid for independence, after centuries of domination by the Ottoman Turks. In the West, their struggle rapidly became a *cause célèbre*, as many Europeans regarded ancient Greece as the cradle of their civilization, and the war inspired many artists and writers.

Lord Byron *by Frederick Gore. The English poet Lord Byron was an active supporter of the Greek cause. He financed a military expedition, but died of a fever before the fighting began.*

▲ **The Women of Algiers** *Western artists often portrayed harems in a gaudy, artificial manner. Delacroix had actually seen one, so his version is simple, understated, and far more realistic.* 1834, oil on canvas, 71 x 90in, Louvre, Paris, France

▲ **Liberty Leading the People** *In this famous picture, Delacroix celebrated the "July Revolution" of 1830, when King Charles X was ousted from power. The artist was sympathetic to the rebels' cause, but took no part in the uprising. The new government bought this painting, though it was quietly removed from public view to quell any threat from lingering revolutionary sentiments.* 1830, oil on canvas, 102 x 128in, Louvre, Paris, France

❝ I do not care for reasonable painting at all. My **turbulent mind** needs agitation, needs to **liberate itself**... There is in me some **black depth** that must be appeased ❞
EUGÈNE DELACROIX

ROMANTICISM

19TH CENTURY

300

Richard Parkes **Bonington**

Self-portrait

b **ARNOLD, 1802**; d **LONDON, 1828**

Although English by birth, Bonington spent most of his adult life in France. He studied there under Gros and became a close friend of Delacroix. Bonington was at his best when working on a small scale. His watercolors and oil sketches are particularly fine, displaying a genuine freshness and spontaneity. He gained recognition in 1824, winning a gold medal at the Paris Salon, but his career was cut tragically short by tuberculosis.

▼ **Calais Pier** *Bonington's coastal scenes are masterful studies of light and atmosphere.* 1823–24, oil on panel, 11¼ x 13¼in, Yale Center for British Art, New Haven, US

Théodore **Chassériau**

Self-portrait

b **DOMINICAN REPUBLIC, 1819**; d **PARIS, 1856**

In his brief career, Théodore Chassériau achieved a convincing blend of Romantic and Neoclassical elements. Born in the West Indies, the son of the French Consul, he was one of Ingres's favorite pupils and shared his enthusiasm for sinuous, well-drawn figures. Increasingly, though, he came under the spell of Delacroix, developing a taste for rich colors and exotic themes. Like that of Delacroix, Chassériau's art was transformed by his African travels—in his case, a trip to Algeria in 1846.

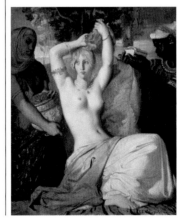

◀ **The Toilet of Esther** *Nominally a biblical subject, this resembles one of Ingres's harem paintings. Esther displays the pale sensuality of a Neoclassical nude, but the richly colored background owes more to Delacroix.* 1841, oil on canvas, 18¼ x 14¼in, Louvre, Paris, France

CLOSERlook

REALISTIC ALLEGORY The lighting makes Liberty the focus of the composition. A highly unconventional allegorical figure, Liberty's dishevelled clothing and gun make her seem strikingly real and modern.

REBELLIOUS YOUTH This figure of a street urchin is said to have inspired the character of Gavroche in Victor Hugo's novel *Les Misérables*.

PARISIAN LANDMARK The towers of Notre Dame help to locate the action. The cathedral was the scene of fierce fighting, as the rebels pulled down the king's flag and raised the republican tricolor in its place.

Francisco de **Goya**

Self-portrait

b **FUENTEDETODOS, 1746**; d **BORDEAUX, 1828**

The Spanish painter and printmaker Goya was one of the outstanding figures of the Romantic movement. His talent was slow in showing itself, however, and it wasn't until well into his thirties that he began to produce work that set him apart from his contemporaries.

By the 1780s, his skills as a portraitist were increasingly in demand. The results were both spectacular and daring—the artist made little attempt to flatter his distinguished sitters—but they were well received, as a succession of honous was heaped upon him. Alongside these commercial efforts, Goya worked privately on more ambitious themes, in which he gave full rein to his imagination. Beginning with *Los Caprichos*, his first great series of prints, and culminating in the magnificent *Black Paintings* of his final years, he portrayed his own dark vision of the human soul, with its petty obsessions, its cruelty, and its folly.

Goya was an exceptionally versatile artist whose output was vast, leaving about 700 surviving paintings, 300 prints, and some 1,000 drawings.

LIFEline

1746 Born near Saragossa, the son of a gilder
1760 Studies under José Luzán
1770 Travels to Rome
1773 Marries Josefa Bayeu, sister of artist Francisco Bayeu
1774 Produces first cartoons for royal tapestries
1786 Appointed King's Painter
1789 Promoted to Court Painter, following the coronation of Charles IV
1793 Becomes deaf
1808 French invasion. Swears allegiance to Joseph Bonaparte
1814 Paints *The Third of May, 1808* (see pp.304–07)
1824 Moves to Bordeaux
1828 Dies in France

▼ **The Parasol** *Goya produced a series of ten decorative scenes designed as models for the royal tapestry workshop. The finished articles were destined for a palace dining-room.* 1777, oil on canvas, 40¾ x 60in, Prado, Madrid, Spain

▼ **The Sleep of Reason produces Monsters** *In the most famous plate from Goya's* Los Caprichos *("Caprices") series, a pessimistic blend of satire and fantasy, the sleeping artist is beset by nightmarish visions.* 1799, etching and aquatint, 8¾ x 5¾in, private collection

"I had three masters: Nature, Velázquez, and Rembrandt **"**
GOYA

CLOSERlook

CREATURES OF THE NIGHT
Owls are usually seen as symbols of wisdom, because of their connection with Minerva, but Goya has intended one of their negative associations here. They are also regarded as birds of ill-omen, harbingers of death, and emblems of the night.

▲ **The Naked Maja** *Female nudes were very rare in Spain and with good reason. The Inquisition denounced this famous example as "obscene" and summoned the artist to appear before a tribunal, to disclose the identity of the patron, and explain the painting's purpose.* c1800, oil on canvas, 38¾ x 75in, Prado, Madrid, Spain

▲ **The Clothed Maja** *Together with its nude companion piece, this painting was commissioned by Manuel Godoy, a royal minister. The* maja *("fashionable young woman") is thought to be the Duchess of Alba.* c1800, oil on canvas, 37¼ x 75in, Prado, Madrid, Spain

▲ **The Duke of Wellington** *This was painted during the Napoleonic Wars when Wellington was head of the British forces in Spain. The portrait was altered in 1814, after he had acquired new medals and honors.* 1812–14, oil on panel, 25¼ x 20½in, National Gallery, London, UK

INcontext

PENINSULAR WAR Some of Goya's greatest paintings were created against the backdrop of a major European conflict. The Peninsular War (1808–14) was fought between France and a coalition of Spain, Portugal, and Britain. Napoleon's troops invaded the Iberian peninsula in 1808, and his brother, Joseph Bonaparte, was placed on the Spanish throne. They were eventually forced out by Wellington's army and a fierce guerrilla campaign by the Spanish people.

Even Worse *from* The Disasters of War, *Goya's shocking catalog of the atrocities committed during the Spanish conflict (1810).*

▲ **The Colossus** *It has been suggested that the giant is a symbolic guardian of Spain, inspired by a contemporary patriotic poem: "A pale colossus rises, caught by the fiery light of the setting sun; the Pyrenees are a humble plinth for his gigantic limbs."* c1808–12, oil on canvas, 45¾ x 41¼in, Prado, Madrid, Spain

CLOSERlook

UNREAL LIGHTING In common with Goya's other war scenes, *The Colossus* is set in an eerie, nocturnal gloom, equally apt for the darker acts of human folly.

PANIC At the sight of the giant, the convoy scatters. Goya may have remembered the legend of the god Pan, who was said to be able to make armies flee in terror (hence the word "panic").

THE GIANT The meaning and identity of the giant have been the subject of endless speculation—personification of War, Pestilence, or Panic, or even a symbol of Napoleon himself.

▲ **Saturn Devouring One of His Children** *This is the most gruesome of Goya's* Black Paintings. *The Roman god Saturn ate his children because of a prophecy that they would usurp him. Goya placed the picture in his own dining room as a macabre joke.* 1821–23, oil on canvas, 57 x 32¾in, Prado, Madrid, Spain

The Third of May, 1808 *Francisco de Goya*
1814, oil on canvas, 102½ x 136in, Prado, Madrid, Spain ►

The Third of May, 1808 Francisco de Goya

This painting depicts an atrocity committed by French forces during the Peninsular War (1808–14), when Napoleon's troops occupied Spain. On May 2, 1808, there was a violent uprising on the streets of Madrid, which the invaders managed to suppress. Their reprisals were swift and brutal. On the following day, soldiers made arrests and carried out a series of executions on the hill of Príncipe Pío, on the outskirts of the city. These actions helped to spark off a nationwide guerrilla campaign against the French. At the end of hostilities, when the Spanish monarchy had been restored, the government decided to commemorate the bravery and sacrifice of the rebels. A year of national mourning was declared and artists were invited to submit their own tributes to the victims. Goya was granted some money, although not an official commission. In return, he produced two masterpieces on the theme.

Composition

Goya's painting was composed six years after the event and, in spite of various exaggerated tales to the contrary, he did not witness the atrocity in person. He took some elements of his composition from secondary sources, such as popular prints. There are strong affinities, for example, with an engraving by Miguel Gamborino (1760–1820), which was published in 1813. Goya also drew on the images he had produced for his pioneering series of etchings *The Disasters of War* (1810–14), which included several scenes of firing squads.

Story

In his painting *The Second of May, 1808*, Goya concentrated on the uprising itself, while here he focuses on its bloody aftermath. Both paintings met with a lukewarm reception. In part, this was due to the radical nature of the artist's approach. Neoclassical pictures, which emphasized the heroism of the rebels, were greeted with far more enthusiasm. In addition, there were suspicions about Goya's loyalties. He had been on good terms with the occupying French regime and had accepted an honor from Joseph Bonaparte (Napoleon's brother). In any event, his paintings were quietly accepted, but not exhibited. Instead, they were deposited in the storerooms of the Prado, where they lay forgotten for two generations.

▲ **THE CITY** None of the buildings in the background can be identified with any certainty. Goya may simply have invented them. Either way, their ghostly silhouette against a starless sky adds to the nightmarish atmosphere of the proceedings.

▲ **THE FOCAL POINT** In contrast to the drab appearance of his fellow victims, this figure is brightly lit, making him the center of attention. Goya depicts the man kneeling. If he were standing, he would tower over everyone.

▲ **THE CORPSES** This is an example of artistic license. Bullets fired from such close range would have propelled these victims backward, but Goya was keen to highlight the bloodshed in the forefront of his picture.

▲ **FIGURE IN WHITE** The spectator's eye is immediately drawn to the man in white, whose arms are raised in protest. His pose carries deliberate echoes of the Crucifixion, a fitting association for an innocent symbol of persecution and martyrdom.

▶ **VICTIMS** Goya took pains to depict the condemned men as individuals, each with differing reactions to their fate. Here, a monk lowers his head and clasps his hands in prayer, while his neighbor stares his killers in the face, defiant to the last.

▲ **SOLDIERS** In contrast to their victims, the soldiers are ordered and anonymous. Their expressions are hidden from the viewer, underlining their role as the faceless, dehumanized perpetrators of violence and oppression.

◀ **NEXT TO DIE** To complete the tragedy, Goya includes a long line of victims, trudging up the hill to their death. Most can hardly bear to look at the fate that awaits them.

Technique

Francisco de Goya used startling innovations in color and form to create an emotional response towards his work, rather than a straightforward, journalistic record of the event. The killings actually took place during the day, but Goya preferred a nocturnal setting for such a nightmarish theme. The somber coloring, which is dominated by browns, blacks, and grays, gives a foretaste of the gloomy *Black Paintings* that Goya produced in his final years. His forms, meanwhile, are sketchy and distorted, often dissolving into shadows.

▲ **FREE HANDLING** Among the most notable features of Goya's mature style were his dynamic brushwork and his astonishingly free handling of paint. Even on an everyday object like a shirt, most contemporaries would have carefully delineated every button and every crease. Goya, however, achieved a far livelier effect by replacing minor details with an energetic swirl of color. He manipulated his paint with knives and fingers as well as brushes.

▶ **THE LIGHTING** The sky is pitch black, with no moon or stars, so the scene is lit entirely by the huge lamp at the soldiers' feet. This creates a firm dividing line on the ground, separating the riflemen from their victims, and also casts long, ominous shadows.

❝ I see **no lines or details**... There is no reason why **my brush should see** more than I do ❞

FRANCISCO DE GOYA

◀ **SUGGESTED FORMS** Academic artists clarified every detail in their paintings. Goya, on the other hand, understood that it was far more powerful to show purely the things he saw, even if some of the details remained vague. On the naked corpse, for example, there are unexplained black markings and the exact position of the head is unclear, but the overall effect is entirely convincing.

Caspar David **Friedrich**

Portrait by
Franz Gerhard
von Kugelgen

b **GREIFSWALD, 1774**; d **DRESDEN, 1840**

Friedrich was the greatest of the German Romantics, producing a uniquely spiritual form of landscape painting. Born in a sleepy Baltic town, he had a strict, religious upbringing. The early death of his mother and brother probably heightened his somber outlook. After studying in Copenhagen, he settled in Dresden, where he swiftly absorbed the latest ideas about Romantic literature and philosophy.

Friedrich only took up oil painting in 1807, but his work made an immediate impact. *Cross in the Mountains*, in particular, shocked his contemporaries due to the radical way in which it conveyed a religious message through a landscape. Increasingly, Friedrich turned his chilly panoramas into yearning, mystical allegories, echoing the human desire to find spiritual comfort. He liked to depict people from behind so that they could serve as "everyman" figures, and was equally fond of cloaking his landscapes in mist to stimulate the viewer's imagination.

LIFEline

1774 Born in Greifswald, near the Baltic coast

1781 His mother dies

1787 Sees his brother drown

1794–98 Studies at the Copenhagen Academy, before moving to Dresden

1808 An early version of *The Cross in the Mountains* causes a scandal

1818 Marries Caroline Bommer

1818 Paints *The Wanderer above the Sea of Fog*

1835 Suffers a crippling stroke; dies 5 years later in Dresden

> **The Wanderer above the Sea of Fog** *This haunting painting may be a posthumous tribute to a colonel in the Saxon infantry.* 1818, oil on canvas, 38¾ x 29½in, Kunsthalle, Hamburg, Germany

> " A painting must not be **devised** but **perceived**. Close your **bodily eye**, so that you may see your picture first with your **spiritual eye** "
>
> CASPAR DAVID FRIEDRICH

> **The Cross in the Mountains** *This mystical landscape, a later version of the theme first explored some 5 years earlier, is full of religious imagery. The barren foreground forms a stark contrast to the celestial vision in the distance. The cross points the way to the latter, while the rocks and the trees are symbols of faith.* 1812, oil on canvas, 17¾ x 14¾in, Kunstmuseum, Düsseldorf, Germany

CLOSERlook

ECHOING FORMS Friedrich used echoing forms to accentuate the grandeur in landscapes. In this case, the central triangle is mirrored on the left, with further, miniature versions on the horizon. Often, his compositions lead the eye upwards, towards salvation, but here the cruel points of the ice slabs offer only despair.

> **The Sea of Ice** *For the Romantics, all human endeavor seemed frail and insignificant when set against the overwhelming power of nature. Here, the sunken mast and timbers of a ship go almost unnoticed, crushed beneath a towering pyramid of splintered ice.* 1824, oil on canvas, 38¼ x 50in, Kunsthalle, Hamburg, Germany

Philipp Otto **Runge**

Self-portrait

b **WOLGAST, POMERANIA, 1777**; d **HAMBURG, 1810**

Despite his tragically brief career and his small output, Runge was a major figure in the German Romantic movement, second only to Friedrich. He was a late developer, only turning to art in his twenties.

Runge was a skilled portraitist, but is better known for his complex allegorical works, which are steeped in obscure Romantic symbolism. "Color is the ultimate art," he declared, "and must remain a mystery which we can divine only through the marvel of flowers." Flowers play a significant role in both *Arion* and the *Hülsenbeck Children*.

Runge's most cherished project was a series of pictures entitled *The Times of the Day*. He intended to display the works in a special building, accompanied by music and poetry. But at the time of his death at the age of 33, only one piece—*Morning*—was completed, leaving this ambitious project unfinished.

◀ **The Hülsenbeck Children** *Runge believed the universe was bound together by a spiritual sense of harmony. Here, three different phases of childhood are echoed by the sunflowers on the left.* 1805–06, oil on canvas, 52 x 57in, Kunsthalle, Hamburg, Germany

LIFEline

1777 Born in Wolgast, the son of a ship owner

1797 First drawing lessons from Joachim Herterich

1799–1801 Trains at the Copenhagen Academy

1801–03 Continues studies at the Dresden Academy

1804 Moves to Hamburg

1808 Paints first version of *Morning*, the most complete section of his *Times of the Day* series

1810 Publishes his treatise on the color sphere

1810 Dies of tuberculosis in Hamburg. His fourth child is born on the following day.

◀ **Arion's Sea Journey** *Arion was famed for his skill with the lyre. He was thrown overboard by pirates, but was rescued by a dolphin, charmed by his music.* 1809, watercolor on paper, 20¼ x 46½in, Kunsthalle, Hamburg, Germany

Karl **Blechen**

b **COTTBUS, BRANDENBURG, 1798**; d **BERLIN, 1840**

A renowned German landscape painter, Blechen initially worked as a bank clerk, before training as an artist at the Berlin Academy. His early style was heavily influenced by Friedrich, whom he probably met in Dresden.

By 1824, he was working as a scene painter at the Königstädtisches Theater in Berlin, and this added a dramatic edge to his paintings. Blechen resigned from his post in 1827 following a dispute with a prima donna, and went traveling in Italy. It was during this time that he developed a more intense, naturalistic style, with free brushwork and bold color contrasts. In 1831, Blechen was appointed professor of landscape painting at the Berlin Academy. However, the onset of mental illness curtailed his career, and his final pictures are full of foreboding.

▲ **Mill in the Valley near Amalfi** *In Italy, Blechen's landscape style altered dramatically as he tried to capture the brilliant light and searing heat.* 1829, oil on paper, mounted on canvas, 5½ x 8¾in, Kunsthalle, Hamburg, Germany

Karl Friedrich **Schinkel**

b **NEURUPPIN, 1781**; d **BERLIN, 1841**

Although he is remembered mainly as a great architect, during Schinkel's early career the political situation in Prussia (then under French occupation) precluded any major commissions, and he concentrated on paintings, panoramas, and theatrical work.

Artist unknown

His style was greatly influenced by Friedrich, whose paintings were exhibited in Berlin in 1810. His views had an artificial, dreamlike quality, while his stage sets combined architectural clarity with Romantic flights of fancy. These culminated in his exotic designs for the celebrated 1816 production of Mozart's *Magic Flute*. In the same year, Schinkel gained his first major commission for a public building—the *Neue Wache* (New Guard House) in Berlin—and his career as an architect blossomed.

▲ **Egyptian Set Design for Act II of The Magic Flute** *Schinkel's stage sets reflected the popularity of Egyptian designs in the wake of Napoleon's recent campaigns in Egypt.* 1815, watercolor on paper, Bibliothèque de l'Opéra National, Paris, France

Peter **von Cornelius**

b DÜSSELDORF, 1783; d BERLIN, 1867

Trained by his father, who taught at the Düsseldorf Academy, Cornelius was a key figure in the revival of German fresco painting. In 1811 he settled in Rome, where he became a leading member of the Nazarenes. Cornelius had a strong nationalist agenda, producing illustrations for two German literary masterpieces, *Faust* and the *Nibelungenlied*. He was employed by influential German patrons— among them Ludwig I of Bavaria and Frederick William IV of Prussia. Not all his work was well received. His most ambitious undertaking was a massive fresco, *The Last Judgment* (1836–39), inspired by Michelangelo. After labouring for four years, Cornelius was met with a lukewarm reaction from Ludwig when it was completed.

LIFEline
1811 In his late 20s, moves to Rome
1819 Summoned to Munich, to work for Ludwig of Bavaria
1821–25 Director of the Düsseldorf Academy
1841 Paints frescoes for the Prussian royal family in Berlin
1853 Returns to Rome
1867 Dies in Berlin

▼ **The Wise and Foolish Virgins** *In the parable from Matthew's Gospel, the wise virgins have oil for their lamps, while the foolish have none.* c1813, oil on canvas, Kunstmuseum, Düsseldorf, Germany

▶ **The Last Judgment** *Often cited as the largest fresco in the world, it was commissioned by Ludwig I of Bavaria.* 1836–39, fresco, 62 x 38ft, Ludwigskirche, Munich, Germany

▲ **Joseph Recognised by His Brother** *Part of a fresco cycle that was produced by the Nazarenes (also called the Brotherhood of St. Luke) for the Prussian Consul General in Rome. The fraternal theme had an obvious relevance for the Brotherhood.* 1816, fresco with tempera, 93 x 114in, Staatliche Museen, Berlin, Germany

Friedrich **Overbeck**

b LÜBECK, 1789; d ROME, 1869

Overbeck was the most prominent member of the Nazarenes, the influential group he founded with a number of fellow students at the Vienna Academy. Calling themselves the Brotherhood of St. Luke, they moved to Rome and set up an artistic community in a disused monastery. Overbeck, in particular, adopted the ascetic lifestyle of a painter-monk. He refused to study anatomy from dissected corpses or female models, saying "I prefer to draw less correctly than damage my feelings, which are the artist's greatest treasure".

Overbeck converted to Catholicism in 1813 and specialized mainly in religious subjects, although he was also a fine portraitist. His style mimicked the strong lines and restrained colors of Renaissance masters such as Perugino, Fra Angelico, and the young Raphael.

LIFEline
1789 Born in Lübeck
1806 Attends Vienna Academy
1809 Co-founds the Nazarenes
1810 Moves to Rome
1813 Converts to Roman Catholicism
1816 Works on the frescoes at the Casa Bartholdy
1828 Completes *Italia and Germania*
1829 Paints *Rose Miracle of St. Francis* in Assisi
1869 Dies in Rome

▼ **Joseph Being Sold by his Brothers** *This is taken from the cycle of frescoes at the Casa Bartholdy—the Nazarenes' most important, collaborative project.* 1816, fresco with tempera, 96 x 120in, Staatliche Museen, Berlin, Germany

▲ **The Adoration of the Magi** *Produced for Queen Caroline of Bavaria, this was Overbeck's first important commission. The theme of the Magi—he first pagans to be converted—was particularly appealing to the artist, as he was about to convert to Catholicism.* 1811–13, oil on panel, 19¾ x 25¾in, Kunsthalle, Hamburg, Germany

" Everything was full of that **immoderate asceticism**, which **appears wraithlike** to a healthy man of our day, like the appearance of **the master himself** "
19TH-CENTURY AUTHOR ADOLF STAHR, 1853, ON OVERBECK'S STUDIO

William **Dyce**

b **ABERDEEN, 1806; d LONDON, 1864**

Portrait by David Scott

Dyce was an influential Scottish painter whose work combined elements from both the Nazarenes and the Pre-Raphaelites. He became friendly with the former during two visits to Rome in the 1820s, sharing their enthusiasm for the revival of fresco painting. He later achieved considerable success in this field, producing Arthurian murals for the new Houses of Parliament in London and a suitably patriotic subject for Prince Albert in *Neptune Resigning to Britannia the Empire of the Sea* (1847).

Dyce proved equally capable in his easel paintings. Deeply pious, he won plaudits for his imaginative religious pictures, and he was also one of the first to appreciate the innovations of the Pre-Raphaelites. Their influence can be seen in his crowning masterpiece, *Pegwell Bay*.

LIFEline

1806 Born in Aberdeen, the son of a lecturer
1825 First visit to Rome
1840 Superintendent of the School of Design in London
1844 Commissioned to produce frescoes for the new Houses of Parliament
1847 Paints Osborne House frescoes for Prince Albert
1860 Completes his masterpiece, *Pegwell Bay*
1864 Dies at home in Streatham, London

▲ **Pegwell Bay: A Recollection of October 5th** *While Dyce's family gather seashells in the foreground, the artist painstakingly records the geology of the cliff-face and the trail of Donati's comet, which was at its brightest on the date of the work.* 1858–60, oil on canvas, 25¼ x 35¼in, Tate, London, UK

▲ **Joash Shooting the Arrow of Deliverance** *Drawn from the Old Testament, this picture shows Elisha aiding the king of Israel. On the prophet's orders, Joash fires an arrow toward the spot where he will win a great victory over the Syrians.* 1844, oil on canvas, 29¾ x 42¾in, Kunsthalle, Hamburg, Germany

INcontext

ABOLITION OF SLAVERY The campaign to abolish slavery began in earnest in the 1770s. Led by political pressure groups and religious sects, such as the Quakers, it managed to secure a parliamentary ban on the slave trade in 1807, followed by full emancipation in 1833.

William Wilberforce (1759–1833) *In Parliament, the most tireless campaigner was the Yorkshire MP William Wilberforce. He died just three days after seeing the Abolition of Slavery Act through in 1833.*

Alexander **Ivanov**

b **ST. PETERSBURG, 1806; d ST. PETERSBURG, 1858**

Training under his father at the St. Petersburg Academy, Ivanov displayed an early preference for conventional Neoclassical subjects. In 1827, one of his paintings was awarded a gold medal by the Society for the Promotion of Artists, and this provided him with a grant to travel in Italy. By 1831, Ivanov had settled in Rome, where he met Overbeck and the other Nazarenes.

Under their influence, he turned increasingly to religious art, which he hoped to produce on a monumental scale. His most ambitious project was a huge painting, *Christ's First Appearance to the People*. Ivanov labored on this for 20 years, producing scores of studies for individual heads and figures. Ultimately, this exhaustive, piecemeal approach may have proved counter-productive, as the finished painting met with a less than enthusiastic reception, while many of the studies were greatly admired. Even so, the next generation of Russian artists led by Repin and Kramskoi were inspired by the work.

LIFEline

1806 Born in St. Petersburg, the son of a painter
1817–24 Studies under his father at the St. Petersburg Academy
1827 *Joseph in Prison* wins a gold medal
1831 Settles in Rome
1837 Begins work on *Christ's First Appearance to the People*
1839 Paints *Ave Maria*
1858 *Christ's First Appearance* is exhibited in Russia
1858 Dies of cholera in St. Petersburg

▼ **King Priam Begging Achilles for the Return of Hector's Body** *Produced by Ivanov at the end of his student days.* 1824, oil on canvas, 46¾ x 49in, Tretyakov Gallery, Moscow, Russia

▲ **Christ's First Appearance to the People** *This monumental scene depicts the prelude to Christ's baptism in the River Jordan. In the foreground, John the Baptist points Him out to the assembled converts.* 1837–57, oil on canvas, 17ft 7in x 24ft 6in, Tretyakov Gallery, Moscow, Russia

CLOSERlook

FOCAL POINT Even though the figure of Christ is one of the smallest in the painting, his isolation ensures that he is the focus of attention.

William **Blake**

b **LONDON, 1757**; d **LONDON, 1827**

Portrait by
Thomas
Phillips

A poet, painter, printmaker, and visionary, Blake came from a family of Nonconformists, and his own, highly individual views did much to shape the course of his art. His apprenticeship with James Basire gave him a thorough grounding in printmaking techniques. He used this skill to produce extraordinary color-printed editions of his own poems, with the words and illustrations appearing on the same page. In visual terms, he was heavily influenced by Gothic art, which he had studied during his apprenticeship, while his muscular figures owed much to the example of Michelangelo. Blake derived many of his subjects from the Bible, Milton, and Shakespeare, although increasingly he portrayed a pantheon of mythological characters, drawn from his own prophetic writings. Blake's paintings baffled his contemporaries, particularly as he often claimed that they were inspired by visions. But he received loyal support from his two main patrons, Thomas Butts and John Linnell, and exerted a huge influence on Samuel Palmer and his followers.

◀ **Glad Day or Albion
Rose** *This is Blake's vision of
the spiritual transformation
of Albion—his symbol for
the British nation.* c1795,
color-printed engraving with
watercolor, British Museum,
London, UK

◀ **The Sick Rose**
*Blake devised a method
of printing that made
his books look like
illuminated manuscripts.
This poem comes from
his* Songs of Innocence
and of Experience. 1794,
etching, ink and watercolor,
4¾ x 2¾in, Fitzwilliam
Museum, Cambridge, UK

LIFEline

1757 Born in London
1772–79 Apprenticed to the
engraver James Basire
1780 First exhibit at the Royal
Academy
1782 Marries Catherine
Boucher
1789 Publishes *Songs of
Innocence*
1799 First commission from
Thomas Butts, his chief patron
1818 Meets the painter John
Linnell, another patron
1827 Dies in London

CLOSERlook

RADIATING LIGHT
Blake liked to use
visionary shafts of light
to convey the spiritual
mood of his pictures.
Here, a blood-red sun
sets out a baleful tone,
as Urizen (Blake's
authoritarian version of
Jehovah) measures out
an imperfect universe.

▲ **The Red Dragon and the Woman Clothed with the Sun**
*Blake's visionary style was particularly well suited to the task of
illustrating the prophecies contained in the* Book of Revelation. *Here,
a satanic monster waits to consume the child, which the woman (the
Church) is about to bear (Rev. 12:1–4).* 1803–05, watercolor on paper,
21¾ x 16¾in, Brooklyn Museum of Art, New York, US

▲ **The Ancient of Days** *This majestic image of the creation
of the universe was originally produced as the frontispiece for
Blake's* Europe. 1794 (this print 1824), etching with gouache and
watercolor, 9¼ x 6¾in, Whitworth Art Gallery, Manchester, UK

Henry **Fuseli**

Self-portrait

b **ZURICH, 1741**; d **LONDON, 1825**

Born Johann Heinrich Füssli, Swiss painter Henry Fuseli initially hoped to follow a career in the church, but his unconventional views soon landed him in trouble and he was obliged to leave Zürich. He settled in London in 1764, still uncertain of his future direction. It was only after a meeting with Joshua Reynolds, four years later, that he decided to devote himself to painting.

Fuseli's breakthrough as an artist came in 1782, when his painting *The Nightmare* caused a sensation at the Royal Academy. This set the tone for his unique brand of Romanticism. Most of Fuseli's themes came from respectable literary sources, but he liked to explore the darker side of human nature. As a result, many of his pictures contain hints of suppressed violence, irrational fears, or sexual perversity.

LIFEline

1741 Born in Zürich, the son of an artist

1761 Ordained as a minister

1764 Moves to London

1768 Meets Reynolds and decides to become a painter

1770 Begins studies in Italy

1779 Returns to London

1781 Paints his masterpiece, *The Nightmare*

1788 Marries Sophia Rawlins

1799 Opens his Milton Gallery. Is appointed Professor of Painting at the Royal Academy

1825 Dies in Putney, London, and is buried in St Paul's Cathedral

▼ **The Three Witches** *Fuseli produced several versions showing the witches delivering their predictions to Macbeth. His source was a series of grotesque heads by Leonardo da Vinci.* c1783, oil on canvas, 29½ x 35¼in, Collection of the Royal Shakespeare Theatre, Stratford-upon-Avon, UK

▼ **The Nightmare** *Fuseli's most famous painting is a potent cocktail of sex and horror. An incubus squats on a sleeping woman's abdomen, causing her to have a nightmare.* 1781, oil on canvas, 39¾ x 50in, Detroit Institute of Arts, Detroit, US

GHOSTLY HORSE This picture may have started out as a visual pun. The word "nightmare" comes from *mara*, the name of an evil demon, rather than the ghostly horse (the "night mare"), which is peering round the curtains.

John **Martin**

b **HAYDON BRIDGE, 1789**; d **DOUGLAS, 1854**

Renowned for cataclysmic scenes of doom and destruction, Martin ironically began his artistic career working in a more genteel vein, as a painter of glass and ceramics. He turned to oils in 1811, rapidly making his mark at the Royal Academy.

Many of Martin's pictures depict stories from the Old Testament and feature tiny, vulnerable human figures, dwarfed by the vast and hostile forces of nature. These pictures became incredibly popular, largely through the medium of prints. Martin was particularly skilled at mezzotint engraving—an elaborate process that enabled him to reproduce his dramatic effects with considerable success. He was also in great demand as an illustrator, producing his finest mezzotints for a deluxe edition of John Milton's *Paradise Lost*.

▲ **Joshua Commanding the Sun to Stand Still** *This is the picture that made Martin famous. Typically, it shows a scene of apocalyptic mayhem, drawn from the Old Testament.* 1816, oil on canvas, 59 x 91in, private collection

Samuel **Palmer**

Self-portrait

b **LONDON, 1805**; d **REDHILL, 1881**

The son of a bookseller, Palmer showed artistic promise from a very early age, exhibiting at the Royal Academy when he was just 14. In 1824, a meeting with William Blake led to a transformation of his style, and an emphasis on the visionary. This intensified after 1826, when Palmer moved to the village of Shoreham in Kent, where he headed a group of artists known as the Ancients. In true Romantic fashion, they rejected the increasing urbanization and industrialization of modern life, retreating instead into an idyllic vision of the past.

Palmer's finest works are small-scale, pastoral fantasies, in which Nature's gifts are portrayed as living proof of God's love. Rolling valleys with golden crop-fields, heavily laden fruit trees, and contented shepherds combine to show Nature and humanity in harmony. Largely forgotten after his death, Palmer was rediscovered in the 1920s.

▲ **Early Morning** *Nothing seems quite real in this famous woodland idyll. Even the human figures appear to melt into the landscape.* 1825, brown ink and sepia, 7½ x 9in, Ashmolean, Oxford, UK

▲ **In a Shoreham Garden** *The luxuriant blossom of an apple tree dominates this scene, and is a reflection of God's bounty.* c1829, watercolor and gouache, 11 x 8¾in, Victoria and Albert Museum, London, UK

Love

The challenge of depicting the emotion of love, has inspired many artists across history and cultures, encouraging them to search for the story, character, or object that best represents the feeling. The classical goddess Venus, for example, has been a long-lasting popular symbol of idealized love in Western art. Post-Renaissance representations of love leaned toward an increased realism, replacing perfect ideas of chivalry and romance with more personal depictions of plain physicality. While artists often preferred to focus on images of romantic, or sexual love; themes of universal, spiritual, and platonic love have also been tackled.

▼ **Mars and Venus from the House of Mars and Venus (wall painting)** Roman *Venus, the goddess of love, is embraced by Mars, the god of war, before a watching Cupid. This fresco subscribes to the story that Cupid was the couple's son.* 1st century CE, wall painting, Pompeii, Italy

▼ **Throne, from the Tomb of Tutankhamun** Egyptian *This affectionate scene of the young pharaoh being annointed by his wife is ornately rendered in gold paint.* c1567–1320 BCE, gold, Egyptian National Museum, Cairo, Egypt

▼ **An Allegory with Venus and Cupid** Agnolo Bronzio *Framed by a group of allegorical figures, including winged Time, Bronzio's eroticized Venus and Cupid demonstrate his skill with flesh tones.* c1540–50, oil on panel, 58 x 46in, National Gallery, London UK

▼ **The Faux Pas** Jean-Antoine Watteau *The viewer is made to feel like a voyeur in their observation of this unwanted advance.* 1717, oil on canvas, 15¾ x 12⅝in, Louvre, Paris France

▲ **Parade Shield Painted with Figures of a Lady, a Knight ,and Death** Flemish *A knight declares his love for a lady, in the presence of Death. The permanance of true love is a feature of the courtly tradition.* 15th century, leather covered shield, British Museum, London, UK

▲ **Allegory of True Love** Pieter Pourbus *The Flemish Mannerist artist depicts a sexualized vision of love unfettered by social convention.* c1547, oils, 52½ x 81in, Wallace Collection, London, UK

▲ **The Proposition** Judith Leyster *The composition emphasizes the physical dominance of this man—propositioning this woman with money—which casts a threatening shadow over the whole scene.*

▲ **Radha and Krishna** Indian School *The love of Radha, a married mortal woman, for the god Krishna, is a popular theme in Hindu literature. The couple are colorfully depicted, surrounded by bountiful wildlife.* c1780, watercolor on paper, Victoria and Albert Museum, London, UK

▲ **Jewish Bride** Rembrandt van Rijn *An awkward initimacy lends this scene its mystery.* 1666 oil on canvas, 48 x 65½in, Rijksmuseum, Amsterdam, Holland

▼ The Kiss Auguste Rodin *The fluidity and motion of The Kiss make it an iconic representation of romance. Rodin did not value the work very highly.* 1888, marble, 72½ x 43¾ x 46½in, Rodin Museum, Paris

▶ Bank Holiday William Strang *Although the couple in the picture are not relaxed in the restaurant setting, the scene is tempered by the flowers and the cat which are symbolic of devotion.* 1912, oil on canvas, 60¼ x 48½in, Tate, London, UK

▼ The Embrace Egon Schiele *Echoing his friend Klimt's* The Kiss, *this passionate work exhibits a growing warmth in Schiele's treatment of love and sexuality.* 1917, oil on canvas, 38⅝ x 66½in, Osterreichisches Galerie, Vienna, Austria

▼ The Kiss Pablo Picasso *This is a typical example of Picasso's use of unconventional techniques—such as multiple perspective—to tackle popular themes.* 1969, oil on canvas, 38¼ x 51¼in, Musée Picasso, Paris, France

▲ Le Sommeil Gustave Courbet *Female sexuality was a favorite subject of Courbet's. His naturalistic celebrations of womens' bodies shocked the artistic establishment.* 1866, oil on canvas, 53 x 79in, Musée du Petit Palais, Paris

▲ Lovers from the *Poem of the Pillow* Kitagawa Utamaro *These delicate illustrations of poems are part of the tradition of* shunga, *a form of Japanese erotica.* 1788, woodblock print, Victoria and Albert Museum, London UK

▲ Jealousy Edvard Munch *Jealousy casts a heavy shadow over Munch's artistic vision. The vitality of the woman in the center of the picture is contrasted with the empty anxiety of the foregrounded lover.* 1895, oil on canvas, 26½ x 39½in, Rasmus Meyers Samplinger, Bergen, Norway

◀ Parade Amoureuse Francis Picabia *Early in his Dadist period, Picabia created a series of pictures that illustrated the sexual suggestiveness of machine parts.* 1917, oil on cardboard, 37½ x 28in, private collection

John **Constable**

Portrait by Daniel Gardner

b **EAST BERGHOLT, 1776;** d **HAMPSTEAD, 1837**

Constable is regarded by many as England's greatest landscape painter. Despite this, his route to success was far from easy. His choice of career was opposed by his father and his bride's family, and official recognition in English art circles was very slow in coming.

Constable's originality lay in his style and his subject matter. To modern city dwellers, his pictures may seem full of rustic charm, but his contemporaries did not find them sufficiently picturesque. Instead of painting spectacular mountains or sweeping panoramas, he focused on the working countryside, with its mills, barges, and a busy, canalized river.

Critics also condemned his pictures as unfinished. Constable was always anxious to capture the precise sensations created by nature—the changes of light under moving clouds, the dampness of rain-soaked fields, the effects of the slightest breeze—and he used vigorous brushwork and white highlights to achieve this. English commentators were unimpressed, but his innovations were better appreciated in France, where Géricault and Delacroix expressed great admiration for his work.

LIFEline

1776 Born in East Anglia, the son of a prosperous grain merchant

1799 Enters the Royal Academy Schools

1802 Exhibits for the first time at the Royal Academy

1809 Becomes engaged to Maria Bicknell

1816 Finally marries Maria, despite her family's disapproval

1821 Paints his most famous work, *The Hay Wain*, which wins a gold medal at the Paris Salon 3 years later

1828 Maria dies of tuberculosis

1829 Elected a full member of the Royal Academy

1837 Dies in Hampstead

▼ **Boatbuilding near Flatford Mill** *Constable painted many rural scenes. This one depicts his father's boatyard.* 1815, oil on canvas, 20¼ x 24¼in, Victoria and Albert Museum, London, UK

➤ **The Hay Wain** *Constable depicts a rural scene that was very familiar to him. He exhibited it under the title* Landscape: Noon. *The picture received a tepid reception at the Royal Academy, but won a gold medal at the Paris Salon and was much admired by Delacroix.* 1821, oil on canvas, 51 x 73in, National Gallery, London, UK

CLOSERlook

RUSTIC DETAILS Constable's painting overflows with many authentic details of country life. A kitchen maid kneels down by the landing stage to scoop up a pail of water from the stream.

➤ **View of Salisbury Cathedral** *Constable used the trees as a natural frame for the cathedral. The figures (to the left) and the cows help to lead the eye to the focal point. It proved to be a troublesome project because the Bishop disapproved of Constable's dark clouds.* 1823, oil on canvas, 34¾ x 44¼in, Victoria and Albert Museum, London, UK

CLOSERlook

THE BISHOP Constable was close friends with the Bishop of Salisbury, John Fischer, who not only commissioned the painting but appears in it with his wife.

❝ No two days are alike, nor even **two hours**; neither was there ever **two leaves of tree** alike since the creation of the world ❞

JOHN CONSTABLE

Joseph Mallord William **Turner**

Self-portrait

b **LONDON, 1775**; d **LONDON, 1851**

Turner was the most original and imaginative figure in the history of English landscape painting. He was a close contemporary of John Constable, but their careers could scarcely have been more different. His talent was precocious, while Constable's matured more slowly; he traveled widely, while Constable concentrated on areas with which he was most familiar. And, while Constable could toil for months on a single canvas, Turner worked quickly and had a huge output.

Turner's style varied considerably over the years. Early in his career, he produced accurate, topographical watercolors that sold well when transferred into prints. After visiting Italy, he also painted serene landscapes in the classical manner, comparable to those of Claude. In his most Romantic paintings, however, Turner tried to capture the sheer power of nature, unleashed in violent storms and raging blizzards. Here, his handling became incredibly free, as he scratched and scraped at the canvas until the forms and figures dissolved into swirling vortices of light and color.

LIFEline

1775 Born, the son of a barber, in London

1789 Begins studies at Royal Academy Schools

1792 Embarks on the first of his many sketching tours

1800 His mother is admitted to Bedlam, London's infamous mental hospital

1802 Fourth youngest ever full member of Royal Academy

1833 Begins relationship with Sophia Booth, a widow

1838 Paints his masterpiece, *The Fighting Temeraire*

1840 Meets John Ruskin, his most ardent supporter

1851 Dies in Chelsea and is buried in St. Paul's Cathedral

▼ **A Canal near the Arsenale, Venice** *Turner made his first visit to Venice in 1819, but it was only in the 1830s that he really fell under its spell. The place inspired some of his most magical watercolors, full of shimmering reflections and ghostly architecture.* Watercolor on paper, British Museum, London, UK

▲ **Ulysses deriding Polyphemus** *On his return from the Trojan War, Ulysses celebrates a narrow escape from a man-eating cyclops— the one-eyed giant of Greek mythology.* 1829, oil on canvas, 52 x 80in, National Gallery, London, UK

CLOSERlook

NATURE'S DRAMA In his subject paintings, Turner conveyed the full impact of the narrative with nature rather than figures. Here, the cyclops appears as an apparition, looming over the ship, and could be mistaken for a cloud formation. Turner focused on the setting, featuring arched rocks from the Bay of Naples.

◀ **Rain, Steam, and Speed— The Great Western Railway** *Turner felt exhilarated by the novel sensation of speed, which the railways provided. During a raging storm, he stuck his head out of a carriage window to experience the full power of the elements.* 1844, oil on canvas, 35¾ x 48in, National Gallery, London, UK

CLOSERlook

VISUAL PUN Turner has underlined the power of the new technology by contrasting it with older symbols of speed. The hare that appears on the track was probably meant as a reference to the fable of "The Hare and the Tortoise."

The Fighting Temeraire, Tugged to her Last Berth to be Broken Up, 1838 *J.M.W. Turner*
1839, oil on canvas, 35¾ x 44¼in, National Gallery, London, UK ➤

CLOSERlook
The Fighting Temeraire J.M.W. Turner

A pale ghost of her former noble and majestic self, the old warship the *Temeraire*, veteran of the Battle of Trafalgar, is towed up the Thames by a steam tug, to be broken up for scrap. Rather than painting a documentary of the event, Turner transformed the ship's final journey into a mournful hymn to the passing of the great days of sail. First exhibited the year after the *Temeraire* was broken up, this has always been one of Turner's best-loved canvases. Turner called it his "darling" and refused all offers to buy it.

Composition

Turner creates a composition based on contrasts—sail versus steam, dark forms versus pale, cool colors predominating on the left contrasting with warm colors on the right where the dying sun blazes. A strong diagonal divides the picture in two, and draws the viewer's eye across the canvas in a way that creates the sense of forward movement suggesting the *Temeraire*'s final journey toward the ominous, dark buoy in the bottom right.

▲ **FORWARD MOTION** The line of mast-tops leads diagonally toward the bottom right, while the dark shapes of tug and buoy suggest another diagonal link. These two diagonals create a point in the bottom left-hand corner, toward which the ship is being drawn to her doom.

▲ **SMOKE TRAIL** A trail of fiery smoke belching from the tug's funnel cuts dramatically across the Temeraire. To accentuate the effect, Turner deliberately altered the boat's design, transposing mast and funnel. He put the funnel at the front and elongated the smoke trail.

Technique

Unlike many of Turner's paintings, which have deteriorated because of his experimental use of materials, this masterpiece is well preserved. He used a relatively conventional oil-paint mix, with walnut oil as a medium. In some areas, such as the hull of the *Temeraire*, paint is applied in thin, fluid veils. In others, such as the sky, Turner uses a technique known as "scumbling," dragging brushloads of thick, opaque paint irregularly across the underlayer.

▶ **IMPASTO YELLOW** Capturing the effects of yellow light preoccupied Turner. Here, he has built up impasto layers, using brilliant lemon yellow, which remains much as it was when he painted it, along with other less stable yellows, which have become more silvery than he intended. Although he often used a palette knife, Turner appears to have used a heavily loaded brush here.

▼ **HULL OF BOAT** In reality, the *Temeraire* was painted in yellow and black, but Turner evokes a ghostly sense of insubstantiality, by depicting her hull in thin veils of gray and brown over ivory-colored paint. The pale lines of her timbers give her a strangely skeletal appearance.

▶ **BLAZING SUNSET** Turner began by painting the sky with thin glazes. When this layer was dry, he thickly brushed on yellows and reds for the clouds. He used several reds: traditional vermilion and Venetian red, both stable, and iodine scarlet, a newly invented pigment that was intense but unstable, and has changed over time.

INcontext
GLORY DAYS The *Temeraire*—whose name means "fearless"—was a 98-gun man-of-war, first launched in 1798. She played a "most noble and distinguished part" in the Battle of Trafalgar in 1805. When Admiral Nelson's flagship, the *Victory*, came under fire, the *Temeraire* came to her aid and captured two French ships before being so battered that she had to be towed away.

The Battle of Trafalgar, 1805 *Clarkson Stanfield, (exhibited 1836). The* Temeraire—*lying the Union Jack— is depicted at the center of the action at Trafalgar.*

Story

Although "based on a true story," Turner's painting transforms reality into an emotionally charged, poetic elegy. The ship was towed in from Sheerness to the breaker's yard in Rotherhithe over two days, probably in daylight hours, but Turner paints the scene at sunset, creating an air of finality. She would have been traveling west, but he shows her travelling east, so as to have the sunset behind her. Her masts would have already been removed, but he shows them intact, in stately opposition to the squat little tug's black funnel.

▼ **ONE TUG NOT TWO** In reality, two steamboats (*Samson* and *London*) tugged the *Temeraire*, one in front pulling her along, and one behind acting as a brake. Turner may have felt that the contrast would be more powerful with a solitary steamboat.

▲ **SYMBOLIC MOON** A crescent moon appears as the sun sets: some contemporary reviewers interpreted this as symbolic of the new era of steam taking the place of the passing age of sail (symbolized by the setting sun).

" A **gorgeous horizon** poetically intimates that the sun of the Temeraire is **setting in glory** "

THE MORNING CHRONICLE, MAY 7, 1839

▲ **FULL SAIL** As the tug pulls the *Temeraire* forward, a number of sailing ships recede into the distance. On the horizon, this ship is shown in full sail, perhaps reminding us of the *Temeraire*'s glory days. Painted with a few deft brushstrokes, its white sails stand out against the darkening sky.

Washington **Allston**

b **WACCAMAW, SOUTH CAROLINA, 1779;**
d **CAMBRIDGE, MASSACHUSETTS, 1843**

▲ **Elijah in the Desert** *The vivid color contrasts in Allston's work earned him the nickname "the American Titian."* He painted several landscapes with biblical subjects. 1818, oil on canvas, 49¼ x 72¾in, Museum of Fine Arts, Boston, US

A pioneer of American Romantic painting, Allston broke with the tradition of portrait painting to produce a small but influential collection of dramatic landscapes. The son of a South Carolina plantation owner, he moved to New England as a child. He graduated from Harvard in 1800 before traveling to Europe, where he studied at London's Royal Academy and worked in Paris and Rome. In 1818, Allston returned to the US and settled in Boston and then Cambridge. He gained some popular success as an author as well as a painter.

322

Frederic Edwin **Church**

b **HARTFORD, CONNECTICUT, 1826;** d **NEW YORK, 1900**

Frederic Church was a much-traveled landscape artist, regarded as one of the most important of the Hudson River School's second generation of painters. He studied under Thomas Cole in the 1840s, and soon achieved an enthusiastic reception for his historical landscapes. After reading the work of the naturalist Alexander Humboldt, he decided to follow in his footsteps and travel to South America—Church's first trip taking place in 1853.

Church made many extended trips abroad, notably to Europe, and the Near East, and also traveled widely in the US. The paintings from these trips, including views of Cotopaxi and Niagara Falls, made him both a popular and a financial success. In 1869, he returned from London, where he had seen the work of Turner, and settled outside New York. Arthritis forced him to give up painting in 1877.

LIFEline

1826 Born into a wealthy Connecticut family
1844 Studies with Thomas Cole
1846 Paints first major work, *The Rev. Thomas Hooker and Company Journeying through the Wilderness from Plymouth to Hartford,* in 1636
1847 Settles in New York
1850 First visit to Maine
1853 Travels to South America
1857 Exhibits *Niagara;* travels to South America again
1865 Visits Jamaica
1867–69 Tours Europe
1900 Dies in New York

Albert **Bierstadt**

b **SOLINGEN, NEAR DÜSSELDORF, 1830;** d **NEW YORK, 1902**

This Romantic landscape painter—one of the last of the Hudson River School (see pp.296–97)—combined Germanic style with American subjects and a distinctly American approach. Born near Düsseldorf, Bierstadt grew up in Massachusetts. When he returned to Germany to study, he spent much of his time with American artists based there.

Like his contemporary Frederic Church, Bierstadt traveled widely but found inspiration mainly from his trips to the West of the US, and the Rocky Mountains in particular. His Romantic mountain scenes and depictions of wagon trains on the Overland Trail, helped by a flair for self-publicity, gained him enormous popularity in the 1860s. His huge output of paintings sold well and gave him a comfortable lifestyle, including frequent trips abroad. By the 1880s, however, Bierstadt's Romantic style was falling out of favor, and his final important work, *The Last of the Buffalo* (1888)—significantly, a portrayal of fast-disappearing glory—was considered too old-fashioned as an American entry to the Exposition Universelle in Paris.

LIFEline

1830 Born near Düsseldorf
1833 Moves to New Bedford, MA, with his family
1853–57 Studies in Düsseldorf
1859 First visit to western US
1889 *The Last of the Buffalo* rejected for Exposition Universelle in Paris
1902 Dies in New York

▶ **The Oregon Trail** *The stunning plains scenery is depicted in glowing colors that typify the Hudson River School.* 1869, oil on canvas, 31⅛ x 49¼in, Butler Institute of American Art, Youngstown, US

▼ **Rocky Mountain Landscape** *In the Rocky Mountains Bierstadt found a worthy alternative to the Alps of European landscapes. His well-observed and often huge paintings of the magnificent, unspoiled west were especially popular after the ravages of the Civil War (1861–65).* 1870, oil on canvas, White House, Washington DC, US

CLOSERlook

LUMINOSITY
Bierstadt painted the glowing skies in this sunset in exaggerated colors, in a style that was sometimes known as Luminism, to help capture the atmosphere of the scene.

▶ **Niagara Falls, from the American Side** *Niagara is one of the foremost scenic wonders of America. Church's detailed, realistic depiction of the Falls captures the power of this natural wonder.* 1867, oil on canvas, 102⅜ x 90⅞in, National Gallery of Scotland, Edinburgh, UK

▼ **Cotopaxi** *Church made a number of paintings of Ecuador's Cotopaxi volcano in different states of eruption. His major concern in all his landscapes was the accurate portrayal of natural phenomena.* 1862, oil on canvas, 48 x 85in, Detroit Institute of Arts, US

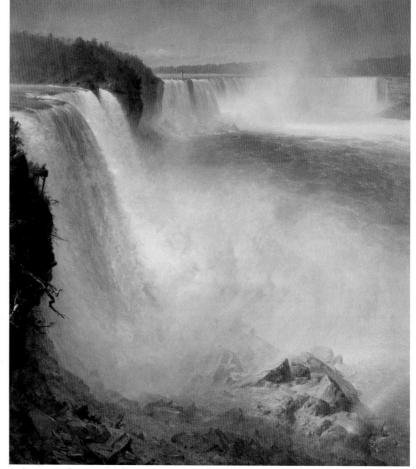

Thomas **Cole**

b **BOLTON, ENGLAND, 1801;** d **CATSKILL, NEW YORK, 1848**

Cole was a founding member of the group of artists known as the Hudson River School, and in his comparatively short career he produced a number of influential landscapes and allegorical paintings. Born and brought up in the industrialized north of England, Cole emigrated with his family to the US at the age of 17, and after two years at the Pennsylvania Academy he joined them in Ohio.

Cole's first success came in New York, when fellow Hudson River School artist Asher Brown Durand, noticed his work and helped him to find buyers. Cole found a studio in nearby Catskill, from which he could make painting trips into the countryside. His growing reputation enabled him to visit Europe, and after his return in 1832 he embarked on two series of huge allegorical paintings, *The Course of Empire* and *The Voyage of Life*. He continued to paint the countryside of the northeastern states until his death, aged 47.

LIFEline

1801 Born in industrial Lancashire, England

1818 Emigrates to rural Steubenville, Ohio

1823–25 Moves first to Pittsburgh, then Philadelphia, and finally New York

1827 Takes a studio in Catskill

1829–32 Visits England and Italy

1833–6 *The Course of Empire* cycle of paintings

1836 Marries Maria Barlow in Catskill, and settles there

1839 Paints the first of the *The Voyage of Life* series

1841–42 Returns to Europe

1848 Dies in Catskill

◀ **The Course of Empire: Destruction** The Course of Empire *series was produced when Cole was at the height of his powers. The cycle charts the rise and fall of an imaginary city, from* The Savage State *through* The Arcadian or Pastoral State *to* The Consummation, *and ending with* Destruction *and* Desolation. 1836, oil on canvas, 39⅜ x 63⅜ in, Collection of the New-York Historical Society, US

▶ **The Oxbow** *This view of a bend in the Connecticut River shows the gentle encroachment of man into the wilderness as a storm passes over. The diagonal division of wild natural scenery and cultivated landscape is emphasized by the leaning tree in the foreground.* 1836, oil on canvas, 51⅝ x 76 in, Metropolitan Museum of Art, New York, US

CLOSERlook

COLE'S UMBRELLA Dwarfed by the vast landscape and barely visible is an umbrella, closed after the passing of the storm; to the left Cole has included himself, almost imperceptibly, on the hillside.

Thomas **Doughty**

b **PHILADELPHIA, 1793;** d **NEW YORK, 1856**

Doughty was one of the first American painters to concentrate on landscapes, anticipating the artists of the Hudson River School (see pp.296–97). He was born in Philadelphia and spent much of his life there. He taught himself to paint while employed as a leather worker—so successfully, in fact, that by 1824 he was able to describe his occupation as "landscape painter."

Doughty exhibited regularly at the Pennsylvania Academy, and his fame spread as far as New York and Boston, where he also showed work. During the 1820s and 30s, his tours of the eastern US and Europe inspired some of his finest work, including the well-known *Nature's Wonderland* (1835). Poor health eventually put an end to his travels, and he spent his final years in New York.

LIFEline

1793 Born in Philadelphia

1816 Exhibits at Pennsylvania Academy of Fine Arts

1824 Is elected Academician in Pennsylvania

1830s Lives in New York, Massachusetts, Connecticut, and Delaware

1837 First visit to Europe

c1845 Settles in New York

1856 Dies in New York

▶ **Denning's Point, Hudson River** *This painting is typical of the tranquil, atmospheric style Doughty adopted from the mid-1830s after visiting Europe.* c1839, oil on mounted canvas, 24 x 29⅞ in, Butler Institute of American Art, Youngstown, US

CLOSERlook

SMOOTH EDGES Gently rounded shapes in the composition of this scene enhance its peacefulness. Framed by the dark foreground and tree, the curve of the mid-ground hill echoes across the picture.

Asher Brown **Durand**

b **MAPPLEWOOD, NEW JERSEY, 1796;** d **MAPLEWOOD, NEW JERSEY, 1886**

▲ **Shandaken Ridge, Kingston, New York** *Durand's landscapes have a classically balanced composition, like those of European painters such as Claude Lorrain.* c1854, oil on canvas, Collection of the New-York Historical Society, US

Working first as an engraver and illustrator, Durand turned to painting in the 1830s and became a founding member of the Hudson River School. Already well known for his engravings of famous American paintings and portraits, he devoted himself to landscape painting after a trip to Europe. His work includes *Kindred Spirits* (1849), a portrayal of his friend Thomas Cole and the poet William Cullen Bryant in the Catskill woodlands.

Origins and influences

In the late 1840s, a circle of writers, artists, and intellectuals held regular meetings at a Parisian bar, the Brasserie Andler. The group's heated discussions covered a broad range of subjects, from radical politics and social issues to the latest artistic trends. They dubbed their meeting place the "Temple of Realism," and it was this nickname which Courbet adopted for his art.

Although they appear anything but revolutionary today, the paintings of Courbet provoked a storm of protest at the Salon—the state-sponsored exhibition in Paris—largely because they contravened normal academic practice. Scenes of rural life were expected to be small and picturesque, providing town-dwellers with a sense

▲ **La Rencontre, or Bonjour Monsieur Courbet**
Gustave Courbet, 1854. *With an air of self-confidence, the artist, Courbet (right), greets his patron Alfred Bruyas. The composition is based on a popular print of the Wandering Jew.*

of escapism. The peasant pictures of Courbet and Millet, however, were large, on a scale that was normally reserved for major historical themes or religious subjects. Worse still, they focused on the hardship of modern

working conditions, a topic that smacked dangerously of socialist politics to conservative critics.

The Realists attracted equal scorn for their figures. Courbet's nudes had double chins and rolls of fat, while Honoré Daumier's workers were wizened caricatures. For critics accustomed to the idealized forms of academic art, this was not realism, but a deliberate quest for ugliness.

Realism proved influential, not just for the style itself, but for the way that Courbet promoted it. His "Pavilion of Realism" at the World Fair of 1855 was a show of artistic independence, and a model for the later Impressionist exhibitions (see pp.340–41).

The Realist movement emerged in France in the mid-19th century, as a reaction against the outdated strictures of academic art. Spearheaded by Gustave Courbet and Jean-François Millet, it signaled a definitive break from the artistic traditions of the past.

Realism

TIMEline

The Barbizon School thrived in the 1840s, when Rousseau and Millet settled in the area. Courbet burst upon the Parisian art scene in 1850; his work was controversial throughout the decade. In the early 1860s, Menzel painted scenes from modern life, while, in 1871 a group of Russians, known as the Wanderers, staged the first of their traveling shows.

1843

COROT The Gardens of the Villa d'Este, Tivoli

1849

COURBET The Stone-Breakers

1850

SPITZWEG The Bookworm

1857

MILLET The Gleaners

c1860–61

DAUMIER The Washerwoman

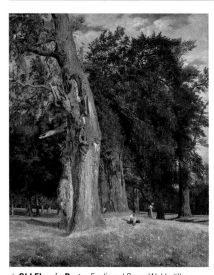

▲ **Old Elms in Prater** Ferdinand Georg Waldmüller *Waldmüller's work predates the Realist movement, but his landscapes often display an almost photographic clarity that is reminiscent of the style of Corot.* 1831, oil on panel, 12½ x 10¾in, Kunsthalle, Hamburg, Germany.

Schools

As a coherent movement, Realism is chiefly associated with France. Naturalist trends, however, were prominent in several European countries.

French

Prior to the Realist controversies, a number of landscape painters began working in the Forest of Fontainebleau, close to the village of Barbizon. Although they are traditionally known as a "school," the group did not have any formal links or joint manifesto. However, they did share a dislike for the artificiality of academic art, preferring to depict a more realistic version of the scenes that lay before them. The leading figures were Théodore Rousseau, Constant Troyon, Narcisse Diaz, and Charles Daubigny, although Camille Corot and Jean-François Millet were also associated with the group. The Impressionists would later cite them as an inspiration for their own movement.

German

Courbet visited Germany several times, making a particularly strong impact in 1869, when he demonstrated his techniques to a group of young artists in Munich. His closest links were with Wilhelm Leibl, who worked with him in Paris for a time. Leibl's fascination with the style is most evident in his starkly realistic portrayals of peasant women. He also transmitted his ideas to a circle of German artists, who became known as "Leibl's Group." This included Hans Thoma, Carl Schuch, Theodor Alt, and Wilhelm Trübner. Naturalist tendencies can also be discerned in some of the Biedermeier painters. Carl Spitzweg and Ferdinand Georg Waldmüller, for example, produced charmingly unaffected depictions of everyday life.

Russian

In Russia, the baton of naturalism was taken up by an association of exhibiting artists, known as the Wanderers, or Itinerants. Led by painters such as Ilya Repin, Ivan Kramskoi, and Vasily Surikov, they created a penetrating study of Russian society. Their range of subjects was very broad. Repin's *Volga Boatmen* and Nikolai Kasatkin's *Paupers Collecting Coal*, for instance, were as

uncompromising in their portrayal of manual labor as anything produced by the French Realists. However, their work was not all contentious, and included atmospheric landscapes and scenes of daily life.

▲ **St. Nicholas Delivers Three Unjustly Condemned Men from Death** Ilya Efimovich Repin *Repin brought a fresh approach to the portrayal of historical subjects. He supported a campaign for the abolition of the death penalty in Russia and here shows the saint saving three condemned men.* 1888, oil on canvas, 84⅝x77¼in, State Russian Museum, St. Petersburg, Russia.

Jean-François **Millet**

Self-portrait

b GRUCHY, NORMANDY, 1814; d BARBIZON, 1875

Inspired by his observations of life on the land in his native Normandy, Jean-François Millet painted mainly rural scenes. His paintings were admired by Realist artists and the young Vincent van Gogh.

Having trained in Cherbourg and Paris, Millet spent his early career as a historical and portrait painter, achieving modest success. However, after the 1848 Revolution and his move to the village of Barbizon, in the forest of Fontainebleau, he wanted to give his painting the social and political significance he admired in Daumier's work. He struggled financially for much of his career (he had a large family to support), but by the end of his life he was achieving recognition and honors (he was made a member of the Legion of Honor in 1868). After his death his paintings became enormously popular.

LIFEline

1814 Born into a prosperous peasant family in Normandy
1832 Moves to Cherbourg to study with local painters
1837 Studies with Delaroche in Paris
1840 One of his portraits is accepted by the Salon
1848 Exhibits *The Winnower*, his first peasant scene
1849 Moves to Barbizon, near Fontainebleau
1867 Exhibition of his work at Paris Exposition Universelle
1875 Dies in Barbizon

▶ **The Gleaners** *Millet often depicted peasants as noble, or even heroic figures. Here, the women picking up the leftovers of the harvest are invested with a monumental dignity; they are the focus of attention in the fertile landscape.* 1857, oil on canvas, 33 x 43¾in, Musée d'Orsay, Paris, France

▼ **The Angelus** *Millet's most popular painting, it fetched a huge price soon after his death and was endlessly reproduced. Originally titled* Prayer for the Potato Crop, *it depicts a peasant couple pausing devoutly as the Angelus bell sounds the time for prayer. This is ostensibly a peaceful rural scene, but can be interpreted as having a more tragic subtext.* 1857–59, oil on canvas, 20¾ x 25¾in, Musée d'Orsay, Paris, France

PRAYING HANDS At first glance, the two figures appear united in prayer, but there is awkwardness between them. This is seen most clearly in their hands: while the woman's are tightly clasped in devout prayer, the man's betray his embarrassment as he self-consciously turns the rim of his hat.

Honoré **Daumier**

b MARSEILLE, 1808; d VALMONDOIS, 1879

The satirical cartoons and caricatures that made Honoré Daumier famous in his own lifetime somewhat eclipsed his paintings and sculptures. These are now recognized both as fine examples of the Realist genre, and as pioneering the techniques of Impressionism.

Honoré Daumier

In 1816, Daumier's father made a disastrous move to Paris, and young Honoré was forced to find work. After a number of menial jobs, which shaped his left-wing politics, he learnt the techniques of lithography, and he started to contribute cartoons to the journal *La Caricature*. For most of his life, Daumier struggled to make a living. He was admired by many fellow artists, including Corot, Degas, and Delacroix, but died in poverty.

LIFEline

1808 Born into a family of artists in Marseille
1816 Family moves to Paris
1822 Produces lithographs to augment the family income
1830 Contributes satirical cartoons and lithographs to *La Caricature*
1832 Imprisoned for depiction of King Louis-Philippe as Gargantua
1835 Works for *Le Charivari*
1845 Befriends art critic Charles Baudelaire
1871 Becomes a member of the Paris Commune
1878 Renowned art dealer Paul Durand-Ruel exhibits his paintings
1879 Dies, virtually blind and dependent on financial support from friends

▼ **The Collector of Engravings** *Daumier's post-1848 paintings are mainly keenly observed and unsentimental scenes of the Paris he knew.* c1860–62, oil on canvas, 16¼ x 12¾in, Musée du Petit Palais, Paris, France

▼ **Ratapoil** *Daumier made a large number of sculptural heads and figures. In them he created the character Ratapoil (skinned rat) who represented the sinister agents of the government.* c1850, colored plaster, height 14¾in, Louvre, Paris, France

▲ **The Washerwoman** *Daumier's choice of subject matter for his paintings places him within the Realist tradition—especially his depictions of everyday life in working-class Paris. Yet his paintings also display a spontaneity and handling of light that anticipate Impressionism.* c1863, oil on canvas, 19¼ x 13¼in, Musée d'Orsay, Paris, France

Gustave **Courbet**

b ORNANS, FRANCE, 1819; d LA TOUR-DE-PEILZ, SWITZERLAND, 1877

Courbet is believed to have coined the term Realism. He was one of the movement's first and most dedicated exponents, expressing his political and social commitment in paintings of outstanding technical achievement. Brought up in rural Franche-Comté, in eastern France, Courbet went to Paris in 1840 to study law. In fact, he spent his time studying works in the Louvre and resolved to become an artist (with the financial backing of his father).

Self-portrait

After some initial success, Courbet's works were rejected as unconventional, and he became increasingly anti-establishment. A trip to Ornans confirmed his dislike of the rarefied Beaux-Arts, prompting him to adopt the Realist style. He was a leading figure in the Paris Commune (opposite), who seized power in Paris following the Franco–Prussian war, but after its collapse in 1871 he fled to Switzerland, and spent his final years there.

❝ The **essence of realism** is its **negation** of the **ideal**… The **expression of beauty** is in direct ratio to the **power of conception** the artist has acquired ❞
GUSTAVE COURBET

LIFEline

1840 Moves to Paris, aged 21
1844 *Courbet with a Black Dog* accepted by Paris Salon
1847 Sees the work of Dutch masters in the Netherlands
1849 First Realist paintings
1855 *The Artist's Studio* is rejected by the Exposition Universelle
1866 Begins a series of erotic paintings, including the notorious *Origin of the World*
1871 Takes charge of art museums in Paris Commune
1871 Arrested for dismantling the Vendôme Column, a monument to Napoleon
1873 Flees France to escape paying a huge fine for the rebuilding of the monument
1877 Dies, exiled in Switzerland

▼ **The Stone Breakers** *In one of his first overtly Realist paintings, Courbet starkly portrays the unglamorous work of laborers. This rebellion against the Romantic conventions of the time gained him some notoriety when exhibited at the Salon of 1850.* 1849, oil on canvas (destroyed in 1945), 63 x 102in, Galerie Neue Meister, Dresden, Germany

◄ **The Artist's Studio**
Subtitled A Real Allegory of Seven
Years of my Artistic and Moral
Life, *this painting shows Courbet
at work surrounded by "the
world of commonplace life" on
the left, and an admiring group
of friends (including novelist
George Sand, art critic Charles
Baudelaire, and politician Pierre-
Joseph Proudhon), on the right.
In the center, turning his back on
a voluptuous nude symbolizing
artistic tradition, the artist paints
a landscape under the gaze of
a small boy and his dog.* 1855,
oil on canvas, 142 x 235 in, Musée
d'Orsay, Paris, France

INcontext
PARIS COMMUNE In the uprising following
the Franco–Prussian war, a citizens' militia
seized power in Paris, demanding a democratic
and social republic. The Commune governed
Paris from March to May of 1871, but it had
great political significance as a model for future
left-wing and anarchist revolutionary movements.

Destruction of the Vendôme Column, 1871
*Courbet was responsible for the city's art museums
during the short-lived Commune. He supervised the
toppling of the Vendôme column commemmorating
Napoleon, for which he was subsequently imprisoned.*

◄ **Burial at Ornans** *The funeral of Courbet's
granduncle was thought an unconventional and
mundane subject for a painting in 1850, especially
one on such a massive scale. The portrayal of
ordinary people, rather than royalty or historical
figures, was a statement of his socialist beliefs. His
choice of this working-class ceremony was, he said,
"in reality, the burial of Romanticism."* 1849–50,
oil on canvas, 124 x 261 in, Musée d'Orsay, Paris, France

CLOSERlook

SYMMETRICAL COMPOSITION The
painting is divided into two distinct rectangles
either side of the central grave: to the left stand
the robed clergy and dignitaries, to the right
less colorful townspeople. The symmetry is
emphasized by contrasting vertical lines formed
by the cross and the mourner in the foreground.

 RURAL SOBRIETY In
contrast to the pageantry
and sumptuous clothes
associated with traditional
depictions of ceremonies,
Courbet shows townsfolk
attending the funeral in
somber mood and wearing
their slightly shabby
"Sunday Best."

Camille **Corot**

Portrait by Constant Dutilleux

b **PARIS, 1796**; d **PARIS, 1875**

A major influence on the next generation of French artists, Camille Corot to some extent anticipated Impressionist landscapes. After a short-lived career in the family's drapery business, he turned to painting (with the help of a small allowance from his father) in his twenties, and in 1827 first had work accepted at the Salon. His reputation started to grow, and he soon established himself as a successful artist, working from sketches made on his travels around France and Italy, and slowly developing a very personal style.

Although a supporter of the Realist artists of the Barbizon school (see p.324) (his commercial success allowed him to help Daumier and Millet financially), he did not share their concern for the social connotations of landscape; figures appear only incidentally, if at all, in his landscapes.

LIFEline

1796 Born in Paris, the son of a draper
1825 Visits Rome and Venice
1827 *The Bridge at Narni* is shown at the Paris Salon
1834 Travels around Italy sketching and painting
1836 Spends time in Avignon and the south of France
1846 Receives the cross of the Légion d'honneur
1872 Buys a cottage for the homeless Daumier
1875 Dies and is buried in Père Lachaise cemetery, Paris

▼ **The Goatherd beside the Water** *Corot's later work shows a softening of the landscape, presaging Impressionism. The distant view, misty lake, translucent trees, and sole human figure are all frequent features of Corot's landscapes.* 1843, oil on canvas, 31¾ x 25½in, private collection

◄ **The Woman with the Pearl** *Although primarily a landscape artist, Corot was equally skilled in figure painting. During his later career he produced a number of female nudes and portraits of friends and family. He never exhibited any of these, preferring to keep his private and public art completely separate.* c1842, oil on canvas, 27½ x 21¾in, Louvre, Paris, France

▲ **The Gardens of the Villa d'Este, Tivoli** *Corot made several trips to Italy, and liked to make landscape sketches that he could develop into full-scale paintings back in his studio. He aimed to capture the scenes just as he saw them. This plein-air (outdoor) approach, which paved the way for young painters such as Camille Pissarro, allowed him to develop a freer, more naturalistic style within the classical French tradition.* 1843, oil on canvas, 11 x 19¾in, Louvre, Paris, France

CLOSERlook

SUBTLE COLORS Corot tended to use a limited range of colors, preferring to achieve his effects through subtle tonal relationships of light and dark, and a creamy surface texture created using small, quick brushstrokes.

Théodore **Rousseau**

Théodore Rousseau

b **PARIS, 1812**; d **BARBIZON, 1867**

Nicknamed *le grand refusé* for his frequent rejection by the Paris Salon, Rousseau was the leading member of the Barbizon school of landscape painters. Uncomfortable with the Neoclassical formality then current in France, he based his style on 17th-century Dutch landscapes, as well as on the work of contemporaries such as John Constable. Unusually for the time, he painted outdoors. Although he struggled early in his career, buy the end of his life he was an acclaimed figure and his posthumous reputation was for a time enormous.

▼ **Holm Oaks, Apremont** *Rousseau's landscapes portray nature as powerful rather than idyllic. His ability to represent a scene realistically was much admired by his fellow Romantics, even if not by the establishment.* 1850–52, oil on canvas, 25 x 39in, Louvre, Paris, France

▲ **The Forest at Fontainebleau: Morning** *Working directly from nature in the open air, Rousseau was adept at capturing the subtle contrasts of light and shade—especially the effects of sunlight through foliage—using small, carefully handled brushstrokes.* 1850, oil on canvas, 38¼ x 52¾in, Wallace Collection, London, UK

CLOSERlook

FRAMING ARCH The effects of sunlight through foliage were a recurrent subject for Rousseau. In this, and several similar paintings, the eye is drawn toward a central area of light through an arched frame of trees.

Carl **Spitzweg**

b MUNICH, 1808; d MUNICH, 1885

The most enduring of the Biedermeier group of artists, Carl Spitzweg took up painting comparatively late in life and with no formal training, having previously worked as a pharmacist. He began his artistic career in the 1830s, becoming an active member of the artistic community in his native Munich.

Having struggled to attain recognition for his anecdotal paintings of Bavarian life, Spitzweg spent some years traveling before taking on work as a graphic artist for the satirical Munich magazine *Fliegende Blätter* (Flying Leaves), putting his work before a wider public. Spitzweg's acutely observed caricatures and studies of provincial life are sympathetic rather than politically critical, and his gentle humor soon made him popular across Europe.

LIFEline

1808 Born into a middle-class family in Munich
1825–28 Trains as pharmacist in Vienna
1828 Works in a Munich pharmacy while doing postgraduate studies
1833 Inherits enough money to become a painter
1835 Joins the Kunstverein, Munich; leaves two years later
1837 First version of *The Poor Poet*, his best-known work
1839 Travels to Dalmatia
1840s Travels around Austria, Switzerland, and the Adriatic
1844–52 Works as illustrator for *Fliegende Blätter* magazine
1860 Turns to landscapes
1885 Dies in Munich

◀ **Sunday Stroll** *From about 1850, Spitzweg's attention moved away from the figures in his paintings to their surroundings, which provides an appropriate setting to the action. He increasingly turned to landscape painting; influenced by the Barbizon School, he created idyllic rural scenes into which he could insert his whimsical petit-bourgeois characters. 1841, oil on canvas, Museum Carolino Augusteum, Salzburg, Austria*

▶ **The Bookworm** *Spitzweg frequently shows his subjects indulging their middle-class enthusiasms—such as butterfly collecting, mineralogy, or in this case literature—gently poking fun at their absurdity. Spitzweg himself was widely travelled and somewhat detached from this provincial world. 1850, oil on canvas, 10¾ x 19¾in, private collection*

INcontext

BIEDERMEIER Originally the pseudonym of a contributor to *Fliegende Blätter*, Biedermeier is now a general term for the urban, middle-class arts in early 19th-century Germany and Austria, which emphasized domesticity and sober simplicity, often tending to the sentimental.

Family Group by Franz Schrank (c1810). This scene expresses the Biedermeier values of modesty and respectability—a reaction against the political and expressive preoccupations of Romanticism.

Ferdinand Georg **Waldmüller**

Self-portrait

b VIENNA, 1793; d HINTERBRÜHL, 1865

Ferdinand Waldmüller, the foremost Austrian landscape artist of the Biedermeier period, based his meticulous technique on a close study of nature rather than an adherence to any particular style of painting. He trained at the Vienna Academy, and, after working as a private tutor in Croatia and a short period as a portrait painter, he returned there as a professor in 1829. His Naturalist approach was, however, at odds with the Academy's ideology; despite his growing reputation and influence as a teacher, he was eventually dismissed. As well as a huge number of landscapes, Waldmüller painted many sentimental rural scenes, which were popularly successful, although not so highly regarded today. He was reinstated at the Academy in 1864, just one year before his death.

LIFEline

1793 Born in Vienna
1817–20 Studies at the Vienna Academy
1825 Travels to Italy
1829 Appointed professor at the Vienna Academy
1857 Dismissed after disputes with the Academy
1862 A major exhibition of his work is held in London
1864 Reinstated as professor at the Vienna Academy
1865 Dies in Hinterbrühl, Austria, aged 72

▼ **Coming Home from the War** *Waldmüller's later work included a series of paintings of peasant life in a sentimental mood, contrasting starkly with his detailed naturalist technique. 1859, oil on panel, 16½ x 20¾in, Kunsthalle, Hamburg, Germany*

▲ **Hallstätter-See** *A belief in the naturalistic depiction of the subject based on close study and observation led to an almost photographic realism and detail in Waldmüller's landscapes. In particular, he used his considerable technical skills and sensitivity to color to reproduce a scene, rather than interpret it, and allow the subject to speak for itself. 1838, oil on canvas, Historisches Museum der Stadt Wien, Vienna, Austria*

CLOSERlook

LIGHT AND DARK Contrasts are sharply defined in this landscape, leading diagonally across the painting, from the luminous sky down the mountains to a rooftop, and through the long shadows to the lowest point.

Wilhelm **Leibl**

b COLOGNE, 1844; d WÜRZBURG, 1900

Wilhelm Leibl studied in his home town of Cologne and at the Munich Academy, but his reputation as the leading Realist painter of late 19th-century Germany came after working with Gustave Courbet in France. Courbet was impressed by a portrait he had seen by Leibl at an exhibition in Munich in 1869, and he subsequently invited him to Paris. Their collaboration was cut short by the Franco-Prussian War in 1870. Leibl had already adopted his mentor's practice of portraying everyday rural life. After a short stay back in Munich, Leibl moved to the country, and spent the rest of his life in various villages around Bavaria. During the 1870s, he developed a meticulous style that emulated the work of Holbein, but later his technique became softer and more fluid, as he worked directly on the canvas with no preliminary drawings.

LIFEline

1844 Born in Cologne
1864 In his early twenties, studies at the Munich Academy
1869 Works with Realist Karl von Piloty, then sets up a group studio
1870 Works in Paris with Courbet; meets Manet
1873 Moves to rural Bavaria and adopts a Holbein-like technique
1878 Lives in Berbling, where he paints the *Three Women in Church*
1892 Settles in Kutterling
1900 Dies in Würzburg

▶ **The Old Farmer** *While living in Schondorf am Ammersee in 1874–75, Leibl painted portraits of peasant folk. Their great detail and enamel-like finish typified what came to be known as his "Holbein period."* 1875, oil on canvas, 18¾ x 15¼in, Kunsthalle, Hamburg, Germany

▲ **Three Women in Church** *Perhaps Leibl's best-known work, this painting is the culmination of his "Holbein period." The unsentimental subject is treated in delicate detail, and the somber atmosphere is intensified by the solid, smooth finish of his intricate brushwork.* 1882, oil on panel, Kunsthalle, Hamburg, Germany

Adolph **Menzel**

Photographer unknown

b BRESLAU, PRUSSIA, 1815; d BERLIN, 1905

Known in his own time as a painter of historical and patriotic subjects, Menzel is today admired more for his small genre paintings that depict the everyday life of Berlin and Paris. Largely self-taught, he started his artistic career producing lithographs to illustrate the many histories of Prussia that were popular at the time. Inspired by Constable, Menzel took up painting in the 1840s, with royal and military subject matter being his primary interest, particularly the reign of Frederick the Great. Menzel visited the Exposition Universelle in Paris in 1867 to see Courbet's rural Realist paintings, but he was more impressed with the Naturalist historical scenes of leading French genre artist Ernest Meissonier, who became a close friend. From this time, while he continued to produce nationalistic paintings and illustrations, Menzel painted several views of Paris, and a series of unorthodox scenes of Berlin life.

LIFEline

1815 Born in Breslau, Prussia (now Wrocław, Poland)
1832 Takes over his father's lithographic workshop after his death
1839 Sees paintings by John Constable in Berlin
1839–42 Illustrates Franz Kugler's *History of Frederick the Great*
1861 Invited to paint the coronation of Wilhelm I of Prussia
1867 Visits Paris Exposition Universelle; meets Meissonier
1898 First painter awarded Order of the Black Eagle
1905 Dies in Berlin

▲ **In The Luxembourg Gardens** *Menzel recreated memories of Parisian scenes in his Berlin studio using techniques seen in France. His visits to Paris and friendship with Meissonier had a marked effect on his style, influencing the way he depicted figures of the royal court.* Late 1860s, gouache on paper, Pushkin Museum, Moscow, Russia

◀ **Breakfast at the Café** *Menzel's fascination with the urban middle class prompted a series of street scenes and interiors, often seen from unusual viewpoints, in which he could explore the effects of light. He also had an eye for the minutiae of city life, which sometimes verged on caricature.* 1894, gouache on paper, 7½ x 4¾in, Kunsthalle, Hamburg, Germany

CLOSERlook

AHEAD OF HIS TIME
Although he disliked many contemporary trends in French painting, Menzel's fresh, spontaneous handling of paint, and especially his treatment of light, anticipate Impressionism.

Ilya **Repin**

Self-portrait

b **CHUGUYEV, 1844;** d **KUOKKALA, 1930**

Ilya Repin became famous for his depictions of Russian history, and his Realist style paved the way for the Socialist Realism of the Soviet era. Born into a peasant family near Kharkov, he trained with a local icon painter before moving to St. Petersburg to study at the Academy of Fine Arts. After spending three years in France and Italy, Repin returned to Russia and joined the *Peredvizhniki* (Wanderers) group, so called because their exhibitions traveled widely, bringing art to the people. He sympathized with this protest movement's social and political concerns, but did not share their anti-academic ideology. He later became a Professor at the St. Petersburg Academy, after reforms had been instituted there. As well as his historical paintings, Repin produced portraits of many eminent Russians.

LIFEline

1844 Born in Chuguyev, Ukraine

1864 Studies at St. Petersburg Academy of Fine Arts

1873–6 Travels in Western Europe

1882 Settles in St. Petersburg

1894 Appointed Professor of Historical Painting at the St. Petersburg Academy

1907 Resigns from Academy

1917 Following the country's declaration of independence from Russia, Repin's home in Kuokkala becomes part of Finland

1930 Dies in Kuokkala, which is later ceded to the USSR and renamed Repino in his honor

INcontext

ST. PETERSBURG ACADEMY Founded in 1757, the St. Petersburg Academy was the most prestigious art institution in Russia, housing a collection of artworks and educating Russian artists. For over a century, its teaching was conservative and academic and resisted new trends in art.

The Antiquities Gallery of the Academy of Fine Arts by Grigory Mikhailov (1836).

▼ **The Boatmen on the Volga** This starkly Realist scene, begun while Repin was a student, was hugely influential. The boatmen's harsh working conditions are portrayed sympathetically, but as an inspiration rather than out of pity. 1870–73, oil on canvas, 52 x 111in, State Russian Museum, St. Petersburg, Russia

▲ **The Zaporozhye Cossacks Writing a Mocking Letter to the Turkish Sultan** *Repin wins the viewer's sympathy with his human portrayal of the figures, and also to capture the elements of their revolutionary struggle: liberty, equality, and fraternity. It took him almost a decade to complete and, when it was finished in 1891, in a cruel stroke of irony, it was bought by the Tsar.* 1880–91, oil on canvas, 80 x 141in, State Russian Museum, St. Petersburg, Russia

CLOSERlook

CENTER CIRCLE Repin creates a mood of camaraderie by interrupting the horizontal aspect of the picture with a central circle of figures. While most of these incline sympathetically inward, four lean back in laughter—one directly out of the picture into the viewer's space.

Ivan **Kramskoi**

b **NOVAYA SOTNYA, 1837;** d **ST. PETERSBURG, 1887**

Kramskoi was leader of the Russian democratic realist movement. He studied at the St. Petersburg Academy, organizing a protest there in 1863 against the institution's old-fashioned ideas, and founding the *Peredvizhniki* (Wanderers) group. Believing it was an artist's duty to take a political stand, Kramskoi painted portraits of sympathetic contemporaries, including author Leo Tolstoy, painter Ivan Shishkin, and art collector Pavel Tretyakov, as well as peasant subjects and several studies of Christ that dealt with ethical rather than theological issues.

▼ **Christ in the Wilderness** *(Detail) Kramskoi's portrayals of Jesus symbolized the moral choices of the individual, particularly his interpretation of Christ in the Wilderness as a crisis of conscience.* 1873, oil on canvas, 233 x 199in, Tretyakov Gallery, Moscow

Nikolai **Ghe**

b **VORONEZH, RUSSIA, 1831;** d **NEAR PLISKI, UKRAINE, 1894**

Ghe, a founding member of the *Peredvizhniki* (Wanderers) with Kramskoi, was born into a land-owning family descended from French nobility. He studied mathematics in Kiev and St. Petersburg before attending the St. Petersburg Academy of Fine Arts. He later worked as a painter in Rome and Florence.

Ghe's most characteristic paintings were of religious subjects, but these were typically treated as moral or psychological human dramas, and presented with intense and almost Expressionist contrasts of color, light, and shade. In 1876, he returned to the countryside, buying a farm near Pliski, where he died in 1894.

▲ **The Last Supper** *Ghe's humanist interpretation of the Last Supper was his first major work, and a break with traditional portrayals of the subject. He shifted the emphasis from religious to psychological tensions, the conflict between Judas and Christ was seen as an allegory of the divisions in Russian society.* 1863, oil on canvas, 315 x 230in, State Russian Museum, St. Petersburg, Russia

Origins and influences

The Pre-Raphaelite Brotherhood was formed in 1848 by a group of seven young artists, including John Everett Millais, William Holman Hunt, and Dante Gabriel Rossetti. They sealed their pact by adding the initials PRB to paintings. This caused an outcry in the press—largely because of the apparent insult to Raphael, who was regarded as the greatest of all painters. The protests were short-lived, however, after John Ruskin lent his support to the group.

Ruskin had advised artists to "go to nature... rejecting nothing, selecting nothing, and scorning nothing." The Pre-Raphaelites adopted this principle wholeheartedly, with the landscape settings of their early pictures often depicted in microscopic detail.

The three main members of the group soon went their separate ways.

▲ **Acanthus wallpaper design** William Morris (1875). *Morris believed that his wallpapers reproduced the charm of the forest inside the home.*

Hunt turned to religious painting, while Millais joined the art establishment. Rossetti carried the movement forward, influencing Edward Burne-Jones and William Morris. They, in turn, introduced Pre-Raphaelite ideas to a wider audience, through the Symbolist (see pp.382–87) and Arts and Crafts movements.

Subjects

The Pre-Raphaelites tackled a wide variety of themes. They shared the Victorian appetite for the color and romance of the Middle Ages, taking themes from Arthurian legend. In spite of these escapist tendencies, they were interested in covering modern issues, such as emigration, prostitution, and religious reform.

The group often focused on a moral or a story, many of which were drawn from literary sources. They avoided classical authors, but Shakespeare, Keats, and Tennyson were popular choices, and Rossetti was passionate about the Italian poet Dante.

Eventually, Pre-Raphaelite was used as a tag associated with some of the movement's most iconic images, from imitations of Rossetti's *femmes fatales* to the pale, androgynous figures in Burne-Jones's designs.

The Pre-Raphaelites burst upon the English art scene in the mid-19th century. In a youthful act of rebellion, they vowed to counter the stifling predictability of academic art by seeking to recapture the honest simplicity of early Italian painters who had flourished before Raphael, hence "Pre-Raphaelite."

The Pre-Raphaelites

John Everett **Millais**

Self-portrait

b SOUTHAMPTON, 1829; d LONDON, 1896

Millais was a child prodigy, becoming the youngest ever pupil at the Royal Academy Schools (a national art school, founded in 1768 and based in London). His superb technical skills were well suited to the precision that the Pre-Raphaelites sought to achieve. In his early work, Millais opted for literary themes—drawn from Shakespeare, Tennyson, and Keats—and autumnal scenes that were reflections on mortality. Gradually, he abandoned his Pre-Raphaelite roots and veered towards a sentimental style, which was in line with mainstream Victorian taste. Millais had a particular gift for portraying children, and they feature prominently in his most famous pictures, such as *The Boyhood of Raleigh* (1870) and *Bubbles* (1886).

LIFEline

1840 Enters the Royal Academy Schools, aged just 11
1846 Exhibits first picture at the Royal Academy
1852 Completes *Ophelia*
1855 Marries Effie Gray, Ruskin's ex-wife
1885 Is made a baronet
1896 Elected President of the Royal Academy
1896 Dies in London and is buried in St. Paul's Cathedral

▶ **The Blind Girl** *The Pre-Raphaelites liked tackling modern issues. This touches on the controversial topics of child vagrancy and treatment of the disabled. 1854–56, oil on canvas, 31¾ x 24¼in, Birmingham Museum and Art Gallery, Birmingham, UK*

CLOSERlook

OTHER SENSES
The blind girl cannot enjoy the visual beauty of the rainbow, but the way that she is touching the grass and the inclusion of the concertina suggest the sharpness of her other senses.

▲ **Ophelia** *The Pre-Raphaelites painted natural details with painstaking accuracy. In this scene from Shakespeare's* Hamlet, *Millais was equally meticulous in portraying the flowers mentioned in the text and Ophelia herself. The model posed for hours in a bath, eventually catching a severe chill. 1851–52, oil on canvas, 29¾ x 44in, Tate, London, UK*

William Holman **Hunt**

Self-portrait

b **LONDON, 1827**; d **LONDON, 1910**

Of all the Pre-Raphaelites, Hunt was the one who remained truest to the group's original principles. From an impoverished background, he worked as a clerk from the age of 12, until he gained admission to the Royal Academy Schools. Hunt was extremely devout, and he used the group's painstaking approach to make his biblical scenes as realistic as possible. He even made several trips to the Holy Land to ensure authenticity. *The Scapegoat* (1854), for example, was painted by the shores of the Dead Sea, in keeping with the Jewish ritual. When his "model" died, he painted a second goat, which he stood in a tray of mud gathered from the site.

LIFEline

1844 Begins his studies at the Royal Academy Schools
1848 Meets Rossetti
1865 Marries Fanny Waugh, who dies a year later
1875 Marries Fanny's sister, Edith
1905 Awarded Order of Merit
1910 Dies in London

▼ **The Scapegoat** *In a Jewish symbolic act of atonement, the scapegoat bears away human sins.* 1854, oil on canvas, 34¼ x 55in, Lady Lever Art Gallery, Port Sunlight, UK

Dante Gabriel **Rossetti**

b **LONDON, 1828**; d **BIRCHINGTON-ON-SEA, 1882**

Charismatic, domineering, and eccentric, Rossetti was the driving force behind the Pre-Raphaelite movement. He proposed the idea of a brotherhood, was the first to exhibit a picture with the group's initials, and inspired the second wave of Pre-Raphaelitism through his contacts with Morris and Burne-Jones.

In early paintings, Rossetti conjured up a romantic, medieval dreamworld, but increasingly he concentrated on pictures of mysterious female beauties. These often reflected the complications of his own tangled love life.

LIFEline

1844 Begins his studies at the Royal Academy Schools
1848 Co-founder of the Pre-Raphaelite Brotherhood
1860 Marries Elizabeth Siddal
1861 Enters partnership with William Morris
1862 Siddal dies from an overdose of laudanum
1869 Begins affair with Jane Morris, William's wife
1882 Dies aged 53

▶ **Proserpine** *A captive in the Underworld, Proserpine turns sadly away from the daylight, which reminds her of her lost freedom.* 1871, colored chalk on paper, 8¾ x 4¼in, Ashmolean, Oxford, UK

▶ **The First Anniversary of the Death of Beatrice** *Beatrice is mourned by the Italian poet, Dante (on the right), after whom Rossetti was named.* 1853–54, watercolor on paper, 16½ x 24in, Ashmolean, Oxford, UK

Ford Madox **Brown**

Self-portrait

b **CALAIS, 1821**; d **LONDON, 1893**

Although he was never an official member of the Pre-Raphaelite Brotherhood, Brown had close links with them and shared many of their ideals. Much of his childhood was spent on the continent where, among others, he was influenced by the Nazarenes. After settling in London, he began painting scenes from early British history. Rossetti was sufficiently impressed by these to ask Brown for lessons, and, although this arrangement soon fell through, the two men remained good friends.

Later, Brown himself was influenced by the Pre-Raphaelites. This is most evident in his best-known work, *The Last of England* (1852–55). The modernity of the subject matter was typical of the group, as was the artist's unfailing attention to detail. In order to capture the wintry setting, Brown painted outdoors until his hands turned blue, while his wife bemoaned the fact that she had to go without her warmest shawl for several months.

▶ **Work** *Brown's ambitious painting is a sermon on the value of labor.* 1863, oil on canvas, 26¾ x 38¾in, Birmingham Museums and Art Gallery, Birmingham, UK

CLOSERlook

BRAINWORK Brown included portraits of the philosopher Thomas Carlyle and the Christian Socialist F. D. Maurice, as examples of "brainworkers".

LIFEline

1821 Born in Calais, but his family later settle in Belgium
1837–39 Trains in Antwerp
1840 Marries his cousin, Elizabeth Bromley
1845–46 Stays in Rome, where his wife dies
1853 Marries Emma Hill
1855 Completes *The Last of England*. Many would regard this work as his masterpiece
1861 Founder member of William Morris's company
1878 Paints murals in Manchester Town Hall

▶ **The Last of England** *This moving scene deals with the topical subject of emigration, showing an impoverished young couple forced to leave their homeland. At the time, Brown was "very hard up and a little mad" and was himself thinking of emigrating.* 1852–55, oil on panel, 32¾ x 29½in, Birmingham Museums and Art Gallery, Birmingham, UK

INcontext

JOHN RUSKIN This English writer, draftsman, and social reformer became the most respected and influential critic of his day. Ruskin's favorite artist was Turner, but he also offered invaluable support to the Pre-Raphaelites in the early days, when they were lampooned in the press. Like them, he was an enthusiastic advocate of detail and truth to nature, as his meticulous drawings and watercolors confirm.

Portrait of John Ruskin by William Collingwood (1897). This dates from Ruskin's final years, when he was mentally ill and living in seclusion in the Lake District.

▶ **Derby Day** William Powell Frith, 1893–94. *Victorian artists such as William Frith enjoyed great popularity with paintings of social panoramas such as this one painted in 1893–94.*

During the lengthy reign of Queen Victoria (1837–1901), Britain enjoyed an unrivaled period of economic prosperity and political influence. These favorable conditions helped to create an air of self-confidence. The leading painters became rich and famous, and many Victorians felt they were living through a golden age in the arts.

Under Victoria the popularity of the arts in Britain scaled new heights. The Royal Academy went from strength to strength, regularly attracting more than a quarter of a million visitors to its annual exhibition. This remained the chief marketplace for artists, although other sources of patronage were increasingly available. Queen Victoria and Prince Albert were knowledgeable collectors—Frith noted that "they knew quite as much about art as most painters"—and there was growing interest from the middle classes. Both the Tate Gallery and the Walker Gallery in Liverpool were formed around the collections of wealthy industrialists.

Subjects

The academic tradition remained one of the surest routes to success. This was maintained by artists such as William Etty, Frederic Leighton, and Sir Edward Poynter (1836–1919), while receiving an added stimulus from the competition to decorate the new Houses of Parliament. New trends did emerge, not least in the field of genre painting. This had enjoyed a surge in popularity before Victoria came to the throne, largely due to the efforts of Wilkie. The key to his success lay in the anecdotal detail of his paintings. The public loved pictures that told a story. The tone of these stories varied considerably. In the case of Wilkie's *Chelsea Pensioners* the message patriotic, but the Victorians were equally fond of moral or sentimental themes. Above all, they enjoyed seeing reflections of their own society. This accounts for the popularity of Frith's social panoramas, which can be described as the pictorial version of a Dickens novel.

Victorian art

334

William **Etty**

b **YORK, 1787**; d **YORK, 1849**

Etty was known, above all, for his paintings of the female nude. He served a lengthy apprenticeship to a printer (1798–1805), before following his true vocation. He studied at the Royal Academy Schools in London under leading portrait painter Thomas Lawrence, but the greatest influence came from his grand tour of Italy (1822–24). Venice, in particular, seemed like a second home as he absorbed the rich hues of Titian and Veronese. Etty concentrated on large-scale paintings of literary or mythological subjects. The sensual coloring of his nudes was sometimes denounced as indecent, but his career still thrived. He became a Royal Academician in 1825 and was later accorded the rare honor of a retrospective exhibition at the Society of Arts in London.

▲ **Sabrina and her Nymphs** *Sabrina, the goddess of the River Severn, is the heroine of Milton's Comus.* 1841, oil on canvas, 23¾ x 31½in, New Walk Museum, Leicester, UK

David **Wilkie**

b **CULTS, 1785**; d **AT SEA, OFF GIBRALTAR, 1841**

▲ **Chelsea Pensioners Reading the Waterloo Dispatch** *Old soldiers receive the news of Wellington's victory with patriotic pride.* 1822, oil on wood, 38¼ x 62in, Wellington Museum, London, UK

The Scottish artist David Wilkie was the finest genre painter of his day. He enrolled at the Royal Academy Schools in 1805, rapidly winning acclaim for his lively peasant scenes. These showed the influence of early Dutch artists, such as David Teniers the Younger and Adriaen van Ostade. Wilkie's pictures contained a blend of good-natured humor and social analysis, but it was their wealth of detail that the public loved. The most popular of all was his *Chelsea Pensioners*, which struck a patriotic chord and, like Frith's *Derby Day*, had to be protected from over-enthusiastic admirers, when it was shown at the Royal Academy.

William Powell **Frith**

b **ALDFIELD, 1819**; d **LONDON, 1909**

The son of a hotelier, William Powell Frith trained at Sass's Academy and the Royal Academy Schools in London. His early work consisted mainly of portraits and literary themes, but in the 1850s he turned to modern life subjects, which brought him fame and wealth.

His three masterpieces in this vein—*Life at the Seaside, Derby Day*, and *The Railway Station*—all follow a similar pattern. They are large canvases, crowded with figures and incidents, portraying people from all walks of life. These proved hugely popular. Indeed, when *Derby Day* was shown at the Royal Academy, a barrier and policeman were required to protect the painting from spectators.

▲ **The Railway Station** *Frith appears in the center of the composition, while on the right two detectives arrest a fugitive.* 1862, oil on canvas, 46 x 101in, Royal Holloway, University of London, UK

Edwin **Landseer**

Portrait by JC Watkins

b LONDON, 1802/03; d LONDON, 1873

One of England's greatest animal painters, Landseer was from a family of artists and revealed his own talent at a very early age. In 1815, he entered the studio of English Romantic painter Benjamin Robert Haydon and is said to have painted the ass in his *Christ's Entry into Jerusalem*. In the same year, he also exhibited at the Royal Academy and won a silver medal from the Society of Arts. Landseer's favorite subjects were animals. He sometimes adopted a sentimental approach, endowing the creatures with human qualities, but he was equally capable of depicting their most savage aspects. He was particularly impressed by stags, which he featured in a number of heroic allegories. Landseer sketched them on his frequent trips to the Scottish Highlands—an area that was popularized by one of his chief patrons, Queen Victoria.

Landseer's most challenging commission was for the lion sculptures at the foot of Nelson's Column in London's Trafalgar Square. He had no experience in this field, so the task seemed especially daunting, but it has become his most famous artistic legacy.

▼ **The Monarch of the Glen** *This famous painting was commissioned for a refreshment room in the House of Lords. Landseer thought stags the noblest of animals, and a living symbol of the Scottish Highlands.* 1851, oil on canvas, 65 x 67in, United Distillers and Vintners, Edinburgh

INcontext
THE NEW HOUSES OF PARLIAMENT
In 1834, most of the old Palace of Westminster was destroyed in a fire. This disastrous event provided a unique opportunity for many English artists as a host of artworks were commissioned to decorate Charles Barry's new Houses of Parliament, which were completed in 1870.

The Houses of Parliament under Construction *by John Wilson Carmichael. Headed by Prince Albert, a committee was set up to provide high-quality British art for the new buildings.*

LIFEline

1802/03 Born in London, his father an engraver
1816 Attends Royal Academy Schools
1824 First trip to Scotland
1831 Becomes a member of the Royal Academy
1850 Receives a knighthood
1866 Declines Royal Academy presidency due to ill health
1867 Trafalgar Square lions are unveiled
1873 Dies and is buried in St Paul's Cathedral

◄ **Man Proposes, God Disposes** *This gloomy scene was inspired by Sir John Franklin's fatal expedition to find the Northwest passage. A telescope and gnawed human remains were discovered in 1854. Landseer used the tragedy as an illustration of nature's destructive powers.* 1863–64, oil on canvas, 35¾ x 96in, Royal Holloway, University of London, UK

Frederic **Leighton**

Portrait by Stanislas Walery

b SCARBOROUGH, 1830; d LONDON, 1896

Painter and sculptor Frederic Leighton came from a wealthy family and spent much of his youth traveling the continent with them for the sake of his mother's health. This, coupled with his own tours of the Middle East, exposed him to a wide range of influences. He settled in London in 1859, by which time he had sold a painting to Queen Victoria. Leighton is best known for his mythological subjects, although he also produced dreamy mood paintings that link him with the Aesthetic movement, who maintained that art should be about visual pleasures rather than moral messages. He enjoyed enormous success and was regarded as the greatest artist of the day, but his reputation declined after his death.

LIFEline

1830 Born the son of a doctor
1846–48 Studies in Frankfurt
1852–55 Based in Rome, meets the Nazarenes
1859 Settles in London
1877 First sculpture exhibited
1878 Elected President of the Royal Academy
1896 Becomes the first artist to gain a peerage
1896 Dies and is buried in St. Paul's Cathedral

CLOSERlook

SKILLED ARTIST The reclining pose of the central figure provides an excellent example of Leighton's skill at foreshortening. Her legs appear far longer than her upper torso, which tapers away. They also reflect the sunshine that illuminates a cluster of fruit, while the rest of the scene is in shade.

◄ **The Garden of the Hesperides** *In Greek mythology the daughters of Hesperus guarded the golden apples that Hercules was ordered to steal. It was often seen as the classical equivalent of the Garden of Eden, an analogy reinforced by the presence of a serpent.* c1892, oil on canvas, diameter 67in, Lady Lever Art Gallery, Port Sunlight, UK

▲ **Flaming June** *Inspired by a model who fell asleep in his studio, this is one of Leighton's most sensual paintings.* c1895, oil on canvas, 48 x 48in, Museo de Arte, Ponce, Puerto Rico

French academic art used to be viewed as the rather dull art of the establishment, opposed to the experiments of the Romantics, the Realists, and the Impressionists. In recent years, opinion has shifted somewhat, and auction prices have risen steeply.

The Salon

The main forum for academic art was the Salon in Paris. Named after its original venue, the Salon Carré in the Louvre, this was France's official art exhibition. Success at the Salon could secure an artist's reputation and lead to lucrative state commissions. For much of the 19th century, the Salon had a conservative outlook, which discouraged new trends. It stemmed from a jury system that tended to favor academic artists and hang their work in the best positions. Artists such as Delacroix and Manet, however, were keen to make their mark there.

Subjects and style

The most prestigious form of academic art was "history painting." This slightly misleading term encompassed religious, mythological, and allegorical subjects, as well as history. Landscapes, portraits, and genre scenes (paintings of everyday life, such as suburban river scenes, racetracks, and cafés), were deemed to be less important, while modern subjects were frowned upon. The question of "finish" was even more crucial. Academic artists favoured a detailed, enamel-like finish, which appeared realistic, even when viewed close up. The most common criticism leveled against the Romantics and the Impressionists was that their work was unfinished—that the painters in question were exhibiting sketches and daubs.

▲ **The Grand Staircase of the Paris Opera House (1861–75)** *With its marble steps and onyx banisters, this is the building's most spectacular feature.*

French academic art

Thomas **Couture**

Self-portrait

b SENLIS, 1815; d VILLIERS-LE-BEL, 1879

The reputation of Couture mirrors that of French academic art as a whole. He was a celebrity in his own time, largely on the strength of one painting—*The Romans of the Decadence* (1847)—but his work is now frequently dismissed as sterile and overblown. A pupil of Antoine-Jean Gros and Paul Delaroche, Couture took three years to complete his enormous masterpiece. On one level, it was meant to illustrate a quote from the Roman poet Juvenal: "Crueler than war, vice fell upon Rome and avenged the conquered world." However, Couture was also drawing a parallel with his own society, which had recently been rocked by a series of political scandals.

LIFEline

1815 Born in Senlis, France
1827 Couture's family move to Paris
1837 Wins the *Prix de Rome*
1847 Exhibits his masterpiece, the *Romans of the Decadence,* at the Salon
1850–56 Manet is his pupil
1879 Dies in his mid-60s

▼ **The Romans of the Decadence** *This huge painting caused a sensation when it was exhibited at the Paris Salon.* 1844–47, oil on canvas, 15ft 4in x 25ft 3in, Musée d'Orsay, Paris, France

Ernst **Meissonier**

b LYONS, 1815; d PARIS, 1891

Although relatively unknown today, Ernst Meissonier was one of the most celebrated painters of his age, and his paintings once commanded record-breaking sums. He trained under Léon Cogniet and began his career working as an illustrator, for a publisher named Curmer. This helped him to develop the finicky attention to detail that became a feature of his style.

Self-portrait

Meissonier specialized in military themes, many of which were set nostalgically in the 17th century or the Napoleonic era—although he was not averse to tackling modern subjects. His *Barricade* (1848), for example, provided a compelling image of the workers' riots of that year. The meticulous finish of Meissonier's pictures set him at odds with the Romantics and the Impressionists, although both Delacroix and Degas were admirers of his technical skill.

LIFEline

1815 Born in Lyons
1831 Exhibits for the first time at the Salon
1848 Paints his masterpiece, *The Barricade*
1870 Joins Napoleon III's army, later becoming a colonel
1889 Wins Grand Cross of the Legion of Honour, the first artist to receive this award
1891 Dies in Paris in his 70s

▶ **The Barricade, rue de la Mortellerie, June 1848** *Meissonier's impassive record of a failed barricade, demolished by soldiers, forms a stark contrast to Delacroix's emotive treatment of a similar subject (see pp.300–301).* 1848, oil on canvas, 11¼ x 8¾in, Louvre, Paris, France

William **Bouguereau**

b LA ROCHELLE, 1825; d LA ROCHELLE, 1905

Bouguereau was the most celebrated academic artist of his age. After completing his studies, he settled in Paris and forged an impressive career at the Salon. He was one of the favorite artists of Emperor Napoleon III, who bought several of his works, including his highly acclaimed *Birth of Venus* (1879). He went on to receive a string of honors and appointments, remaining fêted till the very end of his career.

Bouguereau is chiefly remembered for his female nudes, which were openly erotic but retained a veneer of respectability because of their mythological subject-matter. He also painted rather austere religious scenes. Bouguereau's reputation plummeted after his death but underwent a revival in the late 20th century.

LIFEline

1825 Born in La Rochelle, the son of a local businessman
1846 Studies with Francois-Edouard Picot in Paris
1850 Wins the *Prix de Rome*
1857 Receives a medal at the Salon and gains his first commission from Napoleon III
1876 Elected President of the Académie des Beaux-Arts
1877 Death of his first wife
1879 His *Birth of Venus* creates a stir at the Salon
1896 Marries his second wife Elizabeth Gardner, a former student
1903 Made a Grand Officer of the Legion of Honour
1905 Dies in La Rochelle

◄ **The Wave** *Bouguereau was over 70 when he painted this remarkable picture, confirmation that his powers remained undimmed even in old age. The subject is reminiscent of the mythological birth of Venus, who rose out of the foaming waves.* 1896, oil on canvas, 46 x 62in, private collection

Henri **Fantin-Latour**

Self-portrait

b GRENOBLE, 1836; d BURÉ, 1904

There was no firm dividing line between academic art and the avant-garde. Fantin-Latour had close links with both the Impressionists and the Symbolists, but also managed to sustain a successful career at the Salon, exhibiting there regularly between 1861 and 1899. In addition to his flower pieces, he produced fine portraits. His *Homage to Delacroix* (1864), which featured the artists Whistler, Manet, and Baudelaire, underlined his knowledge of the latest artistic currents. Equally passionate about music, he produced a series of misty evocations of Wagner's operas, which linked him with the blossoming Symbolist movement (see p.382).

LIFEline

1836 Born in Grenoble, the son of a portrait painter
1859 In England with James McNeill Whistler
1862 Produces the first of his Wagnerian pictures
1864 Paints his *Homage to Delacroix*
1875 Wins a second-class medal at the Salon
1899 First major exhibition of his prints
1904 Dies in his late 60s

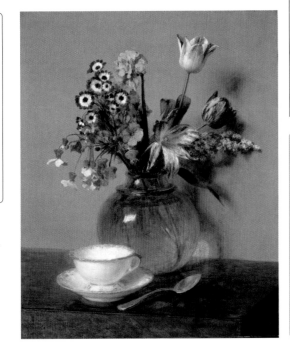

► **Spring Bouquet** *Fantin-Latour's flower-pieces were hugely popular with collectors on both sides of the Channel. Although influenced by the Dutch tradition of flower painting, they displayed a freshness and vitality of their own.* 1865, oil on canvas, 18¼ x 14¾in, private collection

Jean-Léon **Gérôme**

Portrait by Aimé Morot

b VESOUL, 1824; d PARIS, 1904

The taste for classical subjects continued throughout the 19th century, particularly in the 1840s, when there were new archaeological excavations at Pompeii and Herculaneum. Inspired by these, Gérôme founded the *Néo-Grec* (New Greek) group in 1848. From 1854, he made several trips to the Near East, which inspired several Orientalist paintings. Unlike earlier Neoclassical artists, he showed little interest in famous historical or mythological subjects, preferring voyeuristic themes, such as slave auctions, gladiator combats, and bath-house scenes.

LIFEline

1824 Born in Vesoul, near Besançon
1840 Moves to Paris, where he studies under Paul Delaroche and Charles Gleyre
1847 His painting *The Cock Fight* wins a medal at the Paris Salon
1848 Helps found the *Néo-Grec* group of artists
1884 Paints the controversial *A Roman Slave Market*

▲ **A Roman Slave Market** *Although this was a popular subject at the time, Gérôme's leering crowd caused controversy, undermining the notion that bodily perfection could be viewed with a pure, disinterested gaze.* 1884, oil on canvas, 25¼ x 22¼in, Walters Art Museum, Baltimore, US

CLOSERlook

UNUSUAL VIEWPOINT
Gérôme found a novel slant on the common 19th-century theme of the slave market by viewing it from the podium. He shows the scene through the eyes of the next slave to be auctioned off.

INcontext

NAPOLEON III (1808–73) A nephew of Bonaparte, Napoleon III was elected President in the wake of the 1848 revolution. He declared himself emperor 3 years later, retaining this position until he was deposed in 1870. Napoleon had conservative tastes in art. He struck one of Courbet's paintings with a riding crop because it glorified the peasantry, but he was a keen admirer of Bouguereau's work.

Portrait of Napoleon III by William Holl. This official portrait, showing the emperor wearing full military honors, is an engraving based on a photograph by William Mackenzie.

The first half of the 19th century was marked by the weakening of the Tokugawa Shogunate and social confusion. In 1868, a coalition of *samurai* led a *coup d'état* and toppled the government. The end of the feudal society was followed by rapid westernization of the country in the second half of the century.

Origins and influences

The Shogunate's conservative policy of isolation was increasingly challenged by the outside world. Pressure from the US and Britain contributed to the collapse of the Tokugawa regime, and the country re-opened in the mid-19th century.

The new Meiji government was established by a group of radical politicians with the 16-year-old Emperor Mutsuhito as the head of state. The imperial family moved from Kyoto, where they had lived since 794,

Woodblock prints were still the most popular form of art in Japan in the 19th century. The tireless public demand for novel images by the public encouraged the development of new subject matter.

▲ **Emperor Mutsuhito Returning to his Palace in Tokyo** *Japanese School, late 19th century The Emperor adopted Western-style uniform, had his hair cut, and traveled in a horse-drawn carriage. Western-style stone architecture replaced the traditional wooden public buildings.*

to Edo, which was renamed Tokyo (Eastern capital). The Meiji era (1868– 1912) was shaped by modernization of the country, carried out under the slogan *bunmei kaika* (civilization and enlightenment). The whole nation enthusiastically adopted Western customs, fashion, and technology for architecture, trains, and ships.

Subject matter

The last flowering of *ukiyo-e* (woodblock prints) produced great images of landscape, warriors, and historical events. Some 19th-century prints were bizarre and macabre, reflecting the uncertainty and anxiety of the age. Japanese prints were avidly collected within the country and in Europe. The interest in Japanese art resulted in the French aesthetic movement *Japonisme*, while the composition and subjects of *ukiyo-e* prints influenced the Impressionists.

Japanese art

Katsushika **Hokusai**

b **EDO, 1760**; d **EDO, 1849**

A towering figure in the field of *ukiyo-e*, Hokusai excelled in all areas of painting and woodblock prints. His outstanding images are known all over the world. He started his career as a designer of prints depicting actors and beautiful women, but never confined himself to one genre. He also illustrated books, produced privately commissioned luxury paintings and prints, and designed popular landscape prints.

Hokusai was an eccentric man. He changed his professional name over 30 times, moved house 90 times and, despite his fame, was always poor. He left 30,000 designs including 250 books, 3,500 single-sheet prints, and many original drawings and paintings.

LIFEline

1760 Born in Edo
1778 Becomes a pupil of Katsushika Shunsho, given professional name of Shunro
1814–19 Publishes ten volumes of *Manga*
1830s Designs the series of single-sheet prints *The Thirty-six Views of Mt. Fuji*
1840s Publishes *One Hundred Views of Mt. Fuji*
1849 Dies, after a career spanning over 70 years

▲ **Fuji in Clear Weather** *The simple yet striking image of Japan's most sacred mountain comes from the series Hokusai designed aged 70. Hokusai made landscape prints popular as works of art in their own right. c1830, polychrome woodblock print, 10¼ x 14¾in, British Museum, London, UK*

▼ **Studies of Gestures and Postures of Wrestlers from Manga** *Hokusai designed ten volumes of Manga from 1814 as a textbook for drawing. They contained 900 pages of human figures, animals, birds and flowers, insects and fish, and all sort of objects. They were so popular that they continued to be in print until the 1870s. c1849, page from the woodblock-printed book, Victoria and Albert Museum, London, UK*

CLOSERlook

HUMOROUS TRADITION
Hokusai's drawings display his great sense of humor. They belong to the long tradition of comical drawings in Japan, the roots of which go back to the 12th-century scroll called *Frolicking Animals*.

◀ **The Great Wave of Kanagawa** *With his genius for dramatic composition, Hokusai emphasizes the great power of nature and the precariousness of human existence. 1831, from Thirty-six Views of Mt. Fuji, polychrome woodblock print, 10¼ x 14¾in, British Museum, London, UK*

Ando **Hiroshige**

Memorial by Kunisada

b **EDO, 1797**; d **EDO, 1858**

The success of Hokusai's landscape series inspired his younger contemporary artist, Ando Hiroshige, to design the series *Fifty-three Stations of the Tokaido Highway*. Travel was tightly controlled by the Shogunate during the Edo period, and journeys were a rare treat for most people. Travelers were required to stay on the prescribed routes and had to carry a personal identification document.

In 1832, Hiroshige traveled the Tokaido highway (Eastern Sea Route) from Edo to Kyoto as a member of the Shogun's envoy to present a gift of horses to the imperial court. He gained first-hand knowledge of towns and villages along the way, and began publishing the images in 1833.

The tremendous success of this first series was followed by his further landscape series, *Sixty-nine Stations of the Kiso Highway* and *One Hundred Famous Views of Edo*. His landscape prints are characterized by lyrical romanticism and idyllic beauty, which made armchair travel a pleasure for his many collectors.

▲ **Otsu (Fifty-three Stations of the Tokaido Highway)** *Images of the countryside and provincial towns kindled people's imagination, and Hiroshige's first series was an immediate success. Prints also offer an insight into ordinary people's lives in the early 19th century.* 1834, polychrome woodblock print, 9¼ x 14¼in, Victoria and Albert Museum, London, UK

◄ **Sudden Shower at Ohashi Bridge at Ataka (One Hundred Famous Views of Edo)** *Hiroshige was eager to depict the effect of weather conditions and the changing seasons. Rain, wind, and snow feature prominently.* 1857, polychrome woodblock print, 13¾ x 9¾in, Fitzwilliam Museum, Cambridge, UK

CLOSER**look**

NEW BLUE The upper section of the sky is printed in Prussian blue, a new and intense chemical pigment. The technique of *bokashi* (gradation) is used to create a subtle atmospheric effect by partly wiping the color before printing.

JAPANESE ART

339

19TH CENTURY

Utagawa **Kuniyoshi**

b **EDO, 1797**; d **EDO, 1861**

Kuniyoshi is best known for his dynamic *musha-e* (warrior prints), which he produced in triptych (three-part) format. In contrast to Hiroshige's peaceful landscapes, Kuniyoshi's favorite subject matter was historical events featuring *samurai* and monsters. He always chose the most dramatic, sometimes frightening or grotesque, moment of the story. His figures are often caught in the midst of exaggerated movement, and the composition spreads across three sheets for maximum impact.

Kuniyoshi was also an outstanding caricaturist and made candid portraits of Kabuki actors as well as satirical prints criticizing the authorities. Kuniyoshi was very fond of cats and he made many humorous and charming designs of them, including some highly original prints of cats dressed as Kabuki actors.

▼ **Mitsukuni Defying the Skeleton Specter** *Kuniyoshi was inspired by a Kabuki play based on the historical figure Mitsukuni from the 10th century. He is thought to have studied Western medical books to depict the realistic skeleton.* c1845, polychrome woodblock triptych, each panel 14¾ x 10in, Victoria and Albert Museum, London, UK

LIFE**line**

1797 Born in Edo

c1820 Trains under Utagawa Toyokuni, the designer of Kabuki actor prints

1827 Publishes the series *Suiko-den* featuring 108 heroes from Chinese novels

1840s Designs a series of revolutionary triptychs based on historical figures

1861 Dies after a 40-year artistic career

◄ **Mongaku Shonin under the Waterfall** *Mongaku, a 12th-century warrior, became a Buddhist monk after accidentally murdering his lover. The Buddhist deity Fudo Myoo appears at the top of the waterfall.* c1851, polychrome woodblock vertical triptych, each panel 14¾ x 10in, private collection

CLOSER**look**

BIG SPLASH Kuniyoshi shows Mongaku doing penance under the waterfall. The graphic depiction of the splashing water and animated expressions of figures suggest a similarity in style with today's popular Japanese manga comic books.

The Impressionists set out to paint the effects of light. To this end, they used visible brushstrokes of pure color, painting scenes of daily life around Paris. People at the time thought Impressionist pictures looked unfinished and the subject matter pointless. But the new artists spelled the end of a tradition that had held sway since the Renaissance.

Origins and influences

The Impressionists drew many of their ideas from Gustave Courbet and his fellow Realist painters (see pp.324–27). In the 1850s, these artists had campaigned against the influence of academic art (see p.336), with its emphasis on historical, religious, and mythological themes.

Visually, the Impressionist group, was inspired by two important factors. They were particularly impressed by the boldness and simplicity of Japanese woodblock prints, which had only recently reached the West. Their use of pure, bright colors, the lack of modeling in their figures, and their

▲ **Takigawa from the Tea-House,** Ogi Kitagawa Utamaro, 18th century. *Impressionists were influenced by bold Japanese color woodblock prints.*

casual attitude to the laws of perspective prompted many painters to rethink their approach.

The Impressionists were also influenced by developments in the world of photography. Early motion photography demonstrated precisely how humans and animals moved, and had a huge impact, particularly in the depiction of horse-racing scenes. At the same time, the random images produced by the latest "snapshot" cameras made some artists reconsider the very notion of composing a picture.

Subject matter

In their revolt against academic art, the Impressionists developed their own subject matter, celebrating modern Parisian life. In place of morally uplifting heroic stories from the past, the

Impressionism

TIMEline

The roots of Impressionism date back to the early 1860s, when Manet burst onto the art scene. By 1869, a group of artists were holding regular meetings, staging their first exhibition in 1874. Of the group, though, Monet was the only artist to stick to painting light effects, from *Wild Poppies* in 1873 until the 20th century. By the time of the eighth exhibition in 1886, when Degas' *The Tub* gained great acclaim, Impressionism was becoming accepted.

1863

MANET Olympia

1870

PISSARRO The Coach to Louveciennes

1872

MORISOT The Cradle

1873

MONET Wild Poppies near Argenteuil

◀ **Waterlily Pond: Pink Harmony**
Monet. *Claude Monet painted series of waterlilies in his garden at Giverny to see how time of day and different seasons affected the light.* 1900, oil on canvas, 35¼ x 39⅜in, Musée d'Orsay, Paris

Interpretations

The Impressionist movement originated and achieved its fullest development in France, although its impact was felt throughout the West. It was never a school in the narrowest sense of the word, with a precise manifesto and a common style. Instead, it provided an invaluable forum for a group of like-minded friends, enabling them to exchange ideas and formulate their pioneering techniques.

Impressionism in France

From the late 1860s, the French Impressionists, including Monet, Pissaro, Sisley, and Degas, used to meet up regularly at the Café Guerbois to discuss their controversial theories. More significantly, they also decided to organize an exhibition

of their work. This was crucial since, as avant-garde artists, they were effectively excluded from the Salon—the main, public exhibition in Paris and the traditional route to artistic recognition. The first show was held in 1874, when the group described

▲ **Impressionist Exhibition** *The 1894 exhibition that gave the Impressionists their name was held in Paris at the studio of the photographer Nadar.*

Impressionists painted everyday scenes of urban and suburban pastimes, chores, and landscapes. The subject matter was less important than the way it was painted. For most Impressionists it was merely a vehicle for showing how light sparkled and changed, affecting color with highlights and shadows.

Style and techniques

At some stage, all of the Impressionist painters experimented with the practice of *plein-air* (outdoor) painting, completing entire—usually small—pictures on the spot. This enabled them to capture the most fleeting sensations of the light and weather conditions. To achieve this, the Impressionists had to work quickly.

Instead of painting firm, well-defined contours, they conveyed their forms with short, broken brushstrokes and vivid flecks of color. Every item was condensed to its simplest visual form.

▲ **Eugène Manet with His Daughter at Bougival**
Berthe Morisot, c1881, oil on canvas, 28¾ x 36¼in, Musée Marmottan, Paris, France

◄ **Eugène Manet with His Daughter at Bougival (detail)**
Morisot's short, loose brushstrokes of unmixed color are typical of Impressionist techniques.

1874

RENOIR La Loge

1876

SISLEY The Flood at Port-Marly

1880–82

CASSATT Young Woman Sewing in the Garden

1881

RENOIR The Luncheon of the Boating Party

1886

DEGAS The Tub

itself as a "Limited Company." Most of the critics were merciless, but one of their jibes, concerning Claude Monet's *Impression: Sunrise*, provided the style with a name.

Between 1874 and 1886, there were eight Impressionist exhibitions. By this stage, the initial furore had died down and several members of the group were beginning to achieve a degree of success. Stylistically too, they were growing apart. For painters such as Edgar Degas, the outdoor painting experiments were a phase, not a commitment. Even Renoir, one of the keenest advocates of the practice, retained his admiration for the old masters and some traditions. Only Monet remained loyal to the Impressionist philosophy till the end of his life.

Outside France

For most of the 19th century, Paris was the capital of the art world and the focal point of the latest trends, so ambitious painters frequently travelled there. Philip Steer, from England, the Germans Max Liebermann and Lovis Corinth, and the American Childe Hassam all gained first-hand knowledge of Impressionism when they visited the city. Steer, for example, was trained at the Académie Julian and

▲ **Flags on 57th Street, Winter 1918** Childe Hassam
Scenes of rainy streets were his speciality. 1918, oil on canvas, 37 x 25in, New-York Historical Society, New York, US

the Ecole des Beaux-Arts. On his return to London, he helped to found the New English Art Club (1886), where the new style was warmly received. Walter Sickert, a member of the Club, went so far as to organize a special exhibition, dubbed "the London Impressionists" (1889), for devotees of the movement.

The style gained even greater support in the US. Much of the groundwork was carried out by the American-born Impressionist Mary Cassatt, who did her best to find buyers for her friends' work. Further inroads were made by Childe Hassam, who had learned the latest techniques during a stay in Europe (1886–89). Hassam belonged to The Ten, a group of artists from Boston and New York who were influenced by the Impressionists.

Hassam specialized in city scenes while, in Australia, Tom Roberts was more taken with the notion of painting *plein-air* landscapes. After touring Europe, he became the leader of a group of artists known as the Heidelberg School. They set

▲ **Lady and Dog on the Beach** Joaquin Sorolla y Bastida *The Spanish artist applied bright, light color with a wide brush.* 1906, oil on board, 6¼ x 8¾in, Leeds Museums and Galleries, Leeds, UK

up camps in the bush to experiment with the techniques of Monet and his colleagues. The results were shown at an Exhibition of Impressions in 1889, in Melbourne, Australia.

In Germany and Spain, the impact of Impressionism was less marked, although many artists lightened their palettes and took a greater interest in atmospheric effects. Foremost among them were the Spanish painter Joaquin Sorolla and the German Lovis Corinth, who had studied in Paris under French academic painter William Bouguereau (see pp.358–59).

Édouard **Manet**

Photograph by Nadar

b PARIS, 1832; d PARIS, 1883

Manet was a reluctant revolutionary. Although he longed for official recognition, his irreverent use of Old Master paintings and his switch to harsh contrasts in place of subtle shifts in tone created an outcry in 1863, when he was refused the chance to exhibit at the Salon. Yet, some aspects of Manet's education had been conventional. He trained under Couture, a successful academic painter, and made a careful study of the Old Masters in the Louvre. But Manet was equally impressed by the innovations he saw in Japanese prints, as well as the theories of the poet and art critic Charles Baudelaire, who urged him to become a "painter of modern life."

Manet followed Baudelaire's advice and some of his early works were effectively modern updates of traditional themes. These were mocked in official circles, but endeared him to a younger group of artists—the future Impressionists. Manet declined to exhibit with them, however, believing that genuine success could only be achieved through the Salon. Nevertheless, he experimented with painting outdoors, and his emphasis on modernity became a guiding principle of Impressionism.

LIFEline

1832 Born in Paris, the son of a senior civil servant

1848 Enrolls as a cabin-boy, but later fails his naval exams

1850–56 Studies under Thomas Couture

1863 Marries his long-term mistress, Suzanne Leenhoff

1870 Joins the National Guard during the Franco-Prussian War

1874 Paints with Claude Monet at Argenteuil

1881 Awarded the Légion d'honneur

1882 Produces his final masterpiece, *A Bar at the Folies-Bergère*

1883 Dies of syphilis

▶ **Boating** *Manet preferred working in the studio, but experimented with painting in the open air alongside Monet and Renoir at Argenteuil.* 1874, oil on canvas, 38¼ x 51in, Metropolitan Museum of Art, New York, US

▼ **Olympia** *Art lovers were only accustomed to seeing female nudes in the guise of nymphs or goddesses, so the blatant modernity of* Olympia *caused a scandal. Critics interpreted her as a prostitute.* 1863, oil on canvas, 51 x 75in, Musée d'Orsay, Paris, France

> **One must** be of one's time and **paint what one sees**
>
> ÉDOUARD MANET

▶ **The Execution of the Emperor Maximilian** *In a composition inspired by Goya's* The Third of May, 1808, *Manet highlighted a modern scandal: Maximilian had been installed as Emperor of Mexico after a French invasion and then abandoned when the Mexicans rose against him.* 1867–68, oil on canvas, 99 x 120in, Städtische Kunsthalle, Mannheim, Germany

▼ **The Balcony** *Partly inspired by Goya's* Majas on a Balcony, *Manet's picture baffled the critics, who looked for a meaning or story (one woman looks outside the picture, the other prepares to leave), but Manet deliberately avoided this. The seated woman is his sister-in-law Berthe Morisot (see p.348)* 1868–69, oil on canvas, 67 x 49in, Musée d'Orsay, Paris, France

INcontext

SALON DES REFUSÉS

In 1863, a record number of pictures were turned away by the Salon jury and, after numerous complaints, an alternative exhibition was staged for these rejected works (the "refusés"). The idea had been to vindicate the judges' choice, but this plan backfired, as the ensuing scandal turned Manet into an instant celebrity.

Caricature of the First Impressionist Exhibition in Paris by Cham, 1874 *When the Impressionists first exhibited their work together outside the Salon, they became targets for the mockery of cartoonists.*

▲ **A Bar at the Folies-Bergère** *This is Manet's swan song, painted when he was seriously ill with syphilis. He no longer had the strength to work in situ, so a bar was mocked up in his studio and one of the barmaids came to pose for him there. This explains why the foreground details are in sharp focus while the background, painted from memory, is far hazier. Manet also employed a little artistic license, shifting the girl's reflection to the right, so that it could be seen more clearly.* 1882, oil on canvas, 37¾ x 51in, Courtauld Gallery, London, UK

CLOSERlook

CROPPED FIGURES As in a modern snapshot, Manet's figures are often cropped at the picture's edge. Only the feet of a performing trapeze artist are visible in the top lefthand corner.

DISCREET SIGNATURE Manet painted identifiable brand labels on some of the bottles, but he replaced the details on one bottle of wine with his signature and the date.

Déjeuner sur l'herbe *Édouard Manet,*
1863, oil on canvas, 81⅞ x 103⅞in, Musée d'Orsay,
Paris, France ▶

Déjeuner sur l'herbe Édouard Manet

This is the picture that scandalized Parisian art lovers, turning Manet into an overnight celebrity. The title translates as "The Luncheon on the Grass." The original idea came to him, after he saw some women bathing in the Seine at Argenteuil. This reminded him of a picture in the Louvre, which he had copied during his student days. Manet submitted the painting to the 1863 Salon, but it was turned away. In this particular year, however, the jury had been so severe that an extra exhibition was organized for the rejects. Manet's picture was shown at this Salon des Refusés, under the title of *Le Bain* ("Bathing"). Here, it provoked a fierce reaction, most of it hostile.

Composition

This picture is often cited as an early example of the influence of Japanese prints on Manet's work. The artist does not employ traditional perspective, which had been the cornerstone of Western art since the Renaissance. Instead, the scene is composed in bands, leading up to a high horizon. There is no real sense of depth. The figures appear flat and the trees are used to form a screen, which curtains off the outside world, apart from a tiny patch of sky.

▲ **CONTRAST** Manet liked using strong, tonal contrasts. His forms are generally shown in a bright glare of light or else in shadow, with little or no transition between the two.

Technique

Much of the abuse directed against the *Déjeuner* related to its subject matter, but some critics were equally scathing about the artist's technique. They disliked the way that Manet abandoned the traditional academic approach, with its subtle gradations of tone and its enamel-like finish. In its place, they felt, he had a "mania for seeing in blocks," creating overpowering contrasts between light and shade. This seemed to give undue prominence to two of the most controversial aspects of the picture—the nudity of one woman and the size of the other. Reviewers were also critical of the disparity in the handling of the firmly contoured figures and the sketchy background.

◀ **STUDY** Manet produced several sketches and preparatory studies for the *Déjeuner*. This one is particularly interesting because the bather is shown in the correct scale and perspective, which in turn suggests that the "mistakes" in the finished version were entirely intentional.

▲ **SPATIAL GROUPING** The figures are formed loosely into the shape of a pyramid. This is reinforced by the slanting, parallel lines of the man's cane, his male companion's left arm, and the nude woman's right leg.

▲ **DIRECTION** Because none of the figures are looking at each other, the scene has an air of unreality. It gives the impression that Manet's figures are cut-outs taken from different sources, rather than a group of people at a genuine event.

▲ **BRUSH STROKES** Manet made little attempt to create a sense of depth in this painting. His rendering of the foliage is rapid and imprecise and, in places, his paintwork is thin and feathery, prefiguring his work with the Impressionists.

▶ **LUSCIOUS PAINTWORK** Even those critics who poured scorn on the *Déjeuner* found room to praise the still life. Its execution is far more conventional than other areas of the painting. The careful modeling and the skillful use of light give the fruit and bread a convincing, three-dimensional appearance.

Characters and story

Manet took the overall concept of the *Déjeuner* from *Le Concert Champêtre* ("Rustic Concert"), a famous picture in the Louvre, now generally attributed to Titian. This painting featured a similar combination of naked women with fully clothed men, but its mood was very different. The *Concert* was a pastoral idyll, rather than a real event, and the women could easily be interpreted as nymphs or muses. Manet's picture could not be viewed in the same light. The modern attire seemed to rule out any possibility of an allegory or an antique idyll. Instead, many spectators were left with the assumption that the women were prostitutes, taking part in an immoral liaison with their clients.

> **THE FEMALE NUDE** The nude woman is Victorine Meurent, one of Manet's favorite models, who had already featured in several of his paintings. She was a feisty character, as her imperious gaze suggests. Her complete lack of modesty fueled the claim that Manet was portraying her as a prostitute. Victorine's pose is extremely awkward, particularly as her elbow does not rest comfortably on her knee.

▲ **THE WOMAN BATHING** The bather creates a jarring effect. She is too large, both in relation to the boat and to the other figures. Her form is also much too sharp and distinct.

> **THE FROG** The little frog, tucked away in the bottom left corner of the picture, is a humorous touch. It would be perfectly logical to find such a creature near a riverbank, but it undermines any notion that this picture is a serious tribute to a famous Old Master.

◀ **THE FINCH** Like the frog to the bottom left of the painting, the bird was a whimsical addition to the composition. However, it caused a certain amount of controversy because its position was reminiscent of the dove—the traditional symbol of the Holy Ghost—which was often shown at the top of religious paintings, hovering over sacred events.

INcontext

THE OLD MASTERS It was normal practice for artists to borrow the poses of their figures from classical statuary or Renaissance masters. Indeed, the ability of artists to quote from such sources was viewed as a mark of their knowledge and skill. Courbet and the Realists had challenged this process in the 1850s, finding it absurd, and Manet took their mockery a stage further. His figures may echo the poses and gestures of a Renaissance print but, taken out of context, they are completely meaningless. The nudity was even more mischievous because Manet realized that it was open to very different interpretations.

The Judgment of Paris *Marcantonio Raimondi, (c1480–c1534). Manet borrowed his main figures from this engraving based on a lost painting by Raphael. Raimondi's figures were river gods, and both their poses and their nudity made far more sense in the print.*

Berthe **Morisot**

b **BOURGES, 1841;** d **PARIS, 1895**

One of the mainstays of the Impressionist movement, Morisot participated in all but one of the group's eight shows and often hosted meetings at her home.

She came from a prosperous family with distinguished artistic connections (her great-grandfather was Rococo artist Jean-Honoré Fragonard), and her varied education included lessons from Corot. In 1868, she met Manet and they felt an immediate rapport, each influencing the other's work. It has often been suggested that it was Morisot who persuaded Manet to try painting outdoors.

The ties between the two artists became stronger after she married Manet's brother Eugène in 1874. Morisot is best known for her charming domestic scenes of mothers and children, although she also produced fine portraits and atmospheric marine pictures.

▼ **The Cradle** *Exhibited at the first Impressionist show in 1874, this famous painting depicts Morisot's sister, Edma.* 1872, oil on canvas, 22 x 18¼in, Musée d'Orsay, Paris, France

▲ **Pasie Sewing in the Garden at Bougival**
Morisot produced some of her best plein-air *(outdoor) paintings during her three-year stay in Bougival. Pasie was her daughter's maid.* 1881, oil on canvas, 31¾ x 39¼in, Musée des Beaux-Arts, Pau, France

Claude **Monet**

Photograph of Monet

b **PARIS, 1840;** d **GIVERNY, 1926**

Monet's career was central to the Impressionist movement, as he kept faith with its practices and principles until the end of his working life. He spent part of his youth on the coast at Le Havre, where Eugène Boudin encouraged him to begin painting out of doors. By 1859, Monet had moved to Paris, making contact with future members of the Impressionists at the Académie Suisse and Charles Gleyre's studio. The 1860s proved to be an astonishingly fertile period for the development of his art, although his private life was a disaster. He was constantly short of money and endured his family's disapproval of both his career and mistress.

After a brief spell in London during the Franco-Prussian War, Monet settled in Argenteuil, near Paris, where he produced some of his finest work. By the 1880s, the Impressionists were beginning to drift apart, but Monet pursued the group's original aims even more vigorously. This can be seen in his "series" pictures—painting the same subject repeatedly, under different light conditions—and in his celebrated depictions of waterlilies, painted in his Japanese-style garden at his home in Giverny.

LIFEline

1840 Born in Paris, the son of a grocer
1858 Meets Boudin and starts painting outdoors
1859 Attends Académie Suisse in Paris
1862 Enters Gleyre's studio
1865 Shares a studio with Bazille; exhibits at the Salon
1870 Marries Camille Doncieux
1874 First Impressionist exhibition
1879 Camille dies
1883 Settles at Giverny
1914 Builds new studio for his *Waterlilies*
1926 Dies at Giverny, by this time wealthy and world-famous

▼ **Wild Poppies** *Shown at the first Impressionist exhibition in 1874, this painting demonstrates Monet's supreme skill at depicting a figure or a flower with a few deft brushstrokes.* 1873, oil on canvas, 19¾ x 25¾in, Musée d'Orsay, Paris, France

▼ **The Waterlily Pond** *In his final years, Monet painted almost exclusively in his garden at Giverny. He liked to focus very closely on his flowers, omitting the sky entirely.* 1899, oil on canvas, 34⅝ x 36⅝in, National Gallery, London, UK

CLOSERlook

DIAGONAL STRUCTURE
The figures of Monet's wife, Camille, and their son, Jean, are repeated to emphasize the strong diagonal at the heart of the picture.

349

IMPRESSIONISM

19TH CENTURY

▲ **The Gare Saint-Lazare: Arrival of a Train** *In 1877, Monet left Argenteuil and briefly moved back to Paris. After six years in the country, he was anxious to produce city views again, showing no fewer than eight pictures of this station at the third Impressionist exhibition during the same year.* 1877, oil on canvas, 31½ x 38¾in, Fogg Art Museum, Cambridge, US

▲ **Rouen Cathedral, West Façade, Sunlight**
Monet painted dozens of versions of this subject, depicting the stonework of the cathedral under different light and weather conditions. 1894, oil on canvas, 39¼ x 25¾in, National Gallery of Art, Washington DC, US

CLOSERlook

FLEETING EFFECTS
Train stations provided ideal subjects for the Impressionists. They were obvious examples of modern city life, while swirling clouds of steam circulating under a glass roof offered ample opportunity to capture the fleeting effects of light and color.

Pierre-Auguste **Renoir**

Self-portrait

b **LIMOGES, 1841**; d **CAGNES-SUR-MER, 1919**

Today, Renoir is one of the best-loved artists of the 19th century, but success did not come easily to him. His family was poor and at the age of 13 he began an apprenticeship as a porcelain painter. After this he took a job decorating blinds before enrolling at the studio of Paris-based Swiss painter Charles Gleyre (1806–74). There, he met the core of the future Impressionist group. They learned little from their master's polished, academic style, though Gleyre did encourage them to paint outdoors. By the late 1860s, Renoir was doing this regularly, often painting by Monet's side. For a time, their subjects and style were so similar that it can be hard to distinguish between their pictures.

Renoir enjoyed some early success at the Salon (see p.336), but the financial rewards were meager. Ironically, he painted some of his most joyous scenes at a time when he was struggling to survive financially. By the late 1870s, however, his fortunes began to change, as he found a supportive dealer and a number of loyal patrons. Gradually, Renoir abandoned his Impressionist roots, adopting a broader style that placed a greater emphasis on drawing and structured composition.

▶ **Dance at Bougival**
Dances were a favorite theme for Renoir. The model, Suzanne Valadon, later became a distinguished artist. 1883, oil on canvas, 71¾ x 38⅝in, Museum of Fine Arts, Boston, US

▼ **Nude in Sunlight** *This is one of several paintings produced by Renoir in the mid-1870s, showing the effects of sunlight filtering through trees.* c1875–76, oil on canvas, 31⅞ x 25⅝in, Musée d'Orsay, Paris, France

LIFEline

1841 Born in Limoges, the son of a tailor
1854–58 Apprenticed to a porcelain painter
1861 Enters Gleyre's studio, where he becomes friends with Monet, Sisley, and Bazille
1874 First Impressionist exhibition
1881 Paints *The Luncheon of the Boating Party*
1882 Marries Aline Charigot
1903 Moves to the Riviera for his health
1919 Dies in Cagnes and is buried at Essoyes

> ❝ It is not enough for a painter to be a **clever craftsman**; he must **love to caress** his canvas too ❞

CLOSERlook

VIRTUOSO COLORING This study shows Renoir's tremendous skill as a colorist, as well as his incredibly free brushwork. Even so, some critics disapproved. One likened the "green and purplish blotches" on the model's skin to the decomposing flesh on a corpse.

INcontext

MOULIN DE LA GALETTE Situated in the garden of a windmill in the Montmartre area of Paris, the *Moulin de la Galette* took its name from its speciality, a type of cake known as a *galette*. It was Renoir's favorite venue. He took a studio nearby and frequented the balls held there every Sunday. He loved painting dancing scenes, they were perfect examples of Parisian life—a theme so dear to the Impressionists.

Moulin de la Galette *(c1900). Renoir disliked using professional models because their poses were too mannered. Dance halls were good places for finding natural-looking subjects.*

▲ **The Bathers** *By the mid-1880s, Renoir was moving away from Impressionism toward a more severe style. In this experimental piece, the figures were obviously painted in the studio. The outlines are carefully drawn and the lighting seems more artificial.* 1887, oil on canvas, 45¾ x 66⅞in, Philadelphia Museum of Art, US

▼ **The Luncheon of the Boating Party** *The woman on the left is Aline Charigot, Renoir's future wife, and this restaurant was their favorite meeting place. The other figures are their friends, who posed separately for the picture.* 1880–81, oil on canvas, 51¼ x 68⅛in, Phillips Collection, Washington DC, US

▲ **La Loge** *This picture of a theater box was one of the few successes at the first Impressionist exhibition.* 1874, oil on canvas, 31½ x 24¾in, Courtauld Gallery, London, UK

▲ **The Path through the Long Grass** *Renoir painted this at the height of Impressionism, when he was working closely with Monet. Their style and subjects were almost identical.* 1876–77, oil on canvas, 23⅝ x 29⅛in, Musée d'Orsay, Paris, France

CLOSERlook

RAILROAD BRIDGE The modernity of the scene is underlined by this glimpse of the Seine and the railroad bridge at Chatou. The railroads had turned this place into a popular weekend spot, where Parisians could go boating. The *Restaurant Fournaise* was a favorite with oarsmen—hence the shirts and "boater" hats worn by some of the figures.

Frédéric **Bazille**

b **MONTPELLIER, 1841;** d **BEAUNE-LA-ROLANDE, 1870**

Bazille, "the forgotten Impressionist", was born into a wealthy wine-making family. He moved to Paris in 1862 and enrolled in Charles Gleyre's studio. There he met Monet, Renoir, and Sisley. Bazille helped his friends financially and was making great strides in his own career, when the Franco-Prussian War broke out. He volunteered for the Zouaves, a famous cavalry regiment, and was killed during a minor skirmish—his career cut tragically short before the Impressionist adventure had really begun.

▼ **Family Reunion** *Painted near the family home in Montpellier, this picture shows the influence of Monet's* Women in the Garden, *which Bazille had recently purchased.* 1867, oil on canvas, 60 x 91in, Musée d'Orsay, Paris, France

▲ **The Pink Dress** *This is the artist's cousin, Thérèse des Hours, looking out over the village of Castelnau-le-Lez. Because he was based in the south, Bazille tended to use brighter colors than his Parisian counterparts. The girl's averted gaze creates an air of mystery.* 1864, oil on canvas, 58 x 43in, Musée d'Orsay, Paris, France

Camille **Pissarro**

Camille Pissarro

b **ST THOMAS, VIRGIN ISLANDS, 1830;** d **PARIS, 1903**

While he may not be the most famous of the Impressionists, Pissarro played a major part in binding the movement together. He provided a link between the groups at the Académie Suisse (a private art school in Paris attended by Manet and Cézanne) and Charles Gleyre's studio (where Monet, Renoir, and Sisley studied). He was the only artist to participate in all the Impressionist shows. Pissarro was revered as a great teacher, but he was equally willing to listen to younger painters, and he continued to experiment throughout his career. Unlike other Impressionists, his paintings were regularly accepted at the Salon in the 1860s, but the Franco-Prussian War intervened and while he was taking refuge in England, Prussian soldiers occupied his house in Louveciennes and used his canvases as duckboards, destroying more than a thousand paintings. In the 1870s, Pissarro exchanged ideas with Cézanne, and over the course of the following decade he experimented with the pointillist technique after meeting Seurat and Signac. When ill health finally stopped him from working outdoors, he painted street scenes from hotel windows.

LIFEline

1855 Moves to Paris while in his mid-20s

1859 Meets Monet; exhibits at the Salon

1863 His work is shown at the Salon des Refusés

1870 Moves to London during the Franco–Prussian War

1872 Settles in Pontoise

1874 Participates in the first Impressionist show

1885 Meets Seurat and experiments with pointillism

1892 Has his own exhibition

1903 Dies from blood poisoning; buried in Paris

▶ **The Coach to Louveciennes** *This may well be the finest of Pissarro's pre-war paintings. Rarely has a rain-sodden atmosphere been captured more evocatively. As he did so often, Pissarro anchored the composition around a road leading into the picture.* 1870, oil on canvas, 9¾ x 13¾in, Musée d'Orsay, Paris, France

CLOSERlook

VANISHING The Impressionists often used short, broken brush-strokes to convey shimmering reflections in water. Here, Pissarro uses the technique to conjure up the glistening surface of a muddy road.

▲ **The Crystal Palace** *Pissarro lived in London during the Franco–Prussian War, staying for a time in Norwood. The Crystal Palace, which had been re-erected in the area, was an obvious subject for a picture.* 1871, oil on canvas, 18½ x 28¾in, Art Institute of Chicago, Chicago, US

▶ **The Côte des Boeufs at l'Hermitage, Pontoise** *During the late 1870s, Pissarro often screened off his subject with a row of trees, rendering depth through superimposed layers.* 1877, oil on canvas, 45¼ x 34¾in, National Gallery, London, UK

CLOSERlook

HIDDEN FORMS Human figures play a supporting role in many of Pissarro's landscapes. These two were formed with a few simple brushstrokes, have no facial details, and melt into the background.

Alfred **Sisley**

Photograph by Clement Maurier

b **PARIS, 1839**; d **MORET-SUR-LOING, 1899**

Sisley was a French-born painter with English parents. His father ran a business exporting artificial flowers, but he supported his son's decision to become a painter. In 1862, Sisley entered Charles Gleyre's studio in Paris, where he met other members of the future Impressionist group. He joined their discussions and their painting trips, although his early output was rather small. He survived by living off his allowance from his father, but this situation changed dramatically after the Franco–Prussian War when the family business collapsed and Sisley had to support himself. From this point on he lived in extreme poverty, receiving virtually no recognition for his work.

He concentrated almost exclusively on landscapes, specializing in scenes of the picturesque villages along the Seine. Sisley's work is remarkably consistent with a style that comes closest to that of Monet. Although his brushwork is generally less adventurous than Monet's, his best paintings still have a quiet, lyrical appeal.

LIFEline

1866 In mid-20s, has first painting accepted by the Paris Salon
1874 Participates at the first Impressionist show
1876 Paints the floods at Marly
1883 One-man show in Paris
1889 Exhibition in New York
1899 Dies from throat cancer

▶ **Snow Scene at Moret** *Sisley loved painting snow scenes and continued working outdoors, even in the depth of winter.* c1894, pastel, private collection

▲ **The Flood at Port-Marly** *This is one of Sisley's finest pictures. When the Seine burst its banks in his local village, Sisley produced a series of paintings of this street corner, depicting the same view at different times of the day. His brushwork is at its best here, particularly in the reflections.* 1876, oil on canvas, 23¾ x 31¾in, Musée d'Orsay, Paris

CLOSERlook

OBJECTIVE VIEW
Sisley's pictures on this theme give no hint of any danger or inconvenience caused by the flood. Instead, he focuses on its picturesque possibilities, including tiny "gondoliers" in most of the scenes.

Gustave **Caillebotte**

Self-portrait

b **PARIS, 1848**; d **GENNEVILLIERS, 1894**

Like Bazille, Caillebotte came from a wealthy family, and great emphasis is always laid on the financial support that he provided for his Impressionist friends. He qualified as a lawyer, but turned to art in the early 1870s, training under the academic artist Léon Bonnat. Within the Impressionist group, Caillebotte was closest to Degas. In his best works, he shared the latter's taste for unusual viewpoints and unrehearsed poses. His choice of subjects was also very striking, particularly his urban views and interiors.

Caillebotte built up a sizeable collection of Impressionist paintings, which he bequeathed to the State. However, at the time their work was still highly controversial, and not all the pictures were accepted.

▲ **The Floor Strippers** *The influence of Bonnat's meticulous approach is evident here. The asymmetrical composition, however, is more reminiscent of Degas's style, while the modern subject is entirely in keeping with Impressionist aims.* 1875, oil on canvas, 40¼ x 57in, Musée d'Orsay, Paris, France

Mary **Cassatt**

b **ALLEGHENY, 1844**; d **CHÂTEAU DE BEAUFRESNE, 1926**

This American painter and printmaker settled in Paris in 1874, the year that the first Impressionist exhibition took place. Cassatt met Degas three years later and, through him, became a member of the group. She was a talented painter, specializing in pictures of mothers with children, but she was an even greater graphic artist.

Her colored etchings appear deceptively sparse and simple, but were executed with an impressive blend of subtlety and delicacy. Cassatt came from a well-connected family and, in her later years, she did much to aid the Impressionists' cause by finding American buyers for their works.

▼ **Young Woman Sewing** *Cassatt exhibited this painting at the final Impressionist show. The steep background diagonal adds a modern note to a traditional subject.* c1880–82, oil on canvas, 36¼ x 24¾in, Musée d'Orsay, Paris, France

▲ **In the Omnibus** *From the* Set of Ten, *a series of engravings displayed at Cassatt's one-woman show, the bold, spontaneous design of this picture betrays the influence of Japanese prints.* 1891, drypoint and soft-ground etching, 14¼ x 10¼in, Brooklyn Museum of Art, New York, US

Edgar **Degas**

Self-portrait

b PARIS, 1834; d PARIS, 1917

Degas was a hugely influential painter, printmaker, and sculptor. His artistic training was academic: he had lessons from Louis Lamothe, a pupil of Jean-Auguste-Dominique Ingres (see p.271), attended classes at the École des Beaux-Arts (France's top official art school), and made an intensive study of the Old Masters. His art might have followed a traditional path, but a chance meeting with Manet in the Louvre made him alter direction. Degas did not share all the Impressionists' concerns—he had little interest in landscapes, for example—but he became a devotee of modern-life subjects.

Unlike most of the Impressionists, Degas preferred working in the studio. He did try to capture the fleeting moment in his works, not by studying changes in light conditions, but by mimicking the random effects of photography. He labored hard at this, admitting that "no art was ever less spontaneous than mine".

LIFEline

1834 Born a banker's son
1854 Studies with Lamothe
1855 Enters the École des Beaux-Arts
1862 Meets Manet; produces his first horse-racing scene
1870 Serves in the artillery during Franco–Prussian War
1872 Travels to America
1874 Participates in the first Impressionist exhibition
1881 Exhibits *Little Dancer*
1912 Evicted from studio
1917 Dies, and is buried in the family tomb in Montmartre

▼ **The Tub** *Degas' approach to composition was highly audacious. The viewer's attention on the bather is constantly diverted by the plunging perspective and the distracting still life.* 1886, pastel on card, 23¾ x 32¾in, Musée d'Orsay, Paris, France

▲ **The Parade, or Race Horses in Front of the Stands** *Degas admired English sporting prints, which were popular at the time, but his own racing scenes flouted all their conventions, deliberately ignoring the "important" elements of the actual race.* c1866–68, oil on paper, 18¼ x 24in, Musée d'Orsay, Paris, France

▶ **Little Dancer, Aged 14** *This is the only sculpture that Degas ever exhibited. The critics were shocked by its unsettling realism.* 1921, bronze casting of a wax original (1879–81), height 38¾in, private collection

▲ **The Dancing Class** *When artists depicted the ballet, they normally focused on actual performances. Degas, however, preferred the informality of backstage themes, such as rehearsals and classes.* 1873–76, oil on canvas, 33½ x 29½in, Musée d'Orsay, Paris, France

CLOSERlook

CASUAL POSES Degas deliberately avoided the academic art of borrowing poses from classical statues or old master paintings. He loved capturing off-guard moments. Here, one dancer reaches to scratch her back.

▼ **In a Cafe, or Absinthe** *Although this may seem like an authentic portrayal of Parisian low-life, the picture was carefully posed in the studio by an actress and a minor painter. The off-center composition, with a space on the left and the man's cropped pipe, lends the picture the spontaneous air of a snapshot. 1875–76, oil on canvas, 36¼ x 26¾in, Musée d'Orsay, Paris, France*

Henri de **Toulouse-Lautrec**

Toulouse-Lautrec, c1900

b ALBI, 1864; d CHÂTEAU DE MALROMÉ, 1901

Few artists have conjured up the bohemian lifestyle of *fin-de-siècle* Paris as evocatively as Lautrec. Although crippled as a teenager, he was determined that this should not restrict his ambitions. He had a formal, academic training, but was more influenced by the example of Degas and Japanese prints. This is particularly evident in his ground-breaking posters, where he combined basic linear forms with caricature.

After his arrival in Paris, Lautrec gravitated to Montmartre, where he soon immersed himself in the heady nightlife. His favorite models were singers, dancers, and prostitutes, many of whom were his friends. Lautrec's hectic social life took its toll, however, and his career was cut tragically short by the effects of alcoholism and syphilis.

LIFEline

1864 Born into an aristocratic family, descendants of Counts of Toulouse
1882 Studies in Paris under Bonnat
1883 Moves to Cormon's studio
1884 Sets up studio in Montmartre
1888 Exhibits with Les Vingt in Brussels
1889 Opening of the Moulin Rouge
1890 Paints *Dance at the Moulin Rouge*
1891 First commission for a poster
1893 Health deteriorates; moves into his mother's apartment
1899 Committed to a private sanatorium at Neuilly
1901 Dies at his mother's home in Malromé, France, aged 36

▼ **Dance at the Moulin Rouge** *Lautrec's picture used to hang behind the bar of this famous nightspot. With typical dark humor, he placed a grinning skull amid the revelers. 1890, oil on canvas, 45¾ x 59in, Philadelphia Museum of Art, Philadelphia, US*

▲ **The Bellelli Family** *Even in this early painting of his Italian relatives, Degas manages to make a highly structured composition seem spontaneous. His aunt Laure is in mourning for her father, whose portrait hangs beside her. She poses formally with one of her daughters, while the other figures appear momentarily distracted and the little dog scampers out of view. c1858–60, oil on canvas, 79 x 98in, Musée d'Orsay, Paris, France*

▲ **Le Divan Japonais** *This famous poster is an advertisement for a Montmartre cabaret, fashionably decorated in the Japanese style. One of Lautrec's friends, the dancer Jane Avril, watches a performance by the singer Yvette Guilbert. 1892, lithograph poster, 31¼ x 23¼in, Bibliothèque Nationale, Paris, France*

CLOSERlook

DELIBERATE DISTORTIONS
Inspired by Japanese prints, Lautrec distorted objects to suit his decorative scheme. He was particularly fond of depicting stylized versions of a double-bass, often using them to frame his scenes.

INNOVATION Lautrec created a textured, speckled effect by flicking ink on to lithographic stone, a technique he described as *crachis* ("spitting").

Auguste **Rodin**

Photograph
by Paul Nadar

b **PARIS, 1840;** d **MEUDON, 1917**

Auguste Rodin was the greatest sculptor of his age. His achievements were all the more remarkable, given the early difficulties he faced. He was rejected by the École des Beaux-Arts and had to work for years as a lowly artisan, producing architectural ornaments. Rodin was in his mid-thirties before the breakthrough came—with a nude statue so realistic that some critics believed he had cast it directly from the actual model.

This controversy was a foretaste of things to come. Even when his genius was recognized and important commissions came his way, patrons were shocked by the radical nature of Rodin's designs. Major projects, such as the statues of *Balzac* (1897) and *The Burghers of Calais* (1884–89), were delayed for years before they were finally erected. Rodin's great skill was to convey complex ideas through minute details of the human form. The complete absorption of *The Thinker* (1880–81), for example, is underlined by his taut pose, distended nostrils, and even his tightly clenched toes. Fittingly, a copy of this statue was placed over Rodin's tomb.

LIFEline

1840 Born into a working-class family in Paris
1875 Visits Italy, to see the work of Michelangelo
1877 Exhibits for the first time at the Paris Salon
1880 Commissioned to produce the *Gates of Hell*
1884 Wins competition to commemorate *The Burghers of Calais*
1891 Receives commission for a statue of *Balzac*
1898 Completes *The Kiss*
1917 Marries his long-term mistress, Rose Beuret; they both die later that year

▶ **The Gates of Hell**
Commissioned for the entrance of a new museum, this ambitious project was never finished. The design represented Dante's Inferno. 1880–90, bronze, 251 x 158in, Musée Rodin, Paris, France

CLOSERlook

SOURCE OF INSPIRATION The *Gates of Hell* proved an invaluable testing ground for Rodin's later work. *The Thinker*, shown left, and *The Kiss*, shown opposite, both had their origins here.

▶ **The Thinker** *On* The Gates of Hell, *this figure was probably meant to represent the Italian poet Dante, but Rodin enlarged the figure and turned it into a timeless embodiment of thought and concentration.* 1880–81, bronze, height 27¼in, Burrell Collection, Glasgow, UK

IN context
HONORÉ DE BALZAC
Widely regarded as one of France's most talented and prolific authors, Balzac's greatest achievement was *La Comédie Humaine* (The Human Comedy). In this series of interlinked novels, he aimed to produce a panoramic portrait of French society at every level. Balzac worked incredibly long hours, driving himself to an early grave, but was revered as the nation's supreme literary genius.

Balzac Reviewing a Parade of his Characters *Like a military commander, Balzac surveys the rich array of characters he has created.*

▲ **The Burghers of Calais** *Rodin won a competition to portray these medieval heroes, who offered up their lives to save their fellow citizens during Edward III's siege of Calais. The sculptor captured their differing emotions superbly, but the local authorities were disappointed by their lack of nobility.* 1884–89, bronze, height 79in, Calais, France

▼ **Honoré de Balzac** *Rodin's radical vision of the French novelist aroused immense hostility when the design was revealed. The commission was canceled, and the full-size statue was only erected in 1939.* 1897, plaster, height 106in, Musée d'Orsay, Paris, France

❝ The truth of my figures...
seems to **blossom
from within** to outside,
like **life** itself ❞
AUGUSTE RODIN, 1911

▶ **The Kiss** *Rodin produced the first version of this famous sculpture for his* Gates of Hell, *where it represented Paolo and Francesca, the adulterous lovers from Dante's* Inferno. 1888–98, marble, 72 x 44 x 47in, Musée Rodin, Paris, France

CLOSERlook

HIDDEN DETAIL Divorced from its original context and renamed *The Kiss,* Rodin's statue now seems like a vision of universal love. However, one detail of the original story remains. The couple had been reading about Lancelot and Guinevere's doomed affair and, in Paolo's hand, the book can still be seen.

Medardo **Rosso**

b **TURIN, 1858;** d **MILAN, 1928**

Rosso's work has often been described as the sculptural equivalent of Impressionism. Born in Turin, he spent much of his career in Paris (1889–c1915). There, Rosso met and exchanged work with Rodin, although their friendship ended abruptly after he accused the Frenchman of "borrowing" his ideas for the statue of *Balzac* (1897). Rosso blurred the boundaries between painting and sculpture, abandoning firm contours and smooth surfaces, to endow his pieces with a sense of movement and change. These qualities were to inspire the Futurists (see p.428).

▼ **The Caretaker** *Rosso's favorite medium was wax over plaster. The soft, pliable material enabled him to create subtle, Impressionistic effects in his figures.* Wax over plaster, Galleria d'Arte Moderna, Florence, Italy

▲ **Ecce Puer** *This is a commissioned portrait of a young boy, Alfred Mond. Rosso tried to capture a specific moment as he watched the boy peering through curtains. He exhibited it under the title* Impression of a Child. 1906, bronze, height 17¼in, Musée d'Orsay, Paris, France

Lovis **Corinth**

Self-portrait

b TAPIAU, 1858; d ZANDVOORT, 1925

Corinth was a versatile German painter and printmaker. He studied initially at the Königsberg Academy, but received most of his training in Paris, under William Bouguereau. His early taste was for a rugged naturalism, inspired by Courbet and Millet, as well as the Dutch Old Masters. There were also Symbolist overtones in some of his lush, sensual versions of literary and religious subjects.

Corinth's style did not reach full maturity until his move to Berlin where, together with Liebermann and Slevogt, he pioneered the German form of Impressionism. Corinth was prolific for the next decade, but in 1911 he suffered a career-threatening stroke. Gradually, he learned to paint again, though in a much looser manner that was admired by the Expressionists (see p.408).

LIFEline

1858 Born in Tapiau, East Prussia (now part of Russia)

1884–87 Studies with Bouguereau in Paris

1887–91 Works in Königsberg

1892 Joins the Munich Sezession

1900 Settles in Berlin

1903 Marries Charlotte Berend, one of his students

1911 Suffers a major stroke

1915 Succeeds Max Liebermann as president of the Berlin Sezession

1925 Dies of pneumonia in Zandvoort, Holland

▲ **Charlotte Corinth at Her Dressing Table** *Light suffuses the entire scene in this portrait of Corinth's wife.* 1911, oil on canvas, 47¼ x 35⅜in, Kunsthalle, Hamburg, Germany

◄ **Carl Hagenbeck in his Zoo** *A pioneer of modern zoos, Hagenbeck liked to pose with his animals—in this case, a walrus called Pallas.* 1911, oil on canvas, 78¾ x 106¾in, Kunsthalle, Hamburg, Germany

Philip Wilson **Steer**

b BIRKENHEAD, 1860; d LONDON, 1942

A leading pioneer of Impressionist painting in England, Steer had a conventional academic training in France, where his principal masters were Cabanel and Bouguereau. His own style, however, owed more to the influence of Whistler and Monet. On his return to England, Steer became one of the founding members of the New English Art Club, a private society that was dominated by artists who had worked in France and were aware of the latest trends. Steer also participated in a separate exhibition, *The London Impressionists*, which was staged in 1889.

Steer's Impressionist period was comparatively brief, lasting from around 1887 to 1894. His finest pictures in this style were his beach scenes, which boasted the same sparkling colors and sheer exuberance as many of the canvases produced by his French counterparts.

LIFEline

1860 Born in Birkenhead, Merseyside, the son of a portrait painter

1882–84 Studies in Paris, at the Académie Julian and the École des Beaux-Arts

1886 Founder member of the New English Art Club

1889 Takes part in *London Impressionists* exhibition

1889 Exhibits with Les Vingt in Brussels

1893 Begins teaching at the Slade School of Fine Art

1927 As eyesight deteriorates, he switches to watercolors

1931 Awarded Order of Merit

1942 Dies of bronchitis at his London home

▼ **Hydrangeas** *In a masterly demonstration of his skills as a colorist, Steer shows sunlight reflecting on pale fabrics.* 1901, oil on canvas, 33½ x 44⅛in, Fitzwilliam Museum, Cambridge, UK

▲ **Children Paddling, Walberswick** *Steer produced his most overtly Impressionist scenes on the Suffolk coast, at Walberswick, where he often stayed with friends. His technique of using short dabs of contrasting color helps to create an atmosphere of hazy sunshine.* 1891–94, oil on canvas, 25¼ x 36¼in, Fitzwilliam Museum, Cambridge, UK

CLOSERlook

SIMPLIFIED FIGURES Steer effortlessly conveys this extremely foreshortened pose with just a few deft brush strokes.

REFLECTIONS Monet's influence is evident in the sparkling water's surface, with its glints of sunlight and its shimmering reflections.

William Merritt **Chase**

Portrait by James Carroll Beckwith

b **WILLIAMSBURG, VIRGINIA, 1849;** d **NEW YORK, 1916**

This versatile American painter and teacher trained at the Royal Academy in Munich from 1872 to 1877. After several months in Venice, he returned to New York in 1878 and in 1880 became president of the Society of American Artists. He resigned from the society in 1902 to join The Ten, a breakaway group who considered the Society's exhibitions to be too conservative. Known for his portraits, which highlighted his dashing bravura technique, his Impressionist experiments are evident in his landscapes, the finest of which were produced at the Shinnecock Summer School, Long Island.

▶ **Dorothy** *Chase painted several informal portraits of his daughter. His portrait style was heavily influenced by a fellow American John Singer Sargent, as well as the Belgian painter Alfred Stevens.* 1902, oil on canvas, 72 x 35¾in, Indianapolis Museum of Art, Indiana, US

Joaquin **Sorolla** y Bastida

Self-portrait

b **VALENCIA, 1863;** d **CERCEDILLA, 1923**

Sorolla was a prolific painter and illustrator, and the leading exponent of Impressionism in Spain. After studying in Madrid and Rome, he enjoyed a lengthy stay in Paris. Here he was chiefly influenced by the work of Bastien-Lepage, who had made his name with a brand of Impressionism that was "corrected, sweetened, and adapted to the taste of the crowd," and Sorolla soon followed this lead.

Sorolla's brightly colored beach scenes were hugely popular. He won medals at the Paris Salon, and was also fêted in the United States, where he won his greatest commission—a series of 14 enormous murals representing the *Provinces of Spain,* to be installed in the Hispanic Society of America in New York.

▼ **People Sitting on the Beach** *Sorolla was known for his beach scenes of the Costa Blanca, in which he combined intense colors with vigorous brushwork.* 1906, oil on board, 6¼ x 8¾in, Leeds Museums and Galleries, UK

Tom **Roberts**

b **DORCHESTER, 1856;** d **KALLISTA, AUSTRALIA, 1931**

▲ **A Break Away!** *A drover chases runaway sheep in this evocative slice of Australian rural life.* 1891, oil on canvas, 53⅞ x 66⅛in, Art Gallery of South Australia, Adelaide, Australia

Roberts was born in England and trained at London's Royal Academy (1881–84), but he spent most of his career in Australia. In 1885, he settled in Melbourne, where he became a founder member of the Heidelberg School. The group focused on the Australian bush, recording a way of life that was swiftly vanishing. The results were shown at their Exhibition of Impressions (1892), where all the views were painted on identical cigar box lids. Roberts' iconic pictures of sheep-shearers and farmers attracted little attention at the time, but have since been recognized as landmarks in the development of Australia's national identity.

Max **Liebermann**

Self-portrait

b **BERLIN, 1847;** d **BERLIN, 1935**

A German painter and printmaker, Liebermann was the first president of the Berlin Sezession (an alternative group to the formal Association of Berlin Artists). He trained at Weimar, but also made extended visits to Paris, where he met some of the Barbizon painters. He developed a robust, naturalistic style that was sometimes controversial (his *Jesus in the Temple* was criticized in the German Parliament for being "too Jewish"). Liebermann's interest in Impressionism came to the fore in the 1890s, when he painted a series of outdoor scenes that demonstrated his skill at capturing light effects. He also built an important collection of Impressionist pictures, although this was dispersed after his death.

▲ **The Terrace at the Restaurant Jacob in Nienstedten on the Elbe** *Sunlight filtering through leaves was one of Liebermann's favorite themes.* 1902, oil on canvas, 27⅝ x 39⅜in, Kunsthalle, Hamburg, Germany

Childe **Hassam**

b **DORCHESTER, MASSACHUSETTS, 1859;** d **EAST HAMPTON, NEW YORK, 1935**

The American artist Childe Hassam developed an interest in Impressionism during a three-year stay, from 1886, in Paris, where he enrolled at the Académie Julian. On his return to the US, he settled in New York. It was here that he produced his most memorable street scenes and later a series of flag paintings. Away from the city, Hassam also painted at Appledore, an island off the New Hampshire coast, where he often stayed with the poet Celia Thaxter. In 1897, Hassam became one of the founder members of The Ten—an influential group of American artists, who were instrumental in bringing Impressionism to the US.

▼ **Rain Storm, Union Square** *Hassam's urban scenes portray life in New York City during the 1890s. He particularly loved to paint glistening, rain-soaked streets.* 1890, oil on canvas, 35⅜ x 43¾in, Museum of the City of New York, New York, US

INcontext

THE HEIDELBERG SCHOOL Named after a village near Melbourne, this group of artists pioneered in Australia the Impressionist practice of painting in the open air. Led by Tom Roberts, Sir Arthur Streeton, and Charles Conder, they worked together in camps at Box Hill and Eaglemont.

Near Heidelberg *by Sir Arthur Streeton (1890). Streeton became famous for his scenes of the outback. The artists of the Heidelberg School produced the first realistic portrayals of the Australian landscape.*

CLOSERlook

THE BIGGER PICTURE The lady turns her head away. Is she averting her gaze from the man by the fountain? In true Impressionist fashion, we only have a snapshot of this unspoken drama.

Neoimpressionism and Post-impressionism were both an extension of Impressionism and a rejection of its limitations. Neo-impressionism is characterized by the paintings of Georges Seurat and his use of dots of pure color. The central figures of Post-Impressionism were van Gogh, Gauguin, and Cézanne.

Origins and influences

The terms Neo-Impressionism and Post-Impressionism refer to a 30-year period of extensive artistic innovation between 1880–1910 rather than to any single group of artists.

Although this new generation of painters had started on the fringes of Impressionism, many of them began to react against its preoccupation with surface appearances. They pushed beyond the quest for naturalism and sought to express feelings and ideas through a radically new use of color, brushstroke, and content.

Postimpressionist artists were keen to break free from the constraints of the Academy (see pp.336–37), to use new styles of expression to reveal a more personal or even spiritual vision that had far-reaching artistic consequences. Gauguin's bold experiments with color had a powerful impact on the Nabis (see pp.380–81) and Expressionists, and Van Gogh also produced work that appealed to the Expressionists. But it was Cézanne who exerted the greatest influence on other artists. His bold experiments with composition and volume paved the way for Cubism and the birth of abstraction.

Subject matter

The subjects of Neoimpressionist and Postimpressionist paintings were as varied as the painters' styles. Alongside nudes and harbor scenes, Seurat worked on large, formal group

▲ **Michel-Eugene Chevreul,** *caricatured by T. Bianco, 1885–89. Chevruel was the French chemist, physicist, and philosopher who pioneered theories on color which were put in to practice by Neoimpressionists such as Seurat.*

Neo- and Postimpressionism

TIMEline

From Seurat's *Sunday Afternoon on the Island of La Grande Jatte* and Gauguin's *Vision after the Sermon* to Van Gogh's *The Starry Night*, Cezanne's *The Large Bathers*, and Signac's *Entrance to the Port of Marseille*, the evolution of Neoimpressionism and Postimpressionism displays a wide diversity of styles. Artists experimented with every aspect of their art, from color and brushstroke to form and subject matter.

1884–86

SEURAT Sunday Afternoon on the Island of La Grande Jatte

1888

GAUGUIN The Vision after the Sermon (Jacob wrestling with the Angel)

1888

VAN GOGH Sunflowers

1889

VAN GOGH The Starry Night

1891–2

CROSS The Golden Isles

▲ **Gasometers at Clichy** Paul Signac *In this painting, Signac depicts gas storage tanks entirely with small dabs of color in the Divisionist manner. 1886, oil on canvas, 25½ x 32in, National Gallery of Victoria, Melbourne, Australia*

Schools

The two recognizable "schools" were based on the theories of Seurat (Neo-Impressionism) and Gauguin (Postimpressionism). Whereas Seurat sought to make the approach to light and color more rational and scientific, Gauguin renounced naturalism to explore symbolic use of color and line.

Neoimpressionism

The term Neoimpressionism was coined by the art critic Felix Fénéon in his review of the final Impressionist exhibition of 1886. Fénéon was referring to a group of paintings based on Seurat's scientific principles of color and form. As he saw it, Divisionism (or Pointillism) was a technique that pushed Impressionism one stage further in its depiction of light and color.

Seurat's *Sunday Afternoon on the Island of La Grande Jatte* (see pp.364–67) was the painting that launched Neoimpressionism. After Seurat's untimely death at the age of 31, his close friend Signac became the leader of the group, spreading the word through the publication of his treatise on Divisionism, *From Eugène Delacroix to Neo-Impressionism*, in 1889. Its huge influence at the time can be gauged by the number

▲ **Landscape with Goats** Henri-Edmond Cross *Here, Cross uses Divisionist techniques to create an idyllic rural landscape. 1895, oil on canvas, 36¼ x 25⅛in, Petit Palais, Geneva, Switzerland*

portraits. Many of his followers, including Signac, moved to the south of France, where they portrayed bold, maritime landscapes.

Postimpressionists such as van Gogh and Cézanne also chose to work in the south of France, reveling in its bright light and brighter colors. They focused on portraiture, still life, and landscapes, while Gauguin chose religious, symbolic, or domestic themes, depicting pious peasants, "noble savages," and the well-furnished interiors of the bourgeoisie.

Styles and techniques

In their determination to find a simpler, more authentic mode of representation, Neoimpressionists and Postimpressionists reinvented the art of painting by emphasizing geometric shapes, distorting forms, and applying unnatural coloring.

▲ **Model from the Back**
Georges Seurat, 1886, oil on panel, 9⅝ x 6⅛in, Musee d'Orsay, Paris, France

◀ **Model from the Back (detail)**
Seurat highlights the top of the woman's back and the nape of her neck using tiny dots of juxtaposed pure color.

Cézanne's application of broken planes of color marked a revolution in perspective. Seurat carried out investigations into complementary colors, developing a technique known as Divisionism (or Pointillism) in which he applied small, regular dots of pure color to the canvas. These, he hoped, would merge in the viewer's eye to create an optical mix of color. The technique attracted many followers.

1891

SEURAT The Circus

1892

GAUGUIN Manao Tupapau

1896

SIGNAC Sailing Boats and Pine Trees

1904–06

CEZANNE Montagne Sainte-Victoire

1906

CEZANNE The Large Bathers

of artists (among them Pissarro, van Gogh, Matisse, and Kandinsky) who flirted briefly with Divisionist painting before moving on to work in other styles. Neo-Impressionism was also enthusiastically received in Belgium and in Italy, where Impressionism had barely registered. Even the Cubists made playful use of its dotty style.

Postimpressionism

The leading Postimpressionist artists tended to work in isolation, painting alone in Arles (van Gogh) and Aix en Provence (Cézanne). Only Gauguin could be said to have painted in a group. Between 1886–89, he became the unofficial leader of a group of artists based in the fishing village of Pont-Aven in Brittany—including Emile Bernard and Paul Sérusier—who wanted more space to express personal feelings and ideas, and inspired the formation of the Nabis (see pp.380–81) in Paris. Together, they worked out a more simplified approach to painting, with little attempt at realism, that was inspired as much by stained-glass windows as by Japanese prints. This more relaxed approach filtered into the graphic and decorative arts, where it found its truest

expression in the designs of Toulouse-Lautrec's posters.

Outside France, Postimpressionist artists were promoted by exhibitions orgaznized by offshoots from the national académies (similar to the French salon). From 1883, these splinter groups became the main innovatory force in art throughout Europe and America, helping to spread new artistic ideas and influencing the careers of many important 20th-century schools and artists, including the Fauves, the Expressionists, and even the American Abstract Expressionists.

CURRENTevents

1890 Oscar Wilde publishes *The Picture of Dorian Gray*—a key work of *Fin de siècle* literature.

1903 Marie and Pierre Curie share the Nobel Prize for Physics for their work on radioactivity.

1908 The Ford Motor Company introduces the Model T—regarded by many as the world's first affordable car.

▲ **The Meal (The Bananas)** Paul Gauguin *This carefully composed still life was painted in the first months after Gauguin's arrival in Tahiti.* 1891, oil on canvas, 28¾ x 36¼in, Musee d'Orsay, Paris, France

Paul **Signac**

Signac, c1900

b **PARIS, 1863**; d **PARIS, 1935**

Signac came from a prosperous family of shopkeepers, which gave him financial independence. He originally trained as an architect, but a visit in 1880 to an exhibition of Monet's work persuaded him to become an artist instead. In 1884 he became a founder-member of the Salon des Indépendants, through which he met Georges Seurat. They formed a lasting personal and artistic friendship, and Signac became Seurat's most devoted advocate. An enthusiastic sailor, Signac painted a number of maritime landscapes in a style characterized by tessellated daubs of bright, luminous colors. After Seurat's death he was pivotal in spreading the Neoimpressionist style beyond France, through criticism, exhibitions, and his 1899 manifesto *From Delacroix to Neoimpressionism*.

LIFEline

1884 Co-founder of Salon des Indépendants; exhibits with Seurat for first time
1886 In early 20s, exhibits at last Impressionist show
1890 First foreign artist to join Les Vingt (Belgium); spreads Divisionism outside France; paints Portrait of Félix Fénéon
1893 Moves to Saint-Tropez
1908 President of Salon des Indépendants; promotes Fauves and Cubists

▶ **Sailing Boats and Pine Trees** *Signac painted many seaside landscapes at Saint-Tropez. The ghostly sailing boats contrast with the strong lines of the pines.* 1896, oil on canvas, private collection

▲ **Portrait of Félix Fénéon Against the Enamel of a Background Rhythmic with Beats and Angles, Tones, and Colors** *Signac used a whirling, multi-colored backdrop to express his art-critic friend's flamboyant personality. This is a good example of the Neoimpressionist trend towards a flattened, decorative style that owed much to contemporary posters, Japanese prints, and Symbolism.* 1890, oil on canvas, 28¾ x 36¼in, Museum of Modern Art, New York, US

CLOSERlook
SYMBOLIC DECORATION
The decorative petals, stars, and spheres denote a kimono sash, the American flag, and the solar system, representing some of Fénéon's interests.

Henri-Edmond **Cross**

Portrait by Maximilien Luce

b **DOUAI, 1856**; d **LE LAVANDOU, 1910**

Born Delacroix, Cross changed his name to avoid confusion with Eugène Delacroix, the French Romantic painter. He studied law before attending art school in Lille and Paris. In 1881, Cross exhibited at the Salon, but inspired by Monet he turned from Realism to Impressionism, lightening his palette at the same time.

A co-founder of the Salon des Indépendants in 1884, Cross did not adopt Divisionism until his move to the South of France in 1891. However, he stuck to it until his death, exploiting the expressive freedom of the new technique more fully than either of its founders, Seurat or Signac. The freer, brighter, tessellated brushstrokes that he and Signac pioneered would later be adopted by the Fauves.

▶ **The Golden Isles** *Cross's sun-drenched paintings helped to form the popular vision of the Mediterranean coast, none more so than this "hymn of praise to color and sunlight" depicting the Hyères islands. Cross's decorative treatment of the spatial area suggested a possible abstract direction for Neoimpressionism.* 1891–92, oil on canvas, 23¾ x 21¾in, Musée d'Orsay, Paris, France

Giovanni Battista **Segantini**

Etching by Gottardo Segantini

b **ARCO, 1858**; d **PONTRESINA, 1899**

Segantini was the only Italian painter of the late 19th century to enjoy a consistent international reputation. He grew up in poverty in the mountains, losing his mother when he was five before being abandoned by his father. Segantini taught himself to draw while herding sheep, and after running away several times he finally settled in Milan, attending classes at the Brera Academy and teaching art.

From 1878, Segantini gradually replaced his academic manner with a looser style. He relocated to Savognin and Maloja, now in the Swiss Alps, then in northern Italy. His Alpine landscapes of peasants going about their work combined a close observation of nature with a new technique of his. Not unlike Divisionism, it used separate, fluid brush strokes of complementary colors to capture the effects of the mountain light. In his later years, Segantini turned to Symbolism and was strongly influenced by the German philosopher Friedrich Nietzsche.

◀ **Afternoon in the Alps** *The Alps were a constant inspiration to Segantini. He painted many Alpine scenes, including this one of a young goatherd. His preferred mountain backdrop provided him with a setting for his paintings, which he tended to interpret in strongly symbolic ways.* 1893, oil on canvas, private collection

Georges **Seurat**

Seurat, c1885

b PARIS, 1859; d PARIS, 1891

Georges Seurat had a brief but astonishing career, devoting his main efforts to a few very large paintings. While studying at the École des Beaux-Arts in Paris, he attempted to develop a theoretical system for painting that could take Impressionism to a new level and create a template for future artists.

Seurat's technique, which he called Divisionism (more commonly known as Pointillism), was based on scientific principles of color complementarity. It involved applying small dots of primary color directly to the canvas, so that their exaggerated contrast would merge more vividly in the viewer's eye. All Seurat's paintings were based on formal ideas of composition, and were prepared meticulously from numerous studies. He completed around 60 studies for his masterpiece *Sunday Afternoon on the Island of La Grande Jatte* (see pp.364–67).

(see pp.364–67)

LIFEline

1878–79 Aged 19, enrols at École des Beaux-Arts, Paris

1884 Exhibits at Salon des Indépendants; meets Signac

1886 Exhibits *La Grande Jatte* at final Impressionist exhibition

1887 First Neoimpressionist exhibition in Brussels

1889 Involved in second Les Vingt exhibition; moves in with Madeleine Knobloch, model for *Woman Powdering herself*, who bears his child

1891 Dies of meningitis, aged 31

◄ **The Circus** *This dynamic composition brought Seurat his greatest success. It was widely praised by the critics for its "undulating music of lines." Seurat used horizontal (calming), vertical, and diagonal lines to convey movement, danger, daring, social difference, and spatial depth. 1890–91, oil on canvas, 28¾ x 23⅝in, Musée d'Orsay, Paris, France*

CLOSERlook

CLASSICAL PROPORTIONS Seurat based his composition on classical principles, including the golden section. The relaxed, immobile figures recall those of Piero della Francesca (see p.100); the focal point that runs diagonally across the picture is anchored by the large seated figure.

SILHOUETTES

Seurat perfectly captures the stillness of a hot summer's day through tonal contrasts, spatial organization, and Impressionistic brush strokes. He silhouettes the figures against the water by balancing light on one side, shown here by the white flecks around the boy's back, with dark on the other.

▲ **Study for "The Channel at Gravelines, Evening"**
Seurat's use of mosaic-like blobs of color is typical of his oil sketches and contrasts with the smaller dots used in the final work. The shimmering surface and calming influence of horizontal lines convey a strong sense of atmosphere. 1890, oil on panel, Musée de l'Annonciade, St. Tropez, France

▲ **Bathers at Asnières** *Seurat's first exhibited painting, depicting a setting opposite Grande Jatte island and based on over 20 sketches, took nearly a year to complete. Rejected by the official Salon, it was exhibited at the Salon des Indépendants. Signac was hugely impressed by its monumental ambition. 1884, reworked 1887, oil on canvas, 79 x 118in, National Gallery, London, UK*

◄ **Nude** *Seurat started his artistic career perfecting his chalk-and-charcoal drawing technique. This glowing nude demonstrates his skilful use of conté crayon and charcoal on pitted paper to produce a unique grainy, luminous effect. 1881–82, charcoal and crayon, Courtauld Gallery, London, UK*

**Sunday Afternoon on the
Island of La Grande Jatte**
Georges Seurat,
1884–86, oil on canvas, 81¾ x 121¼in,
Art Institute of Chicago, US ▶

La Grande Jatte
Georges Seurat

Seurat's masterpiece caused a sensation when it was shown at the final Impressionist Exhibition of 1886, and became one of the icons of 19th-century art. Featuring contemporary Parisians at leisure on a little suburban island on the Seine, it is a painting full of contradictions. Solemn yet witty, busy yet "frozen," it is a timeless image of modern life painted in an innovative technique, which harks back to the ancient art of Greece and Egypt.

Composition

Rejecting the sketchy, arbitrary nature of Impressionism, Seurat built up his complex, monumental composition through a long, methodical process. He began with on-the-spot oil sketches on cigar-box lids, and spent two years working on the painting in his studio. His meticulous preparations for the final work include about 28 drawings and 28 oil sketches on panel as well as three larger canvases. Adjusting and altering his studies, he removed some characters, and experimented with the relationships between figures as the image evolved.

◀ **LANDSCAPE SETTING,** Seurat does not show the island as it actually was: he left out the drinking and dining establishments, and the nearby shipbuilders' yards and factories. He made several preparatory drawings of landscape elements before painting this study. It appears like a stage set on which he would place his figures.

◀ **CHANGING GROUPS** Numerous studies show Seurat experimenting with different figures and groupings. The five figures clustered in the shadowy foreground here eventually become three, while the isolated woman and child are brought together to form a mother-and-child unit.

▶ **DISTORTIONS OF SCALE** Seurat painted La Grande Jatte in a studio which his fellow-painter Paul Signac noted was too small for such a large canvas—which probably explains discrepancies in the scale of the figures. If the painting is viewed at an angle, the figures appear more (but not perfectly) in proportion.

" *La Grande Jatte* unrolls before you like some **myriad-speckled tapestry** "

FÉLIX FÉNÉON (1861–1944) ART CRITIC

Technique

Seurat developed a new technique based on contemporary ideas about the science of color. He was particularly influenced by Ogden N. Rood, who proposed that when colors mixed in the eye rather than on the canvas they created a more luminous effect. In 1885, Seurat reworked his original painting using his "pointillist" or "divisionist" technique, covering the entire canvas with regular dots and dashes of pure color.

◀ **MAGNIFIED DOTS** This shows the seated woman's skirt against the sunlit grass. According to the theory of divisionism, these closely spaced, almost circular dots of paint appear more luminous because they merge in the eye rather than being blended on the canvas.

◀ **IMPERSONAL CHARACTERS** Having initially completed La Grande Jatte in the spring of 1885, Seurat set it aside until October, when he painted over the original picture with uniformly sized, directional dots and dashes of color. The final technique complements and emphasizes the detached, impersonal nature of the figures.

▼ **BORDER** Seurat painted the border using parallel dashes and dots of red, orange, and blue paint. He varied the color arrangement in different sections to accentuate contrasts with adjacent colors in the painting itself.

▲ **A COUPLE AND THREE WOMEN** As he worked on his composition, Seurat made exquisite tonal drawings, using velvety black conte crayon. He made numerous studies of the woman in the foreground, modifying the distinctive shape of her bustle as he worked.

Characters and story

Seurat has not created a realistic picture of individuals enjoying a Sunday afternoon. Though he began with sketches of figures he observed, he subsequently refined and arranged his cast of characters in the studio. Rather than individuals, he created "types" from different social classes. Their stylized forms and expressionless or unseen faces have an impersonal, artificial quality. Although the painting appears to reflect the ironies of modern city life, Seurat seems have chosen neither to create a "readable" story nor to make clear, moralizing statements.

◄ GROUP ISOLATION
These three figures from different social classes—pipe-smoking, muscular boatman, genteel lady with her book, and dapper, top-hatted "toff" with cane—would have been an unlikely group in reality. Despite their physical proximity on the canvas, the characters remain psychologically isolated from each other.

► FISHING AND SIN
In French, the verb to fish—pêcher—is very similar to the verb to sin—pécher—and puns on these words were popular in Seurat's time. Painting a woman fishing may be a visual pun by which the artist identifies her as a prostitute.

▲ FASHIONABLE COUPLE The woman in a fashionable bustle, and her top-hatted partner appear respectable, but the monkey on a leash may indicate she is a prostitute and he a client.

▲ TOY-LIKE SOLDIERS Reduced to the simplified shape of toy soldiers, these distant male figures may represent the potential "catches" of the woman fishing in the foreground (*see above right*).

▲ CHEEKY MONKEY Monkeys were fashionable pets at the time. However, the monkey is also a symbol of licentiousness, and the word singesse (female monkey) was contemporary French slang for "prostitute."

◄ WET NURSE The distinctive orange headscarf identifies this figure, seen in back view, as a wet nurse. Reduced to a geometric object, she has no "character" or individuality.

Paul **Cézanne**

Self-portrait

b **AIX-EN-PROVENCE, 1839**; d **AIX-EN-PROVENCE, 1906**

One of the greatest of the Post-Impressionists, Cézanne is regarded as "the father of modern art". The son of a wealthy hat-maker and banker, he studied law before persuading his father to allow him to abandon his studies and train as an artist in Paris. His early works were dark, thickly painted, and sometimes wildly erotic. But under Pissarro's influence, his palette and his touch lightened, and he turned to the study of nature.

Despite contact with the Impressionists, Cézanne's abrasive intensity and social awkwardness made him the outsider of the group. And where the Impressionists were concerned with surface appearance, Cézanne was preoccupied with structure, and with how to represent the solid, three-dimensional features of nature on the flat surface of a canvas.

Working painstakingly slowly, painting the same motifs over and over again, Cézanne developed an entirely original pictorial language in which depth and solidity are created not through conventional perspective and modeling, but by subtly varying colors, and by distorting and tilting forms. Cézanne's work had a profound influence on 20th-century artists, paving the way for Cubism and abstract art.

◀ **The Temptation of St. Anthony** *Typical of Cézanne's early work, this painting features forceful, heavily painted nudes in a dark, shallow space. Compare this sexually charged scene with the calm, formal balance of the nude bathers below, painted some 30 years later.* 1869–70, oil on canvas, 22¼ x 12¼in, Bührle Collection, Zurich, Switzerland

LIFEline

1859–61 Studies law in Aix-en-Provence
1861 In early 20s, moves to Paris to become an artist; meets Pissarro
1873 Paints *House of the Hanged Man* while living in Auvers
1886 When his father dies, Cézanne inherits his estate in Aix
1895 One-man-show in Paris establishes reputation among artists
1906 Dies of pneumonia in Aix, aged 67

▶ **The House of the Hanged Man** *In the early 1870s, Cézanne regularly painted in the open air with Pissarro. This light-filled, tightly constructed landscape reveals the profound effect this had on his art.* 1873, oil on canvas, 21¾ x 25¾in, Musée d'Orsay, Paris, France

▲ **Apples and Oranges** *Cézanne painted hundreds of still lifes, exploring spatial relationships by arranging and rearranging a small set of household objects along with fruit and vegetables. This celebrated painting is one of a series of six compositions featuring the same curtain, pitcher, white fabric, plates, and fruit.* c1899, oil on canvas, 29¼ x 36¾in, Musée d'Orsay, Paris, France

CLOSERlook
GEOMETRIC STABILITY
This complex composition, with its tilted, precariously balanced objects, is given stability by the underlying geometry created by the edges of objects and the bold zigzag of white cloth.

Still Life of Peaches and Figs *A celebrated master of watercolor still-life, Cézanne painted both complex compositions and simple arrangements such as this. Exploiting the white paper to create light and space, Cézanne uses what he termed "modulations" in color to depict the rounded forms of the fruit. Graphite and watercolor on paper, 7¾ x 12¼in, Ashmolean, Oxford, UK*

▼ **Mont Sainte-Victoire** *This rugged mountain near Cézanne's home in Aix was a constant source of inspiration. He painted the "stunning motif" time and again, with increasing freedom. In this late work, broad, overlapping patches of color suggest form and space.* c1904–06, oil on canvas, Kunsthaus, Zurich, Switzerland

◀ **Card Players** *One of several versions of the same scene, this is among Cézanne's most popular images. Stripping away detail, he evokes the tension inherent in the card game. Traditional perspective is abandoned: the table appears buckled, as if viewed from shifting angles, and the men's knees appear flattened against the picture surface.* c1893–96, oil on canvas, 18½ x 22¼in, Musée d'Orsay, Paris, France

◀ **The Large Bathers** *This huge canvas is the largest and probably the last of an ambitious series of paintings of monumental female nudes in a landscape setting. Cézanne uses simplified forms, so that some of the figures appear to merge with the landscape. Soaring tree trunks form an elegant arch, framing the view of the river and the opposite bank, where distant figures look toward the bathers—and the viewer.* 1906, oil on canvas, 82 x 99in, Philadelphia Museum of Art, Pennsylvania, US

❝ Treat **nature** by means of the **cylinder**, the **sphere** and the **cone** ❞

PAUL CÉZANNE, 1904

CLOSERlook

INTERLOCKING TRIANGLES
Human and landscape elements combine to create a harmonious, stable composition based on triangles. Beneath the triangular area of sky an inverted triangle is formed by the central figures' outstretched arms.

SIMPLIFIED HEAD
Cézanne's treatment of this bather's head reflects his view that "Painting stands for no other end than itself. The artist paints an apple or a head: it is simply a pretext for line and color, nothing more."

Children

In art, childhood is not always a time of innocence. Before the 19th century, children tended to be incidental inclusions in portraits unless they were the offspring of royalty, rulers, or a god. In formal family portraits, children were usually presented as miniature adults. At the other end of the social scale, children could behave more naturally as the subject of genre scenes of everyday life, particularly popular in the Netherlands. Things changed in the 19th century, and children became the subject of both formal and informal portraits.

◄ The Infant Margarita Teresa of Spain Diego Velázquez *Daughter of King Philip IV of Spain, the girl was painted when she was about five years old.* c1656, oil on canvas, Lobkowicz Palace, Prague Castle, Czech Republic

▼ Children's games (detail) Pieter Bruegel the Elder *The bottom section of the painting shows children playing leapfrog, tug-of-war, and using hoops and tops.* 1560, oil on panel, 46½ x 63½in, Kunsthistorisches Museum, Vienna, Austria

▼ Game of Chess Sophonisba Anguissola *The artist often painted her family. Here, her sisters Lucia, Minerva, and Europa are playing chess.* 1555, Museum Narodowe, Poznan, Poland

► Mother and children Yoruba Culture *Woodcarving is the most important art form of the Yoruba people. Carried out by men, this piece depicts a mother and her four children.* wood, height 28in, British Museum, London, UK

▲ Portrait of Giovanni de Medici Agnolo Bronzino *Depicted as an authoritative figure even as a child, Giovanni de Medici was only two years old when this portrait was painted.* c1545, tempera on wood, 22¾ x 18⅞in, Uffizi, Florence, Italy

▲ The Spinario, copy of Greek original Roman *A young boy is examining the sole of his foot to locate and extract a thorn. His expression conveys intense concentration.* 1st century CE, copy of a 3rd century BCE Greek original, marble, height 30in, British Museum, London, UK.

▲ A School for Boys and Girls Jan Steen *Famed for his humorous paintings of rowdy home life, Steen has here depicted a group of children in a schoolroom. Many of them are misbehaving, creating a lively scene.* c1670, oil on canvas, 6¼ x 9¾in, National Gallery of Scotland, Edinburgh UK

► Lady Caroline Montagu Sir Joshua Reynolds *Thackeray wrote that the child has a smile "so exquisite that a Herod could not see her without being charmed."* c1776, oil on canvas, 57 x 44in, private collection

▼ **Lending a Bite** William Mulready *The Irish-born painter made a career out of painting scenes of everyday life such as this act of guarded generosity.* c1820, oil on canvas, private collection

◄ **Autumn Leaves** Sir John Everett Millais *The youthful beauty of the children is in stark contrast to the heap of dead leaves. The painting is a reminder of the transcience of beauty and certainty of death.* 1856, oil on canvas, 41 x 29in, Manchester Art Gallery, UK

▼ **Chasing Rabbits from the series "Children's Games"** Kobayashi Eitaku *This is one of a series of Japanese woodcut prints depicting children at play.* 1888, color woodcut, Central Saint Martins College of Art and Design, London

▼ **Baby Asleep** Jacob Epstein *Epstein produced several bronze baby heads, considering it important as few other artists had portrayed babies.* c1907, bronze, height 4¾in, private collection

▲ **The Daughters of Edward Darley Boit** John Singer Sargent *In this unusual composition, the subjects, although sisters, show no signs of interacting with one another. They are also dwarfed by a pair of huge Japanese vases.* 1882, oil on canvas, 87½ x 88in, Museum of Fine Arts, Boston, Massachusetts

▶ **The Sisters** Mary Cassatt *The artist applied Impressionist techniques such as sketchy brushwork to domestic subjects—children and motherhood were favorite themes.* 1885, oil on canvas, 18⅛ x 22in, Kelvingrove Art Gallery and Museum, Glasgow, UK

▲ **Children Playing** Oskar Kokoschka *Kokoschka was criticized at the time for not making the children look happier in his portrait. Instead, he focuses on the concerns of childhood.* 1909, oil on canvas, 28¼ x 42½in, Wilhelm Lehmbruck Museum, Duisburg, Germany

▲ **A Baby** Dod Procter *The lighting emphasizes the dome of the baby's head and its round cheeks and throws the folds of the gown into deep shadow.* 20th century, oil on canvas, private collection

Paul **Gauguin**

b PARIS, 1848; d ATUONA, MARQUESAS ISLANDS, 1903

Rejecting what he called "the disease of civilization," Gauguin turned his back on life as a wealthy, respectable stockbroker and family man to devote his life to art. As a painter, printmaker, ceramicist, and sculptor, he sought inspiration and solace among primitive communities in Brittany and the South Seas.

Self-portrait

Gauguin had been a talented amateur painter and collector of Impressionist paintings before he decided to become a full-time artist. Encouraged by Pissarro, he exhibited with the Impressionists, but his aims ultimately differed from theirs. While they were concerned with outward appearance, he wanted his art to express inner meaning.

Despite his self-belief, Gauguin suffered years of poverty and lack of recognition: his reputation was only established after his death, with a huge retrospective exhibition held in Paris in 1906. His bold paintings, with their radical anti-naturalistic use of color, had an immeasurable influence on 20th-century art.

LIFEline

1848 Born in Paris to a radical French journalist father and half-Peruvian mother

1849 Family travel to Peru, returning to France in 1855

1871 Gets job as stockbroker

1873 Marries Mette Gad, with whom he has five children

1874 Meets Pissarro; sees first Impressionist Exhibition

1888 Paints *The Vision after the Sermon* in Brittany; stays with Van Gogh in Arles

1891–93 First period in Tahiti

1895–1901 Second period in Tahiti

1903 Dies in the Marquesas

▼ **Be Mysterious** *Gauguin started experimenting with imaginary exotic settings before his first trip to Tahiti. He was very pleased with this carving, and priced it at three times the cost of his most expensive painting.* 1890, carved limewood, 28¾ x 37¼in, Musée d'Orsay, Paris, France

▼ **Martinique Landscape (or Tropical Vegetation)**
Gauguin painted this colorful scene on a visit to the Caribbean island of Martinique in 1887. He used small, individual brushstrokes in the Impressionist manner to weave together a harmonious, decorative composition. 1887, oil on canvas, 45¾ x 35in, National Galleries of Scotland, Edinburgh, UK

CLOSERlook

DIVIDING LINE Linked by the unrealistic red ground (signifying the mystical nature of the scene), the Breton nuns and priest are separated from the figures in the vision—Jacob wrestling with an angel—by the diagonal tree trunk.

▲ **The Vision after the Sermon** *This painting marks Gauguin's break with Impressionism in both content and style. He wrote: "The landscape and the fight exist only in the imagination." To evoke this visionary experience and create a symbolic rather than naturalistic image, he simplifies line and color, creating bold areas of flat color set within sinuous outlines.* 1888, oil on canvas, 28¾ x 36¼in, National Galleries of Scotland, Edinburgh, UK

❝ I have decided on **Tahiti**… and I hope to **cultivate my art** there in the **wild and primitive state** ❞

PAUL GAUGUIN, 1890

▲ **Breton Women by a Fence** *The contours of the traditional white headdresses and collars worn by Breton peasants appealed to Gauguin's liking for both the decorative and the primitive.* 1889, lithograph, Art Gallery of New South Wales, Sydney, Australia

CLOSERlook

TAHITIAN TITLE To accentuate the painting's exotic, mystical meaning, Gauguin includes the Tahitian title *Manaó Tupapaú* on the background. It also forms part of the decorative scheme.

NIGHT FLOWERS "My feeling for the decorative leads me to strew the background with flowers," Gauguin wrote. Set against a "terrifying" violet, these "*tupapaú* flowers, phosphorescent emanations, were signs of the spirits of the dead.

▲ **Woman with a Flower** *In Noa, Noa,* Gauguin's account of his life in Tahiti, he writes that this was the first Tahitian woman to pose for him. Painted soon after his arrival in 1891, the magnificent portrait shows the young woman wearing a high-collared Western dress, reflecting the modest style of clothing introduced by European missionaries. The flower she holds links her with the decorative background. 1891, oil on canvas, 27½ x 18¼in, Ny Carlsberg Glyptotek, Copenhagen, Denmark

▲ **The Spirit of the Dead Watches** *Gauguin's fascination with Tahitian beliefs and traditions is reflected in his paintings. This extraordinary image was inspired by returning home one night to find his 13-year-old vahine (mistress) Teha'amana lying naked on the bed, terrified because the lamp had gone out. She was convinced that without the light, she was prey to the tupapaús—the spirits of the dead. Blending the real and the imaginary, Gauguin paints the tupapaú as Teha'amana might have imagined it, "like an ordinary little woman" at the foot of the bed. 1892, oil on canvas, 28¾ x 36¼in, Albright-Knox Gallery, Buffalo, New York, US*

◀ **Horsemen on the Beach** *Gauguin painted this harmonious scene on the island of Hiva Oa, in the Marquesas, the year before his death. There are echoes of the realism of Degas's racetrack pictures, but the unrealistic pink of the sand lends the picture its mood of mystery. 1902, oil on canvas, Museum Folkwang, Essen, Germany*

Vincent **van Gogh**

Self-portrait, 1887

b **ZUNDERT, BRABANT, 1853;** d **AUVERS-SUR-OISE, 1890**

The son of a Dutch pastor, van Gogh worked for an art dealer, as a teacher, and as an evangelical preacher before devoting himself to art with the same zealous intensity that he had brought to his preaching. In a brief career lasting only about a decade, he created some 1,000 paintings. He evolved a strikingly original style, in which bold colors and forceful brushstrokes express intense emotions. One of the key figures of Postimpressionism, he had a huge influence on modern art.

Vincent's arrival in Paris in 1886 triggered a turning point in his painting. Under the influence of Impressionism and Japanese prints, his dark pictures of peasants were replaced by the colorful paintings for which he is remembered. Van Gogh suffered severely from mental instability, and committed suicide at the age of 37.

LIFEline

1869 Starts work at Goupil & Co., art dealers. Begins writing to brother Theo
1876 Teaches and preaches in England
1878–80 Evangelist in Belgium. Begins drawing
1880 Resolves to be an artist
1885 Paints his most famous early work, *The Potato Eaters*
1886 Moves to Paris
1888 In Arles; joined by Gauguin. Mutilates ear
1889 Enters St. Rémy asylum
1890 Shoots himself dead

◀ **Head of a Peasant Woman** *This somber portrait of a Dutch peasant is one of a number of studies for Vincent's most famous early painting,* The Potato Eaters. *1885, oil on canvas on millboard, 18¼ x 13¾in, National Galleries of Scotland, Edinburgh, UK*

> " Well, my own work, I am **risking my life** for it and half my reason has gone "
>
> VINCENT VAN GOGH, IN HIS LAST LETTER TO HIS BROTHER THEO, 1890

▶ **The Bedroom at Arles** *This painting shows van Gogh's bedroom at the Yellow House, which he rented in Arles. It was one of his favorite compositions and he hoped it expressed "absolute restfulness." He painted three versions of it: the first was made in 1888 as he awaited Gauguin's arrival, while this is one of two copies made in St. Rémy asylum. 1889, oil on canvas, 28¾ x 35¾in, Art Institute of Chicago, USA*

CLOSERlook

COLOR AND CONTOUR
The influence of Japanese prints can be seen in the way van Gogh encloses areas of flat color within bold outlines, as in this detail of the table leg.

UNSETTLING PERSPECTIVE Despite van Gogh's aim for a restful effect, the painting looks distorted because of its exaggerated perspective: the converging lines of walls and floorboards seem to rush back into the painting's depth.

◄ **Père Tanguy** *The sitter ran an art supplies shop in Paris. He admired and promoted van Gogh's work. He sits in front of an array of Japanese prints, which Vincent collected and which greatly influenced his painting. 1887–88, oil on canvas, 36¾ x 29¼in, Musée Rodin, Paris, France*

◄ **Sunflowers** *During the summer of 1888, while he eagerly awaited Gauguin's arrival in Arles, van Gogh painted five canvases of sunflowers as decorations for the Yellow House. The paintings are created almost entirely of yellow, a color that signified happiness for him and embodied the sunshine and heat of Provence. 1888, oil on canvas, 36¼ x 28¾in, National Gallery, London, UK*

CLOSERlook

BLUE SIGNATURE Background and table are in flat color, making an interlocking pattern with the two-tone jar. Contrasting with the yellows, a blue line and signature appear as naïve pottery decoration.

▲ **The Church at Auvers** *After leaving St. Rémy asylum, van Gogh moved to Auvers, a village north of Paris, in May 1890. He worked furiously, averaging one painting a day, before shooting himself two months later. This painting, with its intense colors and twisted shapes, was one of his final works. 1890, oil on canvas, 37 x 29¼in, Musée d'Orsay, Paris, France*

◄ **Self-Portrait with Bandaged Ear** *Painted just two weeks after he had mutilated his ear, this dignified self-portrait shows the artist resolved to get back to work, wrapped up against the cold, flanked by his easel and a Japanese print. 1889, oil on canvas, 23¾ x 19¼in, Courtauld Gallery, London, UK*

The Starry Night *Vincent van Gogh,*
1889, oil on canvas, 29 x 36¼in,
Museum of Modern Art, New York ▶

The Starry Night Vincent van Gogh

Stars explode like fireworks in a night sky that pulsates with wave-like energy, while the twisted silhouette of a cypress tree flames upward from the landscape below. A mixture of observation, memory, and imagination, *The Starry Night* expresses van Gogh's intense response to nature. The painting contains elements of the actual French Provencal landscape, but the village scene is an invention, with the church spire inspired by memories of van Gogh's native Holland. It is one of several "starry night" pictures that van Gogh painted.

Composition

Despite the asymmetry of the composition, and the busy arrangement of stars dotted over the surface, the painting has an ordered simplicity, which holds the frenetic energy in check and intensifies its impact. The layers of space—foreground, mid-ground, and sky—which exist in depth in nature, appear vertically on the canvas as three areas. The dark cypress tree that springs up from the bottom left is counterbalanced by the brilliantly luminous yellow moon in the top right.

▲ **TIED TOGETHER** The flame-like cypress stretches from the bottom almost to the top of the canvas—creating a visual link that ties the three layers of space together.

▲ **ROLLING ENERGY** Contrasting with the powerful vertical movement of the cypress on the left, clouds roll and swirl horizontally across the canvas—like waves, moving from left to right.

INcontext

ST. RÉMY ASYLUM While a patient at the St. Rémy Asylum, van Gogh often went into the countryside to paint. This sunny landscape is a similar composition (but reversed) to *The Starry Night*. Once again, it is dominated by the distinctive shape of the cypress.

A Cornfield with Cypresses,
Vincent van Gogh, (1889).

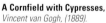

❝ Just as we **take the train** to get to Tarascon or Rouen, we **take death** to **reach a star** ❞

VINCENT VAN GOGH, 9 JULY 1888

▶ **DARK OUTLINES** The village buildings have the bold outlines characteristic of many of van Gogh's paintings, reflecting the influence of Japanese art and, perhaps, old woodcuts. Small squares and rectangles of yellow, indicating lighted windows, create accents of color in the dark landscape and echo the yellow stars above.

Technique

Characteristically for a picture made near the end of van Gogh's life, this canvas is painted with vigorous, impasted (thickly layered), dash-like brush strokes. Applying paint with a heavily loaded brush, van Gogh creates stylized swirls and concentric circles that have a powerful, overall effect. Color is as forceful as the brushwork, with bold contrasts of blue and yellow predominating. Van Gogh's expressive technique gives the whole canvas a frenzied animation, which seems to reflect the artist's state of mind.

▶ **DIFFERENT STROKES** Van Gogh uses distinctly different techniques for the dark cypress and the nearby white star. The cypress is painted in long strokes of fluid paint, while the star has a textured halo created by concentric dashes of thick, drier paint.

▶ **SURFACE PATTERN** Using a limited range of colors—blues, blue-greens, white, and yellow—van Gogh paints the sky in a stylized pattern. Individual dash-like brushstrokes are repeated to form wave-like swirls and circles that give the painting its energy, expressive impact, and pictorial unity.

Origins and influences

The Nabis were a group of rebellious young artists who were inspired by ideas developed in the Pont-Aven artist's "colony" in Brittany. Here, Paul Gauguin and the 20-year-old Emile Bernard developed an alternative vision of art, based on imagination rather than real life, which aimed to capture an object's "essence" rather than its appearance. Inspired by stained glass windows, their new style, known as Cloissonism, was characterized by the use of simplified forms and flat areas of vivid color enclosed in strong lines.

In 1888, a landscape painted by Paul Sérusier, under Gauguin's guidance, encapsulated a new sense of artistic freedom. On his return to Paris, it had a catalytic effect on his student friends, who nicknamed it "the Talisman." They coalesced into a group, called *Les Nabis*, from the Hebrew word for "Prophets." Its

▲ **The Talisman (Bois d'Amour)** *by Paul Sérusier (1888). Sérusier painted this abstract autumnal landscape on the lid of a cigar box, using exaggerated colors for greater effect.*

members, who included Paul Ranson, Maurice Denis, Pierre Bonnard, and Edouard Vuillard, promoted an all-inclusive vision of art that encompassed design and the graphic

arts as well as painting. The Nabis held their first exhibition in 1889, and went on to enjoy considerable success during the 1890s.

Subjects and techniques

While many of the Nabis shared a mystical Christian fervor, the two most distinguished members of the group—Bonnard and Vuillard—ignored pious themes. They focused instead on treating contemporary, everyday scenes in the new style—an approach described as *Intimisme*.

The Nabis emphasized the decorative element at the expense of artistic illusion. Many worked on large-scale decorative panels and in the graphic arts. Some, such as Vuillard and Bonnard, tried to meet a demand for an all-embracing synthesis of art forms by designing stage sets for small avant-garde theaters, as well as posters and tapestries. In 1903 the movement broke up with the closure of the magazine, *La Revue Blanche*, their main source of support.

In the late 1880s, a group of artists, known as the Nabis, sought to revitalize painting. United by their contempt for Naturalism, they developed a simplified, subjective vision, inspired by Symbolism (see p.382) and Paul Gauguin. In this way they blurred the lines between fine and decorative arts.

The Nabis

Pierre **Bonnard**

Self-portrait

b **FONTENAY-AUX-ROSES, 1867**; d **LE CANNET, 1947**

Bonnard studied law before turning to a career in art. A gifted printmaker and designer, his first success came with his influential France Champagne poster. Bonnard's masterful use of color came from his experience of lithography and the strong influence of Japanese prints. His palette became much richer after 1900, following the break-up of The Nabis.

After moving to the south of France in the 1920s, Bonnard's subjects became limited to sun-lit landscapes or bright interiors, often featuring his life-long model, his wife Marthe, bathing, dressing, or sleeping. In these paintings, everything is subordinated to the subtle rendering of light and color effects, leading to him being described as "the last of the Impressionists."

LIFEline

1867 Born into a wealthy French family

1886–89 Studies law in Paris before turning to art

1890 Shares a studio with Denis and Vuillard. Co-founds the Nabis

1893 First lithographs appear in *La Revue Blanche*

1896 First solo exhibition

1925 Moves to Le Cannet in the South of France

1947 Dies in Le Cannet

▲ **Intimacy** *The Nabis aimed to capture feeling through the use of line, pattern, and color. In this asymmetrical composition, the smoke from the pipes appears to blend into the wallpaper. 1891, oil on canvas, 14¾ x 14¼in, Musée d'Orsay, Paris, France*

▲ **Nude in the Bath** *Bonnard painted what he remembered as much as what he saw. In his world his wife Marthe never aged—she was 60 at the time of this painting. Here, he imagines her as a youthful nymph, bathing in a room full of the vibrant light and color of southern France, and framed against a rainbow of glass tiles. 1936, oil on canvas, 36¾ x 58in, Musée d'Art Moderne de la Ville de Paris, France*

CLOSERlook

USE OF COLOR Bonnard usually worked from a palette of eight vivid colors, which he applied very thinly. The water here acts as liquid light, smoothing Marthe's submerged body, which appears to shimmer slightly.

Edouard **Vuillard**

Self-portrait

b CUISEAUX, 1868; d LA BAULE, 1940

Edouard Vuillard is best known for his early intimate domestic interiors, which often featured his family and friends, but he also experimented with other media, including lithography, stage sets, and decorative panels.

Vuillard met his fellow Nabis while he was a student at the Académie Julian. He is often linked with Pierre Bonnard, with whom he shared a studio and style of painting known as Intimism. Another long-term friendship, with the editor of *La Revue Blanche*, Thadée Natanson, led to numerous commissions from his wife Misia and their wealthy friends.

Vuillard's pictures blended the flat colors and emphatic contours of Gauguin with the shimmering Divisionism and careful surface structure of Seurat. These mini-dramas, recreated from his memory and staged against a backdrop of richly furnished interiors, used pattern, texture, and color to create a strong atmosphere. Vuillard's later, more conservative paintings never recaptured the achievements of his 1890s work.

LIFEline

1868 Born into a prosperous middle-class family.

1888–89 Studies at the Académie Julian; meets the future Nabis

1889 Exhibits at the Salon for the first and last time

1890 Co-founder of the Nabis; shares a studio with Bonnard and Denis

1891 First solo show

1900 Interest in photography and Impressionism leads to change in style

1940 Dies while fleeing from German troops

▼ **Pot of Flowers** *After 1900, Vuillard's interest in photography and the Impressionists led to a more realistic style, using light to create space and volume. 1904, oil on cardboard, Scottish National Gallery of Modern Art, Edinburgh, UK*

▼ **Seated woman with a cup of coffee** *Many of Vuillard's Intimist paintings possess dramatic tension within their domestic setting. This portrait of a woman sitting alone is infused with a feeling of melancholy. 1893, distemper on card, 14¼ x 11¼in, Fitzwilliam Museum, Cambridge, UK*

CLOSERlook

FOCUS ON PATTERN
Vuillard often focused on patterns and textures, such as those found here in the wallpaper, using them to "frame" a picture's mood. The dark wall hanging appears to engulf the woman; only her pale face and hands stand out.

Maurice **Denis**

b GRANVILLE, 1870; d PARIS, 1943

▲ **The Fight Between Jacob and the Angel**
This painting shows Jacob struggling with a divine messenger to gain God's blessing. 1893, oil on canvas, private collection

A leading Nabi theorist, Maurice Denis led the reaction against Impressionism and later attempted to revive the genre of religious painting.

Aged 20, he published a highly influential article, from which these lines would become a central creed of Modernism: "… before a painting is a warhorse, a naked woman, or an anecdote, it is essentially a flat surface covered with colors arranged in a particular way." Denis' own art was highly decorative, with flowing lines and patches of color.

Aristide **Maillol**

b BANYULS-SUR-MER, 1861; d PERPIGNAN, 1944

Maillol, the son of a ship's captain, decided at an early age to become a painter. In 1881, he moved from his home in southwestern France to Paris, where he met the Nabis. Encouragement from Paul Gauguin led Maillol to open a tapestry workshop in Banyuls in 1893. The high-quality work produced there gained him considerable recognition for renewing this art form in France.

By 1900, Maillol had abandoned tapestry to concentrate on sculpture, and the latter part of his life was devoted to sculpting female nudes. His revival of classical ideals set a standard for monumental figure sculpture that lasted into the 1940s, and inspired the work of Henry Moore (see p.488).

▲ **Profile of a Young Woman** *From 1890 onward, Maillol's links with the Nabis produced many paintings that emphasized a more decorative aspect through the harmonious balance of line and color. 1890, oil on canvas, 28¾ x 39¼in, Musée Hyacinthe Rigaud, Perpignan, France*

INcontext

LA REVUE BLANCHE (1889–1903) This magazine for avant-garde literature and art was closely associated with the Nabis after 1891, when Thadée Natanson became its editor. Natanson and his beautiful Franco-Polish wife, Misia, formed the heart of an active circle of artists and writers whom they promoted through their journal, exhibitions, and commissions from their wealthy friends.

Poster for La Revue Blanche *by Pierre Bonnard (1894). The Nabis valued the graphic arts as much as painting and devoted much of their time to illustration, posters, and theater sets.*

Symbolism and Art Nouveau were international art movements that flourished in the final decades of the 19th century. Symbolism sought to restore the role of imagination and ideas in the arts, while Art Nouveau fulfilled a more decorative function.

Origins and influences

Symbolism emerged as a reaction against the naturalist movements—Realism (see p.324) and Impressionism (see p.340)—which had dominated the progressive art scene after the 1850s. By concentrating only on what the artist saw, naturalists had largely ignored the imagination, intellect, and emotions. Symbolists aimed to rectify this by producing pictures that evoked certain moods and feelings.

Although Art Nouveau shared with Symbolism the element of fantasy, it was primarily preoccupied with decorative effect. It can be seen as a response to William Morris's Arts and Crafts movement, but was also influenced by other styles such as

▲ **Oiwa** Katsushika Hokusai, 1830. *The sinuous, curved lines of Art Nouveau were strongly influenced by Japanese prints such as Oiwa, from a famous Yotsuya Kaidan tale. Poisoned by her husband, she returns to haunt him in the guise of a lantern-headed ghost.*

Japanese prints and the revival of interest in ancient Celtic patterns. It was the first style to be promoted by mass communications.

Style and subjects

Symbolists aspired to communicate through line, color, and form, like music or poetry. They did not use readily defined symbols, but opted instead for images that were richly evocative. Symbolism was both a literary and artistic trend, with a Manifesto written by the poet, Jean Moréas, in 1886.

Art Nouveau was a concerted attempt to create an international, modern style based on decoration. It is characterized by highly stylized, flowing lines, and organic, plant-inspired motifs.

Symbolism and Art Nouveau

TIMEline

Symbolist trends evolved gradually. Gustave Moreau's lyrical variation of the Orpheus myth predates the formation of the Impressionists, while a Romantic influence can be seen in the work of Arnold Böcklin and Pierre Puvis de Chavannes. Certainly, Symbolism was in full swing by 1886, when Jean Moréas produced the movement's Manifesto, and the first hints of Art Nouveau emerged a few years later, in around 1890.

1865

MOREAU Orpheus

1880

BÖCKLIN The Isle of the Dead

1881

PUVIS DE CHAVANNES The Poor Fisherman

1886

WATTS Hope

1890

REDON The Closed Eyes

▲ **The Shell** Odilon Redon *Redon's most overtly Symbolist work was produced in monochrome, but in the 1890s he began using pastels, revealing his skill as a dazzling colorist. 1912, pastel on paper, 20½ x 22¾in, Musée d'Orsay, Paris, France*

Movements

The closing decades of the 19th century, and the period leading up to World War I, were a time of unprecedented prosperity and modernity, often described as the "New Industrial Revolution." From them sprung two new art movements.

Symbolism

The Symbolist movement developed in France, but found followers in most of Europe. Its roots were in the Aesthetic movement, which placed more importance on evoking a mood with subtle color harmonies than telling a story. The tag of the Aesthetic movement was "art for art's sake." The work of James Whistler was typical, demanding a response to its formal beauty rather than its subject matter.

Symbolism reached its peak during the 1880s, when certain types of imagery became internationally common. These included the pale, sexually ambiguous figures popularized by Gustave Moreau and Sir Edward Burne-Jones, menacing femmes fatales who ensnared their victims with their impossibly long tresses, and the severed head.

Art Nouveau

Art Nouveau took its name from a shop in Paris, but was known differently in other parts of Europe. In Italy, it was the *Stile*

▲ **Salome with her Mother, Herodias** Aubrey Beardsley *One of 16 illustrations Beardsley produced for Oscar Wilde's play, Salome, its sinuous lines are typically Art Nouveau. 1894, lithograph, private collection*

Liberty—after the London department store—while in Germany it was called *Jugendstil*, after a fashionable journal, *Die Jugend*. Given its emphasis on decoration, it is not surprising that Art Nouveau made its strongest impact on the applied arts. Its finest creations include the glassware of Louis Comfort Tiffany and René Lalique, Hector Guimard's ironwork entrances to the Paris Metro, Mucha's posters, and the designs of Charles Rennie Mackintosh.

CURRENTevents

1875 Morris & Co. is established in Britain, promoting the Arts and Crafts movement

1895 Art dealer Siegfried Bing opens his new Parisian store called *Art Nouveau*

1895 First staging in London of the play *The Importance of Being Earnest*, written by the leading literary figure and wit of the Aesthetic movement Oscar Wilde

Gustave **Moreau**

Self-portrait

b **PARIS, 1826**; d **PARIS, 1898**

Moreau was one of the founding fathers of Symbolism. He was influenced by the coloristic approach of Théodore Chassériau and Eugène Delacroix, as well as the Renaissance masters Mantegna and Leonardo. He made his mark in the 1860s with a series of lyrical fantasies loosely based on Greek mythology. It was his paintings of Salome, shown at the Salon in 1876, that had the greatest impact. They featured in Huysmans's novel *A Rebours* (Against Nature)—a key Symbolist text—and inspired a new generation of artists. He became a professor at the École des Beaux-Arts in 1892.

▼ **The Apparition** *Salome is confronted by a vision of John the Baptist, the man whose head she asked for. Her exotic robes, the crouching panther, and the dark, pagan temple create an air of suffocating decadence.* c1876, oil on canvas, 61 x 39¼in, Fogg Art Museum, Cambridge, US

▶ **Orpheus** *This melancholy vision was a hit at the Salon in 1866. Orpheus was an exquisite musician who was torn limb from limb after he shunned the advances of Thracian maidens following the death of his wife, Eurydice. Here, a maiden carries his head away on his lyre.* 1865, oil on canvas, 22 x 18½in, Musée d'Orsay, Paris, France

Pierre **Puvis de Chavannes**

Self-portrait

b **LYONS, 1824**; d **PARIS, 1898**

The son of an engineer, Puvis trained under French painter Henri Scheffer and also studied briefly with Delacroix and Couture. He made his mark painting murals or, more precisely, large canvases affixed to walls. The finest of these is the cycle of paintings about St. Genevieve in the Pantheon, Paris. Puvis's easel paintings often received a hostile reception at the Salon, but for the younger generation of artists, who were in tune with recent developments, they were highly influential. *The Poor Fisherman*, for example, was greatly admired by Gauguin, Seurat, and Picasso.

▼ **The Poor Fisherman** *The bleak, colorless terrain echoes the quiet desperation of a widower as he struggles to support his two children.* 1881, oil on canvas, 61 x 76in, Musée d'Orsay, Paris, France

▲ **The Beheading of St. John the Baptist** *Unlike other Symbolist painters, Puvis focused on John's martyrdom rather than on Salome. She waits in the wings, holding the platter for his head.* 1869, oil on canvas, 49 x 65in, Barber Institute of Fine Arts, Birmingham, UK

CLOSERlook

NO FEMME FATALE By Symbolist standards, this pensive Salome seems very demure. The model is said to be Princess Marie Cantacuzène, who became Puvis's wife in 1897.

Odilon **Redon**

Portrait by Guy Mockel

b **BORDEAUX, 1840**; d **PARIS, 1916**

Although Redon was briefly a student of Jean-Léon Gérôme, his chief influences were the botanist Armand Clavaud and the engraver Rodolphe Bresdin. The former interested him in microscopy, which inspired many of the germ-like creatures in his works. With the latter's guidance, Redon became a master of lithography and charcoal—his favorite media until the 1890s. His images are simple but mysterious. "I place a little door there," he wrote, "opening onto the unknown."

▼ **The Spider** *Redon's images can be humorous as well as disconcerting. The spider has human teeth and nostrils, but a charming smile.* 1887, lithograph, 11¾ x 8¾in, Haags Gemeentemuseum, The Hague, Netherlands

▲ **Closed Eyes** *A giant head towers enigmatically over a moonlit shore. The eyes may be closed in meditation, sleep, or death. The painting is believed to have been inspired by Michelangelo's* Dying Slave *in the Louvre, but the model is Redon's wife.* 1890, oil on canvas, 17¼ x 14¼in, Musée d'Orsay, Paris, France

Alphonse **Mucha**

Alphonse
Mucha, c1925

b **IVANCICE, MORAVIA, 1860;** d **PRAGUE, 1939**

One of the creators of the Art Nouveau style, Alphonse Mucha worked initially as a decorative painter in the theater, before completing his artistic education in Munich and Paris. After settling in Paris, he was employed as an illustrator, until he produced his first poster for the actress Sarah Bernhardt in 1894. This proved such a hit that he was flooded with other poster commissions. Mucha swiftly developed a winning formula for these. He adapted Symbolist subjects, removing their mysterious and sinister qualities, and introducing in their place a mood of flirtatious gaiety. Instead of *femmes fatales*, he portrayed cheerful chorus girls with cascading hair and floating draperies.

Although he is best known today for his posters, Mucha also produced designs for jewelry, calendars, and stained-glass windows. He was a fervent patriot, too, designing new banknotes and postage stamps after Czechoslovakia gained its independence, as well as a huge series of pictures on Slavic history.

LIFEline

1860 Born in Moravia, then part of the Austrian Empire

1887 Moves to Paris, to study at the Académie Julian

1894 His first poster for Sarah Bernhardt is a huge success

1903 First trip to the US

1906 Marries Marie Chytilová in Prague

1918 Czechoslovakia gains independence

1928 Completes *Slav Epic*, a monumental series of pictures of Slavic history

1939 Is arrested by the Gestapo. Dies from a lung infection later that year

▶ **The Arts: Dance** *In the 1890s, when posters were still a novelty, there was a craze for collecting themed sets. Mucha produced several series, including the arts, the seasons, and wild flowers.* 1898, color lithograph, 23¾ x 14¾in, Mucha Trust, Prague, Czech Republic

CLOSERlook

LONG HAIR A feature of *fin-de-siècle* art, long hair was associated by the Symbolists with the *femme fatale*, ensnaring her victims. But in Art Nouveau it became a decorative accessory, aiding the rhythm and flow of the composition.

▼ **Sarah Bernhardt as Medea**
As well as posters for her performances, Mucha designed costumes and jewelry for this celebrated actress. 1898, color lithograph, 81½ x 30¼in, Mucha Trust, Prague, Czech Republic

384

Arnold **Böcklin**

Self-portrait

b **BASLE, 1827;** d **SAN DOMENICO, 1901**

Born in Switzerland, Arnold Böcklin trained with Friedrich Wilhelm Schirmer in Düsseldorf and concentrated initially on landscape painting. In 1850, his first visit to Italy proved a revelation, awakening a love of Renaissance art. Böcklin soon returned for a longer stay, from 1852 to 1857, and made significant alterations to his artistic style. Increasingly, he turned to mythological subjects, avoiding specific legends and focusing instead on imaginary scenes of nymphs, satyrs, centaurs, and mermaids.

As he became aware of Symbolist developments, Böcklin's art assumed a darker tone. His masterpiece in this vein was *The Island of the Dead*. The original was commissioned by a woman whose husband had just died, but the funereal theme haunted the artist and he produced no fewer than five versions of it (1880–86). One of these was later owned by Adolf Hitler, and the image was also adapted for the set of one of Boris Karloff's horror films.

LIFEline

1827 Born in Basle

1845–47 Trains at the Academy in Düsseldorf

1850 Makes the first of many visits to Italy

1860 Takes up a teaching post in Weimar

1880 Paints first version of *The Island of the Dead*

1894 Buys the Villa Belaggio in San Domenico, Italy, where he dies in 1901

▲ **The Island of the Dead**
Böcklin called this haunting painting "a picture for dreaming over." 1886, oil on panel, 31½ x 60½in, Museum der Bildenden Künste, Leipzig, Germany

◀ **Calm Sea** *Böcklin's mermaid pictures were often quaint or sentimental, but this one has an air of menace. She is a* femme fatale, *casting her spell on hapless mariners.* 1886–87, oil on panel, 40½ x 59in, Kunstmuseum, Berne, Switzerland

CLOSERlook

TRANSPORTING THE DEAD The eerie, hooded figure standing in the boat carries echoes of Charon—the ferryman of the dead in Greek mythology. The title of the painting was provided by a Berlin art dealer in 1883.

Ferdinand **Hodler**

Self-portrait

b **BERNE, 1853;** d **GENEVA, 1918**

Ferdinand Hodler was born in Berne, the son of a carpenter, but he spent most of his career in Geneva. He trained there under Swiss painter Barthélemy Menn and initially concentrated on landscapes. However, his style altered dramatically following a trip to Paris when he came into contact with Symbolist ideas. Hodler's best-known work in this style was *Night* (1890), which created a stir at the Salon and won him a gold medal in Munich. Many of his pictures had a quasi-religious feel, which led him to exhibit at the Rose-Croix Salon. Hodler also joined the Vienna Sezession, an avant-garde group, which broke away from the Academy and organized its own exhibitions. In 1904, he was honored with a show devoted to his work at their international exhibition.

▼ **Night** *There is an indefinable air of menace in Hodler's most famous painting. Does the alarming shrouded figure represent death?* 1890, oil on canvas, 45¾ x 118in, Kunstmuseum, Berne, Switzerland

▲ **The Dream** *This picture is full of ominous ambiguities. The naked dreamer is based on an earlier picture, entitled* The Dead Youth. *The girl holds a rose, a traditional emblem of love, but she is surrounded by poppies, which symbolize dreams or death.* 1897–1903, watercolor, chalk, and oil on board, 38¾ x 27½in, Kunsthaus, Zurich, Switzerland

James **Ensor**

Self-portrait

b **OSTEND, 1860;** d **OSTEND, 1949**

A seminal influence on the Expressionists (see p.408) and the Surrealists (see p.470), James Ensor was born in the seaside town of Ostend in Belgium and spent most of his career there. Initially, his best pictures were somber interiors, tinged with Impressionist influences. But by the mid-1880s, his palette had lightened, and there was a strong element of fantasy in his work. Much of this was inspired by the outlandish, carnival-related items that his parents sold in their souvenir shop. Ensor's threatening images of animated masks and skeletons proved too much for conventional exhibitions, but fortunately he gained a more positive response from Les Vingt (The Twenty), an independent exhibiting body.

(see p.408) ... (see p.470)

LIFEline

1860 Born in Ostend, into an Anglo-Belgian family
1877–80 Studies at the Academy in Brussels
1882 Work is rejected by the Antwerp Salon
1883 Becomes a founder member of Les Vingt
1888 Paints *Christ's Entry into Brussels*; starts affair with Augusta Boogaerts
1929 Inaugural exhibition at the Palais des Beaux-Arts is devoted to his work
1949 Dies in Ostend

◀ **Skeletons Fighting Over a Herring** *Ensor loved puns. Here, two critics (the skeletons) tussle over Ensor's art (Art Ensor), which sounds like the Belgian name for smoked herring (hareng saur).* 1891, oil on panel, 6¼ x 8¼in, private collection

▼ **Christ's Entry into Brussels** *In Ensor's largest and most controversial painting,* Palm Sunday *is transformed into a grotesque parade.* 1888, oil on canvas, 102 x 170in, J. Paul Getty Museum, Los Angeles, US

▶ **Self Portrait with Masks** *Ensor drew inspiration from the carnival masks and costumes in his parents' shop, bringing them to life and often using them in* sinister *tableaux vivants (living pictures). Here, they are depicted more conventionally.* 1936, oil on panel, 11¾ x 10¾in, private collection

CLOSERlook

SYMBOLISM Ensor liked to place his own experiences at the center of his art. Here, Christ is shown with the painter's features, taking part in a political demonstration.

Max **Klinger**

b LEIPZIG, 1857; d GROSSJENA, 1920

Max Klinger was a German painter, printmaker, and sculptor who trained in Karlsruhe under Karl von Gussow, an artist and teacher described by one critic as "Germany's most daring painter," and with Belgian painter Emile Wauters in Brussels. He followed his studies with stays in Paris (1883–86), Berlin (1886–88), and Rome (1888–93), before returning to his hometown of Leipzig. Klinger's paintings were closest in spirit to Arnold Böcklin, whom he met in 1887. In his mythological pictures, Klinger achieved an unusual blend of classicism and dream-like fantasy, seen to best effect in an enormous version of *The Judgement of Paris* (1885–87). This caused a considerable stir when it was exhibited in Vienna in 1887. His creative peak however came as a printmaker. In this field, his most celebrated work was a series of etchings entitled *Paraphrases on the Finding of a Glove* (1878–80, first published in 1881). In a sequence of hallucinatory images, the glove became a fetish object, symbolizing a young man's lost love. This potent cocktail of sexual and irrational imagery proved a major influence on the Surrealists.

▼ **Abduction** *This startling image comes from* Paraphrases on the Finding of a Glove, *Klinger's best-known series of prints.* 1878, India ink wash and pen on paper, 35¼ x 8¾in, on loan to the Kunsthalle, Hamburg, Germany

Fernand **Khnopff**

b GREMBERGEN, NEAR ANTWERP, 1858; d BRUSSELS, 1921

Khnopff was a founder member of *Les Vingt*, the main forum for Symbolist art in Belgium. He trained at the Academy in Brussels, but his style was shaped by Moreau and Burne-Jones, whose work he saw at the Paris Exposition Universelle of 1878. Khnopff later became friendly with the Englishman, exchanging a number of drawings with him, and his pictures feature a similar array of pale, otherworldly women. A fellow artist quipped that he "had sunk himself into Burne-Jones's boots up to his neck." Khnopff was a fine oil painter, but his most atmospheric scenes were often produced in pastels, charcoal, or chalk.

◀ **Who Shall Deliver Me?**
Khnopff took both the title and the theme of this picture from a poem by Christina Rossetti. An enigmatic woman, with flaming hair and a haunted expression, is confined in a prison of her own making. Characteristically, the artist has conjured up a mood of dreamlike mystery and underlying menace. 1891, colored chalks on paper, 8¾ x 5¼in, private collection

Edward **Burne-Jones**

Portrait by GF Watts

b BIRMINGHAM, 1833; d LONDON, 1898

Edward Burne-Jones was an influential British painter and designer whose work provides a link between the Symbolists, the Pre-Raphaelites (see p.332), and the Aesthetic Movement (see p.382).

While studying at Oxford University in 1853 he met William Morris, who became his lifelong friend and associate. They both admired the Pre-Raphaelites and joined Dante Gabriel Rossetti in producing a series of Arthurian murals at the Oxford Union Society debating hall.

Burne-Jones and Morris retained their interest in romantic, medieval subjects when they founded their decorating firm in 1861, and their pioneering enterprise helped inspire the Arts and Crafts movement. In his work for the firm, Burne-Jones provided designs for tapestries, stained glass, and book illustrations. He continued painting, conjuring up a lyrical dream-world where pale, androgynous figures mingled with Arthurian knights and classical gods.

LIFEline

1833 Born to a frame-maker
1857 Works with Rossetti on the Oxford Union murals
1861 Sets up firm with Morris
1877 Exhibits to great acclaim at Grosvenor Gallery, London
1889 His international reputation grows after the Exposition Universelle in Paris

▼ **Laus Veneris** *The worship of Venus is a classical myth transformed here into a medieval romance.* 1873–75, oil and gold paint on canvas, 48 x 72in, Laing Art Gallery, Newcastle upon Tyne, UK

▲ **The Dream of Sir Lancelot at the Chapel of the Holy Grail** *In the dream, an angel tells Lancelot he will never see the Grail, because of his adultery with Guinevere.* 1896, oil on canvas, 55 x 67in, Southampton City Art Gallery, UK

CLOSERlook

HIDDEN MESSAGE In the court of Venus, the goddess reclines languidly while her ladies sing her praises. The title of the painting, taken from a Swinburne poem written four years earlier, is written in the music book.

▶ **Green Summer** *At first glance, this scene appears idyllic, even if the girls' expressions are rather sad. In an earlier version, however, Death is unseen beside them, waiting to break into their circle.* 1868, oil on canvas, 25¾ x 41¾in, private collection

George Frederic **Watts**

Photograph by Julia Cameron

b **LONDON, 1817**; d **LONDON, 1904**

G. F. Watts was a versatile painter and sculptor, and one of the leading lights of the Symbolist movement in England. His talent was recognized at an early age, but it was only in the 1880s that he attained popular success. This was achieved with a series of ambitious moral tales and visionary landscapes.

Although Watts's work owed much to the Italian Renaissance masters, he reinvented their formulae in order to produce his "poems painted on canvas." These had a huge impact at the 1878 Exposition Universelle in Paris and at the newly opened Grosvenor Gallery in London, which became the main forum for the Aesthetic Movement. Watts was also a fine portraitist.

▶ **Love and Death** *Inspired by the premature demise of a friend, Watts shows pale Death advancing remorselessly toward the "House of Life."* c1874–87, oil on canvas, 98 x 46in, Whitworth Art Gallery, Manchester, UK

LIFE line

1817 Born in London, the son of a piano-maker
1843 Travels to Italy, after winning a competition to decorate the Houses of Parliament
1867 Elected a member of the Royal Academy
1886 Completes most famous painting, *Hope*, when nearly 70 years old

CLOSER look

SYMBOL OF LOVE
A traditional emblem of love, a dove watches helplessly as the wings of its "playmate" are crushed against the door, trying in vain to halt Death's progress.

◀ **Hope** *The blind figure of Hope perches forlornly on a globe but, in spite of her sadness, a single star still shines overhead and one lyre-string remains unbroken* c1885–86, oil on canvas, 59 x 42¾in, private collection

IN context

TRIAL OF OSCAR WILDE In 1895, the novelist, playwright, and wit Oscar Wilde (1854–1900) was convicted of gross indecency. The trial put his homosexual relationship with Lord Alfred Douglas under the spotlight, scandalizing Victorian society. Wilde served two years' hard labor. Traumatized by the experience, he went into self-imposed exile after his release in 1897. He died three years later.

Oscar Wilde
A perceptive art critic, Wilde was closely associated with the Aesthetic Movement and an admirer of Watts's work. He wrote a favorable review of Watts's Love and Death.

Aubrey **Beardsley**

Photograph by Frederick Hollyer

b **BRIGHTON, 1872**; d **MENTON, 1898**

Beardsley attended classes at the Westminster School of Art, but learned more from his contacts with Burne-Jones and Puvis de Chavannes. His use of sinuous, decorative lines links him with the Art Nouveau movement, but his taste for intense, often perverse imagery allies him far more closely with the Symbolists.

Beardsley's decadent style was typified by his illustrations for Oscar Wilde's *Salome*. This play, which featured an eroticized version of the biblical story, was particularly popular with Symbolist artists, because it included two of their favorite themes—the femme fatale and the severed head. Beardsley's other work was in a similar vein, leading the satirical magazine *Punch* to give him the nickname Aubrey Weirdsley.

LIFE line

1879 First diagnosed with tuberculosis, aged 7
1888 Begins work in an insurance office
1892 Receives first major commission to illustrate Thomas Malory's *Morte d'Arthur*
1893 Produces his finest drawings for Wilde's *Salome*
1894 Appointed art editor of periodical *The Yellow Book*
1897 Moves to the Riviera, as his health deteriorates
1898 Dies of tuberculosis, in a hotel in Menton, France, aged 25

▶ **The Climax** *Salome holds up the head of John the Baptist, whose death she has just ordered. From his dripping blood, a lily sprouts up, symbolizing his purity. The scene is taken from Oscar Wilde's* Salome. 1893, line block print, 13¼ x 10¾in, private collection

Alfred **Gilbert**

b **LONDON, 1854**; d **LONDON, 1934**

British sculptor and metalworker Alfred Gilbert is best known for the Eros statue in London's Piccadilly Circus. Gilbert's work displays a blend of Symbolist and Art Nouveau influences.

In a remarkable series of nude self-portraits he masqueraded as various mythological figures. He also created startling interpretations of traditional themes, most notably in his *Virgin*, enmeshed in a rose bush.

◀ **Eros** *Popularly known as Eros, the correct name for this famous statue is* The Angel of Christian Charity. *It was made to commemorate The Earl of Shaftesbury and his charitable acts.* 1893, aluminum, Piccadilly Circus, London, UK

Although the Scandinavian countries had a long and distinguished artistic tradition and their own academies, until the mid-19th century many artists trained in Germany. As the century drew to a close, there was an increasing mood of internationalism, and Nordic artists allied themselves to trends elsewhere. At the same time, the political landscape was changing too, inspiring nationalist movements, especially in Finland and Norway as they moved toward independence after many years under Swedish, Danish, or Russian rule.

In the latter part of the 19th century, Scandinavian artists had shifted from a predominantly Germanic tradition to a French-inspired model, establishing a Nordic style of *plein air* (outdoor) painting in which nature was often linked with states of mind and imagination.

Origins and Influences

The first seeds of a Scandinavian style came from France. Swedish landscape painters discovered the Barbizon school (see p.324), and in the 1880s a group of Swedes including Carl Larsson set up a summer painting colony at Grez-sur-Loing near

▲ **The Cycle of Life** Gustav Vigeland *Like many Scandinavian artists, Gustav Vigeland studied abroad before returning home to develop his individual vision.*

Fontainebleau, France. Other Swedish painters went to Paris to study, as did the Finn Akseli Gallen-Kallela, the Dane Peder Severin Krøyer, and a number of Norwegians, and then they returned to set up schools in their native countries using the *plein air* techniques they had learned in France.

The clear, Nordic light gave their paintings a distinctively Scandinavian feel, which suited the mood of patriotism and nationalism.

French Realism and Impressionism were obvious influences, but later Scandinavians were influenced by more forward-looking movements. Munch, who also worked in Berlin, discovered Post-Impressionism and Symbolism; and in the 20th century Cézanne and the Cubists became important influences.

CURRENTevents
1809–1917 Finland annexed by Russia, after centuries of Swedish rule.

1835–1836 Lönnrot publishes the first version of *Kalevala*, the Finnish epic poem.

1891 Henrik Ibsen writes *Hedda Gabler*, and exiled in Italy and Germany, returns to Norway.

1901 The first Nobel prizes awarded under the will of Alfred Nobel, the inventor of dynamite.

1905 Norway declares independence from Sweden.

Scandinavian art

Akseli **Gallen-Kallela**

b **PORI, 1865**; d **STOCKHOLM, 1931**

Regarded as Finland's most celebrated painter and a driving force behind the creation of a distinctive Finnish style, Gallen-Kallela was an important figure in the Art Nouveau and Symbolist movements. He studied in Paris and traveled widely, but was increasingly inspired by the haunting Finnish landscape, which he used as a vehicle to explore issues of national identity.

By the 1890s, Gallen-Kallela's early Realism had developed into a simplified style that used bold, often garish colors. He is best-known for his depictions of the epic folklore poem *Kalevala*, about Finland's mythic origins, but he was also a versatile graphic artist and designer.

▲ **The Anger of Kullervo, from Kalevala** *This litho-print is an illustration from a 1908 edition of Kalevala. The mythological subject matter suited Gallen-Kallela's forceful style and patriotic nature. Note the strong outlines and somewhat flattened forms.* 1908, color litho, Bibliothèque des Arts Décoratifs, Paris, France

▲ **Lake Keitele, 1905** *In this painting, inspired by the Kalevala epic, Gallen-Kallela eloquently captures the haunting, silvery light on the lake, the sweeping sense of space, and the silent grandeur of the landscape.* 1905, oil on canvas, 20¾ x 25¾in, National Gallery, London, UK

Peder Severin **Krøyer**

b **STAVANGER, 1851**; d **SKAGEN, 1909**

The most important Danish painter of light in the 19th century, Peder Severin Krøyer is probably best known for his Skagen beach scenes, although his work covered a wide range of themes.

Raised in Denmark by foster parents, Krøyer studied at Copenhagen Academy and traveled extensively throughout Europe. In Paris, he was inspired by Impressionist *plein-air* painting, and thereafter he began to produce the complex light effects for which he became famous. From 1882, Krøyer became a leading member of the Skagen Painters, a group of artists based at Skagen on the Jutland coast. His final decade was blighted by syphilis, mental problems, and failing eyesight.

▲ **Summer Evening on the Skagen Southern Beach with Anna Ancher and Marie Krøyer** *Krøyer's best-known and most popular painting celebrates beach life at its relaxing best. It features his wife and a friend, both fellow artists. The luminous summer evening light and the ghostly white of the sand and the women's dresses create a dream-like sheen.* 1893, oil on canvas, 39¼ x 59in, Skagens Museum, Denmark

Richard **Bergh**

b **STOCKHOLM, 1858**; d **SALTSJO-STORANGEN, 1919**

Richard Bergh became one of Sweden's foremost painters. Inspired by the Nordic light, he drew on French *plein-air* (outdoor) painting and Symbolism to form his distinctly Swedish style of Romanticism. He was also a talented portrait painter whose sitters included fellow artist Julia Beck and the poet Gustaf Froding.

Bergh's parents were artists and members of the cultural elite, so he was introduced to art at an early age. While studying at the Stockholm Academy, where his father was a professor, he became interested in contemporary French painting. Bergh was active in political and social issues, and played an important part in Swedish artistic life. He set up a painting school, helping to develop a new generation of painters, and wrote prolifically about art. He was also responsible for modernizing the National Museum of Art in Stockholm where he was director from 1915.

LIFEline

1858 Born in Stockholm to affluent, liberal parents
1878–81 Studies at the Stockholm Academy
c1881–84 Lives in Paris
1885 Founder member of the Artists' Union, a liberal rival to the Stockholm Academy
1887 Paints *Hypnotic Séance*
1905 Paints *Portrait of August Strindberg*
1915 Made director of National Museum of Art, Stockholm

> **Nordic Summer Evening** *Illuminated by the evening sun, this work typifies the Nordic light paintings; the atmosphere is still and melancholic, suffused with sexual tension. 1899–1900, oil on canvas, 67 x 88in, Goteborgs Konstmuseum, Sweden*

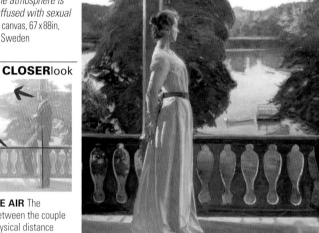

CLOSERlook

SOMETHING IN THE AIR The psychological tension between the couple is emphasized by the physical distance between them, and their outward gaze.

Vilhelm **Hammershoi**

b **COPENHAGEN, 1864**; d **COPENHAGEN, 1916**

Hammershoi, whose muted style has been described as "a weird fusion of Hopper and Vermeer," has enjoyed a resurgence of interest in recent years. He is best known for restrained interiors filled with melancholy and light, but he also painted landscapes, portraits, nudes, and architecture. Hammershoi debuted with *Portrait of a Young Girl* in 1885, and his original style was viewed as controversial. He worked mainly in Copenhagen; his wife, Ida, features in many of his interiors.

▼ **Interior with the Artist's Mother** *The bare, colorless room with a single female figure conjures up a mood of solitude and introspection. Hammershoi's use of light and space was influenced by Whistler. 1889, oil on canvas, 21¾ x 20in, Nationalmuseum, Stockholm, Sweden*

Carl **Larsson**

b **STOCKHOLM, 1853**; d **FALUN, 1919**

The Swedish painter, printmaker, illustrator, and writer Carl Larsson is chiefly remembered for the country house he created with his textile-designer wife, Karin, and the watercolors of his idyllic domestic life, which he shared in his illustrated books. His lasting legacy was the creation of a Swedish interior design style that remains instantly recognizable today.

Born into poverty, Larsson enjoyed little professional success until he met Karin, converted to *plein-air* realism, and started working in watercolor.

▲ **When the Children Have Gone to Bed**
Larsson described his art—like his home—as "modest but harmonious." His watercolors are full of light and cosy domesticity, with influences ranging from Arts and Crafts to Kate Greenaway. c1895, watercolor on paper, 12¾ x 16¾in, Nationalmuseum, Stockholm, Sweden

Anders **Zorn**

b **MORA, 1860**; d **MORA, 1920**

◄ **Dagmar** *Zorn was famous for his voluptuous bathing nudes, which he often painted outdoors in Impressionist style. The play of light on skin and water are both skilfully captured here. 1911, oil on canvas, 34¾ x 24¾in, private collection*

Swedish artist Anders Zorn is regarded as one of Europe's most outstanding genre and portrait painters of the late 19th century. Zorn traveled extensively, spending time in Europe, North Africa, and the US. An illegitimate child from a farming background, Zorn studied at the Stockholm Academy.

His debut watercolor portrait, *In Mourning* (1880), drew acclaim, and Zorn gradually achieved an international reputation. He began working in oils in 1887, and was also an accomplished etcher and sculptor. He considered *Midsummer Dance* (1896), depicting life in Mora, as his best work. His home is now a museum housing his art.

Gustav **Vigeland**

b **MANDAL, 1869**; d **OSLO, 1943**

Vigeland, Norway's most celebrated sculptor, studied briefly under Rodin. He is best known for his allegorical series of monumental figures that he created for Frogner Park in Oslo—a mammoth project that dominated much of his later life.

Vigeland studied art in Oslo and elsewhere in Europe, but his early years were a struggle. Around 1900, his emotional, naturalistic early work evolved into a simpler style that was influenced by medieval sculpture. His portrait busts from 1900 to 1910 established him as the country's leading sculptor.

▲ **Woman with Two Children Riding on her Back**
This sculpture, executed in a simple style with minimal detail, is one of a series in Frogner Park portraying the cycle of life. Granite, Frogner Park, Oslo, Norway

Edvard **Munch**

Self-portrait

b **LOTEN, 1863**; d **OSLO, 1944**

The Norwegian painter and printmaker is regarded as one of modern art's most influential and electrifying protagonists. Munch suffered from depression and mental illness but used them to produce extraordinary, often frenzied, work. His pessimistic view of life was conveyed in bold colors and strong lines, anticipating Expressionism and opening up exciting new avenues for art. He covered existential themes such as life, death, and despair in a self-described attempt to "dissect souls."

Munch began painting in Oslo, but his sojourns in Paris exposed him to Postimpressionist and Symbolist influences, particularly the work of Vincent van Gogh and Paul Gauguin, and he began using swirling brushwork, simplified forms, and non-naturalistic color to convey emotion. Although Munch realized that his genius owed much to his turbulent mind, a breakdown in 1908 inspired a change of style, as he determined to lead a calmer life. His output, however, remained prodigious. Also an acclaimed printmaker, Munch's woodcuts—often executed in color—helped to revive the technique in the 20th century.

LIFEline

1863 Born in Loten, Norway
1885 First visit to Paris at the age of 22
1892–1908 Based mainly in Germany. Produces *The Frieze of Life* series
1893 Paints his most famous work, *The Scream*
1908 Moves back to Norway
1910–16 His Oslo University mural shows extrovert style
1916 Settles at Skoyen, Oslo
1940–42 Paints *Between the Clock and the Bed*
1944 Dies in Oslo

▼ **Jealousy** *This is a powerful visual narrative of Munch's inner turmoil about his lover, Dagny, typically portrayed as the temptress, Eve.* 1894–95, oil on canvas, 27¼ x 39½ in, Rasmus Meyers Samplinger, Bergen, Norway

▶ **The Sick Child** *Munch described this haunting painting as "the breakthrough in my art" and painted six versions of it. Inspired by his sister's death, it conveys the grief and stillness of the sickroom. Munch engraved the layers of paint with a spatula to create the effect of gazing through a film of tears.* 1885–6, oil on canvas, 47¼ x 47 in, Nasjonalgalleriet, Oslo, Norway

▲ **Madonna** *A compelling image of sensual ecstasy and transcendence, Munch's masterpiece straddles 19th- and 20th-century art. Part of his* Frieze of Life *series, it represents the miracle of life. Munch's aim was to portray Woman from a lover's viewpoint, at the moment of conception.* 1894, oil on canvas, 35½ x 28 in, Kunsthalle, Hamburg, Germany

▲ **The Scream** *Munch's most famous work is brilliantly composed to create maximum tension. The shrieking colors and violent juxtaposition of curved and straight lines all flow toward the central, screaming figure, as though the environment itself is expressing emotion through the distorted death-head. The painting may have been inspired by the Krakatoa eruption of 1883, which Munch likened to "a great, infinite scream" passing through nature.* 1893, oil, tempera, and pastel on cardboard, 35¾ x 29 in, National Gallery, Oslo, Norway

CLOSERlook

ADDING DRAMA The swirling brushstrokes of the sky and water are echoed by those of the screaming head, creating a sense of anxiety. Tension is added by the use of perspective in the receding parallel lines of the bridge.

The latter part of the 19th century saw artists in mainland Europe searching for new means of expression that would explode into the revolutionary movements of the early 20th century, but elsewhere, particularly in Britain and the US, French Realism and Impressionism were still exerting a strong influence.

Origins and influences

Artists from all over the world made their way to France to study and work throughout the 19th century, taking the ideas of Realism and Impressionism back to their native countries. Although these styles were no longer at the forefront in European centers of art, they made an impact as they were adopted by comparatively conservative traditions elsewhere, paving the way for Modernism in many countries.

As well as this dissemination of trends from France, several artists decided to remain in Europe. John

◀ **The Lyceum** 1901–02 Ramon Casas *Casas was a leading figure of Modernisme, an art movement centered in his native Barcelona that was essentially a Catalan version of Art Nouveau, but which also blended elements from other turn-of-the century trends.*

Their subsequent reputations often eclipsed by the major figures of the art world in France, a number of painters from other countries enjoyed successful careers outside the progressive artistic centers at the turn of the 20th century.

Singer Sargent, for example, made his name in Paris and London as well as the US, and another American expatriate, James McNeill Whistler, evolved his idiosyncratic style in self-imposed isolation in Britain.

Subjects

In the US, the genre paintings of Thomas Eakins and Winslow Homer's landscapes and seascapes are prime examples of how Realism and Impressionism invigorated the American tradition.

In Europe, however, the influence was more clearly apparent in portrait painting—where realism is practically a necessity—and genre painting, in particular the society painting that was popular with an increasingly affluent and growing middle class.

End of the Century

Winslow **Homer**

b **BOSTON, 1836; d PROUT'S NECK, MAINE, 1910**

One of the leading American painters of his time, Winslow Homer was an artist of great power and originality, whose portrayal of untamed nature reflects his country's pioneering spirit. The sea was his favorite subject, but he was also a landscape and genre painter. He excelled at illustration, watercolor, and oils, and he did much to establish watercolor as an important medium.

Homer was largely self-taught and came to art late, having started out as a commercial printmaker. A visit to France introduced him to Impressionism, although he himself conveyed light and color differently within a solid construction of clear outlines. He worked prolifically from the late 1850s until his death, producing iconic images of 19th-century American life, as well as art that explored the struggle between man and nature. His portrayals of the Maine coast, where he settled, are among his best-known works, recognized for their superb brushwork, emotional intensity, and hint of modernist abstraction.

LIFEline

1836 Born in Boston

1855–57 Apprenticed to a Boston lithographer

1861 Sent to the front as an artist-correspondent for *Harper's Weekly*

1866 Visits France

1873 Begins his first series of watercolors in Gloucester, Massachusetts

1883 Settles in Prout's Neck, Maine

1889 Makes the first of many painting and fishing trips to the Adirondacks

1910 Dies in Prout's Neck, aged 74

CLOSERlook

COLOR TECHNIQUE Homer filled the paper with large areas of wash, then blotted or scraped back areas to create a lively surface.

◀ **Adirondack Guide** *Homer's portrayals of outdoor pursuits in the Adirondack wilderness still influence sporting art today. He was able to isolate action with an almost photographic quality which appealed to popular taste.* 1894, watercolor over graphite pencil on paper, 15 x 21¾in, Museum of Fine Arts, Boston, US

▲ **Driftwood** *Homer excelled at dramatic seascapes. Here, a man in heavy-weather gear struggles in the crashing surf to secure driftwood. Homer's work was characterized by its directness, realism, objectivity, and superb use of color, and this—his final painting—is no exception.* 1909, oil on canvas, 24½ x 28¼in, Museum of Fine Arts, Boston, US

Thomas **Eakins**

Self-portrait

b **PHILADELPHIA, 1844;** d **PHILADELPHIA, 1916**

One of the most outstanding American Realist painters of the 19th century, Thomas Eakins was also a sculptor, a photographer, and an innovative teacher. Often misunderstood and ignored during his lifetime, he is best known for his uncompromising portraits and his scenes of contemporary American life.

While studying at the Pennsylvania Academy, Eakins unusually took classes in anatomy and dissection at Jefferson Medical College, which led to a lasting interest in scientific realism. He began teaching at the Pennsylvania Academy in 1876, and proved an innovative modernizer, later introducing anatomy, dissection, and photography to the curriculum. Eakins' work had great vitality and directness, with a strong sense of form and three-dimensional design. His portraits, in particular, showed acute insight; he refused to flatter, seeking only to reveal the truth as he saw it.

LIFEline

1844 Born in Philadelphia
1862–66 Studies at the Pennsylvania Academy
1866–70 Continues his studies in Europe
1876 Starts teaching at the Pennsylvania Academy. First exhibition at the Centennial Exhibition in Philadelphia
1882 Appointed director of the Pennsylvania Academy
1884–85 Paints *The Swimming Hole*, his finest study of nudes
1889 Paints *The Agnew Clinic*
1916 Dies of heart failure

▼ **Max Schmitt in a Single Scull** *Boating and rowing were among Eakins' favorite themes. Here, he depicts the rowing champion, Max Schmitt, as a contemporary hero. 1871, oil on canvas, 32¾ x 46½in, Metropolitan Museum of Art, New York, US*

▲ **The Gross Clinic** *When this picture was first shown, its gory subject-matter created controversy, but it established Eakins as a major figure in American Realism. It shows the eminent surgeon, Samuel D. Gross, operating in front of students at Jefferson Medical College. 1875, oil on canvas, 96 x 78in, Jefferson College, Philadelphia, US*

James Abbott McNeill **Whistler**

Self-portrait

b **LOWELL, MASSACHUSETTS, 1834;** d **LONDON, 1903**

A stylish American-born painter, designer, printmaker, and wit, Whistler was a central figure in the Aesthetic Movement. He was known for his paintings of nighttime London, his stylistic, full-length portraits, and his superb etchings. His combative nature and dandyish ways also kept him in the public eye. Whistler spent his life as an expatriate, living mainly in London, although he also worked in France. Rejecting the artistic conventions of the time, he maintained that subject matter was secondary to evoking mood and creating harmonies of color and composition. Likening his paintings to visual music, he gave them titles such as "symphonies" or "nocturnes."

Although he was a contemporary of the Impressionists, Whistler developed an individual style that combined French Realism, Japanese decorative influences, and Aestheticism. During his final two decades, Whistler achieved recognition as an artist of international importance. He was also influential in introducing modern ideas into British art.

LIFEline

1834 Born in Lowell
1854–55 Expelled from the West Point Military Academy. Learns etching as a navy cartographer
1855–58 Studies art in Paris. Produces the *French Set* etchings
1859 Moves to London
1874 First solo exhibition at the Flemish Gallery, London
1879–80 Is bankrupted by a libel suit. Travels to Venice
1886 Elected president of the Society of British Artists
1903 Dies at home in London

CLOSERlook

ABSTRACT COLORS
This strongly Impressionistic work is an example of Whistler's philosophy of art for art's sake. The abstract drift of orange and yellow lights reflects Japanese delicacy and helps to convey the ephemeral quality of the fireworks.

▲ **Nocturne in Black and Gold, the Falling Rocket**
Fireworks were considered inappropriate for a painting and this work proved controversial. Savaged by the critic John Ruskin, Whistler sued for libel, but was awarded derisory damages and bankrupted. c1875, oil on panel, 23¾ x 18½in, Detroit Institute of Arts, US

▼ **Red and Black: The Fan** *This painting of Whistler's stylishly-dressed sister-in-law reveals his interest in women's fashions. He skillfully depicts the fan's gauze fabric. 1891–94, oil on canvas, 73¾ x 35¼in, Hunterian Art Gallery, Glasgow, UK*

▲ **Symphony in White, No III** *This painting is a harmonious blend of color, shapes, and composition. Translucent paint layering and delicate brushstrokes add to the mood. 1865–67, oil on canvas, 20 x 30¼in, The Barber Institute of Fine Arts, Birmingham, UK*

Giovanni **Boldini**

b **FERRARA 1842; d PARIS, 1931**

Italian artist Giovanni Boldini was one of the most celebrated society portrait painters of his era. He was best known for his portrayals of beautiful women, but also painted Parisian street scenes. His style was reminiscent of his contemporary, John Singer Sargent. Boldini traveled extensively, although he based himself mainly in Paris. During his lifetime he enjoyed international success, but his frothy style lost its appeal after his death.

◀ **Madame Charles Max** *This expressive painting of a Parisian socialite is typical of Boldini, who was known for his lively brushwork and ability to give his subjects elegance and poise.* 1896, oil on canvas, 39¼ x 80¾in, Musée d'Orsay, Paris, France

Valentin **Serov**

Self-portrait

b **ST. PETERSBURG, 1865; d MOSCOW, 1911**

Although virtually unknown outside his native country, Valentin Serov was the leading Russian portrait painter of his time, gifted at achieving a revealing insight into the character of his sitter. His best work ranks among the cream of Russian Realist art.

Serov studied at the St. Petersburg Academy. From 1890 onward, he concentrated primarily on painting portraits, producing a stunning record of the most prominent people in Russian society, business, government, and the arts. He undertook numerous important commissions, including a portrait of Grand Duke Pavel Alexandrovich (1897).

At the turn of the century, Serov's style changed; Impressionistic elements in his work were replaced by a Modernistic approach, although he remained committed to conveying the truth and realism of his subject matter. During his later years, Serov painted a number of landscapes and also worked on classical mythology themes.

◀ **Girl with Peaches** *Serov's luminous, impressionistic portrait of Vera Mamontova—his debut work—is probably his best-known painting, and heralds the impending move from Realism to Modernism.* 1887, oil on canvas, 35¾ x 33½in, Tretyakov Gallery, Moscow, Russia

Santiago **Rusiñol**

b **BARCELONA, 1861; d ARANJUEZ, SPAIN 1931**

One of the leading figures in Catalan Modernism in the late 19th and early 20th century, Santiago Rusiñol was an outstanding Spanish painter and writer.

He was based mainly in Barcelona, but lived in Paris when Impressionism was coming to the fore, which influenced his use of light and color. Rusiñol introduced Symbolism and other modern French influences to Spain. Although he was an acute observer of nature, Rusiñol believed that painting was a vehicle for conveying emotion, rather than a medium that reflected reality. During his lifetime, he was an eminent art collector and his home at Sitges, near Barcelona, is now a museum.

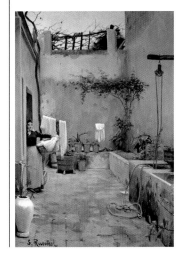

◀ **The Blue Patio** *This is one of a number of patio pictures that Rusiñol painted in the coastal town of Sitges. The light palette and mundane subject matter pay homage to the work of the Impressionists.* 1892, oil on canvas, 20¾ x 26¾in, Abadia de Montserrat, Barcelona, Spain

John **Lavery**

Portrait by Walter Tittle

b **BELFAST, 1856; d KILMAGANNY, 1941**

An Irish-born painter best known for his dashing portraits, John Lavery also painted interiors, landscapes, and outdoor life. After studying in Glasgow, London, and Paris, he was based mainly in Glasgow between 1885 and 1896, then eventually settled in London. Lavery traveled widely, spending the winters in Morocco, where he owned a house.

Despite a glittering career, Lavery evidently regretted playing it safe. He wrote in his autobiography, "I have felt ashamed of having spent my life trying to please sitters... instead of telling the truth."

◀ **Anna Pavlova** *Lavery produced two versions of the famous Russian ballerina rehearsing Dance Bacchanal. This dramatic and expressive work challenged portrait conventions of the day.* 1911, oil on canvas, 78 x 57in, Art Gallery and Museum, Kelvingrove, Glasgow, UK

John Singer **Sargent**

John Singer Sargent

b **FLORENCE, 1856; d LONDON, 1925**

One of the most celebrated and financially successful artists of his era, John Singer Sargent made his mark as a society painter. An outstanding portraitist, he brilliantly conveyed the opulence of his subjects' lifestyles, although he was sometimes criticized for superficial characterization. He also painted Impressionistic landscape watercolors and urban scenes.

An American who lived in Europe, Sargent was a supporter of the avant-garde and admired Monet, Manet, and other contemporaries. He was also noted for his portrayal of the modern woman, at a time when women were asserting their independence and fighting for equality. His radical portrait of *Mr. and Mrs. I. N. Phelps Stokes* (1897) suggests that Mrs. Stokes was the dominant partner.

LIFEline

1856 Born in Florence
1874–76 Studies in Paris
1884 His erotic portrayal of *Madame X* causes a scandal
1886 Moves to London
1887 First trip to the US, where he becomes society portraitist of choice
1892 Is established as the most fashionable portraitist in London
1907 Announces he is giving up portraits to concentrate on landscapes and murals
1916–25 Produces an important mural for the Museum of Fine Arts, Boston
1925 Dies in London

▲ **The Sitwell Family** *Sargent has brought a Baroque grandeur, reminiscent of Velázquez, to this portrait of English aristocracy at home. He skillfully projects an image of the dominant patriarch, dutiful, beautiful wife, and obedient children, surrounded by family heirlooms.* 1900, oil on canvas, 67 x 76in, private collection

▲ **Portrait of Katherine Chase Shapleigh** *This Impressionistic portrait was painted in the United States. The cool white tones of Shapleigh's dress and flowers and the luminosity of her skin contrast with the dark background. Sargent's delicate handling of light and skin tones are superb.* 1890, oil on canvas, 40¼ x 30¼in, Worcester Art Museum, Massachusetts, US

The reputation of Paris as a centre for sculptors, and especially for monumental sculpture, blossomed in the 19th century. It was a period marked by revolution and growing republicanism allied to technical, industrial, and social change. Aristocratic and state patronage provided much work and the systems of technical support were well established.

Origins and influences

The École des Beaux Arts tradition of training drew aspiring sculptors to Paris. While the most ambitious students applied for the Prix de Rome, which enabled them to study in Rome at the State's expense, there was only one place to ensure success as an artist – the annual Salon exhibition, where sculptors competed for patronage. From 1844, Paris held *Expositions Universelles* (World Fairs) to display French commerce and culture alongside pavilions from other countries. Sculpture was prominently featured to decorate both temporary structures and on permanent sites. As foreign students and artists returned from visiting Paris or Rome, the Beaux Arts style went with them and may

▲ **The Eiffel Tower** Erected in Paris as a temporary structure for the *Exposition Universelle* of 1889, at 984ft, it was, in its day, the tallest building in the world.

be seen clearly in the statuary and facades of the World's Columbian Exposition in Chicago in 1893. It is also evident in public sculpture as far afield as Buenos Aires in Argentina and Melbourne, Australia.

Subjects

There was a move away from Neoclassicism towards a much more romantic depiction of the individual, whether fighting to defend the liberty of the people, or in commemoration of the dead. Literary allusions were plentiful and sculptors made ready reference to Dante, Shakespeare, and Tasso or to the subjects of contemporary novels.

From 1848, many sculptors were employed by the state to ornament new buildings with stone or bronze statuary, and Paris also held its own store of marble to be allocated for commissions. Major projects included an extension to the Louvre, new railway stations, stock exchange, law courts, and the Garnier opera house. After 1870, competitions were held to provide colossal public monuments intended to promote and secure the republic. At the same time, new industrial processes allowed smaller works to be reproduced more easily for the domestic market.

Sculpture

François **Rude**

b **DIJON, 1784;** d **PARIS, 1855**

As a boy, Rude studied drawing in his hometown of Dijon. He later moved to Paris, where, in his twenties, he enrolled at the École des Beaux Arts. In 1812, Rude was awarded the prestigious Prix de Rome, but he was unable to take up the prize to study in Italy because of the Napoleonic Wars. In 1815, after Napoleon's fall, he fled Paris for Brussels, living in exile for 12 years to escape the Bourbon restoration, when the Roman Catholic Church was restructured as a power in French politics. He returned to Paris in 1827 and became highly successful. Rude's greatest achievement is the 40-foot-high stone sculpture *The Departure of the Volunteers in 1792*, also known as *La Marseillaise*. One of four large sculptures attached to the Arc de Triomphe, it was unveiled in 1836.

LIFEline

1784 Born in Dijon, the son of a metalworker
1809 Enters École des Beaux Arts in Paris
1812 Awarded the Prix de Rome
1821 Marries Sophie Frémiet
1833 Exhibits at Paris Salon; awarded Cross of Legion d'honneur; friezes and figure group commissioned for the Arc de Triomphe
1836 *La Marseillaise* unveiled to great public acclaim
1838 Denied membership of the Académie
1847 *Napoleon Awaking to Immortality* unveiled
1855 Dies in Paris, aged 71

▲ **Napoleon Awaking to Immortality** *This sculpture of the Emperor throwing off his shroud reflected the desire for change that eventually led to the Revolution of 1848.* 1845–47, bronze, length 9¾ft, Parc Noisot, Dijon, France

◀ **The Departure of the Volunteers in 1792** *Also known as* La Marseillaise *and inspired by real events, this is one of four large sculptures attached to the Arc de Triomphe. The relief idealizes men and boys in classical attire defending the Republic. They are urged onward by the mythical winged figure of Liberty.* 1833–36, stone, height 9¾ft, Arc de Triomphe, Paris, France

CLOSERlook

FACE OF LIBERTY
Along with equality and fraternity, liberty was acclaimed as one of the three great virtues of the republic. Derived from the Roman goddess of war, Bellona, this plaster study for the main figure issues a powerful call to arms.

Antoine-Louis **Barye**

b **PARIS, 1795;** d **PARIS, 1875**

Barye spent much of his time as a young artist drawing animals at the Jardin des Plantes in Paris; in doing so he developed the anatomical knowledge that informed the often savage subject matter of his sculptures.

Nicknamed the "Michelangelo of the Menagerie", Barye was a key figure in the *Animaliers* school of artists, known for their powerful, realistic animal sculptures. Although he gained royal and aristocratic patronage, he was declared bankrupt in 1848 and forced to sell rights to make casts of his work. It took Barye a decade to retrieve his rights.

LIFEline
1818 In his early twenties, enrols at École des Beaux Arts, Paris
1848 Declared bankrupt
1848–50 Director of Casts and Models at the Louvre
1854–75 Professor of Drawings at Museum of Natural History, in the Jardin des Plantes
1867 Awarded Grand Medal at the Exposition Universelle
1868 Elected to the Academy of Fine Arts
1875 Dies in Paris, having produced no new work since 1869

◀ **Tiger devouring an alligator** *A piece typical of Barye's romantic taste for the exotic.* 1832, bronze, length 41¼in, Louvre, Paris, France

▶ **Wolf Holding a Stag by the Throat** *Modeled with scientific precision, Barye's sculptures have also been seen as a metaphor for political life in his time.* 1843, bronze, 8¾ x 14¾in, Brooklyn Museum, New York, US

Jean-Baptiste **Carpeaux**

b **VALENCIENNES, 1827;** d **PARIS, 1875**

Photograph by André Disderi

Carpeaux's abilities were nurtured from an early age. In 1854, he was employed as a sculptor to work on the renovation and expansion of the Louvre. Awarded the Prix de Rome in 1854, he spent three years in Italy and completed his sculpture *Fisherboy Listening to a Seashell*, which was purchased by banker and art collector Baron James de Rothschild. In 1862, a bronze cast of his sculpture *Ugolino and His Sons* was placed in the Tuileries Gardens, Paris; a stone version was later displayed at the 1867 Exhibition Universelle. In 1869, his relief *The Dance* was unveiled at the Garnier Opera house in Paris. Described as the most controversial sculpture of the 19th century, it was splashed with ink within a month. The original, replaced by a full-sized copy in 1969, is now in the Musée d'Orsay.

LIFEline
1827 Born in Valenciennes, to a mason and a lace-maker
1844–50 Studies under Rude at École des Beaux-Arts, Paris
1846 Expelled from Prix de Rome competition for cheating
1854 Wins Prix de Rome
1856–61 Attends the French Academy in Rome
1869 Completes *The Dance*
1875 Awarded Cross of Legion d'honneur; dies in Paris, aged 48

▼ **The Dance** *This Bacchanalian group, from the façade of the Opera Garnier, is led by the* Génie de la Danse. 1865–69, Echaillon stone, height 130in, Musée d'Orsay, Paris, France

▶ **Ugolino and His Sons** *In Dante's* Inferno, *Ugolino tells how his children offered to sacrifice themselves to keep their father alive.* 1857–61, bronze, height 76in, Musée d'Orsay, Paris, France

Frédéric-Auguste **Bartholdi**

b **COLMAR, ALSACE, 1834;** d **PARIS, 1904**

◀ **Statue of Liberty** *This colossal figure was built in sections in Paris in the 1870s and 1880s. Formed from beaten copper sheets, the statue is hollow, supported by an iron structure designed by Gustave Eiffel. The face is believed to be based on that of Bartholdi's mother.* 1874–86, copper, height 152½ft, Liberty Island, New York, US

After studying architecture and painting, Bartholdi became celebrated as a sculptor both in France and in the US. A designer of public statues and fountains, his projects include the *Lion of Belfort* (1880), a massive pink-limestone work symbolizing the French resistance to Prussian assaults in 1870–71. Bartholdi is best known as creator of the *Statue of Liberty* —a gift from the French nation to commemorate the first centenary of the United States. Given to a "sister" republic, it represents republican virtues. From 1887 to 1889, he executed an extravagant lead fountain, *The River Saone and its Tributaries*, for Lyons, based on *Bassin* at Versailles by the Italian-born sculptor Tuby.

Hiram **Powers**

b **WOODSTOCK, VERMONT, 1805;** d **FLORENCE, 1873**

Initially trained as a clock and instrument maker, Powers turned to sculpture after discovering wax modeling while working in a museum. He went on to acquire the skills of casting and made a portrait head of President Andrew Jackson in 1835.

In 1837, Powers traveled to Italy and settled in Florence, establishing himself as the most successful American sculptor of the 19th century, carving "ideal" neo-classical busts and figures.

◀ **The Greek Slave** *This sculpture, Powers's greatest success, was inspired by the contemporary Greek struggles for freedom from Turkish domination in the War of Independence (1821–29). It is based on the most popular sculpture of its day, the* Venus de' Medici *in Florence (1st century BCE).* 1847, marble, height 63in, Corcoran Gallery, Washington, DC, US

Constantin **Meunier**

b **BRUSSELS, 1831;** d **BRUSSELS, 1905**

Having studied sculpture in his youth, Meunier moved on to different media, designing stained glass and fabrics, and painting religious and historical scenes. In the early 1880s, a new subject presented itself—the expanding industrial world. He returned to working in clay, and a heroic romanticism characterizes his sculptures of miners, laborers, and ironworkers in the great unfinished *Monument to Labour*, later acquired by the Belgian government and sited in Laeken. Meunier continued as both painter and sculptor, making life-sized bronze figures of working people—in stark contrast to much of the idealized, allegorical, and symbolic sculpture of his day.

▲ **Industry** *This was one of four reliefs created for Meunier's unfinished project* Monument to Labor. c1897, bronze, 26¾ x 35¼ x 14¼in, Musée D'Orsay, Paris, France

In the 19th century, the African visual arts were wholly integrated in daily life. All objects were made for use, rather than simply for viewing, and expressed cultural meanings that were made visible through their artistic rendering.

Influences

Trade over the centuries had brought many influences. Arab aesthetics was well established across the north of the continent. European traders and colonization by European powers led to a variety of western influences. In turn, African arts taken to Europe ignited and directly influenced the major artistic revolutions in 20th-century western arts.

Forms and materials

African art could be seen in everyday forms. The weaver's loom was carved. A useful and beautiful staff was made to convey ecological values and social principles. Woven textiles embodied a matrix of spiritual concepts and

community values. Materials of every kind and combination, from grass-fiber to gold, were employed for practical and symbolic purposes.

Africa's holistic approach to art is also apparent in its interactive "masquerades." These are cultural performances that are generally associated with secular or religious ceremonies. They interweave music, oral literature, theater, and dance with visual elements such as costumes, elaborate masks, and other objects that reflect and reinforce the important cultural beliefs of the people of a particular community.

▲ **Fulani Chieftan's Blanket** *The skillfully rendered motifs, colors, and patterns of this cotton and wool blanket express the "Fulani way"—consistency and harmony, self-control and patience.*

To put across their society's cultural concepts and moral values, artists had to achieve imaginative and evocative representation. Realism was not effective. They therefore developed sophisticated visual vocabularies using symbolism, abstraction, reduction, emphasis, and other devices to maximize the impact of their work. An immense diversity of styles and techniques evolved both within cultural groups and across the continent.

Africa is a vast continent with more than 900 distinct cultures. From musical instruments, clothing, and tools to religious statues and political insignia, all objects were infused with the community's values, beliefs, and philosophy. Trained through long, specialized apprenticeships, artists were highly valued in African cultures.

African art

Pende

SOUTHWESTERN CENTRAL AFRICA

Expressed in many forms, including architecture, sculpture, furniture, and divination (foretelling) instruments, Pende art ranges from fairly naturalistic to highly stylized. Intended to promote understanding and compassionate behavior, the Pende's dramatic masks are often based on village characters.

▲ **Mbangu Mask** *Representing a disturbed man, the hooded inward-looking eyes and the mask's artistic elements—faceted surfaces, distorted features, and divided color—evoke the experience of personal inner conflict. Picasso copied a mirror image of this Pende mask in "Les Desmoiselles d'Avignon." Wood, pigment, and fibers, height 10½in, Africa Museum, Tervuren, Belgium*

Kota

WEST CENTRAL AFRICA

Kota artists are renowned for their use of extreme abstraction. The sculptures that guard the relics of their ancestors eloquently embody their belief in the spiritual presence and influence of the dead.

▲ **Guardian Figure** *Finely carved and overlaid with contrasting copper and brass, this sculpture combines shimmering surfaces, minimal depiction of physical features and body, and an imaginative elaboration of the head—the source of influence and communication—to create a potent yet ethereal presence. Wood and metals, 25¼ x 11½ x 4½in, Musée du Quai Branly, Paris*

Chokwe

CENTRAL ATLANTIC COASTAL REGION

The Chokwe were politically ascendant in their region during the 18th and 19th centuries and established an impressive tradition of courtly arts.

▶ **Seated Chief** *Calm and introspective, this artwork embodies a balance of refinement and power. Strong hands, firmly grounded feet, and contained physical energy complement the dynamic swirling headdress. The rising curves on the chief's headdress are echoed at the eyes, ears, and in the musical instrument he holds, expressing his expertise as a thinker, seer, listener, and communicator. Pre-1869, wood, cloth, fiber, and beads, height16¾in, Metropolitan Museum of Art, New York, US*

Yombe

WESTERN CENTRAL AFRICA

The art of the Yombe people includes a unique genre of "power figures" that reveal the masterful confluence of function, form, and meaning.

▶ **Nkisi Nkonde** *A legal witness and repository, this sculpture personifies community law. The metal objects driven into the figure publicly record oaths, contracts, or claims for retribution. The figure's commanding stance, all-seeing stare, and torso bristling with "reminders" are centered on a dark recess, referring to both conscience and fear in the pit of the stomach. The visual elements activate psychological forces to promote community, social justice, and compliance. Wood with mixed media, height 46in, Detroit Institute of Arts, Michigan, US*

Fang

WESTERN EQUATORIAL AFRICA

The Fang conduct their lives according to principles drawn from their history—the experience of their ancestors. Many of their impressive artworks relate to memorials and the implementation of ancestral wisdom, which is consulted on all major issues and is the source of moral and political power.

▲ **Ngil Mask** *Worn with full costume in a night masquerade to settle disputes and quell misbehavior, this calm visage was terrifying to wrongdoers. The distortion emphasizing brain, eyes, and nose implies extreme powers of insight and discrimination.* Varnished wood, private collection

▶ **Reliquary Figure** *Surmounting a memorial containing ancestral relics, this sculpture embodies the balancing of intellectual and physical powers. The large head, with its complex composition of contrasting planes and forms, elaborate hairstyle, and emphasized eyes, indicates the importance of knowledge and insight. The fine straight torso contrasts with the muscular limbs suggesting controlled energy. Tranquillity, equanimity, and vitality—qualities esteemed in Fang culture—are evoked by minimal clarity, symmetry, and juxtaposition.* Wood and metal, height 25¼in, Metropolitan Museum, New York, US

Bamana

CENTRAL WEST AFRICA

Among the most admired of Bamana artworks are the elegant headdresses worn in Ciwara masquerades to invoke fertility of the land and celebrate nature's abundance. Political and social organization of Bamana society was closely related to agricultural production, and the all-important relationship between man and nature is clearly reflected in their arts.

▼ **Ciwara Headdress** *A complex balance of straight, curving, horizontal, and vertical forms, this naturalistic example combines notions of female fecundity, animal strength, fluid energy, and the interdependence of human and natural forces.* Wood, 22½ x 2½ x 7in, Musee du Quai Branly, Paris

▲ **Ciwara Headdress** *This fine sculpture depicts the antelope, a metaphor for the Sun and natural energy, and at its base is the burrowing ant-eater, symbolizing hard work. The graceful angles and forms of the head and horns are superbly balanced by the arching neck and skilful geometric patterning of positive and negative space.* Wood and metal, 37¼ x 18¾ x 2¾in, Musee du Quai Branly, Paris, France

Senufo

WEST AFRICA

With a capital city dating back to the 13th century, nine major dialects and more than 30 sub-groups, the Senufo have a long and diverse artistic tradition. Specialist castes provide skilled training in media such as textiles and gold, and, for example, wood-carvers produce richly symbolic carved doors as well as sculptures.

▲ **Poro Mask** *Designed to pay homage to female ancestors, this mask's serene dark oval face is offset by glinting brass, symmetrical extensions, and delicate patterns symbolizing wisdom and beauty.* Wood, metal, horn, cotton, feathers and fiber, height 14in, Metropolitan Museum, New York, US

▲ **Champion Cultivator Staff** *Awarded to the most skilled agriculturalist, this figure portrays fecundity through the ideal attributes of femininity. The prominent head symbolizes wise management; the straight back, a noble attitude; and the full breasts and gently swelling belly, fertility and success.* Wood and mixed media, 40½ x 3½ x 3½in, Museum of Fine Arts, Houston, Texas, US

The first modern humans migrated south into what is now southeast Asia around 75,000 years ago, gradually moving through Indonesia and across the then land bridge into New Guinea and Australia—which at that time were joined together—around 40,000 years ago. Rising sea levels eventually turned Australia into an island, leaving its Australian Aboriginal inhabitants undisturbed to develop their own distinctive culture until European exploration and settlement began in the late 18th century.

Lapita culture

The settlement of the Pacific islands was more complex. In around 3000 BCE Austronesian speakers from Taiwan migrated south into coastal Vietnam, the Philippines, and Indonesia. From there they traveled east toward coastal New Guinea and the near Pacific islands. One group even crossed the Indian Ocean in the 1st century CE to settle in the island of

▲ **Ancestral guardians** *The Asmat people of Irian Jaya —the Indonesian, western half, of New Guinea— along with many other Indonesian islanders carved stylized, wooden figures of their ancestral guardians.*

Madagascar, off the east coast of Africa. Around 1600 BCE the Austronesians developed the Lapita culture—named after the site in New Caledonia—which is noted for its use of shell tools and its distinctive pottery. This culture spread east to Vanuatu, Fiji, Samoa, and Tonga by around 1000 BCE.

Over the next millennium, this cultural area split in two. In the west, it merged with that of the Australian Aboriginal peoples of New Guinea and the Solomon Islands, the ancestors of the modern-day Melanesians, while in the east, in the Fiji–Samoa–Tonga triangle it developed into a distinctive Polynesian culture.

Polynesian navigators

The Polynesians were highly skilled navigators, sailing their twin-hulled, sail-powered canoes across the Pacific in search of new lands with only the stars, waves, winds, and wildlife to guide them. The Polynesians navigated huge distances, first reaching Tahiti around 200 BCE. From here they sailed east to Easter Island around 300 CE, north to Hawaii around 400 CE, and eventually south to Aotearoa (New Zealand) by around 1000 CE. It is possible that some Polynesians even made contact with the Americas.

The human settlement of the southeast Asian, Australian, and Pacific islands took place over thousands of years. The art produced by the settlers was immensely rich and varied, its decoration or plain form often related to its function. In the 19th century knowledge of this art was largely based on artifacts collected by the early explorers.

Oceania

Australia and SE Asian islands

38,000 BCE ONWARD

Australian Aboriginals developed a highly effective culture despite the limited resources of their environment, and their isolation from the inhabited islands to the north. Traditional Australian Aboriginal culture using wood and other natural materials reflected their belief in "dreamtime," a period when semi-human and semi-animal beings created the world before transforming themselves into rocks, and other natural features.

Despite their apparent differences, the southeast Asian islanders have the same Austronesian linguistic origin and a common artistic culture based on motifs inherited from the 1st-millennium BCE Dong-Son metalworking culture of Vietnam. The motifs include boats, birds, and trees, and reflect shared ideas of life, death, and the universe related in myth and expressed in art. Wood and stone, both used for sculpture, were the main materials used, but artisans also produced fine textiles and gold jewelry.

▶ **Bull roarer** *Engraved with carved, geometric dreamtime motifs, the wooden bull roarer was attached to a piece of cord and whirled round the owner's head in a circular motion to produce a sacred whirring sound. 1800s, wood, length 11½in, Central Australia*

◀ **Trophy skull** *Head-hunting was common on Indonesian islands and survived in Borneo as late as the 1930s. The Dayak warriors who engraved this trophy acquired prestige through participating in the raids. Early 1900s, human skull, height 6½in, Borneo*

▶ **Ancestral guardian figure** *The Dayaks of Borneo carved figures with elongated limbs and bodies to honor their ancestral guardians, using shells for their eyes and iron wire for the looped earings. 1800s, wood, shell, iron, height 38in, William Jameson Tribal Art*

New Zealand

c1000 CE ONWARD

Maori art was mainly created to indicate status, with high-ranking individuals owning a wide range of bone, ivory, wood, stone, and jade implements and artefacts. Elaborately carved meeting houses and war canoes expressed the power and wealth of a Maori tribe and were a source of great personal and collective pride. Maori carvings are bold, detailed, and have a deep patina. They mainly consisted of spirals interspersed with manaia motifs—mythical animal, bird, or human forms with a reptilian character—and with tiki motifs—stylized human forms representing family ancestors. Tiki motifs appear on almost all types of object, notably on the hei tiki pendants that were considered prized heirlooms, increasing in importance as they passed down the generations.

◀ **Maori pendant** *A hei tiki neck pendant made from pounamu, a hard, nephrite jade of varying color that is only found in the South Island. The eye color is made with red wax. Pendants like this one were worn by high-ranking men and women.* c1900, nephrite jade, height 4¼in, Philip Keith private collection

▶ **Maori wood panel** *A wooden panel carved with a tiki motif that was used to decorate a meeting house. Similar carvings appear on gable masks, canoe prows, sterns, paddles, bailers, treasure boxes, and musical instruments.* c1870–80, wood, height 71¾in, New Zealand

Fiji

c1000 BCE ONWARD

Although racially and linguistically Melanesian, the Fijian islanders are Polynesian in culture. The mix produces some of the finest art found in the Pacific islands. Many artifacts are concerned with war, as the islanders were obliged by custom to avenge killed or insulted kinsmen, resulting in an almost constant state of warfare, some of it cannibalistic in nature. Figurative sculpture is rare, although human and animals motifs appear in ritual objects used by chiefs and priests. Necklaces, pendants, and pectoral disks were made from marine ivory and shell. Pottery vessels, made by women, were baked in open fires and glazed with pine resin while still hot.

▲ **Cannibal fork** *Ceremonial attendants used this carved, wooden i-culanibokola to feed human flesh to holy men during religious rituals.* 1800s, wood, length 18in, Fiji

▶ **Tapa cloth** *Tapa bark cloths, stenciled and sometimes block-printed in black with occasional red-ocher details, were worn by chiefs or used as bedding or to partition a house. This one was made as a sample of a larger dining cloth.* 1900s, bark cloth, length 18½in, Fiji

Melanesia

3000 BCE ONWARD

The largest and most populated part of the Pacific region, Melanesia lies in the western Pacific Ocean and consists of Irian Jaya, Papua New Guinea, Vanuatu, New Caledonia, and the Solomon Islands. The area is racially and linguistically very heterogeneous, producing art that is similarly varied and has great vitality and exuberance. The main artefacts are masks and carvings that either represent ancestral ghosts or provide a home for them in live in. Belief in the power of witchcraft to cause misfortune, illness, or death is widespread. The small-scale warfare that was common in the region has created many different types of shields, clubs, bows, and arrows. Wood is the main material used, although bark cloth, shells, and beads are also worked.

▶ **Ancestral figure.** *This beautiful wooden ancestral figure, almost abstract in form, was carved in the Trobriand (Kiriwina) Islands to the southeast of Papua New Guinea.* 1800s, wood, height 16in

▲ **Malaita shell pendant** *Shells like this one, which is engraved with stylized fish and a frigate bird, were sometimes also overlaid in tortoiseshell. Such pendants were worn by Solomon Islanders.* Clamshell, width 2½in

▲ **Ancestral skull** *By decorating the skull of an ancestor with feathers, beads, and seeds, the Asmat people of Irian Jaya showed their respect.* Early–mid 1900s, skull, polychrome beads, vegetal fibers, feathers

Art changed completely in the 20th century. With the birth of Modernism, a rapid succession of "isms" followed, movements in which artists rejected naturalism—representing the physical world realistically—and academic art—with its emphasis on classical traditions. Instead, they experimented with technique and form, questioning the very nature of art and humanity.

Early 20th

1900 1910 1920

FAUVISM 1905–1907 **DADA** 1915–c1922

EARLY BRITISH MODERNISM c1900–c1915

VORTICISM 1914–1915

GERMAN EXPRESSIONISM c1900–1930s

BAUHAUS 1919–1923

CUBISM 1907–1920s

FUTURISM 1909–c1916

ORPHISM 1911–c1914

RAYONISM 1912–c1914

CONSTRUCTIVISM 1915–MID 1920s

SUPREMATISM 1915–1920

The Fauves ("wild beasts") gave rise to one of the first 20th-century "isms" with their wild use of color. German Expressionists were equally unfettered in their color schemes, using distorted shapes, a strident palette, and rugged brushwork to express their feelings and views of society. Cubism, by contrast, was less a personal expression than an attempt to break down the tradition of single-point perspective by shifting viewpoints. Futurism added speed and movement to the fragmented forms of Cubism, while abstract art shattered subject matter to the point where it no longer existed. In Russia the Suprematists and Constructivists also rejected the appearance of nature in favor of geometry. The attempt to relate art to post-revolutionary society led them to challenge not just the traditional forms but also the functions of art. Dadaists questioned the role of art by exploring the unconscious, as did the Surrealists. Not everyone rejected realistic art—there were figurative artists in the US and Europe, while in Mexico huge historical murals were created to promote a cultural and political identity.

century

SURREALISM 1920–LATE 1940s

NEUE SACHLICHKEIT (NEW OBJECTIVITY) 1923–EARLY 1930s

Origins and influences

Led by Henri Matisse, André Derain, and Maurice de Vlaminck, the Fauves were a group of friends who sought a more dynamic way of depicting nature. They experimented with bold, non-naturalistic color and applied their paint in short, energetic strokes, which prompted art critic Louis Vauxcelles to dub them *Fauves*, or Wild Beasts. For all the impression of wildness, however, the Fauves soon revealed they were more interested in solid, permanent structure than violent expression or the Impressionist "fleeting moment," and that Cézanne and Seurat were as important as influences as van Gogh.

Subjects and techniques

In the summer of 1905, Matisse and Derain worked alongside each other in the village of Collioure, in the south of

▲ **Collioure beach** *This small fishing village in the south of France, photographed here in 1890, was the cradle of Fauvism. Here, Derain and Matisse created a new way of "seeing" nature.*

France. In the dazzling Mediterranean light, they painted the tiny port from every angle. By the end of summer, they had established a new style.

Pure color—sometimes softened with a touch of white—was applied in little dabs and strokes. The canvas was left bare in places to act as a color itself. At the same time, Vlaminck, the most impassioned of the Fauves, was making similar strides at Chatou, near Paris.

By 1906–07, the parameters of Fauvism had shifted to include line to define shape and larger blocks of more muted color. The human form replaced landscape as the focal point of the paintings. Some of the Fauves, such as Raoul Dufy and Albert Marquet, stayed with their original style, but their approach was generally less daring.

CURRENTevents

1905 A law is passed guaranteeing the separation of Church and State in France. The Church would no longer play an intrusive role in state education.

1906 The political scandal known as the Dreyfus Affair comes to an end. The Court of Appeal declares that the Jewish Army officer, Alfred Dreyfus, is not guilty of state treason.

1907 French colonial policy in North Africa is endangered by an outbreak of factional fighting in Morocco, and a number of French workmen lose their lives.

Fauvism exploded onto the Paris art scene in 1905. Its bright, pure colors, flattened perspective, and simplified detail signalled a new era. Unwittingly, a small group of French artists had developed the first modern art movement.

Fauvism

André **Derain**

Derain, c1930

b CHATOU, NEAR PARIS, 1880; d GARCHES, 1954

Abandoning his engineering studies for painting, André Derain enrolled at the Académie Camillo, Paris, in 1898 where he first encountered fellow student Henri Matisse. Soon after, he met Maurice de Vlaminck on a train and, discovering their mutual love of painting, they agreed to work together the following day. In February 1905, the art dealer Ambrose Vollard bought the entire contents of

Derain's studio. In that summer, Derain went to Collioure to paint with Matisse, and Fauvism was born. In 1906, he twice visited London to paint scenes of the River Thames and the Houses of Parliament. Over the following years, he focused on groups of figures, portraits, and still lifes, with his work gradually adopting a more classical and somber feel.

LIFEline

1880 Born, the son of a baker

1898 Enrols at Académie Camillo where he is taught by Eugène Carrière

1904–05 Paints his first truly Fauvist picture *The Bridge at Le Pecq*

1905 Paints in Collioure with Matisse

1919 Designs costumes for Diaghilev's Ballet *La Boutique Fantastique*

1954 Dies in Garches, after being hit by a car

▲ **Harlequin and Pierrot** *In the post-Fauvist years, Derain toned down his bright palette and returned to using firm line, foreshortening, and perspective. This double portrait of two pantomime characters evokes an 18th-century compositional style. 1924, oil on canvas, 69 x 69in, Musée de l'Orangerie, Paris, France*

▲ **Barges on the Thames** *In this painting of barges at a wharf on the south bank in London, Derain introduces elements of naturalism to his Fauvist style; most notably, the shadows and mistiness. 1906, oil on canvas, 31¾ x 38¾in, Leeds, UK*

CLOSERlook
MISTY BACKDROP (DETAIL)
The sense of spatial recession is achieved through an increasingly "milky" effect toward Tower Bridge. This contrasts with the firm line and color of the foreground crane.

Henri **Matisse**

Photograph by Boris Lipnitski

b CATEAU CAMBRÉSIS, 1869; d NICE, 1954

Matisse once reflected on the significance of the years 1905–07 by saying, "Fauvism is not everything, but it is the foundation of everything". Yet, in the years leading up to this breakthrough, he had despaired of ever making a living from his art.

While completing his law studies, Matisse enrolled at the École des Beaux-Arts and joined the studio of Gustave Moreau. In 1898, he travelled to Corsica, where he produced small, colorful works—precursors of Fauvism—before returning to a darker palette.

Matisse worked alongside the Divisionist painter Paul Signac in St. Tropez in 1904, where he produced sketches for his seminal painting *Luxe, Calme, et Volupté* (Luxury, Serenity, and Pleasure), and with André Derain in Collioure during the "Fauve Summer" of 1905. Between 1906 and 1910, he created some of his most important pieces, affirming his belief in the importance of harmonious, brightly colored composition. Matisse frequently combined portraiture, still life, and landscape, in a way not seen before. These elements occur together in his many interior scenes in which an open window looks out on to the sea or a landscape.

◀ **Luxe, Calme, et Volupté** *Influenced by Paul Signac's Divisionist style, Matisse depicts nymphs and followers of Bacchus in an idyllic setting. They pursue life's pleasures against the backdrop of the Gulf of St. Tropez. 1904, oil on canvas, 38½ x 46½in, Musée d'Orsay, Paris, France*

LIFEline

1892 Moves to Paris to study law. Enrols in drawing classes
1899 Marries Amélie Paraye
1904 Works with Signac at St. Tropez. Paints masterpiece, *Luxe, Calme, et Volupté*
1905 The Fauve Summer, followed by the sensational Autumn Exhibition in Paris
1921–25 French Government starts to buy Matisse's work. He is made Chevalier of the Legion of Honour
1940s In failing health and severely arthritic, yet makes large cut-out paper pictures
1954 Dies in Nice

> ❝A work of art must carry in itself its **complete significance** and impose it upon **the beholder**, even before he can **identify** the subject matter ❞
>
> HENRI MATISSE

▲ **The Young Sailor I** *This was the first of two paintings Matisse made of the young mariner. The cool greens and blues, suggesting the sea, and the dark solid bulk of his body show the influence of Cézanne. For Matisse, Fauvism was just the beginning of a long exploration of color and form. 1906, oil on canvas, 39¼ x 32¼in, private collection*

▲ **Interior with Eggplants** *Background, foreground, and sides are united in a single frontal plane in this busy and colorful interior. The eye tries in vain to decipher exactly where the surfaces meet and how far back the open window is. The landscape visible through the window is painted in much the same palette as the interior, which leads the eye back into the room. 1911, distemper on canvas, 58 x 38¼in, Musée des Beaux Arts, Grenoble, France*

◀ **Large Red Interior** *In front of a flat red background, Matisse's still lifes provide the picture with a sense of depth. Wittily, it is the picture on the wall that employs conventional recession to give perspective. 1948, oil on canvas, 84 x 97in, Pompidou Centre, Paris, France*

The Sadness of the King (La Tristesse du Roi) *Henri Matisse,*
1952, gouache and paper on canvas, 115 x 152in, Pompidou Center, Paris, France ▶

The Sadness of the King Henri Matisse

Henri Matisse's life was a continual search for a balance between color and form. After traumatic surgery left him confined to a wheelchair in 1941, he reinvented himself by turning to découpage (cutting designs from paper), a form he had first experimented with while working on the large commission *The Dance* in 1930–33. Découpage allowed Matisse to "paint" with scissors by cutting into color and then grasping the picture's elements and manipulating them like a sculptor.

Composition

Matisse once said: "The entire arrangement of my picture is expressive; the place occupied by my figures, the empty space around them, the proportions, everything has its share…" Here, he uses horizontal and vertical color blocks to divide the space and provide a balance between the figures (a positive physical presence) and the field (the negative areas between). The interaction of flat, bright colors, shapes, and small motifs gives the composition a strong sense of rhythmic movement.

▲ **DIVISIONS** The picture is divided into three rectangular sections. Each is occupied by different figures. The viewer's attention is subtly drawn to their different roles by the amount of space around them.

▲ **MOVEMENT** The eye is drawn from right to left by the tilting figures and the fluttering yellow lozenges that appear to emanate from the right-hand corner. The lozenges represent leaves, petals, notes, or tears, depending on where they appear.

Story

Matisse once said that he sought to create a serene, balancing art that would "soothe the brain." This autobiographical portrait—a poignant farewell to his favorite things (women, music, and dance)—attempts to do just that. It has been suggested that the subject is inspired by Rembrandt's *David Playing the Harp before Saul* and Baudelaire's description of music soothing the poet's afflictions in his poem *La Vie Antérieure* (from the anthology *Les Fleurs du Mal*, which Matisse had illustrated in 1944): "… And there it was I lived …[amid] perfume-saturated naked slaves/ Who gently soothed my brow with fronds of palm."

▶ **THE ODALISQUE** Matisse's obsession with voluptuous oriental women produced his *Odalisque* series of paintings (1920–25) after a visit to Morocco. The odalisque (a Turkish sultan's slave), wearing harem pants, is probably a percussionist and the orange shape a drum.

▶▶ **THE DANCER** The starkly contrasting black and white dancer is modeled on Delacroix's dancing slave in his *Women of Algiers in their Harem* (1849).

Technique

For this large work, Matisse used découpage, a technique he had perfected, while he was working on 20 colorful, small-scale "improvisations" for a limited-edition book *Jazz* (1947). Nearly all the large scale work of the last year's of his life used this method. Studio assistants prepared the large sheets of paper with gouache, a dense watercolor made from pigment, lime, and the thickener, gum arabic. Matisse cut his shapes from a palette of 11 vibrant colors, including black, white, cobalt blue, cadmium yellow, red, and six secondary colors. He wanted his colors to "react on one another."

▲ **LINES OF MOVEMENT** The black dancer's graceful movements are suggested by the clever use of snaking orange and jagged-edged black curving lines. These decorative patterns curve around her mobile body suggesting a circular motion.

▲ **THE KING (SELF-PORTRAIT)** The king's outline resembles a silhouette of Matisse in his wheelchair. Unconsoled by the sound of his own music, he is surrounded by his guitar's notes, which double up as tears.

◀ **SHAPES** Matisse delighted in creating shapes, such as the lozenge-shaped leaves, that could be interpreted as different things. The pattern on the king's robe and his hands resemble the palm frond motifs of an earlier Polynesian series (1946).

▼ **DÉCOUPAGE** Découpage is the art of cutting designs out of paper and pasting them on to a surface. Discovering a new freedom with color and line, Matisse transformed this technique into a novel art form.

Maurice de **Vlaminck**

b **PARIS, 1876;** d **RUEIL-LA-GADELIÈRE, 1958**

Maurice de Vlaminck's parents loved music, and performance was a vital element to this larger-than-life character. Prior to meeting Fauvism founder André Derain in 1900, he had been a boxer, a champion racing cyclist, and a café violinist. He also frequently contributed articles to the anarchist newspaper *Le Libertaire*.

Mostly self-taught, Vlaminck came to see art as an outlet for his revolutionary zeal. He was greatly influenced by the van Gogh exhibition of 1901, where Derain introduced him to Matisse. During the Fauve years, he mostly painted the landscape near his home at Chatou. A collector of "primitive" art, Vlaminck was also important in revitalizing the woodcut. He maintained his Fauvist palette until 1908, when his colors suddenly became much darker.

LIFEline

1876 Born in Paris, to parents who are both music teachers
1892–93 Moves to Chatou, a suburb of Paris; works as a mechanic; takes up painting
1900 Meets Derain and shares a studio with him at Chatou
1905 Exhibits eight paintings at Autumn Exhibition in Paris
1933 Retrospective of his work in Paris
1958 Dies, in his 80s

▲ **View of the Seine** *This is one of numerous paintings of the area around Chatou. Vlaminck was the most turbulent of the Fauves, and freely admitted that painting saved him from "going to bad." This ordinary scene is invested with a van Gogh-like air of heightened drama.* 1906, oil on canvas, 21¾ x 26in, Hermitage, St. Petersburg, Russia

▶ **A Dancer at the Rat Mort** *A dancer at the famous Paris cafe, Le Rat Mort, takes a break from the night's routine. Vlaminck uses the meerest outline to suggest her body and dress.* 1906, oil on canvas, 28¾ x 21¼in, private collection

CLOSERlook

DABS OF PAINT Hundreds of dabs cover the canvas. Here, it is the dancer's clearly defined legs that inform the viewer that the abstract pattern is in fact her dress.

Georges **Rouault**

b **PARIS, 1871;** d **PARIS, 1958**

A devout Catholic, Georges Rouault was obsessed with the subjects of sin and redemption. One of the 20th century's most maverick painters, he is difficult to bracket. In 1892, he studied alongside Matisse and Marquet at the École des Beaux-Arts, where he was Gustave Moreau's favorite pupil. Although he exhibited at the Autumn Salon in 1905, Rouault had little in common with the other Fauves, either stylistically or in terms of subject. Using a darker palette and heavy outline, he painted clowns, prostitutes, and social misfits. From 1917, Rouault was promoted by French art dealer Ambrose Vollard, who exhibited his work and funded the publication of *Miserere*— a collection of prints on the theme of death—in 1927.

◀ **Head of Christ** *Rouault's religious convictions led him to depict Christ in paintings and drawings. This tender image, with Christ introspectively looking down, has the quality of a religious icon.* 1939, oil on canvas, 26 x 20⅛in, Hermitage, St. Petersburg, Russia

▲ **Prostitute** *From 1903, Rouault painted powerful studies of prostitutes, aiming to shock the viewer into reflecting on society's degradation.* 1905, oil and gouache on paper, 11 x 8¾in, private collection

Albert **Marquet**

b BORDEAUX, 1875; d PARIS, 1947

Raised in Bordeaux, Albert Marquet was a shy man described as being difficult to get to know. He moved to Paris in 1890 and enrolled in the École des Beaux-Arts, where he met Henri Matisse.

By 1898, he had adopted a bright palette, but he never fully applied color in a totally non-naturalistic way. Between 1904 and 1905, he painted alongside Raoul Dufy on the Normandy and Mediterranean coasts, producing pictures of ports and harbors. He also painted nudes and portraits. In 1908, he moved into a studio vacated by Matisse, where he worked until 1931.

▼ **The Beach at Fécamp** *Stylistically between Fauvism and Impressionism, Marquet's coastal scene employs conventional perspective but in an unconventional way, and uses a single light source and bold contours.* 1906, oil on canvas, 19¾ x 24in, Musée d'Orsay, Paris, France

Kees van **Dongen**

b DELFSHAVEN, NEAR ROTTERDAM, 1877; d MONTE CARLO, 1968

A student at Rotterdam's Academy of Fine Arts from 189 to 1897, van Dongen moved to Paris in 1900, where he made satirical illustrations for the French press. In 1904, van Dongen exhibited at the *Salon des Indépendants* (set up as a foil to the formal Salon shows), where he met Vlaminck and Derain, and the following year he exhibited at the infamous Autumn Salon. In contrast to the other Fauves, van Dongen specialized in nudes and portraits. His brightly illuminated cabaret performers combine dynamic color contrasts and eroticism, his "ladies of the night" (prostitutes) are portrayed as pleasure-seekers rather than as social victims. In 1913, a painting he showed at the Autumn Salon was considered obscene by the police and removed.

◀ **The Corn Poppy**
Following World War I, van Dongen's work reflected the carefree spirit that pervaded Europe. He focused his attention on fashionable society, particularly glamorous women. c1919, oil on canvas, 21¾ x 18¼in, Museum of Fine Art, Houston, Texas, US

Raoul **Dufy**

b LE HAVRE, 1877; d FORCALQUIER, PROVENCE, 1953

Portrait by Laure Albin-Guillot

Of all the Fauves, Raoul Dufy was the most attached to capturing fleeting light effects and to painting people at leisure. In fact, the scenes of strollers and sporting events that he painted from 1919 onwards became his personal style. Dufy started taking painting lessons in Le Havre in 1892, before moving to Paris in 1900, where he studied at the École des Beaux-Arts. He regularly exhibited in shows at the Salons. His somewhat naturalistic style changed in 1905 when he saw Matisse's painting *Luxe, Calme, et Volupté* (1904).

After this he adopted a brighter palette. Like Marquet, Dufy used vibrant colors to depict vivid objects, such as beach umbrellas, flags, and clothing, naturalistically, rather than reinventing the color landscape as the other Fauves did. He also undertook a number of designs for the theatre.

LIFEline

1877 Born in Le Havre, the eldest of nine children
1892 Works for a coffee importer and takes evening art classes
1898 Moves to Paris. Enrols at the École des Beaux-Arts
1905 Visits the Autumn Salon, but does not exhibit
1908 Spends the summer at L'Estaque with the Fauve painter Georges Braque
1919 Starts producing his leisure and sports pictures
1937 Makes a large mural— *The Spirit of Electricity*—for International Exhibition, Paris
1953 Receives the main prize at the Venice Biennale; dies in Forcalquier, having achieved enormous popularity

▼ **Still Life with a Fruit Bowl** *Depicted from above, this fruit bowl set against a blue tablecloth is full of vitality. Its texture and sculpting is achieved by cross-hatching over flat color.* c1908, oil on canvas, Musée d'Art Moderne de la Ville de Paris, Paris, France

▲ **Horses and Jockeys under the Trees** *Dufy enjoyed painting horses—either racing or at their ease. Here, it is the trees that create the sense of movement, picked out against a mauve wash.* c1930, watercolor, 19¾ x 25¾in, Galerie Daniel Malingue, Paris, France

CLOSERlook
OUTLINE ON COLOR

Dufy's hallmark style was a combination of vigorous calligraphy with broad strokes of brilliant color. This horse is drawn over a shade of green echoed in the trees and the grooms' coats.

What distinguished Expressionist art was its emphasis on the highly personal psychological and emotional response of the artist to the subject, and not the subject itself.

Die Brücke

It took a group of young architecture students from Dresden, led by Ernst Ludwig Kirchner, to make the decisive move. Along with Karl Schmidt-Rottluff, Erich Heckel, and Fritz Bleyl (1880–1966), they formed Die Brücke (German for "The Bridge"). They chose the name because they shared the view of German philosopher Nietzsche —that man was a bridge to a better world—and because Dresden was famous for its bridges. Working in a disused butcher's shop, they created a style that drew inspiration from van Gogh, Edvard Munch, and old German art of the time of Grünewald and Dürer. They initially painted landscapes and nudes and, after 1911,

▲ **Friedrichstrasse** *Drawn with Ernst Ludwig Kirchner's typically pronounced angularity, this promenade of sophisticated couples exemplifies the "big city" phase of Brücke Expressionism.*

when they moved their headquarters to Berlin, the capital's street life. Their bright, acid colors—set against each other to create a sense of edge—and heavily distorted outline pushed art decisively away from naturalism.

Der Blaue Reiter

Almost at the same time, another style of Expressionism was being formed in Munich by a group of artists that included Wassily Kandinsky (see pp.435–39), Franz Marc, and Alexei von Jawlensky. They published an almanac called *Der Blaue Reiter* (The Blue Rider), from which the group took its name. Believing that creativity was not found in academic art, they printed pictures of ancient Egyptian artifacts, children's drawings, and the newest artistic innovations alongside each other.

Kandinsky, who went on to become a pioneer of abstract art, and Marc shared the view that the artist had a spiritual mission. Their art was less frenetic than that of Die Brücke. They sought to return society to a state of harmony that they felt had been lost in the process of modernization.

In the early 20th century, the classical ideals of academies and the rapidly ageing Art Nouveau (Jugendstil) style held artistic vision in Germany in a stranglehold. Inevitably, any new movement would have to be violently different—that movement was Expressionism.

German Expressionism

Emil **Nolde**

Self-portrait

b NOLDE, SCHLESWIG-HOLSTEIN, 1867; d SEEBÜLL, 1956

Born Emil Hansen, this introverted painter adopted the name of his village at the time of his marriage in 1902. He served an apprenticeship as a cabinetmaker and worked in furniture factories in Berlin and Munich. From 1892 to 1902, Nolde taught furniture design and pursued his own artistic studies. At least 15 years older than other members of Die Brücke, the usually reclusive Nolde joined the group briefly in 1906–07. His art revolved around two primary themes: the local landscape on the north German coast and the interpretation of Biblical stories. He also made many woodcuts that have a unique, painterly touch.

LIFEline

1867 Born, the son of a farmer
1884–87 Works as an apprentice furniture designer and cabinetmaker
1892–97 Teaches ornamental design in Switzerland
1906–07 Joins Die Brücke; meets Edvard Munch
1931 Made a member of Prussian Academy of Art

▲ **The Dancers** *Fascinated by "primitive" and pagan rites, Nolde aimed to show humanity transported to another level of consciousness, as depicted in this vibrant print.* 1912, color lithograph, 22¼ x 27¼in, Kunsthalle, Hamburg, Germany

▲ **Marshland Farmhouse** *Nolde painted many landscape watercolors. He was banned from practicing his art by the Nazis in 1941, but he defied them by painting tiny landscapes on small pieces of paper.* 1947, watercolor on paper, 13¼ x 14¼in, private collection

▲ **Pentecost** *Nolde was intrigued by displays of spiritual fervor, although he was not a devout Christian. Here, the Holy Ghost is descending on the Apostles in the form of a flame.* 1909, oil on canvas, 34¼ x 42¼in, private collection

CLOSERlook

PURPLE PATCH
In Judeo-Christian beliefs, purple is traditionally associated with royalty. As the flames hover over the appointed leaders of the new church, the reflections are depicted in their enraptured faces.

Ernst Ludwig **Kirchner**

Self-portrait

b **ASCHAFFENBURG, 1880**; d **FRAUENKIRCH, 1938**

Kirchner's art is at the center of German Expressionism. His dynamic, acerbic canvases have both great visual appeal—Kirchner distributed color and composed so confidently—and a hard-hitting edginess. During the Dresden years (1905–11), he painted his city, friends and models, and the surrounding countryside. In 1911, the Die Brücke artists moved to Berlin, and this is where he met Erna Schilling, who became his model and life-long companion. Kirchner's new subjects included the city's streetwalkers and fashionable women—often depicted in a surprisingly similar way. After suffering a breakdown during World War I, Kirchner left Germany for Switzerland, where he lived until he committed suicide in 1938.

LIFEline

1880 Born, the son of an industrial chemist
1901 Studies architecture in Dresden
1903–04 Studies at Debschitz and Obrist art school, Munich
1905 Gains architecture degree. Co-founds the Brücke group of artists
1911 Moves to Berlin and sets up modern painting school with Max Pechstein
1913 His criticisms of Die Brücke leads to the group's break-up
1917 In poor health, he moves to a village near Davos, Switzerland
1937 Branded a "degenerate" artist by the Nazis; his work is removed from public places
1938 Shoots himself in Frauenkirch

◀ **Self-Portrait with a Model** *Painted in daring blocks of primary color, the artist and model look back at the viewer.* 1907, oil on canvas, 59 x 39¼in, Kunsthalle, Hamburg, Germany

CLOSERlook

BRIGHT COLORS The wide blue and orange stripes on the artist's dressing gown, the touch of red paint on his paintbrush, and the green buttons announce Kirchner's intention to challenge conservative tastes.

▶ **Standing Female Nude** *The Brücke artists were fascinated by so-called "primitive" art from Africa and Oceania. Like certain Fauve painters, they avidly studied and collected such work. This nude is a wholly Western Expressionist take on a primitive woodcarving.* 1914–15, oil on painted hardwood, 38¼ x 6¼ x 4¾in, Allen Memorial Art Museum, Ohio, US

▲ **Woman on the Street** *In contrast to the Dresden paintings, Kirchner's Berlin style was more angular and darker in tone, and the paint was worked over with cross-hatching.* 1915, oil on canvas, 50 x 35¼in, Brücke Museum, Berlin, Germany

Erich **Heckel**

b **DÖBELN, NEAR DRESDEN, 1883**; d **RADOLFZELL AM BODENSEE, 1970**

Abandoning the study of architecture to join the Brücke group of artists, Erich Heckel became the group's unofficial manager. He found their studios, mounted their exhibitions, and organized their summer painting holidays. His contact with Franz Marc made sure the group was included in The *Der Blaue Reiter* (Blue Rider) almanac. In 1909, he toured Italy's artistic centers and was particularly influenced by Etruscan art.

Heckel's main themes were landscape and scenes of men and women bathing. He initially painted in thick primary colors squeezed straight from the tube, but around 1908 he started applying larger sections of a single flatter color, which the Brücke artists often diluted with gasoline to help speed up the drying process.

LIFEline

1901 Becomes friends with Schmidt-Rottluff at secondary school in Chemnitz
1904–05 Studies architecture, but quits to join Die Brücke
1909 Travels to Italy, spends summer at Moritzburg Lakes with Kirchner
1912 Makes friends with Franz Marc
1914 Volunteers for military service in the medical corps
1918 Returns to Berlin
1949–55 Works as professor of fine arts at Karlsruhe
1970 Dies in Radolfzell am Bodensee

◀ **Man on a Plain** *This lonely figure in a landscape, raising his hands to his head in pain as much as reflection, shows the influence of Norwegian artist Edvard Munch on Heckel and other Brücke artists.* 1917, woodcut, 14¾ x 10¾in, City Museum, Leicester, UK

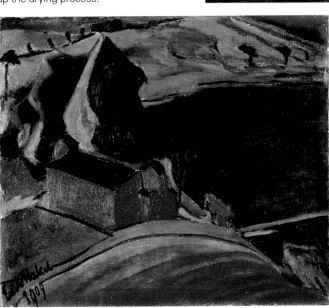

◀ **Lake near Moritzburg** *Like other Brücke artists, Heckel did not employ conventional perspective, and this shows most clearly in their landscapes. They sought a heightened reaction to their work by using color and representation in an extreme way, believing that in time audiences would also share their vision.* 1909, oil on canvas, 23¾ x 27¾in, National Museum and Gallery of Wales, Cardiff, UK

Karl **Schmidt-Rottluff**

b **ROTTLUFF, 1884**; d **BERLIN, 1976**

A school friend of Heckel's, and an original member of Die Brücke, Karl Schmidt-Rottluff suggested the name for the group of artists. Initially, he concentrated on landscape, and was influenced by the passion of van Gogh and the brilliant color of Fauvism. By 1912, he was painting in an expressive angular manner that reflected his admiration for African art. He moved to Berlin in 1911 with the Brücke group, and it was at his suggestion that the Brücke Museum was founded in Berlin in 1964.

▲ **Pensive Woman** *The patterned dress emphasizes the nakedness of the woman's upper body, as she cradles her face in her hands, deep in thought.* 1912, oil on canvas, Brücke Museum, Berlin, Germany

GERMAN EXPRESSIONISM / **EARLY 20TH CENTURY**

Käthe **Kollwitz**

Self-portrait

b KÖNIGSBERG, 1867; d MORITZBURG, 1945

Trained in Munich and Berlin, Käthe Kollwitz chose to devote herself to drawing and printmaking. Vehemently opposed to the social conditions she witnessed in the poorest quarters of Berlin, where she lived and worked alongside her doctor husband, she placed the oppressed at the center of her work. In numerous drawings and prints she portrayed both their personal tragedy and their suffering. She visited the Soviet Union in 1927. Deeply concerned with women's rights, she contributed drawings to a society protecting unmarried mothers. In 1913, she helped found Berlin's Women's Art Union. Though she was opposed to Nazism, the regime did not declare her work degenerate, but used it to promote their own cause, having first removed her name.

LIFEline

1867 Born Käthe Schmidt, in what is now Kaliningrad, Russia
1885 Enrols at Women's Academy Berlin
1891 Marries Dr. Karl Kollwitz, and has two sons, Peter and Hans
1909 Takes up sculpture after a visit to Rodin's studio in 1904
1919–33 Is the first female professor at the Prussian Academy

▶ **Death Seizing a Woman** *A mother clings to her child to save it from death. Kollwitz lost a son in World War I and often saw death and despair in her husband's surgery.* 1934, lithograph print, private collection

▲ **March of the Weavers** *This etching is the fourth of six in a series entitled A Weavers' Revolt and was based on the social drama The Weavers (1892), by German author Gerhart Hauptmann. It depicts an uprising of Silesian workers during a famine in 1844.* 1897, etching, 10¾ x 14¼in, Stadtmuseum, Munich, Germany

CLOSERlook

REVOLT This is not an image of workers resigned to their fate, but of insurrectionary weavers armed with picks and axes. Kollwitz captures their grim determination in the gaunt and furrowed expressions. The Berlin Salon jury wanted to award her the Gold Medal but they were forbidden by Kaiser Wilhelm II.

Ernst **Barlach**

b WEDEL, NEAR HAMBURG, 1870; d ROSTOCK, 1938

▲ **The Avenger** *Barlach's sculpture has a highly expressive inner force and represents the might of the German army during World War I.* 1917, bronze, height 16¾in, private collection

After pursuing art studies in Hamburg and Dresden, Ernst Barlach attended the Académie Julian in Paris from 1895 to 1896. A trip to Russia in 1906 persuaded him to take up sculpture—his theme on his return being Russia's overburdened rural poor.

In 1907 Barlach's financial position was secured when the art dealer Paul Cassirer started paying an annual fee for his work. Also a novelist and playwright, Barlach published his first play, *The Dead Day*, in 1912, accompanied by a collection of his prints.

Wilhelm **Lehmbruck**

b DUISBERG, 1881; d BERLIN, 1919

After completing a course in decorative arts, Lehmbruck attended Düsseldorf's Academy of Fine Arts from 1901 to 1907. As a young man his ideas were shaped by the literature of left-leaning writers such as Emile Zola and by Käthe Kollwitz's highly political art. Stylistically, he was influenced by Rodin (see pp.356–57) and Gothic art, and by his contact with Matisse and Brancusi, whom he met on a visit to Paris in 1910.

In 1911, he made *Kneeling Woman*, which was singled out for praise at an exhibition in Cologne the following year. With his reputation enhanced, a book was published about him in 1913 and he had one-man show in Paris. During World War I he worked in a hospital for the wounded and found the experience deeply disturbing. He committed suicide in 1919, leaving behind four children.

LIFEline

1881 Born the son of a miner in German industrial heartland
1901–07 Studies at the Düsseldorf Academy
1904 Impressed by Rodin retrospective in Düsseldorf
1910 Visits Paris and meets Matisse and Brancusi
1919 Dies in Berlin

▶ **The Prayer** *This sculpture of a naked girl rapt in prayer is both sensual and serene. Like a statue on a Gothic cathedral, her angular form suggests the heaven-bound direction of her thoughts.* 1918, stone, 32¾ x 20 x 13¼in, Kunsthalle, Hamburg, Germany

▲ **Kneeling Woman** *Her elongated body, tilted head, and aura of modesty and calm create a captivatingly Expressionist form, which hovers between the classic and modern.* 1911, cast stone, 70 x 56 x 27¼in, MoMA, New York, US

Franz **Marc**

b **MUNICH, 1880**; d **NEAR VERDUN, 1916**

For Franz Marc, art was a spiritual force that should oppose the corrupting nature of modern industrial society. He studied theology and philosophy before enrolling at Munich's Art Academy. Following visits to Paris between 1903 and 1907, Marc became influenced by van Gogh and the Post-Impressionists. In 1909, he moved to Sindelsdorf in the Bavarian countryside, where, surrounded by nature, he confirmed his belief that only animals possessed the qualities of purity and beauty he found lacking in his fellow human beings. Marc invested color with a specific significance— red for domination and yellow for sensuality, for example. He gradually simplified his style to a few bright colors and uncluttered composition. From 1911 to 1913 he was a leading member of the Der Blaue Reiter group. His work became more complex in construction after 1914 showing the influence of the Futurists and Cubism.

LIFEline

1880 Born in Munich, the second son of a painter
1903 Visits Paris to study new art trends
1909 Moves to Sindelsdorf, Upper Bavaria, where a small artists' colony forms
1910 Art dealer Bernhard Koehler guarantees Marc an income
1916 Dies in World War I at Verdun

▶ **The Red Bull** *Living close to animals, Marc observed and sketched their mannerisms. Color and shape are reduced to bare essentials, with a series of curved lines defining the bull and the surrounding trees.* 1912, oil on canvas, 13¼ x 16¾in, Pushkin Museum, Moscow, Russia

CLOSERlook

SEEING RED For Marc, every color had significance, with red representing not only the material world, but male domination— a fitting color for a bull.

▲ **Fate of the Animals** *In this haunting image of pain and fear, depicting all of nature succumbing to an apocalyptic destructive force, the fragmented forms show the influence of the Futurists. The right-hand section was repainted by Paul Klee after the work was damaged by fire.* 1913, oil on canvas, 77 x 105in, Öffentliche Kunstsammlung, Basel, Switzerland

❝ Is there any more **mysterious idea** for an artist than the conception of how **nature is mirrored** in the eyes of an **animal**? ❞

FRANZ MARC

▲ **Elephant, Horse, and Cow** *By 1914, Marc's work had become influenced by Delaunay's type of abstraction—Orphism. Here, the animals serve more as a device for abstract patterning than suggesting emotionally expressive states.* 1914, oil on canvas, 33½ x 31¼in, private collection

August **Macke**

b **MESCHEDE, WESTPHALIA, 1887;**
d **NEAR PERTHES-LES-HURLUS, CHAMPAGNE, 1914**

August Macke's art did not have the edginess of Die Brücke or the spiritual quest of Der Blaue Reiter. Instead, he portrayed affluent and fashionable middle-class society in and around Munich. His work quite often possessed a whimsical quality, such as in his pictures of bowler-hatted men feeding animals in a zoo, or of a finely dressed woman staring longingly at a display of hats in a shop window.

▼ **The Garden** *The delicate use of color and the criss-cross pattern suggest air and light, and are typical of his watercolor technique.* 1914, watercolor on paper, private collection

Alexei **von Jawlensky**

b **TORZHOK, 1864;** d **WIESBADEN, 1941**

A captain in the Russian army, Alexei von Jawlensky studied art part-time while a soldier, and made friends with Kandinsky before leaving to study art in Munich in 1896. He exhibited his work alongside the Fauves in 1905 and worked in Matisse's studio in 1907. From 1909 to 1914, he was based in Munich and painted landscapes while staying with Kandinsky in Murnau. Althought he did not exhibit with Der Blaue Reiter, he was broadly sympathetic to their aims.

▲ **Head of a Man (Alexander Sacharoff)** *Drawn with a bold, black outline, the subject's glance animates an almost sculptural portrait. Works like this replaced landscape as von Jawlensky's central theme.* c1911, oil on board, 21¼ x 19¾in, private collection

> **Secession Building, Vienna, Austria** *Designed and built by Joseph Maria Olbrich, a student of Austrian architect Otto Wagner, the Secession Building is a striking example of Viennese* Jugendstil *(Art Nouveau) architecture.*

A pulsating metropolis of nearly two million inhabitants, many of whom had come from across the empire to find work in the thriving industrial sector, Vienna was also a deeply divided city. While the poor were packed into tenement buildings, the aristocracy, barons of commerce, and senior civil servants lived in splendid apartments.

At the turn of the 20th century Vienna was an epicenter for music, literature, and the visual arts. The city became a magnet for free-thinking artists from across Europe. At times, this cultural environment led to conflict and scandal.

Jugendstil style

By 1900, an extensive program of public works had been completed, providing an underground train system, new tramways, public buildings, and electric street lighting. The first-ever international automobile rally was held in the city in 1899. Much of the new construction was designed in the Jugendstil, the German term for Art Nouveau. Working alongside architects, leading artists decorated interiors with Symbolist motifs, such as elegant floral patterns and sinuous female forms.

Café culture

Above all, Vienna was a vibrant café society, where artists and their friends met to discuss projects, artistic events abroad, and, most probably, the controversial ideas of Viennese neurologist and founder of psychoanalysis, Sigmund Freud. Upright Viennese society believed Freud's theories concerning primal sexual urges and the meaning of dreams were immoral. It was in the realm of sex and nudity that artists would also have their battles with Viennese notions of decency.

CURRENTevents

1848–1914 Vienna's population booms from 400,000 to over two million.

1897 Karl Lueger, the openly anti-Jewish politician, is elected the city's Lord Mayor.

1908 Vienna is shocked by the first Kunstschau (art show) where Klimt and others show provocative new work.

1911 Death of the leading Modernist composer Gustav Mahler.

Pre-war Vienna

Oskar **Kokoschka**

Photograph by Lotte Meitner-Graf

b PÖCHLARN, 1886; d MONTREUX, 1980

An artist, playwright, and illustrator, Oscar Kokoschka was still a student at Vienna's School of Arts and Crafts when he gained immediate notoriety in 1908 at the newly conceived Kunstschau, where he exhibited a painted skeletal head in blue wash, a screaming self-portrait bust, and a group of violent illustrations for his play *Murderer, Hope of Women.*

Kokoschka went on to paint portraits of many of Vienna's leading intellectuals, exposing them to his frank, psychologically probing brushwork. He later developed a fascination for cityscapes which he addressed with the very same insight and energetic handling.

▼ **Adolf Loos** *The architect Adolf Loos was Kokoschka's great friend and supporter, who introduced the artist to other prominent Viennese intellectuals. Kokoschka's depiction of Loos shows the nervous energy of sitter and artist alike. 1909, oil on canvas, 29¼ x 36¾in, Staatliche Museen, Berlin, Germany*

Egon **Schiele**

Self-portrait

b TULLN, NEAR VIENNA, 1890; d VIENNA, 1918

An expressive and brilliant draftsman, Schiele gained renown for his erotic and somewhat tortured portrayal of the naked body. He also painted still lifes and the local countryside, which he liked to visit by train on day trips.

Schiele portrayed the uneasy relationship he had with his mother in acutely melancholic pictures such as *Dead Mother* (1910). In April 1912, he was arrested on the grounds that children visiting his studio had, when viewing his art, been exposed to pornography. He was imprisoned for 26 days. The scandal only enhanced his reputation and his work gained many new followers.

▶ **Self-Portrait Nude** *Schiele drew and painted his naked form at least 100 times, closely exploring his most private desires and sexual urges. Typically, his body is set against an empty monochrome backdrop, to stress the sense of fragility, and at an awkward angle to heighten the sense of tension. 1910, watercolor and gouache on paper, Graphische Sammlung, Vienna, Austria*

Gustav **Klimt**

Photograph by Moritz Nähr

b BAUMGARTEN, NEAR VIENNA, 1862; d VIENNA, 1918

Fusing Symbolist imagery, a gentle impressionism, and boldly designed patterns, Gustav Klimt created a highly distinctive and sensual style. His decorative art came to typify the spirit of progress and luxury in Imperial Vienna prior to World War I, and he himself had an enormous appetite for life. Klimt was generous to his fellow artists, who affectionately dubbed him "Der König" (The King). He won important commissions from the Viennese authorities and was awarded the Emperor Prize in 1890 and the Gold Prize at the World Exhibition in Paris in 1900.

At times, Klimt's frank, realistic portrayal of nudity and unconventional compositions led to fierce criticism and scandal and accusations that his work was pornographic. Klimt also painted many fine landscapes, but is renowned for his portraits of beautiful, aristocratic, and wealthy women. Many of his drawings were considered too erotic to show in public.

LIFEline

1862 Born, an engraver's son

1876–83 Attends Vienna's School of Applied Arts

1886–88 Works on paintings for Vienna's Burgtheater

1894 Commissioned to paint three Symbolist panels for Vienna University

1903 Visits Italy to study ancient Byzantine mosaics

1905 Returns fee for panels to Vienna University following scandals over nudity

1907–08 Paints *The Kiss* (see pp414–15)

1909–11 Paints friezes for Stoclet Palace, Brussels

1918 Dies from pneumonia

▼ **Fable** *Klimt's technical ability impressed the Viennese art establishment and won him important commissions. This classical scene illustrates the artist's grasp of the dynamic use of dark and light.* 1883, oil on canvas, 33½ x 46½in, Historisches Museum der Stadt Wien, Vienna, Austria

▶ **Judith** *In the biblical tale, the brave and beautiful Jewish widow Judith beheads the drunken Assyrian tyrant Holofernes after a banquet. The choker across her neck reminds us that her pleasure stems from the beheading.* 1901, oil on canvas, 33 x 16½in, Österreichische Galerie, Vienna, Austria

CLOSERlook

CAUGHT IN THE ACT
Surrounded by golden fig trees and grapevines reminiscent of ancient Assyrian times, Judith's face—with lips parted and eyes closed—reveals her at the height of her excitement after the deed.

◀ **Emilie Floege** *This luscious portrait of Klimt's sister-in-law and close companion signals a marked shift in his portraiture. The former mild impressionism is replaced by a flatter, more geometric style. Richly colored patterns and strong design dominate, yet the viewer's gaze is drawn to his model's tender expression.* 1902, oil on canvas, 71¼ x 72¼in, Historisches Museum der Stadt Wien, Vienna, Austria

CLOSERlook

ABSTRACTION Klimt's repeated ornamental motifs allowed him to revel in what in time would develop into almost abstract designs. Here, the artist's use of deep blues, mauves, and pure gold oblongs make for stunning effect.

◀ **Danae** *Klimt's depiction of the mythological story of Jupiter ravishing Danae in the form of a shower of gold caused an unfortunate scandel. Many were offended by the figure's openly sexual position and her expression of dreamy ecstasy.* 1907–08, oil on canvas, 30¼ x 32¾in, private collection

> " All **art** is **erotic** "
>
> GUSTAV KLIMT

The Kiss *Gustav Klimt*
1907–08, 70⅞ x 31½in, Österreichische Galerie Belvedere, Vienna, Austria

The Kiss Gustav Klimt

There is perhaps no other painting in Western art so celebrated for its depiction of sensual love. The image is not just an intimate moment, but a universalized embrace between the sexes. Of the couple's bodies we see only the man's head and neck, and the hands that encourage his lover's lips toward his own. Of the woman, we are shown only her face, arm, hands, and feet. The pictorial space is dominated by elaborate decorative motifs made up of geometric patterns and flowers. It is astonishing that with so little of the couple depicted, Klimt so readily convinces us of their intimacy.

Technique

In *The Kiss* Klimt uses both matt and shiny gold leaf, silver leaf, and silver thread (on the woman's robe). Gold dust covers the umber background. The raised spiral shapes on the robes are gesso-covered in gold. Klimt had studied the decorative arts as a student and was versed in gilding and mosaic work and had visited Ravenna's churches with their Byzantine mosaics. Here, the mosaic is mostly painted effect, but there is some raised ornament. The flowers and flesh are oil paint.

▼ **DETAILED DECORATION** The symbolic element of the decoration is exemplified in the pattern on the robes. The man's is more angular, comprising black, silver, and white rectangles and squares. The woman's robe (below) has colored roundels representing flower heads.

▲ **FLOWERS** The painted naturalistic bed of flowers on which the couple kneel provides an essential counterweight to the stylized clothing and chair. It also serves to anchor this almost mystical description of love on to the material world.

▲ **BACKGROUND** Klimt uses shiny gold dust on top of a warm red umber for the painting's background. The flatness and neutrality does not add depth, but complements the costumes, the couple, and the flowery clifftop.

Composition

The two figures are depicted against a tall wing-backed chair, which is not always noticed by the viewer. Only the diminution of the roundels (circles) toward the top of the canvas gives a hint of depth to the chair. Some commentators have interpreted the man, woman, and chair as forming a phallic shape, suggesting sexual conquest. Another argument is that the lovers are set inside a "golden bell"—symbolizing the couple's isolation from the outside world as they are lost in their embrace.

▲ **LOVERS** Both lovers wear flowers in their hair reminiscent of a nimbus (halo) found in Byzantine icons. Klimt focuses the viewer's attention on the recipient of the kiss. The woman is portrayed submissively, rather than as the *femme fatale* so typical of much of Klimt's work.

THE SUBJECT OF THE KISS At the beginning of the 20th century, artists began to explore the nature of intimacy between the sexes. Two masterpieces of modern sculpture, by Constantin Brancusi and Auguste Rodin, were on the theme of the kiss, while at the same time Norwegian artist Edvard Munch depicted the darker side of intimacy.

The Kiss *Edvard Munch* The young woman's head is obscured by the shadowy male figure, and her body, painted in pearly tones, suggests an innocence that is about to be taken. c1910, oil on canvas, 23⅜ x 17¾in, private collection

▲ **TENSION** The woman's toes curling to grip the earth suggest that she, at least, senses the precariousness of the relationship.

Origins and influences

By the beginning of the 20th century, Europe's most advanced painters were becoming less concerned with creating an illusion of depth and volume in their work. Artists had grown increasingly aware of alternatives to the Western tradition—the art of Africa, for instance, challenged Western art's ideas of naturalism and beauty. By playing with representations of objects and space, Cubism broke down these conventions.

The originators of Cubism were Pablo Picasso and Georges Braque, although their concern with technical innovations meant their paintings were sometimes hard to decipher. "Salon Cubists" like Albert Gleizes and Roger de la Fresnaye worked on a larger scale, with more easily legible subjects.

▲ **The Modern School** Luc Metivet, 1911 *"What's this?" "A Cube as a model since you're a Cubist now." "Well, I never thought that's how it's done." Cubism was just coming out of artists' studios into the public domain when this was published. It is more a satire on the eagerness to follow a new trend than on Cubism itself.*

Style and technique

Most Cubist painting used a limited range of colors (and at one stage was replaced by collage), preferring to concentrate on the analysis of form. Rather than seeing the subject from a single point of view, painters combined different angles and aspects of a subject. The images created have to be deciphered, requiring the viewer to become an active participant.

Subject matter

Picasso and Braque focused on still life and the figure, taking their subjects from Parisian café culture. The "Salon Cubists" painted many multi-figure subjects, possibly because their works were less stylistically complex and designed to appeal to a wider public.

In the space of just a few years, Cubism overturned many of the visual conventions that had dominated Western art since the Renaissance. Initially the project of a handful of painters working in Paris, it laid the groundwork for innovative art for over 50 years.

Cubism

TIMEline

Picasso's *Les Demoiselles d'Avignon* (1906-07) is usually considered the first real Cubist painting. Although seen by few at the time, it set a challenge to all young advanced painters in Paris. First, in 1907, Braque painted a large nude under its influence, then other painters, such as Gris and Léger, became associated with the movement. In 1912, the first book on the subject was published. Its authors were the "Salon Cubists" Gleizes and Metzinger.

1907

PICASSO Les Demoiselles d'Avignon

1911

BRAQUE The Portuguese

1912

GLEIZES The Bathers

1915

GRIS Breakfast

▲ **Seated nude (study for Les Demoiselles)** Pablo Picasso *Picasso spent six months preparing his revolutionary work. On seeing it, Braque was so overwhelmed that he told him "... it is as if you want us to exchange our usual diet for rope and kerosene!"* 1907, oil on canvas, 23¾ x 18in, Musee Picasso, Paris, France

Development

Although Picasso and Braque left little verbal explanation of what they were trying to do, art historians have identified some clearly defined phases in the development of Cubism.

In the period between 1907 and 1909, sometimes called the "Negro Mask" period, Picasso and Braque defied Western traditions of beauty by representing the subject in terms of block-like forms. It was this that gave rise to the name "Cubist," assigned by the critic Louis Vauxcelles.

Early Cubism

The early examples of the movement are described as Analytic Cubism, and the paintings of the years 1909–12 are the most complex and fragmented. Forms are shattered and reconstituted on the picture surface. Stenciled letters sometimes give cryptic clues as to meaning.

A more accessible kind of painting, Synthetic Cubism began to evolve from 1912 onward, and employed simple flat planes of color. The subject is suggested by abstract forms, meaningless except in the context of the painting. This lack of concern for subject-matter has led to Cubism being described as an attempt to achieve a kind of "pure visual music." This was the argument of Picasso's friend, the writer Guillaume Apollinaire, and leads directly to abstract art.

During this period, pasted papers, such as fragments of newspaper or wallpaper, were added, bringing the worlds of commercial culture and politics into the painting. These flat planes are also found in a revolutionary series of sculptures made from cut-out cardboard by Picasso.

Late Cubism

In 1914, Picasso's paintings became more colorful and exuberant. Cubism was now a license for freedom rather than a restraining discipline. Some Cubists, including Braque, found it hard to follow.

During World War I many, but not the Spaniard Picasso, served in the French army. Following the war, there was a widespread reaction against Cubism—sometimes called the "Return to Order"—but Cubism had left its mark, revolutionizing

▲ **Pierrot** Juan Gris *Gris painted a series of pierrots (sad clowns). This work breaks down the figure into a collection of geometric shapes.* 1919, oil on canvas, 35½ x 27½in, Musee National d'Art Moderne, Centre Pompidou, Paris, France

the means of representation, and the process in which a picture represents the world. This impact was felt not only in painting and sculpture, but also on later developments in design and architecture.

Georges **Braque**

Georges
Braque, c1945

b ARGENTEUIL-SUR-SEINE, 1882; d PARIS, 1963

Georges Braque trained as a house decorator before moving to Paris in 1900 to continue his apprenticeship and study art. By 1906, Braque was involved with the Fauve movement, but two events were to lead to a drastic change of style. In 1907 he was impressed by Cézanne's retrospective at the Salon d'Automne and he met Picasso, in whose studio he saw *Demoiselles d'Avignon* (see p.418).

Braque began collaborating with Picasso on a new approach to painting, a process that lasted for over five years. Their new style—Cubism—was based on collapsing perspective into overlapping planes. On reaching the threshold of abstraction, they played with ideas of illusion through the introduction of recognizable elements. Many of their innovations—such as lettering, *papiers collés* (collage using decorative or printed paper), *trompe l'oeil* (literally, deceives the eye, a device used to trick the viewer), and paint thickening—came from Braque's training as a decorator. The partnership ended with Braque's conscription during World War I.

After recovering from a head wound, Braque briefly returned to Cubism in 1917 before moving on to a more personal style. This continued his investigations into space and the relations between objects by seeking a Zen-like balance between color, texture, and design. This more meditative approach is evident in his *Table*, *Billiard*, and *Studio* still lifes and in his repeated treatment of a bird motif.

LIFEline

1907 Creates Cubism with Picasso
1915 Suffers head wound in World War I, spends two years in convalescence
1920s *Table* series are first major paintings in new style
1949–56 *Studio* series
1953 Becomes only living artist to exhibit at the Louvre
1963 Dies in Paris; and is given a state funeral

▶ **Le Portugais (the Emigrant)** *This portrait of a guitarist seated in the window of a harbor café-bar is one of the most sophisticated works from Braque's Cubist period. Its innovative use of lettering paved the way for the use of other creative elements in Braque's work, such as* trompe l'oeil *and collage.* 1911, oil on canvas, 46⅛ x 32¼in, Kunstmuseum, Basel, Switzerland

CLOSERlook

TYPOGRAPHY Lettering and numbers provide clues to deciphering this picture. "D BAL" is a fragment of a poster advertising a *Grand Bal* (a dance), while the numbers "10.40" are from a bar bill; both elements suggest the setting is a cafe. This text plays with the perceptions of two- and three-dimensional space by providing a contrast with the "solid" objects in the space behind.

◀ **The Studio IX** *The nine paintings in* The Studio *series are seen as self-portraits with the artist's studio visited by a bird. In this, the final piece, the bird is an abstract collection of shapes.* 1952–56, oil on canvas, 57½ x 57½in, Pompidou Center, Paris, France

▼ **Bottle, Newspaper, Pipe, and Glass** *Braque introduced wallpaper and* trompe l'oeil *effects during Cubism's Synthetic phase (1912–14). The mix of real objects (newspapers) with drawn and printed objects (wood paneling) added multiple layers of illusion.* 1913, charcoal and collage on paper, 18⅞ x 25¼in, private collection

◀ **Canephora** *After World War I, Braque, like many other painters, was associated with a classical revival. Many paintings of the period have a gritty surface and fluid handling that evoke the musical paintings of antiquity. The monumental nudes of Renoir were in vogue with collectors, following a memorial retrospective of his work in 1920. This massive treatment of the female figure is characteristic not just of Braque but of other European artists of the post-war years.* 1922, oil on canvas, 71¼ x 28¾in, Pompidou Center, Paris, France

CLOSERlook

FERTILITY SYMBOLS
One of the woman's arms is like a trunk, with a gnarled hand that appears to be growing into the fruit basket rather than simply reaching into it. The figure is rooted to the ground by her robes and feet. This association of woman with the fecundity of the earth reflected France's desire to repopulate after the devastation of war.

Pablo **Picasso**

b MALAGA, 1881; d MOUGINS, 1973

Pablo Picasso, 1950s

The prodigious career of painter and sculptor Pablo Picasso provides the backbone of 20th-century art. His fame owed as much to his constant innovation as to the critical and financial success he enjoyed.

Picasso proved a precocious art student, winning academic competitions by the age of 15. As a young artist, he moved to Barcelona before settling in Paris. There, he mixed in bohemian circles and met the artist Georges Braque. Between 1909 and 1914, the two of them were the leading figures in the development of Cubism—they took further than any of their contemporaries the fragmentation of form, the collapsing of perspective, and the playing with reality and illusion, which were all aspects of this complex and enormously influential movement. For a while after World War I, Picasso took part in the widespread revival of classicism, a tendency usually associated with political and artistic restraint. He surprised again in 1925 when he associated himself with the Surrealists, then the most extreme wing of the Parisian avant-garde. After World War II he settled in Vallauris, where he took up ceramics.

Notorious for his womanizing, Picasso made his wives and mistresses a frequent subject for his art. His work went through several recognizable phases, often triggered by his mood or environment. Never adopting a style or movement for long, Picasso cannibalized ideas from everywhere —medieval and African art, bullfights, mythology, Old Masters— reprocessing them through his uniquely humorous and original vision.

LIFEline

1901–04 Produces his "Blue Period" paintings

1904 Settles in Paris

1904–06 Works on "Rose Period" paintings

1906–07 Paints *Les Demoiselles d'Avignon*

1907–14 Develops Cubism with Georges Braque

1917 Meets his first wife, Olga Kokhlova

1920s Neoclassical phase

1925 Participates in first Surrealist exhibition

1937 Paints *Guernica* (see pp.422–25)

1944 Joins Communist Party in wake of the liberation of Paris. Remains loyal member for the rest of his life

1947 Moves to Vallauris in the south of France

1973 Dies, aged 91, and is given a state funeral

▼ **La Vie** This deeply personal and symbolic painting entitled Life *is haunted by the suicide of Picasso's close friend, Casagemas, over an unhappy affair. It offers a commentary on love, death, and relations between the sexes. 1903, oil on canvas, 77¼ x 50¾in, Cleveland Museum of Art, Ohio, US*

▶ **Les Demoiselles d'Avignon** This disturbing depiction of prostitutes in a brothel in Avignon, Barcelona's red-light district, proved to be one of the most notorious pictures of the 20th century and was a precursor of Cubism and modern art. Its collapse of perspective and combination of geometric and primitivist styles—inspired by Iberian sculpture and African art—were a reinvention of the possibilities of art. 1906–07, oil on canvas, 96 x 92in, MoMA, New York, US

CLOSERlook

ANGULAR FORMS
Broken, jagged, intersecting lines dominate the picture, making the eye leap from one jutting, angular form to the next. The fusion of figures and background was inspired by Cézanne's *Bathers* paintings (see p.369).

CLOSERlook

TRAGIC POSES This painting dates from Picasso's "Blue Period." He chose blue to evoke a mood of melancholy. In the background, two sets of figures crouch in tragic poses, as if on paintings propped up against the wall. The upper figures huddle together in despair.

▲ **Violin and Sheet Music** *Cubist still lifes included many references to music and instruments. The latter were often chosen because of their resemblance to a woman's body. Made entirely from cut-out, painted paper, this work introduces layers of illusion. 1912, paper, 30¾ x 25¼in, Musée Picasso, Paris, France*

" Art is a lie that makes us **realize the truth "**

PABLO PICASSO

▲ **Woman with Guitar** *The stenciled letters,* Ma Jolie (My Pretty One), *at the bottom of this portrait are an affectionate reference to Picasso's lover, Eva Goel.* 1911, oil on canvas, 39¼ x 25¾in, MoMA, New York, US

▲ **Still Life with Chair Caning** *The first Cubist collage, this picture subverts artistic illusion by introducing a real element to represent a chair, while choosing an oval rope frame to suggest a tabletop.* 1912, oil and oilcloth on canvas with rope, 10¾ x 13¾in, Musée Picasso, Paris, France

▼ **Women Running on the Beach** *After World War I, Picasso adopted a classical style. The exuberance of these competing women is conveyed by their distorted limbs.* 1922, gouache on plywood, 13 x 16in, Musée Picasso, Paris, France

▶ **The Three Dancers** *This painting heralded a new freedom of expression for Picasso, transforming the flat patterning of late Cubism into a more colorful, Surrealist style. The distorted pose of the crazed dancer on the left marked the start of increasingly violent dissections of the human form, provoked by Picasso's worsening relationship with his wife Olga.* 1925, oil on canvas, 84½ x 56in, Tate, London, UK

▼ **Figures at the Seashore** *Picasso endlessly transformed the human body, fragmenting it into its bare components. This aggressive image is charged with sexual friction, and pushes his representation of the human form to its limits.* 1931, oil on canvas, 51¼ x 77in, Musée Picasso, Paris, France

CLOSERlook

BATTLE OF THE SEXES At first sight, the jumbled mess of brown, bony lumps locked in a embrace appears barely human. But the clues are all there: the spherical breasts and closed eyes of the woman and the dominant arm, phallic nose, and open eyes of the man.

INcontext

ART DEALERS From the start of his career, Picasso found people who supported him, and he was always astute in his business dealings. Wealthy patrons bought his works directly, but he was also sustained by a number of art dealers. Competition between them, often encouraged by Picasso, brought him considerable success, while numerous exhibitions spread his fame.

Kahnweiler and Picasso *The German art critic Daniel-Henry Kahnweiler was a dealer in Paris. He was the first person to exhibit Cubist works, and remained a close friend of Picasso's.*

▶ **Portrait of Dora Maar** *Picasso met the Yugoslav photographer Dora Maar in 1936. She soon appeared in a number of portraits, including the* Weeping Woman *series. Dora's elegant pose contrasts strikingly with the violent distortions of some of his other female portraits. 1937, oil on canvas, 36¼ x 25½in, Musée Picasso, Paris, France*

CLOSERlook

SIMULTANEOUS VIEWS Dora's face is shown in front and profile views, with her eyes—made livelier by the contrasting use of red and green—looking in both directions. Bright colors and angular forms suggest a strong temperament, but the striped background traps her in a cage.

▼ **Woman in a Garden** *Working with Gonzalez, Picasso evolved a new kind of open-work sculpture in welded metal. It leant itself to fantastic transformations that also appealed to the Surrealists. This piece was inspired by his fascination with the myth of Daphne, who was transformed into a tree. 1929–30, welded and painted steel, 81 x 46 x 33½in, Musée Picasso, Paris, France*

▼ **Le Déjeuner sur l'herbe, after Manet** *In his later years, Picasso was not afraid to compare himself to the great artists before him. He produced numerous interpretations of famous works, including this one, which allowed him to revisit a favorite theme—the artist and model. 1960, oil on canvas, 51 x 77in, Musée Picasso, Paris, France*

Guernica *Pablo Picasso*
1937, oil on canvas, 137¾ x 307⅛in, Museo Nacional Centro de Arte Reina Sofia, Madrid, Spain ➤

Guernica Pablo Picasso

Some critics consider *Guernica* to be the greatest painting of the 20th century. It is certainly the most famous anti-war painting, becoming as much a symbol for the misery of modern war in general as for atrocity in the Spanish Civil War. In January 1937, Picasso was commissioned by the Republican government to produce a mural for the Spanish Pavilion at the Paris World Fair. Initially he had planned a studio scene, but the bombing of Guernica three months later changed everything, providing Picasso with his theme. On first showing, it came under severe criticism from fascists ("degenerate") and communists ("anti-social") alike, besides baffling many critics and viewers.

▲ **PICASSO WORKING ON GUERNICA** The canvas was so high that Picasso had to slope it against the wall at one end of his studio to fit it into the space. Picasso used a ladder and brushes strapped on to sticks to reach the top part of the painting.

" The **bull** is not fascism but it is **brutality and darkness**... the **horse** represents the **people**... the Guernica mural is **symbolic** "

PABLO PICASSO, 1945

Composition

Starting on May 1, 1937, Picasso took five weeks to complete *Guernica*, which was staggeringly fast for such a monumental work. Forty-five dated sketches for the composition and figures show how it evolved. By painting *Guernica* as an allegorical history, Picasso was drawing on an established, traditional genre (especially Rubens's *The Horrors of War*), to which he added a frieze-like, triptych structure and seven figures drawn from a combination of art tradition and his own highly personal stock of imagery.

▲ **TRIANGULAR STRUCTURE** The painting is divided into three parts united by a triangular structure. The two diagonals (from the table on the left and the woman's head on the right) meet at the lamp. This composition also draws the viewer's attention to the screaming horse.

INcontext

SPANISH CIVIL WAR Violence erupted in 1936 following a military coup against the newly elected Republican government. The war devastated Spain between July 1936 and March 1939. Society divided into those supporting the rebels, led by Franco, and the Republicans who supported the government. Artists such as Picasso, Miró, and Dalí produced works on the atrocity of the war.

General Franciso Franco *In July 1936, General Franco led the army in a rebellion against the Republican government. After leading the Nationalists to victory Franco became head of state of all Spain in 1939 and remained so until his death in 1975. The Fascist regime he established had far-reaching effects on the art and culture in this period.*

Technique

From the start, Picasso conceived his painting in shades of gray, drawing inspiration from both the expressive possibility of Goya's *Disasters of War* etchings (see p.303), and the distressing photographs he had seen in newspaper reports. The absence of color, irregular perspectives, and use of dark and light areas unrelated to any light source all serve to heighten the scene's nightmarish quality. Picasso borrowed from his formidable armory of artistic styles to express universal suffering, drawing on his personal iconography and the Cubist and Surrealist traditions of distorting and fragmenting shapes.

▲ **UNDERDRAWING** The ambivalent bull/minotaur figure obsessed Picasso and was a regular theme in his work. Here, the visible presence of a faded third eye shows how Picasso continually reworked this painting. The final version shows the helpless bull confronting the viewer with two human eyes.

▶ **DISTORTING HUMAN FORM** The bare-breasted lady was one of the first figures to appear in Picasso's studies, and remained virtually unchanged. Her floating, elongated head and the breasts squeezing her star-shaped hand borrow from his surrealist experiments in distorting human form.

Story

On the afternoon of April 26, 1937, the Basque town of Guernica was devastated by German bombers and fighters from the Condor Legion acting on Franco's orders. The bombardment lasted three hours, destroyed half the town, and left over 1,600 defenseless civilians dead. When Picasso started painting *Guernica*, many of its motifs—such as the horse and bull—were personal, ambivalent symbols related to the *corrida* (bullfight), which had been running through his work for years.

▶ THE WOUNDED HORSE

Originally, Picasso drew a boldly raised arm with a clenched first (the familiar salute of the Spanish Republican forces) as the painting's focal point. However, unhappy with its obvious symbolism, Picasso replaced the raised arm with the twisted features of the horse, whose spiked tongue evokes the primal scream (of pain) of the innocent victims of war.

▶ HIDDEN BULL'S HEAD

After erasing much of his overtly symbolic imagery, Picasso could not resist leaving several hidden motifs within the painting. These included a second bull's head, formed by the horse's bent, front right leg, which appears to be nuzzling the statue's hand. While the bull appears to be neutral, it could be goring the horse from underneath.

◀ TOILET INTERRUPTUS

The semi-clothed figure, who dashes out from the right, desperate to know what is happening, stares blankly at the blazing bulb. Oblivious of her state of undress, she seems to have been interrupted in her actions. Picasso sometimes illustrated her plight to visitors to his studio by pinning toilet tissue to her left hand.

▲ HIDDEN SKULL

Picasso included several subliminal motifs of death, including this skull, formed out of the horse's nostrils and upper teeth. Another larger skull in profile is concealed in the horse's body, forming the lower jawbone out of its bent knee.

◀ PIETÀ

The image of the grief-stricken mother holding her dead child echoes a familiar pose of suffering in art, most famously in Michelangelo's *Pietà*. Picasso distorts the mother's body—splayed fingers, arched neck, and gaping mouth—to heighten the emotional impact.

▼ SUN/LIGHT

Picasso originally painted a sun before converting it into an eye with a lightbulb. The Spanish word for lightbulb is *bombia* which is similar to *bomba*, the Spanish word for bomb.

▲ LADY HOLDING THE LAMP

This ghostly figure holding a lamp, who appears to float through a window, illuminates the chaotic scene. This allegorical motif—the most famous of which is the Statue of Liberty in New York—was a recognized symbol of enlightenment.

Juan **Gris**

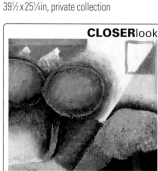

Photograph by Georges Duthuit

b **MADRID, 1887**; d **BOULOGNE-BILLANCOURT, 1927**

Generally considered to be the "third man" of Cubism, Juan Gris was a Spanish illustrator who moved to Paris at the age of 19. He soon became friends with Picasso, and from 1911 he engaged with Cubism. Gris proved himself adept at the new idiom, bringing a rigor—in particular relating to the space between objects—a clarity, and a colorful touch all his own. He also attracted the attention of dealers such as Kahnweiler, the first person to exhibit Cubist works. Gris's early works are constructed with the precision of an engineer's diagram: objects are arranged on a grid according to strict mathematical relationships. After 1915, his mastery of the painterly possibilities of collage, using combinations of cut-outs, superimpositions, and folded planes, demonstrated a real understanding that marked him out from the other Salon Cubists (see below).

LIFEline

1906 Moves to Paris

1912 Exhibits Cubist works at *Salon des Indépendants* with the Puteaux Group

1913 Visits Picasso in Céret, in the French Pyrénées; adopts bright colors

1915 Visits Collioure, France; meets Matisse

1923 Stages his first major one-man exhibition in Paris

1924 Designs costumes and sets and for Diaghilev's *Ballets Russes*. Lectures at the University of Paris

▶ **Landscape at Céret** *In the summer of 1913, Gris joined Picasso in Céret, France, and started composing with areas of bright color. He replaced the linear framework he had used with overlapping planes borrowed from the papiers collés (a type of collage) of Synthetic Cubism. 1913, oil on canvas, 39½ x 25¼in, private collection*

CLOSERlook

OVERLAPPING PLANES
Gris used a system of opaque, overlapping planes to provide the picture's spatial structure. Each plane is differentiated from the others by tone and texture, and so takes its place in front of or behind the surrounding planes.

▼ **Breakfast** *Cubism's stylistic devices are represented here by different color planes, on which objects are drawn (bowl, glass), colored (sky), fragmented (coffee pot), or "metamorphosed" (coffee grinder). 1915, oil and charcoal on canvas, 36 x 29in, Centre Pompidou, Paris, France*

INcontext

THE PUTEAUX GROUP Sometimes called the Salon Cubists or Soction d'Or, the Puteaux Group were a collection of artists who worked in the Parisian suburb of Puteaux. The diverse members included Gleizes, Léger, and Metzinger.

The three Duchamp brothers —*(from left) Marcel, Jacques, and Raymond—were at the heart of a group of artists whose work was influenced by Cubism.*

Fernand **Léger**

b **ARGENTAN, 1881**; d **PARIS, 1955**

Fernand Léger used his art to create a vision of the future, taking the objects and materials of modern, urban life as his subject, and the relationship of humans with technology as his theme. The son of Normandy farmers, Léger trained as an architect's draftsman before moving to Paris in 1903 to study art. He used the language of Cubism to depict his interest in the materials of modern life. His early "tubist" style, with its disjointed, curvilinear forms, became increasingly abstract, and eventually evolved into a simpler "machine aesthetic" in which Léger deliberately adopted the bold, flat colors and lines of commercial art for his depiction of people in the mechanized city.

LIFEline

1906 Discovers Paul Cézanne's work

1911 *Nudes in the Forest* has a huge impact when exhibited

1913 *Contrastes de Formes* series brings him close to abstraction

1919–30 Makes murals for architect Le Corbusier

1940–45 Lives in the US during World War II

1944 Joins Communist Party

▶ **The Wedding** *Léger uses the fragmented forms of metallic shapes to depict a wedding procession. The curved, interlocking white planes evoke a bridal gown. 1911–12, oil on canvas, 101 x 81in, Centre Pompidou, Paris, France*

▲ **The Mechanic** *In the 1920s, Léger shifted his focus to the mechanized city and the relationship of people with their environment. 1920, oil on canvas, 46 x 35in, National Gallery, Montreal, Canada*

Roger **de La Fresnaye**

b **LE MANS, 1885;** d **GRASSE, 1925**

Roger de La Fresnaye, an academically trained painter, applied a Cubist-influenced style to monumental scenes of contemporary life. More concerned with color than many Cubists, he produced a kind of painting that was less fragmented and more easily legible than Picasso, Braque, and Gris. Originally influenced by the Nabis (see p.380), La Fresnaye was drawn into the Puteaux Group (see p.426) after meeting one of the Duchamp brothers, Raymond Duchamp-Villion, in 1910.

Changing his style under the influence of Cézanne, he exhibited at Penteaux exhibitions, but his Cubism was more decorative than structural. After World War I, he abandoned Cubism for a more linear style.

◀ **Sketch for the Conquest of Air** *La Fresnaye's best-known work is a tribute to flight and open-air life. In the finished painting, two figures, rather than three as in this sketch, discuss France's aeronautical triumphs below disc-like clouds and a small balloon.* 1913, oil on canvas, 37 x 28in, Musée d'Art Moderne, Troyes, France

Albert **Gleizes**

b **PARIS, 1881;** d **AVIGNON, 1953**

▲ **The Bathers** *Gleizes often united past traditions (here, bathers in the style of Cézanne) with the modern world (belching factories). This ambitious picture uses a rhythm of forms and colors to flatten the space and unify the composition.* 1912, oil on canvas, 41¼ x 67in, Musée d'Art Moderne de la Ville de Paris, France

Albert Gleizes came from an artistic background, and his early work was inspired by the Impressionists. In 1906, he founded a short-lived utopian community for artists and writers at the Abbaye de Créteil. After moving back to Paris in 1909, he met Jean Metzinger and Robert Delaunay and started to apply a geometric style to his painting.

Gleizes exhibited his first Cubist works in 1910, and soon became one of the leading Salon Cubists, exhibiting with the Puteaux Group (see p.426) and at The Armory Show in New York, which introduced Cubism to the US. He co-authored, with Metzinger, the influential, if partial, guide to the movement's history and principles, *Du Cubisme* (1912). In 1926, he moved to Isère, France, where he founded a community of religious painters and artisans.

Jean **Metzinger**

b **NANTES, 1883;** d **PARIS, 1956**

One of the leading Salon Cubists, Jean Metzinger studied art in Nantes, before moving to Paris in 1903. After dabbling with Impressionism and Fauvism, he turned to Cubism in 1908, showing work at the first Cubist exhibitions and with the Puteaux Group (see p.426). His co-authorship of *Du Cubisme* with Gleizes brought fame beyond his paintings.

▲ **The Knitter** *Techniques of Synthetic Cubism, combining different shapes and textures, are used here while showing Metzinger on the point of adopting a greater naturalism.* 1919, oil on canvas, 46 x 32in, Pompidou Centre, Paris, France

Alexander **Archipenko**

b **KIEV, 1887;** d **NEW YORK, 1964**

The innovative work of Alexander Archipenko played an important role in the evolution of modern sculpture. He grafted the tradition of the Russian icon, with its deep frame and applied incrustation, on to Cubist sculpture, while assimilating influences of Primitivism and collage.

After studying art in Kiev, he moved to Moscow, and then to Paris where he soon became associated with Cubists, becoming preoccupied with the problems of volume, space, and movement. He lived in Berlin from 1921 to 1923, before moving to the US where he remained until his death. His exploration of concave and convex forms, the relationships between solid and void and sculpto-painting left a lasting legacy.

▶ **Woman with a Fan** *Archipenko experimented relentlessly with new techniques and materials in an attempt to find his own style. This painted bronze relief juxtaposes stylized abstract forms (planes, cones, and cylinders), made from glass, metal, wood, and papier-mâché, against a flat background.* 1914, polychrome bronze, height 42½in, private collection

Jacques **Lipchitz**

b **DRUSKINKAI, 1891;** d **CAPRI, 1973**

◀ **Seated Man with Guitar** *Lipchitz's sculptures are probably the closest in spirit to Cubist paintings. Figures and heads are reduced to faceted surfaces and tall, rectangular planes developed around a vertical axis and linked in a jaunty rhythm of curves and angles.* 1918, bronze, height 30¼in, private collection

The Lithuanian sculptor Jacques Lipchitz was an engineering student before arriving in Paris in 1909 to study art. He was one of the earliest sculptors, along with Laurens, to understand how to apply the principles of Cubism to three dimensions. Starting with a naturalistic approach—*Sailor with Guitar* (1914)—that employed a stylized comination of flat planes and faceted surfaces, he extended his range of Cubist expression in a more abstract sense, often evoking architectural forms to emphasize their mass and create a harmonious whole. From the 1920s, he used the imaginative vision of Cubism to experiment with more abstract, open-work forms (transparent sculptures) and bronze figure compositions. In 1941, like many Jews during World War II, he fled to the US.

Henri **Laurens**

b **PARIS, 1885;** d **PARIS, 1954**

The self-taught Henri Laurens is considered one of the most important Cubist sculptors. A trained stonemason, he turned to Cubism after meeting Braque in 1911. Unfit for military service, Laurens remained in touch with Picasso and Gris during World War I, absorbing their influences into his work.

Laurens produced collage constructions, made from wood and sheet metal. They cleverly mirrored the techniques of Synthetic Cubism in three dimensions, evoking likeness and volume through a carefully conceived structure of painted planes. Laurens later turned to carving directly into stone or plaster.

◀ **Amphion** *In the 1930s, Laurens was working in a monumental, classical style. Amphion is typical of the way he mixed classicism with Cubist ideas of metamorphosis to create something that is simultaneously a female figure, a vase and a musical instrument.* 1937, bronze, height 137in, Pompidou Centre, Paris, France

Futurism emerged at a time when Italy was undergoing a difficult period of social and political adjustment, caught between the outdated social structures of its past and the modernizing challenges of the present.

Origins and influences

In his founding manifesto, printed on the cover of France's *Le Figaro* newspaper in 1909, Filippo Marinetti's glorification of technology, speed, dynamism, and war signalled the birth of one of the noisiest and most aggressive avant-garde movements. Its call to arms based on "Art + Action + Life = Futurism" attracted a nucleus of painters, including Boccioni, Balla,

Severini, Carra, and Russolo. Inspired by the ideas of the French philosopher Henri Bergson, they saw dynamism as the principal force behind everything.

Subject and technique

The Futurist manifestos outlined a desire to capture this invisible energy: "... the gesture which we would

reproduce on canvas shall no longer be a fixed moment... It shall simply be the dynamic sensation itself." Futurists aimed to connect with as many people as possible by creating a barrage of constant publicity through manifestos, lectures, exhibitions, and "happenings," a form of performance intended to provoke the audience.

In the years before World War I in Europe, the Futurists, the Orphists, and the Rayonists all believed that a new form of art was needed for changing society. Although their theories were not the same, they all pushed painting in the direction of totally abstract art.

◀ **The Futurists in Paris** *(1912) Gino Severini introduced the Futurists to the Paris scene. From left to right: Luigi Russolo, Carlo Carra, F.T. Marinetti, Umberto Boccioni, and Gino Severini.*

Futurism, Orphism and Rayonism

TIMEline

Early futurist art, such as Giacomo Balla's *Street Lamp*, shows the influence of Neoimpressionist artists Seurat and Signac. By 1912 French artists like Robert Delaunay were conveying the dynamism of modern life, while the Rayonist Mikhail Larionov was trying to depict not so much objects but the relations between them. Later Futurist paintings, such as Umberto Boccioni's *Charge of the Lancers*, were strongly influenced by Cubism.

1909–11

BALLA Street Lamp

1912

DELAUNAY Windows Open Simultaneously

1914

CARRA Interventionist Manifestation

1915

BOCCIONI The Charge of the Lancers

1916

LARIONOV Rayonist Composition

Interpretations

As the art capital of the world, it was no surprise that Paris was the city in which Futurism emerged, nor that its development overlapped with that of Cubism, with which it broke away from traditional methods of representation. Across Europe, exposure to these new styles provoked a flurry of other avant-garde movements, including Rayonism in Russia, and Vorticism in Britain.

Futurism

The Futurist painters proclaimed themselves "the primitives of a new and transformed sensibility." Since their early technique was incapable of portraying the dynamic, modern world they lived in, they combined some elements of Neoimpressionism—such as pointilist brushwork—with photographic analysis and the fractured forms of Cubism. Replacing the Cubists' static subject matter with city life, nightlife, and movement, they added their own pictorial devices, such as unnaturalistic color to heighten the impact of the work on the viewer, and "force-lines" to convey movement and draw the viewer in to the picture. In the later, more abstract phase (1913–1916), the Futurists turned to sculpture and collage sculptures." With

the death of some of its leading members in the war, the movement fizzled out, although a second wave of Futurism—which had always praised violence and war—was closely associated with Fascism.

Orphism

Orphism was a term coined by the critic Guillaume Apollinaire in 1912, after the poet Orpheus, to describe a more colorful and abstract form of Cubism associated with music, that presented "... new structures out of elements that... have been created entirely by the artist himself." It referred mainly to the work of Robert Delaunay and his wife Sonia, who were inspired by complementary color theory to develop increasingly abstract paintings based around color blocks and discs. Seen as a key advance toward abstraction, it was a major influence on Der Blaue Reiter in Germany.

Rayonism

Rayonism was a short-lived Russian movement founded by Mikhail Larionov and his partner Natalya Goncharova, which attempted to synthesize the discoveries of Cubism, Futurism, and Orphism into a single artistic language. It provided a crucial step in the development of Russian abstract

art. Wishing to present the dynamic energy "...which may arise from the intersection of reflected rays [of light] from different objects," their paintings were characterized by rhythmically interacting shafts of color.

▲ **Development of a Bottle in Space** Umberto Boccioni *As the title of this 1912 work suggests, Boccioni's sculpture is preoccupied with the interaction between objects and the space around them.* 1912, bronze, height: 15in, Mattioli Collection, Milan, Italy

▲ **Les Tours de Laon** Robert Delaunay *The vibrancy of this work is typical of early Orphism and very different to the Impressionist paintings of the cathedral that Delaunay had produced only a few years earlier.* 1912, oil on canvas, Pompidou Centre, Paris, France

Giacomo **Balla**

Giacomo Balla

b **TURIN, 1871**; d **ROME, 1958**

Giacomo Balla was the oldest, most naturally inventive, and least bombastic of the Futurists. After staying in Paris at the end of the 19th century, where he was influenced by the Neo-Impressionists, Balla moved to Rome, where his pupils included Severini and Boccioni. His continually evolving style progressed via Divisionism and "dynamism" toward increasing abstraction and expansive plastic forms, which, according to the Futurist Manifesto, were "inspired by the dynamic forces of the universe" after 1915. Balla's growing obsession with new technology, in particular stop-motion photography, led to a series of quasi-scientific studies of movement. These involved repetition and superimposition of the image, like successive stills from a film.

LIFEline

1871 Born in Turin
1895 Moves to Rome; works as an illustrator and painter
1900–01 Exhibitions in Italy and Germany; moves to Paris
1901 Settles in Rome; teaches Severini and Boccioni
1909 Produces the first Futurist painting, *Streetlight.*
1910 Signs Futurist manifesto
1912 Paris show *Dog on a Leash*
1914 Starts sculpting; explores more abstract color forms.
1958 Dies in Rome

" The **gesture** which we would reproduce on canvas… shall simply be the **dynamic sensation** itself "

MANIFESTO OF FUTURIST PAINTERS, 1910

▶ **Swifts: Paths of Movement + Dynamic Sequences** *This painting belongs to a series in which Balla set out to capture the "dynamic sensation" of bird flight. It represents a more fluid expression of movement than his earlier work.* 1913, oil on canvas, 38 x 47in, MoMA, New York, US

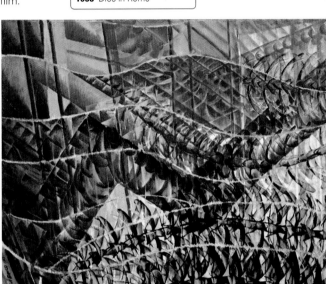

CLOSERlook

INFLUENCE OF PHOTOGRAPHY
Balla recreates the birds' speed and movement by tracing out complex lines of flight, which snake across the canvas against an architectural backdrop. The closely spaced sequences of repeated arcs, representing each wing-flap, are based on the stop-motion "chronophotography" of Étienne-Jules Marey.

▲ **Street Light** *Inspired by Rome's first electric street lamps, Balla took Marinetti's words to heart about killing the moonlight. Here he replaces dots with brightly colored chevrons in order to contrast the forceful rays of electric light with the feeble glow of the moon.* 1909–11, oil on canvas, 69 x 45in, MoMA, New York, US

Carlo **Carra**

b **QUARGNENTO, 1881**; d **MILAN, 1966**

Carlo Carra left home at the age of 12 to work as a mural decorator. After spending time in Paris and London, he enrolled at Milan's Brera Academy in 1906. In 1910, he helped draw up the *Manifesto of Futurist Painters*, which saw the beginning of his most popular and influential phase of painting.

Early works, such as the heartfelt *Funeral of the Anarchist Galli* (1911), combined a Futurist dynamic with a Cubist feel for structure. His Futurist phase ended during World War I, when he met the painter Giorgio de Chirico and discovered metaphysical painting. Carra later turned his back on the avant-garde completely, advocating the support of Fascism through art.

▶ **Interventionist Manifestation**
The virtuoso collage, intended as a "plastic abstraction of civil tumult," was originally published in the Futurist journal Lacerba *in August 1914, as part of Futurism's campaign for Interventionism, urging Italy to enter World War I.* 1914, collage on cardboard, 15⅜ x 11¾in, Peggy Guggenheim Collection, Venice

CLOSERlook

ROTATING TYPE Carra incorporated newspaper cuttings and other typographical fragments into a whirl of "liberated words" inspired by Marinetti's own linguistic experiments, placing "Italia" at the center.

Gino **Severini**

b **CORTONA, 1885**; d **PARIS, 1966**

Gino Severini was a former pupil of Giacomo Balla. Based in Paris from 1906, he became the vital bridge between the Cubists and the Futurists. Severini's figurative paintings from the Futurist period, portraying dynamic subjects such as busy streets, dancers, and trains, are characterized by their Cubist fragmentation and use of strong geometric shapes and colors.

After 1913, Severini's work became more abstract and lyrical as he moved toward a more Orphic approach based on the abstract possibilities of Divisionism. Paintings such as the *Centrifugal Expansion of Light* (1914) used contrasting color forms to convey impressions and trigger memories. During the 1920s, Severini's style became more traditional.

▲ **Pam-Pam at the Monico** *This incident-packed painting— a hit at the Futurist exhibition in Paris in 1912—is set in a famous Parisian nightclub. For Severini, an enthusiastic dancer, it was the perfect subject for a Futurist-styled exploration of movement and rhythm.* 1959, oil on canvas, 110 x 158in, Pompidou Centre, Paris, France

Umberto **Boccioni**

Self-portrait

b **REGGIO CALABRIA, 1882;** d **SORTE, 1916**

Umberto Boccioni was the most loyal supporter of Filippo Marinetti (opposite), the founder of Futurism, and probably the most naturally gifted Futurist artist. As adept in sculpture as in painting, Boccioni created some of the movement's most enduring art. His early work was influenced by Divisionism (he was a pupil of Balla) and Symbolism. In 1910, Boccioni focused on depicting the raw energy of the city—a theme that gave him the subject for Futurism's first major painting, *The City Rises* (1910). Around this time he came up with his theory of "lines of force", a device for linking up objects and drawing the viewer into the center of the picture.

Boccioni then turned away from social themes to focus on illustrating his numerous theories, especially concerning dynamism. Boccioni was an enthusiastic advocate of World War I and volunteered in 1915, but was killed in a riding accident while training. The Futurists never recovered from his death.

▶ **The Street Enters the House** *Boccioni's aim was to recreate the sensation one would experience on opening a window and having "all life and the noises of the street rush in at the same time." He describes these principles of spatial interpenetration and disruption in his* Technical Manifesto. 1911, oil on canvas, Niedersächsisches Landesmuseum, Hanover, Germany

▲ **States of Mind: The Farewells** *Boccioni's* States of Mind *triptych was the first great statement of Futurist painting, synthesizing its theoretical interests in Cubism, the ideas of influential French philosopher, Henri Bergson, and individual experience.* Farewells, *which forms the central panel, is concerned with the emotions of parting. The painting can be read as a hieroglyph that combines flashes of memory, feelings of separation, and the anticipation of travel into a wholly heightened sense of consciousness.* 1911, oil on canvas, 27¾ x 37¾in, MoMA, New York, US

CLOSERlook

EXPRESSIVE FORMS Boccioni wanted to capture the essence of emotion by forcing "colors and form… to express themselves." The swirls of smoke from the train's funnel merge with disc-shaped clouds and pulsing radio signals to heighten the confusion of departure.

LINES OF FORCE Curving lines are used to exaggerate the emotional states of the embracing figures which they surround.

◀ **Unique Forms of Continuity in Space** *This is possibly the most successful realization of the Futurist aesthetic in any medium. Its modern, abstract form seems to explode outward into the surrounding space. A number of bronze castings were made after the artist's death. The Tate, London, and MoMA, New York, both own versions. 1912–13, 46½ x 34¾ x 14¾in, bronze, Mattioli Collection, Milan, Italy*

Luigi **Russolo**

b **PORTOGUARO, 1885;** d **CERRO, 1947**

Luigi Russolo was the most literal-minded and least innovative exponent of Futurism until he transferred his energies from painting to composing. His work was often characterized by its clumsy use of bold colors and forms. He acted like a prototype Futurist should, dabbling in all the arts until he found success as a musical theorist and composer. Russolo invented new noise-making instruments known as *intonarumori* (sound boxes). In 1913, he published his *The Art of Noises* manifesto, which called for a new awareness of the sonic possibilities of the city. He attempted to incorporate the sounds of gurgling pipes and jolting trams into some of his musical scores.

▼ **Revolt** *Russolo described this work as the "collision of two forces"—revolution versus inertia. It addresses the potential unrest arising from the clash between rapid industrialization and an outdated social structure. 1911–12, oil on canvas, 59 x 91in, Haags, Gemeentemuseum, The Hague, Netherlands*

CLOSERlook

RED WEDGE A crowd advances as a red wedge. Buildings seem to retreat, pushed back by pointed red "lines of force." Garish colors enhance the sense of aggression.

INcontext

MARINETTI'S MANIFESTO Filippo Tommaso Marinetti (1876–1944) was born in Alexandria. He studied law in Paris before moving to Milan. On February 20, 1909, this ambitious poet published his remarkable *The Founding and Manifesto of Futurism* on the cover of the prestigious French newspaper *Le Figaro*. His rejection of the past and glorification of war, machines, and speed immediately attracted followers to his standard.

Marinetti (photograph by E O Hoppe, 1913) *In his first Manifesto, Marinetti described a "roaring car" as "more beautiful than the Victory of Samothrace." A superb publicist and provocateur, his Futurist "spectacles" caused riots wherever he went. Marinetti's ardent patriotism and disdain for tradition led to a friendship with Mussolini and his becoming a fascist in 1919.*

▲ **Dynamism of a Cyclist** *Boccioni translated his sculptural revelations on to canvas to produce a series of analytical studies of human movement that proved his most abstract paintings. Shifting planes of color and structural contrasts to fuse the figure into its surroundings, conveying the idea of a cyclist moving through space and time. 1913, oil on canvas, 27½ x 37¼in, Mattioli Collection, Milan, Italy*

▲ **The Charge of the Lancers** *Boccioni was an ardent supporter of war, yet his only major war image was this collage made just before Italy entered the conflict. Over newspaper cuttings describing French advances, cavalry attack a German trench. 1914–15, oil and collage on cardboard, 12¾ x 19¾in, Civica Galleria d'Arte Moderna, Milan, Italy*

Robert **Delaunay**

Robert Delaunay

b **PARIS, 1885;** d **MONTPELLIER, 1941**

One of the first purely abstract painters in Europe, Robert Delaunay developed the style that the poet Guillaume Apollinaire (below) dubbed "Orphism," which was a personal interpretation of many of the elements of Cubism.

 After his parents divorced, Delaunay was brought up by his uncle. He took an interest in painting at an early age and, despite the derisive attitude of his uncle toward modern art, he adopted an Impressionist style as a teenager. In 1906, military service took him to Laon, where he produced his first mature work. On his return to Paris in 1908, his painting took a new direction when he saw the Cubist paintings of Picasso and Braque. A series of paintings of cathedrals and the Eiffel Tower followed, in which he adopted the Cubist style, but with his own sense of vivid color and movement creating tensions and harmonies through contrasting color planes. Delaunay's Orphism influenced Kandinsky's Der Blaue Reiter group (see p.408) and his use of the spectrum of colors to achieve brilliant effects was taken up by his wife Sonia, in her painting, fabric, and fashion design. It was a short step to completely non-representational paintings, which both Delaunays produced for the rest of their lives. The style celebrated technology and modern life, as opposed to the still life preferred by Picasso, Braque, and Gris.

LIFEline

1906–08 Serves as a regimental librarian in Laon

1908–12 Moves toward abstraction in what he calls his "destructive" period

1910 Marries fellow artist Sonia Terk

1912–14 Enters his "constructive" period of virtually abstract painting

1914–29 Lives in Spain and Portugal. Returns to a figurative style

1929 Returns to France, and resumes abstract painting

1940 Moves to the Auvergne to avoid the Nazi invasion; dies in Montpellier the following year

◀ **The Eiffel Tower**
One of a series of Cubist-inspired paintings of the Eiffel Tower, this shows Delaunay's preoccupation with composition rather than representation. He concentrates on juxtapositions of color and shape to achieve movement and tension. 1911, oil on canvas, 79 x 54¼in, Guggenheim Museum, New York, US

▶ **La Ville de Paris** *For all his stylistic novelty, Delaunay continued to aspire to make the big public painting that had been a feature of 19th-century academism. Here, he brings together the Eiffel Tower, a symbol of modernity, with the Three Graces, derived from an antique fresco.* 1910–12, oil on canvas, Pompidou Centre, Paris

CLOSERlook

SHARDS OF COLOR
Combining an Impressionistic fascination for light with the fragmentary approach of Cubism, Delaunay reduces the elements of this scene to a collection of separate shards of color.

▶ **Windows Open Simultaneously (First Part, Third Motif)** *By the time of the* Simultaneous Windows *series, Delaunay had virtually abandoned figurative painting. In this groundbreaking abstract work, he takes the elements of Cubism to extreme, using luminous colors in a prismatic effect that disguises representational images beyond recognition.* 1912, oil on canvas, 18 x 15in, UK

❝ In order that Art attain the **limit of sublimity**, it must draw upon our **harmonic vision**: clarity ❞

ROBERT DELAUNAY, 1912

INcontext

APOLLINAIRE The poet and writer Guillaume Apollinaire also worked as an art critic and had many artist friends. He coined the term "Orphism" to describe the style of Delaunay and his followers after Orpheus, the poet and musician of Greek mythology.

Portrait of Guillaume Apollinaire *Here an unknown French photographer captures Apollinaire reclining (c1910).*

František **Kupka**

b **OPOČNO, 1871;** d **PUTEAUX, PARIS, 1957**

After studying in his native Bohemia, and then in Prague and Vienna, František Kupka moved to Paris in 1895, where he made his name first as an illustrator, but later as an innovative abstract painter.

Kupka's early paintings were in a Symbolist style, making use of mythological and mystical imagery, but at the beginning of the 20th century he began to study color theory and the depiction of motion, combining these with his background in Czech folk art and an interest in science. By 1912, Kupka had evolved a unique vocabulary of shape and color, quite different from that of his Cubist contemporaries. In the purely abstract paintings that followed, he developed this compositional style, using vertical and diagonal strips of color or swirling circular forms. Kupka's work often contains allusions to science and music theory, as well as to his own theories on the conceptual nature of visual art.

▼ **Compliment** *Kupka believed that abstract painting was analogous to musical composition, and strove to achieve harmony and rhythm in his work. Here, basic motifs are repeated, but also go through a process of development and transformation, like the unfolding of a piece of music.* 1912, oil on canvas, 35×42½in, Pompidou Centre, Paris, France

CLOSERlook

COLORS IN HARMONY
The shapes are rounded and have a sense of solidity, unlike the fragments of flat color favored by the Cubists. They are arranged in groups with colors from the same part of the spectrum.

Mikhail **Larionov**

b **TIRASPOL, 1881;** d **FONTENAY-AUX-ROSES, NEAR PARIS, 1964**

A maverick figure in the Russian avant-garde, Mikhail Larionov was a leading figure in a series of avant-garde groups of artists at the beginning of the 20th century, and the initiator of the style known as Rayonism.

Starting in an Impressionistic style while still a student in Moscow, Larionov was anxious to incorporate the latest Fauvist and Expressionist ideas into his work, and he was particularly attracted to Italian Futurism. From these, he developed a Neo-Primitivist style, in about 1912, and the first of his non-objective Rayonist paintings. He traveled with his long-term partner Natalia Goncharova to France, and became an important member of the École de Paris, as well-known for his stage design and writings on art as for his painting.

▶ **Rayonist Composition**
In Larionov's early Rayonist paintings, the subject was fragmented by the depiction of interesting rays of light reflected from it, but he soon moved toward a purer, more abstract interpretation. From about 1913, he produced non-objective compositions, such as this one, in which the reflected and refracted light entirely replaced any subject. 1916, gouache on paper, 22×17¾in, private collection

Natalia **Goncharova**

b **NEGAYEVO, 1881;** d **PARIS, 1962**

In the early years of the 20th century, Natalia Goncharova established herself as a leading member of the Russian Neo-Primitivist movement. She later adopted a more avant-garde approach, and, with her long-term partner Mikhail Larionov, developed the principles of Rayonism. The two met at the Moscow School of Painting, Sculpture and Architecture, where Goncharova studied.

Goncharova's early work was influenced by Russian folk art as well as French Post-Impressionism. In around 1910, however, she adopted elements of Futurism and Cubo-Futurism into her paintings, joined the *Der Blaue Reiter* group, and gained an international reputation. As a designer for Diaghilev's *Ballets Russes*, Goncharova traveled around Europe, eventually settling in Paris in 1919 and becoming a French citizen in 1938. She and Larionov married in 1955. By this time, they were both in poor health and living in poverty, but she continued to paint until her death in 1962.

▼ **The Cyclist** *Painted during the most productive period of her life, this is the best known of Goncharova's Russian Futurist paintings. She uses splintered geometric shapes and repetitions to convey a sense of dynamic movement.* 1913, oil on canvas, 30¾×41¼in, State Russian Museum, St. Petersburg, Russia

▲ **Peasants Picking Apples** *Although Goncharova often worked at the cutting-edge of the avant-garde, she continued to paint figurative scenes inspired by folk art. Her depictions of peasants at work show the influence of lubok prints (simple, colorful prints from wood cuts or copper engravings) and medieval Russian statues, but also of Gauguin, Cézanne, and Matisse.* 1911, oil on canvas, 41×38½in, Tretyakov Gallery, Moscow, Russia

Origins and influences

In the first decade of the 20th century, Fauvist and Expressionist artists had removed the connection between the colours they used to represent nature and nature itself. The Cubists had divided objects into multiple planes, challenging dimensions of space, and the Futurists challenged concepts of time. Certain artists had painted portraits of rare psychological intensity. Many frontiers had been crossed, and the art-going public had trouble keeping abreast of events.

Until 1910, these artists had kept within the bounds of concrete reality – they had depicted recognizable subjects. Even Picasso and Braque had, in the final stages of Analytical

Art without subject matter was a revolutionary concept in the early 20th century. Out went identifiable people and objects. In came floating shapes – some resembling creatures, others geometric – blocks of colour so big that they filled an entire canvas, and vertical and horizontal lines.

▲ **Schroeder House** *Dutch architect Gerrit Rietveld designed this house with abstract concepts in mind, such as the floating white plane and pronounced vertical and horizontal lines. 1923–24, Utrecht, Netherlands*

Cubism, turned away from non-representational art. Their canvases had always included a subject – it had just become harder to identify it.

Removing subject matter

The biggest leap of all – removing any reference to the world of identifiable objects – proved stubbornly elusive.

Artists instinctively knew that the foundation of art was reproducing some facet of the world as the artist saw it. It would be no simple matter for painters and sculptors to take the decisive step to abstraction – art without representation.

Birth of Abstract art

TIMEline

Kandinsky hovered on the brink of abstraction with *The Blue Rider*. Mondrian's *The Gray Tree* (see p.444) has the merest reference to its title, moving closer to the abstract ideal of *Composition with Red, Black, Blue, and Yellow*. In 1915, Malevich launched his brand of abstraction on the public with *Suprematist Composition*. Brancusi's *Mademoiselle Pogani* pares portrait art down to the essence of a face.

1909

KANDINSKY Der Blaue Reiter (The Blue Rider)

1915

MALEVICH Suprematist Composition

c1920

BRANCUSI Mademoiselle Pogani

1925

KANDINSKY Yellow, Red, Blue

1928–1932

MALEVICH Three Little Girls

▲ **Composition 17** Theo van Doesburg *Sharing Mondrian's vision, van Doesburg excluded more and more colours from his work. 1919, oil on canvas, 19¾ x 19¾in, Haags Gemeentemuseum, The Hague, Netherlands*

▲ **Suprematism** Kasimir Malevich and El Lissitzky *Malevich collaborated on projects with Lissitzky, who was developing a new approach to design that fused architectural forms and painting. This is a sketch for a theatre curtain. 1919, pencil, watercolour, and ink on paper, 17¼ x 24½in, Tretyakov Gallery, Moscow, Russia*

Object-free art

Abstract notions were not entirely new. JMW Turner's landscapes and seascapes, painted in the 1830s and 40s were often a whirl of atmospheric colours and abstract elements – although the viewer eventually identifies a cow in a pasture or ship at sea.

The Impressionists had loosened Realism's grip on the physical world and at times approached the abstract. Monet's *Waterlilies* (begun 1899) or misty *Haystacks* series (1890–91) are examples. Significantly, all the pioneer abstract painters went through an impressionistic phase.

In the decorative arts there had always been abstract patterns in ceramics, wall-hangings, and furniture design. Art Nouveau, in all its national variations, had seen such decoration brought into painting. More than anyone else, Gustav Klimt (see pp411–13) had placed abstract decorative motifs at the centre of his works of art – *The Kiss* would have been unthinkable if the couple had been wearing everyday clothes.

Spiritual ideals

By whatever route the abstract pioneers Wassily Kandinsky, Kasimir Malevich, Constantin Brancusi, and Piet Mondrian

had taken to reach their individual abstract styles, they were united by one urge. They wanted to oppose the self-limiting material values that they felt dominated society with a new, profound set of spiritual ideals.

These artists wanted to do the impossible – turn back the clock by leaping into the future and create an art that was equal to any art of the past, each piece containing its own inner universe. Their approach to creativity was steeped in ancient philosophy, esoteric Eastern beliefs, and new mystical writings. They wanted their art to offer the viewer a rationale for an ordered, spirit-enhancing life.

The importance of music

Music provided a guide for abstract artists. Composers had long managed to sweep the listener into other worlds without needing to represent nature directly. Instruments did not imitate cocks crowing or babies chuckling. Yet the concert-goer readily imagined the countryside or memories of childhood. If music could be abstract, ordered, and emotionally charged, then so too could art.

Wassily **Kandinsky**

Photograph by Boris Lipnitski

b **MOSCOW, 1866**; d **NEUILLY-SUR-SEINE, 1944**

One of the pioneers of abstract art, Wassily Kandinsky has some claim to being the first completely non-representational painter to achieve complex compositions with only barely recognizable objects. Aided by his father's funds, he organized artists' groups, taught art, and traveled extensively with his lover, the painter Gabriele Münter. In 1908, they moved to the country, at Murnau in Germany. Kandinsky's style developed toward abstraction from a colorful Expressionist manner, and his work is the starting point for the kind of abstraction concerned above all with emotion rather than geometry and order. In 1912, he published *On the Spiritual in Art*, in which he argues that colors and form can communicate without reference to subject matter. In Russia during the Revolution, he helped reorganize art education in Moscow for the Soviet government before returning to Germany in 1921, when he started work at the Bauhaus (see p.482).

LIFEline

1866 Born in Moscow, the son of a wealthy tea merchant

1886–96 Studies and teaches law at Moscow University

1895 Sees Monet's *Haystacks* in an exhibition and is deeply impressed

1896 Moves to Munich and studies at the Academy

1911 Founds Der Blaue Reiter with Franz Marc (see p.408)

1915–17 Separates from Münter; marries Nina von Andreevsky in Moscow

1921 Leaves Moscow, disillusioned with Soviet arts

1944 Dies, a French citizen

▼ **Winter Landscape** *Showing the influence of Fauvist color in his early work, Kandinsky includes strong line and contour, the essential elements of his later pure abstract works.* 1909 , oil on canvas, 29¾ x 38¼in, Hermitage, St. Petersburg, Russia

◄ **Yellow, Red, Blue** *In Kandinsky's notion of form and color, each of the "primary" shapes has its corresponding color—yellow triangle, red square, and blue circle. Here, Kandinsky elaborates on variations on this theme.* 1925, oil on canvas, 50 x 79in, Pompidou Centre, Paris, France

CLOSERlook

GRID MOTIF Kandinsky first introduced the sloping grid into his work with the painting *Black Grid* (1922). Here, the grid is less dominating partly because it comprises all the colors that surround it in the picture.

▶ **Der Blaue Reiter (The Blue Rider)** *The process of removing narrative and objective content from his work was gradual—a rider and blue horse are clearly discernible. This painting gave its name to the association of artists that Kandinsky formed in Munich in 1911.* 1909, oil on canvas, 37 x 51in, Pompidou Centre, Paris, France

66 Abstract art places a **new world**, which on the surface has **nothing to do with reality**, next to the real world 99

WASSILY KANDINSKY

▲ **Sky Blue** *It is likely that these puzzling floating shapes are Kandinsky's depiction of the microscopic sea creatures that fascinated him on trips to the Normandy coast.* 1940, oil on canvas, 39¼ x 28¾in, Pompidou Centre, Paris, France

Composition VII *Wassily Kandinsky*
1913, oil on canvas, 78¾ x 118⅛in, Tretyakov Gallery,
Moscow, Russia ▶

Composition VII Wassily Kandinsky

Painted between 1910 and 1939, Kandinsky's 10 large-scale *Compositions* were his most complex and ambitious works. A seemingly indecipherable vortex of shapes and colors, *Composition VII* reflects Kandinsky's quest to affirm the need for spiritual awakening in art, as in society, and places biblical references at its core. Its apocalyptic themes—the Deluge, Resurrection, and Day of Judgement—are not expressed in a narrative but in a rising and plummeting Universe in which identifiable objects are almost totally subsumed by some greater force. *Composition VII* was completed between November 25 and 28, 1913. It is the largest of all Kandinsky's paintings.

Composition

At first glance *Composition VII* seems a product of spontaneous creative energy, but is in fact meticulously constructed. There is a powerful diagonal thrust towards the upper right-hand corner, and a further sense of fracture between the picture's left and right sides. On the left, the jagged lines and array of jostling colored forms suggest an epoch of collapsing structures and turmoil. To the right, the lighter, flatter forms and calmer rhythms symbolize the Garden of Eden. On the far right, the silhouette of a blue rider provides hope of spiritual renewal.

▲ **SKETCH 1** The work includes biblical themes that are more evident in the studies and drawings in which angels blowing horns are painted in the folkloric style of *lubki*—brightly colored religious pictures found in Russian peasant homes.

▲ **DEPTH AND SPACE** There is no conventional perspective in *Composition VII*, but the strong dynamics provide a sense of depth and space. Initially the viewer is drawn to the center, the eye of the storm, but then the attention is drawn to the sides in all directions.

▲ **SKETCH 3** Many of the oil studies Kandinsky made for *Composition VII* can be considered as complete artworks in themselves. With such methodical groundwork, the spontaneous and free handwork of the finished painting is all the more astonishing.

MUSIC Kandinsky first realized the emotional power of music when he attended a performance of Richard Wagner's opera *Lohengrin* in the 1890s. Years later, he became a friend of the Austrian composer Arnold Schönberg, whose 12-tone method of composition was a turning point in 20th-century music. Schönberg, whose works are associated with early 20th-century expressionist movements, allowed sounds to remain dissonant and unresolved and rejected conventional structures to give a composition meaning. In a similar way Kandinsky replaced representation with abstraction in his art.

Musical score *Arnold Schönberg's score for* Two Songs, op. 1, for Baritone and Piano *was composed in 1898*

Technique

Preparatory work for the painting took two months and involved making sketches, diagrams, and watercolors. Certain drawings have areas labeled "discontinuity," "abyss," or "genesis." Kandinsky's companion Gabriele Münter took photographs of the work in progress. The photographs show that Kandinsky initially drew in core shapes at the center, and plotted a series of lines and forms radiating out toward the picture's edge. He then applied color over a small central section, moving out along the initial lines.

▼ **COLOR QUALITIES** For Kandinsky, colors have their own qualities; a vermilion red with a fiery tone implies a spiritual vibration such as a flame or, depending on its context and intensity, blood and pain. Dark yellow has a musical quality and dark rose madder evokes a soprano's voice.

◄ **THE LADDER** Besides being an attractive pattern, this brightly colored ladder alludes to musical notation and the keys of a piano. It may also have a particularly Russian significance: according to Orthodox belief and imagery, the ladder represents the perilous path that the godly must climb to reach salvation.

► **PATTERN** This striated pattern of dune-like forms in ochre and raw sienna suggests a desert landscape.

◄ **DIRECTIONAL SIGNIFICANCE** Even the direction of a line possessed an inner significance for Kandinsky: verticals represented warmth and the positive; horizontals the cold and negative. This blue shape may represent a biblical horn.

▲ **ANGLES** Kandinsky saw the acute angle (less than a right angle) as warm and yellow because it occurs abundantly in nature (as in the branches of trees). He believed the right angle to be a cold man-made contrivance, because it does not occur in nature, and painted it a crimson red.

Kasimir **Malevich**

Self-portrait

b **KIEV, 1878**; d **ST. PETERSBURG, 1935**

In his early teens Kasimir Malevich attended drawing classes in Kiev before moving to Moscow for further academic training in 1904. Painting initially in an Impressionistic style, he found influences in Symbolism, Cubism, and Russian folk art. He exhibited extensively in group shows in Moscow and St. Petersburg between 1908 and 1912. In 1910, he met Larionov and Goncharova (see p.432), and, impressed with Rayonism, exhibited in their *Donkey's Tail* show. Malevich also met the composer Mikhail Matuishin and began collaborating on the opera *Victory over the Sun*. His colorful sets and costumes made of geometrical shapes caused a sensation. In 1915, Malevich exhibited 39 non-representational pictures at 0.10 The Last Futurist Exhibition, which announced the arrival of Suprematism (Russian abstract art). The Russian Revolution promoted abstract art and Malevich gained important teaching posts. In 1919 Moscow's State Exhibition was entirely devoted to his work.

LIFEline

1878 Born near Kiev, son of a sugar refinery manager

1895–96 Attends Kiev School of Drawing

1905–10 Works in the Moscow studio of painter Fedor Rerberg

1917-18 Joins Leftist artists' group during the Revolution

1919 Moves to Vitebsk and teaches at the art school

1929 In a reaction against abstraction, the director of Kiev Art Gallery is imprisoned for showing "bourgeois" works by Malevich

1935 Dies in St. Petersburg, city council pays for funeral

▼ **Three Little Girls** The title is ironic, for these simplified female forms hardly suggest childhood. Returning to representational art in 1928, Malevich revisited many of his former themes. He challenges our sensory perceptions as the "girls" seem to advance as we look at them. 1928–32, oil on board, 22¼ x 18¾in, State Russian Museum, St. Petersburg

▲ **Suprematist Composition** Malevich believed that white represented the concept of infinite space better than blue. He used white as a background against which he placed colored lines and masses. These shapes seem to defy gravity by both rising and sinking simultaneously. 1915, oil on canvas, 27½ x 18¾in, Museum of Art, Tula, Russia

◄ **Taking in the Rye** Malevich frequently adapted his style. The previous year he had painted full-length portraits of ungainly workers—a style known as Neo-Primitivism. Within months, these lumbering figures were transformed into neat, tubular forms with a metallic sheen. 1912, oil on canvas, 28¼ x 29½in, Stadelijk Museum, Amsterdam, Netherlands

▶ **Black Square** When it was first shown in 1915, Black Square was hung high up in the corner opposite the entrance, the place traditionally reserved for Orthodox holy icons. Malevich seems to be saying, "Welcome to your new spiritual home." 1915, oil on canvas, 41¾ x 41¾in, State Russian Museum, St. Petersburg, Russia

❝ The **appearances of natural objects** are in themselves **meaningless** ❞

KASIMIR MALEVICH

Constantin **Brancusi**

Constantin
Brancusi

b HOBITZA, 1876; d PARIS, 1957

The importance of Constantin Brancusi to sculpture is comparable to that of Picasso to painting, although in contrast to the flamboyant and multi-faceted Spanish painter, Brancusi endlessly refined a single artistic practice and lived simply in his studio.

Born in Romania, Brancusi was already an accomplished artist when he arrived in Paris in 1904. Like many younger sculptors, he challenged the dominance of Rodin and was drawn to the practice of "direct carving," as opposed to the mechanical reproduction of plaster models in stone, which was usual at the time. For Brancusi, sculpture in any medium—be it bronze, wood, or stone—had to respect the character of the material.

He confined himself to relatively few themes, usually drawn from the natural world, that he simplified to an essential ideal form. Sculptors since have been attracted by his emphasis on sculpture as an object. He left most of his work to the French state, and to this day a re-creation of his studio can be seen at the Pompidou Centre, Paris.

LIFEline

1876 Born in Hobitza, the son of peasants
1886 Leaves school and works as a shepherd
1894 Enrols in Craiova School of Crafts
1898–1902 Studies at School of Fine Art, Bucharest
1904 Moves to Paris, walking most of the way from Munich
1907 Makes first "direct carvings"
1912 Carves first portrait
1926 *Bird in Space* arrives in New York for an exhibition. Customs don't believe it is an art object and levy tax
1937–38 Erects 96-ft-high *Endless Column* in Romania
1957 Dies, aged 81, in Paris

INcontext

BALKAN WARS In the early 1910s, the Ottoman Empire was being pushed back to the Turkish borders by a nationalist upsurge in the Balkans, and there were disputes over territory between the Balkan States. Two wars ensued, in 1912 and 1913, the latter also involving Romania. However, the developing international turmoil did not impede the work of the Bucharest Salon, who awarded Brancusi the first prize for his *Study (Torso of a Girl)* in 1912. Peace was restored in August 1913 with the signing of The Treaty of Bucharest.

Wounded Bulgarian soldiers during the Balkan campaigns, *artist unknown (20th century).*

◄ **The Kiss** *This is one of Brancusi's first "direct carvings" and also the start of one of his most important series. The two figures are united in a single block. Brancusi made a full-length version, which stands as the gravestone of a young Russian suicide, Tatiana Rachewskaia, in Montparnasse cemetery, Paris. 1907/08, stone, 10¼ x 10¼ x 8¾in, Kunsthalle, Hamburg, Germany*

► **Bird in Space** *Brancusi made more versions of this subject than any other. He sought not merely to describe the shape of a bird in flight but to invoke the "essence of flight." His underlying theme was the conquering of space. As the sculpture's highly polished bronze catches the light, moving around the object gives the viewer the feeling of a bird soaring upward. 1940, bronze, height 76in, Pompidou Centre, Paris, France*

► **Mademoiselle Pogani**
Margit Pogani was a young Hungarian painter who Brancusi befriended in Paris. She was the subject of at least six sculptures in marble and bronze. In each, her facial characteristics are encapsulated by the large round eyes, small, thin nose, and tiny mouth. c1920, bronze, height approx 17¾in, Pompidou Centre, Paris, France

▲ **Head** *This is a piece of an earlier sculpture called* Little French Girl II *that Brancusi destroyed around 1918. However, he liked the expressive oak head, which he kept and adapted to become a separate new sculpture that is a construction of solid interlocking masses. c1919–23, oak, 11⅜ x 7½ x 8¼in, Tate, London, UK*

Work

Work became an important theme for art in the 19th century when socialist sympathies encouraged the celebration of the experiences and struggles of the ordinary person. Manual effort lent itself to heroic treatment, and the dock worker or the miner could be a modern Hercules. Before that time, daily life, although depicted, was usually seen as "lower" than the great subjects of history and mythology. It remains to be seen whether or not contemporary artists will be able to do justice to a world of work in which the keyboard is a more vital tool than the pickax.

▼ **The Fisherman** Charles Napier Hemy *Hemy made his name with finely executed maritime scenes.* 1888, 35¾ x 54in, private collection

▼ ▼ **Woman Weaving** Kitagawa Utamaro *The artist's draftsmanship lend an elegance to this woman's work.* 18th century, woodblock print, Musée Guimet, Paris, France

▼ **The Money Lender and his Wife** Quentin Massys *The wife's neglect of her prayer book in favor of the gold and jewels held by her husband is Massys's comment on the dangerous allure of riches.* 1514, oil on panel, 27¾ x 26⅜in, Louvre, Paris, France

▼ **Pavement Detail of a Builder** Byzantine School *Byzantine art is predominantly symbolic rather than naturalistic.* 6th century, mosaic, Church of St. Cosmos and St. Damianus, Jerash, Jordan

▼ **Farmers at Work** Northern Song Dynasty *The murals of the Mogao Caves cover a huge number of subjects, including Chinese agriculture.* 960–1279, wall painting, Mogao Caves, Dunhuang, Gansu Province, China

▲ **Loading a Ship** Roman *This scene of labor is a tiny detail from the narrative of war sculpted in low relief on Trajan's Column.* c110–120, plaster, Museo della Civilta Romana, Rome, Italy

▲ **Sheep Shearing** English School *The small sketches in the border of this page from an English illuminated manuscript are a regular feature of these books.* 15th century, vellum, British Library, London, UK

▶ **The Butcher's: Pig Meat** Italian School *The bold colors in this scene of everyday life are typical of the rich palette used by medieval artists.* 14th century, vellum, Österreichische Nationalbibliothek, Vienna, Austria

▲ **The Forge** Le Nain Brothers *The formal composition imbues Le Nain's forge-workers with dignity.* 1640, oil on canvas, 27¼ x 22⅜in, Louvre, Paris, France

▶ **The Pharmacist** Pietro Longhi *Longhi's work is dominated by scenes from the everyday lives of Venetians.* 1752, oil on canvas, 23⅝ x 19¼in, Galleria dell'Accademia, Venice, Italy

▶ **In the Garden at Pontoise: A Young Woman Washing Dishes** Camille Pissarro *The French Impressionist turns a household chore into a scene filled with light and color.* 1882, oil on canvas, 32¼ x 26in, Fitzwilliam Museum, Cambridge, UK

▼ **Work** Ford Madox Brown *Teeming with life, this scene depicting the installation of sewage works emphasizes the necessity and vitality of labor.* 1863, oil on canvas, 35 x 39in, Birmingham Museums and Art Gallery, UK

▼ **Iron foundry** Graham Sutherland *Sutherland's background as a railway engineer was reflected in his interest in industrial scenes. He painted many of them when he was an official war artist during World War II.* 1945, private collection

▼ **Lloyds** Edward Bawden *The high viewpoint contrasts the size of the building with the people within it, at work in the City of London.* 20th century, lithograh, Fry Art Gallery, Saffron Walden, UK

▼ **Deadline** P.J. Crook *The strong colors and frenzied composition make this scene grotesque.* Late 20th century, acrylic on canvas on wood, 50 x 70in, Morohashi Museum of Modern Art, Koriyama-Shi, Japan

▲ **Sheep Shearing** Natalia Goncharova *Goncharova's blocks of color elevate the work of sheep-shearing from the mundane.* 1907, oil on canvas, Museum of Art, Serpukhov, Russia

▶ **The Dressmaker** William Roberts *Although usually associated with the Vorticists, Roberts developed a more representative style in his later depictions of urban life.* 1931, oil on canvas, 20 x 16⅛in, Victoria Art Gallery, Bath, UK

▲ **Detroit Industry, North Wall (Detail)** Diego Rivera *Rivera considered this huge fresco sequence—capturing the main industries of Detroit—the finest work of his career.* 1933, fresco, 516 x 803in, The Detroit Institute of Arts, US

▲ **Weaving Cloth for the People** Chinese School *Used as propaganda, this image idealizes the role of the worker in society.* 1970, color lithograph, private collection

◀ **Butcher's Shop No.1** Peter Coker *Coker's realistic presentation of unglamorous scenes led to him being described as a "kitchen sink" artist.* 1955, oil on board, 75 x 51in, Sheffield Galleries and Museums Trust, UK

Piet **Mondrian**

b AMERSFOORT, 1872; d NEW YORK, 1944

Piet Mondrian

An abstract artist whose instantly recognizable style emerged only after years of searching, Mondrian trained at Amsterdam's Academy of Fine Arts. He initially painted still lifes and rural scenes in a naturalistic Dutch style, but became influenced by Impressionism and van Gogh. Despite his upbringing in a strict Protestant home, Mondrian's interest in eastern beliefs and theosophy (the study of religious philosophy) came to play a significant role in his art. Between 1906 and 1907, he painted a series of "evening and night landscapes" in which all details dissolve into contours and masses. An interest in Cubism spurred him to move to Paris in 1912, where he painted numerous "tree" pictures in which natural forms splinter into rhythmic patterns of curved lines. His distinctive abstract style—which combines areas of solid color with austere vertical and horizontal lines—emerged around 1920. Although he constantly adapted these forms, he remained faithful to them until his death.

LIFEline

1892–97 Attends Amsterdam Academy of Fine Arts
1911 Sees Cubist works
1915 His *Pier* and *Ocean* paintings signal a switch from Cubism to abstract art
1917 Co-founds *De Stijl*
1920 Writes *Neo-Plasticism*, an essay on art theory
1926 With patron Katherine Dreier begins to achieve success in the art world
1938 Moves to London
1940 Moves to New York and joins American Abstract Artists
1942 First solo show

▲ **The Gray Tree** 1911 *In a series of around 20 paintings made between 1909–13, Mondrian explored the shape of a single tree, using the subject as a means of transforming natural forms into abstract patterns. Influenced by Cubism—which he saw before moving to Paris —he drastically reduced the range of colours in these works.* Oil on canvas, 31¼ x 42½in, Gemeentemuseum, The Hague, Netherlands

> " The truly **modern artist** is aware of **abstraction** in an emotion of **beauty** "
>
> PIET MONDRIAN

▲ **Tableau 1/ Composition No 1/ Compositie 7** 1914 *Mondrian is at the very edge of total abstraction here. The painting is still, at some distance, derived from the complex pattern of Parisian roofs. Only with the aid of a preliminary drawing it is possible to identify the church façade in the lower right of the painting.* Oil on canvas, 47½ x 39½in, Kimbell Art Museum, Fort Worth, Texas, US

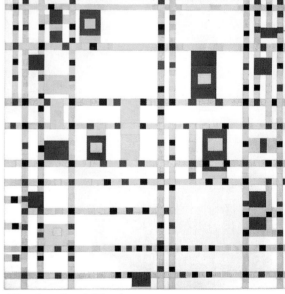

▲ **Broadway Boogie Woogie** 1942–43
In Mondrian's last completed work, the asymmetry, pulsating lines, and solid white squares create strong directional forces that impress themselves on the viewer. A homage to New York, his home during World War II, the painting pays tribute to the dance-hall jazz Mondrian loved so much. Oil on canvas, 50 x 50in, MoMA, New York, US

▲ **Composition with Red, Black, Blue, and Yellow** *Mondrian*
believed that painting could provide the artist with a mathematically
precise means of depicting the "essence" of nature. Limiting his palette
to black, white, gray, and the three primary colors, he constantly explored
the possibilities of line, color, and mass. 1928, oil on canvas, 17¾ x 17¾in,
Wilhelm-Hack-Museum, Ludwigshafen am Rhein, Germany

At the turn of the century, what Percy Wyndham Lewis called the "dramatic winds" of modernism swept over the English Channel. This excited a generation of British painters and sculptures, and revitalized the London art scene—before World War I destroyed the spirit of optimism.

Origins and influences

Virtually the whole generation of British Modernists were educated at the Slade School of Fine Art in London. Founded in 1871 by Felix Slade, it overtook the Royal Academy as the most important art school in the country. Even so, it was artistically conservative, with an emphasis on draftsmanship, especially life drawing. Its foremost tutor, Henry Tonks, famously said, "I don't believe I really like any modern developments." More influential were Camden Town Group leader Walter Sickert, Bloomsbury Group member Roger Fry, and Vorticist pioneer Wyndham Lewis.

▲ **The British Modernists** *This photograph, taken in France in 1911, features some of the leading British artists of the period, including Walter Sickert (back row, third from left), Charles Ginner (back row, right), and Percy Wyndham Lewis (front row, third left).*

Subject matter

British Modernism reached its height just before World War I. Conventional subject matter began to be superseded by abstract painting and sculpture. Vanessa Bell and Duncan Grant made non-representational easel paintings, David Bomberg produced colorful, geometrical images, and Jacob Epstein and Henri Gaudier-Brzeska's sculpture was reduced to simplified forms.

The boldness of British Modernism, however, was shattered by the war, and Gaudier-Brzeska died in the conflict. With few exceptions, the work of this generation of Modernists declined markedly after World War I.

Early British Modernism

TIMEline

Sickert's *Mornington Crescent Nude*—with light skimming across the model and her bed—shows the influence of Impressionism on modern British art of the period. Augustus John's paintings were, like his life, bright and colorful, as the vibrant portrait of the flamboyant Marchesa Casati (right) shows. In contrast, Wyndham Lewis's *A Battery Shelled* is a grimly depressing depiction of the devastation wreaked by World War I.

c1907

SICKERT Mornington Crescent Nude, Contre-jour

1913

GAUDIER–BRZESKA Red Stone Dancer

1914

GILMAN Girl by a Mantlepiece

1918–19

AUGUSTUS JOHN The Marchesa Casati

1919

WYNDHAM LEWIS A Battery Shelled

▲ **Maternity** Jacob Epstein *This deliberately unfinished sculpture accentuates the effects of pregnancy and demonstrates Epstein's decision to allow the raw rock to help determine the shape of the sculpture.* 1910, stone, height 80in, Leeds Museums and Galleries, UK

Schools

There were three major schools of British Modernism—the Camden Town Group, Bloomsbury Group, and the Vorticists.

The Camden Town Group

The Camden Town Group was formed in 1911. It emerged from an informal Saturday afternoon meeting of artists organized by Walter Sickert, and was set up as a rival exhibiting society to the conservative New English Arts Club.

Members of the Camden Town Group included Harold Gilman, Spencer Gore, Charles Ginner and, importantly, Lucien Pissarro, son of the French Impressionist, Camille. Their first exhibition was in 1911 at the Carfax Gallery in St. James's, London.

In many respects, the group represented a late flowering of French Impressionism. Influenced by Pissarro and Sickert, they painted with deft dabs of paint, paying particular attention to the quality of light in a scene. And, like the Impressionists, they focused on the contemporary, urban world. Favorite subjects included the streets and gardens of London, shabby domestic interiors, and women in their beds or at their toilet.

The group lasted until 1914, by which time many of the artists—including Ginner and Gilman—were painting in a Postimpressionist style, with thick textured brushwork. In 1913, the London Group formed from members of the Camden Town Group and smaller arts clubs.

Bloomsbury Group

The Bloomsbury Group comprised friends—mainly writers and artists—who lived in London's Bloomsbury from 1904 to the 1930s. It contained some of the most important cultural figures in modern British life, including the economist John Maynard Keynes and the writer Virginia Woolf.

Before 1910, literature and philosophy dominated the Bloomsbury Group, but after that it was associated with painting. Roger Fry joined the group in 1910 and organized two large and influential Postimpressionist exhibitions in 1910 and 1912. He also set up the Omega Workshops, a decorative arts company that made abstract designs for craftware, such as ceramics. The artists Vanessa Bell and Duncan Grant were co-directors of the Omega Workshops.

▲ **People at Play** William Roberts *Having seen active service in World War I, Roberts went on to make pictures of people playing. They seem to be a reaction to his experience of the carnage of war.* Private collection

Vorticists

The Vorticists were London-based artists and writers, including the artist Wyndham Lewis and the American poet Ezra Pound. The term Vorticism was coined in 1913 by Pound, who drew on the idea of a vortex—a whirlpool of energy with a still center. The Vorticists were influenced by Futurism, but were less figurative in style. The movement lasted until 1915.

Walter **Sickert**

Photograph by Cecil Beaton

b **MUNICH, 1860;** d **BATHAMPTON, SOMERSET, 1942**

A printer, etcher, teacher, and art critic, Walter Sickert was probably the most important Briton in the art world at the end of the 19th century. He was central in disseminating French avant-garde ideas in Britain, ideas he used to create his own distinctive social-realist style of painting. In 1882, Sickert studied under James McNeill Whistler, although Edgar Degas, whom he met in 1883, was a greater influence. Like Degas, Sickert used photographs as reference, created compositions from unusual vantage points, and painted figures with a sketch-like immediacy.

LIFEline

1860 Born in Munich, son of Danish-German artist, Oswald
1868 Family moves to England
1881 Enrols at The Slade School of Fine Art
1882 Leaves The Slade and becomes assistant to James McNeill Whistler
1883 Meets Edgar Degas
1905 Moves to Mornington Crescent, Camden, London
1911 Becomes leader of artist collective, Camden Town Group
1938 Addresses the Euston Road School group of artists
1942 Dies in Somerset

▼ **Mornington Crescent Nude, Contre-Jour** *Sickert's "iron bedstead" work typically showed nudes in the dark interiors of cheap rented houses. In most of these paintings the model is backlit* (contre jour). *1907, oil on canvas, 19¾ x 24in, Art Gallery of South Australia, Adelaide, Australia*

▶ **Ennui** *Sickert invites the viewer to speculate on the couple's relationship. Despite their proximity, they face in opposite directions, seemingly trapped like the stuffed birds in the bell-jar on the chest of drawers. c1913, oil on canvas, 29¾ x 22in, Ashmolean, Oxford, UK*

CLOSERlook

FACIAL EXPRESSIONS
While the wife looks at the wall, the husband stares at the ceiling, their faces seeming to sum up the *ennui* (intense boredom) in this painting's title.

Harold **Gilman**

b **RODE, SOMERSET, 1876;** d **LONDON, 1919**

Harold Gilman was a key figure in Walter Sickert's Camden Town Group of artists. When he met Sickert in 1907, his painting was similar in style and subject matter to Whistler's, but it evolved rapidly. Gilman soon adopted working-class subject matter, as favored by Sickert, and a colorful, sparkling Impressionist technique employed by, among others, Lucien Pissarro. In 1910, after travelling to Paris with fellow artist Spencer Gore and seeing the work of the Postimpressionists, Gilman began to use thicker areas of paint, flatter color, and much more rigid compositional designs.

LIFEline

1896 Attends Hastings School of Art
1897–1901 Studies at The Slade School of Fine Art
1907 With Walter Sickert and Spencer Gore, he starts the Fitzroy Street Group to discuss and sell paintings
1911 Founder member of Camden Town Group of artists with Sickert and Gore
1913 First president of London Group, an exhibiting society of British artists
1919 Dies in London, a victim of the Spanish flu epidemic

▼ **Leeds Market** *The vibrant, working-class life of the market provided the subject matter for several Camden Town painters. Here, Gilman works in a Postimpressionist style, using small but thick brushstrokes to create a heavily textured surface. The tight and structured composition is typical of Gilman's paintings. c1913, oil on canvas, 20¼ x 24in, Tate, London*

▲ **Girl by a Mantelpiece** *Gilman used broken colors and Impressionist techniques to paint the mirror, face, and skirt. The wallpaper design is sketched with rapid and lively brushstrokes and the bright highlights on the earrings, and the glass on the mantelpiece sing out. 1914, oil on canvas, 15¾ x 11¾in, Potteries Museum and Art Gallery, Stoke-on-Trent, UK*

Charles **Ginner**

b **CANNES, 1878;** d **LONDON, 1952**

Charles Ginner is best known for his urban street scenes, paintings of buildings, and landscapes. He grew up in France, where he studied art and worked in an architect's office, before settling in London in 1910. His paintings show the dilapidated corners of his adopted city, as well as its color, bustle, and brashness. Ginner was good friends with fellow Modernists Spencer Gore and Harold Gilman before he arrived in London, and in 1911 he became a founding member of the Camden Town Group. By this time, Ginner had established a distinctive style, using thick regular brushstrokes to create a heavily textured surface and a sense of solidity. This style changed little, and he was the main upholder of the Camden Town tradition after World War I.

◀ **Gardens along Victoria Embankment** *Ginner creates a bold, lively pattern by reducing forms to flat blocks of color with curved outlines. The clouds serve to frame the top of the picture, while the shrubbery's strong tonal contrasts help pull the eye toward the center.* 1912, oil on canvas, 26 x 18⅛in, Anthony d'Offay Gallery, London, UK

Spencer **Gore**

b **EPSOM, SURREY, 1878;** d **RICHMOND, SURREY, 1914**

◀ **Spring in North London—2 Houghton Place** *The pinks and yellows of this rooftop scene are typical of Gore's palette. They contrast with the bluer shadow tones, creating an air of optimism. Dabs of sap-green capture the tree in first leaf.* 1912, oil on canvas, 20⅛ x 16⅛in, Whitworth Art Gallery, Manchester, UK

Spencer Gore was a central figure in British Post-Impressionism. He painted a wide range of subjects, including, like his Camden Town contemporaries, urban and music-hall scenes and figures in interiors. Between 1896 and 1899, Gore studied at The Slade School of Fine Art in London, where he met Harold Gilman, who became a close friend. In 1905, he visited Walter Sickert in Dieppe and persuaded him to return to London, where in 1911 Gore became president of the Camden Town Group of artists, which formed around Sickert in north London. He was influenced by his friend Lucien Pissarro, whose broken brushwork Impressionist technique he adopted. However, Gore was best known for using boldly simplified forms and large, flat blocks of color in bright, decorative patterns.

Vanessa **Bell**

b **LONDON, 1879;** d **CHARLESTON, SUSSEX, 1961**

Born Vanessa Stephens, Bell was a founder of the Bloomsbury Group. In 1904, she and her three siblings (including writer Virginia Woolf) moved to 46 Gordon Square, in Bloomsbury, London, from where Bell ran the Friday Club meetings of artists. Bell's own painting —initially full of bright, bold designs—grew increasingly abstract. By 1914, it was entirely non-representational, influenced by the theory of "significant form" espoused by her husband Clive Bell and her friend Roger Fry. This theory stressed the pre-eminence of form over subject. The simplicity of her art is also evident in her textile designs for Fry's Omega Workshops and her book jackets for Virginia and Leonard Woolf's Hogarth Press.

▲ **Bathers in a Landscape** *Bell produced this screen for Roger Fry's Omega Workshops, which designed ceramics, textiles, dresses, and furniture. The simplified, outlined figures are influenced by Matisse.* 1913, gouache, private collection

Christopher Richard Wynne **Nevinson**

b **LONDON, 1889;** d **LONDON, 1946**

Self-portrait

Christopher Richard Wynne Nevinson was a British pioneer of Futurism (see p.428). In 1912, he met many of the leading lights of the Futurist movement, including Gino Severini, and first used their "broken plane" techniques to depict trains, traffic, and crowds in London.

At the start of World War I, Nevinson worked as a Red Cross ambulance driver. His paintings of the war are bleak. He uses the Futurist "lines of force" to help show a relentless conflict performed by dehumanized soldiers. When he received an official commission to document the aerial fighting, his vision softened and he depicted fields in beautiful patterns beneath the planes. In 1919, he renounced Futurism and began to paint more naturalistic pictures. However, these were still distorted with lively, angular lines.

◀ **La Mitrailleuse** *Unlike the Italian Futurists, Nevinson was quickly disillusioned by World War I. This picture, named after the machine gun, does not have the energy usually associated with Futurist paintings. Instead, soldiers are shown trapped in a tight, claustrophobic composition under a barbed-wire sky. Reduced to a series of angular planes, they have no individual characteristics and seem to have become machines.* 1915, oil on canvas, 24 x 20⅛in, Tate, London, UK

Stanley **Spencer**

b **COOKHAM, 1891;** d **COOKHAM, 1959**

One of the most individual British painters of the 20th century, Stanley Spencer exhibited at the Second Post-Impressionist exhibition of 1912 in spite of the disapproval of his tutors at The Slade School of Fine Art. In World War I he served as a medical orderly and an infantryman. At his first solo exhibition in 1927 he showed *The Resurrection, Cookham*, a vast painting in which the dead awaken in the churchyard of his home village on the Thames in Berkshire. This mixture of the visionary and the everyday was typical of Spencer and has been compared to William Blake and the Pre-Raphaelites. In 1931 he completed a series of murals for a chapel in Burghclere, commemorating the dead of World War I by juxtaposing scenes of the daily life of soldiers with a massive image on the end wall of the dead taking up their crosses. Spencer brought a precise technique and observation to his landscape paintings, which he frequently found easier to sell than the religious works on which his fame rests. He was knighted in 1958.

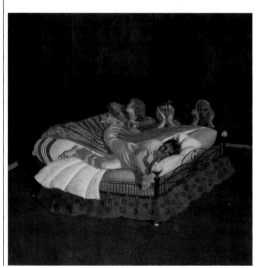

◀ **The Centurion's Servant** *Based on the New Testament story, Spencer had originally intended to provide a second painting showing the arrival of Christ. He placed the scene in the maid's bedroom in the attic of his home in Cookham and was inspired by his mother's account of villagers praying around the bed of a dying man. When first exhibited, the picture was misread as children frightened by an air raid.* Oil on canvas, 45¼ x 45¼in, Tate, London, UK

Gwen **John**

b **HAVERFORDWEST, PEMBROKESHIRE, 1876;** d **DIEPPE,**

Portrait by
Ambrose
McEvoy

Gwen John was one of the foremost British artists of the early 1900s. In contrast to her flamboyant brother, Augustus, she led a reclusive life and had only one solo exhibition in her lifetime. At her death, she was largely unknown, but her reputation revived in the 1960s.

John's work consisted mainly of quiet, contemplative studies of women and girls in interiors, but she also painted the simple, unadorned rooms she lived in; suffused with soft light, these have been read as self-portraits. She also created stark, uncompromising female nudes, painting her models in poses previously considered inappropriate for a female figure.

At the beginning of her career she painted in glazes (transparent layers of paint) with flowing brushstrokes, often on large canvases. However, she later perfected a style using dabs of dry, opaque paint in small, intimate pictures. These paintings have a muted palette and wonderfully subtle transitions of tone.

LIFEline

1884 Her mother dies and she moves to Tenby
1895–98 Studies at Slade School of Fine Art, London
1904 Settles in Paris
1911 Moves to Meudon, on the outskirts of Paris
1913 Converts to Catholicism, saying "My religion and my art, these are my life"
1926 Holds her only solo exhibition, at the New Chenil Galleries, London
1939 Dies in Dieppe

▶ **A Lady Reading** *Gwen John was deeply spiritual, and this painting is full of religious overtones. The figure—shown in full-length with long, loose hair, reading by a window—is similar to the depiction of the Virgin Mary in many northern Renaissance pictures of The Annunciation. John wrote that she originally wanted to base this woman's head on an Albrecht Dürer painting of the Virgin. 1909–11, oil on canvas, 15¾ x 9¾in, Tate, London, UK*

CLOSERlook

STRONG CONTRAST
The curtain's bold color and pattern provide a strong contrast with the subtler colors in the rest of the painting. Its curved shape, however, is echoed in the face and skirt of the model.

> " In 50 years time I shall be known as the **brother** of Gwen John "
>
> AUGUSTUS JOHN, 1942

INcontext
SLADE SCHOOL OF FINE ART
At the end of the 19th century, London's liberal, fee-paying Slade art school was the pre-eminent art school in Britain. Walter Sickert, Harold Gilman, Spencer Gore, Christopher Wynne Nevinson, Duncan Grant, and Augustus and Gwen John all studied there.

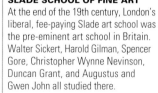

At The Slade School of Fine Art *Life drawing was placed at the center of teaching. Women as well as men attended life classes.*

Augustus **John**

b **TENBY, PEMBROKESHIRE, 1878;**
d **FORDINGBRIDGE, HAMPSHIRE, 1961**

Self-portrait

Augustus John, younger brother of Gwen, was one of the most gifted artists of his generation. In the 1890s, he established his reputation as a brilliant draftsman at The Slade School of Fine Art. By the 1900s, influenced by Postimpressionists, he was making bold, colorful paintings, especially of figures in the landscape. John's lifestyle was as colorful as his painting. He drank hard, womanized, and grew a long beard.

Intrigued by gypsy culture and the Romany language, he lived in caravans with his wife Ida, mistress Dorelia, and his children from both partners. After World War I, John became Britain's leading society portraitist, but as his fame grew, his creativity declined.

LIFEline

1878 Born in Tenby, Pembrokeshire
1894 Enrols at Slade School
1898 Wins Slade Prize for *Moses and the Brazen Serpent*
1899 First one-man exhibition, at London's Carfax Gallery
1914 Becomes official war artist for Canadian army
1928 Elected to Royal Academy
1961 Dies in Fordingbridge, Hampshire

▶ **The Marchesa Casati**
Like John, the Italian heiress Luisa Casati led a licentious life. Here, John portrays her as a glamorous yet slightly sinister character. 1918–19, oil on canvas, 37¾ x 26½in, Art Gallery of Ontario, Canada

▲ **Dorelia and the Children at Martigues** *Unlike his sister Gwen, Augustus usually painted his figures in the landscape. This work, almost a sketch in oils, is typical of his exuberant style. The bold, flat colors and outlined figures show the influence of Paul Gauguin and Henri Matisse. 1910, oil on panel, 9⅛ x 13in, Fitzwilliam Museum, Cambridge, UK*

Wyndham **Lewis**

Portrait by Augustus John

b **NOVA SCOTIA, 1882**; d **LONDON, 1957**

Painter, writer, and polemicist, Wyndham Lewis was an unlikely founder-member of the Camden Town Group in 1911, and worked for Roger Fry's Omega Workshops in 1913. He rapidly fell out with both groups, considering them old-fashioned. Instead, with American poet Ezra Pound, he founded his own movement, Vorticism, which lasted from 1913 to 1915.

Lewis adopted the violent rhetoric of the Italian Futurisists in his publication *Blast*, although his style was closer to the French Cubists. Vorticism combined the two movements and resulted in the first British contribution to Modernism. It celebrated the modern world, its machines and high buildings, often seen from unusual viewpoints. During the 1930s, Lewis ran into widespread opposition to his authoritarian political views, and his sympathies with fascism.

LIFEline

1898–1901 Studies at Slade School of Art in London

1915–17 Serves with the Royal Artillery in World War I

1917–18 Works as an official war artist

1939–45 Lives in the US

1946–51 Works as art critic for *The Listener* magazine, London

1951 Goes blind

▶ **Workshop** *This epitomizes Lewis's Vorticist style, using harsh colors, sharp angles, and shifting diagonals to suggest the geometry of modern buildings and the discordant vitality of the city. c1914–15, oil on canvas, 30¼ x 24in, Tate, London, UK*

▲ **A Battery Shelled** *Lewis combined the geometrical stylization of Vorticism with figurative elements to create a modern, disturbing vision of war. Produced for the British War Memorials Committee in 1919, this painting was criticized for its bleak vision. A group on the left impassively observes the devastation of the war. 1919, oil on canvas, 72 x 215¼in, Imperial War Museum, London, UK*

CLOSERlook

SOMBER SCENE
The palette is somber and the figures, with their stiff Vorticist jaggedness, seem almost mechanical, as if made out of metal tubing. This picture is a long way from Lewis's energetic pre-World War I paintings.

450

Henri **Gaudier-Brzeska**

Gaudier-Brzeska, c1910

b **ORLÉANS, 1891**; d **NEUVILLE-ST. VAAST, 1915**

Henri Gaudier-Brzeska was born in France, but spent most of his tragically brief sculpting career in London. He died in World War I, aged just 23, and yet he still left an impressive body of work.

Gaudier-Brzeska began to establish himself as a sculptor in 1912, while working for a timber importer in London. He made figure studies in the manner of Rodin, including theater, ballet, and wrestling subjects. His work rapidly evolved as he became less concerned with careful modeling and instead began to respond to subject matter and materials emotionally. He spoke of his work as an abstraction of instinct and feeling. He met Jacob Epstein (see opposite) in 1912 and became a pioneer in the revival of carving in sculpture. However, he was most closely associated with the Vorticists, signing their manifesto and contributing articles to their magazine, *Blast*.

LIFEline

1907 Wins scholarship to study at the Merchant Venturers' Technical College in Bristol

1909 Returns to France

1910 Meets long-term partner Sophie Brzeska

1911 With Sophie, moves to London, adopting the surname Gaudier-Brzeska

1911–13 Works as a foreign-language clerk for a timber importer in the City of London

1914 Elected to the London Group. Returns to France and enlists in the army

1915 Is killed by a bullet and buried in a military cemetery

▲ **Bird Swallowing Fish** *Gaudier-Brzeska made several animal and bird sculptures, based on zoo sketches. The fish is jammed into the bird's mouth and the two combatants seem to have been transformed into armored creatures. 1914, plaster, 13 x 24 x 11in, University of Cambridge, UK*

▶ **Red Stone Dancer** *This exemplifies Gaudier-Brzeska's abstract style, with a triangle imposed on the featureless face and shapes on the breasts. The figure defies anatomical convention, as it twists and bends in the dance. c1913, red Mansfield stone, 16⅞ x 9⅛ x 9⅛in, Tate, London, UK*

▲ **Hieratic Head of Ezra Pound** *The Vorticist writer Ezra Pound commissioned this portrait, presenting Gaudier-Brzeska with a block of marble. Pound was delighted with the result— the sharp-edged, geometric forms were in keeping with the Vorticists' machine-age aesthetic. 1914, marble, 36 x 18⅛ x 19¼in, Nasher Sculpture Center, Dallas, US*

Sir Jacob **Epstein**

Photograph by Roland Haupt

b **NEW YORK, 1880**; d **LONDON, 1959**

Jacob Epstein was one of the foremost—and most controversial—sculptors of the 20th century. Rebelling against pretty art, he made bold, massive forms from bronze or stone, and his work is marked by its vigorous, often aggressive approach. Epstein championed many of the principles central to Modernist sculpture. He carved directly into stone, respecting the original blocks he used, and sought to reveal their properties in his final sculptures.

Epstein's work caused outrage, especially the nude statues he designed for the British Medical Association building in London, and the debauched-looking angel on his *Memorial for Oscar Wilde* in Paris (1912). The *W. H. Hudson Memorial* (1925) was tarred and feathered in 1929 and defaced with paint in 1930.

LIFEline

1896 Attends art classes at the Art Students League in New York
1905 Settles in London
1907 Becomes a British citizen
1912–13 Meets Modigliani, Picasso, and Brancusi in Paris
1913 Becomes a founding member of the London Group
1953 A retrospective of his work is held at the Tate, UK
1954 Receives a knighthood
1959 Dies, aged 79

▼ **W. H. Hudson Memorial** *Dedicated to the writer and naturalist William Hudson, this sculpture depicts Rima, one of his most famous characters, surrounded by birds. The figure's nudity caused massive controversy and had to be guarded by the police after its opening.* 1925, stone, Hyde Park, London, UK

▼ **Torso in Metal from "The Rock Drill"** *Epstein initially set this figure on top of a pneumatic rock drill, and even considered adding a motor to make the piece move. After World War I, however, he "emasculated" the work, removing the drill and cutting the figure to half-length.* 1913–14, bronze, 28¼ x 23 x 18⅛in, Tate, London, UK

William **Roberts**

b **LONDON, 1895**; d **LONDON, 1980**

The painter and teacher William Roberts studied at the Slade School of Art in London from 1910 to 1913. He then worked briefly for Roger Fry's Omega Workshops, decorating furniture with Cubist-inspired designs. By 1914, he had moved over to the Vorticists, signing their manifesto, *Vital English Art*. Roberts saw active service in World War I, and later became an official war artist. In the 1920s, he applied his distinctive style of simplified tubular figures to observation of contemporary life.

▼ **Bank Holiday in the Park** *After World War I, Roberts painted groups of figures arranged in energetic compositions. This example, full of gesticulating hands and humor, is typical.* 1923, oil on canvas, private collection

David **Bomberg**

Self-portrait

b **BIRMINGHAM, 1890**; d **LONDON, 1957**

The fifth child of 11 born to a Jewish Polish immigrant leatherworker, David Bomberg spent his youth in poverty in Birmingham and the Whitechapel area of London. However, with the help of John Singer Sargent, he secured a place at the Slade School of Art.

Bomberg's painting reached a creative high just before World War I. He interpreted Jewish and East End subject matter in a modern manner, using angular, clear-cut forms, charged with enormous energy. Wyndham Lewis was taken with his work and encouraged him to join the Vorticists, but Bomberg resisted.

World War I brought a profound change to Bomberg's outlook. The mechanized slaughter and his brother's death destroyed his faith in machine-age abstraction. He turned instead to an expressionist figurative style, painting mainly portraits and landscapes. He produced some of his best work in Spain between the wars, and on trips to Cornwall in 1947 and Cyprus in 1948.

LIFEline

1911–13 Studies at the Slade School of Art
1913 Travels to France with Jacob Epstein; meets Derain, Modigliani, and Picasso
1916 Marries; sent to the front line in France
1945–53 Teaches part-time at Borough Polytechnic, London; students include Frank Auerbach
1957 Dies in London, aged 67

▲ **The Dancer** *Bomberg developed a unique style, using sharp-edged shapes and limited colors. This image appears to be abstract, but it is in fact based on drawings of a dancer.* Victoria & Albert Museum, London, UK

◄ **Trendrine, Cornwall** *In August 1947, Bomberg visited Cornwall and produced a series of semi-abstract landscapes alive with exuberant color and expressive brushwork.* 1947, oil on canvas, 32 x 42in, Arts Council Collection, UK

Edward **Wadsworth**

b **CLECKHEATON, 1889**; d **LONDON, 1949**

Edward Wadsworth was a successful and versatile painter, draftsman, and printmaker. He studied at the Slade School and had his first solo show in 1920. His reputation is based on his pioneering work as a Vorticist, his post-war ink-and-wash drawings of England's Black Country industry, and his seaside paintings. The latter were made with tempera—the pigment being mixed with egg yolk rather than oils.

▲ **The Offing** *The unreal, dreamlike clarity and surprising changes in scale in this picture are clearly influenced by Surrealism.* 1935, tempera on panel, 35 x 25¼in, Bristol Museum and Art Gallery, UK

Ashcan School

Around 1900, America experienced rapid population growth and urbanization. City life became the central theme for a group of young realist painters led by Robert Henri. They became known as the Ashcan School because they depicted the unglamorous side of street life.

Their recognition that the American city and its inhabitants provided a new subject for art made them the first representatives of US Modernism, although their style was conservative by European standards.

Many American artists went to Paris or Rome to study fine arts. They were drawn by the thorough training, but also by the opportunities to see great art galleries and artists' studios.

Visiting exhibitions played a key role in changing the American art world. The photographer and gallery owner Alfred Stieglitz exhibited works by Matisse, Picasso, and Brancusi in New York. In 1913, an exhibition held in New York City's 69th Regiment Armory united 1,600 European and

▲ **Chrysler Building (1930)** *Modernism influenced architecture as well as art. Designed by William Van Alen (1883–1954), this New York skyscraper embodied the Modernist spirit through its Art Deco styling.*

American Modernist artworks under one roof. The Armory Show went on to visit Boston and Chicago, attracting a total of 300,000 visitors in all.

Toward abstraction

By the 1920s, a number of American artists had been influenced by the most advanced European tendencies. What appealed most was the way in which the forms of Modernist art could be equated with the machines that were transforming American life.

The fragmentation in the paintings of artists such as Max Weber and Charles Demuth reflect the hectic bustle of the cities, while Marsden Hartley and Arthur Dove were influenced more by Kandinsky and Expressionism and sometimes came close to total abstraction.

CURRENTevents

1915 DW Griffiths's Civil War movie *Birth of a Nation* leads to riots, as it condemns the emancipation of the slaves and praises the Ku Klux Klan.

1917 The US declares war on Germany hastening the end of World War I.

1925 F. Scott Fitzgerald's novel *The Great Gatsby* shows the excesses of the upper classes during the "Jazz Age."

By the end of the 19th century, the US had forged its own history, both bloody and proud, and writers such as Herman Melville and Walt Whitman had succeeded in creating a distinctive American voice. To do the same for painting, artists opted to engage with the new realities of city life and the challenging artistic ideas coming from Europe.

Early US Modernism

Robert **Henri**

b CINCINNATI, 1865; d NEW YORK, 1929

Robert Henri was an inspirational teacher and a member of The Ashcan School whose dark, brooding urban scenes were first shown at the Macbeth Gallery, New York, in 1908. Henri studied art in Pennsylvania and Paris, where he spent much of the 1890s before settling in New York in 1900. His paintings were influenced by 17th-century Dutch realism and the bold, daring brushwork of Édouard Manet's Spanish pictures.

After teaching at the New York School of Art between 1902 and 1909, Henri founded his own art school, and in 1910 was the driving force behind the first US Exhibition of Independent Artists. Although fearful of "extremes" in painting, he encouraged his pupils to visit the Armory Show and to keep an open mind when seeing the works of Picasso or Matisse.

◀ **Snow in New York** *This almost monochrome cityscape is divided evenly between the dark tones of the architecture, the wintry sky, and the snowbound street. 1902, oil on canvas, 31⅞ x 25⅝in, National Gallery of Art, Washington, DC, US*

John **Sloan**

b LOCK HAVEN, 1871; d HANOVER, 1951

▲ **McSorley's Bar** *The sense of quiet intimacy in this subtly composed and lit picture of a New York bar recalls the domestic scenes found in 17th-century Dutch painting. 1912, oil on canvas, 26 x 31⅞in, Detroit Institute of Arts, US*

John Sloan attended art classes at the Pennsylvania Academy while working as an illustrator in Philadelphia. He took up painting seriously in 1896, and moved to New York in 1904. Fascinated by features of the urban landscape such as elevated trains, buildings, and street lighting, Sloan adopted the city as his central theme. He could evoke both atmospheric intensity, as in *The Wake of the Ferry* (1907), and intimate domesticity, as in *The Cot* (1907)—a study of a woman stepping into bed.

Sloan, along with other pre-World War I artists, lightened his palette and broadened his subject range in response to the Armory Show. Yet, it proved difficult for him to adapt to the highly conceptual ideas behind European Modernism.

George **Bellows**

b COLUMBUS, 1882; d NEW YORK, 1925

George Bellows produced his greatest works while still in his 20s. His paintings primarily depict the raw vitality and survival instincts of New York's lower classes and, by association, modern America.

Bellows trained under Robert Henri and followed his teacher's advice "to express the spirit of the people today." His monumental works include *Pennsylvania Excavation* (1909) and other powerful urban landscapes. He applied the same bold brushwork to gutsy portrayals of private boxing matches, such as *Both Members of This Club* (1909). Bellows's gift was to see great human drama in the lives of ordinary people.

▲ **A Day in June** *Bellows fuses an "Impressionistic" day out with the atmosphere of a fête champêtre —a grand garden party. It is an elegant departure from his earthy city scenes of the same period. 1913, oil on canvas, 42⅛ x 48in, Detroit Institute of Arts, US*

Charles **Demuth**

b **LANCASTER, 1883;** d **LANCASTER, 1935**

Having trained at Pennsylvania Academy of Fine Arts from 1904 to 1911, Charles Demuth spent the years leading up to World War I in Europe. His mature style was influenced by Marcel Duchamp's simplified pictures of machines, as well as by the abstract Cubism of Marsden Hartley, with whom Demuth went on a painting trip to Bermuda in 1917. Here, he laid the groundwork for the cool-toned, detailed, and objective painting style called Precisionism, or Cubist Realism.

Demuth painted machines, industrial sites, and agricultural architecture, with his landmark work, *My Egypt* (1927), painted at his parents' home in rural Pennsylvania during one of the bouts of illness that plagued his final years. He instils in his subject—grain elevators common to any arable farm—a sense of architectural grandeur, and alludes in his title to both the ancient pyramids and to his own "captivity" in provincial America. He also created "poster portraits," in which he characterized his friends in words and objects.

CLOSERlook

NUMBER 5 As the fire engine speeds through the New York streets with "gong clangs, siren howls, and wheels rumbling" (from Williams's poem), the number emblazoned on its rear is depicted getting smaller, creating a sense of constant recession.

LIFEline

1883 Born the son of a wealthy tobacco merchant

1905–11 Studies at Pennsylvania Academy of Fine Arts

1907–08 Makes the first of several visits to Europe

1915 First one-man show

1917–20 Develops the style that leads to Precisionism

1927 Paints *My Egypt*

1935 Dies, from complications due to diabetes

➤ **I Saw the Figure Five in Gold** *This painting—one of the most recognizable images of American Modernism—alludes to a poem of the same name by Demuth's close friend, William Carlos Williams, who describes a red fire engine hurtling down the street.* 1928, oil on composition board, 35¾ x 29⅞in, The Metropolitan Museum of Art, New York, US

Arthur **Dove**

b **CANANDAIGUA, 1882;** d **HUNTINGTON, 1946**

▲ **Reflections** *In muted grays, blues, and turquoise, Dove depicts a swirling abstract landscape in which two trees seem to huddle together in front of a celestial revelation.* 1935, oil on canvas, 15 x 20⅞in, Indianapolis Museum of Art, US

Arthur Dove worked as a newspaper illustrator prior to moving to Paris in 1907, where he exhibited his Fauvist paintings at the Salon des Indépendants in 1908–09. Once back in America, he bought a ramshackle Connecticut farmstead and immersed himself in nature. A pioneer of American abstraction (he produced his earliest abstract works in 1910), Dove derived his abstract compositions from natural forms. He simplified these forms down to their essence, in what he called his "extractions". Dove was fascinated by synesthesia—sounds experienced as colors or shapes. He explored this in *Foghorns* (1929), picturing blaring siren sounds as rhythmically expanding concentric forms in pinks.

Marsden **Hartley**

b **LEWISTON, 1877;** d **ELLSWORTH, 1943**

Marsden Hartley studied at the Cleveland School of Art and at New York's Academy of Design. The early works of this passionate, self-conscious, and remote artist were bold landscapes executed in short, nervy strokes and broken color, for which photographer and gallery owner Alfred Stieglitz gave him his first one-man show in 1909. Three years later, Hartley went to Europe and settled in Berlin. Under the influence of Expressionism, he developed a distinctive style using bold, brightly colored, symbolic shapes. Hartley returned to America in 1916, but continued to travel extensively, including to Mexico. After settling in Maine in 1934, he found new inspiration painting rugged coastal scenes.

▲ **Painting, Number 48** *Influenced by both Fauvist and Expressionist concepts, Hartley created a distinctive style, strangely reminiscent of both floral design and military pageantry.* 1913, oil on canvas, 47¼ x 47¼in, Brooklyn Museum of Art, New York, US

Max **Weber**

b **BELOSTOK, 1881;** d **GREAT NECK, 1961**

◄ **Composition with Three Figures** *Weber gained much from seeing Picasso's bold figure compositions of 1907–08. Here, the three female figures seem hewn out of rock, the angles of their joints knife-sharp, and their mood one of deep repose, almost eternal sleep.* 1910, watercolor and gouache on cardboard, 46⅞ x 23¼in, Ackland Museum, The University of North Carolina, US

Max Weber emigrated to the US from Russia with his Jewish parents when he was 10. Between 1905 and 1908 he studied at both the Académie Julian and the Académie Matisse in Paris. As the only American artist to have fully and naturally assimilated both Fauvist and Cubist ideas, he found his art was widely criticized on his return to the US. His large-limbed nudes, with their sharp, intersecting outlines, are somewhere between Kasimir Malevich's Primitivist figures and Picasso's *Les Demoiselles d'Avignon*, as in Weber's *Composition with Three Figures*. After 1917 Weber took a more naturalistic approach, introducing Jewish themes from his Russian childhood into his work.

Naïve painting, sometimes confusingly known as Primitive art, can be loosely defined as the work of artists with little or no formal art training. It does not imply an amateur, or "Sunday painter" status. When this style entered the mainstream of fine art, it was adopted by formally educated artists such as L.S. Lowry (see p. 495) who might be more properly labeled "pseudo-" or "faux-naïve".

With the revolutionary changes in art at the start of the 20th century came a reappraisal of previously dismissed genres, including Naïve painting. The lack of training of Naïve artists was recognized as a strength rather than a shortcoming, giving their work a refreshing spontaneity and directness.

Origins and influences

There have, of course, always been untrained artists—not only amateurs, but also folk artists and the art of "primitive" cultures outside the Western tradition. Appreciation of their talent only came in the 20th century, when Henri Rousseau was

▲ **So Long** *Previously dismissed as unsophisticated, untutored artists such as Grandma Moses were only properly appreciated in the 20th century.*

noticed by the young Picasso, and the art critic Wilhelm Uhde began to collect French Naïve paintings. The vogue for Naïve art spread to Britain and the US in the 1930s, with the discovery of Alfred Wallis and Grandma Moses, while the Centre d'Art, established by DeWitt Peters in Port-au-Prince, brought the work of Haitian artists to worldwide attention.

Naïve artists were largely untouched by trends in the art world. Their influence on mainstream art, however, has been considerable.

Subjects and technique

Unlike many 20th-century artists, Naïve painters are often motivated by their interest in a subject. Frequently, there is a nostalgic preoccupation with the past, as with Wallis and his sailing ships, and André Bauchant and peasant festivals. Although some, such as Henri Rousseau, have aspired to emulate academic painters, the common stylistic elements come from their lack of training in conventional techniques. The composition, for example, is simple and instinctive, sometimes to the point of being wildly unstructured. This unsophisticated quality is intensified by a lack of scientific perspective.

Naïve paintings are also frequently crowded with detail—especially awkwardly drawn figures—contrasting with flat areas of paint. Combined with a tendency to use bright, unnaturalistic colors, this gives Naïve art vitality and a childlike innocence.

Naïve painting

Alfred **Wallis**

b DEVONPORT, DEVON, 1855; d MADRON, CORNWALL, 1942

Although one-time fisherman and marine scrap merchant Alfred Wallis only began painting in his late sixties, he influenced a generation of British painters in the 1930s. Brought up in south-west England, Wallis first went to sea aged just nine and spent his entire life in and around the fishing boats. Even after his shop "Wallis, Alfred, Marine Stores Dealer" closed in 1912, he remained in St. Ives doing odd jobs in the town, and only took up painting after the death of his wife.

His untrained, naïve style caught the attention of painters Ben Nicholson and Christopher Wood in 1928. He was introduced to several of the major painters of the time, including Jim Ede, who championed his work in London. Yet, despite this recognition, Wallis sold only a few paintings and died in poverty in 1942.

LIFEline

1855 Born in the port of Devonport
c1875 Marries Susan Ward
1890 Gives up fishing, moves to St. Ives, and opens marine scrap business
1922 Takes up painting
1928 Painters Ben Nicholson and Christopher Wood found an artists' colony in St. Ives and discover his work
1942 Dies in Madron Workhouse, Cornwall

▶ **The Island, St. Ives** *Many of Wallis's townscapes seem flat and maplike, with a high viewpoint and a naïve perception of perspective. Objects are arranged side by side rather than overlapping, their size determined by relative importance rather than their distance from the viewer.* Oil on board, 11 x 9⅜in, Whitworth Art Gallery, Manchester, UK

◀ **Land, Fish, and Motor Vessel** *Lack of money led Wallis to paint with very few colors, often on pieces cut from cardboard boxes. Despite these limited means, and an unorthodox approach to scale and perspective, he effectively captured the essence of his subject.* Oil on buff card, 15 x 14⅝, University of Cambridge, UK

CLOSERlook

LIMITED COLORS Wallis's typically restricted range of colors emphasizes the separate areas of land and sea, and enhances the dramatic effect of the very high viewpoint. The viewer's attention is drawn upward over an expanse of ground to the coast, where houses are perched at the water's edge, and then to the ships floating on a featureless gray sea.

Henri **Rousseau**

Self-portrait

b **LAVAL, 1844;** d **PARIS, 1910**

Ridiculed in his own lifetime, but posthumously achieving his ambition of having his work exhibited in the Louvre, Henri Rousseau is nowadays considered a talented Naïve painter. He had no formal training, and for much of his life he worked as a tax collector at the Paris tollgates, earning him the nickname *Le Douanier* (the customs officer). Rousseau often painted huge, brightly colored fantasies set in exotic jungle scenes—all the more remarkable because, despite his boasts to the contrary, he never left France. He had an unshakeable belief in his own talent, which led him to exhibit almost every year in the Salon des Indépendants, an alternative group that allowed artists to show their work outside the formal constraints of The Salon. Rousseau's paintings were later discovered by artists such as Pablo Picasso and Constantin Brancusi, but it was too late to bring him the success he craved. His work anticipated and influenced several 20th-century styles: paintings such as *The Snake Charmer* (1907) and *The Dream* (1910) presage Surrealism in particular.

LIFEline

1844 Born in Laval, in the Loire Valley
1863–67 Serves in the infantry
1868 Moves to Paris and works as a civil servant
1885 Exhibits at the Salon for the first time
1893 Retires from the toll-service to paint
1905 Shows *The Hungry Lion* at the Salon d'Automne
1910 Dies in the Hôpital Necker, Paris

▶ **The Snake Charmer** *The exotic imagery and style are a characteristic of Rousseau's jungle scenes. The dreamlike subject is painted in lush, vivid colors in a bold composition, yet the individual elements— the snake charmer, the bird, and the jungle itself—are quite stiffly depicted, with a curious lack of depth. 1907, oil on canvas, 66½ x 74⅜in, Musée d'Orsay, Paris, France*

CLOSERlook

JUNGLE LEAVES The foliage is painted with an unusual flattened perspective; the almost two-dimensional leaves overlap to give an impression similar to collage.

▼ **The Toll House** *Painted while Rousseau was working as a customs officer, this is a startling view of an unremarkable scene. He uses color rather than perspective to give depth to the separate picture planes, drawing the eye toward the strangely flat building and the two awkwardly posed figures. c1890, oil on canvas, 16⅛ x 13in, The Courtauld Gallery, London, UK*

▼ **The Walk in the Forest** *Early in his career, Rousseau painted several woodland landscapes, which are remarkable for their fine detail. In many of them he added a figure, claiming to have invented a new genre of "portrait-landscape." The effect was that the subject seemed overwhelmed by the weight of the background. 1886–90, oil on canvas, 27⅝ x 23⅝in, Kunsthaus, Zurich, Switzerland*

▲ **War** or **The Ride of Discord** *Rousseau depicts a nightmarish vision of war with childlike straightforwardness. The central figure (reminiscent of Struwwelpeter, a scruffy character from a German children's story), his horse, and the victims are grotesquely posed and proportioned, while the leafless trees and oddly solid clouds are portrayed with little regard for perspective. 1894, oil on canvas, 44⅞ x 76¾in, Musée d'Orsay, Paris, France*

André **Bauchant**

b CHÂTEAU-RENAULT, 1873; d MONTOIRE-SUR-LE-LOIR, 1958

Despite taking up painting comparatively late in life, André Bauchant forged a successful career as a painter and his output was prolific. He had little formal education and followed in his father's footsteps, working as a market gardener. Yet he was an avid reader, especially of classical history and mythology, and discovered his talent for drawing during World War I. Bauchant served in the French Army, at first in Greece and then in France, where he trained as a mapmaker. Shortly after the war, he began his career as a painter, and his naïve paintings of flowers and scenes from history and mythology were soon noticed by collectors. Championed by Swiss architect and painter Le Corbusier and the art dealer Jeanne Bucher in the 1920s, Bauchant built an enviable reputation and worked well into his old age.

LIFEline

c1914–18 Serves in the French Army

1919 Takes up painting full time

1921 His work is shown at Salon d'Automne, Paris

1927 Designs sets and costumes for Diaghilev's ballet company

1937 Exhibits in the *Maîtres Populaires de la Réalité* show in Paris

▼ **Country Reunion** *Bauchant painted some historic scenes and a few, such as this one, of everyday life. These often took the form of landscapes with a rudimentary perspective, peopled with his typically simple figures.* 1953, oil on canvas, 17 x 29in, Musée des Beaux-Arts, Lille, France

Séraphine de Senlis

b ARSY, 1864; d CLERMONT, 1942

Séraphine Louis, better known as Séraphine de Senlis, was working as a housekeeper when the art dealer Wilhelm Uhde saw her work in a neighbor's house in Senlis in 1912. He immediately bought several of her extraordinary, visionary paintings. Séraphine was inspired with a religious zeal bordering on fanaticism, and was committed to a psychiatric hospital in the 1930s. She lived, institutionalized, in Clermont, France, until her death in 1942.

▶ **The Tree of Paradise** *Séraphine used enamel paints, shellac, oil, and even gold to achieve rich and brilliant colors. Her compositions of flowers and trees contain petals and leaves fantastically transformed into feathers, eyes, shells, and animals.* c1929, oil on canvas, 76¾ x 51¼in, Pompidou Center, Paris, France

Wilson **Bigaud**

b PORT-AU-PRINCE, 1931

Encouraged by his neighbor, the artist Hector Hyppolite, Wilson Bigaud took up painting as a teenager and built an international reputation while still in his twenties. Born the son of a farmer in Port-au-Prince, Bigaud has lived in Haiti all his life and his paintings are crowded with details of everyday Haitian scenes.

In 1946, Hyppolite took the young Bigaud to the Center d'Art in Port-au-Prince, which had been established by the American artist DeWitt Peters. This inspired Bigaud to make a career in painting, and provided the contact to exhibit and sell his work. From then until mental illness prevented him from painting in 1957, Bigaud produced some of his finest work: lively pictures of carnivals and dances; biblical scenes, such as the mural *Marriage at Cana* (1951) in the Episcopal Cathedral; and depictions of rites from the Haitian religion of Vodoun, a form of Voodoo. He returned to his art in 1962, and lives and works in the small town of Petit-Goâve.

LIFEline

1946 Hyppolite takes him to the Center d'Art

1950 Wins second prize for *Paradis* at an international exhibition, Washington DC

1951 Paints *Marriage at Cana* for the Cathedral of Sainte Trinité

1957–61 Suffers a series of breakdowns and stops painting

1958 MoMA, New York, buys his *Paradis Terrestre*

1962 Resumes painting at his house in Petit-Goâve

CLOSERlook

SPIRIT OF THE DANCE
The lively atmosphere is captured by the detailed portrayal of members of the band in active poses, picked out in black and white against the colorful background.

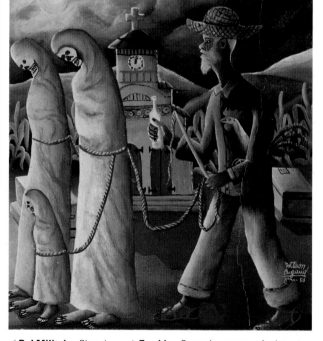

◀ **Bal Militaire** *Bigaud achieves a feeling of depth in his paintings through the use of color, rather than perspective. Here, the golden background helps project the more boldly colored figures forward.* c1950, watercolor on paper, 15½ x 19in, private collection

▲ **Zombies** *Dramatic contrasts of color highlight the symbols of the Haitian religion Vodoun in this moonlit scene. The pale zonbi (Creole for "zombie," a body without a soul) are controlled by a benign-looking farmer who is carrying a chicken and, at the center of the picture, a bottle of protective magic.* 1953, oil on masonite mounted on wood panel, 9¾ x 9in, Figge Art Museum, Davenport, US

Grandma **Moses**

Grandma Moses, 1961

b GREENWICH, 1860; d HOOSICK FALLS, 1961

After a lifetime spent working on farms, Anna Mary Robertson Moses—or Grandma Moses as she became known—was already in her seventies when she began her remarkable artistic career. Widowed in 1927, she started making embroidered pictures, and soon after, when arthritis made this difficult, turned to painting.

At first her work appeared only locally, but in 1938 an exhibition in a Hoosick Falls drugstore was noticed by art collector, Louis J. Caldor. This led to three of her paintings being shown at the Contemporary Unknown American Painters exhibition at MoMA, New York, in 1939. From then on, she became a household name and enjoyed success as a leading "American Primitive" painter, famous for her nostalgic and lyrical landscapes and scenes of everyday life.

LIFEline

1860 Born in Washington County, New York
1887 Marries Thomas Salmon Moses, moves to Virginia
1905 Returns to New York
1940 Has first one-woman show in New York
1961 Dies aged 101

> **Home of Hezekiah King, 1776** *One of five paintings of her great-grandfather's home, this was not painted from memory, as the house burned down in 1800, but presents an idealized view of Moses family history in an idyllic setting.* 1943, casein on masonite, 19¾ x 23½in, Phoenix Art Museum, Arizona, US

▼ **Summer Party** *Moses's landscapes depict changing seasons as she recalled them on her farm.* c1940s–50s oil on masonite, 17¾ x 25½in, Museum of Fine Arts, Houston, US

CLOSERlook

PRIMITIVE FIGURES The figures in Moses's landscapes, such as this horse-drawn cart, often nostalgically evoke a bygone era. Simply depicted with dabs of paint, they were added after the more naturalistically painted sky and landscape had been completed.

Beryl **Cook**

b EGHAM, 1926 ; d PLYMOUTH, 2008

Using a paintbox bought for her young son, Beryl Cook discovered a gift for painting when she was in her forties, and went on to become one of Britain's most popular painters. After leaving school, she worked as a showgirl and shorthand typist, and in the 1960s ran a pub and boarding house in Devon. It was here that guests discovered her playful paintings, leading to an exhibition in 1975 and international recognition.

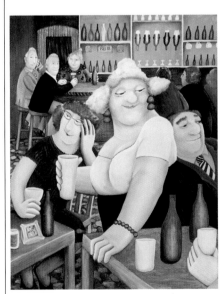

▲ **The Lockyer Tavern** *Cook's humorous paintings are peopled with well-observed and sympathetically portrayed characters at leisure. She is best known for her depictions of flamboyant and independent "fat ladies."* c1974, oil on panel, 30¾ x 24in, private collection

Hector **Hyppolite**

b SAINT-MARC, 1894; d PORT-AU-PRINCE, 1948

▲ **Monument Dumarsais Estimé** *Hyppolite had a spontaneous style offset by symmetrical composition. Here, naked figures bowing beneath crossed swords, held in disembodied hands, add to the totemic quality.* 1945–47, oil on masonite, 28¾ x 22¾in, private collection

Hector Hyppolite was a priest of Vodoun (see right), and its symbolic imagery inspires much of his work. He worked as a shoemaker and housepainter in Saint-Marc, in western Haiti, until 1945, when he moved to Port-au-Prince. It was here, in the remaining three years of his life, that he started painting. In 1946, an exhibition in Paris, organized by French surrealist André Breton, brought his work to a wider public.

INcontext

VODOUN AND ART Vodoun, a variant of Voodoo, was brought to Haiti by slaves from western Africa, and, despite efforts to suppress it, remains the faith of many ordinary Haitian people. Like other religions, Vodoun has inspired many works of art, and its imagery, rites, and legends figure largely in the work of Haitian artists such as Bigaud and Hyppolite.

Entrance to a Haitian Vodoun shrine *Shrines are decorated with paintings, murals, wallhangings, and artefacts depicting symbols of the Vodoun religion.*

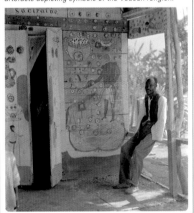

Background

There had not been an artistic hub like Paris since Renaissance Florence. Foreign painters, sculptors, art dealers, and publicists began to descend on the city, some with financial means, others with barely their train fare. Certain artists, such as the suave Amedeo Modigliani, were already fluent in French; others, including Chaim Soutine, had to learn quickly. These newcomers from abroad settled among the resident French artists, both native Parisians and those who had arrived from the provinces.

Journalist André Warnod first described the multi-national mix as an "École" in 1925. However, this school was not an art movement linked by a manifesto, training, or shared political views. Rather, it was a group of artists who were united by a desire to follow a bohemian lifestyle, share their experiences, and choose, if they wanted, to attend Paris's numerous art academies and open studios. In this way Cubists, Futurists, Abstract artists, and figurative painters found common ground.

◀ **Le Dôme café, Paris**
Artists of the École de Paris regularly gathered at artists' studios and cafés such as Le Dôme in the Montparnasse district of the city.

Making a reputation

Most artists arrived to make their reputations. Of all European cities, Paris had by far the largest art market with upward of 100 private galleries. Then there were the art dealers—many of who were often foreigners themselves. Two such men, Léopold Zborowski and Daniel-Henri Kahnweiler, would grant fortunate artists an annual income in exchange for their work.

Certain cities act as cultural magnets, drawing in talent, innovation, and diverse opinions. From 1904 to 1929, the most important artistic center was Paris. In time, the notion of a specifically Parisian artistic phenomenon arose: an *École de Paris* (School of Paris).

École de Paris

Maurice **Utrillo**

Utrello, date unknown

b **PARIS, 1883**; d **DAX, 1955**

Amid bouts of depression and addiction to alcohol, Utrillo found a distinctive way of depicting Parisian streets, landmarks, and churches. The illegitimate son of the French painter Suzanne Valadon, he was dismissed from school for drinking when just 16, and, on the advice of a physician, he was encouraged to paint. His first works were impressionistic in style.

Between 1907 and 1910, Utrillo's paintings of Paris and the surrounding villages developed their own unique style, both architecturally strong and atmospheric. The period between 1910 and 1916, considered Utrillo's finest, was known as his "White Period," since he painted in shades of white mixed with plaster and glue to give texture to his buildings. Around 1919, Utrillo began to gain recognition, but his life was beset by periods of hopitalization for alcoholism and depression.

LIFEline

1883 Born in Paris
1903–05 Starts painting and produces over 150 canvases and drawings
1907–10 Paints impasto cathedrals and street scenes; exhibits at Autumn Salon
1922 Exhibits work with his mother Suzanne Valadon
1928 Awarded the Legion of Honour
1955 Dies of pneumonia

▶ **Montmartre** *Utrillo painted this view of the infamous Lapin Agile cabaret in Montmartre about 100 times.* c1913, oil on canvas, Pompidou Centre, Paris, France

Jules **Pascin**

b **VIDIN, 1885**; d **PARIS, 1930**

Born into a well-off family of shopkeepers in Bulgaria, Julius Pincas studied art in Vienna, Berlin, and Munich before moving to Paris in 1905 and changing his name to Jules Pascin. His work was initially influenced by Fauvism and Cubism, but his developed style was figurative and somewhat impressionistic, with light outlines, pastel shades, and a gossamer touch. Pascin's subjects included his family, cabaret artistes, and nudes. Occasionally, he made large paintings on biblical themes. Pascin's death came by his own hand on the opening day of an important exhibition of his work.

▲ **The Two Sleepers** *Pascin was an expert draftsman, and the drawing visible in his paintings is always light and economical. There was also an ever-present eroticism in the way he posed and dressed his women.* c1926–28, oil on canvas, Pompidou Centre, Paris, France

Marc **Chagall**

Chagall, date unknown

b **VITEBSK, BELARUS, 1887;** d **ST. PAUL-DE-VENCE, 1985**

Born in Belarus (then part of the Russian Empire), into a poor Jewish family, with nine brothers and sisters, Marc Chagall had a happy childhood. His mother had particularly high hopes for him and managed to get him accepted into a good school that was normally reserved for non-Jews. Chagall studied art from 1906 to 1910 in Vitebsk and St. Petersburg.

In 1910, he arrived in Paris and moved into a building known as La Ruche (the Beehive) because of its honeycomb network of artists' studios. There he became friends with the avant-garde painters Robert Delaunay and his wife Sonia, who was herself Russian.

Chagall's work developed under the influence of Fauvism and Cubism. He created a unique narrative style in which the dominant elements were Jewish folklore and beliefs, together with the village life of his Russian childhood. By the 1930s, he had achieved a worldwide reputation, and over the decades, he won many prestigious commissions. He illustrated books, made ceramics, designed for theater, and made stained glass—most notably the 12 tribes of Israel for a Jerusalem synagogue.

LIFEline

1887 Born at Vitebsk, in Belarus
1906–10 Studies art in St. Petersburg
1910 Moves to Paris; finds studio in La Ruche
1915 Marries Bella Rosenfeld
1918 Made Vitebsk's Commissar for Art during the Russian Revolution
1923 Returns to France; begins series of etchings, including *Ma Vie*
1937 Takes French citizenship
1985 Dies at St. Paul-de-Vence, near Nice

▶ **The White Crucifixion** *This depicts the horrors of persecution: a synagogue burns, an old man flees, and a group of Jewish elders bemoan their fate. At the center is the crucified Christ— himself a Jew, and a universal symbol of suffering. It was as if Chagall had foreseen the catastrophe awaiting Europe's Jews.* 1938, oil on canvas, 61 x 54in, Art Institute of Chicago, Illinois, US

CLOSERlook

NAZI ATTACK This depiction of a uniformed Nazi setting light to a synagogue refers to the events of a night in 1938, when drunken Nazis rampaged against Jews.

◀ **The Poet Reclining** *The reclining figure is Chagall who was also an accomplished poet. He lays his head on his artist's palette, expressing the notion of his dual identity. This harmonious picture was painted while he and Bella Rosenfeld were on honeymoon.* 1915, oil on millboard, 30¼ x 30¼in, Tate, London, UK

▼ **To Russia, Asses and Others** *The cow, milkmaid, and church in this Cubist-influenced, dream-like scene are symbolic of village life.* c1911, oil on canvas, 62 x 60in, Pompidou Centre, Paris, France

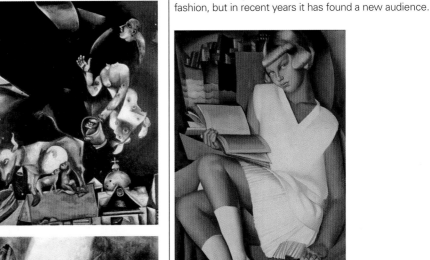

INcontext

Art Deco In style, Art Deco was luxurious, sleek, and angular, employing expensive materials such as jade, chrome lacquer, and ivory. Art Deco was popular in both Europe and the US, and on the ocean liners that traveled between them.

Paris Art Deco Exhibition, 1925 *This exhibition was important in showcasing Art Deco design internationally.*

Tamara **de Lempicka**

b **WARSAW, 1898;** d **CUERNAVACA, MEXICO, 1980**

In 1918, de Lempicka and her Russian socialite husband Tadeusz fled the Russian Revolution for Paris. She soon gained success painting high-society portraits. Her art owed a little to Fernand Léger, but it fitted in well with the prevailing Art Deco style, since it exuded stylishness and finesse. By the 1950s, her work had fallen out of fashion, but in recent years it has found a new audience.

▲ **Kizette en Rose** *This skilfully composed portrait of the artist's 10-year-old daughter fills every available inch of canvas.* 1926, oil on canvas, 45¾ x 30¾in, Musée des Beaux-Arts, Nantes, France

Marie **Laurencin**

b **PARIS, 1885;** d **PARIS, 1956**

▲ **Apollinaire and Friends** *This is a copy of a painting called* Group of Artists, *which Laurencin made as a gift for her companion Apollinaire. The first version was bought by the American art collector and writer Gertrude Stein.* 1909, oil on canvas, 51 x 76in, Musée Apollinaire, Stavelot, Belgium

Having come last in all her subjects at school, Marie Laurencin decided to study porcelain-painting at the factory in Sèvres. When she returned to Paris, she attended Académie Humbert to complete her art education. She became an important figure in the Paris avant-garde, producing paintings, drawings, and prints. A friend of Picasso and companion of poet Guillaume Apollinaire, Laurencin was at the centre of the creative set she painted in *Group of Artists* (1909). That same year she posed with Apollinaire for Henri Rousseau's picture *The Muse Inspires the Poet*.

Laurencin painted and illustrated with pastel colors and a fine wispy line. Her subjects were nearly always women—whether in portraits, as ballet dancers, or just shown relaxing.

Amedeo **Modigliani**

Self-portrait

b **LIVORNO, ITALY, 1884**; d **PARIS, 1920**

Amedeo Modigliani's deceptively simple style owes much to his deep understanding of art history. His work focuses almost exclusively on the female form and his modern, forthright nudes, for example, echo the great masters he so admired—Titian, Ingres, and Francisco de Goya. His full-frontal portraits are instantly recognizable by their staring, often quizzical expressions.

Modigliani contracted tuberculosis as a child and the illness persisted throughout his adult life. He studied art extensively in Italy before moving to Paris in 1906, where he worked as a painter initially. He took up sculpture from 1909 to 1914, before returning to his easel to produce the finest works of his short, turbulent life. Modigliani was gregarious, and prone to alcohol and drug abuse, but he was intensely private and dedicated when at work.

LIFEline

1884 Born the fourth and youngest child of a well-to-do Jewish family

1902–03 Studies art in Florence and Venice; sees the work of Toulouse-Lautrec

1906 Moves to Paris, and sets up studio in Montmartre

1912 Exhibits series of sculpted heads at Salon d'Automne (Autumn Salon) exhibition

1914–15 Gives up sculpture and vigorously affirms his talent as a painter

1917 Meets Jeanne Hébuterne, who gives birth to a daughter, Giovanna, the following year.

1919 Returns to Paris after a prolonged stay in Italy due to ill health

1920 Dies of tuberculosis on 24 January; Jeanne commits suicide the following day

▲ **Caryatid** *A woman's body twists under a heavy burden—one of many drawings, watercolors, and sculptures on the theme.* 1913–14, oil on cardboard, 23¾ x 21¼in, Pompidou Centre, Paris, France

INcontext

OTHER CIVILIZATIONS Like many Parisian artists, Modigliani was interested in so-called "primitive" objects from Africa or Oceania, but he was also deeply immersed in the art of the ancient world. His modernist sculptures bear a remarkable resemblance to those made by the ancient Greeks, Etruscans, and Egyptians.

Bust of Amenophis IV
Modigliani frequently sketched the statues and friezes on display in the Egyptian department of the Louvre in Paris. The power of their simplicity greatly influenced his sculpture, as well as the painting of his final years.

▲ **Nude with Necklace** *With her arms behind her head, the woman poses displaying her glowing flesh and, shockingly for the time, her pubic hair. Modigliani's nudes exude a vibrant sexuality, of which they are keenly aware. He had only one solo exhibition during his lifetime—it was closed down on the grounds of indecency.* 1917, oil on canvas, 28¾ x 45¾in, Solomon R. Guggenheim Museum, New York, US

▲ **Jeanne Hébuterne** *Just 19 when she met Modigliani, Hébuterne embarked on a turbulent love affair with the artist. Pregnant with their second child, she is portrayed here with great tenderness. Her simple pastel clothing suggests a poor farm girl, rather than the lover of Paris's sophisticated wild man.* 1919, oil on canvas, 50 x 31¾in, private collection

CLOSERlook

OVAL FACES
Modigliani's painting was deeply influenced by his sculpture. His subjects' oval faces can convey both a mask-like indifference and subtly incisive characterization.

ELONGATED SHAPES
Stylized forms, a twisted or elongated body for example, are often used to stress traits of a sitter's personality, such as arrogance, aloofness, or, as here, gracefulness.

Julio **González**

b **BARCELONA, 1876;** d **ARCUEIL, NEAR PARIS, 1942**

The pioneering semi-abstract sculptures created by Julio González stemmed from his apprenticeship as a metalworker in his father's forge in Barcelona. He subsequently took up painting and became friends with Picasso before moving to Paris in 1900. There, he earned his living making jewelry and selling the occasional painting or drawing. González was deeply affected when his painter brother, Joan, died in 1908. It took him almost two decades to find his niche, but in 1927 he wholeheartedly devoted himself to metal sculpture. González made many important works, including the uncharacteristic *Montserrat*. He collaborated with Picasso between 1928 and 1932, providing the technical expertise for *Monument to Apollinaire* (1928–32). His influence on subsequent generations of sculptors was enormous.

LIFEline

1876 Born in Barcelona, the son of a goldsmith and metalworker
1891 Begins apprenticeship under his father's tutelage
1897 Meets Picasso
1900 Sets up studio in Paris
1908 His brother Joan dies
1918 Works at Renault's Boulogne-Billancourt factory, in the welding shop
1922 Exhibits paintings, sculptures, and jewelry
1927 Takes up metal sculpting full-time
1937 Exhibits *Montserrat* at Paris World Fair
1942 Dies, near Paris

▶ **Woman Arranging Her Hair** *Iron had become associated with weaponry and death. González's answer was to transform the metal into witty and touching human forms. He learnt the new skill of oxyacetylene welding while working at Renault's Boulogne-Billaincourt factory. Employing this industrial technique, he revolutionized sculptural art. 1929–30, iron, Pompidou Centre, Paris, France*

Chaim **Soutine**

b **SMILOVICHI, BELARUS, 1893;** d **PARIS, 1943**

Chaim Soutine, a Lithuanian Jew from an impoverished family of 11 children, chose to contravene the Orthodox ban on image-making and became a painter. After studying art at Minsk and Vilnius, he moved to Paris in 1913, staying at low-cost artists studios La Ruche. He worked solely in oils, developing an impassioned style that unified bold colors, strongly directional brushwork, and thick surface texture. He is most associated with portraits of Paris's working class, such as porters, hotel maids, bellboys, and cooks. He was a shy, mistrustful man, and these were perhaps the people with whom he felt most at ease.

Between 1919 and 1921, Soutine worked extensively at Céret, in the south of France, where he painted more than 100 canvases, many of which he later destroyed. In 1923, the American pharmaceutical millionaire Albert C. Barnes visited Paris. He discovered Soutine's work and bought 52 pictures, changing the artist's fortunes at a stroke.

◀ **Landscape at Céret** *A Soutine landscape has an extraordinary, almost vertigo-inducing energy. Here the houses, stormy sky, and rock forms reel across the canvas, bending the horizon in all directions. Despite the dynamism, there is a sense of his isolation and loneliness, which was heightened by the death of his friend Modigliani. 1920–21, oil on canvas, 35¾ x 44¼in, Tate, London, UK*

▶ **Woman in Red** *Soutine had no desire to ridicule his sitters. The woman's twisted body, her battered hat curving down to where her mouth attempts to curve up, and her wandering eye are a tribute to his subject's individuality. The abundant red—a symbol of intense passions—reminds the viewer of the passing of time, like an expressionistic memento mori. 1922, oil on canvas, 35¾ x 24¼in, private collection*

Origins and influences

Constructivism can be traced back to Vladimir Tatlin's visit to Picasso's studio in Paris early in 1914. Tatlin's achievement was to transform the painted planes of the Cubism that he saw there into "real materials in real space." He began by making wall-mounted "painted reliefs": paintings in form, but employing metal, string, and wood projecting out from the surface. By 1915, he was creating free-hanging sculptures, in which natural materials were used for their qualities of color, texture, and shape. At the same time, artists like Alexander Rodchenko and El Lissitzky were strongly influenced by the Suprematist movement developed by Kasimir Malevich (see p.440). They had a very different purpose in mind, however.

Far from believing in art for art's sake, they thought such forms could be of use in building a new society.

Subjects

The emphasis on materials became more meaningful after the workers' state had been established. Wood, metal, glass, and plastics were used in industry, so when artists used these materials, they were cementing their bond with the working people. By 1919, Constructivism had gained the

Communist Party's backing. By 1920–21, however, a political division developed in Constructivist circles between those who believed that artists should maintain a personal involvement with the creative process, and those who believed that artists were "intellectual workers." This led to some artists leaving Russia for the West to make "pure art," while those who stayed placed their talents at the service of the new regime's economic and political requirements.

◀ **OBMOKhU Exhibition** At an exhibition in Moscow in 1921, Alexander Rodchenko and his pupils explored Constructivism's major preoccupations— the structural properties of materials and forms .

When the Russian Revolution took place in 1917, there was already an advance guard of progressive artists prepared to help build a new communist society. Such a task required a new artistic language that could encapsulate the ideals of the revolution—that "language" was Constructivism.

Constructivism

Vladimir **Tatlin**

b **MOSCOW, 1885**; d **MOSCOW, 1953**

While training as an artist, Vladimir Tatlin worked as a merchant seaman, a circus wrestler, and a busker. In 1914, he visited Pablo Picasso's Parisian studio, where he saw "constructed objects" such as *Guitar* (1912–13), as well as Cubist paintings. Tatlin's response to these was his "painted reliefs" and free-hanging "constructed" sculptures. They formed the Constructivist ethos that the inherent qualities of a material—its suppleness, texture, color, and hardness—should define its potential usage in a construction. Committed as he was to the aims of the Russian Revolution, Tatlin's next step was to use this idea to aid factory production of everyday objects. Accordingly Tatlin designed an efficient heating stove and warm winter clothing. He also made designs for grand projects, such as *The Monument to the Third International* (1919–21) and a man-powered flying machine.

LIFEline

1902–13 Works as a merchant seaman, but studies and paints during home leaves
1914 Travels to Paris via Berlin, and visits Picasso's studio
1915 Participates in *0.10, The Last Futurist Exhibition*
1919–21 Designs *Monument to the Third International*
1921 Teaches sculpture at Petrograd Academy of Arts
1953 Dies in Moscow, aged 67

▲ **Corner Relief** *This reconstruction of one of Tatlin's sculptures from 1914–15 appears free-hanging, but is attached to two adjoining walls with wires. Made from industrial materials, it emphasizes their natural colors and textures and creates a strong sense of spatial dynamics.* 1993, steel, aluminum and paint, 37¾ x 37 x 90in, Kunsthalle Düsseldorf, Germany

▲ **The Fishmonger** *Tatlin admired those who earned their living from the sea, and he frequently painted sailors and fishermen. This work shows the Primitivist influence of his friend Mikhail Larionov (see p.433).* 1913, glue-based paint on canvas, 30¼ x 39in, Tretyakov Gallery, Moscow, Russia

◀ **Monument to the Third International** *Had it been built, this vast structure would have been twice the height of The Empire State Building and housed the HQ of international communism—the Comintern. The model toured the country as a symbol of Soviet aspiration.* 1919–21

Naum **Gabo**

b **KLIMOVICHI, 1890;** d **WATERBURY, 1977**

Born Naum Neemia Pevsner, Gabo adopted a new name to distinguish himself from his older brother, the artist Antoine Pevsner. Gabo studied at Munich University, where he met Wassily Kandinsky.

In 1914–15, he visited his brother in Paris, experienced Cubism first-hand, and saw fellow Russian Alexander Archipenko's glass and paper assemblages. Gabo and his brother returned to Russia in 1917, where Gabo's method of constructing his sculptures led to the coining of the term "Constructivism". In 1920, they issued the *Realistic Manifesto*—so-called to contradict critics who labeled their work abstract. In 1922, Gabo visited Berlin with an exhibition of Russian art. He stayed in the West, sensing that the Russian regime's liberal attitude to the arts would soon change.

LIFEline

1890 Born in Belarus
1910 Begins studying medicine at Munich University, but changes to engineering and natural sciences
1915 World War I begins; flees to Oslo, where he makes geometrical sculptures
1920 Issues the *Realistic Manifesto* with his brother
1922 Leaves Russia for Berlin, where he lives for ten years
1946 Settles in the US, where he receives many public commissions

▶ **Construction: Stone with Collar** *This is one of five constructions Gabo made on the theme. It was probably conceived and executed in Paris, and introduced direct carving into his work.* 1933–35, stone, metal, and plastic, Tate, London, UK

▲ **Linear Construction in Space Number 1** *Gabo explores the interface between space and solid in this fluid, non-geometric sculpture. The transparent quality of the plastic gives the central hollow space a strong three-dimensionality.* 1944–45, plastic, 11¾ x 11¾ x 2⅜in, University of Cambridge, UK

Antoine **Pevsner**

Pevsner, 1954

b **OREL, 1886;** d **PARIS, 1962**

Influenced by his love of Byzantine art, Antoine Pevsner attended Kiev's School of Fine Arts from 1902 to 1909. He also studied at the St Petersburg Academy, but left in 1911 to visit Paris, where he painted in a Cubist style. He returned to Russia in 1917 and taught at the Moscow School of Painting, producing his own neo-abstract work. With his brother Gabo, he issued the *Realistic Manifesto* (1920), which outlined their non-Marxist Constructivist ideals in the form of a poster. Their declaration mocked Italian Futurism—and by association certain pro-Futurist Russian artists—for its idolization of all things modern. Pevsner left Russia in 1923 and settled in Paris, where he took up sculpture.

LIFEline

1886 Born in Russia
1911–14 Makes lengthy visits to Paris, and becomes friends with Modigliani
1915–17 Lives with his brother, Naum Gabo, in Oslo, before returning to Russia
1920 Issues *The Realistic Manifesto* with his brother
1923 Leaves Russia for Paris
1930 Becomes a French citizen
1962 Dies in Paris a year after being awarded The Legion of Honor by the French state

▶ **Meeting of Planets**
Pevsner began constructing sculptures after leaving Russia in 1923. Prior to that he had explored Constructivism in painting. In this late work Pevsner returns to paint to explore the relationship between space and form, with the added ingredient of prismatic color. 1961, oil on canvas, Musée d'Art Moderne de la Ville de Paris, France

CLOSERlook

PLANET OR SPACECRAFT?
This discus-shaped object seems to be in orbit around the light source, and the red planet. In the year this picture was painted, the Soviet Yuri Gagarin became the first to orbit the Earth, in the spacecraft *Vostok 1.*

▲ **Head** *Exploiting plastic's transparency and pliability, this focuses the attention on internal and external surfaces simultaneously. The two bisecting plastic planes, which serve as the neck, also resemble a throat when seen from certain angles.* c1923–24, plastic, 30¼ x 23¼ x 36¼in, Tate, UK

Alexander **Rodchenko**

Portrait by
Nikolai
Afanasyevich

b **ST. PETERSBURG, 1891**; d **MOSCOW, 1956**

From 1910 to 1914, Alexander Rodchenko attended Kazan Art School where he met his wife and lifelong artistic collaborator, Varvara Stepanova. His early painting showed the strong influence of Cubism, but, from 1916, he moved toward abstraction. Rodchenko was a founder member of Moscow's Institute of Painterly Culture (1920) and advocated utilitarian or "production art" to satisfy the needs of society. In 1921, he exhibited three monochrome paintings in the primary colors, entitled *The Last Painting*. Rodchenko was at odds with Kasimir Malevich's abstract spiritualism. This was apparent in the transition toward Constructivism where he argued his paintings were "constructions," since they were made from real materials—canvas, wood, tacks, and pigment in oil.

Rodchenko worked with Wassily Kandinsky in setting up regional art museums that would promote progressive art outside Moscow and St Petersburg. In 1925, he designed an entire room of a working-men's club, complete with folding chairs and tables, just for show at the International Exhibition of Decorative and Industrial Design in Paris.

CLOSERlook

SILVER PAINT Rodchenko maximized the impact of these shapes by painting one side silver. He applied the paint to each oval slightly differently, so the reflections would change as the construction gently moves in the light.

◀ **Oval Hanging Construction, Number 12** *This is made from a single sheet of plywood, cut in concentric bands from the outer circumference to the center Tiny threads of wire hold the ovals in place. When closed, the structure forms a flat, oval plane.* 1920–21, painted plywood and wire, 32¾ x 23¼ x 17in, Tretyakov Gallery, Moscow, Russia

LIFEline

1911–14 Attends Kazan School of Art

1916 Moves to Moscow

1917 Arrives at abstraction in his *Lines* and *Circles* series

1923–25 Designs propaganda posters, photographic montages, and advertisements for industry

1929 Designs costumes and sets for *The Bedbug*, a play by Vladimir Mayakovsky

▶ **White Circle** *Rodchenko called his* Circle *series* Concentration of Color. *In it he explored how different colors react in conjunction with different backgrounds and forms. In* White Circle, *an optical conflict occurs as the viewer's eye tries to determine which of the two circles should hold precedence.* 1918, oil on canvas, 35 x 28¼in, Russian State Museum, St. Petersburg, Russia

▲ **Illustration for the poem *Pro Eto* by Vladimir Mayakovsky**
Rodchenko was also an innovative photographer and developed the technique of photomontage. In this book dedicated to Mayakovsky's poem, Rodchenko's collages brilliantly mirror the poet's text. 1923, collage, 19 x 13in, Russian State Library, Moscow, Russia

El **Lissitzky**

b **POLCHINOK, NEAR SMOLENSK, 1890; d MOSCOW, 1941**

Lazar Lissitzky, better known as El Lissitzky, grew up in Vitebsk, in Russia, but studied engineering and architecture in Germany. In 1919, Marc Chagall, who was director of the Vitebsk Art Institute, appointed him as professor of graphics and architecture. Within months, El Lissitzky had abandoned his formerly figurative style in favor of geometric abstraction. Fellow artist Kasimir Malevich also taught at the institute, and the two worked together designing propaganda for the revolution.

From 1921, El Lissitzky took a post at Moscow's Higher State Artistic Workshops, which resembled the Bauhaus School of Art and Design. El Lissitzky was the creator of Proun – an acronym meaning "Project for the Affirmation of the New"—which synthesized Suprematism (see p.462) and architectural drawing. A "Proun Room" was a major installation at the Great Berlin Art Exhibition of 1923.

LIFEline

1909–15 Studies architecture in Darmstadt, Germany
1919 Creates the *Proun* project and produces *Beat the Whites with the Red Wedge*
1919–21 Teaches art in Vitebsk; works alongside Kasimir Malevich
1922 Travels to Berlin, and meets leading Dada artists
1930–40 Is the leading Soviet graphic artist
1941 Dies, aged 51

▶ **Beat the Whites with the Red Wedge**
This street poster applies Suprematist forms to revolutionary propaganda. Its aim was to convey the message that the red wedge of Bolshevism would shatter the white circle, which represents the old order. 1919, poster, Stedelijk van Abbe-Museum, Eindhoven, Netherlands

CLOSERlook

TYPOGRAPHY Many Constructivist artists were influenced by Dadaist use of typography and photo-montage. Here, El Lissitzky includes the poster's title in the image.

▲ **Abstract Composition in Gray, Yellow, and Black** *This deceptively concrete form is constructed from geometric shapes in contrasting colors. The architectural quality of the design is animated by two figures, like those of Malevich, wearing top hats.* c1920, litho, Gemeentemuseum, The Hague, Netherlands

◀ **Construction Proun 2** *El Lissitzky's Proun explored the formal properties of color, shape, line, transparency, and opacity. His chief innovation was to take Malevich's geometric shapes and distribute them as if they were organic elements within complex structures.* c1920, oil, paper, and metal on wood, 23½ x 15¾in, Philadelphia Museum of Art, US

Joaquin **Torres-Garcia**

b **MONTEVIDEO, 1874; d MONTEVIDEO, 1949**

In 1891, Joaquin Torres-Garcia moved from his native Uruguay to Barcelona. There, he enrolled at the city's academy and joined the bohemian set which included the young Pablo Picasso. From 1903 to 1907, he designed stained-glass windows for Antoni Gaudi, including those for the Sagrada Familia Cathedral in Barcelona. In the late 1920s, Torres-Garcia developed a more geometric painting style that he called "Constructive Universalism," and in 1930 he became a founder member of the abstract group, *Circle and Square*. In 1934, he returned to Uruguay, where he became the spokesperson for Latin American Modernism and set up his own art school.

▲ **Cover of *Raison et Nature*** *In 1926, Torres-Garcia wrote a theoretical treatise entitled* Reason and Nature. *The text was his personal take on Constructivism, and served as a manifesto for his humanistic approach to design and architecture.* 1932, private collection

INcontext
AGITPROP POSTER
Agitation propaganda, (agitprop) posters were crucial to the Bolsheviks after they seized power in Russia in 1917. During the social reconstruction that followed the Revolution, these posters relayed everyday information and political news to a mostly illiterate population.

Russian Railway Advertisement by Vladimir Mayakovsky (1921).

❝ Structure means **recognition** that unity is at the **foundation** of everything ❞
JOAQUIN TORRES-GARCIA

Origins and influences

Dada started in 1916 in Zurich where Hugo Ball, a German actor, musician, theatrical producer, and playwright, established a small music hall called the Cabaret Voltaire. Ball was soon joined by other émigrés, including Hans Arp, Tristan Tzara, Marcel Janco, and Richard Huelsenbeck. They chose the name Dada—French for "hobby horse"—randomly from a French-German dictionary.

The Dadaists loudly rejected the old artistic structures and set out to scandalize and outrage their audience. They composed, printed, and performed nonsense poetry and songs, and produced imagery and objects designed to shock the

▲ **Hugo Ball (1886–1927)** *Much Dada poetry relied on public performance, and Ball would flap his "wings" at the moment of inspiration as he began reciting sound poems in the style of Catholic liturgy.*

viewer. More than any previous art movement, Dada rejected established institutions. When the war ended, the Dada spirit spread quickly to Cologne, Berlin, and Hanover. Finally, Dada grew in Paris, where Marcel Duchamp and Man Ray, already active in New York, had recently settled. By 1921, most of the important Dadaists had gathered in the French capital around the poet and critic André Breton.

Subjects

Dada challenged the rules of art. Everyday objects as art, political collage, the use of chance, a playful metaphysics—all these techniques energized the movement.

The Dada group dissolved acrimoniously in 1921 amid violent arguments and riots. Many of the artists went on to become Surrealists.

Dada was a richly subversive art movement that developed at the time of World War I as a protest against bourgeois conventions and the folly of war. The aim of the Dadaists was to destroy traditional values in art and to create new art to replace the old.

Dada

EARLY 20TH CENTURY

Francis **Picabia**

b **PARIS, 1879;** d **PARIS, 1953**

Francis Picabia trained as an artist from a young age and by his twenties had a gallery contract to show his Impressionist paintings. Later, he experimented with Fauvism, Futurism, Cubism, and Orphism in a restless search for his own language. Around 1911, he met Marcel Duchamp, who became a life-long friend. In 1913, Picabia traveled to New York for the Armory Show, where he began producing "mechanomorphic" paintings, in which machines become humanized and eroticized. During World War I, Picabia spent time living in New York, Spain, and Switzerland, where, in 1917, he published the Dadaist magazine *391*. For the next few years, he remained involved with the Dadaists in Zurich and Paris. However, Picabia eventually denounced Dada in 1921 for the mediocrity of their closed and now established ideas and for no longer being "new." For him, the real Dada spirit that had existed between 1913 and 1918 was gone.

LIFEline

1895 Enrols at École des Arts Décoratifs, Paris

1905 Stages first solo exhibition

1911 First meets Duchamp and Apollinaire

1913 Exhibits at the Armory Show in New York

1917 Publishes the first issue of *391* magazine

1921 Denounces Dada

1924 Makes the film *Entr'acte* with René Clair

1953 Dies in the house he was born in

▶ **Front cover of** *Dada 4-5* Picabia's ink drawing Alarm Clock 1 *featured on the cover of the journal Dada 4-5. He used parts of a dismantled clock to print the cogs of his original image. 1919, color lithograph, 10¾ x 7½in, Bibliothèque Littéraire Jacques Doucet, Paris, France*

▼ **Girl Born without a Mother** *To make this work Picabia painted over an illustration of a steam engine to create an ironic metaphor for human life. 1916–17, gouache and metallic paint on printed paper, 19¾ x 25¾in, Scottish National Gallery of Modern Art, Edinburgh, UK*

Marcel **Duchamp**

b BLAINVILLE, 1887; d PARIS, 1968

Photograph by Arnold Newman

Born into an artistic family, Marcel Duchamp was an accomplished painter from an early age. Around 1912, he began to rethink accepted notions of "art" and "non-art" alongside Francis Picabia and the poet and art critic Guillaume Apollinaire. In New York during and after World War I, he became actively engaged in the Dada movement, with gently ironic projects involving ready-made objects, word games, optical experiments, and metaphysical speculation. He made creative use of chance, language, and ephemera such as dust and shadows and created a playful alter ego called Rose Sélavy. In 1920, Duchamp exhibited with the Dada group in Paris before returning to New York to complete *The Large Glass*. It was widely believed he had ceased to make art after abandoning this unfinished work. Only on his death was a further grand project revealed—a room-sized mixed-media installation, called *Étant Donnés*, which is now in the Philadelphia Museum of Art.

LIFEline

1913 Exhibits *Nude Descending a Staircase, No.2* in New York. Conceives his first ready-made exhibit, *Bicycle wheel*

1915 Begins *The Large Glass* in New York

1923 Leaves *The Large Glass* in a "state of incompletion"

1926 *The Large Glass* is badly broken on return from exhibition in Brooklyn

1954 Marries Alexina (Teeny) Sattler

1968 Dies in Paris. The room-sized installation *Étant Donnés* is discovered

◀ **The Large Glass** *or* **The Bride Stripped Bare by Her Bachelors, Even**
This piece poetically explores the relationship between the sexes—man is the lower half and woman the upper half in the work. The original was badly damaged and several reconstructions have been made, including this one by Ulf Linde (1961). 1915–23, mixed media, 107 x 67in, original in Philadelphia Museum of Art, US

▼ **Fountain** *Duchamp submitted an upturned urinal signed R. Mutt to a New York exhibition where he was on the organizing committee. Despite the exhibition's rule of non-selection, it was rejected. 1917, glazed ceramic replica (original lost), 14¼ x 18¾ x 24in*

◀ **Nude Descending a Staircase, No.2**
The dynamic energy of the figure is shown through repeated lines and planes as it moves downwards in space and time. This is similar to early photographic experiments by Étienne-Jules Marey, who captured sequences of the figure in motion, which Duchamp had first seen in 1911. 1912, oil on canvas, 58 x 35in, Philadelphia Museum of Art, US

CLOSERlook

DESCRIPTIVE PAINTING The viewer's eyes follow the lines, shapes, and surfaces from left to right, as they describe the moving body. In describing his work, Duchamp spoke of "de-composing" forms.

INcontext

WORLD WAR I Eight million people died in The Great War (1914–18). Artists on both sides became actively involved, and many were killed at a young age. Some of the survivors expressed their sense of devastation and horror through semi-abstract paintings. Others, highly critical of the war, resorted to artistic anarchy. The Dada movement grew from this discontent.

Soldiers Eating in an Advanced Post in the Champagne Region, *Jacques Moreau (1916)*

❝ I have forced myself to **contradict** myself in order to **avoid conforming** to my own taste ❞
MARCEL DUCHAMP

Hans **Arp**

Portrait by Ivo Hauptmann

b **STRASBOURG, 1887;** d **BASLE, 1966**

Hans Arp, also known as Jean Arp, was a leading participant in the Dada movement. In 1916, he performed at the Cabaret Voltaire in Zurich, where he decorated walls and recited poetry in reaction to the savagery and insanity of World War I. Later, he became associated with both Surrealism and Abstraction. Over a long creative life, Arp produced works in many different media, including collage, tapestry, *papiers déchirés* (torn paper), engraving, drawing, and, above all, sculpture and poetry. During the 1920s and 1930s, Arp lived in Paris. His studio was close to those of Miró and Max Ernst, and he would also have known of Brancusi. An influence on Henry Moore and Barbara Hepworth, Arp sought "to surpass the human and achieve the infinite and eternal."

LIFEline

1915 In his 20s, moves to Zurich

1920 Joins André Breton and the Surrealists in Paris

1940 Flees to Grasse and later returns to Zürich

1954 Receives sculpture prize at the Venice Biennale

1958 Large retrospective at MoMA, New York

► **Collage with Squares Arranged According to the Laws of Chance** *Arp made a "chance collage" by dropping rectangles and pasting them on to a larger sheet. 1916–17, torn and pasted paper, 19¼ x 13¾in, MoMA, New York, US*

◄ **Terrestrial Forest Form**
In contrast to his earlier geometric works, here Arp creates forms that are freely drawn to echo nature and its processes. Natural elements, such as twigs, pebbles, or leaves, are simplified in a series of layered asymetric painted reliefs. 1917, painted wood, 33½ x 23½in, private collection

Man **Ray**

Photograph by Roger Schall

b **PHILADELPHIA, 1890;** d **PARIS, 1976**

A central figure in both the Dadaist and Surrealist movements in New York and Paris, Man Ray was a close friend of Marcel Duchamp. His playful, experimental, and dreamlike art defies easy definition, since it includes photography, drawing, painting, collage, assembled objects, and film. Man Ray was the oldest child of a tailor and a seamstress, and objects from his parents' working lives—dummies, sewing machines, irons, and needles—often feature in his work.

A successful fashion and portrait photographer, Man Ray developed new techniques, such as solarization, where light is introduced into the darkroom during the developing process, reversing the tones in the image. He also developed the direct photographic process of Rayography, in which various objects were placed on to photosensitive paper, then briefly exposed to light.

LIFEline

1890 Born, the son of Russian–Jewish immigrants

1897 Family settles in New York

1920 Publishes first and only issue of *New York Dada* magazine

1921 Moves to Paris

1930–31 Makes first solarized prints

1940 Moves to Hollywood

1951 Returns to Paris

1976 Dies in Paris, in his 80s

► **Metronome (Object to be Destroyed)** *Man Ray renamed this* Indestructible Object *after a group of reactionary art students violently destroyed the original in 1957. Wood, metal, and paper, 9⅛ x 4¼ x 4¼in, Kunsthalle Hamburg, Germany*

◄ **Rayogram/Rayograph**
Many of Man Ray's images were self-portraits, in this case a mannequin with pencils in hand (suggesting an artist), and with a drill pointing at his heart. 1923, photographic print, 19¼ x 15¾in, private collection

CLOSERlook

MYSTERY SHAPES These curved shapes, perhaps created using shirt collars or tags, could represent the photographic film of Man Ray the society and fashion photographer.

Kurt **Schwitters**

b **HANOVER, 1887;** d **KENDAL, 1948**

The German artist Kurt Schwitters is associated with the term *Merz*, his highly personal and unofficial form of Dada in which he used scrap materials for artistic creation, giving them equal status to paint. Schwitters met the Berlin Dadaists in 1918, but he had little time for their political aspirations. He was interested in pure art and was encouraged by Hans Arp—a pioneer in the medium of collage—to make highly concentrated, delicate, and disciplined collages. His works, especially between 1919 and 1923, included printed ephemera and other discarded materials. Schwitters worked across many disciplines. He was a designer and publisher, producing a *Merz* magazine for over 9 years, and also experimented with poetry, abstract drama, photography, typography, music, and cabaret. His *Merzbau* (1923–37) was the first of three "architectural" projects. Built in Hanover over a period of 13 years, the constructions occupied eight spaces in his house. Abandoned in 1936 when Schwitters fled to Norway, the *Merzbau* was later destroyed in Allied air raids.

LIFEline
1909–14 Studies at Dresden Kunstacademie
1917 Works as a military draftsman
1923–37 Creates *Merzbau* installation in Hanover
1924 Starts an advertising agency
1937 Exhibits in the Munich *Entartete Kunst* exhibition; emigrates to Norway
1940–41 Is interned on the Lofoten Islands
1945 Moves to the Lake District, England, where he dies in 1948

▼ **Cover of *Die Kathedrale*** This is from a volume of Schwitters's lithographs to which he added a printed anti-Dada sticker when efforts had been made to exclude him and Merz from the Berlin Dada group. 1920, lithograph with collage, 8¾ x 5½in, private collection

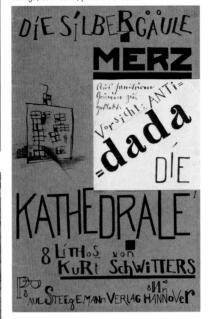

▼ **Mirror** This mixed-media assemblage incorporates patterned fragments, chocolate packaging, and other "rubbish." The oval frame suggests a mirror, although the writing remains the correct way around. 1920, mixed media on ivory with velvet surround, private collection

◀ **Merzbarn** Constructed on the wall of a barn in the Lake District, this work is made from materials found on country walks. He made this harmonious abstract assembly avoiding overt political, literary, or narrative references. 1947–48, mixed media, Hatton Gallery, University of Newcastle upon Tyne, UK

John **Heartfield**

b **BERLIN, 1891;** d **BERLIN, 1968**

Born Helmut Herzfelde, John Heartfield is famous for his powerful anti-Nazi imagery. His early work consisted of montages, produced in collaboration with George Grosz and other Dadaists. Photomontage was a Dadaist invention. By juxtaposing images and text, they believed that a wholly new or provocative set of ideas might emerge. In Heartfield's hands, this technique was frequently directed toward deflating pomposity and questioning propaganda.

In 1918, Heartfield joined the Communist Party and co-founded a publishing company. Much of his work was mass-produced, either in satirical Communist Party journals or, as Hitler's plans became clear, in cover drawings for the weekly left-wing newspaper *Arbeiter-Illustrierte Zeitung*. His most potent images were made in the 1920s and 1930s, but in later life he continued to argue against exploitation and war.

LIFEline
1907–11 Studies poster design in Munich
1918 Is founder member of Berlin Dada
1924 Produces first politically motivated posters
1938 Moves to Prague to escape Nazi censorship
1961 Awarded the GDR Peace Prize

▶ **Millions Stand behind Me** Heartfield used Nazi statements, but subtly altered their meaning. Hitler's claim to popularity is here subverted to expose his financial backing from German industrialists. 1932, lithograph, private collection

◀ **On the Crisis Party Congress of the SPD** In 1931, more than 4 million Germans were unemployed. The Social Democratic Party was in crisis after expulsions, resignations, and sustained challenges from the Nazi Party. Here, the SPD is portrayed as a tiger roaring, but with few teeth. 1931, photomontage, 15 x 10⅝in, private collection

> ❝ We are **soldiers of peace**. No nation and no race is **our enemy** ❞
> WIELAND HERZFELDE, BROTHER OF JOHN HEARTFIELD

Origins and influences

The Surrealist movement was started in Paris by the poet and critic André Breton, who published the first Surrealist Manifesto and launched the journal *La Révolution Surréaliste* in 1924. Influenced by Sigmund Freud's work on psychology and dreams and by the political writings of Karl Marx, Breton and his fellow writers wanted to free the imagination by tapping into the unconscious mind. They tried to achieve this by using automatic writing, a process of free association, in their poetry and prose to produce unexpected imagery and ideas.

Breton found support for his ideas in the visual arts. He admired the Cubist paintings of Pablo Picasso, not for their abstract design, but for the way they fragmented the body to create fantastic figures. Giorgio de Chirico's strange vistas and the Dadaists' use of found objects also provided inspiration.

Styles

Although there was no single style of Surrealist art, there are two dominant strands: dreamlike paintings, and those using free association, which the Surrealists called automatism. The latter was achieved by such means as staring at a pattern until a hallucination occurred. The Surrealists sometimes incorporated photography in their work as they were able to link the real and surreal by manipulating photographic techniques, or simply using it to isolate the unexpected. Taboo-breaking images of sexuality, violence, and blasphemy were also common.

▲ **La Révolution Surréaliste** *Published in 1924 by André Breton, this journal helped spread the Surrealist philosophy. Its scandalous first issue (above) included features on suicide, death, and violence, all dealt with in a pseudoscientific style.*

Surrealism started as a literary and political movement but had a profound effect on art, photography, and film. Influenced by the work of Freud, it aimed to uncover the subconscious, using dreamlike imagery that challenged perceptions of reality.

Surrealism

TIMEline

Starting with the prescient early works of Giorgio De Chirico, Surrealism continued until the death of René Magritte, a lifelong practioner, but it mainly flourished between 1924 and 1945, notably in the works of Max Ernst, Joan Miró, and Salvador Dalí. After 1945 the principal artists had gone their separate ways and Surrealism was overtaken by the development of Abstract Expressionism.

1914

DE CHIRICO Mystery and Melancholy of a Street

1924–25

MIRÓ Harlequin's Carnival

1931

DALÍ The Persistence of Memory

1933

MAGRITTE The Human Condition

1943

MASSON Antilles

▲ **Illustration from La Femme 100 Têtes** Max Ernst
This was the first in a series of collage novels using illustrations cut out of old magazines and catalogs. The title refers to the heroine who represents womanhood, with no single face but one that constantly changes. 1929, steel engraving, 9¾in, Bibliothèque Nationale, Paris, France

Interpretations

André Breton was fascinated by Freud's theories of a repressed unconscious. For Breton, this had a political as well as a psychological significance: the society responsible for this repression had been badly tarnished by World War I. The Surrealists saw art as a means of challenging bourgeois assumptions about the nature of reality. Artists who had lived through World War I wanted to discover new ways of life and new forms of art beyond nihilistic Dada.

Europe

Paris was the center of Surrealism until 1945. Max Ernst, André Masson, and Joan Miró were joined in 1929 by René Magritte, who moved to Paris from Brussels and became a leading figure in the movement. His detailed depiction of strange objects in dreamlike settings create a hallucinatory effect, where everything looks normal but is in fact contradictory. Salvador Dalí also moved to Paris in 1929 and started working in a similar vein, using dreamlike imagery to create disturbing paintings. Although based in France, part of the strength of Surrealism was the way in which it could accommodate the nationalities of the artists drawn to it. Max Ernst's work had strong roots in German Romanticism, while Miró and Dalí drew on their Spanish and Catalan heritage.

America

At the outbreak of World War II, most of the Surrealists left Paris for New York. André Breton arrived in America in 1941 and, with Marcel Duchamp, organized the *First Papers of Surrealism* exhibition in 1942, involving nearly 50 artists from Europe and the US. Notable American Surrealists included Arshile Gorky and Roberto Matta.

Automatism had a powerful impact on post-war American painting. More broadly, Surrealism has had a lasting influence on advertising and film, to such an extent that the word "surreal" has come to mean anything fantastic or dreamlike.

CURRENTevents

1900 Sigmund Freud publishes *Interpretation of Dreams*. The ideas in the book influence the art of the Surrealists.

1919 The magazine *Littérature*, edited by André Breton and Louis Aragon, includes the work of the 19th-century poet Comte de Lautréamont, a source of inspiration to the Surrealists.

1929 The Surrealist film *Un Chien Andalou* by Luis Buñuel is released.

1939 World War II breaks out. Many artists leave Europe for New York.

1942 First Papers of Surrealism exhibition in New York.

Max **Ernst**

Photograph by Sam Rosenberg

b **BRÜHL, NEAR COLOGNE, 1891**; d **PARIS, 1976**

Max Ernst first experienced hallucinations as a child and began painting when he was a philosophy student at the University of Bonn. Through the writings of Sigmund Freud he became interested in the unconscious and the art of mental patients. By 1920, Ernst was actively involved with the Dada movement in Cologne, then in 1922 he moved to Paris, where he joined Paul Eluard, André Breton, and the other Surrealists. Ernst developed a number of unusual painting techniques, which were intended to reveal his own unconscious responses. These included *frottage* and *decalcomania*—methods that involved the discovery of imagery within a patterned surface. Using printed catalogs, technical and scientific textbooks, and other neglected ephemera, Ernst created rich, Surrealist collages.

LIFEline

1914–18 Fights in World War I as field artillery soldier
1918 Marries Luise Struss. She dies in Auschwitz in 1945
1922 Moves to Paris
1927 Marries second wife, Marie-Berthe Aurenche
1939 Is interned twice as an enemy alien
1941 Moves to New York
1942 Marries wealthy US art collector, Peggy Guggenheim
1946 Marries his fourth wife Dorothea Tanning
1953 Returns to France, where he dies in 1976

▲ **Murdering Airplane** *This postcard-sized image conflates an early biplane with the arms of a young woman. Below, an injured man is carried off from this battlefield between the sexes. 1920, photo-collage, 2¼ x 5½in, Menil Collection, Houston, Texas, US*

▲ **Oedipus Rex** *In this work, Ernst's bird-man figure has its head removed from its body, representing Sigmund Freud's theories on man's detachment from feeling and a true comprehension of life. 1922, oil on canvas, 36¾ x 40¼in, Collection of Claude Herraint, Paris*

▲ **Zoomorphic Couple** *Ernst identified strongly with the bird-man figure, here tied in a possibly uneasy relationship. The image has clearly been drawn into or has emerged from the loosely textured background. 1933, oil on canvas, 36¼ x 28¾in, Peggy Guggenheim Foundation, Venice, Italy*

▲ **The Robing of the Bride** *Beneath a mighty red cape, the bride is reflective. It is thought that Ernst based her on his companion at the time, Leonora Carrington. The bird-man to her left—a stork, a symbol of fertility—is perhaps Ernst himself. A second naked figure, eyes closed, is brushed aside while the arrow, a familiar phallic symbol, directs the viewer's gaze. 1940, oil on canvas, 51 x 37¾in, Peggy Guggenheim Foundation, Venice, Italy*

CLOSER look

UNCOMFORTABLE STARE Ernst pictures the bride beneath an imperious owl-headed cape. Her face is almost completely obscured, but the owl's piercing eyes stare straight at the viewer.

TEARS OF LOSS A many-breasted, pregnant hermaphrodite (a person with male and female sexual organs) sheds a tear for sexual freedom lost by the forthcoming marriage.

❝ Thus **I obtained a faithful fixed image** of **my hallucination** and transformed into **revealing dramas** my most **secret desires** ❞

MAX ERNST (ON COLLAGE), 1936

Joan **Miró**

Self-portrait

b BARCELONA, 1893; d PALMA DE MALLORCA, 1983

While best known for his large, colorful, and witty paintings developed from doodles, Joan Miró also excelled as a sculptor and graphic artist.

He was inspired by the Catalan culture into which he was born, and his early work was influenced by Fauvist and Cubist painting. Miró visited Paris in 1919 where he met other young artists, such as the Surrealist André Masson and Picasso. Much of his work is a classic example of Surrealist automatic drawing. This attempt to set on paper the mysterious workings of the unconscious mind was initiated by Masson.

Miró developed a pattern of spending the winter in Paris and the summer at his family's farm near Barcelona. In 1936, with the onset of the Spanish Civil War, he settled in Paris where his imagery briefly became more brutal. Although Miró has often been identified as a light-hearted artist, there is a strong element of savagery in his work, and at one time he declared an almost Dadaist ambition "to destroy painting."

LIFEline

1911 Takes up a bookkeeping job at his parents' insistence

1926 Collaborates with Max Ernst on the set designs for Diaghilev's *Romeo and Juliet*

1928 Visits Holland and is influenced by Vermeer's work

1929 Marries Pilar Juncosa

1930 Works with a range of media, including lithography, etching, sculpture, and collage

1940 Leaves Paris for Spain before the Nazis arrive

1974 Major retrospective of his work is held at the Grand Palais, Paris

▲ **Painting 1925** *Late in Miró's life, drawings were discovered showing that apparently spontaneous paintings like this one were in fact carefully planned.* 1925, oil on canvas, 57½ x 61in, Peggy Guggenheim Foundation, Venice, Italy

➤ **Harlequin's Carnival** *A party of imaginary beasts takes place within the confines of a room with a window opening out to a night sky.* 1924–25, oil on canvas, 26 x 36⅝in, Albright Knox Art Gallery, Buffalo, New York, US

CLOSERlook

MALE FIGURE Complete with mustache and pipe, a man looks straight at the viewer, striking a melancholy note among the party revelers.

CHILDLIKE PALETTE
The primary colors are set off by the thin, warm, mid-tone washes of the floor.

Giorgio **de Chirico**

b **VOLOS, 1888**; d **ROME, 1978**

Giorgio de Chirico is best remembered for his ability to make the viewer take a fresh—and disturbing—look at the familiar. Instead of people, he painted tailors' dummies, faceless statues, and silhouetted figures, placing them in harshly lit, unnervingly empty streets.

His early art education took place in Athens and Florence. In 1906, he went to the Munich Academy, where he was influenced by the philosopher Nietzsche and the paintings of Swiss Symbolist Arnold Böcklin. After moving to Paris in 1911, de Chirico met Picasso and the poet and art critic Apollinaire, who supported his work. De Chirico's paintings had a powerful effect on writers and artists who were later to become, like himself, key figures in the Surrealist movement.

From 1910 to 1920, he shared Surrealism's passion for the city as an eerie but seductive labyrinth. But de Chirico was increasingly drawn to classical painting, and his former fellow Surrealists criticized his later work as conventional and slick.

LIFEline

1888 Born in Greece of Italian parents
1910 Moves to Florence and produces the first of his town-square paintings
1911 Moves to Paris
1915 Returns to Italy, where he is conscripted into the army
1917 Launches Metaphysical Painting as a movement with Futurist artist Carlo Carrá
1978 Dies in Rome, aged 90

CLOSERlook

CONTRASTS Extremes of light and shade and steep perspective make a commonplace street look disturbing.

SHADOWS On the face of it just a child rolling her hoop on the way home, the silhouetted girl is destined to cross paths with the looming shadow at the end of the otherwise empty street.

▼ **Old Horses near a Lake** *In his later works, de Chirico abandoned experimental art and returned to a more mainstream style. He painted a series of horses on beaches amid classical ruins.* c20th century, oil on canvas, 15¾ x 19¾in, private collection

▼ **The Mystery and Melancholy of a Street** *De Chirico was a master at giving an everyday scene—here a row of shops closed for the day as shadows lengthen and people go home—an unsettling twist.* 1914, oil on canvas, 34¼ x 28in, private collection

André **Masson**

b BALAGNY, 1896; d PARIS, 1987

After being seriously wounded in the World War I, André Masson was left emotionally scarred, suffering insomnia and nightmares, and subject to fits of rage and violent emotional states. In 1924, he met André Breton, and became closely involved with the Surrealist movement. He evolved automatic drawing as a means of working beyond conscious control and in paintings he used sand and oil to create random shapes to stimulate his imagination. In 1929, he fell out with Breton and left the Surrealist group, although their friendship was revived in 1936. In 1941, he took refuge from World War II in the US. Upon arrival in New York, five of his drawings were destroyed because customs deemed them pornographic.

▼ **Antilles** *Made during Masson's stay in America between 1941 and 1945, the figure merging into the vibrant, energized background was inspired by women in Martinique, which he visited on his way to the US. His paintings had an important influence on Abstract Expressionism.* 1943, oil, tempera, and sand on canvas, 50½ x 33⅛in, Musée Cantini, Marseilles, France

▲ **The Earth** *Part dream and part fantasy, this oil and sand-inspired work is an erotic reflection coupled with violence as the red claw attacks the breast.* 1939, sand and oil on plywood, 16⅞ x 21in, Pompidou Center, Paris, France

Paul **Delvaux**

b ANTHEIT, 1897; d VEURNE, 1994

▲ **Sleeping Venus** *In this skillfully painted, dreamlike, classical setting, Venus is surrounded by troubling figures and a skeleton.* 1944, Oil on canvas, 68 x 78¼in, Tate, London, UK

Paul Delvaux's name is associated with the Belgian Surrealists, although he was never a participating member of the group. From early naturalistic landscapes, he developed a new style around 1933, influenced by the metaphysical paintings of Giorgio de Chirico. He made his first Surrealist works around 1935, inspired by fellow Belgian painter René Magritte.

In the early 1930s, he visited the Brussels Fair where skeletons and a mechanical Venus figure made a strong impression. Childhood memories of reading Jules Verne continued into his mature paintings, as did frequent images of mesmerized naked women in dream landscapes or classical piazzas. He described his aim as "poetic shock."

Meret **Oppenheim**

b BERLIN, 1913; d BASLE, 1985

Meret Oppenheim grew up in Switzerland and southern Germany. Her father, a doctor, was interested in the theories of influential Swiss psychiatrist Carl Jung. In 1932, she went to Paris to study art, meeting André Breton and many other established Surrealists. A free spirit, she modeled for Man Ray, and, encouraged by Giacometti, made her first sculpture.

Everyday objects were a feature of Surrealist art of the time, often used in combinations that confounded logic or suggested unconscious or poetic connections. In 1936 Oppenheim made her best-known work—the fur-covered cup, saucer, and spoon.

▲ **Object** *Oppenheim was inspired by Picasso, who commented that "one could cover just about anything with fur." The work is also called* Luncheon in Fur. 1936, fur-covered cup, saucer, and spoon, height 2.8in, MoMA, New York, US

Salvador **Dalí**

Salvador Dalí

b FIGUERES, CATALONIA, 1904; d FIGUERES, 1989

With his hyper-realist style, dreamlike landscapes, and eccentric public persona, Salvador Dalí has remained the best known of the Surrealist artists. As a child, he was precocious, but given to violent, hysterical outbursts—a subject he explored in his later works.

Dalí moved to Paris in 1929 and became actively involved with the Surrealist group. He was deeply influenced by André Breton's writings on the work of Sigmund Freud, the father of psychoanalysis, and his work on the unconscious. He sought to tap into a seemingly limitless source of fantastic and dreamlike imagery, which he believed would revolutionize modern life. He invented a means of generating images that he called paranoiac-critical activity, which involved staring intensely at one set of objects until he could see others. He explored subconscious secret desires and his works reveal sexual anxiety, paranoia, and disgust.

His best work was produced before 1939, when he was expelled from the Surrealist group because of his support for Franco after the Spanish Civil War, but he continued to work in a Surrealist manner. In later years, he transformed a theater in Figueres into a museum and art gallery dedicated to his own work.

LIFEline

1904 Born the son of a notary
1914 First drawing lessons
1928 Meets Picasso and Miró
1929 Joins Paris Surrealist group led by André Breton. Makes the first Surrealist film *Un Chien Andalou*
1940–48 Moves to the US
1941 Major retrospective at MoMA, New York
1942 Publishes his autobiography, *The Secret Life of Salvador Dalí*
1974 Opens Theatro Museo Dalí at Figueres
1989 Dies of heart failure

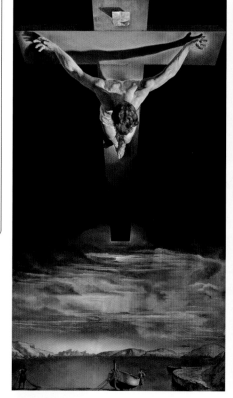

▶ **Christ of St. John of the Cross** *Dalí claimed this image came to him in a "cosmic dream" although it also relates to a drawing made by the Spanish friar St. John, around 1575.* 1951, oil on canvas, 80¾ x 45¾in, Kelvingrove Art Gallery and Museum, Glasgow, UK

◀ **Gradiva Rediscovers the Anthropomorphic Ruins—Retrospective Fantasy** *Gradiva (Latin for "The one who walks") appears in several Surrealist works. It was also the artist's nickname for his wife, Gala. In this dream landscape, a woman embraces the shell of a man in front of enticing ruins.* 1931, oil on canvas, 25⅝ x 21¼in, Thyssen-Bornemisza Collection, Madrid, Spain

◄ **Soft Construction with Boiled Beans: Premonition of Civil War** *Completed six months before the outbreak of the Spanish Civil War, this painting graphically depicts a gigantic agonized body at war with itself. On the ground are a handful of beans. Dalí explained that, "one could not imagine swallowing all that unconscious meat without the presence (however uninspiring) of some mealy and melancholy vegetable."* 1936, oil on canvas, 39½ x 39½in, Philadelphia Museum of Art, Pennsylvania, US

❝ **I cannot understand** why man should be capable of **so little fantasy** ❞

SALVADOR DALÍ

▶ **Lobster Telephone**
Several versions of the classic Surrealist object exist, one being made for the important British collector of Surrealist art in the 1930s, Edward James. Both hard-shelled objects, lobsters and telephones held powerful sexual associations for Dalí. In 1938, he proposed a "Telephone Aphrodisiaque." 1936, mixed media, 5⅞ x 11¾ x 6¾in, Museum Boymans van Beuningen, Rotterdam, also at Tate, London, and Edward James Foundation, Sussex, UK

INcontext

FREUD AND DREAMS The psychologist Sigmund Freud, who founded psychoanalysis, published *The Interpretation of Dreams* in 1900. He believed people's unconscious thoughts and feelings could be brought to consciousness with free association and by analyzing their dreams.

Sigmund Freud (1856–1939) *Seen here in 1931, Freud believed "a dream is a (disguised) fulfilment of a... repressed wish." He also identified the sexual instincts and the importance of their role in human behavior.*

The Persistence of Memory *Salvador Dalí*
1931, oil on canvas, 9½ x 13in, Museum of Modern Art, New York, US

The Persistence of Memory Salvador Dalí

In his autobiography, *The Secret Life of Salvador Dalí* (1942), the artist describes working on a painting of a landscape near Port Lligat, in northeast Spain, "with rocks lit by a transparent and melancholy twilight—in the foreground an olive tree with branches cut." He relates how, after ending his evening meal with strong Camembert cheese, he "meditated on the philosophic problems of the super soft" before going to look for one last time that day at the work in progress. It was then that the image of two soft watches, one hanging from a branch of a tree, occurred to him. Just two hours later, he says, "the picture was complete."

Technique

Dalí brought his fantasies and visions to life with a meticulous painting technique and attention to detail. He described the results as "hand-painted dream photographs." He was indebted to the traditional techniques of earlier times—especially the skills of early Flemish and Venetian painting. It is thought that he used fine sable brushes and a jeweler's glass for close work, and built up the layers of paint gradually.

▼ **MELTING CLOCK FACE** Softened or melting, the watch no longer appears to be rational or familiar. The hands emphasize the folded face, and the construct of time itself is undermined.

Story

There has been much speculation on the symbolism of this small and intense picture. It is one of a series of sparsely populated landscape paintings from the 1930s. In contrast to the sunlit and specific outer world of sea and cliffs, the dreamlike foreground represents a timeless and nameless inner space. The watches clearly allude to time passing, memory, and decay. The softness of the instruments for measuring time, however, renders them unreliable.

Psychological analysis suggests the limp watch may symbolize the return to a state of amorphousness or a remembrance of the period of time before birth. Other critics have interpreted it as expressing a fear of impotence—Dalí's sexual anxieties are well-documented elsewhere.

INFLUENCES

DESERTED LANDSCAPES The desolate deep perspectives of Dalí became something of a cliché among painters in the 1930s and 40s. There was an international fashion for barren spaces, usually with picturesque ruins. The experience of war gave their air of devastation a new resonance.

Figure in a Deserted Landscape *John Minton, 1942* The young man seems in a reflective mood—an idea reinforced by the ruined building and leafless trees. The artist committed suicide in 1957, aged 39.

▶ **LIMP HEAD** A dormant head lies slumped across the small stone ridge. It is thought to be Dalí's own face in profile, its shape deriving from a large standing rock near the coast at Cadaqués. It had already appeared in earlier works, notably *The Great Masturbator* and *The Enigma of Desire*, both from 1929. The long eyelashes and tongue-like protuberance heighten the erotic feel of this creature.

▼ **INSECTS** For Dalí, insects were associated with decay. Here, together with the fly, they act as *memento mori*, reminding him of a childhood experience of finding a dead lizard being eaten by ants.

▲ **TREE** A single, apparently dead olive tree underlines the dreamlike and desolate character of this landscape. Traditionally the olive branch is a symbol of peace, purification, and plenty. Olive groves are a common sight in the region of Catalonia where Dalí grew up.

René **Magritte**

b **LESSINES, 1898;** d **BRUSSELS, 1967**

Belgian painter René Magritte was a leading figure in the Surrealist movement. His alter ego, who frequently appears in his pictures, was an anonymous bowler-hatted clerk, who lived—as Magritte did—in a Brussels suburb.

Photograph by Daniel Frasney

Magritte's artistic hero was the influential Italian painter Giorgio de Chirico, although his own images seem to inhabit a more commonplace world. In 1927, he moved to Paris, where he met members of the Surrealist group, including André Breton, Jean Arp, Salavador Dalí, and Joan Miró. He returned to Belgium in 1930.

Magritte's paintings explore a dreamlike irrationality, where positive becomes negative, glass holds the image seen through it, and different realities collide. He reveals the slippery nature of language, challenges solidity and scale, and queries the relationship between art and the visible world.

LIFEline

1910 Magritte's mother commits suicide

1916–18 Studies at Académie Royale des Beaux–Arts, Brussels

1922 Works briefly as a wallpaper designer

1927 Moves to Le Perreux-sur-Marne, near Paris

1930 Returns to Belgium

1936 Exhibits at the *Fantastic Art, Dada, Surrealism* show at MoMA in New York

1951–53 Produces murals for Knokke-le-Zoute casino, Belgium

1965 First visit to New York for a retrospective of his work

◀ **This is not a Pipe** *Also known as* The Treachery of Images *or* The Air and the Song, *this image seems contradictory, but is, in reality, exactly what it says.* 1928–1929, oil on canvas, 25¾ x 37in, Los Angeles County Museum of Art, US

◀ **The Empire of Lights** *In this, one of three versions of this painting, day and night are visible simultaneously, creating a typically dreamlike and irrational Surrealist scene.* 1953–54, oil on canvas, 77 x 52in, Peggy Guggenheim Collection, Venice, Italy

▲ **The Human Condition** *Here, Magritte plays with relationships between art and nature, inside and outside, solid and transparent, coincidence and design. The tree is seen in the picture in the room and, one assumes, in the landscape, too.* 1933, oil on canvas, 39¼ x 31¾in, National Gallery of Art, Washington, DC, US

CLOSERlook

NIGHT OR DAY? This is a play on our usual expectations of day and night, but the glow of the street light and from within the house seem to confirm that it is after dark.

María **Martins**

b **CAMPANHA**; d **RIO DE JANEIRO, 1973**

María Martins, a Brazilian diplomat, was married to Brazil's Ambassador to the US. During the 1940s, she had great success as a Surrealist sculptor in Paris and New York, and her work was bought by important museums. She became the lover of artist Marcel Duchamp, and was the inspiration for his last major work, *Etant Donnés*. Executed in a variety of materials, Martins's own work draws upon Amazonian Indian mythology and possesses a wild and erotic energy.

▼ **Impossible III** *Her best-known work, this sculpture depicts male and female characters locked in perpetual opposition. Their heads have been morphed into a menacing series of tentacles that simultaneously touch and threaten each other, expressing the irresistible attraction and insurmountable incompatibility between men and women.* 1946, bronze, 31⅕ x 32¾ x 21in, MoMA, New York, US

Matta **Echaurren**

b **SANTIAGO, 1912**; d **TARQUINIA, 2002**

▲ **Invasion of the Night** *Echaurren likened the inner workings of the human psyche to the fiery and seismic eruptions of volcanoes.* 1941, oil on canvas, 37¾ x 60in, San Francisco Museum of Modern Art, US

In autumn 1937, Chilean-born Matta Echaurren met André Breton and joined the Surrealists. He absorbed two important innovations, biomorphism and automatism. Biomorphism (creating abstract art that evokes organic forms) enabled him to develop an organic and semi-abstract pictorial language, while automatism (a kind of free association) gave his brush strokes a spontaneity he believed sprang from his subconscious. Echaurren's art conceptually fused subject and process. He poured, wiped, and sponged thin glazes of color to build up a multi-layered translucent surface. To Echaurren, his works were "inscapes" or "psychological morphologies"—analogies for states of consciousness in perpetual transformation. Echaurren moved to New York in 1939, where he had a significant impact on the developing Abstract Expressionist movement (see pp.502–09).

Wifredo **Lam**

b **SAGUA LA GRANDE, 1902**; d **PARIS, 1982**

Cuban-born artist Wifredo Lam lived in Europe for 15 years where he absorbed Cubism and Surrealism and befriended Pablo Picasso. After returning to his native island in 1941, Lam immersed himself in his Afro–Cuban cultural heritage, spending the next decade exploring the spiritual traditions of the Santería religion within a modernist style.

In Lam's Santería paintings, devotees give offerings and perform rituals as they wait to be mystically united with their deities (*orishas*) by means of sacred trance. Breaking apart form in a Cubist manner, Lam imbues the primitivism of Picasso with a new and vibrant spiritual energy.

CLOSERlook

HEAD START The crescent shapes and multiple eyes on Lam's figures reflect the process of trance. The African-based Santería religion believes gods enter the head first, "mounting" their believers like horses.

FERTILITY The prominent breasts resemble ripe fruit and thus function as bodily offerings to the gods. On another level they hint at fertility, revealing humanity's natural place within the fecundity of nature.

Remedios **Varo**

b **ANGLÉS, 1908**; d **MEXICO CITY, 1963**

The Spanish artist Remedios Varo began her involvement with the Surrealists in Paris in the 1930s as the companion of the poet Benjamin Perét. Due to the political turmoil in Europe, the couple emigrated to Mexico in 1941, where Varo would remain for the rest of her life. In Mexico she began a close friendship with the British painter Leonora Carringtons, and together they studied alchemy and other mystical traditions. Her paintings often portray women in dreamlike settings, embarking on journeys of exploration both mythical and scientific. Riding atop fantastical vehicles of transit, Varo's haunting female characters also sport a sly humor.

▼ **The Great Jungle** *or* **Light in the Forest** *Lam, who observed ceremonies of the Santería religion at first hand, portrayed ecstatic bodies in the process of transformation and merging with the lush surrounding foliage.* 1942, oil on paper laid on canvas, private collection

INcontext

INTERNATIONAL MOVEMENT In contrast to most other avant-garde movements, Surrealism involved artists of many nationalities and did not prescribe one style. This internationalism was supported by the publication of journals, Surrealist movements springing up in different countries, and by artists and writers moving from place to place. The home of Surrealism remained Paris, however.

André Breton
The writer and poet André Breton (1896–1966) was one of several European Surrealists who spent time in Latin America. He visited Mexico in 1938, declaring it a Surrealist country. In turn, many artists from Latin America visited the "Surrealist capitals" of Paris and New York.

◄ **Tiforal** *Between 1942 and 1949, Varo supported herself by doing commercial illustrations for a pharmaceutical firm in Mexico. Done under the pseudonym "Uranga," these small gouaches gave her the opportunity to develop her personal Surrealist style.* 1947, gouache, 9⅝ x 12⅝in, private collection

Also known as the New Realism, Neue Sachlichkeit was characterized by a newfound attention to the realistic representation of objects in a detailed way. The term was first used by G.F. Hartlaub who was director of the Mannheim Art Museum. Two years later he mounted a major exhibition of the artists he considered had "remained true or have returned to a positive, palpable reality."

Reactionary movement

There was no specific style, nor even a shared political perspective; though certain artists were deeply angered by society's callousness and wished to place their art at the service of their indignation. However, New Objectivity is perhaps best seen as an art movement in reaction to what had gone before. The unifying subject New Objectivity artists were concerned with was people. They painted either portraits with a cool, analytical, detachment or groups of figures, often at social gatherings.

▲ **Germany in the 1920s** *The decade after World War I brought unprecedented artistic freedom to German cities like Berlin, where the visual arts thrived amid a world of cabarets, nightclubs, and salons.*

Social commentary

Both Otto Dix and George Grosz made searing social commentaries by juxtaposing individuals of radically different social status in the same frame: Grosz to show his disgust with social division, Dix to share his disgust with human rottenness. Other artists such as Max Beckmann painted with the desire to reveal what they felt was a deeper truth behind surface appearances. His art possesses a sense of nostalgia, almost melancholy, in his arrangements of classically posed figures.

CURRENTevents

1924 American banker Charles G. Dawes agrees to loan Germany $88 million to relieve financial crisis. Resulting economic boom is synonymous with the Jazz Age.

1924-28 Berlin becomes Central Europe's cultural center with the publication of Thomas Mann's *Magic Mountain*, Fritz Lang makes *Metropolis*, and Bertholt Brecht directs *Threepenny Opera*.

1929 The German airship Graf Zeppelin offers travelers a new way across the Atlantic. In 1929, it flies to Friederichshaven from New York in just over 55 hours.

When Expressionism's passion was nearly spent, and angry Dada risked becoming merely chic entertainment, German art had to take a long hard look at itself and the role it played society. Neue Saclichkeit (New Objectivity) was just that look.

Neue Sachlichkeit

George **Grosz**

b **BERLIN, 1893**; d **BERLIN, 1959**

Grosz was first and foremost a graphic artist, whose biting satire tore into respectable bourgeois society. A member of the Communist Party, Grosz had little time for the art market and believed that a modern cult of artistic individuality had been fabricated by art dealers to improve their profits.

Having been active in the Dada movement, in the early 1920s Grosz increasingly turned to oil painting "to show the oppressed the true faces of their masters." His satire and moral outrage at capitalist society's corruption shows Grosz's admiration for not only Hogarth and Goya, but also to the cruel and hallucinatory world of Hieronymous Bosch.

LIFEline

1893 Born a bartender's son
1907 Expelled from school
1909–16 Studies art in Berlin and Dresden
1917–22 Leading Dada artist
1928 Put on trial for blasphemy, wins case
1933 Emigrates to America with Nazi's coming to power
1959 Returns to Berlin, dies three months later

▶ **The Pillars of Society** *This shows a Nazi, a Nationalist, a Social Democrat, a Judge, and a militarist—Grosz's alliance of "respected" citizens.* 1926, oil on canvas, 79 x 42½ in, Nationalgalerie, Berlin, Germany

▶ **Coffee House 2** *Frenetic lines and superimposed images of drinkers, a dog, and a nude mirror the frenzied hedonism of Berlin in the years after the Great War.* 1918–20, Indian ink on paper, 17¾ x 15in, Kunsthalle Hamburg, Germany

Christian **Schad**

b **MIESBACH, 1894**; d **STUTTGART, 1982**

Schad was encouraged to follow a career in art by his father, who was a lawyer. He briefly studied at Munich Academy and when the war broke out, avoided military service by feigning a heart condition. He then moved to Zurich and Geneva (1915–20) where he became involved in Dada. Schad moved to Berlin in 1928 and became a leading force in the Neue Sachlichkeit movement. His portraiture's suprarealism and icy sentiment made him the movement's most extreme representative. His themes were café life, homosexual clubs, and sexual encounters.

◀ **Agosta the Pigeon-chested Man and Rasha the Black Dove** *Meticulously executed, frank pictures of deformity and black identity were taboo subjects, but would soon be forbidden.* 1929, oil on panel, 47¼ x 34½ in, private collection

Max **Beckmann**

b LEIPZIG, 1884; d NEW YORK, 1950

Both of Beckmann's parents died before he was ten and the themes of loss and nostalgia resound in his painting. In 1906 he painted his mother's dying in *Great Scenes of Death*. Its painful honesty is reminiscent of Munch. Before the war, Beckmann became known for his large-format disaster paintings in which he depicted either contemporary events such as in *The Sinking of the Titanic* (1912) or allegorical scenes as in *The Flood* (1908).

Between 1918 and 1923 he focused on aspects of life in Berlin, in claustrophobic and nightmarish scenes. Then, in the mid-1920s, Beckmann's style became less hallucinatory, the figures more joyful and composed, and his themes infused with a visionary quality and mythological content.

LIFEline
1884 Born in Leipzig
1900–03 Studies in Weimar
1914–15 Serves in medical corps, suffers a breakdown and moves to Frankfurt
1947 Emigrates to teach in US
1950 Dies in New York

▼ **Night** *A scene of torture and sexual violence as a family receive a visit from the bailiffs.* 1919, oil on canvas, 52½ x 61in, Kunstsammlung Nordrhein-Westfalen, Düsseldorf, Germany

CLOSERlook

ORDER FROM CHAOS There is a clearly ordered framework to this nightmarish scene. Beckmann has constructed a grid of perpendicular, horizontal and diagonal lines over which the bodies of victims and perpetrators adhere. The effect is to provide a chilling sense of cohesion to this scene of rape and torture.

▲ **The Little Fish** *In Beckmann's allegorical later paintings, the motif of a fish can represent the phallus, the mystery of life, and also Christ.* 1933, oil on canvas, 53 x 45¼in, Musée National d'Art Moderne, Centre Pompidou, Paris

Otto **Dix**

Photograph by Hugo Erfurth

b UNTERMHAUS, THURINGIA, 1891; d SINGEN, 1969

Although Dix's early works were influenced by Cubism, by the early 1920s he was painting like an Old Master. Grosz called him Hans Baldung Dix, after the 16th-century painter.

It was only after World War I, and his involvement in Dada, that Dix's mature style emerges. A fluent draftsman, etcher, watercolorist, and oil painter, Dix's 50 etchings in the War series (1924) are a harrowing commentary on violence and death. These two themes, coupled with sex, are the driving force behind Dix's painting.

As a portrait artist Dix was brutally revealing—yet he frequently received commissions. Notorious for his frank portrayals of prostitutes, he also painted the habitués of nightclubs and aging lovers.

LIFEline
1891 Born, the son of a foundry worker
1905–09 Apprenticeship as decorative painter
1909–14 Studies at Dresden School of Applied Arts
1914–18 Volunteers for military service
1920 Participates in the first international Dada Fair
1927–28 Professor of Art at Dresden
1933–45 Avoids Nazi persecution by painting landscapes
1962 Dies in Singen

❝ I didn't paint war pictures **in order to prevent war**. I would never have been **so presumptuous**. I painted them to **exorcise war**. All art is exorcism ❞

OTTO DIX

▲ **Metropolis** *The triptych, associated with altarpieces, is an ironic dig at the sanctity of Weimar society. The gaiety of the club contrasts with the grim reality depicted in the flanks.* 1928, mixed media on wood, 71¼ x 158½in, Galerie der Stadt, Stuttgart, Germany

CLOSERlook

FAMILIAR FACES Dix modeled a number of the characters on real personalities from Dresden's social set, who were also his friends. The violinist, for example, is the painter Gert Wollheim, and the man wearing the monocle has been identified as the then director of architectural studies at Dresden Academy, Wilhelm Kreis.

CABARET IN BERLIN In the late 1920s, Berlin's cabaret scene was a mix of eroticism, political satire, music, and theater. This in turn influenced playwright Bertolt Brecht and opera composer Kurt Weill to write the satirical *Mahagonny Songspiel*.

Origins and influences

Bauhaus, which means "Building House," was the vision of the modernist architect Walter Gropius. Established in the city of Weimar, Bauhaus aimed to overcome the prejudice that raised high art over lowly design.

Classes were held in workshops with apprentices taking a compulsory preliminary class before moving on after six months to train in the field of their choice. The school's first teacher was Johannes Itten, who taught color theory and practical use of materials. His successor, László Moholy-Nagy, was as much scientific inventor as artist. He taught draftsmanship, painting, and photomontage.

Under political pressure to justify its funding, Gropius staged an exhibition of Bauhaus designs—kitchenware, tables, and textiles—in a purpose-built show house. Despite international

▲ **Staatliches Bauhaus** *Gropius designed the Bauhaus building in Dessau. Built between 1925 and 1926, it comprised workshops, lecture, rooms and, as seen here, ultra-modern students' quarters.*

acclaim, the Bauhaus was forced to leave Weimar for Dessau in 1925. In the new Bauhaus the emphasis was on industrial rather than craft design.

Subjects and techniques

New products, such as ceiling lamps, cantilever chairs, and furniture suitable for office or home, were designed by Bauhaus technicians and produced by companies who owned large-scale factories such as that of Standard-Möbel furniture.

In 1928, Gropius resigned and was replaced by Bauhaus architect Hans Meyer. He had produced the first pre-fabricated housing and stressed the need to design for people's needs. He resigned in 1930 due to his left-wing views. His replacement, Mies van der Rohe, would go on to design New York's Seagram Building. By 1931, Nazis had gained Dessau and, in 1932, Bauhaus made its final move to Berlin.

Founded in Germany in 1919, the Bauhaus School of Art and Design survived shortages of funds, political instability, and occasional internal divisions. It was twice forced to relocate and produced just 500 graduates in 14 years, yet it was the 20th century's most influential school of design.

Bauhaus

Lyonel **Feininger**

b **NEW YORK, 1871**; d **NEW YORK, 1956**

Although he was a gifted musician, Lyonel Feininger chose a career in art and studied in Paris and Berlin. A successful graphic artist, he secured contracts with publications in both Germany and the US. Feininger turned to painting in 1907, when he was posted to Paris for two years. On his return to Germany he specialized in landscapes. The turning point came in 1911, when he encountered Cubism and his work developed the splintered prismatic forms of Orphism, in which light is as important as mass. In 1917, a successful exhibition established his reputation. He was Gropius's first appointee at the Bauhaus in Berlin, where he headed the print workshop from 1919 to 1925. It was in this capacity that he developed his students' interest in the art of printing from woodcuts.

LIFEline

1871 Born in New York; moves to Berlin when 16

1887 Leaves Germany to study music, but embarks on art studies within a year

1888–93 Studies at art institutions in Hamburg, Berlin, and Paris

1907–11 Concentrates on painting, and is influenced by Cubism

1919 Founder and longest serving member of the Bauhaus

1937 Returns to New York, paints and teaches

◄ **Tower I** *Monumental and luminous, Feininger's townscapes often feature a church tower. Painted as if the light were shining from within, his towers came to symbolize rebirth in the years after World War I.* 1923–26, oil on canvas, 24 x 18¾in, Kunstmuseum, Basel, Switzerland

▲ **Sailboats** *This image captures the sense of speed, light, and air involved in sailing. Clearly defined shapes drawn with the lightest touch link the boats, sea, and sky in a network of interlocking planes. With a minimum of color, Feininger has arrived at an almost naturalistic scene.* 1929, oil on canvas, The Detroit Institute of Arts, Detroit, US

CLOSERlook

DYNAMIC MOVEMENT Upward- and downward-pointing triangles cut across the canvas to represent the sails and rays of light. This, coupled with the movement from left to right, creates a sense of constant progress.

László **Moholy-Nagy**

b **BÁCSBOROD, 1895**; d **CHICAGO, 1946**

Hungarian artist László Moholy-Nagy studied law at Budapest University. He took up painting while he was convalescing from a war wound. He was mostly self-taught and was influenced by Constructivism, creating photograms (photographs made by exposing objects to light on photo-sensitive paper), photomontage, and collage. In 1922, he exhibited at the Sturm Galerie in Berlin and was Walter Gropius's choice to replace Johannes Itten to teach on the Bauhaus preliminary course.

Portrait by Hugo Erfurth

Light, its effects and creative potential, was the core of much of Moholy-Nagy's work. He taught in a scientific way and was the first artist to work with electricity creatively. He constructed rotating light machines for what he called *The Theater of Totality*, aiming to create a new theatrical experience in the process.

LIFEline

1895 Born in Hungary
1917 Turns to art while convalescing
1919–21 Moves to Vienna and then Berlin, where he meets Russian Constructivists Malevich and El Lissitzky
1923–28 Appointed at the Bauhaus where he teaches in the metal workshop initially
1928 Becomes a stage designer for Berlin avant-garde theater
1936 Designs the sets for sci-fi film *The Shape of Things to Come*
1939 Founds his own school of design in Chicago
1946 Dies in Chicago

▼ **Z8** *Moholy-Nagy was interested in illusory effects, particularly the three-dimensionality of apparently flat objects.* 1935, oil and galalith on board, 28¾ x 34¼in, private collection

◄ **Kinetic Construction**
This design shows the intended effect of one of Moholy-Nagy's machines. His aim was to project the theatrical action at the spectator and remove the barrier between stage and audience. c1925–30, working sketch, Magyar Nemzeti Galéria, Budapest, Hungary

CLOSERlook

GRAND AMBITION The size of the figure shows the scale of the artist's vision. After years of experimenting with rotating lights and shadows, he made his *Light Space Modulator* machine, which made him feel like the "sorcerer's apprentice."

Josef **Albers**

b **BOTTROP, GERMANY, 1888**; d **NEW HAVEN, 1976**

Working intermittently as a schoolteacher, Josef Albers studied art in Berlin, Essen, and Munich from 1913 to 1920. He then enrolled at the Bauhaus, where he was the first graduate to join the staff. From 1923 to 1933, he worked in the stained-glass, typography, and furniture design workshops. He also co-ran the preliminary course with Moholy-Nagy. In 1933, he moved to the US and took up oil painting. From 1949 until his death, he painted variations on a series of precise, formal, abstract pictures entitled *Homage to the Square*. From 1950 to 1959 he taught design at Yale University and published his theoretical essay *Interaction of Colors*.

▲ **Homage to the Square** *Albers sought to explore spatial dynamics and color combinations in a format removed from any reference to the natural world. Since there are no right angles found in nature, Albers chose to focus his studies on the square—four consecutive right angles.* c1960, oil on masonite, Gemeentemuseum, The Hague, Netherlands

Oskar **Schlemmer**

b **STUTTGART, 1888**; d **BADEN-BADEN, 1943**

One of the Bauhaus School of Art and Design's most influential teachers, Oskar Schlemmer trained in marquetry before enrolling at the Stuttgart Academy from 1906 to 1911. His artistic career was varied: he painted, sculpted, designed for the stage, and wrote on art theory. At the Bauhaus, at both Weimar and Dessau, he worked in the metalwork, sculpture, and stage design workshops. His *Triadic Ballet*, a Constructivist tour de force with music by Paul Hindemith, was first staged in Stuttgart in 1922 and the following year at the Bauhaus. Schlemmer remained a figurative painter believing that pure abstraction had a tendency to be soulless. His own work retains a cool and detached quality, however.

▲ **Four Figures and a Cube** *Schlemmer combines illusional shapes with human forms. The viewer is drawn into the distance, where the smallest figure stands. The juxtaposition of figures and cube has a strangely disarming feel.* 1928, oil on canvas, 97 x 63in, Staatsgalerie, Stuttgart, Germany

▲ **Three Girls (and a Head in Profile)** *Schlemmer's most important theme was the human figure in space, either moving or stationary. In this painting of three girls it is the sense of stillness that holds the viewer.* c1926–29, oil on paper, 25¼ x 18¾in, Kunsthalle, Hamburg, Germany

Paul **Klee**

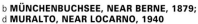

Paul Klee,
1921

b **MÜNCHENBUCHSEE, NEAR BERNE, 1879;**
d **MURALTO, NEAR LOCARNO, 1940**

An accomplished violinist, Paul Klee decided to forego a musical career
to study art. He moved to Munich in 1898 and enrolled at the academy.
It was there that he studied under the rigorously classical Fritz von Stuck.
But from the very beginning, Klee's work defied convention. Between
1903 and 1905 he produced a series of bitterly satirical monochrome
etchings called *Inventions*, which featured disturbingly distorted figures.
He moved from a graphic to a painterly style in 1914 following a trip
to Tunisia. Klee's child-like creations and whimsically titled pictures draw on every
conceivable influence from Cubism, ancient hieroglyphs, and Mozart operas to Baroque
art. In 1920, Klee joined the Bauhaus School of Art and Design where he established
an enduring friendship with Kandinsky and created a vast number of works, each of
which he carefully annotated.

LIFEline

1898 Moves to Munich to
study art

1906 Marries pianist
Lily Stumpf

1914 Visits Tunisia, which has
a major influence on his work

1916 His close friend Franz
Marc dies. Klee is conscripted

1920 Joins the Bauhaus

1924–25 Holds his first show
in New York; a year later he
contributes to an exhibition
of Surrealist art in Paris

1931–33 Leaves the Bauhaus;
joins the Düsseldorf Academy
until forced to flee Nazi
Germany

1940 Dies of heart failure

▼ **Street Cafe in Tunis, (no 55)** *Klee accompanied fellow artists August
Macke and Louis Maillot on a painting trip to Tunisia, where he produced 30
watercolor sketches that were influenced by the art theory of Robert Delaunay.*
1914, watercolor and pencil on card, 3¾ x 8½in, Kunsthalle, Hamburg, Germany

▲ **Senecio** *This brightly colored face, made up of
gentle geometric shapes, is named after a genus
of plants, perhaps because it resembles a seed head.
The quizzical head has a totemic quality—a focus
for adoration as much as for amusement.* 1922, oil on
canvas, 16¼ x 14¾in, Kunstmuseum, Basel, Switzerland

▲ **Untitled (Signs of Growth)** *Around 1937, Klee's line
became much heavier and his colors more basic. In 1935 he
had been diagnosed with the fatal disease scleroderma, and
it is probable that he simplified his approach so he could work
more rapidly, aware that time was short.* 1937, oil on paper,
24¼ x 18¾in, Kunsthalle, Hamburg, Germany

◀ **Red Balloon, (no 179)**
The lightness of touch and uncluttered composition of Klee's Tunisian paintings gradually took on a more precise edge. The viewer can tell this is a townscape even though it is veering toward abstraction. Paradoxically, it is the red balloon that acts as the visual anchor and unites the different elements. 1922, oil on muslin on cardboard, 12¾ x 12¼in, Guggenheim Museum, New York, US

CLOSERlook

TECHNIQUE The sky is the thinnest of oil washes under which the chalk-primed muslin can still be seen. Against this misty background the balloon, with its thick red pigment, appears even more dominant.

❝ What is really **essential**, really **productive**, is the **Way**—after all, **Becoming** is superior to **Being** ❞

PAUL KLEE

INcontext

WORTHLESS CURRENCY In 1923, Germany defaulted on war debt repayments, and Belgium and France occupied the Ruhr. Astronomical inflation ensued, and within weeks the German mark became worthless. High-denomination notes were rushed out, including one designed by Bauhaus professor Herbert Bayer.

Fifty billion mark banknote *Even multi-billion mark notes had little value.*

Origins and influences

Ben Nicholson and Barbara Hepworth were at the forefront of the British avant-garde movement. They married in 1933 and traveled through France, visiting artists such as Pablo Picasso, Constantin Brancusi, and Jean Arp.

Along with Henry Moore, they helped establish Unit One in 1933, the first British modernist movement to embrace art, design, and architecture. Other members included Paul Nash and Edward Wadsworth. Unit One organized exhibitions across Britain, which sparked debate and polarized opinion on modern art.

Subjects

The British avant-garde artists eschewed the urban subject matter and naturalistic style of Sickert's Camden Town Group. Instead, they tended toward abstraction—but also

▲ **Hepworth and Nicholson** *The couple were central figures in what the critic Herbert Read called "a nest of gentle artists" who lived close together in Hampstead, London and brought advanced artistic ideas from Europe.*

continued the tradition of British landscape art. In the 1930s, Hepworth's sculpture drifted away from recognizable human forms and became more severe and geometrical. In 1939 Hepworth and Nicholson moved to Cornwall and the landscape became an important representational element in their work.

Moore and Graham Sutherland were also affected by a love of landscape. Moore sculpted figures

but found inspiration in natural forms—sea-smoothed pebbles, rolling hills, and animal bones. Sutherland painted landscapes suffused with feeling.

Two American artists—Alexander Calder and Stuart Davis—were also connected to the European avant garde. Both artists lived in Paris in the late 1920s and Calder extended his stay into the 1930s. The random motion of Calder's steel and wire sculptures was influenced by Dadaists and Surrealists. But his sculptures were also indebted to American folk art—he began as a maker of toys, including a whole circus of animals.

Davis was inspired by Cubism but his subject matter was distinctly American. Unlike his British contemporaries, he celebrated the urban world in joyous, decorative paintings that depicted modern buildings, neon lights, street signs, posters, and commercial packaging.

Between the wars, Britain and America produced a variety of avant-garde artists. They looked to Paris and European modernism for inspiration, but they produced art that reflected their own national backgrounds.

Avant Garde in Britain and the US

Ben **Nicholson**

b **DENHAM, BUCKINGHAMSHIRE, 1894;** d **LONDON, 1982**

The son of painter Sir William Nicholson, Ben Nicholson was one of the most influential British abstract artists. He began painting in his father's style—with a great sense of order and sureness of touch. Nicholson's work was influenced by Cubism, and in particular the genre of still life. He painted his first abstract painting in 1924 and nearly a decade later produced his most innovative work—austere geometric paintings and reliefs. In this later work, Nicholson shifted between abstraction and representation, often in same picture. He cut, painted, and assembled flat boards into elegant abstract reliefs and also made big, freestanding reliefs, including one in marble in the garden of Sutton Place, Surrey.

Although Nicholson admired the work of "naïve" painters (including Rousseau and St. Ives painter Alfred Wallis), his was always an art of high aestheticism and formal rigor rather than instinctive expression.

LIFEline

1910–11 Studies at Slade School of Art
1920 Marries the artist Winifred Roberts
1924 First solo show at the Twenty-one Gallery, London
1933 With Hepworth, joins the Paris-based Abstraction-Création group; produces first geometric and abstract reliefs
1938 Marries Hepworth
1951 Divorces Hepworth
1958 Moves to Switzerland
1974 Returns to London

◀ **1933 (guitar)** *By using an oddly shaped piece of wooden board rather than canvas, Nicholson created a work that lies somewhere between painting and relief. He admired "naïve" painters—such as retired seaman Alfred Wallis—and the simplicity of the materials and the style here shows their influence. 1933, oil on board, 32¾ x 7⅞in, Tate, London, UK*

CLOSERlook

TEXTURED SURFACE
Nicholson created a lively surface texture by adding a layer of plaster to the board and then cutting into it while it was still wet.

▶ **1935 (white relief)** *In 1933, Nicholson began making abstract reliefs and by 1935 he had banished all color. This was seen by some critics as a cold, mechanisitic extreme of abstract art. This piece, however, was made from an old tabletop found in a junk shop so it had a worn, "lived-on" surface. 1935, painted wood, 40¼ x 65½in, Tate, London, UK*

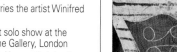

Barbara **Hepworth**

b **WAKEFIELD, 1903**; d **ST IVES, 1975**

Barbara Hepworth was the most important British female artist of the 20th century. Her sculpture—in stone, wood, and bronze—is suffused with a romantic feeling towards nature and landscape. Indeed her artworks, with their smooth, rounded forms, almost look as if they have been left to the sea and wind.

Hepworth pioneered the technique of direct carving—working without a preliminary model or drawings of what the finished sculpture will look like. She was also the first British sculptor to introduce the hole into work, in her 1931 piece, *Pierced Form*. During the late 1930s and 1940s, she began to concentrate on the counterplay between mass and space in sculpture. By the 1950s, she was one of the most respected sculptors in the world and won a stream of important commissions including the memorial to Dag Hammarskjold, *Single Form* (1963), at the United Nations in New York.

LIFEline

1920–21 Studies sculpture at Leeds School of Art

1921–24 Wins county scholarship to the Royal College of Art, London

1925 Marries artist John Skeaping and moves to Rome

1926 Returns to London

1933 Divorces Skeaping

1938 Marries Nicholson

1939 Moves to St. Ives at the outbreak of World war II

1943 First major solo exhibition, in Leeds

❝ In the contemplation of **nature we are perpetually renewed**, our sense of mystery and **our imagination is kept alive** ❞

BARBARA HEPWORTH, 1934

▲ **Three Forms** *By the mid-1930s, Hepworth's sculpture was becoming increasingly abstract. Here, she uses the simplest forms and eliminates all color. The work can be read repesentationally, as a landscape, or as the head, back, and legs of a reclining female nude. Perhaps the three forms also refer to the triplets Hepworth had in 1934. 1935, marble, 8¼ x 21 x 13⅜in, Tate, London, UK*

◀ **Doves** *For centuries, exquisitely detailed Italian sculpture has been made from fine white parian marble. Hepworth makes this tradition modern by simplifying and smoothing the form of the doves. She learned to carve marble while living in Rome. 1927, parian marble, 11½ x 13 x 9in, Manchester Art Gallery, UK*

▲ **Curved Form (Trevalgan)** *Trevalgan is the name of a hill near Hepworth's home. There, Hepworth wrote, "the cliffs divide as they touch the sea facing west." As well as divided cliffs, this piece reminds the viewer of antlers or trees next to a pond. 1956, bronze, 35½ x 23½ x 26½in, Tate, London, UK*

▶ **Pelagos** *Meaning "sea" in Greek, Pelagos was inspired by a view of the bay at St. Ives in Cornwall, where two arms of land reach out into the sea. The sculpture's sensuous curves also recall other natural forms—a shell, a wave, or the roll of a hill. The strings remind us of a musical instrument and also of the oft-cited maxim that all abstract art aspires to the condition of music. 1946, part painted wood and strings, 17 x 18 x 15½in, Tate, London, UK*

CLOSERlook

PAINT AND STRINGS
Hepworth used paint and strings in many of her sculptures of the 1940s. She spoke of the color of the paint as "plunging me into the depth of water, caves and shadows" and the taut strings as expressing "the tension I felt between myself and the sea, the wind or the hills."

Henry **Moore**

Photograph by Marino Marini

b **CASTLEFORD, YORKSHIRE, 1898;**
d **MUCH HADHAM, HERTFORDSHIRE, 1986**

Born into a mining family as the seventh of eight children, Henry Moore would become the most famous British sculptor of the 20th century. He gained his reputation by staying true to his materials, making sculptures by carving stone and wood and trying to establish an active relationship with the material. He rejected classical and Renaissance ideas of beauty, and instead looked to the vitality of ancient and "primitive" sculpture for inspiration. Two subjects kept recurring in his work—the mother and child, which he rendered without sentimentality, and the female figure, which usually undulated like a landscape. During the war, he was appointed as a war artist, creating moving drawings of people sheltering in London's Tube stations. After the war he started working in bronze. This made possible a new range of forms, the later work often has a new expressive power, and also enabled him to keep up with the increasing number of public commissions that resulted from his international reputation.

LIFEline

1917–19 Serves in the army; gassed in World War I

1921–24 Studies at Royal College of Art; teaches there until 1931

1928 First one-man show at the Warren Gallery

1932–39 Head of sculpture at Chelsea School of Art

1940 Moves from London to Much Hadham, where he lives for the rest of his life

1951 First retrospective held at The Tate

1976 Establishes The Henry Moore Foundation

1986 Dies, aged 88

◄ **The Warrior** *Made in 1946, this piece seems to be Moore's response to the horrors of the war. Precariously perched on a plinth, with limbs amputated and head gashed, his warrior does not seem to be much of a hero. He appears to hold his shield up to ward off more suffering.* 1946, bronze, Kunsthalle Mannheim, Germany

▶ **Figure in a Shelter** *During World War II, Moore made a series of drawings showing Londoners sheltering in Tube stations. They are bleak images of underground existence—this ghostly figure under a shroud is particularly despairing. Yet the drawings were seen as metaphors for the stoic resistance of the British people. As a result, they were exhibited at the National Gallery, London, in 1941.* 1941, pencil, ink, wax crayon, and wash, 15 x 22in, Wakefield Museums and Galleries, West Yorkshire, UK

▶ **Mother and Child** *Inspired by non-Western sculpture, Moore rejects tradition in this depiction of maternal love. In line with his "truth to materials" philosophy, he has carved directly into the stone. And the figures have been imbued with the solidity and strength associated with stone. Moore wrote in 1934 that stone "should not be falsified to look like soft flesh... It should keep its hard tense stoniness."* 1925, Hornton stone, 25¼ x 16⅛ x 14¼in Manchester Art Gallery, UK

❝ The sensitive **observer of sculpture** must also learn **to feel shape as shape**, not as description or reminiscence ❞

HENRY MOORE, 1937

▼ **Four-Piece Composition: Reclining Figure** *Although the title refers to a figure, Moore evokes natural forms—animal bones and a landscape. He wrote: "The human figure is what interests me most deeply, but I have found principles of form and rhythm from the study of natural objects, such as pebbles, rocks, bones, trees, plants."* 1934, Cumberland alabaster, 7⅛ x 18⅛ x 7⅛in, Tate, London, UK

CLOSERlook

ROCK CARVINGS
The curves of the incised lines, reminiscent of prehistoric stone carving, echo the undulations of the four forms.

Stuart **Davis**

b **PHILADELPHIA, PENNSYLVANIA, 1892;** d **NEW YORK, 1964**

Davis made idiosyncratic abstract paintings that captured the vitality of American life – its cities, its street life, advertising, and neon lights. He was, in effect, the first Pop artist. In the 1930s, while most of his contemporaries were painting realist images, he developed a new style—contrasting geometric areas of flat color with objects clearly defined in linear perspective. These images possess a wit and gaiety. The bright, dissonant colors and lively, repetitive rhythms can be seen as analogous to jazz music, which Davis loved. He was recognised in his lifetime with retrospectives at the Museum of Modern Art in 1945 and the Whitney Museum of American Art in 1957.

▼ **Visa** *Davis used advertising imagery years before the Pop artists. Here, a lively jumble of letters and shapes creates a painting that grabs you as a poster would.* 1951, oil on canvas, 40¼ x 52in, MoMA, New York, US

Graham **Sutherland**

b **LONDON, 1903;** d **LONDON, 1980**

Sutherland was one of the most important and versatile modernist artists to emerge from Britain. Not only a painter, he was a printmaker and designer of ceramics, stage costumes, and posters. In 1921, he abandoned a railway engineering apprenticeship to study etching and engraving. For ten years, he worked as a printmaker. His late 1930s paintings of South Wales were mysterious landscapes of light and dark. They were far removed from the clarity and simplicity of abstract artists and heralded a romantic revival in British art, which dominated the next decade. An official war artist, he was shocked by photographs of Nazi concentration camps and took up religious painting after the war. His expressionist portraits often caused controversy—Lady Churchill destroyed his portrait of Winston Churchill.

Photograph by Roland Haupt

▼ **Welsh Landscape with Roads** *Sutherland uses unnaturalistic coloring and low-key tones to create a threatening atmosphere in this landscape. He wrote that paintings like this expressed the "intellectual and emotional" essence of a place.* 1936, oil on canvas, 24 x 36in, Tate, London, UK

CLOSERlook

ANCIENT PAST Sutherland conjures up a sense of the landscape's history through the inclusion of the animal skull in the foreground.

Alexander **Calder**

b **PHILADELPHIA, PENNSYLVANIA, 1898;** d **NEW YORK, 1976**

Calder, c1975

Calder revolutionized sculpture by inventing "mobiles"—a term coined by French artist Marcel Duchamp in 1931. His delicately balanced constructions consist of abstract shapes suspended from wires and moved by air currents. Calder himself described them as "four dimensional drawings." He spent much of his thirties in Paris where he became friends with many of the avant-garde artists, including Piet Mondrian and Joan Miro. Indeed, with their colorful shapes, Calder's mobiles look like animated versions of Miro's paintings. Later in his career, Calder produced huge mobiles for public commissions, including Kennedy Airport, New York, (1957) and the UNESCO headquarters, Paris, (1962). Some are motorized—like the 46 ft-wide *Red, Black, and Blue* at Dallas Airport (1967).

▶ **Mobile** *This is a typical example of Calder's mobiles. The suspended shapes look like natural forms, petals, and berries, and are attached to wires that resemble the branches of a tree. French philosopher Jean-Paul Sartre called Calder's mobiles symbols of nature, "abruptly causing a thousand butterflies to take wing."* c1932, metal, wood, wire, and string, approx 59⅛ x 78¾ x 78¾in, Tate, London, UK

◀ **Black Widow** *Calder also produced large static sculptures, which French sculptor Jean Arp called "stabiles." These were made of bolted sheets of metal. The bold curves are similar in shape to the mobiles. They invite the viewer to walk around them, implying the idea of movement.* 1959, painted sheet steel, 91¾ x 171 x 89in, MoMA, New York, US

LIFEline

1923–26 Studies at Art Students League, New York

1926 Makes small animated animals in wood and wire

1928 First one-man exhibition at the Weyhe Gallery, New York; moves to Paris

1931 Joins the Abstraction-Creation group

1933 Returns to US, lives mainly in Roxbury, Connecticut

1944 First major retrospective at Museum of Modern Art in New York

Far from being anachronistic, many 20th-century figurative painters were very much of their time—not only in their choice of subject matter, but also in the various styles they adopted—continuing a tradition of representational art through to the present day.

Origins and influences

The realist and figurative painting of this period had two principle sources. One was the 19th century social realism of artists, such as Courbet and Millet, who were concerned with the representation of everyday working life. This was especially significant for American painters such as Edward Hopper and Grant Wood. The other was the revival of the classical style in

▲ **Breton Woman at Prayer** Christopher Wood 1930 *Breton subjects had been popular with artists since the late 19th century. This fishing region in North France with its ancient history and traditional costumes was viewed as a kind of refuge from the modern world.*

Europe following World War I, a tendency associated with nationalism and political conservatism. This did not exclude an element of social commentary or even a poetic and symbolic dimension.

Style and subject

Many of these figurative artists had previously experimented with Cubism and other avant-garde styles, and some had also worked as commercial artists or photographers—inevitably this influenced their representational style. As well as nostalgic rural genre paintings and landscapes, there was an emergence of realistically depicted urban scenes and interiors reflecting an ever increasing industrialized environment, and often portraying the psychological tensions of the modern world.

In the 1920s and 1930s, a number of artists resisted the trend toward abstraction, preferring to work more conventionally while still reflecting contemporary life. Figurative painters in Europe and America continued the tradition of Realism, but in several diverse styles.

Realism and Figurative painting

TIMEline

After World War I, figurative painting enjoyed a revival. The American regionalists, such as Grant Wood, emerged in the 1920s and 1930s, while in Europe there was a renewal of the Realist tradition with artists like Luigi Pirandello. The 1940s saw Edward Hopper reach the peak of his achievements with atmospheric works such as *Nighthawks.* Laurence Lowry, who had been painting seriously from the 1920s, only achieved recognition in the 1950s.

1930

WOOD American Gothic

1931

PIRANDELLO Interior in the Morning

1942

HOPPER Nighthawks

1942

LOWRY An Island

▲ **Steam Turbine** Charles Sheeler *The geometrical shapes of urban and industrial scenes, meticulously depicted by Sheeler and other Precisionists, echo elements of Cubism and Abstract art as well as the more obvious influences of photography and commercial illustration. 1939, oil on canvas, 22 x 18in, Butler Institute of American Art, Youngstown, Ohio, US*

Interpretations

Both painting styles portray social reality and truth rather than aesthetics and ideals. In the US these paintings were the first expression of American-born painters attempting to interpret American life.

America

The realism of the Ashcan school was followed by a gentler and more nostalgic figurative style during the Depression years—seen in the work of the American regionalists, predominantly Thomas Benton, John Curry, and Grant Wood, but this realism resurfaced in New York with Hopper's bleak portrayals of urban life. Although distinctly different in character, the regionalists and Hopper shared a background in commercial illustration that informed their painting and contributed to its local flavor.

Also working in the 1920s and 1930s were Precisionist painters such as Charles Sheeler, who was also a commercial photographer. His paintings of cityscapes and the machinery of modern technology are almost photographic in their realism, yet the mainly figureless scenes and geometric shapes verge on the abstract in their composition. Georgia O'Keeffe was similarly

influenced by photography, but alongside her landscape painting developed a naturalistic, rather than a realist, style: studies of sun-bleached bones and extreme close-ups of flowers also give an impression of abstraction.

Europe

Representational painting in Europe also had regional variations, but some form of realism continued into the 20th century across most of the continent. The Realist tradition of social commentary survived too: overtly with artists such as Solana, whose depictions of Spanish working-class life carried a strong political message, but less obviously in other figurative painting of the period.

Pirandello, for example, adopted a form of "poetic realism," distorting perspective and introducing irrational elements into otherwise mundane domestic scenes, which introduced a metaphorical as well as social tone to his work; and Balthus took on some of the allegorical mannerisms of Surrealism in interior paintings that are dreamlike and often disturbingly erotic. Yet another interpretation of Realism can be seen in the very English industrial landscapes of L.S. Lowry, who affected a simplified, faux-naïve style.

▲ **The Washer Women** Jose Gutierrez Solana *The subject matter of figurative painters such as Solana, working people in everyday situations, places them firmly in the Realist tradition, but recognizably 20th-century in style. 1931, private collection*

Georgia **O'Keeffe**

Portrait by Alfred Stieglitz

b **SUN PRAIRIE, 1887**; d **SANTA FE, 1986**

In a career that spanned much of the 20th century, Georgia O'Keeffe combined both the figurative and the abstract in her paintings of flowers, bones, and shells. Her works present their subjects in exquisite detail, as abstract images with symbolic connotations. They are often suggestive of female genitalia, although O'Keeffe denied that they had any feminist subtext.

Born in rural Wisconsin, O'Keeffe took an interest in art at an early age and left home in 1905 to study in Chicago and New York. For a while, she worked as a commercial artist, but then abandoned art to became a teacher. In 1915, however, she produced a series of abstract charcoal drawings that launched her career. They were shown at a gallery in New York run by the photographer Alfred Stieglitz, who continued to show her work regularly, and whom she eventually married in 1924. Her works began to command high prices, and she became one of the US's most successful living artists.

LIFEline

1887 Born on a dairy farm
1905–06 Studies in Chicago
1907–08 Studies at the Art Students League in New York
1916 Her work is exhibited in Alfred Stieglitz's 291 Gallery
1924 Marries Stieglitz
1929 Spends first of many summers in New Mexico
1946 Stieglitz dies
1949 Moves to Abiquiu, near Santa Fe, New Mexico
1971 Goes blind; takes up pottery
1986 Dies, aged 98

▶ **Red, White, and Blue** *A sun-bleached cow's skull was a recurrent subject for O'Keeffe. Here, set against the blue of New Mexico skies, between red borders, there is also a sly reference to the American flag.* 1931, oil on canvas, 39¾ x 35¾in, Metropolitan Museum of Art, New York, US

▼ **My Autumn** *In the late 1920s, O'Keeffe began a series of paintings of flowers and plants in extreme close-up. The cropped images and often enormous scale force the viewer to examine the subject more closely, seeing it for what it is rather than as an element within a composition.* 1929, oil on canvas, 40¼ x 29⅞in, private collection

> " Nothing is **less real** than realism... It is only by selection, by elimination, **by emphasis** that we get at the **real meaning** of things "
>
> GEORGIA O'KEEFFE, 1922

Charles **Sheeler**

b **PHILADELPHIA, 1883**; d **DOBBS FERRY, 1965**

A leading figure in American Modernist painting, Charles Sheeler was also a highly respected photographer, which undoubtedly influenced the smooth, sharply defined Precisionist style that he used to capture the modernization of the US. He studied both industrial design and art in Philadelphia before traveling to Europe, where he came across work by Cézanne and the Cubists. On his return to the US in 1912, Sheeler earned his living as a commercial photographer, but continued to paint, mainly urban and industrial scenes, and in an increasingly photographic manner. In the 1940s, his work started to become more abstract, although it was no less meticulously painted. Following a stroke, Sheeler retired from both painting and photography in 1959.

◀ **Upper Deck** *Sheeler's work as a photographer affected his choice of subject. He mainly concentrated on factory scenes, urban landscapes, and domestic interiors, subjects that allowed him to explore geometric shapes in a Cubist-influenced style. Upper Deck can be seen as a Precisionist representation of machinery, but it is also a study in colors and forms.* 1929, oil on canvas, 28¾ x 21¾in, Harvard University Art Museums, US

John Steuart **Curry**

b **DUNAVANT, 1897**; d **MADISON, 1946**

With Grant Wood and Thomas Hart Benton, John Steuart Curry led the Regionalist movement of the 1930s, a collection of artists depicting scenes from the Midwest. He was one of the great American scene painters, showing life in his native Kansas, even though much of his own life was spent outside the state. Before settling in New York, Curry studied in Chicago, and later Paris, and from 1936 he worked as artist-in-residence at the University of Wisconsin. Murals for the Kansas State Capitol building, now considered to be his masterpiece, aroused much controversy at the time and were left uncompleted.

▼ **Baptism in Kansas** *Curry made his name with this rural Kansas scene, painted from memory in New York. It is typical of his folksy narrative style, which was popular with East Coast urbanites.* 1928, oil on canvas, 40¼ x 50in, Whitney Museum of American Art, New York, US

Grant **Wood**

b **NEAR ANAMOSA, 1891; d IOWA CITY, 1942**

With the phenomenal success of *American Gothic*, Grant Wood became probably the best known of the American Regionalist painters. Born on a farm in Iowa, he spent his teenage years in Cedar Rapids, then traveled and studied in the US and Europe before returning to his home state in 1932. He joined the staff of the University of Iowa's School of Art in 1934 where he taught painting.

Much influenced by Netherlandish Renaissance oil painting, Wood developed a boldly realist style in his depictions of the Midwest, which are often tinged with a wry humor. He continued painting and teaching until his death from liver cancer, the day before his 51st birthday.

◄ **American Gothic** *Named after the architectural style of the building in the background, Wood portrays an enigmatic, impassive farming couple in affectionate detail.* 1930, oil on board, 29⅛ x 24⅜in, Art Institute of Chicago, US

Thomas Hart **Benton**

b **NEOSHO, 1889; d KANSAS CITY, 1975**

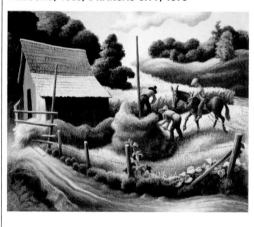

◄ **Haystack** *Benton's historical murals and Midwestern scenes were not simply narrative, they were also social comment, that reflected his populist Marxist views.* 1938, tempera with oil glaze on linen on panel, 24 x 29⅞in, Museum of Fine Arts, Houston, US

The son of a US congressman, Thomas Hart Benton rejected the family's traditional career of politics in favor of art. He studied at the Art Institute of Chicago, and also in Paris. On his return to the US, he moved to New York, where he painted in a Modernist, sometimes abstract, style. However, he found it increasingly difficult to reconcile the elitism of this style with his notions of the artist's place in society, and eventually abandoned Modernism absolutely.

During the 1920s and 30s, Benton's realist paintings and murals of rural life established him as a leading Regionalist painter. Appalled by the politics of the New York art world, he left to teach at the Kansas City Art Institute in 1935, where Jackson Pollock was one of his students. He was dismissed in 1941 for his controversial leftist views and spent the rest of his career painting public murals in the Midwest.

Edward **Hopper**

Photograph by Oscar White

b **NYACK, NEW YORK, 1882; d NEW YORK, 1967**

Edward Hopper's atmospheric portrayals of East Coast scenes have made him the best-known American Realist painter of the 20th century. He was trained and worked as a commercial illustrator, but achieved the success he yearned for as a painter in the 1920s when *House by the Railroad* became the first painting bought by the Museum of Modern Art in New York.

This was a turning point in Hopper's career, enabling him to concentrate on painting in the introspective, melancholic style that had evolved from his earlier Impressionistic work. He and his wife took painting trips to rural New England, where he produced numerous pictures of typically American architecture. During the 1930s, Hopper also began to depict urban scenes with bright lights and intense shadows peopled with solitary figures. Toward the end of his life, when abstract art became fashionable, Hopper's work was unfairly dismissed as "illustrative," a term he loathed.

LIFEline

1882 Born in Rockland County, New York State
1899–1906 Studies illustration and painting
1906 Makes the first of several trips to Europe
1910–24 Works as an illustrator in New York
1923 Paints *The Mansard Roof*, which is bought by the Brooklyn Museum
1925 Paints *House by the Railroad*, the first of his mature works
1942 Paints *Nighthawks*, his most famous work
1967 Dies in New York

▼ **Evening Wind** *Many of Hopper's early etchings featured female figures in urban New York settings, anticipating the lonely figures in his later paintings.* 1921, etching, 7⅛ x 8¾in, Whitney Museum of American Art, New York, US

▼ **Nighthawks** *Hopper's best-known work is a powerfully evocative depiction of urban alienation. The desolate mood of the almost empty diner and deserted streets is enhanced by Hopper's impassive Realist style and the simplicity of the composition.* 1942, oil on canvas, 29⅞ x 59¾in, Art Institute of Chicago, US

CLOSERlook

INNER LIGHT SOURCE The brightly lit diner throws the street outside into gloomy, *film-noir*-style shadows, making the diner an island of light in a dark streetscape. This contrast forces the viewer's attention to the interior scene, starkly illuminated by an overhead light on the right—the only light source in the painting.

FOCAL POINT At the center of the diner, the woman's red dress and auburn hair stand out from the muted colors around her, intensifying the anonymity of the male customers. All of them appear to be contained in a glass-sided case with no exit.

◄ **The Mansard Roof** *To begin with, Hopper only used watercolor for his illustrative work, but, encouraged by his colleague and future wife Jo Nivison, he began to use the medium for seascapes and architectural paintings. 1923, watercolor over graphite on paper, 14¼ x 20⅛in, Brooklyn Museum of Art, New York, US*

◄ **Room in Brooklyn** *Hopper's paintings often depict scenes of solitude or detachment. There is seldom any interaction between his characters, and often only a single figure. This feeling of isolation is emphasized by his predilection for harsh, one-directional light and sharply defined shadows. 1932, oil on canvas, 29⅛ x 33⅞in, Museum of Fine Arts, Boston, US*

Balthus

b **PARIS, 1908**; d **ROSSINIÈRE, 2001**

Known by the childhood nickname "Balthus", Balthazar Klossowski de Rola exhibited alongside the Surrealists although his work was always distinguished by traditional painting skills. He achieved public recognition only later in life, and some notoriety, for his disturbingly erotic depictions of childhood and adolescence.

Photograph by Boris Lipnitski

Balthus painted from an early age, encouraged by family friends, such as Rainer Maria Rilke and André Gide. In 1934, he had his first one-man show in Paris, and then established himself as a portrait and landscape painter. He continued to explore the erotic and surreal elements of his early maturity, culminating in his masterpiece, *The Room* (1952–54).

> " My paintings have many **layers of meaning**, vanishings in the canvas "
>
> BALTHUS

LIFEline

1908 Born in Paris to Polish parents
1914 Moves with his family to Berlin
1924 Returns to Paris
1937 Marries Antoinette de Watteville
1961–77 Serves as director of the French Academy in Rome
1962 Travels to Japan, where he meets his second wife
1977 Moves to Rossinière, Switzerland

▶ **The Room** *In this erotic and dreamlike painting, Balthus explores psychologically unsettling subject matter with traditional techniques.* 1952–54, oil on canvas, 107 x 132in, private collection

▲ **The Mediterranean Cat** *As a teenager, Balthus produced an album of drawings of the adventures of the cat Mitsou, and cats feature in many of his subsequent paintings. He sometimes referred to himself as "His Majesty, King of the Cats."* 1949, oil on canvas, private collection

CLOSERlook

IMPASTO In later work, Balthus used an impasto technique, building up thick layers of paint to give an impression similar to that of fresco painting. He also tended toward warm and bright colors, increasing the resemblance to Italian Renaissance frescoes.

José Gutiérrez **Solana**

b **MADRID, 1886**; d **MADRID, 1945**

A respected artist and writer, José Gutiérrez Solana was a major figure in the revival of Spanish culture at the turn of the 20th century. He studied at the Academia de Bellas Artes in Madrid from 1900–04, and then became involved with writers of the "Generation of 1898," a mainly literary movement trying to restore cultural life after the disastrous Spanish-American War.

As a painter, Solana was greatly influenced by Goya and the Spanish Baroque masters. He painted mainly urban scenes, depicting the darker side of life in Madrid—prostitution, alcoholism, grief, and tragedy—in somber colors. He exhibited frequently in Spain and won several awards for his painting, but, because of his cynical outlook, lived an isolated and reclusive life.

▲ **The Clowns** *Solana's typically somber colors and oppressive setting are apparently at odds with the gaiety of this subject, but very effectively convey the bleakness of the characters behind the greasepaint—the tragic "tears of the clown."* 1920, oil on canvas, 39 x 49in, Museo Nacional Centro de Arte Reina Sofia, Madrid, Spain

INcontext

CLOWNS IN PAINTING The emotional ambiguity of traditional clown characters, such as Harlequin and Pierrot, appealed to many artists in the first half of the 20th century. The melancholy underlying their comic antics was a powerful metaphor, particularly in a time of discovery in psychology and psychoanalysis.

Circus Clown *Popular in circuses and music halls, clowns inspired artists such as Solana, Georges Rouault, Raoul Dufy, and Bernard Buffet.*

LS **Lowry**

LS Lowry

b STRETFORD, 1887; d GLOSSOP, 1976

Best known for his paintings of industrial Manchester and Salford, Laurence Stephen Lowry came to prominence late in life, and continued to work as a rent collector even when he was one of the most popular painters in England.

However, Lowry was by no means an amateur painter: he studied in the evenings for more than 20 years at art colleges in Manchester and Salford.

In his twenties, Lowry moved to Pendlebury, where he spent much of the rest of his life and drew inspiration from the mills and factories. From his first exhibitions in the 1920s, he built a reputation gradually, only achieving popular success when he was in his sixties, and continued to live a simple and private life.

LIFEline

1887 Born in a middle-class area of Manchester

1905 Takes evening classes at the Municipal College

1909 Moves to Pendlebury, an industrial part of Salford

1910–52 Works as a rent collector

1915 Studies part-time at Salford School of Art

1921 Has his first exhibition in Manchester

1934 Is elected to the Royal Society of British Artists

1948 Moves to Mottram-in-Longdendale, Cheshire

1962 Is elected to the Royal Academy

1976 Dies of pneumonia

◀ **An Island** *Although he often depicted industrial cityscapes with some affection, Lowry also conveyed a sense of their bleakness. He invariably used drab colors to portray grimy urban buildings and overcast skies, dominated by ever-present smoking factory chimneys.* 1942, oil on canvas, 18⅛ x 24in, Manchester Art Gallery, UK

▲ **Coming out of School** *Typical of Lowry's urban landscapes, this is a vivid record of life in industrial northern England. The playful figures leaving the red-brick school, next to a terrace of small houses, are overshadowed by the huge factory buildings and a lowering sky.* 1927, oil on wood, 13¾ x 21in, Tate, London, UK

CLOSERlook

MATCHSTICK MEN
Lowry's spindly figures have become the best-known feature of his work. In early paintings, each "matchstick" figure was carefully and individually depicted. About 1930, they became less distinctive, anonymous members of the crowd.

Fausto **Pirandello**

b ROME, 1889; d ROME, 1975

The son of the Nobel-Prize-winning dramatist, Luigi Pirandello, Fausto Pirandello studied first as a sculptor, but made his name as a painter in the 1920s. His early influences included Gaugin and Van Gogh. During a period living in Paris, from 1927–31, he became part of the *Italiani di Parigi* (Italians of Paris) group and adopted some elements of Cubism.

Back in Rome in the 1930s, Pirandello developed a very individual realist style, incorporating irrational subjects and dramatically skewed perspective. He had considerable success in Italy and abroad with dreamlike depictions of everyday life, such as *The Staircase* (1934), and incisive portraits such as the 1993 one of his father. His later works became more abstract, influenced again by Cubism, and he continued to paint until his death in 1975.

LIFEline

1889 Born in Rome, the son of dramatist and novelist Luigi Pirandello

1919–20 Studies sculpture with Sigismondo Lipinsky

1927 Moves to Paris

1929–30 Exhibits in Paris and Vienna

1931 Returns to Rome, and shows *Interior in the Morning* at the Sindacale Romana

1933 Paints *Luigi Pirandello*, a portrait of his father

1951 First retrospective at Palazzo Barberini, Rome

1975 Paints *Bathers*, his last major work; dies in Rome

▼ **Interior in the Morning** *In the 1930s, Pirandello painted scenes of working-class life in a starkly realist style, but included almost surreal details, such as the picture-frame around the head of the central figure.* 1931, oil on board, 70 x 59½in, Pompidou Centre, Paris, France

❝ He has a **personal impact** of his own... You may **accept or refuse** the painter Pirandello, but you **cannot ignore him** ❞

VIRGILIO GUZZU, ART CRITIC

Origins and influences

Mexican art is a rich blend of diverse sources that reflect the complex historic and social forces underlying the formation of its national identity. European influences, dominant from colonial times onward, became a point of contention at the beginning of the 20th century as the Mexican Revolution challenged its citizens to form their own vision of themselves as a nation. Looking at their Pre-Columbian past and indigenous populations with a fresh eye, free of European value judgments, Mexican artists began to enthusiastically incorporate the nature, people, and culture around them, instead of emulating foreign trends.

Fueled by social protest brought on by centuries of colonial occupation, Mexican art in the 20th century often focused on the formation of a new national identity. From panoramic murals to modest still lifes, Mexico's people and culture were at the ideological center of art production.

▲ **Mexican Muralism** *David Siqueiros painted this mural on the Polyforum Cultural Siqueiros in Mexico City, built 1964–71.*

Subject

Art that focused on *Mexicanidad* (all things Mexican) became an important part of the search for national identity.

American Indian holidays, costume, and folk art became a source of inspiration. These scenes were often mixed with references to ancient gods and religious practices. The distinctive Mexican landscape also featured. In a gesture of cathartic political purging, artists also portrayed the cruelties and injustices of the Spanish Conquest.

Style

Although no one style was ever promoted or followed, Mexican art retains a distinctive look that is due in part to its diverse sources. For example, a unique color palette often reflects indigenous aesthetics, the abstracted form is reminiscent of archaic monumental sculpture, and the satiric commentary comes from popular graphics.

Mexican art

TIMEline

The popular graphic artist José-Guadalupe Posada lovingly critiqued the passions and foibles of Mexicans of all classes in cheap and widely distributed broadsheets. The muralists José Orozco, Diego Rivera, and David Siqueiros created murals on government buildings that were meant to educate Mexicans on their history, from the grandeur of past civilizations to the heroic battles of the revolution.

1913

POSADA La Catrina

1938

KAHLO Construction

1942

TAMAYO The Dancers

1945

RIVERA Great City of Tenochtitlan (detail)

▲ **The Flowered Canoe** Diego Rivera, 1931 *In a utopian mingling of the classes, urban mestizo (European-Amerindian) tourists float down rural canals on boats at Xochimilco.*

Muralism

Orozco, Rivera, and Siqueiros were the most important muralists and came to be known as *Los Tres Grandes* (The Three Great Ones). Each had his own distinct style, technique, subject matter, artistic influences, and even political beliefs.

Studying in Europe for over 13 years, Rivera was highly influenced by both Cubism and Italian Renaissance murals. Orozco shunned Rivera's didactic Marxism and had a vision of humanity that was darker and more complex; his messages tend to have more universal appeal. An ardent revolutionary who fought in the Spanish Civil War and in other revolutionary battles, Siqueiros was the most experimental in terms of composition and technique and has had the most lasting influence on future generations of artists. Other talented and visionary artists also painted murals in Mexico, but not exclusively.

The far-reaching influence of Mexican muralism on artwork created all over the world cannot be underestimated. Throughout Latin America, Mexican art led the way to developing mature and unique political expressions. The Mexican muralists executed some of their best work in the US and their innovative painting techniques helped to pave the way for Abstract Expressionism (see p.502).

Other visions

Mexican artists have also followed more individual paths of self-expression. The wife of Rivera, Frida Kahlo, was a tireless promoter of *mexicanidad*; with her husband, she amassed important collections of Pre-Columbian antiquities and folk art, which they later donated to the people of Mexico. She painted intimate portraits of herself and loved ones, which explored themes of illness, love, and psychological suffering. Her work displays aspects of Surrealism, a movement she was peripherally involved in.

Rufino Tamayo was a subtle and lyrical colorist, whose work explores his American Indian origins. Like Kahlo, he was also influenced by Surrealism. Part of the generation that began to pull away from the political themes of the muralists, Tamayo used myth and abstraction to convey a more universal search for meaning.

CURRENTevents

1910 The decade-long Mexican Revolution begins; oil is discovered on the Gulf Coast.

1917 A radical new constitution is formed.

1920–24 Alvara Obregón is made president, ushering in calm; a program of social reforms begins.

1926 Church strike due to anti-clerical policies.

1929 The National Revolutionary Party is founded; it retains power for 71 years and leads to Mexico becoming a one-party democracy.

1938 The holdings of foreign oil companies are nationalized—a major economic turning point.

Diego **Rivera**

b GUANAJUATO CITY, 1886; d MEXICO CITY, 1957

Diego Rivera was one of the greatest 20th century Mexican artists, and his public persona matched his legendary large physical size. He was classically trained, but absorbed Modernism during a 17-year stay in Europe. Rivera returned to Mexico after the revolution to work on mural programs run by the Minister of Education, José Vasconcelos, in Mexico City. From this point until his death, he would be a central and controversial figure in Mexican painting and culture.

Along with his wife, the artist Frida Kahlo, Rivera promoted a form of cultural nationalism known as *Mexicanidad* in his murals, paintings, and lifestyle. His collection of Mesoamerican Art, along with *Anahuacalli*, his Pre-Columbian-inspired studio, was donated to Mexico when he died. During his stay in the US (1930–33), Rivera painted significant murals and influenced a generation of American artists. However, in 1933 his mural *Man at the Crossroads* provoked international scandal when it was destroyed at the Rockefeller Center, New York City, due to its depiction of Lenin.

LIFEline

1907–21 Studies in Spain, settles in Paris
1922 Begins to participate in Mexico's mural program
1929 Marries Frida Kahlo
1930–33 Paints murals in San Francisco, Detroit, and New York
1937 Leon Trotsky deported from Soviet Union; he and his wife arrive in Mexico and live with the Riveras
1954 Death of Frida Kahlo

CLOSERlook

CAUSEWAYS The Aztec capital was built on an island in Lake Texcoco. Causeways led from the ceremonial center to other cities along the shore, each with its own pyramid-shaped religious structures.

◀ **The Tortilla Maker** *This depiction of monumental Indian women, kneeling in front of stone metates (corn grinders) that have remained unchanged since pre-Hispanic times, suggests the antiquity and enduring nature of Mexican indigenous culture.* 1925, oil on canvas, 48 x 38¼in, University of California, San Francisco, US

▶ **The Great City of Tenochtitlan** *Rivera's panoramic murals of Pre-Columbian civilizations are committed to authentic detail, but give an idealized view of ancient Mexican life.* 1945, fresco, 193 x 382in, Palacio Nacional, Mexico

José Clemente **Orozco**

b CIUDAD GUZMÁN JALISCO, 1883; d MEXICO CITY, 1949

One of the "Great Ones" of Mexican muralism, Orozco was also an expressive painter, draftsman, and printmaker. Critical of the Mexican Revolution and scornful of propaganda in art, Orozco's examination of history was a complex attempt to get at the truth. His work addressed universal social concerns, such as the role that technology played in war and the subjugation of peoples. One of his favorite themes was the Greek myth of Prometheus, who he recast as "the Man of Fire." This figure served as a metaphor for the artist's role in society as the self-sacrificing harbinger of change, hope, and salvation.

Early in his career, poverty forced Orozco to work in the US for a number of years, where he executed important mural commissions. When he returned to Mexico, with a more firmly established reputation, he painted numerous murals in Guadalajara and Mexico City.

▶ **American Civilization—Ancient Human Sacrifice** *Orozco's mural at Dartmouth is one of the most spectacular examples of Mexican art in the US. Epic in scope, the fresco cycle portrays the dualities of the Indian and European historical experience in North America.* 1932, fresco, 120 x 119in, Dartmouth College, New Hampshire, US

▲ **The Spanish Conquest of Mexico** *Situated in a deconsecrated church, this mural is widely considered Orozco's greatest work. Seeking to create a balanced view of history, Orozco depicts both the negative and positive aspects of the Spanish Conquest.* 1938–39, fresco, Hospicio Cabañas, Guadalajara, Mexico

José Guadalupe **Posada**

b AGUASCALIENTES, 1852; d MEXICO CITY, 1913

▲ **Calavera Catrina** *This calavera of a society lady sporting an ornate and pretentious hat has become a beloved emblem for Mexicans, who often incorporate it into altars, crafts, and costumes for the Day of the Dead.* 1913, zinc relief etching, 4¾ x 6¼in, private collection

A master of popular engraving, José Guadalupe Posada captured the spirit of Mexican society under the dictator Porfirio Díaz (who ruled from 1884 to 1911). After the revolution, contemporary artists revived his reputation and celebrated his work as being authentically Mexican.

Posada specialized in illustrations for newspapers that avidly fed the public appetite for sensational news. With a deft hand and a joyous love of gruesome detail, he portrayed the notorious crimes of his day. Religious scenes, bullfights, popular heroes and bandits, political portraits, and natural disasters were all part of his repertoire. However, he is best known for his images of skeletons produced for the Day of the Dead celebration.

David Alfaro **Siqueiros**

b **CAMARGO, 1896;** d **CUERNAVACA, 1974**

A member of the legendary "The Great Three," along with Rivera and Orozco, David Alfaro Siqueiros was the youngest of this group. A militant social activist, he frequently participated in demonstrations, strikes, and other revolutionary activities and was involved in the first, bungled assassination attempt on Leon Trotsky.

Although he was primarily a muralist, Siqueiros broke away from the traditional use of fresco and experimented with new techniques and materials, often taken from the industrial world. He applied paint with a commercial airbrush and often used Duco paint (an automobile lacquer), and other plastic media. In the 1930s, he headed an experimental workshop in New York, which was to prove influential for future generations of American artists, such as Jackson Pollock.

CLOSERlook

BALCONY FIGURES
Attired in finery with military and ecclesiastic emblems of office, the balcony contains the aristocratic, wealthy, and powerful of this unholy congregation. In a satirical quotation from Leonardo's *Last Supper*, Siqueiros has placed a presidential couple in front of an arched window and blue sky.

▲ **The Devil in the Church** *Passionately dedicated to Marxism, and a political activist all of his life, Siqueiros probably meant this as an anticlerical statement. The monstrous creature tearing through the roof is evocative of evil and the Antichrist.* 1947, enamel on celotex, 84¼ x 60½in, Museo de Arte Moderno, Mexico City, Mexico

▲ **Zapata** *A talented printmaker, Siqueiros here offers an iconic representation of the revolutionary leader Emiliano Zapata. This transfer lithograph on zinc reveals a bold handling of light and dark that suited the artist's political zeal.* 1931, lithograph, 21 x 15¾in, private collection

Rufino **Tamayo**

b **OAXACA, 1911;** d **MEXICO CITY, 1991**

Rufino Tamayo was part of the generation of artists that followed the Mexican Muralists, and although he painted a number of important murals both in Mexico and the US, he was an outspoken advocate of greater expressive freedom. Rejecting traditional descriptive realism, Tamayo fused figuration and abstraction to create a bold personal style, which he deemed more in line with Modernist formal experimentation.

Utilizing a brilliant color palette, along with the flat planes and shallow space of Cubism, Tamayo painted with a raw and expressive power, often inspired by the pre-Columbian and folk arts of his country. The forms of his figures consistently drew upon Mesoamerican pottery and sculpture, which he avidly collected and eventually left to a museum he established in his native Oaxaca. Tamayo refused to confine his work to nationalistic statements, however, and insisted on placing Mexican and Latin American art within the discourse of international Modernism.

LIFEline
1911 Born in Oaxaca, but is sent to Mexico City to live with relatives
1920s Influenced by Mexican Muralism, but rejects its dogmatic nationalism
1926–1928 Lives in New York
1934 Marries Olga Flores Rivas Zárate
1936–49 Lives intermittently in New York and teaches art at the Dalton School, Manhattan
1950 Represents Mexico at the XXV Venice Biennale
1964 Retrospective of his work is held in Mexico City
1991 Dies, aged 80

◀ **The Dancers** *Rich, exuberant color, combined with a sculptural use of form, lends a powerful emotional charge to these monumental dancers. Tamayo balances hot and cool colors, and pairs movement with frozen gestures. Enveloped in a fiery red background, these iconic and abstracted female figures evoke a timeless and universal sense of vitality.* 1942, oil on canvas, 46 x 36½in, private collection

CLOSERlook

RESTRICTED COLORS
Tamayo felt that the more limited the use of color, the more significant were its expressive possibilities. The violent contrast of the different ranges of reds, blues, and blacks in this scene succeeds in evoking an emotional intensity.

▲ **Watermelons** *Tamayo painted many still lifes with watermelons and other fruits, perhaps evoking his childhood selling fruit at his aunt's market in Mexico City. The vibrant color and sinuous lines were inspired by the folk art of his native Oaxaca.* 1968, 51¼ x 77in, oil on canvas, Museo Tamayo Arte Contemporáneo, Mexico City, Mexico

▲ **Two Lovers Contemplating the Moon** *Humans contemplating the cosmos, and perhaps their place in it, was a favorite theme for Tamayo. Resembling ancient Mesoamerican ceramic figures, his lovers seem to defy gravity by floating in space while gazing at the moon.* 1950, oil on canvas, 32 x 39½in, private collection

Frida **Kahlo**

Photograph by Diego Rivera

b **COYOACÁN, 1907**; d **COYOACÁN, 1954**

Raised in the shadow of the Mexican Revolution, Frida Kahlo was an ardent supporter of social justice who, together with her husband Diego Rivera, promoted a greater appreciation for the complex culture, history, and peoples of her country. A hallmark of all her work is the inclusion of specifically Mexican artistic references, including Aztec sculpture, colonial religious art, and folk art.

Much of Kahlo's work is biographical in nature, exploring her emotional and psychological states of mind, yet it often transcends the personal by questioning gender roles and the power relations between individuals and nations. Kahlo's distinctive public persona can also be considered a type of early performance art, aimed at challenging the status quo.

LIFEline

1914 Contracts polio, which damages her right leg
1925 Is severely injured in a bus accident
1929 Marries Diego Rivera in Coyoacán
1930–33 Travels to the US
1937 The Bolshevik revolutionary Leon Trotsky and his wife move into Frida's house
1939 Exhibits in the *Mexique* exhibition, Paris
1953 Solo show in Mexico City

▶ **The Suicide of Dorothy Hale** *Kahlo based this composition on Catholic ex-votos. Produced in thanks for miraculous salvation, they typically show terrible events. In this intense work, Hale is shown as a tragic figure who does not survive her anguish.* 1938–39, oil on hardboard with painted frame, 19¾ x 16⅛in, Phoenix Art Museum, US

▲ **What the Water Gave Me** *The bathwater reflects an odd assortment of objects and people that have significance for the artist. Kahlo's parents, her favorite dress, and cacti, float on the surface.* 1938, oil on canvas, 36 x 28in, private collection

INcontext

MEXICAN REVOLUTION
1910–20 This bloody civil war sought to correct the gross social inequalities between the small landholding élite and the poor landless peasants, who were primarily of Indian or *mestizo* (mixed) descent.

Emiliano Zapata *The revolutionary leader became an iconic hero figure, repeatedly portrayed by the Muralists and other Mexican artists.*

▲ **The Two Fridas** *This double self-portrait reveals Kahlo's painful sense of a divided self. The dualities of her mixed European and Indian heritage are shown in the costumes, but the figures are united by an artery connecting the two hearts.* 1939, oil on canvas, 68½ x 68in, Museo de Arte Moderno, Mexico City, Mexico

CLOSERlook

BLEEDING HEART The heart on Kahlo's "unlovable" European half is shown exposed, as an artery from it drips blood on to her dress. This may be a reference to Catholic images of the sacred heart of Mary, common in Mexico.

Before World War II, the Surrealists had used images of dreams to mock bourgeois conventions. After the War, artists were more concerned with the opposite: to find general truths in the unconscious mind that would piece society back together. In the US, the Abstract Expressionists flouted traditional painting techniques in an effort to find and express common human ground.

1945

1945 1955 1965

ABSTRACT EXPRESSIONISM 1940s–LATE 1950s

MINIMAL ART MID 1960s–1980s

POP ART LATE 1950s–LATE 1960s

KINETIC ART 1960s

for something else in the real or subconscious world. In the 1960s, the next generation of artists reacted against what they saw as the sterile and stuffy atmosphere of abstract art, whatever it was or was not expressing. Pop music, comic strips, packaging, and advertisements provided the raw material for Pop art. It was swiftly followed by optical art, dubbed Op art, which relied on shimmer. Kinetic sculptures really did move, either mechanically or in air currents. Conceptual art presented an idea rather than an object, while Superrealism went back to representational art but, in an unsettling twist, made it look more real than the real thing. Neo-Expressionism was likewise a figurative reaction to abstraction, and looked deliberately crude in technique and materials.

onward

CONCEPTUAL ART LATE 1960s–LATE 1970s

SUPERREALISM LATE 1960s–LATE 1970s

NEO-EXPRESSIONISM MID 1970s–LATE 1980s

YOUNG BRITISH ARTISTS (YBAs) LATE 1980s ONWARD

NEW CHINESE ART LATE 1980s ONWARD

The term Abstract Expressionism was first used in connection with modern American painters in 1945 by Robert Coates, art critic of *The New Yorker*, but it had also been applied to the work of Wassily Kandinsky in the 1920s.

By the 1950s the term was in common currency, even though some Abstract Expressionists, such as Willem de Kooning, did not produce abstract work.

Influences

The Surrealists were a major influence on the Abstract Expressionists. Their ideas of unleashing the power of the unconscious and painting automatically were adopted by the Abstract Expressionists—as was biomorphism, a style of painting based on non-geometric shapes and motifs

▲ **New York** *replaced Paris as the world capital of contemporary art after World War II thanks to the emergence of Abstract Expressionism.*

that evoke living things. Most of the Abstract Expressionists—including its two best-known artists, Pollock and Rothko—began painting in a biomorphic style in the 1940s.

Abstract Expressionism was also a response to post-war American society. In a conservative, and increasingly homogenized culture, artists felt a need to communicate their innermost feelings and experiences. In doing so, they created the first American art movement to achieve worldwide influence.

Abstract Expressionism flowered in the 1940s and '50s in New York. It covered a variety of painting styles, but all its practitioners conveyed a strong emotional content, emphasized the sensuousness of paint, and generally worked on large canvases.

CURRENTevents

1944 Wassily Kandinsky, considered the founder of modern Abstract Expressionism, dies at Neuilly-sur-Seine.

1941 US enters World War II.

1942 The Art of This Century gallery, displaying abstract art, is opened by Peggy Guggenheim in New York.

1948 The Cold War between the US, and its allies, and Russia, and its allies, begins

1950 United Nations building completed in New York.

Abstract Expressionism

TIMEline

Abstract Expressionism grew out of Surrealism. Gottlieb's Eyes of Oedipus and Pollock's Eyes in the Heat retain the non-geometric biomorphic imagery favored by the Surrealists. David Smith's sculpture, created from agricultural implements, suggests action suspended. By the mid-1950s Rothko had established his Color Field style and Borduas was pursuing his "all-over" painting. De Kooning carried Abstract Expressionism into the 1960s.

1945

GOTTLIEB Eyes of Oedipus

1946

POLLOCK Eyes in the Heat

1950–52

DE KOONING Woman I

1952

SMITH Agricola VIII

1955

ROTHKO Unititled

1962

TWOMBLY Achilles Mourning the Death of Patroclus

▲ **The Plough and the Song** *Archile Gorky's fluid, expressive brushstroke and sinuous linework anticipate the Action painting of Pollock and de Kooning. 1947, oil on canvas, 50½ x 62½ in Allen Memorial Museum, Oberlin college, Ohio, US*

Interpretations

Abstract Expressionists can broadly be divided into two groups. The Action painters, a term coined by the critic Harold Rosenberg in 1952, included Jackson Pollock, Willem de Kooning, and Franz Kline. Their paintings are full of drama, with the paint applied urgently and passionately. The Color Field painters, championed by critic Clement Greenberg, include Mark Rothko, Barnett Newman, and Clyfford Still. Their paintings are quieter and emphasize the emotional force of color.

Action painting

In Action painting, the "act" of painting becomes the content of the work—so the image reflects the raw emotions held by the artist while creating it. Action painters poured, dripped, and spattered paint on to the canvas. Hans Hoffman was among the first to do this, but Pollock took the technique to its logical conclusion—he abandoned the restrictions of brushes and upright easels to create images that he described as "energy and motion made visible." These pictures, full of restlessness and flux, with no one part of the picture more important than another, were said to be "all-over" in style.

Rosenberg summed up Action painting: "What was to go on canvas was not a picture but an event." Pollock's work, in particular, looked forward to the performance art and happenings of the 1960s. Look at a Pollock and you have a record of his "performance."

Color Field painting

Where Action painting was bold and assertive, Color Field painting was contemplative and carefully constructed. The works consist of large expanses of color, often without strong contrasts of tone or obvious focal points.

Many Color Field paintings were intended to create transcendental feelings of awe and wonder. Newman said his art was "religious" and concerned with the "sublime." Rothko said his work was about "the basic human emotions—tragedy, ecstasy, doom." The huge size of many of these paintings does seem to overwhelm the viewer, inducing a feeling of isolation in a limitless world.

If Action painting was the result of a heightened state of consciousness on the part of the painter, Color Field painting was intended to create a heightened state of consciousness on the part of the viewer.

▲ **1955-D** *Clyfford Still was one of the leading Color Field painters of the 1950s. This large, single-color painting provokes a sense of awe in the viewer. 1955, acrylic on canvas, Kunsthalle, Hamburg, Germany*

Jackson **Pollock**

b CODY, 1912; d NEW YORK, 1956

Jackson Pollock, 1949

Jackson Pollock was a leading exponent of Action Painting and Abstract Expressionism. Fellow Abstract Expressionist Willem de Kooning said, "He broke the ice for the rest of us."

 Pollock began making his drip paintings in 1947. They established his reputation and completely revolutionized the way a painting was supposed to be made. Instead of using an easel, Pollock laid the canvas on the floor. Instead of using brushes, he poured the paint from a can and dripped it from sticks. He also revolutionized the idea of composition. Pollock moved over and sometimes through the canvas with free, dancelike gestures. This created an "all-over" style, where no part of a picture was more significant than any other. The composition had no focal points, and often the center was no more important than the edges. They were pictures, Pollock said, with "no beginning or end."

 The drip paintings earned Pollock notoriety as well as acclaim. Dubbed "Jack the Dripper" by *Time* magazine, he was the first American painter to become a star, and he lived up to the reputation, drinking hard and living recklessly.

LIFEline

1929–31 Studies at the Art Students League of New York under Thomas Hart Benton

1937 Begins treatment for alcoholism

1943 First solo exhibition at Peggy Guggenheim's Art of the Century gallery

1945 Marries the painter Lee Krasner and moves to East Hampton, Long Island, where he works in a barn

1947 Begins drip paintings

1949 Featured in an article in *Life* magazine that asks "Is he the greatest living painter in the United States?"

1951 Abruptly abandons drip style, returning to the use of figurative elements

1954 Stops painting entirely

▼ **Eyes in the Heat (Sounds in the Grass Series)** *This work, made a year after Pollock moved to Long Island, looks forward to his drip paintings. Instead of using a brush, he applies the pigment on to the canvas directly from the tube, pushing and smearing it with blunt instruments to create a thick, textured crust.* 1946, oil on canvas, 54 x 43in, Peggy Guggenheim Foundation, Venice, Italy

◄ **Number 14** *This is one of a series of black and white paintings Pollock embarked on after his drip phase. Figures reappeared in these paintings, but his technique remained unconventional. Working on the floor, he applied the paint with sticks and basting syringes, which his wife, Lee Krasner, said he wielded "like a giant fountain pen."* 1951, enamel paint on canvas, 58 x 106¼in, Tate, London, UK

► **Man with Hand Plow** *In the 1930s, Pollock painted the rural West where he grew up. The energetic rhythms in these paintings suggest the turbulence of the Great Depression. They also look forward to the energetic patterns of his drip paintings.* c1933, oil on canvas, 21¾ x 27¼in, Museum of Fine Arts, Houston, US

CLOSERlook

BRUSHWORK The road and field are registered with little detail. Instead, the emphasis is on the bold brushwork, and areas are almost abstract.

INcontext

PEGGY GUGGENHEIM The renowned art collector was one of the first champions of the Abstract Expressionists, in particular Pollock. In 1943, she gave Pollock a contract that enabled him to concentrate on painting. In the same year, she held his first one-man show at her Art of the Century gallery. His second show there in 1945 led critic Clement Greenberg to hail him the "strongest painter of his generation."

Peggy Guggenheim, *photographed by Frank Scherschel in 1953.*

▲ **Moon Woman** *In the early 1940s, Pollock was influenced by Surrealism and he made many paintings and drawings of American Indian mythic figures, especially the moon woman. Here, he paints living forms and primitive symbols. Other shapes emerge as a result of the free handling of the paint.* 1942, oil on canvas, 69 x 43in, Peggy Guggenheim Foundation, Venice, Italy

Autumn Rhythm (Number 30) *Jackson Pollock*
1950, enamel on canvas, 105 x 207in, Metropolitan Museum of Art, New York, USA ▶

Autumn Rhythm Jackson Pollock

Pollock had been painting in the drip style for three years before he made *Autumn Rhythm*. It represents the high point of his drip paintings; soon after he returned to more figurative work. The colossal scale and intricacy of the painting engulf the spectator, what Pollock called being "in the image." The gaze is carried along dramatic paths of paint that rise and fall and double back over the entire canvas. The viewer is also drawn into the painting – the black lines seem to come forward while the brown, white, and gray marks sit back. The restless, eddying energy suggests music or dance, and the vast size hints at heroic landscapes of the American West, where Pollock grew up.

◀ **POLLOCK AT WORK**
Pollock made his drip paintings in a barn at his East Hampton home. The size of the barn allowed him to paint from all four sides. He worked rapidly, stepping up to or on to the canvas again and again, swinging the paintstick with dance-like flourishes and flicks of hand, arm, and body.

Technique
Pollock was influenced by Surrealist automatism—abandoning conscious control of the picture, and instead allowing the unconscious to guide the hand. Pollock stated, "When I am in my painting, I'm not aware of what I am doing." So when painting *Autumn Rhythm*, Pollock did not have an image in mind. Instead he had an encounter with the canvas. The painting became a record of that encounter—part spontaneous, part considered. When asked if he painted from nature, Pollock replied, "I am nature."

▲ **LAYERING OF COLOR**
Pollock first applied black paint in complex linear swirls to his unprimed, unstretched canvas. This created a "skeleton" over which he added the other colors. Pollock used enamel house paint because traditional oil paints were not fluid enough.

▶ **MARK MAKING** The variety of marks creates whirling visual rhythms and sensations. Elegant, curving lines of dilute black paint contrast with the tick-like marks made with thicker brown and white paint. Colors collide, creating thick textural areas, and spattered paint ensures every area of the canvas is filled with activity. Some marks are the result of careful choreographed movement, others the result of chance; some suggest chaos, others order.

▶ **LIMITED PALETTE**
(Actual size) On top of the initial application of black, Pollock weaves an intricate web of white, brown, and turquoise-gray lines. The colors evoke the autumn of the painting's title and their energetic application suggests trees in an autumnal gale.

❝ The **modern painter** cannot express his age, the airplane, the atom bomb, the radio, in the old forms of the Renaissance or of any other past culture. Each age **finds its own technique** ❞
JACKSON POLLOCK, 1950

Arshile **Gorky**

Photograph by Gjon Mili

b **KHORKOM, ARMENIA, 1904**; d **CONNECTICUT, 1948**

Gorky played a key role in modern art, providing a link between European Surrealism and American Abstract Expressionism. Born Vosdanig Manoog Adoian, he changed his name after emigrating to the US—taking Arshile from the Greek hero Achilles and Gorky ("bitter one" in Russian) from left-wing author Maxim Gorky.

In the 1920s and 1930s, his painting was derivative of Cezanne, Kandinsky, and Picasso. By the 1940s, he had evolved a distinctive style. Under the influence of Surrealists Andre Breton and Roberto Matta, he began painting in a free, arbitrary manner, setting dream-like doodlings against a background of melting colors. The fertility of nature and human sexuality were major inspirations.

Gorky's painting became increasingly abstract with color becoming decorative not descriptive. He thinned paint so it dripped uncontrollably and thickened it to reveal gestural brushstrokes. This delight in paint for paint's sake looks forward to the Abstract Expressionism of the 1950s.

LIFEline

1916 Family flees Turkish invasion of Armenia

1920 Joins relatives in US

1926–31 Teaches at Grand Central Art School, New York

1946 Fire destroys his studio; he is diagnosed with cancer

1948 Breaks neck in car crash; later commits suicide

▼ **Diary of a Seducer** *Taking a cue from the title, it is possible to see the whole of this painting as a representation of the act of copulation. It has a rolling rhythm and, in the darkness, you can make out genitalia and the swelling forms of buttock and breasts.* 1945, oil on canvas, 50 x 62¼in, MoMA, New York, US

CLOSERlook

AMBIGUITY Is this shape an ear, an insect, or a water-borne organism? Gorky leaves all forms deliberately ambiguous, as they reflect his dreamlike imagination.

SEXUAL FORM At the heart of the picture, the eye is drawn to a form that resembles a labia. It is almost as if the viewer is implicated in the seduction of the title.

◀ **Virgina—Summer** *Gorky produced many graceful and fluid drawings of the Virginia landscape, which reflect a day-dreaming mind.* 1946, pencil and crayon on paper, 18⅞ x 24½in, Museum of Fine Arts, Houston, Texas, US

▶ **Water of the Flowery Mill** *This picture depicts the remains of an old mill and bridge on the Housatonic River, near Gorky's home in Sherman, Connecticut. And yet the real subject seems to be paint itself—thin brilliant washes of color overflow and overlap in a style that looks forward to fully fledged Abstract Expressionism.* 1944, oil on canvas, 42 x 49in, MoMA, New York, US

Adolph **Gottlieb**

b **NEW YORK, 1903**; d **NEW YORK, 1974**

Gottlieb adopted the term "pictograph" for paintings he created in the 1940s to suggest something between image-making and writing. Like Rothko and Newman, he was fascinated by myth and sought a kind of painting that was "timeless and tragic". The figurative elements were not related rationally. He wrote: "I take the things I know—hand, nose, arm—and use them in my paintings after separating them from their associations as anatomy". The later series, the exhilaratingly explosive 'Bursts' (1957–74) are closer to the popular image of Abstract Expressionist wildness.

▲ **Eyes of Oedipus** *This is from Gottlieb's* Pictograph *series.* 1945, oil on canvas, 35¾ x 27⅜in, Israel Museum, Jerusalem, Israel

Lee **Krasner**

b **BROOKLYN, NEW YORK, 1908**; d **NEW YORK CITY, 1984**

▲ **Gothic Landscape** *This is one of Krasner's paintings made in the aftermath of her husband's and her mother's deaths. The violent and expressive gestural brushstrokes can be seen as reflections of her grief.* 1961, oil on canvas, 70 x 94in, Tate, London, UK

Abstract Expressionist Lee Krasner was better known for being the wife of Jackson Pollock. In the 1930s, she worked for the Federal Art Project, and was rapidly promoted to supervisor in the mural division. However, it was under German painter Hans Hofmann that her painting flourished, and she began creating abstract still lifes and diagrammatic figure studies.

In the 1940s, Krasner socialized with the first generation of Abstract Expressionists in New York, marrying Pollock in 1945. Her Abstract Expressionism varied from "all-over" work—with repeating rhythms of hieroglyphic-type signs—in the late 1940s, to bold, gestural work in the late 1950s and 60s.

Willem **de Kooning**

Photograph by Tony Vaccaro

b **ROTTERDAM, 1904**; d **EAST HAMPTON, NEW YORK, 1997**

Along with Pollock and Rothko, de Kooning is the most celebrated Abstract Expressionist. His brushwork was bold and spontaneous and, by painting without using preliminary studies, he gave his pictures a thrilling physical immediacy.

Throughout his career, de Kooning was happy making abstract and figurative work. He is best known for a series of provocative paintings of women (*Women nos I–VI*) he made in the early 1950s. With their toothy snarls, pendulous breasts, and vacuous eyes—all rendered with slashing, impassioned brushstrokes and dripping paint—these women were crude, ferocious, and comical. This non-traditional way of depicting women shocked the public and some critics, while fellow Abstract Expressionists considered de Kooning's use of figurative representation to be regressive.

In the late 1950s, de Kooning painted a series of landscapes. These evolved from complex exercises in composition and color to images of broadly painted simplicity. By the 1960s, he was showing women in the landscape with flamboyant, liquid brushstrokes, revealing a painter at peace in his new Long Island home.

▶ **Painting** *De Kooning stated "even abstract shapes must have a likeness," and here the tense curves suggest the forms of breasts, torsos, and buttocks.* 1948, enamel and oil on canvas, 42½ x 56¼in, MoMA, New York, US

▼ **Woman I** *The first of a series of paintings of women,* Woman I *went through 2 years of transformations before it was finished. Throughout, de Kooning painted the woman vigorously, almost violently, reversing traditional female representations, which he summarized as "the idol, the Venus, the nude."* 1950–52, oil on canvas, 76 x 58in, MoMA, New York, US

LIFEline

1916 Apprenticed to a firm of commercial artists

1926 Enters US as a stowaway, settles in New Jersey

1935–37 Works on Federal Arts Project

1943 Marries artist Elaine Fried

1948 First one-man show in New York consists of black-and-white compositions

1950–51 Teaches at Yale School of Art

1968 Visits Netherlands for his retrospective at Stedelijk

1969 Begins sculpting

INcontext

HAROLD ROSENBERG Art critic Harold Rosenberg was highly influential in the success of Abstract Expressionism. He coined the term "Action Painting" in a 1952 article in Art News as a response to the work of Pollock and de Kooning. He celebrated Action Painting as a means of unleashing artists' instinctive creative forces, and as a dialog between painter, materials, and the canvas.

Harold Rosenberg *(1906–78) Renowned for his fiercely intellectual criticism of art, Rosenberg also used these skills to write about politics and society.*

War

The representation of war in art is judged by criteria that may not be those of the artist. The pacifist demands an adequate representation of war's horrors. The military demands meticulous accuracy in circumstantial detail of uniforms and equipment. The politician will demand that the balance of heroism and atrocity be weighted to the needs of propaganda. Despite all this, some artists have risen to the challenge of representing the effects and experiences of war in various ways—through symbols (like Rubens or Goya), by concentration on the plight of the individual (Géricault) or by implication through the impact on the land (Paul Nash). Besides any political or ethical issues, the presentation of large numbers of figures in action presents the artist with a formidable technical challenge.

◀ **The Burning of "The Royal James" at the Battle of Sole Bank, 28 May 1672** Willem van de Velde, the Younger *The artist's practiced depiction of maritime scenes led to him painting sea battles from an English perspective for Charles II, king of England.* 17th century, oil on canvas, 41¾x60in, private collection

▼ **The Consequences of War** Peter Paul Rubens *Rubens contrasts the sumptuousness of his execution with the tragedy of his subject matter.* 1637–38, oil on canvas, 81 x 135in, Palazzo Pitti, Florence, Italy

▼ **Relief Depicting Two Soldiers Carrying the King's War Chariot** Assyrian *One of many military scenes from the Palace of Sargon II, Khorsabad, Iraq.* 8th century BCE, gypsum, height 50in, Louvre, Paris

▼ **The Alexander Mosaic** Roman *This mosaic depicts Darius III at the Battle of Issus (333 BCE), where he fought against Alexander the Great. It is composed of over a million tesserae—small, colored tiles.* 1st century BCE, mosaic, 135 x 208in, Museo Archeologico Nazionale, Naples, Italy

▲ **Night Attack on the Sanjo Palace** Japanese School *This scroll illustrates the Heiji Disturbance, a conflict between two Japanese warrior clans in 1159.* 13th century, ink and color on paper, 16⅛x 264in, Museum of Fine Arts, Boston, US

▶ **The Siege of Jerusalem by Nebuchadnezzar** Jean Fouquet *Fouquet was one of the most prominent painters of the 15th century, and this colorful biblical scene is typical of his illuminated manuscripts.* Bibliotheque Nationale, Paris, France

▲ **The Arrival of the Allied Army at Itapiru, Paraguay** Candido Lopez *Lopez was a soldier, and war is a recurring subject of his work. The panoramic nature of this painting demonstrates the magnitude of this conflict between the triple alliance of Brazil, Argentina, and Uruguay against Paraguay (1864–1870).* 1866, oil on canvas, Museo Historico Nacional, Buenos Aires, Argentina

◀ **The Wounded Cuirassier** Theodore Géricault *The ominous clouds in the background add to the emotional intensity of the scene. This painting is a fine example of Gericault's work, and of the Romantic sensibility. The anonymous character is thought to represent the defeat of Napoleon's army.* 1814, oil on canvas, 141 x 116in, Louvre, Paris, France

The Carnivorous Vulture, Plate 76 of "The Disasters of War" Francisco de Goya *Goya's dark series of etchings, inspired by the Spanish War of Independence, is a disturbing insight into the horrors of war.* 1810–14, etching, 7⅛x8¾in, private collection

Balaclava Lady Elizabeth Butler *This realistic presentation of the effects of war on its participants was controversial when first exhibited, not least because it was painted by a woman.* 1876 oil on canvas, 23¼x30in, Manchester Art Gallery, UK

We Are Making a New World Paul Nash, *The blithe optimism of the title sits in bitter contrast to the barren landscape, ravaged by the efffects of war. Nash's depictions of conflict were influenced by Vorticism.* 1918, oil on canvas, 28x35¾in, Imperial War Museum, London, UK

The Battle of Midway Ian Hamilton Finlay *The artist created this tableau with the help of James Stoddart and James Boyd as a memorial to those lost in what became the most influential battle for supremacy in the Pacific during World War II.* 1977, mixed media, Chateau d'Oiron, Loire Valley, France.

Barricade in the Rue de la Mortellerie , June 1848 (Memory of Civil War) Ernest Meissonier *The realistic observation of this scene —from the detailed cobblestones to the limp, lifeless bodies—is notable for its emotional detachment.* 1849, oil on canvas, 11⅜x8¾in, Louvre, Paris, France

The Defense of Sevastopol Aleksandr Alexander Deineka *Deineka gained the approval of the Soviet political establishment with his idealized representations of Russian soldiers in World War II.* 1942, oil on canvas, 79x157½in, State Russian Museum, St. Petersburg, Russia

Blue Baby, Blitz Over Britain Edward Burra *Even in his representation of the destruction of war, Burra retains a macabre sense of humor that is characteristic of his work.* 1941, watercolor on paper, 27¼x40¼in, private collection

Mark **Rothko**

b **DVINSK, 1903**; d **NEW YORK, 1970**

Portrait by
Ben Martin

The Russian-born painter Mark Rothko was a leading Abstract Expressionist whose emotionally resonant use of color led him to be categorized as a Color Field painter (an abstract style characterized by its use of large expanses of solid color). In the 1930s, Rothko painted in an Expressionist manner, but in the early 1940s, like many of his fellow Abstract Expressionists, he adopted a Surrealist style, drawing upon the myths of antiquity and using calligraphic, biomorphic imagery. He began to develop the distinctive style for which he is best known—featuring large blocks of color—in the late 1940s. By the end of the 1950s, his work had earned him international acclaim. Despite this, he became increasingly depressed, and eventually took his own life in 1970.

LIFEline

1913 When he is 10, Rothko's family emigrate from Russia to the US

1921–23 Studies liberal arts at Yale University

1925 Moves to New York, and studies at the Art Students League under Max Weber

1933 First one-man exhibition, at the Portland Art Museum

1948–49 Helps run The Subjects of the Artist art school with Baziotes, Hare, Motherwell, and later Newman

1951–54 Teaches in the art department at Brooklyn College, New York

1961 Retrospective of his work at the MoMA, New York

▼ **Slow Swirl at the Edge of the Sea.** *This image, from Rothko's Surrealist period, shows two sinuous creatures that seem to float between sea and sky, surrounded by arabesques, spirals, and stripes that can be read as musical notation.* 1944, oil on canvas, 75¼ x 84½in, MoMA, New York, US

▶ **Untitled** *To create his famous Abstract Expressionist images, Rothko worked on untreated, unprimed canvases. He applied repeated thin layers of pigmentation with light, fast brushstrokes, so that underlying layers showed through. The result was a painting of great transparency and luminosity.* 1955, acrylic and mixed media on canvas, 54¼ x 27½in, Israel Museum, Jerusalem, Israel

CLOSERlook

SOFT EDGES Rothko generally painted his rectangles with soft, uneven edges. As a result, they seem to be gently hovering or floating over the canvas—even when the rectangle is of a cool, recessive color, as the blue is here.

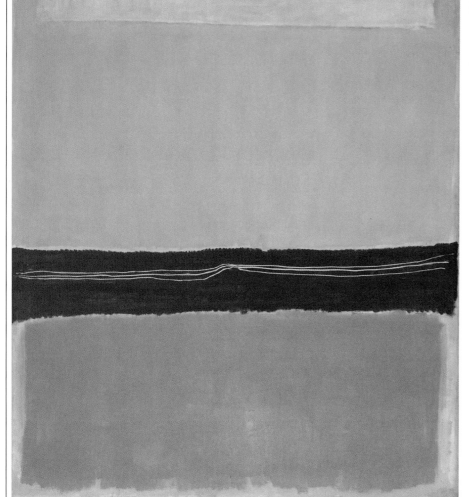

◀ **No. 5/No. 22** *In this early example of his abstract painting, Rothko uses hot, intense colors that give an air of exuberance and vitality. In the early 1950s, his palette often contained vibrant reds, oranges, and yellows.* 1950, oil on canvas, 117 x 107in, MoMA, New York, US

▶ **Untitled** *This dark, somber work is typical of the paintings Rothko produced in the last two years of his life. Lonely, suspicious, and separated from his second wife, he drank, smoked, and took prescribed drugs to excess. His paintings became gloomier and more mysterious, and used browns, grays, and dark blues, or reds and black.* 1969–70, synthetic polymer paint on canvas, 78 x 66in, MoMA, New York, US

Barnett **Newman**

b **NEW YORK, 1905;** d **NEW YORK, 1970**

After Rothko, Barnett Newman was the preeminent Color Field painter (see p.502). He became famous for his "zip" paintings, in which he used thin stripes of color against a plain background. He saw the zip as a way of expressing the sublime, and recognized that it was capable of endless explorations. Indeed, he continued to paint zips for two decades—changing their color, width, and the way the paint was applied, so that each painting had a unique personality.

Unlike his fellow Abstract Expressionists—Pollock, Rothko, and de Kooning—Newman was largely ignored by the art world in the 1950s. His reputation was only cemented in 1960s, when Minimalists such as Don Judd admired the way in which he derived his composition from the shape of the canvas. In turn, Newman's late work was influenced by Minimalism, with his zips becoming crisper and less expressive and in the 1960s he started making equally simplified steel sculptures.

LIFEline

1905 Born in New York, the son of Russian Jewish immigrants

1948 Paints first of his "zip" paintings

1950 First one-man exhibition, at the Betty Parsons Gallery, New York

1958–62 Paints in black and white

1965 Begins making steel sculptures

1970 Dies, aged 65

▼ **Uriel** *Named after the archangel of light, this is the last and largest of a group of pale turquoise paintings. While the vast turquoise expanse seems to enfold the viewer, the dark tones provide a kind of visual anchor.* 1955, oil on canvas, 96 x 216in Kunsthalle, Hamburg, Germany

▲ **Onement 1** *This painting was Newman's artistic breakthrough—the first time he used his signature mark, the zip. Newman applied the light cadmium red zip on a strip of masking tape, creating a thick, irregular band on the smooth field of Indian Red.* 1948, oil on canvas and oil on masking tape, 27¼ x 16in, MoMA, New York, US

▲ **Adam** *From the mid-1940s, Newman was preoccupied with the Jewish myths of Creation, and his zips may relate to artistic traditions that present God as a single beam of light. The name Adam derives from the Hebrew word* adamah, *meaning "earth," and the relationship between the brown and red here may symbolize man's intimacy with the earth.* 1951–52, oil on canvas, 95¾ x 80in, Tate, London, UK

Clyfford **Still**

b **GRANDIN, NORTH DAKOTA, 1904;** d **BALTIMORE, 1980**

A pioneering Abstract Expressionist, in the mid-1940s Clyfford Still became one of the first artists of the New York School to paint on a large, "heroic" scale, and one of the first to ignore representational subject matter. Still's work married the two strands of Abstract Expressionism. Like the Color Field painters, he was concerned with the emotive power of color. Like the Action Painters, he was interested in the expressive possibilities of brushwork, typically using a heavily loaded brush to create jagged, impasto forms.

In the early 1950s, Still severed ties with commercial galleries and worked in increasing isolation. His uneasy relationship with the art world, and his reluctance to exhibit, meant that he did not receive the acclaim given to his contemporaries.

◀ **Untitled** *Here, Still's jagged flashes of color give the impression that a layer of color has been torn off the painting. The palette and the emptiness of this painting is evocative of the bleak and vacant landscapes of his native North Dakota.* 1953, oil on canvas, 109 x 92in, Kunsthalle Hamburg, Germany

Hans **Hofmann**

b **WEISSENBURG, BAVARIA, 1880;** d **NEW YORK, 1966**

◀ **The Veil in the Mirror** *This painting, juxtaposing strongly colored rectangles, is characteristic of Hofmann's Abstract Expressionist style. There is feeling of depth, as the hot colors—especially the pink rectangle in the top right corner and the yellow in the bottom right corner—appear to loom forward. Hofmann termed this the "push and pull" effect.* 1952, MoMA, New York, US

Hans Hofmann was an influential Abstract Expressionist artist, and an important, highly respected teacher. Trained in Munich and Paris, Hofman emigrated to America in 1930, and ran an art school in New York from 1934 to 1958. There, he taught many of the younger Abstract Expressionists, including Lee Krasner and Helen Frankenthaler. The degree of contact he had with European artists was rare and much valued among the New York School.

Hofmann developed a highly distinctive form of abstraction, based on patches of vivid color. The dense surfaces, which were often vigorously and impulsively painted, linked his work to the Action Painters, yet his painting was closer to the Color Field painters. He sought to create a tension between the flatness of an abstract painting and the illusion of depth in a representational painting. The result, he declared, was a pictorial space that was "alive, dynamic, fluctuating, and ambiguously dominated by forces and counter-forces."

David **Smith**

b **DECATUR, INDIANA, 1906;** d **NEAR BENNINGTON, VERMONT, 1965**

Photograph by Arnold Newman

David Smith is regarded as America's greatest post-war sculptor. The son of an engineer, he sculpted by welding iron and steel—marrying these modern American industrial materials with the aesthetic developments of the leading European avant-garde artists.

Smith trained as a painter but turned to sculpture in the 1930s after seeing Picasso's and Julio Gonzalez's welded metal pieces. In 1940, he found the perfect place to work at Bolton Landing in the Adirondack Mountains, upstate New York. He developed a deep affinity with the place, spending hours arranging and photographing his sculpture in the fields around his studio. Smith evoked the landscape through his sculptural method of "drawing in space." From the late 1950s, his sculpture became increasingly monumental. He joined cubes and cylinders together at dynamic angles so they reached out into space. Intended for the outdoors, they were enhanced by the effect of the light on their polished or painted surfaces.

LIFEline

1925 Works as a welder and riveter at the Studebaker automobile plant in South Bend, Indiana.
1926 Moves to New York, studies painting at Art Students League
1942–44 Works during World War II as welder of tanks and locomotives in a defense plant
1948 Teaches in New York, Veromont, and other schools
1950 Awarded a Guggenheim Foundation fellowship, which freed him from having to teach
1965 Dies in car crash, aged 59

▲ **Hudson River Landscape**
This piece is created from a series of drawings made on train journeys beside the Hudson River. Smith used the tensile strength of steel and his welding skills to create a beautiful, weightless, "drawing in space." 1951, welded painted steel and stainless steel, 49½ x 73½ x 16½in, Whitney Museum, New York, US

▲ **Zig IV** Zig *was Smith's abbreviation of ziggurat, the terraced pyramid-like temples of ancient Babylon. The complex, shifting planes of the sculptures are also reminiscent of early Cubism. Smith painted this piece with automobile enamel and mounted it on wheels so it became independent of a plinth or base.* 1961, painted steel, private collection

▲ **Agricola VIII** *"Agricola" is Latin for farmer and Smith made a series of sculptures from welding together agricultural implements, many of which he found near his home. Like many Modernist artists, Smith saw beautiful forms in functional objects.* 1952, bronze and steel, painted brown, private collection

66 What associations it [steel] possesses **are those of this century**: power, structure, movement, progress, **suspension, destruction, brutality** 99
DAVID SMITH, 1952

Philip **Guston**

b **MONTREAL, CANADA, 1913;**
d **WOODSTOCK, NEW YORK, 1980**

Guston had an extraordinarily varied career. In the 1930s, he was a socially and politically committed artist. He made drawings that satirized the Ku Klux Klan and from 1934 to 1942 worked as a mural painter (largely for the Federal Art Project) in Los Angeles and New York. In the 1950s, however, painterly concerns displaced political ones. He turned to Abstract Expressionism, creating paintings of shimmering and luminous color. By the 1970s, however, he was again addressing social issues, becoming one of the few Abstract Expressionists to return to figurative painting.

▼ **Legend** *Superficially, Guston's paintings look like Pop art. However, they are not a celebration of modern society; instead they show violence, alienation, and emptiness. With the broken glass and truncheon, this looks like the scene of a fight.* 1977, oil on canvas, 69 x 78¾in, Museum of Fine Arts, Houston, Texas, US

Ad **Reinhardt**

b **BUFFALO, 1913;** d **NEW YORK, 1967**

Reinhardt was a pioneering abstract painter. As a member of the American Abstract Artists (1937–47), he painted crisp, geometrical images. He adopted an Abstract Expressionist style in the late 1940s. It was for his one-color paintings, however, that he became famous. He worked in blue and red in the early 1950s, then in black from the mid-1950s. The paintings were purged of subject matter and painterly expression. He declared, "I am simply making the last paintings that can ever be made." In fact, they inspired a new generation of painters—the Minimalists (see p.529).

▲ **Abstract Painting** *At first glance, this is simply a black painting. In fact, the picture is made up of squares that have extraordinarily subtle changes of hue and texture. These subtleties are lost in reproduction—as Reinhardt knew they would be.* 1956, oil on canvas, 80 x 70⅛in, private collection

Paul-Emile **Borduas**

b **SAINT-HILAIRE QUEBEC, 1905;** d **PARIS, 1960**

Borduas was the most influential Canadian abstract painter. In the early 1940s, influenced by the writings of Surrealist André Breton, he formed a group called the Automatistes, who published their manifesto *Refus Global* in 1948. It attacked Quebec's conservative art world and the Catholic church and led to Borduas losing his job as a teacher and emigrating to the US. His two years in New York were productive. One of the first paintings he made there was called *Les Signes S'envolent* (The Signs Disappear), which summed up his new style. He eliminated objects and used knives to apply paint. Borduas spent his last years in Paris where he concentrated on geometric composition.

LIFEline
1923 Enrols in School of Fine Arts, Montreal
1928 Moves to Paris
1930 Returns to Canada, as church decorator
1937 Appointed professor of drawing and decoration at the École du Meuble, Montreal
1946 Borduas's Automatistes group holds exhibitions in a series of makeshift galleries
1953 Emigrates to US, lives in Provincetown then New York
1955 Moves to Paris
1960 Dies in Paris of a heart attack

▶ **Painting** *This picture is typical of Borduas's "allover" style: no part of the picture is more important than another. He painted it in Paris where he increasingly began to use white.* 1956, acrylic on canvas, 5⅛ x 6¾in, private collection

CLOSERlook

USE OF A KNIFE Borduas applied paint with a knife and then dragged it across the canvas creating lively, blade-like marks. Colors combine in unexpected ways and exciting textures emerge.

Jean-Paul **Riopelle**

b **MONTREAL, QUEBEC, 1923;**
d **ILE-AUX-GRUES, QUEBEC, 2002**

Riopelle was a leading postwar Canadian abstract artist. In 1943 he enrolled at the Ecole du Meuble in Montreal, where he formed a close association with his instructor Borduas, and with other Canadian avant-garde artists who had formed the Automatistes group. Riopelle settled in Paris in 1947, and became involved in the Lyrical Abstraction group.

During the 1960s, Riopelle worked in a variety of media including ink on paper, watercolors, lithography, and collage, as well as oils. He wanted materials to free him, to dictate the art he would make. In 1969, he also started making sculpture.

▲ **The Hour of the Mad Spirit** *In the 1950s, Riopelle made many paintings like this—they have been called his "grand mosaics." He used a spatula to create an image that resembles an aerial view of a landscape.* 1956, oil on canvas, 18⅛ x 21¾in, private collection

Franz **Kline**

b **WILKES-BARRE, PENNSYLVANIA, 1910;**
d **NEW YORK, 1962**

Until the end of the 1940s, Kline was a representational painter, most notably of urban landscapes. In 1950, however, having seen some of his drawings enlarged by a projector, he began to make vigorous, large-scale calligraphic abstract paintings in black and white. His first one-man exhibition at the Egan Gallery, New York, in 1950 quickly led to his recognition as one of the leading Abstract Expressionists. From 1958, he occasionally introduced strong colors into his works.

▼ **Meryon** *These bold marks are characteristic of Kline's work with a strong architectural sense. This work relates to an engraving of a clock tower by French artist Charles Meryon.* 1960–61, oil on canvas, 93 x 77¼in, Tate, London, UK

Cy **Twombly**

b **LEXINGTON, VIRGINIA, 1928**

Twombly is a painter, draftsman, and printmaker. He grew up as part of the Abstract Expressionist scene; in the early 1950s, he studied at Black Mountain College under Motherwell and Kline, and traveled to Europe and North Africa with Rauschenberg. Twombly, however, developed an idiosyncratic style, based on scribbled and graffiti-like marks, worked in chalk and pencil as well as paint. He is inspired by classical art and mythology and in 1957 settled in Rome. Many of his paintings have the look of ancient walls and tablets, often with numbers and words appearing in spiky, hesitant hand.

▼ **Achilles Mourning the Death of Patroclus** *The vigor of the mark-making here verges on a scrawl. It shows the influence of Action Painting—the act of painting becomes the subject of the image. Here, the turbulence of the marks with their deep color suggests grief, explaining the mourning in the title.* 1962, oil and graphite on canvas, 102 x 119in, Pompidou Center, Paris, France

Robert **Motherwell**

b **ABERDEEN, WASHINGTON, 1915;**
d **PROVINCETOWN, MASSACHUSETTS, 1991**

Motherwell was one of the youngest Abstract Expressionists. While the others painted in a realist style in the 1930s, he was studying philosophy. He started to paint full-time after moving to Greenwich Village in 1941, and by 1944 he was exhibiting at Peggy Guggenheim's Art of This Century gallery. He is most famous for his *Elegies to the Spanish Republic* series, started in 1949. Executed with rapid brushstrokes, they integrate accidental effects, such as spattered paint. In addition to oils, Motherwell also worked in collage and was the only one of the original Abstract Expressionists to embrace printmaking.

▲ **Iberia No. II** *Motherwell saw this image as a bullfight—the ocher paint representing the sand of the bullring and the black symbolizing the bulls.* 1958, oil on canvas, 47¼ x 80in, Tate, London, UK

After the exhilaration of victory there was a long period of uncertainty. The atrocities of the war created an existential crisis in France and artists across the continent struggled with the same issues. Art represented political freedom and contemporary work became a matter of national prestige. Success in exhibitions such as the Venice Biennale was sought by governments as well as by artists.

Influences

The Surrealist movement (see p.470) attracted fewer followers, but had the greatest influence of all the prewar art movements. Many leading figures of the post-war period, notably Alberto Giacometti and Jean Dubuffet, had been linked to Surrealism in their youth, and automatism was central to the abstractions of artists such as Wols.

▲ **Libération Marianne** Paul Colin *Post-war art mirrored the preoccupations of the times. In this 1944 print, Marianne, the symbol of the French Republic, is pushing back the past and looking toward the future.*

Style and subject

The idea of the transformation of the body—as in the forms of Germaine Richier—was of continued significance. The work of sculptors such as Henry Moore was thought to mirror the fears of the time, especially the threat of nuclear war. The critic Herbert Read referred to it as the "geometry of fear."

World War II decimated much of Europe, leaving it politically divided and economically devastated. In western Europe post-war art reflected the social unease of the period, and political factors were central to its development.

Post-war Europe

TIMEline

The immediate angst of the post-war years, as expressed by Wols's ambiguous image of 1946, Bernard Buffet's bleakly realistic scene of 1948, and Kenneth Armitage's faceless walking statue of 1952, gradually gave way to a less intense, more colorful approach, as expressed by Yves Klein in 1961. The subdued colors and limited palette of the earlier period were replaced by a more expressive use of color and more direct imagery.

1946

WOLS The Blue Grenade

1948

BUFFET The Net

1952

ARMITAGE Friends Walking

1961

KLEIN Imprint

Interpretations

The artistic climate of post-war Europe was one of rigor, with artists engaging with the political and philosophical issues of the time. The art scene started up again in Paris in autumn 1944 with a retrospective of Picasso's work at the Salon de la Libération, but the break with the past was evident in an exhibition the following year by Jean Dubuffet, Jean Fautrier, and Wols. Attacking the traditional values of art, Dubuffet and others developed Art Brut (Raw Art), a rough form of art that drew on the work of those considered marginal to society.

Abstract versus figurative

The choice between abstract or figurative work took on a different flavor in the post-war climate. Figurative painting was often associated with the political left, partly because it claimed to address social issues and partly because modernist art was still discouraged in the eastern European Communist countries. In France, Italy, and Britain there was still a strong current of realist art, which was interpreted by some as politically motivated.

Abstract art abandoned the geometric purity of work from the interwar years.

Painters such as Antoni Tapies and Jean Fautrier explored texture, while artists such as Nicolas de Stäel made works halfway between abstraction and landscape. In Britain, Henry Moore's abstract sculptures inspired younger sculptors, such as Kenneth Armitage and Reg Butler, to break away from realistic representations of form. Modern sculpture was now used in public spaces. The 1951 Festival of Britain, a vast open-air exhibition in London, which celebrated the end of the war and promised a better future, was distinguished by large-scale sculptures that would have only been seen in avant-garde work previously.

Existentialism

The existentialist philosophy, popularized by the French writers, Albert Camus and Jean-Paul Sartre, influenced artists all over Europe. It promoted freedom, stating that humans had to be responsible for their own values in an absurd world. The isolated figures in Bernard Buffet's paintings did not just represent the hard living conditions of the post-war years, but stood for the loneliness of the human condition. Sartre thought Alberto Giacometti an existentialist hero, grappling with the uncertainty of how to make an honest image of another person.

▲ **Man Pointing** Alberto Giacometti *Giacometti's elongated, almost featureless sculptures, whether single or in groups, are existential masterpieces, summing up the despair of modern existence and forming an anguished response to loneliness and death. 1947, bronze, 70 x 37½ x 20½in, Tate Liverpool, UK*

▲ **Batons Rompus** Nicholas de Stäel *Immediately after the war, de Stäel expressed his feelings with abstract compositions and a dark palette, peppered with patches of bright light, as shown in this composition. He later lightened his palette and returned to more figurative work. 1947, oil on canvas, 32 x 25½in, private collection*

Jean **Fautrier**

b PARIS, 1898; d CHÂTENAY-MALABRY, NEAR PARIS 1964

Described as a pioneer of *Art Informel* (a movement consisting of related types of Abstract painting), Fautrier resisted the label, as he did all others, and insisted his work was based in reality. That reality was often harsh: his studio at Châtenay-Malabry was near a wood where, during World War II, the Nazis executed prisoners each night. Their screams haunted Fautrier, who conveyed his feelings of helplessness and terror in his *Otages* (Hostages) series of paintings and sculptures. After the war, Fautrier developed *haute pâte* (high paste), a multi-layered, almost sculptural painting technique. The works show a restrained and subtle of eroticism, shot through with pain and tragedy.

▼ **Symmetries** *The thick surface of Fautrier's post-war paintings is achieved by applying layers of paint and pigment to the canvas. He then scored these to break up the surface. 1957, oil and pigment, 20⅞ x 28in, private collection*

▲ **The Jewess** *The French critic André Malraux described the* Otages *(Hostages) series, of which this is a part, as a "hieroglyph of pain". This painting pays homage to a murdered Jew, its pinkish hue suggesting her beauty. 1943, oil on canvas, 45¾ x 287¼in, Pompidou Center, Paris, France*

Jean **Dubuffet**

b LE HAVRE, 1901; d PARIS, 1985

Jean Dubuffet was not only fascinated by the work of children and amateur painters, but that of psychotics and others considered marginal by society. He called their work *Art Brut* (rough or raw art), and used aspects of it in his own, considerably more sophisticated paintings. For Dubuffet, "real art is always lurking where you don't expect it, where nobody's thinking about it, or mentions its name."

Dubuffet incorporated informal and ephemeral elements into his work, including grass, dirt, writing, and graffiti. He composed in a naïve way, with a childlike, often crude simplicity. This approach appeared to be a radical and subversive challenge to mainstream culture and to the production of art itself, emphasizing, as it did, spontaneity while refusing to comply with accepted techniques and principles.

◄ **Le Voyageur sans Boussole** *Translated as* Traveler without a Compass, *this is one of a series that the artist called "landscapes of the brain." Typical of Dubuffet is the sense there is little distinction to be made between the human figure and base materials. 46½ x 61in, oil on hardboard, Pompidou Center, Paris, France*

▲ **Jazz Band (Dirty Style Blues)** *The elongated forms, simplistic technique, lack of perspective, and limited, muddy palette are all in keeping with Dubuffet's work. This sextet of jazz musicians is presented face on, as they might appear to a child. 1944, oil on canvas, 38¼ x 51¼in, private collection*

► **Le Métafisyx** *This deliberately crude painting of a woman, one the* Corps de Dames *series, is influenced by the graffiti Dubuffet saw on walls around Paris. The representation is basic and scatological, and suggests scribbles on a lavatory wall, with the harsh lines scratched roughly into the thick paint. 1950, oil on canvas, 45¾ x 35in, Pompidou Center, Paris, France*

CLOSERlook

FACIAL FEATURES
The staring eyes, bared teeth, and pointed nose set in a skull-like face are not meant to be realistic. Instead they reduce her to a set of basic attributes.

Nicolas **de Staël**

b **ST. PETERSBURG, 1914;** d **ANTIBES 1955**

Exiled from his native Russia as a child following the revolution, Nicolas de Staël traveled widely before finally settling in France in 1938. His work was initially representational, but by the 1940s it was increasingly abstract and violently expressive in its dynamic approach, reflecting the dramas of everyday life and death. Dense, somber areas of paint were pierced with sharp edges of light to create a surface of strong contrasts. De Staël was trying to transfer his own experiences into paint, using a non-figurative structure based on Cubism.

From 1948 onward, de Staël's palette lightened considerably and soon became brilliant in its use of reds and yellows. Four years later, he reintroduced figures, although their presence in his essentially abstract world provided some serious challenges for him. By now, de Staël was enjoying considerable success, exhibiting in London, Paris, and New York, but he remained a troubled man and eventually took his own life.

LIFEline

1914 Born into an aristocratic Russian family
1919 Family exiled and moves to Brussels
1933 Studies at the Belgian Royal Academy
1938 Settles in Paris
1939–40 Serves in the French Foreign Legion
1944 Holds his first solo exhibition, in Paris. Becomes friendly with Georges Braque
1952 His exhibition in London is enthusiastically received
1955 Kills himself in Antibes

▶ **Abstract Composition** *Painted just as he was lightening his palette, this is typical of de Staël's abstract work. Dark areas of paint are set against contrasting lighter patches, while the entire painting is built up with strong textures.* 1949, oil on canvas, 63¾ x 56¾ in, Pompidou Center, Paris, France

CLOSER**look**

HEAVY APPLICATION
For most of his career, de Staël applied paint to his canvases in thick layers, using the palette knife or trowel more than the brush.

▲ **Les Indes Galantes** *De Staël was a music-lover and was frequently inspired by it. This work was the result of a visit to a ballet set to music by the 18th-century composer Jean-Philippe Rameau.* 1953, oil on canvas, 61 x 46½ in, private collection

◀ **Les Toits** *De Staël's later pictures are more representational. The broad patches of paint in this painting of roofs are delineated by contrasting frames and the wash of color indicating a Parisian skyline.* 1952, oil on canvas, 78¾ x 59⅛ in, Pompidou Center, Paris, France

Alberto **Giacometti**

b **BORGONOVA, 1901;** d **CHUR, 1966**

Swiss artist Alberto Giacometti is best known for his sculptures of thin, elongated human figures. However, his first sculptures were flat, almost two-dimensional, and showed his interest in primitive art. By 1930 he had become a Surrealist, attempting to evoke fantastic images from his unconscious. From the mid-1930s, he went back to working from models, representing the exterior rather than interior world. Finding it difficult to translate reality into sculpture, he increasingly worked from memory, with his figurines becoming smaller and smaller. He spent World War II in Switzerland, but returned to Paris in 1945 and renewed friendships with Picasso, author Simone de Beauvoir, and philosopher Jean-Paul Sartre. His work epitomized the existentialism of post-war Paris, his elongated figures an anguished response to solitude and death.

Photograph by Pierre Vauthey

LIFEline

1901 Born, the son of painter Giovanni Giacometti
1922 Moves to France in his early twenties
1941–44 Stays in Geneva, Switzerland, for three years, before returning to Paris
1962 Wins main sculpture prize at the Venice Biennale

▶ **The Table** *Giacometti's interest in Surrealism is evident in this bronze sculpture. Its disembodied figure, severed hand, and elongated furniture are all typical of Surrealist art.* 1933, bronze, height 56¼ in, Pompidou Center, Paris, France

▲ **Caroline** *This is typical of Giacometti's portraits—the elongated figure sitting face on, her face partly hidden and with a haunted expression, the background only roughly filled in.* 1962, oil on canvas, 39⅜ x 32 in, Kunstmuseum Basel, Switzerland

Bernard **Buffet**

b **PARIS, 1928;** d **TOURTOUR 1999**

Bernard Buffet spent World War II in great poverty in occupied Paris. In 1948, he held his first solo exhibition there, and in the same year he also exhibited with other young Realists.

The preface to the catalog of the show, written by French art critic Jean Bouret, states that, "painting exists to bear witness, and nothing that is human can be foreign to it." Buffet's work uses traditional imagery to show the horrors of the period. His portraits are bleak and unforgiving in their despair.

▼ **The Net** Buffet turns this picture of a person mending a fishing net into an image of tension and suppressed violence. The verticals and horizontals are elongated to dramatic effect. 1948, oil on canvas, 78¾ x 121¼in, Musée d'Art Moderne de la Ville de Paris, France

Hans **Hartung**

b **LEIPZIG, 1904;** d **ANTIBES, 1989**

Born into a musical and medical German family, Hans Hartung studied at Dresden Academy before moving to France in 1926. His work in oil painting, watercolor, and sculpture is almost entirely abstract and dynamic, although in later years it became more static and meditative.

▼ **T–54–16** The T of the title stands for toile (canvas), while the numbers indicate that this is the 16th canvas Hartung produced in 1954. Its strong lines are set against a more harmonious background. 1954, oil on canvas, 56 x 73¼in, Pompidou Center, Paris, France

Germaine **Richier**

b **GRANS, 1904;** d **MONTPELLIER, 1959**

Professionally trained by a one-time assistant of Rodin, Germaine Richier initially produced classical sculptures. After World War II, her work portrayed disturbing people and creatures, often showing the violence of nature she had observed as a child in Provence. Her *Christ*, commissioned for Le Corbusier's church at Assy in 1950, depicted him as a tortured, suffering figure, and created such a scandal that the Church authorities removed it.

▶ **Tauromachie** This depiction of a bullfight is typical of Richier's vision of decay, perhaps especially disquieting for observers of the period in being the work of a female artist. 1953, bronze, 45¼ x 39 x 21¾in, Musées Royaux des Beaux-Arts, Brussels, Belgium

Antoni **Tàpies**

b **BARCELONA, 1923**

The best-known Spanish artist of his generation, Antoni Tàpies initially studied law for three years before devoting himself to art in 1943. He helped to co-found the *Dau al Set* (Seven-sided Die) movement in 1948, which had affinities with both Surrealism and Dada. His early works were influenced by Joan Miró and Paul Klee, but in the 1950s he began the abstract and semi-abstract paintings for which he is known. Their rich, scarred surfaces evoke walls and doorways marked by weathering and graffiti. He made "object-sculptures", which are related to Art Povera of the late 1960s (Italian for "Poor Art", which used cheap, accessible materials). Tàpies's work became a symbol for Catalan nationalism, repressed by the reactionary Franco regime in Spain, and inspired a generation of Spanish abstract painters.

LIFEline

1949 Holds his first exhibition, in Barcelona

1958 Receives painting prize at Venice Biennale

1966 Arrested and fined for his political, anti-Franco activities

1970 Complements painting with work on "object-sculptures" using everyday items

1990 The Fundació Antoni Tàpies, a center dedicated to the study of modern and contemporary art, opens in Barcelona

◀ **Le Chapeau Renversé** A wide variety of mixed media, including oil, glue, and marble dust, have been used in this painting of an upside-down hat. 1967, mixed media on canvas, 39 x 63¾in, Pompidou Center, Paris, France

(Alfred Otto Wolfgang Schulze) **Wols**

b **BERLIN, 1913;** d **CHAMPIGNY-SUR-MARNE, 1951**

The son of an authoritarian chancellor of the German state of Saxony, Wols studied briefly at the Bauhaus School of Art and Design before spending a year in Paris in 1932, where he worked as a photographer. The following year, he emigrated to Spain, but he returned to France, where he was interned as an enemy alien at the beginning of World War II. While in various prisoner-of-war camps, Wols drew strange, claustrophobic watercolors. His post-war oil paintings symbolize explosion and disintegration and are disturbingly ambivalent in their references to both inner and outer worlds. However, their sensitive use of brilliant color, and the violent working of the paint, make Wols one of the greatest *Art Informel* (abstract) painters.

◀ **The Blue Grenade** The violence of this painting and its unsettling effect are typical of Wols's post-war work. 1946, oil on canvas, 18⅛ x 13in, Pompidou Center, Paris, France

Yves **Klein**

b **NICE, 1928;** d **PARIS, 1962**

Yves Klein first began to paint while he was a student in the 1940s. He traveled widely in Italy, Britain, Spain, and Japan from 1948 to 1952 before settling in Paris in 1955. In 1960, with the critic Pierre Restany, he founded the New Realism movement, which consisted of a group of artists who rejected traditional easel painting.

Most of Klein's early paintings were monochrome in a variety of colors (one of his first acts as an artist was to "sign" the brilliant blue sky of the French Riviera, calling it his "first and biggest monochrome"), but by the late 1950s they were almost all deep blue, a color he eventually patented as International Klein Blue (IKB), although it was never produced commercially.

As well as conventional paintings, Klein also used models covered in paint and laid upon or dragged across the canvas as "living brushes," a technique he called anthropometry.

LIFEline

1928 Born the son of two painters
1942 Begins his studies at the French merchant navy
1947 Composes his first *symphonie monotone* (monochrome painting)
1948–52 Travels widely in Europe and Asia
1955 Settles in Paris, where he holds a solo exhibition at the Club des Solitaires
1960 Founds New Realism movement
1962 Dies of a heart attack

▶ **Imprint** *One of Klein's anthropometry works, this piece was created by placing a model on an enamel sheet and then spraying International Klein Blue paint around her.* 1961, spray paint on enamel, private collection

CLOSERlook

POOLS OF COLOR The blue spray paint has pooled in places on the enamel, appearing almost black in its depth. At its edges it blurs imperceptibly into the enamel background.

▼ **Ci-git l'Espace** *The name of the work recalls the inscription on French tombstones (ci-git.../ here lies...). Klein, before his death, was photographed beneath the work, suggesting the possible futility of his spiritual aspirations.* 1960, monogold on wood, dry pigment in synthetic resin on sponges, and artificial roses, 49¼ x 39¼in, Pompidou Center, Paris, France

▲ **Fire Painting** *The scorch marks on this painting were created by burning the surface of it with a gas burner, either breaking through it completely or merely scorching.* 1961, burned paper on wood, 55 x 40¼in, Kaiser Wilhelm Museum, Krefeld, Germany

Kenneth **Armitage**

b **LEEDS, 1916;** d **LONDON, 2002**

A student of both Leeds and the Slade, Kenneth Armitage initially carved his sculptures, although after World War II he destroyed all his prewar carvings and began to use plaster, later cast into bronze. He created groups of figures involved in such everyday activities as going for a walk or sitting on a bench, the bodies appearing as flat sheets with projecting limbs.

In 1958, Armitage was one of the three British representatives at the Venice Biennale exhibition; the critic Herbert Read coined the term "geometry of fear" to describe his and others' work. The human figure continued to form the basis of his work until the late 1970s when, in his *Richmond Oaks* series, he turned to non-figurative subjects. Although most of his works are in bronze, he also worked in wood, plaster, paper, and fiberglass.

LIFEline

1934–37 Studies at Leeds College of Art
1937–39 Studies at the Slade School of Fine Art, London
1946 Head of Sculpture at Bath Academy of Art
1958 Wins best young sculptor at Venice Biennale
1970 Works as visiting professor at Boston University
1972–73 Arts Council holds a touring exhibition of his work

▼ **Figure Lying on its Side (No 5)** *The prone figure appears to be struggling to get up, her thin arms and legs in motion as they try to lever the body off the ground.* 1957, bronze, 15 x 32¾ x 324in, Arts Council Collection, Hayward Gallery, London, UK

▲ **Friends Walking** *Armitage achieves the feeling of movement and great vitality in these walking figures, despite their monolithic shared body and spindly legs.* 1952, bronze, 22 x 24¼in, private collection

Asger **Jorn**

b **VEJRUM, 1914**; d **ARHUS, 1973**

▲ **Letter to My Son** *Painted during a period in which Jorn firmly established an international reputation, this is one of his most ambitious and impressive pieces.* 1956–57, oil on canvas, 51¼ x 77¼in, Tate, London, UK

Asger Jorn first visited Paris in 1936, frequenting Fernand Léger's studio. In 1937, he created a monumental fresco for Le Corbusier's building Le Pavillon des Temps Nouveaux, taking a child's drawing as a starting point. In Denmark from 1938, he returned to France in 1947 and became a founder member of the Cobra group (see right). In his work, his concern was to restore culture to its authentic origins and to promote the sense of sensual expression.

Pierre **Soulages**

b **RODEZ, 1919**

Often known as "the painter of black" because of his interest in that color, Soulages held his first exhibition in Paris in 1947. He has also worked as a set designer and from 1987 to 1994 produced 104 stained glass windows for the abbey church in Conques, France.

In 2001, Soulages became the first living artist to exhibit at the Hermitage Museum in St. Petersburg.

▼ **Painting** *A special quality of Soulages's paintings is the way he makes black appear luminous.* 1956, oil on canvas, 65 x 45in, Pompidou Center, Paris, France

Karel **Appel**

b **AMSTERDAM, 1921**; d **ZURICH, 2006**

After studying in Amsterdam, Karel Appel moved to Paris, where, in 1948, he became one of the founder members of the Cobra group (see right). At this stage he was making sculptures assembled from discarded objects, but he then turned to reliefs inspired by children's drawings. They were made from pieces of wood sawn at random and violently colored. His later paintings became expressionistic and dynamic.

▲ **Phantom with Mask** *Karel's expressionist portraits feature crudely drawn figures painted in vivid colors with a loose handling of drips and trickles, as if painted by a child.* 1952, oil on canvas, private collection

INcontext

COBRA GROUP Founded in 1948, the Cobra movement took its name from the initials of the members' home cities: Copenhagen (Co), Brussels (Br), and Amsterdam (A). The group held two large exhibitions and was primarily concerned with semi-abstract paintings of brilliant color and violent brushwork inspired by primitive art and folk art.

Hanging Day *Members of Cobra bring their work to the first international exhibition of experimental artists, held at the Stedelijk Museum, Amsterdam, in November 1949.*

Ossip **Zadkine**

b **VITEBSK, BELARUS, 1890**; d **PARIS, 1967**

Born in Russia of Jewish and Scottish extraction, Ossip Zadkine went to art school in London and then settled in Paris in 1909. He first sculpted elongated figures with simplified features in a lyrical and expressive style, but subsequently developed an original style with a more angular approach that was strongly influenced by Cubism and the primitive arts. Zadkine was drawn to the expressiveness of Rodin, and so combined Cubist geometric forms with dramatic emotionalism.

As a Jew, Zadkine fled to Paris during World War I and then to the US, where he taught in New York before returning to France in 1945. His mature work uses convex and concave shapes, lines, and parallel planes to achieve a sense of rhythm and unity.

▲ **Odalisque** *The Cubist influence on Zadkine's work is evident in the multifaceted shapes and imagery of this piece.* 1936, polychrome wood, Musée Reattu, Arles, France

▲ **The Destroyed City** *The ruins of the bombed city of Rotterdam, which Zadkine visited in 1946, made a deep impression on him and inspired this monument, in which the arms of the figure, with a hole torn in its body, are stretched out in horror.* 1953, bronze, height 256in, Rotterdam, Netherlands

Pierre **Alechinsky**

b **BRUSSELS, 1927**

Pierre Alechinsky studied illustration techniques, printing, and photography in his native Brussels and, in 1945, discovered the work of Jean Dubuffet. A founder member of the Cobra group (see above), he participated in both their exhibitions and then moved to Paris in 1951 to study engraving. He held his first exhibition in 1954 and started to become interested in oriental calligraphy, which he studied in Japan. In their use of bright colors, playful images, strong brushwork, and distorted forms, his paintings are related to French abstract painting (tachism), Abstract Expressionism, and lyrical abstraction styles.

▲ **Parfois C'est l'Inverse** *This painting of people running, sitting, bathing, and throwing, is set above a series of small illustrations that are arranged like a crazy strip cartoon.* 1970, acrylic on paper, 7⅛ x 12in, Musée d'Art Moderne, Brussels, Belgium

Reg **Butler**

b **BUNTINGFORD, 1913;**
d **BERKHAMSTEAD, 1981**

Originally trained as an architect, Butler worked as a blacksmith during World War II, and he drew on this experience of forging iron in his early sculptures. In 1953 he achieved international fame when he won first prize in a competition for a monument to the *Unknown Political Prisoner*. His later work was in bronze and generally concentrated on the human figure. In the 1970s he made a number of realistically painted nude figures in provocative poses.

◀ **Woman** *This sculpture reflects Butler's background as a blacksmith but also his interest in Picasso and Surrealism. The process of forging enabled him to turn iron into organic forms. 1949, forged and welded iron, 87 x 28 x 18⅞in, Tate, London, UK*

Jean Robert **Ipoustéguy**

b **DUN-SUR-MEUSE, 1920;** d **DUN-SUR-MEUSE, 2006**

Born Jean Robert, he later adopted his mother's maiden name as his *nom d'artiste*. He trained as a painter and made stained glass but abandoned painting in favor of sculpture in 1949.

At first his forms were abstract and geometric but by 1955 they became lumpier and as he became more and more concerned with the human figure. Inspired by surrealism, themes of life and death continue to be his chief concern.

◀ **La Terre** *Ipoustéguy's first life-size sculpture of a human figure was soon followed in 1963 by another, entitled L'Homme. 1962, bronze, 74 x 27¼ x 21¼in, Tate, London, UK*

Eduardo **Chillida**

b **SAN SEBASTIÁN, 1924;** d **SAN SEBASTIÁN, 2002**

At one time a goalkeeper for Real Sociedad, San Sebastián's soccer team, Eduardo Chillida trained as an architect before taking up drawing. He became a sculptor after seeing ancient Greek sculptures in the Louvre in the early 1950s. His work in iron, steel, and stone has always been abstract—his first exhibition in Madrid in 1954 was the first abstract sculpture exhibition in Spain—but he rejects the label of abstract and prefers to call himself a "realist sculptor."

Although many of his works are monumental, they all suggest tension and movement and are characterized by his respect for his materials. Many are inspired by his Basque upbringing.

▲ **Mesa de Omar Khayam II** *Chillida is best known for his work in steel. This is typical of the organic ribbon-like forms he achieves, which is quite unlike the more mechanistic appearance of sculptures created by those who work in welded metal, such as Anthony Caro. 1983, steel, 19¾ x 62 x 121in, Museo Nacional Centro de Arte Reina Sofia, Madrid, Spain*

Eduardo **Paolozzi**

Paolozzi, 1924

b **LEITH, SCOTLAND, 1924;** d **LONDON, 2005**

After training in Edinburgh and London, Eduardo Paolozzi moved to Paris in 1947. His collage of the same year, *I Was a Rich Man's Plaything* is viewed by some critics as the first true example of Pop Art, although he has always described his own work as surrealist.

In 1952 Paolozzi was founder member of the Independent Group of artists that met in London for three years and is seen as a precursor of the 1960's British Pop Art movement. His early sculpture was described by the critic Herbert Read as an example of "geometry of fear" because of its reflection of post-war anxiety. Later sculptures by Palozzi were more colorful and playful and have sometimes been associated with Pop Art.

Paolozzi is best known for his public sculptures, which were often largely life-like statues with elements added or removed, or were the human form deconstructed in a Cubist manner. He also created the mosaic patterned walls of Tottenham Court Road tube station in London.

LIFEline

1924 Born the eldest son of Italian immigrants
1943 Studies at Edinburgh College of Art, then in London at St. Martin's and Slade
1947 Works in Paris
1952–55 A founder member of the Independent Group
1984 Completes the mosaics in Tottenham Court Road underground station, London
1995 His bronze statue *Newton* is placed outside the British Library in London

◀ **Metalization of the Dream** *For artists of Paolozzi's generation, print was a way of reaching a wider public. Although 40 examples were made, each is printed in different colors. 1963, screen print, 19⅜ x 19¼in, Victoria & Albert Museum, London, UK*

▲ **Frog** *Paolozzi worked closely with the "Brutalist" architects Alison and Peter Smithson, who believed that raw concrete was a suitable material for mass housing in a consumer society. The "Brutalist" aesthetic was also identified with sculpture such as this. 1958, found objects, clay, wax, 27½ x 31½ x 31½in, Ferens Art Gallery, Hull, UK.*

CLOSERlook

TEXTURE
Paolozzi created the craggy surfaces in this sculpture by impressing machine parts into wax, and casting the results in bronze.

For artists working in America in the early 1950s, Abstract Expressionism was the dominant influence, yet some were already looking for new ways of interpreting abstract painting. Experimenting with highly diluted oil and acrylic paint, they developed a distinctive and purely abstract style.

Origins and influences

Helen Frankenthaler was a pioneer of this new abstraction, influenced by the techniques of Jackson Pollock's action painting and the large blocks of color in work by Mark Rothko and Robert Motherwell. Her "soak stain" technique eliminated brushstrokes and surface texture, placing more emphasis on the form and shapes of

▲ **In Britain, the leading interpreters** *of the movement that became known as "post-painterly abstraction" were the New Generation sculptors who exhibited at London's Whitechapel Gallery (above) in 1965. In the US, the movement was primarily concerned with painting.*

fields of color, and was soon taken up by other artists looking for an alternative to Abstract Expressionism.

Style and technique

Frankenthaler's new soak stain technique was simple, but radical: pouring very diluted oil or acrylic paint directly on to unprimed canvas and allowing it to soak in. The idea was similar to Pollock's action painting, but the results completely different—large areas of flat, translucent color, bonded into, rather than applied on to, the canvas. Other artists took up the technique of this color field painting, and the purity of its abstraction led to an interest in simple geometric shapes and bold colors in the work of Ellsworth Kelly and Kenneth Noland, for example, which in turn inspired a similar movement in abstract sculpture.

From the Abstract Expessionism of postwar America, a second generation of abstract artists emerged, using innovative techniques in a less subjective style and avoiding painterly gesture. Often on a huge scale, their work was absolutely non-representational and characterized by clarity of composition and color.

Abstract painting and sculpture

TIMEline

In the early 1950s, Helen Frankenthaler's new "soak stain" techniques were adopted by artists such as Morris Louis and Jules Olitski. The pure abstraction of this color field school evolved into the hard-edge abstracts of Kenneth Noland and Ellsworth Kelly, which inspired many British sculptors in the 1960s, and were taken a stage further in the shaped canvases of Al Held and Frank Stella.

1957

FRANKENTHALER Lorelei

1958

KELLY Broadway

1959

NOLAND Half

1966

TUCKER Thebes

1986

STELLA Cricche, Crocche e Manico D'Uncino

▲ **Spawn** Morris Louis *Color field painting, using the new acrylic paints and innovative techniques for applying it to the canvas, arose in the US in the 1950s. Its purity of color and form was in distinct contrast to the Abstract Expressionism that preceded it.* Acrylic on canvas, private collection

Interpretations

The techniques developed by American abstract painters in the 1950s resulted in a wide variety of interpretations, from color field paintings through hard-edge geometric compositions to complex mixed-media work, but they had one thing in common— the avoidance of painterly gesture.

Painting

Helen Frankenthaler exhibited the first major painting using soak stain technique, *Mountains and Sea*, in 1952. This not only launched her career, but also provoked a reaction to Abstract Expressionism with its unemotional style and gentle colors. As other painters experimented with her techniques, different styles began to evolve in the early 1960s, and the critic Clement Greenberg coined the term "post-painterly abstraction" for an exhibition in Los Angeles in 1964 as a general description of the interpretations of the style. Among the artists included were Jules Olitski and Ellsworth Kelly, who simplified composition, often taking the principles of color field painting to extremes with canvases of a single color; Morris Louis and Kenneth Noland (leading members of the so-called

Washington Color School) explored geometric shapes and bolder colors, in various series of stripes, circles, chevrons and so on, which developed into the "hard-edge" style; and Frank Stella and Al Held worked on irregularly-shaped canvases and introduced three-dimensional elements, while retaining the dispassionate style.

Sculpture

Post-painterly abstraction was initially an American movement, and as the name suggests concerned almost exclusively with painting. Its influence, however, soon spread elsewhere, most importantly to Britain, and manifested itself in a school of abstract sculpture. Anthony Caro and his students at St. Martins School of Art in London began using industrial materials such as sheet metal and plastic to create abstract forms, painting them in flat, bold primary colors. In the US, meanwhile, painters including Ellsworth Kelly and Frank Stella were branching out from the purely color field style, and as well as producing mixed-media two-dimensional work began to adapt their styles to sculpture. Like their paintings, these sculptures were often on a massive scale, requiring industrial equipment to cut and assemble.

▲ **Twin Peaks** Anthony Caro *British artists, particularly sculptors, were also inspired by the clarity of American "post-painterly abstraction." Among them was the influential teacher Anthony Caro, whose students in the "New Generation" further developed the style of abstract sculpture during the 1960s.* 1977–78, bronze, 37¾ x 19 x 16½in, private collection

Helen **Frankenthaler**

b **NEW YORK, 1928**

One of the leading figures to emerge from post-war Abstract Expressionism, Helen Frankenthaler pioneered the technique of Color Field painting (see p.523), in elegantly simple compositions with luminous colors.

Frankenthaler studied at the Dalton School in New York and at Vermont's Bennington College, and then became involved with the New York School of abstract painters, which included Willem de Kooning, Jackson Pollock, and her future husband Robert Motherwell.

Attracted by Pollock's method of painting on unprimed canvases, Frankenthaler took the technique a step further, allowing thinned paint to soak into the raw canvas. *Mountains and Sea*, which used this "soak stain" technique, brought about her breakthrough in 1952, and she has since developed the idea in increasingly abstract and uncomplicated compositions.

▼ **Lorelei** *In the 1950s, Frankenthaler produced a number of huge paintings by her "soak stain" technique. Using heavily thinned oil paint allowed the texture of the unprimed canvas to show, and gave an impression similar to a watercolor.* 1957, oil on unprimed canvas, 70½ x 86⅝in, Brooklyn Museum of Art, New York, US

▲ **The Bay** *Adapting her technique to the newly developed acrylic paints, Frankenthaler explored simpler forms in her paintings during the 1960s, juxtaposing large areas of intense, contrasting colors. This huge canvas is divided into only four areas of color.* 1963, acrylic on canvas, 80¾ x 82in, The Detroit Institute of Arts, Detroit, US

Morris **Louis**

b **BALTIMORE, 1912;** d **WASHINGTON DC, 1962**

After moderate success as a Cubist painter, Morris Louis completely changed direction at the age of 40, adopting Helen Frankenthaler's "soak stain" technique (see left), and becoming a leading figure in the Washington Color School. Born Morris Louis Bernstein (he dropped the surname in 1938), he studied in his home town of Baltimore from 1927–1932, before joining the Works Progress Administration Federal Art project in New York. At the end of the 1940s, Louis began using the new oil-based acrylic paints, and after seeing Frankenthaler's *Mountains and Sea* (1952), he embarked on a series of abstract paintings in the Color Field style (see p.523). By this time, he had moved to Washington, DC.

Along with like-minded painters, including Kenneth Noland, he established a group in response to the Abstract Expressionism of the New York School. Louis's work in the 10 years before his untimely death from lung cancer is divided into three distinct series of paintings, with self-explanatory titles: *Veils*, *Unfurleds*, and *Stripes*.

LIFEline

1912 Born in Baltimore
1936–40 Lives in New York
1952 Moves to Washington, DC
1953 Sees Frankenthaler's *Mountains and Sea*
1954 Begins a series of *Veils* paintings
1955–57 Destroys much of his earlier work and resumes work on the *Veils* series
1959–61 Paints the *Unfurleds* series of paintings
1961 Begins the *Stripes* series of paintings
1962 Dies in Washington, DC, aged 50

❝ Louis's paintings **don't shout**, but **neither do they whisper**… yet they transform their surroundings **as only great art can** ❞

TERRY FENTON, ARTIST AND WRITER

▶ **No. 182** *Painted in the last two years of his life, the* Stripes *series explored the impact of pure colors in vertical columns on a neutral background. By carefully pouring thinned acrylic down a suspended canvas, Louis achieved a remarkable clarity of color and texture.* 1961, acrylic on unprimed canvas, 82¼ x 33in, Phillips Collection, Washington, DC, US

Kenneth **Noland**

Photograph by Christopher Felver

b ASHEVILLE, 1924

Painter and sculptor Kenneth Noland studied in his native North Carolina and in Paris before settling in Washington, DC. There, he became a member of the Washington Color School (see p.523), and, with his sharp contours and flat color, was a leading exponent of Hard Edge painting. Initially influenced by Klee, and then the work of Picasso, Miró, and Matisse during a year in France, Noland discovered Jackson Pollock and Abstract Expressionism when he returned to the US in 1949. He befriended Morris Louis in Washington DC, and together they visited Helen Frankenthaler's New York studio, which inspired them to experiment with new techniques of Color Field painting (see p.523).

In the mid-1950s, Noland reacted against the unfocused composition of Abstract Expressionism culminating in a series of paintings of concentric circles set centrally in square canvases. These clearly defined shapes evolved gradually into ellipses, and were then replaced by chevrons, stripes, and grids, often in lozenge-shaped or irregularly shaped canvases. Around 1967, Noland also began working as a sculptor, influenced and encouraged by his friend Anthony Caro.

LIFEline

1946 Studies at famous experimental institution, Black Mountain College, North Carolina

1948–49 Studies in Paris

1949 Moves to Washington

1953 Visits Frankenthaler's studio with Morris Louis

1956 Paints the first of his circle paintings

1961 Moves to New York

1962 Begins a series of chevron paintings

1970s Explores irregular-shaped canvases, and makes sculptures

▼ **Gamma Epsilon** *In his* Unfurleds *paintings,* Louis *began to use colors that were much more intense and opaque, but applied more sparingly.* Gamma Epsilon, *like all the works of this series, contrasts diagonal stripes of poured acrylic on the left and right of an empty canvas.* 1960, acrylic on unprimed canvas, 34 x 75⅝in, private collection

◄ **Blue Veil** *The watercolor-like translucence of the "soak stain" technique inspired Louis to begin his* Veils *series. Extremely diluted acrylic paint poured on to enormous unstretched and unprimed canvases produced paintings that give the impression of folds of gauzy cloth.* c1958–59, acrylic resin paint on unprimed canvas, 233 x 396cm, Harvard University Art Museums, US

CLOSERlook

SMOOTH FINISH By literally pouring the thinned paint on to canvas, Louis eliminated any surface texture and painterly gestures such as brushstrokes. The free flow of the paint creates an illusion of three-dimensional depth.

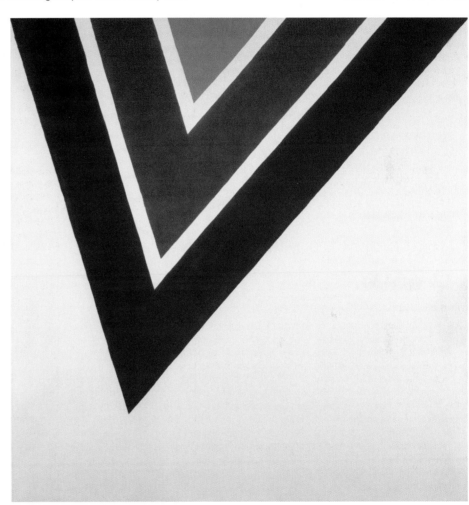

◄ **Half** *Noland's series of circle paintings evolved during the late 1950s from indistinct rings to precise, target-like images of concentric circles with sharply defined edges in contrasting colors.* 1959, acrylic on canvas, 68½ x 68½in, Museum of Fine Arts, Houston, US

▲ **Sarah's Reach** *In New York, Noland embarked on a series of Hard Edge chevron paintings. The first of these were symmetrical compositions of V shapes, appearing to hang from the top edge of an otherwise bare canvas.* 1964, acrylic on canvas, 93¾ x 91¾in, Smithsonian American Art Museum, Washington, DC, US

Al **Held**

b NEW YORK, 1928; d TODI, 2005

A leading Hard Edge painter, Al Held studied in Paris for three years, where he came across the modern European masters, but turned to abstract painting on his return to New York in 1952. He developed his idiosyncratic style during the 1950s as a reaction to the painterly style of Abstract Expressionism.

His first abstract works were in an Impressionistic, watercolor-like style of early Color Field painting (see p.523), but he later adopted the clean lines and flat colors of the Hard Edge school. In the late 1960s, frustrated by the lack of spatial depth in his work, Held introduced elements of illusionist perspective—geometric, and sometimes irrational, figures—intuitively placed on his often circular canvases. These black-and-white "spatial conundrums" were gradually replaced with colored shapes in his later work.

▶ **Skywatch II** *Placed apparently at random on this huge circular canvas, cubes, prisms, and hoops are depicted diagrammatically and with an ambiguous perspective.* 1971, synthetic polymer paint on canvas, diameter 72in, National Gallery of Australia, Canberra

> " I like to make **structures** that I can't imagine. If I could **imagine** them in my mind there'd be no reason to **make** them "
>
> AL HELD

Jules **Olitski**

b SNOVSK, 1922

Like many American artists of his generation, Jules Olitski studied in Paris after World War II, before establishing himself as a painter and sculptor in New York. Originally named Jevel Demikovsky, he was born in Soviet Russia just after his father's political execution, and emigrated with his family to New York as a baby.

He became an American citizen and adopted his stepfather's name while serving in the US Army. Olitski's early work was brightly colored and dramatic, often employing experimental techniques such as painting blindfolded, but this was supplanted by monochrome paintings after his return to the US. In the 1960s, he stained and spray-painted canvases with acrylic, using techniques he learnt from Kenneth Noland. More recently, he has explored the textures of thickly applied paint and sculpture.

▲ **Instant Loveland** *After working with "soak stain" techniques, in the 1960s Olitski adopted a method of spray-painting thinned acrylic to achieve subtle color variations. Paintings such as this present a monochrome, all-over composition, with fine gradations of tone.* 1968, acrylic on canvas, 116 x 254¼in, Tate, London, UK

Ellsworth **Kelly**

b NEWBURGH, NEW YORK, 1923

Although never a member of any particular school, Ellsworth Kelly has been a major influence on the post-war American abstract movements of Color Field painting, Hard Edge painting, and Minimalism.

Kelly's studies as a technical artist were interrupted by World War II. After his discharge from the army, he studied at the École des Beaux-Arts from 1948 to 1949, living in Paris for a total of six years as he developed an original style of abstract painting. Returning to New York in 1954, Kelly produced a number of large paintings with blocks of flat color, and experimented with different-shaped canvases. This emphasis on geometrical shapes has continued throughout his career, and is also apparent in his sculptures made of sheets of metal.

LIFEline

1941–43 Studies at the Pratt Institute, in Brooklyn
1943–45 Serves in the army
1945 Studies in Boston
1947–48 Studies in Paris
1954 Returns to the US
1970 Paints a series of pictures of curves in two colors
1973 First retrospective of his work, at MoMA in New York
2008 Works on commissions for US embassies in Berlin and Beijing

▶ **Broadway** *Using featureless geometric shapes and primary colors, Kelly suggests a feeling of depth in a patently flat picture plane.* 1958, oil on canvas, 78 x 70in, Tate, London, UK

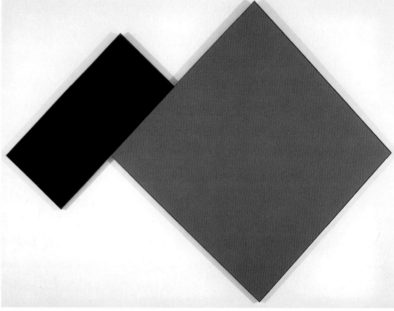

▲ **Green Black** *A recurrent theme in Kelly's work from the 1960s onward is the juxtaposition of panels painted in bold single colors. These can be rectangular shapes joined together—and sometimes displayed diagonally, as here—or composites of irregularly shaped canvases.* 1988, oil on canvas (two joined panels), 102 x 131in, Museum of Fine Arts, Houston, US

Frank **Stella**

Frank Stella

b **MALDEN, MASSACHUSETTS, 1936**

Frank Stella has been one of the most influential figures in American Abstract Art. His technically inventive work has ranged from an austerity close to Minimalism in his early pinstripe paintings to the multi-colored three-dimensional exuberance of his later work.

Stella first attracted attention in the late 1950s, when his so-called *Black Paintings* were exhibited at the Museum of Modern Art in New York. During the 1960s, he experimented with shaped canvases and different materials, a process that culminated in his massive and colorful *Protractor* paintings. At the same time, he was exploring various methods of printmaking—screenprinting, etching, and offset lithography—and had begun to use wood and aluminum as a base for his painting. More recently, Stella has introduced elements of relief and collage, to the extent that many of his paintings might better be considered as sculpture.

LIFEline

1950 Studies painting and art history at Phillips Academy Andover, in Massachusetts

1958 Graduates from Princeton and moves to New York

1966 Begins the *Irregular Polygons* series

1967 Produces his first abstract prints

1967–71 Paints series of *Protractor* paintings

1970–73 Experiments with different materials and relief in the *Polish Village* series

1982–83 Resident at the American Academy in Rome

1986 The Charles Eliot Norton lectures he gave at Harvard are published as *Working Space*

1992–93 Designs the decorative scheme for Princess of Wales Theatre in Toronto

▲ **Cricche, Crocche & Manico D'Uncino** *Realizing a work like this, which features high-relief and collage techniques, often entailed using industrial metal-working equipment and a team of assistants.* 1986, mixed media on canvas, 171 x 178 x 30¼in, private collection

▼ **Agbatana II** *Perhaps the most striking of Stella's paintings, and the most radical departure for him in terms of the bold colors used, were the Protractor Paintings. Characterized by interlocking arcs and square borders, they were named after Middle Eastern cities he had visited.* 1968, oil on canvas, 120 x 180in, Musée d'Art et d'Industrie, St Étienne, France

CLOSERlook

BARE CANVAS The bands of color in the *Protractor Paintings* are separated by fine lines of raw canvas, a technique Stella developed in the early 1960s.

▼ **Empress of India** *During the 1960s, Stella experimented with aluminum and copper paints and elaborately shaped canvases. This work is formed of four chevron-shaped panels joined together.* 1965, metallic powder in polymer emulsion paint on canvas, 77¼ x 216in, MoMA, New York, US

❝ You can't **shake** your own **sensibility**. No matter what the **concept** is, the artist's eye decides when it's **right** ... which is a notion of sensibility ❞
FRANK STELLA

Anthony **Caro**

b **NEW MALDEN, SURREY, 1924**

The foremost British sculptor of his generation, and an inspiring teacher, Anthony Caro adopted his groundbreaking abstract style following a vist to the US in the late 1950s, where he discovered the work of David Smith and Kenneth Noland. Caro had previously worked in a loosely figurative style, influenced by the time he had spent working as Henry Moore's assistant.

On his return to London, Caro started work on a series of large-scale sculptures in metal, painted in single primary colors and, significantly, placed on the ground rather than on a plinth. In the 1970s, these evolved into massive constructions of less regularly shaped scrap metal, left unpainted. From around 1980, he was increasingly concerned with the shapes of found objects as well as sheet metal, and his work became reminiscent of Cubism. This trend continued into the 1990s, eventually leading to a renewed interest in figurative forms and some smaller scale works.

LIFEline

1947–52 In his 20s, studies at the Royal Academy Schools, London

1951–53 Works as assistant to Henry Moore

1953–79 Teaches part-time at St. Martin's School of Art

1959 Travels to the US and befriends David Smith

1963–65 Teaches at Bennington College, Vermont, with Smith and Olitski

1975 Major exhibition of his work at MoMA in New York

1980s Adopts a more cubist, sometimes figurative style

1990s Starts a series of sculptures inspired by the Trojan War

2005 Tate Gallery in London holds a retrospective to mark his 80th birthday

◁ **Tundra** *Irregular metal sheets and offcuts are welded together in massive vertical planes, and coated with clear varnish to show the color and texture of the metal.* 1975, metal, 107 x 228 x 52in, Tate, London, UK

▽ **Midday** *Caro's most important innovation was dispensing with a plinth and placing his sculptures directly on the ground. Midday was constructed from industrial metal parts welded into a light and open composition, which belies the weight of the material.* 1960, painted steel, 92 x 37½ x 148¾in, MoMA, New York, US

▽ **The Soldier's Tale** *Deriving its title from a piece of music theatre by Stravinsky, this work is composed of pieces of scrap metal from a dockyard. The central bowl shape, suggesting an open mouth, is surrounded by a frame-like structure of steel sheets.* 1983, painted steel, 72 x 82 x 53in, Tate, London, UK

William **Turnbull**

b **DUNDEE, 1922**

William Turnbull made his name in London in the 1950s as a painter, printmaker, and sculptor. After serving in the RAF during World War II, he studied at the Slade School in London, then worked in Paris for two years. On his return to London, he shared a studio with Eduardo Paolozzi. The late 1950s proved a turning point in Turnbull's career, when he saw exhibitions of modern American art and visited the US for the first time. As a result, his work became completely abstract and influenced by the Color Field artists (see p.512–13). In his painting and sculpture, Turnbull began to adopt a Minimalist approach, but returned to a more figurative style in the late 1970s.

▲ **5 x 1** *In the 1960s, Turnbull produced a number of painted steel sculptures in which he reduced the composition to essential geometric shapes. Many, like 5 x 1, involve the repetition of identical shapes within a simple form.* 1966, painted steel, 72½ x 21 x 22in, Tate, London, UK

Phillip **King**

b **KHEREDINE, 1934**

▲ **Slant** *Chevron shapes cut from a cardboard cone provided the pattern for the six overlapping elements in this work, which were made from sheet plastic. It was originally painted green, but repainted when shown on grass at an exhibition in London's Battersea Park.* 1966, arborite (plastic sheeting), 84¼ x 216 x 72¼in

One of the "New Generation" of British sculptors of the 1960s, Phillip King studied at St. Martin's School of Art in London. After working for a year as Henry Moore's assistant, he returned to St. Martin's, where he taught with Anthony Caro. King worked in a loosely figurative style until 1960, but made the fundamental change to abstraction at much the same time as his mentor, Caro. Influenced initially by the simplicity of Greek architecture, King also discovered the work of American abstract artists, which prompted brightly painted sculptures in fiberglass and sheet metal exploring simple geometric forms. His later works, using a wide range of materials, have become more intricate in composition and smaller in scale.

William **Tucker**

b **CAIRO, 1935**

Born in Egypt to an English family, William Tucker made his name as part of the "New Generation" of British sculptors in the mid 1960s. He later moved to the US and has now taken American citizenship. Tucker graduated in history at Oxford University in 1958, and then went on to study sculpture at the Central School and St. Martin's in London. His early work, influenced by Anthony Caro and contemporaries such as Phillip King, was marked by simplicity of form and brightly painted geometric shapes in wood, sheet metal, or fiberglass. Later sculptures, particularly those made after his move to the US in 1977, show a move to more organic forms, and even some figurative elements.

▲ **Thebes** *Tucker replaced the severe straight lines favored by many of his contemporaries with gently rounded shapes. He also rejected the identical repetition of Minimalism in favor of an almost narrative variation of colors and positioning of elements.* 1966, painted wood, 48 x 54 x 80in Hayward Gallery, London, UK

Minimal art was usually on a large, imposing scale. This was not just to impress and awe. The combination of simplicity and size was designed to draw attention to the space around the work, and to make the spectator engage with the work as a real object, rather than an image of something else. In earlier abstract art, there is always the sense of an imaginary world inside the picture frame, or on the plinth. In Minimal art, the object stands only for itself.

Origins and influences

Minimal art was the product of a generation of artists who were, by and large, university trained and enormously aware of the history of modern art. Behind its apparent simplicity, there lay a complex web of influences and ideas. Donald Judd and Robert Morris—two leading Minimal artists—were prolific writers and theorists as well as practitioners. They

▲ **5 Cubes with Hidden Cubes** *by Sol Le Witt (1968). Like much Minimal Art, Le Witt's constructions and drawings were worked out following predetermined systems in an attempt to avoid the exercise of "taste."*

drew on the tradition of Geometric and Constructivist Abstraction (pp.462–65), but they viewed it through the recent history of American art. From Abstract

Expressionism, they took the sense of scale and, from Jackson Pollock especially, the idea of revealing the performance in the making of art. From Jasper Johns and Claes Oldenburg they took the idea of art as an object.

Subject and interpretation

For many commentators, Minimal art was the most abstract art yet, but for others, it represented a complacent acceptance of the world of industrial production.

Minimal art was sometimes found threateningly aggressive and masculine, while the critic Michael Fried attacked the way in which, instead of becoming involved in what was happening inside the work, the attention of the spectator was drawn to the context outside.

Donald Judd, a leading proponent, described Minimal art as "neither painting nor sculpture." This style, which is most associated with American artists of the 1960s and 1970s, used basic, simple forms. Minimal artists often used geometric shapes, but the work was far from the world of earlier geometric abstract artists.

Minimal art

Lucio **Fontana**

b **ROSARIO (SANTA FE), 1899;** d **COMABBIO, 1968**

The son of a Milanese sculptor, Fontana moved from his native Argentina to Milan with his family in 1905. His early sculpture, now lost, was figurative, but in the 1930s he made engraved abstract sculptures under the influence of Surrealism and semi-abstract sculptures in colored ceramic, as well as making more conventional public work for the Fascist regime.

Fontana returned to Argentina in 1940, where he published with his students the *White Manifesto* (1946). Its demand that "art have its own values, free from the style of representation,"- and its attack on traditional forms of painting and sculpture foreshadowed the theory and practice of the Minimalists of the 1960s. He returned to Milan in 1947 and achieved an international reputation for his slashed and punctured monochrome canvases. He also worked with installations in neon light and collaborated with architects on exhibition pavilions.

◄ **Spatial Concept "Waiting"** *Fontana's slashing and piercing of the surface of the canvas, always carefully premeditated, was less an act of violence than an attempt to draw the viewer into the surface of the painting and establish a sense of space. Oil on canvas, Museo Revoltella, Trieste, Italy*

Tony **Smith**

b **ORANGE COUNTY, 1912;** d **NEW YORK, 1980**

As a child, while isolated from other children because of tuberculosis , Smith made models from cardboard boxes. He trained and worked for many years as an architect, although he was friendly with leading Abstract Expressionists, including Jackson Pollock and Barnett Newman. A serious road accident in 1961, and frustrations with his architectural practice led him to take up sculpture. Smith's box-like forms, fabricated industrially in steel and based on plywood models, were the first real American Minimal art, although they led to less austere works on an environmental scale.

INcontext

MASS PRODUCTION Siegfried Giedion's famous book *Mechanization Takes Command* (1948) presented a history of mass production, which showed how it could be both a liberating and an oppressive force. The Minimalist use of industrial material often invoked the dirt and grease of the factory floor, rather than the clean high precision of industry as seen from the design office.

At the Rambler plant assembly line *Minimal art could suggest mass production, through its use of industrial processes and materials, such as steel and aluminum, and by its repetition of identical forms—a feature shared with the Pop works of Andy Warhol.*

◄ **Die** *This simple cube was deliberately scaled to be neither an object nor a monument. It is constructed to "float" just above the floor, so it can be imagined from all sides.* 1962, steel with automobile undercoat paint, 72 x 72 x 72in, Whitney Museum of American Art, New York, US

Robert **Morris**

b **KANSAS CITY, 1931**

An involvement with avant-garde theater and avant-garde Fluxus performance art inspired Robert Morris's classic 1960s Minimalist works. Simple geometrical constructions had served him as props, and he saw their potential as sculptures in their own right. Placing large, plywood polyhedrons in a gallery led to what Morris called an "extended situation"—rather than becoming engrossed in the detail and formal relationships within a work, the viewer would become aware of their relationship to the objects in space and time. They would see how the sculptures are perceived differently depending on the spatial context, the lighting, and their own position in the gallery. This "embodiment" of the viewer had a profound influence on contemporary art. Extending the situation of art still further, Morris has gone on to produce "anti-form" sculptures and Land Art.

LIFEline

1960 Moves to New York

1964 His geometrical objects are shown in a solo exhibition at the Green Gallery, New York

1966 First two parts of his seminal essay *Notes on Sculpture* are published

1968 Shows "anti-form" felt works at Leo Castelli gallery, New York

1971 Large-scale exhibition at the Tate, London, is closed due to numerous viewer accidents

▲ **Untitled (1967–8)** *This piece is hung at the average spectator's line of vision, exactly how a viewer sees it will depend of their height. This kind of interaction with the body of the spectator is typical of Morris.* 1967–8, plastic, 18⅛ x 96 x 96in, Tate, London, UK

▲ **Untitled (Felt Tangle)** *Morris experimented with soft materials, such as felt, pioneering what he termed "anti-form." Slashed and pinned to the wall, Morris let the material fall, and accepted the final shape as a work of art.* 1967, felt and metal eyes, 74¾ x 158 x 86½in, Kunsthalle Hamburg, Germany

CLOSERlook

FLUID FORM
Morris's *Felt Triangle* falls to the floor in a heap, its exact shape beyond the artist's control. His interaction with the material is not expressive but mechanical: nailing and cutting.

Donald **Judd**

b **EXCELSIOR SPRINGS, 1928;** d **NEW YORK, 1994**

Donald Judd's far-reaching contribution to the development of modern art was to conceive of a type of artwork that was neither a painting nor a sculpture, but what he termed a "specific object." Such a work would be an organization of shape and color and yet, unlike painting, it would declare its literal quality as an object existing in space. For Judd, who started out as a painter, the problem with even totally abstract paintings was that they remained both illusionistic, suggesting a spatial depth that was not actually there, and compositionally balanced, implying an underlying order that did not exist in the real world. His solution was to utilize industrial materials, such as copper, aluminum, and Plexiglas, as elements brought together in simple, geometric, and symmetrical arrangements. Every part would retain its own sensual integrity, while cohering together as a whole.

LIFEline

1948 Studies at the Art Students League, New York

1949–53 Studies philosophy at Columbia University

1957 Holds his first solo exhibition in New York

1959–65 Writes criticism for *Arts Magazine*

1965 Publishes his seminal essay *Specific Objects*

1968 Retrospective of his work at the Whitney Museum, New York

1979 Buys land in Texas, to house a collection of his work

◄ **Untitled** *This is one of Judd's "stacks"—wall-mounted works in which his famous aphorism "one thing after another" is most literally manifested. Each unit is identical in size, and they are spaced equal distances apart, suggesting the possibility of an ongoing, perhaps endless series.* 1980, steel, aluminum, and perspex, 9⅛ x 40¼ x 31⅛in (each unit), Tate, London, UK

▶ **Untitled** *Like other Minimalist artists, Judd used the simple form of the cube to explore spatial volumes and the relation between the viewer and the object. This factory-manufactured work may be spare, but, like much of the artist's output, it is highly sensual.* 1972, copper, enamel, and aluminum, 36¼ x 61½ x 70⅛in, Tate, London, UK

" **Actual space** is intrinsically more **powerful and specific** than paint on a flat surface "
DONALD JUDD, 1964

Carl **Andre**

b **QUINCY, 1935**

Carl Andre is best known for floor pieces consisting of arrangements of pre-formed, common construction materials such as metal tiles and bricks. Influenced by the sculptures of Brancusi, particularly his *Endless Column* (1938), Andre began to make work with repeated patterns, chiseling notches and cutting shapes into timber beams.

Andre's breakthrough came when he realized that, rather than the artist cutting into the material, the material itself could be thought of as cutting into space. Following this revelation, he preferred to use solid, interchangeable units, laying them in neat grids. The orderly, geometrical blocks that result hug the ground and give the impression of a volume of space being displaced. Working with rather than against gravity, and keeping his works low and horizontal rather than reaching skyward, Andre has spoken of his desire to make art that resembles roads more than buildings.

LIFEline

1935 Born in Quincy, Massachusetts

1960–64 Works as a railway freight conductor

1966 Shows his first brick works at the Tibor de Nagy Gallery, New York

1976 *Equivalent VIII* causes controversy when it is shown at the Tate Gallery in London

▼ **144 Magnesium Square**
Toward the end of the 1960s, Andre made squares from steel, copper, aluminum, magnesium, and other industrial materials. Here, tiles are laid flat on the gallery floor where they may be walked upon. Rising less than half an inch off the ground, the work can go unnoticed, while remaining a solid presence. 1969, magnesium, ⅜ x 144 x 144in, Tate, London, UK

▲ **Equivalent VIII, 1966** *This is one of a series of works, each consisting of 120 firebricks stacked two deep and arranged to form grids of varying widths and lengths. This piece caused an outcry over "wasted" taxpayers' money when it was bought by the Tate, and became known in the media as "the bricks."* 1966, firebricks, 5⅛ x 27¼ x 90¼in, Tate, London, UK

Dan **Flavin**

Photograph by John Jonas Gruen

b **NEW YORK, 1933;** d **NEW YORK, 1996**

After starting his career as an abstract painter, Dan Flavin moved on to create more object-based wall pieces. Then in the early 1960s, he began attaching light bulbs and tubes to monochromatic hardboard boxes. It was only in 1963, however, that he had the idea of taking a solitary fluorescent tube and attaching it diagonally to his studio wall. From that moment on, the fluorescent light became Flavin's exclusive artistic medium. It was an elegant solution to artistic problems of the time. On the one hand, the fluorescent tube is a mass-produced, industrial object in the tradition of Duchamp's "readymades". On the other hand, the effect produced by pulsating light can be highly atmospheric and, in the case of colored fluorescence, sensuous and beautiful. In Minimal Art terms, Flavin follows the path of literalness—his fluorescent tubes with their casing, wall fittings, and power supply are undisguised objects; simultaneously, he makes the viewer aware of the gallery space by filing it with diffused light.

LIFEline

1957–59 Studies art history at Columbia University

1961 Marries his first wife. Begins attaching lights to wall-mounted boxes, calling them "icons"

1962 Flavin's twin brother dies. An "icon" is dedicated to him

1964 First exhibition of his new fluorescent works takes place in New York

1992 Marries his second wife, Tracy Harris, amid his own installation at the Guggenheim, New York

1996 Dies after complications from diabetes

◄ **"Monument" for V Tatlin**
Flavin admired the revolutionary artistic ideas and plastic innovations of the Russian Constructivists. He made many versions of this work, arranging fluorescent tubes in an approximation of Vladimir Tatlin's model for a proposed Monument to the Third International *(see p.462) .* 1966–69, mixed media, 120 x 23 x 3½in, Tate, London, UK

▲ **Diagonal of May 25, 1963** *This was Flavin's first work to use an industrial fluorescent tube not as an appendage attached to another form, but as the sole art object itself. This literalness is reflected in the title, which designates the date of Flavin's eureka moment as well as the angle at which it is attached to the wall.* 1963, fluorescent tube, 96in, Tate, London, UK

Eva **Hesse**

b **HAMBURG, 1936;** d **NEW YORK, 1970**

Eva Hesse became something of a heroine to the burgeoning women's art movement. She came to stand for an opposition to the rigid geometry of some Minimal Art by her use of floppy, physically unstable materials, such as latex. Although this has been interpreted as a kind of feminist resistance to a male-dominated modern art, she was influenced by the felt work of Joseph Beuys and by Robert Morris's concept of "anti-form" (see p.530). Hesse's choice of materials has created great challenges for museum conservators, and she even thought of writing to collectors of her latex works to warn them that they would not last.

Hesse once described her subject as "the total absurdity of life". Indeed, it is possible to see Minimal Art in general as rational only in the most superficial sense. On examination, the art reveals how chance and the unpredictable disrupt the apparent order of things.

LIFEline

1939 Family moves to London, then New York, to escape Nazi persecution of the Jews
1963 Exhibits drawings based on machine parts in New York
1964 Works in Germany, making constructions from materials found in a factory
1966 Work included in *Eccentric Abstraction* exhibition, New York
1970 Dies from a brain tumor

▼ **Accession II** *Hesse counted 50,760 holes in this box, each of which had to be threaded by hand with plastic tubing. The Minimalist cube was disrupted and made visceral and erotic by all these additions. Works like this one led the critic Robert Pincus-Witten to coin the phrase "Post-Minimalism." 1968–69, galvanised steel and plastic, 30¾ x 30¾ x 30¾in, Detroit Institute of Arts, US*

INcontext

SOFT FORMS Morris and Hesse applied the pared-down aesthetic of Minimalism to soft and flaccid forms, which had a very different effect on the viewer to the rigid geometrical shapes and pristine factory-made look more typical of Minimalism. For Serra, the process by which materials such as steel rusted and changed appearance over time became an integral element of his work.

Soft Engine Parts No. 2 *by Claes Oldenburg (1965). Morris and Hesse were influenced by Oldenburg's neurotic soft sculptures.*

► **Hang up** *Hesse called this "the most ridiculous structure I have ever made and that is why it is good." Like much Minimal Art, it is neither painting nor sculpture. 1966, acrylic paint, cloth cord, and steel tube, 72 x 86 x 78in, Art Institute of Chicago, US*

Richard **Serra**

Richard Serra, 1992

b **SAN FRANCISCO, 1939**

Of all the major Minimalist artists, Richard Serra evokes the world of industry and the factory most, through his use of materials such as lead and rusted steel. Some of his work has been described as "Process Art," in that its form is derived purely and simply from the way that it is made. Serra's sculpture frequently depends on its exact relationship to its site for its effect and meaning. When his controversial sculpture *Tilted Arc* (1981) was removed from its place in Federal Plaza, New York, Serra claimed that to remove it was to destroy it. There has sometimes been an element of political protest in his art. In the 2006 Whitney Biennial exhibition, for example, Serra showed a drawing attacking the ill-treatment of Iraqi prisoners by American troops in the Abu Ghraib prison.

LIFEline

1964 Completes art studies at Yale University
1968 Takes part in the Process Art exhibition *Nine*. Makes the first of his "prop" pieces in lead
1981 His controversial *Tilted Arc* is erected in New York. It was removed in 1989
1987 *Fulcrum*, a massive work in rusted steel, is erected outside Liverpool Street station in London
2007 Retrospective exhibition is held at MoMA in New York

◄ **One Ton Prop (House of Cards)** *This is one of a series of propped lead sculptures made by Serra. The components have not been welded together, but stand up by virtue of the weight and softness of the material. 1969, lead plates, height 48in, MoMA, New York, US*

▲ **The Matter of Time** *This installation in steel was commissioned for the Guggenheim Museum in Bilbao. Serra provides an experience that is only available at first hand to the visitor prepared to negotiate the passages created by the structure. 2005, steel, Guggenheim Museum, Bilbao, Spain*

Origins and influences

The term "Pop art" was first used in the mid-1950s to describe a group of young British artists and soon caught on in the US as well as in Britain.

As a reaction against the "art for art's sake" philosophy of post-war abstract art, Pop art can be seen as having its roots in Dada and Marcel Duchamp's ready-mades (see p.467). However, the striking imagery of popular culture that young artists saw all around them, in Hollywood movies, in the graphics used in advertising and packaging, comic strips, cartoons, and television, provided the bold new iconography they needed to debunk the stuffiness of the art world. Pop art emerged from meetings of the Independent Group (which included

▲ **Swingeing London 67** Richard Hamilton *The rock star Mick Jagger and Hamilton's art dealer Robert Fraser were arrested on drugs charges. This painting was made from a news photograph.* 1968–69, 26½ x 33½in, acrylic, collage, and aluminum on canvas

Richard Hamilton, Eduardo Paolozzi, and Lawrence Alloway) in London at the same time—but autonomously— that the Americans Jasper Johns and Robert Rauschenberg were starting to incorporate elements of commercial art into their work.

Style and subjects

Rejection of the painterly techniques of Abstract Expressionism prompted Pop artists to return to a figurative style and adopt the clean lines and flat colors of Hard-Edge painting (see p.523). The bold, stylized imagery of commercial art led to a detached and sometimes ironic style, with connotations of mass production rather than individuality.

As well as portraying mundane images of everyday life in the style of advertising billboards and comic strips, some artists, such as Rauschenberg in his combine paintings, incorporated the objects themselves into their work. Others, notably Andy Warhol, adopted techniques such as screenprinting, creating by implication a marketable product rather than a work of art.

Pop art challenged the distinction between "high" and "low" art and became the dominant art movement of the 1960s and 1970s in Britain and the US. Drawing its imagery from popular culture made it accessible, popular, and commercially successful.

Pop art

TIMEline

Pop art first appeared in the mid-1950s, when Jasper Johns started incorporating everyday objects and elements of popular culture into his work, as in *Target with Plaster Casts*. It reached its peak in the 1960s, when the rise of an affluent consumer society and mass media provided both a wealth of imagery and an appreciative market for American and British Pop artists such as Andy Warhol, Roy Lichtenstein, and David Hockney.

1955

JOHNS Target with Plaster Casts

1962

WARHOL Campbell's Soup

1963

JONES Man Woman

1964

LICHTENSTEIN Anxious Girl

1968

HOCKNEY American Collectors

Interpretations

More than any other movement in modern art, Pop art achieved widespread public appreciation and considerable commercial success, largely because it used familiar iconography in a figurative style. Despite its popularity, it was very much a British and American phenomenon, although related movements appeared elsewhere.

The US

American Pop art had its beginnings in Robert Rauschenberg's combine paintings, in collages or assemblages made from magazine cuttings, and objects such as Coca-Cola bottles, which symbolized the consumer society. At the same time, Jasper Johns, already a successful commercial artist, was producing pictures of familiar objects in paintings of flags, targets, and typographic symbols.

A later generation of Pop artists rejected the painterly style of these artists, but retained the commercial imagery: Claes Oldenburg created enlarged replicas of fast food and soft sculptures, Roy Lichtenstein

made huge comic strip scenes, and Andy Warhol produced flamboyant screenprinted pictures of celebrities and consumer products in his studio, aptly named "The Factory." The Pop artists' work was often characterized by humor and satire, exposing the consumerist values and obsessions of contemporary society.

Britain

British Pop artists were a less unified group than the Americans and many of them later rejected the label altogether. Richard Hamilton was perhaps the first to use the imagery of popular culture, and, together with Peter Blake and Eduardo Paolozzi, paved the way for the group of Royal College of Art graduates whose 1961 *Young Contemporaries* exhibition first brought Pop Art to the attention of the public.

The style of the British artists, although figurative and heavily influenced by graphic design, was less glossy and glamorous than American Pop art, and members of the group, including Patrick Caulfield, Allen Jones, and David Hockney, soon developed diverging styles of their own.

▲ **Family I** Sigmar Polke *Cheap, mass-produced comic strips inspired artists such as Roy Lichtenstein and Sigmar Polke to experiment with techniques that replicated the off-register effect of downmarket printing processes and to blow up images to a large scale. Polke increased the size of this family snapshot to 63 x 49½in.* 1964, dispersion color on canvas, on loan to Kunsthalle, Hamburg, Germany

▲ **Lipsticks in Piccadilly Circus, London**
Claes Oldenburg *This was the artist's irreverent proposal to replace the statue of Eros in Piccadilly Circus with a giant lipstick sculpture. Mass-produced objects and images often feature in Pop art.* 1966, mixed media on board, 10 x 8in, Tate, London, UK

Richard **Hamilton**

b LONDON, 1922

A British painter, printmaker, teacher, exhibition organizer, and writer, Richard Hamilton is regarded as one of the pioneers of Pop art. He is famous for his montages reflecting contemporary culture and advertising. In fact, Hamilton worked in advertising and commercial art before turning to painting. He also had a successful career as a teacher and organized a number of exhibitions, notably *The Almost Complete Works of Marcel Duchamp* at the Tate, London, in 1966.

Hamilton's paintings and prints have explored various aspects of popular culture, as well as the relationship between mass-produced and handmade imagery. His style has been criticized as austere and self-conscious, but he is generally noted for his wit, technical innovation, and intellectual sophistication. Hamilton has had a significant influence on many British artists, including David Hockney.

LIFEline

1922 Born into a working-class family in London
1938 Studies at the Royal Academy Schools, London
1948–51 Following World War II and National Service, continues his studies at The Slade School of Art
1952 Joins the Independent Group, a collection of artists and writers instrumental in the development of Pop Art
1953 Lecturers at King's College, Durham, until 1966
1970s Enjoys international acclaim with major exhibitions of his work around the world

► **"Just What Was it That Made Yesterday's Homes So Different, So Appealing?"** *Hamilton's most famous work marks the birth of British Pop Art. Made up of advertising images, the photomontage is a satire on consumerism and suburbia. It was produced for the* This Is Tomorrow *exhibition held by the Independent Group at Whitechapel Gallery, London, which explored the themes of technology and consumer culture. 1959, collage, 10¼ x 9⅜in, Kunsthalle, Hamburg, Germany*

▼ **Adonis in Y-Fronts** *This image incorporates classical references (Greek god, Adonis) and consumer culture (Y-fronts, a.k.a. briefs, were then considered sexy), showing how new fashions can be advertised to the masses.* 1962–63, silkscreen, 24 x 32¼in, Pallant House, Chichester, UK

CLOSERlook

THE LOLLIPOP The over-sized American Tootsie lollipop has the word "Pop" across its wrapper, a reference to John McHale, who collaborated on the work, and invented the term Pop art in 1954.

THE JAZZ SINGER The living-room window looks out over the street where a theater advertises a screening of Al Jolson's *The Jazz Singer*, the first talkie. It signifies technological progress and innovation.

THE PORTRAIT A painting of Victorian art critic John Ruskin is a reference to the relationship between fine art and consumer culture. He believed art should tell the truth and also encompass the artist's moral outlook.

Peter **Blake**

b DARTFORD, 1932

Painter, sculptor, and designer Peter Blake is often described as the godfather of British Pop art. He was determined to make art accessible, and a fascination with popular culture forms the basis for his work. Blake's use of imagery, from pin-up magazines to advertisements, captured the mood of the swinging 60s.

Portrait by Adam Birtwistle

He works across many different media and also produces graphic art, notably album covers. Blake often plays on the difference between reality and illusion, combining paint and collage so it is difficult to decide which is which.

LIFEline

1951–53 Does his National Service in the RAF
1953–56 Studies at the Royal College of Art, London
1962 Has his first solo show at the Portal Gallery, London
1983 Retrospective of his work is held at the Tate, London
2002 Receives a Knighthood

▼ **Siriol, She-Devil of Naked Madness** *Fake gems adorn this collage of a hermaphrodite-type figure, which was inspired by the billboards used to advertise circus freaks—a popular theme in Blake's work.* 1957, oil on canvas, 29½ x 8¾in, Pallant House, Chichester, UK

Robert **Rauschenberg**

Photograph by Bob Berg

b **PORT ARTHUR, TEXAS, 1925**; d **FLORIDA, 2008**

Together with fellow painter Jasper Johns, Robert Rauschenberg was one of the most influential figures in the move away from Abstract Expressionism. He is best known for the creation of "combine painting", an art form in which he combined an often bizarre mix of images and media, such as oil painting with screen-printed images and three-dimensional consumer objects. During the 1960s, Rauschenberg began working in two dimensions, using collages of news images to create silkscreen prints. Although seemingly abstract, viewed close up, the images relate to each other and he used them to illustrate a point about modern life. During the 1980s and 90s, he focused on collage, finding novel ways to transfer photographic images.

LIFEline

1948 Studies art at the Académie Julian, Paris

1948–52 Studies at famous experimental institution, Black Mountain College, North Carolina, and in New York

1958 Holds first solo show

1964 Controversially awarded Grand Prize at Venice Biennale

1970 Sets up studio in Florida, where he still lives

1998 The Guggenheim, New York, holds a retrospective

▼ **Tracer** *One of a series of silkscreen paintings Rauschenberg created between 1963 and 1964, this alludes to the Vietnam War and features a bald eagle and helicopters—symbols of patriotism and war. 1964, oil and silkscreen on canvas, 84¼ x 60in, Nelson Atkins Museum of Art, Kansas City, US*

POP ART

535

1945 ONWARD

▲ **Monogram** *Rauschenberg's most famous "combine painting" consists of a color-splashed wooden platform featuring a stuffed goat wearing a tire. It is thought to be a reworking of the religious masterpiece* The Scapegoat *by Pre-Raphaelite William Holman Hunt. 1955–59, mixed media, 42 x 63 x 64in, Moderna Museet, Stockholm, Sweden*

INcontext

TELEVISION The 1950s were a time of great optimism and consumer confidence, when increasing numbers of products were mass-marketed and advertised. Television was an exciting new medium that beamed entertainment and advertising messages into millions of homes, all of which had a huge impact on Pop art.

Advertisement for Philips Color Television, *published in* Réalité Magazine *in September 1967.*

66 Painting relates to both **art** and **life**. **A pair of socks** is no less suitable to make a **painting** than wood, nails, turpentine, oil, and fabric 99

ROBERT RAUSCHENBERG

▲ **Canto XXXI** *This is one of a series of illustrations of the 14th-century allegory Dante's* Inferno, *in which Dante and Virgil tour Hell. Rauschenberg used images transferred from print media to represent characters in the allegory; here, the Guardians of Hell are portrayed as Olympic athletes. 1959–60, solvent transfer, pencil, gouache, and color pencil, 14⅝ x 8¾in, Neuberger Museum of Art, New York, US*

Canyon *Robert Rauschenberg*
1959, combine on canvas, 81¾ x 70 x 24in,
private collection

Canyon Robert Rauschenberg

Rauschenberg's Canyon is one of the most celebrated of his "combine paintings." The artist was on the verge of international celebrity when he made it, but at the time the work of painters such as de Kooning was still far better known. Works such as *Canyon*, which bridged painting and sculpture, seemed to offer a way forward just when Abstract Expressionism (see p.502) had stopped attracting promising younger painters, and its language of expressive gesture was becoming conventional. Rauschenberg's use of second-hand images and real objects was to inspire the Pop artists who emerged on the New York scene soon afterward.

Composition

The critic Leo Steinberg has argued that Rauschenberg's methods of composition represent a fundamental shift in art, moving away from the idea of the painting as a vertical surface toward what he called the "flatbed picture plane" on which objects or images could be scattered. This concept applied regardless of whether the paintings were displayed on the wall or the floor.

◀ **"COMBINES"** By the time he produced *Canyon*, Rauschenberg had been working on his "combine paintings" for several years. Combine paintings lie somewhere between painting and sculpture: some works hang on the wall but also rest on the ground; others, like this one, have elements that exist in real space such as the eagle, or are subject to actual gravity (the hanging pillow).

❝ **When** working **the artist** must know that he **is doing it** for the **first time** ❞

ROBERT RAUSCHENBERG

Technique

Rauschenberg's materials frequently included stuffed animals which he collected for his work, usually without first knowing exactly how he would use them. The eagle was purchased at the auction of the estate of a deceased sculptor. This was in contrast to the Dadaist Marcel Duchamp's preference for mass produced objects or to Pop Art's concentration on consumer culture.

◀ **COLLAGE AND LETTERING** Picasso and Braque were the first to use stenciled lettering in their Cubist paintings. Rauschenberg's use of the device showed how Cubist influence not only served as a path to abstraction but also contributed to a new painting of modern life.

▶ **ABSTRACT EXPRESSIONISM INFLUENCE** Rauschenberg, who once made an artwork by erasing a de Kooning drawing, was ambivalent about Abstract Expressionism. He adopted its vigorous brushwork without its sense of emotional commitment. These marks owe as much to accidents of gravity as to personal passion.

Story

Any reading of Rauschenberg should take account of his love of the accidental during the working process. It is also likely that his homosexuality led him to conceal some of the meanings in his work. Nonetheless, *Canyon* suggests two distinct story lines. One is America in the space race. The other is a retelling of the classical legend of Ganymede, who was seized by an eagle to be cup bearer for Jupiter, the King of the Gods.

▲ ▼ **AMERICAN POWER** The eagle (above) and the Statue of Liberty (below) are both symbols of American power. They linked flight with national identity at a time when the US was engaged in a space race with the USSR. Part of the function of the pillow might be to symbolically ensure a soft landing.

◀ **SOURCE MATERIAL** Rauschenberg sometimes chose images of personal significance. This is a photograph of his son Christopher.

▼ **SPACE RACE** The image of the night sky could represent both the heavens into which Ganymede is raised and a symbol for the aspirations to travel into outer space.

INFLUENCES

REMBRANDT'S GANYMEDE
In his depiction of *The Abduction of Ganymede*, Rembrandt painted the boy being graspsed by an eagle. The buttocks in Rembrandt's version are echoed by the hanging pillow in *Canyon*. Another of Rauchenberg's works, *Pail for Ganymede*, comments on the urination of the boy in the painting.

The Abduction of Ganymede
Rembrandt, 1635

Jasper **Johns**

Photograph by C. Felver

b **AUGUSTA, GEORGIA, 1930**

Jasper Johns is a prolific painter, sculptor, and printmaker. He influenced the course of American art in the late 1950s by challenging the dominant Abstract Expressionist style with images of familiar, recognizable objects. *Flag* (1954–55) was a key work—a flat, literal representation of the *Stars and Stripes* that was the start of a series of paintings of flags. Such works by Johns and his close friend Robert Rauschenberg paved the way for Pop art, although Johns has never shared Pop's obsession with modern commercial culture. In his hands, what seem like copies of objects are in fact artistically modified, with textured surfaces for example, and subsequently led on to long series of related images varying in form, color, or media. Ordinary objects freshly perceived have also been the basis for sculptures, collages, and prints. In his later work Johns has continued to strike out in new directions.

LIFEline

1954 Settles in New York and paints his first flag picture
1955 Targets and numbers become frequent subjects
1958 Holds his first one-man show in New York
1959 Paints *False Start*
1974 Begins making abstract work with dense cross-hatchings
1985 Creates a series of prints entitled *Seasons*
2006 *False Start* sells for $80 million, the most expensive painting by a living artist.

◀ **Target** *Targets, like flags, were ordinary objects that made an early appearance in Johns's work. He used them repeatedly with many variations. Here, the presence of the plaster casts of body parts in compartments that open and shut adds an enigmatic touch.* 1955, encaustic and collage on canvas, 29½ x 26in, MoMA, New York, US

▼ **Three Flags** *More elaborate than the original* Flag, *this consists of three canvases of different sizes, each painted with the Stars and Stripes. By putting them together, Johns transforms them into a single three-dimensional work.* 1958, encaustic on canvas, 30¾ x 45¼in Whitney Museum of American Art, New York, US

◀ **Numbers in Color** *Beginning in 1955 with works in the form of a single digit, Johns created dozens of number images, including this large, game-like grid, rendered in a colorfully rough, patchy manner.* 1958–59, encaustic and newspaper on canvas, 66½ x 49½in, Albright-Knox Art Gallery, Buffalo, New York, US

▼ **Painted Bronze II: Ale Cans** *Johns has made sculptures of objects such as paint pots, metal cans, and shoes. They may be real objects sprayed to give a metallic finish, or, as with this, cast in bronze and painted. One of the cans is solid (full) and one hollow (empty).* 1964, painted bronze, private collection

◀ **Field Painting** *Apart from the vertical lines of stencilled lettering, this painting harks back to Johns's youthful Abstract Expressionist style. Among the objects attached to the canvas is a battery-operated neon "R".* 1963–64, oil on canvas and attached objects, artist's collection

CLOSERlook

MIXING DIMENSIONS Embedded into the two-dimensional surface of *Field Painting* is a three-dimensional object of personal significance: a Savarin coffee can. Johns used it in his studio to hold brushes and it was also the subject of one of his sculptures.

❝ Sometimes **I see it and then paint it**. Other times **I paint it and then see it**. Both are impure situations, and **I prefer neither** ❞
JASPER JOHNS

Claes **Oldenburg**

b **STOCKHOLM, 1929**

One of the most influential and original artists working in the US, Swedish-born sculptor and graphic artist Claes Oldenburg is famous for his giant sculptures of food and his soft sculpture of typically rigid objects such as typewriters. His art is sometimes whimsical, often provocative, and is influenced by Dada and Surrealism.

After settling in New York in the mid-1950s, Oldenburg came into contact with artists such as Allan Krapow, whose theatrically orientated work offered an alternative to Abstract Expressionism. Oldenburg helped create props and costumes for performance art, sparking an interest in three-dimensional work. Later, he focused on creating colossal art projects for several cities, such as *Lipsticks in Piccadilly Circus* (1966). In 1995, the National Gallery of Art in Washington DC and the Guggenheim in New York held retrospectives of his work.

LIFEline

1929 Born in Stockholm, the son of a consular official

1946–50 Studies art and literature at Yale University

1953 Becomes a US citizen

1956 Moves to New York

1959 Stages his first exhibition at the Judson Gallery, New York

1961 Opens *The Store* in his New York studio, selling everyday objects made of painted plaster

1969 His colossal monument, the iconic *Lipstick (Ascending) on Caterpillar Tracks* is initially installed at Yale University

▼ **Floor Burger** *This giant hamburger is an early example of Oldenburg's soft sculptures. His first wife, Patty Muscha, sewed the canvas cover and Oldenburg painted it with delicate washes of color. He uses everyday objects to explore the different identities a form assumes through changes of scale, material, or environment. 1962, acrylic on canvas, filled with foam rubber and cardboard boxes, 52 x 83⅞in, Art Gallery of Ontario, Toronto, Canada*

CLOSERlook

DISPARITY By invoking sensations of touch and taste, Oldenburg highlights the disparity between the subject and the material. This is in distinct contrast to traditional still life, which tries to overcome the distinction between the subject and the material.

▶ **Three-Way Plug, Model**
The incongruity of the size of this giant sculpture of an electric plug and the fact that it is suspended like a mobile is typical of Oldenburg's quirky humor. 1969, wood and masonite, 59⅛ x 39 x 28¼in, Kunsthalle Hamburg, Germany

▲ **Toy Box** *Oldenburg used familiar objects such as children's toys and recreated them using painted fabric. 1963, wooden box and 21 objects of fabric and paint, 9⅜ x 36 x 24in, Kunsthalle Hamburg, Germany*

Roy **Lichtenstein**

Photograph by Ray Fisher

b **NEW YORK, 1923**; d **NEW YORK, 1997**

An American painter, printmaker, and sculptor, Roy Lichtenstein is famous for his highly distinctive work based on cartoons and advertising. He magnified his images to a grand scale, recreating the garish, primary colors, black outlines, flattened forms, and Benday dots of mass-produced printing processes. Although his art reflects popular culture in a humorous, often ironic way, he presents it in a detached, deadpan manner.

Lichtenstein's preoccupation with Pop art is reported to have begun in the early 1960s when one of his children pointed to a comic strip and said, "I bet you can't paint as good as that." By the mid-60s, he was producing screenprints and also Pop parodies of famous paintings by artists such as Mondrian. Lichtenstein's work has enjoyed worldwide critical acclaim and has an enduring popular appeal.

LIFEline

1923 Born in New York

1949 Graduates from the School of Fine Arts, Ohio

1962 Holds his first one-man show of Pop Art, in New York

1963–65 Produces paintings based on war and romance comics

1966 Becomes first American to exhibit at The Tate

1970s His work expands to include sculpture mostly in polished brass with an art deco influence

1995 The Los Angeles County Museum launches a traveling exhibition covering two decades of his prints

1997 Dies from viral pneumonia, aged 73

▲ **Sandwich and Soda** *During this period, Lichtenstein was experimenting with high art subjects such as still life, recreated in a mechanical style using unrealistic colors. 1964, screenprint, 22 x 24in, Fred Jones, Jr. Museum of Art, University of Oklahoma, US*

➤ Anxious Girl *From a series of paintings featuring close-ups of girls in distress, Lichtenstein transformed the comic image into something much more personal. His use of Benday dots and black-outlined forms is part of his distinctive style, along with the use of stereotypical female subjects from comic strips, such as this all-American, blue-eyed blonde. 1964, private collection*

CLOSERlook

DOTS/PIXELS Lichtenstein re-created the effect of Benday screening by using a technique that simulated the mass-produced, cheap printing typically used for comics. In the late 60s, he began to make the dots larger in proportion to the size of the canvases.

◄ Reflections on Crash
Lichtenstein began his Reflections series in the mid-1980s. It reveals his concern for composition and form, in which he combines the abstract with his comic images. 1990, lithograph, woodcut, screenprint, and collage on paper, 65 x 79½ in, Delaware Art Museum, Wilmington, US

INcontext

COMICS Mass-produced, cheap, and highly visual, comic books were another aspect of popular culture that had a great impact on the development of Pop Art in the 1950s and 60s. Their garish colors, simplistic forms, melodramatic narrative, and immediacy were used to reflect society, often in an ironic or humorous way.

Pop art *used imagery from popular comic strips of the 1950s and 60s.*

Andy **Warhol**

b **PITTSBURGH, 1928**; d **NEW YORK, 1987**

Andy Warhol, 1983

Born Andrew Warhola to Czech immigrant parents, Warhol worked as an award-winning commercial artist from the 1950s, before becoming a Pop Art pioneer. His art embraced the popular culture of mass media, celebrity, and consumer goods, with imagery ranging from the banal (repeated rows of Coke bottles or a six-hour film of a sleeping man) to the glamorous (portraits of Hollywood stars) and the macabre (car crashes and suicide). It deployed the distinctive visual language of modern advertising with its use of garish colors, simplified imagery, and repetition.

Setting himself up as businessman first and artist second, Warhol devoted an enormous amount of time and skill to the cultivation of publicity in order to raise his profile and thus his prices. At the same time, he turned his "art" into a successful enterprise with the use of mechanical printing processes, such as serigraphy (silk screens) to allow the rapid production of (almost) identical images. He deliberately removed all traces of involvement by the artist by employing assistants to realize his ideas and by not signing his work.

A key figure in 20th-century art, Warhol, like Picasso before him, represented a turning point for the role of artists and their way of doing things. He also pursued parallel careers as a film-maker, fashion designer, promoter, and publisher.

LIFEline

1928 Born in Pennsylvania
1941 Begins his career as a commercial artist
1961 Creates his first artwork, *Campbell's Soup Cans 200*
1963 Founds The Factory
1964 Exhibits at *The American Supermarket* show
1966 Directs his best-known film, *Chelsea Girls*
1968 Is shot and wounded near-fatally by former employee Valerie Solanas
1973 Founds *Interview* magazine
1987 Dies from a heart attack, leaving an estimated $100,000,000

▶ **Brillo Boxes** *These screenprinted boxes marked Warhol's move into sculpture with the mass reproduction of the packaging for popular brands, such as Brillo, Heinz, and Del Monte. The 1964 New York show* The American Supermarket, *at which they were exhibited (and sold for $350 each), was a pivotal event in the acceptance of Pop Art in the USA. 1964, enamel on plywood, 16¾ x 20¼ x 16¾in, Allen Memorial Art Museum, Ohio, USA*

▲ **Campbell's Soup Can**
This iconic image of consumerism (and a favorite food of Warhol's) created a sensation when it was first exhibited. Warhol adopted the bold, direct techniques of commercial art, using a stencil to help him apply the paint and give it the appearance of a billboard with its bright, flat colors and clean lines. 1962, screenprint, 20¼ x 16¼in, Saatchi Collection, London, UK

▶ **Marilyn Diptych** *When the actress Marilyn Monroe committed suicide, she was already a legend—her combination of glamour and tragedy made her the perfect subject for Warhol. His Marilyn portraits—based on a famous publicity still—of which he produced many variations, introduced a radical new technique (serigraphy) to the traditional genre of portraiture. Marilyn's status as a star shared by millions but known by none is reinforced by the image's repetition, while the contrast between the gaudy glamour of the left against the fading tones of the right mirrored her own mortality. 1962, acrylic on canvas, 4¾ x 6¾ft, Tate, London, UK*

POP ART

1945 ONWARD

Flowers *A photograph of hibiscus flowers on a green background was overlaid with endless different vibrant color combinations and produced in vast numbers. The effect was to transform the flowers into a kind of psychedelic decor.* 1966, silk-screen print, 82 x 141 in, Saatchi Collection, London, UK

◀ **The Electric Chair** *Warhol's fascination with death found expression in his* Death and Disaster *series, with its indifferent images of suicide, car crashes, and the electric chair. He used repetition and color washes to distance the viewer from the subject, thereby reducing it to a decorative object.* 1967, acrylic and silk-screen enamel on canvas, 54 x 73 in, private collection

CLOSERlook

YELLOW BRUSHSTROKES Six colors were applied to the left side with the help of a stencil. In each panel, Marilyn's portrait is subtly altered by variations in pigment. The use of wide yellow and orange brushstrokes is visible.

SCREEN PRINTING An excess of black paint occasionally obliterates or spoils the image. These deliberate variations highlight the technical process behind its production.

◀ **Mao Tse-Tung** *In 1972, Warhol decided to celebrate an easing of relationships with China by creating a series of portraits of Chairman Mao. Painting different colors over the same iconic photograph, he transformed a mass-reproduced state image into art, while simultaneously subverting its original propaganda message with a tone of high camp. The squiggles around the head were hand-drawn by the artist.* 1972, silk-screen print, 36 x 36 in, private collection

> " **Making money is art**, and working is art, and **good business is the best art** "
>
> ANDY WARHOL, 1975

INcontext

THE FACTORY In 1963, Warhol painted his Greenwich Village studio silver and renamed it The Factory in homage to his business model of mass-producing art. He was also heavily involved there producing "underground" films, such as *Chelsea Girls* (1966), and music, including the Velvet Underground.

Andy Warhol with Actors at "The Factory" *The most famous workers at The Factory were its superstars—the polysexual actors featured by Warhol (left) in his films.*

David **Hockney**

David
Hockney

b **BRADFORD, 1937**

With his trademark shock of white hair and glasses, David Hockney has been a colorful and familiar public figure since the 1960s. By his mid-20s, this British painter, draftsman, printer, photographer, and designer had already achieved international success, and he has gone on to become the most famous British artist of his generation.

Hockney is probably best known for his California swimming pool paintings, his huge double portraits of friends, and his photographic collages. The main characteristics of his work include his treatment of color and light, and his ongoing battle with the conventions of perspective. Hockney's work is often autobiographical, and sometimes homoerotic. Witty, versatile, and inventive, he has experimented with many media, including acrylics in the 1960s, Polaroid film in the 1970s, and digital art in the 1990s. He is also a brilliant graphic artist, a stage designer, and a respected art commentator and writer.

LIFEline

1959–62 Studies at the Royal College of Art, London
1963 Holds first solo exhibition
1964 Moves to Los Angeles and produces his first swimming pool paintings
1970 First retrospective is held in London. Paints *Mr. and Mrs. Clark and Percy*, the best-known of his double portraits
1982–84 Makes first composite Polaroids and photographic collages
1990 Creates *40 Snaps of My House*, one of his first works with digital photography
2003 Receives Lifetime Career Award at the Florence Biennale

▼ **Ron Kitaj Reading** *An artist and close friend of Hockney's, Ron Kitaj was well-known for his love of books; his studio was also a library. Here, Hockney experiments with perspective by placing Kitaj as a large, vertical form in the foreground against the background bookcase—a grid of smaller vertical and horizontal lines. 1974, colored crayons, 16⅞ x 28in, private collection*

◀ **American Collectors** *This double portrait of Marcia and Fred Weisman has come to epitomize American art collectors. Standing in intense Californian sunlight, the couple seem unaware of each other and of their collection. Their rigid stance and form is echoed variously in the art. 1968, acrylic on canvas, 84 x 120in, Art Institute of Chicago, US*

▲ **Meeting the Other People** *from* **A Rake's Progress**
Hockney's first set of prints was based on etchings by English artist William Hogarth for A Rake's Progress. Hockney's version is a semi-autobiographical series of 16 prints set in New York. Here, the formerly successful young man is destitute, and about to be consigned to the mindless masses, the "other people." In the final print, Bedlam, he stands side by side with identical figures. Having lost his sense of identity, he is only distinguishable by a red arrow above his head. 1961–62, etching and aquatint on zinc, red and black ink on paper, 12¼ x 15¾in, Yale Center for British Art, US

▲ **Sunbather** *Part of the famous California swimming pool series, this painting shows Hockney's move from Realism to Naturalism, when he started painting specific people and places. It also illustrates his preoccupation with perspective; here, he juxtaposes flat and deep space. There is often a homoerotic quality to his work, as in the muscular, bare buttocks of the male figure. 1966, acrylic on canvas, 72 x 72in, Ludwig Museum, Cologne, Germany*

CLOSERlook

WATER In California, Hockney began using acrylics, applying them as a smooth surface of intense, flat color that helped to emphasize the bright sunlight on the water. The wavy lines are used to show the hypnotic effect of the pool's ever-changing, reflective surface.

❝ **Surface is illusion**, but so is depth ❞
DAVID HOCKNEY

Eduardo **Arroyo**

b **MADRID, 1937**

The Spanish painter, sculptor, printmaker, and stage designer Eduardo Arroyo often uses imagery in the Pop Art style to satirize and provoke. Largely self-taught, he went to Paris in 1957 to avoid military service, and first showed there at the Salon of Young Artists around 1960. His work is representational and figurative, often alluding to clichés, historic events, and public figures to tell a story or to criticize—usually controversially. A retrospective of his work was held in Paris in 1982, and in the same year he was presented with the National Award for Fine Arts by his native Spain. The following year, France made him a Knight of the Arts and Literature.

◄ **Blue Rider on the Canabiere** *Typically colorful and ironic, this work is characterized by flattened perspective and a lack of spatial depth.* 1987, oil on canvas, 86½ x 73¼in, Musée Cantini, Marseilles, France

CLOSERlook

COLOR The simplification of areas of color on the central male figure's face brings Arroyo's work closer to abstraction.

Mel **Ramos**

b **SACRAMENTO, 1935**

A hugely popular American artist, Mel Ramos is best known for his jokey nude or scantily clad "pin-ups." He says of his work, "I always make sure that my pictures are not too erotic and that they have a trace of humor." This is usually reflected in his titles, such as *You Get More Spaghetti with Giacometti.*

▼ **Vinaburger** *Ramos's pin-ups are draped over oversized commercial items from popular culture, such as this hamburger, to parody the supposed glamour of advertising.* 1965, color litho, 18⅞ x 15in, Wolverhampton Art Gallery, UK

Allen **Jones**

b **SOUTHAMPTON, 1937**

▲ **Man Woman** *Inspired by German philosopher Friedrich Nietzsche, Jones made a series of paintings showing fused couples as metaphors for creativity—a perfect marriage between masculine and feminine sides.* 1963, oil on canvas, 84½ x 74½, Tate, London, UK

An English painter, sculptor, and printmaker, Allen Jones is a leading figure in Pop Art. He received the *Prix des Jeunes Artistes* (The Young Artist Prize) at the 1963 Paris Biennale, and moved to New York the following year. Jones is best known for his controversial portrayals of women, based on the fetish magazines of the 1940s and 50s, including his sculptures in which female figures double as pieces of furniture.

Sigmar **Polke**

b **OELS, GERMANY, 1941**

Sigmar Polke is considered one of the most important German painters of the post-war generation. Marked by irreverence for traditional painting techniques and materials, his work has an anarchic element, which has seen him described as a "visual revolutionary." Polke uses Pop Art-related images in unexpected, often contradictory combinations to encourage the viewer to question conventional methods of art evaluation. His series of *Grid Pictures,* for example, was painted with the aid of projectors.

Polke's paintings usually take the form of commentaries on other works of art and employ humor to parody artistic pretentiousness, particularly concerning modern art.

LIFEline

1965 His *Girlfriends* painting questions the authority of the printed image
1977–91 Made professor at the Academy of Fine Arts, Hamburg
1981 *Untitled—Referring to Max Ernst* commentates on other paintings
2002 *The Hunt for the Taliban and Al Qaeda* shows his newly developed technique of machine-painting

INcontext
THE RISE OF POP ART coincided with increasing public anxiety about the manipulative power of the advertising industry, whose images were a source of inspiration for Pop artists. There was a feeling that the ordinary consumer was no more than a pawn.

Vance Packard's book *The Hidden Persuaders* (1957) lifted the lid on the techniques used by advertisers to control the desires of their audience.

The Hidden Persuaders
Vance Packard

► **Moderne Kunst** *In this parody of 1950s expressive gestural abstraction, Polke creates patterns similar to those of artists such as Soulage and Hartung.* 1968, artificial resin and oil on canvas, 59 x 49¼in, on loan to the Kunsthalle, Hamburg, Germany

Moderne Kunst

CLOSERlook

PARODY Polke exaggerates the expressive brushwork that characterizes informal abstraction, to parody what he views as the artistic pretentiousness of modern art.

▲ **George and Gugu** *Polke combines signs and techniques to provoke and intrigue, rather than to tell a story. The shadowy figure on the right is modern; those on the left are clowns, probably from the* commedia dell' arte, *evoking a contrasting historical era.* 1968, acrylic on fabric, 23½ x 86½in, on loan to the Kunsthalle, Hamburg, Germany

Portraits

Portraiture played an important role in ancient Greek and Roman art, but for centuries during the Middle Ages it was of only minor significance, confined mainly to coinage and tomb statues. From the Renaissance portraiture once again developed into a major artistic practice, broadening in scope as it embraced various levels of society. In the 19th century, photography offered a powerful challenge to the traditional documentation of portraiture, but many modern artists have shown fresh ways of approaching the subject.

► **Mummy Portrait of a Young Man Wearing a Golden Wreath** Egyptian, *Mummy portraits—attached to the face of mummies about to be buried —are an example of the ancient tradition of panel painting.* c138–192, encaustic on panel with gold leaf, 16⅛ x 7⅞in, Staatliche Museen zu Berlin, Germany

▼ **Mona Lisa** Leonardo da Vinci *The enigmatic expression of the Mona Lisa is attributable to the artist's use of* sfumato, *a subtle blurring of colors and tones.* c1503–6, oil on panel, 30¼ x 21in, Louvre, Paris, France

► **The Shrimp Girl** William Hogarth *Howarth's vivid sketch has a freshness and vitality which eluded him in more formal portraits of the wealthy and powerful.* c1745, oil on canvas, 25 x 20in, National Gallery, London, UK

▼ **Family Group in a Landscape** Frans Hals *Hals' charming depiction of a family is set against a background painted by another, unidentified artist.* c1647–50, oil on canvas, 58¾ x 98¾in, National Gallery, London, UK

▲ **Portrait of Margaret van Eyck** Jan van Eyck *The subtle detailing of the subject's face helps create the realism for which van Eyck's portraits are noted.* 1439, oil on panel, 13 x 10¼in, Groeningemuseum, Bruges, Belgium

▲ **Elizabeth I, Armada Portrait** English School *This portrait is a celebration of English sea power as well as an idealized image of the monarch, and so funcions as propaganda on two levels.* c1588, oil on panel, 43¾ x 50in, private collection

◄ **Miniature portrait of Mrs. Pemberton** Hans Holbein the Younger *Holbein's miniatures embody the power and detail of larger portraits in a smaller form.* c1535, vellum mounted on playing card, Victoria and Albert Museum, London, UK

▲ **Mrs. Sarah Siddons, the Actress** Thomas Gainsborough *The rich, dramatic colors of this portrait reflect Siddons' status as the leading tragic actress of her age.* 1785, oil on canvas, 49½ x 39¼in, National Gallery, London, UK

➤ A Woman Holding a Dog in her Arms, from "Five Physiognomies of Beauty" Kitagawa Utamaro *Delicately rendered female forms are a recurring subject of Utamaro's work.* c1804, woodblock print, 15½ x 10¼in, School of Oriental and African Studies Library, London, UK

▼ Willhemina Cotta Christian Gottlieb Schick *This formal composition is typical of Schick's classical approach to portraits.* 1802, oil on canvas, Staatsgalerie, Stuttgart, Germany

▼ Portrait of Guillaume Apollinaire Giorgio de Chirico *The poet Apollinaire's likeness is seen only in the dark and in profile. The more prominent head with dark glasses is a symbol of researches into the unknown.* 1914, oil on canvas, 321 x 256in, Musée National d'Art Moderne, Centre Pompidou, Paris, France

▼ Girl with Roses Lucian Freud *Translucent skin, stark backgrounds, and troubled expressions are all hallmarks of Freud's portraiture.* 1947–48, oil on canvas, 41¾ x 29⁹in, British Council, London, UK

▲ Arrangement in Gray and Black No.1, Portrait of the Artist's Mother James McNeil Whistler *Although one of the most popular images of motherhood, for Whistler this was primarily an exercise in color and tone.* 1871, oil on canvas, 56¾ x 64¼in, Musée d'Orsay, Paris

▲ Portrait of Ambroise Vollard (1868–1939) Pablo Picasso *In this portrait of his dealer, Picasso demonstrates an extraordinary virtuosity by producing an image of a curved and bald head entirely out of jutting angles.* 1909, oil on canvas, 36¼ x 25½in, Pushkin Museum, Moscow, Russia

▲ Self Portrait Jenny Saville *This is a typical example of Saville's large, fleshy depictions of women.* c1991, oil on canvas, 80¼ x 80¼in, private collection

◀ Gilbert and George *The duo's photo-montages often feature an element of self-portrait, and are frequently set behind grids, giving the appearance of stained glass.* 1986, paper, 95¼ x 79½in, Whitworth Art Gallery, Manchester, UK

➤ Portrait of Ambroise Vollard Pierre-Auguste Renoir *Renoir's fine brushstrokes and subtle coloring complement Vollard's reflective expression.* 1908, oil on canvas, 32¼ x 25½in, Courtauld Gallery, London, UK

Op, or optical art, is painting or sculpture that utilizes the illusions and optical effects that our eyes perceive. Kinetic art refers to works that have real or apparent motion.

Op art

Op art as a term was first used in an unsigned article in *Time* magazine on October 23, 1964, but its origins can be found both in the use of ornament, anamorphosis (visual distortion), and trompe l'oeil effects in art history, and the colored and graphic effects of Post-Impressionists, Futurists, Dadaists, and the Bauhaus artists. It also has links with psychological research into the relationship of the mind to the eye and to the nature of perception itself.

▲ **The Responsive Eye** *The survey of Op art held at the Museum of Modern Art in New York in 1965 entitled "The Responsive Eye" did much to popularize Op art.*

Kinetic art

Kinetic art first developed in the years 1913–20 when artists such as Marcel Duchamp, Naum Gabo, and Vladimir Tatlin began to emphasize mechanical movement in their work, Man Ray and Aleksandr Rodchenko first made hanging mobiles, and a few years later, members of the Bauhaus explored projection techniques to develop light and movement. The word "kinetic" was first used in reference to art by Gabo and Antoine Pevsner in 1920, but it was the publication of a chronology of kinetic art in 1960 by the filmmaker Wolfgang Ramsbott that established the movement in its own right.

CURRENTevents

1960 John F. Kennedy is elected president of the US.

1963 March against racial discrimination led by Martin Luther King, Jr., takes place in Washington, D.C.

1964 The "British Invasion" of the US begins with the first visit by the Beatles.

1964 US Congress approves war with North Vietnam.

1969 The first people set foot on the moon watched by an estimated 700 million television viewers around the world.

During the 1960s, Op art and kinetic art became immensely popular and, in the case of Op art, the subject of much commercial interest and exploitation. Both had their origins in the early years of the 20th century, and retain their importance today.

Op art and Kinetic art

TIMEline

Op art's quick development from black and white geometry to color manipulation can be seen in these works by Vasarely and Riley, painted only seven years apart. Both are precisely planned and produce the same illusory effect of depth. Kinetic art's evolution can be seen in the early mechanical works of Jean Tinguely, through the use of wood and wire by Jésus Rafaël Soto and to the large-scale mural installation in the Elysée Palace in Paris by Yaacov Agam.

1954

TINGUELY Meta-Mecanique a Trepied

1956

VASARELY Mindoro II

1963

RILEY Fall

1963–66

SOTO Large Writing

1972

AGAM Salon Agam

▲ **Wackel-Baluba** *Jean Tinguely The impact of Dada and Surrealism is evident in this kinetic construction by Jean Tinguely, the chimp on top echoing King Kong astride the Empire State Building, New York, in the 1933 classic horror film. 1963–72, mixed media, 71¾ x 29½ x 29½ in, private collection*

Development

The first works of modern Op art were produced by Victor Vaserely in the 1950s. At the same time, Jean Tinguely started to create the first modern works of kinetic art.

Modern Op art

Op artists use color, line, and shape to produce shimmering, shifting, sometimes dazzling surfaces that lend the work the appearance of motion. Both the geometric images and colors are worked out in advance to achieve the intended effect, which is often produced by studio assistants rather than the artist, as technical rather than artistic skills are required.

Initially working in black and white, Vaserely's introduction of color transformed his work, as the addition of a differently colored geometric form to the basic structure began to explore the full extent of optical, two-dimensional art. Bridget Riley also first started with black and white designs, but introduced color in the mid-1960s, again expanding the range of optical illusions she produced.

Riley preferred to use the term "perceptual abstraction" to describe her art, as did William Seitz, who was curator of the groundbreaking "The Responsive Eye" exhibition (see above); it was held in New York in 1965 alongside a commercial, sell-out show in the Richard Feigen Gallery. Riley had two paintings in the exhibition, which launched her as an international artist, but she disliked the appropriation of her and other's work for commercial uses later in the decade, when Op Art was adopted as part of the 1960s' counterculture movement in music, fashion, and design.

Modern kinetic art

The development of Kinetic art during the 1960s followed either the Constructivist tradition (see p.462), in which the work was technological or natural in origin, or the Dadaist tradition (see p.466), in which the work was conceived within an environment or required human intervention and participation.

Kinetic art is a diverse form, using paint, fluorescent strip lights, reflecting surfaces, found materials and much more, whether as individual pieces or large-scale installations, to achieve its effects. It declined in importance during the 1980s, but retains its influence today in works requiring audience participation.

▲ **Untitled (Winged Curve)** *Bridget Riley Riley's use of a series of differently spaced and thickened curved lines creates the illusion of a three-dimensional moving object despite its two-dimensional, static state. 1966, screenprint on paper, 22¾ x24½in, private collection*

Jean **Tinguely**

b **FRIBOURG, 1925;** d **BERN, 1991**

Photographer
Eric Preau

Jean Tinguely began experimenting with mechanical sculptures when he was a teenager, hanging objects from the ceiling and using a motor to make them rotate. He went on to produce his first abstract, spatial constructions in 1953. These early machines, which he termed "meta-mechanical devices," were equipped with moving mechanisms that could be set in action by the viewer and were characterized by their use of movement as a central part of their construction.

In the mid-1960s, Tinguely started to produce large-scale works welded out of scrap metal, and subsequently turned his attention to fountains, the most notable of which is the *Stravinsky Fountain* (1982) outside the Pompidou Center in Paris. A series of three-part altars, called *Poja* (1982–84), suggests a religious aspect to his work. In 1986, he introduced another new theme, death, in *Mengele*—a *danse macabre* in the form of a mechanical theater.

LIFEline

1945 Paints in a Surrealist style, but soon abandons this to concentrate on sculpture

1953 Moves to Paris

1955 Participates in *Le Mouvement*, an exhibition of Kinetic Art in Paris

1960 Co-founds the *Nouveau Réalisme* movement

mid-1960s Produces his first monumental works for urban settings

mid-1970s Designs fountains for public places

1986 Produces 16 *Mengele* sculptures on the theme of death

▼ **La Bascule VII** *Tinguely's use of scrap materials animated by an electric motor can be seen in this playful representation of a seesaw, which rocks from side to side.* 1967, iron, wood, steel, rubber, and electric motor, 48½ x 32¼ x 80¾in, Museum of Fine Arts, Houston, US

◀ **Méta-Mécanique à Trépied** *A small electric motor drives the wheels, arms, and counterweights of this construction set on top of a simple tripod. The piece was designed around movement and cannot properly be assessed when stationary.* 1954, mixed media, 39½ x 35½ x 11¾in, private collection

CLOSERlook

WHEELS IN MOTION
The use of wire to make the wheels, struts, and cogs, rather than factory-manufactured gears and other parts, gives the machine an uneven, mechanistic movement.

Yaacov **Agam**

b **RISHON-LE-ZION, 1928**

Yaacov Agam studied at the Bezalel Academy in Jerusalem in 1946, and, from 1951, at the Atelier d'Art Abstrait and the Académie de la Grande Chaumière in Paris. He claimed that his one-man exhibition at the Galerie Craven in Paris in 1953 was the first ever exhibition of Kinetic Art and that he was the first optical-kinetic artist. These claims have been disputed. Agam was, however, among the first artists to encourage spectator participation, allowing people to arrange the various elements of the *Transformable Pictures* series (1951–53) and the sonic elements of *Sonore* (1961), which he described as a tactile painting with acoustic effects. His later works are as much optical as kinetic in their effect.

▲ **Salon Agam** *Agam produced this light installation in the Elysée Palace for President Georges Pompidou. The walls are covered with polymorphic murals of changing images, while the ceiling and carpet are kinetic. The scene changes according to the spectator's position and point of view.* 1972, mixed media, 185 x 216 x 245in, Pompidou Center, Paris, France

Julio **Le Parc**

b **MENDOZA, 1928**

▲ **Continual Mobile, Continual Light** *White light reflects off the polished metal pieces in the center of this piece to produce a sensation of continuous movement.* 1963, mixed media, 23½ x 23½ x ½in, Tate, London, UK

One of the most active of the South American Kinetic artists working in Paris in the 1950s, Le Parc played a major role in launching Kinetic Art in Europe. In 1960, he joined the French art group, Groupe de Recherche d'Art Visuel, where his theoretical rigour established his reputation. In 1953 he began working on two-dimensional compositions in color or black and white, but later developed a series of works that made use of "skimming" light, reflected and broken up by polished metal surfaces.

Hélio **Oiticica**

b **RIO DE JANEIRO, 1937;** d **RIO DE JANEIRO, 1980**

Hélio Oiticica emerged during the 1950s as one of Brazil's most innovative artists, liberating color from two-dimensional painting into three-dimensional artworks. His first paintings were solid-color abstracts, but in the *Metaesquemas* series of 1957–58 he sought to dissolve the two-dimensional picture and its grid stucture with a dynamic combination of squares and rectangles outlined in various colors. He followed this with a series of white-on-white paintings, *Série Branca* (1958–59), in which he experimented with layering and brush techniques to maximize the effect of light on color. These experiments led him to produce three-dimensional works that hung from the ceiling or stood on the floor, forcing viewers to walk through them.

▲ **Grande Núcleo (Grand Nucleus)** *The luminous yellows of the outer panels give way to violet tones at the center of this vast open maze, giving the piece vibrancy and life.* 1960–66, oil and resin on wood fiberboard, César and Claudio Oiticica Collection, Rio de Janeiro, Brazil

Victor **Vasarely**

b **PECS, 1908**; d **PARIS, 1987**

Vasarely studied at the Budapest Academy of Painting and the Mühely Academy, known as the "Budapest Bauhaus." There, he became aware of the geometrical language used by the main teachers of the original Bauhaus, such as Wassily Kandinsky and Paul Klee.

He moved to France in 1930, and in the 1940s developed a geometric abstraction based on Mondrian and Malevich. Vasarely paid tribute to the latter in his series *Homage to Malevich* (1952–58), using his black square on a white background, but turning it on its axis so that it became "dynamized." Vasarely used illusory effects like this to transform structures into vibrant forms that could dazzle the spectator's eye.

➤ **Mindoro II** *Vasarely's debt to Malevich is evident in the black and white geometric abstraction of this work, in which two overlapping rectangles are pulled apart to create a kinetic impact.* c1956, oil on canvas, 51¼ x 76¾in, Pompidou Center, Paris, France

" **Every form** is a base for color, **every color** is the attribute of a form "

VICTOR VASARELY

Jesús Rafaël **Soto**

b **CIUDAD BOLIVAR, 1923**; d **PARIS, 2005**

Soto's early style was influenced by Cézanne and Cubism, and he was also aware of the Soviet Constructivists, through reproductions of their work. In 1950, he moved to Paris, where he began to produce abstract paintings with repeating geometric forms that suggested movement. He produced his first kinetic work, *Spiral*, in 1955.

Soto preferred to work with modern and industrial synthetic materials, such as nylon and steel, but in the early 1960s he investigated the textures of found objects, such as old wood, rusty wire, and rope. His kinetic sculptures create an opposition between dynamic and static elements, in his large installations blurring the distinction between reality and illusion. His work usually exploits the "moiré patterns" created when objects are placed above repeated thin lines.

▲ **Large Writing** *Soto's use of wire and wood in this kinetic work sets up a dynamic between the various elements that invites the viewer's visual and intellectual involvement in understanding the piece.* 1960s, wire and wood, 41 x 67 x 6¼in, Phoenix Art Museum, Arizona, US

Bridget **Riley**

Riley, 1979

b **LONDON, 1931**

One of the most celebrated exponents of Op art, Bridget Riley became interested in optical effects through her early study of Pointillist technique. Her first Op art paintings in the early 1960s were black and white and used simple, repeating shapes, but she distorted them in every way. Riley turned to color in 1966, painting mainly horizontal or vertical stripes that contrasted one color against a complementary color to heighten or dull it. By now she was attracting considerable interest in her work, winning the international painting prize at the Venice Biennale in 1968. Later variations in her style include the use of diagonal lozenges and flowing curves. Riley's work shows a complete mastery of Op art, using subtle variations in shape, size, color, and location of the repeating images across the work to create a dazzling vibration.

LIFEline

1952–55 Studies at the Royal College of Art, London
1961–65 Paints black and white geometric forms
1966 Introduces color; paints mainly in stripes
1979–80 Visits Egypt and later introduces new colors to her palette
1986 Breaks up her vertical stripes with diagonal lozenges
1997 Introduces flowing curves

➤ **Fall** *Parallel, curved lines, compressed toward the base of the painting, give a billowing effect that suggests the canvas is being blown by a strong wind.* 1963, emulsion on hardboard, 55½ x 55¼in, Tate, London, UK

▲ **Achaean** *A visit to Egypt inspired Riley to develop her "Egyptian palette" —colors of greater intensity than she had used before. This coincided with her decision to change from acrylic to oil paint, and to return to painting stripes rather than curves.* 1981, oil on canvas, 94 x 79½in, Tate, London, UK

Origins and influences

Artworks made from found objects appeared as early as 1936 in the work of Joseph Cornell, and by the time Jean Dubuffet coined the term "assemblage" in 1953, it had become an established art form. Collage was an influence on early assemblages, and there was also a precedent in the "ready-mades" of Marcel Duchamp—an idea taken further in Robert Rauschenberg's combine paintings, for which the critic Lawrence Alloway coined the term "Junk art" in 1961.

Techniques

Moving away from the traditional genres of painting and sculpture, assemblage and Junk artists created

Although using found objects in artworks was by no means a new idea, it gave rise to distinct genres in the 1960s and 70s, making it a very creative period. There were also some sharp divisions in the art world, with a gulf widening between "popular" and "serious" culture.

▲ **Wrapped Cans. Part of Inventory** Christo (Christo Javacheff), 1959–60. *At the forefront of the Junk art movement, Christo began wrapping everyday objects, such as these enamel paint cans, in the late 1950s, and later adapted his wrapping techniques to create large-scale Land art.*

hybrid three-dimensional forms by assembling discarded objects and scrap materials in boxes, free-standing constructions, or installations. Sometimes they even presented the objects without modification, but in a new setting, out of context.

Land art (also known as Earth art) developed in the 1970s and drew inspiration both from the natural environment and its raw materials. Rather than depicting a landscape, Land artists worked directly on the landscape itself, sculpting it to make earthworks, or building structures and installations with natural materials, such as branches or rocks.

Assemblage, Junk and Land art

TIMEline

Joseph Cornell produced his first boxed assemblages in the 1930s, but it was another two decades before the genre was established. Elements of collage reappeared in early Pop art in the late 1950s and developed further in the 1960s in Kienholz's tableaux, then in the Junk art sculptures by César Baldaccini and John Chamberlain. In the 1870s Land artists such as Smithson left the studio and worked on the land to create artworks.

1964

CORNELL The Sixth Dawn

1964

KIENHOLZ While visions of sugar plums danced in their heads

1988

LONG Sahara Line

1988

GOLDSWORTHY Spherical Leafwork

1995

CHRISTO AND JEANNE-CLAUDE Wrapped Reichstag

Art of recycling

Because they were made from everyday materials and bits of trash, assemblage and Junk art sometimes evoked a mood of nostalgia, but they also highlighted the wastefulness of consumer society and rejected the commercialism of Pop art. This implicit social commentary became more overt throughout the 1960s and 70s. Land art, in particular, also sought to raise awareness of man's place in both the natural and urban environments.

Assemblage and Junk art

The terms "assemblage" and "Junk art" are to some extent interchangeable, but generally speaking refer to stages of the same movement—the principle of arranging found objects and debris remained essentially the same. Primarily an urban artform, assemblage had its roots in New York, where Joseph Cornell's idea of boxed objects was adopted by Louise Nevelson and extended in Edward Kienholz's tableaux. Junk art, meanwhile, spread quickly from New York across America, and appeared in Europe at about the same time:

the *Arte Povera* (Poor art) movement in Italy was similar in philosophy, influencing Alberto Burri, Pino Pascali, and Mario Merz, and in France, César was producing scrap-metal sculpture along much the same lines as John Chamberlain in the United States.

Land art

In some ways, Land art was an even less conventional movement, creating art outside galleries or public spaces, in the context of the natural world. Often this was done on a massive scale, particularly in the open spaces of North America where it could only be seen properly from the air, but it was also taken up by European artists such as Andy Goldsworthy in the more intimate settings of woodland and seashore, using leaves, twigs, and stones. Land artists also occasionally produce their work in galleries, by creating installations made from materials taken from the landscape.

An urban variation of Land art can be seen in the work of Christo and Jeanne-Claude, whose *Nouveau Réalisme* technique of wrapping household objects progressed to wrapping up historic buildings, and then parts of landscapes. As well as challenging the notion of art as exhibits divorced from the outside world,

▲ **Stones and Stars 2003** *Working outdoors and using the raw materials of the landscape itself, Land artists such as Richard Long reflect the continuing concerns of the environmentalist movement of the 1970s and 80s.* 2003, phototograph and text, 34½ x 50¾in

▲ **Compression** César (César Baldaccini) *In contrast to the recycled ephemera and trivia of assemblage, Junk art uses waste material as its basic medium, especially the discarded debris of industrial society, such as the crushed car parts of César's Compressions series.* c1960, mixed media, Kunsthalle, Hamburg, Germany.

Land art explores the effects of time and decay: many of these ephemeral creations have disappeared due to natural erosion. The impermanence of Land art, which mainly survives only in photographs or video records, links the movement to similar ideas in Conceptual and Process art.

Christo and Jeanne-Claude

Portrait by Bruni Meya

CHRISTO: b GABRAVO, 1935
JEANNE-CLAUDE: b CASABLANCA, 1935

Christo escaped from Bulgaria while visiting Prague, eventually settling in Paris where, in 1958, he met Jeanne-Claude. Since 1961, the two of them have worked on a number of ambitious, large-scale works of art, which often involve years of negotiation and planning, and the collaboration of many workers and agencies. They commonly use fabric to create forms that interact with an already existing environment—for example, by wrapping buildings or bridges. Projects may take years and much effort to realize, but the works themselves are always temporary, making them unique but ephemeral, aesthetic, and interactive experiences, rather than enduring monuments. Unlike most Land artists, Christo and Jeanne-Claude do not work in remote locations, but in populated areas where their art will be experienced first-hand and free of charge by large numbers of people.

LIFEline

1935 Christo and Jeanne-Claude are born on the same day—June 13

1957 Christo, studying in Prague, escapes Communist Europe in a medicine truck

1958 Christo and Jeanne-Claude meet in Paris

1961 First collaborative work, wrapping oil barrels with tarpaulin in Cologne harbor

1968 The couple wrap their first public building, the Kunsthalle in Berne

1985 Pont Neuf bridge in Paris is wrapped in fabric

1995 Their 24-year project to wrap Berlin's Reichstag is realized

▼ **Wall of Oil Barrels (Iron Curtain)** *The artists' first major public intervention was an unauthorized protest against the Berlin Wall, which had been built the previous year. Two hundred and forty oil barrels created a wall of colored circles across the narrow Rue Visconti in Paris, blocking traffic for eight hours. 1962, oil barrels, Paris, France*

▼ **Surrounded Islands**
Christo and Jeanne-Claude have said that they wish to create works of art of joy and beauty. In this aesthetically exuberant piece, 11 small islands in Biscayne Bay, Miami, were surrounded by luminous, shiny, pink, floating fabric. 1983, Miami, US

◄ **Wrapped Reichstag**
The project to wrap Berlin's Reichstag began in 1971, but was not finally realized until 1995, about midway between Germany's reunification and the re-use of the building as the seat of parliament. Over a two-week period, five million visitors experienced the enigma of this familiar landmark transformed into a solid abstraction of flowing drapery. 1995, fabric, Berlin, Germany

> " We only create **joy and beauty**. We have never done **a sad work** "
>
> CHRISTO, 2002

Richard Long

b BRISTOL, 1945

Richard Long has based his art around a single activity: walking. He undertakes solitary journeys on foot, often across hundreds of miles of landscape. The walks themselves are structured around certain limits, usually communicated in the title of the work. These include a starting point and destination, of course, but also boundaries of time, as in *A Thousand Miles in a Thousand Hours* (1974), or poetically suggestive actions, such as collecting water from each river crossed to be poured into the next one, as in *Water Walk* (1999). On the way, Long sometimes creates ephemeral, geometric forms from sticks, stones, and other objects. His walks are represented in photographs and maps, often accompanied by evocative texts.

Long is keen to differentiate his own practice from American Land Art, which for him is obsessed with imposing gestures demanding money and industrial machinery. By contrast, Long's own encounter with the landscape is marked by subtlety, simplicity, and a perceptive readiness for what it offers up.

LIFEline

1945 Born in Bristol, UK

1962 Attends the West of England College of Art; creating work which engaged directly with the surrounding landscape

1967 While a student at St. Martins College, undertakes his first walking work, *A Line Made by Walking*

1968 Solo exhibition of his work at the Konrad Fischer Gallery, in Düsseldorf

1976 Represents Britain at the Venice Biennale exhibition

1989 Wins the Turner Prize on his fourth nomination

▼ **Geneva Circle Two** *As well as temporary works created on location, Long also makes sculptural works and wall paintings for galleries. Universal shapes such as circles and lines are used, suggesting a link between the ancient and the contemporary. Site specificity is important, and these stone slabs would have come from a local Swiss quarry. 1987, stone, diameter 197in, private collection*

▼ **Sahara Line** *Although he is a quintessentially English artist in many ways, Long has walked all over the world, from Lapland to the Andes. Here, scattered rocks are arranged to constitute an obviously human intervention, creating a juxtaposition with the monolithic desert backdrop. 1988, rocks, 45 x 33in, Sahara desert, Africa*

Robert Smithson

b PASSAIC, 1938; d AMARILLO, 1973

Of all the American artists of the 1960s, Robert Smithson perhaps best embodied the trajectory away from traditional disciplines and formalist notions of what art should be. Best known for monumental land pieces, such as the iconic *Spiral Jetty* (1970), Smithson's thinking went beyond the visual aspect of his work, to also offer a philosophical reflection on man's place in nature. He challenged human-centered ideas—represented in the "picturesqueness" of landscape painting, a tradition he saw persisting in Abstract art—with an appeal to "inhuman" concepts that diminished mankind's self-importance: geological time, the crystalline structure of minerals, and entropy (the physical law of increasing disorder). Smithson saw art less as a unique, finished object and more as a dynamic, social, physical, and mental process that could take multiple, interacting forms.

LIFEline

1938 Born in Passaic, New Jersey

1957 Moves to New York

1966 Shows his work at the legendary Minimal Art exhibition *Primary Structures*, held at the Jewish Museum

1967 Solo show at Dwan Gallery, New York

1970 Obtains lease for an area of land on the Great Salt Lake, in Utah; constructs *Spiral Jetty* in six days

1973 Is killed in a plane crash, aged just 35, while surveying land for an earthwork in Texas

▲ **Mirror Stratum** *In the mid-1960s, Smithson's sculptural works adopted the pared-down geometries of Minimalism, but displayed a deliberate connection to physical processes, such as the stratification of rocks. 1966, mirrors, 14¼ x 14¼ x 5⅞in, James Cohan Gallery, New York, US*

▲ **Spiral Jetty** *Located in a remote region of Utah's Great Salt Lake, this work was built from six and a half tons of rock and earth. The spiral shape is a reference to a mythical whirlpool at the bottom of the lake, and to the circulation of blood in the body (the water has a reddish tint). 1970, black rock, salt crystals, earth, red water (algae), 181 x 1772in, Great Salt Lake, Utah, US*

CLOSERlook

CRYSTAL STRUCTURE
Smithson intended saline crystals from the water to form on top of the rock surface, and this has indeed happened, creating a white halo that contrasts with the pinkish water.

Dennis **Oppenheim**

b **ELECTRIC CITY, WASHINGTON, 1938**

Oppenheim's work has spanned land art, performance, video art, and sculpture, and is based on a questioning of the traditional art object. For him, art is an action in real time, not a timeless precious object, and the photographic record he makes merely documents a moment in the process. The plowing of a field, the suntanning of a body, and even the consumption and digestion of a gingerbread man are all material. His objects are unconventional and often disturbing, even when he makes them for museum display. In *Attempt to Raise Hell* (1974), a metal head is struck by a bell every 60 seconds.

> "An **artist** works through **exposed wounds**"
>
> DENNIS OPPENHEIM

▲ **Cancelled Crop** *This picture represents just one stage in the artistic process, as Oppenheim himself explains. "The route from Finsterwolde (location of wheat field) to Nieuwe Schans (location of storage silo) was reduced by a factor of 6x and plotted on a 50 x 876ft field. The field was then seeded following this line. In September the field was harvested in the form of an 'X'. The grain was isolated in its raw state, further processing was withheld." 1969, Netherlands*

Walter **De Maria**

b **ALBANY, 1935**

Best known for his celebrated *Lightning Field* (1977), Walter De Maria began his artistic career making witty sculptures, creating musical pieces, and taking part in "happenings" under the influence of the avant-garde composer John Cage. In 1968, he produced two significant Land Art works: *Mile Long Drawing* consisting of two parallel chalk lines in the Mojave Desert in California, and *Earth Room* at the Heiner Friedrich gallery in Munich, where he filled the pristine space with soil, which could be viewed from behind a glass barrier.

▲ **Lightning Field** *This field contains 400 steel rods, spaced at 220ft intervals and set in the ground so that the tops of them are at an even height to create an enormous grid in the desolate landscape. The work's title suggests the awesome and potentially threatening encounter with nature to be had when experiencing it first-hand. 1977, steel rods, New Mexico, US*

Andy **Goldsworthy**

Photograph by Philippe Caron

b **CHESHIRE, 1956**

Andy Goldsworthy is part of the lineage of Land artists who move beyond the gallery and the salable object to make transient interventions in non-urban environments. These interventions take the form of delicate and beautiful structures made from material found close to hand.

Goldsworthy's work follows the Minimalist ethic of presenting the material as it is, using it neither for representational nor abstract purposes, and of revealing the means of its construction. However, unlike Minimalism, with its industrial, factory-made aesthetic, Goldsworthy's objects are a result of hands-on communication with nature. Leaves, stones, flowers, snow, and twigs are some of the typical materials he uses, arranging and attaching them in patterns that mimic natural forms: spheres, spirals, and lattice shapes. The ephemerality of these sculptures reminds us that death and decay are an integral part of nature.

LIFEline

1956 Born in Cheshire, son of a professor of mathematics

1969 From the age of 13, he often works as a farm labourer in the Yorkshire countryside

1975–78 Studies fine art at Preston Polytechnic

1996 Begins work on *Sheepfolds* in Cumbria

2000 Awarded the OBE

2003 Frozen sculptures, including *Icicle Star*, are used to illustrate Royal Mail Christmas stamps

2007 A retrospective of his work is held at Yorkshire Sculpture Park

▶ **Spherical Leafwork**
Goldsworthy adopts natural materials, not only as formal elements, but also tools that hold new shapes together, for example using thorns as a pinning device in this structure. Leaves are a familiar sign of passing time, turning brown and disintegrating with the changing seasons—a process the artist embraces through the sculptures themselves. 1988, leaves, City Art Gallery, Leeds, UK

▲ **Icicle Star** *Goldsworthy's sculptures often appear so exquisite because they utilize the very forms produced by natural processes to create new and suggestive objects. Part of the charm of this piece lies in the contrast between the modesty of the material— mere water—and the exuberance it seems to express, and between its actual coldness and the burning heat of the star it resembles. Ice, Dumfrieshire, Scotland*

Joseph **Cornell**

b NYACK, 1903; d FLUSHING, 1972

The American artist Joseph Cornell is best known today for his pioneering of Assemblage Art, but he also made numerous collages and worked as a filmmaker and writer. His work in all genres was very much influenced by Surrealism, without espousing the Surrealists' ethos, and paved the way for Pop and Installation Art.

Apart from five years studying at Phillips Academy in Andover, Massachusetts, Cornell lived in his native New York City, for most of the time in a working-class part of Queens. He worked in the textile industry until 1940 to support his mother and disabled brother. During a period of unemployment in the Depression, he made contact with Julian Levy, who in 1932 included Cornell's collages in an exhibition of Surrealists at his gallery. Cornell had his own one-man show later that year. Over the following decades he succeeded in establishing a reputation for himself by making boxed assemblages and collages from found items—not junk, but objects that had at one time been someone's treasured possessions.

LIFEline

1917–21 Studies at Phillips Academy in Andover

1921–31 Works as a textiles salesman

1925 Joins the church of Christian Science

1932 Shows collages in an exhibition in New York

1936 First boxed assemblage, *Untitled (Soap Bubble Set)*

1939 First film, *Rose Hobart*

1940 Full-time artist and writer

1972 Dies in New York, almost unknown outside the art world

CLOSERlook

NOSTALGIC IMAGES
Among found bric-à-brac items, Cornell pasted and hung photos and pictures from bygone eras, evoking a mood of both nostalgia and surreal fantasy.

◀ **Soapbubble Variant** *Many of Cornell's boxed assemblages appear in a series of similar works. He produced "variants" of the original 1936 Soapbubble Set, partly because he was fascinated with the objects, but also to satisfy demand for his work.* c1956, mixed media, 9⅜ x 15 x 3⅞ in, private collection

▲ **The Sixth Dawn** *Cornell's collages were inspired by those of Max Ernst. Unlike Surrealist collages, they did not represent the darker side of imagination. The Sixth Dawn has an air of child-like innocence.* 1964, collage on paper mounted on masonite, 17¼ x 14⅝ in, The Israel Museum, Jerusalem, Israel

John **Chamberlain**

b ROCHESTER, 1927

Best known for his constructions of crumpled automobile parts, the sculptor and painter John Chamberlain has combined in his work the methods of Junk Art and the aesthetic of Abstract Expressionism.

Indiana-born Chamberlain was raised in Chicago and studied at the Art Institue of Chicago and Black Mountain College, before settling in New York in 1957. It was there that he started welding together car parts to create striking, dynamic, and implicitly violent compositions that became his trademark. He continued to develop the idea in the 1960s, using a range of motor and industrial objects, sometimes for social comment—such as his recurrent use of oil barrels during the US fuel crisis. He also made several films and experimented with Action Painting using car spray paint; which led to much of his later sculpture being spray-painted in vivid colors.

◀ **Untitled** *With his later car-sculptures, assembled from scrapyard materials, Chamberlain brought the spontaneity and dynamic color of Abstract Expressionism to Junk Art. In particular, the sense of frozen movement, achieved as much by his handling of the materials as by their association with motor vehicles, can be seen as a three-dimensional form of Action Painting.* Sheet metal, Galleria Nazionale d'Arte Moderna, Rome, Italy

Louise **Nevelson**

b KIEV, 1899; d NEW YORK, 1988

The daughter of a Jewish timber merchant, Louise Nevelson was born Leah Berliawsky in Kiev, but moved with her family to Rockland, Maine, as a child. She grew up playing with wood in her father's lumberyard, and had early ambitions of becoming a sculptor.

She moved to New York after marrying Charles Nevelson in 1920 and began to teach herself art. She later studied sculpture at the Arts Students League and with Hans Hofmann in Munich, going on to assist Diego Rivera and teach at the Educational Alliance School of Art in Manhattan. In the 1940s, Nevelson exhibited her assemblages and collages of wooden objects. Her international reputation was secured in 1958 with a major one-woman show at the Grand Central Moderns Gallery, in New York, which featured her distinctive monochrome walls of boxed assemblages.

CLOSERlook

INSIDE THE BOXES The scraps of wood in each box are of all shapes and sizes; some are purely abstract Cubist or primitive motifs, others are more figurative.

▲ **Tropical Garden II** *A series of tall, thin boxes joined together form the wall-like structure of Tropical Garden II. Each one contains found wooden objects. The whole is painted black, unifying the disparate components and disguising their origins. The enclosed compositions are revealed only by their shadows.* 1957–59, painted wood, 71 x 130in, Pompidou Centre, Paris, France

Alberto **Burri**

b CITTÀ DI CASTELLO, 1915; d NICE, 1995

The Italian painter and sculptor Alberto Burri trained as a doctor, but took up painting while in a POW camp in the US. On his return to Italy, he became a leading figure in the Art Informel movement, which paved the way for Arte Povera (see p.551), the Italian minimalist style.

In the late 1940s, Burri moved from an expressionist to a purely abstract style, rejecting any metaphorical references in his work. A series of paintings and sculptures with titles such as *Tars*, *Sacks*, *Irons*, *Combustions*, *Clays*, and *Woods* explored unorthodox materials and techniques such as collage, burning, and cutting.

▶ **Sacco IV** *Burri embarked upon his Sacchi (sacks) series of collages in 1950. Various theories have been suggested to explain the choice of medium, but Burri simply stated, "The poorness of a medium is not a symbol: it is a device for painting."* 1954, burlap, cotton, glue, silk, and paint on black cotton backing, 44¾ x 29¾in, Denney Collection, Toulouse, France

556

Edward **Kienholz**

b FAIRFIELD, 1927; d HOPE, 1994

Edward Kienholz used his environmental assemblages ("tableaux") as social or political comment, and juxtaposed macabre, erotic, and everyday items to often shocking effect to make his point.

Edward Kienholz, 1965

Kienholz was born and brought up in rural Washington state, and although he was keen on painting as a teenager, he had no formal training in art. Drifting in and out of jobs and college courses, he worked for a while in a psychiatric hospital, and ended up in Los Angeles in 1953, where he took an interest in sculpture. His first pieces took the form of roughly painted wooden relief panels, but in the late 1950s he began working with assemblage.

▶ **While Visions of Sugarplums Danced in Their Heads** *This assemblage of an intimate bedroom scene is disturbing in its matter-of-fact depiction of mundane, respectable, suburban life.* 1964, mixed media, 72 x 144 x 108in, Pompidou Centre, Paris, France

CLOSERlook

IN THEIR HEADS The couple making love are lost in their own thoughts, their "faces" turned away from one another. Inside the bulbous heads are miniature tableaux of naked Barbie and Ken dolls acting out their private fantasies.

LIFEline

1927 Born, the son of a farmer
1953 Moves to Los Angeles
1962 Creates *Roxy's*, his first tableau
1966 A retrospective at LA County Museum causes outrage
1972 Meets Nancy Reddin, his future wife and collaborator
1973 Moves to Idaho
1973–94 Regular trips to Berlin to work with his wife
1994 Dies in Hope, Idaho, aged 67

Pino **Pascali**

b BARI, 1935; d ROME, 1968

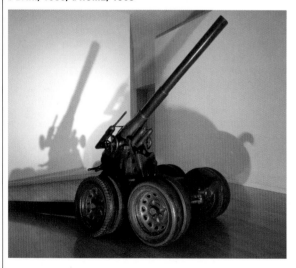

◀ **Cannone Semovente (Mobile Cannon)** *In 1965, Pascali made a number of life-size replicas of cannons and big guns using scrap metal, wood, and rubber, which he then painted a military green. The largest of these, Cannone Semovente, is disturbingly life-like, and as well as its contemporary reference to the war in Vietnam, it echoes Pascali's childhood memories of World War II.* 1965, wood, scrap metal, and wheels, 99 x 134 x 97in

In his tragically short career, Pino Pascali was a prominent member of the Arte Povera movement (see p.551), working as a sculptor, set designer, and conceptual artist. His experiences as a child in Italy and occupied Albania during World War II were a significant influence on his art and political stance.

During the 1950s, Pascali studied at the Liceo Artistico, Naples, and the Accademia di Belle Arti, Rome, followed by four years as a television set designer before embarking on his career as an artist. In the short time before his death in a motorcycle accident in 1968, he achieved remarkable success, first as a painter and then for his "happenings" in Rome, but most importantly for his large-scale sculptures and installations. Often using unorthodox materials, Pascali captured the mood of the times: the series of big guns made of scrap metal coincided with the Vietnam War, and the massive and disturbing *Trap* appeared amid the student unrest of 1968.

Mario **Merz**

b MILAN, 1925; d MILAN, 2003

Starting as a painter in the Art Informel style, Mario Merz turned to sculpture in the 1960s as a rejection of the notion of representing images in favor of presenting the objects themselves. Initially using ready-made objects and employing the techniques of Arte Povera (see p.551), he soon realized their shortcomings for his philosophy of portraying the inherent social and scientific connotations of abstract and concrete images.

The most striking of his innovations in the late 1960s was the use of neon lighting, sometimes with glass panels, as an integral part of his sculpture. When juxtaposed with constructions such as igloos, which feature in many of his pieces, the lighting provided a metaphor for old and new, poverty and progress.

◀ **Homage to Arcimboldo** *The three main elements—neon lights, a crocodile, and a structure based on the Fibonacci mathematical sequence—were recurrent themes in Merz's work. Rather than contrasting these disparate images, he points to their connections: the mathematical structure of natural patterns such as the crocodile's scales, the modernity of primeval symbols, and the continuum from past to future.* 1988, mixed media, Nationalgalerie, SMPK, Berlin, Germany

Origins

The term "concept art" was first used in 1961 by the American anti-art activist Henry Flynt to describe his performance art. The term was extended to "Conceptual art" by the American artist Sol LeWitt in his 1967 article "Paragraphs on Conceptual Art" for *Artforum* magazine. This article recognized that a generation of artists was creating a new form of art and popularized the term.

Media

Conceptual art revolutionized the way we appreciate art. To Conceptual artists, a work of art was primarily for intellectual—not aesthetic—stimulation and was no longer a beautiful, hand-crafted object. It did not have to take the traditional form of painting or sculpture, but might be a photograph, a film, or an installation. It could be made from found objects, or produced by the artist's assistant.

In Conceptual art, the idea or concept behind the work is as important as the work itself. Marcel Duchamp made the first examples of Conceptual art before World War I, but it only became recognized as a distinct art form in the 1960s.

EVERYTHING IS PURGED FROM THIS PAINTING BUT ART. NO IDEAS HAVE ENTERED THIS WORK.

▲ **Everything is Purged from this Painting** John Baldessari, 1967–68. *Much of the Conceptual art of the 1960s relied primarily on verbal and intellectual rather than visual means of communication.*

Some Conceptual artists, such as Joseph Beuys, created performance art to make statements about the pain of human existence or man's relationship with nature. Others turned to Land art, making artworks directly in the landscape (see p.551).

Conceptual art was a reaction against Abstract Expressionism, which dominated the art world in the 1950s. While Abstract Expressionists sought to express their emotions and experiences in large, heroic paintings, the Conceptualists were often cool and cerebral. Piero Manzoni, one of the first Conceptual artists, began his series of *Achromes* in 1957. In these works he soaked the canvases in kaolin, a white clay, to produce a "white surface that is simply a white surface and nothing else."

Conceptual art

TIMEline

In 1961, Piero Manzoni started signing humans to create living works of art. Each person was given a certificate of authentication. Letters and words are important elements of Marcel Broodthaers' *Pipe Alphabet* (1968–71) and On Kawara's date paintings. Mona Hatoum's 1994 *Corps Étranger* shows a video made from an endoscope traveling into her intestines.

1961

MANZONI Living sculpture

1966

LEWITT Serial Project I (ABCD)

1968–71

A , B , C , D , E ,
F , G H I , J
K , L M , N O , P ,

BROODTHAERS Pipe Alphabet

1979

DEC.12.1979

KAWARA Dec. 12th 1979

1994

HATOUM Corps Étranger

▲ **The Pack (Das Rudel)** Joseph Beuys, 1969. *The installation, an arrangement of objects in a given space, became an important medium for Conceptual artists. Here Beuys has positioned 24 sledges, resembling a pack of dogs, so they seem to tumble out of the back of a Volkswagen van.*

Interpretations

The pioneer of Conceptual art was the French artist Marcel Duchamp (see p.467). In 1913, he began exhibiting his readymades, industrially manufactured objects that he had decided were works of art. As there was little or no craft involved in making them, Duchamp was explicitly questioning the nature of art. By putting his readymades in galleries, Duchamp was also questioning the institutions that legitimize art for the public.

Another important artist in the development of Conceptual art was the American Robert Rauschenberg (see pp.535–37), who worked with found objects. Rauschenberg recognized the importance of the concept that underpinned a "work of art." To demonstrate this, he acquired a drawing by the Abstract Expressionist Willem de Kooning in 1953, erased it, and then exhibited the result.

The role of art

Conceptual art questions our assumptions not only about what qualifies as art, but what the function of the artist should be and what our role as spectators should involve. Conceptual artist Joseph Kosuth wrote in

1969, "The "value" of particular artists after Duchamp can be weighed according to how much they questioned the nature of art."

Many Conceptual artists began to rely on language to convey their message, rather than the visual image or object. Kosuth produced large photocopies of the dictionary definitions of common words and On Kawara painted calendar dates, aiming to complete each painting on the date shown. John Baldesarri painted statements from contemporary art theory—then decided to remove all work by his own hand completely and employed a sign painter to paint the lettering.

The role of museums

Conceptual art also questioned the role of galleries and museums in presenting artworks, particularly the way in which they legitimize and sanctify objects traditionally considered to be art. Joseph Beuys used museum-like glass display cases to show "valueless" objects, such as felt, fat, or rubbish swept up from the street. Christian Boltanski used display cases in a similar fashion to show children's toys. Marcel Broodthaers went even further, converting his own house into a museum as a comment on the institutionalization of art.

CURRENTevents

1959 The first "happening" takes place at the Reuben Gallery in New York.

1961 Yuri Gagarin becomes the first man in space; the Berlin Wall is constructed.

1963 US President John Kennedy is assassinated.

1965 American students demonstrate against the bombing of North Vietnam. Britain passes the Race Relations Act, prohibiting discrimination on grounds of race.

1967 The Summer of Love begins in San Francisco.

1968 In Paris, students demonstrate against the government, leading to a general strike.

1969 Neil Armstrong becomes the first man to walk on the moon.

Joseph **Beuys**

b KREFELD, 1921; d DÜSSELDORF, 1986

Charismatic and unconventional, Joseph Beuys was a leading political artist and teacher. He strongly believed that his art, which he called "social sculpture", had the power to shape a better society and, as part of his artistic career, he became increasingly active in politics, campaigning for educational reform, grass-roots democracy, and the Green Party.

In his sculptures and installations, Beuys deliberately used non-art materials, including fat, felt, earth, stones, food, and copper and iron sheets. As his reputation grew, he was invited to create ever-more ambitious projects. He made room-sized installations, and eventually his work spilled out of the museum into activist events, such as his tree-planting, *7,000 Oaks* (1982–87).

Importantly, Beuys also pioneered the idea that the artist could communicate through "actions"—performances, public discussions, and political campaigning – as well as artifacts. In his most famous "action", performed in New York in 1974, he spent three days in a room with a coyote. The title of the work, *I Like America and America Likes Me*, is ironic—Beuys opposed the war in Vietnam and his work challenged the hegemony of American art.

LIFEline

1921 Born in Krefeld, in northwest Germany

1940 Joins the Luftwaffe

1943 Involved in a plane crash in the Crimea

1945 Spends time in a British prisoner-of-war camp

1946–51 Studies sculpture at Düsseldorf Academy of Art

1961 First one-man exhibition, in Kleve; returns to Düsseldorf Academy of Art to take up professorship

1962 Participates in the intermedia Fluxus movement

1979 Is one of 500 founding members of the German Green Party. Retrospective held at New York's Guggenheim Museum

◀ **Earth Telephone** *This piece is influenced by Marcel Duchamp's "ready-mades"— artistic constructions made from manufactured objects to provoke thought. Here, by connecting a telephone to earth and grass, Beuys perhaps underlines his belief that art should be connected with the wider world.* 1968, mixed media, 8 x 18½ x 30in, Kunsthalle Hamburg, Germany

▲ **How to Explain Pictures to a Dead Hare** *In this piece, Beuys walked around an exhibition with his face covered in honey and gold leaf, while lovingly carrying a dead hare in his arms. He looked at pictures and explained them to the hare. By using a dead animal and disfiguring his face, Beuys seemed to allude to the serious injuries he suffered several times during World War II.* 1965, performance, Schmela Gallery, Düsseldorf, Germany

◀ **Action Piece** *Beuys toured the world giving lectures, which he called "actions," on sculpture, democracy, and green politics. His teaching was closer to performance art than academic lectures, and the blackboards he covered in diagrams and slogans have come to be regarded as works in their own right.* 1972, lecture at the Tate, London, UK

Piero **Manzoni**

b **SONCINO, 1933**; d **MILAN, 1963**

Manzoni was a Milan-based conceptual artist who made witty, provocative art, designed to both mock the art establishment and question the artist's role in a capitalist, commodity-driven era.

Manzoni believed that everything was art—humans, whom he signed; human waste, which he canned; and even the whole world, which he pretended to mount on a plinth. He attacked the pomposity of angst-ridden artists, especially the Abstract Expressionists, by posing for photographs with a smiling face, with his cans of excrement or his signed humans. He satirized Minimal art by painting lines on scrolls of paper, then putting them away in tubes and canisters. He also poked fun at the overinflated art world in his *Artist's Breath* series, which involved blowing up balloons, attaching them to plinths, and then letting them deflate.

LIFEline

1951–55 Starts career painting landscapes in a traditional style

1956 Produces images by dipping keys, scissors, pliers, and pincers in paint and impressing them on canvas

1957 Begins to make *Achromes*—textured white paintings. First one-man exhibition in the foyer of the Teatro delle Maschere, Milan

1963 Dies in Milan of cirrhosis of the liver, aged 29

▼ **Merda d'Artista** *Manzoni made 90 cans purporting to contain his own feces. Although Manzoni said his aim was to expose "the gullibility of the art-buying public," London's Tate Gallery and New York's MoMA have bought cans. They now seem doubly gullible, as Manzoni's fellow artist, Agostino Bonalumi, has since claimed that the tins contain plaster. 1961, MoMA, New York, US*

◄ **Achrome** *Manzoni wanted to banish narrative content from painting—this meant removing even color. To get to his desired "nothingness," he soaked his canvases in kaolin, a soft china clay. The weight of the material caused it to sag, creating folds across the canvas. 1959, kaolin on canvas, 24 x 24in, Kunsthalle Hamburg, Germany*

▲ **Magic Base** *In January 1961, Manzoni made his first "magic base," explaining that as long as any person or any object stayed on this base he, or it, was a work of art. The base had handy footprints on which the user could place his feet. Here, Manzoni himself was photographed on the plinth. 1961, performance, Kopecke Gallery, Denmark*

◄ **Living Sculpture** *Beginning in January 1961, Manzoni started signing people to create "living sculptures." Each person was given a mock bureaucratic certificate of authentification. Manzoni continued to sign people on his travels around cities in Europe until June 1962, when the writer Umberto Eco became his last sculpture. The publicity for a solo show at a gallery in Copenhagen declared, "become a living work of art." 1961, Piero Manzoni Archive*

❝ Are not fantasizing, abstraction, and self-expression **empty fictions**? There is nothing to be said: **there is only to be, to live** ❞

PIERO MANZONI,
FREE DIMENSION ESSAY, (1960)

Marcel **Broodthaers**

Photograph
by Platen

b BRUSSELS, 1924; d COLOGNE, 1976

Broodthaers was a poet, who at 40 became a visual artist. In a short, but influential, artistic career he was particularly concerned with the museum's place in contemporary culture, and how art is presented to the public.

In 1968, Broodthaers converted the ground floor of his Brussels house into a "Museum of Modern Art." In his first exhibit, he showed empty packing crates from the Palais des Beaux-Arts and postcards of 19th-century French paintings from the Louvre. The exhibition questioned the nature and validity of art, and the difference between an artistic masterpiece and a commercial souvenir. Broodthaers's work also examined the relationship between language and the objects it describes. In 1974 he produced *Les Animaux de la Ferme*, a parody of educational posters, showing different types of cow labeled with the names of cars.

LIFEline

1940 Becomes a poet
1957 Makes his first film, *La Clef de l'Horloge (The Key to the Clock)*
1958 Starts to publish articles illustrated with his own photos
1963 Decides to become an artist
1964 First one-man exhibition at the Galerie St. Laurent, Brussels
1968 Establishes the Musee d'Art Moderne (Section XIXe siecle), Departement de Angles [Eagles] in his house in Brussels
1972 Exhibits 266 objects all containing representations of an eagle at the Stadtische Kunsthalle in Düsseldorf

▼ **Pense-Bête** *Broodthaers made this work by dunking 50 unsold copies of his own book of poetry into wet plaster. The title* Pense-Bête *means "a reminder," but if the words are taken literally it could mean a wild or stupid thought.* 1964, books, plaster, and rubber ball

CLOSERlook

UNREADABLE BOOKS
The plaster makes the poetry in the books unreadable, but Broodthaers seems to be asking whether the artwork produced as a result is readable itself.

▲ **Pipe Alphabet** *This work is clearly a homage to the Belgian Surrealist artist René Magritte and his famous painting* The Treachery of Images *(1928–29), which shows a painted picture of a pipe and the inscription "Ceci n'est pas une pipe" (this is not a pipe).* 1968–71, painted plastic, 33 x 46¾in, Galerie de l'Art Moderne, Paris, France

Sol **LeWitt**

b HARTFORD, 1928; d NEW YORK, 2007

LeWitt's sculptures and installations, composed of cubes and other austere geometric forms, came to the public attention in the mid-1960s. Many critics described him as a Minimalist. However, LeWitt denied this association and instead, in 1967, coined the term "Conceptual art" to describe his work, explaining that he started with an idea, rather than a form.

To stress the importance of the idea in art, LeWitt made several works in which the end products were non-visible—including a metal cube buried in the ground in Holland, entitled *Box in the Hole* (1968). This piece was documented by a series of still photographs, but the exact location of the work has never been disclosed.

LIFEline

1945–49 Studies Fine Arts at Syracuse University
1949 Moves to New York
1962 Makes abstract black and white reliefs
1965 First one-man exhibition in New York
1967 Writes the influential article, *Paragraphs on Conceptual Art*

▼ **Serial Project, I (ABCD)**
LeWitt worked in simple forms, such as open or closed cubes, to create structures in a pre-determined, logical system. This piece presents combinations of squares and cubes, laid out on a grid. 1966, mixed media, 20¼ x 157 x 157in, MoMA, New York, US

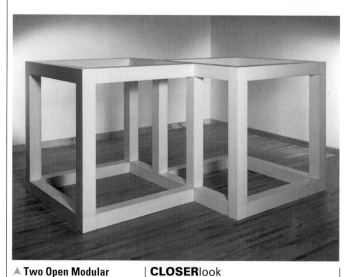

▲ **Two Open Modular Cubes** *LeWitt once declared that the most interesting thing about the cube was that it was relatively uninteresting. This meant that the spectator would think about the system and basic unit employed, rather than units used to express that system.* 1972, enamelled aluminum, 63 x 120 x 91¾in, Tate, UK

CLOSERlook

THE IDEA LeWitt had his work fabricated industrially. However material was just the vehicle for an idea, bringing him much closer to the realm of Conceptual art.

On **Kawara**

b **AICHI-KEN, 1932**

The Japanese conceptual artist On Kawara has lived in New York since 1965. His work deals with the largest subjects—our conception of time and place, life and death—in a deceptively simple manner.

In the 1960s, Kawara began to dispassionately record his life. He made maps of his daily walks and cab rides, and lists of the people he met. He sent telegrams to friends with the words, "I am still alive—On Kawara", and postcards from wherever he was, each rubber-stamped with his temporary address and the time he got up. He is most famous for his date paintings. Sometimes Kawara makes several date paintings on one day, sometimes none at all. If he doesn't finish a painting by midnight, he destroys it. The paintings are sometimes exhibited together—often thematically, for example all from one year, or all from a particular day of the week.

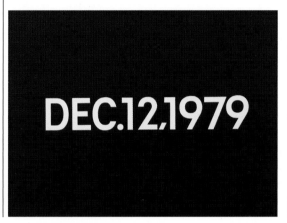

◀ **Wednesday, Dec. 12, 1979** *On January 4, 1966, Kawara began a series of date paintings, which he called the Today Series. Each painting consists of the date it was made, hand painted in white on a dark-toned canvas. The white letters can be seen as symbolizing daytime, the dark canvas nighttime.* 1979, synthetic polymer paint on canvas, 18¼ x 26¾in, MoMA, New York, US

Daniel **Buren**

b **BOULOGNE-BILLANCOURT, PARIS, 1938**

Buren is a French conceptual artist who is sometimes classified as an abstract minimalist. He came to fame in the 1960s, by painting stripes across urban environments in unauthorized, bandit-style acts. The stripes are based on a popular French awning fabric – they are always 3.4in wide, and white is always alternated with another color. At his first solo exhibition, Buren blocked the entrance of the gallery with stripes. In 1986, he created a controversial sculptural installation, entitled *Les Deux Plateaux,* in the great courtyard of the Palais Royal. It consisted of truncated columns painted with black and white stripes.

▲ **Striped posters flyposted on billboards** *Buren applies stripes over posters, in metro stations, on steps, plinths, and benches, as well as in museums. By pasting up his stripes like wallpaper, he makes the viewer look again at the urban environment.* 1968, posters, Paris, France

Hans **Haacke**

b **COLOGNE, 1936**

The German conceptual artist Hans Haacke creates incisive, forthright political art that exposes power and privilege. His early work focused on natural processes. *Rain Tower* (1962), *Condensation Cube* (1963–65) and *Grass Cube* (1967) allowed for interactions between animals, plants, water, and wind. He also made forays into Land art.

In the 1970s, Haacke's work became overtly political. His targets included governments, multinational corporations, property developers, and museums. Haacke argues that, whether intentionally or not, all art plays a role in the socio-political environment in which it is produced and seen, and therefore affects the *Zeitgeist* and has political consequences.

◀ **Germania** *This was presented in the German pavilion at the Venice Biennale. Entering the pavilion the visitor was "greeted" by a photograph of Hitler during his visit to the same pavilion in 1934. Upon the dictator's orders the pavilion's parquet floor was later replaced by marble plates. Hitler had planned to rename Berlin "Germania"— after his expected victory in World War II. Above the entrance, where the Nazi insignia had been displayed, Haacke affixed an enlarged replica of a 1 Deutsch Mark coin with the minting date of 1990, the year of German reunification.* 1993, temporary installation, Venice Biennale, Italy

Joseph **Kosuth**

b **TOLEDO, OHIO, 1945**

Joseph Kosuth creates conceptual art, inspired by philosophy and linguistics. Precocious and provocative, he had produced some of his most celebrated works by the age of 20. Kosuth summed up his ideas in the 1969 essay *Art after Philosophy*, writing, "Being an artist now means to question the nature of art… If you make paintings you are already accepting (not questioning) the nature of art." Kosuth's preferred medium was language. Words displaced images, while intellectual stimulation replaced the contemplation of aesthetic objects.

This idea was exemplified in *First Investigations* (1966), a series that included photostats of the dictionary definitions of "water," "idea," "meaning," and other words. These images were accompanied by instructions, indicating that the works could be remade. In this way, Kosuth undermined the preciousness of the unique art object, and sought to demonstrate that the "art" is not located in the object itself, but in the concept.

LIFEline

1965 Moves to New York; attends School of Visual Arts
1967 Founds the Museum of Normal Art in New York—it hosts his first solo show
1969 Becomes editor of the *Journal of Art and Language,* for British and American artists interested in linguistic and Marxist analysis of art
1981 Major retrospectives at Staatsgalerie in Stuttgart, and Kunsthalle in Bielefeld
1986 Produces *Zero and Not,* comprising words printed on paper then partially obscured by tape

◀ **One and Three Chairs** *Here, Kosuth presents a chair, with a photograph of a chair, and a dictionary definition of the word "chair". Kosuth is asking "What is art?". Can a chair be art, in the same way that Marcel Duchamp said a urinal was art? And can descriptions of the chair—a photograph and a verbal definition—be art?* 1965, mixed media, chair 32¼ x 14¾ x 20¾in, MoMA, New York, US

Mona **Hatoum**

b BEIRUT, 1952

The Palestinian-born artist Mona Hatoum has worked mainly in London and Berlin. She works in many media, producing performance and installation pieces, video art, photography, and sculpture.

Her work is unsettling—the familiar becomes grotesque, and the grotesque familiar. A necklace looks as if it is made from large, decorative, brown beads, but turns out to be an eerie combination of wood, leather, and human hair. A "welcome" doormat is actually made of steel pins. Hatoum's work often concerns the human body and elicits a visceral response in the viewer. Sometimes, there is even a suggestion of violence.

LIFEline

1970–72 Attends Beirut University College
1975–79 Studies at the Byam Shaw School of Art
1979–81 Studies at the Slade School of Art
1989–92 Teaches at Cardiff Institute of Higher Education
1994 Solo exhibition at the Pompidou Centre, Paris
1995 Is short-listed for the Turner Prize

❝ I saw endoscopy as... the **ultimate in the invasion** of one's **boundaries** ❞

MONA HATOUM

▼ **Corps Étranger** *This video installation immerses viewers in amplified recordings of human internal organs. The images, from an endoscope, are of the artist's own insides.* 1994, installation at the Pompidou Centre, Paris, France

CLOSERlook

LOOKING INTO THE ABYSS The video unfolds on the floor. As the camera goes down the intestine, viewers look down into a swallowing hole.

Christian **Boltanski**

Photo by Christopher Felver

b PARIS, 1944

Boltanski is a French artist whose artworks and installations have huge emotional power, often inspiring meditation and reverence. Boltanski left school aged 12, and started painting in 1958. In 1967, he began to explore his own personal history, assembling documents and photographs from his family albums. In *Three Drawers* (1970), he made plasticine sculptures of a child's possessions, which remind us of the inconsequential treasures we cherished as children.

Boltanski's other great subject is death, and in particular the Holocaust. In *Chases School* (1986–87), he created an altar-like construction by placing framed photographs of Jewish schoolchildren on top of tin boxes. In 1988, in his *Reserve* series, he lined a whole room with musty, hand-me-down clothes—stimulating the sense of smell as well as sight. The room resembled the warehouses in which the Nazis stored the belongings of the deported.

LIFEline

1944 Born in Paris, to a Jewish father
1968 First solo exhibition
1969 Publishes first book, a fictional autobiography
1970 Starts *Reference Display Cases* series
1977 Starts *Compositions* series of color photographs
1984 Retrospective at the Pompidou Centre, Paris
1986 Exhibits in an old prison at the Venice Biennale
1998 *Last Years* exhibition at the Pompidou Centre, Paris—designed as a single walk-through piece

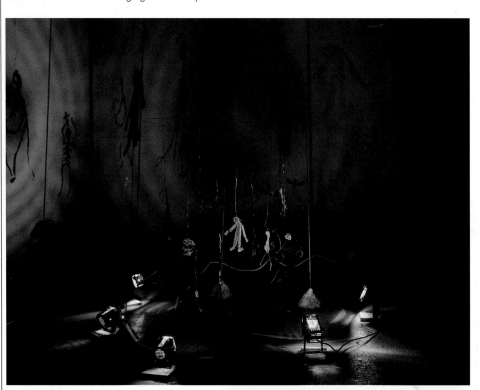

▲ **The Shadows** *In the early 1980s, Boltanski made small marionette-like figures and photographed them. These photos led to kinetic installations, in which the boldly lit figures create a mysterious environment of silhouettes in movement.* 1984, collection Frac Bourgogne

▶ **Reserve of Dead Swiss** *With its thin corridor of boxes, this installation looks like a crematorium or a crypt. The lamps resemble the blinding lights used by interrogators, and add to the unsettling effect.* 1990, Kunsthalle, Hamburg, Germany

CLOSERlook

PHOTOS OF THE DEAD On the boxes are photographs of dead people, taken from a Swiss newspaper's obituary column. Some smile incongruously.

Origins and influences

The London-based American artist, RB Kitaj, coined the phrase "School of London" in 1976 for a generation of British figurative painters, comprising Kitaj himself, Francis Bacon, Lucian Freud, Leon Kossoff, Frank Auerbach, and Michael Andrews. This "school" was held together by friendship, rather than stylistic similarities.

The painter David Bomberg was an important influence on the group. After the war, he taught at Borough Polytechnic in south London, where his students included Auerbach and Kossoff. Bomberg stressed the sense of touch as well as sight.

◀ **The Life Room (Norwich School of Art)** John Wonnacott, 1977–80. *One of Britain's leading portraitists and figure painters, Wonnacott usually shows his figures in context, depicting their environment in perfect proportion and perspective.*

Subject matter

The six artists mainly painted the human figure and its environment, and often sat for one another. Bacon's portrait of Freud and Freud's painting of Auerbach are now considered significant works. These artists all derive strength from the old masters. The knowing spectator can see echoes of Van Eyck, Ingres, and Watteau in the work of Freud. Kossoff and Auerbach constantly return to London's National Gallery to make drawings after their favourites such as Titian and Poussin.

After 1945, the US also produced realist figurative painters – although the critics often ignored them in favour of Abstract Expressionists and Minimal, Pop, and Conceptual artists. Stylistically, they were disparate. Pearlstein and Katz both produced unsentimental figure studies, while Andrew Wyeth made more emotional paintings.

During the post-war period abstract painting was often seen as the logical development for art. Yet figurative painters have not simply rested on tradition; they have produced challenging images of the human condition in a changing world.

Figurative painting

Francis **Bacon**

Francis Bacon, 1984

b **DUBLIN, 1909;** d **MADRID, 1992**

Francis Bacon was the most celebrated British painter of the 20th century. He produced dramatic paintings focused on the figure, which he distorted to express isolation, brutality, and terror. He first gained notoriety in 1945, when he exhibited *Three Studies for Figures at the Base of a Crucifixion*, a horrific triptych depicting half-animal, half-human creatures, writhing in anguish.

Most of Bacon's paintings, even his portraits, were based on photographs. The photograph was a starting point, then a fervid imagination and a skilled oil technique took over. Bacon smeared and smudged the paint so that his subjects were often transformed into nightmarish, ill-formed, slug-like creatures. Many of Bacon's figures seem to have their faces turned inside out and many are isolated – trapped by geometric or cage-like constructions.

LIFEline

1914 Bacon's family move from Dublin to London

1928 Starts work as an interior decorator in London

1949 Starts *Screaming Popes* series – nightmarish versions of Velázquez's famous portrait of Pope Innocent X

1954 Represents Britain at the Venice Biennale

1962–63 Retrospectives at the Tate Gallery, London and Guggenheim, New York

1971 Retrospective at the Grand Palais in Paris

◀ **Study for Bullfight No1**
This is one of three paintings Bacon made of toreadors grappling with bulls. Perhaps Bacon is painting his own struggle with his demons – he drank, gambled, and had to deal with society's attitude to his homosexuality. The bold, hot palette is suggestive of Spanish light and landscape, but also suggests passionate struggle. 1969, oil on canvas, 78 x 58¼in, private collection

▶ **Three Studies for a Crucifixion** *Bacon painted many idiosyncratic versions of the crucifixion. Here, he uses the triptych format associated with Renaissance altarpieces. By depicting butchered bodies, misshapen figures, and spattered blood, Bacon seems to be subverting the format to show the evils of man, rather than the virtues of Christ. 1962, oil on canvas, 78 x 17¼in, Guggenheim, New York, US*

CLOSERlook

DARK SHADOW
Paintings of the crucifixion often had saints at the foot of the cross. Here, there is a dark, mysterious shadow before the "crucifixion" in the right panel. It suggests, perhaps, that there is no salvation, just death.

Study After Velázquez's Portrait of Pope Innocent X *Francis Bacon*
1953, oil on canvas, 60¼ x 46½in, Des Moines Art Center, US

Study After Velázquez's Portrait of Pope Innocent X
Francis Bacon

Bacon's screaming pope, seething with anger and pain, is one of the greatest—and most troubling—British paintings. It is an explicit reworking of Diego Velázquez's 1650 painting of Pope Innocent X. Bacon's papal portrait is an attempt to reinvent Velázquez's painting in a way that would be valid for the mid-20th century. The result is a devastating depiction of existential angst and an apparent rejection of the power of faith in the modern world.

Story

Bacon started painting interpretations of Velázquez's portrait of Pope Innocent X in 1951 and over the next 14 years he returned to the same subject again and again, creating around 50 paintings. He acquired a large collection of books, catalogs, and postcards with reproductions of the portrait. Despite spending three months in Rome in 1954, he apparently never saw the original painting. Throughout his career Bacon made "religious" paintings. sIt was as if he saw it as his mission to subvert the hierarchical order and spiritual authority embodied in traditional religious painting.

▶ **CLENCHED HAND** In Velázquez's portrait the Pope comfortably rests his arms on the chair, reflecting his confident, composed bearing. In Bacon's picture, the Pope's arms are tense and the hands grip the chair in panic and desperation.

▼ **MOUTH AND EYES** The face is an image of terror. The mouth is a black hole, and blood seems to drip from an eye. Nothing is defined–the glasses are created with dabs of white paint, while the lips and flesh tones are suggested with touches of local color.

Composition

The composition is full of dynamic diagonals that seem to underline the Pope's rage. In the lower half of the painting, bold yellow diagonals of the throne are prominent. In the upper half, two diagonals formed by the arms and sloping shoulders lead us to the screaming head. The dynamism of the composition is echoed by the aggressive brushwork.

▶ **GOLDEN THRONE** Rather than sitting on a throne, Bacon's Pope seems to be imprisoned in a cage-like structure. Indeed it almost looks as if he is manacled to an electric chair, and is being jolted into life for the last time.

Technique

The rage of the Pope is reflected in Bacon's bold and energetic application of paint. The paint is smeared and spattered onto the canvas. The brushstrokes are free and emphatic. The curved white brushstrokes used to render the white tunic and the brown vertical brushstrokes in the background are particularly vigorous—like the subject, they "scream out" at the viewer. Bacon seems to have been engaged in a passionate, emotional struggle—not dissimilar, perhaps, to the one he depicted.

▲ **TRANSPARENCY** Dry brushwork lets underlying layers of paint shows through. The technique is known as scumbling and creates broken color effects. While Velázquez's Pope is a solidly modeled, flesh-and-blood person, Bacon's becomes a ghostly apparition.

◀ **COLORS** The yellow and purple immediately catch the eye. As complimentary colors, they come alive when used next to each other. The drama is enhanced by the strong contrast between the white of the Pope's smock and the dark background.

INFLUENCES
VELÁZQUEZ AND *BATTLESHIP POTEMKIN* In Velázquez's portrait, Pope Innocent X looks commanding and composed—a fitting portrayal of a man renowned for his vigor and iron grip. Bacon's Pope is the exact opposite—tyrannical, terrifying, and terrified. The artist seems to want to undermine the traditional conception of him.Bacon often used images from films. One that obsessed him was the nursemaid's scream in *Battleship Potemkin* (1925), where the woman's open mouth forms an "0".

Pope Innocent X Diego Velázquez, 1650 *While Velázquez's Pope exudes power, Bacon's Pope seems possessed with impotent anger. Velázquez portrays the Pope's public image, while Bacon seems to delve into his Pope's private psychosis.*

Lucian **Freud**

Self-portrait

b **BERLIN, 1922**

The grandson of the psychologist Sigmund Freud, Lucian Freud came to Britain as a child as a refugee from the Nazis. With Francis Bacon, he is considered the leading 20th-century British painters of the figure.

Freud's early work was meticulously painted in flat, thinly applied oils with finely pointed sable brushes. Smooth and linear, the style has often been compared to the work of the 19th-century French painter Ingres. However, in the mid-1950s, Freud's work started to become looser and more energetic. He began to use stiffer hogs'-hair brushes and to work standing up. Since the mid-1960s, Freud has focused more and more on the nude—using coarse, broad brushstrokes to give the illusion of the suppleness of flesh. In the mid-1970s, he began using a heavy, granular pigment called cremnitz white, which allowed him to build up flesh tones with bold impasto effects.

Freud mostly paints people he knows and often makes them sit for many days. He says he underplays facial expression because he "wants expression to emerge through the body". Nevertheless, his sitters often have a hunted look and appear to be in spiritual—if not physical—pain.

LIFEline

1933 Freud's family flees the Nazis and moves to Britain

1939 Becomes British subject

1941 Serves on North Atlantic convoy for three months

1972 Begins a series of paintings of his mother, which he continues until the mid-1980s

1974 First retrospective, at the Hayward Gallery, London

2000–2001 Paints Queen Elizabeth II and receives critism of his portrayal from the British press

2002 Retrospective at Tate Britain, London

▲ **Annie and Alice** *This painting is typical of Freud's work at the height of his powers in the 1970s. It is an unsentimental, some would say unsettling, depiction of nude figures. The vigorous, thickly applied brushstrokes, which perfectly capture the sponginess of flesh, and the earthy colors are characteristic of his uncompromising style.* 1975, oil on canvas, 9⅛ x 10⅝in, private collection

▶ **Wasteground with Houses, Paddington** *Freud looks at the city with the same lack of sentiment and objectivity as he does his nudes. Here, he spends as much attention on the trash-strewn backyard (and its fight with the plant life) as he does on the elegant townhouses.* 1970–72, oil on canvas, 66 x 139¾in, private collection

▲ **Girl with Beret** *Until the mid 1950s, Freud worked in a tightly-focused style. This head-and-shoulders format and the composed expression show the influence of Northern Renaissance portraitists, especially Jan van Eyck.* 1951, oil on canvas, 14¼ x 10¼in, Manchester Art Gallery, UK

Philip **Pearlstein**

b **PITTSBURGH, 1924**

A leading American painter of the nude figure, Philip Pearlstein helped pioneer a return to figurative painting in the 1960s.

Pearlstein started his painting career as part of the Abstract Expressionist generation of the 1950s, and his work was characterized by vigorous handling. By the late 1950s, he began concentrate on landscapes. In rocks and cliffs he found cracks and smooth rotundities that looked like features of the nude body. By the 1960s, he was painting nude figures—mainly females—at first with a creamy broken surface, but from the mid-1960s with a clinical precision.

Pearlstein's sitters are unidealized—there is none of the sensuousness traditionally associated with the nude. In fact, Pearlstein tries to eliminate his emotional response to the model. He has spoken of rescuing the body from "its tormented, agonized condition given it by the Expressionistic artists."

LIFEline

1943–46 Serves in US army

1949 Moves to New York to study history of art

1958 Paints landscapes in Italy on a Fulbright grant

1959 Returns to New York City; begins to paint the human figure

1983 Retrospective at the Milwaukee Art Museum

▼ **Two Female Models, One on Floor, One on Iron Bench** *Pearlstein often shows his models from unusual angles, cropping off parts of the body. The sitters, like the woman on the bench here, are frequently put in uncomfortable poses. The resulting pictures seem physically intimate, yet emotionally remote.* 1973, oil on canvas, 60¼ x 72in, private collection

INcontext

FIGURATIVE ART AS PROPAGANDA
The Rent Collector's Courtyard was the subject of much debate among Figurative painters in the West during the 1970s, particularly its simplistic association with political indoctrination in Communist China during the Cultural Revolution.

The Rent Collector's Courtyard *This reconstruction of a tableau about the brutality of landlords in China during the Cultural Revolution was made by Cai Guo-Qiang for the Venice Biennale in 1979.*

Andrew **Wyeth**

Photograph by Richard Schulman

b CHADDS FORD, 1917

The son of a celebrated illustrator, Andrew Wyeth is an enormously popular artist. His *Christina's World* (1948) rivals Edward Hopper's *Nighthawks* (1942) and Grant Wood's *American Gothic* (1930) as the most iconic image of 20th-century America.

Wyeth first made his name with colorful, exuberant watercolors of the Maine coast. But his reputation was established by his meticulously painted images in tempera, in which pigment is mixed with egg yolk, then thinned with water. Unlike oils, tempera cannot be applied quickly—it demands a slow, precise approach. Wyeth explained, "Oil is hot and fiery, almost like a summer night, where tempera is a cool breeze, dry, crackling like winter branches blowing in the wind."

Most of Wyeth's paintings have a wintry feel. They show weathered barns and farmhouses, bleak landscapes and lonely people who stoically endure a hard existence on the margins of society. The pictures are often meditations upon the frailty of life and the imminence of death.

LIFEline

1936 First show, at the Art Alliance of Philadelphia

1948 *Christina's World* is bought by MoMA, New York

1963 Becomes first painter to receive the Presidential Freedom Award

1967 His exhibition at the Whitney, New York sets new musuem attendance record

1971 Starts long-term series of portraits of his neighbor, Helga Testorf, who posed in secret

1987 Shows Helga pictures at the National Gallery of American Art, Washington, DC

► **Winter 1946** *Wyeth painted this image just after the death of his father. He explained that the hill became a symbolic portrait of his father, while the figure of the boy running aimlessly "was me, at a loss." The unusual vantage point, high up and distant, helps emphasize the boy's alienation.* 1946, tempera on composition board, 31½ x 48in, North Carolina Museum of Art, Raleigh, US

▲ **Christina's World** *The girl is Christina Olson, a neighbor, who suffered from polio. She is painfully pulling herself up the hillside with her arms. Wyeth explained, "The challenge... was to do justice to her extraordinary conquest of a life which most people would consider hopeless."* 1948, tempera on gessoed panel, 32¼ x 47½in, MoMA, New York, US

CLOSER look

PRECISE DETAIL Every blade of grass, and every strand of hair, is defined individually. For months, Wyeth worked on the grass in a struggle that echoes the endeavor of his subject on the hill. When he started the figure, "I put this pink tone on her shoulder—and it almost blew me across the room".

Sidney **Nolan**

b MELBOURNE, 1917; d LONDON, 1992

Australia's most acclaimed modern painter, Sidney Nolan was a prolific artist. He worked in a variety of styles and media, experimenting with fabric dyes, polyvinyl acetate, and ripolin (a fluid, fast-drying, high-grade commercial enamel). He traveled extensively across the world, and also worked as a draftsman, printmaker, stage and costume designer.

In his painting, Nolan focused on the figure and landscape. Using a fast painterly style, he captured the fierce light and rugged character of the Australian outback. He often used radically simplified forms—most famously in his depictions of the black armor of the 19th-century outlaw Ned Kelly. Nolan's "Kelly" paintings developed into poignant meditations on the themes, of injustice, love, and betrayal.

LIFEline

1940 Holds his first one-man exhibition, in Melbourne

1945 Produced his first *Ned Kelly* paintings and drawings

1955 Moves to London

1956 Visits Turkey, which inspires a series of paintings

1958 Travels across the US

1981 Is knighted

▼ **Carcass** *In 1953, Nolan was commissioned by an Australian newspaper to make a series of drawings of the drought in the Northern Territory. This painting, with its contorted carcass and parched-soil palette, was made from those drawings.* 1953, ripolin paint on hardboard, 35¾ x 47½in, private collection

▲ **Kelly and Armour** *In 1945, Nolan began painting Ned Kelly, an idealistic 19th-century Irish-Australian outlaw who was hanged for murder. Generally, Nolan shows him in his homemade black armor, starkly simplified against the Australian bush. Here, however, his armor lies discarded, and Kelly appears as a mortal not the myth.* 1962, oil and enamel on board, 48 x 60¼in, private collection

Alex **Colville**

b TORONTO, 1920

The painstaking realism and formal composition of Alex Colville's work have made him the foremost Canadian figurative painter of the postwar period. Not only did he work outside the mainstream of abstract painting, he also broke with the Canadian landscape tradition.

After studying at Mount Allison University, Colville served as an official war artist during World War II— an experience that shaped his artistic principles of accurately observing and recording significant events. Taking many months to plan and complete each individual painting, Colville presents images from his personal experience in precisely worked-out geometric structures that reflect his existentialist philosophy.

▼ **Horse and Train** *Inspired by the lines, "Against a regiment I oppose a brain, And a dark horse against an armoured train" by poet Roy Campbell, this painting depicts with meticulous realism the confrontation of man and nature.* 1954, glazed tempera on hardboard, 16⅛ x 21¼in, Art Gallery of Hamilton, Canada

Alex **Katz**

b NEW YORK, 1927

The detached, "modern realist" style of Alex Katz's mature work—often associated with Pop Art, but in fact pre-dating it—evolved from his attempts to reconcile elements of Abstract art with his representational works.

Studying in New York and Skowhegan, Maine, from 1946 to 1950, Katz was influenced by Abstract Expressionism. In the 1950s, however, he painted a series of portraits of his friends and family in which he developed a figurative style, with flat planes of color and simplified figures. During the 1960s, Katz also produced a number of lithographs and screenprints in this simplified style, and some figures painted on free-standing wooden or metal cut-outs.

After being outside the mainstream of modern art for many years, Katz gained critical and popular success in the 1980s thanks to the somewhat impersonal atmosphere and smooth finish of his paintings.

▲ **Summer Picnic** *Katz's reputation was largely established with his portraits, many of his wife Ada and son Vincent and their friends, often in a domestic setting. Reducing both figures and background to simple, flat planes gives the scene a cool and dispassionate mood.* 1975, oil on canvas, 78 x 144in

Fernando **Botero**

b MEDELLÍN, 1932

Although he is now a cosmopolitan figure with an international reputation, Fernando Botero described himself as "the most Colombian of Colombian artists" when he came to prominence in the late 1950s.

Self-portrait

Born and brought up in Medellín, Botero embarked on his career as an artist at the age of 16, when he exhibited at a show of local artists. After high school, he moved to Bogotá, where he became involved with the artistic community centered around the Café Automatica. He spent much of the 1950s traveling, before eventually settling in New York. During this period, Botero's painting developed from a Picasso-influenced style to the neo-figurative portrayals of rotund figures that are characteristic of his mature work.

Although Botero's paintings and sculptures are not intended as caricatures, the exaggerated proportions of the figures are good-humored. Much of his work also has an element of social commentary—sometimes indirectly, but recently overtly in his paintings of the Medellín drug cartels and the Abu Ghraib prison in Iraq.

LIFEline

1944 In his teens, attends a school for bullfighters

1951 Moves to Bogotá and has his first one-man show

1952–54 Travels around Europe

1956 Marries Gloria Zea and moves to Mexico

1960 Divorces Gloria and buys a studio in New York

1973 Moves his studio to Paris

1974 His four-year-old son is killed in a car accident

1983 Settles in Tuscany, Italy

▲ **Our Lady of Fatima** *In a highly unconventional handling of the subject, Botero portrays the Virgin Mary in what was to become his trademark "fat lady" style. The work shows the influence of Picasso in the childlike simplicity of the figures, and of Abstract Expressionism in the texture of the brushwork.* 1963, Museo de Arte Moderno, Bogotá, Colombia

❝ I describe in a realistic form a **nonrealistic reality**. When you start a painting, it is somewhat outside you. At the conclusion, you seem to **move inside the painting** ❞

FERNANDO BOTERO

▼ **The Dressmaker** *As well as many slightly satirical portraits of pompous middle-class figures, Botero painted still lifes and scenes of everyday life. This dressmaker, for example, is more sympathetically portrayed: although still amply proportioned, she is less of a caricature, and the tools of her trade not only help define her character, but play an important role in the composition.* private collection

Frank **Auerbach**

Portrait by
Lucian Freud

b BERLIN, 1931

Frank Auerbach was sent to Britain from Germany by his parents, who later died in a Nazi concentration camp. After World War II, he studied at Borough Polytechnic under David Bomberg, and at St. Martin's School of Art and the Royal College of Art.

A one-man show in 1956 established his reputation, but also gained him some notoriety for his technique of very heavy impasto—so thick on some paintings that they were laid flat rather than hung—which gives his work an almost sculptural quality. Auerbach often limits his palette to earth colors and even monochromes, and has restricted his subjects to portraits of people he knows well and scenes close to his London studio.

CLOSERlook

IMPASTO Building up layer on layer of paint, and reworking it at each stage, Auerbach creates an unusually thick impasto that gives his painting its characteristic texture.

▶ **JYM in the Studio VII** *Auerbach prefers to paint subjects he knows well, especially portraits of his wife Julia, lover Stella, and the model Juliet Mills—the JYM of this painting's title.* 1965, oil on board, 36½ x 17¾in, Abbot Hall Art Gallery, Kendal, UK

Jack **Vettriano**

b FIFE, 1951

A former mining engineer, Scottish painter Jack Vettriano was born Jack Hoggan, but adopted his mother's maiden name after the success of his work in the late 1980s. Entirely self-taught, he started painting as a hobby in his twenties, and first exhibited at the Royal Scottish Academy annual show in 1988.

Vettriano's work was an instant popular success, leading to exhibitions worldwide during the 1990s. His paintings attracted celebrity buyers and unprecedented prices, and reproductions of his work became best-sellers. Despite his commercial success, Vettriano's realist style and romantic, or mildly erotic, subjects remain controversial in the academic art world.

▲ **The Singing Butler** *Set on a wind-swept beach, Vettriano's most popular work is typical of his style. The subject appeals to nostalgia, while his evocation of atmosphere is skillful.* 1992, oil on canvas, 28 x 36in, private collection

▲ **Society Lady (Woman on Balcony with Gloves)** *This portrait affectionately pokes fun at the pretensions of the bourgeoisie—a recurrent theme in Botero's painting. Despite the sophisticated technique and attention to detail, the curtain and the plump figure retain his characteristic flat perspective, emphasizing the irony of the image.* 1995, oil on canvas, 52 x 40¼in, private collection

Michael **Andrews**

b NORWICH, 1928; d LONDON, 1995

▲ **Melanie and Me Swimming** *Andrews's most popular painting is an unusually personal image. It was painted after the first of several family holidays to Glenartney, in Scotland.* 1978–79, acrylic on board, 72 x 72in, Tate, London, UK

Michael Andrews studied at the Slade School of Art with William Coldstream, whose theory that all artists' marks should relate to something seen, made a profound impression on him. Afterwards he became associated with the group of figurative painters loosely known as the School of London. Fellow members included Auerbach, Lucian Freud, and Francis Bacon. During the 1960s, Andrews painted a series of party scenes that captured the mood of the time. He followed these with his *Lights* series of aerial views. A trip to Uluru (Ayers Rock) in Australia in 1983 inspired a new spiritual context for much of his later landscape painting.

Superrealism is a style of art based on imitating photographs in paint, and imitating real objects in sculpture. The name was coined by Malcolm Morley, the pioneer of the genre, in 1965. Other terms used to describe this movement are Photorealism and Hyperrealism.

Origins and influences

The obvious forerunner to Superrealism was *trompe l'oeil* (to fool the eye) painting, in which the artist tried to convince the viewer that what they were seeing was not a painting of objects, but the objects themselves. This genre originated in the Renaissance and flourished in Dutch painting of the 1600s and American painting of the 1800s.

The highly finished surfaces of 17th-century Dutch painting, which are especially evident in Vermeer's work, were also influential on many Superrealists, especially Richard Estes.

Superrealist artists work with unnerving precision, confounding the viewer's expectations of art by presenting a world that is, unsettlingly, truer than true. The style flourished in the US in the late 1960s and the 1970s.

◀ **Supermarket Shopper**
Duane Hanson, 1970. Hanson's people sculptures are wonderful examples of Superrealism. They are so lifelike, they often initially fool the viewer into thinking they are real people.

Subjects

Superrealist painters usually try to mimic the unique qualities of a photograph—the way the image falls in and out of focus, the way the lens distorts features, and the way the shutter freezes motion. Malcolm Morley's paintings of ships, for example, look like photographs that have been cheaply reproduced, while Richard Estes's paintings of the wide cityscapes of New York look like panoramic photographs. Superrealists usually try to remove emotion from their paintings, thus replicating the apparent detachment of mechanically produced images.

Superrealist sculptors strive to mimic real objects, especially the human figure. The two most famous Superrealist sculptors—John DeAndrea and Duane Hanson—cast directly from the human body. They work in polyvinyl, which gives a smooth, flesh-like finish and allows for detailed painting of the surface.

Superrealism

Malcolm **Morley**

Photograph by John Jonas Green

b LONDON, 1931

In over 50 years as a painter, Malcolm Morley has refused to settle into a single style. His work has covered Abstract Expressionism, Pop Art, and Conceptual Art. But he is most famous for helping to initiate two influential art movements: Superrealism and Neo-Expressionism.

In the 1950s, Morley was entranced with Abstract Expressionism, creating paintings with black and white horizontal bands, not dissimilar to the work of Barnett Newman. In the mid-1960s, he pioneered Superrealism and painted ships, using postcards as reference. To avoid painterly expression and emotional responses, he would often turn both the canvas and postcard upside down while he painted. The result was a picture faithful to the look of mass-produced photographic imagery. In the early 1970s, Morley produced Conceptual Art, but by the 1980s he had turned to Neo-Expressionism, and his work was full of loose, robust brushwork and sensual color.

▶ **Wall Jumpers** *Morley recently returned to Superrealism, creating what he calls "fidelity" paintings. Here, the subject matter is troubling – Palestinians leaping over a wall into Israel – and yet Morley paints a sensuous image, full of color and athletic movement. 2002, oil on canvas, 90 x 69in, Musée d'Art Moderne et Contemporain de Strasbourg, France*

LIFEline

1952–53 Attends Camberwell School of Arts and Craft in London

1954–57 Studies at the Royal College of Art, London

1958 Moves to New York

1965 Begins Superrealist style, painting warships and ocean liners

1972 Becomes Professor at the State University of New York

1975–76 Produces pictures depicting scenes of disaster

1984 Becomes first winner of the Turner Prize

▲ **Farewell to Crete** *This painting, from Morley's Neo-Expressionist phase, is made up of pairs of images—two fertility goddesses, two naked couples, a bull and a horse. It is one of a series of paintings of Greece and Crete that explore myth and reality, and the ancient and modern worlds. 1984, oil on canvas, 80 x 164in, private collection*

CLOSERlook

IMITATING THE PHOTO The original photo was taken with a telephoto lens. This creates a shallow depth of field, with only a narrow section of the view in focus. Morley has imitated this effect, showing the wall and figures in focus, but letting the background slip out of focus.

Chuck **Close**

Photograph by
James Leynes

b **MONROE, WASHINGTON, 1940**

Chuck Close uses Superrealism to create mural-sized portraits. He works meticulously from photographs, drawing a grid over the photograph before drawing a grid over the canvas and copying the photograph, square by square.

Close took up Superrealism in 1967, spending 30 months creating eight huge, black and white airbrushed portraits. In the 1970s, he moved on to color. He also started making "fingerprint" portraits by inking his finger and making impressions on the gridded surface of the paper. Other portraits were created from small paper disks, of varying colors and shapes, glued to a gridded canvas.

Close chooses his subjects from among his friends, including the artists Richard Serra, Roy Lichtenstein, and Robert Rauschenberg. He does not take commissions, saying, "Anyone vain enough to want a nine-foot portrait of themselves would want the blemishes removed."

LIFEline

1958–64 Studies at the University of Washington, then at Yale

1967 First solo exhibition, at the University of Massachusetts; begins painting in Superrealist style

1969 His work is included in the Biennial Exhibition at New York's Whitney Museum

1988 A blood clot in his spinal column leaves Close paralyzed, initially from the neck down

1989 Begins painting again—at first by holding a brush between his teeth

1998 Major retrospective of his work is held at MoMA, New York

CLOSERlook

TINY PAINTINGS Using a brush strapped to his hand, Close painted little shapes inside each square of the grid. "I saw that each grid was in fact a tiny painting," he said.

▶ **Linda** To make color portraits like this one, Close imitated the mechanical reproduction techniques used by a printer—applying first cyan (blue), then magenta, then yellow. This mural-sized painting of the writer, Linda Rosenkrantz Finch, took Close 14 months to finish. It is amazingly detailed – individual hairs, eyelashes, and pores can be seen. 1976–78, acrylic and pencil on canvas, 108 x 84in, Akron Art Museum, Ohio, US

▼ **Alex** This picture of the painter Alex Katz was created while Close was paralyzed from the neck down. It consists of easy-to-make shapes—circles, diagonal lines, lozenges—and, as a result, appears looser and more painterly than his early work. The effect is like looking through hammered glass. 1991, 28 x 23¼in, Cecil Higgins Art Gallery, Bedford, UK

John **DeAndrea**

b **DENVER, 1941**

The American sculptor John DeAndrea makes polyvinyl (PVC) casts of the human figure, usually nude. The figures are astonishingly realistic. He sets hair into plastic scalps a few strands at a time. He paints the PVC not just with flesh tones, but also with moles, tiny veins, and scars. Even pressure marks on the flesh made by clothing are preserved by the casting material.

▲ **Couple (Man Clothed)** DeAndrea's life-size sculptures often take the viewer by surprise. At first glance, these figures, designed to lean against a wall, might easily be taken for real people. 1978, cast PVC painted in oil, life size, private collection

Audrey **Flack**

b **NEW YORK, 1931**

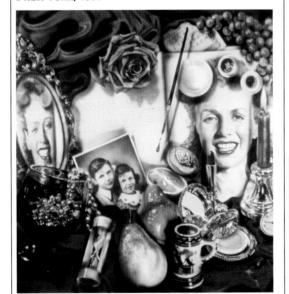

▲ **Marilyn (Vanitas)** A vanitas is an allegorical still life, in which the objects remind the viewer of the transience of life. This is a vanitas for the modern age, with the pink hour glass suggesting passing time, and the cut fruit hinting at the inevitability of decay. 1977, oil over acrylic on canvas, 96 x 96in, artist's collection

Audrey Flack came to prominence in the 1970s with a series of Superrealist still-life paintings showing "feminine" subject matter—jewels, cosmetics, cut glass, cream cakes. Unlike many Superrealists, who dispassionately render photographs, Flack aims to stimulate an emotional response in the viewer. She works by projecting a slide on to her canvas and then painting the projected image.

Richard **Estes**

b **KEWANEE, ILLINOIS, 1932**

Estes studied at the Art Institute of Chicago, then moved to New York in 1956. Around 1967, he began to paint New York street scenes in a Superrealist manner, working freehand from his own color photographs.

Estes rarely reproduces his photographs faithfully—he subtly alters details or, by using two or more photographs, completely reinvents the world he depicts. He focuses obsessively on reflections. They appear boldly in puddles and panes of glass and unfold, like oil slicks, on the shiny, curved surfaces of cars.

Clothing Store Estes loves to depict reflections in shop windows. As the objects inside are obscured by reflections from the outside, wonderfully mysterious, complex compositions arise. The result in this instance is an almost abstract arrangement of hard-edged shapes. 1976, acrylic on board, 20⅛ x 22in, private collection

Origins and influences

Inspired by the Women's Movement of the late 1960s, many women artists began to incorporate social and political themes of feminism into their work. This new generation of feminist artists wanted to express the experience of women on their own terms. As well as producing works of art that were recognizably "female", some created a platform exclusively for women artists—notably the groundbreaking Feminist Art Program set up by Judy Chicago and Miriam Schapiro at the California Institute of the Arts in 1971.

Subjects

Not all women artists can be labeled "Feminist"—it is the subject matter that distinguishes Feminist Art from other contemporary movements: issues of discrimination, oppression, criticism of patriarchy and male violence, and celebration of female sexuality. The imagery is necessarily often sexual, but challenges the stereotype of woman as an object of male erotic desire or fantasy.

Style, medium, genre

No specific style, medium, or genre is associated with Feminist Art, although more avant-garde forms have tended to predominate. Some Feminist Art uses the traditional media of painting and sculpture. However, it is argued that the prestige these forms carry is bound up with male dominance and that alternatives need to be found.

Certain Feminist artists have adopted the devices of the mass media to present their message in an immediate, accessible form. Feminist Art has also emphasized needlework, ceramics, and other crafts traditionally associated with women, and not previously regarded as "fine art," exemplified by Judy Chicago's *The Dinner Party* (1974–79).

◄ **Women, Art and Power**
Feminist ideology informed the work of an increasing number of women artists, who challenged the male dominance of mainstream art.

Until the 20th century, women artists had been effectively excluded from the art world, and even by the 1960s only a few had achieved recognition. In the following decades, the diverse work of some women artists to counter this male domination has become known as Feminist Art.

Feminist art

Barbara **Kruger**

b **NEWARK, NEW JERSEY, 1945**

Barbara Kruger is best known for her photo-based work, which combines her background as a graphic designer with an interest in poetry and the influence of contemporary mass media. After studying at Parsons School of Design, New York, Kruger went on to become the chief designer at *Mademoiselle* magazine, before moving to California in 1976 to concentrate on her art and poetry.

Having already designed several political book covers, Kruger continued to tackle subjects of social commentary, in particular issues of misogyny and abuse of power. Using the visual language of advertising and the mass media—on posters, billboards, and T-shirts, as well as in galleries—she subverts the iconography of the consumer society to act as a vehicle for her messages.

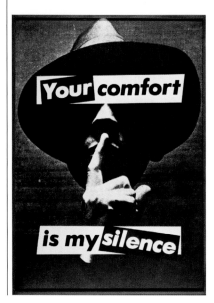

◄ **Untitled (Your Comfort is My Silence)** *Presented with the scale and immediacy of billboard advertising, Kruger's tabloid-style texts superimposed on an enlarged black-and-white photo have an unsettling impact. A terse statement such as "Your comfort is my silence" accompanied by a shadowy image forcefully conveys the anti-sexist message.* 1981, photo work, 56 x 40½in, Daros Exhibitions, Zurich, Switzerland

Jenny **Holzer**

b **GALLIPOLIS, OHIO, 1950**

Originally an abstract painter and printmaker, Jenny Holzer became interested in conceptual art as a graduate student in 1975, and has concentrated on works using text as art in public places since her move to New York in 1977. Holzer introduced texts into her abstract paintings gradually, but they have now entirely replaced images.

In *Truisms* (1977), they took the form of posters of aphorisms displayed in public places. Subsequent versions of this and other works have included texts on LED billboards, projected on to buildings, and printed on stickers, T-shirts, and even condoms.

▼ **Inflammatory Essays** *In this site-specific installation, texts from several of Holzer's series are displayed on an LED signboard around a spiral ramp. The statements, in different colored lights, are proclamations of Feminist ideology.* 1990, LED electronic display signboard, Guggenheim Museum, New York, US

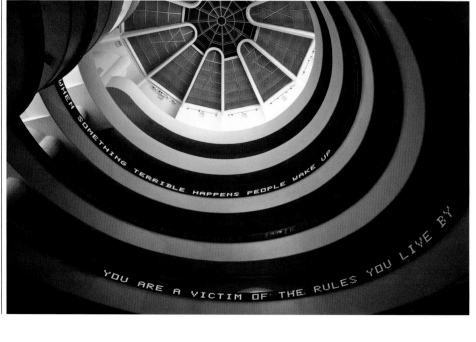

Louise **Bourgeois**

b **PARIS, 1911**

The parents of sculptor and painter Louise Bourgeois restored tapestries in Paris and encouraged their daughter to assist them by providing designs for missing or worn sections. Although she initially studied mathematics, she went to the École du Louvre and École des Beaux-Arts, Paris, and for a time worked as the assistant to painter and designer Fernand Léger. In 1938, Bourgeois met and married the art historian and critic Robert Goldwater and moved to New York, where she first exhibited her prints.

She moved from printmaking to sculpture in the 1940s, but did not adopt the abstract style of her contemporaries. Instead, she created stylized figures with symbolic significance (often with ambiguously sexual images) and used unusual materials. After the death of her father and her husband in the 70s, Bourgeois's work became overtly feminist, notably in *Destruction of the Father* (1974), and she gained considerable critical and public acclaim. She has continued to work into her 90s, producing popular large-scale sculptures.

LIFEline
1926 Studies mathematics at the Sorbonne
1938 Marries Robert Goldwater, moves to New York
1938–40 Studies painting at New York art school Art Students League
1949 Stages her first exhibition of sculpture
1973 Goldwater dies
1974 Creates *Destruction of the Father* sculpture
1993 Represents the US at the Venice Biennale
1999 The first artist to exhibit in the Turbine Hall of Tate Modern, London

> 66 It is a great **privilege** to be able to **work with**, and I suppose **work off**, my **feelings** through **sculpture** 99
> LOUISE BOURGEOIS

◀ **The Blind Leading the Blind** *One of a series of similar sculptures of the 1940s portraying a row of pairs of stylized legs, their individual instability countered by a horizontal beam—symbolizing the collective strength of women working together. 1947–49, painted wood construction, 70½ x 97 x 17¼in*

▲ **The Destruction of the Father**
Bathed in a macabre red light, the menacing and ambiguous dome-like shapes convey the mood of anger Bourgeois felt about her father's infidelity. This work marked the beginning of a period of more explicit feminism in her work. 1974, plaster, latex, wood, fabric, and red light, 93½ x 142½ x 98in

CLOSERlook

EXPRESSION OF ANGER On a dinner table in a cave-like interior, the domineering patriarch, cast in latex from lamb and chicken bones, is torn apart and cannibalized by his tyrannized children.

Judy **Chicago**

b **CHICAGO, 1939**

Born Judy Cohen, but later adopting the name of her native city, Judy Chicago has been at the forefront of American Feminist Art since the 1970s. She left Chicago in 1957 to study in Los Angeles and has been based in California as a teacher and artist ever since. She co-founded the Feminist Art Program at the California Institute of the Arts and the Feminist Studio Workshop in Los Angeles in the 1970s. Chicago's political commitment has always figured largely in her art, and the themes of feminism and oppressed minorities have inspired many of her most important works. The success of *The Dinner Party* (1974–79) and *Holocaust Project* (1993) has established her as one of the major figures of contemporary American Art.

▼ **The Dinner Party** *Consisting of a huge triangular table, laid with place settings for 39 women guests, standing on a porcelain-tiled floor inscribed with the names of 999 other women. this work was produced under Chicago's direction by a team of several hundred women volunteers. 1974–79, installation, Elizabeth A Sackler Center for Feminist Art, Brooklyn Museum, New York, US*

CLOSERlook

PLACE SETTINGS The 39 place settings each have a plate and tablecover, individually embroidered with motifs associated with a particular woman. Chicago purposely chose ceramics and needlework, because these are crafts traditionally associated with women.

The Neo-Expressionists emerged in the 1970s in the US, West Germany, and Italy, producing bright, figurative paintings, often using unusual techniques. In the 1970s in New York graffiti art thrived, and by the 1980s many of its exponents were exhibiting in galleries, rather than in the streets.

Origins and influences

The Neo-Expressionists rejected the austere, cerebral work of the Minimalists and Conceptual artists of the 1960s and instead returned to figurative painting as their primary medium of expression. By the 1980s, Neo-Expressionism had become the dominant style of avante-garde artists in the West. Much of this work was of dubious quality but it helped fuel a feverish art market, especially in New York.

The Neo-Expressionists drew their inspiration from many sources—including the work of the German Expressionists of the 1910s and 1920s, the Abstract Expressionists of the late 1940s and 1950s, and the late aggressive paintings of Pablo Picasso.

▲ **Merlin's Hat** Joe Zucker *The artist's colorful paintings of the late 1970s typify the exuberance of Neo-Expressionism.*

Style and technique

Neo-Expressionism was characterized by style rather than subject. The work was dramatic, with distorted subject matter and strong contrasts of color and tone. The paint was often applied in thick *impasto* with aggressive brushwork, giving the appearance of spontaneous execution.

Many Neo-Expressionists set out to shock with unconventional techniques and media. From 1969, the German Georg Baselitz began to hang his paintings upside down to emphasize the passionate brushwork rather than the subject matter. In New York in the 1970s, graffiti artists transformed the city with their colorful, spray-painted artwork. They "bombed" subway trains, so their art travelled through the city.

Neo-Expressionism and Graffiti art

TIMEline

Jorg Immendorff's *Café Deutschland* series of the late 1970s and early 1980s comprised colorful paintings of an imaginary café and highlighted the divisions and insecurities in German society. Julian Schnabel's massive *The Student of Prague* contains found objects such as broken crockery. Jean-Michel Basquiat's *Pyro* is full of crudely drawn images of violence and angst, while Anselm Kiefer's *Belief, Hope, Love* is a more conceptual piece.

1978

IMMENDORF Café Deutschland I

1983

SCHNABEL The Student of Prague

1984

BASQUIAT Pyro

1984–86

KIEFER Belief, Hope, Love

Interpretations

There were three main centres of Neo-Expressionism—Italy, West Germany, and the US.

Italy

Italian Neo-Expressionists became known as the *transavantgarde* ("beyond the avant garde"), a term coined by art critic Achille Bonito Oliva. The main artists in the group—Sandro Chia, Francesco Clemente, Enzo Cucchi, and Mimmo Paladino—were all interested in myths, legends, and art history. Their styles, however, were very different, from Clemente's meditative work, which was influenced by Asian spiritualism, to the classic Expressionist style of Paladino, who declared that his work comes from a psychic explosion that he carries directly on to the canvas.

Germany

The revival of figurative painting in Germany was led by Georg Baselitz in the 1960s and by Anselm Kiefer and Jorg Immendorff in

◀ **Untitled (Figure with Raised Arm)** Georg Baselitz *Neo-Expressionism's characteristic energy and passion can be seen in Baselitz's crudely modeled and painted sculptures.* 1982–84, painted wood, 99½ x 28 x 18⅛in, Scottish National Gallery of Modern Art, Edinburgh, UK

the 1970s. Kiefer's large canvases are now regarded as seminal early works of Neo-Expressionism.

At the beginning of the 1980s, a new generation of German artists emerged—the *Neue Wilde* ("new wild ones"). In Berlin, artists such as Rainer Fetting and Helmut Middendorf based their works on the city's punk and new wave sub-culture. In Cologne, a group of artists—including Hans Peter Adamski and Walter Dahn—rented a studio to make witty, ironical pictures. In Hamburg, artists such as Albert Oehlen reacted against the era's political apathy and brash affluence.

US

The American artists Julian Schnabel, Keith Haring, and Jean-Michel Basquiat, made their name in New York. Haring and Basquiat started as graffiti artists, but when they began exhibiting in galleries their work changed dramatically. Basquiat's paintings were highly emotional, full of violent brushwork, while Haring's work was playful, his bold designs equally at home on T-shirts as on canvases. These two artists followed in the wake of the Puerto Rican-born New York graffiti artist Lee Quniones, whose 1979 exhibition at the Galleria Medusa in Rome introduced New York street art to the rest of the world.

▲ **Untitled** Keith Haring *The artist's mixture of doodle-inspired imagery and crude writing evolved from his work as a graffiti artist.* 1982, acrylic on tarpaulin, Deichtorhallen, Hamburg, Germany

Georg **Baselitz**

Photograph by Roland Weihrauch

b **GROSSBASELITZ, 1938**

Georg Baselitz's work is raw, unsettling, and uncompromising. In both his painting and his sculpture, he uses a vigorous—even violent—technique to provoke visceral emotions in the viewer.

In his early work of the late 1950s and early 1960s, Baselitz rebelled against the dominance of Abstract Painting, proposing in its place a very personal and expressive figurative art. This was often brutally erotic, and apparently influenced by art produced by the mentally ill. His work was the antithesis of the detached work of the Pop Artists and Minimalists, who dominated the 1960s art world. For inspiration, Baselitz looked back to the rebels of art—the Expressionists of early 20th-century Germany and the Mannerists of 16th-century Italy. In the 1980s, he was widely acknowledged as a father figure of the Neo-Expressionist movement.

LIFEline

1965 Studies at Villa Romana, in Florence, and is inspired by Mannerist paintings there
1977 Made Professor of painting in Karlsruhe
1980 Shows at the Venice Biennale exhibition; his Nazi imagery causes controversy
1983 Teaches at the Hochschule der Bildenden Künste in West Berlin

▶ **Model for a Sculpture** *This is one of the first of Baselitz's monumental wood sculptures, in which he used axes and chainsaws to attain a raw, uncompromising look. Here, he shows a human torso, seemingly giving the Nazi* Sieg Heil *salute while rising from a block of wood.* 1980, painted limewood, 70 x 58 x 96in, Ludwig Museum, Cologne, Germany

▼ **Two Meissen Woodmen** *This painting is one of five similarly sized paintings of woodmen. The series developed following the first appearance of* Der Neuer Typ *(the new man)—in Berlitz's work in 1965.* 1967, oil on canvas, Pinakothek der Moderne, Munich, Germany

CLOSERlook

UPSIDE DOWN By painting his pictures upside down, Baselitz stresses the formal qualities of the painting—the color, tonal contrast, and the texture of the brushwork.

▲ **Die Mädchen von Olmo II** *Baselitz rebelled against Abstract Art, but he also despised paintings that passively accepted external appearances—especially Pop Art. As a result, in 1969 he began to paint upside down. Ironically, by inverting the image he encourages the viewer to look at his paintings as abstract arrangements of shape and color.* 1981, oil on canvas, 98½ x 98in, Pompidou Centre, Paris, France

" I'm a **Mannerist** in the sense that I deform things. I'm **brutal, naive, and Gothic "**

GEORG BASELITZ, 1995

Jörg **Immendorff**

b **BLECKEDE, NEAR LÜNEBURG, 1945;** d **DÜSSELDORF, 2007**

The German Neo-Expressionist Jörg Immendorff sought to instigate political debate and change. "I am for a form of art," he said in 1976, "that sees itself as one of the many means through which human society can be changed."

In the 1960s, Immendorff was inspired by the "happenings" of the conceptual artist Joseph Beuys. He developed his own form of politicized, absurdist performance art—christening it "Lidl," a nonsense word based on the sound of a baby's rattle. He formed a "Lidl Academy"—a utopian vision of a professor-free art school. In the late 1970s, Immendorff began his *Café Deutschland* paintings. Set in an imaginary nightclub, they ask questions of a Germany traumatized by post-Nazi guilt, dominated by consumerism and totalitarism, and threatened by nuclear destruction. In his last years, Immendorff was confined to a wheelchair and had to direct assistants to complete works following his instructions.

LIFEline

1963 Enrols at the Kunstakademie in Düsseldorf; becomes a student of Joseph Beuys
late 1970s Starts his *Café Deutschland* paintings
1982 First large show, at the Kunsthalle in Düsseldorf
1997 Awarded the Marco, the world's most lucrative art prize, worth $250,000, by the Museum of Contemporary Art in Monterrey, Mexico
1998 Awarded Germany's Order of Merit, the *Bundesverdienstkreuz*
2005 His 60th birthday is marked with a retrospective at Berlin's Nationalgalerie

▼ **Yellow and White Baby** *In the late 1960s, Immendorff painted a series of Buddha-like babies in lurid tones.* 1967, oil on canvas, 56 x 57in, Museum Kuppersmuhle, Duisburg, Germany

▲ **Café Deutschland I Museum** *Immendorff's most celebrated accomplishment was his* Café Deutschland *series. The café is a fantasy world populated by historical characters, imaginary events, and Immedorff himself. In the café, we see both real walls and people with "walls" in their heads.* 1978, oil on canvas, 110 x 126in, Museum Ludwig, Köln, Germany

CLOSERlook

ONE GERMANY The artist pictures himself in front of the Berlin Wall, his hand stretched through a hole toward his friend the painter A. R.- Penck, seen in reflection on the other side.

Anselm **Kiefer**

b **DONAUESCHINGEN, 1945**

Anselm Kiefer has created art in a vast variety of media, and addressed diverse subjects. But his main concern, especially during the 1970s, has been German history and, in particular, the tragedy of World War II and the role of Nazism in that conflict.

In 1969, Kiefer produced a series of photographs of himself giving the *Sieg Heil* salute. From 1975, he concerned himself with the *Nibelungen* legends, pointing beyond the original German epic to its adaptation by Richard Wagner and the Nazis' use of it for nationalistic purposes. In the 1970s, he also began painting a series of highly worked, burned German landscapes. These images suggest destruction, but also the possibility of new growth, intimating that there is redemption and healing for Germans who feel guilty about their past. Kiefer often worked on these images with a blowtorch, and embedded straw, lead, clay, and ashes into the canvas.

In 1991, the year after Germany's reunification, Kiefer left his homeland. He settled in the south of France in 1992. This change had a marked effect on his style and themes, which ranged from the sunflowers of Arles, to the Chinese leader, Chairman Mao.

Photograph by Bertrand Guay

LIFEline

1966 In his 20s, abandons law studies to pursue art
1969 Produces *Occupations* photos, showing himself saluting like Hitler
1970 Becomes a student of the conceptual artist Joseph Beuys in Düsseldorf
1971 Paints his first large-scale landscapes
1973 Starts paintings of melancholy wooden interiors
1991 One-man show at the National Gallery in Berlin
1992 Moves to Barjac in southern France

▼ **Faith, Hope, Love** *The three blades of this propeller sculpture are inscribed with the three virtues—faith, hope, and love. Are these virtues simply aspirations? The lead propeller, after all, will never rise above the earth.* 1984–86, mixed media, 110 x 150 x 29½in, Art Gallery of New South Wales, Sydney, Australia

▼ **The Sorrow of the Nibelungen** *Kiefer made a series of paintings alluding to Wagner's opera, The Ring. Here, he smeared blood above each name in the* Nibelungen *narrative.* 1973, oil and charcoal on burlap, Museum of Fine Arts, Houston, US

▲ **The High Priestess** *Kiefer arranged 200 lead books, each weighing 660 pounds, on two steel bookshelves, leaned against each other, but separated by a panel of heavy glass. Through this installation, Kiefer communicates the weight that knowledge of German history has on him.* 1985–89, mixed media, 158 x 315 x 39½in, private collection

CLOSERlook

PAGES OF THE PAST

Most viewers never get to open the books and see the images within. They contain weathered and damaged photographs of landscapes and natural objects like seeds.

Sandro **Chia**

b **FLORENCE, 1946**

The Italian artist Sandro Chia first made his name in the late 1960s and early 1970s as a conceptual and installation artist. In the late 1970s, however, he turned to figurative painting—celebrating human sensuality and animal vitality in large, vibrantly colored oils. Chia was a leading artist in *Transavanguardia*, a group of Italian painters who sought inspiration in myths, legends, and the great masters.

▼ **Water Bearer** *Chia often shows male figures bound on some unidentified mission. This painting recalls a story from the* Apocrypha *about Tobias, who was told to take a large fish with him on his journey to find a bride.* 1981, oil and pastel on canvas, 81½ x 67in, Tate, London, UK

Julian **Schnabel**

b **NEW YORK, 1951**

Schnabel rose to fame at the end of the 1970s, with paintings that incorporated objects such as deer antlers and tree branches. In 1979, he started using broken crockery. He wanted to shock—the works were big and brash, and plates would occasionally crash to the floor. He also used unconventional supports, such as tarpaulin, animal hides, and Japanese theater screens. He is now well known as a filmmaker.

▼ **The Student of Prague** *Schnabel has added crucifixes over broken china vessels, but there is little suggestion of spiritual succour. The painting is a troubling vision of a broken world.* 1983, mixed media, 116 x 228in, Guggenheim Museum, New York, US

❝ My paintings take up room, they **make a stand**. People will always react to that. Some people get **inspired**, others get **offended**. But, that's good ❞

JULIAN SCHNABEL, 2003

Banksy

b **BRISTOL, 1974?**

Britain's most celebrated graffiti artist, Banksy creates witty and gently subversive stenciled images—often with political messages. His work has appeared in the streets of cities across the world, but as graffiti is generally illegal, he rigorously maintains his anonymity.

Banksy's work includes subversive stunts. In 2004, "Banksy of England" issued ten-pound notes with Princess Diana's head replacing the Queen's and, in 2006, he put a life-sized replica of a Guantanamo Bay prisoner, wearing an orange jumpsuit, into Disneyland. He also produces new versions of famous artworks, such as Monet's *The Waterlily Pond*—with shopping carts dumped in the water.

▼ **Stenciled Image** *Banksy's stencils make a point about life and art from their being placed in a real space rather than within a picture frame. Should we find more interesting the bored warder or the precious framed painting?* Near Arsenal Emirates Stadium, North London, UK

Keith **Haring**

b **READING, PENNSYLVANIA, 1958; d NEW YORK, 1990**

Haring was a New York-based artist who believed that art should be integrated in the life of the city. In 1980, he began to create drawings in subway stations, using white chalk on unused advertising panels covered with black paper. Haring produced hundreds of these rhythmical drawings, saying the subway was a "laboratory" that helped him to evolve his spontaneous, free-flowing style. He also drew on objects he found in the street—fridge doors, discarded cribs, or stuffed animals. In 1986, Haring opened the Pop Shop in SoHo, selling, at a low cost, T-shirts, toys, posters, and magnets bearing his images. Haring was diagnosed with AIDS in 1988 and died in 1990, aged 31.

LIFEline

1976 Enrols at Ivy School of Professional Art in Pittsburgh
1978 Moves to New York
1982 Makes his SoHo gallery debut with an acclaimed one-man show at the Tony Shafrazi Gallery, New York
1989 Establishes the Keith Haring Foundation to fund AIDS organizations

▲ **Untitled** *Much of Haring's work has a childlike appeal. This image, with its lively surface pattern, bold color combinations, and comically fearsome, human-capturing monsters, looks as if it could be an illustration in a children's book.* 1983, silkscreen, Deichtorhallen, Hamburg, Germany

Jean-Michel **Basquiat**

b **NEW YORK, 1960; d NEW YORK, 1988**

Born to a Haitian father and Puerto Rican mother, Basquiat was brought up in New York. He had a troubled childhood—his parents separated when he was seven and he lived with his father, but often ran away. As a child he learned Spanish, French, and English and frequently visited New York's museums.

Basquiat first gained notoriety for his cryptic graffiti messages in SoHo in Manhattan. His rise to fame was quick—the *Village Voice* interviewed him about his graffiti in 1978, he began painting on canvas around 1980, and by 1983 he was good friends with Andy Warhol and included in the Whitney Museum's Biennial. Basquiat's painting consciously evoked the unfinished look of graffiti—and sometimes incorporated materials scavenged from the streets. His subject matter was autobiographical, with references to art history, sports legends, hip-hop and jazz music, and racism.

LIFEline

1974–75 Aged 14, moves with his father to Puerto Rico
1977 Signs graffiti in Manhattan, using the pseudonym SAMO
1978 Leaves home, earns money selling collage postcards and painted T-shirts
1982 First one-man show in New York
1985 Works with Warhol on a show at Bischofberger's
1988 Dies of a drug overdose

▶ **Pyro** *This seems to refer to a car crash in which Basquiat, then aged seven, broke his arm and suffered internal injuries. Here, the figure's face is contorted with pain, his internal organs exposed, and his left arm depicted with slashing strokes.* 1984, mixed media on canvas, 86 x 67¾in, private collection

CLOSERlook

PAGODA Basquiat's inclusion of a pagoda in this scene is mysterious. It speaks of a spiritual solace and peace that he rarely depicted in his work, or found in his life, but maybe envisaged in his death.

Traditional materials and techniques are far from having been abandoned, but today's artists no longer define themselves primarily in terms of disciplines. They have embraced new technologies as a means of expressing, reflecting upon, and competing with the new cultural landscape of mass communication and entertainment.

Origins and influences

Early avant-garde movements made use of non-conventional materials and non-traditional media in order to attack the exclusive status of art and the unique, precious character of the art object. With the institutional establishment of contemporary art, boundaries could be crossed without this being a negation of art as such.

The 1960s witnessed a far-reaching reappraisal of what art could be. Pioneers utilized the new video technology, while an interest in the

▲ **Four Knights** *Gilbert & George have adopted photography to depict gritty scenes of urban life, presented as large collages. Their images appear strikingly new, while alluding to the age-old tradition of stained glass.*

physical space in which art was placed lead to artists making "installations" for specific spaces and occasions.

Subjects

New Media artists have moved away from abstraction and toward an engagement with the world around

them. Using photography, film, and video—technologies that record impressions of actual, physical reality—the lives of ordinary people can be relayed in recorded images.

Common themes include people's interactions with their environment, relationships with one another, their hopes, fears, and self-image. People have also become not simply the subjects, but active participants in the creation of the works.

New Media art draws attention to the artifice of its own construction, and to the spatial, cultural, and historical context in which it exists. Allusions to past works of art and movements are frequent, and techniques of framing, editing, and digital manipulation are not hidden but revealed. It is this reminder of the artificiality of all images that allows contemporary art to engage with mass visual culture, while maintaining a critical attitude toward it.

Art today is characterized by its vitality and diversity. Contemporary artists utilize a whole range of media and methods to explore the world around them—everything from hybrid paintings using unfamiliar material, to digitally manipulated photographs and video works.

New Media

Jeff **Wall**

b VANCOUVER, 1946

A contemporary incarnation of what the poet Baudelaire called "the painter of modern life," Jeff Wall reveals aspects of today's world through a deep engagement with the enduring qualities of art of the past.

Wall's images are backlit transparencies. This illumination gives them an intense, cinematic quality, emphasizing the collision of old and new, documentary and artificiality. The photos may have a look of "real life" reportage, but they are in fact meticulously composed. In spite of their staged and self-reflexive nature, Wall remains a realist, expressing social truths in enigmatic scenes condensed from the flux of life.

LIFEline

1970s Attends London's Courtauld Institute of Art
1977 Produces his first transparencies in lightboxes
1978 Creates his first major work, *The Destroyed Room*
1990s Starts photomontages
2005 Major retrospective at Tate Modern, London
2007 Major exhibition at MoMa, New York

◀ **Insomnia** *Here, the glow of Wall's backlit transparency seems to reflect the coldly lit claustrophobia of the scene. The man on the floor is awake, and yet seems absorbed in some inner anxiety, oblivious to the room around him. 1994, transparency in lightbox, 69 x 84in, Kunsthalle, Hamburg, Germany*

▼ **Milk** *A carton of milk is crushed in a moment of frustration and a dramatic arc of white explodes against the rigorously perpendicular wall behind. Wall often makes carefully composed reconstructions of everyday mini-events, where violence erupts in a social setting. 1984, transparency in lightbox, 73½ x 90¼in, Collection FRAC Champagne-Ardenne, Reims, France*

◀ **The Destroyed Room** *The theme of artifice is embedded in this work. The chaotic scene is really artfully composed. 1978, transparency in lightbox, 62½ x 92in, National Gallery of Canada, Ottawa*

CLOSERlook

ARTIFICE REVEALED The constructed, set-like nature of the room is exposed by the struts visible through the doorframe.

Gilbert & George

GILBERT: b SAN MARTIN, ITALY 1943; GEORGE: b DEVON 1942

Since they met at St. Martins School of Art and decided to become "living sculptures," Gilbert & George have exchanged their individual personae for a singular identity, and transformed their lives into an ongoing work of art. Instantly recognizable in matching suits, the pair seem both serenely removed from and emphatically grounded in real life. Their imagery is rooted in the material, and even, by certain standards, in the vulgar. From grimy street scenes depicting drunks or graffiti, to pictures of naked bodies, human excrement, and bodily fluids (often their own), their work has caused controversy. As Gilbert & George see it, their role as artists is to represent and celebrate life in all its forms, including the seedy and the corporeal. Sex, death, love, hope, fear, and the search for meaning: these are a few of the universal human themes the artists communicate in a life and work that discovers the sacred in the profane.

LIFEline

1967 Gilbert Prousch and George Passmore meet while studying sculpture at St. Martins in London

1969 Make the short film *The World of Gilbert & George*

1970 Perform together as *The Singing Sculptures*

1980 Begin to apply bright colors to their photo works

1986 Win the Turner Prize

1987 Major exhibition at the Hayward Gallery, London

1994 *Naked Shit* works

2007 Large retrospective held at Tate Modern in London

▼ **The Singing Sculptures** *In this, their most famous early performance work, Gilbert & George became what they called "living" or "human sculpture." Covered with metallic paint, the pair moved slowly to a recording of the music hall favorite, Underneath the Arches. 1970, performance*

▼ **Attacked** *Here, the artists appear miniaturized in fleshy colored suits, and stand erect on the tips of a pair of tongues—that place where the viscous interior of the body interacts with the outside world. Fears of contagion are expressed in this alien and frightening landscape. 1991, acrylic on canvas, 100 x 196in, private collection*

Andreas **Gursky**

b LEIPZIG, 1955

Andreas Gursky documents our massively populated, urban-centered, global world as if with the detachment of an extra-terrestrial visitor. What he appears to find is a vast mechanism or organic system, within which humans appear as tiny, anonymous elements. Gursky uses a large format, wide-angle camera, enabling him to capture the awe-inspiring massiveness of the contemporary landscape, while simultaneously revealing every detail in sharp focus. This technique accounts for the non-heirarchical quality of the image: because it has no central focus, it invites the viewer to scan it in an almost forensic manner. The hyperealism is heightened by the large scale of the works, allowing the viewer to imaginatively step into each scene.

LIFEline

1980 Gursky begins studying photography at the renowned Kunstakademie in Düsseldorf

1988 Holds his first solo show

2001 A retrospective of his work is held at MoMA in New York

2007 Gursky's *99 Cent* becomes the most expensive photograph in the world when it is sold for over $3 million at auction

▲ **Union Rave** *Seldom have the tensions between individualism and collectivity been better expressed than in Gursky's photos of raves. Scanning this image, we can identify individual personalities, dressed uniquely and doing their own thing; and yet they have joined together, as if in one body, for an ecstatic, collective celebration. 1995, photograph, 73 x 120in*

▶ **99 Cent** *Viewed with Gursky's alien-eye objectivity and detachment, the everyday activity of shopping begins to look distinctly strange. Gazing coldly at this supermarket scene, we are confronted with a contradiction: on the one hand, the choice of goods appears to be limitless; on the other, everything is reduced to the level of sameness—each item is a standardized multiple, and even the price is the same. 1999, photograph, 82 x 133in, private collection*

Cindy **Sherman**

Self-portrait

b **GLEN RIDGE, NEW JERSEY, 1954**

The photographic work of Cindy Sherman arose at a time when postmodernism and feminism had turned attention to questions of identity. She has explored many visual genres, including horror, pornography, and Old Master paintings, and makes use of props and prosthetics in ways that are often both disturbing and humorous. Sherman's work shows how mass visual culture ingrains certain representations and character types in our collective consciousness. Yet, it also suggests how artificial and unstable these identities are if one person—Sherman—is able to assume so many of them convincingly. Sherman makes visible the way female identity is constructed, but she does this by reproducing mass cultural imagery and making herself the object of voyeuristic desire. As a result she has been criticized for reinforcing gender stereotypes. Ultimately, however, it is this very conflict of opposing ideas that gives her work its fascination.

◀ **Untitled No. 225** *Sherman produced a number of "History Portraits," using herself as a model in parodies of Old Master paintings. Here, she plays a Renaissance Virgin Mary. The false breast estranges the viewer from the sacred beauty of the scene.* 1990, photograph

▼ **Untitled No. 412** *This work exemplifies Sherman's interest in the grotesque. The clown is a particularly potent image of collective nightmares, perhaps because it collapses boundaries between adult and child, male and female, real person and fake appearance.* 2003, photograph, 56 x 40in

▶ **Untitled Film Still No.53**
This is one of many "film stills" in which Sherman uses herself as model. She assumes many roles, from femme fatale to secretary, and though the various characters seem familiar, they do not refer to specific films. 1980, gelatin silver print, 26 x 38¼in, Allen Memorial Art Museum, Ohio, US

Nam June **Paik**

b **SEOUL, 1932; d MIAMI, 2006**

Renowned as a pioneer of video art, Paik went on to explore its potential amid changing technology. He started out as a musician, and this interest is apparent in works such as *TV Cello*. In the 1960s, he moved to New York and became involved with Fluxus—a cross-disciplinary avant-garde art movement, influenced by artist Marcel Duchamp and composer John Cage. Paik's video installations and performances question perception in an idiosyncratic and humorous way.

▲ **TV Cello** *This work, consisting of three TV sets stacked in the shape of a cello, was made for a performance with cellist and collaborator Charlotte Moorman. As she drew her bow along the sculpture, she produced video images on the screens.* 1971, Walker Art Center, Minneapolis, US

Sam **Taylor-Wood**

b **LONDON, 1967**

Sam Taylor-Wood presents life condensed into singular moments of intensity and theatricality. One such example was famously presented in the artist's video, *David* (2004), an hour-long single take of the footballer David Beckham sleeping, with the work's title referring to Michelangelo's icon of male beauty. The images Taylor-Wood creates have a contrived sense of casualness, but are in fact carefully composed. They seem equally inspired by allegorical paintings as by fashion photography and operatic stage sets. She has also moved beyond the gallery to theater itself, for example designing the video installation backdrop for concerts by the British pop music duo the Pet Shop Boys.

CLOSERlook

ONE CHARACTER
Taylor-Wood creates a sense of self-enclosed narcissism in this carefully arranged scene. Although they are surrounded by other people, each larger-than-life character seems absorbed in their own thoughts, locked in their own pose, and blissfully unaware of what is around them.

▲ **Five Revolutionary Seconds XI** *Many of the images taken in Taylor-Wood's converted loft space, often use actor-friends as models, and convey a sense of bored decadence and narcissism. Here, the space becomes a panoramic stage set, an effect created using a 360° rotating camera.* 1996, color photograph on vinyl with sound, 28¼ x 28¼in, White Cube gallery, London, UK

INcontext

IMAGES OF WOMEN Like Pop art from the 1960s, much contemporary art is concerned with reflecting and exploring the world of mass media imagery, especially that used in advertising. For Pop artists this had to do with juxtaposing high and low culture. Today, female artists approach the mass media—and particularly the portrayal of women—as a powerful ideology that needs to be highlighted and challenged.

Persuasive pictures *Advertisers draw on our unconscious desires to persuade us to buy their products. The prevalent image of women as narcissistic sexual objects has an influence on the real lives of both women and men.*

Gillian **Wearing**

b **BIRMINGHAM, 1963**

In her photographic and video work, Gillian Wearing pursues an endless fascination with people—their appearance and projected self-images, their thoughts and desires, and their need to tell their own story. She is also interested in how social conventions determine the way we behave and act differently in public and private.

▼ **Confess All On Video. Don't Worry, You Will be in Disguise. Intrigued? Call Gillian** *Wearing put this advertisement in a London listings magazine. Thirteen people responded and, behind the anonymity of masks and disguises, revealed a fascinating variety of transgressions.* 1994, video installation

Bill **Viola**

b **NEW YORK, 1951**

▲ **Quintet of the Silent** *With the dramatic lighting and composition of an Old Master painting, five figures move in extreme slow motion and absolute silence.* 2001, video installation, Indianapolis Museum of Art, US

The technology of video has been accused of spawning a superficial and disembodied virtual reality. In an extraordinary reversal of this, Bill Viola has embraced video technology to create vivid visual experiences that explore the great mysteries of the human condition—love, pain, meaning, and mortality. Viola's video installations often involve multiple projections, and act on the viewer visually, aurally, in space, and over time. The experience is intensified by special effects, such as superimposition and extreme slow motion, opening up perceptions that transform our normal view of reality. Archetypal symbols, such as fire and water, recur in his work, while passageways and thresholds suggest the boundary separating life from death. Video operates in Viola's work not as an artificial disconnection from reality, but as a reconnection with the essential spiritual dimension of human life.

Pipilotti **Rist**

b **GRABS, 1962**

Pipilotti Rist approached the mass visual culture of television and popular film not as something to be deconstructed, but as a common language, available for use and experimentation. Filters, overlays, and other special effects constitute an electronic palette with which Rist creates exuberant, colorful, and surreal images in time. Her works resemble pop videos and are often accompanied by a song. However, unlike the slick, professional videos used by the music industry, Rist's are quirky, awkward, and cheaply produced, flaunting the home-made aesthetic of video-editing software in the DIY spirit of punk.

▼ **Ever is all Over** *A two-screen video installation juxtaposes a tranquil field of flowers with an exuberant fantasy of transgression and excess, in which the artist skips down the street in a dress and heels, cheerfully smashing car windows with a flower-like iron wand.* 1997, video installation

Tracey **Emin**

Tracey Emin, 2008

b **CROYDON, 1963**

Tracey Emin makes work that is autobiographical and directly emotional. Her art is bound up unashamedly with her personality and life experiences, and so the popular notoriety of her work has turned Emin herself into something of a media celebrity. Emin's art is confessional, relating—and in some way coming to terms with—intimate, often traumatic experiences, such as being in love, abandonment, abortion, and rape. Her childhood and adolescence, spent in the seaside town of Margate, have been a recurring theme and are the subject of two of her films. Art was in many ways an escape from that oppressive environment, and even seems to have satisfied a spiritual need. Emin has used a variety of media—everything from ready-made elements and photo documentation, to embroidery and neon—a common quality of the work being that it combines mechanistic technique with a candid exposure of feeling.

LIFEline

1963 Born, one of twins
1987 Studies painting at the Royal College of Art, London
1994 Major solo exhibition at the White Cube gallery
1995 Makes *Everyone I have Ever Slept With 1963–1995*
1999 Nominated for the Turner Prize. Although she does not win, her work, *My Bed*, makes headlines
2004 *Top Spot*, Emin's feature film, is released
2007 Emin represents Britain at the Venice Biennale Exhibition

◀ **My Bed** *A graphic illustration of themes of conception, sex, loss, illness, and death, this work quickly gained media notoriety, representing for many the vulgarity and lack of skill of contemporary artists. The bed was unmade and appeared used, with crumpled, stained sheets surrounded by, among other things, dirty underwear, condoms, and cigarette packets.* 1998, mattress, bedding, and ephemera, 31 x 83 x 92in, The Saatchi Collection, London, UK

◀ **Everyone I Have Ever Slept With 1963–1995** *This work brought Emin to public attention. It consists of a tent, which the viewer may peek or crawl into to see the appliquéd names of lovers, friends, and family members—all Emin's intimate sleeping partners, including herself and two aborted fetuses.* 1995, appliquéd tent, mattress, and light, 48 x 26½ x 84½in

▲ **Something is Terrebly Wrong** *Emin's monoprints seem to reveal fragility in their shaky expressivity. They often depict the artist in a vulnerable or awkward pose, accompanied by text which relates to the image as a memory or obsessive thought.* 1997, monoprint on paper, 22¾ x 32in, Tate, London, UK

Damien **Hirst**

b BRISTOL, 1965

Photograph by Rune Hellestad

In the 1990s, the name Damien Hirst quickly became synonymous zwith the brash provocation and media furor that defined Young British Art. Since that time, Hirst has gone on to become one of the most famous, and expensive, of living artists. He was instrumental in creating Young British Art, organizing *Freeze*—a now legendary exhibition of student work in a disused Docklands building in London—while still studying at Goldsmiths College. It was attended by the collector Charles Saatchi, who later funded *The Physical Impossibility of Death in the Mind of Someone Living*—a shark in formaldehyde that made Hirst a household name in the UK. Mortality is a subject that Hirst has continued to explore, using materials such as dissected cows and maggot-infested meat, which some have taken as a deliberate provocation. His formaldehyde-filled tanks actually resemble the austere shapes of minimalist sculpture, while his appropriation of items such as toy figurines, as well as his employment of assistants to produce his multi-colored "spot" and "spin" paintings, show Hirst's work to be indebted to Pop Art and the legacy of Andy Warhol.

LIFEline

1988 While still a student, organizes *Freeze* exhibition
1993 Shows *Mother and Child Divided* at the Venice Biennale
1995 Wins the Turner Prize
2007 *For the Love of God* sells for £50 million

◀ **Untitled** *Alongside his spectacular three-dimensional work, Hirst has produced a large number of "spot paintings" and "spin paintings." Although instantly recognizable, these pictures are made according to a random process, and usually produced not by Hirst himself, but by assistants.* Colour print, 33¾ x 24¼in, City Art Gallery, Leeds, UK

▶ **Prodigal Son** *After the shark, Hirst went on to use other animals, sometimes sliced in half like this calf, and displayed like museum exhibits or medical specimens.* 1994, steel, glass, calf, and formaldehyde, 39 x 59 x 18⅞in

◀ **For the Love of God** *This work consists of a platinum skull, complete with real teeth, and adorned with over 8,000 diamonds. This literally dazzling object combines to an extreme the two things Damien Hirst is most famous for: an obsession with death and the market value of his work.* 2007, platinum, diamonds, and human teeth, life-sized

> ❝ You **kill** things to **look** at them ❞
> DAMIEN HIRST

Rachel **Whiteread**

b LONDON, 1963

Rachel Whiteread's sculptures are memorials to lived time. She makes casts, usually not of objects themselves, but of the space surrounding them: beneath chairs and tables, behind bookshelves, within rooms. These are the spaces that our bodies inhabit and move around in, inside the homes where much of our lives are spent. In Whiteread's work, existence is marked not by possessions or likenesses of people, but by a materialized absence, which reminds us of how these solidified and now impenetrable spaces were once occupied. Her work includes signs of the passage of time and the presence of individuals—scratches and indentations picked up from furniture or flooring, or traces of wall paint adhering to the casts. Whiteread has also been commissioned for several large-scale public art projects, including the temporary work *Plinth* in London's Trafalgar Square, and the *Holocaust Memorial* in Vienna.

▲ **House** *This is a cement cast of the last remaining Victorian house on an East London street. On full public display, this striking and curious monolithic memorial provoked thoughts on subjects such as homelessness and gentrification, and became something of a cause célèbre before it was demolished by the local council in the following year.* 1993, cement, life-sized.

◀ **Untitled (Freestanding Bed)** *Mattresses, or the spaces under beds, are a favorite subject for Whiteread. Yellowing dental plaster here turns a soft mattress into a solid memorial to the human bodies that have lain on it.* 1991, dental plaster, 40¾ x 72in, Southampton City Art Gallery, UK

Chris **Ofili**

b MANCHESTER, 1968

Combining the decorative with the figurative, Chris Ofili's large works feature swirling patterns and pulsating colors and exude a celebratory excess through imagery rich with cultural associations. Layers of paints, resin, collage, glitter, and other media, combined with areas of uniform tone, lend Ofili's figures a flatness, rather than a realistic depth, and turn them into icons. However, these symbolic representatives derive as much from modern pop mythology as from traditional religious images. Black culture is central to this vision, most obviously in the influence of 1970s blaxploitation and contemporary gangsta rap, which the artist utilizes to communicate a confident exuberance, but also to confront racial stereotypes.

◀ **Blossom** *This is one of the artist's most richly colorful paintings. An image from a pornographic magazine becomes a celebration of fertility and sexuality. Ofili has said that his work "allows you to laugh at things which are potentially serious."* 1997, acrylic and oil paint, polyester resin, paper collage, glitter, map pins, and elephant dung on canvas, 96 x 72in, Contemporary Fine Arts, Berlin, Germany

Origins and influences

What static imagery is appropriate for a digital age—an era of speed and change? This is the challenge for the contemporary sculptor.

For the last 25 years, urban regeneration has been a strong catalyst in creating a wider acceptance of new commemorative or celebratory sculpture, along with sculpture parks, art trails, and outdoor exhibitions. Regeneration has led to greater public involvement.

Exhibition spaces

Leading sculptors are part of an international art scene that generates exhibitions and commissions worldwide. In London, Tate Modern's Turbine Hall installations have involved major international stars like Louise Bourgeois and Bruce Nauman. Artists are also exhibiting in unconventional spaces beyond galleries or museums. Innovative temporary projects, such as Rachel Whiteread's House (1993) on a park site in London's East End, gain international attention and extend our thinking about public art.

Understanding of the roles of sculpture in modern society, new technical possibilities, and enlightened patronage have all played a part in revitalizing the medium. At the same time there has been a revival of interest in traditional processes such as bronze casting and stone carving.

Materials

Contemporary sculpture is a broad field—urban or rural, temporary or permanent, public or private, large scale or intimate. In practice it involves a myriad of individuals and the subject matter is as diverse as the interests of artists and commissioners.

Each new work explores the nature of sculpture. The sheer variety of contemporary practice is exhilarating and opportunities for the sculptor today are greater than for over a hundred years.

▲ **Alison Lapper Pregnant** Marc Quinn, 2005. *Displayed on the empty fourth plinth in Trafalgar Square, London, which has hosted a series of temporary installations, this has proved an important testing ground for the idea of impermanence in the public domain.*

In the 21st century sculpture remains a vital and strong art form with renewed popular appeal. Great commissions and modern exhibition spaces challenge the adventurous artist. However, the realization of major works can be as slow and dedicated today as in any previous century.

Contemporary sculpture

Antony **Gormley**

b LONDON, 1950

An established and prolific sculptor, Antony Gormley has worked extensively with the human figure throughout his career. By making direct plaster molds and casts of his body, or by computer scanning, he has used his own figure to explore aspects of experience, such as space, memory, and presence. There is a theatrical character to his installations, in which pose, gesture, scale, and location have all been used to great effect.

Gormley has a particular interest in the relationship of art to its audience, and has been very persuasive in securing numerous large-scale commissions. The very large work *Field for the British Isles* (1993), later remade in different locations worldwide, directly involved local communities in making hundreds of small standing clay figures to densely fill a gallery floor. A recent and popular work, *Another Place* (1997), consists of 100 cast iron figures sited along a tidal foreshore, near Crosby on Merseyside.

LIFEline

1968–71 Studies archaeology, anthropology and history of art at Cambridge
1971–74 Travels in India
1977–79 Studies at the Slade School in London
1994 Wins the Turner Prize
1997 Receives OBE for services to sculpture
1998 Best-known work, *Angel of the North*
2003 Elected to the Royal Academy

◀ **(Seeing and Believing) Quantum Cloud XX** *This is one of a series of at least 36 similar sculptures, made between 1999 and 2002. A figure materializes in a haze of energetic lines, which give the appearance of a forcefield.* 2000, stainless steel bars, 92 x 59 x 47¾in, Nasher Sculpture Center, Texas, US

▲ **The Angel of the North** *Situated near the A1 motorway and the main east coast railway line in the north of England, this enormous sculpture is passed by 90,000 people daily, and is said to be one of the most viewed artworks in the world.* 1998, COR-TEN steel, height 65½ft, wingspan 177ft, Gateshead, UK

Tony **Cragg**

b **LIVERPOOL, 1949**

Cragg's earliest sculptures used found materials arranged by color, size, or character. The groups of objects were given a unifying painted or drawn surface. His later, richly idiosyncratic, cast sculptures take the form of large vessels and spun columns and stand as unique forms. Cragg is a considerable draughtsman and has used computer software in the development of his ideas.

When young, Cragg worked as a laboratory technician at the Natural Rubber Producers' Research Association. Some of his recent large bronzes appear deceptively rubber-like in the flexibility of forms—stretched, curved, and twisted. In 1988, Cragg represented Britain at the 43rd Venice Biennale exhibition and won the Turner Prize.

▲ **Here Today Gone Tomorrow** *Computer-generated and made by machine, these sculptures change dramatically as the viewer walks round them. The unbalanced stacks stretch, blend, and merge to reveal facial silhouettes from certain angles. 2002, stone, height 177in, Cass Sculpture Foundation, Goodwood, UK*

Richard **Deacon**

b **BANGOR, 1949**

▲ **Kiss and Tell** *These two large, contrasting forms—one rough and open, the other smooth, rounded, and closed—depend on each other to stand securely in space. 1989, epoxy, timber, plywood, and steel, 69 x 92 x 63¾in, Hayward Gallery, London, UK*

Richard Deacon's sculptures are developed from low-tech materials and are essentially hand-made. Typically, they involve linear elements, silhouettes, or larger open structures that form elegant, decorative drawings in space. They make reference to the human body and to relationships. Deacon describes himself as a "fabricator", and his larger pieces are often made by assembling repeated smaller units.

Deacon has exhibited widely. He won the Turner Prize in 1987 and was elected a Royal Academician in 1998. He received a CBE in 1999 and represented Wales at the Venice Biennale exhibition in 2007. Since 1999, Deacon has also been a professor of sculpture at the École des Beaux-Arts in Paris.

Anish **Kapoor**

Photograph by Brad Barket

b **BOMBAY, 1954**

Anish Kapoor has said that he does not want to make sculptures about form, but about experience that is outside material concern—"I am really interested in the 'non-object' or the 'non-material'". Accordingly, there is a transcendent quality, especially to his later sculptures, which use reflective surfaces to incorporate the surroundings and undermine their physicality.

From a rich cultural heritage—his father was a Hindu and his mother an Iraqi Jew—Kapoor explored abstract, organic, and geometric forms in his early sculptures. Many are coated with brightly colored pigments—an echo perhaps of his Indian upbringing. He progressed to using sizeable stone blocks, and cutting into the surface. His sculptures rely on opposites: interior and exterior, solid and transparent, presence and absence. Sometimes Kapoor challenges the structure of the gallery itself, letting vortex-like holes into the floor, or making walls bulge out. In recent years he has undertaken very large, site-specific works.

LIFEline

1973–77 Attends Hornsey College of Art

1977–78 Studies at Chelsea School of Art

1980 Holds his first solo exhibition, at Patrice Alexandre, Paris

1982 Is Artist in Residence at Walker Art Gallery, Liverpool

1990 Represents Britain at the Venice Biennale exhibition

2002 Designs *Marsyas* for Tate's Turbine Hall

2004 *Cloud Gate* unveiled at Chicago's Millennium Park

2006 *Sky Mirror* installed, Rockefeller Center, New York

▼ **Marsyas** *Named after a satyr who was flayed alive by the god Apollo in Greek mythology, this is thought to be the largest indoor sculpture ever made. 2002, PVC and steel, 45 x 30 x 200ft, temporary installation at Tate Modern, London, UK*

◀ **S-Curve** *The highly polished concave and convex surfaces of this S-shaped wall show the surrounding space in distorted reflection. This has the effect of dematerializing the weighty object, and disrupting the viewer's connections to it. 2006, polished steel, 85½ x 384 x 48in, Regen Projects, Los Angeles, US*

Jeff **Koons**

b **YORK, PENNSYLVANIA, 1955**

Once described as the "postmodernist king of kitsch", Koons is a commercially successful designer of paintings and three-dimensional objects. At Jeff Koons Productions, Inc., his New York studio, a large group of assistants work on his behalf. He says that he is the idea person—"I'm not physically involved in the production. I just don't have the necessary abilities".

Koons's early works placed domestic equipment in Perspex boxes, seemingly with little intervention. Later works, such as the *Banality* series (1988) and the *Made in Heaven* series (1991) rely on great craftsmanship, and allude to consumerism, advertising, and wealth. Koons has many detractors, who question the apparently soulless and superficial character of his work.

LIFEline

1963 Copies and signs old-master paintings for sale

1972–76 Attends Maryland Institute College of Art, Baltimore

1977 Moves to New York

1980–86 Works as a commodity broker on Wall Street

1992 Installs 12m-high *Puppy* at Documenta in Kassel

1998 Produces sculpture of Michael Jackson and Bubbles

2002 Named as Chevalier of the French Legion of Honour

▲ **Popples** *This sculpture is part of Koon's Banality series, featuring pop-culture icons. The character is based on one of a series of soft toys used as a TV marketing tool by American Greeting Cards and Mattel. 1988, porcelain, 29½ x 23½ x 15¾in, Kunsthalle, Hamburg,*

◀ **Small Vase of Flowers** *This work from the Made in Heaven series, which includes erotic sculptures of Koons with his then wife, was described by the artist as "very sexual and fertile". 1991, wood and paint, 37½ x 55 x 37½in, Kunsthalle, Hamburg, Germany*

CLOSERlook

IN BLOOM No fewer than 140 flowers were carved in wood for this piece. Koons often plays with the tension between the beauty of the making and the vulgarity of the effect.

Ron **Mueck**

b MELBOURNE, 1958

After working in children's television, special effects, and advertising for 20 years, Mueck started making sculpture in 1996, when he collaborated on a project with Paula Rego (see p.587). He gained international attention with his poignant, half-sized sculpture *Dead Dad*, which was included in the *Sensation* exhibition at London's Royal Academy in 1997. It was typical of Mueck's smaller works—striking for its concentrated hyper-naturalism.

Muerk has since made several over-sized figures, including the crouching *Boy* (1999) for the Millennium Dome in London and *Untitled (Big Man)* (2000). Modeled in clay and cast in resins and silicone, these figures achieve a striking realism through Muerck's attention to surface detail. They are not alive, but when seen up close it is almost possible to suspend disbelief.

▼ **Man in a Boat** *Naked, alone, and adrift—powerful symbolism surrounds the plight of this diminutive figure, who looks askance at what lies ahead.* 2002, mixed media, 166 x 55 x 48in, private collection

▼ **Pregnant Woman** *Mueck's sculptures have presence. He says: "I never made life-size figures. It never seemed interesting, we meet life-sized people every day."* 2002, resin on fiberglass, 99 x 31 x 28¼in, National Gallery of Australia, Canberra

Bill **Woodrow**

b HENLEY, 1948

Like many artists of his generation, Bill Woodrow used cleverly transformed junk in his early works. Saucepans, shopping carts, and bicycle frames were "deconstructed." Manufactured objects generated surprising hand-made companions, and suggested narrative connections. Woodrow's sculptures have grown more substantial over time—and more frequently bronze-cast—but he has retained this playful approach, both to materials and imagery. Poetic stories abound, especially in small and highly inventive crafted models. There are echoes of Surrealism, and his later works have perhaps become darker. If there is a recurrent theme, it is the resilient power of nature over intellect.

▲ **Regardless of History** *Tendrils of tree roots grip the fallen head of a statue and a book of knowledge and ideas, as nature triumphantly reclaims the classical plinth.* 2000, bronze, 221 x 212½ x 98½in, for the Fourth Plinth project, Trafalgar Square, London, UK

◀ **Seychelles Evaluator** *This is one of a series of sculptures in which bronze-cast branches form skeletal creatures. Each one holds its own colored territory, containing a watery or muddy bronze pool.* 2005, mixed media, 34½ x 70½ x 45¼in, Waddington Galleries, London, UK

David **Mach**

b FIFE, 1956

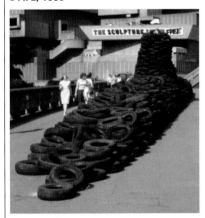

▲ **Polaris** *This submarine, made of 6,000 car tires, "surfaced" on London's South Bank. One person died trying to set it on fire.* 1983, tires, temporary installation for the Hayward Gallery, London, UK

David Mach is an assembler of discarded mass materials, magazines, wire coat hangers, car tires, and Scrabble blocks. He is a figurative artist for whom sculpture takes many different forms: "The artist must be an ideas-monger, responding to all kinds of physical location, social and political environments, to materials, to processes," he says. Recently, Mach has turned to collage, exploiting its subversive possibilities.

Peter **Randall-Page**

b ESSEX, 1954

Since his student days, Randall-Page has worked prolifically as a stone carver. He was briefly assistant to the sculptor Barry Flanagan, and for a year worked on the conservation of 13th-century sculpture at Wells Cathedral. His work has always been informed by observation and study of nature, and has moved from literal interpretations of specific botanical forms to a closer look at underlying principles, such as the Fibonacci mathematical sequence. Resilient outdoors, his sculptures are frequently sited in either natural or man-made landscapes.

For the new Education Resource Centre at the Eden Project, he worked closely with architects and structural engineers to ensure the patterns underlying both nature and his sculpture were integrated into the building.

◀ **Seed** *At the heart of the Eden Project's Education Centre, away from the bustle of visitors, a massive sculpture derived from seed-heads, pods, and cones stands as a symbolic object for contemplation.* 2007, Cornish granite, 158 x 118 x 118in, the Eden Project, St. Austell, UK

Doris **Salcedo**

b BOGOTÁ, 1958

In past works, Salcedo has transformed mundane domestic furniture into powerfully felt and deceptively simple objects and installations that evoke the violence of modern-day Colombia. Of working in a country in turmoil she says: "Every work of art is political, is breaking new ground, and is against the status quo."

Sometimes the setting is crucial—in her work *Noviembre 6 y 7* (2002), wooden chairs were lowered down the façade of the new Palace of Justice in Bogotá on the anniversary of an earlier violent seizure of the Supreme Court. In challenging our expectations of familiar objects, with utmost simplicity Salcedo memorializes people caught up in the drug wars and civil unrest.

◀ **Shibboleth** *Intended to encourage reflection on the place and experience of immigrants, a dramatic crack in the gallery floor suggests a structural collapse.* 2007, length 548ft, temporary installation at Tate Modern, London, UK

CLOSERlook

IN THE CRACK Steel mesh in the crack refers to fences as a way of excluding other people. Eventually, the crack will be re-filled, but a "ghost" of the work will remain.

Australian Aboriginal painting has always been closely linked with their society and mythology. The arrival of the Europeans disrupted this culture and dispersed the Australian Aboriginals, forcing them to adopt alien lifestyles. In some cases, however, traditional culture was retained, forming the basis of modern Australian Aboriginal art.

The new art

During the 1930s the Aranda school of watercolorists at the Hermannsburg Mission in central Australia produced drawings in the European manner. Albert Namatjira (1902–59) developed this style, becoming the first Australian Aboriginal painter to attract widespread attention. At the same time, bark paintings continued to be produced in commercial quantities, using both ritual and more representative imagery.

The big change in Australian Aboriginal art came around 1971, when the art teacher Geoffrey Bardon working at the Papunya settlement west of Alice Springs, encouraged the local artists to paint with acrylic on canvas and board rather than using vegetable dyes on sacred objects such as stones or wooden slabs. At first such paintings were realistic in their representation, but soon dots and dabs of acrylic paint were used in increasingly abstract ways.

Dot paintings

This new style of "dot paintings" incorporates symbolic motifs—curved and wavy lines, and concentric circles —marked out in highly decorative patterns of dots to depict a particular

▲ **Uluru** *The largest freestanding rock in the world, Uluru lies in the center of Australia and has been home to the Anangu people for at least 22,000 years. The rock is one of the most sacred sites for Australian Aboriginals.*

geographical location associated with either a mythological event or person. Such works are produced for the western art market, but are painted by Australian Aboriginal artists across central and northern Australia who remain very much a part of their own communities and retain their links to the sacred lands in which they have traditionally lived.

In the last 40 years, Australian Aboriginal art has undergone a transformation in both style and medium, keeping to a traditional iconography but transforming it in innovative and radical ways. Australian Aboriginal art is now highly prized and much sought after.

Australian Aboriginal art

Emily Kame **Kngwarreye**

b ALHALKERE, c1910; d ALICE SPRINGS, 1996

Living in relative isolation in central Australia, Emily Kame Kngwarreye only began work in her 70s, producing batiks from 1981 and then paintings from 1989 onward. She held her first solo exhibition in Sydney in 1990, received an Australian Artist Creative Fellowship in 1992, and was included in the national pavilion in the 1997 Venice Biennial.

Her work is very influential, for it defies the traditional symbolic iconography of Australian Aboriginal paintings and uses instead massed dots and loose, layered webs in a vibrant abstraction of pigments. Her paintings are directly related to Australian Aboriginal women's ceremonies and to her sense of her country, Alhakere.

▶ **Bush Yam Awelye** *Kngwarreye first produced colorful silk and cotton batiks. She used their shimmering colors and shapes that merge into each other when she later started to paint on canvas. 1990s, acrylic on canvas, 46½ x 19in, private collection*

CLOSERlook

A LOOSE WEB
Pinks, pale oranges, and a range of other hues emerge through the web of bright red, the edges of each color loose and blurred.

Ginger Riley **Munduwalawala**

b LIMMEN BIGHT, NORTHERN TERRITORY, c1936; d BORROLOOLA, 2002

Born on the Limmen Bight River in Arnhem Land in the Northern Territory, Ginger Riley Mundawalawala spent most of his adult life as a cattle drover and stockman. He did not begin to paint until he was almost 50, after he had met and was inspired by his fellow landscape artist Albert Namatjira in Alice Springs.

Mundawalawala's work was inspired by the bark paintings of his area but he soon developed his own distinct style based on bold and colorful depictions of his native landscape and the mythological beings that brought it into existence. Dubbed by the Australian artist David Larwell as the "Boss of Color" he helped to break down the distinctions between Australian Aboriginal and contemporary art.

◀ **Limmen Bight River Country** *Mundawalawala always returned to the subject of his home river, painting its valley with bold colors and an almost childlike but highly effective simplicity. 1992, synthetic polymer paint on canvas, 96 x 96in, Collection: Art Gallery of New South Wales, Sydney, Australia*

Clifford Possum **Tjapaltjarri**

Clifford Possum Tjapaltjarri, 1999

b **NAPPERBY, NORTHERN TERRITORY, c1932;**
d **ALICE SPRINGS, 2002**

A stockman until he was 36, in the 1960s Tjapaltjarri began painting watercolors in the Aranda-school style. He also became an expert wood carver of boomerangs, snakes, and other tourist items. Around this time he lost the sight of one eye in a riding accident.

In 1972 he was one of the last and youngest people to join the founding group of artists at the Papunya settlement. One of the most talented members, his extensive knowledge of the sacred lands his subject matter. By the late 1970s, he adopted his dot-art, acrylic on canvas technique to produce large-scale canvases. Later, smaller works incorporate elements such as fire, water, kangaroos, and possums. One of the most visionary and collected Australian Aboriginal artists, he died the day he was to receive the Order of Australia and a medal in honor of his contribution to the Australian Aboriginal community.

LIFEline

c1932 Born in Napperby, Northern Territory

1968 Ends work as a stockman, by which time he has begun painting watercolors

1972 Joins the Papunya settlement artists

c1978 Adopts his dot-art technique to large-scale works

mid-1980s Leaves the Papunya artists and works independently on the outskirts of Alice Springs

1990 The first Aboriginal artist to be received by the Australian head of state, Elizabeth II, in London

◀ **Narriri (Worm) Dreaming** *The underlying representation of the individual dreaming is almost over-whelmed by the perfection of palette, spatial design, and technical virtuosity.* 1987, acrylic on canvas, 35½ x 47¼ in, Corbally Stourton Contemporary Art, Australia

▶ **Corkwood Dreaming** *Painted after Tjapaltjarri had moved into Alice Springs and begun to work independently of the Papunya collective, the previous dynamism is now broken with paths and blocks of single, complementary colors.* 1992, acrylic on canvas, 64½ x 50½ in, Corbally Stourton Contemporary Art, Australia

Joseph Jurra **Tjapaltjarri**

b **KIWIRRKURA, WESTERN AUSTRALIA, c1952**

Born in Western Australia, Joseph Jurra Tjapaltjarri was brought with his family to Papunya, northwest of Alice Springs, in 1964 after being sighted by a welfare patrol. He started painting in 1986 and since 1987 has painted for the Papunya Tula Artists. His work has been exhibited widely around the world and is in many important collections.

Tjapaltjarri has produced woodcuts, but his main work is with synthetic polymer paint on linen. Painting mainly bold abstractions, he uses a monochrome color—often a pinkish-red or dark gray—over a different colored base, notably in the dotted meanderings he has featured in recent years.

▲ **Untitled** *The meandering, dotted subject matter in monochrome color over a different-colored base is typical of the artists recent work.* 2003, synthetic polymer paint on linen, 47½ x 47½ in

Rover Thomas **Joolama**

b **WESTERN AUSTRALIA, c1926;**
d **WESTERN AUSTRALIA, 1998**

Rover Thomas lived in the bush until his mother died, when he was around 10, and was then initiated into traditional law before working as a jackaroo or trainee stock worker. He later worked as a carpenter's assistant building community housing.

Moving to Warmun, Western Australia in 1975, he became the Dreamer or vehicle of the Gurirr-Gurirr ceremony—a dance cycle of songs and images. The images were based partly on a dream Thomas had following the death of an old woman in a car accident and also on Cyclone Tracy that devastated Darwin in 1974. He and his uncle Paddy Jaminji painted a series of plywood boards that were carried on the shoulders of participants in the cycle, each ocher board complementing a specific verse. From there he began to paint on canvas. His often somber paintings express the landscape of the Kimberly Plateau of Western Australia as well as both real and mythological events in history. In 1982 he began a series of paintings based on Kimberly rock art. Roads Cross, a major retrospective of his work, was held by the National Gallery of Australia in 1994.

▶ **Ord River, Bow River, Denham River** *Three rivers converge in the Australian outback. Both rivers and the surrounding land are portrayed using simple ocher colors, the rivers delineated by lines of little white dots.* 1989, acrylic on canvas, 71 x 35½ in, Musée du quai Branly, Paris, France

European art exists in an increasingly globalized art scene, created by the internet and cheaper, easier travel.

Changing roles

In spite of enormous support from the French government, including the building of the Pompidou Centre, Paris has never quite recovered the role it played in the development of modern art up to the mid-20th century. Ever since the international success of Neo-Expressionism, Germany has become increasingly important in the art world.

For earlier generations of artists a considerable career could be built on a local reputation, and many figures celebrated in their own countries had little following outside them. Now it seems that it is vital to establish an international audience. What plays best on the world stage is frequently that which clearly belongs to its country of origin. So Tuymans is clearly a Belgian artist who looks back to Ensor and Magritte, while Richter has reflected on the political traumas of West Germany.

Common themes

One feature of the contemporary scene is that many of the old conflicts are no longer of such importance. Abstract versus figurative, or conceptualism versus painting and sculpture, no longer arouse such passions. Artists who are stylistically and technically very different may nonetheless be united by common themes. The three women artists shown here are a painter and two installation artists. However, Annette Messager is far closer to the painter Paula Rego in her critical look at feminine identity and her exploration of the power of childhood memory. Sylvie Fleury, by contrast is, at least on the surface, a "post-feminist," exulting in the rich woman's joy in shopping.

◀ **The Guggenheim Foundation** *From its origins in New York in the 1930s, the Guggenheim Foundation developed to a multinational corporation for collecting and displaying modern art. Frank Gehry's dramatic design for the foundation's branch in Bilbao, which opened in 1997, has attracted as much attention as the art inside.*

From the 1980s onward European art regained some of the prominent position in the world it had lost to the US. The dramatic and sudden collapse of Communism at the end of that decade tended to re-establish a sense of European unity.

Europe today

Gerhard **Richter**

Photograph by Christopher Felver

b DRESDEN, 1932

Gerhard Richter is both one of the great technical virtuosi of contemporary painting and one of its most intelligent and thoughtful practitioners. He was trained in former East Germany where painters were required to produce a realist art that supported the propaganda requirements of the state. When he moved to the West he developed a style that was an alternative both to realism and abstraction by working from photographs. However, the intention was not to achieve greater realism. Instead, Richter's paintings tend to emphasise the imperfections of the photographic process and question our use of it as a source of information about the world. When Richter came to work as an abstract painter he, by contrast, introduced a high level of illusionism into the work.

LIFEline

1952–56 Studies at Hochschule fur Bildende Kunst, Leipzig

1961 Moves to Düsseldorf, then in West Germany. Influenced by the work of Bacon and Giacometti.

1962 Produces first paintings based on blurred photographs.

1985 Receives Oskar Kokoschka Prize in Vienna

1991 Retrospective exhibition at Tate Gallery, London

▼ **Untitled** *One of a series of large paintings, the effect was achieved by scraping across several layers of wet paint. There is a suggestion of dim, unidentifiable images in a dirty mirror, but when the original work is seen the viewer is continuously brought back to the paint itself.* 1989, oil on canvas, Kunsthalle, Hamburg, Germany

▲ **The Schmidt Family** *Typical of the Richter's paintings from the 1960s, this was painted from a snapshot rather than from life.* 1964, oil on canvas, 49 x 51in, Kunsthalle, Hamburg, Germany (loan)

▲ **S. with Child** *Even in an intimate scene such as this, the artist's wife with her new born child, we see it second hand through an imperfect photograph. Richter has made a number of portraits of his family using the snap shot as a basis.* 1995, oil on canvas, Kunsthalle, Hamburg, Germany

Paula **Rego**

Photograph by
Charles Sturge

b LISBON, 1935

Paula Rego is a painter who has continued to place narrative at the center of her art. Her art draws upon fairy tales, legends, popular cinema, and cartoon strips. She has often been described as a "feminist painter," a term that she does not refute. Her work frequently addresses topics such as the subjugation of women and violent relationships between the genders. Although she has worked in London for many years and is now regarded as one of the leading figures in British art, much of her work still reflects her response to the highly repressive atmosphere of the Portuguese society in which she grew up. She has developed from a semi-abstract manner close to the Cobra group (p.521) to the figurative manner for which she is best known but her work reminds us that tradition is significant in art in so far as it illuminates the present.

LIFEline
1952–56 Studies painting at Slade School of Art, London
1957–75 Lives between Portugal and London. Her paintings frequently satirize the conservatism of Portuguese society
1976 Settles permanently in London following the fall of the Fascist Salazar regime.
2000 Produces a series of prints protesting Portuguese abortion laws
1989 *"Nursery Rhymes"* etchings published

▲ **The Vivian Girls with China** *The Vivian girls were the creation of an obsessive American artist called Henry Darger. That a child's toy, a cuddly bear, should be involved in their violent world, is typical of Rego's work.* 1984, acrylic on paper, Bristol City Museum and Art Gallery, UK

▶ **The Artist in her Studio** *The painting is heir to a whole tradition of representations. Here the artist is both dreamer and controller declaring her command of the space by her strident posture, black boots, and, above all, by her pipe, a sign associated customarily with the potent male artist.* 1993, acrylic on canvas, 71 x 51in, Leeds City Art Gallery, UK

CLOSERlook

STUDIO PROPS
Rego plays with the power of painting to simultaneously suggest dead and living matter. This threatening hybrid of dog and cat, one of many plaster casts within the artist's studio, provides a protective resting place for a little girl.

Luc **Tuymans**

b MORTSEL, 1958

Like many painters today, the Belgian artist Luc Tuymans depicts the world as seen through photographs. However, these are not the high focus, colorful, paintings of the photo realists but images fading into mystery. The handling of paint is highly sensitive and poetic.

Characteristically Tuymans uses very pale colors and sometimes cracks are deliberately induced in the painting's surface. There is often a suggestion of violence and pain, and his imagery is frequently inspired by published photographs of war and brutality. It is as though the painting is a beautiful cover for the secrets of a half-forgotten atrocity.

▶ **Illegitimate III**
Tuymans often uses titles to suggest readings of images. This one inevitably colors our understanding of this pale headless figure. The abuse of children is a theme that is frequently suggested by the artist but in a cryptic way that mirrors the silence around it. 1997, oil on canvas, 63 x 54in, Tate, London, UK

Sylvie **Fleury**

b GENEVA, 1961

▲ **Untitled** *The consumer products that are Fleury's raw materials are laid across a carpet. "I think shopping is never complete unless you buy at least one pair of shoes." She has said that she always buys her size "in case the sculpture is never sold."* 1992, mixed media, Deichtorhallen, Hamburg, Germany

Sylvie Fleury's world is that of the female consumer. In an assault on both the politically high-minded feminism of an earlier generation but also the sober austerity of much abstract art produced by male artists, she celebrates the act of shopping. Unlike the Pop artists she focuses unashamedly on luxury branded goods. She once exhibited 100 bottles of an expensive perfume at an art fair. They were all stolen by the end of the opening night. If there is any irony in her attitude towards her material she is meticulous in not allowing it to show. If the sociologists who see branding as our contemporary religion are right then she is a religious artist for our time.

Annette **Messager**

b BERCK, 1943

Messager describes herself as both artist and collector. She makes installations from old clothes, toys, and books, which are frequently prodded into startling, jerky, life. The inclusion of the ordinary and everyday was partly inspired by her participation in the revolutionary student movements of 1968 as it was something that opposed the elitism of "great art." She has taken a critical look through photographs from women's magazines of the pressures to conform to a standard of female beauty. Her work mixes the disarmingly innocent with the downright sinister. Appropriately, one of the entries in her biography is participation in a "festival of sorcery" in Castres.

▲ **Hanging Installation** *Colorful padded letters are hung from the ceiling confronting the visitor with a confusing maze. Messager values the engagement of the spectator above the preciousness of the art object.* 1995–97, mixed media, Kunsthalle, Hamburg, Germany

Extreme change and upheaval characterized African cultures and their art-making during the 20th century. Differing colonizing powers imposed varied foreign art values and systems. Local patronage systems were disrupted; so-called superior artworks were imported; and aspects of Western art-market and museum systems introduced.

With progressive attainment of self-government and freedom from foreign rule, the fundamentally altered African cultures began the task of reclaiming and re-shaping their societies. The colonially defined borders had split or forced togethter more than 900 culturally distinct groups, resulting in multicultural populations and highly varied post-colonial artistic contexts in today's 53 independent nations.

The contemporary art scene in Africa is highly diverse, experimental, and idiosyncratic. A myriad initiatives scattered over a vast area, it is not constrained by any monolithic art history or theorizing, and not standardized by conformist art education.

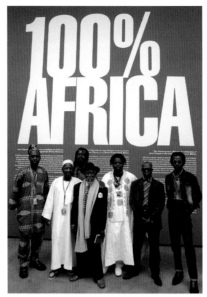

▲ **Diverse expression** *Artists from across the continent at the opening of 100% Africa exhibition at the Guggenheim Museum in Bilbao, Spain in 2006.*

Styles and media

Today's artists draw freely on the continent's stylistic traditions of abstraction, psychological expressiveness, and symbolic representation, as well as bringing in and adapting European trends of realism, picture-making, and naturalistic representation. African artists' traditionally open approach to form and media, seen in their use of everyday materials, found objects, and mixed techniques, has successfully absorbed the potential of two-dimensional media, photography, and video. In addition, there is marked re-invention in historically important African fine arts such as textiles and multi-media performance.

Concept and content

Evolving within established African examples of politically relevant and socially engaged art-making, contemporary artists are primarily concerned with ongoing struggles for more humane societies. Their artworks deal with both everyday realities and profound philosophical concepts. Touring exhibitions such as Africa Remix (starting in Düsseldorf, Germany in 2004), and participation in international biennales, have only recently begun to reveal the global relevance of contemporary art in Africa.

Africa today

Abdoulaye **Konaté**

b **MALI, 1953**

Painter, graphic designer, and director of Bamako's Conservatoire for Arts and Media in Mali, Abdoulaye Konaté has increasingly worked in textiles, one of Africa's signature media. Diverse traditions and techniques are drawn together: appliqué figures, patchwork, flags, rags, embroidered symbols, and specific archetypes such as *gris-gris* (tightly sewn bundles containing talismans that ward off evil) and hooded cloaks (worn by the *griot*, spiritual leader of Islamic African societies). Cotton, which Konaté uses, is highly significant as a crop made profitable by the slave trade and a key product in Africa's current battle for equitable trading.

Konaté's works highlight the need for contemplation, measured use of power, the well-being of all humanity, and respectful coexistence.

▲ **Le Dos Ime** *Dark, roughly formed landscape with figures bearing symbols of various human political and religious systems protected by rows of gris-gris (talismans) woven into the white background.* 2008, cotton, artist's collection

El **Anatsui**

b **GHANA, 1944**

Professor of Sculpture at the University of Nigeria, El Anatsui is one of Africa's outstanding artists. An intellectual and a master-craftsman, his works embody historical and cultural meanings through skilful manipulation of material, process, and form.

Materials such as discarded milk tins and cassava graters, used printing plates, broken pots, or English railroad ties made from African hardwoods, carry evidence that challenges established Western discourse on relations between Africa and the rest of the world. His work questions memory and the stereotypes of tradition and modernity. Recently, Anatsui has been making wall-hung metal sculptures that reference the significant role of textiles in Africa's interactions with the rest of the world. Beautiful to look at, they carry layers of cultural meaning.

▶ **Flag for a New World Power**
The bold colors trumpet pride, and glinting surfaces fall like silk. Beneath the superficial richness, however, the material recalls the exchange of alcohol for slaves and modern economic iniquities. 2005, metals, artist's collection

CLOSERlook

Illusion of wealth *This shimmering emblem representing wealth and power is, in reality, made out of the poor and humble: used bottle-tops, collected from alcohol distributors, cut, beaten, pierced, and stitched together.*

Jane **Alexander**

b **SOUTH AFRICA, 1959**

Figurative art always mirrors humanity and the viewer is unavoidably implicated in Jane Alexander's enigmatic tableaux and photomontages. Through a finely calibrated mix of realism, symbol, and nightmare, the artist makes aspects of the human psyche and pathologies visible. Damage caused by mental states of fear or aggression, and knowledge or memories of brutal acts, "appear" in the flesh of perpetrator, victim, and bystander. The altered yet undeniably human figures suggest ambiguous narratives, eliciting a personal, often visceral, response and deeply shocking recognition.

▼ **The Butcher Boys,** *Life-size, repulsive, sinister, waiting. Mutants, without ears, their eyes are dark, opaque; their lips merged solid, beneath flattened snouts. Horns grow from misshapen skulls; chests are slashed, stitched up; genitals grown over; backs slit open. The "butcher boys" embody the psychological deformities of a degraded society—the inhumanity not only of apartheid South Africa but also of brutal and repressive systems in the world today.* 1985–86, mixed media, dimensions 506 x 841 x 348½in, South African National Gallery, Cape Town, South Africa

Samuel **Fosso**

b **CAMEROON, 1962**

Samuel Fosso uses photographic self-portraits to explore subjects such as the quest for personal beauty, vulnerability in war situations, the constructions of identity, propaganda, self-invention, and African representation. At age 13 he set himself up as a passport photographer and quickly recognized the camera's potential to create desirable self-images. His study of cool poses and fashion trends evolved into a deep fascination for the meanings conveyed by the costumes and props of popular personas. Fosso's superbly composed self-portraits as pirate, English golfer, and liberated American woman, among others, play with the reflective ambivalence, intrinsic critique, and subtle wit possible in assuming alternative identities. Strangely disconcerting, they reveal photography as an agile tool for masquerade, lending "truth" to manipulated images, and refuting common notions of "documentary" veracity.

◄ **Le chef qui a vendu l'Afrique aux colons** *Fosso represents himself in a cleverly detailed parody of notions of the African chief. Obviously theatrical, it challenges the viewer to discern fiction, reality, difference, and prejudice.* 1997, photograph, 39½ x 39½in

Romuald **Hazoumé**

b **BENIN, 1962**

Mundane objects are skilfully appropriated as vessels of significant meaning in the work of Romuald Hazoumé. In particular he has transformed one of Benin's most common items—the plastic jerry can. Altering the distinctive form with cuts and additions, Hazoumé fashioned a series of striking masks, individual portraits of local characters, quirky protagonists in a modern masquerade depicting harsh economic realities. Both form and content echo older histories and reflect on resourceful or desperate survival strategies. This work evolved into composite groups—a pile of skulls, mass transportation—photographic studies, and large-scale installations combining sound, video, and other sensory elements. Although primarily African, many works deal with the effects of globalization, international power relations, and the dehumanizing view of people as commodities in today's exploitative labor markets.

Romuald Hazoumé

▲ **La Bouche du Roi** *Composed as a slave ship, each mask representing a trapped individual, this installation is titled after a place from where thousands of slaves were transported. It evokes the horrific conditions through sounds and smells, and juxtaposes modern forms of slavery in video clips.* 1999–2004, mixed media, 394 x 114¼in, artist's collection

Chéri **Samba**

b **DEMOCRATIC REPUBLIC OF CONGO, 1956**

Visual delights and critical social messages characterize Chéri Samba's art. Starting at an early age, he learned his skills on the street and actively sought inspiration in comics, films, and advertising. He was a pioneer of the unique local genre known as the Congolese School of Popular Painting, which has roots in African traditions of dramatic storytelling, masquerade, and art as a medium for social engagement: intended to reach the widest possible audience, stimulate public debate, and educate through entertainment.

Chéri Samba

Employing precise draftsmanship, striking color, and symbolic imagery, Samba transforms current issues into bold visual narratives that are a pleasure to look at and easy to understand. Fact and reality combine with imaginative or fantastical elements, often laced with humor, epigrams, or surprising graphic twists, to clearly convey his messages. Appropriating western graphic techniques and materials, he continues the local use of dynamic and evocative visual language to engage people in the dilemmas and problems of living in modern times.

CLOSERlook

SYMBOLISM Reprising Africa's symbolic emphasis on the human head and highlighting the essence of the problem, Samba's graphic inventiveness encapsulates the mental state of the superpower psyche.

▲ **Après 11 Sept 2001** *This protagonist is no superhero, just a fleshy body, impelled by a head full of aggression, leaving mounds of dead bodies in his wake. The otherwise clear sky swirls and darkens with his destructive minions.* 2002, oil on canvas, 78¾ x 138in, Contemporary African Art Collection

Since the early 20th century, certain Asian artists have made a career in the West while retaining elements of their national traditions. Charles-Hossein Zenderoudi from Iran, for instance, worked successfully in the post-war École de Paris (pp.458–461), while the Japanese artist Yayoi Kusama was part of the New York art scene in the 1960s. Such a move is no longer necessary to reach a worldwide public, due to ease of travel and communication and internationally-minded critics.

Chinese artists have been especially visible in recent years, but throughout Asia artists are providing a perspective on the world that is quite distinct from Western traditions.

The Far East

Contemporary Japanese art collapses the distinction between fine art and popular culture. The most successful artist in Japan today, Takashi Murakami, has a corporation that disseminates not only his own images, but those of a whole stable of protégés. Art has gone much further in becoming part of mass culture than even the Pop artists envisaged.

Up to the mid-1980s Chinese art was controlled by the Communist Party who imposed a populist propaganda art that drew on both Western academic styles and traditional folk sources. Today, some of the biggest names, including Xu Bing, work outside China itself. Chinese art includes challenging performance and video art, but there are also many painters who reflect the contemporary life of the country or revisit old political icons with irony and scepticism.

The Islamic world

The use of decorative script—the strongest tradition in Islamic art—is a key feature of contemporary work and has a certain affinity with Western abstract art sense and emphasis on the "artist's handwriting." Political art looks at issues such as the role of women and the Palestinian conflict.

◄ **Novel art gallery** *Art in China, fueled both by foreign collectors and wealthy Chinese, has made possible enterprises such as this contemporary art space in an abandoned electronics factory.*

Asia today

Charles-Hossein **Zenderoudi**

b **1936 TEHRAN**

Zenderoudi graduated from Tehran's High School of Arts in 1958. He is one of the principle exponents and founders of the *Saggakaneh* movement in Iranian art. *Saggakaneh* literally means "water fountain" and makes specific reference to public drinking fountains, the erection of which has a religious significance in Shi'a Islamic culture. The artists use traditional symbols such as calligraphy to communicate specifically to Iranians. In spite of these origins, Zenderoudi's art has been acclaimed in the Western, as well as the Islamic, world. The emphasis on calligraphy is traditional to Islamic culture but also has affinities with leading Western modern artists such as Twombly (see p.515). Since 1961 Zenderoudi has lived in Paris but he had a retrospective exhibition at the Tehran Museum of Contemporary Art in 2002. He has also made tapestries and paintings for Riyadh and Jeddah airports.

▶ **Untitled** *The calligraphy in this print is taken from the opening of the Qur'an and is in a decorative script favored by Iranian calligraphers. At the same time the accumulation of layers in different colors gives the work an abstract appeal in addition to its religious significance.* 1986 Silkscreen on paper 26 x 19¾in British Museum, London, UK

Shirin **Neshat**

b **1957 QAZVIN, IRAN**

In 1974 Neshat moved to the United States to complete her education. The Islamic Revolution of 1979 meant that she was unable to return to Iran until 1993. In that year she resumed the artwork that she had given up for years while working at Storefront, an alternative art space in New York. Since then she has lived and worked in both Iran and America, although she was only able to exhibit in Iran during a period when the regime was comparatively liberal. She has worked with photography and film to explore the role of women within Islam and Western perceptions of these roles from, what she herself describes as, the point of view of an exile. As with many contemporary artists working with film, she often uses a multi-screen format. Collaborators have included the composer Phillip Glass.

▲ **Allegiance with Wakefulness** *In 1993 Neshat began a series entitled* Women of Allah. *These were photographs of women in Islamic dress with Farsi texts written across their skin. Neshat has said that the "female body seemed to become a canvas for a particular intersection between sexuality, politics and violence."* 1994 Offset Print, Israel Museum, Jerusalem, Israel

▲ **Passage** *This video was filmed in Morocco in a coastal town with scenery similar to Iran. In it men carry a body wrapped in white across a beach, intercut with scenes of women digging a grave with their hands and a child arranging a stone circle.* 2001, video and sound installation, Solomon R. Guggenheim Museum, New York, US

Liu Xiaodong

b **1963 JINCHENG, NORTHERN CHINA**

Liu Xiaodong's paintings are vivid and haunting documents of a China undergoing headlong economic and political transformation. He draws on photography but only as source material, not like the Photorealists as something to transcribe literally. For him what painting loses in terms of details of the objective world, it makes up for in psychological observation. Although there is not the element of ironic political satire found in some other Chinese painters there is nonetheless in his work, a scepticism towards official mythologies. He has stated that it is his aim to show the "humanity" that has been devalued in China at the expense of grandeur and heroism. His sympathy, as illustrated in the series of paintings based on the Three Gorges dam project, is with the victims of ruthless social change.

Photograph by Ji Guoqiang

LIFEline

1988 Graduates from Central Academy of Fine Arts, Beijing, China

1989 Takes part in Chinese Avant-garde art exhibition, Beijing

1998–1999 Academy of Fine Arts, University of Complutense, Madrid, Spain

2001 Trip to Singapore to research series of paintings on the theme of prostitutes and transvestites

2006 Exhibits paintings on theme of Three Gorges Project

◀ **Three Girls Watching TV** *Depicting three girls in a brothel in Singapore, the theme is not unusual in Western art, but is unexpected in a contemporary Chinese painter.* 2001, oil on canvas, 51¼ x 59in, private collection

▼ **Three Gorges: Newly Displaced Population**
Lui's paintings of the Chinese government's project for the Three Gorges demonstrate the disaster for the two million whose homes and livelihoods are destroyed. 2004, oil on canvas, 118 x 118in

Xu Bing

b **1955 CHONQUING NEAR BEIJING**

Xu Bing is one of the most important artists to have come out of China in recent years. As a young man he was sent to the countryside as part of the Cultural Revolution. He now lives and works principally in the United States. His work has been preoccupied with words and language. A section of his installation *A Book from the Sky* was first seen in Beijing in 1988 and gave him international attention. *A case Study of Transference* was an installation in which a male and female pig had, respectively, Chinese and English characters printed on them. They went on to produce piglets.

▲ **A book from the sky 1987–91** *This installation consists of sheets of 4,000 characters, all of them invented by the artist, while bound books cover the floor. It recalls the wall newspapers pasted up for the Chinese to read, and comments on the collapse of political dialog.* Woodblock print, wood, leather, ivory, Four banners: 40½ x 2½ x 3¼in (each, folded): 19 boxes: 19½ x 13¼ x 4in (each, containing four books)

Takashi **Murakami**

b **1962 TOKYO**

Murakami studied at the Tokyo National University of Fine Arts and Music. He gained a PhD in Nihonga, a mixture of traditional Japanese painting and Western styles, but decided to make an art that would be more accessible to contemporary audiences and successful in today's market place. His art draws on the Japanese popular forms of manga (comics) and anime (animated films), what is sometimes called otaku culture after the obsessive kind of fan who lives entirely by it. He developed this art through a company he called Kaikai Kiki, which has a factory with ninety employees, just outside Tokyo.

◀ **Napping** *This is Mr Oval, one of the many characters created by Murakami. He based this giant sculpture on Humpty Dumpty at the suggestion of the fashion designer Issey Miyake. These colorful images can be merchandised in many forms.* 2002, inflatable

Yayoi **Kusama**

b **1929 MATSUMOTO**

▲ **Soul under the Moon** *Kusama's environments engulf the viewer, so they can share in her hallucinations.* 2002, mirrors, ultraviolet lights, water, plastic, nylon thread, timber, and synthetic polymer paint, 134 x 280½x 236¼in, Queensland Art Gallery, Queensland, Australia

Kusama moved to New York from Japan in 1958 and became involved in the avant-garde art scene of happenings and anti-war protest art. Her trademark became the repeated use of colored spots, not only on paintings but on objects, environments, and even clothing. These relate to a personal obsession. On one occasion she recalls that while painting she imagined her own hands covered with the dots. In spite of becoming famous in the New York art world, she returned to Japan in 1973 and, in 1977, voluntarily entered a psychiatric institution where she has lived ever since, although she has continued to work prolifically as an artist.

In the early 1990s, installation art and video appeared to hold sway in the North American art scene—today, however, diversity reigns.

Painting and performance

By the late 1990s, critics were pointing to the re-emergence of figurative painters, in particular John Currin, Elizabeth Peyton, and Lisa Yuskavage, who are all concerned with the way beauty is constructed in contemporary culture. Of the three, Yuskavage is the most controversial. Her female nudes are exquisitely painted yet borrow from soft pornography—their brash, vulgarity quintessentially American.

The North American art scene is no longer centered on New York. Mike Kelley works in Los Angeles drawing inspiration from punk and teenage culture. His work, which is musical, theatrical, and visual, combines elements of high and low art. He

has often collaborated with Californian-based artist Paul McCarthy, whose performances feature psychopathic children's television heroes and sets covered with ketchup, mayonnaise, mustard, and chocolate sauce as substitutes for blood, sperm, sweat, and excrement.

African-American voices

Increasingly African-American voices are being heard in the art world. In "*RYTHM MASTR*," Kerry James

Marshall creates a superhero comic book for the 21st century in which some ancient African sculptures come to life and fight a cyberspace elite that is losing touch with traditional culture. Many black female artists, such as Kara Walker and Kenyan-born Wangechi Mutu, tackle gender and sexual identity along with racial identity. Since 9/11, much art has been political, such as the paintings of Jules de Balincourt that bleakly expose the divisions in American society.

◀ **US World Studies II**
In this painting de Ballincourt shows an inverted US as an island, with mixed up states, surrounded by the dark nations of the rest of the world. It llustrates America's internal disunity and uneasy relationship with the rest of the world after the invasion of Iraq in 2003.

Today's North American art embraces a huge range of media and styles—from collage to conceptual pieces, painting to performance. It also addresses a wide variety of issues, including consumerism and popular culture, racial and gender identity, and post-9/11 and post-Iraq war tensions.

North America today

Bruce **Nauman**

Photograph by Horst Ossinger

b FORT WAYNE, INDIANA, 1941

Nauman works in a wide range of media—including sculpture, video, film, printmaking, performance, and installation—but it is ideas, not medium, that governs his work. He is concerned with how an activity or process can become a work of art and is inspired by the activities, speech, and materials of everyday life. In the late 1960s, he molded sculptures from parts of his body and filmed himself pacing about the studio and performing repetitive activities.

He is fascinated with space, and the ways it can alter our behavior and self-awareness, and in *Walk with Contrapposto* filmed himself in an uncomfortably narrow corridor to elicit physical and emotional responses from the audience. He displays words and phrases to question language as a means of communication and tool of control—often using wordplay and neon, a medium that calls attention to the object-like quality of words rather than their meaning.

LIFEline

1964 Graduates from the University of Wisconsin
1965-66 University of California; begins to make performance pieces and films
1966 Moves to San Francisco; first one-man exhibition, of fiberglass sculptures
1979 Moves to a ranch in New Mexico
1999 Videos himself doing repetitive tasks on his ranch
2005 In the Tate Modern he shows *Raw Materials*, an aural collage created from playing 22 spoken texts

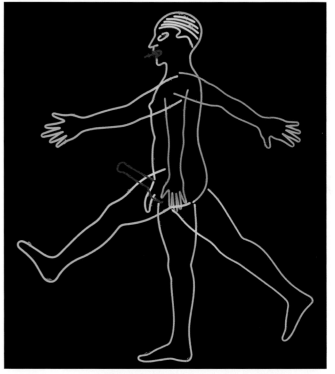

▲ **Marching Man** *In this playful yet explicit piece in neon, a man continuously walks while getting an erection. The shock value of the work, however, is undermined by endless repetition.* 1985, Neon tubes on aluminium panel, Kunsthalle, Hamburg, Germany

◀ **Anthro/Socio (Rinde Spinning)**
In 1990, Nauman started making "video sculptures" of stacked monitors and related wall projections. He began by videoing himself but in this piece uses an actor. The work questions the role of language and the spectators' involvement in the installation experience. 1992, video installation, Kunsthalle, Hamburg, Germany

CLOSERlook

UNSETTLING EXPERIENCE
In icy green-blue light, a close-up suspended head aggressively spews forth the same sounds and phrases. It is an unsettling experience, visually and aurally.

Norval **Morrisseau**

b **FORT WILLIAM, ONTARIO, 1931;** d **TORONTO 2007**

A self-taught painter, Morrisseau was a deeply spiritual First Nations Ojibwa. He signed his paintings Copper Thunderbird, the name a medicine woman gave him.

His early work evokes ancient symbolic etchings on birchbark and tackles traditional spiritual knowledge (he was originally criticized for disclosing this by his community). Initially, he painted on any material he could find—including birchbark, moose hide, and cardboard—but as his style evolved, he generally worked with acrylics on canvas or paper. His palette became progressively brighter, and by the 1980s and 1990s it obtained a neon-like brilliance. The themes also changed and he started depicting his own personal struggles rather than traditional myths.

▼ **Storyteller of the Ages** *Bold colors and strong outlines are typical of Morrisseau, and the closeness that he saw between the human and animal world is explicit: the storyteller has a fish's head and the listeners are associated with birds. 1970, acrylic on canvas, Fred Jones Jr. Museum of Art, University of Oklahoma, US*

Jimmie **Durham**

b **WASHINGTON, ARKANSAS, 1940**

Durham is a Wolf Clan Cherokee who has worked as an artist, essayist, poet, and political activist for American Indians. He studied at L'École des Beaux-Arts, Switzerland, before his involvement with the American Indian Movement brought him back to the US in 1973.

As an artist in the 1960s and 1970s, Durham focused on theater and performances. Since the 1980s he has used detritus and other found objects to create sculptures that radically challenge conventional representations of American Indians. In the 1990s and 2000s, he made work that questions the establishment and their triumphant architectural symbols: *Arc de Triomphe for Personal Use, Turquoise* (2003), for example, is the antithesis of monumental architecture.

▲ **Flower of the Death of Loneliness** *A large stone, painted with a crude, mad-eyed face, has crashed on to a mirror on the gallery floor. The face stares up from the shards, creating a work that is at once funny and alarming. 2000, mixed media, 35¼ x 35¼ x 9¾in, Saatchi Gallery, London, UK*

John **Currin**

b **BOULDER, COLORADO, 1962**

Currin creates fabulously accomplished, satirical figurative paintings—mainly of women and family life. He often distorts the female body, elongating limbs and enlarging breasts, which has led some critics to claim his work is sexist, others that it critiques modern-day notions of beauty. His paintings enchant and repel—their refined surfaces and graphic rhythms are seductive but they often show clichéd subjects with an almost caricaturist style. Currin's delight in artifice and stylistic extravagance is that of a modern-day Mannerist.

In 1989, he held his first major New York show—portraits of girls based on high-school yearbook photographs. He has had retrospective exhibitions at the Whitney Museum of American Art and the Museum of Contemporary Art, Chicago. In the 2000s, Currin has varied his subject matter—from explicitly erotic pictures to mail-order porcelain.

◄ **Thanksgiving** *This painting is rather unsettling. In the foreground, the turkey and flowers are faithfully and lovingly rendered. In the background, however, the figures, captured in an unlikely pose, seem to be the subject of Currin's satire. 2003, oil on canvas, 26¾ x 20½in, Tate Gallery, London, UK*

Matthew **Barney**

b **SAN FRANCISCO, 1967**

After his graduation from Yale, Barney gained instant success and controversy in the art world. In 1991, aged only 24, he had a solo exhibition at the San Francisco Museum of Modern Art, and in 1993 and 1995, was included in the Biennial at New York's Whitney Museum.

Barney is best known as the creator of the five visually lavish *Cremaster* films. They are a mix of history, autobiography, and mythology and feature Barney in many roles, including a satyr, a magician, a ram, Harry Houdini, and even the infamous murderer Gary Gilmore. Each film is packed with symbols and actions that suggest sexual reproduction—the title of the films refers to a muscle that raises and lowers the testicles according to temperature, external stimulation, or fear.

▲ **The Cabinet of Baby Fay La Foe** *For each* Cremaster *film, Barney produces a group of objects and a book of still images. This piece shows objects associated with a character in* Cremaster 2 *(1999): a stylized séance table, barbells cast in solar salt, and a veiled top hat filled with honeycombed beeswax. 2000, Mixed media 59 x 96 x 38¼in, MOMA, New York, US*

Kara **Walker**

b **STOCKTON, CALIFORNIA, 1969**

Walker is an African-American artist who employs an old Victorian medium—silhouettes—to address contemporary issues, such as gender, sexuality, and race. She generally works by displaying cut-out paper figures on walls in room-sized installations. These figures fornicate and fight, and through them Walker challenges racial myths and stereotyping. The paper Walker uses to cut out most of the images is black so rendering her figures "black"—the race of each character only visible through stereotype and caricature.

In 1994, Walker graduated from the Rhode Island School of Design and had an acclaimed exhibition at the Drawing Center in New York. In 1997, she showed at the Whitney Museum Biennial exhibition, and in 2002 represented the US in the São Paulo Biennial.

▼ **Section of artwork by Kara Walker (part of the Artes Mundi Prize)** *Here Walker seems to invert racial stereotypes. The animal-like figure with a tail and monkey face is cut out in white, while the southern belle he appears to be ravishing is cut from black. From an exhibition at National Museum Gallery, Cardiff, Wales, UK*

Maya **Lin**

b **ATHENS, OHIO, 1959**

▲ **Civil Rights Memorial** *Commissioned in 1988, this work was the first to commemorate the victims of the Civil Rights Movement. The wall is inscribed with words Martin Luther King often quoted: "...until justice rolls down like waters and righteousness like a mighty stream." Water cascades over the granite, inviting the spectators to touch it. 1989, black granite, Montgomery, Alabama, US*

Maya Lin is a Chinese-American artist who creates sculptures, parks, and monuments. She was catapulted into the limelight in 1981 when, as a student at Yale, she won a national competition to design the Vietnam Veterans Memorial in Washington, D.C. The memorial, which initially met fierce criticism, consists of two black granite walls inscribed with the names of the fallen. It is a place of quiet remembrance that visitors descend into, not a proud, heroic monument.

Another notable work is the Wave Field (1995) at the University of Michigan, Ann Arbor, in which earth is shaped like the sea. Lin draws inspiration from many culturally diverse sources, including Japanese gardens, Hopewell Indian earthen mounds, and works by American earthworks artists of the 1960s and 1970s.

Glossary

A

Abstract Expressionism A style of painting that emerged in New York in the late 1940s and continued to dominate the American art scene through the 1950s. Abstract Expressionists usually worked on large canvases and emphasized the sensuousness of paint.

Abstraction Non-representational art.

Academic art Art produced by artists trained at professional schools. Their aim was to produce highly educated artists, usually versed in Classical art, life drawing, and anatomy.

Acrylics An emulsion paint made from synthetic acrylic resin. First used in the 1940s, it has proved a convenient alternative to oil paints as it dries quickly, is soluble in water, and can be used on a variety of supports.

Aerial perspective A method of creating the illusion of depth in a painting by making distant objects paler and bluer. It imitates the way we perceive objects through the dust and large moisture particles in the atmosphere.

Aesthetic Movement A British and American artistic movement, that emerged in the second half of the 19th century and covered literature as well as painting and the decorative arts. The leading figures of the Aesthetic Movement believed the arts should provide refined sensuous pleasure, without necessarily conveying moral, political or religious messages.

Altarpiece A devotional piece of art placed on, above or behind the altar in a Christian church. It can be painted or sculpted, often contains multiple scenes and usually represents scriptural episodes and sacred people.

American Scene Painting American figurative painting of the 1920s and 1930s that depicted contemporary American life, usually of small town and rural life. Often called Regionalism.

Anamorphosis A two-dimensional artwork, or more usually a figure in an artwork, which seems distorted when looked at from a frontal position but assumes the normal proportions when looked at from one side or in a curved mirror.

Annunciation The archangel Gabriel's revelation to Mary that she would conceive the son of God. It was one of the most popular subjects in Medieval and Renaissance painting.

Appliqué A method of decoration in which work is applied to, or laid over, another material. Commonly used in lacework and metalwork.

Aquatint A specialized etching technique that involves using a metal plate coated with porous resin to create a granulated effect.

Art Informel Term coined by the French critic Michel Tapie to describe the spontaneous abstract painting popular in Europe in the 1940s and 1950s.

Art Nouveau A decorative style that spread throughout Europe at the end of the 19th century and in the first decade of the 20th century. It makes use of curved shapes derived from tendrils, plant stems, flames, waves, and flowing hair. The name was taken from a shop in Paris that opened in 1895.

Arte Povera A style of art popular in Italy in the 1960s and 1970s in which humble, commonly available materials are used, including sticks, stones, rope, sand, wood, metal, and newspaper. The term, means "poor art" in Italian and was coined by art critic and curator Germano Celant in 1967.

Arts and Craft Movement A very broad, loosely structured British movement, chiefly in architecture and the decorative arts, that promoted craftsmanship and simplicity of design in the late 19th century. The movement had no distinctive style but its leading figures stressed the "honesty" in producing artistic objects that clearly showed what they were made of and how they worked.

Ashcan School Early 20th-century school of American realist painters interested chiefly in the depiction of everyday New York scenes, often showing social deprivation. The school was not an organized group and the name was only used retrospectively.

Assemblage The use of three-dimensional found objects to create artworks. This technique was popular in the 1940s and 1950s.

Assumption Mary's elevation into heaven, often seen as a symbol of the promise made by Jesus to all Christians that they too will be received into paradise.

Atelier A term, derived from French, for an artist's studio or print-maker's workshop.

Automatism A technique involving using the "automatic" use of the brush, without rational control and thus attempting to encourage the expression of subconscious impulses.

Avant-garde Seeming to be ahead of its time.

Aztec Civilization that thrived in the 15th and early 16th centuries in ancient Mexico. In the arts, Aztecs are famed for their elaborate temple sculptures.

B

Barbizon School A group of French landscape painters who, from around 1830 to 1870, worked near the village of Barbizon, southeast of Paris. Their choice of rural imagery represented a reaction to the rapid urban growth of Paris.

Baroque The prevailing artistic style from the late 16th century to the end of the 17th century. The style is usually associated with dynamic movement, emotional intensity, and theatrical effects.

Bauhaus A pioneering modernist design school founded by architect Walter Gropius in Weimar in 1919. It promoted functional design and collaboration between architects, fine artists, and applied artists.

Biennale An international art exhibition held every two years. The earliest, and most famous, is the Venice Biennale, first held in 1895.

Biomorphic art A style of painting based on curves and motifs that refer to, or evoke, living things.

Blaue Reiter, Der A group of Munich-based expressionist artists who formed from 1911 to 1914. The name is German for "Blue Rider." They produced lyrical, mystical expressionist paintings, often semi-abstract with bright colors.

Blot drawing A technique, described by English watercolorist Alexander Cozens in 1786, that proposed that an image be developed from an accidental blot or mark.

Blue Rose group A group of Russian painters active in the first decade of the 20th century, led by Victor Borisov-Musatov. They were influenced by the Symbolists and to a lesser extent the Fauves.

Bodegon Spanish for tavern, the term bodegon has been in use from the late 16th century for paintings depicting scenes involving food and drink, especially in kitchens.

Bottega The workshop of an established Italian medieval or Renaissance artist.

C

Camden Town Group A group of London artists who in 1911 set up a rival exhibiting society to the conservative New English Arts Club. They worked in an Impressionist and Postimpressionist manner, often painting the streets and interiors around the run-down Camden Town area of London. They disbanded in 1914.

Camera lucida A camera obscura with a prism to concentrate and project the light.

Camera obscura A darkened box with a hole or lens in one side which casts an image of the objects in front of it onto a ground glass screen or a sheet of paper at the back of the box. This cast image can then be traced. Many artists used the device to make preliminary drawings for paintings.

Canton School Chinese artists who worked in a European style for European patrons in the late 18th and early 19th century. Subject matter included views of Canton, botanical drawings, and studies of agriculture and industry.

Cast An art object—for example a medal or plaster cast—made by running liquid material into a mold.

Cherub A child angel, usually a chubby infant, depicted in western art from the 15th century. Cherubs often lament events shown elsewhere in the painting.

Chiaroscuro Term referring to the effects of light and dark in a painting, especially when they are strongly contrasting.

Classical The term has many meanings. It refers to the art and architecture of Greek and Roman antiquity. In its broadest sense, classical art is the opposite of romantic art. It describes art that is rationally rather than intuitively created, in which adherence to aesthetic ideals take precedence over personal expression.

Cloisonnism A style of art characteristic of Postimpressionist painting, in which flat colors are surrounded by strong dark outlines. It was developed by Emile Bernard and takes its name from its similarity to cloisonné enamel.

COBRA A group of European artists founded in Paris in 1948 that aimed to revive expressionism. The name derives from the initial letter of the capital cities where important members of the group lived—COpenhagen, BRussels, Amsterdam.

Color field painting Painting that uses large areas of more or less unmodulated color, with no strong focal points or marked tonal contrasts.

Combine painting A term invented by Robert Rauschenberg to describe the assemblage works he made in the 1950s.

Complementary colors Pairs of color that sit on opposite sides of the color wheel. When used next to each other in a painting, each complementary color appears to be stronger and more vibrant.

Composition The arrangement of elements in a painting or other work of art.

Brücke, Die Association of German expressionists that formed in Dresden in 1905 and disbanded in 1913. They produced landscapes and figure studies in strong colors with simplified and angular forms.

Byzantine art Art of the East Roman Empire from the 5th century CE to 1493. Byzantine artists did not usually aspire to individual expression but conveyed Christian theological meaning according to accepted conventions.

Conceptual art Art in which an idea is at least as important as the physical artwork. The term was coined in 1967 by American Conceptual artist Sol LeWitt.

Constructivism An art movement, originating in Russia around 1914, characterized by abstraction and the use industrial materials, such as glass and standardized metal parts. Constructivist art was intended to meet social needs, especially after the Revolution in 1917.

Contrapposto A term used to describe poses in which one part of a figure turns or twists away from another part.

Cubism A radical and highly influential style of painting from 1907 to 1914 in Paris. It abandoned the traditional fixed viewpoint that had dominated western art since the Renaissance. Instead subject matter, most often still life, was shown from many sides simultaneously.

D

Dada Dada, from the French word for hobbyhorse, is the deliberately meaningless name given to the first anti-art movement. Dadaists intended to offend, not to please. They celebrated the role of chance in artistic production. The movement began in Zurich around 1915, but spread to New York, Berlin, Paris, and elsewhere.

Danube School A loosely associated group of artists active in the German territories near the Danube in the first half of the 16th century. They often depicted mountainous landscapes with thick forests.

Decoupage The process of cutting designs out of paper and applying them to a support to make a collage.

Diptych A picture consisting of two different panels, often hinged together.

Distemper Water-based paint that generally uses glue as a binder. Often used for wall decoration or stage scenery.

Drip painting The technique in which paint is dripped—not brushed—on to the canvas.

Dry brush (painting) The use of thick, dry paint so color only adheres to parts of the support and creates broken brushstrokes (in contrast to a smooth wash of paint).

Dry plate process Photographic process, invented in 1871 by Richard Maddox, that uses light-sensitive gelatin emulsion to record an image. This replaced the wet-plate process, which required light-sensitive collodion liquid to be poured on to the photographic plate.

Dry point The printmaking technique of engraving directly on copper with a sharp needle.

E

École de Paris Originally used for figurative painters, often Jewish, working in Paris in the early 20th century. Later used for the whole Paris-based modern movement in the first half of the 20th century.

Encaustic A painting technique, originating in ancient times, in which pigments are mixed with hot wax.

Engraving A printmaking process in which a design is incised on a metal plate (usually copper). The plate is then inked up, wiped clean, and so only the ink in the incised grooves makes a mark on the paper in the printing press. The technique was first developed in the early 15th century.

Etching A printmaking process in which a design is bitten into a metal plate with acid. The plate is covered with an acid-resistant ground, which is drawn into with an etching needle. The plate is then dipped in an acid bath, which corrodes the exposed areas, creating furrows to hold the ink. After the ground is cleaned off, the etched plate is inked and printed in the same manner as an engraving.

Etruscan art Art produced by the people of Etruria (today's Tuscany) from the 7th to the 3rd century BCE—notably ceramics and bronze, and terracotta sculptures.

Euston Road School A school of London artists, that lasted from 1937 to 1939. The artists eschewed abstraction and instead looked back to Walter Sickert and the Camden Town Group for inspiration. Their painting was naturalistic, often with subdued color and unobstrusive brushwork.

Existentialism A philosophy concerned with the existence of the free individual in an absurd or meaningless universe.

Expressionism Art in which the artist's subjective reactions and emotions take precedence over observed reality. Color and form are often exaggerated or distorted. More specifically, expressionism refers to two German movements at the beginning of the 20th century—Die Brücke and Der Blaue Reite.

F

Fauves An early 20-century art style of painting in France, characterized by fierce, expressive color. The name Fauves, French for "Wild Beasts" was coined by art critic Louis Vauxcelles at the first Fauve exhibition in 1905.

Fête champêtre A type of early 18th-century Rococo painting, found chiefly in France, in which small figures are seen in parkland setting. It literally means "pastoral or outdoor feast." It is sometimes called Fête galante, "feast of courtship."

Figurative art Representational art.

Finial Ornament at the top of an architectural feature—for example, a gable.

Fin de siècle French for "end of century," fin de siècle is a loose term for the decadence found in much of the art and literature at the end of 19th century, specifically the decade of 1890s.

Focal point The area in a pictorial composition to which the eye returns most naturally.

Fontainebleau School A group of Italian, French, and Flemist artists working from c1530 to c1560 in a Mannerist style on François I's palace at Fontainebleau, southeast of Paris.

Foreshortening The technique of depicting an object lying at an angle to the picture plane by means of perspective.

Fresco Painting done by applying pigments mixed with water to wet lime or gypsum plaster.

Frottage The technique of reproducing a texture by laying a piece of paper over an object and making a rubbing with a crayon or pencil. The technique was often used by the Surrealists.

Futurism An artistic movement founded in 1909 by the Italian writer F. T. Marinetti. The Futurists celebrated the modern world, especially its machines and technology.

G

Genre painting A painting that shows a scene from daily life, particularly popular in 17th-century Holland.

Geometric art Greek art from c900 to c700 BCE when pottery was covered with geometric patterns.

Gestural painting A general term for the work of leading Abstract Expressionist

action painters and of European artists working in the same vein.

Glaze In ceramics, a vitreous coating designed to make the pot impervious to water and also serving as decoration. In painting, a transparent layer of paint applied over another layer to modify its color and tone.

Gothic The style of art and architecture that flourished in western Europe from the 12th century to the 15th century. Gothic architecture, best exemplified in the cathedrals of northern France and England, is characterized by flying buttresses, pointed arches, and elaborate tracery.

Gouache Opaque version of watercolor, also called bodycolor.

Graffiti art A movement that emerged in New York in the 1970s. Originally graffiti artists spray-painted the streets and subway trains of New York City, but by the 1980s many were showing in its galleries.

Grand tour A tour of Italy to see the classical and Renaissance art and architecture, generally undertaken by the British aristocracy in the 18th and 19th centuries.

Graphic art Art that involves designing of text and artwork.

Greek revival An architectural style, inspired by classical Greece, started in the mid-18th century by Scottish architect James Stuart. By the end of the 18th century, the style was widely adopted in urban planning schemes and new public buildings of Europe and the US. The style continued to c1840 in Britain and longer in the US.

Grotesque A kind of ornament, derived from ancient Rome, composed of loosely connected motifs, including human figures, realistic and fantastic animals, and scrollwork. Grotesque decorations were first found in subterranean ancient ruins in Rome and Naples at the end of the 15th century.

Ground A surface specially prepared for painting, often made with gesso.

Guild In medieval times an association of artists or craftsmen, organized along strictly hierarchical lines—a member served as an apprentice, before becoming a master.

H

Hard-edge painting A term coined by the Los Angeles critic Jules Langsner to describe abstract painting in which flat areas of color are defined by clean, hard edges.

High Renaissance The period from c1500 to c1520 when the great Renaissance painters Leonardo, Raphael, and Michelangelo were all working.

History painting Painting in which the subject is taken from classical, mythological, or biblical events (or historical events of the near past).

Hudson River School A term applied to a group of American landscape painters working in the Hudson River Valley and the Catskill Mountains of New York State from c1825–c1875.

Hyperrealism Alternative name for Superrealism

I

Icon An image of a saint or other holy person on panel produced for the Byzantine, Russian, or Greek Orthodox churches.

Illuminated manuscript A handwritten vellum or parchment book, common in the Middle Ages, illustrated with images, usually in gold and rich colors.

Illusionism The use of pictorial devices, chief among them perspective and foreshortening, to heighten the illusion of reality in a picture.

Impasto Thick, textured brushwork applied with a brush or a knife. Many of Rembrandt's paintings contain impasto passages.

Impressionism An art movement and style of painting that started in France in the late 1860s. The Impressionists rebelled against painting promoted by the academies. Rather than producing detailed and highly finished paintings, they painted with a freshness and spontaneity, using broken brushwork.

International Gothic A style in painting, sculpture, and the decorative arts—prevalent from c1375 to c1425—characterized by its elegance and delicate, naturalistic detail.

International Style Named given to pre-World War II European modernist architecture by historian Henry-Russell Hitchcock and architect Philip Johnson. Sometimes used in reference to 1920s architecture only.

J

Jugendstil German and Austrian form of Art Nouveau.

Junk art Deliberately anti-aesthetic art composed of humble objects—first used by the critic Lawrence Alloway to describe the combines produced by Robert Rauschenberg.

K

Kalighat painting An Indian school of popular painting associated with a temple built in 1809 at Kalighat, south of Calcutta. From c1832, the school mass-produced bold, rough watercolors as devotional images for poor pilgrims.

Kinetic art Art which incorporates an element of movement. Also used to describe art that gives the illusion of movement .

L

Landscape format A picture that is wider than it is high.

Limner Name for artist used in Britain in 15th and 16th centuries.

Literati painting Painting done by Chinese men of letters. It began in the 13th century and flourished during the Ming Dynasty (1368–1644). Literati painters revealed their inner character through the depictions of nature, man, or objects.

Lithograph A print made by drawing on fine-grained limestone (the term literally means "writing on stone"). After the drawing is made, the stone is wetted and greasy lithographic ink applied. The lithographic ink only adheres to the drawn lines and is transferred to paper in a press. Lithography was invented in 1798 in Munich by Aloys Senefelder.

M

Magic Realism Term coined by the German art critic Franz Roh to refer to the more conservative element of Neue Sachlichkeit (New Objectivity) movement of the 1920s.

Mandala A diagrammatic design of the universe used in Hinduism and Buddhism as a focus for contemplation.

Mannerism A 16th-century style of painting between the Renaissance and the Baroque characterized by imbalance and distortion. Michelangelo's later works and Parmigianino elegantly elongated figures are typical of the style.

Miniature A small portrait, popular in Europe from the 16th century to early 19th century. Miniatures were originally painted in watercolor or gouache on vellum or ivory.

Minimal art A type of abstract art that flourished in the 1960s, characterized by simplicity of form and deliberate lack of expressive content. Most minimal art was three-dimensional.

Modeling In painting, creating the illusion of three-dimensional form.

Modernism A style of architecture, inspired by Le Corbusier, in which form follows function and decoration is kept to minimum. In a broader sense, Modernism is used to describe avant-garde 20th-century arts.

Multimedia An artwork made in more than one medium.

Mural A picture painted directly on a wall.

N

Nabis A group of artists who in the 1890s were inspired the work of Paul Gauguin. The name, coined by the poet Henri Cazalis, is Hebrew for "prophets."

Nanga School A school of Japanese painting which flourished from the end of the 17th century to the late 18th century. Its members imitated the "literari painting" practiced in China from the 13th century onward.

Neoclassicism A style of decoration based Ancient Greek and Roman art and architecture, which appeared in the 1750s as reaction to the excesses of the Rococo. It is characterized by a preference for the linear and symmetrical.

Neo-Expressionism A style of painting, popular in the 1970s and 1980s in the US, West Germany, and Italy. Neo-Expressionists created dramatic figurative paintings, usually with distorted subject matter and strong contrasts of color and tone.

Neoimpressionism A style of painting that uses vibrant dots of pure color, which when seen from a distance appear to blend together. Using dots of pure color is known as pointillism or divisionism and the blending perception is known as optical mixing. Neoimpressionism emerged in the 1880s.

Neo-Plasticism A term coined by the Piet Mondrian to describe his severely geometrical abstract art.

Neue Sachlichkeit (New Objectivity) A style of painting from 1920s Germany, in which subject matter was rendered in matter-of-fact detail.

New York School Alternative name for the Abstract Expressionists.

Nouveau Realisme French movement (meaning new realism) founded in 1960 by the critic Pierre Restany and artist Yves Klein. The movement sought to bring life and art closer together using a wide variety of media, including painting, assemblages, installation, and happenings.

O

Olmec culture Civilization in ancient Mexico which flourished from c1200 to c400 BCE—famous for their stylized statuary and small jadework.

Op Art An abbreviation of "optical art," op art was a 1960s abstract art movement that used hard-edged flat areas of paint to simulate the eye and create an impression of movement.

Optical mixing The process by which the eye blends discrete touches of pure color placed next to each other so that they appear to create new colors.

Orphism Term coined by Guillaume Apollinaire in 1913 to describe a Cubist-inspired abstract art that employed overlapping planes of bright, contrasting colors. Robert Delauney was a leading figure.

P

Performance art Style of art, originating in the 1960s, which combines elements of theater–, dance, and music with visual art.

Perspective The method of representing solid objects on a two-dimensional surface in order to give the correct impression of their height, width, depth, and position in relation to one another.

Photogram A photographic print made by placing an arrangement of objects on photosensitive paper. The paper is exposed to light and developed, resulting in an image of the objects' shapes.

Photorealism Alternative name for Superrealism

Photomontage A picture created by arranging and pasting down existing photographs.

Pictogram A picture representing a word, sound or idea. Also called a pictograph.

Picturesque, the In late 18th century and early 19th century Britain, the picturesque referred specifically to a landscape full of variety, curious details, and interesting textures. Medieval ruins, country cottages, winding paths, and partly kept woodland were typical of the picturesque landscape.

Picture-plane The imaginary plane occupied by the physical surface (eg the canvas) of a picture.

Pieta Italian for "pity," pieta is a term applied to a painting or sculpture showing the Virgin Mary supporting the body of the dead Christ.

Plastic arts Art that involves modeling in three dimensions—for example, sculpture and ceramics; also used for two-dimensional art that strives to convey an illusion of depth.

Pointillism A technique of painting with dots of pure color that when viewed from a distance appear to merge together to create a new color. Also called divisionism.

Pop Art Art which makes uses the imagery of popular culture—for example, comic strips and packaging. Pop Art began in Britain and the US in the 1950s and flourished in the 1960s.

GLOSSARY

598

ART

Portrait A painting, photograph or other likeness of an actual person; usually commissioned.

Portrait format A picture that is higher than it is wide.

Postimpressionism Term coined by British critic and artist Roger Fry in c1914 to describe artistic developments arising from and after Impressionism.

Postmodernism The term Postmodernism came into use in the 1970s with reference to architecture. It describes architecture that borrows from classical, vernacular, and commercial styles. Since the 1970s, postmodernism has been applied to all branches of the arts. It describes art that is inventive, playful, and borrows from eclectic sources.

Post-painterly abstraction Term coined by critic Clement Greenberg in 1964 to describe painters who created abstract paintings with large unmodulated fields of color.

Precisionism A 1920s school of American painters who depicted industrial and architectural scenes—such bridges, barns, and factories—in a clean, simple, and sharply defined manner.

Predella A long horizontal painting placed beneath the main scene or main series of panels in an altarpiece.

Primitivism Art inspired by so-called primitive art—usually understood to mean the art of Africa and the Pacific Islands.

Process art Art of the 1960s and 1970s where the process of creation becomes the subject matter.

R

Rayonism Art movement and style of painting featuring beams of color, influenced by Cubism, Futurism, and Orphism. It was practiced from 1912 to 1914 by Russian painters Mikhail Larinov and his wife Natalia Goncharova.

Ready-made Term coined by Marcel Duchamp to describe a pre-existing, everyday object that he accorded the status of a work of art. Duchamp exhibited his first ready-made in 1913.

Realism A mid-19th century French movement, in which contemporary subject matter, including urban and rural life, was painted in a detailed, accurate, and sober manner.

Regionalism Alternative name for American scene painting

Relief A sculpture made so that all or part of it projects from a flat surface.

Renaissance A rebirth of the arts and learning that occurred from end of the 14th century to the end of the 16th century, especially in Italy, the Germanic states, and Flanders. It was inspired by the classical cultures of Rome and Greece, and informed by scientific advances, especially in anatomy and perspective. In Italy, the period is usually divided into the Early Renaissance until c1500, the High Renaissance until c1520, and the Late Renaissance until c1580.

Rococo A lighter and more playful version of the Baroque that dominated the arts from c1700 until Neoclassicism came into vogue in the 1750s and 1760s.

Romanesque Term coined around 1825 to describe the pre-Gothic art and architecture from the close of the tenth century to the 12th century. In architecture, it is typified by the round arch and heavy construction.

Romanticism A broad term generally referring to a style in the visual arts, music, and literature in the late 18th century and early 19th century. Romantic artists reacted against the reason and intellectual discipline of Neoclassicism and the Enlightenment. Instead they celebrated individual experience and expression, and often sought inspiration in nature and landscape.

S

Sacra conversazione Italian for "holy conversation," the term refers to depiction of the Virgin and Child surrounded by saints, all of whom are engaged in dialog or, at least, aware of one another's presence. It first evolved in Florence in the mid-15th century.

St. Ives painters A loosely connected group of British artists who lived in the Cornish coastal village of St. Ives from the 1940s to the 1960s.

Salon, the An official French painting exhibition, first held in 1667. In 1881, the government withdrew support and thereafter it began to lose prestige to independent exhibitions—including Salon d'Automne, Salon des Indépendants, and Salon des Refusés.

Salon d'Automne An annual exhibition first held in Paris in 1903. It held the first Fauve exhibition in 1905.

Salon des Indépendants An annual exhibition first held in Paris in 1884. It showed important Neoimpressionist and Postimpressionist works.

Salon des Refusés An exhibition held in Paris in 1863 on the orders of Napoleon III to show works rejected from the official Salon—including Eduoard Manet's *Déjeuner sur l'Herbe* and works by James Whistler and Camille Pissarro.

Sand painting A technique of making designs in different colors of sand, practiced among others by American Indians and Australian Aboriginals.

Sassanian art The art of Iran, Iraq, and neighboring areas under the Sassanid dynasty (224–651 CE). There was an emphasis on metalwork, often with stylized hunting scenes.

Screenprinting A printmaking technique in which printing ink is pressed through a screen with a rubber blade onto paper. Different colored inks are applied individually, with different parts of the paper masked each time.

Secondary color The three colors made by mixing pairs of the three primary colors—that is, green (blue and yellow), purple (red and blue), and orange (yellow and red).

Sfumato An Italian term, meaning smokey, used to describe transitions of tones so subtle they seem imperceptible.

Sgraffito The technique of scratching through one layer to reveal another layer of contrasting color. The term is used most commonly in reference to pottery—but also to painting.

Silverpoint A method of drawing with a metal rod of silver on a paper surface specially prepared with white pigment. Minute particles of silver are left in the paper surface, producing a grayish line that darkens with time.

Socialist Realism The name for the official art of the Soviet Union instigated in the late 1920s. Naturalistic in style, Socialist Realism glorified manual work and celebrated Soviet cultural and technological achievements.

Solarization Solarization is the result of exposing a black-and-white photographic negative or print to light during its development, causing a partial reversal of light and dark values. Also known as the Sabattier Effect.

Soft style A German version of the International Gothic, flourishing in the late 14th and 15th centuries, characterized by harmonious compositions, with flowing, softly folding draperies and delicate figures (often the Virgin Mary). Sometimes called the "sweet style."

Soft-ground etching A printmaking technique that reproduces the effect of a chalk or pencil drawing. The design is drawn onto a sheet of paper placed over an etching plate prepared with a soft ground that includes tallow. The pressure of the pencil or chalk clears a path to the ground.

Standing stones Solitary stones set vertically in the ground by Neolithic civilizations, common in Western Europe, especially Britain.

Stijl, De Dutch for "the style," De Stijl was a loose association of artists, named after a magazine set up by Theo van Doesburg in 1917. Their art was generally austere and abstract and ranged from painting and sculpture, to architecture, to graphic and furniture design.

Stupa A dome-shaped monument containing sacred relics, found in both Buddhist and Jain religious architecture.

Superrealism A style of art based on imitating photographs in paint and real objects in sculpture. It was popular in the late 1960s and 1970s. The term was coined by Malcolm Morley, the pioneer of the genre, in 1965.

Suprematism Art movement, devised by Kazimir Malevich in 1915, which used simple abstract forms such as the square, triangle, and circle.

Surrealism An artistic and literary movement, founded by the poet André Breton in 1924, that flourished in the late 1920s and 1930s in Paris. Some surrealist artists sought to access to the subconscious while they painted—a technique known as automatism. Others sought to paint the dream-like worlds of the subconscious with a super-real clarity.

Symbolism Loose term for a late 19th-century artistic and literary movement. Artists favored subjective, personal representations of the world, and were influenced by religious mysticism and primitive art.

Synchronism American version of Orphism, which arose in 1912.

Synthetism A term, adopted by Paul Gauguin, Emile Bernard, and their followers at Pont Aven in the late 1880s. It described their philosophy of synthesizing their impressions and painting from memory rather than from life.

T

Tachisme An alternative name for Art Informel.

Tempera A medium used to bind pigments—most commonly made from egg yolk, but also from milk or various glues and gums. In Italy, egg tempera was the standard medium used for panel paintings from the 13th to the 15th century.

Tertiary colors Colors—tending to be shades of brown, black, and gray—produced by mixing two of the three secondary colors (green, orange and purple).

Triptych A picture consisting of three panels, usually hinged.

Trompe l'oeil French for "fool the eye," the term refers to paintings, usually still lifes, which persuade viewers that they are looking at actual objects. Popular in 17th-century Dutch art.

U

Ukiyo-e Japanese for "pictures of the floating world," ukiyo-e were a popular art from the 17th to 19th centuries. They depicted transient, everyday life including theater scenes, geishas, and the nightlife of Edo (as Tokyo was then called) as well as landscapes and scenes from historical legends.

Underdrawing A preliminary drawing for a painting, often done in charcoal, which is then painted over.

V

Vanitas An allegorical still life—popular in 17th-century Holland—in which the objects, such as an hour-glass or a human skull, were meant to be reminders of the transience of human life.

Vienna Secession The artists and architects, led by Gustav Klimt, who broke away from the official academy in Vienna in 1897. They opened their own craft studio in 1903, the Wiener Werstatte.

Vorticism A London-based literary and artistic movement. Influenced by Italian Futurism and French Cubism, the style was energetic and divided into planes.

W

Watercolor A type of transparent paint in which watersoluble pigments are combined with a binder—usually gum arabic. Watercolor was a favored medium of the British landscape artists of the late 18th and early 19th centuries.

Wet plate process Photographic process, invented by Frederick Scott Archer in 1851, in which a light-sensitive collodion solution was poured over a glass plate. The plate was exposed to light in the camera and developed while still wet.

Wood engraving A printmaking technique developed from the woodcut. Wood engraving uses hardwood sawn across the grain—rather than along it as in the woodcut. This gives a harder, smoother surface to help give finer, more detailed prints.

Woodcut A print made from a block of wood, parts of which are cut away leaving the design standing proud to receive the ink. The technique is thought to have been invented in China.

Z

Zen art Zen is a mix of Buddhism and Taoism. The Zen artist usually works with a horsehair brush, black ink, and either paper or silk and tries to suggest by the simplest possible means the essential qualities of his subject matter.

Index

In this index, names of works are given in italics with artists names in brackets. Page references in bold type refer to main entries.

INDEX

609

ART

Acknowledgments

Dorling Kindersley would like to thank the following for their assistance with the book: Kathryn Wilkinson, Angela Wilkes, Martha Evatt, Nicola Hodgson, Kim Dennis-Bryan, and Megan Jones for editorial assistance; Paul Drislane, Simon Murrell, Silke Spingies, Liz Sephton, and Steve Setford for design assistance; Hilary Bird for indexing; Amber Tokeley and Patricia Monahan for contributions; Martin Copeland and Jenny Baskaya in the DK picture department; Pandora Mather-Lees, Imogen Pasley-Tyler, Sian Phillips, and Nick Dunmore atthe Bridgeman Art Library.

Cobalt ID would like to thank the following for their assistance with the book: Darren Bland, Claire Dale, Maddy King, and Shane Whiting, all at cobalt id; Rebecca Johns and Mandy Earey for design assistance; Neil Mason and Steve Setford for editorial assistance; and Klara and Eric King at Communication Crafts for proofreading.

Picture Credits The publisher would like to thank the following for their kind permission to reproduce their photographs: (Key: a-above; b-below/bottom; c-center; f-far; l-left; r-right; t-top)

UK, © The Estate of L.S.Lowry 2008 495cla; Maser, Treviso, Veneto, Italy, Giraudon 137tc; Masjid-i-Jomeh, Isfahan, Iran 73bl; Mattioli Collection, Milan, Italy, 431tl; 431tl; Mattioli Collection, Milan, Italy / Lauros/Giraudon, © DACS London 2008 428c, 429tl; Mattioli Collection, Milan, Italy, Lauros / Giraudon 428bl; Mauritshuis, The Hague, The Netherlands 9br, 231fbr, 232br, 237tr; Mauritshuis, The Hague, The Netherlands, Giraudon 237cla; Meenakshi Temple, Madurai, Tamil Nadu, India, Lauros / Giraudon 292bl, 292br; Melk Abbey, Austria 250bl; Memling Museum, Bruges, Belgium 148crb; Menil Collection, Houston, TX, US / Lauros / Giraudon, © ADAGP, Paris and DACS, London 2008 471tr; Metropolitan Museum of Art, New York, US 128ca, 139c, 172r, 182br, 392cl, 513br; Metropolitan Museum of Art, New York, US, 342c; Metropolitan Museum of Art, New York, US, © ARS, NY and DACS, London 2008 491cl; Metropolitan Museum of Art, New York, US, Giraudon 195crb; Metropolitan Museum of Art, New York, US, Photo © Boltin Picture Library 323cr; Mezquita (Great Mosque) Cordoba, Spain 73cla; Mittelrheinisches Landesmuseum, Mainz, Germany 67cb; Moderna Museet, Stockholm, Sweden © DACS, London/VAGA, New York 535cl; Moderna Museet, Stockholm, Sweden/ Cameraphoto Arte Venezia, © Succession Marcel Duchamp/ADAGP, Paris and DACS, London 2008 467tr; Mogao Caves, Dunhuang, Gansu Province, NW China 442fcla; Monasterio de El Escorial, El Escorial, Spain, Giraudon 206cra; Monasterio de El Escorial, Spain, Giraudon 223l; Morohashi Museum of Modern Art, Koriyama-Shi, Japan 443cra; Mucha Trust 384cra, 384tc, 384tl; Musee Archeologique et Historique, Angouleme, France 63bl, 63cl; Musee Bargoin, Clermont-Ferrand, France, Lauros / Giraudon 215tl, 274cb; Musee Cantini, Marseille, France, / Giraudon, © ADAGP, Paris and DACS, London 2008 470fcr, 474ca, 545tl; Musee Cernuschi, Paris, France, Bonora 51br; Musee Cernuschi, Paris, France, Lauros / Giraudon 78cb; Musee Cognacq-Jay, Paris, France, Lauros / Giraudon 247cra; Musee Conde, Chantilly, France 14cb; Musee Conde, Chantilly, France, 247tl; Musee Conde, Chantilly, France, Giraudon 8clb (Otto II), 67tc, 89bl, 103cb, 147br, 152bc, 235cla; Musee Conde, Chantilly, France, Lauros / Giraudon 126tl, 150cra; Musee d'Art et d'Histoire, Geneva, Switzerland 166cr; Musee d'Art et d'Histoire, Geneva, Switzerland, Photo © Held Collection 166br; Musee d'Art et d'Industrie, St Etienne, France, Lauros / Giraudon, © ARS, New York and DACS, London 2008 527c; Musee d'Art Moderne de la Ville de Paris, Paris, France / J P Zenobel, © ADAGP, Paris and DACS, London 2008 463tr; Musee d'Art Moderne de la Ville de Paris, Paris, France / Lauros / Giraudon © ADAGP, Paris and DACS, London 2008 407cra; Musee d'Art Moderne de la Ville de Paris, Paris, France, Lauros / Giraudon, © ADAGP, Paris and DACS, London 2008 517bl; Musée d'Art Moderne de la Ville de Paris, Paris, France, Lauros / Giraudon. © ADAGP, Paris and DACS, London 2008 380cfa, 416cr, 427tc; Musee d'Art Moderne, Troyes France, Lauros / Giraudon 427tl; Musee d'Art Thomas Henry, Cherbourg, France, Giraudon 248tl; Musee d'Histoire Contemporaine, BDIC, Paris, France / Archives Charmet 516t; Musee d'Orsay, Paris, France 20cra, 57cb, 57cla, 326-327cra, 341c, 353bl, 354cr, 355bl, 360fcr (1891-2), 362bl, 368cl, 372ca, 393fcl, 394bl; Musee d'Orsay, Paris, France, 341fcr, 353bc, 354cla, 356br, 374tl, 375br; Musee d'Orsay, Paris, France © ADAGP, Paris and DACS, London 2008 407tl; Musee d'Orsay, Paris, France, © DACS / Lauros / Giraudon 362fclb; Musee d'Orsay, Paris, France, Giraudon 34cr, 324cr, 325cla, 325clb, 327tl, 336bl, 340cl, 340cr, 342clb, 344-345, 346br, 346clb, 347b, 347clb, 347crb, 347tr, 348cl, 349ca, 350ca, 351bc, 352cl, 355tl, 361b, 369cr, 380tc, 382clb, 395br, 395fcra, 547clb; Musee d'Orsay, Paris, France, Giraudon, © Succession H Matisse/DACS 2008 403tr; Musee d'Orsay, Paris, France, Lauros / Giraudon 209clb, 261ca, 324fcr, 325crb, 336cr, 340bl, 340c, 341cl, 343cra, 352clb, 352cr, 353tr, 354clb, 357br, 361fcl, 361t, 363tr, 368clb, 382cc, 382fcl, 382fcr (1890), 383ca, 383cb, 383crb, 455bl, 455c; Musee d'Unterlinden, Colmar, France, Giraudon 139fcl, 170bl, 170br, 170c, 170crb; Musee de l'Annonciade, Saint-Tropez, France, Giraudon 363bl; Musee de l'Ile de France, Sceaux, France 402clb; Musee de l'Orangerie, Paris, France, © ADAGP, Paris and DACS, London 2008 402bl; Musee de l'Orangerie, Paris, France, Lauros / Giraudon 31cra; Musee de la Marine, Paris, France, Lauros / Giraudon 247clb; Musee de la Ville de Paris, Musee Carnavalet, Paris, France 298cb; Musee de la Ville de Paris, Musee Carnavalet, Paris, France, Lauros 395tc; Musee de la Ville de Paris, Musee Carnavalet, Paris, France, Lauros / Giraudon 327cra; Musee de la Ville de Paris, Musee du Petit-Palais, France, Giraudon 231br, 315clb; Musee de Picardie, Amiens, France, Lauros / Giraudon 214tr; Musee des Antiquites Nationales, St. Germain-en-Laye, France, Giraudon 63br; Musee des Arts Decoratifs, Paris, France, Giraudon 289cl; Musée des Beaux-Arts, Lille, France, Lauros / Giraudon. © ADAGP, Paris and DACS, London 2008 456tl; Musee des Beaux-Arts et d'Archeologie, Besancon, France, Giraudon 246tl; Musee des Beaux-Arts, Arles, France, Peter Willi 210tl; Musee des Beaux-Arts, Arras, France, Giraudon 328tl; Musee des Beaux-Arts, Caen, France, Giraudon 206bl; Musee des Beaux-Arts, Caen, France, Lauros / Giraudon 165bl; Musee des Beaux-Arts, Dijon, France, Lauros / Giraudon 140cr; Musee des Beaux-Arts, Grenoble, France/Peter Willi © Succession H Matisse/DACS 2008 403cr; Musee des Beaux-Arts, Lyon, France 298tr; Musee des Beaux-Arts, Lyon, France, Giraudon 217bl; Musee des Beaux-Arts, Marseille, France, Giraudon 215tc; Musee des Beaux-Arts, Nantes, France / Giraudon, © ADAGP, Paris and DACS, London 2008 459tr; Musee des Beaux-Arts, Orleans, France, Giraudon 245tl; Musee des Beaux-Arts, Pau, France, Giraudon 348bl; Musee des Beaux-Arts, Rennes, France, Giraudon 210br; Musee des Beaux-Arts, Rouen, France, Lauros / Giraudon 154tl, 298tc; Musee des Beaux-Arts, Strasbourg, France 208bc; Musee des Beaux-Arts, Tours, France 213tc; Musee des Beaux-Arts, Valenciennes, France, Lauros / Giraudon 268ftl; Musee des Monuments Francais, Paris, France, Giraudon 180fcra; Musee Fabre, Montpellier, France, Giraudon 324tl; Musee Fabre, Montpellier, France, Lauros / Giraudon 248tr; Musee Goya, Castres, France 302tl; Musee Guillaume Apollinaire, Stavelot, Belgium, © ADAGP, Paris and DACS, London 2008 459br; Musee Guimet, Paris, France 282br; Musee Guimet, Paris, France, Giraudon 185t, 281br, 282t, 283br, 291ca; Musee Guimet, Paris, France, Lauros / Giraudon 442fcra; Musee Gustave Moreau, Paris, France 129cla; Musee Gustave Moreau, Paris, France, Roger-Viollet, Paris 383tl; Musee Hyacinthe Rigaud, Perpignan, France / Lauros / Giraudon. © ADAGP, Paris and DACS, London 2008 381bc; Musee Hyacinthe Rigaud, Perpignan, France, Lauros / Giraudon 215clb; Musee Marmottan, Paris, France 19bl; Musee Marmottan, Paris, France, 352tc; Musee Marmottan, Paris, France, Giraudon 33tr, 341cra, 348tc, 353tl; Musee Nat. du Chateau de Malmaison, Rueil-Malmaison, France, Lauros / Giraudon 269cb; Musee National d'Art Moderne, Centre © ADAGP, Paris and DACS, London 2008 Pompidou, Paris, France 441tr; Musee National d'Art Moderne, Centre Pompidou, Paris, France / Flammarion, © ADAGP, Paris and DACS, London 2008 434bl, 435bc; Musee National d'Art Moderne, Centre Pompidou, Paris, France / Giraudon 458br; Musee National d'Art Moderne, Centre Pompidou, Paris, France / Lauros / Giraudon. © ADAGP, Paris and DACS, London 2008 474cla; Musee National d'Art Moderne, Centre Pompidou, Paris, France / Peter Willi. © ADAGP, Paris and DACS, London 2008 435c; Musee National d'Art Moderne, Centre Pompidou, Paris, France, © DACS London 2008 481tr; Musee National d'Art Moderne, Centre Pompidou, Paris, France, © ADAGP, Paris and DACS, London 2008 429br; Musee National d'Art Moderne, Centre Pompidou, Paris, France, © Succession H Matisse/DACS 2008 11bl, 403br; Musee National d'Art Moderne, Centre Pompidou, Paris, France, Giraudon © ADAGP, Paris and DACS, London 2008 416br; Musee National d'Art Moderne, Centre Pompidou, Paris, France, Giraudon / © ADAGP, Paris and DACS, London 2008 517cb; Musee National d'Art Moderne, Centre Pompidou, Paris, France, Lauros / Giraudon © Foundation Antoni Tapies, Barcelona/VEGAP, Madrid and DACS, London 2008 519bl; Musée National d'Art Moderne, Centre Pompidou, Paris, France. © ADAGP, Paris and DACS, London 2008 417tr; Musee National d'Art Moderne, Centre Pompidou, Paris, France/Peter Willi. © ADAGP, Paris and DACS, London 2008 434cr; Musée National d'Art Moderne, Centre Pompidou, Paris, France/Peter Willi. © ADAGP, Paris and DACS, London 2008 427br, 427tr, 433cla, 435br, 458bl, 479ca, 479cra, 479tr, 518cr; Musee National d'Art Moderne, Paris, France, Lauros / Giraudon. © ADAGP, Paris and DACS, London 2008 417bc; Musee National d'Art Moderne, Paris, France, Peter Willi 416fcr, 426bl; Musee Naval, Toulon, France, Giraudon 215cla; Musee Picasso, Paris, France / Giraudon, © Succession Picasso/DACS London 2008 419br; Musee Picasso, Paris, France / Peter Willi, © Succession Picasso/DACS London 2008 420, 421br; Musee Picasso, Paris, France / Peter Willi, © Succession Picasso/DACS London 2008 315cra; Musee Picasso, Paris, France, / Lauros / Giraudon, © Succession Picasso/DACS London 2008 418clb; Musee Picasso, Paris, France, © Succession Picasso/DACS London 2008 420-421, 421tc; Musée Picasso, Paris, France, Giraudon 455tl; Musée Picasso, Paris, France, Giraudon, © Succession Picasso/DACS London 2008 416bl; Musee Reattu, Arles, France / Giraudon © Succession Picasso/DACS London 2008 521bl; Musee Rodin, Paris, France, Peter Willi 356cra, 375tl; Musee Rodin, Paris, France, Philippe Galard 315tl, 357cl; Musee Toulouse-Lautrec, Albi, France, Giraudon 26crb; Musees des Beaux-Arts de Belgique, Brussels, Belgium 149bc, 269t; Musees Royaux des Beaux-Arts de Belgique, Brussels, Belgium, Giraudon 9cb, 128clb, 139fcr, 148cra, 163tl; Museo Archeologico Nazionale, Naples, Italy 55ca, 60fbl, 152cla, 314fcla; Museo Archeologico Nazionale, Naples, Italy, Alinari 510cla; Museo Archeologico Nazionale, Naples, Italy, Giraudon 58br; Museo Archeologico Nazionale, Naples, Italy, Index 58cl; Museo Archeologico Nazionale, Naples, Italy, Lauros / Giraudon 60t; Museo Archeologico Nazionale, Naples, Italy, Photo © Held Collectio 208cla; Museo Archeologico Nazionale, Naples, Italy, Photo © Held Collection 61tl; Museo Archeologico Nazionale, Naples, Italy, Roger-Viollet, Paris 60clb; Museo Archeologico, Venice, Italy 128cla; Museo Capitolino, Rome, Italy 59t; Museo Civico Rivoltello, Trieste, Italy, Alinari 529bl; Museo Civico, Recanati, Italy, Giraudon 125bl; Museo Correr, Treviso, Italy, Lauros / Giraudon 244tl; Museo Correr, Venice, Italy, Alinari 127bl; Museo Cristiano Lateranese, Rome, Italy, Alinari 64br; Museo Dali, Figueres, Spain, © Salvador Dali, Gala-Salvador Dali Foundation, DACS, London 2008 129fcrb; Museo de Arte Contemporaneo, Mexico City, Mexico / Photo: Jorge Contreras Chacel 498bc; Museo de Arte de Catalunya, Barcelona, Spain, Photo © Held Collection 150bl, 150br; Museo de Arte Moderno, Bogota, Colombia, Index 568r; Museo de Arte Moderno, Mexico City, Mexico / Giraudon, © DACS London 2008 498cla, 498fcla, 498ftl; Museo de Arte Moderno, Mexico City, Mexico, Art Resource/Schalkwijk, © 2008, Banco de Mexico Diego Rivera & Frida Kahlo Museums Trust, Mexico DF / DACS London 499br; Museo de Bellas Artes, Seville, Spain 498cla; Museo de Bellas Artes, Seville, Spain, Giraudon 218tl; Museo de Cadiz, Spain, 195bl; Museo de Santa Cruz, Toledo, Spain 183br; Museo del Banco Central de Reserva, Lima, Peru, Bildarchiv Steffens 80br; Museo dell'Opera del Duomo, Florence, Italy 94br; Museo dell'Opera del Duomo, Siena, Italy 83br, 83crb, 85crb; Museo dell'Opera del Duomo, Siena, Italy, Alinari 83bl, 85bl; Museo della Civilta Romana, Rome, Italy, Giraudon 442clb; Museo di San Marco dell'Angelico, Florence, Italy 99b, 99br, 99tl; Museo di San Marco, Florence, Italy 94tr; Museo Dolores Olmedo Patino, Mexico City, Mexico, Photo: Gabriel Figueroa, © 2008, Banco de Mexico Diego Rivera & Frida Kahlo Museums Trust, Mexico DF / DACS London 496bl; Museo e Gallerie Nazionali di Capodimonte, Naples, Italy, Giraudon 162tr; Museo Historico Nacional, Buenos Aires, Argentina, Index 510crb; Museo Lazaro Galdiano, Madrid, Spain 297t; Museo Lazaro Galdiano, Madrid, Spain, Giraudon 154cc; Museo Nacional Centro de Arte Reina Sofia, Madrid, Spain / Giraudon. © DACS, London 2008 494tr; Museo Nacional de Antropologia y Arqueologia, Lima, Peru, Bildarchiv Steffens 80br; Museo Nacional de Antropologia, Mexico City, Mexico 191br; Museo Nacional de Antropologia, Mexico City, Mexico, Jean-Pierre Courau 81br, 191l; Museo Nacional de Antropologia, Mexico City, Mexico, Photo: Michel Zabe / AZA 128tr, 191cr, 191tr; Museo Nazionale del Bargello, Florence, Italy 94cr, 95bl, 95cla, 97tc, 177c; Museo Nazionale Romano, Rome, Italy 60-61; Museo Nazionale, Reggio Calabria, Italy 158v; Museo Picasso, Barcelona, Spain, Lauros / Giraudon / © Succession Miro/ADAGP, Paris and DACS, London 2008 472tl; Museo Picasso, Barcelona, Spain. © DACS London 2008 472tl; Museu de Arte, Sao Paulo, Brazil, Giraudon 21bl, 460tl; Museu Picassc, Barcelona, Spain. © DACS 220fcla; Hamburger Kunsthalle, Hamburg, Germany, © Man Ray Trust/ADAGP, Paris and DACS, London 2008 468bl; Museum Boymans-van Beuningen, Rotterdam, The Netherlands 232tr; Museum Carolino Augusteum, Salzburg, Austria, Interfoto 329cla; Museum der Bildenden Kunste, Leipzig, Germany 382cl; Museum der Bildenden Kunste, Leipzig, Germany, 384crb; Museum Folkwang, Essen, Germany, Giraudon 373bc; Museum fur Volkerkunde, Vienna, Austria 191tc; Museum Narodowe, Poznan, Poland 370ca; Museum of Art, Serpukhov, Russia / Giraudon, © ADAGP, Paris and DACS, London 2008 443clb; Museum of Art, Toledo, Ohio, US, Giraudon 35fcla; Museum of Art, Tula, Russia 434cl, 440cl; Museum of Fine Arts, Boston, Massachusetts, US, Abbott Lawrence Fund, Seth K. Sweetser Fund 256tr; Museum of Fine Arts, Boston, Massachusetts, US, Anna Mitchell Richards Fund 51cra; Museum of Fine Arts, Boston, Massachusetts, US, Bequest of Mrs Alma H. Wadleigh 391bl; Museum of Fine Arts, Boston, Massachusetts, US, Bequest of Winslow Warren 279bl; Museum of Fine Arts, Boston, Massachusetts, US, Centennial Gift of Landon T. Clay 138fcr; Museum of Fine Arts, Boston, Massachusetts, US, Denman Waldo Ross Collection 78br; Museum of Fine Arts, Boston, Massachusetts, US, E. Rhodes and Leona B. Carpenter Foundation Grant 40br; Museum of Fine Arts, Boston, Massachusetts, US, Edward Ingersoll Brown Fund 279br; Museum of Fine Arts, Boston, Massachusetts, US, Fenollosa-Weld Collection 91fcl; Museum of Fine Arts, Boston, Massachusetts, US, Francis Bartlett Donation 291cla; Museum of Fine Arts, Boston, Massachusetts, US, Gift of Mary Louisa Boit, Julia Overing Boit, Jane Hubbard 15cla, 371clb; Museum of Fine Arts, Boston, Massachusetts, US, Gift of Mr and Mrs Henry Lee Higginson 146tr; Museum of Fine Arts, Boston, Massachusetts, US, Gift of Mrs Frederick L. Ames 281t; Museum of Fine Arts, Boston, Massachusetts, US, Gift of Mrs Samuel and Miss Alice Hooper 322tl; Museum of Fine Arts, Boston, Massachusetts, US, Henry H. and Zoe Oliver Sherman Fund and other funds 391ccb; Museum of Fine Arts, Boston, Massachusetts, US, Keith McLeod Fund 283cb, 293br; Museum of Fine Arts, Boston, Massachusetts, US, Marshall H. Gould Fund, Frederick L. Jack Fund and 293bl; Museum of Fine Arts, Boston, Massachusetts, US, Picture Fund 350tr; Museum of Fine Arts, Boston, Massachusetts, US, Robert

Dawson Evans Collection 266bl; Museum of Fine Arts, Boston, Massachusetts, US, Ross-Coomaraswamy Collection 293cla; Museum of Fine Arts, Boston, Massachusetts, US, Special Chinese and Japanese Fund 79cla; Museum of Fine Arts, Boston, Massachusetts, US, The Hayden Collection - Charles Henry Hayden Fund 208crb, 493tr; Museum of Fine Arts, Boston, Massachusetts, US, William Francis Warden Fund 78t; Museum of Fine Arts, Boston, Massachusetts, US, William S. and John T. Spaulding Collection 287bc; Museum of Fine Arts, Houston, purchase with funds from the Brown Foundation Accessions Endowment Fund © Ellsworth Kelly 526br; Museum of Fine Arts, Houston, Texas, US 28bl, 457ca, 580tl; Museum of Fine Arts, Houston, Texas, US / Mr & Mrs Frank J Hevrdejs Fund, © ARS, NY and DACS, London 2008 503cb, 503cb; Museum of Fine Arts, Houston, Texas, US / Museum purchase with funds provided by Oveta Culp Hobby, © ADAGP, Paris and DACS, London 2008 508bl; Museum of Fine Arts, Houston, Texas, US. © 2008 Andy Warhol Foundation for the Visual Arts / Artists Rights Society (ARS), New York / DACS, London 2008 542ftl; Museum of Fine Arts, Houston, Texas, US. © ADAGP, Paris and DACS, London 2008 549cla; Museum of Fine Arts, Houston, Texas, US. © DACS London 2008 525bc; Museum of Fine Arts, Houston, Texas, US. © DACS, London/VAGA, New York 2008 523c; Museum of Fine Arts, Houston, Texas, US, Funds provided by the Alice Pratt Brown Museum Fund 514cra; Museum of Fine Arts, Houston, Texas, US, Funds provided by the Caroline Weiss Law Endowment Fund 576ca; Museum of Fine Arts, Houston, Texas, US, Gift of Audrey Jones Beck, © ADAGP, Paris and DACS, London 2008 407bl; Museum of Fine Arts, Houston, Texas, US, Gift of Herbert Godwin 205cra; Museum of Fine Arts, Houston, Texas, US, Gift of Mr Frank J Hevrdejs, © T H Benton and R P Benton Testamentary Trusts/DACS, London/VAGA, New York 2008 503bl; Museum of Fine Arts, Houston, Texas, US, Gift of Mrs. R. O'Connor in honour of L. Sarofim & M. Stude 40cra; Museum of Fine Arts, Houston, Texas, US, Gift of Throckmorton Fine Art Gallery 499tl; Museum of Fine Arts, Houston, Texas, US, Museum purchase with funds provided by the Museum Collectors 41tc; Museum of Fine Arts, Houston, Texas, US, The Bayou Bend Collection, gift of Miss Ima Hogg 280tc; Museum of Fine Arts, Houston, Texas, US, The Dr. Gus K. Nicholson Collection 397br; Museum of Fine Arts, Houston, Texas, US, The Target Collection of American Photography 491tl; Museum of Modern Art, New York, US 6-7, 360fcr, 376-377, 378br, 378tr, 379; Museum of Modern Art, New York, US. © Succession Picasso/DACS London 2008 419tr; Museum of Modern Art, New York, US. © DACS London 2008 428fcl, 429tr; Museum of Modern Art, New York, US. © DACS /Giraudon 362tr; Museum of Modern Art, New York, US. © The Willem de Kooning Foundation, New York/ARS, NY and DACS, London 2008 502c, 509cb; Museum of Modern Art, New York, US. / Lauros / Giraudon, © Succession Picasso/DACS London 2008 10br, 418cl, 418-419; Museum of the City of New York, US 359bc; Museum of the Holy Ma'sumeh Shrine, Qom, Iran 72crb; Museum voor Schone Kunsten, Ghent, Belgium 138cr, 156br; Museum, Vienna, Austria 184fcl; Private Collection / Peter Willi, © Man Ray Trust/ADAGP, Paris and DACS, London 2008 468crb; Private Collection © Agnew's, London, UK 153clb, 184ca, 184tr, 241cra, 277br, 567br, 567cra; Stapleton Collection, UK, 335cl, 387cr, 468; Private Collection © Christie's Images, London, UK, 264b; Private Collection, © DACS/ National Academy Museum, New York, US 392tl; National Archaeological Museum, Athens, Greece 53cb, 55ftr, 55tr; National Archaeological Museum, Athens, Greece, Lauros / Giraudon 54bl, 56cla; National Gallery of Art, Ottawa, Ontario, Canada. © ADAGP, Paris and DACS, London 2008 426br; National Gallery of Art, Washington DC, US 22bl, 101tr, 349clb, 452bl; National Gallery of Art, Washington DC, US, Lauros / Giraudon 211bl; National Gallery of Art, Washington DC, US, Lauros / Giraudon, © ADAGP, Paris and DACS, London 2008 470cr, 478cr; National Gallery of Scotland, Edinburgh, Scotland 23br, 23crb, 137clb, 218ca, 245br, 259cr, 262clb, 263tr, 360cl, 370clb, 372clb; National Gallery of Scotland, Edinburgh, Scotland, 322br, 372cra, 374tr; National Gallery of Victoria, Melbourne, Australia 14bl; National Gallery of Victoria, Melbourne, Australia, © DACS /Felton Bequest 360bl; National Gallery of Victoria, Melbourne, Australia, Felton Bequest 359crb; National Gallery of Victoria, Melbourne, Australia, Presented through the NGV Foundation by Rio Tinto Limited 153t; National Gallery, London (On Loan) UK 148tc; National Gallery, London, UK 18br, 18tr, 22cl, 22cr, 25tr, 32bl, 34cl, 89br, 98cra, 100br, 102ca, 102cb, 103cla, 106bl, 125cr, 126bl, 128cra, 129cb, 138c, 139cr, 141cla, 149cl, 153tl, 163tr, 173bc, 175c, 176bc, 176crb, 178tr, 194cl, 196t, 199tl, 205tl, 211cla, 212tr, 213cra, 222tl, 224cb, 224crb, 226cla, 226r, 227tr, 233bc, 233br, 233cla, 234crb, 235ca, 236cla, 236crb, 242cr, 242fcr, 256b, 257cra, 258cb, 260cb, 261cb, 261cla, 263clb, 263crb, 264bc, 265bc, 271cla, 297cl (The Hay Wain), 302crb, 314ca, 316c, 317tc, 317tr, 360cr, 363c, 378cbl, 546cra, 546crb, 546tr; National Gallery, London, UK, 317tl, 348-349bc, 352br, 375ca; National Gallery, London, UK, Photo © Christie's Images 23tl; National Museum and Gallery of Wales, Cardiff, © DACS London 2008 409bl; National Museum and Gallery of Wales, Cardiff 18tl, 152br, 227bl, 259tl, 449ftl; National Museum of Ancient Art, Lisbon, Portugal, Giraudon 150cla; National Museum of Art of Romania, Bucharest, Romania, Lauros / Giraudon 41tr; National Museum of India, New Delhi, India 75bl, 293cra; National Museum of Iran, Tehran, Iran 45fbr; National Museum of Ireland, Dublin, Ireland 69crb; National Museum of Ireland, Dublin, Ireland, Photo © Boltin Picture Library 71bc; National Museum of Karachi, Karachi, Pakistan, Giraudon 50bl; National Palace Museum, Taipei, Taiwan 79crb, 260bc; National Trust of Scotland, Fyvie Castle Coll., Scotland 253clb; Nationalgalerie, Berlin, Germany, © DACS London 2008 480bc; Nationalgalerie, Berlin, Germany, Giraudon 154cb; Nationalgalerie, SMPK, Berlin, Germany 273crb; Nationalgalerie, SMPK, Berlin, Germany / Wolfgang Neeb © DACS, London 2008 556br; Nationalmuseet, Copenhagen, Denmark, Ancient Art and Architecture Collection Ltd. 68br; Nationalmuseum, Stockholm, Sweden 17bl, 273clb, 389bl, 389cra; Nationalmuseum, Stockholm, Sweden, 273cra; Naturhistorisches Museum, Vienna, Austria, Ali Meyer 40bl; Nazca, Ica, Peru, Bildarchiv Steffens 81clb; Nelson-Atkins Museum of Art, Kansas City, US. / Lauros / Giraudon, © DACS London/VAGA, New York 535tr; Neue Pinakothek, Munich, Germany 18cl, 33cla; Neue Residenz, Bamberg, Germany, Lauros / Giraudon 139tl; New Walk Museum, Leicester City Museum Service, UK, 334bl; New Walk Museum, Leicester City, Museum Service, UK. © DACS London 2008 409clb; Nezu Art Museum, Tokyo, Japan, 286cl; Niedersachsisches Landesmuseum, Hanover, Germany 430tr; Norton Simon Collection, Pasadena, CA, US, 208cra; Norwich Castle Museum and Art Gallery 563t; Nottingham City Museums and Galleries (Nottingham Castle), 259c; Ny Carlsberg Glyptotek, Copenhagen, Denmark 373br; Oeffentliche Kunstsammlung, Basel, Switzerland 411bl; On Loan to the Hamburg Kunsthalle, Hamburg, Germany 386cl, 532cra, 533crb, 545bc, 545br; Onze Lieve Vrouwkerk, Antwerp Cathedral, Belgium 194cr (Rubens), 224cra; Oriental Museum, Durham University, UK 281fcr, 284clb; Orsanmichele, Florence, Italy 97bl; Osaka City Museum, Osaka, Japan, Giraudon 79bl; Osaka Museum of Fine Arts, Japan 281c, 282ca; Osterreichische Galerie Belvedere, Vienna, Austria 243c, 251bl, 329tc, 410tl; Osterreichische Nationalbibliothek, Vienna, Austria, Alinari 442bc; Osterreichische Galerie, Vienna, Austria 315ca; Ottobeuren, Germany, Bildarchiv Steffens 242tc; Ouro Preto, Minas Gerais, Brazil, Hugh O'Shaughnessy 223br; Palacio Nacional, Mexico City, Mexico, Sean Sprague/Mexicolore, © 2008, Banco de Mexico Diego Rivera and Frida Kahlo Museums Trust, Mexico DF / DACS London 496fcr, 497cra, 497tr; Palazzo Altemps, Rome, Italy, Alinari 52crb; Palazzo Barberini, Rome, Italy 204r; Palazzo del Te, Mantua, Italy 176br; Palazzo Ducale, Mantua, Italy 106br, 106crb; Palazzo Ducale, Urbino, Italy 179cb; Palazzo Ducale, Venice, Italy 255crb; Palazzo Ducale, Venice, Italy, Cameraphoto Arte Venezia 139cl, 155cla; Palazzo Farnese, Rome, Italy 196cla; Palazzo Medici-Riccardi, Florence, Italy 99cr, 99crb, 104cla; Palazzo Pitti, Florence, Italy 122cla, 152t, 203cla; Palazzo Pitti, Florence, Italy, Alinari 120tr, 510cra; Palazzo Pubblico, Siena, Italy 83cra, 83tr; Palazzo Pubblico, Siena, Italy, Alinari 85cra; Palazzo Vecchio (Palazzo della Signoria) Florence, Italy 178bl; Pallant House Gallery, Chichester, UK / Wilson Loan / © Peter Blake. Licensed by DACS 2008 534br; Paris, France, Giraudon 336tr, 394t; Paris, France, Lauros / Giraudon 180cra; Peale Museum, Philadelphia, PA, US 280cla; Peggy Guggenheim Foundation, Venice, Italy, © ADAGP, Paris and DACS, London 2008 471bl, 471fr, 471c, 471cr, 478bl, 478br; Peggy Guggenheim Foundation, Venice, Italy, © ARS, NY and DACS, London 2008 503br, 503tr; Peggy Guggenheim Foundation, Venice, Italy, © Succession Miro/ADAGP, Paris and DACS, London 2008 472tr; Pennsylvania Academy of the Fine Arts, Philadelphia, US 278crb, 280tr; People's Republic of China, Lauros / Giraudon 51t; Persepolis, Iran 42fcr, 45cr; Petit Palais, Geneva, Switzerland 360br; Petworth House, Sussex, UK 241cla; Philadelphia Museum of Art, Pennsylvania, PA, US 350br, 361fcr, 368-369cb; Philadelphia Museum of Art, Pennsylvania, PA, US, © Salvador Dali, Gala-Salvador Dali Foundation, DACS, London 2008 475t; Philadelphia Museum of Art, Pennsylvania, PA, US, © Succession Marcel Duchamp/ADAGP, Paris and DACS, London 2008 467bl, 467cb; Philadelphia Museum of Art, Pennsylvania, PA, US, Peter Willi 355cr; Phillips Collection, Washington DC, US 341cr, 351t; Phillips Collection, Washington DC, US. © DACS London 2008 209ca; Phoenix Art Museum, Arizona, US. © 2008, Banco de Mexico Diego Rivera & Frida Kahlo Museums Trust, Mexico DF / DACS London 499tr; Phoenix Art Museum, Arizona, US, Bequest of the Estate of Hugh Homer. © ADAGP, Paris and DACS, London 2008 550cr; Phoenix Art Museum, Houston, Arizona, US, Gift of Mrs N A Bogdan, NY, in memory of Mr Louis Cates 457tr; Photo © Boltin Picture Library 527tl; Piazza della Signoria, Florence, Italy 97tr; Piazza Navona, Rome, Italy 194tc, 201bl; Piazza San Pietro, Rome, Italy 201bc; Pinacoteca di Brera, Milan, Italy 126ca; Pinacoteca di Brera, Milan, Italy, Alinari 197ar; Pinacoteca Nazionale, Bologna, Italy, Alinari 197br, 197cr; Pinacoteca, Sansepolcro, Italy 174cla; Pisa Cathedral, Italy 82bc, 82cb, 84bc, 84cb; Place de la Concorde, Paris, France 249br; Plaza Mayor, Madrid, Spain, Giraudon 187br; Polesden Lacey, Great Bookham, Surrey, UK, 265br; Polonnaruwa, Sri Lanka 74t; Prado, Madrid, Spain 15bl, 22bc, 25br, 56br, 92br, 93t, 130tc, 131crb, 138cl, 146b, 158-159, 160cl, 160cra, 160-161, 161bc, 161bl, 161cla, 161cr, 161crb, 182tr, 207tr, 216cra, 218bl, 221tr, 240cra, 296c, 302cl, 302clb, 303, 303crb; Prado, Madrid, Spain, 32; Prado, Madrid, Spain, Giraudon 19cla, 19cra, 52c, 99cl, 141tr, 154cla, 157t, 165tr, 169br, 195cr, 208cb, 216tl, 222bl, 302bc; Prado, Madrid, Spain, Index 56crb, 137bl, 156bl, 222tl; Private Collection 14clb, 15bl, 19crb, 20br, 20clb, 21cl, 23cra, 26bl, 26cla, 26clb, 27br, 28br, 28cra, 29bl, 29cb, 29ftr, 33br, 34bc, 57c, 96t, 106tl, 107tl, 116crb, 119cra, 130tl, 151tr, 152bl, 171cra, 172bc, 172bl, 173ftr, 241tl, 248bl, 248br, 252clb, 258cra, 261crb, 263tl, 264cr, 265tl, 275br, 275cla, 277cra, 278clb, 301tr, 313tl, 324c, 325fcbr, 329clb, 332tc, 337br, 339br, 353cl, 353fclb, 354tl, 362cb, 366fcla, 366ftr, 370br, 382fcr, 387tl, 408crb, 409tl, 411bc, 411br, 412, 413br, 424bc, 427bc, 429tl, 430tl, 443ca, 443crb, 446br, 448cra, 450fclb, 450ftl, 451clb, 451tl, 460r, 462bc, 489clb, 489tc, 495tl, 511tc, 523bl, 525cla, 528cb, 544tl, 546cb, 548bl, 566cl, 566clb, 566cra, 566tl, 569tc, 571, 571bl, 571br, 574t, 576clb, 579cla; Private Collection © Succession Picasso/DACS London 2008 424tl; Private Collection / © Alan Cristea, Gallery, London, © The Estate of Patrick Caulfield. All rights reserved, DACS 2008 209crb; Private Collection / © Crane Kalman, London, © SODRAC, Montreal and DACS, London 2008 515bl; Private Collection / © Crane Kalman, London, © SODRAC, Montreal and DACS, London 2008 427bl; Private Collection / Giraudon, © DACS London 2008 498bl; Private Collection / James Goodman Gallery, New York, US. © ADAGP, Paris and DACS, London 2008 574cr; Private Collection / James Goodman Gallery, New York, US. © The Joseph and Robert Cornell Memorial Foundation/DACS, London/VAGA, New York 2008 555cla; Private Collection / Lauros / Giraudon © ADAGP, Paris and DACS, London 2008 516bl, 517cb; Private Collection / Lauros / Giraudon © ARS, NY and DACS, London 2008 503tl; Private Collection / Marlena Eleini © ARS, NY and DACS, London 2008 527t; Private Collection / Peter Willi. © ADAGP, Paris and DACS, London 2008 494bc, 494clb, 518clb; Private Collection © DACS London 2008 518ftr; Private Collection / Phillips, Fine Art Auctioneers, New York, US/ © DACS London 2008 473tr; Private Collection / Photo © Bonhams, London, UK, © 2008 Andy Warhol Foundation for the Visual Arts / Artists Rights Society (ARS), New York / DACS, London 2008 543cr; Private Collection / Photo © Christie's Images, © ADAGP, Paris and DACS, London 2008 381tl; Private Collection / Photo © Christie's Images, © DACS London 2008 479bc, 521cra; Private Collection © Held Collection, © ADAGP, Paris and DACS, London 2008 548bl, 548fcl, 549cra; Private Collection / Photo © Lefevre Fine Art Ltd, London, © ADAGP, Paris and DACS, London 2008 517tl; Private Collection /Dreamtime Gallery, London © DACS London 2008 586bc, 586bl; Private Collection, 258cla, 259tr, 264clb, 371tl, 387c, 393bc, 408bc; Private Collection. © 2008 Andy Warhol Foundation for the Visual Arts / Artists Rights Society (ARS), New York / DACS, London 2008 543tc; Private Collection. © Agnew's, London, UK / 313bl; Private Collection. © ARS, NY and DACS, London 2008 491bl, 514br; Private Collection. © Barford Sculptures Ltd 523bl; Private Collection. © Calder Foundation, New York / DACS London 2008 31cla; Private Collection. © Chris Beetles, London. U.K. 26ca; Private Collection. © Christian Schad Stiftung Aschaffenburg/VG Bild-Kunst, Bonn and DACS, London 2008 480br; Private Collection. © Connaught Brown, London 516cr, 520br; Private Collection. © DACS 14br, 502cr, 533cr, 533fcl; Private Collection. © DACS /Giraudon 385cra; Private Collection / Index 490br; Private Collection. © DACS /Peter Willi 21cr, 361c, 362cla; Private Collection. © DACS /Photo © Bonhams, London, UK 33bl; Private Collection. © DACS London 2008 10tr, 385br, 469fcra, 470fcl, 473br; Private Collection. © Estate of David Smith/DACS, London/VAGA, New York 2008 514bl, 514ca; Private Collection. © Estate of Francis Bacon/DACS London 2008 563crb; Private Collection. © Hattula Moholy-Nagy/DACS London 2008 483cla; Private Collection. © Jasper Johns / VAGA, New York / DACS, London 2008 538tr, 539bc, 539tr; Private Collection. © Michael Graham-Stewart 456bc; Private Collection. © Philip Mould Ltd, London 226tl, 241crb, 241tc; Private Collection. © Piano Nobile Fine Paintings, London 534tr; Private Collection. © SODRAC, Montreal and DACS, London 2008 515tc; Private Collection. © The Estate of Roy Lichtenstein/DACS London 2008 541c; Private Collection, © The Fine Art Society, London, UK 28ca, 371cra, 451tr; Private Collection. © The Heartfield Community of Heirs/VG Bild-Kunst, Bonn and DACS, London 2008 469bl, 469br; Private Collection. / Marlena Eleini © ARS, NY and DACS, London 2008 523fcr; Private

Collection, Alinari 102tl, 197tc, 204tl, 206clb; Private Collection, Ancient Art and Architecture Collection Ltd. 40cla; Private Collection, Archives Charmet 239fcra, 269cr, 338t, 340br, 342tl, 360t, 362tl, 417tl, 420bl, 432br, 441tr, 470t; Private Collection, Copyright Richard Lond 2008 553clb; Private Collection, Courtesy of Simon Gillespie Studio, London 449tr; Private Collection, Courtesy of the Procter Estate 371crb; Private Collection, Courtesy of Thomas Brod and Patrick Pilkington 21br; Private Collection, Elizabeth Harvey-Lee 393fclb; Private Collection, Giraudon 15cra, 123tl, 197cla, 336cl; Private Collection, Ian Mursell/Mexicolore 496cl, 497crb; Private Collection, Index 217t, 302cra, 303cra; Private Collection, James Goodman Gallery, US 568tc, 569clb; Private Collection, Johnny Van Haeften Ltd., London 240cla; Private Collection, Ken Welsh 112tl, 118tl, 124tl, 199br; Private Collection, London, UK / Peter Willi 411tl; Private Collection, Lucien Herve 458cl; Private Collection, Munch Museum/Munch - Ellingsen Group, BONO, Oslo/DACS, London 2008 415blur; Private Collection, Peter Newark American Pictures 499bl; Private Collection, Peter Willi 262cla, 362br, 386bl; Private Collection, Photo © Bonhams, London UK 25bl, 35br, 250br, 285t, 300bl, 442ftr, 477tr; Private Collection, Photo © Christie's Images 5crb, 26fcr, 31br, 179bl, 186clb, 186cr, 186fcr, 187br, 187cla, 187cra, 224tl, 227cdb, 253br, 260clb, 260cra, 264bl, 266fcr, 279fbr, 281fcr (chicken), 284br, 337cl, 354bl, 386br, 389cb, 454tc, 496cr, 498br, 498cra, 498fcra, 569cla; Private Collection, Photo © Crane Kalman Gallery, London, UK 57crb; Private Collection, Photo © Heini Schneebeli 41l, 54tc, 128fbr; Private Collection, Photo © Held Collection 208clb, 397fcla; Private Collection, Photo © Lefevre Fine Art Ltd, London 544cla; Private Collection, Photo © Lefevre Fine Art Ltd., London 328ca, 337bl, 426c, 511bc, 547crb; Private Collection, Photo © Rafael Valls Gallery, London, UK 510tr; Private Collection, Roger-Viollet, Paris 328tr, 330tc, 350bl, 403tl, 418tl, 435tfl, 459tl, 474tr, 494tl, 573br; Private Collection, The Stapleton Collection 105br, 138t, 142tl, 148br, 156tc, 162tl, 213tl, 280cb, 312tl, 325tr, 335tl, 354tr, 382br, 387bc, 387fclb, 447tl, 471tl; Private Collection, The Stapleton Collection, © DACS London 2008 469cra; Private Collection, Wolfgang Neeb 485br; Private Collection/Giraudon, © ADAGP, Paris and DACS, London 2008 406bl; Pushkin Museum, Moscow, Russia 17br, 26tr, 57clb, 330cr, 340tc; Pushkin Museum, Moscow, Russia / Giraudon, © Succession Picasso/DACS London 2008 547ccb; Pushkin Museum, Moscow, Russia, Giraudon 20fclb, 214clb, 411tc; R.S.A, London, UK, 264cla; Rasmus Meyers Samlinger, Bergen, Norway, © DACS 17cra; Rasmus Meyers Samlinger, Bergen, Norway, © Munch Musem/Munch - Ellingsen Group, BONO, Oslo/DACS, London 2008 390tr; Rasmus Meyers Samlinger, Bergen, Norway, © Munch Museum/Munch - Ellingsen Group, BONO, Oslo/DACS, London 2008 315crb; Residanz, Wurzburg, Germany, 243fclb; Residanz, Wurzburg, Germany, Lauros / Giraudon 254-255; Rijksmuseum, Amsterdam, The Netherlands 195fcl, 229br, 231fbl, 237br, 314br; Royal Academy of Arts, London, UK 262tl; Royal College of Art, London, UK 27crb; Royal Geographical Society, London, UK 457br; Royal Holloway and Bedford New College, Surrey, UK 334br; Royal Holloway, University of London, 335ca; Royal Pavilion, Libraries & Museums, Brighton & Hove 232bl; Royal Society of Arts, London, UK, 241br; Ruskin Museum, Coniston, Cumbria, UK, 333br; Russian State Library, Moscow, Russia, © DACS London 2008 464bl; Saatchi Collection, London, UK, © 2008 Andy Warhol Foundation / DACS, London. Trademarks, Campbell Soup Company. All rights reserved 542cl; Saatchi Collection, London, UK, © 2008 Andy Warhol Foundation for the Visual Arts / Artists Rights Society (ARS), New York / DACS, London 543tl; Saatchi Collection, London, UK 533cl; Samuel Collection, City of London 235cb; Samuel Courtauld Trust, Courtauld Institute of Art Gallery 10clb, 141b, 155tr, 341fcl, 342-343ca, 351bl, 363bc, 375bc; San Diego Museum of Art, US, Gift of Anne R. and Amy Putnam 216crb; San Diego Museum of Art, US, Gift of the Baldwin M. Baldwin Foundation 27ca; San Francesco, Arezzo, Italy 92cr; San Francesco, Arezzo, Italy, 100tc; San Francesco, Lower Church, Assisi, Italy 87br; San Giorgio Maggiore, Venice, Italy, Camerapholo Arte Venezia 136c; San Giovanni, Siena, Italy 97bc; San Lorenzo, Florence, Italy 180bl; San Michele Visdomini, Florence, Italy 177br; San Paolo Maggiore, Bologna, Italy 201cr; San Petronio, Bologna, Italy, Alinari 95tr; San Pietro in Montorio, Rome, Italy 123br; San Pietro in Vincoli, Rome, Italy, Alinari 118cl; San Vitale, Ravenna, Italy 65cl, 65cr; Sant' Anastasia, Verona, Italy, Alinari 88crb; Sant'Alvise, Venice, Italy 255t; Sant'Apollinare Nuovo, Ravenna, Italy, Giraudon 64cb; Santa Maria del Popolo, Rome, Italy 198tr; Santa Maria della Grazie, Milan, Italy 114-115, 116cra, 116fcr, 117clb, 117crb, 117tr; Santa Maria della Vittoria, Rome, Italy 200crb; Santa Maria della Vittoria, Rome, Italy, Alinari 200t; Santa Maria Gloriosa dei Frari, Venice, Italy, Giraudon 131l; Santa Maria Maddalena dei Pazzi, Florence, Italy 104crb; Santa Maria Novella, Florence, Italy 86bc, 92cl, 96tr, 105bl, 105c; Sant Luca e Martina, Rome, Italy 204tr; Santo Spirito, Agrigento, Italy, Alinari 252cla; Sarnath, Uttar Pradesh, India 50br; Schloss Charlottenburg, Berlin, Germany, © Foundation Oskar Kokoschka / 2008 DACS 412bl; Schloss Charlottenburg, Berlin, Germany, Giraudon 244ca; Schloss Sanssouci, Potsdam, Brandenburg, Germany, Alinari 23bl; School of Oriental & African Studies Library, Uni. of London 547tl; Schroeder House, built in 1923-24 (photo), Rietveld, Gerrit (1888-1964) / Utrecht, Netherlands 434t; Scottish National Gallery of Modern Art, Edinburgh, UK 153ca, 574bl; Scottish National Gallery of Modern Art, Edinburgh, UK, © ADAGP, Paris and DACS, London 2008 381cla, 466bl; Scottish National Portrait Gallery, Edinburgh, Scotland 311tl; Scottish Portrait Gallery, Edinburgh, Scotland, 259br, 265ca; Scrovegni (Arena) Chapel, Padua, Italy 86bl, 86tl, 86-87, 87bc, 87bl; Scrovegni (Arena) Chapel, Padua, Italy, Alinari 86tc; Scrovegni (Arena) Chapel, Padua, Italy, Alinari 24br, 32cla; Scrovegni (Arena) Chapel, Padua, Italy, GGiraudon 82br; Scrovegni (Arena) Chapel, Padua, Italy, Giraudon 84br; Scuola di San Giorgio degli Schiavoni, Venice, Italy, Giraudon 260tr; Sheffield Galleries and Museums Trust, UK 443br; Skagens Museum, Denmark 388br; Society of Antiquaries of London, UK 164tl; Solomon R Guggenheim Museum, New York, US 460clb; Solomon R Guggenheim Museum, New York, US / Lauros / Giraudon, © Estate of Francis Bacon/DACS 2008 363bl; Solomon R. Guggenheim Museum, New York, US / Lauros / Giraudon, © DACS London 2008 484-485; Southampton City Art Gallery, Hampshire, UK 153crb, 490t, 582bl; Southampton City Art Gallery, Hampshire, UK 485br; Sean Sprague/Mexicolore / © DACS 497bc; St Nicholas' Church, Art Museum of Estonia, Tallinn, Estonia 174bl; St. Bavo Cathedral, Ghent, Belgium, Giraudon 142b; St. Peter's, Louvain, Belgium, Giraudon 149cra; St. Peter's, Vatican, Rome, Italy 118fcl, 200tr, 207bc; St. Petersburg, Russia, Lauros / Giraudon 249tr; St. Sebastiano, Venice, Italy 137cra; St. Wolfgang, Austria 167bc; St. Wolfgang, Austria, Interfoto 167bl; St.Martin, Colmar, France, Lauros / Giraudon 167tc; Staatliche Gemaldegalerie, Berlin, Germany 164br, 207br, 212tl, 236clb; Staatliche Kunstsammlungen Dresden 537cr; Staatliche Museen, Berlin, Germany 310clb; Staatliche Museen, Berlin, Germany, Photo © Held Collection 54b; Staatsgalerie, Stuttgart, Germany 483bc; Staatsgalerie, Stuttgart, Germany, © DACS London 2008 481crb; Stadtische Galerie im Lenbachhaus, Munich, Germany / Peter Willi, © ADAGP, Paris and DACS, London 2008 31cb; Stadtische Galerie im Lenbachhaus, Munich, Germany, Interfoto 261tc; Stadtische Kunsthalle, Mannheim 488tr; Stadtmuseum, Munich, Germany / Giraudon © DACS London 2008 410tr; State Art Gallery, Tchelyabinsk, Russia 464tl; State Russian Museum, St Petersburg, Russia, © DACS London 2008 464br; State Russian Museum, St. Petersburg, Russia 324br, 331ca, 434fcr, 440cra, 440tl; State Russian Museum, St. Petersburg, Russia, 331br, 331clb, 393tc; State Russian Museum, St. Petersburg, Russia, © ADAGP, Paris and DACS, London 2008 433cra; State Russian Museum, St. Petersburg, Russia, © DACS 511cb; State Russian Museum, St. Petersburg, Russia, Giraudon 331c; State Russian Museum, St. Petersburg, Russia, RIA Novosti 440br; Statens Sjohistoriska Museum, Stockholm, Sweden 29tr; Stedelijk Museum "de Lakenhal", Leiden, The Netherlands 155crb; Stedelijk Museum, Amsterdam, Netherlands 440cclb; Stedelijk Museum, Ostend, Belgium / Lauros / Giraudon, © DACS London 2008 385br; Stiftsmuseum, Klosterneuburg, Austria 251br; Sto Tome, Toledo, Spain 182t; Sun Temple, Konark, Orissa, India, Dinodia 75tc; Tarquinia, Lazio, Italy, Giraudon 59br; Tassili N'Ajjer, or Djanet, Algeria, Photo © Held Collection 39cb; Temple of Borobudur, Central Java, Indonesia 76bl, 76br; Temple of the Jaguar, Tikal, Guatemala 81tc; Teotihuacan, Valley of Mexico, Mexico, Sean Sprague/Mexicolore 80t; Terme Museum, Rome, Italy 61br; The Barber Institute of Fine Arts, University of Birmingham 263ca, 392br; The Barber Institute of Fine Arts, University of Birmingham, 383clb; The Barnes Foundation, Merion, Pennsylvania, US 335br; The Board of Trinity College, Dublin, Ireland 9clb, 70, 71cla, 71clb (materials); The Bowes Museum, Barnard Castle, County Durham, UK 247bc; The Chrysler Building, New York, US 452tc; The Crown Estate 320bc; The Dayton Art Institute, Dayton, Ohio, US, Gift of Mr and Mrs Harry S Price, Jr. 262r; The Detroit Institute of Arts, US, Bequest of Eleanor Clay Ford 104cra; The Detroit Institute of Arts, US, Founders Society Purchase 322bl; The Detroit Institute of Arts, US, Founders Society purchase and Julius H. Haass fund 164cr; The Detroit Institute of Arts, US, Founders Society purchase with Mr and Mrs Bert L. Smokler 296cl, 313cra; The Detroit Institute of Arts, US, Founders Society purchase, Dexter M. Ferry Jr. Fund 279tr; The Detroit Institute of Arts, US, Founders Society Purchase, Dr & Mrs Hilbert H DeLawter Fund 524bl; The Detroit Institute of Arts, US, Founders Society purchase, General Membership Fund 8crb, 42cr, 45cl, 452bc; The Detroit Institute of Arts, US, Founders Society purchase, Mr and Mrs Edgar B. Whitcomb fund 185br; The Detroit Institute of Arts, US, Founders Society Purchase, R.H. Tannahill Foundation fund 278bl; The Detroit Institute of Arts, US, Founders Society purchase, W. Hawkins Ferry fund 23cr; The Detroit Institute of Arts, US, Gift of Dexter M. Ferry Jr 392cr; The Detroit Institute of Arts, US, Purchased with the Lizzie Merrill Palmer Fund 452br; The Illustrated London News Picture Library, London, UK, 393cb; The Maas Gallery, London, UK 335br; The Potteries Museum and Art Gallery, Stoke-on-Trent, UK 446c, 447bc; The Putnam Foundation, Timken Museum of Art, San Diego, US 148cla; The Trustees of the Chester Beatty Library, Dublin 72bl, 291bl; The Trustees of the Chester Beatty Library, Dublin, 289fcrb; Thorvaldsens Museum, Copenhagen, Denmark 273bc; Thyssen-Bornemisza Collection, Madrid, Spain 105tr; Thyssen-Bornemisza Collection, Madrid, Spain, © Salvador Dali, Gala-Salvador Dali Foundation, DACS, London 2008 474br; Tokyo Fuji Art Museum, Tokyo, Japan 205br, 338bl; Tokyo National Museum, Japan 188bc, 188bl; Tokyo National University of Fine Arts, Tokyo, Japan, Giraudon 188tc; Toledo, S.Tome, Spain 183bl; Toledo, S.Tome, Spain, Giraudon 175fcr, 183l; Tomb of Qin shi Huang Di, Xianyang, China, Bildarchiv Steffens 50t, 51bl; Topkapi Palace Museum, Istanbul, Turkey, Giraudon 288br; Tretyakov Gallery, Moscow, Russia 65bl, 331tl, 393c, 393cr, 462bl; Tretyakov Gallery, Moscow, Russia 311cra, 434bl; Tretyakov Gallery, Moscow, Russia, © ADAGP, Paris and DACS, London 2008 433crb; Tretyakov Gallery, Moscow, Russia, RIA Novosti 331cr; Trinita, Florence, Italy 105tl; Trinity College, Cambridge, UK 264tr; Trivandrum, Kerala, India, Dinodia 292t; UCL Art Collections, University College London, UK 273tl; Uluru National Park, Northern Territory, Australia 586tr; United Distillers and Vintners 261bl, 335tc; University of California, San Francisco, CA, US, Index, © 2008, Banco de Mexico Diego Rivera & Frida Kahlo Museums Trust, Mexico DF / DACS London 497cla; University of Liverpool Art Gallery & Collections, UK 276crb; van Haeften Gallery, London, UK 32cb; Vatican Museums and Galleries, Vatican City, Italy 8bl, 61tr, 118-119, 119br, 202tc, 203cr; Vatican Museums and Galleries, Vatican City, Italy, Alinari 55bl; Vatican Museums and Galleries, Vatican City, Italy, Giraudon 93c, 120c; Vatican Museums and Galleries, Vatican City, Italy, Lauros / Giraudon 52fcr, 58c; Victoria & Albert Museum, London, UK 14cla, 18bc, 257fcra, 276t, 287cra, 290l, 293tr, 296fcr, 315bl, 316bc, 316tl, 316tr, 335tr, 338br, 339bl, 339tr, 382t, 451cb, 546bl; Victoria & Albert Museum, London, UK 267crb, 313br; Victoria & Albert Museum, London, UK, © Trustees of the Paolozzi Foundation, Licensed by DACS 2008 522bl; Victoria & Albert Museum, London, UK, The Stapleton Collection 314crb; Victoria Art Gallery, Bath and North East Somerset Council 265clb, 443bl; Viking Ship Museum, Oslo, Norway 88bc; Villa dei Misteri, Pompeii, Italy, Giraudon 60bl; Villa Farnese, Caprarola, Lazio, Italy 179br; Villa Farnesina, Rome, Italy 121tr; Villeneuve-les-Avignon (Hospice), Anjou, France, Giraudon 150tr; Wakefield Museums and Galleries, West Yorkshire, Uk 488ca; Walker Art Gallery, National Museums Liverpool 129bc, 212c, 275tl, 483bl; Walker Art Gallery, National Museums Liverpool, 195cl; Wallace Collection, London, UK 194fcr, 228r, 233cra, 234cra, 235bl, 236bc, 243cla, 314cclb; Wallace Collection, London, UK 243cr, 246crb, 328fcr; Wallraf Richartz Museum, Cologne, Germany 56fcrb, 243fcl, 245bl; Wallraf-Richartz Museum, Cologne, Germany 329bl; Walters Art Museum, Baltimore, US 77br, 337cr; White House, Washington D. C., US 322tr; Whitney Museum of American Art, New York, US, © Jasper Johns / VAGA, New York / DACS, London 2008 538-539; Whitworth Art Gallery, The University of Manchester 454crb; Whitworth Art Gallery, The University of Manchester, UK 27bl, 277tl, 296cl, 448tc; Whitworth Art Gallery, The University of Manchester, UK, 312cr, 387cl; Wien Museum Karlsplatz, Vienna, Austria 329crb, 412cr, 413cla, 413tr; Wieskirche, Wies, Germany 250t; Wilberforce House, Hull City Museums and Art Galleries, UK 311bc; Wilhelm Lehmbruck Museum, Duisburg, Germany, © Foundation Oskar Kokoschka / 2008 DACS 371cb; Wilhelm-Hack-Museum, Ludwigshafen am Rhein, Lauros / Giraudon, © 2008 Mondrian/Holtzman Trust, c/o HCR International Warrenton, Virginia, US 445; Wolseley Fine Arts, London, UK 448fcl; Wolverhampton Art Gallery, West Midlands, UK © DACS, London/VAGA New York 2008 545tc; Worcester Art Museum, Massachusetts, US 16bl, 235crb; Yale Center for British Art, New Haven, US 19ca; Yale Center for British Art, Paul Mellon Collection, US 20cb, 152crb, 241cb, 257bl, 258bl, 264tc, 275bl, 275cra, 276bc, 277tr, 290tl; Yale Center for British Art, Paul Mellon Collection, US 246bc, 301cr; Yale Center for British Art, Paul Mellon Fund, US 273clb, 544bl; York Museums Trust (York Art Gallery), UK 31clb; **The Trustees of the British Museum:** 74bc, 74br, 281cl, 282bl, 284cra; © DACS, London 2008 552cb; **Buren Studio:** © ADAGP, Paris and DACS, London 2008 561cca; **C.A.A.C. - The Pigozzi Collection, Geneva:** Patrick Gries © Chéri Samba 591br; **Cass Sculpture Foundation:** 584cla, 585ftr; **Courtesy Cheim & Read, Galerie Karsten Greve, and Hauser & Wirth:** Photo: Rafael Lobato 573clb; ChinaFotoPress: 79br, 79tr; **Christie's Images Ltd:** 457bc; © DACS/AAA/VISCOPY 2008 587bl; © **Christo:** Wolfgang Volz 551fcr, 552bc, 552cra; **The Cleveland Museum Of Art:** Andrew R and Martha Holden Jennings Fund, 1964.43 186cl; Purchase from the J H Wade Fund, 1959.46 187bl; **Collection Dia Art Foundation:** Photo: John Cliett. © Dia Art Foundation 554tr; **Collection Walker Art Center, Minneapolis:** Formerly the collection of Otto Preminger, New York, Gift by exchange of Elizabeth Goldring, Massachusetts, 1998; **Collection Walker Art Center:** Gift of T B Walker Acquisition Fund, 1992 580bl; **Collection: Flemish Community on loan to SMAK:** Photography: Dirk Pauwels, 560cl; **Corbis:** Malcolm Lubliner, © Jasper Johns / VAGA, New York / DACS, London 2008 27cra; 311crb; Paul Almasy 518tr;

BBC 29cla; Bettmann 410tl, 457tl, 480tc, 494br; Rudolph Burckhardt/Sygma © ARS New York and DACS London 2008 506tc; Burstein Collection, © 2008 Mondrian/Holtzman Trust, c/o HCR International Warrenton, Virginia, US 444br; Philippe Caron/Sygma 554clb; Christopher Felver 525tc, 532clb; Christopher Felver © Gerhard Richter 588cl; Rune Hellestad 582tl; E O Hoppé 431br; Hulton-Deutsch Collection 458t, 551clb; Malcolm Lubliner 538tl; Francis G. Mayer 107bl, 151l; Chema Moya/EFE 590tc; National Gallery Collection; By kind permission of the Trustees of the National Gallery, London 171bl; Eric Preau/Sygma 548tr; Steve Schapiro 543br; Richard Schulman 567tl; Roland Weihrauch 575tl; Oscar White 492tc; **Anthony d'Offay, London:** 585fclu; **Daros Collection, Switzerland:** 572bl; **Dean and Chapter of Westminster:** 273tc; **Des Moines Art Center, Iowa:** 564, 565bl, 565cl, 565cla, 565clb, 565cr, 565rl, 565tr; **The Detroit Institute Of Arts:** Founders Society Purchase, Eleanor Clay Ford Fund for African Art. Photograph © 1998 The Detroit Institute Of Arts 396fcr; **DK Images:** Judith Miller / Jo De Buck 399fcra; Judith Miller / JYP Tribal Art 398tc; Judith Miller / Kevin Conru 399cca; Judith Miller / Philip Keith Collection 398bl, 399tl, 399fcla; Judith Miller / William Jamieson Tribal Art 398btr, 398cb, 399bc, 399br, 399ftr; Penguin Books 545crb; **DNP Archives.com:** 188br, 286tr; **The English Heritage Photo Library:** Kenwood House, London, UK/ The Iveagh Bequest 230, 231cla, 231cla, 231cr, 231fclb, 231tra, 231tr, 231tr; **Ferens Art Gallery: Hull Museums & Art Gallery:** © Trustees of the Paolozzi Foundation, Licensed by DACS 2008 522crb; **Figge Art Museum:** 456br; © **Fondazione La Biennale di Venezia - ASAC:** Photo: Giorgio Zucchiatti 566br; Photo: Giorgio Zucchiatti, © DACS London 2008 561bl; Frac Bourgogne: © ADAGP, Paris and DACS, London 2008 562cr; **Courtesy Gagosian Gallery:** © Pino Pascali 556clb; **Gagosian Gallery:** © Rachel Whiteread. Courtesy of Gagosian Gallery. Photo credit: Sue Omerod 582cb; **Galerie Loft:** © Liu Xiaodong 593br; **Getty Images:** 486tc, 535tl, 563clb, 584tc; AFP 576tl; Ray Fisher / Time Life Pictures 540tc; John Jonas Gruen 531tc; Lionel Healing / AFP 591crb; Hulton Archive 428t; © DACS London 2008 558tt; Ben Martin/Time Life Pictures 512tl; ND/Roger Viollet 402t; Barbara Sax / AFP 569bl; Frank Scherschel/Time Life Pictures 503bc; Art Shay / Time Life Pictures 529br; Time Life Pictures 556tc; © **Gilbert & George:** 578t, 579tr; **Gladstone Gallery, New York:** © Shirin Neshat 592bc; **Andy Goldsworthy:** 524br, 554ftr; **Harvard University Art Museums:** Fogg Art Museum, Anonymous Gift and the Kate, Maurice R and Melvin R Seiden Special Purchase Fund in honour of Philip A and Lyn Straus, 1997.2. Photo: Imaging Department © President and Fellows of Harvard College 25tl; **Courtesy Haunch of Venison:** 551c, 553cra; Copyright Richard Long 2008 551bl; **Reproduced by permission of the Henry Moore Foundation:** 29br, 29crb, 488b, 488tl; **Courtesy of the Herbert F. Johnson Museum of Art, Cornell University:** George and Mary Rockwell Collection 283cla; **Hirshhorn Museum And Sculpture Garden:** Regents Collections Acquisition Program with Matching Funds from the Jerome L Greene, Agnes Gund, Sydney and Frances Lewis, and Leonard C Yaseen Purchase Fund, 1989 573cla; **Imaginechina:** 593tl; **iStockphoto.com:** Franky De Meyer 165fbr; Stephan Hoerold 179tr; David Iliff 182bl; **James Cohan Gallery, New York:** © Estate of Robert Smithson / DACS, London/VAGA, New York 2008 553bl; © Estate of Robert Smithson / DACS, London/VAGA, New York 2008, Collection: DIA Center for the Artists, New York / Photo: Gianfranco Gorgoni 553br; **Courtesy Jay Jopling / White Cube (London):** Courtesy Centre Pompidou, Paris / Photo: Phillipe Migeat 557fcr; © the artist 581crb; © the artist / Photo: Antony Oliver 582ca; © the artist / Photo: Prudence Cuming Associates Ltd 582cra; © the artist / Photo: Stephen White 580cb, 581bl, 583bl; © the artist / Photo: Stephen White / Courtesy Jay Jopling/White Cube (London) 581crb; **Kaikai Kiki New York LLC:** Galerie Emmanuel Perrotin © 2002 Takashi Murakami 593bc; **David King Collection:** 462t; **Konrad Fischer Galerie:** © ARS, NY and DACS, London 2008 529t; **Kunstmuseum Basel:** Gift of Raoul La Roche 1952, Photo Martin P Bühler. © ADAGP, Paris and DACS, London 2008 416c, 417cl; **Kunstmuseum Bern:** © ADAGP, Paris and DACS, London 2008. 438ca; **Kurokawa Institute of Ancient Cultures:** 79tc; **Kyoto National Museum:** 285br; **Lisson Gallery, London:** 584ca; **Louis K. Meisel Gallery:** 571cb; **Marian Goodman Gallery, New York:** 578bc, 578bl; **Marlborough Gallery, Inc.:** © DACS, London/VAGA, New York 2008 568bl; **Mary Boone Gallery, New York:** © Liu Xiaodong 593c; **Courtesy of the Artist and Metro Pictures:** 583ca, 580tc; **The Metropolitan Museum of Art:** George A. Hearn Fund, 1957 (57.92) © ARS New York and DACS London 2008 504-505, 506bc, 506c, 506cla, 506-507r; **Ministère de la Culture et de la Communication, DRAC Rhône-Alpes, Service régional d'archéologie:** 38bl; **Minneapolis Institute of Arts:** Gift of Bruce and Ruth Dayton 284br; Gift of Ruth and Bruce Dayton 281bl; **MKM Museum Küppersmühle für Moderne Kunst, Duisburg:** Sammlung Sylvia und Ulrich Ströher, © Courtesy Galerie Michael Werner 575tr; **MOCA The Museum of Contemporary Art, Los Angeles:** Courtesy of LUX 572t; © **2008 Mondrian/Holtzman Trust, c/o HCR International Warrenton, US:** 444tl; **Monika Sprüth - Philomene Magers Galerie:** Courtesy Monika Sprüth Galerie, Köln/VG Bild-Kunst, Bonn/DACS, London 2008 579cb, 579crb; **Musee Renoir - Cagnes-sur-Mer:** 34fcrb; **Museo Nacional Centro de Arte Reina Sofia, Madrid:** © Zabalaga-Leku, DACS, London 2008 522cr; © ADAGP, Paris and DACS/Picasso London 2008 421tr; **Museo Nacional Del Prado, Madrid:** 219, 220-221 (Las Meninas details), 304-305, 306-307; **Nasher Sculpture Center:** RDN and PRN Foundation, Dallas / Photographer: David Heald 450br; **National Gallery Of Australia, Canberra:** © DACS, London/VAGA, New York 2008 526tl; Purchased with the assistance of Tony and Carol Berg 2003, © Ron Mueck 593tc; **National Gallery, London:** 10bl, 24c, 24cr, 24cra, 24fcr, 24fcra, 32cr, 32cra, 32fcr, 33ca, 33cb, 33cl, 102br, 138fcl, 143, 144-145, 297cr, 318-319, 320-321 (The Fighting Temeraire), 388bl; Victoria and Albert Museum, London, UK 97cla; **Nationalmuseet (National Museum Of Denmark):** 41cra; **Newspix Archive/Nationwide News:** Leon Mead © The Estate of Clifford Possum Tjapaltjarri licensed by DACS/AAA/VISCOPY 2008 587tl; **North Carolina Museum of Art, Raleigh:** Purchased with funds from the State of North Carolina, © Andrew Wyeth 567cla; **October Gallery:** © El Anatsui 590br; **Old Holland Classic Colours since 1664 www.oldholland.com +31 343-518224:** 33cra; © Dennis Oppenheim: 554tl; **PA Photos:** Horst Ossinger/DPA 594cl; **The Phillips Collection, Washington, DC:** 524tr; **Private Collection:** **Private Collection, UK:** © Jack Vettriano, courtesy the artist, www.jackvettriano.com 569bc; **Projeto Helio Oiticica:** Cesar Oiticica Filho 549br; **Quattrone fine art photographers, Florence:** © Antonio Quattrone 116cla; **Peter Randall-Page:** Photo: Ben Foster 585bl; **Réunion des Musées Nationaux Agence Photographique:** © CNAC/MNAM, Dist. RMN © Adam Rzepka 575bl; © Photo CNAC/MNAM, Dist. RMN - © Jacqueline Hyde, © ADAGP, Paris and DACS, London 2008 548fcr, 549; © Photo CNAC/MNAM, Dist. RMN - © Peter Willi, © ADAGP, Paris and DACS, London 2008 550tl; Jean-Gilles Berizzi / Paris, Musée du Quai Branly © Warmun Art Centre / Jane Yalunga 537br; Musée Guimet, Paris, Dist RMN - ©Ghislain Vanneste 282cla; © Photo CNAC/MNAM, Dist RMN / © Philippe Migeat - © ADAGP / Paris and DACS, London 2008 426tr; © Photo CNAC/MNAM, Dist. RMN / © Droits réservés - © ADAGP, Paris and DACS, London 2008 516fcr, 520bl; © Photo CNAC/MNAM, Dist. RMN / © Droits réservés - © L&M Services B.V. The Hague 20080305 432cr; Photo CNAC / MNAM, Dist. RMN - © Philippe Migeat, © DACS, London 2008 495r; Photo CNAC / MNAM, Dist. RMN - © Philippe Migeat, © DACS, London 2008 517tr; Photo CNAC/MNAM, Dist. RMN / © Philippe Migeat 502fcr, 515tr (1962), 562bl; Photo CNAC / MNAM, Dist. RMN - ©Philippe Migeat, © DACS London 2008 490cl; Photo CNAC/MNAM, Dist. RMN / © Georges Meguerditchian/ © ADAGP, Paris and DACS, London 2008 517tr; Photo CNAC/MNAM, Dist. RMN / Philippe Migeat © Samuel Fosso 591cra; Photo RMN / © Michele Bellot 556cla; RMN / ©Michel Urtado 281fcl, 282cra; Reuters: 119bl; **Rex Features:** Tony Kyriacou / © DACS London 2008 557crb; Charles Sturge 589tl; **Rheinisches Bildarchiv Köln:** 574cl, 575, 575crb; **Royal Museum of Fine Arts of Belgium, Brussels:** © ADAGP, Paris and DACS, London 2008 519tr, 521br; **The Royal Museum for Central Africa:** 396fbl; **The Saatchi Gallery, London:** © Jules de Balincourt 594tc; © Jimmie Durham 595c; **San Francisco Museum of Modern Art:** Bequest of Jacqueline Marie Onslow Ford, © ADAGP, Paris and DACS, London 2008 479clb; **Photo Scala, Florence:** © 2008. Digital Image, The Museum of Modern Art, New York, © Cader Foundation, New York / DACS London 2008 489bc; © 2008. Digital Image, The Museum of Modern Art, New York, © 1998 Kate Rothko Prizel © Christopher Rothko ARS, NY and DACS, London 2008 512bl, 512br, 512cl; © 2008. Digital Image, The Museum of Modern Art, New York, © The Willem de Kooning Foundation, New York/ ARS, NY and DACS, London 2008 509cra; 254tl, 314bc, 408t; Photo Art Resource/Scala, Florence 492ca; © 2006. BI, © ADAGP, Paris and DACS, London 2008 459tc; Biblioteca Marcelliana 198tl; © 2008. Digital Image, The Museum of Modern Art, New York 410br, 430c, 479tl, 557cr, 561cla, 581cra, 595bl; © 2008. Digital Image, The Museum of Modern Art, New York, © Succession H Matisse/DACS 2008 57ca; Digital image, The Museum of Modern Art, New York, © DACS London 2008 474bl; © 2007. Image copyright The Metropolitan Museum of Art/Art Resource, © ADAGP, Paris and DACS, London 2008 508br; Musee du quai Branly, photo Patrick Gries/Bruno Descoings 397cra, 397tr; Musee du quai Branly, photo Patrick Gries/Valérie Torre; 396bl; Musee National d'Art Moderne, Centre Pompidou, Paris, © L&M Services B.V. The Hague 20080305 428br; © 2008. Digital Image, The Museum of Modern Art, New York, © Andrew Wyeth 567clb; © 2008. Digital Image, The Museum of Modern Art, New York, © ARS, NY and DACS London 2008 561br; © 2008. Digital Image, The Museum of Modern Art, New York, © ARS, NY and DACS, London 2008 513bl, 527b, 532bc, 557cl, 560cra; © 2008. Digital Image, The Museum of Modern Art, New York, © Estate of Stuart Davis/DACS, London/VAGA, New York 2008 410cla, 429ca, 468ca, 509cr; © 2008. Digital Image, The Museum of Modern Art, New York, © Salvador Dali, Gala-Salvador Dali Foundation, DACS, London/VAGA, New York 2008 489cla; © 2008. Digital Image, The Museum of Modern Art, New York, © Barford Sculptures Ltd / © 2008. Digital Image, The Museum of Modern Art, New York 528cra; Acquisition made possible through the extraordinary efforts of George and Zinaida Costakis, and through the Nate B and Frances Spingold, Matthew H and Erna Futter, and Enid A Haupt Funds. 1986. © 2008. Digital image, The Museum of Modern Art, New York. © DACS London 2008 464tr; New York, Museum of Modern Art (MoMA). Given anonymously. 346.1963.31. © 2008. Digital image, The Museum of Modern Art, New York. © DACS London/VAGA, New York 535br; The Museum of Modern Art Archives, New York. Acc. n: IN7579 548t; New York Metropolitan Museum of Art, Alfred Stieglitz Collection, 1949. Inv. 49.59.1. © 2007. Image copyright The Metropolitan Museum of Art/Art Resource/Scala/Florence 453tc; The Newark Museum/Art Resource 395bc; A E Gallatin Collection, 1952. Acc.n.: 1952-61-72. © 2007. Photo The Philadelphia Museum of Art/Art Resource/Scala, Florence 465bl; © 2008. Photo Smithsonian American Art Museum/Art Resource, © DACS, London/VAGA New York 2008 525cr; The Metropolitan Museum of Art/Art Resource 283crb, 396br, 396tr, 397crb, 397t; **Science Ltd (London):** © the artist 261cra; **Peter Sharrock:** 77cla, 77t; **The Solomon R. Guggenheim, New York:** Photograph by Erika Barahona Ede, © _ARS, NY and DACS, London 2008 532br; Gift, The Jerry and Emily Spiegel Family Foundation, 2007 574c, 576cla; Partial gift of the artist, 1989, © ARS, New York and DACS, London 2008 572br; Solomon P Guggenheim Founding Collection, Gift, Solomon R Guggenheim © L&M Services B.V. The Hague 20080305 432tr; **Sonnabend Gallery:** 557t; Courtesy Sonnabend Collection © DACS, London/VAGA New York 536, 537bl, 537br, 537c, 537ca, 537cla, 537cra, 537tr; South African National Gallery: Iziko Museums of Cape Town / Cecil Kortjie © Jane Alexander 591cra; **The State Hermitage Museum, St. Petersburg:** Photograph © The State Hermitage Museum 266cl, 274cla; **Steve Strike:** 39tr; © **Succession H Matisse/DACS 2008:** 404, 405bl, 405bc, 405ca, 405cb, 405cl, 405cra, 405fclb, 405ftr, 405tl; **Tate, London:** © 2008 Andy Warhol Foundation for the Visual Arts / Artists Rights Society (ARS), New York / DACS, London 543fcra; © 2008 Andy Warhol Foundation for the Visual Arts / Artists Rights Society (ARS), New York / DACS, London 542-543, 543cra; 11fbr, 311st, 315t, 332crb, 410bl, 446cl, 446t, 447tr, 448bl, 448br, 450bc, 450cla, 451ca, 489cra, 522tl, 523t, 547st, 548c, 550bc, 550br, 551t, 569crb, 581cla, 584tr; © ADAGP, Paris and DACS, London 2008 441bc, 459bl, 461tr, 463br, 522tc, 549bc; Bowness, Hepworth Estate 487b, 487tl, 487tr; © Doris Salcedo 585br, 585fbr; © Estate of Walter R Sickert/DACS 2008 447bc; © Calder Foundation, New York / DACS London 2008 489crb; © Christo 551t © _Dedalus Foundation, Inc./DACS, London/VAGA New York 2008 515br; © Judd Foundation. Licensed by VAGA, New York/DACS, London 2008 530bl, 530br; © Donation Jorn, Silkeborg/DACS/2008 521tc; © L&M Services B.V. The Hague 20080305 428tl, 432bc; © DACS London 2008 558b; © DACS London 2008 528bl; © DACS, London/VAGA New York 2008 526bl, 531cla, 531clb, 533clb, 576cra; © Luc Tuymans 589bl; © ARS New York and DACS London 2008 509clb; © ARS, New York and DACS, London 2008 11tr, 513bc, 515bc, 531bc, 531r; © ARS, NY and DACS, London 2008 503cla, 530cla, 560crb; © Estate of Gwen John. All Rights Reserved, DACS, London 2008 449cl; Presented by E J Power through the Friends of the Tate Gallery, EK 166, © Ellsworth Kelly 523cl, 526tr; © Salvador Dali, Gala-Salvador Dali Foundation, DACS, London 2008 473cl; © DACS, London 2008 © Succession Picasso/DACS London 2008 420tr; © the Artist, courtesy Sadie Coles HQ, London 595cr; © The Estate of L S Lowry 2008 495clb; The works of Naum Gabo © Nina Williams 463tl; © Angela Verren Taunt 2009. All rights reserved, DACS 486bc, 486bl; **Through the Flower:** © ARS, New York and DACS, London 2008 573cra, 573crb; **Victoria Miro Gallery, London:** Courtesy Contemporary Fine Arts, Berlin, © Chris Ofili 582br; Ota Fine Arts, Tokyo © Yayoi Kusama 594cr; **Waddington Galleries:** Photo: Prudence Cuming Associates, London 585cra; **Werner Forman Archive:** 68t; **Courtesy Sperone Westwater, New York:** 570; Courtesy the artist and Sperone Westwater, New York / Collection Musee d'Art Moderne et Contemporain de Strasbourg 570crb; **Whitechapel Art Gallery, Whitechapel Archives:** Photo: Martin Koretz 523tc; **Whitney Museum Of American Art, New York:** Gift of Gertrude Vanderbilt Whitney 31.159 491br; Purchase 54.15. © Estate of David Smith/DACS London/VAGA, New York 2008 514cla; Purchase, with funds from the Louis and Bessie Adler Foundation, Inc., James Block, The Sondra and Charles Gilman, Jr Foundation, Inc., Penny and Mike Winton, and the Painting and Sculpture Committee 89.6 529bc; **Courtesy Xu Bing Studio:** 593bl

All other images © **Dorling Kindersley** For further information see: **www.dkimages.com**

Jacket image: akg-images: The Kiss, Gustave Klimt/Erich Lessing Postcards